3/95

The Renaissance Print

The Renaissance Print

1470–1550

David Landau and Peter Parshall

YALE UNIVERSITY PRESS
NEW HAVEN AND LONDON
1994

Designed by Faith Brabenec Hart
Set in Linotron Plantin by Best-set Typesetter Limited, Hong Kong
Printed by C.S. Graphics, Singapore

Library of Congress Cataloging-in-Publication Data

Landau, David.
 The Renaissance print: ca. 1470–1550 / David Landau and Peter
Parshall.
 p. cm.
 Includes bibliographical references and index.
 ISBN 0-300-05739-3
 1. Prints, Renaissance. 2. Prints—15th century. 3. Prints—16th
century. I. Parshall, Peter W. II. Title.
NE441.5.R44L35 1993
769.94'09'024—dc20 93-5682
 CIP

Preface

THE HISTORY OF the print in western Europe is a story that has been told many times. Although there are innumerable points of detail which have not been, and may never be, satisfactorily resolved, it is not our intent to offer a new account of its origins. Rather, we set forth and conclude our study *in medias res*, concentrating mainly on the period between about 1470 and 1550, the critical stage in the maturation of early printmaking as an art form. Our approach is broadly based, opening with the material and institutional circumstances surrounding print production, and then proceeding to examine workshop practices including technical and aesthetic experimentation undertaken by particular masters. Our eventual aim is to give a better approximation of the ways Renaissance prints of various sorts were realized, distributed, acquired, and eventually handled by their public. In order to do so, we have valued certain aspects of this development that are given much less attention in the standard histories of Renaissance art. Since this study makes no pretense to offering a survey of its subject, we have been highly selective in our choice of topics, artists, and regions, sometimes giving little attention to important matters that have been closely studied elsewhere. We aspire to cast a broad light on the realities that rendered the new medium such a remarkable success within so few generations after its start.

Our purpose here is to examine the history of the print in its first maturity, when printmaking came to be adopted by well-recognized masters, and so to offer a fuller context for understanding the Renaissance print as an artistic achievement. We shall concern ourselves on the one hand with a range of practical questions about production — what were the materials used, where and how were they acquired? In short, how did a Renaissance printmaker's workshop operate? Then we shall examine the nature of these prints in relation to their probable markets. What evidence is there that individual prints were beginning to be valued as works of art rather than as inexpensive substitutes for them, or as objects of interest primarily for devotional or practical ends? What is the relationship between prints made to be collected and those of a more ephemeral nature intended for a wider

audience? How should we understand the perception of the value of prints during our period — the material worth and also the relative value of woodcuts to engravings, or engravings to etchings? How did prints evolve in relation to the pictorial arts of the Renaissance generally? In particular, how did prints develop alongside the theory and practice of painting, and how and when did the phenomenon of the reproductive print actually arise? What were the particular developments in print production and print reception that opened the way for the appearance of the sixteenth-century publishing houses? To what extent did the print revolutionize the transfer of knowledge in the early modern world?

We approach this complex of questions along two principal avenues — the gathering of documentary evidence of all kinds directly and indirectly pertinent to print production, distribution, and reception; and a careful examination of particular prints and specific impressions by certain masters in order to discover the clues they themselves yield about all of these matters. Our objective on both counts is not to provide a comprehensive picture of the period, but to offer a context for re-evaluating the achievements of what is historically the most influential era in the history of European printmaking. Because the archival documentation relevant to printmaking is widely scattered and very scarce — relative, for example, to the history of book printing — we have had to cast a wide geographical net in gathering our material. Though we have committed substantial time to archival research for this study, the majority of the sources martialed here have been previously published by others. We have concentrated our efforts mainly on the accumulation and assessment of this mine of disparate material never before assembled and analyzed.

Given the desire to provide a kind of "ground level" account of the Renaissance print rather than a rehearsal of artists' biographies and their masterpieces, we have often given emphasis to less well known figures and less ordinary kinds of prints. Thus, in an attempt to characterize the spectrum of graphic production we grant more space to Israhel van Meckenem than to Martin Schongauer. The detailed evolution of Marcantonio Raimondi's

Roman prints takes precedence over Parmigianino's renowned contribution to the history of etching, and the intricacies of the invention of chiaroscuro woodcut in the north outweighs the attention given to the activity of the young Dürer. We concentrate on what seem to be exemplary developments in the major centers of print production — principally the activities of printmakers in Antwerp, Augsburg, Florence, Nuremberg, and Venice. Though the study is laden with references to the history of the book and to book illustration, in general we have not entered directly into this crucial aspect of early printmaking as a problem in itself on the grounds that it properly merits separate treatment. Moreover, the individual, single-leaf print has a technical evolution and an aesthetic history with a place of its own in the annals of evaluating, collecting, and displaying objects.

An important objective of this study is to try to lay out a patch of common ground between two different, if not discrete, perspectives on the history of prints. On the one side, there is the direct kind of experience of prints most fully achieved by the curators of major collections, and also by dealers and private collectors, a point of view only partly represented in catalogues and in censuses of particular and collected works. In the normal course of their profession, these scholars encounter an extraordinary range of quality and individual variation that much more closely approximates the reality of Renaissance print production with all of its accidents, its wonderful inanities, and its endless varieties than anything we might glean from the standard histories of the subject.

On the other side, there are those historians whose first concern has been to synthesize, to discover over-arching patterns, to elucidate social context, or to trace the principal outlines of a period, an iconographic theme, or an artisanal specialty. Alongside art historians whose primary purpose has been to chart the development of styles and iconography, and for whom prints have often been of secondary concern, in recent years we have witnessed a resurgence of social history. There, for obvious reasons, the phenomenon of the print has taken on a new and quite special significance. And yet for this latest generation of historians it is very often the practical and material knowledge of printmaking, precisely the sort that requires an expertise typically commanded by curatorial scholars, that has proven most important and most difficult to acquire. Although the traditional divide between these two perspectives is a logical consequence of the setting within which scholars work and the particular responsibilities required of them, it is well to remember that curators of the stature of Campbell Dodgson, A. M. Hind, and William Ivins, Jr., rank among the most informed and expansive cultural historians of our century.

In short, we have found the need expressed among all parties for a history which is built more firmly upon the practical aspects of printmaking — not just technical matters, but institutional and commercial ones as well where these help to explain the extraordinary artistic achievements of the Renaissance print. To meet this end, we have drawn upon a great variety of sources, often very difficult of access, and constructed a history of the print with very different lineaments than anything presently to be found in the literature on this vast subject. It is a history that throws previous assumptions into doubt as often as it attempts to construct new understandings. It is a history that is intentionally fragmentary, dictated by concentrations of evidence in very uneven terrain. Though at many points our discussion becomes quite technical and detailed, we hope not to have lost the forest for the trees. It is our intention to provide a resource of value to a wide audience — generalists in Renaissance studies, historians of technology, art historians and specialists in the history of the print, artists, curators, and collectors alike. In undertaking such an ambitious task, it should be clear that we regard our efforts as a foundation, and in this sense as preliminary. We have attempted to map the terrain in a history that better describes the interplay of technique, style, and meaning in the context of a market and an audience, and thereby to provide a more integrated view of the Renaissance print as a social and artistic enterprise.

* * *

This book is the consequence of a collaboration begun by two colleagues and completed by two friends. It represents well over a decade of joint research and the free exchange of ideas, a pleasurable effort that has at last been drawn together in a common argument. Those already familiar with the field of Renaissance print studies will recognize that the historiography of this general subject varies greatly north and south of the Alps. The centrality of print production has long been acknowledged in the scholarship on German and Netherlandish art, whereas, for a complex of reasons, research on Italian printmaking has only recently gained a mature and prominent place in Renaissance art history. Moreover, given the important distinctions in the nature of artistic self-consciousness and the way this affected artistic developments in Italy and in northern Europe, different sorts of questions need to be posed and oftentimes different strategies found to answer them. Because of these disparities, and because of the exceptional demands presented by a project of this scope, we decided early on that our subject was best approached by apportioning it along geographical lines. As a result David Landau wrote the entirety of Chapter IV, and the sections on Italy in Chapters III, VI, and VII. Peter Parshall wrote the

brief introductory chapter and Chapters II and V, as well as the sections on northern Europe in Chapters III, VI, and VII.

The very many colleagues and friends who have helped us to complete this project can hardly be repaid for their efforts. But first and foremost we are grateful to David Freedberg. It was he who, on a fateful day in 1980, introduced us to one another at the Tate Gallery, London, and, as our fields of research naturally overlapped, suggested that we consider working together. His steady encouragement and warm friendship have been a constant point of reference during these years of preparation.

Jan Piet Filedt Kok offered personal and professional support from its very beginning, and in the last stages of writing he kindly agreed to read through the entire manuscript and offer his suggestions. We have done our best to address them, and, although we do not pretend to meet his standard of scholarship, this book should be taken as a testimony to Jan Piet's generosity of spirit. Throughout an exceptional career as an historian and curator of prints he continues to demonstrate by his own example that scholarship is best conducted as a communal enterprise.

To Antony Griffiths, Keeper of the British Museum print room, we owe a debt that is equally difficult to describe: both as a friend and as a professional adviser, his role has been fundamental throughout. He too agreed to read a draft of the manuscript, contributed much important material, and saved us from a number of blunders. To him we are also immensely grateful. Indeed, this study could not have been entertained without the full support of the staff of the British Museum print room. What we have enjoyed over the years, however, has been much more than that, and so we wish to acknowledge the patience, courtesy, and efficiency of all who have endured our frequent visits, particularly Andrew Clary, Hilary Williams, and Ben Johnson. A very special tribute goes to Paul Dove, who undertook the arduous task of filling a complicated and very long photographic order, with many requests for special favors and many last-minute and still more last-second changes of mind. It is largely due to his kindness and efficiency that the illustrations to this book are what they are.

Of equal importance to the project were the staff and resources of the Warburg Institute, London. Among those many members of the Institute who have given us help, special mention is due here to Elizabeth McGrath for invaluable points of assistance, and for her tremendous patience in obtaining many of the photographs for illustration. In addition we should like to thank Jennifer Montagu, former curator of the photographic collection, and also John Perkins who proved ready to solve one vexing bibliographical dilemma after another.

In addition, we would like to mention the following institutions that have substantially furthered our research in various ways: the Rijksmuseum and print cabinet in Amsterdam, the Kupferstichkabinett, the Staatsbibliothek, and the Kunstbibliothek in Berlin, the British Library in London, the J. Paul Getty Museum in Malibu, the Zentralinstitut für Kunstgeschichte and the Staatliche Graphische Sammlung in Munich, the Metropolitan Museum of Art in New York, and the Graphische Sammlung Albertina in Vienna.

Yale University Press and the authors would like to thank the Samuel H. Kress Foundation for a generous grant given to help defray expenses for illustrating the book.

Among those great many individuals to whom we owe additional thanks are: Clifford Ackley, Frank Auerbach, Michael Baxandall, Suzanne Boorsch, Antonio Brancati, Asa Briggs, Michael Bury, Barbara Butts, Ulf Cederlöf, Charles Choffet, Alessandra Corti, Keith Christiansen, Peter Day, Gianvittorio Dillon, Rudolf Distelberger, Peter Dreyer, Alexander Dückers, David Ekserdjian, Marzia Faietti, Tilman Falk, Sylvia Ferino, Richard S. Field, Henry and Felicity Fisher, Michael Gaunt, Jane Glaubinger, Richard Harprath, Craig Hartley, Carlos van Hasselt, Lee Hendrix, Christian von Heusinger, Lesley Hill, Charles Hope, Michael Jacobsen, Pierrette Jean-Richard, Jan Johnson, Thomas da Costa Kaufmann, Wouter Kloek, Joseph Koerner, Fritz Koreny, Renate Kroll, Eva Küster, Gisèle Lambert, Erika Langmuir, Ger Luijten, Elizabeth Lunning, Margery Mason, James Marrow, Jane Martineau, Jean Michel Massing, Ahmet Menteš, Hans Mielke, Keith Moxey, Konrad Oberhuber, Friederike Paetzold, Nicholas Penny, Jane Peters, Maxime Préaud, Cristiana Romalli, Andrew Robison, John Rowlands, Werner Schade, Chris Schuckman, Larry Silver, Ad Stijnman, Julien Stock, Alan Stone, Laura Suffield, Charles Talbot, Martha Tedeschi, Jan van der Waals, Umberto del Vedovo, Thea Vignau-Wilberg, Robert Williams, Nancy Yocco, and Henri Zerner.

Yale University Press has been extraordinarily cooperative in carrying our manuscript efficiently through to its final printing. John Nicoll has most graciously accommodated our many aspirations, and he has been especially generous in the provision for its illustration and format. Over the several years since our preliminary discussions, he has remained unfailingly patient with our progress. Faith Hart edited and designed the book for the Press, carrying it through its crucial stages with the love and attention of a true professional and a dear friend. Not only was she kind enough to host us during the final stages in preparing the layout, she managed to maintain her serenity through many requests for last minute changes. Bill and Luke Hart also deserve a vote of thanks for their patience while we were driving Faith mad.

Lastly, for her cheerfulness and reliability in helping us with many details in preparing the final typescript and checking the proofs, for her assistance in compiling the index, and for having performed innumerable other thankless tasks with accuracy and efficiency, we express our fond gratitude to Jennifer Peterson Amie.

David Landau owes an enormous debt to Joseph and Ruth Bromberg: as the first Michael Bromberg Fellow at Wolfson College, Oxford, in 1978 he was given the chance to devote himself to the history of art, particularly to the history of prints, thus sowing the seeds for his contribution to this book. He sees in its publication a personal homage to their generosity in endowing the Fellowship, and a tribute to their warm friendship, which he enjoyed for many years. He would equally like to acknowledge the help of Christie's: as the first Christie's Fellow in Renaissance Studies at Worcester College, Oxford, in 1981 he was able to continue his research in Italian and German printmaking without impediment. The award of a four-month scholarship by the German Academic Exchange Service further enabled him to study the prints of a number of German public and private collections, where many of the observations that appear in this work were first noted down. The continuous support and encouragement of the Provost and Fellows of Worcester College deserve to be made public and thanked here. This debt goes hand in hand with the constant and precious advice of Francis and Larissa Haskell, who merit a special tribute of their own for their ready and warm hospitality over many years. So do the members of staff of the Ashmolean Museum's print room, who shared their desks with him for five years — particularly David Brown, Jon Whiteley, Ian Lowe, and Christopher Lloyd — and the two Directors, David Piper and Christopher White, who, in such different ways, were so helpful to him. No one, however, endured the preparation of this book as generously as Simi Bedford, who saw any hopes for a normal life, let alone holidays, constantly dashed by the unremittingly slow process of bringing it together. She put up with all this with a smile; in it David found the strength to bring the book to completion.

Peter Parshall's exploration of this subject really began during his two-year tenure as a Samuel H. Kress Foundation research fellow at the Warburg Institute from 1969 to 1971, the initiation of a sustained and invaluable dependency on this matchless library and photographic archive. Over many years the former Directors, Sir Ernst Gombrich and Joseph Trapp, made the Institute a home abroad and a place of encouragement for this and other projects. In addition, his research has benefited from the support of the National Endowment for the Humanities, the Center for Advanced Study in the Visual Arts at the National Gallery of Art in Washington, D.C., and the Howard H. Vollum Fund at Reed College. Reed College deserves particular thanks for its generous provision of clerical and financial help, and especially for its willingness to accommodate periodic leaves of absence for research and writing, and for repeated assistance with travel and library resources. Even more importantly, the College has provided him a haven for asking difficult questions in a congenial but ever-challenging setting for more than twenty years, throughout which time Charles Rhyne has been a model colleague and a steady reminder of what good scholarship is about. In a myriad of essential if often intangible ways this book is also, and very importantly, indebted to several generations of Reed College students who have shown themselves ready to engage those perennial problems that make the history of art such a pleasurable and practicing discipline. Peter's final and most inexpressible thanks go to his dear wife, Linda, who more than anyone else has helped to shepherd the project through to completion. The shape and content of this book reflect her contribution at every level: as an informal editor, as a linguist and a stylist, a measure of cogency and general good sense, as a faithful guardian of morale, but most of all as a patient and perfect companion.

Photographic Acknowledgments

Public Collections:

Amsterdam,
Rijksmuseum: 1, 43, 230, 231, 249, 301, 305, 315, 343, 345, 346, 357, 370
University Library: 261

Augsburg, Augsburg Stadtarchiv: 263, 264

Austin, Harry Ransom Humanities Research Center, University of Texas at Austin: 232

Basel, Öffentliche Kunstsammlung: 29, 194, 224, 349, 358

Berlin,
Staatliche Museen zu Berlin — Kupferstichkabinett: 22, 24, 35, 189, 190, 204, 222, 223, 233, 244, 269
Staatsbibliothek, Preussischer Kulturbesitz: 254, 257, 259, 260, 262, 265

Bern,
Kunstmuseum: 7
Universität Bern, Botanische Institut: 256

Besançon, Musée des Beaux-Arts: 167

Bologna, Pinacoteca Nazionale: 281

Boston, Courtesy of Museum of Fine Arts: 53, 1931 Purchase Fund; 65, Stephen Bullard Memorial Fund; 133, 183, Bequest of William P. Babcock; 280, Katherine Bullard Fund; 342, Harvey D. Parker Collection

Braunschweig, Herzog Anton Ulrich-Museum: 186

Budapest, Szépmüvészeti Múzeum, Budapest: 120

Cambridge, England, © Fitzwilliam Museum: 199, 286, 288

Cambridge, Massachusetts, courtesy of the Fogg Art Museum, Harvard University Art Museums: 63

Chicago,
Courtesy of The Art Institute of Chicago © 1992 All Rights Reserved: 21, Clarence Buckingham Collection, 1972.1; 54, Mr. and Mrs. Potter Palmer Collection, 1950.1673; 354, Hugh Dunbar Memorial Fund; John H. Wrenn Memorial Collection, 1953.531
Newberry Library: 196

Cincinnati, Ohio, Cincinnati Art Museum: 23, Bequest of Herbert Greer French

Cleveland, The Cleveland Museum of Art: 56, Purchase from the J. H. Wade Fund, 67.127; 109, Gift of Leonard C. Hanna, Jr., 24.532; 116, 211, 268, John L. Severance Fund, 52.66–69; 290, 292, Delia E. Holden Fund, 58.313, 58.314

Coburg, Kunstsammlungen Veste Coburg: 339, 373

Dresden,
Kupferstichkabinett: 203
Staatliche Kunstsammlungen: 320

Florence, Uffizi: 69, 122, 168, 169, 285, 289, 294, 295, 299

Hamburg, Kunsthalle: 73, 74, 75, 97, 98, 334, 378

Istanbul, Saray Museum: 84, 86

Karlsruhe, Kunsthalle: 226

London,
The British Library, Map Library: 246
By permission of the Trustees of the British Museum: 2, 4, 5, 12, 18, 19, 31, 46, 50, 61, 64, 67, 68, 70, 71, 72, 77, 80, 81, 88, 91, 92, 95, 96, 101, 106, 107, 108, 117, 118, 125, 132, 135, 137, 138, 144, 145, 147, 152, 154, 155, 162, 171, 174, 182, 184, 188, 195, 205, 206, 208, 209, 228, 229, 235, 242, 255, 267, 270, 271, 276, 277, 283, 284, 309, 330, 351, 365, 367, 368, 369, 374, 379
Courtauld Institute Galleries: 273
Warburg Institute, © University of London: 27, 30, 32, 44, 60, 89, 111, 112, 113, 115, 121, 128, 129, 131, 134, 136, 139, 140, 141, 142, 150, 151, 158, 161, 170, 175, 177, 179, 180, 181, 185, 200, 202, 212, 213, 214, 215, 221, 237, 240, 272, 302, 303, 304, 306, 310, 311, 314, 316, 321, 323, 325, 326, 327, 328, 333, 335, 337, 338, 344, 348, 350, 353, 356, 359, 360, 361, 362, 364, 371, 372, 376, 380, 381, 382, 383

Malibu, J. Paul Getty Museum: 366

Minneapolis, Courtesy of the James Ford Bell Library, University of Minnesota: 247

Munich,
Bayerische Staatsbibliothek: 248
Staatliche Graphische Sammlung: 103, 192, 201, 216, 217, 347

New York,
 Metropolitan Museum of Art: 49, Purchase, Rogers Fund and Elisha Whittelsey Collection, Elisha Whittelsey Fund, 1986 (1986.1159); 62, Harris Brisbane Dick Fund, 1928 (28.97.108); 159, Rogers Fund, 1922 (22.73.3–11); 160, Rogers Fund, 1922 (22.73.3–27); 166, Purchase, 1917, Joseph Pulitzer Bequest (17.50.10); 274, 282, 336, Harris Brisbane Dick Fund, 1927 [27.78.1 (leaf 7)], 1938 (38.27), 1926 (26.64.7); 308, Elisha Whittelsey Collection, Elisha Whittelsey Fund, 1949 (49.95.11); 355, Rogers Fund, 1917 (17.72.14)
 Pierpont Morgan Library: 10, PML 20588; 11, PML 19745; 250, 251, PML 20602; 252, 253, PML 25978

Nuremberg,
 Germanisches Nationalmuseum: 191
 Stadtbibliothek: 16

Oxford, © Ashmolean Museum: 28, 187, 193, 197, 198, 210, 227, 236, 238, 241, 332

Paris,
 Bibliothèque Nationale: 90, 104, 324
 Ecole Nationale Supérieure des Beaux-Arts: 99, 341
 Fondation Custodia (Coll. F. Lugt), Institut Néerlandais: 297, 363
 Louvre, Cabinet des Dessins: 110, 266, 298
 Petit Palais: 340

Pesaro, Biblioteca Oliveriana: 82, 83

Portland, Oregon, Multnomah County Library: 15

Providence, Rhode Island, Museum of Art, Rhode Island School of Design: 258, Gift of Mrs. Brockholst Smith in memory of her mother, Jane W. Bradley

Ravenna, Biblioteca Classense: 85

Siena, Pinacoteca Nazionale: 291

Stockholm, Nationalmuseum: 313

The Hague, Rijksmuseum Meermanno-Westreenianum: 9

Turin, Biblioteca Reale: 78

Vienna,
 Albertina: 33, 34, 45, 47, 52, 55, 57, 59, 79, 130, 143, 153, 156, 163, 164, 172, 176, 178, 245, 279, 296, 300, 312, 318, 319, 322, 329, 331, 377
 Österreichische Nationalbibliothek, Bild-Archiv: 219, 220

Washington, D.C.
 Library of Congress, 14, 293
 National Gallery of Art: 20, 36, 37, 38, 39, 40, 41, 42, 58, 100, 243, 375, Rosenwald Collection

Weimar, Graphische Sammlung: 157

Zurich, Graphik-Sammlung E.T.H.: 275

Private Collections and Dealers:

Chatsworth, Duke of Devonshire and the Chatsworth Trustees: 76 (Prudence Cuming Ass. Ltd.); 165, 287

Courtesy of the Josefowitz Collection: 102

Courtesy Julien Stock: 114

Courtesy Hill-Stone: 127, 278

Windsor, Royal Library, by Gracious Permission of H.M. Queen Elizabeth II: 119, 123, 124, 307

Photographers:

Anderson: 317

Fratelli Alinari: 66, 173

Contents

I. Framing the Renaissance Print 1

II. Craft Guilds, Workshops, and Supplies 7
PRINTMAKERS AND THE ORGANIZED CRAFTS 7
THE PRINTMAKER'S WORKSHOP AND ITS NECESSITIES 12
PAPER: THE PRINTMAKER'S GROUND 15
BLOCKS AND PLATES: THE PRINTMAKER'S MATRIX 21
Woodblocks 21
Engraving 23
Etching 27
PRINTMAKING PRESSES 28
PRODUCTION RATES, COSTS, AND MARKET VALUE 30

III. How Prints Became Works of Art: The First Generation 33
BOOK ILLUSTRATION AND SPECIALIZATION IN THE WOODCUT TRADE 33
THE NORTH
ANTON KOBERGER'S ENTERPRISE 38
ANTON KOLB AND JACOPO DE' BARBARI: NORTHERN ENTERPRISE ABROAD 43
NORTHERN ENGRAVING AND THE INVENTIONS OF THE MASTER ES 46
MARTIN SCHONGAUER: HIS INNOVATION AND HIS IMITATORS 50
ISRAHEL VAN MECKENEM: ENTREPRENEURIAL PRINTMAKER AND PIRATE 56
EARLY TRACES OF PRINT COLLECTING 64
ITALY
THE DEVELOPMENT OF A TONAL SYSTEM 65
THE IMPRESSION AS A WORK OF ART 78
PRINTS AS COMPETITORS OF PAINTINGS 81
THE MARKET 91

IV. From Collaboration to Reproduction in Italy 103
THE EARLY YEARS 104
MARCANTONIO, AGOSTINO VENEZIANO, AND MARCO DENTE 120
Prints and Prototypes 120
The Plates 121
The Drawings 123
The Repetitions and the Copies 131
The Signatures, the Dates, and the Inscriptions 142
Conclusion 146
TITIAN, PARMIGIANINO, AND ROSSO AND THEIR COLLABORATION WITH
UGO DA CARPI, CARAGLIO, AND ANTONIO DA TRENTO 146
THE BIRTH OF THE REPRODUCTIVE PRINT 162

V. THE CULTIVATION OF THE WOODCUT IN THE NORTH 169

THE REFINEMENT OF THE SINGLE-LEAF WOODCUT: 1500–1512 169
THE FIRST MASTERS 170
COLOR PRINTING 179
ALTDORFER AND THE MINIATURE WOODCUT 202
EMPEROR MAXIMILIAN'S WOODCUT PROJECTS 206
MAXIMILIAN'S BLOCK CUTTERS THEREAFTER 211
Jost de Negker 211
Hans Lützelburger 212
Hieronymus Andreae 217
CORNER PRESSES AND THEIR PUBLIC 219
The Liefrincks and the Start of Print Publishing in Antwerp 220
Hans Guldenmund and Print Publishing in Nuremberg 223
MURAL WOODCUTS AND THEIR PROPER WALLS 231
PRINTS AND FACTS: THE SPECIALIZED MARKETS 237
Printed Maps and City Views 240
Printed Herbals and Descriptive Botany 245

VI. Artistic Experiment and the Collector's Print 260

ITALY
THE INNOVATORS AND THEIR FOLLOWERS 261
ITALIAN PRINTMAKERS: THEIR MILIEU AND THE MARKET 284
PRINT PUBLISHING IN ITALY 298
THE NORTH
NORTHERN ENGRAVING: THE REFINEMENT OF THE ART 310
ETCHING: THE FAILED EXPERIMENT 323
The Hopfers of Augsburg and the History of Iron Etching 323
Copper Etching in the Netherlands 332
Albrecht Altdorfer: Opportunity as the Mother of Invention 337
The Etched Landscape: A Print Collector's Genre 342
NORTHERN PRINTMAKERS: THEIR MILIEU AND THE MARKET 347

VII. Epilogue 359

ITALY
THE NORTH

Appendix: Currencies, Values, and Wages 369
Abbreviations 372
Notes to the Text 373
Bibliography 415
Index 429

I

Framing the Renaissance Print

AN ACCOUNT OF the origin and eclipse of the Renaissance print is best begun by qualifying the much-acclaimed invention of this art. It is important to recognize that neither the concept nor the technique of replicating images was a discovery of the period. Making a series of images by impression was, after all, as ancient as Assyrian cylinder seals and the stamping of coins. Furthermore, the basic procedures for relief and intaglio printmaking are technically and conceptually rudimentary. On the overall scale of human ingenuity, the invention of printmaking should rank somewhere below the discovery of how to make a soufflé. Yet its consequences were profound for the history of art, as indeed they were for the exchange of images and ideas in western culture generally.

However ancient the techniques of replication might be, never before had images of such extraordinary intricacy and such astonishing density of detail been successfully multiplied. It was an innovation of great consequence for Renaissance art, and not merely for practical reasons. For precisely at the time the print was being refined in its formal capacity for managing a subtle illusion with the basic elements of line, tone, and paper, a talent for draftsmanship came to be the accepted measure of artistic brilliance in European art. This not altogether fortuitous conjunction of technical and aesthetic imperatives destined the print to be swept into the mainstream of artistic invention in the Renaissance. The coincidence of its formal suitability and its potential for mechanical replication was quickly recognized by a number of exceptional masters who secured a position of extraordinary influence for the print in the history of western art. Their achievement is at the center of our investigation.

Over a short time the fundamental techniques of relief and intaglio printmaking came to be widely practiced throughout Europe. Woodblock printing had long been a familiar technique in Asia and the West, employed centuries earlier for cloth decoration in a manner not significantly different from its first application to making images on paper.[1] Woodblocks were almost certainly being printed on paper by the late fourteenth century, and given the relative simplicity of the technique, within two to three generations the practice became common throughout much of Europe. Intaglio printing from incised metal plates followed soon after, apparently undertaken in a serious way during the 1430s somewhere along the Upper Rhine region of southwestern Germany. Once again, the basis for the technique was available. The decorative inscribing of a metal surface with a stylus or a burin was a skill known to goldsmiths from a much earlier date — the burin was described already by Theophilus in the twelfth century. A fifteenth-century print of *St. Eloy*, patron of goldsmiths, shows a metalworker's shop filled with implements including the basic tools of the engraver who would have made this very image (fig. 1). The *St. Eloy* has often been taken as evidence of the close association between early engravers and precious metalsmithing.[2] Thus, like woodblock prints, engravings are usefully thought of as a technical adaptation of an older craft more than as a new invention in their own right.

The processes of relief and intaglio printmaking are, however, inherently very different. Not only are the antecedents for relief and intaglio printmaking quite separate, as techniques for transposing an image they are in important ways unrelated to one another. What both types of printmaking did have in common was not technique as such, but the objective of manufacturing a replicable image on paper. The one practical ingredient required by all printmakers was a supply of paper in sufficient quantity to make printing worthwhile. The nature and availability of paper was indeed the critical

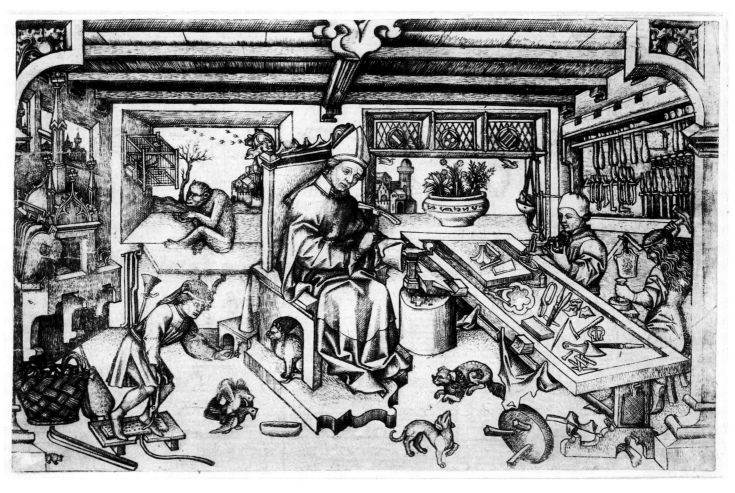

1. Master of Balaam, *St. Eloy in his Workshop*. Engraving (Holl. 15), 115 × 185 mm. Rijksmuseum, Amsterdam.

factor in bringing about the success of the new medium. Therefore, in reflecting in a general way upon the beginnings of early printmaking, we must presume that opportunity was more important than any single act of discovery. Initially it was not so much a matter of what was possible as what was practicable. But once the new medium had established its presence, the extraordinary potential of these two techniques and their particular formal proclivities were bound to have an enormous impact.

Woodcut printing in its first stages served mainly as a source of inexpensive devotional images — especially images of Christ, the Virgin and Child, and the saints. Most likely the greater percentage of these early woodcuts were designed, cut, and printed in small monastic workshops or by independent craftsmen, including playing-card makers. These craftsmen are often termed "Jesus makers" or "saint makers" in archival records. Probably they worked mainly on their own, but also sometimes at the instigation of monasteries or convents which may have taken charge of distributing the prints as well. Certainly prints were being made within cloister walls, though one should not suppose in every case where there is evidence of a connection with a religious order that this demonstrates the presence of a monastic workshop. Convents were certainly also active in print production or com-

missioning, for at least in a couple of cases there is firm evidence that a workshop was actually established on a convent's premises. We have an inventory of a convent in the Flemish town of Mechelen in the 1460s which housed some sort of press along with a set of woodblocks for printing images.[3] Holy images of the kind manufactured by these workshops were undoubtedly meant for both the religious community and its lay public (fig. 2). Votive prints were also acquired as pilgrims' souvenirs, as modest illustrations for religious books, and as pious reminders or protective talismans to be pinned up in domestic interiors or pasted down in order to decorate ecclesiastical and household furnishings.

The woodcut became intimately tied to book printing in the second half of the fifteenth century, because it was quickly adopted as the most effective means of illustrating texts being printed with movable type. This alliance had crucial implications for woodcut printmaking in several respects. First, it quickly exported knowledge of the technique across the continent and abroad. By 1480 the press had spread in less than thirty years from its birthplace in Mainz downwards along the Rhine to the Netherlands, across southern Germany into Swabia, and south over the Alpine passes into Lombardy and the Veneto. Driven by the enterprise of itin-

erant German printers, the technology of the type press moved rapidly along the chief trade routes to settle in towns and cities from the Baltic to Iberia, and from the Adriatic to England. Soon it cropped up in many outposts even further afield.[4] Shortly afterwards some form of printmaking was also being practiced in most of these regions. Book illustration further ensured that the skill required to cut subtle drawings in relief would be widely cultivated by an industry with somewhat different expectations from those that stimulated the market for inexpensive devotional imagery. Finally, the requirement of illustrating many different sorts of texts made the woodcut into an arena of iconographic innovation that it might otherwise never have achieved. In many respects the early woodcut had a history very much its own, more closely connected to the activities of illuminators and other bookmen than to intaglio printing. Given the differences in origin, in working procedure, and in milieu, it was only around 1500 that the woodcut began to realize an important kinship with the engraved print.

Exactly when the thought first occurred that designs cut into metal plates could be transferred to paper by intaglio printing we will never know for certain.[5] The fact that intaglio printmaking seems to have arisen in precisely the same region where Gutenberg introduced printing with movable type is tantalizing and suggestive. Indeed, much effort has been expended in trying to establish a common etiology for the two occurrences. Yet once again, apart from a common need for skilled metalwork,

the differences between these two procedures are more apparent than their similarities.[6] Because book printing is a relief process, it requires a press of a sort useless for printing incised plates in intaglio. Furthermore, the first generation of intaglio prints, and of woodcuts as well, were probably printed without the help of a press. To some degree we can consider the genesis of intaglio printing separately in Italy and the north. Although the earliest known intaglio prints from Italy came later than their northern counterparts, it is not safe to presume that Italians simply learned the process from German examples. In some cases this is evidently true. Yet certain of the earliest Italian engravings relied upon niello, a local technique for decorating precious metals and one not practiced widely in the north.

It is apparent that once the basic techniques of printmaking matured, the stylistic quality and range of subject matter cultivated in relief and intaglio prints differed only by degree. Doubtless such differences reflect both the ambience in which each medium was normally practiced and the audience for which each was mainly intended. Though these lines cannot be strictly drawn, they are meaningful nonetheless and are more readily apparent in the incunabulum period than afterwards. Like woodcut printmakers, engravers were widely engaged in the manufacture of devotional subjects. They also ventured into improvisations of courtly decorative themes, purely ornamental patterns, grotesque alphabets, and occasional social and literary satires as well, subjects rarely, if ever, found in early single-leaf woodcuts. These non-religious preoccupations find their closest parallel in decorated metalwork, tapestry, and other luxury items such as carved ivory mirrors and jewelry boxes. Thus, a wealthier and more urbane clientele has often been assumed for early intaglio prints in contrast to woodcuts, although it must be said that the evidence for it is entirely inferential. In addition to whatever there may have been in the way of a lay market, there were certainly also artisans looking to buy figural models or ornamental patterns to enhance the appeal of their own products. Hypotheses of this kind about audience, especially regarding the early interest in intaglio prints, are common throughout the scholarly literature on the period. From our present point of view it may seem peculiar to imagine that a cultivated merchant or nobleman might trouble to acquire a mere printed image that was at the same time in range of an artisan's humble purse. Yet we should be hesitant to reject the traditional view out of hand. As replicated images, prints could readily move through the market at adjustable rates of exchange. The fact that they were traded among artisans need not exclude their capacity to claim a better price in other circles. It must be remembered that we are not dealing with a time when a visible market set a recognized value on an object as small and ephemeral as a print.

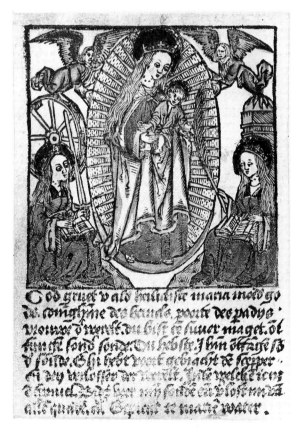

2. *Virgin and Child in Glory with St. Catherine and St. Barbara.* Woodcut, hand-colored (Schreiber 1154), image 79 × 79 mm. Printed at the Brigittine Convent of Marienwater, Netherlands. British Museum, London.

3

3. Master of the Playing Cards, *Five of Beasts*. Drypoint, undescribed, 146 × 87 mm. Private collection.

The early manufacture of prints not only for the entertainment of the leisured but for the practical needs of the artisanry is well reflected in the earliest known body of work in the history of this art — that of the Master of the Playing Cards (fig. 3). These appear to have been executed with a drypoint stylus rather than a burin and were almost certainly printed by hand-rubbing and not with a press. Because he worked in engraving, the Master of the Playing Cards was also the first to introduce tone into a print. He managed this with thin, straight parallel lines, a solution inspired by the style of drawing current among his contemporaries. The *Playing Cards* probably date from the late 1430s and have come down to us mainly in two sets of impressions, though there are in addition a vast number of copies in engraving and other media. The prolific evidence of copies made after the *Playing Cards* suggests that they achieved very wide currency in their own time. Although they were probably conceived from the outset for gaming, in the early 1450s a number of the plates were cut apart and reprinted in the manner we now mainly know them. This suggests a change in motive favoring their distribution as models for the use of illuminators and other artisans, essentially as an adjunct to workshop model-books.[7]

Prior to the last quarter of the fifteenth century, printmaking was practiced by a varied and now almost entirely anonymous group of artisans. These masters worked in a lively, often derivative, but richly fertile artistic vernacular. Perhaps it is not surprising that the earliest groups of prints that can with credibility be attributed to single hands were done in intaglio. The Master ES, active in the Rhine region, and the Florentine artists of the so-called Fine Manner developed the technical capacities of intaglio printmaking in notable ways. Under their control the skilled integration of burin and drypoint work allowed for greater nuances of pictorial rendering. The stage was set for artists of more highly refined pictorial skills to adopt intaglio, and then relief printmaking, for more aesthetically ambitious undertakings. We can see that around the 1470s the character of printmaking began to change both north and south of the Alps.

The last generation of the fifteenth century brought forth a class of printmakers still often referred to as the *peintre-graveurs* after Adam Bartsch's designation for those masters who were both painters and engravers, or, more complexly, masters who can be said to have conceived of printmaking primarily as an extension of the painter's art. It is precisely this generation — its origins, its history, and the cause of its temporary disappearance — that constitutes the principal subject of our study. Bartsch was committed to the independent importance and ultimate superiority of the autograph print, one designed by a master and explicitly intended for a medium of replication. It was Bartsch's in-

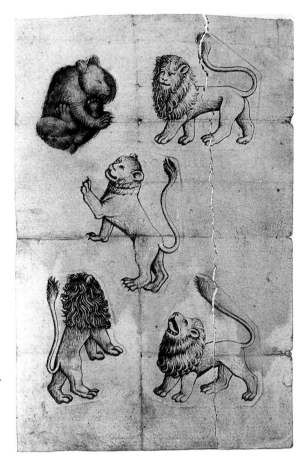

fluence and his age that eventually canonized the distinction between original and reproductive printmaking and made this distinction a qualitative as well as a functional one. But the roots of his observation lay in the actual practices (if not the prejudices) of the Renaissance, for it was in the period between 1470 and 1550 that the notion of the autonomous print as a work of art was born and fulfilled.

Two dramatic and unusually ambitious images from the 1470s illustrate the advent of the *peintre-graveurs* in a conspicuous way: Martin Schongauer's *Large Procession to Calvary* (fig. 29) and Andrea Mantegna's *Entombment* (fig. 47). Large and immensely impressive, both of these compositions signal an undeniable change in the status of prints. These objects were undoubtedly made by the artists for the sake of other artists, but almost certainly for another and perhaps even smaller public as well, a public inclined to collecting and interpreting works of art. Schongauer and Mantegna developed a style of engraving that proved highly effective in incorporating certain tonal aspects of painting and drawing, while at the same time retaining the distinctively graphic character of a print. Schongauer introduced cross-hatching along with a range of other strokes to capture subtle light effects and, more importantly, nuances of textural difference through a more extensive and complex use of the burin. Meanwhile, Mantegna translated the features

4

of a highly distinctive drawing style onto an intaglio plate, creating images of sculptural vitality and rich chiaroscuro that bear the unmistakable stamp of his experimentation in draftsmanship and in painting. In the succeeding generation Marcantonio Raimondi and Albrecht Dürer would take these achievements further and firmly establish the print as an item in the repertoire of objects to be sought by collectors.

The certainty that printmaking was beginning to attain a new status during the last quarter of the fifteenth century finds confirmation elsewhere as well. We have evidence of printmakers interested in the peculiarities of graphic technique apart from its capacity for replication, and on the other side artists setting out to exploit this practical advantage to the fullest. The Housebook Master, active between about 1470 and 1500, worked as a painter and a drypoint specialist. Given the technique, his delicately incised drypoints must have been issued in tiny editions of barely a dozen or so for a select audience, suggesting an approach to making images with line that is neither practical nor expedient.[8] His clientele could have had nothing to do with a mass market, which surely goes some way to explaining the peculiar charm and eccentricity of his imagery. The Housebook Master's immediate audience may have been as exclusive as that of any court painter at the time, and yet, like the works of court painters, his prints were transmitted through copies and imitations to artists and patrons beyond his own circle. The goldsmith and printmaker Israhel van Meckenem, on the other hand, was engaged in an expedient form of printmaking on a much more ambitious level than were those craftsmen of the previous generation. He was the first northerner to sign his prints with his full name, and he industriously copied the works of his predecessors and contemporaries in order to sell them under his own sign. Israhel's remarkable career introduced a commercial dimension to printmaking that anticipated the domination of entrepreneurial publishers a half-century later.

Like intaglio prints, woodcuts were also entering a new phase during the 1470s in Italy and in the north. During these years book publishers began using woodcut illustrations made from blocks that were cut and trimmed to fit among frames of type and printed together with the text in complete pages. Initially these border decorations and text illustrations were of a relatively crude sort, but as the printed book gained footing within the marketplace a demand for illustrations of more refined quality emerged. This development is evident in Germany and especially Italy, in Nuremberg and Venetian book illustration in particular. The luxury printed book was caught in a commercial and aesthetic struggle with the illuminated manuscript, a struggle that the former was destined to win for obvious practical reasons. But the period of competition led to experiments in which each

mode of production adopted certain techniques and formal tendencies of the other.[9] This development was critical for the evolution of the woodcut medium in that it eventually led to the rise of block cutters skilled in translating increasingly more intricate designs into relief for the type press. The consequent migration of woodcut-making from monastic contexts and the pedestrian workshops of cardmakers to the more demanding ateliers of bookprinters both secularized and professionalized the skill. Woodcut design and block cutting became sought-after and highly valued specializations in the last quarter of the fifteenth century.

It is not accidental that in the last quarter of the century during the careers of Schongauer, Mantegna, and van Meckenem, and also contemporary with the refinement of woodcut book illustration, we have the first tangible evidence of patrons accumulating prints in larger numbers both north and south of the Alps. To be sure, the evidence is fragmentary at best, consisting of the print album of Jacopo Rubieri da Parma now in Ravenna,[10] the famous Album of Jakub Beg in Istanbul containing a group of rare fifteenth-century Italian engravings along with many other images of Turkish, Persian, and Chinese origin,[11] and the important example of the humanist scholar Hartmann Schedel of Nuremberg, whose library harbored large numbers of engravings and woodcuts pasted into his printed books and manuscripts.[12] Nevertheless, taken together these assemblages demonstrate the appeal of prints in circles traditionally associated with pursuing what we presume were more prestigious kinds of objects. By 1500 the circumstances of print production and reception were rapidly evolving.

Thus, through a convergence of skills, commercial circumstances, and an expanding audience, by the 1470s the stage was set for the emergence of printmaking as a fine art, and by the end of the fifteenth century printmakers had begun to show the extent to which a two-dimensional illusion could be attained without color, and how an area of blank paper could be taken for an expanse of sky. In the following generations the study of this proposition took many forms. In their effort to recreate reality in black and white, printmakers sought ever richer gradations of light and dark through new means of shading with lines, flicks, and dots. In time, prints came to compete with presentation drawings and paintings, and their scale increased accordingly. On the other side, prints were made to vie with precious metalwork, rivaling its celebration of the miniscule and jewel-like. Some printmakers concentrated on distinguishing each individual impression. Experimentation in this area took many forms. A few artists concentrated their efforts on the paper, by varying either its texture or its color; some achieved startling effects with the color and viscosity of their inks. The more

adventurous realized that they could obtain subtle variations in the transition between black and white by working directly on the plate during the printing process, for instance by playing with surface and plate tone to impart particular patterns, or even by scratching the unengraved sections of the plate surface itself. The intimate, solitary, and independent nature of this art stimulated it to constant innovation and to a strong competitiveness.

The critical steps in the maturation of printmaking were taken by masters of exceptional flexibility and experimental ingenuity, those whom we associate with the more conspicuous achievements of the medium in the Renaissance period — Albrecht Dürer, Albrecht Altdorfer, Lucas van Leyden, Marcantonio Raimondi, Giulio Campagnola, Domenico Beccafumi, and Parmigianino, to name the most revered figures of the age. Woodcut rose from its place above the modest burgher's hearth to the wainscotted chambers of the wealthy, where it could efficiently supply a classical frieze or an allegorical invention on a mural scale. But this first flourishing of the *peintre-graveurs* did not last indefinitely. Indeed its span covered barely more than a couple of generations. Once the artistic, technical, and commercial potential of printmaking had been so effectively realized, the mechanism for an eclipse of the master designer was already in place.

By the middle of the sixteenth century, the termination of our study, conditions of printmaking had altered dramatically. In Italy commercial publishers had begun to take over print production already in the late 1530s and 1540s when Antonio Salamanca and his successor Antonio Lafrery established their atelier in Rome.[13] They were followed in their efforts by Hieronymus Cock of Antwerp, who began his publishing career in the 1550s.[14] For over half a century such firms governed print publishing. Their customary practice was to commission drawings from known masters and then have them etched or engraved by craftsmen skilled in working the plate. The plates were then printed and reprinted under the publisher's supervision, sometimes for decades. Print designers who worked on their own plates became fewer and fewer. At the same time the collector's market expanded in concert with the greater availability of printed images. During this period the interest in refined woodcuts also began to wane, the medium no longer quite equal to meeting the contemporary demand for a painterly style, and no longer commercially viable for the production of intricate designs.

The great *peintre-graveurs* cast an imposing shadow over their immediate successors, and in this light it has often been proposed that Dürer and Mantegna were proven to have had no real progeny,

but only pale imitators. Such an obviously heroic evaluation of early printmaking must be greeted with suspicion by historians, and yet it accords well with the inclination of Renaissance criticism to value individual contribution above all, and to measure the accomplishments of each generation against the last. This view found particular favor in northern European art historiography for at least the first century after the generation of the *peintre-graveurs*, a period of ever increasing adulation for the founding fathers that crested in the so-called Dürer Renaissance in the late 1500s and after. It was a climate of opinion that was likely to intimidate innovation to some degree.

The technical possibilities of engraving and woodcut were thus in certain fundamental respects taken to their limit within a generation's time, and this on its own may have helped to cause a temporary retardation of the masterwork. Artists' designs could now be translated by skilled technicians who knew and intimately understood the exigencies of the various graphic media. And once printers were confronted with the obvious commercial opportunities presented by the print, the inventor became less important than the execution. This we can see anticipated by the emergence of the professional woodblock cutters in the sixteenth century, among them many enterprising craftsmen who became small-time printers on their own, printers who ultimately pioneered the way to the large-scale publishing houses of mid-century. Here we glimpse an important and very different aspect of the evolution of a new medium: the print's inherently commercial nature and the effect of this attribute on its status. As printmaking increased in scale, it was destined to become an art of speculation, a medium in which the relation between maker and audience was necessarily indirect. The successful purveyance of prints therefore required a marketing network, and the prospect of replication on a wider scale was inclined to assembly-line production and finally to monopoly. The eventual domination of the large-scale publishing houses at Rome and Antwerp was encouraged by the very nature and possibility of printmaking. Whatever hypotheses we may favor to explain the eclipse of the *peintre-graveur* around 1550, it was only a temporary fluctuation in the long-term history of western printmaking. For it was but a generation after Hieronymus Cock opened his press in Antwerp that the career of Hendrik Goltzius began. Goltzius was a virtuoso engraver of exceptional brilliance who, like Domenico Beccafumi in the south, made a virtue of conspicuous technique and opened the way to the achievements of later generations. This, however, takes us well beyond the boundaries of our present task.

II

Craft Guilds, Workshops, and Supplies

PRINTMAKERS AND THE ORGANIZED CRAFTS

IN ITS GENESIS the print was a bastard art, and it may be that this very attribute served it best in the shifting commerce of Renaissance culture. From a strictly technical perspective the execution of a painting on panel had little relationship to the incising of a copper plate or the cutting of a design into a plank of pearwood to be inked and then printed. Moreover, the techniques of relief and intaglio printmaking themselves differ markedly in the tools and manipulations required to carry them out, entailing as they do in one case planing, carving, or casting, and in the other various means of incising metal, including chemical erosion. Even in its early stages the art of printmaking was highly diverse, and in several respects these differences were critically important to its history. For one thing, medieval craft alliances were usually determined by technical and procedural similarities rather than by formal criteria or by the particulars of a product. The materials employed or the tools used to fashion them were the common means of establishing associations among artisans.[1] And yet, whatever the criteria, even in towns with large populations of artisans each guild tended to be heterogeneous.

During the period of interest to us here, the visual arts were evolving dynamically in response to fluctuations in Renaissance patronage, and the arts were destined to present special problems for traditional schemes of guild organization. In medieval guilds, painters and sculptors had generally been grouped together, as we can see from the membership of the Parisian corporation of "image makers, painters, sculptors, and carvers of crucifixes" (imagiers, peintres, sculpteurs et tailleurs de crucefis).[2]

However, even if a collective notion of the visual arts was in some respects implicit at this point, it had yet to be articulated. Artists were not readily susceptible to being defined by their skill in working some particular material as carpenters and cabinetmakers were, nor could they be very aptly identified by the finished objects they made as was true for goldsmiths or clockmakers. Since the various systems for arranging the crafts were inherited and deeply rooted in local practices and politics, they threatened to obstruct experiment and to frustrate any tendency to cross received boundaries. On the other hand, the very heterogeneity of the guilds ensured contacts that could be an encouragement to change.

Prints were especially inclined to elude conventional definition within the crafts. The planing and finishing of woodblocks and the cutting of their designs required the tools of the cabinetmaker and the sculptor. However, these tools were being used in order to make images on paper, typically a matter for the illuminators. An engraver, on the other hand, employed the tools and the materials of a metalsmith, but once again to different ends. Furthermore, the print meant relatively large-scale production slated for an open market rather than working under commission, and this sometimes involved another guild with priority in governing the trade in small objects. Such considerations are a part of the material and technical history of the visual arts, that is to say of their artisanal aspect. But in the Renaissance these arts were gradually improving their status and shedding their material and procedural identities. The essence of this change was the reviving perception of the arts as primarily a medium of imitation and illusion, in effect an element in which materials were less salient than the transformations performed upon

them. This change in perspective would eventually require a shift from classifying the visual arts materially to defining them according to the conceptual nature of their endeavor. In some places it was eventually also to mean their removal from the guilds into newly founded academies. Prints entered the stage at just the time these changes so intimately associated with the Renaissance were coming about.

An important part of the history of the printed image is the way in which the print itself evolved as a catalyst in this redefinition of art. From the last quarter of the fifteenth century a small number of skilled painters began to put aside their brushes in order to experiment intermittently with plates, blocks, knives, burins, and eventually presses. They learned to work in reverse of the outcome, like those who made designs for tapesters, and to make salable pictures in black and white rather than in color. Eventually, prints were taken under the cloak of the painter's art, being a ready expression of the draftsman's skill. If not technically, at least pictorially the line between a drawing and a print was a fine one. Yet the beginning of printmaking was as closely tied to the activities of metalworkers as to painters, and here there was a different relation between skill in execution and conceiving the product. Many a trained goldsmith knew very well how to handle a burin and inscribe a design on a metal surface.[3] For him the technical barrier to making an engraved print was inconsequential, but composing a passable figure or inventing a *historia* was something not so often done. Therefore, being apprenticed as either a painter or a metalworker meant approaching the making of a print with very different skills at hand, and consequently many of the earliest *peintre-graveurs* had the advantage of both kinds of training. In Germany there were also a few instances of sculptors who made prints — Hans Leinberger, Peter Flötner, and Veit Stoss, for example — but by and large they were left behind in the evolution of the printmaker's art. The sculptors might well have provided another bridge between the two crafts of painting and metalwork, as the exceptional case of Antonio Pollaiuolo so impressively demonstrates, but in practice they seem to have left it largely aside.

Because image printing drew craftsmen from quite different specialties and used a variety of materials and a range of skills, in the abstract the plausible craft alliances were several. Not all towns were strictly guild organized, and even in those towns that were, the pictorial arts of painting and book illumination and the art of precious metal-smithing were sometimes not connected with guilds. In a typical guild town by the first quarter of the sixteenth century, however, most artists engaged in printmaking would have been allied with the painters in guilds that frequently also included

sculptors. Less often they could be found among the goldsmiths, who were deemed the most prestigious of the craftsmen because of the value of their material and the expense of their product.

Throughout the Netherlands we usually find printmakers registered along with painters in the guilds of St. Luke. This was true in Antwerp, which held the largest concentration of artists to be found anywhere in northern Europe. Here by the early sixteenth century craftsmen identified as *printsnydere*, *plaetsnydere*, *figuersnydere*, or *fyguerprintere* were grouped in the St. Luke's Guild along with painters, sculptors, mapmakers, and book printers. In fact, at least two different printmakers were elected to the deanship of the Antwerp guild during the first half of the century.[4] Amsterdam, Haarlem, and Leiden were also arranged this way, as well as Louvain and most other towns in the southern Netherlands for which documentation survives.[5] In Paris the printmakers, or *dominotiers*, were among the Corporation des Imagiers.[6] In Augsburg the *Schmiedezunft* or metalsmiths headed a broadly mixed guild of artisans that included painters and sculptors as well as goldsmiths and apparently also those artists who made prints. Similarly, Strasbourg, a notoriously conservative city in its political and commercial dealings, placed the printmakers under the aegis of the catch-all guild Zur Steltz, which included practitioners of the various pictorial arts, smiths of precious and ordinary metal, and an assortment of other trades.[7]

Consistent with the guild divisions we find that the majority of known printmakers and print designers identified themselves first as painters or goldsmiths. In Venice and Padua the print trade seems to have been under the control of the painters' guilds already by the middle of the fifteenth century. In this region we have evidence of at least two conspicuous waves of printmaking, first in the 1440s and then again in the 1460s, when appeals were made to legislate the control of the painters' guilds over print sales in order to protect the local market from outside competition. For example, in a document of 1440 there is reference to no fewer than 3,500 woodcuts that a skin dyer working in Padua had agreed to sell on behalf of a Flemish trader. Then in 1461 the Fraglia, or guild of painters in Padua, reasserted its absolute monopoly on the sale of prints, extending a right they had been granted since 1411 to purvey their own goods. The concern to establish clear authority is explained when six months later Francesco and Domenico della Seta were sued by the guild for buying and selling prints without being members of the Fraglia. In their appeal the della Setas argued that they were being unfairly treated, since many others who were also not guild members were engaged in the same practice.[8]

In Italy we find a telling geographical divide among printmakers who were also either painters

8

or metalworkers. In Venice as well as Mantua and Padua, artists engaged in printmaking were often painters, perhaps predominantly so — Andrea Mantegna, Nicoletto da Modena, Benedetto Montagna, Girolamo Mocetto, and the two Campagnolas. In the 1530s the Fraglia dei Pittori in Venice included draftsmen, painters of saints, gilders, scribes, stationers, illuminators, and cabinetmakers, a group that appears also to have embraced the printmakers' sundry expertise.[9] Noted Florentine engravers, on the other hand, were almost without exception goldsmiths — Cristofano Robetta, Antonio Pollaiuolo, and the niellists Maso Finiguerra and Baccio Baldini. Although Pollaiuolo was a painter, a sculptor, and a goldsmith he joined only the guild to which goldsmiths were assigned, the Arte della Seta, and not the guild of painters. The illuminator, engraver, and cartographer Francesco Rosselli is an important exception, as we shall see from the content of his workshop inventory. In part this pattern can be accounted for by the fact that Florence was the leading center of goldsmithing throughout Italy.[10]

It was likely an advantage that no specific guild had an exclusive claim on the printmakers' expertise. In at least some instances they were assigned to a guild not on grounds of practicing a cognate craft but because of the commercial nature of their product. In Basel the printmakers were placed in the Safranzunft, which included tapesters, glovemakers, and apothecaries, but excluded goldsmiths, silversmiths, painters, and sculptors. This was primarily an organization of small merchants, retailers we might say, who kept shops in which they sold various items in addition to what they manufactured themselves. Yet a Swiss artist like Urs Graf, who practiced as a goldsmith as well as an engraver, draftsman, and woodcut designer, was able to sign up with the Basel goldsmiths in the Zunft der Hausgenossen.[11] Printmakers in the Swabian town of Ulm were also grouped in a retailers' guild, the Kramerzunft, another catch-all for manufacturers of otherwise uncategorized, salable crafts that in this case actually included the painters, sculptors, cardmakers, and block cutters as well.[12] Certainly local practice also depended upon whether the town had a sufficient number of people working in one area to justify the creation of a separate guild. The protection of a retailers' guild in towns like Basel and Ulm held special advantages for makers of a small and readily transportable product like prints. Among other things, the regulations enforced by the town council usually inhibited foreign competition except on specified days and during strict hours.

In addition to engravers and woodcut designers, there were also the pure technicians of early printmaking, the woodblock cutters, whose guild associations are often difficult to establish. A. M. Hind assumes that block cutters normally belonged to the carpenters' guilds, as was the case in Louvain during the fifteenth century.[13] But it appears that these specialists typically followed the painters and sculptors, as we know to have been the case in Antwerp, Amsterdam, and Strasbourg,[14] or they went with the card painters and document illuminators who were placed in the merchants' guild with other printmakers in Basel.[15] It has been posited that in Venice independent workshops specialized in block cutting and sub-contracted their skills to print designers and book publishers.[16] Some block cutters cut letter-text as well as images, a kind of skill that could also be employed for the demanding task of making type fonts, which required cutting delicate relief punches for the casting molds. Refined relief work in wood and metal for type, medal, and coin die-casting was best done by those trained in fine woodcutting or engraving. In some cases these people were assigned to the carpenters' guilds, and elsewhere they could be found among the ranks of painters, goldsmiths, armorers, and gem cutters. In the sixteenth century Giulio Campagnola was commissioned to cut type punches for Aldus Manutius; Geoffroy Tory did so for his own press in Paris, and Hieronymus Andreae for the Emperor Maximilian. There were many others. Moreover, one should recall the fashion for elaborate intarsia furniture or paneling in Renaissance Italy and later on in the north — a kind of pictorial inlay work that, like woodcut-making itself, promoted intricate carving techniques also dependent upon the designs of painters and draftsmen. The sculptor Peter Flötner who was responsible for large numbers of woodcuts was equally involved in making elegant patterns for furniture and interior architectural appointments such as doorways, fireplaces, and window frames. He published these designs in woodcuts. Here the affinity of various woodworking skills is surely not accidental, but a reflection of the archaic habit of relating crafts by tools and materials. The diversity of Flötner's interests, on the other hand, is a symptom of a new and less bounded age. Flötner made a point of reminding us of his favorite material by signing himself with the woodworker's chisel and mallet (fig. 227).[17]

Many northern European towns drew a distinction between what they termed the "free arts" (freie Künste) and those organized into guilds or otherwise regulated. It was a distinction that had nothing to do with the modern notion of a "liberal art," or for that matter a "fine art." Rather, the free arts were those neither bound by the rules of the guilds nor protected by the town council. Important for an understanding of the commercial status of the artisanry, the free arts were customarily given no trade protection from outside competition or from competition with local guilds. Such was the case in Nuremberg, a city of great significance for the history of printmaking, where it has been estimated that roughly half of the 50,000

inhabitants in the mid-sixteenth century were artisans and their families.[18] In Nuremberg, guilds had been banned two centuries earlier with the quelling of a major artisans' revolt, after which all means of craft organization from below were prohibited. This included self-regulation of any kind, such as the forming of religious brotherhoods, craftsmen's drinking chambers, any formal association with craftsmen of other cities, and any political activity undertaken in the name of a trade. It was a model much praised by the imperium in its effort to control factional politics among the chronically troublesome artisanry, and as a consequence under the imperial reform of 1548 a free arts designation was adopted at Ulm and Augsburg as well.[19]

There were two orders of craft permitted in Nuremberg, the free arts and the sworn crafts (*geschworene Handwerke*). Along with many others, the practitioners of the *freie Künste* included painters, sculptors, and printmakers, who were free to practice without fees but also without any form of protection. In contrast, the designated or sworn crafts were overseen by a master elected by the craftsmen but entirely invested by the town council, which maintained a large bureaucracy to monitor trade and production. Strict regulations were kept on matters elsewhere assigned to guild purview, the effect being that Nuremberg retained all the controls formerly exerted by guilds but centralized and administered them as part of the city government. These restrictions often extended much further than guild controls in other towns: certain craftsmen were prohibited from contact with foreigners lest they divulge trade secrets; wages, working conditions, and hours were all fixed; and trade in designated products was protected against outside competition. Despite these regulations, the council records of Nuremberg show repeated attempts by members of the free arts to become associated with a sworn craft in order to gain the advantage of trade protection. The free arts were more often than not at a lower station in the social and economic hierarchy within the artisan community, being in effect unrecognized. This was of some importance in a conservatively aristocratic city like Nuremberg. On the other hand, highly distinguished crafts evolved out of the free arts to attain international recognition. Certainly there were levels of distinction, and often a marginal association was established between a free art and one of the sworn crafts. In Nuremberg the book printers had such an arrangement.[20]

All manner of *Flachmaler* were designated as free arts: cardmakers, engraving and document illuminators, or *Briefmaler*, as well as woodcut designers and block cutters came under this banner. Because of their particular skills, these artisans were becoming more closely associated with the influential printing houses and already in the late fifteenth century began to make frequent requests for protection from the council.[21] Such appeals suggest that open competition was increasingly demanding, and that local markets were being invaded by imported products. To make matters worse, it appears that although practitioners of the free arts were enjoined from making things reserved to the sworn crafts, the opposite was not necessarily true. For example, a document of 1546 declared that members of the sworn craft of goldsmiths could teach apprentices to engrave plates, explicitly because engraving was a free art and thus unprotected.[12] So far as woodcuts were concerned, publishers like Koberger were permitted to commission designs and blocks from any workshop within the city or elsewhere.

In Augsburg the freedom to commission work abroad was apparently not allowed, as we discover from the injunction placed upon Günther Zainer to employ only woodblock cutters from the local guilds.[23] And in Nuremberg, book publishers had become sufficiently prestigious and were operating on a large enough economic scale to allow them a status approaching that of the sworn crafts. Eventually, as the subversive potential of this medium became more apparent, the council's attention was drawn to scrutinize the business of printers and their allies at all levels.[24] It was to the authorities' advantage to dispense certain protective privileges to the printers simply in order to gain some additional sway over their activities. Nuremberg's open-door policy encouraged a sound school of printmaking, remarkable for its unrivaled sophistication in craftsmanship, but also noteworthy for the stability of its style and subject matter.

A survey of those towns spawning lively communities of printmakers reveals one significant attribute all of them held in common: the presence of an important book printing industry. Antwerp, Strasbourg, Basel, Augsburg, Nuremberg, Florence, and Venice were all major forces in printing through the early decades of the sixteenth century. In contrast, Ulm was a declining center of book publishing and a city of decreasing consequence in print production. Lyons and Amsterdam were hastily up and coming on both fronts. Somewhat like Paris and Frankfurt, they remained relatively conservative throughout this period in their publishing repertoire and in their use of illustration; however, both served as major clearing houses for paper merchants and book dealers, and probably for print dealers as well. In book publishing, Rome was barely astir during the first decade of the sixteenth century, though it was soon to become a major capital of printmaking.

Book printing was classified among the free arts in Nuremberg, Basel, Ulm, Cologne, and Munich. Nevertheless, for the sake of maintaining good commercial relations printers tended to join a guild voluntarily when it was possible to do so. Usually this meant the merchants' guild, or less often the

goldsmiths' and metalworkers' guild.[25] Thus in Basel the powerful book publisher Johannes Amerbach elected to join the mercantile guild or Safranzunft.[26] In Strasbourg, a tightly regulated guild town, the early printers were occasionally also goldsmiths, painters, or calligraphers, and so belonged to the goldsmiths' guild Zur Steltz, among the richest in the city. However, many small-time printers and craftsmen engaged in subsidiary or related aspects of the trade began to prosper outside guild control. As printing supplanted scriptoria, many illuminators, draftsmen, calligraphers, and others went with the independent printers, resulting in a decline in guild membership and finances. Finally in 1502 a regulation was passed incorporating into Zur Steltz all the major printing firms and their attendant specialties: binders, block cutters, job printers, card painters, and makers of saints' images, these latter groups carrying less financial responsibility within the guild structure.[27] This sort of policy reflects a trend towards civic control of printing in response to its rapidly growing economic and political importance. Strasbourg exemplifies one pattern of accommodation to the success of the book trade. The Netherlands also absorbed its printers into the guilds of St. Luke. Printing houses in Paris, then the main source of printed devotional literature, remained for a time under the control of the university, as had long been true of the scriptoria.

Unlike painters' workshops that were only partly engaged in printmaking, the book publishers frequently operated on a very large scale, were heavily staffed, and depended upon considerable sums of capital investment. Publishers therefore often surfaced among the entrepreneurial elite close to the centers of economic and political power. Several factors encouraged the larger publishers towards monopoly. It was once assumed that no exclusive and officially chartered corporation of printers came into being in Europe prior to the Venetian guild set up in 1548, followed by the London Company of Stationers in 1557. However, it appears that informal conclaves, and certainly close business dealings among publishers, had been the practice long before.[28] Moreover, in Lyons, a free arts town in much the same manner as Nuremberg, the publishing trade was dominated by a small number of powerful investors who kept no printing houses, but underwrote publications which they farmed out to various presses. Printers' guilds eventually were formed in order to resist the control exercised by this kind of financial oligarchy.[29] The publishing world in general stood at the advanced edge of entrepreneurial experiment and conflict in early modern Europe.[30]

Historians have traditionally held that the guilds, once the center of political and communal identity within the towns, had by the later Middle Ages become rigid, archly conservative, and monopolistic. Those who occupied the upper reaches of the guild hierarchy formed an important aristocracy of their own, wielding substantial political and economic power in the towns and protecting their exclusive position by constantly raising the requirements for masterhood, by setting more difficult standards for the *chefs d'oeuvre*, demanding higher admission fees, and so on. The dividing line between rich and poor craftsmen, the argument goes, was increasingly apparent, and the welfare role of the guilds became sharply compromised. As manufacturing methods, efficient trading routes, and international banking raised competition to a far less parochial scale, the guilds found themselves becoming obsolete. By this account an organized artisanry was an encumbrance to the progress of emerging European capitalism.

The case for this interpretation has very likely been overstated, and it has given way in more recent scholarship to an emphasis upon the difficulties of maintaining such a tightly regulated system within the dynamic commercial setting of many Renaissance towns. Instead of considering the guilds as an entirely stifling influence, it can be argued that in providing certification in a craft, they encouraged mobility by ensuring that journeymen could find employment elsewhere. Indeed, itineracy was especially common among those associated with printing and printmaking as it was among artists in general. Furthermore, guilds were in certain cases entirely prepared to revise their procedures to accommodate changes in the demand for products or changes in fashion.[31] Moreover, the avenues for skirting local regulations were no doubt many, and the importance of the small-scale, unregulated cottage industry must not be overlooked simply because in retrospect it is so difficult to measure.[32] As Richard Goldthwaite concisely puts it, "Craftsmen operated in a marketplace where social structures were loose, where relations were fluid, where the cash nexus dominated, and where contracts were protected by impersonal legal authority."[33]

We must recognize that the makers of prints were in an excellent position to take advantage of just these sorts of initiatives. There is much evidence of family workshops, among cardmakers for instance, where wives were engaged in producing and purveying their husbands' products. In Rouen, servants were granted dispensation by the guild to sell cards in the second-hand trade.[34] Indeed, cardmaking especially seems to have been a family affair often carried on within a single household over a span of several generations. Women also played a role in printmaking workshops, most often as illuminators who hand-colored prints, but occasionally also as woodblock cutters. In a testament from January 1531, "Katherina Hetwigin formschneiderin" of Nuremberg lists her meager belongings, and notes that she is owed seven *gulden*

for a cut woodblock in the possession of Pfaltzgraf Friederich in the Neuenmarckt.[35] Johann Neudörfer remarks in his chronicle of 1547 that Georg Glockendon's daughters worked alongside him at his Nuremberg corner press.[36] What evidence there is suggests that women labored primarily in subordinate roles, though it is surely significant that in Antwerp and Brussels, in the Netherlands, and very likely elsewhere, they were being admitted to the guilds. Furthermore, there are cases in which the wife of a printmaker inherited her husband's workshop and continued to operate it, or at the very least maintained some control over the income gained from editions reissued from her husband's blocks and plates.[37]

In the final analysis print production flourished just where we might have predicted it would, the major cities of Antwerp, Nuremberg, Strasbourg, Florence, and Venice being in the first rank. All five are noteworthy for their wealth, for lavish patronage of the arts, for book publishing, and for their international trade contacts. In addition, Nuremberg and Venice stand apart for their strongly conservative governmental management of craft industries. It is difficult to say whether this latter feature was a help, a hindrance, or ultimately a matter of indifference to the printmakers, since an important dimension of the modernity of printmaking is reflected in its varied alignment within and without traditional craft relations. The guilds were not well-suited to regulate this kind of production in the workshop compared to managing products of a less ephemeral and more substantial sort. Town councils responsible for legal disputes between craftsmen and their patrons began to find themselves inordinately preoccupied with the affairs of printmakers, very frequently in cases involving disputes with citizens from other towns. However, the adaptability, transportability, and relative cheapness of prints made most attempts at external control more or less ineffectual. Printmaking developed early on as a trade capable of eluding conventional practices and consequently attracting artisans with the initiative to work in the shadowy interstices that lay between the guilds and local governments. Furthermore, printmakers were bound by the nature of their product to develop an art form that could succeed on the open market. The increasingly indirect relation of maker to purchaser entailed in printmaking meant that speculation and experimentation became guiding principles within the aesthetic and iconographic preferences of the medium. Prints were quintessentially an open market commodity, and being relatively inexpensive to produce and distribute, they were supple in their ability to respond to the interests of their audience.

Looked at from a commercial point of view, printmaking came into its own at an extraordinarily opportune moment. The early sixteenth century witnessed the development of an active open art market in which a readily portable and relatively inconspicuous product bore inherent practical advantages. A second factor in the eventual success of the print was the explosion of the Reformation, a religious conflict that overthrew the established Church as the major source of patronage for sculpture and painting in northern Europe. The curtailment of church commissions proved a stimulant to the print trade both as a substitute in the north for what was lost, and as a counter-measure of religious propaganda in those areas that remained predominantly Catholic. Finally, the changing attitude towards the visual arts in the Renaissance began to encourage the collecting of images in various ways as an aspect of status, not only among the very wealthy, but also among the bourgeoisie and perhaps even the upper level artisanry. Though prints were as yet a poor cousin in this domain, their relation to the more traditionally esteemed arts was growing closer all the time. Not only were conditions for the success of the print in the Renaissance auspicious, but by virtue of their many uses and fluid exchange, prints were actively helping to create these conditions as well.

THE PRINTMAKER'S WORKSHOP AND ITS NECESSITIES

Our best picture of the stocks of a Renaissance printmaker's workshop comes from a posthumous inventory of the belongings of one Alessandro di Francesco Rosselli (called Matassa), a Florentine merchant who died intestate in 1525, having for some time owned a substantial atelier for the printing and selling of maps, woodcuts, and engravings. He appears to have inherited this operation largely from his father, the distinguished Francesco, who for many years had practiced in Florence and elsewhere as an illuminator, printmaker, and mapmaker and died in 1513. After Francesco's death Alessandro seems to have merged his father's business with his own mercantile activities and maintained it until his own passing. Thus, we find in addition to the print shop a list of sundry items ranging from ribbons and string to straw hats and Venetian gold glass, a veritable Florentine department store. Though there is no evidence that Alessandro himself was an engraver or a designer of prints and maps, he must certainly have employed craftsmen to continue pulling impressions under his management. Indeed, it seems that Alessandro's son Lorenzo was apprenticed as a printmaker in this very shop. Whether or not the shop was still actively commissioning new prints is uncertain. Among the many identifiable items in the inventory, a few can be placed with some assurance after the death of Francesco. But these appear to be stocks of prints that were acquired from the artists or

from other dealers and not printed by Alessandro himself. Despite the very rich stocks in the atelier, it appears that the best part of what Alessandro dealt in he had inherited from his father. Therefore, the 1527 inventory is predominantly the record of a printmaker's workshop as it was in the first decade of the century, if not earlier.[38]

The inventory is arranged in three sections, the second of which includes thirty-four items detailing the rather elaborate furnishings of the workshop and thus allows us to gain a tangible picture of its operations. There is a shop sign listed and a cleat for hanging it, and a world globe, apparently also to be hung out to advertise that printing maps was a specialty of Rosselli's. Even a forked stick for retrieving items from shelves or wall hooks is noted, an indication of the thoroughness of this inventory. There are many tables, benches, cabinets, boxes, and bookshelves for storage and working space. Scales and weights are recorded, no doubt for weighing coins or copper, and a press with two large screws ("1° stretoio con dua vite largo braccia 1½"). This is likely a bookbinder's press, though it may have served other purposes as well. "7 teste di giesso di relievo" would seem to be a set of plasters, probably casts for use as models for training apprentices how to draw. Casts for this purpose were a common staple in the Renaissance atelier (figs. 303–04).

Interestingly enough there is no mention of paper stocks, though it is certainly the case that printing of different kinds was being done here. However, of great importance to us is the mention of printing apparatus in entries 17 and 18: "1° torcholo da stanpare chon sua fornimenti"; and "3 tanburi da stanpare." The first of these is a flat-bed press with its accoutrements, probably of the sort standardly constructed for printing books and woodcuts. The term *torcholo* is still used for a flat-bed or platen press. The mention of "fornimenti" might refer to the tympan, though it may also mean ink dabbers and conceivably type fonts. However, type fonts would be of such value that it is hard to imagine them not being cited more precisely. In any case, the few books listed in the inventory give no evidence that Alessandro was engaged in printing books or pamphlets himself.[39] It may well be that the shop maintained type fonts sufficient only for short inscriptions such as appear on maps. The "tanburi" are almost certainly for printing intaglio plates, a matter that will be treated more fully below. We should note the absence of any reference to braziers for warming intaglio plates, or of engraving and woodcutting tools — knives, burins, burnishing and polishing tools, punches, and so on. These lacunae strengthen the conclusion that Alessandro's was strictly a printing shop no longer engaged in making woodblocks or engraving plates, though even so we might expect to find such tools simply for maintenance, for example for re-engraving a plate or trimming up a damaged block.

The first section of the Rosselli inventory lists woodcuts and intaglio prints stocked for sale with their prices indicated. There are twenty-six such entries, many comprised of lots of several prints, and some of albums or books, presumably with large numbers of prints bound into them. Twelve of the twenty-six lots are maps, charts, or city views, still a specialty of the shop as it was of its founder, Francesco Rosselli. Some of these prints are laid down on canvas, and some of them colored. There are many "quaderni di disegni" (albums, almost certainly of prints and not drawings), including twenty-four albums and additional loose sheets after Raphael. These are among the prints that were probably acquired by Alessandro after his father's death. In two instances large quantities of prints are designated by reams, in one case no fewer than fifty-two reams (around 26,000 sheets!), half of them cited as woodcuts and slated as prints "of good and bad quality" (cose fra buono e chativi). Designated types of prints include books of designs apparently for architecture and architectural details, sixteen impressions of Marco Dente's *Massacre of the Innocents* after Bandinelli (B.21), and finally a batch of shabby prints listed as "torn and in tatters" (rotte e straciate). Having no market value, the latter are calculated only by weight (about three pounds). Altogether these stocks are given a total value of nearly 800 *lire*, a matter to which we will give closer attention further on in our discussion of print prices.

Alessandro Rosselli was certainly dealing in prints apart from those he was pulling in his own shop. This is evident from the third section of the inventory in which there appear seventy-nine separate entries listing woodblocks and metal plates of copper, brass (twice), and tin or pewter (once). The first thirty items appear to be woodblocks exclusively, amounting to about seventy blocks in all; the remainder are plates, somewhere over one hundred of them, the exact figure being unclear from the descriptions. Sizes are described according to sizes of paper — "fogli chomuni, fogli reali." A couple of the blocks and many of the plates were cut on both recto and verso, as was common for a time when copper in particular was a valuable commodity. Also for this reason the assessors took the trouble of weighing the metal plates and giving an exact sum in their accounting. This came to 475 Florentine *libre* in total, a very substantial weight equaling roughly 160 kilograms or about 355 pounds of copper altogether.[40] The metal plates vary greatly in size, many certainly of folio scale given the number of maps to be counted among them.

Our understanding of a printmaking operation is further enhanced by a major inventory that comes from the shop of Cornelis Bos, a dealer as well as a versatile if somewhat derivative printmaker active in the flourishing commercial and artistic center of

Antwerp. Bos is first recorded in the St. Luke's Guild of Antwerp in 1540. Shortly thereafter his fortunes took an abrupt turn for the worse in the increasingly unstable political and religious climate of the southern Netherlands. Bos was accused of heretical activities, in particular of holding Loïst sympathies. The so-called Loïstes were followers of Loy Prustinck, a religious and political libertine formerly associated with the radical Anabaptist and sometime artist David Joris, a dangerous web of associations in the eyes of the local government. On the orders of the Council of Brabant in Brussels and under the authority of Emperor Charles V, Cornelis Bos was formally charged on 10 March 1544. He seems to have escaped from the city in time to avoid incarceration and trial. The Council's judgment cites Bos among more than a dozen offenders, at least one other of whom, Jan Ewoutsz., was a block cutter and corner press printer active mainly in Amsterdam. Both Jan and Cornelis Massys were likewise implicated, a fact that underscores the prominence of artists in the whole affair.[41] As was customary in such cases, all of Bos's belongings were confiscated and sold by the state. His household in the Lombaardstraat was duly inventoried on 3 August 1544, and then a second tally compiled on 13 January 1545, noting the value of many items that had been sold.[42]

Bos's shop was located together in the same building with his dwelling, and the notary in charge of recording his belongings took them down for the whole premises room by room, as was customary for household inventories. Thus, in the private areas we catch a glimpse of seemingly comfortable furnishings and Bos's sundry cooking utensils as well as a number of pictures and prints employed as decoration. Some of these latter objects we shall return to in our eventual consideration of the use of prints for wall adornment. Bos's house seems to have included a kitchen and pantry, a couple of small rooms for the children, and separate living and working areas with at least two rooms devoted to the workshop. Most of the rooms also had a hearth.

It is the stocks and operations of the printmaker's shop that most directly concern us here, of course. Bos kept a considerable collection of models for his work, the exact nature of which it is not possible to guess from the inventory descriptions themselves. There is one reference to a "leden manneken," probably a small, articulated model of a human figure of the sort commonly used by draftsmen from the Renaissance to the present day. There are "patroonkens," one painted by hand ("metter hand beworpen"), possibly stencils or even plaster casts. But most likely these are drawings used as patterns for prints, since in one case they are mentioned along with "figuerboecken," clearly model-books of figure studies kept for that very purpose.

Bos's activities as an independent printmaker are reflected in a substantial stock of equipment as well as plates, blocks, and impressions presumably kept for sale. There were twelve reams of paper and another ream along with three or four books of paper in large format stored away in cupboards. A table or desk with a tilted surface might have served as a drafting table. Bos had two presses, one of which was still in the process of being built. Neither of these is specifically enough identified to be absolutely certain whether it refers to a platen press or a roller press, though it is very likely from the copper plates inventoried that at least one press must have been designed for printing in intaglio.

A number of copper plates are recorded in the inventory, a couple of them noted as the property of others. This suggests they were given to Bos for printing, or that the contract for engraving them provided for their eventually becoming the property of the commissioner. In addition there are groups of plates listed in lots, wrapped in protective cloth and stored away. The records indicate that some of these plates were completed and others not, some "gesneden" (engraved) and others "gebeten" (etched). Interestingly enough, in one case the color of the copper plates is specified, an acknowledgment of a distinction in quality, as we shall see shortly. Along with prepared and completed plates there is also mention of fragments of copper plates — trimmings or used plates. These fragments were all notably bought up in the sale and so were apparently of some value. Also among the items listed are medals done in lead and a smelting kettle ("smeltketele"), the latter perhaps to melt lead for casting. Finally, there are fifty-nine woodblocks mentioned. Certain of the cupboards and chests contained various sorts of prints, their full wealth emerging only in a general way through the later records of purchase, where a great many bundles of prints were sold off, mainly in unspecified lots.

Like most Renaissance crafts, printmaking had to discover its sources for raw materials and had to invent or improvise implements and machinery for the specialized requirements of its own techniques. Here we are concerned with an age in which technical treatises were only beginning to be written. Typical of pre-modern practice, techniques were mostly learned or developed in the workshop and passed on to apprentices without being recorded in any lasting way. Extant workshop inventories are rare, even among the several surviving testaments of well-known masters. Contracts yield some evidence about costs, at least in those less usual cases where printmakers worked on commission. But by and large the printmaker's operation was a small one, and its regular costs rather low compared to those of many of the more elite crafts. Consequently, letters, invoices, and other written sources reflecting the day-to-day economic realities of the

14

printmaker's workshop are rare. This is true even of someone as prominent and prolific as Albrecht Dürer. The considerable corpus of his own writings, and in addition the early biographies, testimonials, and other related documentation that have come down to us, contain practically nothing about Dürer's activity as a printmaker apart from his own records of sales made on his journey to the Netherlands. Therefore, most of what can be gleaned about printmakers' supplies comes only indirectly from related sources. Here we are very fortunate to have extensive and well-researched documentation on the early book printers. The history of book printing has long been a matter of scholarly attention, and the sheer scale of many Renaissance publishing houses with their international trading networks has ensured the survival of a good deal of primary source material for the print scholar. Furthermore, certain kinds of printmakers were regularly in the employ of the book industry and probably availed themselves of their big brothers' services in many informal ways as well. As a field of inquiry, the historiography of early book printing stands out for the quality and rigor of its scholarship. It is only surprising that this fund of information has not been more systematically exploited by art historians with an interest in prints. Let us now consider the materials and tools needed by these masters for practicing their craft.

PAPER: THE PRINTMAKER'S GROUND

Paper was being manufactured in western Europe well before the period that concerns us here, indeed in Italy and France it was being made in large quantities already by the fourteenth century. A very brief outline of the procedures for making paper may prove helpful at this point, both to recall its general pattern and also to help explain certain more intricate problems we encounter in identifying papers by watermark. Papermaking basically depended upon two elements — decent rags and clean running water. As linen began to replace woolen clothing in Europe, suitable rags became available in abundance. The printing revolution would likely not have taken place without this change in cloth production. Rag paper first required accumulating the raw material, sorting it for quality, and letting it stand to ferment in dampness sometimes with an alkaline substance such as lime to assist in breaking down the fiber. The resulting mass was then sorted and washed, placed in wooden or stone troughs, and mechanically beaten. Stamping mills were constructed of a series of wooden hammers driven by cams geared to a waterwheel. This system of preparing rag was employed in more or less the same manner from medieval times through the Renaissance (fig. 4).

The macerated, liquid pulp from the stamping troughs was then removed to vats. A frame called a deckel stretched with a fine wire screen or mold was then dipped into the pulp by the vatman and the liquid deftly maneuvered over its surface and drained to leave a thin residue of fiber. The deckel was then removed from the mold and passed to a second craftsman, the coucher, whereupon the vatman took up a second mold in his frame and continued. Thus there was typically a team of two men to a vat, employing two screens or molds in any one session. The coucher who received the mold let it drain further and "couched" it, that is turned the now congealed sheet out onto an absorbent felt. After a certain number of sheets had been couched, the stack of felts interleaved with raw sheets of paper were put into a press and squeezed to get rid of any excess water. The felts often leave an irregular texture of their own visible over the pattern of chain and laid lines. (A residue of fibers from these felts is also often visible incorporated into the pulp of early paper.) The pressed sheets were removed from the felts and repiled directly upon one another, pressed again, and hung on lines to dry completely. Then the sheets were at last ready for whatever sizing and surface treatment needed to be applied.

In mountainous regions and along fast running rivers where fresh water was abundant enough to power the rag stampers and supply the vats, paper mills were rapidly being constructed or converted from grain mills. Between 1470 and 1550, paper production was expanding steadily across the European continent. Supplies of paper became simpler to obtain, if not locally then by shipment to those areas where no mills were in operation. Even so, printers continued to complain about unevenness of quality, short supply, high costs, and transit taxes. Therefore it must be assumed that in most towns the ready availability of good paper for printing could not be taken absolutely for granted at any time during the Renaissance.[43]

Throughout most of its history in western Europe, paper has been sold in standardized lots and dimensions. From early on, the basic measure of the quantities appearing regularly in documents are:

the bale = 5,000 sheets (10 reams)
the ream = 480 or 500 sheets (20 quires)
the quire = 24 or 25 sheets

For the most part these designations can be taken straightforwardly when they occur in sixteenth-century records.[44] However, especially in earlier documents one must be alert to local eccentricities, a point rarely noted in historical accounts which usually take the conventional denominations for granted. The bale is a particularly troublesome measure and may often mean little more than a bulk shipment. Sometimes it appears to vary by weight, such that a bale of large-size paper would include fewer reams than a bale of small paper. For

4. Jost Amman, *Papermaking*, from *Eygentliche Beschreibung aller Stände auff Erden . . .* (Frankfurt, 1568). Woodcut. British Museum, London.

15

example, a Basel account of 1476 calculates a bale of small format paper at twelve reams,[45] whereas a later negotiation for royal and imperial formats to be sent from a mill in Verona to a consortium of publishers in Venice in 1507 specifies only five reams to a bale.[46] In one fifteenth-century Italian document the ream is given as 200 rather than 500 sheets.[47] Paper graded for writing was often sold in Germany, the Netherlands, and probably elsewhere at 24 rather than 25 sheets to a quire (or 480 rather than 500 sheets to the ream).[48] In this case the adjustment in quantity was probably adopted as the simplest means of accounting for the higher cost of writing paper. Such deviations for the most part seem to have a logical explanation, and furthermore it is the deviations and not the norms which we find specifically noted in the records. Therefore in most documents where the terms *ream* and *quire* appear without any such qualification, one can reasonably assume the standard measures apply. Any reference to bales of unspecified size cannot be trusted.

In 1398 the measurements for individual sheets of paper were set for the Bologna mills officially regulating paper sizes and their corresponding weights by statute.[49] In descending order of scale, these dimensions in centimeters were: *carta imperiale* (50.0 × 74.0); *carta reale* (44.5 × 61.5); *carta mezzana* (34.5 × 51.5); and *carta reçute* (31.5 × 45.0).[50] However, there is little clarity about consistent standards being maintained in the production of paper sizes during the Renaissance period, and about consistency in the use of the terms commonly applied to paper sizes. In any case, prints tend to conform approximately to certain patterns of their own, and probably are fractions of paper sizes available in particular times and places. However, one must keep in mind that for ease of printing and to counter any possibility of movement in the press, a generous margin probably surrounded woodcuts and perhaps also intaglio prints. This margin has been trimmed away in most surviving impressions, if not by the original printer then by later collectors who habitually pasted their prints into albums. Therefore, if one takes the size of prints as measured from the borderline or plate mark, one must expect wide deviations from the sizes of standardly available sheets. Nevertheless, as the Rosselli inventory and other early references show, prints were commonly referred to by conventional paper sizes as a means of assessing their value.[51] When Albrecht Dürer distributed, traded, or sold his prints during his journey to the Netherlands in 1520, for instance, he identified them not only by subject matter but as quarter, half, or full sheets.[52] This is murky terrain. A cognate terminology was used across Europe, but often to express no more than approximate measures (small, medium, and large).

Although we have no secure statistics about paper sizes having been either widely standardized or widely variable in the early period of printing, one would expect them gradually to have become more consistent once book printers emerged as the papermakers' major clients, and as the accoutrements of the printing press came to be scaled to certain regular expectations. Using fractions of standardly available sheets would simply have been the best way to design a book without wasting paper. When paper did not conform to expectation there was trouble. For example, in 1497 Anton Koberger rants on in a letter to his colleague Hans Amerbach in Basel about a shipment of medium-size paper sent to Amerbach by the dealer Cunrad Meyr. There were no fewer than twenty-five bales of it, and Koberger writes with a sample sheet before him: "Such paper is too narrow, too short, and too thin." Having measured it with his own rule he finds it entirely "unsuitable" both in size and in quality, causing him to be "put out not a little" with Meyr. He urges Amerbach, who was subcontracting for Koberger, not to use a single sheet of it, and in future to procure only paper of the correct size. Koberger insists that Meyr has sought to deceive him, and that he can take back his bales of paper and "do whatever he pleases with them."[53] From this incident we recognize that variations in size and weight were anathema to a publisher, and that supplies could best be controlled by requesting specimens of any lot for advance approval.

Over-size sheets could of course always be trimmed down. Paper was trimmed by the mill or the purchaser in any case to remove the rough edge from the deckel. However, unnecessary trimming was wasteful and doubtless avoided whenever possible. But what of special requirements for extra-large papers? This is a matter of considerable interest for the visual arts, but one left completely unexplored in the histories of early papermaking. Renaissance printmaking includes one prominent and astonishing instance of paper that widely exceeds the maximum size we know to have been regularly available at the time. Jacopo de' Barbari's famous woodcut *View of Venice* (fig. 18) published in 1500 was originally printed on six sheets of paper which measure on average 70 × 100 cm — roughly double the width of an imperial folio. It would have required a minimum of two vatmen and two couchers working together simply to wield the tray and the mold. Unfortunately, we have no means of knowing which mill produced these extraordinary sheets of heavy white paper, since they seem to bear no watermark.[54] The paper was certainly made under some sort of special commission for Anton Kolb of Nuremberg who sponsored the *View* and had it published in Venice. The mill was probably chosen from among those several operating in the Veneto, a province already famous for the quality of its paper, though so far as we are able to determine,

sheets of this magnitude are unique for the period. Somewhat later in the century we find unusually large papers bearing watermarks from the Veneto, yet nothing that rivals the scale of the sheets for de' Barbari's map.[55] Over time the demand for larger sheets increased, especially for painter's cartoons, maps, and architectural drawings. But in its earlier stages the paper market served only average needs and required others to improvise by sticking sheets together.

In early documents paper is often identified by its place of origin as well as its size and occasionally its watermark, the region of manufacture clearly having been an important indication of quality: fourteen quires of Bolognese royal folio; a quire of royal folio from Fabriano; eight bales of Basel paper; fifty bales of medium folio Milanese paper.[56] Quality varied greatly, most mills issuing paper in both fine and coarse grades. The poorer sorts were also termed blotting, wrapping, or packing paper to distinquish them from printing or writing paper. These are some of the grades or uses cited, for example, by Johannes Pinicianus in his lexicon of 1516 giving the Latin technical terms and their German equivalents.[57] Inferior papers were made from rags of lower quality. As the industry developed and was further regulated, stipulations about the collection and proper sorting of rags began to appear in the records of town councils.[58] Since good linen and cotton rag was in limited supply, it was among the first aspects of the industry to be controlled in order to protect local interests.

From at least the latter part of the fifteenth century, paper of good quality came in issues designated for either printing or writing, a distinction which had to do with the amount of sizing given to the finished sheets. Sizing was usually applied by soaking the sheets in lime water and sometimes polishing (glazing) them with a piece of pumice. Lightly sized paper served well for the oil-based inks used in printing, whereas the water-based inks normally used for writing could more readily diffuse through the paper fibers and thus blur intolerably. Once it is heavily sized for writing, however, paper becomes less flexible and more resistant to the dampening required to take a clean impression from a type press, let alone from a wood block or an intaglio plate. Thus in 1480 Johan Nelle of Cologne refused to accept a delivery of paper from Basel (he wanted Zurich paper in the first place!) because it was "too dry" to be usable ("zu trocken und untauglich").[59] As the market for paper shifted inexorably from the manuscript ateliers and civic notaries to the heavier demands of book printers, the mills naturally began to produce more and more stocks that were only lightly sized.[60] In the late fifteenth century, paper for printing was becoming a common commodity, yet this does not necessarily mean that paper suitable for fine printmaking was easy to come by.

Despite the many difficulties involved in interpreting them as evidence, in recent years the recording of watermarks has become an obligation for *catalogues raisonnés* of works of art on paper. This information offers a very specialized, but importantly limited, kind of evidence about early paper supplies and print production. Therefore the subject requires more detailed comment. Published documentation of watermarks appearing in fifteenth- and sixteenth-century European writing and printing papers is extensive and steadily increasing.[61] In the process of assembling an enormous corpus of data, the study of watermarks has become a highly technical and confusing business. Part of the general difficulty is that, despite the attention paid to collecting examples of watermarks, too little is known about the history of particular mills, legal regulations, and other matters that might help to localize the various papers manufactured during the early period more precisely. Although Germany has been quite thoroughly researched, the equally if not more important paperproducing areas of Italy and France so far remain relatively unstudied. Yet this is but one difficulty in making use of watermarks as historical evidence.

Print scholars have traditionally employed watermarks in two different ways. The first of these aims at the dating and localization of paper by comparing watermarks with the examples published by Briquet and his successors. As a subtle and accurate determination of location and date these tempting resources are fraught with problems. Here it is necessary to digress somewhat into the technical nature of using watermarks as evidence, since this issue has a direct bearing on certain practical matters about how paper was manufactured, sold, and used.

From the earliest period of European papermaking, watermarks were customarily woven into the wire sieve of the molds used to dip from the vat. As the fiber settles over the mold this finely threaded wire design creates a corresponding thinness in the paper, thereby leaving a translucent imprint readily visible against the pattern of chain and laid lines in each finished sheet. Often within a given mill more than one type of watermark was employed for different types of paper, and these particular watermark patterns varied over time as well. They also varied slightly from one mold to another in a single mill, and can be presumed to have been distorted from wear, cleaning, and repair during the life of a single mold. Larger mills would have kept several molds in service at any one time, and as we have noted above it was the normal practice for a vatman to employ two molds alternately in making a single lot of paper. One lot would therefore bear two variations of the same mark. Then in the course of turning out or couching the sheets, removing them from the felts and stacking them, hanging them to dry, sizing, finishing, restacking, and packing

them for shipment, not to say the subsequent unpacking, restacking, and storing by dealers, the continuity of a particular lot could easily be lost.

Hence a very thorough and specific examination of variations among particular watermarks is needed just to break down the more common types into related sub-groups. This is the initial objective of watermark compilations and the drawings in actual size that now regularly appear as appendices to print catalogues. These drawings may record with more or less accuracy a specific mark imprinted by the wires of one mold.[62] In practical terms these tracings serve merely as approximations of the watermark of a mold used for some finite but unspecified period of time. The general type of watermark might have been employed anywhere from a few months to several decades.[63] The grouping and relation of watermarks through the standard compilations is a matter of adducing probabilities, not historical certainties. Exact comparisons can be made by various photographic and radiographic means that allow for directly overlaying an image of one mark on another. In this way it is possible to establish that two sheets of paper were actually made from the same mold, or in the case of a large project like a book to identify a pair of molds used to make one lot. A precise trace of a set of molds through several stages in which the watermarks were slightly altered, reversed, and even switched has in fact been carried out for at least one early incunabulum.[64] But such a controlled case is bound to be difficult if not impossible to find in papers used for making single-leaf prints.

It must be kept in mind that during the fifteenth and early sixteenth centuries a watermark was often taken as a sign either of a paper's quality or of its dimensions, not foremost as an indication of its source. To be sure, in some cases distinctively local watermarks were employed, a city coat of arms for example. However, in many areas of paper production very common watermarks such as certain forms of the "Gothic P," the "Crown," or the "Ox-head" were used to indicate specific sizes of paper such as chancellery or royal folio.[65] We have little precise evidence for localizing most of these papers solely on the basis of their watermarks. Both common and unusual watermarks tend to be localized according to where the papers were used and rarely provide any independent evidence about specific mills or local regulations. Tracing the sources for paper supplies during our period is therefore a difficult problem which can rarely be solved by watermark comparison alone.

Watermarks must also be used with caution in attempting to date the manufacture or use of paper. Dates assigned to the watermarks described in standard reference books are not dates of production but dates of use — the dates of publication taken from books, or the dates noted on archival documents from which the watermarks have been recorded. The span of time between the production of a sheet of paper and its use is subject to many variations. How long was a particular tray employed by the mill? Was it used continuously until worn out? How long was paper kept and stored by dealers, or mixed with other lots in the shipping barrels? Was all the paper stocked by a printer or town council used in roughly the order it was acquired and within a reasonable span of time, or on the other hand was it bought at low market prices and stored for long periods?[66] The same questions apply to the practices of printmakers, and the mere identification of a watermark does not answer any one of them. Given the normal measures of accuracy sought by historians treating the chronology of Renaissance works of art, the dating of watermarks by reference to the standard encyclopedias is highly imprecise.

It is possible to be somewhat more exact in cases where a Renaissance watermark is accompanied by a countermark. Variations in the "Anchor" watermarks, especially common in Venetian papers, correspond to differences in quality, weight, and size of paper as was conventional for watermark usage elsewhere. From the early sixteenth century on, however, countermarks were added by the Veneto mills as a kind of signature, at first the initials of the maker and eventually the date as well. In certain cases these countermarks can be shown to have developed in an unbroken chronological series.[67] Since countermarks appear on the half of the sheet opposite the regular watermark, a fully intact sheet is required to be useful as evidence. If one had the good fortune to discover both a watermark and a countermark on the paper used for a print (necessarily a print of large size), the possibility of specifying date and place of origin by reference to a well-researched compendium is much enhanced. However, once again the practical application of this for the print scholar is rather limited.

The second means of employing watermarks as historical evidence for dating works of art is more tightly circumstantial. This approach aims at establishing a relationship between two works of art on the basis of the paper used for each. Here dissimilar marks tell us nothing about the relation of one print or drawing to another; as in all cases of circumstantial evidence, only positive correlations are meaningful. Close examination of watermarks (for example by superimposing photographs or radiographs of them) can determine that two watermarks are indeed identical, and thus that the two papers were turned out of the same mold while that specific configuration of the mark was intact. Given other documentary or stylistic evidence of a relationship between the two objects, identical watermarks help confirm a common place and plausibly a common date of use. For example, if the precise watermark found in a signed and dated drawing by

Hans Baldung Grien also appears in a sheet of paper used for an engraving by Albrecht Dürer, then the watermark may be taken as support for the hypothesis that Baldung was active in Dürer's workshop during that time, or in any case that one or the other of them had possession of both the drawing and the plate. It would also point toward (though not confirm) a particular date for pulling that specific impression of the print. It should be clear that using watermarks as a means of reinforcing a circumstantial relationship between two works of art can be undertaken quite independently of any information about the mill in which the paper was produced or about the date it was made. Conversely, a lack of correlation in watermarks does not speak against a close association between two works. Consider, for example, that there are numerous multi-block woodcuts for which each block was logically printed in a press run of its own and then the set assembled at the end. As a consequence, different parts of a composition commonly carry different watermarks even though they may have been made as part of a single campaign.

In actual practice the purchase of papers in the Renaissance probably depended more on a knowledge of mills and dealers than on discriminating among watermarks. The texture, density, and uniformity of early paper was important for book printers, but even more so for printmakers, and these features were best sought by examining the available merchandise.[68] In the matter of quality there were no enforced standards, however. Paper from certain regions, and to be sure certain mills, held to a consistently higher standard than others, the best Italian paper being the most prized of all through to the end of the sixteenth century. Yet every lot from whatever source needed to be inspected, and as we have seen from Koberger's troubles, ordering paper at a distance was inevitably a risky business. For this reason, independent paper merchants cropped up in towns throughout Europe where they played a crucial role in distribution. Paper was a major commodity bought and sold by dealers and printers' agents traveling to the important fairs, such as the famous trade fair held periodically at Frankfurt am Main.

Paper stocks were bound to be simpler to obtain in areas where book publishing was active and consequently where there was much local trading, regardless of whether or not a mill operated close by. For the book printers, obtaining paper stocks was a constant financial aggravation, since it was by far their greatest expense (shown to vary anywhere from one- to two-thirds of their cost). Large paper purchases also had the effect of miring cash flow. Buying large quantities of paper was essential because printers had to complete a full edition of a book in one campaign lest they tie up their type fonts and presses interminably. This procedure could in any case take months from layout to composing the type, then printing and distributing the book, with a long time between cash outlay and the eventual return of a profit. As a consequence it was not uncommon for major publishers to own or control their own mills. Printmakers did not have this advantage, but neither did they have the same difficulties, since there was no loss in printing only a small edition and then reprinting the plate if and when demand warranted. It is unusual to find an artist engaged in the paper business, as was the case with Lucas Cranach the Elder, who dealt in paper among his several entrepreneurial endeavors. Though his workshop cannot be counted as typical of the period, he ran a fully equipped printing house and a pharmacy in addition to his painting workshop.[69]

Paper could be acquired directly from the mills or more commonly from dealers. In most important publishing centers there were a number of local paper dealers, and foreign dealers entered into competition during the authorized trade fairs. Paper reached markets all across Europe by being shipped overland or by boat along the regular commercial waterways. Like books, paper was normally packed in barrels when it was transported. There were transit taxes for handling it, and usually a small tax imposed for selling it in cities.[70] Certain town councils reserved the right to give options to local craftsmen on the purchase of paper as a means of hedging competition among crafts or between locals and outsiders.[71] The variety of possible transactions means that consistent information on paper prices is difficult to come by. Much scattered documentation has been published for the German-speaking territories, and somewhat less for Paris and Antwerp. Evidence can also be gleaned from artists' use of paper in Italy, Florence in particular. Accordingly, we can reconstruct a vague but relatively consistent pattern in paper pricing across Europe from the late fifteenth through the middle of the sixteenth century.

Frankfurt's annual fairs attracted much of the northern European traffic in paper. Here the market tended to be dominated by paper stocks manufactured in the thriving commercial town of Ravensburg. The quality of its paper made Ravensburg the best-known mill in the German-speaking regions, though there were a good many other mills active in the mountainous areas of northern Switzerland, Austria, and southern Germany. Paper prices throughout Germany rose steadily over the period between 1470 and 1550.[72] Italian prices also show a gradual escalation from about 1470 through the first decade of the sixteenth century.[73] Book publishers buying in larger quantities sought to keep the rising, or in any case irregular, cost of paper under control. The Giunti family of printers banded together with some other publishers in Venice in 1507 to contract for shipments of royal and imperial printing paper from a Veronese mill at

19

a fixed price.[74] Notably, there is no reference to paper in the Rosselli inventory, either because whatever remained was deemed of too little value or because there was simply none present. For France, documented figures come primarily from the accounts of paper dealers and mills in Troyes and from the inventories of Paris book printers' establishments.[75] These sources confirm the general pattern of inflation through the first quarter of the sixteenth century, and then a flattening of prices. More complete documentation is available for the Netherlands, where there was very little paper manufacturing, in fact none in the northern part of the region for lack of water power. Most of their paper was probably imported from French mills through Parisian intermediaries, although Italian and German paper purchased at the Frankfurt fairs was certainly also used. The records here show a relatively steady cost from the 1490s through the first quarter of the sixteenth century, and then a sharp rise towards the middle of the century.[76] Recall that Cornelis Bos had over thirteen reams in standard and larger size paper in his Antwerp workshop, that is to say more than 6,500 sheets at the time his belongings were detailed by the authorities in 1544. As this paper was not recorded in the final sale, quite possibly all was confiscated for use by the officiating council. If we estimate its approximate worth at around thirteen *guilder*, Bos's paper stock was among his most valuable possessions. As the century progressed, good quality paper continued to command a very high price. In 1568–70 the elite printing house run by Christopher Plantin was normally paying out one to three and a half *guilder* a ream for French and German paper. But this is a bare pittance compared to the twenty-one to twenty-three *guilder* it cost him to get a ream of the first grade Italian paper he acquired for the publication of the famous Polyglot Bible, a project lavishly subsidized from the royal coffers of Phillip II.[77] Between 1560 and 1600 prices for printing and writing papers inflated substantially, 25 percent or more even within local markets.[78]

The fluctuation of prices paid for paper from the late fifteenth until the middle of the sixteenth century appears to reflect the pattern of general inflation that affected the European market for most commodities throughout this period. Yet it seems that even accounting for inflation there was a gradual net increase in the actual value of paper. This is the opposite of what one might expect given the growing number of mills and the vast increase in paper use throughout Europe. All this holds diverse implications for the printmaker. In a commercial and publishing capital like Nuremberg, paper of all levels of quality must have been available much of the time. The only testimony we have from Albrecht Dürer about acquiring paper comes from a letter he wrote from Italy to Willibald Pirckheimer, and it appears to support this as-

sumption. Pirckheimer, it seems, requested that the artist find him some good paper stock while he was abroad, probably printing paper for one of Pirckheimer's publications. Dürer wrote back to say that he had found nothing there any better than what could be had at home.[79] Yet the same variety could not be counted on in all towns. Hence, depending upon where one lived, the discriminating printmaker had to be more or less attentive to the problem of finding good quality paper. Indeed some must have had to give considerable effort to the quest.

What was the value of paper in relation to a print? Without much more precise information on print prices, this question can hardly be answered with any confidence. A vague idea of the relationship can be gleaned from a document of 1515 recording the purchase of seven impressions of two recently engraved masterpieces by Albrecht Dürer.[80] If we coordinate this purchase with the rough cost of good printing paper at the time, we can conclude that three or four impressions of Dürer's *Melencolia I* could have been exchanged for a five hundred sheet ream of good printing paper. Even recognizing that this is an exceptional print, it would appear that the mere cost of paper, independent of the effort required to get it, was not a significant percent of the cost of the print.

The vicissitudes inherent in the manufacture of handmade paper have a bearing on our understanding of several practical aspects of the printmaking trade. Simply because of irregularities in the macerated fibrous pulp and in the vatman's handling of the mold, for instance, the weight or thickness of individual sheets could vary by up to 25 percent in any lot.[81] The amount of sizing would have varied as well, partly determined by whether a given lot was designated for printing paper or writing paper. Yet even within these categories the differences could be significant from one lot to the next. As many poor impressions of woodcuts demonstrate, a paper with coarse enough laid lines will interrupt the register of finer lines in the block. Such considerations probably bore more directly on printing from intricate intaglio plates than woodblocks simply because the receptivity of the surface and the suppleness of the paper are less critical to getting a sharp image from a woodblock. An engraver, however, must have looked hard to find papers as thin and flexible as those employed by Dürer in many of his most subtle engravings. Since there is no evidence to suggest that papermakers were being commissioned to make special lots for engravers, we must imagine the more scrupulous artist sifting through a dealer's stock separating out individual sheets, perhaps then soaking them in warm water to rid them of some of their sizing, and finally segregating his own stocks into grades of quality for printing different kinds of plates or blocks. It would behoove such a print-

maker to keep an eye out on his travels for stocks of exceptional quality, and to maintain close connections with dealers and publishers, who were constantly trafficking in large lots of paper.

Various attempts have been made to describe the range in quality and character of the many papers used for Renaissance prints. However, the discrimination of paper quality is a skill that can best be acquired by direct experience, because for lack of a commonly understood vocabulary it is presently more difficult to translate into words than the qualities of impressions of a given print.[82] In contrast to the connoisseurship of Rembrandt's papers, none of the accounts of the papers used for Renaissance prints has been able to be very specific about its sundry grades and variations. One important reason for this is the fact that, whereas Rembrandt in his later career employed papers that were significantly different in manufacture, Dürer's papers were relatively uniform but differing by degree or even accident rather than intention. Thus we can generalize to the extent that Dürer and Lucas van Leyden preferred engraving papers that tended to be somewhat thinner and suppler than their woodcut papers, though this was not always so, and that at least today their colors can be seen to vary from cream to white to grayish tones. However, the overall uniformity of these papers belies any precisely scaled grading. As we have tried to demonstrate in our discussion of early papermaking, this is a practical and unsurprising consequence of Renaissance paper production.

By the second half of the century, inks had become commercially available, and in a publishing center like Antwerp it was doubtless worthwhile acquiring them this way, as we know the Plantin press did.[83] But certainly throughout the early period of printing and printmaking, inks were concocted by artists on their own premises, and in most small printmaking ateliers this probably continued to be the case. Lamp black or suspended "vine black," made from wine yeast and lees in linseed oil reduced by boiling, results in an ink of appropriate radiance and viscosity for printmaking and could be further thickened for use in intaglio printing. Larger quantities of carbon ink were manufactured from the soot of burned pitch scraped from the sides of an iron tent set to catch the particles. Ink prepared in this way will occasionally yield a brown "halo" around the printed lines if the pitch is incompletely burned, presumably an unintended effect, but one that can nevertheless result in a warm and elegant impression.[84]

The repertoire of early printmaking includes a wide range of ink tones extending from the most brilliant, glossy blacks typical of south German prints to the matt, sepia-colored inks particularly favored among fifteenth-century Italian engravers. To an extent these differences reflect local preferences for the color of water-based inks in making

workshop drawings. Experiments with colored inks, especially reds, blues, greens, and lavenders, were also carried out during this period. Engravers were often highly attentive to the characteristics of their inks, and we should by no means assume that making an effective and sufficiently refined intaglio ink was a simple and widely shared skill. Dürer's inks are still recognized as exceptionally bright and difficult to match. Thus it is not surprising to find the Italian printmaker Giovanni Battista Scultori writing to Cardinal Granvelle in 1547 asking him to find a recipe for ink to print copper plates, and acknowledging that this is something best sought for among the Germans.[85] Scultori was expressing an aesthetic judgment which dominated the connoisseurship of prints for centuries to come, namely the recognition of Albrecht Dürer's inks as the highest standard for graphic coloration.

BLOCKS AND PLATES: THE PRINTMAKER'S MATRICES

Woodblocks

The skill of cutting a design in relief on the plank surface of a woodblock began to attain an astonishing degree of refinement around 1500. Consequently, there came a need for extremely resilient, fine-grained plank capable of accommodating relief cutting of extraordinary minuteness and precision. Woods of widely differing strength and tractability were probably in use for making woodcuts at one time or another. But once woodcuts were the standard means of illustrating printed books and employed to take large numbers of impressions, it was all the more essential to select material of such density and stability that it might endure sustained use under the intense pressure of the book printer's type press. Such wood was valuable and not necessarily easy to obtain. For example, in Spain, where wood supplies were in general hard to come by, plank appropriate for woodcuts at least sometimes had to be imported: in 1495 we discover a shipment of woodblocks sent from a dealer in Ravensburg to a German book printer's agent in Saragossa.[86] In Nuremberg, on the other hand, plank cut to size could be bought directly from local carpenters.[87]

Firm documentary evidence detailing the exact sorts of woods used for blocks is scarce. The earliest reference known to us occurs in Tuscany in Cennino Cennini's *Trattato della pittura* of ca. 1390, which recommends pearwood or nut wood blocks for textile printing.[88] Especially later on in the sixteenth century one detects a regular preference for pear and boxwood, the latter brought into Europe from Asia Minor and the Black Sea. In 1558 the sculptor Alessandro Vittoria purchased, along with some drawings, a pearwood block for a chiaroscuro

5. Jost Amman, *Draftsman*, from *Eygentliche Beschreibung aller Stände auff Erden* . . . (Frankfurt, 1568). Woodcut. British Museum, London.

print bearing a design by Parmigianino.[89] Vasari speaks of both pear and boxwood in his rather poorly informed discussion of woodcut-making.[90] Jost Amman's *Panoplia*, or *Book of Trades*, prints a verse by Hans Sachs describing the procedures of a professional woodcut designer, a draftsman or *Reisser*. Sachs speaks of him drawing his designs on a limewood plank (fig. 5).[91]

A great many early woodblocks cut for print-making have been preserved and provide us with a direct resource for understanding Renaissance techniques.[92] Many of the very detailed blocks cut for Albrecht Altdorfer's woodcuts were once thought to be out of boxwood. These extremely fine-grained blocks, now a smoky gray-brown hue, were later identified without further evidence as a species of hard European maple.[93] Other woods mentioned by modern commentators on early block cutting include various sorts of nut and fruit wood including beech, cherry, and apple. Yet the identification of ancient woods is a highly specialized undertaking, and none of these initial speculations was substantiated by sound scientific investigation. Then in 1964 certain of the Altdorfer blocks in the Derschau collection in Berlin were subjected to laboratory analysis. Though not conclusive so far as exact species are concerned, this study identifies the blocks as being among the fruit woods in the family Rosaceae including the common pear (*Pyrus communis* L.), apple (*Malus* sp.), and medlar (*Mespilus germanica* L.) All the Altdorfer blocks examined are made of the same species of wood even though they range in size and in the dates when they were cut.[94] To the best of our knowledge this remains the only such study that has been done on early woodblocks for printing.

A planed woodblock prepared for drawing had to be free of knots and splits and properly finished to a very smooth, flat surface. Imperfections in the plank were frequently overcome by cutting them out and inserting plugs. (Over time these plugs often contract, making a slight gap in the design visible in late impressions.) It was typical for two or more planks to be joined together to make larger blocks, always with the grains running parallel to one another. The larger of Dürer's surviving woodblocks usually have metal cletes fastening the joined planks together.[95] We cannot be certain whether the cletes were added later in the life of the block, as seems most likely, or whether they were introduced for additional strength when the block was first made. Woodcut blocks vary somewhat in thickness depending upon the overall size of the block, with those intended to serve for book illustration being cut so as to sit at the proper depth framed-in next to the composed type. Thinner plank could also be nailed to a second plank to give it the required thickness, a step that may have been taken to conserve valuable woods or to provide additional resistance to warping. It was not at all

uncommon for woodcuts to be executed on both the recto and verso of a block.[96]

The planks for woodcut blocks are generally taken from the outer sections of the log sawn parallel to the grain. Thus warping, when it eventually does occur, will tend to split the block down its longer axis. Splitting is also encouraged by the pressure of the press straining against a warp. Yet to choose a plank cut at an angle to the run of the grain increases the chance of early splitting because of contradictory tensions which make it less able to bow uniformly.[97] Of course, any significant warping seriously complicates the task of printing, and the resulting splits in the block will register clearly in any undoctored impressions taken from it. Such difficulties are evident in the majority of impressions of single-leaf woodcuts from the sixteenth century. On the other hand, one must recognize the remarkable endurance of woodblocks. However shabby they may have become, they were often kept in use for centuries. Blocks for some sixteenth-century broadsheets, for example, were actually redeployed as late as the eighteenth century by publishers issuing catchpenny prints, and modern editions from Renaissance blocks continue to be pulled to this day.[98]

As many uncut and partially cut Renaissance woodblocks reveal, the block surface was often covered with a thin ground of white paint, the better to receive the draftsman's design.[99] In cases where a design was transferred rather than drawn straight onto the block itself by the artist who invented it, various means may have come into play. Carboning, incising and pouncing, or pasting a design on paper onto the block were all undoubtedly employed at one time or another during the period. A fifteenth-century account from the Katharinenkloster in Nuremberg enlightens us on one of these procedures. The document explains how to lay down a design onto the block in reverse for cutting. The drawing must be made on a thin sheet of paper, which was then impregnated with oil to render the paper transparent. It was then glued face down onto the block.[100] The design would be visible from the back, such that cutting could proceed through the layer of paper into the block. In 1544 the Zurich publisher Heinrich Froschauer wrote to his draftsman bemoaning the tribulations of the block cutter having to cope with designs being submitted on heavy paper. "Those you have still left to do . . . make them on thin paper. If you have none I'll send you some . . . [T]he thinner it is, the better he can see through it, since he must draw everything in reverse or backwards onto the woodblock."[101]

A reversing procedure was instrumental in any number of cases where it was crucial to replicate an image or a diagram requiring the same orientation as the original design. Woodcut maps of course were always transferred so as to avoid reversal, and

since reversed and unreversed replicas of early woodcuts are so common it is often assumed that cutting a design through a sheet of paper must have been a very common procedure. This may well be true. However, it is worth noting that even a thin sheet of paper causes considerable interference for the cutter and poses certain limits on the order of delicacy achievable. Because of its fraying and otherwise obscuring of the actual surface grain of the block, it is far more difficult, and at a certain level impossible, to accomplish fine work in this way. For technical reasons alone we should presume that very detailed designs or those with exceptional graphic fluency were drawn onto the block surface directly and not transferred by gluing down sheets of paper. In addition to designers working straight on the block, the task of transferring an existing design free hand to a block became a cultivated skill and eventually an artistic specialty.

Cutting a design into the block was already a specialist's task from an early date. Anyone who has attempted to make a woodcut will recognize why this was so. As the examination of early woodblocks makes clear, the basic tool used by block cutters was much the same as it is now — a simple knife, pointed at the tip and beveled along one side of the blade.[102] This one can see from the regularity of the angle of cutting still evident on the original blocks, and from the fact that the repertoire of cuts in the line work can be managed best with this kind of tool. The dense cross-hatching, tightly ranked parallel lines, and rhythmically stacked curling patterns, which constitute some of the most demanding cuts to be found in Renaissance woodblocks, all appear on close inspection to be done with a pointed knife. Chisels were used as well. One often finds the clear trace of chisel marks with narrow, flat and curved tips in open areas where expanses of the block surface have been cut away. On rare occasions it appears that chisels might also have been used for broader line work, but this would have been exceptional.

It may be that by the latter part of the sixteenth century woodblocks were worked on the end-grain rather than the plank, either with or without engraving tools. The proper technical term for working end-grain is "wood engraving" (frequently used interchangeably with "woodcut" in earlier literature). The advantage of end-grain is that because of having no bias in the direction of the grain it can be cut in very fine detail either with a knife or, as later became common, with engraving tools. (Boxwood is actually so dense and has such a fine grain that it approaches this property even on the plank surface.) An additional advantage of wood engraving is the strength of the grain and the consequent longevity of the block. One difficulty with the technique is the restriction in size due to cutting and preparing the blocks of wood across rather than along the axis of the logs. In later wood

engraving this was accommodated by clamping several blocks together. If wood engraving was used in the Renaissance it was likely for purely practical rather than aesthetic reasons, namely, to cut the sorts of decorative initials or border panels used repeatedly by book publishers and consequently subject to very heavy wear.[103] The demands put upon block cutters by Renaissance artists neither required nor were particularly well served by engraving tools. Furthermore, in our period we have encountered no instances in which the style of cutting betrays the use of these tools.[104] Simple knives and not engraving tools were the instruments that achieved the effects to be found in early woodcuts. The fact that a cutting tool of rudimentary design but finely tempered steel and extraordinary sharpness was all that was needed for making Renaissance woodcuts may explain why in 1521 a block cutter named Franz von Köln found himself no less than three *gulden* in debt for the cost of a single knife.[105]

The final stage of preparing a block for printing was the application of ink. Book printers no doubt managed this with dabbers in the same way that they inked their type. Dabbers are soft leather balls stuffed with rags and then rolled in the greasy ink used for printing. This is a very effective means for coating a complex relief surface so long as the ink is sufficiently clear of impurities that might clog the design. Traces of incomplete inking on impressions of some white-line woodcuts suggest that sometimes a brush and in other cases a sort of brayer or ink roller was being used already in the sixteenth century.[106] Nevertheless, inks for printing exceptionally complex woodcuts had to be absolutely free of foreign particles and carefully maintained at an appropriate level of viscosity to avoid clogging in the delicate interstices of a design. Chronic failure to manage this feat is betrayed in great numbers of Renaissance woodcuts.

Engraving

A Renaissance printmaker needed to pay close attention to the quality and material value of his metal plates. This is reflected in both the Rosselli and Bos inventories. The assessors of the Rosselli shop actually troubled to weigh the plates, indicating their worth as raw metal alone. Intaglio plates were normally made of copper, but in Italy at least they were sometimes made of brass and tin or pewter as well. (Tin and pewter are not clearly distinguished in the early documents.) Recall that Rosselli's stocks included plates made of all three substances — *rame*, *ottone*, and *stagno*.[107] Brass, an alloy of copper, is the hardest of these to engrave, and significantly enough it was specified by contract as the metal to be employed for Bramante's famous architectural design engraved by Bernardo

7. Niklaus Manuel Deutsch, *St. Eloy's Workshop*, 1515. Painting on panel, 1206 × 835 mm. Kunstmuseum, Bern.

6. Israhel van Meckenem, copper plate, verso. Private collection.

Prevedari in Milan in 1481 (fig. 92).[108] The decision to use brass for his architectural plate implies either that it was intended to publish an unusually large edition of the print, or that there was some concern about ensuring the strength of such a large plate while it was being printed. Conceivably, both of these advantages were considered. Tin, pewter, and possibly other alloys of a similar kind were selected for their relative softness and lack of resistance to the burin. The wonderfully vital and seemingly spontaneous drypoints by the House-book Master, for example, are presumed to have been done in tin or a pewter-like alloy of similar low density.[109] Although tin plates would have worn quickly under the pressure of printing, they could be more amateurishly engraved or used for drypoint. Iron and steel were probably rarely if ever engraved for printing, though they were used for etching during the first half of the sixteenth century.

Copper was then, as it still is, the metal most commonly preferred for engraving in intaglio. Pliant and durable, easily repaired and yet resilient under pressure, it can achieve a texture and density ideal for responding to the engraver's tool. During the early part of the sixteenth century the trade in copper ore issuing mainly from Hungarian mines came largely under the control of the Fugger enterprises in Augsburg. Records of dealings in Würzburg show that the worth of copper fluctuated markedly during this period, declining in value over the second half of the fifteenth and then rising rapidly at the beginning of the sixteenth century.[110] As the Renaissance metallurgist Biringuccio tells us in his 1540 treatise on the subject, refined copper came in the form of cakes or ingots that could be hammered into sheets either by a professional coppersmith or less likely by the printmaker himself.[111] Certain other metals were also processed into rolled sheets at this period, but documents from the mid-sixteenth century specify using hammered copper for intaglio printmaking. Indeed, the recent discovery of an original plate for one of Israhel van Meckenem's engravings shows on its reverse a surface heavily dented from having been hammered out (fig. 6).[112] Hammering was crucial to the hardness and density of the plate, and thus had an effect upon its resistance to the burin and its longevity under the press. It was a tedious job to achieve the perfectly polished, even surface needed for printing, as the very common evidence of accidental polishing scratches on so many impressions of engravings shows.[113]

The officials who priced the plates in Bos's inventory were aware of the relative value of particular qualities of the finished metal. This is evident from an entry recording "several small plates of copper, some white and some red" (zekere plaetkens van copere som wit ende som root). In certain quarters the distinction had implications other than financial. Alchemists understood the redness of copper according to the theory of the humors to be a symptom of its hot and dry nature. They therefore associated the allure of this metal with the power of the planet Venus![114] A more scientific, if less intriguing, account is given by Georg Agricola in his treatise on mining and metallurgy published in Basel in 1556. Agricola explains how these color variations result from impurities in the ore. It appears that red copper was most valued for its superior strength and malleability,[115] and indeed it was expressly preferred for plates a century later by Abraham Bosse in his 1642 treatise on the techniques of engraving and etching.[116] Many impressions of Renaissance prints betray damage to copper plates extending from actual cracks to mysterious pitted areas registering as irregular concentrations of black stipple. In contrast to the normal recurrence of polishing scratches, these disfigurations record difficulties that must have arisen from unevenness in the quality of the copper itself.

Finished copper plates were therefore a valuable commodity, and any extravagance in the matter was to be avoided. Hence, plates tend to be trimmed near to the border of a design in order to salvage extraneous bits of metal, and when generous borders do occur we can normally take this as a sign of relative prosperity.[117] Plates were commonly recycled as well, either by burnishing out a previous design or by rehammering.[118] Theoretically, copper trimmings and other fragments could be melted down and reforged. Presumably for this reason the broken plates from Bos's shop were bought up in the 1544 sale of his goods. As the shop inventories and numerous surviving examples testify, copper plates were also often engraved on both recto and verso. One would suppose this to have occurred only after one side was well used up, since otherwise the strength and freshness of each engraving would be diminished unnecessarily by having to be run through the press twice for every one impression gained. The evidence, however, suggests that this was not the practice in either Mantegna's or Francesco Rosselli's workshop.

The tools employed for cutting metal plates were essentially two — the drypoint and the burin. In a painting of St. Eloy in his workshop (fig. 7) by the Swiss artist Niklaus Manuel Deutsch we can see more closely a representation of the goldsmith's customary tools, including the burin and stylus. In all probability, the earliest intaglio printmakers depended largely upon the drypoint needle to incise their designs, especially the lighter lines used for interior modeling and tone as opposed to the deeper channels often used to outline a figure. By the latter part of the fifteenth century, however, this tool served mainly as an intermediary step. Engravers customarily inscribed their designs on the plate with light scratches of the drypoint and

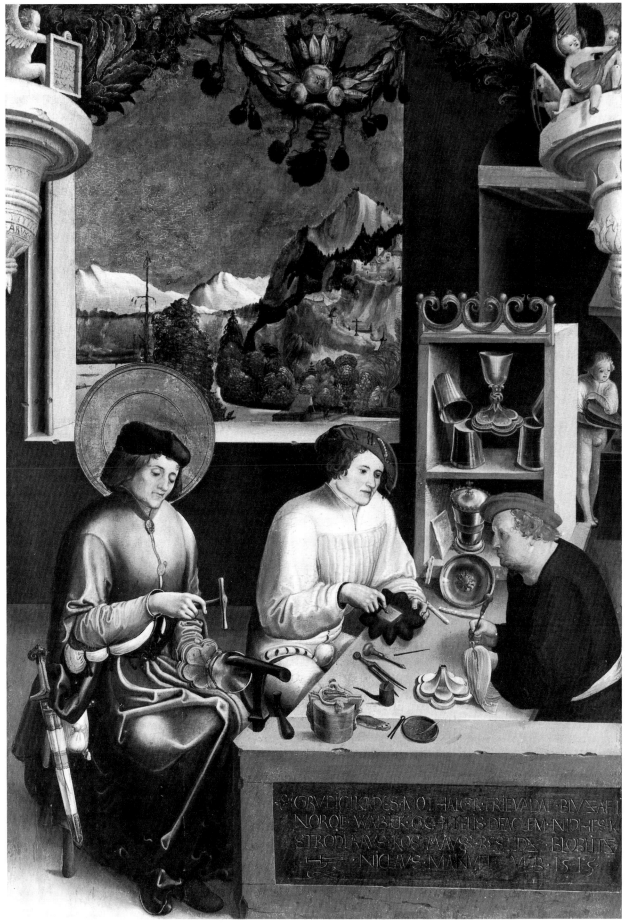

then went on to engrave these lines more deeply with the burin. Traces of this procedure are abundant in proof impressions and even in later impressions. Burin technique had been developed initially by goldsmiths, who employed the tool for incising patterns and figure designs on metalwork. Goldsmithery with engraved designs was most widely practiced in Germany, although it was also being done in France and Italy by the later Middle Ages. Engraving in metal was a specialized skill, and the preeminence of German craftsmen in the use of this technique was no doubt significant for the fact that intaglio printmaking emerged first along the Rhine.[119]

Skill in doing decorative work on brass was cultivated in different workshops from those normally involved in training intaglio printmakers. Because it is harder and less malleable than copper, hammered sheets of brass were used for making precision instruments such as astrolabes, which were decorated with engraved designs and calibrations cut into the metal with tempered steel scribers or burins. But given its relative hardness brass posed more difficulty for the burin than did copper and was thus not especially amenable to printmakers.[120] The limitations can be clearly perceived in Prevedari's engraving mentioned above, where the burin lines appear to be relatively shallow and stiff. Furthermore, there are a number of details added on top of other lines in the print which make it evident that the engraved lines could not be readily burnished out of the plate.[121]

The hardest of metals were iron and steel, and these were never used for printmaking except in etching, where chemical means were employed. However, before leaving our consideration of very durable metals, we must call attention to a curious document which may complicate the historical question of what metals might and might not have served the early printmaker's needs. In his artist's handbook of 1549, Valentin Boltz describes a curing process for "preparing steel, iron, copper, or other metals, so that one can engrave, inscribe, or cut them." He recommends a chemical solution for simmering a metal plate to render it softer for working. Thereafter the plate can be re-tempered by heating in a furnace and rapid cooling in cold water.[122] Boltz's means of curing plates for easier cutting alerts us to the possibility that a variety of metals might have served the needs of Renaissance printmakers.

Two additional techniques of preparing metal plates for printing deserve brief mention, metalcuts and casting. Metalcuts were a common method of making prints during the late fifteenth century in the north, the so-called dotted print being the best-known type. To make a metalcut, a plate of copper or tin was worked with a variety of metalworker's tools — gouges, knives, burins, and stamps and punches of different design. The plate was fashioned by use of these instruments and then normally printed in relief like a woodcut. Metalcuts no doubt employed softer metals, since these could be more easily incised with such a variety of tools, some of which impress the plate rather than plough into it to remove the material itself. Occasionally one finds evidence of stamping in intaglio prints as well, for example already in the 1470s for the lettering on maps,[123] but stamping appears to have been reserved mainly for relief plates and primarily in the early stages of printmaking.

Especially in Parisian book printers' workshops, metalcuts were employed for decorative uses such as elaborate initials, vine rinceaux, small figures of saints, religious subjects, and other sorts of border designs. These plates were generally nailed onto lead or wood blocks for fixing into forms of composed type for the press. Stocks of them appear often in printers' inventories under various rubrics that normally include woodcuts as well as metalcuts.[124] Since these reliefs tend to be rather coarsely done, the distinction between the two media is by no means readily apparent from the printed designs themselves. However, metal must have been preferred for its relative durability in the rough and tumble of a printer's shop.

Refined casting was a highly developed technique in the Renaissance. It was fundamental to a number of crafts ranging from the casting of bronze sculpture to goldsmithery, medal casting, and type casting. Not surprisingly, therefore, casting processes have been conclusively demonstrated to have been a part of very early printmaking as well. In Italy the niello technique for metal decoration was converted to a medium of printing by casting techniques. This entails engraving a silver plaque and then filling in the lines with niello, a black, enamel-like concoction. It appears that in Italy some of the first engraved images we know to have been printed on paper were taken either from such plaques before they were filled in or conversely from sulphur cast replicas of these plaques.[125] Later in the century, casting was also used in the north for making relief and intaglio prints. Many of the eccentric and once lavish devotional images known as "paste prints" appear to have been done by printing casts of some relatively soft alloy taken from metalcuts.[126] These casts were apparently used to print both in intaglio and in relief. Casting was also used for making small portions of text to be fixed to the blocks for printing woodcut maps in the sixteenth century, a technique called stereotyping. A strip of lead type composing a place name or whatever may be needed is fixed together, impressed into a mold, and then cast in facsimile in lead. The resulting cast strip is next fixed onto the woodblock and printed as a unit.[127]

The basic technique of casting plates was adapted from that used for casting type fonts, therefore the method would have come easily enough to an

experienced printer. Indeed, the specialist in small-scale casting was an essential figure in the printing business.[128] Stereotyping and casting plates for paste prints were probably both in use by printers already during the fifteenth century. Consequently it may be that casting was not limited to making stereotypes of letters and paste prints alone.[129] It is clear that Renaissance metalworkers who were engaged in crafting many different kinds of objects had in common the experience of a wide range of tools and techniques. The title page of the 1535 *Kunstbüchlin* (fig. 8) promises its readers a knowledge of the arts practiced with and without the use of fire, and directed either to alchemical or to natural ends, and it treats the hardening or tempering, softening, smelting, cutting, etching, and casting of metals, the preparation of colors, gilding, embroidery, and working with precious stones. Among the tools arrayed below are a crucible with fire and bellows, forger's tongs, saws, metal cutters, a plane, mallets, chisels and gouges, a hammer, a file, a burin, and callipers. Since printmakers by the nature of their craft often associated closely with metalworkers, and book printers and thus type casters, letter designers, medal makers, and the like, one must be open-minded about the possibility that casting entered into the printmakers' repertoire of tricks more often than has hitherto been noticed.

Etching

Etching — the chemical biting of a plate for intaglio printing — constitutes a special case in the history of Renaissance printmaking techniques and requires separate treatment.[130] This method was probably first used for making prints around 1500, in all likelihood in the Hopfer workshop in Augsburg, the first workshop actually to specialize in it. Etching was apparently done initially on iron or steel, metals not altogether clearly distinguished from each other in this period.[131] Plates of iron and tempered steel were prepared in the same manner as copper, that is by hammering. Then some acid-resistant substance, either varnish, paint, or wax, was laid down, through which the design could be drawn with a stylus. In some cases the varnish or paint was applied in a pattern intended to register in the print rather than to serve as removable ground, as was always true with wax. After the design was complete the plate was immersed in an acid bath that bit into the metal wherever the coating was removed. The practice of etching meant that workshops had to stock containers of acid distillates and trays for bathing or laying mordant paste on the plates; these gave off noxious fumes, and Renaissance manuals dealing with armor etching already warn that this needed to be controlled to maintain tolerable working conditions.

A number of recipe books survive with prescriptions for acids suited to biting iron plates, mordants which no doubt had already been in use in ironsmiths' shops from at least the beginning of the fifteenth century and probably much earlier.[132] Vinegar was the basic ingredient in most of them. Mordants were made in two consistencies, either liquid or paste, and were then applied by soaking or by rubbing on accordingly. The strength and corrosive property of the acids would certainly have varied from one preparation to the next, and could be enhanced by warming the paste or bath during the biting process. These acids appear to have been quite efficient. Boltz's manual gives a recipe for *Etzwasser* suitable for iron and steel which he claims will bite a plate in only a half to a full day.[133] Thus it is possible to assume that with the aid of a strong mordant an etched plate could be completed within a day or two with a press run to follow. Etching on iron presumably had the advantage of allowing for a larger edition of impressions than could be taken from a copper engraving, not to say an etching on copper, for though the depth of biting was customarily shallower than the depth of an engraved line, the density of hammered iron surely resisted the pressure of the press to a much greater degree than copper could do. Yet iron and steel plates also had an important disadvantage. As many impressions taken from badly corroded plates from this period testify, moisture in the air causes these metals to rust very quickly if they are not carefully protected by coating with a film of oil or fat.

In spite of its drawbacks, iron and steel etching had a rich and energetic life through the second quarter of the century, by which time it began to be replaced by copper etching. There were other candidates among available metals as well, though as far as we know none of them appears to have become at all significant.[134] It seems that copper etching was not begun until sometime around 1515–20 in Italy and the Netherlands, in all likelihood for lack of a suitable mordant, and it took still longer to arrive in German-speaking regions. Copper plates had the advantage of allowing for a mixed technique, since etched plates could be heightened simply with the additional application of burin or drypoint. Rust was not a problem, and the delicacy of line and predictability of biting were much improved in comparison with iron or steel. Thus, for many practical as well as formal reasons, copper was bound to prevail. What is surprising and in need of explanation is why etching on iron persisted as long as it did. Possibly this was because the recipes for copper mordants were kept guarded and took some time to reach the Danube region.

The history of the copper etching as it superseded iron and steel is difficult to reconstruct because we must depend largely upon the evidence of impressions rather than of surviving plates at those points where the transition appears to have been taking place. It must be clearly stated that the distinction between an impression of an etching done on iron and one done on copper is by no means readily apparent on the basis of the etched lines alone. As the technique of iron and steel etching progressed, acids probably became more efficient and, most important, these metals were more effectively forged into uniform plates. The capacity of etching on iron or steel to achieve a clean, varied, and elegant line would appear to have advanced to a high degree of subtlety during the first half of the sixteenth century. It may well have been the strength of iron plates that kept them in regular use for nearly three decades after the invention of copper etching. However, the reasons for this can only be inferred, since no certain evidence survives about the plate life of etching on iron and steel relative to copper.

By and large, etching, like engraving, was practiced by painters mainly as a sideline. In the north, it remained the choice of only a minority of artists, except in the Danube region, where a high premium was placed upon vibrant styles of draftsmanship. Those who came to etching from an earlier concentration on engraving tended not to like the new medium. When Dürer, Lucas van Leyden, or Domenico Campagnola wanted a freer play of line he brought it forth in woodcut. Italy had a separate affair with etching, since for a time the technique seemed to hold out possibilities for modeling and linear play unachievable in engraving and woodcut. In Italy the appeal of etching must have sprung from its special capacity for capturing and expressing the virtues of *disegno*, a quality that perhaps best explains its success in Italian artistic capitals (apart from Venice, where tonal qualities were valued over line). The etching technique was in many respects only getting started in the period we are considering. However, its history has much to tell us about the evolution of the print in the Renaissance, and thus we shall be giving it much closer attention.

PRINTMAKING PRESSES

A careful look at the evidence makes clear that we know far less about printing presses in this period than the literature often assumes. Most scholars have simply imagined the regular availability of woodblock presses from the time of Gutenberg on, and of roller presses from at least the latter part of the fifteenth century. Though this presumption is reasonable for woodblock presses, it is much less certain for intaglio presses. Very few have troubled to ask what sort of presses were involved, what they might have looked like, and how available they in fact were.[135] Documentary evidence of early printing presses is confined almost entirely to those used by book publishing houses, and even here the information is fragmentary at best, founded on rudimentary descriptions and a very few surviving illustrations. The construction of early type presses beginning with Gutenberg has been exhaustively researched, and contemporary illustrations of these presses survive from at least Dürer's time, though not any earlier. Nevertheless, fundamental doubts persist about the accuracy of these early illustrations until well into the sixteenth century.

The book printer's press, whatever particular form it took, would have suited the woodblock printer's usual needs, although woodblocks occasionally exceeded the normal scale of the type press,[136] and it is very likely that independent printmakers availed themselves of the presses maintained by book publishers on an occasional if not regular basis. In Troyes during the late fifteenth and early sixteenth centuries the *dominotiers* or *imagiers* (professional block cutters) apparently had to have their blocks printed by master printers if they included type-set texts. In such a case the blocks would then have become the property of the printer.[137] A press might also be rented out for a fee in connection with a particular project. In Paris in 1515 it seems one could hire a press for only forty *sous* a year.[138] Much later in Rome, in 1556, we have a document recording the lease of a press ("un torchio per stampare figure") along with seventy cut woodblocks for ten *scudi* a year. The document clearly implies that this was not a book printer's press, but a more rudimentary one made for printing blocks alone.[139] It is just this kind of

apparatus for which no useful descriptions survive. Furthermore, there were traveling printers who had presses of a less elaborate sort that were nevertheless equipped to print with movable type. For example, the Emperor Maximilian retained a portable type press for publishing his various pronouncements on his travels.[140] But just exactly what these itinerant printers were using can only be imagined.

The monetary value of a type press varied depending essentially on two factors. The first was its durability, in particular whether it had a metal screw. The second was its scale, especially the size of the platen, which determined whether it required resetting and two pulls to print a full sheet, or whether the surface could manage this in a single pull. For the book printer a press was a less significant item in the overall budget than it would have been for an independent printmaker. Type presses recorded in Parisian inventories during the early 1520s range in value from nine to twenty *livres*, in these cases apparently varying in cost according to the accessories such as the number of tympans. The price rose over the century.[141] By the second half of the sixteenth century, Plantin expended on average fifty to sixty *Carolus guilder* for each press in his establishment.[142] These were no doubt of the very best construction, but any press approaching that value would mean a substantial outlay for a printmaker. Until at least the eighteenth century, printing presses were being custom built by carpenters with the assistance of screwmakers, presumably according to designs provided by the printing house. Taking all this into consideration, it seems certain that simpler modifications suited to woodblock printing alone were in use as well.

Though it is unclear just what an early platen press made strictly for woodcut printing might have looked like, we must allow for the possibility of various designs suited to various needs. Perhaps there were tabletop models as simple as a bookbinder's press, or for that matter something like the average linen press employed in any well-outfitted middle-class household.[143] Printing a complex woodblock, however, requires a press that can distribute a good deal of pressure equally. Therefore the press needs to be precisely balanced to avoid uneven pressure of the platen on the block. The relief border strips surrounding woodcuts are there partly to protect the design around the vulnerable margins of the block, but also to assist in balancing the pressure of the platen. Another aspect of woodcut design determined by the exigencies of printing are the flights of birds so often populating the open areas of sky. Like woodblock borderlines, these details are present in part to float the sheet of paper evenly across the emptier spaces of the block. Lucas Cranach actually placed triads of dots at strategic points in the blank areas of

his compositions for this purpose. Failing such precautions, the dampened paper would often sag into the irregularly chiseled depressions on the block and become badly smudged with ink. Impressions flawed by this sort of problem are legion.

Difficulties in balancing a press for woodblock printing are evident in many uneven impressions. Occasionally we also find instances of blind printing — a case in which an un-inked or masked woodblock has been pressed into a sheet of paper leaving the trace of its design.[144] Japanese woodcut printers frequently used blind printing to give a patterned texture to a white area in a design, a patch of drapery for example. We are unaware of any such use in Renaissance Europe, where blind printing was a pressman's technique for checking the register of what he was about to print and balancing the press accordingly.[145] Where we find examples of blind printing it is good evidence that a powerfully constructed press was in use. Although many of the coarser broadsheets published in our period might have been printed by means of a rudimentary press (hand-printing being too inefficient after a point), woodblocks of the calibre of those designed by Dürer required a substantially built press either of the same sort as a printing press or of like construction unaccoutred with the paraphernalia for type printing.

Alessandro Rosselli and Cornelis Bos both had printing apparatus recorded in their workshops, but again the precise character of these is not at all clear from the documents. As we have noted, both workshops seem to have been printing in relief and intaglio. In Rosselli's inventory the reference to a "torcholo da stanpare chon sua fornimenti" is surely to a platen press, and one probably capable of printing letter type as well.[146] The second entry, for "3 tanburi da stanpare" (literally, drums for printing), can only mean an apparatus for printing in intaglio. But are these in fact three roller presses, a considerable number for a single shop? Contrary to the assumption of A. M. Hind and others that this may be our first written reference to the use of a roller press,[147] Henry Meier suggests they are just as likely large, weighted drums designed to be set on a table and rolled over an intaglio plate by hand. This entirely plausible hypothesis leads Meier to speculate that the drum method was inherited from Francesco's shop, and thus provides evidence for one way intaglio impressions were taken in the latter part of the fifteenth century in Italy. As we shall see, Mantegna's way of printing large plates seems to support Meier's hypothesis, whereas Prevedari's printing of the 1481 engraving after Bramante points to some form of fixed roller. Experiment began early on, but uniform practice probably came late.[148]

At least one of the presses cited in Bos's inventory must also be some form of roller or a roller press, since engraving was his major specialty.[149]

Yet again we are left far from a description of an apparatus. Furthermore, the surprisingly low price paid for Bos's functioning press at the sale of his goods suggests it was a rather simple machine.[150] In one lot thirty impressions of a print sold for the same price as the press! The first secure reference that has been uncovered to a press specifically used for printing copper engravings is contemporary with the Bos inventory, however. It occurs in the inventory of a Flemish book printer and dealer's shop in Mechelen in 1540. There, among stocks of maps, books, paper, prints, and copper plates, we find a "copper plate press and other implements" (coperen plaetpersse ende andere greetscap).[151] For a really detailed account of just exactly how a roller press was built we must turn to Abraham Bosse's seventeenth-century treatise on engraving.[152] Nevertheless, the invention of the roller press was undoubtedly not in itself a serious technical problem since, much as there were models for the flatbed press, analogues for a roller press were already present in the form of cloth drying ringers and rolling mills. The question in 1500 is not whether the roller press was yet available, but rather what printmakers felt they required to register their plates. Unfortunately our discussion of early printmakers' presses leaves us with more questions than it does answers.

Production Rates, Costs, and Market Value

Is it possible to make any sound generalizations about production time and costs and their relation to the market value of finished prints in the Renaissance? We have given some indication of the value of supplies required by the workshop, and it is apparent that the capital and equipment needed to become a printmaker were a good deal less than what it took to be a goldsmith, and a very great deal less than was required to begin printing books even on a small scale. The shop of a painter, sculptor, or metalworker could append a printmaking operation without substantial cost so long as space for some sort of press or printing apparatus was available. There were, after all, no licensing fees, no additional guild fees, and in most cases no restrictions on the hiring and maintaining of assistants.

Yet our understanding of the investment of time in the making of prints is hindered by a lack of documentation in the form of contracts or similar evidence that might shed light on rates of production. Woodcuts constitute a somewhat better documented case because they soon came to be the product of two to three separate specialists working in collaboration — a designer, a block cutter, and often a printer in addition. Much more will be said about this in a later chapter. There are also rare

instances of commissions for copper engravings or metalcuts that give us a vague idea of the time and expense involved, one of them remarkably early in date. In Lübeck on 20 August 1459 the craftsman Bertold Borsteld made a contract with one Hans Leiden for payment of a debt of "100 Marks Lübsch." Bertold was to make restitution for his debt with ten copper engravings or metalcuts to be completed over the course of fourteen and a half months, with a heavy financial penalty should he default.[153] Slightly later evidence is recorded in the aforementioned contract of 1481 for Bernardo Prevedari's notably large engraving, which states explicitly that the plate is to be executed in the household of the patron, and that Prevedari shall labor day and night in order to complete it within the space of two months. For this feat he is promised the lavish fee of forty-eight *lire imperiali*.[154]

A different sort of testimony about the rate of production comes from the exceptional instances during the first half of the sixteenth century when two printmakers recorded the exact dates of completion on their plates. Both the Italian engraver Marcantonio Raimondi and the Netherlandish painter, engraver, and etcher Dirk Vellert frequently troubled to date their prints to the day. This practice may have been adopted from the colophons in printed books and be closely related to the manufacturing ethos engendered by printing. Some of Marcantonio's engravings are dated within two weeks of one another.[155] And if we look at the chronology of Vellert's twenty-odd intaglio productions, fifteen of which are dated to the day, we find that he tended to work in sprints. For example, three prints were completed in a month's time between 16 August and 14 September 1522, and three more in a month and a half during 1524. The shortest time separating an engraving from the previously dated print is seventeen days. For an etching there is a space of only four days.[156] Heinrich Aldegrever has left us a number of meticulous preparatory drawings which he regularly dated in reverse, affirming that they were intended from the outset as designs for prints. The dates on these drawings are commonly one year earlier than the dates subsequently recorded on the engraved plates.[157]

These statistics are suggestive in spite of their sparseness and our ignorance of surrounding circumstances. Probably one did not make a good engraving even of small size in less than a week, whereas a good etching certainly required less time, perhaps only a day, depending upon the duration required to bite the plate. It is safe to say that on average an engraving consumed much more concentrated manual labor than an etching of comparable scale and linear complexity. This is simply a question of the technique itself. But how long it might have taken to complete a print is also, in some part, a matter of individual habits and talents.

An accounting of the full production of the most prolific and technically accomplished intaglio print-makers of the Renaissance supports our contention that engravings were a time-consuming project, not something to be turned out at a rate of two or three a week. Over Dürer's thirty or more years of activity he seems to have made a little over 100 engravings. Spread evenly this comes to fewer than four a year. Lucas van Leyden's twenty-five year career yielded about 175, or seven engravings a year. And finally Marcantonio, who so far as we know specialized exclusively in printmaking, made around 300 in thirty years' time, or ten a year. This figure is generous since there are a great many works that may have been done in his style or by other members of Raphael's workshop.

There are common-sensical hypotheses about the practice of printmaking that are also worth rehearsing. For those painters who made them as part of their regular output, prints were an opportunity to fill the spaces between commissions for altarpieces or other large projects. Furthermore, prints could always be made after dark by candlelight. Later illustrations show the use of a vessel of water interposed between a candle and the engraver's working surface as a way of easing strain on the eyes.[158] Printmaking also had no seasonal dependence, no need for the light of long days and the warmth of summer for drying oils, a consideration of somewhat more importance in northern Europe than it was in Italy. Making prints was an effective way of increasing production time in the painter's workshop.

A final problem concerning the economic basis of printmaking is the size of the editions that could be made from woodblocks and metal plates in the Renaissance. This is an area of occasional speculation in which most calculations are inevitably derived from a knowledge of modern practices, and less understandably ranked by estimates of connoisseurship premised on modern standards of quality. Even so, opinions about the number of feasible impressions of good quality ranges widely in the scholarly literature. On the one hand, we have Alan Shestack's cautiously technical statement that an early engraved plate could yield only 50 to 60 impressions before the finer lines began to disappear.[159] A. J. J. Delen asserts that engravings were good for about 200 impressions of "high quality," and etchings only about 50 because of their relatively finer lines and shallow biting, the latter assertion based presumably on copper rather than iron etching.[160] Friedrich Lippmann says an engraved copper plate will withstand 200 "brilliant" impressions, an additional 600 good ones, and another 600 tolerable impressions, that is, 1,200 to 1,500 usable images, leading to a completely exhausted plate after about 3,000.[161]

Documents that are precise about the actual sizes of editions in the Renaissance are next to non-existent. Albrecht Dürer's donation of two portrait engravings of Albrecht of Brandenburg — the first sent to the Cardinal in 1519 along with 200 impressions, and the second in 1523 with 500 impressions — appears to have been meant to solicit an unspecified donation rather than to fulfill a contract.[162] Although these two deliveries have sometimes been taken as a measure of what was qualitatively acceptable, the implications are not so clear. Both times Dürer included the plates with the shipment, implying they were still good for more and also that he would not profit further from them himself. Dürer's technique of engraving with deep incisions would certainly have withstood pulling more impressions than the plates of many of his contemporaries. On the other hand, it has been suggested that the portraits of the Cardinal were intended to be used only as book plates and so did not need to meet the standards that might have been held for a collector's print. However, Dürer printed at least some of these portraits with great care, for example wiping the plate in such a way as to leave tone to shade the Cardinal's coat of arms. This degree of sensitivity to a single impression surely belies the notion that standards of quality were being compromised.[163]

We do have some testimony on the matter of intaglio edition sizes in somewhat later treatises. Most striking is the degree to which these pre-modern estimates deviate from our common assumptions. For example, a document from the mid-sixteenth century records a printer from the school at Fontainbleau who supposedly pulled 2,000 impressions from his copper plate.[164] Heinrich Zeising's early encyclopedia of technology, *Theatrum Machinarum* of 1622, states that 1,000 impressions can be taken from a copper plate, and more if the lines are strengthened by re-engraving.[165] This is confirmed in a tract of 1698 by Christoff Weigel who cites 1,000 to 2,000 impressions as possible.[166] Of course, judgments about what constitutes an acceptable impression are central to these figures. Nevertheless, there must be some practical relation between the upper limits proposed and the number of truly rich impressions that could be taken from a given plate. Keeping this in mind, we must take account of a surprising document that would seem to cast all of our previous testimony in shadow. In a letter of 1754 the Antwerp publisher J. J. Moretus writes to his engraver with the following request about some prints he has commissioned: "These plates must be engraved by you entirely with a burin and not etched or engraved with spirits or by any other means." This is important, he says, because "my copperplate pressman is very experienced in printing so that he prints more than 4,000 copies before the plates have to be retouched."[167] This is apparently a case of printing engravings for book illustration, an area where we might expect a uniformly high standard of quality to be especially

critical. So far as we know, neither the basic materials nor techniques had changed dramatically between 1500 and 1754.

Subtle understanding of how to manage the making and printing of a plate might have great consequence for its longevity, as might any number of other factors. Hence, the entire matter of potential edition sizes cannot be resolved with any precision. The number of variables is simply too great. Apart from the style of cutting and the nuances of printing there are a legion of other elusive technical factors to be considered. What sorts of copper alloy were being used? How thoroughly were the plates hammered? How deeply were they incised with the burin? How much pressure was a press applying, and how was a plate cushioned? What of the character of inks and papers that might render intense pressure less necessary? Moreover, all of the numbers given above are for copper plates and not etched iron plates, which constitute a separate class. However cautious we might be in questioning the range of estimations that have been proposed, the eighteenth-century Antwerp document should give us pause about establishing too low a ceiling on editions of engravings during the early modern period.

Finally, our consideration of the practical aspects of Renaissance printmaking should not obscure the fact that a great many less tangible factors were at play. The material context of print production seems in retrospect to be an especially important part of its commercial character, and one essential feature that distinguishes it from the kindred arts of painting and precious metalwork. However, the fact that prints were replicable and largely independent of traditional patterns of patronage in the arts should not lead too quickly to the conclusion that the *peintre-graveurs* operated by an altogether different set of rules when they were making prints rather than panel paintings. On the contrary it is very probable that, as van Mander tells us of Lucas van Leyden,[168] rather than exploit printmaking for its advantage in mass production, painters were inclined to impose high standards of quality on the editions issued under their name. Moreover, the potential size of print runs is irrelevant in the absence of a demand for so many impressions, and the value of a print may not have been entirely unrelated to its rarity. Printmakers understood this kind of calculation, and in very many ways their prints testify to a preference for prizing quality over quantity.

III

How Prints became Works of Art:
The First Generation

DURING THE LAST quarter of the fifteenth century as the print began to claim some marginal prominence among the pictorial arts of Europe, printmakers gradually adopted the formal vocabulary of painters and sculptors. At the same time, they began to shed their anonymity as craftsmen. Although both woodcut and engraving aspired to the standards set by the ennobled arts, each printmaking technique did so by following its own path. On the one hand, the refinement of woodcut came about mainly through a division of expertise into designing and block cutting, two very different skills that quickly became dependent upon one another. Engraving, by contrast, found its way to maturity through the diversified skills of single artists, especially painters, who were now training themselves to move with great facility from their customary pens, styluses, and brushes to metalworkers' drypoints and burins. Our present task is to examine the early history of these changes as they unfolded more or less concurrently north and south of the Alps. It was a critical stage in the evolution of European printmaking, one that came about partly by exchange of ideas and partly by each tradition acting according to its own independent lights.

BOOK ILLUSTRATION
AND SPECIALIZATION IN THE
WOODCUT TRADE

Books and prints were close acquaintances from the very outset of printing, as we have seen; indeed, the maturation of the woodcut was a direct consequence of printed book illustration. This was not only a matter of the status that books eventually bestowed upon prints by their association. Book illustration had much to do with the technical improvement of woodcut making, and consequently with its eventual acceptance as a legitimate medium for the designs of painters. Correlations between the rise of the print and its functional capacity in the book printing industry have long been acknowledged, but mainly on the level of the cataloguing of styles and influences, traffic in woodblocks, and particular alliances between printers and independently recognized masters. It has been calculated that fully one-third of all books printed before 1500 were illustrated.[1] Nevertheless, the book industry has rarely been acknowledged as the dominant and moving factor in the emergence of the print as an independent art form of aesthetic stature and commercial success. Yet the fact is that those areas in which important schools of relief printmaking arose were also closely tied to the book industry. Here we shall consider this relationship and some of the practical and artistic reasons for it.

In Germany the first steps in woodcut book illustration were taken in the early 1460s in Bamberg, marking the beginning of what quickly emerged as a major dimension of the printing industry. It was during the decade of the 1470s, coincident with its proliferation in Italy, that woodcut illustration grew with extraordinary speed. Literally thousands of blocks were designed and cut for book printers in the German-speaking regions, France, and the Netherlands over the next generation. By far the majority of these illustrations were done for scriptural and devotional books, and a large percentage were of a narrative kind. The texts were various and often newly written, and many of them were published with dense illustrations. Thus, early printed book illustration required the invention of a very considerable number of new compositions,

in woodcut may well have stimulated both Schott and Rusch to take special effort in recruiting an inventive designer and skillful cutter.

Although the names of the northern artists and craftsmen involved in early woodcut book illustration are almost entirely lost to us, there is a definite stylistic continuity to be discerned within particular regions and indeed within specific workshops. A distinctive style developed in Augsburg and nearby Ulm, for instance, and this style retained its essential character well into the following century, marking these as two prolific centers of woodcut production. The beginnings can be traced to Günther Zainer, who first came to Augsburg at the behest of a monastery to set up a printing workshop on behalf of the residents. This led to one of the most successful printing operations in the incunabulum period, carrying over to Günther's relative Johannes Zainer, who became the main printer at Ulm. Günther issued the first printed book to be extensively illustrated, a two-volume edition of Jacopo da Voragine's *Golden Legend* printed in 1471–72 (fig. 11). These early entrepreneurs were followed by others, such as Anton Sorg, who built upon their success, adopted their designs, occasionally purchased their blocks, and perpetuated the Augs-

9. Frontispiece, from Bernard von Breydenbach, *Peregrinationes in Terram Sanctam* (Mainz: Erhard Reuwich, 1486). Woodcut. Rijksmuseum Meermanno-Westreenianum, The Hague.

10. *A Holy Man Floating on the Sea*, from *Die Wunderbare Meerfahrt des Heiligen Brandan* (Augsburg: Anton Sorg, ca. 1476), fol. 8v. Woodcut. Pierpont Morgan Library, New York.

since the illustrators' repertoire needed to extend far beyond the models available in painting and manuscript illumination.

For the first twenty years or so we have precious little evidence north or south of the Alps about the procedures that publishers followed in developing new cycles of illustration. How often were the designers and block cutters one and the same? Did the designers work under detailed instructions from the author or publisher, or did they read the texts and compose subjects on their own? We may glimpse evidence relating to these questions in a document of 1489 in which Canon Peter Schott complains to the Strasbourg printer Nicolaus Rusch that their plans for an illustrated Virgil were delayed because of difficulties in finding both a designer and a block cutter.[2] The fact that this was a classical text that had never before been illustrated

burg style. A fine example of the engaging simplicity and cleanliness of this style can be seen in the illustrations for Sorg's *Life of St. Brandon* (fig. 10).

In Swabia and elsewhere the scale of production alone implies that workshops of considerable sophistication and orderliness had developed. We must presume that efficient transfer and copying techniques were being used, and that a major publishing workshop employed quite a number of block cutters at a time in order to complete its larger projects. Much of the early production was not especially challenging to the technical skills of the cutters or designers, however. The first instance where we discover a designer making exceptionally strenuous demands on the woodcut medium is in Bernard von Breydenbach's luxury edition of the *Peregrinationes in Terram Sanctam* published in Mainz in 1486. The illustrations for this account

of a journey to the Holy Land were designed by the painter Erhard Reuwich, who accompanied his patron on the journey, laid out the illustrations, and doubtless oversaw their realization in woodcut and print.[3] At the time, nothing north or south of the Alps could equal the intricacy of design and cutting in the frontispiece (fig. 9). The ornamental style of this elaborate heraldic composition drew its graphic sharpness and rich chiaroscuro from sources outside the woodcut medium. Breydenbach's luxurious volume set an influential precedent in northern European book illustration, but one that for some years proved very difficult to match. This was far from a typical case in the early history of printing. Not only did the project have the advantage of aristocratic patronage, but an original program of illustration was undertaken which included the unusual feature of topographical studies; and finally, a designer of acknowledged talent was employed.

With the exception of the Reuwich woodcuts, northern printed book illustrations of the 1470s and 1480s were typically less refined than the work of Italian contemporaries, who eventually achieved magnificently coloristic and textural effects in the language of woodcut. Only rarely did northern blocks sport a comparable sense of pictorial adventure or such a complex understanding of the integration of abstract design with naturalism (fig. 11) as we see displayed in the acknowledged masterpiece of the Venetian school of book illustration, Aldus's *Hypnerotomachia Poliphili* (fig. 12). But the example of Breydenbach stimulated a number of ambitious projects in the north and pointed the way to a far more pictorial and less humble approach to the possibilities of woodcut. By the last decade of the fifteenth century, Nuremberg began to compete with Venice in the sheer extravagance, if not the classical refinement, of her book illustration.

In Italy the major capitals of book printing during the last quarter of the fifteenth century were Venice and Florence.[4] Although Florence had previously been responsible for producing the most elegant illuminated manuscripts, after an awkward start graphic illustration reached its highest level in Venice. Both styles are shown to have derived ultimately from important painters of the time — Domenico Ghirlandaio and Sandro Botticelli on the one hand, the Bellini family and Vittore Carpaccio on the other. Surely it is not merely a coincidence that woodcut book illustration came into its own in northern Italy precisely during the ripening of what Vasari terms the "second Renaissance style," a style characterized by a manner of deliberate draftsmanship readily translatable into the more limited vocabulary of the woodblock.

Although the style of Italian woodcut illustration from this period echoes the work of monumental painting, there is no evidence to suggest that these same painters were yet directly engaged in making

designs for publishers. Botticelli's drawings for the *Divine Comedy* are a glaring exception, and in any case he employed engraving rather than the less supple woodcut.[5] Furthermore, this project was abandoned in its early stages, in all likelihood because of the technical difficulties inherent in printing engraved illustrations meant to be integral with a printed text. A concurrent project of this kind was undertaken in the Netherlands — Collard Mansion's scheme for using engravings to illustrate the text of Boccaccio's *Livre de la ruine des nobles hommes et femmes* published in Bruges in 1476. Judging from the different constructions of known copies, this, like the Dante publication, also seems not to have come to fruition.[6] The engraver of the Boccaccio illustrations appears to have been recruited from among the artists active around the spectacular Burgundian court in the Netherlands. Both of these experiments in printing engraved

11. *St. John Chrysostom,* from Jacopo da Voragine, *Leben der Heiligen* (Nuremberg: Anton Koberger, 5 December 1488). Woodcut. Pierpont Morgan Library, New York.

12. *Poliphilus in a Wood,* from *Hypnerotomachia Poliphili* (Venice: Aldus Manutius, 1499). Woodcut, 106 × 130 mm. British Museum, London.

35

illustration were under way in the same years, and both entailed the illustration of an Italian literary work doubtless intended for an exclusive audience.

In the case of Italian woodcut illustrations, little is known about those who designed and cut the often exquisite productions of the incunabulum period. Although woodcut makers are documented since at least the first quarter of the century, they appear to have been involved mainly in the printing of playing cards and what they termed *santini*, small images of saints carried for devotion or as amulets for protection.[7] Essling has demonstrated that woodcut book illustrations in Venice did not fall within the territory of these established woodcut makers. Instead, woodcut book illustrations developed from an old trick used since at least the first quarter of the fifteenth century in Venetian miniaturists' *botteghe*. There the ground was prepared for the illuminator by lightly printing by hand the outlines of the image with a so-called *stampiglia* — a woodblock attached to a wooden handle.[8] As the fashion for woodcut book illustration spread to Venice from the north, the less scrupulous illuminators quickly adapted this old custom by simply inking more thoroughly and printing more accurately, still using what must have been little more than a glorified *stampiglia*. The stark linearity of Venetian fifteenth-century book illustration that we now admire so much may well have originated in the inherent limitations of the *stampiglia*, which carried only the barest possible outlines of a composition for the illuminator to use as a trace for hand-coloring.

The earliest illustrated books published in Venice were thus produced differently from books printed north of the Alps, and they were made according to a method that contradicted the principal advantage of printing by movable type.[9] The illustrations of these early Venetian books were stamped into the copies by hand, most often after the book had been bound. This can be easily confirmed by the smudges of greasy ink that occasionally seeped through onto the two or three pages following an illustration — pages that, in a press, could not possibly follow one another.[10] On the whole, very few fifteenth-century Venetian books actually contained true woodcut illustrations.[11]

This practice was not confined to Venice. If there is a common denominator among all early examples of illustrated books in Italy, it is the carelessness with which most printers dealt with woodcuts, inserting them where convenient to the publisher rather than the reader. A typical example is a *View of Genoa*, apparently based on a drawing from nature, used a second time in the same book as a view of Rome, with a new title[12] (an efficiency that we also find somewhat later in the Nuremberg *Weltchronik*). In Venice the same woodcuts were used to illustrate books on different subjects by different printers, making it obvious that publishers

— who at this time were one and the same as printers — had little to do with the production of the illustrations. The printers' stocks included only type fonts and initials;[13] the illustrations were completely controlled by the guild of illuminators who sold or more often rented their woodblocks. For a long period illuminators continued to produce crude woodcuts and to print them by hand after the copies of the book had been bound. Kristeller found signs of this practice well into the 1470s, not just identifying the obvious difference in ink between text and cuts, but also discovering a number of cases in which the same block had been printed twice on one page, something that could only have happened if the printing were done by hand.[14]

Both the design and the cutting of the woodcuts was therefore in the hands of illuminators at this early stage, and it is unlikely that they would hire designers, let alone painters, to do a job similar to what they had done for decades. On the other hand, cutting blocks other than in the form of crude *stampiglie* was something they knew nothing about, even if they may have been unwilling to admit it. This curious set-up explains why so often in the early history of Venetian book illustration the design was good but the cutting very coarse. This happened outside Venice as well: the *De re militari* by Robertus Valturius, published in Verona in 1472, has beautifully designed illustrations — probably the work of the sculptor and medallist Matteo de' Pasti or of Valturius himself — but it is clear that no experienced cutter was available for the job.[15]

A gulf soon grew between what the market — and therefore the publishers — sought and what the illuminators could offer, until the 1480s when there was a fairly abrupt improvement in the quality of illustrations, likely the result of new designers and cutters entering the fray, and illuminators abandoning it. The task of block cutting seems to have been taken up by sculptors in wood and *intarsia* makers, since their skills were closest to those required in handling the cutting of a small woodcut. We know, for instance, that some of the leading *intarsia* makers of the time, such as Lorenzo Canozi di Lendinara and Matteo Civitali, turned to publishing illustrated books and probably cut many of the images themselves.[16] At the same time, the role of designing images was taken over by artists whose names we might not recognize today but who carved a niche for themselves by specializing in this activity. Indeed, many of them are known not by their names but only by their styles, although a few signed their productions conspicuously.[17] Hind calls the two most important designers of the 1490s the "popular designer" (now known as the Pico Master) and the "classical designer," responsible respectively for the 1490 and 1493 editions of the so-called Malermi Bible. He

13. *Anatomy Lesson*, from Johannes de Ketham, *Fascicolo di Medicina* (Venice: Johannes and Gregorius de Gregoriis, 1493/94). Stencil-colored woodcut, 300 × 198 mm. Private collection.

also notes the emergence in Venice of an increasingly competitive market for good designers, though these were still often let down by insufficiently experienced cutters.[18] Thus special relationships formed between Venetian designers and cutters, relationships that would set the pattern for many a collaboration during the sixteenth century.[19]

Towards the close of the century there is further improvement in the quality of Venetian book illustrations, with an increasing use of parallel hatching, taken straight from the example of Mantegna's engravings,[20] and with the arrival on the scene of one or two extremely gifted designers. This resulted in an obvious change in attitude to woodcut illustrations on the part of the public. The two greatest books published in Venice during the fifteenth century, the *Fascicolo di medicina* of 1494 (fig. 13) and the *Hypnerotomachia Poliphili* of 1499 (fig. 12), contain such high-quality illustrations that it is possible, if not probable, that one of the leading painters of the city was prevailed upon to provide the designs. All the obvious names have been proposed for the authorship of these beautiful images, from Montagna to Cima, from Jacopo to Giovanni Bellini, but what is important here is the extent to which the status of woodcuts had changed over the preceding twenty years. Now an artist rather than a specialized craftsman was involved in the creation of a relief print. This was an important development, setting a precedent for such distinguished followers as Jacopo de' Barbari and Titian.

Although the primacy of Venice in book production by 1500 was not in question, on average the quality of book illustration was superior in Florence. It was not until 1490 that illustrations appeared in a Florentine book, but when they did they seemed to be better designed, cut, and impaginated than at anywhere else at the time.[21] Indeed, the colophon of the greatest Florentine illustrated book of the century, the *Epistole e Evangelii*, printed by Lorenzo Morgiani and Johann Petri for Piero Pacini da Pescia in 1495, reminds the reader of the richness and quality of its truly extraordinary cuts.[22] The very fact that practically all Florentine book illustrations were surrounded by decorative borders in imitation of frames, suggests that these small images were meant to be perceived as individual compositions.[23] As in Venice, Florentine cutters worked for different printers — who, in turn, worked with different publishers — but did not normally design the images themselves. Because of the exceptional imagination and daring of many of them, it has often been suggested that some of the best painters of the time were discreetly involved.[24] In the light of Botticelli's precedent, this may, indeed, have been the case. If it was, it is even more extraordinary than may appear at first sight, since there is evidence that books illustrated with woodcuts were disregarded by literati, that

few reached the libraries of great collectors, and that, instead, they were destined for a much larger, and supposedly less refined, audience of Florentine citizens. Many early publications illustrated with woodcuts were little more than pamphlets, often printed as programs for *rappresentazioni* and *giostre*, and were enjoyed and discarded after use; this is why they are so exceedingly rare.[25]

⇒○⇐ THE NORTH ⇒○⇐

ANTON KOBERGER'S ENTERPRISE

Anton Koberger built up Europe's largest printing establishment in the conservative and wealthy mercantile center of Nuremberg in south-central Germany. Through a network of agents posted all across the continent, and through close connections with other printers, Koberger distributed his publications over a wide area. A true citizen of his town, Koberger was less a pioneer than he was adroit at recognizing and promoting the innovations of others and at maintaining a high standard of production within his firm. His bibliographical contributions to the history of fine printed books rest on the imagination and mediation of such learned men as Sebald Schreyer and Hartmann Schedel. Yet his impressive productions reflect a financial genius that kept Koberger ahead of his competition and relatively immune to the effects of piracy.

As early as 1488 Koberger printed a luxury edition of Jacopo da Voragine's *Lives of the Saints*, and then in 1491 the *Schatzbehalter* appeared, a finely illustrated devotional text.[26] Koberger's best-known and most ambitious undertaking was Hartmann Schedel's famous Nuremberg *Weltchronik* of 1493, a publication that followed in the steps of the *Peregrinationes in Terram Sanctam* to set a new standard for illustrated book printing in northern Europe. Whereas Aldus Manutius captured an influential corner of a narrower humanist trade in book publication, Koberger absorbed much of the northern European market for biblical and devotional texts, and cultivated a particular taste for fancy productions both in the vernacular and in Latin. The introduction to the archetype for the great *Weltchronik* declares that it is "not meant for students of antiquity, but rather for the delight of the general public."[27]

As in Italy, the style of German book illustration grew out of local roots, chronologically coincident with the evolution of Italian book decoration but stylistically more or less immune to it. Koberger's house designers were Michael Wolgemut and Hans Pleydenwurff, draftsmen with a strong sense of graphic layout both in the design of an individual composition and in the construction of a page. Comparison of the woodcuts executed for the *Schatzbehalter* with those of the *Weltchronik* completed only two years later betray a significant shift in style

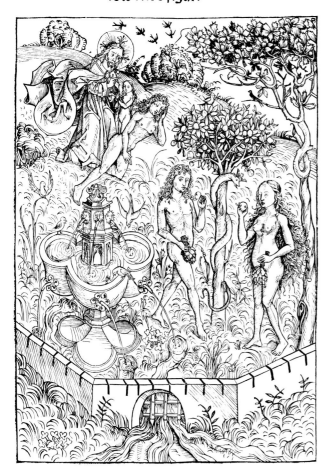
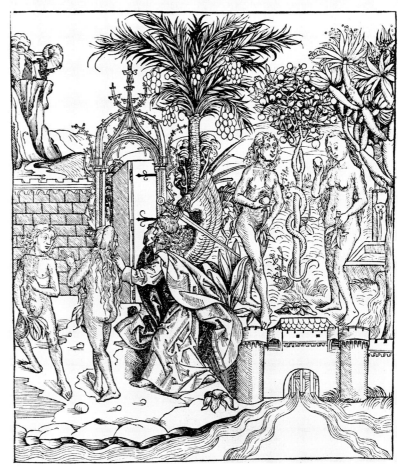

and particularly in graphic sensibility (figs. 14, 15). The cuts for the earlier text are engagingly rhythmic and graceful, the later ones staccato and angular. The compositions for the *Schatzbehalter* tend to weave over the whole surface of the block, whereas those in the *Weltchronik* are relatively liberal in their allowance of white, unprinted regions. Here priority is given to the arrangement of figures within a framed field, with greater stress on contrasting areas of dark and medium tone. These differences lie with the designs themselves, not with the skill of the block cutters, which is in each case sufficient to the task though not exceptional.

The extended cycle of woodcut illustrations in the *Weltchronik* controls the positioning of the text on the printed sheet in a way that sustains the stark flatness and legibility of the page. However much indebted to manuscript illumination for its initial inspiration and its strategy of integrating text with illustration, the *Weltchronik* emerged a product of the printer's and printmaker's sensibility. In all likelihood this project served directly or indirectly to incubate Albrecht Dürer's special passion for the woodcut. Though much is known about the creation and financing of the *Weltchronik* at various stages, we are entirely uninformed about the block cutters who finally realized the designs for the printer. There must have been a number of them,

and they seem to have been mostly well schooled and moderately well disciplined. Yet these craftsmen remain anonymous, with the possible exception of Dürer, whose participation in the design or in the cutting of these blocks has only been inferred on insecure stylistic grounds.

Nevertheless, Koberger's procedure for illustrating the *Weltchronik* changed the history of specialized woodcut making in northern Europe. The contract agreements reflect what must have been a new manner of arrangement for printers and their backers confronted with financing large illustrated books.[28] The project involved six major players: apart from Koberger himself, there was the author Hartmann Schedel, two financial contributors named Sebolt Schreyer and Sebastian Kammermeister, and the two aforementioned painters, Wolgemut and Pleydenwurff, who were responsible for the illustrations and additional matters as well.

The first of the two known contracts for the publication is dated 21 January 1491, and it establishes the relationship between the illustrators and the sponsors, Schreyer and Kammermeister. The painters were committed to providing the archetype or layout for the book; they also had the responsibility for overseeing the cutting of the woodblocks as well as protecting and maintaining their quality while the edition was being printed. Much empha-

14. *Fall of Man*, from Stephan Fridolin, *Schatzbehalter* (Nuremberg, 1491). Wooduct, 250 × 170 mm. Library of Congress, Washington, D.C.

15. *Fall of Man*, from Hartmann Schedel, *Nuremberg Weltchronik* (Nuremberg, 1493). Woodcut, 255 × 223 mm. Multnomah County Library, Portland, Oregon.

sis is given to guarding the designs in order that they not be pirated in the course of printing. Wolgemut and Pleydenwurff were to be advanced 1,000 Rhenish *gulden* to cover their expenses in acquiring the paper and having the book printed. Surprisingly enough, they also had to see to its distribution and sale. The first profits were to be set aside to cover the initial outlay of Schreyer and Kammermeister, in other words their 1,000 *gulden* advance to the painters and any other costs they might incur in the meantime. Thereafter, the profits were to be divided evenly among the painters and their sponsors. It will be noted that Koberger was not party to any of this. The backers also maintained the right to undertake reprintings, though on the understanding that the two painters were to keep an option to participate on an equal basis and to manage the refurbishing of the blocks if this were necessary. Should Schreyer and Kammermeister choose not to reprint the book, then Wolgemut and Pleydenwurff were free to do so on their own. All matters of contention involving these arrangements fell under the arbitration of Koberger.

A second contract was made two months later, on 16 March 1492, this time between Koberger the printer and the sponsors. The second contract sets the conditions for acquiring the paper and managing the printing. The size and quality of the paper is specified, with examples supplied as a minimal standard to be exceeded. The manner of paying for the paper is laid out in some detail, since it constituted a major capital expense and could easily result in the printer being caught short between expenditures and returns. Once printed, the finished sheets were to be purchased from Koberger by the sponsors at a cost of four Rhenish *gulden* per ream. When the printing was completed, the blocks and the archetype were to be returned to Schreyer and Kammermeister.[29]

These contracts for the *Weltchronik* point to certain practices relevant to our study. To begin with, the publication of the book was funded independently of the printer, whose job it was to provide the expertise in fine printing along with the facilities for carrying it out. Koberger functioned largely as a job printer and seems to have borne no direct liability for the eventual success or failure of the project. Secondly, Koberger's "house draftsmen" were not really subordinates in the undertaking but rather entrepreneurs, acting almost as equal partners with their sponsors Schreyer and Kammermeister. It seems the painters, like the printer, were not committed to provide any capital for the venture. Rather, their interest in the profits derived entirely from the fact that they contributed what was most essential to the success of the book, namely, its woodcut illustrations. That they did not retain the rights to their designs foretells a pattern that would become standard in the later history of printmaking, once publishing houses took control.

Blocks were too important as collateral, and in Koberger's day they tended to remain with the principal investors. The designers took their profits from the distribution and sale of the book. One might have expected Koberger himself to have taken care of distribution, since it was he who must have had the necessary contacts with agents and printers elsewhere. Finally, though Koberger's role in the enterprise appears at first to have been most sharply delimited — entailing the lowest risk and consequently the lowest potential gain — he was nevertheless the manager of the overall arrangement. The contracts therefore establish an interesting set of checks and balances designed to ensure that those expert in a particular area carried the obligation for that part of the project along with an appropriate expectation of gain. The author disappears from sight, doubtless having been paid off for his efforts well ahead of the arrangements for realizing his text in print.[30]

As we have implied, the block cutters go unmentioned in the *Weltchronik* contracts. Probably they were recruited from Koberger's stable and were under the supervision of the painters. On the basis of another document we can, however, reconstruct the financial worth of the Nuremberg block cutter's skill. In 1494 Sebald Schreyer undertook the patronage of a second publication that was at least comparable, if not even more ambitious, in scope. This was the *Archetypus triumphantis Romae*, an anthology of classical authors that so far as we know never appeared from the press, or, if it did, no example of it has survived. Schreyer contracted in two stages with the chief author Peter Danhauser for preparing the text and illustration of the project. This seems to have been a case where the author figured importantly as a sort of production manager overseeing details in furthering the work. Danhauser's initial arrangement with his sponsor included board, payment for materials and labor, and also a share in the expected profits. The author's benefits were to be rendered partly in cash and partly in copies of the publication. In the second contract, made in 1496, the two parties agreed to a much expanded vision of the project and to organizing the transcription of exemplars, and the illustration, typesetting, proofing, and printing of it within a specified length of time.[31]

The specific expenses are interesting, as they provide us with the only complete record of which we are aware prior to 1500 that includes costs for all stages of making woodcut illustrations. For the better part of the woodcut designs drawn on paper (217 designs of various size or complexity), Danhauser paid over nine *gulden*, from which it can be deduced that most of the designs cost between ten and eleven *denar* each.[32] These preliminary drawings established the layout and were then enhanced and likely modified in the final scheme, which required no fewer than 233 large and 83

small woodcuts, nearly one hundred additional designs. For the 316 woodblocks required, Danhauser again paid his carpenter a little over nine *gulden* (about eight or nine *denar* for the larger blocks and half that for the smaller ones). For drawing the designs directly on the blocks, the illuminators were paid altogether a little over thirty-seven *gulden* — about three times what it cost for the preliminary designs done on paper; a large design on a block ran about thirty-four *denar*, a smaller design half this.[33] Drawing the designs on the blocks was in effect to execute the complete design such that it would be suitable for the exigencies of the cutting. This was where the real skill came in. To judge by the exemplar for the *Weltchronik*, the preliminary designs were only rough sketches, simply a guideline for the printer estimating his page construction (figs. 16, 17). The final transfer may also have included putting down a ground or oiling and polishing the surface of the blocks as well. It is notable that at each stage the author appears to have engaged different craftsmen.

The most serious expense in this part of the project, however, lay in the cutting of the designs on the blocks. This was done by, or under the supervision of, a *Formschneider* named Sebolt Gallensdorfer — 233 large blocks were cut for a little over half a *gulden* each (one hundred thirty-five *denar*), and 83 smaller blocks were cut at half the price of the larger ones, for a total of nearly one hundred and fifty *gulden*.[34] Thus, as with the transferred designs, the costs of cutting were calculated by size. If we compute the total design cost — ten or eleven *denar* for the original design plus thirty-four or seventeen *denar* for drawing onto a block — it turns out that the cutting of a design cost almost exactly four times the amount paid for its initial invention and transfer. Very likely this reflects the time required at each stage and takes relatively little account of the designer's creative task in generating an appropriate figure. In sum, for any one of his large blocks, Danhauser expended around three-quarters of a *gulden* which paid for the wood, the preliminary design, the finished draftsmanship, and the cutting.

It seems that if the blocks were ever completed they were never published in conjunction with a text.[35] We can only assume that the subjects were

16. *Adam's Descendants,* page layout for the *Nuremberg Weltchronik.* Pen and ink, 394 × 270 mm. Nuremberg, Stadtbibliothek.

17. *Adam's Descendants,* from *Nuremberg Weltchronik,* fol. 10r. Woodcut, printed surface, 375 × 220 mm. Private collection.

41

simply too peculiar to be of use elsewhere and were relegated to the scrap pile. It is not known for certain why the Danhauser project never reached completion, but the contracts tell us something about the enormous financial commitment entailed in putting together an extensively illustrated publication of this kind. The accounts for the *Archetypus* run over three hundred thirty-five *gulden* for the illustrations alone, which must be a large part of the reason why it may never have been printed.

There is a long history of major projects for which the enormous cost of illustration was paid out with the consequence either of bankrupting the project or seriously retarding the printed edition.[36] Each case may have its own explanation, and printers embarking on such projects could face a high financial risk. Expensive books were not secure investments, and clearly a part of Koberger's genius was the fashion in which he managed to support his enterprises through encouraging financial backing from others. By sharing costs and profits with other publishing houses and collaborators (very likely including the designers if not the block cutters as well), he was successful in bringing many of his projects to completion. Given the time required for finishing a major book, the crucial difficulty for printer and publisher was cash flow. Furthermore, this became most critical at the final stage when paper had to be purchased in very large quantities to bring out a first edition. The design and execution of illustrations could be spread out over a long period of time without serious loss, and wages for the actual printing operation were a relatively low expense. But when it came to printing, a full edition had to come forth in short order lest a printer's type fonts remain indefinitely tied up. All recent studies of the early printing industry have confirmed this point. Illustration was expensive, but paper and available type fonts were more often than not what determined whether a text got beyond the designing stage to be typeset, printed, and put on the market.

Anton Koberger's *Weltchronik* and its related publications set an important precedent for woodcut production. Not only did Koberger establish a high standard, he also unveiled the potential market for luxury printed books in the north. It is not clear whether the *Chronik* actually reaped a significant profit. Judging from the number of unsold copies and outstanding accounts listed in the final reckoning in 1509, fully fifteen years after the initial printing, it may well have been only a modest success. In spite of Koberger's influence, the text was pirated soon after it appeared, and must certainly have reached a broad distribution in its various versions.[37] The motive behind the *Weltchronik* enterprise should in any case not be explained entirely on financial grounds. It served to promote the reputation of its printer. For the two Nuremberg humanists Hartmann Schedel and Sebald Schreyer,

the book was a glorification of Nuremberg itself and a statement of the new historical consciousness then emerging in northern lands. In this respect as well, the *Weltchronik* set a precedent for the use of printing and especially of woodcut.

Anton Koberger's printing projects had immediate consequences for Albrecht Dürer, Koberger's godson and an apprentice of his house draftsman Hans Wolgemut. Dürer was almost certainly an apprentice in the workshop during the making of the *Weltchronik* and also during the very first stages of designing the *Archetypus*. In 1495, after returning from his *Wanderjahr* in Italy, Dürer must have quickly set about designing the cycle of woodcut illustrations to the Revelations of St. John, the most celebrated and markedly un-Italianate achievement of his early career. As the colophon proclaims, the *Apocalypse* was printed by Dürer himself and published in 1498 in separate editions with Latin and German texts. In its format the *Apocalypse* departed from the usual priority of text over illustration in printed books. The text is heavily abridged and printed on the reverse of the illustrations, though not arranged so that the appropriate image always appears facing its passage of text. It is as though the artist included the text as an ornament to lend something additional to his compositions without finally challenging their self-sufficiency, in short a reversal of the usual ordering of text and illustration.

There is no question that Dürer conceived his *Apocalypse* cycle principally as a bound portfolio of images accented by a text. This project also shows that the idea of publishing a book of images alone, without any text to accompany them, was not one that had occurred to Dürer, or one that was as yet acceptable to the market. We may infer something about the level of its reception from the fact that when Dürer reprinted it in 1511 with a newly conceived title page he did so only in a Latin edition (fig. 183). Most likely, Dürer's clientele for this cycle was drawn largely from among the better educated. The *Apocalypse* was no doubt quickly recognized as an extraordinary artistic achievement and purchased accordingly by clerics and humanists, who must have regarded it less as an object of religious meditation than a work of the draftsman's art meant for the private library or print cabinet. In fact, inventories of print cabinets and libraries throughout Europe frequently record copies of Dürer's books later in the sixteenth century. As a collector's object the *Apocalypse* set an important landmark in the history of the woodcut, a sign that it was no longer merely a form of vernacular art but rather a medium capable of aspiring to the highest level of excellence. The illustrated book and particularly the lavish imprints from the Koberger printing house were critical steps in bringing about a reassessment of the woodcut in the Renaissance.

ANTON KOLB AND
JACOPO DE' BARBARI:
NORTHERN ENTERPRISE ABROAD

By any measure, one of the most spectacular achievements of monumental woodcut making during the Renaissance was the great *View of Venice* of 1500, designed by the Italian master Jacopo de' Barbari (figs. 18, 19).[38] This aerial perspective of the city, recording virtually every street and every building, covers nearly four square meters of wall space when its six sheets are properly assembled. Not coincidentally, this extraordinary monument to Venice emerged straight out of a tight web of associations with Nuremberg. The *View* was produced under the auspices of Anton Kolb, a Nuremberg merchant resident in Venice. Kolb's relations with book publishers back in his native city are well recorded. In fact we know that he was engaged in selling copies of Schedel's *Weltchronik* in Venice sometime before 1499 when he finally settled accounts with Koberger for thirty-four copies held on consignment.[39]

Jacopo de' Barbari was a Venetian who had by then been active for an undetermined length of time in the city. Circumstantial and later documentary evidence points to an encounter between Jacopo and Dürer during the northern master's *Wanderjahr* in 1495. Dürer arrived fresh from Wolgemut's shop where the *Weltchronik* had only recently been completed. Reciprocal influences later on suggest that the two artists were much impressed with one another's work.[40] We do not know how long the project for the *View of Venice* was under way before its publication in 1500. However, given the elaborate surveys and other preparations needed to carry out such an undertaking, Kolb must have engaged Jacopo about the time he would have met Dürer, or very soon thereafter.

Just as the young Dürer was drawn to the city of Venice, so Jacopo de' Barbari was attracted to Nuremberg. Jacopo must have departed from Venice shortly after he completed the designs for the aerial map, since he is already documented at work for Maximilian in April 1500 as a "portraitist and illuminator" (*contrefeter und illuminist*) with a year's stipend of 100 Rhenish *gulden*, fully six months before Kolb applied to the Venetian Senate for permission to publish the *View of Venice*. Probably it was Kolb who commended the Italian painter to the Emperor's service. We also know that Kolb, Jacopo, and Maximilian were engaged in some project together shortly thereafter, since the three of them are recorded as settling an account in 1504.[41] In any case, it is very clear that we have here a notable intersection of artists and patrons who together played an essential role in changing the character of the woodcut medium.

Apparently the design and publication of the *View of Venice* were sponsored by Kolb principally as a financial enterprise. However, it is hardly likely that he could have brought it off without the cooperation, indeed the encouragement, of the alert and protectionist Venetian Senate. Considering the military application of accurate maps, one cannot imagine Kolb completing the project, including printing and publishing the blocks on Venetian soil, without official sanction. It is in any case certain that the Senate endowed Kolb with a full copyright and an uninhibited privilege to sell and export the *View* for a four year period.[42] Indeed, this appears to be the first instance of an official privilege being issued for an image, not strictly speaking a work of art, but nevertheless an important extension of a practice initiated in Venice when a printer was granted a privilege for a specific text in 1486.[43] Certainly it is not coincidental that the first recorded privilege for a book was issued in Venice, a city that kept tight control over commerce and sought every means to protect its own interests and those of its residents where they served the economic and political ends of the state.

Anton Kolb's appeal to the Venetian authorities includes mention of the fact that no woodcut of such size utilizing blocks of this scale had ever been done before. The consequent difficulties in printing seem to have been partly claimed to justify the high cost he wished to charge for the *View of Venice* in order to recoup his expenses. He was granted permission to sell it for three ducats a copy. The quality of cutting in most portions of the blocks is very high, indeed superior to the cutting of two other woodcuts with designs by Jacopo de' Barbari which Paul Kristeller regards as having been cut in a manner characteristic of Venetian work around this time. Consequently, Kristeller proposes that Kolb or Jacopo may have commissioned German block cutters to undertake the task.[44] If so, the project was even more strikingly an import. Unmentioned in the appeal for the privilege is the fact that the paper used for these prints is as unprecedented as the size of the wood blocks. As we have noted earlier, the only means of accounting for the paper used by Kolb is to suppose that a special commission was arranged for that as well.[45] The best paper among the first state impressions is of very high, uniform quality, and it is well worth noting that this aspect of the project was an ambitious technical achievement in itself.

Anton Kolb's permission to sell the *View of Venice* for three ducats a copy establishes our first firm record of a price for a major woodcut, albeit of a very special sort. What value does this figure represent? It is instructive to recall that those copies of the *Weltchronik* recorded in Kolb's possession in 1499 were valued at better than one and a half ducats a piece. Since these were on consignment, the figure probably does not reflect their retail value. At any rate, the great aerial map was worth at

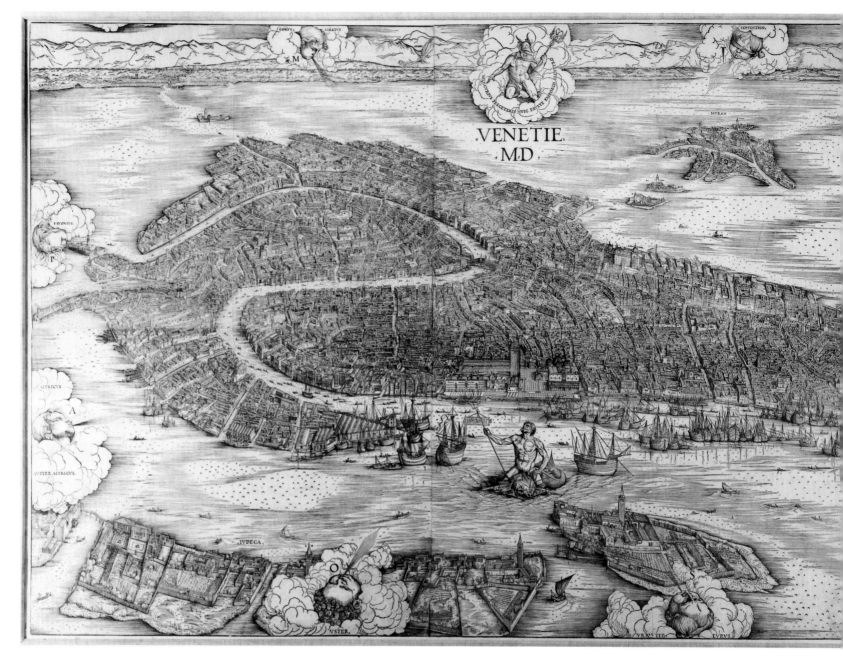

least twice the price of Anton Koberger's prize publication. Consider as well the catalogues of books from Aldus Manutius's press recorded in 1499 and in 1503: certain of his Greek editions, including the works of Aristotle, cost three ducats a volume. Thucydides and Herodotus were priced at a ducat each. These were quarto and folio editions, octavos and Latin editions costing a fraction of this. They were intended for an elite market, indeed the sort of market that would likely have been attracted to the *View of Venice*, and furthermore would have had the means to display it.[46] Quite clearly, luxury editions of books with lavish illustrations, like the aerial map, were intended for a discriminating and privileged clientele. The *Weltchronik*, or *Liber chronicarum* in the Latin edition, and Colonna's *Hypnertomachia Polifili* were well beyond the means of most professional people, not to say the average artisan. Aldus's complete set of Aristotle would

have cost two months' salary for a teacher in Venice in the early sixteenth century.[47]

Much has already been written about the significance of Jacopo de' Barbari's *View of Venice* as a cartographic, propagandistic, and artistic achievement. For our purposes it should be stressed that the undertaking itself and its technical achievement depended upon the entrepreneurial and artisanal expertise of Nuremberg as well as Venice. The conception of this woodcut derives ultimately from Erhard Reuwich's fold-out view of the city in Breydenbach's *Peregrinationes in Terram Sanctam* published in Mainz in 1486, and subsequently from the orientation, though not the accuracy, of city views established by Wolgemut in the Nuremberg *Weltchronik*. Although innovative in many respects, particularly in perspective and surveying practices that led to a topographical plan of unprecedented scope and accuracy, the *View of Venice* would

44

MERCVRIVS PRECETERIS HVIC FAVSTE EMPORIS ILLVSTRO

VENETIE MD

not have been realized without the ambitious explorations in printing being pursued by northern European publishers in the late fifteenth century.

The artistic and cartographic importance of the *View of Venice* was certainly recognized in its own time, as the unusually large number of surviving impressions attests. But the *View of Venice* was a business enterprise as well and accordingly done for profit more than for the renown of its designers and patrons. It is most significant that on the block no reference appears to the publisher, the artist who designed it, the block cutters, or indeed to the privilege granted by the Venetian Senate. We can identify the financial backer only through notarial records and a diarist's reference to him, neither source bothering to name the designer. Conceivably, Jacopo de' Barbari did mean to include a signature covertly in the magnificent figure of Mercury who

overlooks the city prospect like a resplendant Salvator enthroned at the Judgment, for Mercury bears the caduceus, Jacopo's personal insignia. Whether this constitutes a signature or not, it can hardly be taken as an effective gesture of self-promotion (fig. 19).[48] More to the point is the long tradition of honoring Mercury as the patron god of merchants. The god is embraced by an inscription proclaiming precisely this association: "I Mercury shine favorably on this above all other emporia" (MERCVRIUS PRE CETERIS HVIC FAUSTE EMPORIS ILLVSTRO). Importantly, this cartographic view was commissioned by a merchant of the Fondaco dei Tedeschi to celebrate his adopted city as a great center of commerce. Given that it was issued anonymously, the *View of Venice* can be understood as a civic publication only in an indirect way. Nevertheless, it bears all the characteristics of a promotion and certainly proclaims the stature and

18. Jacopo de' Barbari, *View of Venice*, 1500. Woodcut from 6 blocks, 1390 × 2820 mm. British Museum, London.

19. Jacopo de' Barbari, *View of Venice* (detail).

45

magnificence of the city on an impressive and entirely unprecedented scale.

These few examples give an idea of the importance of the illustrated book for the early cultivation of fine woodcut making, especially in the major centers of Nuremberg and Venice. It was, of course, these two cities that fertilized the early career of Albrecht Dürer, the first to undertake woodcut making for its artistic potential. The finely made woodcut for a collector's taste was only likely to become a reality once the skill of block cutting achieved a level of sophistication equal to the pictorial demands being put upon the image in the Renaissance. Luxurious book printing and extraordinary projects like Jacopo de' Barbari's *View of Venice* had the effect of placing the woodcut within the ken of the highest orders of patronage. These endeavors supplied the medium with expertise and with respectability. They were critical steps toward making woodcut suitable even to the artistic ambitions of an emperor.

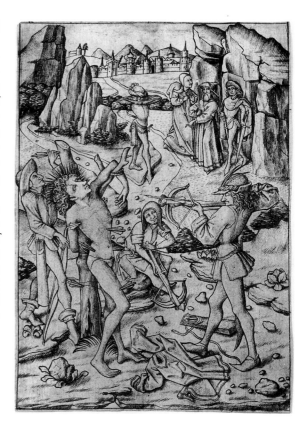

NORTHERN ENGRAVING AND THE INVENTIONS OF THE MASTER ES

The early history of engraving in the north followed a different pattern of development from what we have seen in woodcut. Despite close connections with metalworkers and occasionally with book illuminators, engraving was never allied to a dominant source of patronage in the way woodcut was to book printing. Perhaps largely for this reason the earliest distinguishable personalities in the history of printmaking are engravers, and the first of these to leave a corpus of work that is substantial, widely varied, and strikingly individual is now known only by a pair of letters that appear in a few of his prints — the Master ES.[49] In all likelihood the Master ES began making prints in the 1450s and continued doing so until 1467, the date appearing on what are probably his last plates.

Although the Master ES's career immediately precedes the period of greatest interest to us, his engravings pose a number of questions about the early status of prints and their relation to other media. This is, of course, a crucial matter for interpreting the advent of the *peintre-graveur*, and along with it the eventual liberation of printmaking from its status as a craft. Our concern here will be to interrogate the scarce evidence that we have about the activities of the three major northern engravers of the century in order to understand better the conditions which made possible the artistic ascendency of the print. Here two essentially technical factors take on critical importance. The first is the capacity of the instruments employed (along with the skill of their handlers) to generate an image that could be perceived as competitive with the illusionistic stan-

dard set by painting and the ornamental standard set by fine metalwork. The second is the development of a means of incising and printing a plate such that good quality impressions could be taken from it in reasonably large numbers. Bridging these technical matters is a third and more elusive factor, the cultivation of a new market for prints, and along with that the emergence of engraving as a medium having an identity, and consequently an interest, peculiarly its own.

Sometime during his early years, the Master ES composed the first of several versions of a *Martyrdom of St. Sebastian* (fig. 20). It was a subject that had special currency in times of plague, a threat that was in any case never far from the public mind. From an engraver's point of view a plague image (or *Pestbild*) was a commercially secure one because it was bound to be in regular demand. However, the *Martyrdom of St. Sebastian* was also an unusually challenging subject pictorially. Not only was there the chastely naked body of the saint to portray, but his executioners had to be rendered in strained and contorted postures wrestling with their sinister machinery, and typically an open landscape was required as well. We get a good sense of the Master ES's style from this print, the way he spread out his composition like an ornamental surface laid over the sheet, with deep contours from the burin used to define the margins of each major element. His formal syntax was based mainly upon extended ungulating incisions, parallel scoring, a short leaf-shaped gouge, and a won-

derfully vigorous screw pattern. In the slightly labored quality of the Master ES's line we can sense the resistance of the copper to the burin being driven through it, a feature that is also betrayed in frequent slips of the tool recorded in the impressions. Perhaps he was accustomed to a burin less sharp than it might have been, and he had likely not yet discovered the usefulness of a pillow to balance and control the plate while he worked on it.

The composition of the *Martyrdom of St. Sebastian* is oddly fitted together, rather as if it were a pastiche of figures rearranged from other sources. Indeed, it has been argued that it was based on a lost painting of the Strasbourg school.[50] Regardless, the artist did not concern himself much with a plausible organization of the episode. The spatial dynamics are quite detached from the action of the figures. For example, in the foreground a crossbowman aims point blank at Sebastian while his cohort, withdrawing a bolt from the tree, stands perilously in the line of fire behind the saint. In the middle distance a third bowman takes his aim directly out of the landscape at us, the innocent and unsuspecting admirers of the image. He seems placed there to bring us up short, as indeed he does. This is a deftly executed, not to say witty, passage of foreshortening that gains further effect through the artist's use of his favorite scissor-step pose. The Master ES certainly did not invent this arresting motif. In fact the crossbowman had a prior history as a workshop model and continued to be used in other prints and also on playing cards.[51] The bowman is a device for prompting our attention in a way that helps to make the space of the image more credible. The Master ES used the motif in another of his engravings — *Emperor Augustus and the Tiburtine Sibyl* (Lehrs II.192), where, from the city gateway in the distance, the bowman once again catches us looking down the wrong end of his sights. This trompe l'oeil has no relation to the subject of the print, but of course that is not the point. He is a cipher for the artist's presence, our antagonist so to speak, stalking us from behind the scenes.

By their self-conscious presentation alone, the prints of the Master ES demand to be taken seriously. But what of their originality? We must acknowledge the artistic subordination of engraving at this stage in its history, and also its undoubted dependence on the prestige and example of other media. The case has been forcefully put that many fifteenth-century northern prints were intentionally made to reproduce specific works of art. In fact, like the *Martyrdom of St. Sebastian*, the Master's *Augustus and the Tiburtine Sibyl* has also been argued to be a reproduction of a fifteenth-century painting, now lost.[52] This hypothesis is based upon closely similar formulations of figures and stylistic affinities between the engravings and certain surviving works from the upper Rhine region. Yet,

in the absence of any clear and complete correspondence of one existing work with another, we cannot be certain whether these two prints are in fact detailed or even summary reproductions of paintings. There are, however, a number of instances where, by carefully reconstructing the history of a composition, engravings have been shown to be derived ultimately from paintings. On the basis of a careful examination of certain of these cases, Fritz Koreny has asserted that the origins of the reproductive print — in his terms, a print made primarily to record another work of art made in a different medium — are traceable to this, the earliest phase of the engraving medium.[53] As Koreny admits, the case for this hypothesis rests almost entirely upon the meticulous reconstruction of lost prototypes, since we presently have but one case in which a fifteenth-century print can be securely shown to have copied a painting.[54]

Intriguingly, most of the prints put forward as examples of reproduction can be traced back to the milieu of Netherlandish painting. As Koreny points out, a practice parallel to the one he is seeking to uncover among early printmakers is evident in the tradition of early Netherlandish art, where there appears to have been a demand for paintings that were close copies or shop replicas of other works. A number of these survive today, some of the best known of them stemming from the workshop of Rogier van der Weyden. The quality of certain of these replicas is so high that their attribution and relative priority are often still in dispute. Koreny cites this frequency of painted copies in the Netherlands along with the close relation of several early engravings to compositions that seem also to have originated in this region as evidence that, already from the period before the advent of the *peintre-graveurs*, a certain percentage of engravings were made as reproductions specifically in order to publish well-recognized and much-admired prototypes in a more available form. The implication of this hypothesis bears importantly on the whole enterprise of early printmaking and therefore requires our further attention.

Let us for a moment digress on the phenomenon of copying in early Netherlandish painting. To begin with, we should question whether the number of such painted workshop copies found in the circle of Rogier van der Weyden, for example, can best be explained as a response to the esteem of particularly well known originals. Literal copies of major altarpieces or portions of them are few compared to the replicas of private devotional images, and these, of course, would not have been widely available to the public in the first place. Is it not more plausible to explain most of these cases as evidence of an efficient workshop practice of recycling approved and successful models, that is to say an extreme symptom of a visual tradition that was inherently conservative, rather than as a

result of the widespread veneration of particular masterpieces? Consider, for example, the extraordinary number of recognizable variations on Rogier van der Weyden's *Altarpiece of St. Columba* (Munich, Alte Pinakothek), a great many of which come from the hands of independently recognized masters such as Dirk Bouts, Hans Memling, and Gerard David. Such cases point to the extraordinary power of certain compositional inventions within the Netherlandish tradition, but not necessarily to the

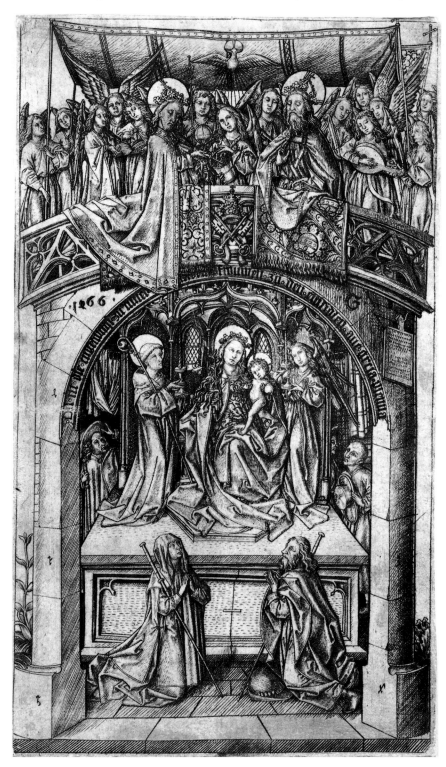

21. Master ES, *Large Einsiedeln Madonna*, 1466. Engraving (Lehrs II.81), 209 × 125 mm. Art Institute of Chicago.

acknowledged reproduction of a given masterpiece.

These same characteristics of imitation can be found in abundance in schools of manuscript illumination exactly contemporary with the development of printmaking. It is clear that model-books were being widely used in scriptoria, and that compositions and individual figures were being recopied many times in the same and different workshops, sometimes for decades. The capacity to improvise upon a vocabulary of standard figural and compositional types is part of the artistic fertility of early Netherlandish painting, a trait underwritten by the practice of making and disseminating workshop drawings. The evidence for patrons seeking replicas of widely known and particularly venerated originals is scant, and the evidence for an interest in miniature replicas is even smaller. In an age where the cultic significance of an image still held precedence over its status as a work of art, the practice of recording a prototype was bound to be approximate at best, and concerned more with essential identifying features than with capturing the lineaments of a style or a figural invention. In this important sense it is inappropriate to think of the fifteenth-century practice of imitation in any general way as reproduction.

Reproductive prints were eventually to have their day, of course, but this would come along with a more conscious sense of the importance of the work of art as such, and with the canonization of artistic genius. Northern prints in the Master ES's time were certainly an imitative if not a reproductive medium, but even the degree of the Master ES's dependence may be overstated. Intaglio printmakers quickly found a comfortable place within the milieu of modified compositions and conventional figure types being traded about the painters' workshops of the southern Netherlands and along the middle and upper Rhine. It was precisely in this constant and often imaginative exchange that the capacity for invention was best exercised. This was an arena for improvisers and pasticheurs, the dependence of prints being only a relative condition typical of the pictorial arts in general.

Furthermore, it is important to recognize that the nature of conservatism and innovation within early printmaking must be differently understood if one is speaking of intaglio prints rather than woodcuts. Woodcut designers and block cutters were challenged to realize new subjects by the demands of publishers who needed book illustrations. It is often forgotten that during the last quarter of the century, woodcuts of unprecedented devotional, narrative, and allegorical subjects were commissioned in great numbers by book printers. For the freelance engraver, invention was another matter, the choice of subject for the most part being left entirely up to him. There were, of course, typical sorts of things such as coats of arms that had currency in the repertoire of metalworkers' shops,

or popular devotional images like the Virgin or local saints common to the repertoires of both engraving and woodcut. But the intaglio printmakers had to generate fresh subjects for themselves. They were catering from the beginning to an open and less clearly defined audience. In effect, when it came to subject matter, the engravers were left to their own devices whereas the woodcut designer was, more often than not, set his problem by the publisher. Under these conditions, and considering patterns of development in the pictorial arts of the period generally, printmakers were bound to seek ideas among the painters as well as the other arts, but this is quite apart from suggesting that engravers actually set out or were commissioned to reproduce works in other media.[55]

In 1466 the Master ES worked under commission from the Swiss Monastery of Einsiedeln, then celebrating its quincentenary jubilee. This event commemorated a miraculous appearance of the Virgin and Christ child accompanied by angels supposed to have occurred in the year 966, a miracle for which a papal indulgence was granted and a chapel dedicated on the site. The Einsiedeln commission entailed making at least three and very possibly many more prints to be sold under the auspices of the monastery to the flood of pilgrims come to worship at the shrine. Three prints portray the miracle taking place in an approximate representation of the actual shrine, and all of them bear the date 1466 (Lehrs II.68, 72, 81). The most elaborate of these is the so-called *Large Einsiedeln Madonna*, the only one of them also to carry a signature — the date in the upper left soffit of the chapel arch, and the letter *E* in the right soffit (fig. 21).[56] It is notable that in 1466 and the following year the Master ES first dated his plates (fourteen of them), and seemingly first marked them with the letters *E* or *ES* (eighteen plates). Since they were intended to be commemorative, the Einsiedeln prints obviously required the date on independent grounds not necessarily connected to the aspirations of the maker, and yet the commission may well have provoked the Master ES to make a steady practice of dating as well as initialing his prints.

The prospect that the Master ES might have finished his career in the employ of the Swiss monastery has been suggested, most forcefully by Horst Appuhn, who proposes that the initials *ES* are in fact not related to the identity of the printmaker but rather to the patron, and that the practice of initialing and dating was stimulated by the Master's connection with the monastery rather than out of a wish to claim his work as his own. This quite plausible hypothesis must be questioned first on grounds that two of the three prints representing the Einsiedeln shrine itself carry no initials at all, and second because of the likelihood that certain dates appear as if they were added retrospectively.[57] In our opinion the interpretation of these

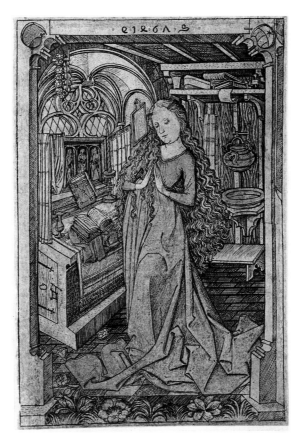

letters has not yet been conclusively resolved, and likely cannot be resolved without firm documentary evidence. In any case, Appuhn's hypothesis is sufficiently compelling to cast serious doubt on any assumption that the Master ES was in fact the first printmaker to present his work with a systematic claim to authorship, in some respect anticipating the practices of the *peintre-graveur*.

Whatever the explanation, the dating and initialing of engravings was an important precedent that must have been meant to identify the prints by their origin. There is a further piece to the puzzle presented by the Master ES's late works, a technical feature that so far as we are aware has not previously been recognized. In strong impressions of several of the dated engravings such as the *Virgin Mary in Prayer* (fig. 22) there are traces of a newly shaped burin, or less likely the adoption of some new means for printing plates. The difference can be discerned in the ragged edge along the richly inked and most deeply incised lines of some of the dated prints, a characteristic we have not observed elsewhere except in cases where plates may have been reworked. It is by no means self-evident that this change would have been perceived as a formal improvement. Rather, it appears to indicate a technical alteration made in order for the plate to yield a larger number of good impressions, and indeed these prints are among those that survive in several examples.[58] Both the identification of the plates and the technical change may have been

49

precipitated by an encounter with the goldsmith and engraver Israhel van Meckenem whom we know to have acquired a large number of the Master's plates. To this we shall return shortly.

Thus, the culmination of the Master ES's activity was a propitious moment in the history of printmaking. Whether he himself or the Monastery of Einsiedeln inspired the monogramming and dating of these prints, the practice was nevertheless a recognition of their importance as commodities worthy of being claimed. The technical evidence reinforces this conclusion, since it points to an interest in increasing the size of editions, and therefore acknowledges a commercial potential being pursued as the medium matured and presumably as its practitioners began to acknowledge a wider market potential. Furthermore, the extraordinary degree of influence being exercised by the Master ES's prints, especially on metalwork and sculpture, was probably becoming evident to him by the later stages of his career. The omnipresence of the ES figure type may have played a part in the monastery's decision to engage this particular engraver's services on its behalf.

MARTIN SCHONGAUER: HIS INNOVATIONS AND HIS IMITATORS

The engravings by Martin Schongauer of Colmar took a crucial step towards the imitation of nature as it was understood in Renaissance terms. His career sharply revised the conventional approach to the medium by bringing it into line with a prevailing style of calligraphic draftsmanship and tonal modeling, and in this respect he played a role in the evolution of the northern European engraving that is directly comparable to the impact of Mantegna in Italy. Both artists have in common the discovery of new ways in which the graphic relation of line to paper could be orchestrated into forms defined by volumes and tones, rather than forms composed from discrete shapes in coded schema. The marked technical as well as stylistic differences between Schongauer and Mantegna, however, alert us to the fact that a successful imitation of nature could be accomplished by very diverse means. The change in Schongauer's work was made possible partly by the extraordinary refinement of his burin work, but the true differences have more to do

23. Master ES, *Nativity*. Engraving (Lehrs II.23), 206 × 162 mm. Art Museum, Cincinnati.

24. Martin Schongauer, *Nativity*. Engraving (Lehrs V.5), 258 × 170 mm. Kupferstichkabinett, Berlin.

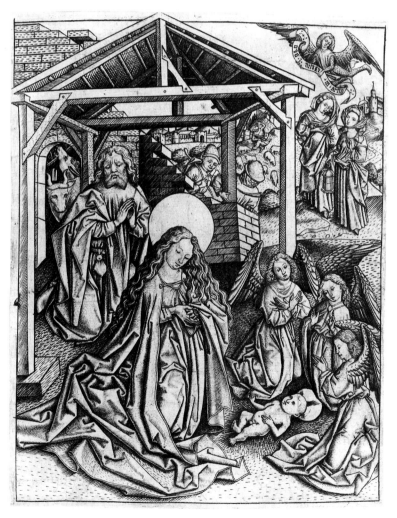

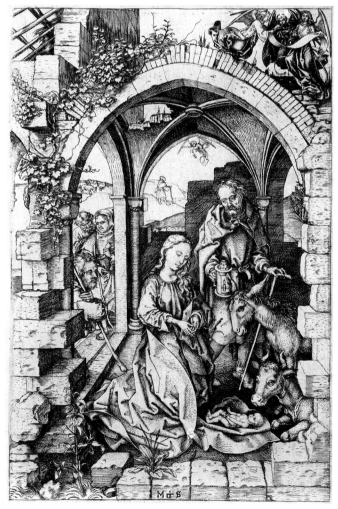

with his very conception of engraving than with technique in the narrower sense.[59]

To illustrate these assertions more clearly, let us turn for a moment to consider the change in the manner of representation between the Master ES and Schongauer. Two versions of the *Nativity* engraved in near identical scale, one an early work by the Master ES and the other an early work by Schongauer, establish the widest extremes of style and technique in the work of the two engravers (figs. 23, 24). We can suppose that both prints were executed essentially with the same sorts of instruments at hand, though slight variations in shape and temper must certainly be assumed. Furthermore, both masters employed the basic vocabulary of strokes fundamental to the engraver's art — parallel lines, cross-hatching, and stippling. Yet Schongauer's print evokes an extraordinary pictorial quality in comparison to the work of his predecessor. Exactly why is this so?

The Master ES approached his descriptive problem systematically. On the ground plane and the brick wall behind, shadowing patterns shift from one area to the next according to fixed formulas. Bright light is signaled by an array of parallel flecks, medium shade by cross-hatching or hatching over the stipple. Surfaces on different perspective planes are separated by shifting the direction of a shading pattern — diagonal to cross-hatching or diagonals altered to a different angle. Though the figures are neatly disposed in a conventional arrangement, the sense of space they occupy is constricted by the rigid planarity of the architecture and its own inconsistent relation to the frame. The Master ES never quite broke away from a patterned sense of design where figures and props compete for attention within a cluttered arena unmodulated by subtleties of light and shade. It is an exaggeration of a compositional quality that was, to be sure, common even to painting at the time, but nevertheless it lent an important linear emphasis that limited the print's ability to obtain certain pictorial effects. To speak of these earlier prints as patterns is to acknowledge something of their aesthetic character as well as their practical function. Schongauer was not in fact so revolutionary in his conception of engraving as it might at first seem, however. In the Master ES's later work, such as the spatially complex engraving of the *Virgin Mary in Prayer* (fig. 22) dated 1467, there is a liberal use of cross-hatching, and we can discern closer attention to describing variations in surfaces throughout the print. One still recognizes the degree of system that gave his earlier compositions their particular order and coherence, but in the late work he began to turn more directly to the manner of rendering promoted in painting. Partly this became possible because of an increase in technical facility, but we must also recognize that by furthering the complexity of materials and spaces he portrayed, the Master ES consciously set out to heighten the order of difficulty in achieving a successful representation.

Martin Schongauer took his technical cue from the later style of the Master ES. Simultaneously he cast a sensitive eye upon the achievements of contemporary painters working along the Rhine, and especially in the Netherlands. Schongauer staged his early version of the *Nativity* by first enclosing the scene within an irregular architectural frame placed inside the rectangular space of the sheet. As he rendered the figures and their surroundings, he concentrated primarily on evoking a sense of textural variation and profusion of detail — the pits and furrows of the masonry, the carefully observed plants and furry animals, details that are enhanced by allowing other areas of the image to be obscured in darkness. On a minute level the standard vocabulary of strokes is varied — stippling sometimes in straight parallel lines, but more often random and curled; hatching deployed according to the logic of actual architectural surfaces; and modeling lines conforming to the shape of a thing, be it an element of architecture, a figure, or a passage of drapery. We can see these devices anticipated in the late engravings of the Master ES, but they are now realized with a control of the burin equal to what can be managed with a pen. The fundamental difference is that Schongauer engraved coloristically, that is to say with the eye of a painter who understands light as a function of texture, and texture as a principal objective to be sought in describing a surface. From the early Master ES to the mature Schongauer, engraving overturned its formal premise and, less importantly, acquired a superior technical facility. Schongauer was the first to realize the promise of the Master ES's bowman: judged by the measure of the painters, a printed image might indeed effect a successful trompe l'oeil.

The profound importance of Schongauer's stylistic innovation was recognized almost immediately by his contemporaries. Like the prints, his paintings lean strongly towards the monumental and sculptural aspects of the Netherlandish tradition. We now come to the point where a truly intimate relationship between painting and printmaking was consummated. Yet almost as quickly as it appeared, it began to be redefined by Schongauer in the stark graphic layout evident in much of his later work. What is crucial to understand about this first moment of intersection between graphic art and painterly sensibility is its implication for the status of the print as a collector's item. For there is no doubt that Schongauer initiated a new stage in the qualitative regard for prints. The evidence to support this claim is various and mainly inferential, but when taken together it is highly convincing.

Max Lehrs records over 3,000 engraved plates made in northern Europe during the fifteenth-

century. The number of surviving impressions from those plates is of course higher, although the percentage of unique impressions is considerable. Of these 3,000 prints, over 300 are given to the Master ES, 115 or 116 to Schongauer, and about 620 to Israhel van Meckenem — around one-third of the entire known production attributable to a mere three masters. It is reasonably certain that all of Schongauer's engravings have come down to us, since nearly all of those that we have survive in a number of impressions. Compare this to the Master ES, whose corpus includes 95 unique impressions (nearly one-third of the total), and an additional 50 known in only two impressions — nearly half of his recorded production suspended by the merest thread.[60] In fact, taking into account the copies and incomplete series by the Master ES that are extant, an original oeuvre of somewhere around 500 engravings has been projected.[61] Two reasons for this discrepancy in survival rate come to mind. The first of them is that Schongauer's technique allowed him to pull a larger number of strong impressions from his plates. But there is a second and more important factor: that Schongauer's prints were highly esteemed on the market already in the artist's own lifetime, and furthermore that they retained this value for the two to three generations it took for print collecting to become widespread and retrospective in its ambitions.

Around 1550 an embroiderer named Hans Plock living in the Saxon town of Halle turned his two-volume edition of Luther's Bible into a kind of picture album. He ornamented the Bible with a selection of Grünewald's drawings as well as a large number of other drawings, engravings, and woodcuts which he pasted in between passages of text and onto the endpapers at the back. Plock had previously lived in the Catholic stronghold of Mainz, from which he was expelled for his Protestant beliefs, an allegiance that makes his enthusiastic regard for prints and drawings especially interesting. Beneath an impression of Martin Schongauer's somber and impressive engraving of the *Death of the Virgin* (fig. 25), Plock made the following note in his own hand:

> This image was judged in my youth to be the finest work of art to have come out of Germany; therefore I pasted it into my Bible, not because of the story, which may or may not be true [properly portrayed]. However, once the unsurpassed engraver Dürer of Nuremberg began to make his art, this [estimation of quality] no longer holds. The engraver was called "Hübsch Martin" on account of his art.[62]

Schongauer's *Death of the Virgin* (fig. 26) was frequently copied and certainly meets the stature Plock claims for it (figs. 27, 28). Even in a rather modest passage like this one, Plock's regard for the print carries a sense of nostalgia and a special

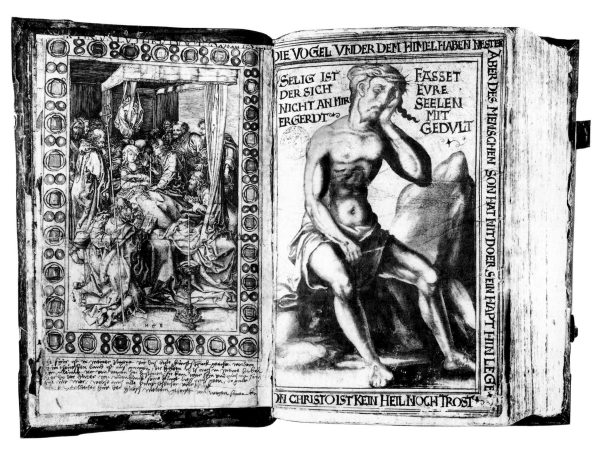

25. Martin Schongauer, *Death of the Virgin*. Engraving (Lehrs V.16) and *The Man of Sorrows*, drawing in grisaille. From the Plock Bible. Kupferstichkabinett, Berlin.

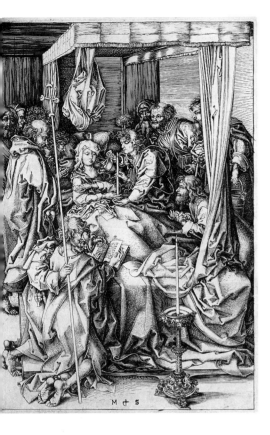
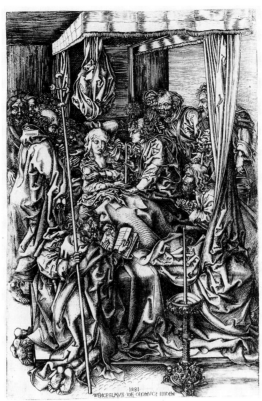
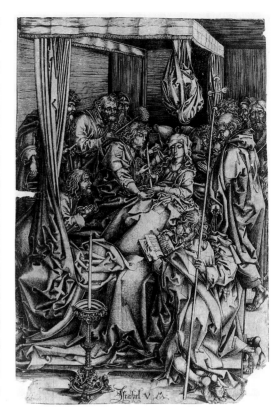

respect for Schongauer's founding place in German printmaking. Indeed, already in Plock's time Schongauer's work may have been difficult to acquire and accordingly expensive.[63]

The two prints by Schongauer discussed thus far are strikingly pictorial in their profusion of stuffs and their complex arrangements of detail. The *Death of the Virgin* with its suitably tenebrous and elegiac atmosphere and its gallery of emotive gestures and expressions particularly aspires to intimate narrative involvement and devotional intensity. Both it and the *Nativity* are virtuoso performances in rendering and were much imitated. Possibly the most influential of all Schongauer's prints, however, is the great *Procession to Calvary* (fig. 29), a large engraving that demonstrates, among other skills, the master's ability to print a sizable plate successfully. The pictorial dimension of Schongauer's engravings, most dramatically illustrated in this above all of his prints, demonstrates the artist's integration within the tradition of Netherlandish painting and its extended sphere of influence. The general composition and certain of the figures in the *Procession to Calvary* are drawn from a formulation of this subject that almost certainly descends from the workshop of Jan van Eyck. Others of Schongauer's prints as well as his paintings reflect a close awareness of the work of Rogier van der Weyden and Dirk Bouts. For Schongauer, engravings of this kind were fundamentally and unmistakably extensions of the painter's art — his supple method of adapting and improvising upon compositional types derives entirely from the formal conservatism and love of narrative detail manifested in contem-

porary painting. In a sense the *Procession to Calvary* repaid Schongauer's debt to this rich and varied resource, in that the engraving was imitated and excerpted by painters as well as printmakers again and again for decades after its appearance. Indeed, it is no exaggeration to say that this was the most influential print made in northern Europe throughout the full span of our inquiry.

In his mature years it seems that Schongauer, alongside the ambitious pictorial aspirations represented by the *Procession to Calvary*, pursued a more abstract approach to compositional design. In engravings like the *St. Sebastian* (fig. 30), for example, he was content with a bare suggestion of landscape and mainly stressed the delicate pattern of the tree arrayed against the white of the sheet and the finely drawn figure of the saint made serene and graceful in the condition of his martyrdom. The same sensibility is evident in an emblematic image such as the *Griffin* (Lehrs V.93), both intensely naturalistic in its zoological fantasy and artificially heraldic in its pose. In these two engravings we see Schongauer's embrace of graphic effects, a reductive formal preference that Dürer would recapitulate in the first decade of his own explorations in engraving. It is as though in their campaign to take possession of the technical facility of engraving both masters passed through the imitation of painting on their way to achieving an aesthetic more closely defined by the basic elements of printmaking — the glistening line of ink on the white of a rag paper sheet.[64]

The high regard for Schongauer's work and the authority it lent to the intaglio medium is most

26. Martin Schongauer, *Death of the Virgin*. Engraving (Lehrs V.16), 255 × 169 mm. Kupferstichkabinett, Berlin.

27. Wenzel von Olmütz, *Death of the Virgin*, 1481. Engraving, copy after Schongauer (Lehrs VI.11), 254 × 168 mm. British Museum, London.

28. Israhel van Meckenem, *Death of the Virgin*. Engraving, reverse copy after Schongauer (Lehrs IX.49), 248 × 167 mm. Ashmolean Museum, Oxford.

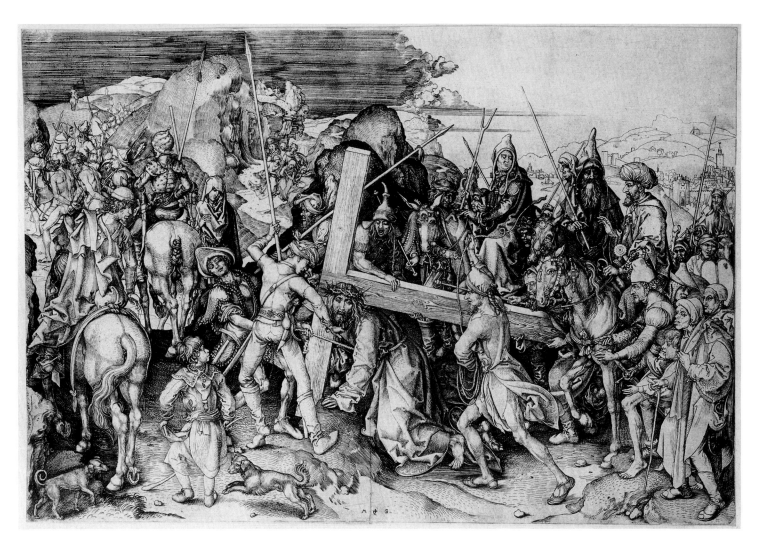

29. Martin Schongauer, *Large Procession to Calvary*. Engraving (Lehrs V.9), 284 × 426 mm. Öffentliche Kunstsammlung, Basel.

dramatically reflected in the wave of copies that soon surged onto the market. Israhel van Meckenem produced fifty-eight copies of Schongauer's prints; Wenzel von Olmütz, around fifty; the Monogrammist AG, thirteen. At least another half-dozen copyists within equally close range can be cited. Cycles such as the *Passion of Christ* (Lehrs V.19–30) and the *Twelve Apostles* (Lehrs V.41–50) were done by several different imitators and seem to have been exceptionally in demand. The many copies produced by the Schongauer school range from close replicas of his prints to free variations on them.[65]

Wenzel von Olmütz, active through the 1480s until the late 1490s, was among the first to pillage Schongauer's accomplishments systematically.[66] Wenzel signed his copy of the *Death of the Virgin* with his full name and the date: "Wenceslaus de Olomucz. Ibidem. 1481" (fig. 27). This is the first dated instance of a northern European printmaker signing his full name in the plate, and as such it is an important moment in the history of the medium. Why did he choose a copy of another master's work on which to declare himself so fully? By proclaiming his identity and his town it would seem

Wenzel was also laying special claim to the print itself, despite what we know of its real origin. This curious signature has been read as an anticipation of the later practice of including the engraver's name on the plate along with the designer, thus asserting the importance of skilled execution as well as invention.[67] But the implication of Wenzel's signature is less modest. It would seem he is proclaiming that the maker of the object is its rightful author. Most of the early copyists issued their works under their own monograms in this way without any reference to the model. In this sense we see again that a replica is not so much an honor intentionally bestowed on a prototype as it is an appropriation of an image by the copyist. We cannot, of course, be certain how such prints were deemed by those contemporaries who could recognize them as copies, but it is difficult to suppose that they were ever purchased as substitutes for an acknowledged original.

Wenzel von Olmütz was the first major pirate of the profession: out of the ninety-one engravings recorded in Lehrs's catalogue, the vast majority are known to be copies of other masters. Of the fifty done after Schongauer, over two-thirds are in the

54

same orientation as the original.[68] In only a small percentage of cases can we infer a specific iconographic prohibition against reversal, such as the need to retain a benediction delivered with the right hand, the placement of the wound in Christ's right side, or some other such requirement. Even these points of orthodoxy were ignored from time to time by printmakers, though with Wenzel's copies it tends to be prints of unusual and particularly secular subjects that are reversed rather than more familiar devotional stories. Wenzel's usual practice suggests that he held the formal integrity of his models in high regard, but that he was not in the business of perpetuating Schongauer's name and reputation in preference to his own.

We can conclude that the surge of copies after Schongauer's prints must reflect admiration on the part of printmakers and buyers for the autonomous qualities of the work. Copies were not being acquired as secondary versions of well-known originals so much as representatives of an admired style of printmaking. This hypothesis is reinforced by the number of prints presumed to be after lost drawings by Schongauer or members of his workshop, pastiches based on his prints and drawings, and prints done recognizably in Schongauer's manner. For example, at a sharp distance from the slavish copies of Wenzel von Olmütz, we find a handful of extraordinary engravings by the little-known Master PM. There are only five prints attributed to his hand, all of good quality and all done in the resolved ambience of Schongauer's style.[69] Most astonishing among them is an engraving of two pairs of nude figures posed front and back as if based on a set of life studies in a painter's workshop (fig. 31). They are clearly identified as Adam and Eve in that she is holding apples and he modestly covers his sex in a manner typical of representations of the Fall.[70] Certainly they are based upon sketches done in the format of Temptation scenes, but most curious is the fact that this print was definitely not conceived as a biblical narrative or in any commonly recognized sense as a finished design. The light, preliminary outlines of the four figures were tentatively inscribed in drypoint before the application of the burin. And yet despite their lack of finish, the exceptional delicacy of the draftsmanship, the gentle treatment of interior modeling, the indications of *pentimenti* in certain areas, and the carefully observed nudes all suggest a print done with unusual skill and sensitivity.

Why was such effort lavished upon something seemingly planned from the outset as a trial piece? Engraving was manifestly a secondary interest for the Master PM. Lehrs has proposed that the artist's familiarity with the nude implies he was a sculptor, though there is no particular reason to suppose that sculptors worked from life any more than painters. Judging from the adept handling of the human figure in miniature, it is more likely the engraving was done by a manuscript illuminator or by a panel painter. Three of the compositions attributed to this master betray the symptoms of having been trial pieces or workshop models, if not yet collector's items. The two most ambitious prints — the *Women's Bath* (Lehrs VI.5) and the *Massacre of the Innocents* (Lehrs VI.2) — are not only unusually complex subjects, but they require the managing of nude and clothed figures in a variety of difficult poses. Clearly, in some circles engraving was becoming an experimental medium by the close of the

30. Martin Schongauer, *St. Sebastian*. Engraving (Lehrs V.65), 165 × 111 mm. British Museum, London.

31. Master PM, *Adam and Eve*. Engraving (Lehrs VI.1), 139 × 209 mm. British Museum, London.

figuratio · facierum · Israhelis · et · Ide · eius · uxoris · I · V · M ·

fifteenth century. In all likelihood the Master PM was a painter attracted to engraving for its suppleness and agility in recording and replicating good draftsmanship.

Original work of exceptional quality therefore does emerge from among the circle of Schongauer's close followers. For lack of documentary evidence, none of the sundry copyists and the other artists working in Schongauer's manner has been securely connected to his shop, though it is certainly probable that some of them were trained there. At the very least a considerable wealth of workshop drawings must have been circulating from an early date. All this leads us to the conclusion that Schongauer's career must have coincided with the beginnings of print collecting in the north. Indeed, more than that, he must have stimulated it. When Albrecht Dürer set off in 1495 on the first leg of his *Wanderjahr*, it was Schongauer he hoped to see. For well over a decade Colmar had been recognized as the locus of fine engraving north of the Alps. Such a marked change in the patterns of production that led to widespread copying seems to imply a growth in the market for prints of unusual design and varied subject matter. Schongauer contributed to northern printmaking something that it had not previously known: an authoritative style. In the north a *peintre-graveur* had definitely arrived.

ISRAHEL VAN MECKENEM: ENTREPRENEURIAL PRINTMAKER AND PIRATE

Schongauer's achievement can be best understood almost entirely within the framework of contemporary painting, and regarded in this context he supplied the requisite degree of quality to draw the attention of a discriminating public to the virtues of a replicated medium. In seeking to publish his designs, it is self-evident that he was also attentive to the commercial advantages of the print. However, it was Israhel van Meckenem who explored this potential in a systematic and genuinely inventive way. The span of his work overlapped the activity of Schongauer and Mantegna, as well as the early stages of Dürer's, Jacopo de' Barbari's, and Marcantonio Raimondi's careers. However, Israhel's name was struck long ago from canonical accounts of early printmaking, particularly as the preferences of scholars and collectors centered on the rise of the *peintre-graveurs*.[71] And furthermore, we can fairly well guess that none of these masters was likely to spend much effort marveling over the subtlety of Israhel's craft. Nevertheless, it can be argued that his contribution to the eventual success of printmaking as an art form was the equal of any. Indeed, in certain very particular respects he can be

counted as the most historically important northern printmaker at work around 1500.

The heresy of this statement lies in the fact that Israhel was undoubtedly the most voracious pirate in Renaissance printmaking. Out of the several hundred prints connected with his name, only 10 percent have not been identified as reworked plates, copies, or probable copies of other prints. Not only did he acquire a large number of plates by the Master ES, he made around two hundred copies of the Master ES's prints as well. Israhel acquired and reworked plates from several other printmakers which he also issued under his own name. In his early years as a copyist, Israhel tended to be rather blunt. Occasionally he copied closely, but, like Wenzel von Olmütz, more often he redrafted a composition in the harsh and identifiable vernacular of his own style. Israhel rarely bothered about the propriety of reversing his prototypes. He incised his plates deeply and composed in rich matrices of line to ensure the longevity of his plates. Their draftsmanship is characteristically stilted and the figures often strained, altogether lacking the Netherlandish gracefulness that Schongauer managed so well. This may appear to make a very good case for ranking him among the deadbeats rather than the heroes of printmaking. But evidently this was not the view held by his contemporaries, nor was it the opinion of commentators writing up to a century after Israhel's death in 1503. As early as 1505 the German humanist and chronicler Jacob Wimpheling cited Israhel van Meckenem without prejudice alongside Dürer and Schongauer as a founder of the printmaker's art whose work, he claimed, was then being sought after by painters throughout Europe.[72] So far as we are aware, this judgment was nowhere contradicted in northern accounts of early printmaking throughout the entire course of the century.

Although Martin Schongauer had come from a family of goldsmiths from whom he certainly learned the use of metalworking tools, he made his living mainly as a painter and a printmaker. Israhel, in contrast, advertised himself as a goldsmith on the rare occasions when he identified his profession in the signature on his plates. This is not at all surprising given the fact that goldsmiths were regarded as the elite among craftsmen. And as we can further see from his *Self-Portrait with his Wife Ida* (fig. 32), the first instance of a formal self-portrait in a print, he was certainly very conscious of his status and of taking opportunities to advance his reputation. Circumstantial evidence points strongly to the conclusion that Israhel received his initial training as an engraver under his father, also known as the Master of the Berlin Passion, and later with the Master ES, probably in Switzerland or in Alsace. If the Master ES introduced printmaking on a large scale in northern Europe, and Schongauer carried it to technical refinement, then Israhel was responsible for realizing its full potential as a commercial enterprise. He recognized the value of engraved plates as commodities, and he was undoubtedly very canny in assessing the appeal of various sorts of subjects for different audiences. We know nothing about the means he employed for distributing his engravings, though he must have cultivated some channels for exporting them from the town of Bocholt where he seems to have lived the better part of his career. Some of Israhel's prints definitely moved great distances in short periods, as we know, for example, from their acquisition and use by painters and manuscript illuminators already in the last decade of the century in an area extending from the Baltic to Spain.[73]

Israhel's work improved in the last decade of his career, and in some degree this change was related to an encounter with the work of Hans Holbein the Elder in Augsburg. He fell under the influence of Holbein's style during the 1490s, when he issued a suite of prints of the *Life of the Virgin* (Lehrs IX.50–61) that have been convincingly shown to be closely made after drawings (no longer extant) by Holbein or his workshop. Israhel, of course, copied from many sources, and there is no way of knowing whether his models were consigned to him, purchased, or purloined for this purpose.[74] In any case, the connection between these two men raises the question of whether we might have a northern European counterpart to the arrangement Marcantonio Raimondi had with the Raphael workshop in Rome. Holbein's influence is part of a general improvement in the quality of Israhel's draftsmanship during the mid- to late 1490s, a change sufficiently marked to ask whether there may not have been a new face about in the Bocholt workshop, or whether Holbein sought the services of a proven mimic in order to capitalize on his talent.

There is no doubt that Israhel van Meckenem took ample advantage of the efforts of others and often did so as a matter of pure expedience. But it is commonly disregarded that within conventional categories of subject matter and within the small percentage of prints that appear to be his own, Israhel broke new ground that proved to be remarkably fertile for the later history of printmaking. We can see this indirectly in some of the ways he found to market his prints, and also in his invention of new subjects and new strategies for presenting them. Israhel pursued the commercial possibilities of replicated devotional imagery in a concerted way, and in this context made the first self-declared reproductive print we know of in northern Europe. He furthered the occasional practice of earlier printmakers in developing cycles and compositions of several prints that could be marketed separately or together. Israhel also introduced a range of topical references into his prints, a feature that may have been stimulated in part by the work of the House-

book Master. And finally, he broke away from conventional means of formulating religious narratives, and introduced new strategies for thinking about the interplay of pictures with texts. Let us examine each of these endeavors in turn.

Israhel van Meckenem was apparently the first to issue engraved (as opposed to woodcut) indulgences granting relief from purgatory in exchange for enacting specific devotional exercises. A notorious instance of this is a *Mass of St. Gregory* probably from the 1480s (fig. 35), which bears an inscription promising 20,000 years' pardon for each recitation of three prayers made before the image. In the following state of the engraving Israhel burnished out the number and increased its allowance to 45,000 years![75] These were not authorized indulgences issued under the aegis of the Church, but rather a bootlegged version with an inflated reprieve that was never subject to papal review. And yet, despite their lack of official status, one cannot but wonder how prints of this kind may have helped to fuel the discontent that eventually led to Luther's reforms.

Like the *Pestbilder*, prints meant to protect against plague, the popularity of the Gregorian image of Christ had a certain guaranteed interest. For similar reasons, Israhel made two other engravings reproducing a mosaic icon in Rome (fig. 33), an object that still survives in the Church of Santa Croce in Gerusalemme. In Israhel's time this Byzantine, or Italo-Byzantine, icon had come to be venerated as the actual image made after St. Gregory's vision, and as a consequence Santa Croce was then becoming a favorite site for pilgrims visiting the Holy City.[76] Both of Israhel's two engravings carry an inscription declaring them to be true copies, in effect reproductions of this icon. Although such a case has obvious parallels with the *Einsiedeln Madonnas*, it is the first we know of in which a northern print was made to perpetuate the value — in this instance explicitly the cultic value — of another image. That these prints probably date from the mid- to late 1490s suggests that they were made in anticipation of the jubilee year of 1500 when the incidence of pilgrimages to Rome, and of course to Santa Croce, would greatly increase.

Part of Israhel van Meckenem's genius for the market rested on what we would currently term "packaging." For example, like Schongauer he published a number of prints in small sets and cycles especially suitable for pasting into devotional books as illustrations or bound together and sold in suites. A bound copy of Israhel's *Passion* cycle was printed with two scenes to a sheet arranged so as to be folded into a quire. That is to say, the engravings were printed in pairs, not according to the Passion story but so that they would follow the proper sequence after they were bound together.[77] He also printed a set of six engravings showing the twelve Apostles in pairs with a single portion of the *Credo*

inscribed on each print (Lehrs IX.294–99), such that the full set is required in order to have the complete text. We can trace the origin of issuing prints in sets to engraved series by the Master ES and the Master of the Banderoles, but Israhel was the first to make a regular practice of it.[78] Israhel also made and printed plates with separately framed but contiguous images placed together with the engraver's signature distributed across them, such as the single plate of *Sts. Mary of Milan, Luke, Theophista, and Eustace* (fig. 34).[79] Here the placement of the signature suggests the intent to have either two or four figures together as a composition, but they can all just as well be cut apart and treated separately.

A number of Israhel's religious subjects suggest that he was addressing a regional audience. Some of the less common saints in his repertoire, like St. Quirinus of Neuss, were especially venerated in the region of the lower Rhine where he lived and worked. Furthermore, there is some basis for supposing that the panoramic engraving of *Judith and Holofernes* (Lehrs IX.8) actually depicts the lifting of the siege of Neuss, which the artist himself may have witnessed, and indeed the attention to military detail is striking.[80] Documentary references of this sort were new to prints at the time, though it was an idea that had a future, for example in the portrayals of sieges and battles that occupied many printmakers of the sixteenth and seventeenth centuries in making propaganda for princes and appealing to the public attraction to war news.

This inclination to topicality is also a feature of Israhel's pictorially most ambitious engraving, the *Dance at the Court of Herod* (fig. 36). Here he staged a New Testament subject as a patrician dance in a contemporary palace hall with merrymakers and musicians attired in the Burgundian fashion of the day. To be sure, there is nothing strikingly original about portraying a biblical story in contemporary garb, but Israhel has gone to the length of specifying the court where the celebration takes place. It was pointed out some time ago that the artist has taken care to show the three musicians sporting the piper's badges which identify their special office in the town of Münster.[81] This appears to be evidence that the artist meant to recall a particular seasonal event recognizable to a local population. Such top-

37. Israhel van Meckenem, *Ill-sorted Couple*. Engraving (Lehrs IX.502), 161 × 110 mm. National Gallery of Art, Washington, D.C.

38. Israhel van Meckenem, *Juggler*. Engraving (Lehrs IX.503), 159 × 108 mm. National Gallery of Art, Washington, D.C.

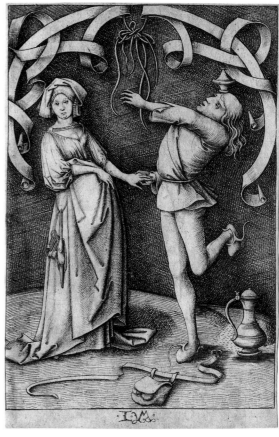

39. Israhel van Meckenem, *Fight for the Pants*. Engraving (Lehrs IX.504), 159 × 109 mm. National Gallery of Art, Washington, D.C.

40. Israhel van Meckenem, *Church-Goers*. Engraving (Lehrs IX.499), 163 × 110 mm. National Gallery of Art, Washington, D.C.

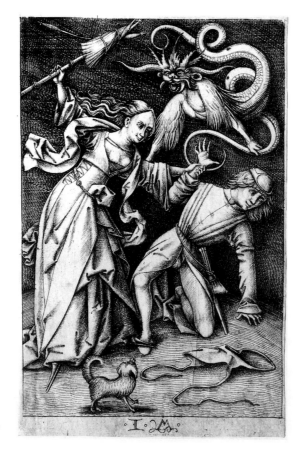

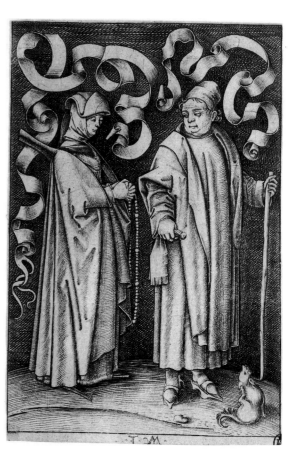

icality as we find in the *Dance at the Court of Herod* lends a special twist to Israhel's astonishing subordination of the biblical event within a panoramic composition, the most striking and innovative aspect of the image. St. John the Baptist's beheading occurs discreetly in the left background, and the presentation of his head on the plate is shown in the right background opposite.[82] Suppressing the scriptural and dramatic significance of the scene like this can be read in quite contradictory ways — that the martyrdom is a mere pretext for exploiting an interest in costumes and courtly fêtes, or on the contrary that it is emphasized all the more sharply by its very understatement. Since this is one of the largest of Israhel's prints and also among his most experimental treatments of narrative subject matter, we must acknowledge this print as an important speculation on his part about the public appeal of prints around 1500.

Israhel was not the first engraver to invest a religious scene with the characteristics of a genre scene, but along with the Housebook Master he was the first to do so in a concerted and imaginative way. An ambitiously large composition like the *Dance at the Court of Herod* anticipates certain of Lucas van Leyden's engravings in which a biblical event is found secreted somewhere in an open landscape or a crowded scene. The anecdotal appeal of a print such as this can be found in Israhel's treatment of profane subjects as well, and here his inventions are among the most engaging and original of all. Often as not these subjects are directed against human foible and carry a satirical bite, though at other times they seem to be more neutral observations of intimate exchange, social custom, or sartorial fashion. Among the best known of his genre scenes are twelve engravings of couples, all of them in courting postures of one sort or another. A sustained play on flirtation, legitimate or uncondoned, runs through the full list of these suggestive encounters: an ill-sorted couple appears, with an old man wishfully placing his hand on a young woman's hip (fig. 37); a juggler demonstrates his talent to a thoroughly unimpressed maiden, his shoes untied, his purse dropped at his feet, and a flagon of wine conspicuous beside him (fig. 38); encouraged by the devil, a young girl drubs her mate with a distaff in an effort to capture his pants (fig. 39); a pious couple walk in procession to church, and he glances back with a fetching smile to catch her eye while at their feet a dog scratches a nagging itch of its own (fig. 40); a man plays a small table organ while a young lady pumps up his bellows, the waiting bedroom visible through the window behind (fig. 41); seated at the foot of a bed, a young dandy plumed with ostrich feathers embraces an overclad (and pregnant?) housewife, his sword momentarily discarded but his knife discreetly jamming the bolt on the bedroom door (fig. 42).

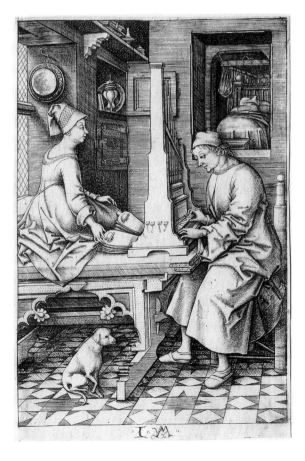

41. Israhel van Meckenem, *Organ Player*. Engraving (Lehrs IX.507), state I, 159 × 109 mm. National Gallery of Art, Washington, D.C.

42. Israhel van Meckenem, *Couple Seated on a Bed*. Engraving (Lehrs IX.508), state II, 160 × 109 mm. National Gallery of Art, Washington, D.C.

Profane subject matter invaded the pictorial arts through the medium of prints. The story of this incursion is a long and intricate one which we can only touch upon in our present inquiry. Engravings initially took the lead in exploring the appropriateness for the market of the quotidian, the anecdotal, and the satirical. Given the degree to which religious subjects dominated the more commonly accessible forms of pictorial art up until the late fifteenth century, it would be unreasonable to expect painters and engravers to turn abruptly to aspects of daily life in a direct and unmediated way. Such a notion of pure observation would have had little significance for artists or buyers. The printmaker's problem was precisely how to invest the commonplace with some meaning through the addition of a story or a bit of popular wisdom. Hence, each of Israhel van Meckenem's images of couples plays to some degree on the obvious, not to say universal, theme of sexual advance and parry. Courtly literature and decorative art had long indulged this topic, and now, adjusted to a more satirical slant, it entered the iconographical lexicon of the printmakers.

A good number of Israhel's prints including the couples have elaborate banderoles looping around the figures as if ready for inscribing. This is a common feature not only in Israhel's work; it is also the basis for the name by which the Master of the Banderoles is known. Banderoles are also frequent in the drypoints of the Housebook Master, for example in his *Two Nuns*, portraying one nun reading to or instructing a companion who sits attentively listening (fig. 43). It is impossible to imagine that all of these prints with their empty banderoles betray unfinished states, particularly in

the case of Israhel van Meckenem who took inordinate pride in exercising his spikey calligraphy. Rather, it may have been expected that collectors themselves would inscribe these strips with sayings or proverbs, or even with dialogue as we often find engraved on prints of this period or later.[83] The banderoles may serve as an invitation to interpret, to provide a witty aphorism for the subject; in this sense they represent an artist's ploy to engage the ingenuity of his client in playing at inventing a subject.[84] The empty banderole is a device that tells us something important about the early development of "subjectless" art, or genre imagery as it eventually came to be termed.

The happy and frequent combinations of printed images with inscriptions in the north results partly from the practical fact that woodcuts and engravings could so easily accommodate texts. But at a more complex level, the interplay of pictures and texts reflects a clientele that had as yet no sufficient aesthetic rationale for attending to or possessing an image for its own sake. Thus, an important endeavor of printmakers during the last quarter of the century was precisely to find ways of making printed images self-sufficient by providing them with the means for their own interpretation. The difficulty of managing this task without the help of words has much to do with the close association we find between prints and texts in our period, not just in book illustration but in the single-leaf print as well. This was a relationship that evolved over the Renaissance into a particular fondness for allegorical subjects, personifications, emblems, and literary conceits, as well as into more popular expressions such as broadsheets and instructional posters. Many prints were simply meant to be "read" in the manner of an exemplum or an aphorism.

Israhel van Meckenem was more acutely aware of the peculiarities of the print as a marketable commodity than any of his peers or his predecessors. His innovative constructions of secular and narrative subject matter show this very clearly. Furthermore, he experimented in a strikingly original way with figurative imagery. Probably already in the late 1480s, Israhel made a very curious engraving of *King David with Sayings from Psalms* (fig. 44).[85] The iconography of this print appears to be unprecedented in its joining of popular proverbs with quotations from scripture to orchestrate a sequence of moral admonitions. Standing at the left, King David introduces to us three artisans and a fool. The action of each character is glossed with two passages of text: one from Psalms and the other a popular saying or aphorism. Each of the characters acts out the sense of the aphorism, an arrangement that results in a sort of program for reading figurative imagery in texts and pictures. We begin with the relatively abstract poetry of Psalms, which requires the skill of an exegete to unveil its meaning. These verses are then given

their counterparts in proverbial folk wisdom, which are in turn illustrated by the depictions of craftsmen and the fool who transform what are, in effect, "figures of speech" into action. King David the psalmist announces the opening theme of the print: "A little that a righteous man hath is better than the riches of many wicked" (Ps. 37:16). The first figure to his right shows a well-attired man hammering a sickle against an anvil. The banderole above him reads: "Thou lovest evil more than good, and lying rather than to speak righteousness" (Ps. 52:3). And below, the corollary proverb: "What is true I can make crooked; thus I wear red scarlet."

The sequence continues accordingly to the smithy who makes his shafts true, and as a consequence of his honesty practiced in a dishonest world he remains poor. Following him is a knife sharpener who "slips and slides" his way deceitfully through life, and lastly the poor fool who does not recognize the cat that first will lick and then will scratch.[86] This set of aphorisms cast in three languages, one of them visual, would have found its closest counterpart in the rhetorical techniques of popular preachers such as Johann Geiler von Kaisersberg of Strasbourg, and later on in the more scholarly context of Erasmus's massive corpus of proverbial and aphoristic wisdom, the famous *Adagia*. The condensed formulations of Israhel's print give us a lesson in the allegorical reading of language and image, an essay on the relation of textual and visual metaphor proceeding from the

obscure suggestions of Old Testament verse to the proverbial expressions of the common people. Incorporated into the bargain is a satire on various walks of life extending from the charlatan hammering away in a doctor's gown to the fool in his cap and bells, the favorite moral punching bag of the time. The cleverness of this engraving is surely not the product of a pedestrian and uninventive imagination.

Present here are the seeds of several important tendencies that would develop in the print repertoire as it matured in the hands of subsequent generations. So far no evidence has arisen to suggest that the prints we have been discussing ultimately belong, like so many of Israhel's plates, to the work of another artist. It cannot be entirely coincidental that the most innovative prints issued under his name are not only characteristic of his style but betray no clear connection to his usual sources. Israhel was above all else a printmaker with a canny eye for the market. Seen from this perspective, his inventions are simply another aspect of a well-organized commercial enterprise. They reflect the fact not only that Israhel took whatever he could find, but that if he could not find it, he invented it himself. Not only the variousness of his inventions, but also the clever turns on the conventions of others were meant to cultivate a public that was accustomed to thinking of images as always having something to say for themselves. Israhel was a minor genius when it came to making images that could talk.

44. Israhel van Meckenem, *King David with Sayings from Psalms*. Engraving (Lehrs IX.487), state II, 143 × 208 mm. British Museum, London.

Early Traces
of Print Collecting

We have followed the expansion of print production over the last quarter of the fifteenth century in northern Europe partly with an eye to inferring changes that must have been taking place in the market. Being small, transportable, and relatively inexpensive to produce, the print by its very nature had a kind of autonomy that needed to forge a context for itself. In order to do this, prints had either to depend upon existing interests or to generate an interest of their own, a simple condition of any market that does not depend upon a bespoke relationship between maker and patron. Prints were an early form of "found object," a medium that required marketing and was thus inherently inclined to induce the phenomenon of collecting.

But is there good evidence of print collecting as such being undertaken in northern Europe already during the late fifteenth century? The one substantial instance of someone known to have assembled prints in large number during these years is Hartmann Schedel, a well-educated town dweller and a professional man who perfectly fits the profile we have outlined for the likely buyer of the finer prints being made at the time. Yet his tastes turn out to have been quite different from what we would expect.

Hartmann Schedel, Nuremberg medical doctor, humanist, and author of the *Weltchronik*, acquired several hundred prints during his lifetime. Some three hundred of these are accounted for since he used them to ornament the books in his library, a substantial part of which can still be identified among the holdings of the Bayerische Staatsbibliothek in Munich. Pasted into these volumes are large numbers of engravings, metalcuts, and woodcuts, and a smaller number of paste prints, drawings, and hand-painted miniatures. Schedel's varied acquisitions seem to have occupied him over a period of several decades up until his death in 1514.[87] In many cases the loose sheets were pasted onto the boards at the front and back of his codices. They were also entered into blank pages in the body of the text, and sometimes placed where space was apparently left for them between passages of Schedel's own writings. Many of the prints were hand-colored, most often rather badly and most likely by Schedel himself. Often the relation between the subject of an image and the text it accompanies is indirect if not completely irrelevant, and in other instances the placement appears to have been carefully determined. Sometimes the connection is quite inventive, such as the use of the *Raising of Lazarus* to illustrate a text on the immortality of the soul by Marsilio Ficino. Sometimes it is even whimsical, as for example the use of *Christ Appearing to the Magdalene in the Garden* to ornament a text on medicinal plants.[88] The way

Schedel displayed his prints suggests an element of personal play and private pleasure that we associate with the collector's mentality, but whether we can properly term his print holdings a collection is less clear. Schedel's acquisition of prints and his arrangement of them lack a degree of system that seems basic to the notion of collecting as we find it manifested, for example, in Schedel's approach to building up and organizing his library. Nevertheless, Schedel's is a case that tells us much about one educated person's attitude to prints, and perhaps also something about the availability of prints as well.

The practice of pasting prints into books must have been very common, since so many prints were made in series as though they were intended to be kept together in this way, perhaps specifically intended as cycles of illustration for certain kinds of books. The most conspicuous example of this practice is the number of Passion cycles that survive among the engravings of the incunabulum period. In addition to Israhel van Meckenem's *Passion* there are several other examples that survive intact or are in some way able to be connected to codices or cycles of prayers.[89] It was not a large step for someone like Schedel to begin to use prints rather randomly as book illustrations. The association of prints with books was a customary one by 1500 and would have a continuing history among collectors. The development of the print album in the sixteenth century really begins with these more limited enterprises.

From what can be reconstructed of his holdings, Schedel's prints were made almost exclusively in local workshops, if not in Nuremberg itself then mainly in south Germany or along the Rhine, the few Italian prints such as those by Jacopo de' Barbari also no doubt acquired while the artist was working in Nuremberg. This suggests that Schedel did not actively seek prints abroad, but rather bought what was readily available to him in the shops, at the fairs, and on the streets of his home town. The parochial character of Schedel's acquisitions implies that apart from the very few *peintre-graveurs* who had begun to be recognized internationally by 1500, most prints did not achieve a very wide geographical distribution in these early years. Still more remarkable than the regional nature of Schedel's sources is the absence of prints by some of the major figures of the time, most conspicuously work by Schedel's fellow townsman Albrecht Dürer. Only the small woodcut *Passion* and a book illustration by Dürer have been connected with the collection. Conceivably, Schedel had other prints by Dürer that he treated differently, possibly keeping them in portfolios or albums that have since been lost or dismantled.[90] We cannot eliminate the possibility that his interest in prints abated after 1500, or that the more valuable portions of his holdings were later stripped

away and sold off. However, the equally surprising absence of prints by Martin Schongauer tends to support the conclusion that Schedel was not guided by the standards of artistic quality we know to have been held by some of his more visually cultivated peers. Though Hartmann Schedel was a good scholar, it begins to look as though in the pictorial arts he may simply have had indifferent taste.

Thus we finish our examination of the first phase of Renaissance printmaking in northern Europe on an uncertain note. No doubt some of the printmakers themselves were beginning to recognize the true promise of the new medium, both its technical and its artistic possibilities. By 1500 the range in quality of prints being made was broad, and we can only suppose that the market for them was equally widely distributed. Yet if Hartmann Schedel was not buying engravings by Schongauer and Israhel van Meckenem, who was? And how widely were they being distributed? In his encomium to German printmakers of 1505 previously mentioned, Jacob Wimpheling boasts that Schongauer's work was already known in Italy, Spain, France, and Britain.[91] Though inevitably there is an element of hyperbole in this claim, Schongauer's influence abroad can be confirmed on other grounds. Nevertheless, it is likely that by 1500 most prints continued to be sold nearby the place they were made. Prints had not yet won a secure position in the artistic hierarchy, and partly as a consequence of this, whatever interest they may have found among collectors and patrons has gone almost entirely unrecorded. There must have been a good many lesser Schedels about, but it would be an exaggeration to think of them as constituting a community of collectors for whom printmakers were conceiving their products. Rather, the acquisition of a print must still have been an occasional thing done for any one of many possible reasons, some of them perhaps quite capricious. One gets a sense of this anarchy in the range of works by the masters we have been discussing, and indeed a sense of all things being possible must also have been evident to them.

◆❧◦❦◦ ITALY ◦❧◦❦◆

The early development of engraving in Italy took roughly the same formal point of departure as in Germany, but almost immediately Italian engraving betrayed aspirations of a grander order than anything we find along the Rhine until well into the 1470s. Already in the decade before Schongauer's work began to mature, Mantegna had embarked upon engravings of astonishing scale and pictorial ambition. Masters of independently recognized stature turned to engraving earlier in Italy than in the north, and not surprisingly they began much earlier to think of it in various ways as an exten-

sion of painting. Thus, for example, Italian plates were often large, and more importantly their prints incorporated pictorial devices that suggest the intention of displaying them in quite formal ways on the walls of houses and in monastery cells. Italian engravers were quick to pursue the illusionistic potential of the monochrome print, and they repeatedly sought to invest their images with a sense of presence and importance.

THE DEVELOPMENT OF A TONAL SYSTEM

The key to bringing the print into line with the principles for pictorial representation outlined by Alberti in the 1430s was to develop its capacity for registering tone, and consequently for coherent modeling of three-dimensional form. It was natural that the earliest attempts to produce tone in a print should involve the use of thin, straight, parallel lines. Such a solution had been in use in northern drawings for some time, but was particularly fashionable among artists working in the 1440s, when the first prints were made from metal plates (fig. 3). The Master of the Playing Cards was obviously inspired by contemporary drawings, if not by his own, when he first attacked the surface of a plate with a tool that must have been very close in shape to a silverpoint.

There are advantages and disadvantages in this technique, as printmakers were soon to discover: its main virtue is that the raised metal edges at either side of the grooves — the burr — produce a rich tone filling the white space of the paper between contiguous lines. Most of the surviving impressions of prints by the Master of the Playing Cards have a richness and warmth that had not previously been achieved, or more probably even sought, in drawings of the period. The shortcoming of drypoint is that the fragility of the raised metal edges, and their tendency to be pushed back into the groove, mean that very few impressions can be pulled from a plate before most of its tonal richness is lost. It is doubtful that this in itself was seen at the time as a particularly worrying inadequacy, as there is no evidence that many impressions *were* pulled from a plate. Most of the prints by the Master of the Playing Cards are known in only one or two impressions, all very early and rich, and there are only a couple of his plates known to have been used in a worn state.

Andrea Mantegna, the artist who can best be claimed to have "invented" printmaking in Italy, must certainly have seen a German print, either by the Master of the Playing Cards or by the Master ES.[92] In Mantegna's first experiments with printmaking, which probably date from the 1460s, we can see the influence of his German predecessors. Throughout his career he sought new means of

45. Andrea Mantegna,
*Entombment, with Four
Birds*. Engraving
(H.V.21.11b),
453 × 362 mm. Albertina,
Vienna.

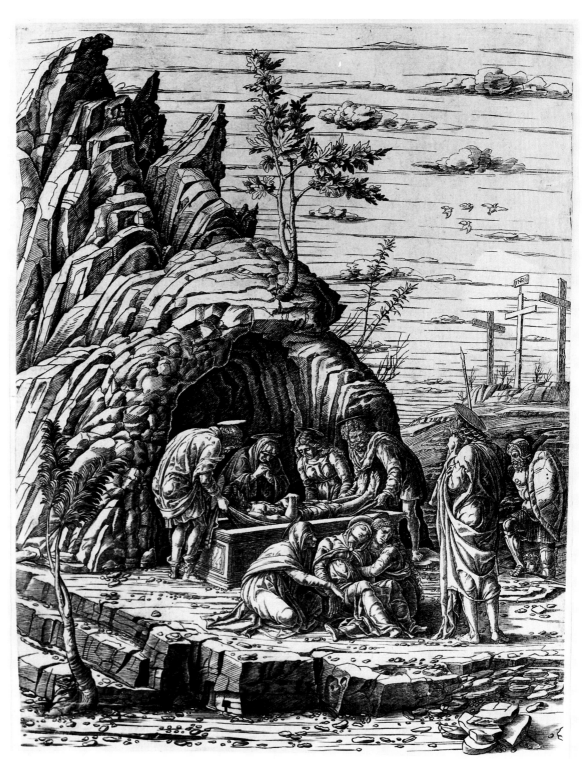

recreating the effects of light in different media. More specifically, the control of tone directed Mantegna's explorations in making finished monochrome drawings and grisaille paintings, and was the common denominator in his invention of new printmaking techniques as well.[93]

Mantegna's earliest prints, such as the *Entombment with Four Birds* (fig. 45) and the *Descent from the Cross* (fig. 46), demonstrate how closely he imitated the example of the Master of the Playing

Cards and the Master ES. The black areas are made by short, parallel, regular strokes that are completely independent of form. There is no subtlety in the progression of tone from light to dark — an area is either black or white — and this technical constraint gives these prints an appearance of hardness. In this they show greater similarity to German contemporary models than to Italian ones, suggesting that the artist made a considered aesthetic decision in seeking inspiration for his first

66

46. Andrea Mantegna, *Descent from the Cross.* Engraving (H.V.19.10), 454 × 362 mm. British Museum, London.

prints. Mantegna was in Florence in 1466, and undoubtedly saw the nielli and engravings which were being made there in considerable quantity by workshops such as those of the goldsmiths Maso Finiguerra, Baccio Baldini, and the so-called Master of the Vienna Passion.[94] Although the prints made by these artists were of utterly different kinds — on the one hand tiny, precious, and highly finished nielli with considerable formal ambition, on the other hand larger, crude, and cheap prints for devotional or practical purposes — they all shared the feature of relying on cross-hatching for building up the darker areas of the image. This particular approach most probably originated with the need for goldsmiths to hatch metal surfaces before laying on enamel. The same practice came to be used for niello plates, making it possible for the *nigellum* to stick to the metal; it must then have been transmitted to niello prints and standard engravings. Although it has been suggested that the use of

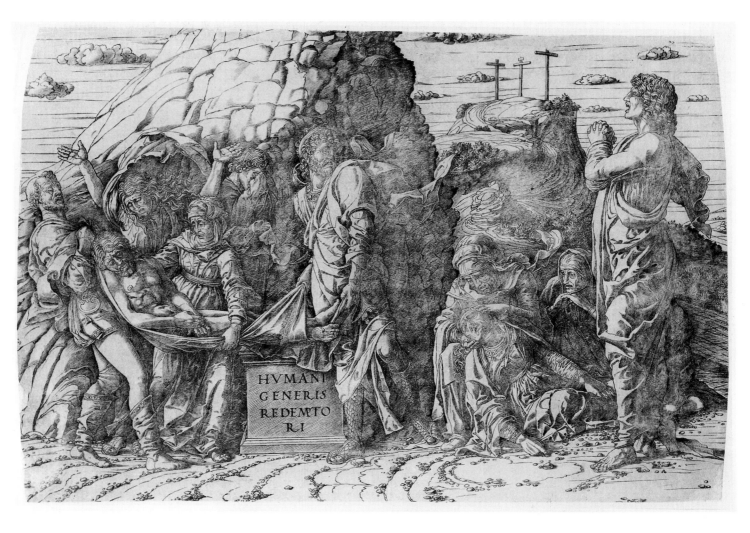

47. Andrea Mantegna,
Entombment. Drypoint
(H.V.10.2), 333 × 467 mm.
Albertina, Vienna.

thin cross-hatching in the prints was meant to imitate the effect of the wash which Maso Finiguerra used to build up tone in his drawings,[95] it is also apparent that most Florentine drawings of the mid-Quattrocento employed cross-hatching as the only alternative to wash as a means of shading.[96] The type of cross-hatching used by Florentine print-makers consisted of straight lines crossing one another at more or less regular angles: they seldom curved or interacted with the design whose darker areas they were meant to describe. The degree of care with which the lines cross one another seems, in fact, to be directly correlated to the overall quality of the prints, so that those destined for the lower end of the market are cross-hatched with lines that meet at haphazard angles.

It is nearly impossible to imagine that Mantegna encountered no prints during his Florentine sojourn where goldsmiths' shops were open to the street and prints were being made in full view of passers-by. The statutes of the Arte di Por Santa Maria made it, in fact, compulsory for the *botteghe* to be open onto the streets, so that every customer could see for himself what was being done inside.[97] Prints must have circulated with some abundance among artists and craftsmen, many of whom would have

treasured them as patterns. Hence Mantegna's rejection of cross-hatching in favor of the German method of parallel hatching was deliberate besides having considerable implication for the development of printmaking as an art form rather than a craft in northern Italy.

In his first two prints his use of parallel hatching is still tentative, however, and he includes a small amount of cross-hatching to provide sufficient density of black in the darkest areas. Most of the lines are short and thick, and on the basis of the only surviving evidence — the early impressions of the two prints themselves — it is difficult to establish the nature of the tool used. The extremities of the engraved lines appear rounder and blunter than we might expect from a burin with a lozenge-shaped section; it is possible that the burin Mantegna used for these first prints had a round section (similar to those used much later by wood-engravers). He would have taken this tool from the goldsmith's shop and particularly from the niellist where it would have been used to cut grooves deep and especially wide enough to retain the *nigellum* once it cooled off. Such a tool was commonly used by goldsmiths in Florence, where it was called *ciappola*.[98]

Mantegna seems to have been virtually obsessed with chiaroscuro. He set out to find a technique that would allow his prints to turn the infinite range of tone required to describe shading in the natural world into effective depictions in black and white. His experimentation led to the *Entombment*, arguably one of the finest prints created in the fifteenth century. The quality of his achievement is discernible even though the print is known mostly from impressions taken from a completely reworked plate. The only known impression of its first state shows that here Mantegna attempted to use pure drypoint (fig. 47). Characteristic of the first state of the horizontal *Entombment* — one also found in limited areas of Mantegna's later prints — is what is usually called the return stroke, a device which recent literature on Italian fifteenth-century printmaking has given disproportionate importance, considering that it was employed on some scale by most German practitioners of the drypoint long before its use south of the Alps. The return stroke was managed naturally by the hand holding the drypoint and scratching the surface of the plate with a short zig-zag pattern, in a manner similar to the way a draftsman creates a short-hand version of parallel hatching with the pen. A printmaker obviously could not effect a natural return stroke with a burin, because he was pushing the tool rather than pulling it: he thus emulated the effects of this device by placing the lines at very acute angles, losing, however, much of the softness produced by the earlier technique. In the prints of Mantegna's pupil Giovanni Antonio da Brescia, the device evolved into one of long, straight lines crossing other long, straight lines at very acute angles, producing a soft, almost gray overall effect, but sometimes resulting in a disconcerting *moiré* pattern in the darkest areas of the image.

The overall aesthetic appeal of the *Entombment* image has suffered considerably because of the problems encountered in printing this sheet; however, those portions that were successfully printed show an extraordinarily vivid and subtle rendition of light and dark (fig. 48). Mantegna achieved this end by modifying the rather mechanical, short, mainly straight parallel lines of the type used in his earliest prints and before that in northern drypoints. Now Mantegna began to employ two types of lines: one creating a darker and one a lighter shade of black, each obtained by varying quite carefully the depth of the groove produced by the drypoint. This had the consequence not only of varying the thickness of the layer of ink in the two lines, but also the amount of burr generated at their edges. Therefore, while the deeper lines print a rich black, the shallower ones produce a gray tone, and the burr further increases the lively interplay between them. It is this extraordinary approach, never repeated so far as we know in the history of printmaking, that is responsible for the softness seen in

the first state of the *Entombment* as well as in the early impressions of the *Virgin and Child* (fig. 50 and detail, 51), *Bacchanal with a Wine Vat* (fig. 49), and the *Battle of Sea Gods* (fig. 76) — the last of these enhanced by lines engraved with a burin to add further variety to the chiaroscuro. The inability of these delicate touches to survive more than a very small number of printing sessions, particularly if these involved the high pressure generated by a roller press, meant that the effect disappeared with Mantegna.

There is no reason to suppose that Mantegna approached printmaking with any further goal in mind than achieving a new and startling emulation of color tones in black and white. Neither is there any evidence that at the beginning of his printmaking career he was concerned about the size of his print editions; if anything, there is evidence to the contrary. The number of extant early impressions is, as already mentioned, tiny. Even Dürer, unable to acquire an impression of each, was forced to copy two of the prints painstakingly in a life-size drawing. Further, the influence of Mantegna's prints during these early years was very small compared to that of his paintings which hung in public places. Lastly, and very interestingly, the few early impressions that have survived did so even if they were as poorly printed as the impressions of the *Entombment* or the *Bacchanal with a Wine Vat* now in the Albertina. Would Mantegna have kept such unsatisfactory impressions had better ones been readily available?

It is clear that Mantegna encountered serious problems in printing these two impressions, problems that are revealing about his technique, as

48. Andrea Mantegna, *Entombment* (detail).

50. Andrea Mantegna, *Virgin and Child*. Engraving and drypoint (H.V.10.1.I), 250 × 210 mm. British Museum, London.

51. Andrea Mantegna, *Virgin and Child* (detail). Arrows indicate areas of ink caught by burr.

49. Andrea Mantegna, *Bacchanal with a Wine Vat*. Engraving and drypoint (H.V.13.4), 335 × 454 mm. Metropolitan Museum of Art, New York.

they undoubtedly derive from the difficulty of distributing firm and even pressure on the plate at a time when a roller press may not have been available. Mantegna had obviously been struck by the novelty and potential offered by printmaking when he first encountered it, but he probably had no idea of how to go about producing an object such as he must have seen. The German intaglio prints of the time could be printed by rubbing with the back of a spoon; they were so small that there was no risk of the ink drying out in one corner of the plate while it was being applied at the opposite one. Mantegna, always ambitious, started his printmaking career with a plate almost half a meter wide. This created problems of two kinds: the need for an ink that would stay viscous enough not to clog during the laborious process of application, and the means of producing a sufficient and even pressure along a line that was at least as long as the print was wide. The solution Mantegna probably adopted was a primitive roller made for the purpose, very similar to that used later by Prevedari in 1481.[99] The unevenness of the roller surface shows through in the *Entombment* and the

Bacchanal, both of which have horizontal striations about two and two and a half centimeters apart. Mantegna also failed to ink the plates successfully, particularly the *Entombment*, where all the darkest areas printed the poorest, the ink probably having been too thick to penetrate into the very close grooves created by the drypoint.

While trial and error would solve Mantegna's problems with the ink, and there is evidence of such experimentation,[100] the other shortfalls of home-made printmaking would only be solved by two further technical innovations that probably came to Italy again from north of the Alps: the burin and the roller press. Most of the other early impressions of Mantegna's prints show no sign of uneven pressure in the printing, suggesting that the roller press was introduced into Mantua not long after the artist had begun making prints. The impression of the *Battle of the Sea Gods* in Chatsworth (fig. 76), the earliest and most beautiful that has come down to us, shows a tiny printer's crease at the top center of the right sheet, of the type typically produced by a roller press. Both halves of the print are evenly and crisply printed,

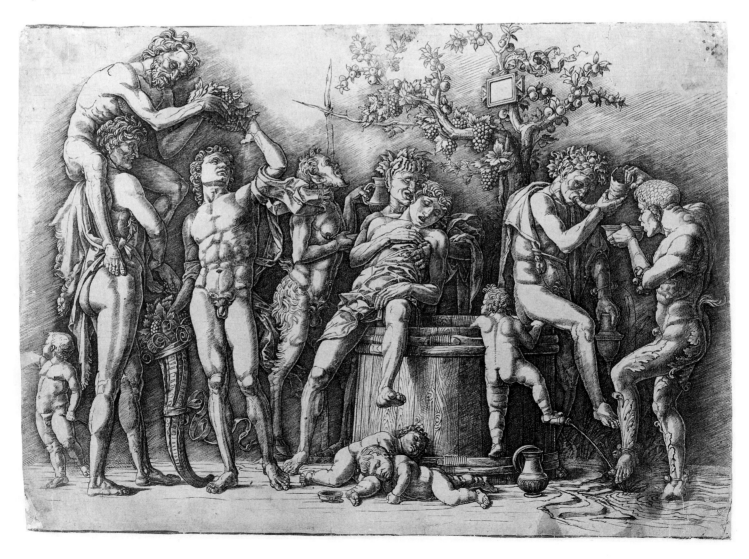

suggesting that Mantegna had access to such a press in the mid-1470s or soon after. The issue of when the burin might have been introduced to Mantuan printmaking, or to Italian printmaking in general, is shrouded in even greater mystery. Some of Mantegna's prints made after the horizontal *Entombment*, such as the *Battle of the Sea Gods* and the *Bacchanals*, show that the artist was using a combination of drypoint and what appears to be, from the character of the engraved lines and their sharply tapering extremities, a burin with a lozenge-shaped section. In most circumstances he seems in fact to have used two burins, one of which made thicker, blacker lines, the other thinner but similarly black lines. The use of two tools presumably aimed to imitate the effect previously obtained by the alteration of the depth of the incision. The fundamental difference was, however, that what was achieved was not a play between black and gray lines, but between two black lines, one thick and one thin. This solution must have been welcome insofar as it almost entirely solved any inking problems, the grooves being all of the same depth. However, if adopted on its own, it would have had the effect of conspicuously altering the appearance of the prints by rendering them somewhat harder and less subtly tonal, something that Mantegna had been trying to get away from. By varying the combination of the three tools, he could achieve the effect he desired in a particular set of lines: the softer the image, the greater the use of the drypoint. For his last and most beautiful print, the *Virgin and Child* (fig. 50), Mantegna used the two burins for most of the descriptive lines and used the drypoint for the areas of chiaroscuro, such as on the adjoining cheeks of the Virgin and Child, where richness and variety of tonal range were most important (fig. 51).

Italian printmaking was not limited to Mantua, however, as other centers in Italy were producing large numbers of prints by this time. In Ferrara the solutions found for creating chiaroscuro were fundamentally based on the use of cross-hatching, much more similar to those adopted in Florence than in Mantua. This is a curious anomaly, since Ferrara was geographically, politically, and artistically much closer to Mantua, yet Ferrarese prints show no technical indebtedness to Mantegna whatsoever. It may be that a member of one of the three Florentine workshops had moved to Ferrara. The author of one of the best-known series of fifteenth-century Italian prints, the so-called *Tarocchi*, adopted all the technical conventions of Fine Manner prints, and none of Mantegna's. He used cross-hatching as his only device for producing chiaroscuro, and even imitated the Florentine practice of setting the image within decorative borders.[101] Early impressions of the *Tarocchi* are rare, and are characterized by their softness of tone and what appears to be a deliberate lack of interest in strong chiaroscuro: the

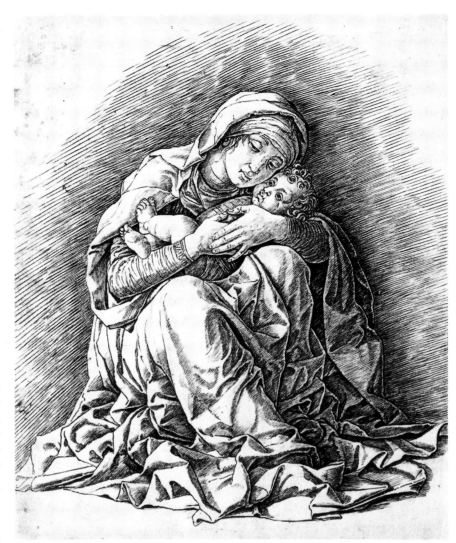

formal goal of the engraver (or engravers) of this school seems to have been the creation of a subtle variety of grays rather than blacks. This effect was achieved by employing very thin and extremely regular, disciplined cross-hatching, coupled with the use of grayish inks, and was unwittingly intensified by the obviously deficient printing techniques employed in this workshop. Early impressions of the *Tarocchi*, as well as most other Ferrarese prints of the period, seem to have been printed without the use of a press. They often appear blurred, possibly more than was intended.

It would be a mistake, however, to think that all printmakers in Florence were a sleepy lot, immune to the lively atmosphere of experimentation and continuous development that characterized the activity of their colleagues the painters. Francesco Rosselli was obviously aware of the failings of the technique used by Baccio Baldini in rendering tone, and from early in his career he followed a different path. Although he could not help employing the same tool that Baccio was using — the goldsmith's burin[102] — and was therefore also the victim of its thin, shallow, and fragile lines, nevertheless he appears to have abandoned cross-hatching early in his career. Not surprisingly, at that point Francesco turned to the only other form of shading then known in Italy, Mantegna's.

Francesco's early prints were shaded with short, parallel lines, engraved at an angle and very similar to Mantegna's. Not only did Rosselli imitate this Mantuan stroke, he also adopted Mantegna's preference for making ambitious, large-scale folio prints such as the first version of the *Deluge* (fig. 97). Oberhuber has reconstructed his vast corpus,[103] but has to some extent failed to explain the sudden transformation from tentative practitioner of the Fine Manner, the technique employed for the *Deluge*, to the champion and principal representative during the last two decades of the century of the so-called Broad Manner. This is characterized by the use of a line of a much darker black than we find in Fine Manner prints, a line that must have been produced by a tool capable of engraving a deeper groove. Although Fine Manner prints were constantly reworked, as they wore down very quickly indeed, Broad Manner plates suffered little in the printing and were rarely, if ever, freshened up.

There is still enough confusion surrounding the definition of Fine Manner and Broad Manner to warrant a brief digression. The terms themselves are misleading, since the distinction between the two modes of shading is not, as seems implied, the thickness of the lines, but rather the way in which the lines are actually used for shading. The term Fine Manner is normally applied to prints characterized by clear, thick contour lines with thin cross-hatching for the shading. The term Broad Manner is, on the other hand, applied not only to

prints engraved with thicker, blacker lines, but also, and inappropriately, to all early Florentine engravings shaded only with parallel lines rather than with cross-hatching. In fact, these so-called Broad Manner engravings employ two clearly different technical approaches. Some are engraved with fine, long lines and some with thick, short lines. The cause of the confusion is that the two techniques appear in prints that are stylistically very similar, as they were both made, albeit at different times, by the very same hand — that of Francesco Rosselli. Generally speaking, it is now clear that Fine Manner prints chronologically preceded Broad Manner prints, and it is easy to demonstrate that Rosselli's own Fine Manner prints were engraved before he started using the second technique. Nevertheless, some mystery still surrounds the whole issue of how, when, and by whom this new, quite revolutionary mode of engraving was introduced to Florence. Its arrival radically changed not only the number of impressions that could be pulled from a plate, but, more importantly, their visual appearance: as Rosselli's confidence in his handling of the technique increased, the scale and daring of his chiaroscuro grew to generate formidable images in black and white, images that could well compete with paintings.

Francesco Rosselli must have been the one who introduced to Florence the tool that yielded Broad Manner prints. There is much circumstantial evidence to suggest this. As previously discussed, Francesco's son Alessandro died in 1525 leaving a major print shop. The shop inventory made at

AGEO PROPHETA

ECIEL SON GRANDI E SIMILLORNATVRA
ET PARTO RIR A CREDO PRESTAMENTE
COLVI CHESALVERALACREATVRA
DISIDERATO EGLE DAOGNI GENTE
MAQVELSASCHONDERA DASVO CALVRA
NONPVO VEDER TALOPRA CERTAMENTE
CHO STVI ANASCER DVNA VERGINE SANTA
ONDOGNI SPIRITO SIRALLEGRAE CHANTA

this date lists forty-nine engraved plates, all of which can be identified as prints done in the Broad Manner. In fact, the list includes all the major prints engraved in this technique, and it also provides us with the evidence that Francesco Rosselli was the author of the important Fine Manner prints which are characterized by parallel, rather than cross-hatched, shading. The proof lies in the presence in the Rosselli inventory of what are certainly the two known versions of a *Diluvio* (Deluge) — one executed in the Fine Manner and one in the Broad Manner, although both of them are shaded with parallel, oblique hatching. Each is described as being engraved on the verso of a plate inscribed with a typically Broad Manner print: in one case the *Adoration of the Magi*, in the other *Solomon and the Queen of Sheba*.[104] The fact that these four prints were not only present in the Rosselli workshop but actually paired in this fashion provides strong circumstantial evidence for Francesco's authorship.

Until ca. 1480 Francesco Rosselli was in Florence with his wife and children. According to a letter sent to the Signoria by his brother Cosimo, the painter, Francesco had left by then to go to Hungary, leaving Cosimo with the care of the whole family and conspicuous debts. Two years

later the printmaker was back in town and began making money within a very short time. Only a few months after returning home he was able to buy a new house with a workshop, and his finances continued to improve until he died, a rich man, in 1513. What had happened that changed Francesco's life so dramatically during his sojourn north of the Alps? Likely it was there that he learned how to use the burin with a lozenge-shaped section, the tool that German engravers had borrowed from their colleagues the goldsmiths and first applied to printmaking. It must also have been the burin that changed so conspicuously the appearance of Florentine prints, since this was certainly the tool responsible for making the prints done in the Broad Manner. No doubt to the delight of Francesco's bankers, the burin solved the problem of wear in the fine lines engraved with the older technique employing the *ciappola*, thus allowing a much greater number of impressions to be pulled from the plate. The burin also brought with it a sharper and more daring chiaroscuro which conformed well to the fashion for crisper imagery in contemporary Florentine painting.

Francesco apparently guarded the secret of his new technique, protecting it in a fashion reminiscent of the della Robbia family with their glazed terracotta sculpture or the Benintendi with their ex-voto busts in wax. Francesco probably started out by carefully copying a number of prints in the Fine Manner, including the sets of *Prophets* and *Sybils* by Baccio Baldini (figs. 52, 53), and for some time thereafter he appears to have been the only printmaker employing this type of burin. He then turned his attention to his own earlier work in the Fine Manner, and copied it over in the new technique. The two versions of the *Deluge* are a perfect example of this. The next, natural step was to burnish out the exhausted earlier versions of prints in Fine Manner and rework them in the new style. This happened, for instance, with Francesco's own series of the *Life of the Virgin and of Christ* (fig. 54), where a majority of the prints from the set were completely re-engraved, mostly following the earlier design but, in the case of the *Flagellation*, using an entirely new composition (fig. 55).[105]

Rosselli was the only printmaker in Florence to be affected by the introduction of the burin. He did not reveal his secret to Antonio Pollaiuolo, a fellow goldsmith. Although active as a painter, sculptor, and draftsman all his life, Pollaiuolo never abandoned his membership in the Arte della Seta — the goldsmiths' guild — for the Arte dei Medici e Speziali, which included the painters. Yet, when it came to making his only extant print, he adopted the same technique that Baccio Baldini and the early Rosselli were already using, and in doing so he conceived a masterpiece in the Fine Manner. His *Battle of the Nudes* — an important statement of his abilities as a master of the naked figure in

53. Francesco Rosselli, *Haggai*. Engraving (H.I.173.C.I.20.B.I), 177 × 105 mm. Museum of Fine Arts, Boston.

54. Francesco Rosselli, *Life of the Virgin and of Christ: The Flagellation*. Engraving (H.I.123.B.I.7.I), state I, 223 × 163 mm. Art Institute of Chicago.

55. Francesco Rosselli, *Flagellation*. Engraving (H.I.123.B.I.7.II), state II, 223 × 162 mm. Albertina, Vienna.

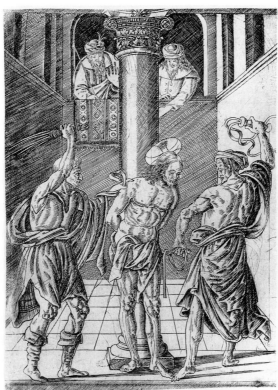

56. Antonio Pollaiuolo, *Battle of the Nudes*. Engraving and drypoint (H.I.191.D.I.1), state I, 406 × 607 mm. Cleveland Museum of Art, Cleveland.

57. Antonio Pollaiuolo, *Battle of the Nudes*. Engraving (H.I.191.D.I.1), state II, 400 × 607 mm. Albertina, Vienna.

movement as seen from different angles — is a milestone in Quattrocento printmaking and the first print in Italy to be signed by an artist. In the first state, surviving in just one impression, the engraver followed Mantegna's convention for hatching, though he transformed it by the use of the typically Florentine *ciappola*, which he used for most of the contour lines, while the rest of the image was engraved in pure drypoint (fig. 56). The plate was later reworked, however, this time with the new type of burin (fig. 57). It is possible that the two states were not produced too far apart because an early impression of the second state (Cambridge, Fogg) is printed on paper bearing a watermark identical to the only known impression of the first state.[106] It is noteworthy that Pollaiuolo's reworked plate underwent a treatment so similar to Rosselli's plates. The presence of the same watermark in the Fogg impression of the second state of the *Battle* may suggest that it must have been Pollaiuolo himself who reworked the plate, but a comparison between impressions of the two states confirms beyond doubt that Pollaiuolo could not be responsible for the rework: its crude, short strokes obliterate the subtle effects of chiaroscuro obtained by the drypoint in the first state.

The one disadvantage of Rosselli's technique is that, although the prints appear much crisper in their depiction of light and dark, they lose almost entirely the subtle gradations of tonality that had made Mantegna's engravings so successful and beautiful. It would have been quite impossible for Pollaiuolo to depict with any accuracy the rippling muscles of his fighters had he chosen to use the burin in Francesco's manner. Flesh is not drapery, and Pollaiuolo had found Mantegna's lesson very useful in his first state of the *Battle*. He could not, however, use the "return stroke" to intensify the shadow at the edge of the muscles, something he had done copiously with the drypoint in the first state, because this is practically impossible to do with the burin. The problem was solved here by applying the "zig-zag stroke." The effect of the two lines touching at acute angles at their summits was a perfect technical response to the need for more tonal richness, and successfully emulated Mantegna's solution. This device, even if it had nothing to do with the artist, helped to make Pollaiuolo's only print very influential in the further development of Italian printmaking. The large number of extant impressions in its second state suggests the popularity of this glorified pattern sheet among artists and collectors in late fifteenth-century Italy. Additionally, the widespread use of the zig-zag stroke in prints produced after 1480 bears witness to the number of printmakers who must have looked very carefully at the *Battle*.[107]

By this time, then, Italy could boast a wealth of means to achieve an effective range of chiaroscuro in a print, and printmakers had learned to employ

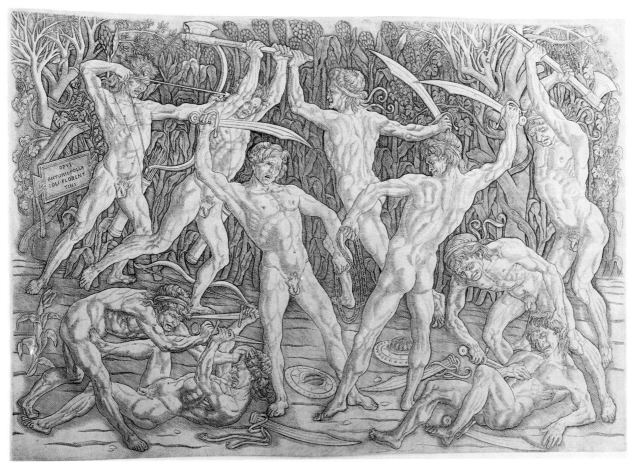

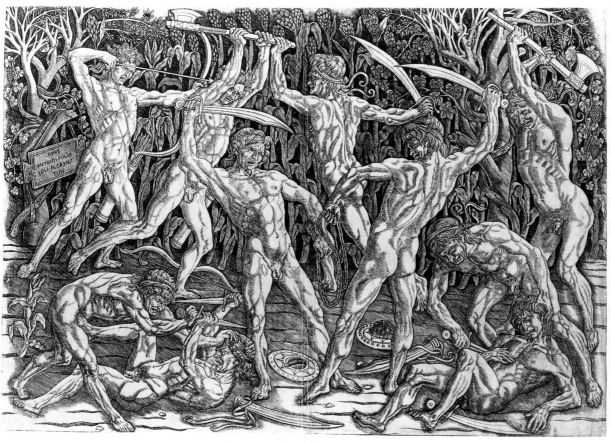

the burin with increasing confidence. Some, like Robetta, preferred to stick to the old manner of engraving, simply substituting the new tool for its predecessor. His prints are shaded with a not too regular, nor very imaginative, cross-hatching that contributes little to improving the awkwardness of the design. Some others, like Giovanni Antonio da Brescia, made progress by trying to mix the achievements of Mantegna with those of Pollaiuolo and even Baldini. At the beginning of his career, and still under the direct influence of his master, Giovanni Antonio produced images whose strong tone was obtained by making Mantegna's straight parallel hatching even more regular and thus even less descriptive of the form. He slowly evolved his style by adding to his repertoire first the zig-zag stroke and then, increasingly, a very close and perfectly regular cross-hatching, which often yielded a dark and at the same time soft setting for his figures (fig. 59). Giovanni Antonio was, at this time, the most advanced printmaker in Italy in his research into the effects of a black background. He was no doubt influenced by Mantegna, but another inspiration could have been the spectacular *Virgin and Child with a Bird* by the Master ES (fig. 58), the only engraving of its type from the fifteenth century, and a highly experimental work in that it was printed in intaglio using white ink on black pigmented paper.[108] His constant curiosity about the achievements of other printmakers, and his careful copying of a number of Dürer's early prints, added yet another dimension to his handling of the burin. Giovanni Antonio traveled extensively in northern Italy, as did his prints, which were much

more influential than is commonly acknowledged. Nicoletto da Modena was obviously inspired by them, and all of Nicoletto's early prints show a clear debt to the technical solutions found in Giovanni Antonio's engravings. Not a craftsman who would waste too much time on detail, however, Nicoletto soon gave up his search for more satisfactory ways of enriching the printmaker's palette.

One who did not give up, and who must have looked very closely at Giovanni Antonio's prints during his formative years, was the young Marcantonio. Although draftsmanship was not among his gifts,[109] he made up for this through his persistence in mustering every nuance of gray and black on white. There was no tone that, in his maturity, Marcantonio could not attain, and it is precisely this ability that must have struck Raphael and convinced him that prints could be works of art even if produced through collaboration. Similarly, it was this same command of tone and its technical accessibility that gave printmakers of the following generation the confidence to seek to "reproduce" drawings, paintings, and frescoes.

Marcantonio's prints before 1506 demonstrate how quickly he developed. From being an imitator of Giovanni Antonio's technique and constrained by the goldsmith's and niellist's approach taught him by Francesco Francia, Marcantonio emerged as a confident engraver who had discovered in Dürer's rounded cross-hatching and flicking system a new way to enrich his palette. In no more than five or six years, Marcantonio built a solid basis in a system of his own, created from a totally adaptable combination of cross-hatching, dots, and flicks of different thickness according to the size of the image, but always parallel and regular, so that they could follow any contour line, however varied (fig. 60). The relationship among the three components of his system never altered, no matter

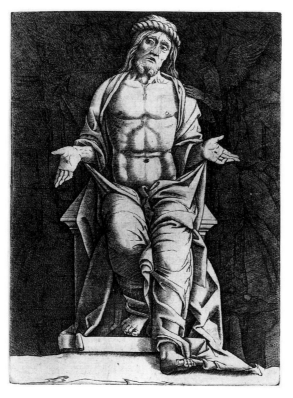

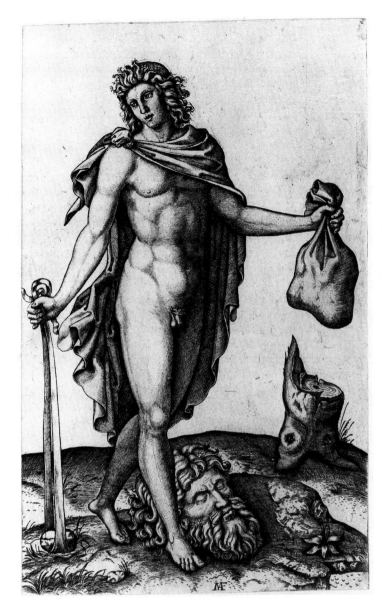

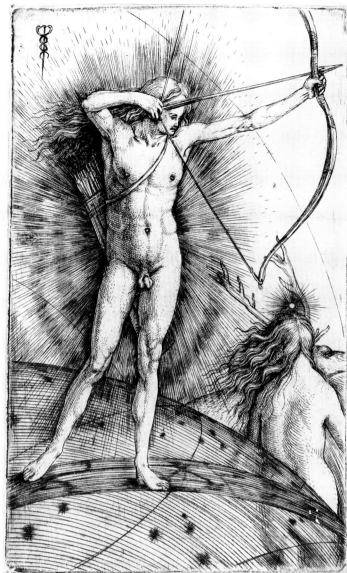

how small the area to be engraved. It was this adaptability that ensured the longevity of Marcantonio's method, one whose principles could be readily understood by an apprentice and applied to engraving all parts of a plate.

It is not, in a way, surprising that such a painstaking, methodical approach should be the one chosen by a craftsman whose enthusiasm was not matched by a gift for drawing. This was certainly not the case, however, with Jacopo de' Barbari, whose prints were contemporary with Marcantonio's early attempts and yet reveal a totally different sensibility. His confidence in describing a figure or its surroundings with no more than a few lines found perfect expression in his engraved work. Before he encountered Dürer's prints, which obviously convinced him that he also had to abide by the new rules of regular and systematic hatching, Jacopo made some extraordinarily daring images. In these, the chiaroscuro was generated mostly by

flowing lines, each one apparently going its own way, occasionally interrupted or accompanied by a rounded and sensitive cross-hatching, made up primarily of very short lines. This idiosyncratic solution, which influenced Dürer himself to a considerable degree, only worked in the hands of a highly imaginative artist such as Jacopo, and was of little use to most other printmakers, particularly as the systems then offered by Dürer and Marcantonio provided them with easy ways of hiding whatever failings they may have had as draftsmen. The extraordinary degree of refinement reached by Jacopo in handling his burin can be seen most spectacularly in his *Apollo and Diana* (fig. 61), made ca. 1504–05 at the height of his years of experimentation in printmaking. In the bottom right corner of the image, the body of Diana almost disappears behind the crystalline sphere of the stars, her corporeity suggested by a few short, thin, and masterly strokes of the burin.

60. Marcantonio Raimondi, *David with the Head of Goliath*. Engraving (B.XIV.13.12), 163 × 110 mm. British Museum, London.

61. Jacopo de' Barbari, *Apollo and Diana*. Engraving (H.V.153,14), 160 × 100 mm. British Museum, London.

THE IMPRESSION AS A WORK OF ART

We have so far limited our comments to the efforts of printmakers to make their prints come closer to the richness of tone found not only in other art forms but ultimately in nature itself. These were all attempts to increase the command of light and dark by using tools in different ways, and the success or otherwise of the struggle affected the appearance of all their prints. This implies a notion of progression that might make sense *a posteriori*, but which could not have been as obvious to the printmakers themselves as it might appear in this account of it. We know what Dürer's and Marcantonio's prints looked like in 1515, and it is easy for us to surmise that, consciously or not, most printmakers before them tried to reach a mastery in the medium similar to that eventually attained by these two artists. Repeated experimentation by a very few is the only direct evidence we have that printmakers consciously strived to make particular impressions of their prints look specifically different, surprising, or distinctively beautiful.

While the Master LCZ and especially Mair von Landshut are known to have experimented extensively with colored papers in Germany, there is very little evidence of its use for engravings in

Italy.[110] However, extensive use was made of the other most obvious means available to printmakers to give a particular impression an appearance that distinguished it from others, that of changing the ink used for printing it. As one would expect, Mantegna was the earliest and most adventurous artist to explore the possibilities offered by colored inks, although it is now difficult to assess how much of the variation is due to his own intention and how much to chemical alterations that have occurred over the centuries. It seems that he tried to print impressions in a silvery gray ink, perhaps in order to emulate the effects of metalpoint on a prepared ground. The first state of the *Entombment* (fig. 47) is likely an attempt at achieving this quality. Early impressions of Mantegna's prints suggest that he did indeed use a variety of hues of brown and black inks, and that the shades of both, but particularly the black, varied considerably, from pitch black to greenish or bluish black. Such experimentation with color went further than giving just a slightly colored tone to a black ink, and early, perhaps fifteenth-century, impressions of prints by Mantegna and Giovanni Antonio da Brescia survive that are printed entirely in green and blue (fig. 67). The fact that many prints by these two artists now boast a rich chocolate or reddish brown ink has often been explained by the tendency of black ink to fade or alter chemically over time.[111] There are a few instances where brown ink does appear to have resulted from fading, such as in an impression of Giovanni Maria da Brescia's *Virgin and Child Enthroned, with Four Saints* in the Metropolitan

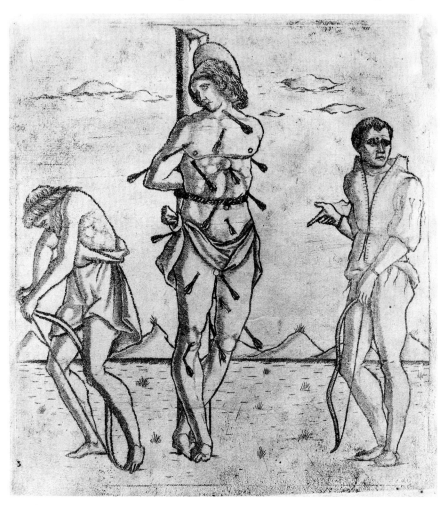

Museum, New York. Even more intriguingly, the Munich impression of Giulio Campagnola's *Tobias and the Angel* — his earliest print, almost certainly produced during his Mantuan training — is partly in a crisp brown ink and partly in a splotchy black ink: which color turned into the other is debatable, but this impression confirms Giulio's inexperience in preparing his materials. However, Mantegna should not be lightly accused of such mistakes, and

a cursory comparison of some early impressions of his brown-toned engravings with his drawings in pen and ink is enough to convince one that they could not be the result of a mere chemical quirk.[112] Moreover, as there are many other examples in Mantegna's school of impressions in brown, it seems unlikely that this color alone was unintended.

Most Italian printmakers of the period played at least once with colored inks. For example, there are impressions in red and green.[113] Experiments in various shades of blue extend from the darkest of Mantegna's own *Battle of the Sea Gods* and a group of Florentine nielli in the British Museum, through the medium hue employed for an impression of Nicoletto da Modena's *Hercules and Antaeus* in Amsterdam, to the lightest blue also printed by Nicoletto for his *Two Grotesque Animals*

64. Anonymous Florentine Artist, *Crucifixion, Surrounded by Fourteen Other Scenes from the Passion*. Engraving (H.I.28.A.I.9), 262 × 190 mm. British Museum, London.

65. Anonymous Florentine Artist, *St. Jerome in Penitence*. Engraving (H.I.40.A.I.39), 245 × 159 mm. Museum of Fine Arts, Boston.

Coiled about a Tree (fig. 68). Even Marcantonio attempted to print an impression of his *Woman Watering a Plant* in very light greenish gray ink (New York, Metropolitan), at a time when he had achieved an almost total command of tonality in black. The fascination with gray was common to many printmakers, perhaps because of its affinity with certain types of drawing. We have mentioned Mantegna's pleasure in using gray inks, and there is, in addition, a group of extraordinarily soft-looking, grayish toned Ferrarese prints of the 1470s, including a large number of impressions of

66. Spinello Aretino, *St. James and St. Philip with Scenes from their Lives* Fresco, S. Domenico, Arezzo.

the *Tarocchi* and the exceptional *Martyrdom of St. Sebastian* in New York (fig. 62).[114] Furthermore, one should not forget similar experiments by Nicoletto da Modena.[115]

A richer gradation of tone than that achieved by the burin alone could result from a thin film of greasy diluted ink left on the surface of the plate. When this occurs accidentally one normally refers to the presence of "plate tone"; the term "surface tone" is more appropriate when the tone has been purposefully used to enhance the darker areas of an image while in other areas the plate has been carefully wiped clean.[116] The use of surface tone was not widespread until the seventeenth century, Rembrandt making the most imaginative use of it. But already in the period under discussion some of the more creative printmakers, both in the north and in Italy employed surface tone to enrich their palette. Nicoletto da Modena often used this effect in order to produce more intensely dark prints,[117] even to the point of transforming an impression of his *Mars* into a night scene (fig. 63). That this is a case of surface rather than plate tone is shown by

the fact that the edges of the plate outside the borderline were wiped clean. It is not surprising that the ever daring Jacopo de' Barbari would also play with the surface of his plates.[118]

On rare occasions surface tone was developed into an even more subtle system of enhancing the particular quality of an impression. The dark areas in the foreground of the platform and in the background of the wall behind the figure of the Virgin in the Ferrarese *Annunciation* of ca. 1470 (Boston) were managed by scratching the surface of the plate very lightly to retain the ink and enrich the surface tone. These lines are so fine that they must have been re-engraved regularly to retain this quality, though we have only one surviving impression from which to judge. The effect is very similar to that of the contemporary Ferrarese *Martyrdom of St. Sebastian* discussed above. About forty years later Marcantonio would develop this same idea in his most unusual *Judgment of Paris* (see p. 127). A rather different, if no less imaginative, approach was that of Girolamo Mocetto, who pressed the ink on with a cloth to produce a patterned surface tone

67. Andrea Mantegna, *Battle of the Sea Gods*. Engraving and drypoint (H.V.15.5), 297 × 429 mm. British Museum, London.

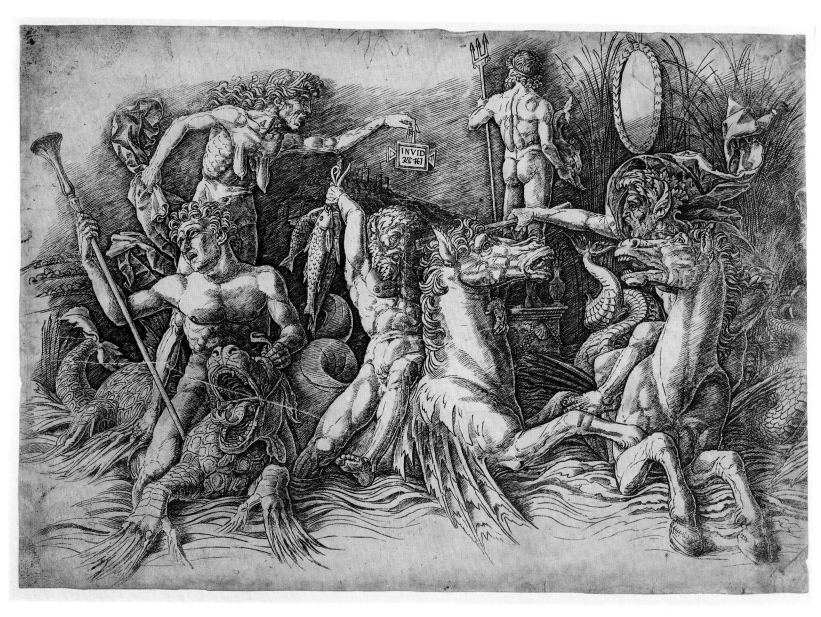

in a very special impression of his *Judith with the Head of Holophernes* (H.10.II), now in the British Museum.

All these experiments, and the survival of the impressions documenting them, demonstrate the care that artists in the latter quarter of the fifteenth century devoted to the making of prints as special objects. The status of printmaking in Italy grew in geometrical progression, and its leading representatives were honored long before Dürer gave the art a comparable preeminence in Germany.

PRINTS AS COMPETITORS OF PAINTINGS

The premium on technical innovation demonstrates the extent to which certain printmakers were consciously competing with one another. But towards the end of the century, prints increasingly appear to have begun rivaling paintings. Yet due in the main to their intrinsic fragility, there is little surviving evidence of this view. A small number of prints were of such quality and size that they could stand among paintings in the decoration of rooms where they might be displayed similarly framed. But it is likely that most large prints were pasted down directly onto the wall, with the result that they were quickly and inevitably destroyed. Smaller prints were collected and pasted to the leaves of albums, although these albums as well were eventually dismembered.[119] Thus, in the absence of any archival endorsement, the evidence to prove the existence of a taste for collecting prints in Italy must be mostly of an indirect nature and derives from an investigation of such disparate issues as the devices used by printmakers to relate their prints to the viewer, and the size, subject matter, and complexity of the images themselves.

It is obvious that most religious prints were used as cheap substitutes for devotional paintings. This is suggested not only by their choice of subject matter — normally confined to one of the main episodes of the New Testament or to the depiction of a locally venerated saint — but also by the similarly direct, simplified, and didactic approach to the treatment of such subjects. Moreover, especially in Italy, printed images tended to address the viewer by the same visual formulas as employed in contemporary painting. Thus, many fifteenth-century Italian engravings show their main subject surrounded by smaller images depicting related episodes,[120] in a manner analogous to the conventions traditionally applied to fresco decoration and the construction of altarpieces (figs. 64, 66). Such images were sometimes accompanied by detailed inscriptions that helped the viewer follow the intended meaning of each episode, focusing religious attention.[121] Since some degree of literacy was required for the enjoyment of such prints, we may

assume they were not destined for poorer households. More commonly, however, the texts accompanying the images were simply the words of a prayer in the vernacular.[122] In some instances the texts were in Latin, hinting at a high level of cultivation in the intended audience.

The use of prints for private devotion is further suggested by the fact that in many cases the image is framed by a decorated border with a floral or animal motif (fig. 65). This was a solution typically adopted by miniaturists and indicates that these prints were probably also meant to be pasted to the pages of albums or to the inside covers of books. On the other hand, the size of many prints of religious subjects made in Italy before 1500 would have made them unsuitable for such use, and one can explain the presence of ornamental borders by the simple fact that many a printmaker was trained as an illuminator for whom it would have been natural to repeat a device familiar from his early training.[123] In the majority of cases early prints were surrounded by one or more borderlines, designed to create a sense of perspectival

68. Nicoletto da Modena, *Two Grotesque Animals Coiled about a Tree.* Engraving (H.V.138.118), 150 × 125 mm. British Museum, London.

69. Anonymous
Florentine Artist, *Ascension*.
Engraving (H.I.31.A.I.14),
245 × 186 mm. Uffizi,
Florence.

70. Anonymous
Florentine Artist, *St.
Catherine of Siena*.
Engraving (H.I.51.A.I.66),
249 × 188 mm. British
Museum, London.

71. Anonymous
Florentine Artist, *Trinity
with Christ as the Man of
Sorrows Adored by St. John
the Baptist and another
Saint*. Engraving
(H.I.53.A.I.72),
243 × 190 mm. British
Museum, London.

72. Anonymous
Florentine Artist, *Nativity:
The Virgin Adoring the
Child*. Engraving
(H.I.53.A.I.75),
236 × 177 mm. British
Museum, London.

recess and thus to imitate — again in the tradition of illuminated manuscripts — the convention of a framed painting. A most striking example of such a device can be seen in a Florentine *Ascension* of the 1460s, where the drapery of one of the saints is engraved in trompe l'oeil as if it were unfolding outside the image and occupying the space described by the frame (fig. 69).

In ways such as these it is easy to detect a progression from the practices of the illuminators to those of painters, and to recognize a comparable development in prints from intimate images of

private devotion to images which, because of their size and complexity, could be shared by many. The most conspicuous symptom of this transformation is the depiction of trompe l'oeil frames, and there are copious examples of these in Italian prints of the time ranging from the simple (fig. 70) to the complex (fig. 71) — and, at the most elaborate, a tabernacle (fig. 72). When Francesco Rosselli conceived his cycle of the *Life of the Virgin and of Christ*, he provided it with separately engraved horizontal and vertical borders which could be used by his customers to divide the scenes when pasted to canvas, wood, or wall. A number of such combinations have survived, some mounted on canvas, some on wood, and all richly colored. A complete set of fifteen prints laid on canvas is in Hamburg (figs. 74, 75); single examples laid on wood, similarly mounted, and provided with an illuminated border of flowers are to be seen in the Louvre, the Metropolitan, and the British Museum. The most striking example, however, must have been the group of twelve subjects mounted together to constitute a wooden predella of an altarpiece, conserved in Berlin until the Second World War.[124] It is worth recalling that a devotional image was an integral part of the furnishing of any bedroom in late fifteenth-century Florentine households, and that it might be present even where other pictorial decoration had still not been completed or even planned. The Medici inventory of 1492 for the Villa di Poggio a Caiano lists only a small number of works of art, yet in every one of the eight bedrooms it describes a small *Madonna* or an image of a saint, some painted on wood, some on canvas.[125] In less prosperous households these would almost certainly have been prints.

This disparate evidence suggests that prints of religious subject matter had been competing with

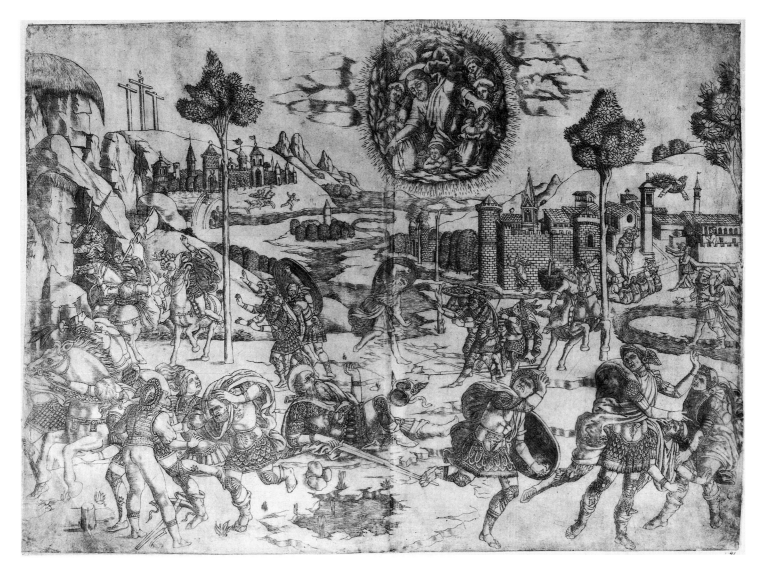

the lower end of the market for devotional paintings for some time before the grander feats of Francesco Rosselli in the 1490s. Although most of the engravings we have mentioned so far were printed in small folio (about 268 × 400 mm) and were thus comparatively diminutive at a time when paintings were on average very much larger, it was not long before prints started catching up in size. Mantegna, again, can be credited with the first use of the royal folio or *foglio reale* (about 445 × 615 mm) for Italian prints, and many of the engravings produced in Mantua in the fifteenth century were of this larger size. There is no evidence that any was ever mounted on wood, nor does any of them boast a trompe l'oeil borderline, an ornamental border, or an illusionistic frame. The fact that many of them are either surrounded by a large unprinted margin that is fundamental to the correct reading of the image, or are engraved to reach the edges of as large a sheet of paper as was then available, excludes the possibility that they were ever meant to be mounted in albums. Our conclusion must be that these larger prints were meant either to be

kept loose in drawers or — possibly after being mounted on canvas — to be framed and hung on the wall, like paintings. The same can be inferred for the small but important group of prints by Baccio Baldini and Francesco Rosselli that were inspired by large drawings made on vellum by Maso Finiguerra, such as the engraved *Conversion of St. Paul* (fig. 73), the *Judgment Hall of Pilate*, and the *Deluge* (H.B.III.1). The grandeur of their compositions suggests in itself that these engravings were meant to decorate the walls of a room in competition with paintings, while the refinement with which the subject is treated and the plate engraved seems to undermine the hypothesis that they would be glued to the wall without the benefit of a support and/or frame. How can one imagine Giovanni Pietro da Birago's *Last Supper* or, even less likely, Pollaiuolo's *Battle of the Nudes*, of similar size, glued on the rough surface of a fifteenth-century wall? Would any of these prints have survived had they been treated in this way? It may be interesting in this context to remember that one of the items listed in the Rosselli inventory is a

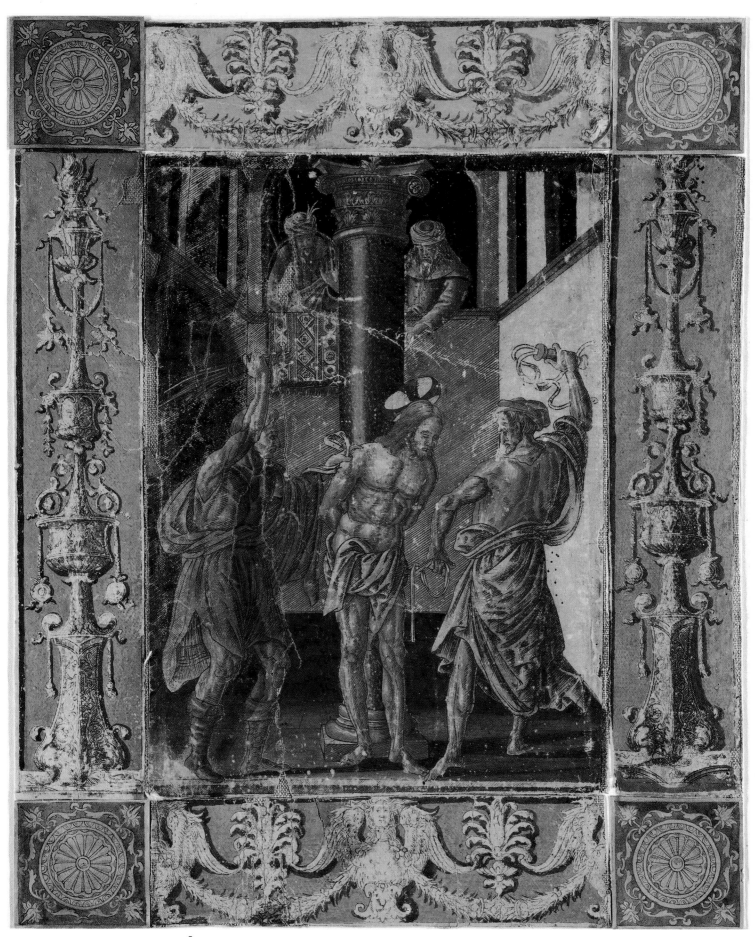

84

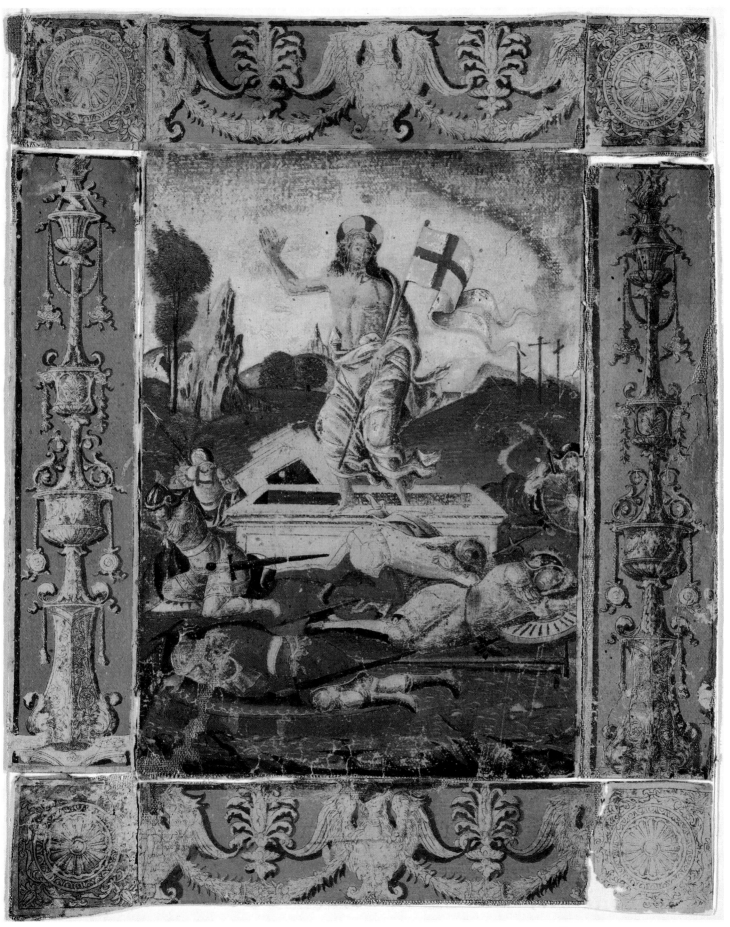

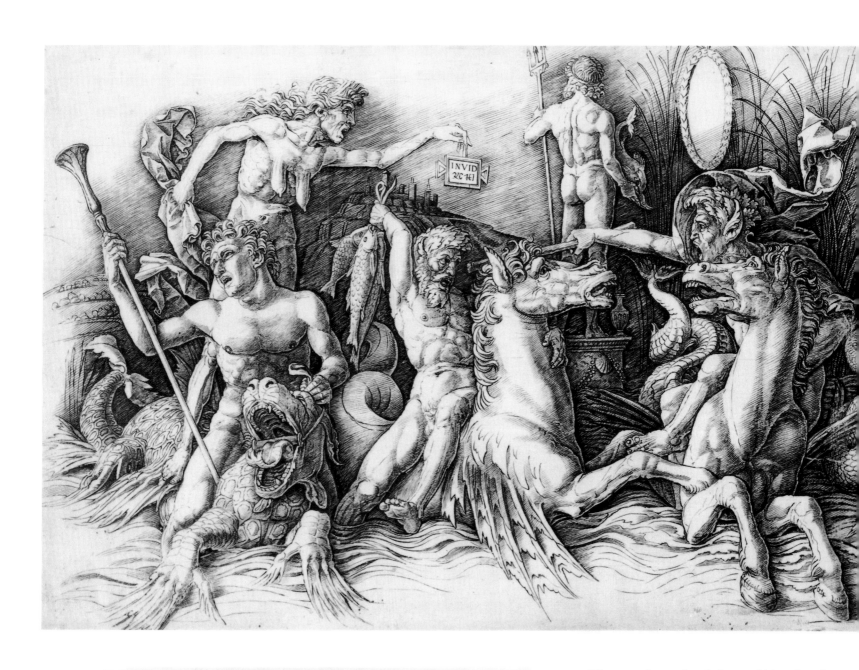

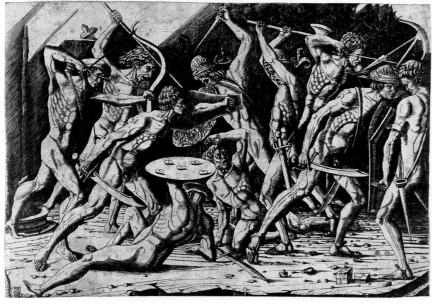

group of "twenty-four printed sheets of histories of various sorts on linen" (24 telaia di istorie instampate in tela di piu sorte), an obvious suggestion that prints were being mounted on canvas already in the shop, and sold in this form.[126]

The same purpose must also apply to the increasing number of fifteenth-century Italian prints made of more than one sheet. In fact, the *Judgment Hall of Pilate*, though engraved on one large plate, had to be printed on two sheets of royal-size paper.[127] Difficulties of this kind must have been chronic with large engraved compositions. Any solution that entailed printing a large plate onto two smaller sheets of paper was doomed to being abandoned before long, as it created too many difficulties. The obvious solution for those artists who needed a larger expanse to express their ambitions was to divide the image between two or more plates. Although there seem to be a number of precedents among map-makers — Breydenbach,

for instance — it is not surprising that the leader among printmakers was again Mantegna, whose *Battle of the Sea Gods*, almost 900 mm across, appears to be the earliest engraving of high aesthetic aspiration to be made from two plates (fig. 76).[128]

The solution offered by this magnificent image was soon exploited by a number of printmakers all over Italy and in time became the standard means of showing frieze-like scenes such as Triumphs, Processions, or Battles, whether in engravings or in woodcuts. In Florence it was first imitated by the author of the *Triumph of Bacchus and Ariadne* (H.A.II.26), the two halves together comprising an image about 560 mm wide, and then by Lucantonio

76. Andrea Mantegna, *Battle of the Sea Gods*. Engraving and drypoint, two plates (H.V.15.5 and 6), 283 × 826 mm. Duke of Devonshire and the Chatsworth Settlement Trustees, Chatsworth.

77. (far left) Anonymous Paduan Artist, "*Hercules and the Giants*." Engraving (H.I.192.D.I.2.I), 370 × 552 mm. British Museum, London.

78. Anonymous Artist after Antonio Pollaiuolo, *Battle of the Nudes*. Pen and ink, 120 × 327 mm. Biblioteca Reale, Turin.

79. Jacopo de' Barbari, *Triumph of Men over Satyrs*. Woodcut from three blocks, 130 × 885 mm. Albertina, Vienna.

degli Uberti, whose *Last Supper*, closely inspired by Perugino's fresco in the refectory of the Convent of S. Onofrio, measures more than a meter in width. It is also possible that the so-called *Hercules and the Giants*, a Paduan work usually attributed to the school of Pollaiuolo but by an imitator of Mantegna's style (H.D.I.2), was intended to be twice as large, that is, more than 1,200 mm in width. The unfinished first state of the left half clearly shows that the composition was meant to continue into a right half, and a drawing in Turin suggests what this would have looked like (figs. 77, 78).[129] During the last decade of the century prints extending horizontally to two plates or blocks became more common, but it was probably not until Jacopo de' Barbari's *Triumph of Men over Satyrs* of the late 1490s (fig. 79) that an attempt was made to divide a scene into three parts. This immensely influential woodcut, soon followed by the magnificent *View of Venice* in six blocks, set the pattern for what was to become both in Italy and north of the Alps one of the most fashionable forms of printmaking in the sixteenth century: the large decorative woodcut in multiple blocks.

The bird's-eye *View of Venice* was, notwithstanding its exceptional aesthetic quality, still a product of the tradition of large maps in several sheets. Between 1478 and 1490 Francesco Rosselli himself made a number of multi-sheet maps, including a *View of Florence* in six sheets, and a *View of Rome* in twelve, both of which are known only from copies and from the inventory of his son's *bottega*.[130] With the possible exception of Jacopo's *Triumphs*, the first appeal to a taste for large, decorative, multi-block woodcuts in Italy was the *Triumph of Caesar* (Pass. I, p. 133, no. 1), the result of a collaboration in 1504 between the northern European block cutter Jacob of Strasbourg and the miniaturist Benedetto Bordon.[131] This print measures more than four and a half meters in

length, and could only have been displayed by being pasted directly to a wall or by being glued to canvas for hanging in a manner similar to multi-block maps such as the *View of Venice*. While we know of a number of views made from several blocks published in travel books prior to 1504, the importance of the two *Triumphs* lies in their having transposed a typically "artistic" subject into the typically "decorative" format of the map-makers.

In all likelihood Jacopo de' Barbari's *Triumph of Men Over Satyrs* was intended for the same sort of clientele as Bordon's *Triumph*. Although its source has not yet been identified with certainty, Jacopo's *Triumph* follows closely a text of Appian,[132] and may therefore have been intended for binding into a book of his work. Yet there is no evidence that this ever happened, and the size of the twelve-block woodcut by Bordon makes this possibility remote since, once folded, the print would have been several centimeters thick and a nightmare for the binder. The implication must be that the increasing size of some prints allowed them to stray from the path of the devotional image and become framed competitors of paintings; yet only a generation later, it was their even greater size that led them back to the same fate as that of their progenitors, namely, to be pasted directly to walls. Whether pasted directly to a wall or hung there after having been mounted on canvas, prints were being transformed from objects of devotion to objects of admiration.

The first engraving from three plates appeared, hardly surprisingly, in Venice, the work of a follower of Mantegna's, Girolamo Mocetto, who also produced a print on two sheets (H.V.163.6/7) and would contribute in 1514 a map in four plates for Ambrosius Leo's *De Nola Opusculum* (H.V.170.19/22). The fact that he left unfinished his *Battle between Israel and the Amalekites* (H.V.162.3/5) might well mean that the experiment with three plates did not work to his satisfaction. Although

devotional engravings and woodcuts had been produced from two vertically joined sheets on a few rare occasions during the fifteenth century,[133] it fell again to Mantegna to apply this concept to "artistic" prints. His collaboration with Giovanni Antonio da Brescia, the *Allegory of the Fall and Rescue of Humanity* (fig. 102),[134] was conceived in two vertical halves with a convenient space provided at the bottom of the upper sheet for pasting up the other half of the composition. Once the large-scale print had been given Mantegna's imprimatur, it was quickly imitated elsewhere in Italy. In Florence, Francesco Rosselli produced his largest and most impressively painting-like print, the *Assumption of the Virgin* (fig. 80), while Jacob of Strasbourg collaborated with Benedetto Bordon to make the highly finished and equally painting-like woodcut of the *Virgin and Child with St. Sebastian and St. Roch* (fig. 81),[135] which they both proudly signed with their names.

If it is indeed true that printmakers were beginning to compete with painters for the attention of a small and sophisticated market in late fifteenth-century Italy, we would expect to find similar tastes reflected in the subject matter of these prints. In a sample of more than 2,000 dated paintings from the period 1420 to 1539, Peter Burke has established that about 87 percent were of religious subjects.[136] If we apply this simple yardstick to Italian prints of the period between 1450 and 1500 listed in Hind's volumes, we find an unexpectedly different result. In the group of Florentine engravings including anonymous prints together with the work of Baccio Baldini and Francesco Rosselli (though excluding the book illustrations), only 65 percent are of religious subjects, and the percentage is almost the same when we survey the oeuvre of, say, Cristofano Robetta. This difference is even more significant if one keeps in mind that most of the 13 percent of secular paintings counted by Burke are portraits, a

genre that barely existed in printmaking at the time. These findings are confirmed if a count is made of the work produced by other schools in Italy: Mantegna himself made only eleven prints, eight of religious, three of profane subject matter, and among those produced under his influence in Mantua the majority (60 percent) were secular. This is the same ratio we find in the oeuvres of two other leading printmakers of the time, Nicoletto da Modena and Jacopo de' Barbari. In fact, the closer we come to the end of the century, the greater the number of secular prints being made in Italy. Artists like Nicoletto, who presumably had to make a living out of his printed works, or like de' Barbari, who mainly expressed a more public appeal through prints, devoted the majority of their engravings to historical, mythological, or allegorical subjects. In the light of this, it is not surprising that most of the larger works composed of two or more plates or blocks, by definition made for public consumption, were of secular subject matter.

In the cross-section of Italian printmaking around 1470, we recognize the beginnings of an interest in larger prints — as opposed to nielli — that are evolving from relatively coarse objects, produced by craftsmen for practical purposes, to increasingly sophisticated images, some with real artistic ambitions. Thus, for instance, Florentine images related to love and marriage grew eventually from the so-called Otto prints of the 1460s — often crude decorations for lids of boxes (*scatoline d'amore*)[137] presumably given away as presents to wedding guests — to complex allegories such as those engraved by Robetta. As aesthetic ambition and the complexity of the visual message increased, so did the demands being made on the viewer. While the Otto print required only a recognition of some straightforward symbols of fidelity and the matrimonial bond, Robetta's prints presupposed a more refined interpretation of spiritual and carnal

80. Francesco Rosselli, *Assumption of the Virgin*. Engraving from two plates (H.I.141.B.III.10), 826 × 560 mm. British Museum, London.

81. Benedetto Bordon and Jacob of Strasbourg, *Virgin and Child with St. Sebastian and St. Roch*. Woodcut, 542 × 397 mm. British Museum, London.

love, informed by a symbolic vocabulary often derived from classical sources.[138] Therefore, while most of the secular subjects produced in Italian prints before ca. 1470 were calendars, pattern-sheets, or depictions of unusual animals or natural portents, after that date their subject matter became increasingly distant from everyday life and slowly evolved an obsessive attention to the heroes, tales, and allegories of the classical world. It is important that this evolution was gradual. Myths and allegories such as the *Planets* and the *Triumphs*[139] had appeared before 1470, and calendars continued to be made alongside depictions of events from the lives of Hercules or Apollo. Yet, as more and more goldsmiths, miniaturists, and painters became involved in printmaking, the formal quality of prints

made in Florence, Bologna, Mantua, Venice, and Milan also improved, and calendars and pattern-sheets were increasingly relegated to the lesser printmakers. Thus a more definite distinction began to emerge between artists and craftsmen, and, consequently, between the customers who were buying their products.

What was the audience for those prints aimed so obviously at the top end of the market? Who was it that delighted in unraveling the complexities of the allusions hidden in Mantegna's *Battle of Sea Gods*, in Giovanni Antonio da Brescia's *Allegory of the Fall and Rescue of Humanity*, in Robetta's *Allegory of the Power of Love*, or in Mocetto's *Metamorphosis of Amymone*, with its fantastic lettering, maybe in Latin, maybe in Greek, maybe in both? Who were the buyers who enjoyed decorating their walls and filling their albums and drawers with images of satyrs, tritons, and nymphs, with depictions of the Labors of Hercules, the more pleasurable adventures of Leda, or with straightforwardly erotic subjects? To find an answer we must look more closely at the documentary evidence relating to the printmakers' milieu, to the people they worked with and their clientele, to their status in society and, ultimately, to their own attitude towards their prints. By these means we can attempt to establish whether early Italian printmakers looked at their prints as the works of a craftsman for the use of other craftsmen or as the expressions of an artist for the delight of the learned.

THE MARKET

There is little record of fifteenth-century print ownership in Italy. We know of only two surviving groupings of prints from that period, those in the Biblioteca Classense of Ravenna and in the Saray Museum in Istanbul. As we shall see, for intrinsic reasons these two "collections" are not likely to throw light on the taste for secular prints in the latter two decades of the century. That they survive at all may well be due to the fact that each was conserved in an inaccessible library located in a peripheral center. This in itself will be of interest when we look for reasons to explain the disappearance of other contemporary accumulations of prints.

A group of forty-six woodcuts, four engravings, and one dotted print are pasted into a collection of papers now in the Biblioteca Classense in Ravenna; to this should be added two woodcuts in the Biblioteca Oliveriana in Pesaro. The group was assembled by Jacobus de Ruberiis, an undistinguished notary who was born in Parma around 1430. Rubieri, as he was called out of court, studied at Ferrara, worked for ten years in Rome, was sent to Dalmatia around 1470, moved to Padua a year later, and finally settled in Venice in 1478 and there made his will in 1487.[140] From his own notes he appears to have been a narrow-minded bigot, as fearful of women as he was of the devil — at times confusing the two — and consistently envious of the successes of his better, and richer, colleagues.

Rubieri used the prints he acquired to adorn a mixed collation of juridical notes, mostly put together in the latter part of his life, and of which only five volumes divided in seven tomes have survived, although more must have existed, since he refers to others in his writings. Most of the prints were removed from the pages in 1938 in a destructive "conservation program"; only two pages decorated with prints — the ones in Pesaro — have survived intact. From these, and from an incomplete set of photographs taken before "restoration," we can form an idea of what the original Rubieri albums looked like. It appears that he used these prints, mainly woodcuts, to enliven the pages of his causidical notes by pasting them onto the blank pages in between sections of text, although in most cases there was no meaningful relationship between the two. The only certain exception seems to be the case of a woodcut of the *Martyrdom of S. Simonino da Trento* which was used as a frontispiece to a section treating torture. On a few occasions Rubieri drew his own images to accompany his text (and in one case imitated a woodcut in pen and brush that fooled even Schreiber!). Rubieri enjoyed embellishing the prints by surrounding them with borders usually made of a light-colored wash background pitted with pen-drawn stars and dots (figs. 82, 83), and he even felt free to silhouette most of his prints either with scissors or by choosing one

part of the composition, normally the main figure, and then covering the remainder with a thick layer of black ink. It has been suggested that this severe disfiguration was probably not his doing, though the argument is unconvincing.[141]

Rubieri's unusual treatment of his prints extended on occasion to excising such crucial figures as the Virgin and St. John in a *Last Judgment*. In addition, when he was tired of an image, or when he had acquired a better one, he pasted the new print on top of the old and blackened out whatever part had remained uncovered in the process. Sometimes he did this twice, so that three layers of prints have been found by restorers! Interestingly, there is one example of a dotted print in his collection, a German *St. Roch* (fig. 85), and the fact that it was pasted on the inside front cover of one of the volumes, that it is well preserved with its full margins, and that it was not disfigured, may mean that he prized it more highly than his other prints, possibly because he had paid a higher price for it.

With the exception of one cut-out fragment of a ship, all the images collected by Rubieri are of religious subject matter. Most are single images of saints and are generally of mediocre quality, the kind of print one would expect to be sold at shrines or by peddlers at markets and fairs. What appears to have escaped the attention of scholars is that there is practically no duplication of subject matter among the images.[142] As we have mentioned, Rubieri traveled almost incessantly throughout his life, and we know from his notes that he was a pious man. This assemblage of prints may therefore represent a record of the shrines and places of pilgrimage he visited, or it may reflect a conscious effort to compile a rich variety of images.[143]

Rubieri appears to have been a somewhat eccentric man, driven by a passion for acquiring images as souvenirs of the salient points of his pious life. There is no evidence that Rubieri treated his prints as precious objects, let alone as important works of art, with the possible exception of the dotted print. But then he probably paid a pittance for most of them, or indeed was given them as presents at the small shrines along the Dalmatian coast that he visited in his capacity as a magistrate from Rome. Rubieri's case is interesting for us specifically because he was not a learned humanist or a prince, as it demonstrates that an assembly of prints, albeit of an idiosyncratic kind, was put together in fifteenth-century Italy by a representative of the middle classes.

The collection of fifteenth-century Italian prints now in Istanbul is kept in the Saray Museum. It is made up of sixteen sheets, the fifteen engravings described in detail by Hind; he omits discussion of the *Ornamental Scroll*, probably on account of its pornographic subject (fig. 84).[144] Circumstantial evidence suggests that the collection was acquired

Following pages:

82. Anonymous Italian Artist, *Virgin and Child*. Woodcut on a manuscript page, 156 × 125 mm. Biblioteca Oliveriana, Pesaro.

83. Anonymous Italian Artist, *St. Christopher*. Woodcut on a manuscript page, 195 × 65 mm. Biblioteca Oliveriana, Pesaro.

periculuz obmissionis . Lxxx . dist . penitetes . h . guil . y . mon .
Laud . ubi . supra

Ut . Ille . q . obmisit dice horas cano. ex Impe. vel aliá rã
Legitima cessate ille teneat z sibi muing debeat ut ipsas hor
ras obmissas recitet solu. dicendum . Oz si tanta fuit Infir
mitas uel Impe. oz ex toto fuit Impedit dice. p osequens
fuit excusate. A dicendo non tenet redice post qenie
fuit liberat addi. y. deu no reã. Addudica tamen ad
cautella h pare uellit come band est sm hostien. o. ay. i no.
y celeb. missa. z. i. z. glo. ult. Obligao eniz se no
remisit. xxij. q. iij. si illic. z y. opera dist. aut clemen
z y. dispa. z y. hijs omnibz . s. z k. i es.

Explicit tractat. z s z horis dicendis opillata. p Grellmuz dorct.
doctores. d. petz. y l und. q. postea fuit asupto ad odi malat
p d. 55 om pp z xi y x o d 1375. in messe oreby fuit poste elle
to z asupto in pp z nominatg benedictz xiij.

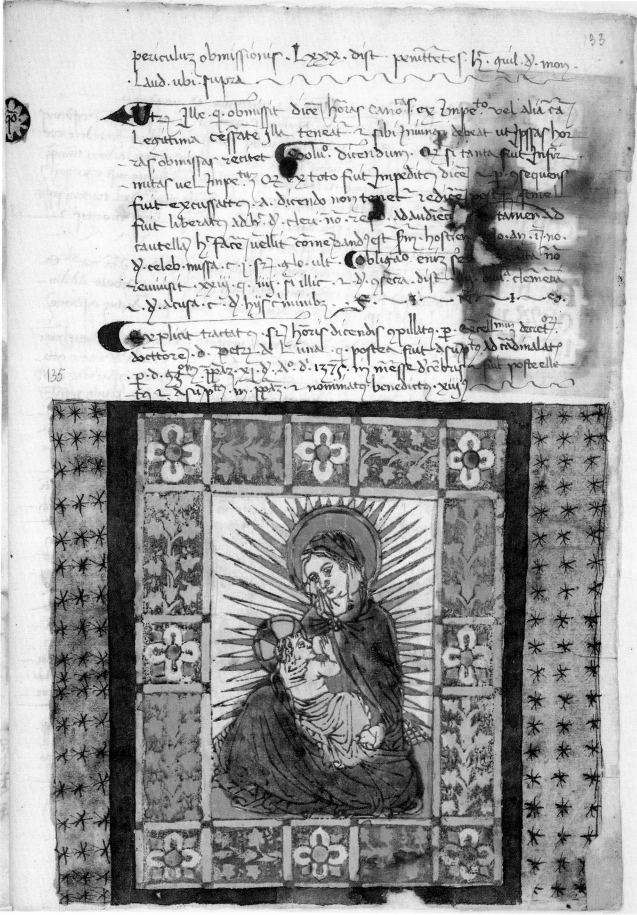

non tede
deat te le
gere q̃c
utilisim̃

Tractatus. clar̄mi utriq̄; iur̄ doctor̄
d̄. Anḡ. de perigl̄is. de perusia. in
m̃a. Societatu̅. et sociae̅ a ia̅lu̅ ꝯti
ꝯtinet. m̃ se omnes
caus seu as ꝯ Jnfra
scriptos uid e licet.

A nimalia reaipiendo ad melio
zandu̅ transfert dom̃ium.
Et non est societas sz ꝯtracty
Jnnom̃inatue.

A nimalib; datis ad ꝯho pare
du̅ et Jmpingnandum qu
om̃o debet fructy ex eis nacty pa
rtiri;.

A nimalib; datis extimatis ut
ꝯmodu̅ z Jncomodu̅ sit
reaipietis Cu̅ ꝯtracty resultet
et q̃ uid dampni illi poterie possit

A nimalib; ꝯcessis Rustico..
neꝗ; appareat quom̃o con
ꝯessa sunt in dubio. Cui ꝯtrac
tus ꝯsebitur. Et q̃ uid Juris
erit. Et de qⁱd recturendu̅.

A nimalib; Custodia tradd
ta sine societate et non
transluro dom̃io sz aliq̃ dato uel
recepto Q̃ uid Juris habeit.

L ucrum et dampnum pro
quibus partib; diuidi deb
ant si uterq̄; sociu̅ m̃ixtim ponit
pecunia̅ z ꝯpam Sz un̅s
maiore̅ quãtitate̅ pecunie
q̃ alter.

 S OCIETAS on̅ ꝯt
rahit ad

aliq̃ mechan̅as uel Arte̅

by or for the Sultan Mehmed II (1431–1481), but the details of its acquisition are unclear. Relations between Florence and Istanbul were extremely close in the 1460s and 1470s, both politically and commercially, with more than fifty Florentine firms established in Turkey,[145] and the Sultan was in contact with many leading Florentine families living in the Italian community of Pera. Because most of the prints in the group are Florentine, it is probable that they came to Mehmed through a resident of Florence, or perhaps through someone who visited there. Many names have been put forward in this connection, such as the geographer Francesco Berlinghieri, who dedicated his *Geographia* of ca. 1481 to Mehmed,[146] or Niccolò Ardinghelli, who presented the Sultan with a copy of Leonardo Aretino's commentary on the first book of Polybius's *History of the Punic Wars*.[147] Other suggestions have included such disparate characters as Gentile Bellini, who visited the Turkish court in 1479–80; Antonio di Bernardo de' Medici, who also went there in 1479 following the Pazzi conspiracy; or even Francesco Rosselli, who might have gone there, at the time of his travels to Hungary (1481–82), when he engraved a *View of Istanbul* recorded in the Rosselli inventory. It is highly unlikely that the prints could have been a diplomatic gift to the Sultan, including as they do not only five images of Christian subjects but one item of blatant pornography. Furthermore, among them is an improbable, fanciful portrait of the Sultan himself, lettered "El Gran Turco," a name by which he was known in Italy (fig. 86).

More likely the prints constituted the collection of a Florentine resident of Pera and were acquired by Mehmed himself, who might have been shown them by their owner.[148] The variety of subjects suggests a privately made album: it comprises

an idiosyncratic mixture of religious images — including two representations of St. Sebastian as a protection against the plague, mythological and allegorical subjects such as *Hercules and the Hydra* and two versions of *Cupids at the Vintage*, images of popular lore for the enjoyment of the whole family such as the *Combat Between Women and Devils* or the *Monkeys and the Peddler*, and, finally, the scroll occupied by putti and penises for the merriment of adult guests at a dinner in Pera.

This collection is more secular, varied, and open-minded than the group of prints assembled by the notary Rubieri, and it better corresponds to what we imagine might have been the taste of a Florentine trader. Eleven of the fifteen prints are Florentine, in the Fine Manner, and five are Ferrarese, one probably a copy of a Florentine prototype;[149] what is quite unexpected is that most of the Florentine prints are printed in a similar greyish ink, most of them with unusually generous margins around their platemark. Some are printed on brownish paper, and many show traces of hand-coloring. These characteristics suggest that they may all have come from the same workshop in Florence. This could well be the workshop to which the so-called Master of the Vienna Passion belonged, since so many of the prints ascribed to him share some or all of these features.[150] Nine of the fifteen prints in Istanbul are unique; five of the remaining six are known in only one other impression. All share most or all the features of the Florentine workshop group. It would thus appear that the person who assembled this collection must have been close to an important Florentine workshop, for he probably acquired most if not all the Fine Manner engravings from it. The source for the five Ferrarese prints is more difficult to establish, but it is likely that they also come from the Florentine connection.[151]

A very probable candidate for the compiler of the Saray group is Benedetto Dei, who arrived in Istanbul in 1460 and resided there for seven years.[152] Dei was a prominent figure in the local Florentine community and a close and trusted friend of the Sultan, whom he accompanied during the Bosnian campaign of 1463 and who sent him as special envoy to the Mamluck Sultan in 1466.[153] The connection between Benedetto and the world of Florentine printmaking is as close as one could hope: the Dei family was one of the most prominent dynasties of goldsmiths in that city, and Benedetto's uncle Matteo was, along with Maso Finiguerra and Antonio Pollaiuolo, one of the most distinguished niello engravers of the fifteenth century. Furthermore, Miliano Dei, Benedetto's twin brother, shared with Antonio Pollaiuolo and Betto Betti one of the most important commissions of the time: a reliquary for the fragment of the True Cross in the Baptistry of the Duomo. These relationships suggest the intriguing possibility of a connection

84. Anonymous Artist, *Ornamental Scroll with Putti and Penises*. Pen and ink. Saray Museum, Istanbul.

between the Master of the Vienna Passion and the Dei family.

The Ravenna and Istanbul albums, having been conserved in peripheral centers, were more likely to be left alone. And in addition to these, one should mention the Abbey of Mondsee, in the Salzkammergut, where a corpus of the prints by the so-called Master of St. Wolfgang has survived undisturbed over the centuries.[154] But there are other instances where groups of prints were likely to have been kept together because of their origin in a single workshop, for example the so-called Otto prints, which were acquired in a single purchase in Florence by the diplomat and collector Baron Philippe de Stosch between 1731 and 1757.[155] Similar homogeneous groupings of prints, probably from a single workshop, include those by the Master of the Playing Cards and by the Housebook Master. Practically the entire oeuvre of the former has survived in single impressions, now divided between the Louvre and Dresden, possibly split up in the seventeenth century.[156] Similarly, the drypoints by the Housebook Master have come down to us together and mostly in single impressions.[157] There is no proof that either album of prints was compiled by the Italian workshop rather than, for instance, by a patron, yet the fact that in both cases some are spotted with paint or show signs of repeated handling suggests that the former may indeed be the case.

It is, on the other hand, possible that the two groups of prints passed during the fifteenth century to the workshop of other artists where they were used as models. This would not be at all surprising, since it is certain that artists, including printmakers, were among the earliest to accumulate prints in a concerted and systematic way. Condivi, for instance, relates that Michelangelo copied an impression of Schongauer's *Tribulations of St. Anthony* when training in Ghirlandaio's workshop,[158] and we know that contemporary German prints were copied and imitated throughout the peninsula, and that even German copper plates traveled south of the Alps.[159] For quite some time during the middle of the century, painters had attempted to keep the production and sale of prints under their control, at least in Venice and Padua. In this area of northeast Italy there seem to have been at least two waves of fashion for prints, in the early 1440s and in the early 1460s, both leading local authorities to legislate against the commerce of prints outside the control of the painters' guilds (see p. 8).

Other groups of fifteenth-century prints have come down to us in various kinds of association or relation to one another. The set of Fine Manner Sybils now in the British Museum was removed from a copy of Philippus de Barberiis's *Opuscula* (*Dicta Sybillarum*) of 1481; another set was used to decorate a treatise on the subject by Giovanni Filippo dal Legname.[160] A group of six devotional engravings, probably German, are stuck to the pages of a fifteenth-century Italian manuscript in the Biblioteca Riccardiana, Florence,[161] while five engravings by Jacopo de' Barbari were pasted to the leaves of Hartmann Schedel's *Liber antiquitatum*, a manuscript that was bound in 1504.[162] The fact that Schedel provided each engraving with a drawn border and left a space around each so that it would relate aesthetically to his text on each page, makes this small group of prints come the closest yet to a collection.

It is not surprising that prints were so often associated with manuscripts or books.[163] One of their main functions in the fifteenth century was indeed as cheap substitutes for book illustrations, and we have seen how closely illuminators were engaged in printmaking at the time.[164] The reverse was also true; it is known that Francesco Rosselli was involved with his brother Cosimo, Attavante, and others in painting the miniatures that adorned the two volumes of the Bible which Vespasiano da Bisticci brought with him to Urbino in 1482. Federigo da Montefeltro's library was, according to Vespasiano, one of the greatest in the world, and the ruler was proud not to have succumbed yet to the dreadful custom of buying printed rather than handmade books. He was not alone among bibliophiles of his time. Similar preferences can be found in less exalted households: in 1487 the library of Antonio Benivieni, the most famous Florentine physician of the century, comprised 169 books, of which only one, a Virgil, was printed.[165] The most compelling evidence is offered by the case of Sweynheim and Pannartz, two Germans who brought printing to Italy in 1465 and went bankrupt in 1471 simply because there was not yet a market for their editions of the Latin classics.[166] Only during the last decade of the century were illustrated printed books to succeed in supplanting their manuscript predecessors. This was particularly true in Florence under the aegis of Girolamo Savonarola, who succeeded in attracting some of the best artists of the time to provide illustrations for his printed pamphlets. Botticelli, Filippino Lippi, Fra Bartolommeo were only some of those who are said to have collaborated with the preacher,[167] and his influence on printmaking was similarly evident in the engraved work of Francesco Rosselli, who sold his house so that the Dominicans could build a convent in its place.[168]

Vespasiano himself, probably the leading *libraio* (bookseller) of his generation, retired soon enough not to have to bother with printed books, let alone prints; but it is likely that his younger colleagues together with the *cartolai* (stationers) had been dealing in both for some time. A curious connection between a book dealer and the collection in Urbino is provided by two manuscripts now in the Biblioteca Vaticana, but originally from the

96

EL GRAN TVR

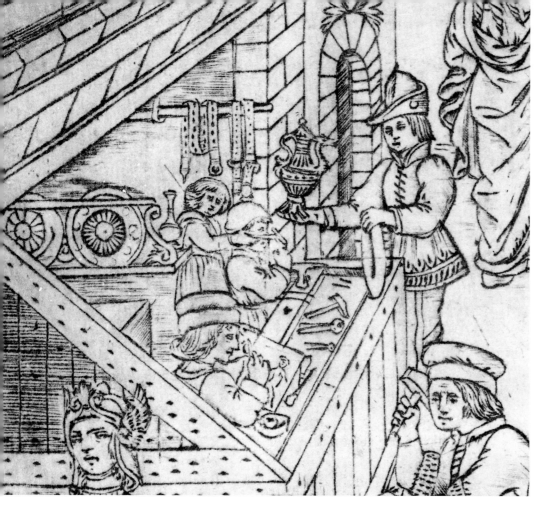

MERCVRIO E PIANETO MASCHVLINO POSTO NELSECONDO CIELO ET PECHO MAPERCHE IA
ZVA SICITA EMOLTO PASSIVA LVI EFREDO CONGVEGLI ZENGNI CH ZONO FREDDI EVMIDO COG
LI VMIDI E LOQVENTE INGENGHIOZO AMA LESCIENTIE MATEMATICA EZTIVDIA NELLE DIVI
HAEDINE A ILCORPO GRACILE COS ECHIET TO ELSEI ZO TTILI ETATVRA CHIGNIVTA DE
METALLI A LARGIENTO VIVO ELDI EVO E MERCOLEDI COLLA PRIMA ORA IP IZ EZZ
LANOTTE ZVA EDELDI DELLADOMENICHA A PERAMICO IZZOLE PER NIMICO AVENE
RE LAZVA VTROVERO EZALTATIONE EVIROO LASV MORTE OVERO NVMMILAEIONE
E PRICE HA HABITASIONE GEMNI DIDI VIRGO PINOTTE VA E IZ ZENGNI IN ZE
DI COMINCIAN DA-I VIRGO IN ZO DI E Z ORE VA VN ZENGNO ☞

87. Baccio Baldini, *Mercury* (detail).

88. Baccio Baldini, *Mercury*. Engraving (H.I.82.A.III.6.a.I), 324 × 220 mm. British Museum, London.

Montefeltro library. They are both of a poem by Ludovico Lazzarelli entitled *De imaginibus gentilium Deorum* and are illustrated with drawn copies of the so-called *Tarocchi* engravings. According to Lazzarelli's nephew, the author had been inspired to compose his poem on the "Images of the Pagan Gods" after acquiring a set of the prints from a bookseller's shop (*bottega di librajo*) in Venice. Since one of the two manuscripts was originally dedicated to Duke Borso d'Este da Ferrara — he was duke there for only a few months during 1471 — this document provides not only a terminus ante quem for the completion of the manuscript and of the *Tarocchi* series, but also a convenient proof that prints were sold by book dealers at that date.[169] There are, moreover, at least four sets of the *Tarocchi* bound in volumes that appear to have been put together in the fifteenth century.[170]

The bookshop was not, however, the most common channel for the distribution of Italian prints in the late fifteenth century. Much more likely, the printmakers — independent artists and craftsmen as they were — sold most of their work directly, or used the services of colporteurs. In the famous Fine Manner print of the *Children of Mercury* an engraver is shown at work on a plate in the *bottega* of a goldsmith in Florence (figs. 87, 88), and it is likely that the printmakers of the generation and background of Maso Finiguerra and Antonio Pollaiuolo would have conducted their trade in

prints from similarly accessible workshops. But they had come to engraving through metalwork, and the *bottega* existed long before they started using the burin. Although there were as many as forty-four gold and silversmiths' workshops in the late 1470s in Florence,[171] it is unlikely that many would have been involved in such a specialist activity as niello- and printmaking. No other evidence survives concerning this side of printmakers' lives, but we can at least attempt to reconstruct the milieu in which they lived, the people they knew and with whom they shared their interests outside printmaking, and to whom they may have tried to sell their prints. It is unlikely that in a small town like Florence or Venice the market would have extended much beyond the engravers' own immediate circle of acquaintances. A short survey will show that it was among the more advanced and learned ranks of humanists, philosophers, artists, and inspired patrons that the printmakers of this period found their friends, and that their printmaking was celebrated time and again in poetry and prose. It is more than likely that those who praised printmakers as artists were the same as those who bought their work.

In his *Trattato dell'architettura*, written between 1457 and 1464, Filarete lists Maso Finiguerra and Antonio Pollaiuolo among the best goldsmiths in Italy, but it is interesting that of the former he adds that "he engraved beautifully in the niello

technique" (intagliava a niello bellissimo). Maso's fame continued to grow among fifteenth-century collectors long after his death in 1464, and as late as 1487 he was held up as a paragon to the goldsmith and printmaker Francesco Francia. In his *Epitalamii pro nuptiali pompa...Anibalis... Bentivoli...* of 1487, the poet A. M. Salimbeni wrote:

> But among the goldsmiths I shall mention
> Francia, whom I cannot omit for any reason,
> Polygnotus he surpasses with his brush
> And Phidias in his making of sculpture,
> And he acquired so much fame with his burin
> To eclipse even that of Maso Finiguerra,
> And I compare him even to the dead,
> So that those who live would not be envious.

> (Ma fra gli orafi io diro il Franza
> Che io non lo scio lasciar per maggior cura,
> Lui Polygnoti con il pennello avanza
> E Phidia all'operar della sculptura,
> E col bullino ha tanta nominanza
> Che la sua a Maso Finiguerra oscura,
> A costui fo comparation di morti
> Perche chi vive invidia al ver non porti.)[172]

This is not the only mention of Francia in the Bolognese literature of the time. In 1502 Lunardi praised him for being able to produce such complex images on such small plates.

Recent research has further revealed how close the connections were between printmakers and humanists in Bologna.[173] The University and the enlightened rule of the Bentivoglio family, particularly of Giovanni II, combined to make the city a leading center for humanists in the last twenty years of the fifteenth century. Thinkers such as Giovanni Battista Pio, Filippo Beroaldo, and Codro, poets such as Salimbeni and Giovanni Filoteo Achillini mingled daily with artists like Francesco Francia, Amico Aspertini, and Marcantonio Raimondi. Their closeness is documented by their continuous exchange of words and images: Francia made a portrait of Codro and of his biographer, Bartolomeo Brandini; Aspertini made a portrait of Achillini, and the latter responded by writing in praise of the best artists living in Bologna at the time, telling of Aspertini's passion for recording inscriptions and sculpture found in Roman grottoes, and for investing his great knowledge in these matters in his beautiful paintings.[174] Achillini also wrote about Marcantonio:

> I also consecrate Marcantonio Raimondi,
> who follows in the footsteps of the masters of
> antiquity,
> and who is so skillful both in drawing and
> with the burin
> as is clear in the beautiful engraved plates
> he has made of me, as I'm writing, a portrait
> on copper,

> and I am now in doubt, which one is more
> alive.

> (Consacro anchor Marcantonio Raimondo
> che imita degli antiqui le sante orme
> col dissegno e bollin molto e' profondo
> come se vedon sue vaghe aeree forme
> Hamme retratto in rame come io scrivo
> Chen dubio di noi pendo qual e' vivo.)[175]

The engraving Achillini refers to is one of Marcantonio's most successful works before his departure from Bologna (fig. 89) and shows the poet singing his verses and accompanying himself on a stringed instrument. It is emblematic of the refined circle of literati of which Marcantonio and the engravers of his generation were an important part. While the members of the "Studio" (University) pursued their three expressed goals — to collect inscriptions from antiquity, to re-read and analyze classical texts, and to formulate new allegorical interpretations of classical myths — the artists contributed by recording the recently unearthed examples of Roman statuary, by imitating and emulating them in their paintings, drawings, and prints, and finally by giving visual form to the allegories devised by their colleagues and friends. It cannot be a coincidence that practically all of the earliest prints by Marcantonio depict obscure allegories or conceits of one sort or another, and that the exact meaning of most such representations now escapes our comprehension. Their message was probably clear to no more than a few dozen Bolognese at the time, and it is surely for their use and pleasure that these engravings were made.

There is plenty of evidence that a humanistic fervor gripped many of the Bolognese intelligentsia in the 1480s and 1490s. Lawyers, notaries, and physicians competed with philosophers, artists, and musicians in acquiring a new Roman coin, a medal, a cameo, or a bronze, ivory, or marble sculpture that might appear on the market. Bologna was full of art collections, and Angelo Poliziano and Pico della Mirandola stopped there to see them in 1491 on their way to Venice in search of rare codices for the library of Lorenzo de' Medici.[176] Giovanni Filoteo Achillini was a well-known collector himself, and it is not unlikely that he included Marcantonio's engraved portrait of himself among his treasures, together with some of the niello prints by his other friends Francesco Francia and Peregrino da Cesena, which could well have served him as cheaper substitutes for expensive bronze plaquettes.[177]

Were Bolognese printmakers an exception? The few documents we have confirm that the status of printmakers elsewhere in Italy was very similar to what we have seen in Bologna. In Rome, Giovanni Battista Palumba's engravings of *Leda and the Swan* (fig. 90) and *Venus and Cupid* were praised in two Latin epigrams by the humanist Evangelista

89. Marcantonio
Raimondi, *Portrait
of Giovanni Filoteo
Achillini*. Engraving
(B.XIV.349.469),
183 × 134 mm. British
Museum, London.

quotations from Vitruvius, Aristotle, Pliny, and Alberti.[179] Jacopo's erudition has its counterpart in the classical subject matter of many of his prints, including the tendency to make concealed references — for example the introduction of a joke into one of his prints, a small *remarque* of a face engraved with tiny dots that can be seen in early impressions of his *Satyr Playing the Fiddle* (H.19). This must have been understood by initiates as a response to a similar face hiding in the rockery of Mantegna's *Descent into Limbo* (H.9).[180] Such a taste for esoterica points to a sophisticated circle of cognoscenti for whom prints of this type must have been intended.

The case of Giulio Campagnola is clearer still. He was the son of a man of letters, who encouraged him to pursue his artistic career and helped him to join the courts of Mantua and then Ferrara through his network of humanist friends. Giulio was exceptionally gifted, and in his early teens was described as having already mastered painting, illumination, engraving, sculpture, and the cutting of gems, and indeed as destined to challenge the supremacy of both Mantegna and Bellini. He was also said to be a good poet, a singer, a player of the lute and cithern, and he spoke and read Latin, Greek, and Hebrew as if he had absorbed these languages with his milk in the cradle.[181] With such a background, it is unlikely that once settled in Venice Giulio would have ceased to move among the exalted circle of humanists and painters as he was accustomed to do. His natural talent, his social and academic skills, his probable collaboration with Mantegna and later with Giorgione and Titian, must have made him a notable figure among the Venetian intelligentsia who offered a ready audience for his small, highly refined, and erudite prints.

Mantegna was undoubtedly revered as the greatest painter of his time — *pictor incomparabilis*, as Felice Feliciano put it. He moved in the highest circles of society; he discussed the meaning and significance of Latin inscriptions with the most learned humanists of the era. In his immense verse chronicle Giovanni Santi, Raphael's father, listed the best contemporary artists, and he dedicated by far the greatest number of lines to Mantegna, reminding us that he was advanced to knightly rank solely because of his genius as a painter.[182] It is inconceivable that his contemporaries would have judged Mantegna's prints a lesser form of artistic expression than his paintings or drawings. The care with which the artist prepared each print is evident from the number of surviving drawings connected with the engravings,[183] and this in itself suggests the importance Mantegna attributed to his prints. Moreover, his patrons demonstrably treated prints with the same respect they conferred on any other work of art by the master.

The care taken in the preparation of prints finds a match in the care with which prints were handled

Maddaleni dei Capodiferro.[178] Palumba, whom Capodiferro referred to as "Dares," was within the milieu of the Accademia Romana headed by Cardinal Riario and the humanist Pomponio Leto. During these same years other artists such as Amico Aspertini and Jacopo Ripanda were associated with the Accademia. Ripanda, who had become famous for his painstaking copies of the reliefs of Trajan's Column, made while hanging precariously from its top, was to collaborate with Marcantonio on what was probably one of his first engravings done in Rome, the *Triumph* (fig. 111). From Venice we have the example of Jacopo de' Barbari. Though little is known about his life there before he left in 1500, nor about his circle of friends, it is clear that he was sufficiently learned and sophisticated to write a long letter to Frederick of Saxony on the subject of the excellence of painting, and that this letter was dense with learned allusions and hidden

in certain circles. In 1491 Mantegna wrote to the Marquis Francesco reminding him of some promises he had made when the artist had given him what is described only as a *quadretino*, or small picture. A second document reveals that the Marquis had decided to make a gift of this *quadretino* to somebody in Milan — possibly to Gian Galeazzo Sforza, with whom he was in close contact at the time. Francesco had instructed Silvestro Calandra to take care of this, and Silvestro confirmed that he had had a *guaina* made (a soft cover, probably of leather) and had provided it with a ring so that the courier could carry the picture without it being damaged ("chel non se guasti"). A third document, a letter from Mantegna to the Marquis of a few days later, comes as something of a surprise. Mantegna writes that, having "heard that Your Excellency has donated the small picture to Milan, I am sending you another as I have the plates to make others . . ." (inteso che la Ex. V. ha donato el quadretino a Milano, Jo uene mando un altro rimanendomi pero le stampe da farne de li altri . . .).[184]

This correspondence obviously refers to a print, and it is particularly revealing of the perception of certain prints within elite circles towards the end of the fifteenth century. It shows, first of all, that one of the most esteemed artists of the time was happy to donate a print to his patron. Further, he thought enough of it to mention the gift in a letter mainly devoted to an important and entirely different matter. For his part, the Marquis had been pleased enough with the print to give it in turn to someone else and to ask his Minister to deal with it personally. Calandra treated the print with obvious care, clearly aware of its fragility, and, moreover, thought the charge important enough to report on it in writing. The fact that Mantegna then wrote again to his patron explaining that he had the plate and would therefore let him have another impression, suggests that the Marquis understood something about printmaking and would not be surprised at receiving a second picture identical to the one he had just given away. Furthermore, this case is not unique: an inventory of the *guardaroba* of the Este family, made in 1494, lists a small box with plates (?) for prints inside ("una capsetina cum stampe de charte dentro"), another indication that prints were owned by ruling families and kept by them with some care.[185]

It is obvious from the few documents mentioned that printmaking was not considered a lowly craft during the last twenty years of the fifteenth century in Italy, and that its important practitioners were not mere artisans. We have found no reference to prints before Vasari's time that indicates they were qualitatively valued any lower than drawings or paintings among Italian artists and patrons. Many artists tried their hand at making prints, some possibly only once, like Pollaiuolo and Lorenzo Costa, some on a large

scale, like Francesco Francia, Benedetto Montagna, and Girolamo Mocetto. Late fifteenth-century Italy was buzzing with *peintre-graveurs*.

The pride taken in their work by this generation of printmakers cannot be demonstrated more plainly than by the prominence they gave to their own signatures. Antonio Pollaiuolo introduced the signature to Italian engraving in his *Battle of the Nudes*, signing it prominently in an ansate tablet: OPUS ANTONII POLLAIOLI FLORENTINI, a wording that recalls the inscription by Piero della Francesca on his *Flagellation* in Urbino: OPUS PETRI DEBURGO SANCTI SEPVLCRI. Pollaiuolo might have decided to engrave and sign his *Battle* as a proprietary response to the appearance of another *Battle* made by a Paduan engraver using part of one of his drawings;[186] whatever the reasons for putting it there, his signature was the statement of an artist proud of his work. The addition of the word *Florentini*, moreover, implies that he expected the print to

90. Giovanni Battista Palumba, *Leda and the Swan*. Engraving (H.V.257.9), 150 × 99 mm. Bibliothèque Nationale, Paris.

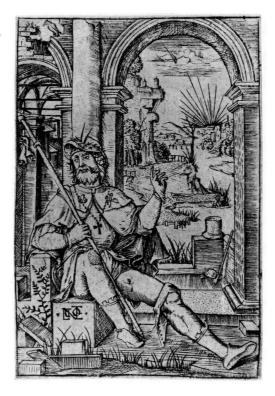

91. Nicoletto da Modena, *St. Roch*. Engraving (H.V.128.66), 97 × 69 mm. British Museum, London.

least twelve versions of his monogram, more and more frequently investing his signature with an aesthetic value of its own (fig. 91). His pride at being a successful engraver is revealed by his depiction of a burin next to his signature in one of his prints.[189] In Venice, Giulio Campagnola and Benedetto Montagna engraved their own names in the most prominent parts of compositions — for example in the midst of an empty sky — revealing a remarkable willingness to intrude upon an image for the sake of self-promotion.

In Italy it is symptomatic of the type of artist inclined to make prints, and of the type of collector likely to praise them, that private languages began to emerge within these private and privileged circles. By the turn of the century the subject matter of many contemporary prints had become obscure and esoteric. In similar gestures the printmakers themselves sometimes shrouded their identity in codes. Capodiferro's "Dares" (that is, Giovanni Battista Palumba) employed this pseudonym in poems written to his friend. Perhaps with similar intention he composed a rebus for the signature on his prints — his initials and a pigeon, a *palombo* (fig. 90).

Seen overall, the state of printmaking at the turn of the sixteenth century differed substantially north and south of the Alps. In both regions we can clearly detect a division emerging in the print market, a division of quality that must reflect a new order of clientele for replicated images. In northern Europe, however, this development occurred more or less in the mainstream tradition of religious art, along with a subordinate impulse from the modest humanism emerging in certain capitals of early German bookprinting. In Italy, however, the stimulus for the conversion of the print to a work of art began a good deal earlier and in much more closed circles. There the practice of making prints for a discreet and highly refined audience was apparently incubated in a courtly and academic milieu where unusually close relations between patrons and artists obtained. In this context it is not difficult to understand how, after Alberti, the more self-consciously literary understandings of art and its ancient tradition proved congenial to the possibilities and appeal of prints. Prints were especially suited to making exchanges, to establishing a mutual basis for critical response and appreciation. Moreover, they could best address the increasingly private and hermetic interests of classical humanist culture. In sum, this may be where the intimate associations that we now consider to be so characteristic of the print as an art object had their start.

show the quality of his achievements and to spread his fame far and wide, since everybody in Florence knew already that he was a local son. Evelina Borea has noted that, analogous to painting, there was no need to sign a print if it had been commissioned, the patron knowing full well who the author of the work was. Hence, it is safe to assume that most signed prints were independent endeavors.[187] This conclusion tallies with the fact that Mantegna, who lived all his mature life as the court painter of the Gonzaga family in Mantua, never signed a print — though a signature was scarcely needed, so characteristic was his style. The ansate tablet, however, became a kind of trademark for Mantegna's work, since he used it repeatedly in his paintings and engravings.

Most, if not all, the printmakers of Pollaiuolo's generation followed his example. Giovanni Antonio da Brescia was often content with using a monogram, though he changed it over the years from ZA (Zoan Antonio) to IA (Ioanne Antonio) and then to GAB (Giovanni Antonio Brixianus) to reflect the pronunciation of his name in the regions where he operated.[188] Robetta made sure his name was spelled out *in extenso*. Nicoletto da Modena betrayed an obsession with his signature, not unlike his northern contemporary Israhel van Meckenem: Nicoletto used thirteen different forms of it and at

IV

From Collaboration to Reproduction
in Italy

IT IS COMMONLY assumed that Raphael was the first artist to realize the potential of prints as a means to propagate his artistic fame, and that Marcantonio Raimondi, by agreeing to engrave prints after Raphael's works, became the first reproductive printmaker. There can be little doubt that Raphael and Marcantonio worked together, and that the prints the latter produced as a result of this collaboration were instrumental in spreading Raphael's designs across Italy and the rest of Europe. What is less obvious, however, is that the prints made by Marcantonio were meant to "reproduce" independent works of art by Raphael. This is indeed a misconception, transmitted to us over the last two centuries by those art historians, particularly print scholars, who happened to be working at times when originality was seen as a fundamental ingredient in assessing the quality of an independent work of art. In the light of the surviving evidence, there is a strong case to be made for placing the birth of the first consciously reproductive print in Italy some time after Marcantonio's death, in circumstances which were quite different from those informing his relationship with Raphael.

Early in the nineteenth century Bartsch chose to call his general catalogue of Old Master prints *Le peintre graveur*, so as to make absolutely clear that he was not overtly interested in "reproductive" prints, and he was thus forced to attach, for instance in the case of Marcantonio, an artist's name to each print that was not in his view the engraver's own creation. Early in this century, Franz Wickhoff dismissed Marcantonio's engravings as simply a kind of appendix to Raphael's genius — the equivalent of good photographs of great works of art — and Marcantonio's reputation as a mere reproductive engraver persisted.[1] It is only recently that this view has been challenged with some force.[2]

Significantly, the fallacy took root at a time when reproductive prints must have played a role similar to photographs in the mind of connoisseurs. From this perspective, Vasari was the Wickhoff of his time, and it is surely with Vasari that we find the origin of this attitude. In the first edition of the *Vite* of 1550, Vasari dedicated very little space to prints. They are mentioned here and there, almost always to prove the point that a particular drawing, painting, or fresco was so highly thought of that it deserved to be engraved. Perhaps as a consequence of a higher regard for prints in artistic circles around the middle of the century, or perhaps simply for the sake of completeness, Vasari decided to devote a whole chapter of his second edition of 1568 to prints. This he placed within his story of the life of Marcantonio Raimondi, in itself a symptomatic choice. There had been greater printmakers than Marcantonio before Vasari's time, but they were of less interest to him, since their prints were meant to be independent works of art. For Vasari the central role of the print was not to invent but to reproduce the *invenzione* and the *disegno* of another work of art. This attitude is not at all surprising in the middle of the century when Italy must have been flooded with reproductive prints, churned out in the thousands by enterprising Roman publishers such as Salamanca and Lafrery. The few prints being made by *peintre-graveurs*, however great their quality, could hardly compete in the perception of the market against the overwhelming quantity of contemporary reproductive prints.

Thus the whole history of printmaking according to Vasari found its natural place not in the Life of Mantegna, Giulio Campagnola, or Parmigianino, to name just some of the greatest *peintre-graveurs* before Vasari's time, but in the Life of the man who, in his view, had done most for prints, the man

who had transformed a craft into a proper and useful activity by inventing reproductive prints.[3]

When examining the surviving evidence about the rise of reproductive prints, it will soon become clear that this was not a sudden phenomenon. Nor were reproductive prints "invented" by any one artist at a specific time. Making careful copies of the works of the master was central to the formation of a craftsman, and pattern-books survive as the most obvious evidence of the encouragement given by established artists to their younger or distant colleagues to imitate their designs. Printmakers were no different in this respect.[4] They assimilated whatever was available, whether a figure in its entirety, a limb, a passage of drapery, or an element of landscape; on rare occasions before the late 1530s this might even be a whole composition. Never, however, did these artists copy with the explicit intent of "reproduction," but rather of "furthering a tradition ... to develop and refine treatments of subjects handed down to [them] and to pass them on in an improved form to posterity."[5] In this process, whereby each engraver contributed to current artistic developments, there occurred isolated cases in which a printmaker realized that a fellow artist might provide him not only with some assistance such as described above, but with a whole design that would actually be more advanced, fashionable, or pleasing than his own. A collaboration could ensue, in which both artist and printmaker contributed their respective skills to the creation of an independent work of art. A next step might entail a more mechanical relationship wherein the painter provided the engraver or woodcut maker with a finished design for him to follow closely, but without the painter's direct intervention. The real birth of the "reproductive" print did not come about, however, until the relationship between painter and printmaker became so tenuous that the printmaker felt entitled to copy a work of art that the painter had made for an entirely different purpose. This initially took the form of reproducing drawings, simply because of their similarity in size and in visual adaptability. Then, during the second quarter of the sixteenth century, printmakers succeeded in transforming the colors of paintings and frescoes into black and white and, at the same time, managed to reduce them in size to a scale that could be carried in a portfolio. In so doing they effectively abdicated their right to generate independent works of art, for the sake of emulating as closely as possible works by other artists in other media. It is only at this point that we can safely place the birth of reproductive engraving. This chapter will attempt to reconstruct this long gestation.

92. Bernardo Prevedari, *Interior of a Ruined Church, or Temple, with Figures.* Engraving (H.V.102.1), 705 × 513 mm. British Museum, London.

THE EARLY YEARS

The earliest document to raise the possibility of a print having been conceived as a reproduction is a contract dated 24 October 1481 between the painter Matteo de' Fedeli and the engraver Bernardo Prevedari.[6] The passage that bears most importantly on our considerations reads as follows:

The said Master Bernardo pledges to produce before next Christmas for Master Matteo one brass[7] plate[8] with buildings and figures following a drawing on paper made by Master Bramante da Urbino and to engrave the plate properly following the said drawing so that the plate would print the good work and the good figures; Master Bernardus pledges to work in the house of Master Matteo in order to make the plate and to work on it day and night according to custom from today until it is finished. Master Matteo pledges to give Master Bernardo for the said plate well made and done according to the drawing forty-eight *lire imperiali* ... Master Bernardus pledges to give Master Matteo the (?) ownership [patronum] or better the drawing by the said Master Bramante once the plate is finished for three *lire imperiali* which Master Matteo pledges to give Master Bernardo within the next fifteen days.[9]

The contract relates to one of the largest prints made during the fifteenth century, the *Interior of a Ruined Church, or Temple, with Figures*, as Hind called it, or the *Departure of St. Barnabas from Milan after Having Consecrated Anatalone as its Bishop*, as Mulazzani has more recently suggested.[10] Only two impressions survive of this print, one in the Raccolta Bertarelli in the Castello Sforzesco of Milan, the other in the British Museum (fig. 92). An examination of the print and of the physical characteristics of the two impressions in relation to the document is illuminating. The first rather striking discrepancy is the fact that the print is signed BRAMANTUS/S.FECIT/.IN MLO. No mention appears of the names of either Matteo de' Fedeli or Bernardo Prevedari. Moreover, the engraver has employed the term *fecit* which, at least later on in the history of printmaking, is meant to imply that Bramante actually engraved the plate himself rather than had it engraved by somebody else. The relationship between these three *maestri* is impossible to define with any certainty. On the face of it, it would appear as if Matteo, a painter by profession, owned a drawing by Bramante and gave it to Bernardo, who belonged to a family of goldsmiths,[11] to engrave a plate reproducing it. Although it has been suggested that Matteo de' Fedeli was in fact acting on behalf of more distinguished people who preferred not to appear, but who felt the issue was important enough to engage a notary,[12] we really have no evidence that either Bramante or anyone

105

93. Detail, showing the overlap between the two sheets of paper.

94. Detail, showing the striations on the surface of the print.

besides the two signatories of the contract was involved at all. The only certain fact is that the owner of the drawing — whether Matteo, Bramante, or somebody else — must have been sufficiently concerned about the way it was going to be handled to mention in the contract that Bernardo would receive three *lire imperiali* if he gave it back when the plate was finished. That the owner of the drawing was concerned about its destiny might have had something to do with the presumably destructive techniques possibly employed at the time for transferring a drawing to a plate. Unfortunately, in this instance there is no evidence to be gleaned from the two impressions about the technique chosen for the transfer. The drawing was probably not reversed in the operation, since the smith seen in the frieze at top right is using his right hand to hold the hammer, and we must assume, because of the specific clause in the contract, that the technique employed would not harm the drawing. Unless we accept that Bramante was so directly involved that he actually drew the image in reverse — and there is no evidence for such an assumption — then we must probably accept that Bernardo transferred the drawing onto the plate through the use of a tracing, or that this job was done by Matteo himself, though presumably such an important collaboration on the part of Matteo would have been referred to in the agreement.

Another very curious feature of the contract, when compared to the two extant impressions, is that there is no mention of the printing of the plate. An examination of the two prints reveals that this must have been an extraordinarily complicated matter. First of all, the size of the plate (about 705 × 520 mm) meant that there was no sufficiently large sheet of paper available: in both impressions the image is printed on two sheets of paper of royal size, the top one overlapping the bottom one by about a centimeter. The fact that this strip is in both impressions the best-printed area (fig. 93), and the fact that the striations produced in the printing and described below follow from one sheet to the other, leave no doubt that the two sheets were glued together before, rather than after, printing. Once the difficulty of a large enough sheet of paper had been resolved, the problem of printing from such a huge plate would have arisen. Even now, with a modern roller press, printing a plate of these dimensions is not easy; in Prevedari's time it must have been a nightmare. Again, the two impressions come to our rescue in clarifying what technique must have been followed. First of all, the strip where the two sheets overlap is, as mentioned above, printed much better than any other area: it is in fact the only well-printed area in both prints. This indicates some mechanical means of exerting pressure during the printing, for had the impressions been made with a hand roller, there would be no reason why in both cases the pressure would increase uniformly and only in those two small areas. The even pressure, just sufficient to print the image rather faintly, increased where the paper was of double thickness because the roller was fixed. The usual explanation, that this increase of pressure could easily be produced by the felt used during the printing, is contradicted by another very curious feature of both impressions: their vertical striations (fig. 94). These are very conspicuous on the recto of the British Museum impression as stripes of darker and lighter printing, and they appear on the verso of the one in Milan as white ridges indenting the entire print at a right angle to the very fine laid lines. It is quite obvious that these striations could

only have been produced by a roller, and that no felt was used between it and the paper. This roller, at least 520 mm wide, must have been made for the purpose, and was almost certainly turned on a lathe, the most likely explanation for such a clear pattern of striations. Whether it was a wooden or a metal roller is impossible to say, but the regularity of the lines suggests that it may well have been the latter. Prevedari came from a family of metal-workers, and could have had the roller made by one of his relatives.[13]

Even this brief analysis of the technique used to print this image suggests that it must have been a difficult operation requiring skilled labor, yet the contract is mute about this aspect: it is clear from the wording that *stampa* means plate and not print; to produce impressions from the plate does not seem to have been part of the job given to Maestro Bernardo. He is to engrave the plate and is given exactly two months to do so.[14] The contract specifies that he is meant to work "day and night"; this was a formula in contracts of this sort,[15] although these were the shortest months of the year, and Prevedari must indeed have worked by candlelight as well as by daylight if he managed to complete the job in so short a time. That he was expecting to succeed is confirmed by another document, an agreement signed by Bernardo Prevedari on 15 November 1481, that is to say only three weeks after having contracted himself to make Bramante's plate.[16] This contract stipulates that Bernardo would leave for Rome in time to be at the Roman branch of Antonio Meda's metalworking business on 15 January 1482, that he would engage himself to stay there for two years working in the *arte fabraria*, that he would be paid a fixed salary of 72 *lire* in the first year and 88 in the second, and that he would pass on to Antonio all the money earned in the *bottega*.[17]

For us the importance of this second contract lies more in what we can infer from its wording than in what it actually says. It demonstrates, first of all, that in 1481, at least in Milan, it was normal for a skilled metalworker who was a *maestro* to be given a short-term contract; that such a contract might engage a goldsmith such as Bernardo to engrave a plate for a print; and that such a job could be very well paid. Prevedari had obtained 48 *lire imperiali* for the Bramante plate which took him at most two months, but which he could conceivably already have been about to finish or even have finished when he signed the new contract three weeks after the first. The second contract ensured an average earning of 80 *lire imperiali* a year in Rome, possibly to do work of a different nature.

Matteo de' Fedeli must have been satisfied with Prevedari's work, since he let him go to Rome. Yet, if one looks at the print, particularly at its right edge, one wonders how he could accept what is obviously an unfinished job. The lower part of the image, where the horsemen are seen entering the ruined church, appears completed, but the entire strip of plate above this group is unresolved: the architecture is abruptly interrupted as if the prototype simply finished at this point, and the engraver has left trial patches of closely hatched lines as if that portion of the image were not meant to be seen, or would be engraved later, after these marks had been burnished out. If it was Matteo, rather than Bernardo, who copied Bramante's drawing onto the plate, it is conceivable that he slightly misjudged the space needed for the architecture but would not dare fill in parts that were not in the original drawing. That some *pentimenti* were introduced on the plate is clear: the large fragment of entablature on the floor at bottom right was engraved not only after the lines marking the floor had been incised, but also after the shadows delineating the cracks in the paving stones had been cut.

From everything we have seen about Prevedari's contracts and about the two impressions of the print, it is clear that Bramante was not a *peintre-graveur*. The print bearing his name and the magic word *fecit* was engraved by a professional craftsman, possibly without the intervention, or even the knowledge, of the painter-architect. Nevertheless, some form of close collaboration between a painter and an engraver must have been necessary, since the contract stipulates that Bernardo stay at Matteo's place for as long as it takes to finish the plate. This was an unusual clause, in that Bernardo was a *maestro*, and it was not customary for an established craftsman to work in another's *bottega*. Indeed, his family were goldsmiths and were established only a few hundred yards from Matteo's house, so that his moving must have been prompted by a very special reason.[18] This could have been, as tentatively suggested above, because of the need for Matteo's constant supervision and collaboration. If so, the making of this print did not follow any of the patterns known at the time. It is not an independent work by a printmaker using another artist's idea, and it appears to be the only known work in this medium by Prevedari. Since the drawing has not survived, we cannot establish whether the printmaker was simply copying it or whether he was trying to imitate its tonal values, and therefore to "reproduce" it: this impressive print is, in any event, the closest we come to candidacy for the earliest documented reproductive print. All the evidence, on the other hand, points to the likelihood that it was an isolated case: a goldsmith was asked to engrave a plate by a painter who had come to realize the potential of prints, perhaps as a consequence of seeing those by Mantegna, but who had failed to appreciate the technical difficulties involved in printing the image. The very fact that a notarial contract was deemed necessary — the only such occurrence known to us

95. Baccio Baldini, *The Styx, with the Punishments of Wrath*. Engraving (H.I.112.A.V.2.8.I), 96 × 176 mm. British Museum, London.

96. Baccio Baldini, *The City of Dys, and the Punishments of Heresy*. Engraving (H.I.113.A.V.2.10.I), 96 × 176 mm. British Museum, London.

97. Francesco Rosselli, *Deluge*, first version. Engraving (H.I.136.B.III.1), 270 × 407 mm. Kunsthalle, Hamburg.

98. Maso Finiguerra, *Deluge*. Pen and ink and wash on vellum, 285 × 413 mm. Kunsthalle, Hamburg.

in the history of Italian Renaissance printmaking — tends to confirm the exceptional nature of the circumstances.

Another event took place in 1481 which saw the collaboration between a designer and a printmaker: the publication of the illustrated *Divine Comedy* with Christoforo Landino's commentary.[19] The text was meant to be fully illustrated with engravings by Baccio Baldini (figs. 95, 96) based on drawings by Sandro Botticelli. The final preparatory drawings have not survived, but ninety-three other drawings by Botticelli illustrating the *Comedy*, divided in two cycles, have come down to us. These drawings are all in pen and ink over a trace of silverpoint on smoothly finished vellum sheets almost half a meter wide, and a few of them are richly colored in tempera, either in part or in full.[20] Besides serious problems of chronology — it is impossible on stylistic grounds to accept a dating for these drawings before 1481 — it is clear that the disparity in size (the prints are about one-third the size of the drawings) and in formal quality mitigate against the possibility that the drawings served as a basis for the engravings. As Bellini has convincingly argued, there must have been a completely different set of drawings for this project, none of which has survived.[21] On the other hand, these prints share so many features with Baldini's other Fine Manner engravings, and their quality is, in reality, so very poor in comparison with anything we know from the work of Botticelli, that we are tempted to assume the engraver's own contribution was substantial. The project had a painful birth, not only because of the difficulty encountered in printing the text in relief and the images in intaglio, but also because Botticelli was not available. Just when he was most needed, the painter was called to Rome to work on the frescoes for the Sistine Chapel. Only nineteen of the planned one hundred illustrations saw the light of day, and only a few copies of the book contain all these. Hind has reconstructed five different versions, arranged on the basis of which illustrations were present and whether these illu-

strations were actually printed directly on the pages of the book, or were printed on separate sheets of paper and then pasted onto the pages of the book. Peter Dreyer has succeeded in explaining why these five variations came about,[22] and argues convincingly that Botticelli did not start providing Baldini with the drawings until his return from Rome in 1482, and that the work then proceeded slowly until 1487, when it was suddenly interrupted by Baldini's death.

Two things suggest close collaboration between the two artists. First, Botticelli supplied his drawings over a number of years, with Baldini engraving and printing them at different times, presumably as soon as they reached him: this is suggested by his use of a variety of slightly differently colored inks for the prints not printed directly onto the leaves of the book. Second, the whole project came to a sudden conclusion with the death of the engraver on 12 December 1487, yet Nicholò di Lorenzo, the publisher of the book, did not try to switch to another engraver in order to complete the project. As we have already noted, Francesco Rosselli had been extremely active as a printmaker in Florence for a long time, and it would have been natural for the publisher to turn to the other leading printmaker in town when Baldini died. The fact that he did not can only confirm the importance of the collaborative nature of enterprises such as the illustrations for the *Divine Comedy*.

In this connection, it is worth devoting some attention to Rosselli's supposed collaboration with Maso Finiguerra, even though this takes us back to the decade before our survey begins. Among the engraver's earliest works are two, a *Deluge* (fig. 97) and the *Moses on Mount Sinai and the Brazen Serpent* (H.V.B.III.5), which are very close to two drawings on vellum by Maso Finiguerra (see fig. 98).[23] It appears unlikely, however, that Rosselli actually collaborated with Finiguerra, if for no other reason than at the time of Finiguerra's death in 1464 Rosselli was only fifteen or sixteen years old. It is improbable that Maso, himself an

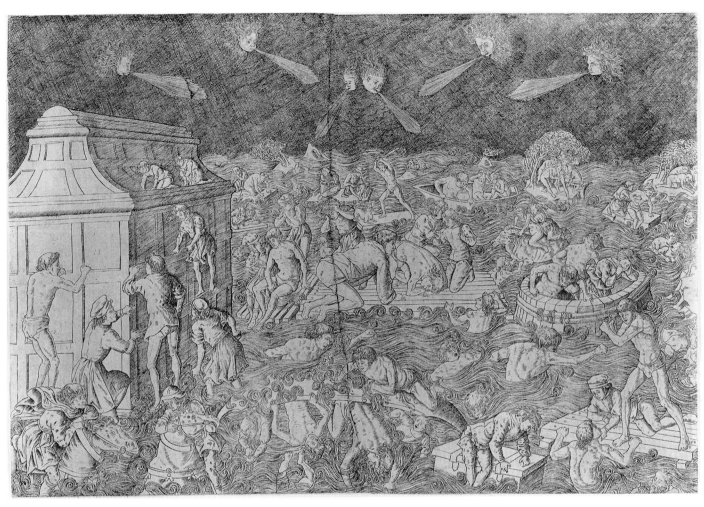

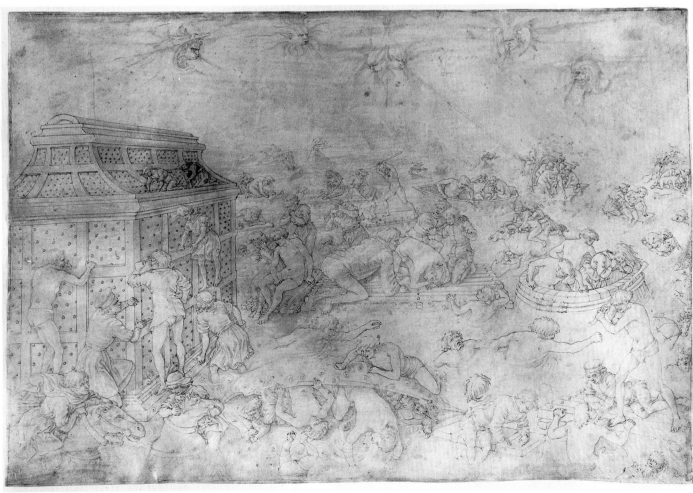

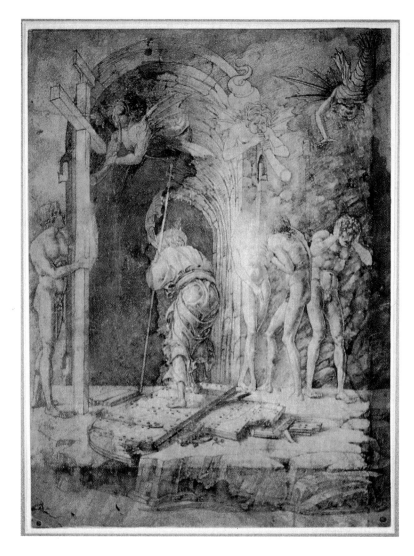

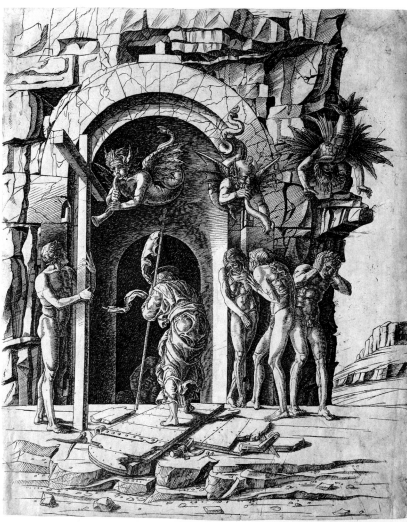

99. Andrea Mantegna, *Descent into Limbo*. Pen and ink and wash on vellum, 372 × 280 mm. Ecole Nationale Supérieure des Beaux- Arts, Paris.

100. Andrea Mantegna, *Descent into Limbo*. Engraving (H.V.18.9), sheet 422 × 343 mm. National Gallery of Art, Washington, D.C.

101. Andrea Mantegna, *Fall and Rescue of Ignorant Humanity: Virtus Combusta*. Pen and ink and point of brush heightened with white over color-prepared paper, 287 × 443 mm. British Museum, London.

102. Giovanni Antonio da Brescia, *Fall and Rescue of Ignorant Humanity: Virtus Combusta*. Engraving (H.V.27.22), 299 × 433 mm. Josefowitz Collection.

engraver, would have entrusted a very young pupil with producing the two largest prints yet made in Florence or anywhere else. We cannot establish whether the two drawings were made to be preparatory for the prints: they are highly finished, drawn in pen and ink and wash, and, unusually for Maso, on smoothly polished vellum, a support he seldom employed. On the other hand, no other use for the drawings has been proposed, perhaps because there is nothing comparable in size in all of Maso's rich oeuvre as a draftsman, and because the other two drawings of similar character, one in Frankfurt and the other in the Louvre, can be more or less loosely connected with nielli by Maso.[24] It seems unlikely that Maso would have gone to the considerable expense of using vellum for a drawing that was meant to be preparatory for a work in another medium, although one might argue that these would have been his first attempts to produce large prints, as opposed to tiny nielli, and that he therefore would have wanted to prepare carefully for them and would not have been too concerned with cost. Yet this, however attractive, fails to account for the fact that at least three such drawings have survived; and had Maso wanted to experiment

for his first large engraving, surely he would have produced the first drawing and had it engraved before going on to draw on the second piece of vellum, particularly if he were collaborating for the first time with an inexperienced engraver in his mid-teens! If, then, it is unlikely that the drawings were conceived with Rosselli's prints in mind, there is no denying that these vellum sheets were in fact used by Rosselli for engraving the plates. The superimposition of enlarged transparencies of the Hamburg *Deluge* drawing and Rosselli's first engraved version of the same composition proves conclusively that all their outlines correspond exactly and, therefore, that the transfer of the image must have been obtained by mechanical means. Rosselli probably used *carta lucida*, transparent transfer paper, since there is no trace of indentation or other transferring marks on the surface of the vellum.[25] The same applies to the case of the *Moses on Mount Sinai and the Brazen Serpent*.

Even if we assume that there was no collaboration between Finiguerra and Rosselli in the making of these engravings, can we then call the *Deluge* a "reproductive" print? By simply comparing the two illustrations, it becomes immediately clear

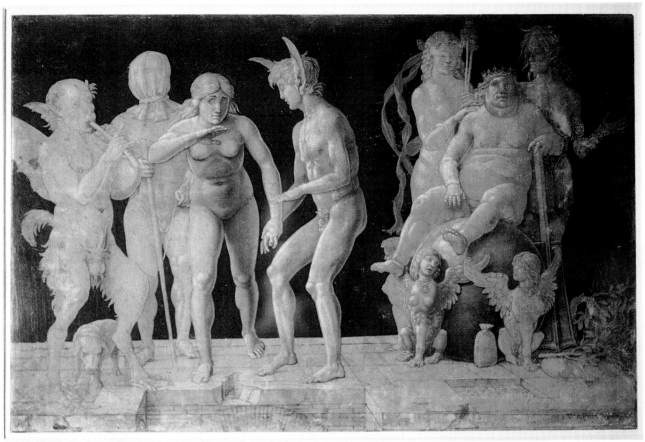

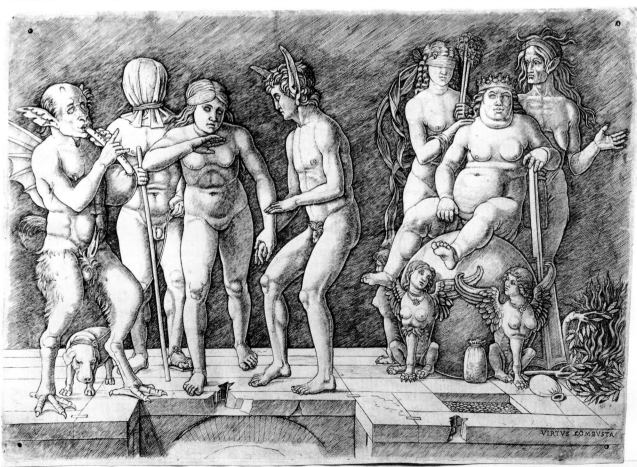

III

that reproduction could not have been Rosselli's motive. Although the outlines are identical, there is no relationship between the subtle treatment of light in Maso's washes and the harsh effect of Rosselli's engraving tool. The drawing is black on white; the print is, fundamentally, white on black, with no attempt whatsoever to imitate, let alone emulate, the chiaroscuro of the model. This print is not a reproduction, but an extreme case of appropriation, one, moreover, that we are not surprised to discover among Rosselli's oeuvre, since we know that he was to pirate his way through Florentine printmaking for the rest of his life. For his second version of the *Deluge* (H.V.B.III.3), Rosselli obviously decided to borrow less than the entirety of Maso's composition, copying only some figures and groups. In the case of the *Moses on Mount Sinai and the Brazen Serpent* (H.V.B.III.5), he traced the figures from Maso's vellum drawing but then made a number of changes, including the elimination of the landscape.[26]

None of these episodes appears to be a firm precedent for the birth of reproductive engraving; for this, one must turn to Andrea Mantegna and to Mantua, the other most active Italian print-making center of the fifteenth century. By the time there is any evidence of engravers "reproducing" Mantegna's work, he had long been an accomplished engraver himself, the first and greatest Italian *peintre-graveur* of his time. That he had at least one engraver, Giovanni Antonio da Brescia, working for him in Mantua is evident from the prints the latter produced under Mantegna's spell, but less clear is what relationship there was between designer and engraver. Very little evidence has survived apart from the prints themselves and a small number of related drawings. We must turn to a comparison between these in the hope of finding some clues.

There are a number of drawings by Mantegna that are preparatory for the prints he himself engraved.[27] From the beginnings of his career as a printmaker the only surviving drawings are rapid sketches in pen and ink, in which he elaborated the position of the main figures, their poses, and movements. For the later prints, however, there are a number of highly finished drawings, in which every detail of the image was worked out in advance. That such finished preparatory drawings survive for only some of the prints may well be due to chance,[28] but one can detect a clear development within them. For instance, the drawings for the *Descent into Limbo* (figs. 99, 100) and for the *Risen Christ with St. Andrew and Longinus* (figs. 103–04) differ considerably.[29] While in the *Descent*, the earlier of the two, the artist left parts of the composition unfinished in the drawing, completing such details at the stage of working on the plate, for the *Risen Christ* he made all the changes on the drawing itself, even going to the extent of

cutting out the head of Christ and replacing it at a slightly different angle (fig. 105). The reason for changing his working practice is obvious: any substantial change made to the image once it had been engraved entailed burnishing out the undesired lines and then hammering the verso of the plate to even out the depression caused on the recto during burnishing. This was not only a laborious procedure — much more so than making a correction on a drawing — but it was practically impossible in Mantegna's case, since he always engraved his plates on both sides and could not therefore hammer the verso of the copper. This also accounts for the fact that many, indeed half, of Mantegna's early prints are unfinished: on the verso of each finished plate was an engraving that had been abandoned because it could not be corrected, the finished side naturally being the first engraved. On the verso of the finished *Entombment with Four Birds* (fig. 45) is the unfinished *Descent from the Cross* (fig. 46); on the verso of the finished *Descent into Limbo*, the unfinished *Flagellation with a Pavement*.[30]

Once Mantegna had prepared a full study for the print, he transferred the image to the plate by mechanical means, that is, by tracing. This is clear for at least two reasons. First, the contour lines of the drawings and prints can be superimposed exactly (again by using enlarged transparencies), and it is even possible to establish the number of stages which the transfer required and the extent of image that was transferred in each session. Second, most plates were incised with very light transfer marks at the four corners — made either of two lines meeting at variable angles or, more commonly, of irregularly lozenge-shaped geometrical forms. These marks were engraved in order to ensure that the registration of the two images during the transfer procedure would be consistent. There are no traces of transfer processes on the surface of the preparatory drawings, such as indentation or pouncing marks, so Mantegna must have employed a non-destructive transfer method. It is possible that he used a sheet of transparent transfer paper, *carta lucida*, which he would lay over the preparatory drawing and on which he would trace the image; the sheet would then be reversed, and the image transferred from it to the copper plate, the surface of which would have first been prepared with a thin layer of wax, itself covered with white *biacca* or *bianco di Spagna*.[31] This technique would have allowed Mantegna to engrave the image without reversing it and, at the same time, without ruining the preparatory drawing. As Mantegna became increasingly famous and his works sought after, such conservation must have become an important consideration. He could never satisfy the constant stream of requests from the Gonzagas, let alone from all those who were writing to them in hopes of obtaining something from the hand of the

maestro. This demand may well have been one of the reasons Mantegna started making prints in the first place — although there is little evidence that he pulled more than a handful of impressions from any one of his plates; it was also a good reason not to damage a large and meticulously finished drawing that had taken a long time to make.

By about 1475 Mantegna had probably exhausted his interest in printmaking, at least as an activity in which to experiment with his own hand, and he started seeking the assistance of a professional engraver. Having disastrously failed in this, and having instead become involved in an alleged attempt to murder the painter Zoan Andrea and the engraver Simone da Reggio,[32] Mantegna is likely not to have devoted much attention to prints for some years. He resumed his tools once, for the magnificent *Virgin and Child* (fig. 50), but thereafter entrusted the incising of the plates to Giovanni Antonio da Brescia, and possibly to others.[33] By this time he was a proficient printmaker who had experimented for years with the medium and who knew what an assistant needed in order to realize a print worthy of Mantegna's name. There was no chance that he would provide the engraver with any less than a fully worked out preparatory drawing; the evidence suggests that these were richly colored drawings, in which the washes were used to help the engraver understand more easily the pattern of light and shade, so that he could emulate their rich chiaroscuro with the parallel hatching that had become Mantegna's trademark. The use of tonal preparatory drawings for prints was to become a precedent a few years later for Raphael in his relationship with Marcantonio and a standard in many prolific workshops thereafter.

There are only a handful of drawings directly related to prints of the so-called Mantegna school. This would be surprising in itself were we to assume that the master produced drawings for other purposes, and that these were then copied or "reproduced" by the engravers. Mantegna was immensely famous towards the end of his life, and since many of the surviving drawings are highly finished and most accomplished, it seems very unlikely that dozens more similar sheets might have been produced and subsequently lost. It is more probable that the few preparatory drawings were made specifically for the engravers, and that Mantegna cast his eyes carefully over their shoulders while they worked. Given how punctilious and difficult a man Mantegna is known to have been, and given the care with which he prepared himself when he engraved his own plates, he would not have left such a crucial issue, on which his fame might have to rely in distant places, to the whims of a younger craftsman in his employ. Mantegna would instead draw his design directly on the plate and let a pupil handle the burin under his guidance, or he would provide the engraver with a highly

finished drawing as a model. The latter probably happened only in the 1490s, when Mantegna was in his sixties, and when he felt Giovanni Antonio da Brescia had acquired sufficient skill to handle the complexity of transferring a drawn image onto a copper plate.

It is therefore logical that all the surviving drawings connected with prints not by Mantegna himself are late, and that all are richly textured in color and chiaroscuro. The most famous is that in the British Museum, depicting the top half of a complex allegory, the *Fall and Rescue of Ignorant Humanity*, and representing the *Realm of Ignorance* (fig. 101). Its comparison with an impression of the print is illuminating (fig. 102). The most obvious feature is that the printmaker has produced a most extraordinarily close rendering of the drawing, every line of which is followed with the greatest accuracy; the superimposition of enlarged transparencies confirms that the image was transferred mechanically from drawing to print.[34] There is only one area in which the print does not equal the drawing: in the drawing the rudder appears firmly standing on the ground, but in the print it is somewhat unconvincingly rendered with its base not actually seeming to touch the stone floor. One might object that such a careful copy could have been made by a skillful engraver at any time, and that there is no reason to assume Mantegna was overseeing its production. There are, however, some clues which suggest that the master was indeed there to advise the printmaker. All the *pentimenti* in the drawing, such as the break in the stone at the foot of the blind woman, are incorporated into the print, while there are some *pentimenti* in the print itself, and some changes that are unlikely to have stemmed from the engraver's initiative. The slight changes to the position of the left foot of the blind woman and to the right foot of the man with long ears, aptly personifying Error, are corrections which hint at the presence of some adviser. That this could only have been Mantegna himself is suggested by two facts: first, that the figures of Fraud (with the sack over his head) and Lewdness (the satyr playing a bagpipe) are unfinished in the drawing, as noticed by Popham and Pouncey,[35] but are convincingly finished in the print; second, that the engraver has clothed the left foot of Fraud with a sandal, an iconographical addition which no "reproductive" engraver would ever have taken the liberty to introduce.

There are at least three further drawings that are very close to prints produced by followers: *Hercules and Anthaeus* and *Faun Attacking a Snake* in the British Museum,[36] and *Hercules and the Lion* in Christ Church, Oxford.[37] These are all highly finished, with particular attention paid to the chiaroscuro, and it would be fair to assume that they were faithfully translated into prints by pupils of Mantegna.[38] Only the drawing of the *Faun*

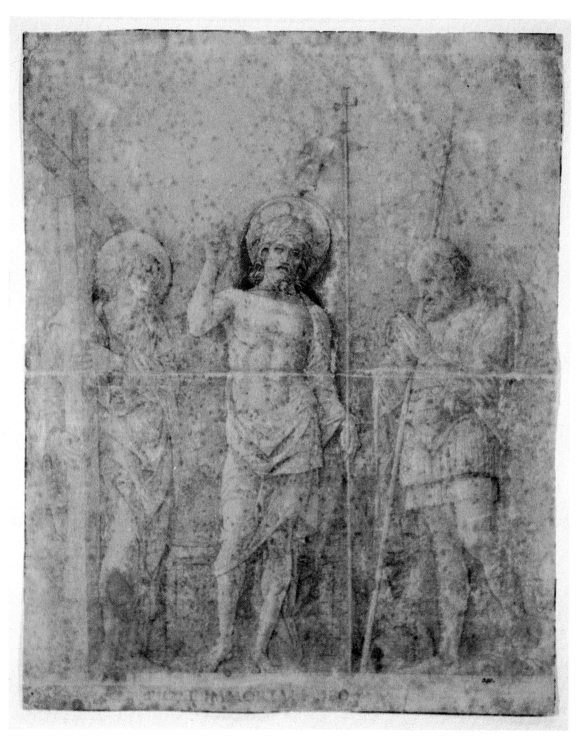

Attacking a Snake, however, is by Mantegna himself, and the superimposition of enlarged transparencies of drawings and prints in this group has confirmed that this drawing is also the only one that was used by an engraver, as its contours were traced in order to produce the print.[39] This approach is quite unlike that of Girolamo Mocetto's *Calumny of Apelles* (fig. 106)[40] after Mantegna's drawing in the British Museum (fig. 107).[41] Here all evidence suggests that Mocetto's print was not the result of a collaboration between the two artists but was simply an appropriation of Mantegna's design by the engraver. Various details suggest that the drawing might have suffered its present damage before it was used by Mocetto. For instance, the stain under the legs of the judge and the rubbing of part of the word *dec[e]ptione* correspond to two misunderstandings in the print, something that would not have happened had Mantegna been overseeing its production. Even more blatant, and in some ways an ironic misunderstanding, is that the scene — drawn by Mantegna in reverse, according to

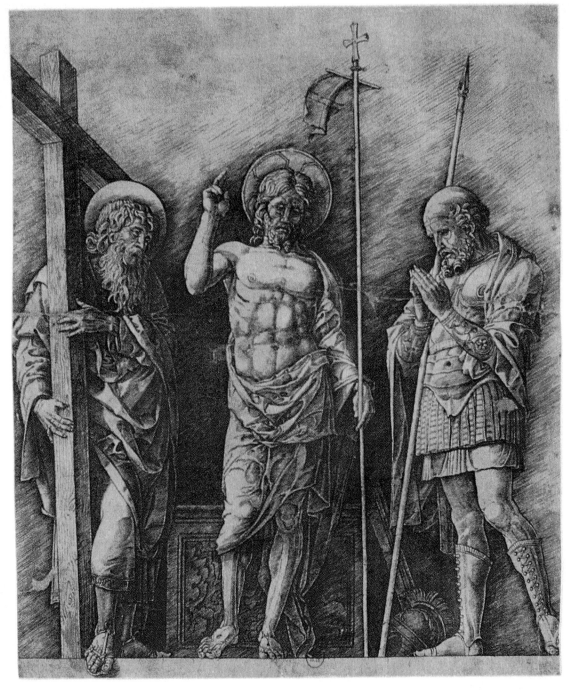

104. Andrea Mantegna, *Risen Christ with St. Andrew and Longinus*. Engraving (H.V.16.7), sheet 319 × 270 mm. Bibliothèque Nationale, Paris.

105. Detail, showing the *Klebkorrektur* of the head.

Popham and Pouncey — was painstakingly copied in the same wrong sense by Mocetto![42] Moreover, when Mocetto added his own background, the Campo di San Zanipolo in Venice with the recently installed equestrian portrait of Colleoni by Verrocchio, he engraved it directly on the plate, so that the whole square appears reversed! There is no question that he knew the square well; he had worked for years on a glass window of the church of SS. Giovanni e Paolo, depicted in the background.[43] The case of this print fits with our notion of a progression towards the birth of reproductive prints, since it greatly resembles all those instances

106. Girolamo Mocetto, *Calumny of Apelles*. Engraving (H.V.165.12), 325 × 448 mm. British Museum, London.

107. Andrea Mantegna, *Calumny of Apelles*. Pen and ink and white heightening, 207 × 380 mm. British Museum, London.

where the printmaker appropriated the design of a more famous artist, with the intention, however, not of reproducing it, but rather of transforming it into an independent work of art in the form of an engraving. This is obviously an extreme case, entailing the appropriation of a whole composition, and that is why we have discussed it at length; but it does not justify a confusion, or even an assimilation with the concept of "reproduction."

All other, mostly isolated, cases of prints made before ca. 1510 which may appear to be "reproductive" in fact lie well within the traditional framework of Italian printmaking of the time: either they are the expression of a close and active collaboration between a painter and an engraver, normally master and pupil, or they are examples of

an independent printmaker intent on producing a finished work of art and borrowing from another artist a motif which suits his composition particularly well. We can think of examples, such as the anonymous print of *St. Jerome in his Study* (fig. 108),[44] which is very closely related to a drawing by Filippino Lippi in Cleveland (fig. 109).[45] Here the engraver went one step further than in any of the instances we have considered so far, pricking all those portions of the drawing he was interested in, so that he could easily transfer them to his plate, and obtaining an image very similar to that of the model. Since he had avoided pricking through some of the details of the drawing, he added his own setting, one very different from that which Filippino designed for his painting of the same

subject.[46] The print stands on its own, and is not a reproduction of either the drawing or the painting.

Other instances occur in the work of Giovanni Antonio da Brescia who, before moving to Rome, had settled for some time in Milan. There, he often used drawings by Leonardo as the inspiration or model for his engravings, whether encouraged by the master himself we do not know. He took sketches by Leonardo from various sheets and arranged them on one plate,[47] and he translated some of Leonardo's portraits into engravings, including one of his own mentor, Mantegna.[48]

Marcantonio Raimondi, on two occasions before arriving in Rome, had also borrowed freely from designs by his master, Francesco Francia. Around 1503–04 he used two figures each from drawings by Francia for two of his prints — the *Baptism of Christ* (B.22) and *St. Catherine of Alexandria and St. Lucy* (B.121). In the *Baptism*, he did much the same as the anonymous engraver had done with the Filippino drawing, extracting the two main figures and setting them in a landscape of his own invention. In the second print, he went even further, not only reversing the two borrowed figures, but changing the St. Dorothy of his model to a St. Lucy, deriving the attributes of this new saint from a painting by Francia.[49] In the excitement of finding here the first seeds of what might have

become Marcantonio's "reproductive" habits, one must remember that these are the only documented instances in which he is known to have borrowed extensively from another artist before he arrived in Rome. Marzia Faietti and Konrad Oberhuber have reconstructed a convincing picture of Marcantonio's pre-Roman activity as an independent printmaker working from his own designs, and these two exceptions cannot alter their conclusions. They represent, however, a necessary preliminary to what comes closest yet to representing a "reproductive" print: Marcantonio's rendering of Jacopo Ripanda's drawing of a *Triumph*, now in the Louvre (figs. 110–11).[50] The print and the drawing are very similar in size, and there is no reflection of this drawing in Ripanda's frescoes in the Palazzo dei Conservatori in Rome, or anywhere else. Though of different ages, the two artists may have been friends because they were both trained in Francia's shop. In separate ways each was evidently eager to participate in the rediscovery of antiquity, surely the main topic of conversation in the Roman artistic milieu of around 1510. It is tempting to assume on these grounds that they decided to collaborate in the production of this print. Jacopo brought to the partnership his consummate skill in constructing pastiches in the classical vein by using figures copied from various antique sources, and Mar-

108. Anonymous Artist, *St. Jerome in his Study*. Engraving (H.V.217.D.IV.6), 280 × 204 mm. British Museum, London.

109. Filippino Lippi, *St. Jerome in his Study*. Pen and ink, 242 × 209 mm. Cleveland Museum of Art, Cleveland.

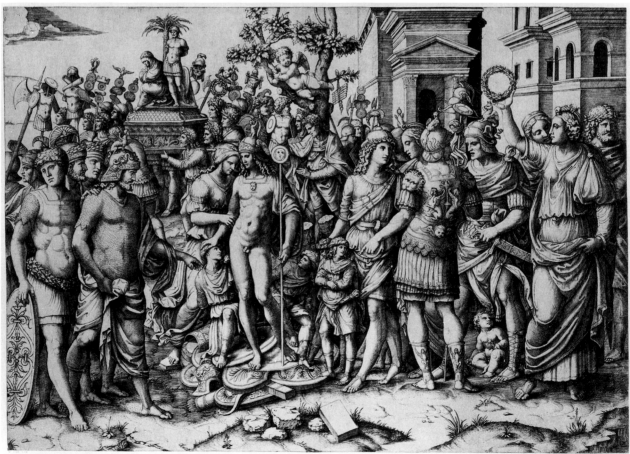

cantonio contributed his ability to recreate complicated spatial relationships with the burin through the use of chiaroscuro. In light of the possible relationship between the two Bolognese artists, and because of the many improvements over the drawing introduced in the print, it is most likely that they discussed the project together, and that the engraving is the result of a genuine collaboration. This *Triumph* sets a precedent for the radical changes which took place in Roman printmaking during the following twenty years, a revolution in which Marcantonio was to play the role of protagonist.

When Marcantonio arrived in Rome in his mid-twenties, he was already a successful and highly proficient independent printmaker who had produced some of the most refined Italian engravings of his time. Brought up in the humanist circle of Bologna, he had traveled widely through the most important centers where the "new" art was being produced. He had almost certainly met Dürer, had been in close contact with the Venetian intelligentsia, and had certainly encountered the work of Giorgione. He must also have seen Michelangelo's *Battle of Cascina* cartoon in Florence. Marcantonio's arrival in Rome was a climax for a young artist who was a natural player in the fashions of his time, and a friendship with his compatriot Ripanda conforms to the pattern of his previous career. Ripanda had gained an unchallenged reputation in antiquarian circles in Rome, mostly thanks to his close study of Trajan's Column. His great patron at the time was the powerful Cardinal Riario; among his friends were Andrea Bregno, who left him part of his famous collection of antiquities in 1503, and Pomponio Leto, the

leading light of the "Accademia Romana."[51] It is entirely plausible that Marcantonio joined this circle, since he was ideally suited to it. In any case, he was soon to put his skills as an engraver in the service of the antiquarian cause. His first known print done in Rome, the *Triumph*, probably made in collaboration with Ripanda, was Marcantonio's most ambitious engraving yet, larger in size and with far more figures than any before it, and a truthful representation of Ripanda's confused and cluttered antiquarianism.

Raphael's arrival in Rome must have been tantamount to the appearance of a savior, offering Marcantonio the chance of collaborating with an interpreter of his own "classical" aspirations far more subtle than Ripanda. Marcantonio's *Dido* (fig. 112) and *Lucretia* (fig. 113) reflect, in close succession, his reaction as an independent printmaker to the arrival of this new star. Both prints are related to a magnificent drawing by Raphael (fig. 114)[52] in a way that reminds us immediately of the use Marcantonio had made of Francia's drawings earlier in his career. The engravings are free of the antiquarian clutter of the *Triumph* but are imbued with "classical" feeling — expressed by the tablets inscribed in Greek and, in the case of the *Lucretia*, by the restrained architectural setting. Whether it is true, as Vasari says, that Raphael was shown an impression of the *Lucretia* and so realized the potential of a collaboration with the Bolognese engraver, or whether their eventual engagement came about differently, we cannot know. One must remember that when all this was happening, Bramante was among the foremost literati in Rome and undoubtedly an early friend of Raphael's. Recall the document discussed at the inception of

112. Marcantonio Raimondi, *Dido.* Engraving (B.XIV.153.187), 159 × 126 mm. Albertina, Vienna.

113. Marcantonio Raimondi, *Lucretia.* Engraving (B.XIV.155.192), 212 × 130 mm. Rijksmuseum, Amsterdam.

114. Raphael, *Lucretia.* Pen and ink and chalk, 398 × 292 mm. Private collection.

110. Jacopo Ripanda, *Triumph.* Pen and ink, 328 × 490 mm. Cabinet des Dessins, Louvre, Paris.

111. Marcantonio Raimondi, *Triumph.* Engraving (B.XIV.173.213), 347 × 507 mm. British Museum, London.

119

this chapter recording an engraving commissioned after a drawing by Bramante. It should not be discounted that the architect himself might have encouraged a collaboration between Raphael and Marcantonio. However it came about, this alliance changed the course of Italian printmaking, and thus deserves a full discussion on its own.

MARCANTONIO, AGOSTINO VENEZIANO, AND MARCO DENTE

Vasari's writings being the only extensive sixteenth-century discussion of the birth of reproductive engraving, we naturally tend to look to him whenever we enquire about relationships between artists: between Raphael and Marcantonio; between both of them and Agostino Veneziano or Marco Dente da Ravenna; between the latter two and other contemporary artists whose work they "reproduced"; and so forth. Did Raphael and his contemporaries commission, organize, or encourage the production of prints "after" their works, or was it the engravers who promoted such activity? In either case did the latter set up a common workshop, where they could share such facilities as a press, stock of paper, and even *garzoni* to prepare the plates or the ink, or did each of the printmakers have his own independent workshop, perhaps in his own house? When an engraving "after" a work by Raphael or Bandinelli had been completed, who owned the plate and who the copyright? When, as was often the case, more than one printmaker produced a print "after" the same drawing by Raphael, had this been decided by the painter himself to increase the number of impressions available at the height of the fashion for his latest creation, or were the printmakers competing with each other to be the first on the market with the new image?

It is therefore not only to answer the basic question of whether it is in fact true that either Raphael or Marcantonio invented reproductive printmaking, but to solve many other closely related problems that we go back to Vasari hoping for an informed, authoritative, and near-contemporary answer. For centuries art historians and collectors have consulted Vasari with very different results, depending on which part of his description they gave more prominence.[53] A careful reading of all references to prints in the *Vite* reveals an astonishing lack of consistency in Vasari's answers to questions about collaboration. If he was sure about the basic tenet that Marcantonio was indeed the man to be credited with the invention of reproductive printmaking, much of the information found in the Life of Marcantonio, Raphael, or Bandinelli is confused and contradictory, and often shows complete ignorance of the facts. For instance, throughout the *Vite* Vasari seems to assume that Marcantonio

"reproduced" paintings and frescoes as well as drawings by Raphael, but the evidence of the prints themselves belies this completely.[54] Other contradictions abound in Vasari's account: in the Life of Andrea del Sarto, for example, Vasari tells us that his *Man of Sorrows* had been so praised by those who had seen it that the painter eventually yielded to their insistence that a print should be made of it and commissioned one from Agostino Veneziano. In the Life of Marcantonio, however, the same story is recounted but in a completely different way, with the initiative given to the printmaker, who is described as having left Rome for Florence only in order to convince Andrea that he should let him make a print after one of his pictures. Further errors include attributing prints to Marcantonio that are patently not his, such as Agostino's famous *Spasimo di Sicilia*[55] or his *Portrait of Ferdinand I*[56] — both, incidentally, conspicuously signed and dated by the engraver. Vasari's chronology of the prints is as confused and mistaken as the rest of his information about the engravings produced around Raphael: Agostino's *Cleopatra* after Bandinelli is described as among the earliest works of Bandinelli in his Life, but in the Life of Marcantonio it is described as one of Bandinelli's more mature efforts, done well after Raphael's death in 1520; in fact, the print is dated 1514. Agostino's *Man of Sorrows* after Andrea del Sarto, mentioned above, bears the date 1516, but is described by Vasari among the prints the engraver produced in Florence after escaping from Rome during the Sack of 1527.

It may therefore be safer temporarily to discard Vasari as our chief witness and opt instead to look for some of the answers in the only certain pieces of evidence, the surviving impressions of the prints themselves.

Prints and Prototypes

The prints originating from what Bartsch called the school of Marcantonio[57] are never "after" paintings or frescoes by Raphael or his pupils but are always related to drawings.[58] Even when they betray a close relationship with a painting or fresco, careful examination shows that the engraver's source must have been not the painting or fresco itself but a drawing connected with it. This is not at all surprising. As we have seen, in the early sixteenth century there was no tradition in Italy of prints actually reproducing a painting or fresco, the few instances where such a connection can be suggested being exceptions to the rule. On the other hand, we have already discussed the close connection between prints and drawings in Mantegna's school and in the circles of Botticelli in Florence and Leonardo in Milan. There is no reason why Marcantonio, beginning his collaboration with Raphael, should have introduced working practices com-

pletely different from those he had been taught in Bologna, had encountered during his trips to Venice or Florence, or had himself followed during his earlier activity in Rome. Even among the dozens of small easel paintings we have by Raphael, none is "reproduced" in a print by Marcantonio or by the other two artists who form the first generation of his "school," Agostino Veneziano and Marco Dente da Ravenna. Among their hundreds of prints, only two seem to be so close to a painting or fresco as to make us wonder whether they might have been made "after" them rather than "after" a drawn *modello*.

Agostino Veneziano's engraving the *Spasimo di Sicilia* is very close to Raphael's painting; but, as others have noted, there would probably have been little time available to the printmaker between the day Raphael finished the picture and the date it was shipped to Sicily.[59] Moreover, one should not overlook the painting's huge size — more than three meters by two — which in itself would have slowed down Agostino; and it is most probable that a *modello* existed in any case, since the picture, although partly the work of the master, was mainly painted by assistants, who would themselves have needed such a *modello* to follow. The only other obvious case of an unusually close relationship between a print and a finished picture by Raphael is Marco Dente's depiction of the *Fire in the Borgo* (B.XV.33.6), which follows very closely the fresco in its eponymous room in the Vatican. An explanation for the existence of such an exception is much simpler: that the print, as suggested by Bartsch himself, is not by Marco Dente at all, but by a later hand, and was engraved in the 1540s, when the practice of reproducing frescoes in prints was widespread.

There can be little doubt that Konrad Oberhuber is right in stating that the reproductive print as we now understand it did not exist during Raphael's lifetime, and that its birth can be placed sometime after his death.[60] It is only with the following generation of engravers, that of Caraglio, Bonasone, and the Master of the Die, that truly "reproductive" prints made their first appearance, probably because, as Oberhuber himself suggested, the drawings by Raphael were no longer available and the engravers were forced to — and, we would add, had by then been given the technical means to — try their hand at reproducing finished paintings and frescoes.

The Plates

It has always been assumed that Marcantonio and his colleagues made their plates in close vicinity of Raphael, and that they transmitted his designs to some extent. Vasari does not doubt for a minute that these engravings were the result of Raphael's

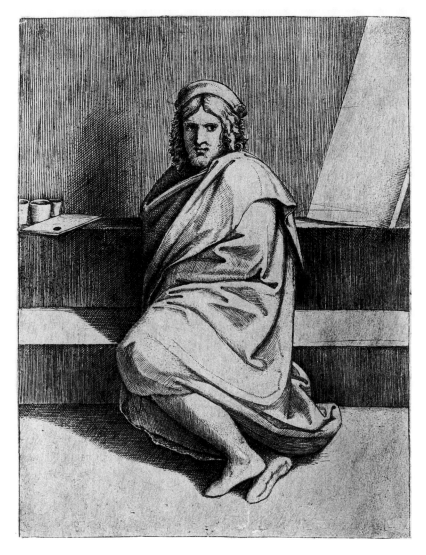

entrepreneurial efforts, and that they were all the product of an operation for which Raphael provided the drawings, Marcantonio and his colleagues the engraving skills, and Baviero de' Carrocci the organization. That il Baviera, as he was called, was a close associate of Raphael there can be little doubt. In November 1515 he is known to have bought two houses acting on behalf of the master;[61] furthermore he is said by Vasari to have been left all the plates by Raphael at his death, so that he could provide sustenance for the artist's mistress, the "Fornarina." That Marcantonio was himself a close collaborator, if not a friend of Raphael, cannot be doubted either. As early as 1511 Marcantonio was depicted as a *sediario* in the fresco in the Stanza di Eliodoro,[62] in 1515 he acted as a witness in the acquisition of the two houses just mentioned, and, probably around 1518, he made a most beautiful and intimate engraved portrait of Raphael, on which neither name, however, appears (fig. 115).[63]

The implication of Vasari's statement that Raphael left all his plates to il Baviera is that these did not belong either to the printmaker, as we

assume had mostly been the case hitherto, or to the publisher, the role il Baviera seemed to have played in the organization. On the other hand, still according to Vasari, all Marcantonio's plates, already worn out from over-use, were carried off by German soldiers during the Sack of Rome, thus leaving him penniless and desperate.[64] If both stories are true, then Raphael must have retained the plates of the prints engraved from his drawings, and Marcantonio kept others, presumably those he had produced after his own designs and possibly those of artists other than Raphael. As Oberhuber has pointed out,[65] of the more than 250 engravings made by Marcantonio, only about 50 are related to Raphael drawings. Whether Marcantonio would have agreed to give up the ownership of these plates against some form of reward is impossible to determine, although there is a precedent in Prevedari having engraved a plate and then given it back to the man who commissioned it.[66]

Though we have decided to take Vasari's words with a pinch of salt, we can still try to verify his two stories about the plates against the evidence provided by the prints themselves. If it is true that the plates engraved by Marcantonio after Raphael were bequeathed to il Baviera and thus had a different history from Marcantonio's other plates, it should be possible to check this through surviving impressions. Since we know that il Baviera, possibly because of his German origins, did not suffer unduly during the Sack of Rome and went on commissioning engravers to make prints after drawings by artists other than Raphael,[67] we may posit that none of the plates in his possession was requisitioned by the invading lansquenets. There might therefore be a greater chance of encountering a late impression of a Marcantonio done "after" Raphael than a late impression of a Marcantonio done after his own or some other artist's design. And since we are further told by Vasari that the plates robbed from Marcantonio were worn out, we must keep in mind that it would not suffice for the impressions of the prints derived from a Raphael drawing to be just "late," but there would have to be evidence, for instance in the form of later inscriptions, that they were printed well after Marcantonio's lifetime.

This exercise is not unduly difficult, as out of about 250 prints by Marcantonio we have found only 47 that were at all reworked, that is, where we know of the existence of more than one state (although a careful catalogue raisonné of his prints, when it is produced, will undoubtedly reveal that their number is greater). Of these 47, some can be eliminated straight away, since they represent states obviously produced by Marcantonio himself either during his normal working procedure,[68] because of a mistake that needed correction,[69] or because the inscription was not complete in an earlier proof.[70] We will also exclude others where

we cannot be sure whether the retouching, although certainly by another hand, is much later, or, in any case, late enough for our calculations.[71] What remains is, with a few exceptions, a rather homogeneous group of prints "after" Raphael, including all the most important subjects: the Quos Ego (B.352), retouched (by Villamena?) after it had already been published by Salamanca; the Dance of Cupids (B.217), retouched in the latter's workshop; and the Supper at the House of Simon the Pharisee (B.23), given similar treatment before being reissued by Lafrery. The latter two prints had inscriptions added to them by the new owner of the plate, as did the Judgment of Paris (B.245 — also issued by Salamanca), while the sets of the Apostles (B.64–76) and the Emperors (B.501–12) had numbers added to the plates when these were reprinted later in the century.

So far, then, our findings seem to corroborate Vasari's statements about the ownership of the plates. There are two further elements that seem to confirm his account indirectly. First — with the exception of those plates discussed above that were still being printed long after Marcantonio's death — very few of his engravings are to be found in late, that is to say worn, impressions. This may be because these prints were not easily salable later on, and because Marcantonio often re-engraved the same plates again and again for new compositions, as traces seen in early impressions show without doubt.[72] It may, however, have more to do with the fact that most of the plates that survived until 1527 were melted down by those who confiscated them during the Sack, in accordance with Vasari's account. The second element that seems to corroborate Vasari, albeit again indirectly, is a comparison between the number of surviving late impressions of Agostino Veneziano's or Marco Dente's plates with those of Marcantonio. While the latter's are, as we have just described, comparatively rare, those by Agostino are extremely common. One can actually say that most plates of prints by Agostino survived the Sack of Rome and were reissued first by Salamanca and later by other publishers. On the other hand, very few indeed of Marco Dente's plates were reissued by later publishers,[73] and this may be related to the fact that only those plates not in his studio, such as those after Raphael, which could have been with il Baviera, or that after Bandinelli, which could have belonged to the painter, survived the attack by the German invaders in which Marco Dente himself died. In this context it may be well worth underlining the fact that of the two versions of the Massacre of the Innocents, arguably the most valuable plate in il Baviera's stock, only the copper of the first version, that with the fir tree, was saved, and still survives today, in Pavia. Did il Baviera hold the plate of the other version? As we shall see, he probably did not.

The Drawings

The evidence discussed thus far does not conflict with the possibility that Raphael or il Baviera actually owned the plates of the prints that the three engravers made after Raphael's drawings. If this is true, then it must also be true that Raphael, or il Baviera on his behalf, had a real say in what was engraved, by whom, and when. To check this, as no other documentary evidence apart from Vasari seems to have survived, let us return again to the prints. What was the relationship between the engravings by Marcantonio, Agostino, and Marco Dente and the drawings by Raphael and his pupils, particularly Giulio Romano and Giovan Francesco Penni?

Current scholarly opinion holds that most prints were made after drawings which were somehow available in the studio of the great master, and that in just four surviving cases Raphael drew with the specific intention that the image would be transformed into an engraving: the *Massacre of the Innocents* (B.18), the *Quos Ego* (B.352), the *Morbetto* (B.417), and the *Judgment of Paris* (B.245).[74] All four were engraved by Marcantonio and are unanimously considered his masterpieces. It is likely that their beauty is indeed the result of a much closer collaboration between Raphael and Marcantonio than occurred with any of the other prints linked to the two artists. Related drawings exist for all of these prints, and much has been written about most of them.[75]

Of the series of beautiful drawings for the *Massacre of the Innocents* (fig. 117) that survive, three in particular show the evolution of the design in Raphael's mind (figs. 118–20). What must have been Raphael's first idea has come down to us only in a copy (fig. 116). Among those by Raphael himself, one is very detailed and very close to the composition as it was eventually resolved in the print (fig. 120). Yet it is likely that there was a further final drawing by Raphael including the background with the Ponte Quattro Capi, since it is inconceivable that Raphael, at this time as famous an architect as he was a painter, would have delegated such an important and unifying part of the composition to Marcantonio. We cannot be certain whether he copied the bridge from the Codex Escurialensis[76] or, as is more plausible, directly from life. In either case he would not have left this feature to Marcantonio, who had previously opted to take his backgrounds from Dürer or Lucas van Leyden, a dependency hardly inspiring of Raphael's confidence. The Budapest

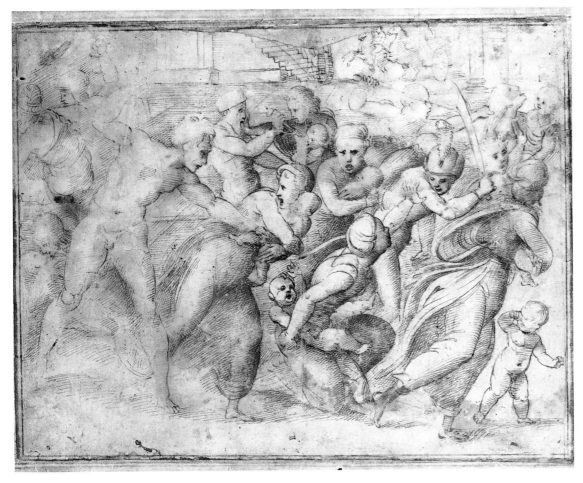

116. Attributed to Berto di Giovanni after Raphael, study for *Massacre of the Innocents*. Pen and ink, 240 × 305 mm. Cleveland Museum of Art, Cleveland.

123

118. Raphael, study for *Massacre of the Innocents*. Pen and ink, 232 × 377 mm. British Museum, London.

119. Raphael, study for *Massacre of the Innocents*. Pen and ink and chalk, 248 × 411 mm. Royal Library, Windsor.

120. Raphael, study for *Massacre of the Innocents*. Pen and ink, 265 × 402 mm. Szépművészeti Múzeum, Budapest.

117. Marcantonio Raimondi, *Massacre of the Innocents*. First version, with fir tree. Engraving (B.XIV.19.18), state III, 283 × 434 mm. British Museum, London.

drawing, moreover, shows the parapet of the bridge behind the figures, thus suggesting that Raphael already had this setting in mind. If a detailed, final *modello* indeed existed, its disappearance may be connected with the technique used in its transfer to the plate: it might have been pricked so thoroughly that it did not survive, although many pricked drawings by Raphael, including the study for this print in the British Museum, have survived such treatment. More likely, it was oiled and pasted face down onto the plate, whose dimensions are almost identical, so that the image in the print would appear in the same direction as in the drawing.

Two small drawings for the lateral scenes of the *Quos Ego* survive at Chatsworth.[77] They are comparable in technique, as Gere and Turner have noticed,[78] with the Budapest drawing for the *Massacre of the Innocents*, being drawn in pen and ink and expressing tone through a detailed and fully worked out cross-hatching. They also share with that drawing a very poor state of preservation, on this occasion due to the contours of most figures having been pricked, and the small sheets having been "rubbed over and almost obliterated with powdered black chalk in the course of transferring."[79] As these two small drawings are so close in many

ways to the Budapest drawing — though they must date from three or four years later — one is tempted to suggest that they also represent the last stage of a Raphael sketch in pen and ink, used for transferring onto a detailed sheet which was given to the engraver and then destroyed in the production of the print. Here again, both drawings are in the same orientation as the engraving, and their size is almost identical to the corresponding sections of the print.

Three drawings have been related to the invention of the *Morbetto* (fig. 121). Their technique and character is varied, ranging from a pen and ink study of cows (fig. 124)[80] to a beautiful, airy *Landscape with Classical Ruins* (fig. 123)[81] for the right half of the print, to a final, fully developed composition (fig. 122). The latter drawing and the Windsor *Landscape* share a somewhat unusual appearance, achieved in the first case by using metalpoint heightened with white on a pale brown prepared paper,[82] and in the second, pen and brown ink with brown wash, enriched with white highlights on buff-prepared paper. These drawings are distinguished not only by their appearance; they are also in reverse to the print, a rarity among the drawings connected with the prints by our

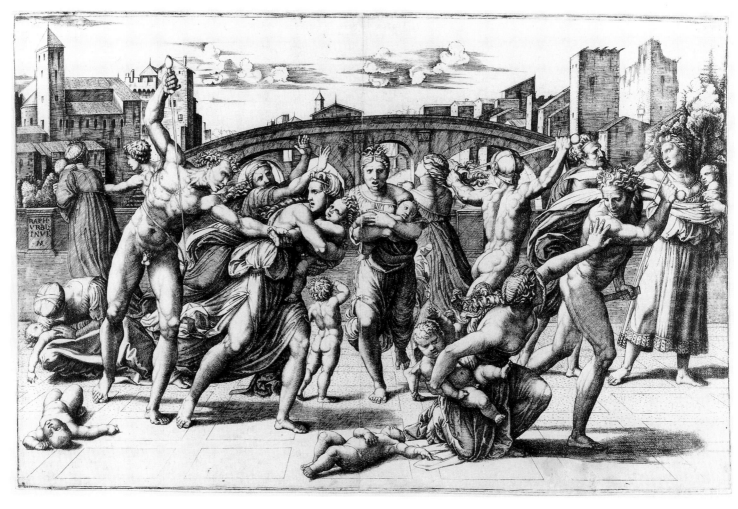

124

three engravers. Carolyn H. Wood has suggested that in fact the composition makes more sense as it is depicted in the final drawing, the narrative sequence going from the plague victims in the left foreground to Aeneas's dreams in the upper right.[83] Most other scholars have also agreed with her second suggestion that Marcantonio must have found the reproduction and imitation of a wash drawing too difficult in an engraving, and therefore copied the drawing directly onto the plate, thus reversing the image.[84] In view of the similarities between the Uffizi drawing and those preparatory for the *Massacre of the Innocents* and the *Quos Ego* — near identity with the print and a pitiful state of preservation (not a customary occurrence in Raphael drawings, always very valuable and hence well treated) — we would contribute a further suggestion: the *Morbetto* was specifically designed by Raphael for Marcantonio to demonstrate the engraver's skills in reproducing the effects of light and darkness in the two halves of the same print.[85] It is akin in this respect to the so-called *Dream of Raphael* (B.359), a piece of bravura that Marcantonio had made in Venice to rival Giulio Campagnola,[86] and which constitutes the first night scene in an Italian print. If, as we are assuming, this print is indeed the result of such a close collaboration between Raphael and Marcantonio, it may well be that the painter suggested brush and wash instead of pen and ink as the best way to capture the effects of night and day in the preparatory drawing, one that he would not, however, wish to be damaged in the process. This being the first time Raphael had not prepared a pen and ink drawing for the engraver, Marcantonio could not easily transfer the image to the plate, and the composition was therefore copied onto it, resulting in a reversal. Marcantonio and his colleagues must have soon acquired the ability to transform the chiaroscuro obtained with brown wash into the cross-hatching of an engraving, however, since most of the other finished *modelli* related to prints were in fact done in this technique, and they are almost all in the same direction as the prints made from them (see below). This followed in the tradition set by Mantegna, who prepared richly tonal drawings for his engravers, and probably developed the use of transfer paper to reverse the image with ease, while preserving the prototype.

Much less preparatory material from Raphael's hand has survived for the last print in this group of major collaborative efforts, the *Judgment of Paris* (B.245; fig. 125). The first idea for this composition can be seen in a small grisaille in the Stanza della Segnatura, executed by a member of Raphael's school,[87] while a drawing of a *Venus* in Budapest[88] was used for the goddess in the print.[89] No other preparatory drawing by Raphael is known, but several copies of lost drawings testify to the effort which went into producing this striking image.[90]

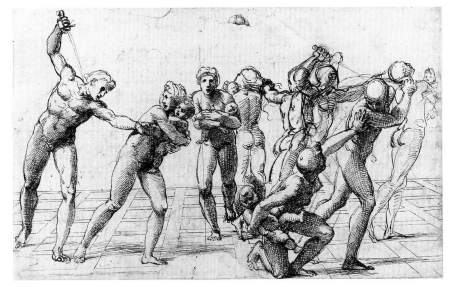

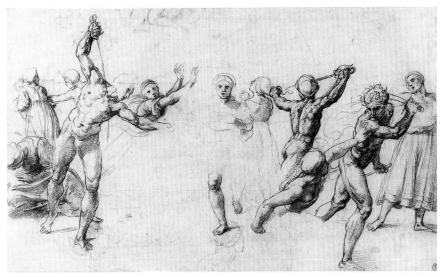

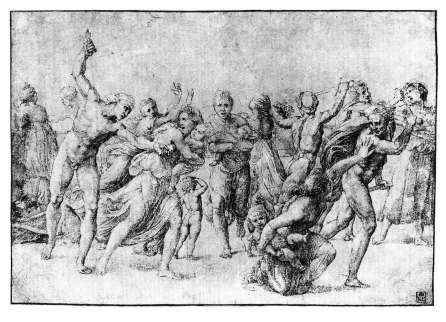

121. Marcantonio Raimondi, "*Morbetto*." Engraving (B.XIV.314.417), 195 × 248 mm. British Museum, London.

122. Raphael, study for "*Morbetto*." Pen and ink, chalk, and wash with white heightening, 200 × 249 mm. Uffizi, Florence.

126

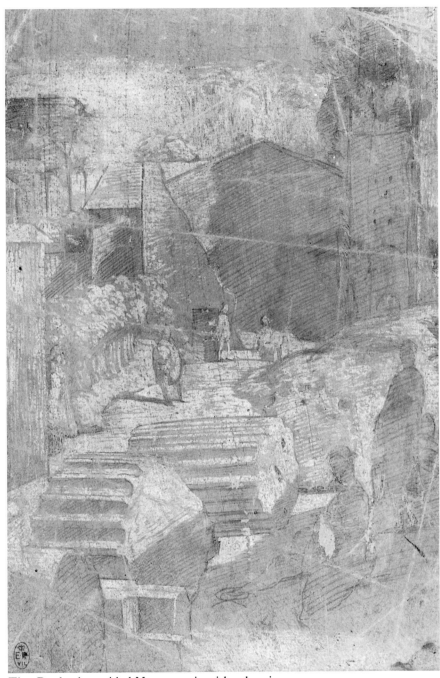

123. Raphael, study for "*Morbetto.*" Silverpoint and white heightening on prepared paper, 210 × 141 mm. Royal Library, Windsor.

124. Raphael, study for "*Morbetto.*" Pen and ink, sheet 256 × 322 mm. Royal Library, Windsor.

That Raphael provided Marcantonio with a drawing is most likely, not only because Vasari specifically refers to this when he mentions the print,[91] but because of the complexity of the image.[92]

There is one factor at variance with the assumption that the engraver had a detailed drawing at his disposal. The remarkably rich tone of the print, representing the darkness of night in the bottom half broken by daylight coming from the top right, was obtained by scoring the plate with some abrasive, such as a pumice-like stone (fig. 126).[93] But, as Delaborde was the first to notice,[94] Marcantonio had to score the plate *before* he started engraving it; had he had a *modello* to copy, he would not have needed to score the whole plate first, but only the area below the clouds, whose edge divides night

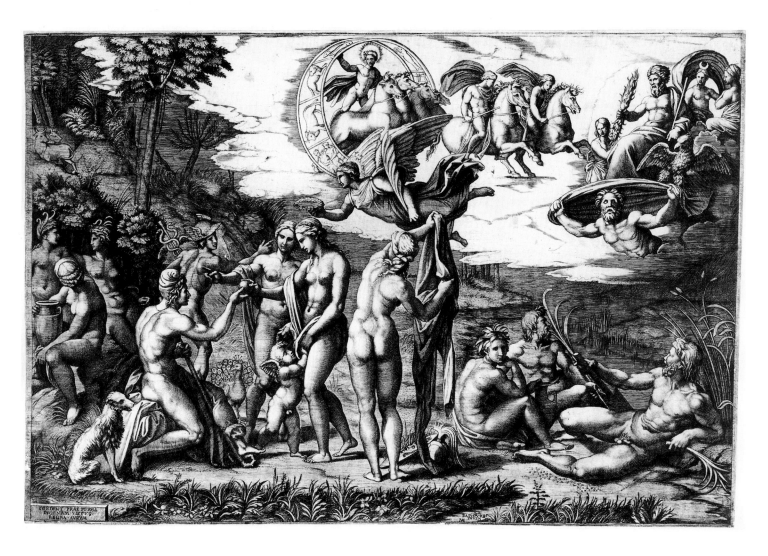

125. Marcantonio Raimondi, *Judgment of Paris*. Engraving (B.XIV.197.245), 298 × 442 mm. British Museum, London.

126. Detail, showing the scoring marks on the plate.

and day. A careful inspection of early impressions of the *Judgment of Paris* confirms beyond doubt, however, that Marcantonio did score the entire plate first and painstakingly burnished out the scoring marks from all the unshaded parts of the plate. That this was a tiresome task is shown by the fact that he left these marks in as many dark areas of the "daylight" side of the print as he could.[95]

Are the four cases described here significantly different from what one might expect to find in most other prints produced by Marcantonio, Agostino, and Marco for which preparatory drawings by Raphael, Giulio, or Penni are known? We have investigated another twenty-eight instances where we could discover one or more drawings by Raphael or his two close collaborators that most scholars accept as autograph and that are closely related to the preparation of a print. This excludes the hundreds of drawings generally held to be copies after prints rather than preparatory for them. The resultant group of thirty-two includes what must be a representative selection of those drawings by the hand of the three painters, either made specifically for one of the three engravers or made for a completely different purpose but used

by the engraver for a print, with or without the painter's knowledge or agreement. Each case relates to one print only, but may include, as in the instance of the *Massacre of the Innocents* or the *Morbetto*, a number of different drawings.

The most striking common feature is that, in twenty-five cases, the image in the drawing(s) and in the print is in the same direction. Since it is undoubtedly more complicated to transfer an image to a plate without reversing it, particularly if the engraver cannot sacrifice the drawing, we must ask first whether this means that all three engravers were obliged to follow the composition in the drawing, perhaps as a customary requirement on the part of its owner, and second, whether and when the use of transfer paper was introduced in Roman practice. If one divides the group further between sketches, however developed, on the one hand, and drawings that are obviously finished and highly detailed *modelli* on the other, one discovers that eleven of the seventeen sketches are in the same orientation as the print,[96] as are twelve of the fifteen finished *modelli*.[97] The three reversed drawings are that for the *Morbetto*, the Windsor drawing for the so-called *Blinding of Elymas* by

128

CEDENT PRAE FORMA
INGENIVM VIRTVS
REGNA AVRVM

Agostino Veneziano (B.43), and the Penni drawing in the Steinberg collection for the *Vintage Season* (B.306). That Agostino would be asked on this occasion to reverse the scene is not surprising, since Raphael had drawn it in reverse so it would appear correctly when woven into the tapestry for which it was originally conceived. The Steinberg drawing seems to constitute an exception as well, since it is quite different from the print[98] and, alone among these *modelli*, is of a considerably different size from its model (see below). We can conclude that at this early stage of the history of Italian "reproductive" prints, it was the custom for printmakers not to reverse the image of their source. Whereas Marcantonio would continue this practice after Raphael's death — as, for example, in his print after Peruzzi's Chatsworth rendition of the *Lion Hunt* demonstrates,[99] the convention lasted hardly a generation. Almost all the prints by Caraglio, the Master of the Die, or Bonasone were made in reverse of the drawings they follow.

The other common feature of the *modelli* is that they are all, with the single exception of the Steinberg drawing, very similar in dimension to the prints made from them. Allowing for shrinkage or expansion of the papers of both the drawings and the prints over the last five centuries, we are confident that the dimensions of the images were originally identical, and that a method of direct transfer from drawing to print must have been used. In the case of chalk drawings, a simple

method would have entailed using counterproofs. An example is the *St. Andrew* by Marcantonio, made from a drawing by Giulio, a counterproof of which has survived (fig. 127).[100] It is impossible to decide whether this means the drawings were made specifically in order to be engraved, but it is certainly safe to assume that, whatever their original purpose, these *modelli* were used by the engravers and were probably transferred to the plate using transfer paper. Were these drawings passed down to Marcantonio, Agostino, or Marco by il Baviera, as Vasari would have us believe; were they the final result of lively discussions between painter and engraver; or were they just lying about in Raphael's workshop where Marcantonio or his colleagues would drop by from time to time to see whether anything was available for them to engrave? We shall come back to these questions.

The third characteristic linking these *modelli* is that they are almost all "tonal" drawings, with a richness of shadowing not obtained with cross-hatching, as in the drawings for the *Massacre of the Innocents* and the *Quos Ego*, but through the use of brown wash and white highlights, very often on brown- or buff-prepared paper. Considering the difficulties this tonality caused for the engraver, this seems a strange choice for use in models and may lend weight to the hypothesis that the drawings were not made for the prints in the first place. On the other hand, Marcantonio may have soon discovered that following somebody else's cross-hatching system was itself an impossible task — the cross-hatching in the Budapest drawing for the *Massacre of the Innocents* is completely different from that in the print, as is that of the Louvre drawing by Ripanda that was faithfully engraved by Marcantonio in his *Triumph*.[101] Moreover, ever since the illustrious precedent of Mantegna's drawing for the *Virtus Combusta* and of the other drawings connected with prints produced in his school, wash drawings have very often constituted the intermediary step between a painting and the print made after it in later reproductive print-making.[102] It may therefore be that these "tonal" *modelli* were in fact required by the engravers themselves, possibly after Marcantonio had succeeded so marvellously in conveying the subtle tonal range of Raphael's *modello* for the *Morbetto*.

In the case of what we earlier called sketches, and which should better be called *concetti*, as opposed to *modelli*,[103] it is obviously even more difficult to find evidence that any were conceived in relation to a print. Their size is very rarely related to that of the print, and none of them, with the single exception of the Windsor drawing by Penni used by Agostino Veneziano for the left half of his *Tarquinius and Lucretia*,[104] is drawn in as complex a technique as any of the *modelli*. Most are in pen and ink, or in black or more often red chalk; many appear to be connected with other projects of the

Raphael workshop, whether paintings, frescoes, or tapestries, in some cases separated from the print by many years. One may safely assume that they were not conceived with a print in mind.

The problem of the finished *modelli* is more complicated. A much greater effort was required from the painter in order to produce such a drawing, and he would have done so only if he had a specific purpose in mind. In Raphael's workshop, *modelli* were normally the stage between *concetti* and *cartoni*,[105] and only a couple of dozen of them were produced by the artist, out of the 360 or so extant drawings from his prolific hand. Even if a *concetto*, particularly a slight sketch, may have lain unrecognized or been lost, it is most unlikely that a Raphael *modello* would not have survived. Since there are so few of them known, those that cannot be connected with any other work by Raphael or his close followers must have been produced with the print in mind. Of the fifteen we discussed above, seven are by Raphael, and five of these were transformed into prints by Marcantonio, one by Agostino, and one by Marco Dente. It seems probable to us that, with the possible exception of the Oxford drawing for the print *Alexander Preserving the Works of Homer*[106] — connected with a grisaille in the Stanza della Segnatura, but nonetheless much closer to the print than to the fresco — the other *modelli* were made by Raphael for Marcantonio.[107] Raphael's *modello* used by Agostino for the so-called *Blinding of Elymas* was not made with the print in mind, but the engraver must have been specifically asked to reverse the image. The *modello* for the '*Madonna del Pesce*' used by Marco Dente[108] may have been a presentation drawing, although, as Gere and Turner have noticed,[109] it is quite unusually finished for this purpose. Marcantonio seems to have used three *modelli* by Giulio,[110] all of which are related to other works as well; they were obviously used by the engraver some time after their invention, perhaps confirming Giulio's own testimony to Vasari that, out of respect for his master, he had never had any of his own compositions engraved during Raphael's lifetime.[111] Agostino does not appear to have used any *modello* by Giulio, and that used by Marco, the *Juno, Ceres, and Psyche* in the Albertina, seems in fact closer to the print than to the fresco[112] and was probably made for the engraver. Of the five *modelli* by Giovan Francesco Penni, that of the *St. Cecilia* in the Petit Palais must have been made for Marcantonio's print, as it is so different from Raphael's picture,[113] while the Steinberg, as we have seen, was almost certainly not. It is probable that the Oslo *modello* for the *St. Michael* was drawn by Penni for Agostino,[114] but it is unlikely that his *modelli* for *God Appearing to Isaac* (B.7) and *Noah's Sacrifice* (B.4), known only through the two copies in the Albertina,[115] were conceived in the first place for the prints rather than the Logge frescoes.

Although the results of our investigations into plates and preparatory drawings are not at all conclusive, a picture seems to be slowly emerging of an organized workshop where Raphael collaborated with Marcantonio while retaining some rights over the use of his drawings and over the ownership of the plates. If we now look more closely at the prints themselves, particularly at their relationship to each other, and, secondly, at the way our three printmakers signed or inscribed them, we may finally be able to reconstruct more clearly the methods and patterns of the Roman engraving school of the second decade of the century.

The Repetitions and the Copies

An aspect of this school that has always fascinated and puzzled scholars is the existence of what Bartsch called "repetitions," and what we shall in some cases call replicas. These can be distinguished from straightforward copies because copies normally repeat their source line by line, and even when they do not, they demonstrate a misunderstanding of some detail in the prototype rather than manifest any substantial contribution to the image on the part of the printmaker. The existence of a great number of copies, even within the same workshop, is not so surprising, particularly if one recalls the precedent of the many copies Giovanni Antonio da Brescia made of Mantegna's prints.[116] But, unlike copies, replicas had never cropped up before in the history of prints, and it is therefore worth studying them now with greater attention.

In our investigation we have attempted to examine all forty-two cases (series, such as the *Apostles*, are counted as one) in which a replica or a copy was made by Marcantonio, Agostino Veneziano, or Marco Dente of another print either by the same printmaker or by one of the other two. Although for the attributions we have relied heavily on the judgment of Bartsch and Oberhuber among many others, obviously it has been necessary to decide about the attribution of unsigned prints and about the precedence of one print over another. The reasons are argued only in the most significant cases discussed below, but even here they may be based mainly on connoisseurship. Moreover, the chronology given for the work of these artists, especially of Marcantonio, is often clearly at odds with what can be read in much of the literature; in a few instances we will try to justify this on the basis of an analysis of the inscriptions in the plates, but this is not the place to argue each case individually.

Of the forty-two instances, twelve are examples of Marcantonio repeating the same composition twice,[117] and three are Agostino doing the same;[118] in fifteen cases Marco Dente repeats a Marcantonio print,[119] and in seven Agostino does the same;[120] in one case Marcantonio repeats a print by Agostino,

128. Marcantonio
Raimondi, *Apollo*.
Engraving
(B.XIV.250.332),
216 × 141 mm. British
Museum, London.

129. Marcantonio
Raimondi, *Apollo*.
Engraving
(B.XIV.251.333),
321 × 149 mm. British
Museum, London.

in three Marco Dente does the same; and lastly Agostino repeats a print by Marco.[121] The repetitions are not always of the same type. First are those instances where an engraver made two prints of the same composition; second are those repetitions that can be seen as independent versions based on a common prototype; third are repetitions that seem closer to straightforward copies, where very little has been changed; and fourth are those instances where the copy is so close to its model that it can only have been made in order to deceive. We shall consider a few exemplary cases of each.

The most intriguing category is when the same engraver has apparently produced a replica of his own work. This practice has aroused the curiosity of all the scholars who have written about Marc-

antonio and Agostino, but only two explanations have found general consensus: either it is assumed that a print was so successful that the plate wore out and the engraver had to make a new one, or it is suggested that the printmaker, sometime later in his career, re-engraved the same image to show off his improved technique and style.[122] Both reasons are unconvincing. Neither event has ever been conclusively shown to have occurred in the history of printmaking. There is no plate that cannot be reworked again and again, as testified to by the hundreds that passed through the stocks of Salamanca, then Lafrery, then de' Rossi and on to many other publishers before reaching their resting place in the Gabinetto Nazionale delle Stampe in Rome. Nor, to our knowledge, has any printmaker

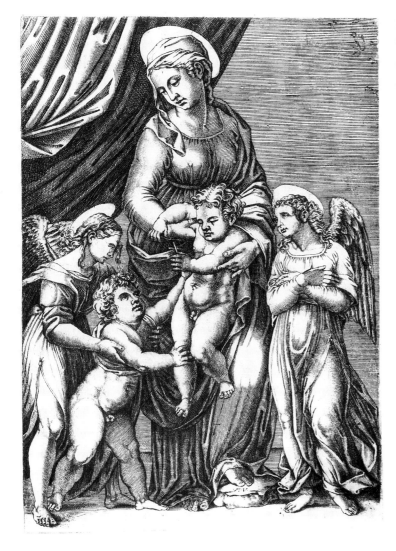
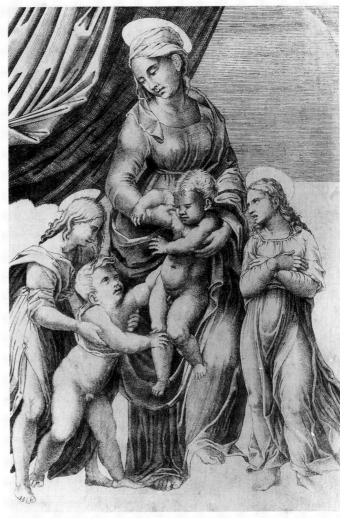

before or after Marcantonio and Agostino found the development of his own style and technique so compellingly significant, and his earlier work so mediocre, that he would re-engrave his own compositions in his later style. There must have been other, more practical grounds for going to the immense trouble of re-engraving a plate of the size of the *Massacre of the Innocents* or the *Bacchanal*. An obvious explanation is that the engraver could not pull more impressions from his successful plates for the simple reason that he no longer had access to them. Perhaps il Baviera really was holding on to them, and getting all the profit. But let us scrutinize the evidence further.

It is conceivable that its very mediocrity convinced Marcantonio that he should re-engrave his first *Apollo* (fig. 128). It is conceivable that he felt ashamed of the awkward perspective and unconvincing musculature of this youthful work. The replica (fig. 129) is not only reversed, but, more importantly, almost twice as large as the first version. It is obviously a completely new image of what must have been a popular subject, and we can well believe that at the height of his fame the artist

would not have wished to offer his first, inept attempt to his customers.

We might go as far as to admit that Agostino may not have been very proud of his first version of the *Virgin and Christ, St. John, and Two Angels* (fig. 130) and hence re-engraved it in his more mature style (fig. 131), but this interpretation cannot hold for Marcantonio's *Lamentation of the Virgin* (B.34, 35). The changes, such as the tree or the clothing of the Virgin's right arm, cannot possibly be seen as major improvements. The ordering of the versions is clear, since, apart from the stylistic considerations proposed by Shoemaker,[123] the wound on Christ's chest, not present in the Louvre *modello* or in the first version of the print, could certainly have been added, but never omitted. (Moreover, there definitely seems to be a small number *2* engraved — or should one say hidden — at the bottom left of the second brick from the left in the lowest layer, just above the grass. What better evidence than that?)

We have already discussed the number of drawings Raphael made for the *Massacre of the Innocents*, a composition obviously close to his heart, and one

130. Agostino Veneziano, *Virgin and Christ, St. John, and Two Angels.* Engraving (B.XIV.56.50), 242 × 170 mm. Albertina, Vienna.

131. Agostino Veneziano, *Virgin and Christ, St. John, and Two Angels.* Engraving (B.XIV.56.51), working proof, 251 × 171 mm. British Museum, London.

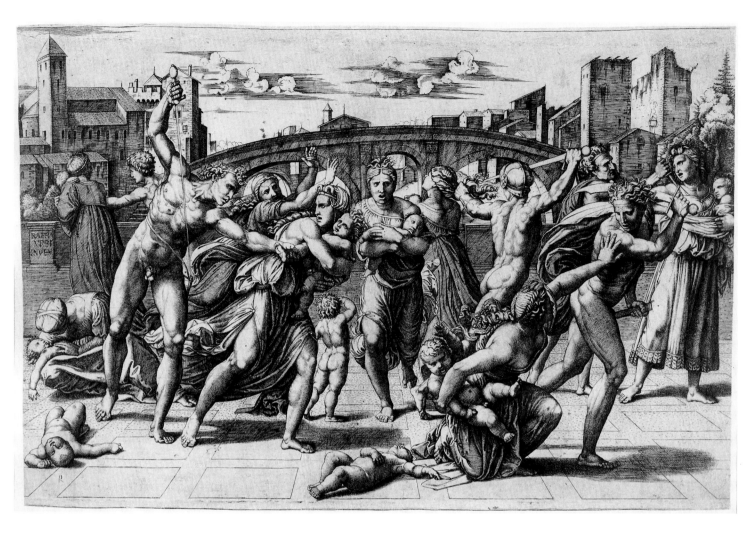

132. Marcantonio Raimondi, *Massacre of the Innocents*. First version, with fir tree. Engraving (B.XIV.19.18), state I, 283 × 434 mm. British Museum, London.

133. Marcantonio Raimondi, *Massacre of the Innocents*. First version, with fir tree. Engraving (B.XIV.19.18), state II, 283 × 434 mm. Museum of Fine Arts, Boston.

134. Marcantonio Raimondi, *Massacre of the Innocents*. Second version, without fir tree. Engraving (B.XIV.21.20), 280 × 425 mm. British Museum, London.

perhaps meant to be his and Marcantonio's answer to both the *Battle of Anghiari* and the *Battle of Cascina*. The evidence afforded us by the early surviving impressions shows that the engraver put great effort into it. There are at least three states of the print. The first, known to us only in an impression in the British Museum (fig. 132), shows a blatant mistake on the right edge of the body of the child standing with its back to us in the center of the composition; there is no hatching on the blade of the sword of the man wearing a helmet, and no inscription on the tablet. In the second state, of which there is an impression in the Boston Museum of Fine Arts (fig. 133), the shape of the child's body has been corrected, and the hatching has been added to the blade of the sword. The final state carries the inscription. The *Massacre of the Innocents* must have created a stir among its public: it was the most complex and articulated engraved scene since Mantegna's and Pollaiuolo's battles. It had all the ingredients for being a commercial success, and we have no reason to doubt that it was, as it was copied in all forms and sizes.[124] Why, then, would Marcantonio re-engrave it a few months or years later (fig. 134)?

Those scholars who see both versions as be-

ing by Marcantonio would seem to be correct, and we would add some observations to support Shoemaker's stylistic arguments for placing the version with the pine tree earlier.[125] First and foremost, the shape of the child's body in the second version corresponds to the later states of the version with the pine tree, where the mistake is corrected; second, a number of details in the second version appear as corrections of small mistakes in the first, such as, for instance, the perspective of the roof of the smaller house in front of the two taller buildings in the right background, or the chimney over it; third, the lettering of the inscription is crude in the version with the pine tree but classically refined in the replica; and fourth — significantly — the first plate had at both top and bottom very roughly sloping edges of irregular, rugged shape, whereas in the second the edges of the plate were cleanly cut. In all possible respects, the version without the fir tree shows a more mature, and far more technically competent, engraver, but the same hand.

There exist a number of other cases where the differences between the two versions of a print are minimal. In these, the second version can often be identified as such because it contains corrections to

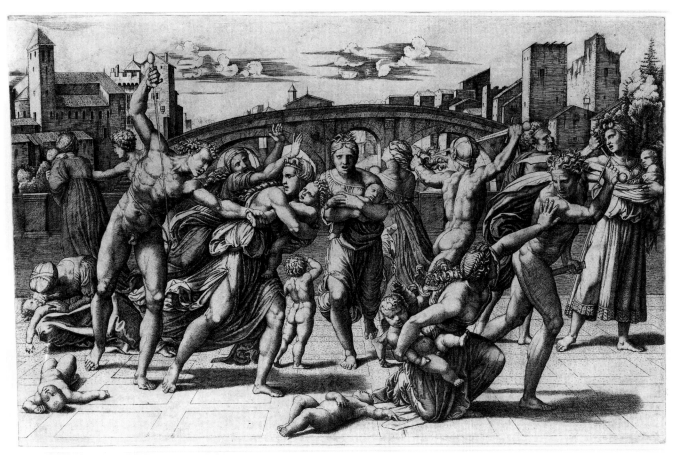

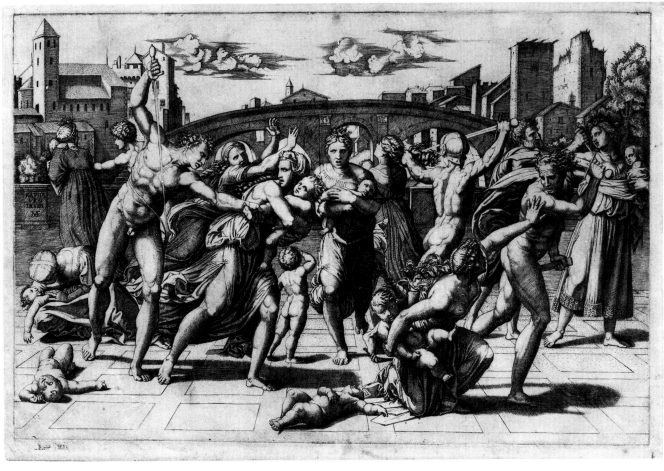

135. Marcantonio Raimondi, *Portrait of Leo X*. Engraving (B.XIV.368.493), 83 × 49 mm. British Museum, London.

136. Marcantonio Raimondi, *Portrait of Adrian VI*. Engraving (B.XIV.368.494), 83 × 50 mm. British Museum, London.

137. Marcantonio Raimondi, *Portrait of Leo X*. Engraving, undescribed, 83 × 56 mm. British Museum, London.

138. Marcantonio Raimondi, *Portrait of Adrian VI*. Engraving, undescribed, 84 × 60 mm. British Museum, London.

slight mistakes found in the first. This is difficult in such an extreme case as the *Venus after the Bath* (B.297, 297A), where one can spot hardly any differences, although the second, which seems more finely engraved than the first, is smaller, part of the drapery at the left having been omitted. The two replicas of the *Cleopatra* (B.199, 200) are also very close, the main difference being that the somewhat meaningless space above the figure has been reduced in what, contrary to Bartsch's opinion, must have been the second to appear (B.199). The two large *Bacchanals* (B.248, 249) are, again, very similar, although B.249 is in reverse, not surprising in a print of this size: it must have been very much quicker to copy it directly onto the plate. This is undoubtedly the second version, as early impressions show the traces of a letter *M* at the base of the herm, in exactly the same position as this letter of the monogram is found in the first version; but because the image had been reversed, there would not have been enough space to complete the monogram, and Marcantonio had to erase the *M* and engrave his cypher elsewhere.

There are two further examples of replicas where the pairs are so close that they have thus far escaped the attention of the cataloguers. The small portraits Marcantonio engraved of Leo X and Adrian VI (figs. 135–36) both exist in a second version (figs. 137–38), which are almost identical, line for line, the only difference being that the outer circle in one case does not reach the edge of the image, and in the other is cut by it. Possibly the repetitions where the outer circle is complete are the later ones, since the image is more successful here, and Marcantonio would not have made the mistake of breaking into the circle having done it correctly the first time. It is also possible that these small roundels were grouped on one plate, as is the case for some

other small prints by Marcantonio, and when he re-engraved one, he re-engraved them all.[126]

That the ownership of the plates must be the crux of the matter has already been hinted. Marcantonio, realizing that all the gains were Raphael's or, more probably, il Baviera's, may have started pirating his own most successful prints. Il Baviera could keep the plate of the first version of the *Massacre of the Innocents* — as we know he did, since it passed down to other publishers — and Marcantonio would keep that of the second, whose existence the publisher might never suspect. Whether Marcantonio would have started doing this before or after Raphael's death is a matter we shall have to come back to. But let us first see whether the evidence relating to the other replicas we have mentioned supports this theory. If il Baviera was in fact so much in control of the situation as we are here implying, it must have been not only through the ownership of the engraved plates, but also through careful use of the drawings by his master. If he was in charge of allotting the drawings to one of the three engravers, then we need to clarify their practice of engraving the same designs, copying each other, and competing against one another.

According to Bartsch, Marco Dente made copies or replicas of Marcantonio prints on at least fifteen occasions, and Agostino Veneziano on seven. Some of these must be discussed in greater detail, either because the evidence points to the engravers looking at a common source rather than at each other's prints, or because it suggests that the one making the repetition was Marcantonio rather than the other way round. The case of the *Virgin with the Long Thigh* (figs. 139–40) is revealing. At first sight, the two prints are quite different. There are major changes in Marco Dente's version: for example, the addition of a barrel at the left and of a window in

136

the center, and the exclusion of the ass behind St. Joseph. If, on the other hand, one compares the contour lines of the bodies, one realizes that in fact these are almost identical, even if such details as the facial expressions and the hair are quite dissimilar and are characteristic of the style of each engraver. Moreover, one can exclude the possibility that Marco used Marcantonio's print as his source, because he obviously misunderstood some parts of the architecture: he did not engrave the door at the top of the stairs, and he rotated the arch seen behind the wall at top left by ninety degrees, providing it, however, with a shadow whose contour is similar to the shape of the brick wall adjacent to the same arch in Marcantonio's print. It is thus apparent that the two engravers used a common source and not each other's print, and this was most probably a *modello* by Raphael, where, as was often the case, the landscape or background was adumbrated in the wash but not depicted in detail.[127] Even more strikingly different are the two versions of another *Holy Family* (B.60, 61), in the second of which the figure of St. Joseph is missing

entirely, and the faces, hair, and background could hardly be more different; yet the contour line of the Virgin and Child in the two prints can be superimposed, so close are they to one another. This is true even for so complex an image as the *Abduction of Helen* (B.209, 210), where the changes are again limited to the landscape or other parts of the background, to the hair, expression, and, at times, drapery of the figures, leaving their contours once again unaffected. We could say exactly the same for the *Galatea* (B.350, 351) or for the *St. Michael* (B.105, 106), the two versions of which are signed by Marco Dente and Agostino respectively.

Another common denominator in all these cases is that in each of them the two versions are engraved in the same direction, maintaining the composition of the common source. This is not surprising, as it corroborates our previous findings about the relationship between most prints and their preparatory drawings. The three versions of the *Three Marys Lamenting the Dead Christ* (figs. 141–43), the first by Marcantonio, the second and third by Agostino, share this feature, although a closer

139. Marcantonio Raimondi, *Virgin of the Long Thigh*. Engraving (B.XIV.65.57), 401 × 267 mm. British Museum, London.

140. Marco Dente, *Virgin of the Long Thigh*. Engraving (B.XIV.66.58), 405 × 269 mm. British Museum, London.

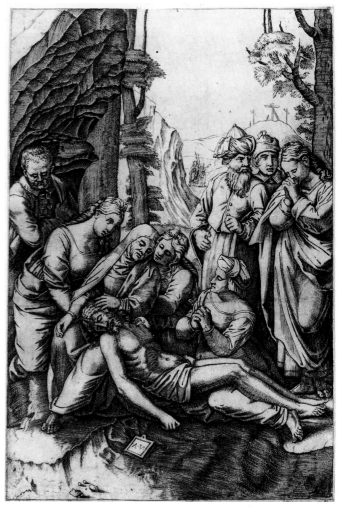

141. Marcantonio Raimondi, *Three Marys Lamenting the Dead Christ.* Engraving (B.XIV.43.37), 211 × 168 mm. British Museum, London.

142. Agostino Veneziano, *Three Marys Lamenting the Dead Christ.* Engraving (B.XIV.44.38), 239 × 163 mm. British Museum, London.

inspection of the prints, side by side, reveals something else. First of all, it is probable that Bartsch's order should be reversed, for Agostino would not have omitted the wound on Christ's chest had it been there; this would suggest a sequence similar to that described above for the more intimate *Lamentation of the Virgin* (B.34, 35). Second, the comparison makes quite evident that Agostino's second version (fig. 142) is not, as assumed by Bartsch, a copy of Marcantonio's print (fig. 141), but a replica of Agostino's own 1516 engraving (fig. 143), possibly made, as suggested for other similar instances, because Agostino did not have the plate in his possession any longer. It also becomes apparent that Marcantonio's print is a straightforward copy of one of the two versions by Agostino, probably the replica, to which only the wound on the chest of the dead Christ has been added.[128] We are entering here into a wholly different category of repetitions: the copies our three artists made of each other's prints.

These copies are of two quite disparate types: either they are repetitions where an engraver has copied the print of a colleague very closely, with no major changes to the composition or the details,

but without trying to hide in any way his own style or technique — indeed, very often signing his own version; or they are copies where an engraver has duplicated his prototype line by line, not altering even the smallest detail — including, in some cases, his colleague's signature.

The two versions of the *Last Supper* by Marcantonio and Marco Dente (figs. 144–45) fall into the first category. These appear practically identical, apart from the signature and the clear difference in style and handling of the burin characteristic of the two engravers: one print is a copy of the other. The relation of copy to prototype is an issue over which we are at variance with Bartsch: early impressions, such as the one in the British Museum, show that Marco Dente's plate is full of small *pentimenti*, changes that would certainly not be there had he been the copyist. For instance, there are traces of a knife at the extreme left of the table, eventually left out (fig. 146); the jug next to it has been moved to the right and upwards, after the right hand of the Apostle was moved to the right to make room for the jug. It is possible that Marco was required by il Baviera to make these small changes so that his print would follow Raphael's drawing (now in

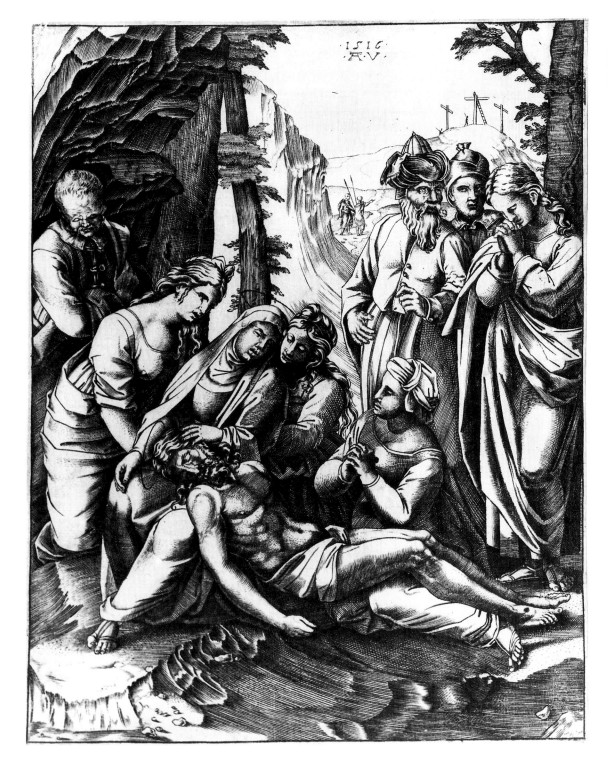

143. Agostino Veneziano,
*Three Marys Lamenting
the Dead Christ.*
Engraving (B.XIV.44.39),
215 × 168 mm. Albertina,
Vienna.

Windsor) more closely; the drawing is in too poor a
state to be able to say. But it is certain that in
Marcantonio's copy the position of the objects on
the table is repeated exactly from Marco's version,
thus suggesting Marco's precedence. It is also
useful to remember that it was the plate for Marco's
and not Marcantonio's version that eventually
entered Salamanca's stock — a fate, as we shall see,
that befell most of the prototypes, but very rarely
the copies.

There are many more examples one could men-
tion of this type of copy; most of them, how-
ever, show that the engraver did not bother about
the direction of the image, so that, unlike the
two instances just mentioned, or the *Hercules and
Anthaeus* (B.346, 347) which Agostino took from
Marcantonio, these copies tend to be reversed.[129]
How sloppy these printmakers could become is
shown in the series of *Christ and the Twelve Apostles*
(B.64–76, 82–91). Marco Dente copied Marcan-

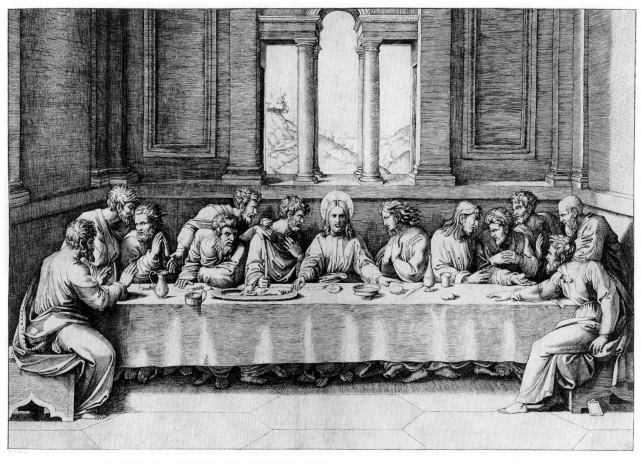

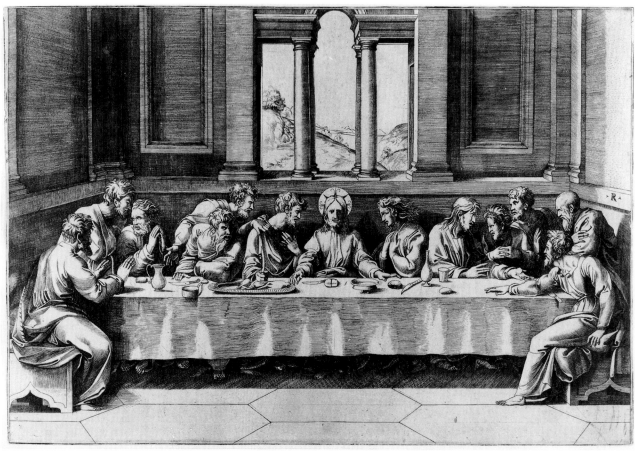

tonio's set straight onto the plate, and his prints are therefore reversed. We must dispute Oberhuber's recent claim that Marco must have engraved his series first because they are closer to Giulio's drawings in Chatsworth.[130] Surely, Christ would not be blessing with his left hand, nor would St. Peter hold his keys in his, St. Philip his cross, or St. Paul his sword!

Such incidents did not occur among the second type of copy emerging from this small, but obviously very busy, school. Marcantonio's *Virgin with the Cradle* was copied line by line by Marco (B.63, 63A), as was his *Martyrdom of St. Cecilia* (B.117, 117A), his *Dance of Cupids* (B.217, 217A), and, most sensationally, his *Judgment of Paris* (figs. 125, 147). In each of these cases, the only way to distinguish one from the other is to look at the two versions side by side, something more possible nowadays in the print rooms of the world than would have been true in the *studiolo* of a Roman connoisseur of the second decade of the sixteenth century. These copies must have been made with the intent of deceiving the customer by making him believe that he was acquiring a masterpiece by

Marcantonio. In Marco's *Judgment of Paris* not only does every line correspond to the original, including inscriptions and signature, but small mistakes and even slips of the burin in the original are faithfully repeated: the inverted letter *S* of the word *Sordent* has been left uncorrected; and the thin line parallel to the bottom borderline just below Marcantonio's monogram, a slip of the tool that makes the *F* of the cypher look like an *E*, even this has been repeated in Marco's copy (figs. 148–49). Why would Marco Dente go to such trouble? Not to mislead his unwary customers, who could hardly be expected to notice such minutiae in any case. But what about Marcantonio, who would surely have spotted the forgeries? Both engravers lived in Rome and were probably in close contact; the duplicates must have been made before Marcantonio left the city, since we know that Marco was killed during the Sack. We can offer only one possible solution to this mystery: the intended dupe of the forgeries was il Baviera. He must have been the keeper of all the original plates made by Marcantonio and his colleagues with Raphael's collaboration or after a Raphael *modello*, and he was

144. Marcantonio Raimondi, *Last Supper*. Engraving (B.XIV.33.26), 299 × 431 mm. British Museum, London.

145. Marco Dente, *Last Supper*. Engraving (B.XIV.33.27), 294 × 436 mm. British Museum, London.

146. Detail (of fig. 145), showing the *pentimenti*.

147. Marco Dente,
Judgment of Paris.
Engraving (B.XIV.198.246),
288 × 432 mm. British
Museum, London.

148. Detail (of fig. 125),
showing the inscription.

149. Detail (of fig. 147),
showing the inscription.

able to enjoy all the profits derived from the success of the whole operation — to such an extent that the printmakers took their financial stake into their own hands and started producing forgeries. If this explanation is correct, the culprits must have been either accomplices or deadly enemies, and we would likely know had they been the latter.

The Signatures, the Dates, and the Inscriptions

The most remarkable feature of the signatures in the school prints is the inconsistency with which they seem to appear. Marcantonio signed somewhat less than half of his prints with his monogram. Both Agostino and Marco Dente signed most of theirs. If any pattern can be recognized within Marcantonio's work, it is that he signed the vast majority of the work he did before settling in Rome, and that his monogram began by being very conspicuous and became more and more discreet as time went by. During his early years in Rome, when he was making more prints, particularly of small format, than ever before or after, he seemed

142

to sign about half of his output. But there seems to be no sure criterion to explain why some of these prints are signed and others are not. It may be that Marcantonio started by signing his Roman prints, as he had done once before, but then stopped, since there was little need for a monogram any longer. After all, until Agostino Veneziano's arrival, probably in 1514, Marcantonio was the only engraver of standing working in Rome, and his style was unmistakable. During the engraver's spell of activity under the influence of Raphael, very few prints appear to be signed. As has been recognized before,[131] many of the signatures on prints from this period were actually added in later states.[132] The most striking and, in this context, significant instance of Marcantonio not signing a print at this point in his career is the *Portrait of Raphael* itself (fig. 115), a print that he may have made in answer to Raphael's inclusion of Marcantonio's portrait in the Stanza della Segnatura. No late prints are signed with the monogram, Marcantonio having instead used the empty tablet that some authors have felt was meant more broadly to represent the school rather than Marcantonio himself.[133] Hirth's suggestion that this practice began around 1515[134] has been generally accepted. On purely stylistic grounds, however, and corroborated by the indirect evidence gleaned from Agostino's use of the tablet, this suggestion is not convincing. There can be little doubt that all the prints signed with the tablet and attributed to Marcantonio by Bartsch are in

fact by his hand; that is, twenty-four of twenty-seven, the other three being by Agostino. The important question is whether the blank tablet had some further significance. It appears unlikely that Marcantonio would feel the sudden need to distinguish his unsigned prints again in some manner, and would choose, for unknown reasons, the tablet instead of the more obvious and already well known monogram.

The inscriptions found on prints by Marcantonio tend to support the general pattern just outlined. Not counting the repetitions, there are just seven instances in which the engraver's monogram is associated with that of the inventor of the image: five times with Raphael (B.18, 116, 117, 245, 247), once with Michelangelo (B.488), and once with Baccio Bandinelli (B.104). The latter two are in their own way atypical. The *Bather* (fig. 150), after Michelangelo's cartoon for the *Battle of Cascina* dates almost certainly from 1509 when Marcantonio

150. Marcantonio Raimondi, *Bather*. Engraving (B.XIV.363.488), 210 × 134 mm. British Museum, London.

151. Marcantonio Raimondi, *Bathers*. Engraving (B.XIV.361.487), 284 × 228 mm. British Museum, London.

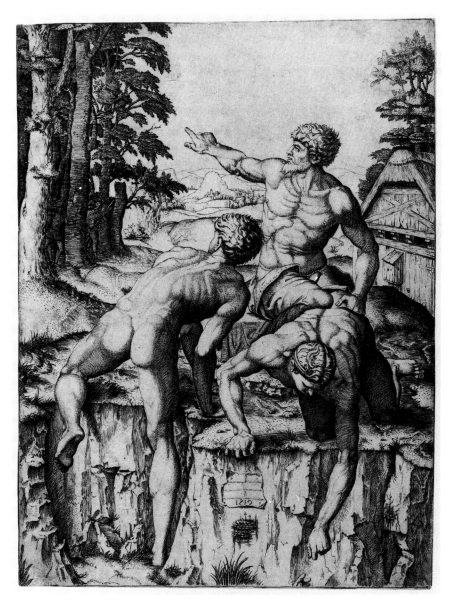

152. Titian and Ugo da Carpi, *St. Jerome.* Chiaroscuro woodcut from two blocks (B.XII.82.31), 156 × 96 mm. British Museum, London.

was in Florence, and, on stylistic grounds alone, predates the other, more complex rendition of the subject (fig. 151), which is dated 1510. It is thus the first engraving to join the names of a painter and an engraver, and is the first dated appearance in the history of printmaking of the word *invenit*: IV.MI.AG.FL./.MAF.[135] The *Martyrdom of St. Lawrence*, after a drawing by Baccio Bandinelli, a sketch for which is in the Louvre,[136] is connected with the famous episode recounted by Vasari about how Clement VII, when shown the drawing and the print, judged that the latter had greatly improved on the former. It can thus be dated sometime after 1525, when Marcantonio was released from jail for having engraved the licentious *Modi*, and when he seemed to owe a great favor to Bandinelli, who claimed to have been instrumental in his regaining his freedom.

Both these prints are therefore very far from the main corpus of Marcantonio's engravings, both in chronology and in character. Of the five prints bearing Raphael's name, only three, as we have seen, seem to have borne this inscription from their first appearance (B.116, 117, 245). Of the eight by Agostino Veneziano where the names of both inventor and engraver are inscribed in the plate, six bear Raphael's name and Agostino's monogram (B.6, 208, 244, 349, 492), one the painter's name

alone (B.42), and again one Michelangelo's and one Bandinelli's name. The *Cleopatra* after Bandinelli (B.193) is one of the earliest dated prints by Agostino, but its inscribed date of 1515 arouses suspicion, not because of the style of the engraving, which is consistent with his other prints of the period, but because it appears only in worn impressions.[137]

Strikingly coincidental with Marcantonio's case, the print bearing Michelangelo's name is also after the cartoon for the *Battle of Cascina* (B.423), and is dated 1523. All the prints Agostino did after drawings by Raphael have dates between 1523 and 1530, and the only one which is not dated, and which is likely to have been produced during the master's lifetime, is not signed. This is very consistent with the pattern found in Marcantonio's prints, and suggests more than just coincidence. Marco Dente's name is never associated on a plate with Raphael's, after whose drawings he made a number of prints, and in fact appears only once with any other artist — Baccio Bandinelli — on the plate for the latter's rendition of the *Massacre of the Innocents* (B.21).

It seems that an analysis of these inscriptions alone can be seen as strong evidence that, at least until Raphael's death in 1520, the prints by Marcantonio and his two colleagues were not intended to spread the inventors' names to the rest of the world. With the very few exceptions discussed, it appears that there were no "reproductive" prints bearing Raphael's name before his death; and those who encountered these prints as far away as Bari or Nuremberg could not have identified him as their inventor. In fact, it would appear that every effort was being made to suppress their authorship. What better example of this than the beautiful portrait Marcantonio engraved of Raphael, that bears neither the name of the sitter nor the monogram of the engraver?

Whether Raphael, il Baviera, or the engravers themselves instigated this self-effacing practice is impossible to say, but it appears that the initial function of these prints was to broadcast not particular works by Raphael, but, more generally, his "classical" designs, his *invenzione* and *disegno*. These came not in the form of careful reproductions of finished works such as paintings, frescoes, or even drawings, but as carefully chosen samples of the painter's revolutionary formal achievements, specimens of the "new" art, which could please the adept and inspire fellow artists. As these prints were "by" Raphael, there was no need for them to be signed.

If it is true that it was not Raphael's wish to see his name on the prints made after his drawings, and that engravers were discouraged from signing these plates with their own monograms, would this help clarify the mystery of the blank tablet? Could it not be that when Raphael died, Marcantonio and his colleagues wished once more to sign their plates

after Raphael's drawings? Agostino used his monogram again, and Marcantonio, perhaps out of respect for the wishes of his lost master and friend, used the empty tablet instead. It seems unlikely that we shall find any further evidence in Marcantonio's oeuvre to support this suggestion, but Agostino's plates offer us some help, since throughout his life he seemed very keen on inscribing them with his monogram and date.

Bartsch lists eight dated prints by Marcantonio, all between 1505 (B.322) and 1510 (B.487), including one after Dürer (B.643). There is at least one other, which probably reads "1506 = D i8," inscribed under the front beam, at right, in the *Annunciation* after Dürer (B.627).[138] Agostino Veneziano, on the other hand, dated dozens of his prints, from the earliest in 1514, also after Dürer (B.25), to the latest in 1538 (B.400). It is therefore possible to follow, almost year by year, his development as a printmaker, and this may help us in clarifying the riddle of the tablet, which Agostino himself employed no fewer than thirty-three times.[139]

The tablet appears in Agostino's prints in three different ways: empty, empty but accompanied by the monogram somewhere else in the print, and, finally, enclosing the monogram. There are only five instances in which the empty tablet appears on its own (B.194, 336, 406, 473, 491) and only two where both the empty tablet and the monogram appear, but separately (B.196, 426). The attribution of four of these prints is questionable: both the *Child Presented to Priapus* (B.336) — a copy of a print by Jacopo de' Barbari — and the *Man with a Laurel Branch* (B.491) are very similar to one another but so different from any other print by Agostino that it is hard to place them anywhere in his oeuvre. The *Emperor Meeting the Warrior* (B.196) is so close to a late Marcantonio in some parts that one is tempted to think of Agostino completing an unfinished print by his colleague, and a similar solution has often been proposed for the *Carcass* (B.426), whose attribution to Agostino has often been challenged.[140] The other three prints mentioned in these first two groups can be confidently dated to the early 1520s, for their style is closest

153. Ugo da Carpi, *Death of Ananias*. Chiaroscuro woodcut from four blocks (B.XII.46.27), 252 × 392 mm. Albertina, Vienna.

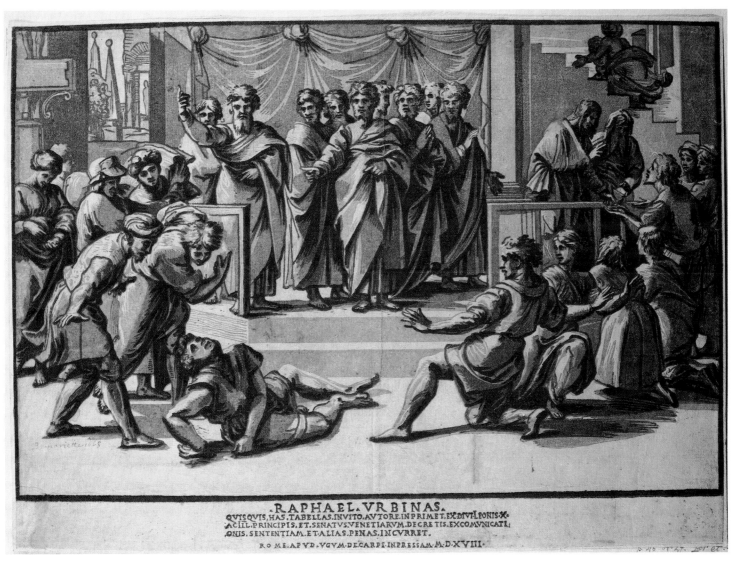

.RAPHAEL.VRBINAS.
QVISQVIS.HAS.TABELLAS.INVITO.AVTORE.IN PRIMET.EX DIVI LEONIS.X.
ACIIL.PRINCIPIS.ET.SENATVS.VENETIARVM.DECRETIS.EXCOMVNICATI,
ONIS.SENTENTIAM.ET.ALIAS.PENAS.INCVRRET.
RO ME.APVD.VGVM.DE CARPI.INPRESSAM.M.D.XVIII.

to the prints of that period (B.6, 198, 423, for example). By far the largest group is that in which the tablet is inscribed with Agostino's monogram, twenty-six engravings in all. Most of these are dated between 1530 and 1533 (B.201, 315, 316, 349, 541–45), and, in at least one other case, their late date is confirmed by other evidence.[141] Hence, Agostino's use of the tablet appears in all cases to follow Raphael's death. Is it not likely that Marcantonio did the same?

Conclusion

There is sufficient evidence to suggest that the plates for the prints Marcantonio engraved after Raphael's designs had a different history from those he engraved after his or other artists' designs. There is sufficient evidence to suggest that Raphael drew finished *modelli* for Marcantonio and his colleagues, and that the engravers had to follow specific rules with regard to size, direction of the image, closeness to the prototype in changes to the setting or figures, and the presence or otherwise of inscriptions and signatures. There is sufficient evidence to suggest that, even when these *modelli* may not necessarily have been conceived with a print in mind but were used for this purpose, the same rules applied. There is sufficient evidence to suggest that on those occasions where more than one engraver was given or allowed to use the same design, the same rules applied yet again, and that this was not the case when the engravers simply copied each other's prints. There is sufficient evidence to suggest that the engravers were forced to make deceptive copies of their own prints or of prints by their colleagues.

This evidence then corroborates Vasari's account of the school and shows it to have been a highly organized operation whose profits must have gone mainly to Raphael through the good services of il Baviera. The evidence also suggests, however, that the engravers may not have liked this situation and consequently started producing forgeries to fool either Raphael or il Baviera or, ultimately, the unwary buyer. It seems highly unlikely that this would have happened during Raphael's lifetime; we also know from an account given to Dürer by Tommaso Vincidor a few months after Raphael's death, that the Roman workshop had completely dissolved and his pupils and collaborators had dispersed.[142] Our conclusion is therefore that il Baviera must have held on to the plates, as Vasari claims he had been instructed to do, and that the engravers reacted in the only way they could to what must have seemed to them an arbitrary means of profit-making. If our interpretation is correct, then, with the few exceptions discussed in this chapter, both the forgeries and any of the prints after Raphael signed with a monogram or with a tablet — empty or not — were produced after 1520 to damage il Baviera and to redress the financial balance of the whole operation in favor of the engravers. Throughout the years of their collaboration with Raphael, all three had engraved prints from their own and from other artists' designs; Agostino, for one, seems at times to have been closer to Bandinelli than to Raphael. They almost certainly had their independent workshops, were probably proud craftsmen sometimes collaborating and sometimes competing with one another, and were respected figures among the Roman literati. Marcantonio was friendly with Aretino and even had access to the Pope, according to Vasari. Raphael's death struck this circle like a bomb: he had left behind a very considerable corpus of paintings, frescoes, buildings, tapestries, and drawings, but the world still expected much more from him. His premature death left a void that could be filled only by the prints Marcantonio, Agostino, and Marco had made and could make after his designs, prints that could travel widely and confirm the greatness of Raphael's inventions to those who had heard so much about him but had never been to Rome.

The step from these prints to "reproductive" prints was a small one: there must have been a sudden thirst for the novelty of Raphael's art, a novelty that had not needed recording while Raphael was alive and generating more and more new images every year. But that was past. On meeting Vincidor and hearing of Raphael's death, Dürer agreed to exchange his graphic oeuvre for a set of prints recording Raphael's designs. He must have been among the first to recognize the importance of preserving the master's ideas, something that must soon have become apparent to other printmakers in Rome. The Sack of Rome of 1527, among the many changes it brought to Italian art, abruptly terminated the first generation of engravers of Raphael's designs, and thus probably gave an unexpected impetus to the birth of reproductive printmaking during the following decade.

TITIAN, PARMIGIANINO, AND ROSSO AND THEIR COLLABORATION WITH UGO DA CARPI, CARAGLIO, AND ANTONIO DA TRENTO

In woodcut production, a form of collaboration between designers and makers, resembling what we have seen in Rome, had existed for a long time. As early as 1470 in Nordlingen, Friedrich Walther and Hans Hurning had their names appear side by side in the colophon of a *Biblia pauperum* on whose illustrations they had worked together, the former called *Maler* (designer) the latter *Schreiner*

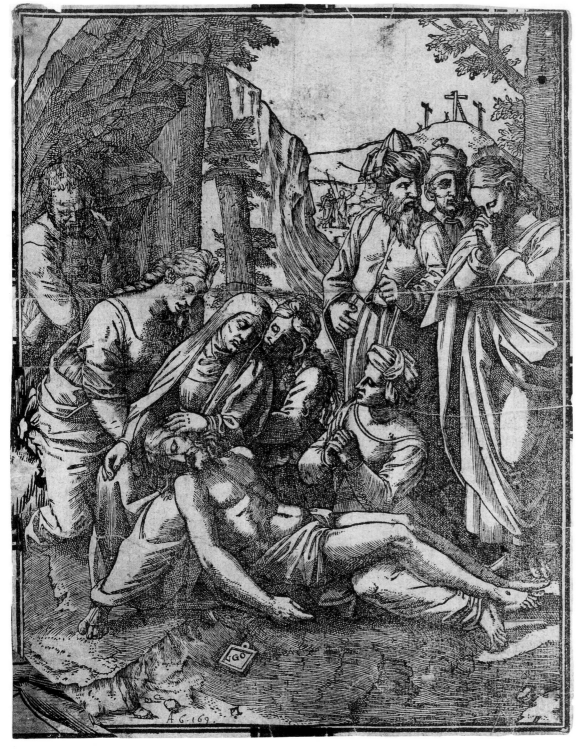

154. Ugo da Carpi, *Three Marys Lamenting the Dead Christ*. Woodcut, 218 × 172 mm. British Museum, London.

Following pages:

155. Ugo da Carpi, *Hercules Chasing Avarice from the Temple of the Muses*. Chiaroscuro woodcut from two blocks, first version (B.XII.133.12), 312 × 237 mm. Albertina, Vienna.

156. Ugo da Carpi, *Hercules Chasing Avarice from the Temple of the Muses*. Chiaroscuro woodcut from two blocks, second version, 297 × 228 mm. British Museum, London.

(cutter).[143] Much later in Venice a collaboration was celebrated in still more extravagant terms. On the last page of the *Legenda de Sancta Margherita Vergine & Martire Istoriata*, published in Venice ca. 1513–15, three octaves are dedicated to the three men involved in bringing the book to completion, the printer, the poet, and the cutter.[144] The first use of the term *fecit* appeared in Italy in the Bramante/Prevedari print of 1481, and of *invenit* in the Marcantonio/Michelangelo *Bather* of about 1509.

We find the first appearance of *pinxit* in a print in the large and beautiful woodcut of the *Virgin and Child with St. Sebastian and St. Roch* (fig. 81). The tablets at the top of the image bear two names: at the left and therefore the first to be read is *Benedictus pinxit*, the miniaturist Benedetto Bordon who had drawn the composition on the block; on the other side is *Jacobus fecit*, the cutter Jacob of Strasbourg or Jacobus Argentoratensis.[145]

The collaboration between Bordon and Jacob is

147

148

149

a particularly important one and yielded another print, a *Triumph of Caesar*, for which Benedetto was granted on 30 March 1504 a ten-year privilege by the Venetian Senate: "Benedetto Bordon, miniaturist . . . with very great labor and not indifferent expense took the initiative to print the drawings of the triumph of Caesar, drawing them first onto the blocks . . . and having them then cut in the said wood."[146] The wording of this application is of particular interest, since it indicates that the print was the fruit of a collaboration between a designer and a cutter, and that the former drew the images directly onto the woodblocks for his colleague to cut. The fact that it was Benedetto and not Jacob who applied for the privilege confirms the direct involvement of the designer as well as his financial interest in collaborative printmaking in Venice at the beginning of the century.

The example of Benedetto Bordon and Jacob of Strasbourg has considerable relevance for us, since it provides an important precedent for the *St. Jerome* signed by Titian and Ugo da Carpi around 1516 (fig. 152). This is not the first instance of Titian closely collaborating with a cutter in the making of a print,[147] but it is likely the first chiaroscuro woodcut produced by Ugo da Carpi, or at least the first one he released just before or after he applied to the Venetian Senate for a copyright on his "invention."[148] By that time Titian had been involved in at least one other important project, the *Submersion of Pharaoh's Army in the Red Sea*,[149] a woodcut of gigantic proportions, where the quality of the line makes it palpably evident that the painter drew the images directly onto the blocks, and supervised very closely the work of his unknown cutter. A second very large woodcut, the *Sacrifice of Abraham*, was grouped with the first in the copyright application made to the Senate in February 1515 by the publisher Bernardino Benalio.[150] This woodcut, also signed by Ugo da Carpi, was probably also drawn on the blocks by Giulio Campagnola,[151] confirming the vitality of such arrangements among artists in Venice during the second decade of the century, just at the time when similar alliances were being formed in Rome.

By 1518 Ugo da Carpi had moved to Rome. In fact by then he had set up his own workshop, probably in his house, finished at least one major chiaroscuro woodcut in four blocks, the *Death of Ananias* (fig. 153), and obtained a copyright for it from Pope Leo X. His copyright promises swift excommunication and further penalties for anyone daring to make an imitation of it. The inscription that appears in the first state of the print also mentions the privilege obtained from the Venetian Senate:

RAPHAEL.URBINAS.
QUISQUIS.HAS.TABELLAS.INVITO.AUTORE.INPRIMET.EX.DIVI.LEONIS.X.AC
ILL.PRINCIPIS.ET.SENATUS.VENETIARUM.DECRETIS.EXCOMUNICATI:
ONIS.SENTENTIAM.ET.ALIAS.PENAS.INCURRET.
ROME.APUD.VGVM.DE.CARPI.INPRESSAM.M.D.XVIII.

(Raphael from Urbino. Whoever will print these images without the permission of the author will incur the excommunication of Pope Leo X and other penalties of the Venetian Senate. Printed at Rome at Ugo da Carpi's 1518.)

As Jan Johnson has observed, however, the copyright on the Roman print appears more limited in scope than the one applied for in Venice, since it covers only this print and not the technique of chiaroscuro woodcutting as a whole.[152] Such a sweeping condemnation of copyists on Ugo's part seems somewhat misplaced; it is obvious from the prints themselves that he was not blameless in this respect. Indeed, comparison of this woodcut with its possible sources demonstrates quite unmistakably that Ugo copied the image from an engraving of the same subject by Agostino Veneziano (B.XIV.48.43).[153] Particularly interesting is that the inscription names Raphael as the (implied) creator of the composition. In this respect, the *Death of Ananias*, together with a number of other chiaroscuro woodcuts by Ugo, comes closest to our definition of a truly "reproductive" print. However, these prints are not in fact "reproducing" another finished work of art but merely copying another print. Moreover, they depart from Raphael's prototypes in one fundamental aspect: they do not try to emulate the tonal values of the frescoes, and we can surmise that they did not attempt to emulate those of a preparatory drawing either. As Caroline Karpinski has noted, the colors employed in the woodcuts printed while Ugo was in Rome — including the *Death of Ananias* — show no correlation whatsoever with the colors of any known drawing by Raphael.[154] We have seen that copying was a thriving activity among printmakers in Rome at the time, and how this phenomenon may have been a response to il Baviera's suffocating hold on the plates. Ugo had no obligations towards Raphael, il Baviera, or any other printmaker, and he was printing, according to the inscription, on his own premises. Hence, he was free not only to copy Agostino Veneziano's or Marcantonio's prints (such as the *Massacre of the Innocents* or the *David Slaying Goliath*) but also to inscribe them with Raphael's name in association with his own signature, something that, in our reconstruction of the activity of the school, no other printmaker had felt able to do. Ugo also copied in a woodcut, line by line, dot by dot, Marcantonio's replica (fig. 141) of Agostino Veneziano's *Three Marys Lamenting the Dead Christ* (fig. 154), and felt free to insert his name in the empty tablet, thus perhaps prompting Agostino to do the same in his second version of the subject (B.38, fig. 142).

It is unlikely that Ugo produced many prints that were not copies of other prints but original, independent works made alone or in collaboration with another artist. He was brought up in the block cutter's tradition, and in all surviving documents

157. Francesco Parmigianino, *Adoration of the Shepherds*. Pen and ink and wash with white heightening, 188 × 245 mm. Graphische Sammlung, Weimar.

158. Jacopo Caraglio, *Adoration of the Shepherds*. Engraving (B.XV.68.4), 210 × 243 mm. British Museum, London.

152

RAPHAEL VRBINAS

PER VGO DACARPI

160. Ugo da Carpi, "*Raphael and His Mistress.*" Chiaroscuro woodcut from three blocks (B.XII.140.2), 181 × 144 mm. Metropolitan Museum of Art, New York.

and inscriptions he always describes himself as a cutter, or as a printer. It seems unlikely that he would attempt to invent a design for a chiaroscuro woodcut by himself. Nearly all of his Roman prints appear to be copied from engravings by his contemporaries. One such is *Hercules Chasing Avarice from the Temple of the Muses* (fig. 155), where the names of both Baldassarre Peruzzi and Ugo are inscribed in the outline block, suggesting either that Ugo used a drawing by Peruzzi or, more in line with past practice, that he collaborated with the Sienese artist in the production of the print. Vasari refers to this very print,[155] although he confuses

the issue by claiming that it was cut by Peruzzi. One wonders whether Vasari assumed this because, as was to be expected, Peruzzi retained the two blocks. Another quite curious feature of the print supports this. What were assumed by all previous scholars to be two states of the same print (the second of them quite subtly reworked) have been shown by Jan Johnson to be two almost identical versions of the same subject (fig. 156).[156] In the second it seems obvious that the cutter was trying to mislead his customers, repeating every line and dot with such precision that even a comparison of two impressions side by side would deceive all

159. Ugo da Carpi, *Sybil Reading, Facing Right.* Chiaroscuro woodcut from two blocks (B.XII.89.6), 287 × 240 mm. Metropolitan Museum of Art, New York.

153

but the most perceptive eyes. This is of course a familiar scenario by now. It happened with many engravings by Ugo's colleagues in Rome, and might be explained by a similar hypothesis, namely that Ugo lost access to the blocks because they reverted to Peruzzi, and so he replicated them.[157]

Did Ugo ever collaborate with Raphael, whose name he used freely in his woodcuts? There are two prints for which such a possibility should be entertained, as they stand out quite dramatically from his other productions in Rome. The first of these is the *Sibyl Reading, Facing to the Right* (fig. 159), which Johnson was the first to recognize as the original version among the four described by Bartsch, who clearly mistook their order of precedence.[158] The second is the so-called *Raphael and his Mistress* (fig. 160), a small, mysterious, and fascinating print. The intimate, tranquil settings remind us of Raphael's two beautiful drawings in Oxford and Chatsworth of *Mother and Child*, one of them portrayed reading a book. Somehow these two woodcuts appear more daring than any other made by Ugo in Rome, and by inscribing the second PER.VGO.DA CARPI, Ugo seems to acknowledge his status as a mere vehicle for somebody else's design, perhaps indicating the more direct involvement of another artist than hitherto.

A similar form of signature appears in the woodcut done with or after Baldassarre Peruzzi, and reappears, accompanied by the name of Francesco Parmigianino, in what is universally considered Ugo da Carpi's masterpiece, the *Diogenes* (fig. 163). It is interesting to note that another feature links these two prints: as in the description of the *Hercules Chasing Avarice*, Vasari here again seems muddled about the author of the cutting. Just as he claims for the *Hercules* that Peruzzi cut the block, he writes of the *Diogenes* that Parmigianino cut it himself,[159] although elsewhere he contradicts this by suggesting that the painter had it cut ("fece intagliare").[160] As might have been the case for the *Hercules Chasing Avarice*, the designer could have kept the blocks, while a very deceptive replica by Ugo circulated unrecognized.[161] On Popham's authority,[162] most authors have agreed that this woodcut was made by Ugo as a copy of an engraving by Jacopo Caraglio (fig. 164), who was working on prints in Rome in very close collaboration with Parmigianino until 1527.[163] Popham's opinion in matters relating to Parmigianino cannot be taken lightly, but a comparison between the chiaroscuro and the engraving demonstrates so overwhelming an aesthetic superiority of the former that we are willing to challenge the good scholar's order of priority. There are several factors supporting this thesis. First, the engraving is much smaller than the woodcut, and the disparity of size would have made Ugo's job exceedingly complicated, as well as totally unprecedented. We know he had copied other prints in the past without difficulty, but in all cases their dimensions were similar, if not nearly identical. Corresponding size was a feature common to practically all such copies made in Rome at the time. Second, wherever Ugo's model can be identified, we find that the copy never omits, adds, or radically changes important details of the composition, as it does in this case. Third, there is no precedent for Ugo making what can only be called a powerful image from so weak a model. This is Ugo's masterpiece, and he must have had Parmigianino's hand very close to his woodblock when he produced it.

Parmigianino collaborated on some scale with three or possibly four printmakers in the 1520s and early 1530s, and we shall look at these relationships with some interest, as they confirm what had by now become a pattern in Italian printmaking of the period: some of the greatest artists of the time were using some of the best contemporary printmakers to make independent images that could spread their *invenzione* and *disegno* quickly and effectively. Parmigianino made at least one important, highly finished drawing specifically for Iacopo Caraglio to engrave: the *Adoration of the Shepherds* in Weimar (fig. 157).[164] As was the case with most drawings made for Marcantonio, Agostino, and Marco Dente by Raphael, Giulio, and Penni, this is drawn in pen and ink and wash, heightened with white, achieving a rich variety of tonal values for the engraver to emulate with his hatching. As Karpinski has observed, in this drawing the figures are outlined with a stylus.[165] Caraglio was quite successful in recreating the effects of a night sky lit by a falling star (fig. 158), much more so than he apparently was in his version of the *Diogenes* (B.XV.94.61), for which, however, the preparatory drawing has not survived.

Parmigianino's drawings for Caraglio became more and more ambitious in scale and scope, and it is possible that the drawing in Chatsworth (Popham 692), faithfully transformed into one of Caraglio's finest prints (B.XV.66.1), was done with the purpose of showing off through an engraving Parmigianino's ability to create complex compositions of figures in an articulated and complicatedly lit architectural setting. A similar case is that of the *Martyrdom of St. Peter and St. Paul*. Though the drawing has not survived, it has come down to us in two quite different versions: an engraving by Caraglio (fig. 161) and a chiaroscuro woodcut by Parmigianino's other great collaborator, Antonio da Trento (fig. 162). A comparison of these two versions is most instructive and may help dispel suspicion that either of them can be thought of as "reproductive." The engraving was produced in Rome before the Sack of 1527, and the woodcut in Bologna just after artist and block cutter had moved there in the same year. Yet the changes are substantial and were first worked out by Parmigianino in a number of separate sketches.[166]

161. Jacopo Caraglio, *Martyrdom of St. Peter and St. Paul*. Engraving (B.XV.71.8), 256 × 445 mm. British Museum, London.

162. Antonio da Trento, *Martyrdom of St. Peter and St. Paul*. Chiaroscuro woodcut from three blocks (B.XII.79.28), 288 × 475 mm. British Museum, London.

There can be no doubt that Parmigianino and Antonio da Trento worked side by side in the production of chiaroscuro woodcuts. According to Vasari — whose word can be believed in this case, since he was in Bologna in 1529 for the preparations of the coronation of Charles V — the painter and the printmaker lived together in Parmigianino's house after Antonio had escaped from Rome at the time of the Sack.[167] Vasari mentions a number of woodcuts the two artists produced then, including the *Martyrdom of St. Peter and St. Paul*. There

are more than twenty drawings by Parmigianino directly connected with the woodcuts made in Bologna, and they well illustrate the process of continuous re-elaboration of an image, particularly in the relationship between light and dark, until it was ready for the block cutter to interpret and transform into final form.[168] Their collaboration was not successful for long. Vasari recounts how early one morning while Parmigianino was still asleep, Antonio da Trento opened his coffers, stole all the engravings and woodcuts as well as all the

155

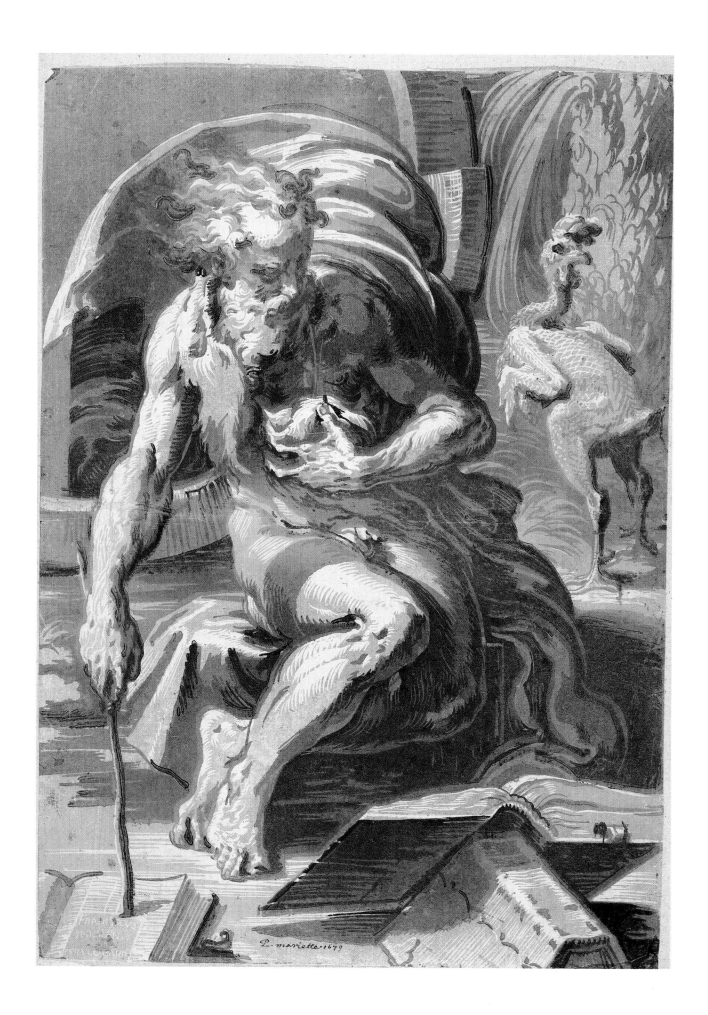

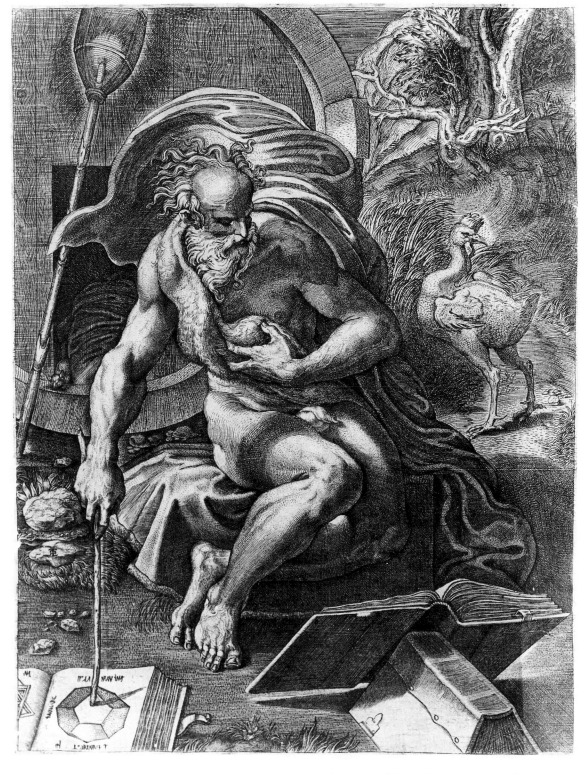

164. Jacopo Caraglio,
Diogenes. Engraving
(B.XV.94.61),
287 × 218 mm. Albertina,
Vienna.

drawings he could find, and made off never to be seen again. Vasari goes on to say that Parmigianino managed to get the prints back, because they were left with a friend in town, but he never retrieved his drawings.[169] It seems probable that what Antonio took, and what Vasari meant to suggest, were the plates and woodblocks rather than the prints themselves. The former would have been of much greater use to him, but at the same time difficult to trans-port because of the weight and bulk of the copper plates and woodblocks (sometimes three for each print), a burden for Antonio who was attempting to disappear quickly from the scene.[170]

Popham suggests that Parmigianino's relationship with the block cutter Niccolò Vicentino was of a quite different nature. He argues that the two did not collaborate in the making of chiaroscuro woodcuts, and that those the block cutter made

163. Ugo da Carpi,
Diogenes. Chiaroscuro
woodcut from four
blocks (B.XII.100.10),
490 × 354 mm. Albertina,
Vienna.

157

after the painter's drawings were done after Parmigianino's death, and are therefore straightforwardly reproductive prints. This is also suggested by Vasari,[171] who must have known, as these events took place at the time he was writing the *Vite*. It may be that Parmigianino's drawing of *Christ Healing Lepers*, now in Chatsworth (fig. 165), was among those stolen by Antonio da Trento (their fate is unknown), and that Niccolò acquired it in order to make a woodcut after it (fig. 166). It seems made specifically to be translated into a chiaroscuro, with a careful working-out of the three tones in the composition. If, indeed, the print is not the fruit of a collaboration between designer and cutter, it well illustrates how skillful the professional cutters of the time had become in the reproduction of finished drawings. During the 1530s Niccolò collaborated closely with Pordenone in at least two magnificent woodcuts, a *Saturn* (B.XII.125.27) and a *Marcus Curtius*,[172] for the first of which a beautifully finished drawing exists.[173] Their character is so similar to Niccolò's *Christ Healing Lepers*, and so dissimilar to the reproductive work he was churning out at the time, that one is tempted to suggest that Parmigianino had a say in its making.

Vasari also mentions that Parmigianino was collaborating in Bologna with an engraver, one Girolamo Fagiuoli, of whom we have no trace,[174] and that "he had many plates there to be engraved on copper and printed, as he had Antonio da Trento there for this purpose."[175] We have no evidence that Antonio was in any way involved with any technique other than woodcutting, but the passage can be read to imply that he could assist the painter with the printing alone. It is clear that another printmaker was involved with Parmigianino in Bologna between 1527 and 1530, this time an etcher. Popham has gone some way towards reconstructing the relationship between the twenty-six etchings signed *F.P.* and a bewildering number of drawings by or after Parmigianino, chiaroscuro woodcuts, and other copies made of this group of etchings.[176] He shows that these two series of small etchings — one devoted to the *Apostles* and the other to mythological and allegorical subjects — because of the work gone into their preparation, must have been produced "under Parmigianino's supervision by a craftsman in his employment."[177]

In Rome Parmigianino had learned to collaborate with leading printmakers in order to produce prints, and it is significant that he attached so much importance to this activity even after leaving the city, and probably even after having started making etchings from his own designs. Evidently he did not consider Caraglio's or Antonio da Trento's prints to be "reproductions" of his work, just as Raphael did not consider Marcantonio's as such. The tradition of this kind of collaboration was well established in Rome when Parmigianino arrived there, so much so that Caraglio, as we shall soon

see, was in no position to devote all his time to the genius from Parma.[178]

Caraglio was spending most of his time, at least between 1524 and 1527, with Rosso Fiorentino, who was in Rome during this period, and who devoted his energies almost entirely to the production of more than thirty *disegni di stampe* for Caraglio to engrave.[179] Their relationship was very close, so much so that the final result of such a collaboration could at times be more successful than the preparatory drawing made for it. This is evidently the case with the *Pluto in a Niche*, where Caraglio's engraving (B.XV.78.30) betters the drawing, now in Lyons.[180] There were also alterations between the preparatory drawing stage and the final translation into a print. In the drawing *Bacchus in a Niche* now in Besancon (fig. 167), part of a dog appears, its missing parts covered in a *pentimento*; the dog is omitted in its entirety from the engraved version (fig. 168). Carroll was certainly right in suggesting that such a change must have been discussed by the two artists before the plate was engraved.[181] It is interesting to note that both these drawings, as we know was customary in Raphael's workshop, are in the same orientation as the prints and identical to them in dimension. Linking the two groups even more closely is the fact that the plates for most engravings by the Rosso/Caraglio partnership apparently belonged to our old acquaintance il Baviera, as they had all been commissioned by him.[182] Rosso is said to have fallen out with il Baviera just before the Sack, explaining why only two prints in the series of the *Loves of the Gods* were produced by this partnership, while another sixteen were commissioned by il Baviera from the Perino del Vaga/Caraglio partnership. The two produced by Rosso/Caraglio are numbered *1* and *8* in the series, and late impressions of them are printed with late impressions of the other prints from the series, suggesting that the plates belonged neither to Rosso nor to Caraglio, but to il Baviera. This is indirectly confirmed by the absence of plates among Rosso's possessions when he hurriedly fled Arezzo in 1529, though there were, for instance, dozens of drawings.[183]

The small scale of the printmaking circle in Rome is indicated by the earliest of the engravings Rosso designed, the *Allegory of Death and Fame*. He entrusted this not to Jacopo Caraglio but to Agostino Veneziano, as early as 1516. Rosso's highly detailed, finished drawing (fig. 169) was translated into a magnificent print by Agostino (fig. 170), who proudly signed it, for the first time with his full name: AVGVSTINVS/.VENETVS.DE./ MVSIS./ FACIEBAT./1518./.A.V. (B.XIV.320.424). As Carroll has observed, it is certain the drawing was specifically made to be engraved, since it was drawn in reverse. The action reads more logically in the print than it does in its model, the right-handed gestures appearing more natural than the

165. Francesco Parmigianino, *Christ Healing Lepers*. Pen and ink and wash with white heightening, 271 × 420 mm. Duke of Devonshire and the Chatsworth Settlement Trustees, Chatsworth.

166. Niccolò Vicentino, *Christ Healing Lepers*. Chiaroscuro woodcut from three blocks (B.XII.39.15), 297 × 411 mm. Metropolitan Museum of Art, New York.

159

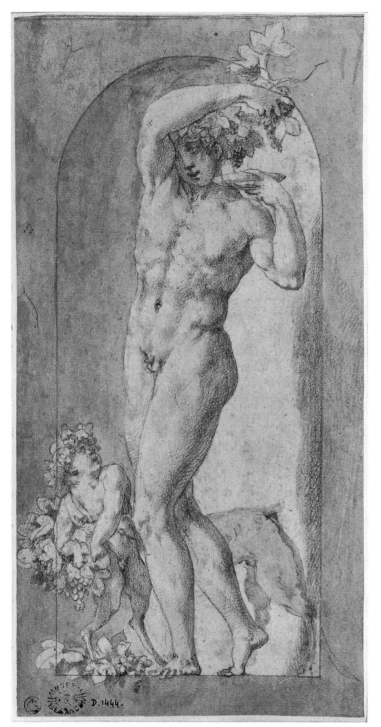

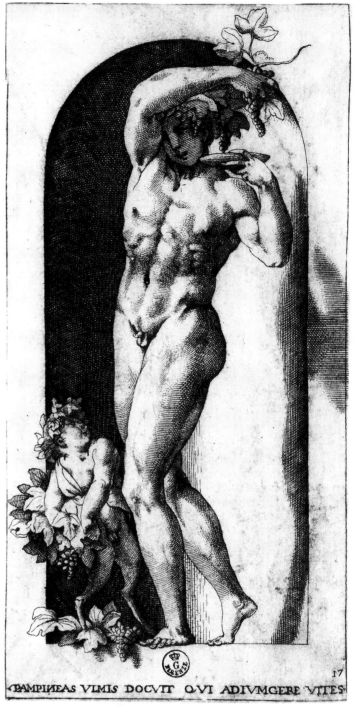

PAMPINEAS VLMIS DOCVIT QVI ADIVMGERE VITES

167. Rosso Fiorentino, *Bacchus in a Niche*. Red and black chalk and wash, 215 × 110 mm. Musée des Beaux-Arts, Besançon.

168. Jacopo Caraglio, *Bacchus in a Niche*. Engraving (B.XV.79.40), 215 × 109 mm. Uffizi, Florence.

left-handed of the drawing.[184] What is, however, unlikely is Carroll's suggestion that Rosso sent this drawing to Agostino in Rome, while himself remaining in Florence. This was one of the largest and most complex compositions yet attempted in an engraving, measuring over half a meter in width and including some twenty-five figures, a worthy rival for the *Battle of Anghiari*, the *Battle of Cascina*, and the *Massacre of the Innocents*. We do not know Agostino's movements at the time, but we must at least accept Karpinski's suggestion that he possibly went to Florence for this commission,[185] since it

seems incredible that Rosso would not have wanted to supervise the engraver's progress in the creation of a work so crucial to the establishment of his fame. We must not forget that these events were taking place only a few years after the onset of the activities of the Roman "school," when the idea of a "reproduction" of a finished drawing, even if commissioned by the draftsman himself, must have appeared totally foreign to contemporary practice. Twenty years later such attitudes had changed completely, and reproductive prints proper began to appear in droves.

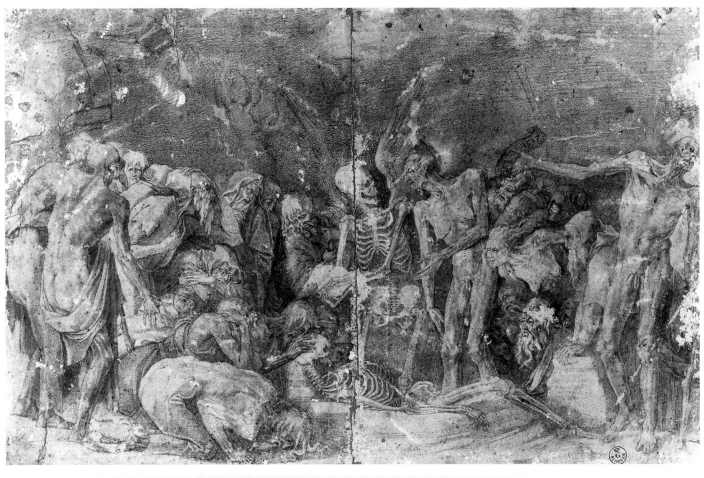

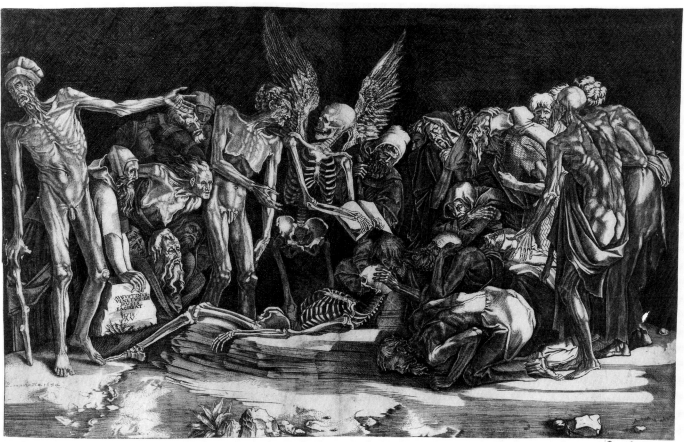

The Birth of the Reproductive Print

Thus far, in our reconstruction of the events leading slowly to the birth of the reproductive print, we have not yet found an example that fulfills all the criteria required by a strict definition of this practice as it pertained to Italian printmaking in the Renaissance: a print that was a faithful and complete copy of an independent work of art in another medium; a print whose apparent purpose was to provide a straightforward representation in black and white of another work either in black and white or in color; a print that was not the fruit of collaboration between designer and printmaker; and, lastly, a print whose maker's exclusive purpose was to adapt his technical skills to the reproduction of the chiaroscural effects of his model.

The prints produced in the second and third decades of the century by Marcantonio, Agostino Veneziano, and Marco Dente after finished *modelli* by Raphael, Giulio Romano, Penni, or other artists cannot be called reproductive even in those cases where we assume the *modello* was not made specifically with the print in mind. Such prints surely fall within the tradition of those made under the creator's supervision, as we can only think of il Baviera as a faithful arm of Raphael's wishes, even after the latter's death. It further appears more than likely that the other painters of Raphael's school followed the house rules in their dealings with the printmakers. There is no evidence to the contrary. Similar arguments apply to most of the instances we have touched upon, and the many more not mentioned or discussed. This constitutes a strong case for the presumption that no reproductive print was produced in Italy before about 1530, at the earliest.

Earlier in this chapter we have taken into account a number of cases in which fifteenth-century printmakers copied entire compositions from drawings by other artists; it remains to consider the few instances in which they used frescoes or paintings as models, to assess whether these are instances of reproductive printmaking or whether we are, again, faced with examples of appropriation. The woodcuts adorning the first book printed in Rome, Turrecremata's *Meditationes*, are supposed to reproduce a cycle of lost frescoes in Santa Maria sopra Minerva, Rome, because so much is said in the colophon: "Meditationes ... Johannis de turre cremata ... Romane ecclie cardinalis depicte de ipsius mādato in ecclē ambitu Ste. Marie de Minerva Rome" (Meditations of Johannes de Turrecremata ... by the cardinal of the Roman Church ... painted by his command in the church of Santa Maria sopra Minerva). This inscription has misled countless scholars.[186] Although the reason for such a claim in the colophon of the

book is still unexplained, it has been recently shown that these cuts must have been based on an illuminated manuscript.[187] There are two other prints whose composition is close to the fresco of *Hell* by Buffalmacco in the Camposanto of Pisa (H.V.A.I.59, 60), yet a close comparison confirms that in both cases the printmakers changed a substantial amount of detail to suit their own needs and to fit the format of their plates.[188] On the other hand, the print closest to the fresco (fig. 171) bears an inscription of particular interest to us here: QUESTO.ELINFERNO.DEL.CHĀPOSANTO.DI PISA. (This is the *Hell* of the Camposanto of Pisa). Although no early impressions are known of this print before it was heavily reworked,[189] the inscription follows fifteenth-century spelling and the type of lettering commonly found in Fine Manner prints and is probably original. Its anonymous author thus appears to have been the first printmaker to acknowledge the source of his creation in a manner that became common about half a century later: whether this print was meant to be used, so to speak, as a "postcard" or as a powerful and frightening depiction of Hell, we do not know, but it represents an important precedent of an engraver reminding his customers that the *inventio* of the image was not his own. Not too dissimilar is the case of another anonymous print, *Dante as Poet of the Divine Comedy* (fig. 172), dated by Hind ca. 1465–80, which "reproduces" the 1465 frescoes of the same subject by Domenico di Michelino in the Duomo of Florence (fig. 173).[190] The comparison between model and resulting print is illuminating: if not the size, the format of the two is similar, and so is the position of the figures and buildings within the composition. In both there is a two-line inscription at the foot of the scene and, although that in the fresco is in Latin and that in the print in Italian and much simplified, they convey the same message. Whereas the overall appearance of the two images is thus similar, inducing the casual viewer to describe the print as a reproduction of the fresco, a more careful examination reveals substantial differences between the two. There is, in fact, hardly anything in the print that demonstrates an intention to copy its model in detail: the number of small figures in the background and at the left is different and, though portrayed as acting in a similar manner, in the print they are often moving in different directions, gesturing differently, and are clearly given different features from those in the painting. Even the depiction of Florence is dissimilar in its detail, the printmaker having conspicuously altered the size of the buildings and the relationship among them, besides adding considerable detail, for example to the gate of the city in the foreground or to the tower to its immediate right (presumably the tower of the Palazzo della Signoria), adorning it with two lions. The amount of liberty taken by the engraver in

changing his model suggests that this is, indeed, not a reproductive print, but rather another example of enthusiastic appropriation. Having set himself the task of engraving an image of parochial pride — a likely bestseller — the printmaker found no better inspiration than Domenico di Michelino's fresco, and used it freely as a starting point for his own composition. There is no mention in the print of the authorship or location of its source, but there was probably no need for either in any case; every Florentine buyer would have instantly recognized the scene painted on the left wall of the town's cathedral. Rather than trying to "reproduce" the fresco, the engraver was here exploiting his public's familiarity with the subject matter of his print in order to sell more impressions of it.

The attitude manifest in this print is not fundamentally different from Baldini's setting the activities of man under the effect of the planet Mercury in the center of Florence (fig. 88)[191] or from the anonymous engraver's print *St. Anthony of Padua with the Santo and a Map of Padua* (H.V.E.III.55), whose composition is very close to that of the Florentine engraving showing Dante, but whose target market was probably the pilgrims visiting the shrine rather than the locals. It is equally likely that the Florentines would have recognized Perugino's *Last Supper* in the poor translation by Lucantonio degli Uberti (H.V.D.III.1), and the Milanese would have recalled Leonardo's fresco of the same subject in Santa Maria delle Grazie when confronted with Pietro da Birago's rendition of it in an engraving (fig. 174).[192] The painting was finished in 1497, and, as Hind suggests, it is likely that the engraving was produced soon after. It is characteristic of Pietro, and symptomatic of the attitude towards its relationship to the fresco, that a lively image of a spaniel munching a bone has been introduced in the foreground. More importantly, the engraver took the extraordinary liberty of correcting the size of the figure of Christ, painted in slightly larger proportion than the Apostles in order to convey the hieratical position of Jesus at the Supper.[193] Another possible example is that of a rather free rendition of Andrea del Sarto's fresco *San Filippo Benizzi Healing a Beggar* in SS. Annunziata, Florence, found in an anonymous print that, on stylistic grounds, can be dated to the second or third decade of the century.[194] In all of these cases, the two fundamental criteria being employed to qualify a print as reproductive do not apply: first, that it copy the model as closely as possible and, second, that the printmaker show an intention to approximate in black and white the tonal effects of the colors of its model. And yet reproductive prints proper evolved slowly from these humble beginnings.

When can one then place their appearance as an established form of printmaking? Most prints of the 1530s that might deserve the title of reproduc-

171. Anonymous Florentine Artist, *Hell*. Engraving (H.I.49.A.I.59), 223 × 284 mm. British Museum, London.

tive print appear not to be dated. Some printmakers, such as the so-called Master of the Die and Giulio Bonasone, while producing independent prints, borrowed motifs with such freedom and enthusiasm that they often skirted the boundaries of reproduction. Others frequently picked groups of figures or entire scenes, sometimes representing very complicated actions or stories, out of Raphael's or Michelangelo's paintings or frescoes, and set them within their own compositions. This is the case with a print by Giovanni Antonio da Brescia, where the borrowings from a Raphael fresco in the Logge are substantial and even acknowledged in one of the earliest inscriptions, of the type common on actual reproductions: "Equesto e depīto ī camera del.s. papa" (And this is painted in the apartments of the Pope; H.V.43.21). However, these prints cannot be called "reproductive," as they are in fact only the extreme manifestation of the tradition of appropriating somebody else's *invenzioni* for one's own. Nor can the term be properly applied to those prints which utilize in a similar manner — even without adding much of consequence to the existing composition — sketches or even complex drawings by Raphael or Michelangelo; there are dozens of such prints, and they illustrate the entire gamut of possible degrees of appropriation. From Michelangelo's *Battle of Cascina*, for instance, Marcantonio happily borrowed one figure for his celebrated *Mars, Venus, and Amor* (B.XIV.257.345) of 1508, one for his later *Man Putting on his Breeches* (B.XIV.351.472) and one and three respectively for his two versions of the *Climbers* (figs. 150–51). Agostino Veneziano had gone further, borrowing six figures (out of

172. Anonymous Florentine Artist, *Dante as Poet of the Divine Comedy.* Engraving (H.I.49.A.I.61), 196 × 282 mm. Albertina, Vienna.

173. Domenico di Michelino, *Dante as Poet of the Divine Comedy.* Fresco, Duomo, Florence.

the twenty that populate the prototype) and setting them in an incongruous Veneto landscape (fig. 175): this print is of particular interest, as it bears, in the second state, the inscription *Michaelangelus Buonarotus, inventor*, Agostino's monogram, and the date 1524, and therefore illustrates the extent to which independent printmakers of that age felt entitled to borrow whatever they fancied from well-known compositions designed by their more famous contemporaries. Whether or not they bothered to acknowledge the source of the *inventio* or the *disegno*, they did not attempt to "reproduce" the image from which they had appropriated some or most of the elements that made up their own work.[195]

The situation was quite different when, for instance, in 1546 Enea Vico reproduced in an engraving (B.XV.305.48) Michelangelo's highly finished presentation drawing of a *Children's Bacchanal*, not only copying accurately every detail of the model but also trying to convey through the chiaroscuro of the print the tonal values of the drawing.[196] In this case the role of the engraver has become obviously subservient to that of the *inventor*: the printmaker was no longer borrowing from someone else's composition in order to recreate, with his own *ingegno*, a new composition. He was emulating, as closely as his skills allowed him and as passively as his conscience or greed dictated, the work in another medium by a more famous artist. This was no longer the sort of copying that had become a common practice among Renaissance printmakers — engravers copying each other's work. It is important to distinguish, on the one hand, between careful copies of engravings in their entirety and, on the other, copies of drawings. At times the difference is difficult to quantify, but it is symptomatic that copies of engravings were

normally made by young printmakers trying to increase their skills by imitating the technical achievements of some more proficient colleague, whereas copies of drawings were made by skilled, experienced printmakers such as Vico, emulating the *colore* of a painting and normally executed at the request of a publisher.

The development of printmaking from an activity devoted mainly to the creation of independent works of art — however crude and however much dependent on borrowing from better models — to a craft devoted mostly to the reproduction of finished works by other artists in other media, was not a linear progression and cannot be described with scientific accuracy. The chronological and conceptual boundaries between copies, replicas, borrowings, complete appropriations, collaborations, reproductions, to name but a few, are at best unclear and at worst indeterminable. And yet underlying this progression in Italy during the first half of the sixteenth century was a parallel evolution of the concept of *inventio*: from, at one end of the spectrum, very simply the structure, or backbone — as Borea called it —[197] of a composition, to, at the other end, the representation in a scene of the complex interactions among setting, figures, their movements and expressions, all of which, in combination, provide a unique depiction of that subject matter.[198] Thus, models, if seen as mere compositional or scenic inventions, could be pillaged with ease by printmakers (often skillful craftsmen with little drawing ability or education) in need of a good figure, or a group of good figures. When however, the model started being approached as an *inventio* in its entirety, as a complete work of art, an image whose strength lay in the unique combination of devices with which its meaning was conveyed to the viewer, then the engraver could hardly attempt to

174. Pietro da Birago, *Last Supper*. Engraving (H.V.88.9), 230 × 450 mm. British Museum, London.

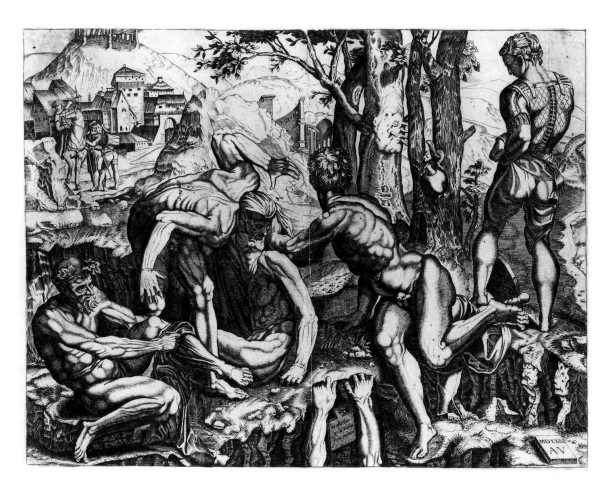

175. Agostino Veneziano, *Bathers*. Engraving (B.XIV.318.423), 327 × 440 mm. British Museum, London.

borrow piecemeal from it without in the process destroying the integrity of the invention. In such circumstances, the only option open to the print-maker was to copy the whole composition as carefully as he could, and at the same time emulate its tonal values. His print thus became a reproduction — normally in black and white — of a drawing, painting, or fresco — normally in color.

The earliest dated print that is a conscious reproduction of an independent, complete work of art is probably the undistinguished rendition of Raphael's last great painting, the *Transfiguration*, published in 1538 by Antonio Salamanca (fig. 176). Its inscription reads:

SIC.ROMAE.DEPINXIT.RAPF.VRB.IN.TEMPLO.D.PETRI.IN.MONTE.AUREO.
ANT.SALAMANCA.EXCVDEBAT.MDXXXVIII

These words also represent the earliest full "caption" of a reproductive print, including the name of the painter (even if it is here misspelled), the city and precise location of the picture (in Rome in San Pietro in Montorio, where the painting was actually sent by Cardinal de' Medici as soon as he heard of Raphael's death), and finally the name of the publisher. It is indeed fitting that the first, the most active and most enterprising of all Roman print publishers should have his name linked to what appears to be the earliest dated reproductive engraving. It is also somehow apt that this print

should not bear the name of the engraver who made it, and that it should thus remain in the limbo of anonymous mediocrity, where it firmly belongs. It is not surprising that the next dated print of this kind should also be after a painting by Raphael: Giulio Bonasone's rendition of the *St. Cecilia* (fig. 177). The inscription here reads simply RA.IN.IVLIO.F., and the date 1539 appears at top right, obtained in white *al risparmio* on the darkly hatched background.[199] A Bolognese printmaker, Bonasone could not have found a better subject to reproduce than the most acclaimed painting then seen in his home town.

The earliest reliable date found on a print after a fresco appears to be that on Niccolò della Casa's engraving in ten plates reproducing (what else?) Michelangelo's *Last Judgment*. The plates bear different dates, one of them 1543.[200] Slightly later are two anonymous engravings after Raphael's frescoes, a depiction of the *Stanza del Borgo* (B.XV.33.6) and of the Chigi *Wedding of Psyche* (B.XV.43.14) which carry, although only in their second state, inscriptions with the date 1545, the second being accompanied by the name of Salamanca.

These dates, in relation to both paintings and frescoes, may appear very late. It is indeed likely that among the hundreds of undated prints produced during the 1530s there are many that could

166

definitely be called reproductive. As we mentioned, when the floodgates opened, the tide was irresistible. Bonasone, the Master of the Die, Nicholas Beatrizet, Enea Vico, the Scultoris, and Giorgio Ghisi spent the 1530s and 1540s reproducing drawings which specialized draftsmen, sent roaming around churches, palaces, and public and private buildings, were making after the pictures of the great masters of the past. At the same time, the engravers and their publishers were trying to keep abreast of contemporary painting so that any novelty could be immortalized in a print. If they lagged behind, the painters themselves often alerted them to their latest work, or even — as in the case of Luca Penni, according to Vasari — became themselves publishers of prints after their own pictures. The quality of the reproduction was often coarse, but the prime concern of more and more publishers was to record the composition and its major details, in a way that ironically resembled the earlier approach of the engravers of the 1520s who were more interested in capturing the innovation of

a design, the *invenzione*, than in transmitting the complex meaning of a finished work. As we shall see, all evidence points to the increasing importance of publishers in the production of prints. Some more enterprising engravers remained independent by turning into publishers themselves,[201] but few Italian printmakers could take the risk of remaining independent in a very competitive market, where copying was rife and privileges ineffectual outside the boundaries of the Papal territory.

We have seen how, in Raphael's circle, the name of the master was not to be mentioned, while that of the printmaker could be inscribed with a restrained monogram. These restrictions did not apply in the era of open market competition. A reproductive print not bearing the name of the model's creator is, in some ways, a contradiction in terms, and there was scarcely a print published during these years without a full acknowledgment to the painter whose work was being reproduced. Just as Agostino Veneziano consistently signed his

176. Anonymous Artist, *Transfiguration*. Engraving (B.XV.19.9), 343 × 237 mm. Albertina, Vienna.

177. Giulio Bonasone, *St. Cecilia*. Engraving (B.XV.130.74), 320 × 193 mm. British Museum, London.

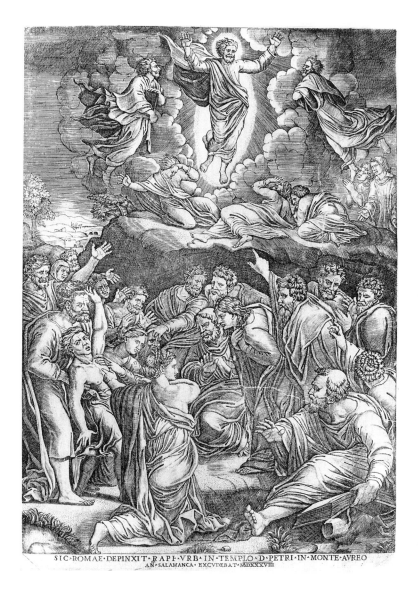

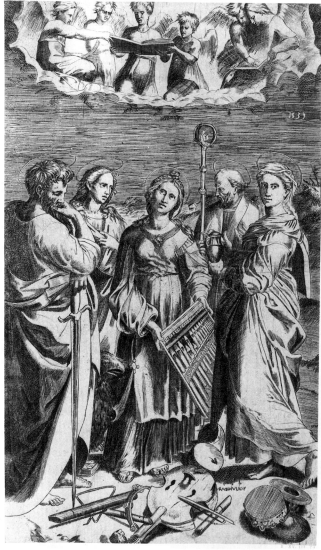

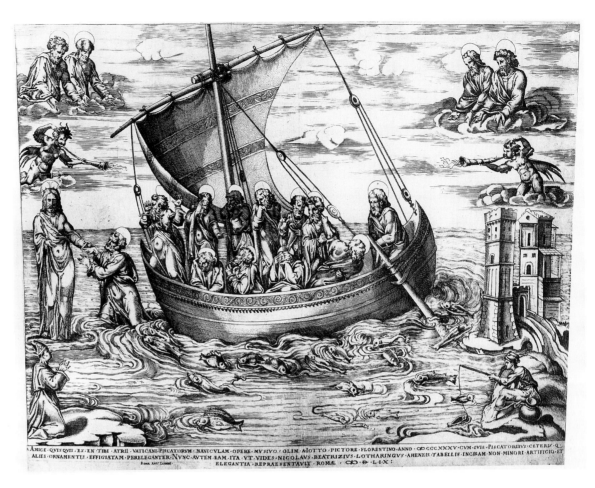

prints of the 1530s, engravers of the 1540s and
1550s, such as Beatrizet, learned to use the inscriptions on their prints as their best form of advertising.
The clearest example of this is Beatrizet's and
Lafrery's direct and personal address to their customers, an early case of soft-selling technique. This
can be found in the lower margin of a reproduction,
dated 1559, of Giotto's *St. Peter Walking on Water*
(fig. 178). The inscription reads:

AMICE.QUISQUIS.ES.EN.TIBI.ATRII.VATICANII.
PISCATORVM.NAVICICVLAM.OPERE.MVSIVO.OLIM.
A.IOTTO.PICTORE.FLORENTINO.ANNO.MCCCXXXV.
CVM.SVIS.PISCATORIBVS.CETERIS.ALIIS.
ORNAMENTIS.EFFIGIATAM.PERELEGANTER.NUNC.
AVTEM.EAM.ITA.VT.VIDES.NICOLAVS.BEATRIZIVS.
LOTHARIGVS.AHENEIS.TABELLIS.INCISAM.NON.
MINORI.ARTIFICIO.ET.ELEGANTIA.
REPRAESENTAVIT.ROMAE. M.D.L.I.X.

The buyer is addressed as a friend; Giotto's work is
fully described with its title, medium, and year of
execution, and its virtues as a work of art are
extolled; then follows an assurance that not only
is this reproduction faithful, but it was engraved
in copper, with no less skill and brilliance than
Giotto's original, by Niccolò Beatrizet from Lorraine. The inscription concludes with place and

date of production, while Lafrery's name is left to a
less dignified position engraved in smaller letters.[202]

The primary purpose of these reproductive engravings is never forgotten: Lafrery, for instance, in
a depiction of a Roman marble plaque guarantees
that it is "exactissime delineata" (B.XV.265.92).
The customers are not only reassured of the faithfulness of the reproduction, but are helped to
understand its meaning. During these years longer
explanatory inscriptions, sometimes in verse, started
to appear in tablets at the bottom of mythological or
allegorical images, and often in series reproducing
cycles of frescoes. Prints not only sold themselves,
but became the postcards of sixteenth-century
Rome. In this way reproductive engraving helped
create the myth of a city full of treasures. As the
inscription of a mediocre print after an *Ornament*
by Perino del Vaga, engraved by the Master of the
Die, puts it:

> The poet and the painter proceed together, and
> share in their ardor the same goal, which is well
> expressed in these sheets, adorned with works of
> art, of which Rome provides good example,
> Rome the place for all great minds, whose grottoes have shut out the day, but now by art are
> given light again.[203]

V

The Cultivation of the Woodcut
in the North

THE REFINEMENT
OF THE SINGLE-LEAF WOODCUT:
1500–1512

THROUGHOUT THE ANNALS of early printmaking, woodcuts have tended to be accorded second-class status. Indeed, it is fair to say that over most of its six hundred year history the woodcut has served a less demanding market, and done so without the need for exceptional refinements in draftsmanship or block cutting. The many hundreds of thousands if not millions of catchpenny prints sold to adults as well as children over the centuries attest to the importance of the woodcut as an efficient, if often coarse, means of replicating images.[1] Yet, as the masterpieces of Hans Burgkmair, Lucas Cranach, Parmigianino, and Beccafumi admirably demonstrate, in the Renaissance a percentage of the woodcuts made in Europe were fashioned with excruciating care and were almost certainly intended for a discriminating clientele. Shortly we shall glimpse the brilliance of this medium in Italy. Our present task is to trace the development of the fine woodcut in the north from its early stages at the close of the fifteenth century until a generation or so later when it had become an established item in the print trade. During the course of this account we hope to overturn the conventional, and in our opinion mistaken, view that woodcuts were always the poor cousin of the print family.

Let us begin by examining the history of this prejudice and the actual distinctions that do obtain between the refined and the less crafted orders of woodcut. As a matter of convenience, modern historians have classified early woodcuts according to their format and their presumed purpose. Thus, the "single-leaf woodcuts" incline to be distin-

guished from those meant to be issued in series or as book illustrations. However, within the class of single-leaf woodcuts are the broadsheets (*Bilderbogen* or *Flugblätter*), usually images accompanied by texts and apparently in some way intended for passing on information or giving instruction. Then, at the opposite end of the spectrum, the single-leaf woodcut is taken to have more encompassing, indeed self-consciously aesthetic, aspirations. Thus, qualitatively we tend to place the fine, single-leaf woodcut at one extreme, and the generally coarser illustrated broadsheet at the other. Yet there are a great many single-leaf woodcuts of a very poor grade, and on the other hand some finely crafted broadsheets designed by masters like Albrecht Dürer and cut by the best of his *Formschneider*.

It is important to recognize that the convenient designations "single-leaf woodcut" and "illustrated broadsheet" are entirely anachronistic to the sixteenth century. At that time the German word *Brief* was used indiscriminately for works on paper whether they were woodcuts, watercolors, or drawings. Some of these were apparently done for the lower end of the market, such as very crude woodcuts of plague saints with prayers accompanying the illustrations, a kind of image turned out in large numbers especially during periods of epidemic. However, a *gemalter Brief* could just as well be an elegantly illuminated and historiated proclamation, a crude astrological chart, or a finely done devotional image in imitation of panel painting. Furthermore, it is artificial to separate woodcuts published independently from those meant to be part of a series, whether bound or not. Single-leaf woodcut is simply a term employed to describe any woodcut not printed as a book illustration. Yet many of these were as likely to be pasted into books or kept in portfolios and cabinet drawers as they were to be

posted on walls. And as we have already pointed out, in its finer aspects the woodcut medium was first cultivated in the context of book illustration and only gradually emancipated itself from that association. When Dürer distributed his prints during his journey to the Netherlands, he often did so in lots, mixing single prints with series of prints, and most often giving them away in groups or sets. In fact, unlike early engraving, it seems impossible to divide the history of single-leaf woodcut from the design and issue of woodcut series or cycles, including bound volumes of woodcuts both with and without texts. To make a clear distinction here is to think of sixteenth-century prints more as independently conceived objects designed for a museum than in the way they were perceived in their time.

The historiography of Renaissance woodcuts explains some of the expectations that have typically been brought to the subject.[2] In the 1920s, after centuries of relative neglect, sixteenth-century woodcuts once again came into high regard and began to be given more serious attention by European scholars. Curiously enough, this renewed interest proceeded from two quite separate perspectives. On the one hand, the Renaissance woodcut was regarded as an early form of "popular" art, and in this sense an anticipation of modern methods of mass communication. This approach was stimulated by a very topical and, in fact, prescient fascination with the power of modern political propaganda. In 1922 Karl Schottenloher, the historian of printing in the Reformation, published his now classic study on the history of the news media, in which he gave close attention to the emergence of the illustrated broadsheet in the sixteenth century. Schottenloher was the first to grant the small, corner-press print publishers their proper historical and political importance in the history of the press. In the introduction to his book Schottenloher states explicitly that he was drawn to the subject by his astonishment over the power of the popular press to influence events during the course of the First World War.[3]

Almost simultaneously with Schottenloher's political and social point of view there came a revival of interest in the sixteenth-century woodcut as an artistic form. This was most prominently initiated with the publication of Max Geisberg's multi-volume corpus of German woodcuts made between 1500 and 1550. It was Geisberg's specific intention to rehabilitate the aesthetic integrity of these prints.[4] Consistent with his purpose, Geisberg carefully sought out impressions of good quality for reproduction. Since a great many early woodcuts survive only in late impressions showing damage to the blocks, he regularly saw to having the illustrations for the corpus touched up so that the images could be presented in their best light. Hence, it is important to be aware of Geisberg's interventions when comparing his illustrations to the originals from which they were taken. Following in Geisberg's

footsteps, only a few years later the Dutch bibliographer Wouter Nijhoff compiled the basic corpus of Netherlandish woodcuts from this period.[5] There can hardly be any doubt that this revived historical and aesthetic interest in sixteenth-century woodcuts during the 1920s and 1930s was encouraged, if it is not indeed explained, by the contemporary revitalization of woodcut among German Expressionists.

It was thus during the interwar period in modern Europe that the Renaissance single-leaf woodcut regained its artistic status, although even so it still retained something of the stigma of a secondary art form. Albrecht Dürer's woodcuts, for example, continued to be interpreted as a reflection of the more modest, distinctively northern and artisanal side of his artistic personality — expressionist, visceral, markedly unclassical, and counter to the Albertian principles of the Italian Renaissance. Such a view is evident, for example, in the assessment of the German woodcut given in Erwin Panofsky's monograph on the artist:

> Woodcuts were thus ill suited for a display of "art for art's sake" where connoisseurs might revel in pictorial refinements or in the consummate beauty of the nude. They did not invite minute examination and leisurely enjoyment. But the very succinctness and directness of their style produced a strong and instantaneous psychological reaction, and the non-realistic quality of the medium was favorable to excursions into a domain essentially inaccessible to copper-plate engraving: the realm of the fantastic and the visionary.[6]

This passage reveals a sensibility still under the sway of German Expressionism. Although Panofsky's vivid characterization of Dürer's style suits the *Apocalypse* of 1498 reasonably enough, the woodcut *Life of the Virgin* begun only a few years later remains one of the great monuments of placid and coherently laid out narrative to be found anywhere in Renaissance art north or south of the Alps. We must recognize that the sixteenth-century woodcut is a great deal more supple and multifaceted a technique than the "expressionist" account of its history would imply.

THE FIRST MASTERS

As a professional painter and engraver Dürer set a decisive precedent by ambitiously venturing into woodcut design early in his career. His folio woodcuts of *Samson Rending the Lion* (fig. 179), the *Martyrdom of St. Catherine* (fig. 180), the *Men's Bath* (fig. 181), and the illustrated *Apocalypse* were all made in the years shortly before 1500, when the artist was still in his twenties. The range of subject matter alone reflects a recognition of the woodcut as a flexible and experimental arena for a draftsman.

179. Albrecht Dürer, *Samson Rending the Lion*. Woodcut (B.2), 382 × 278 mm. British Museum, London.

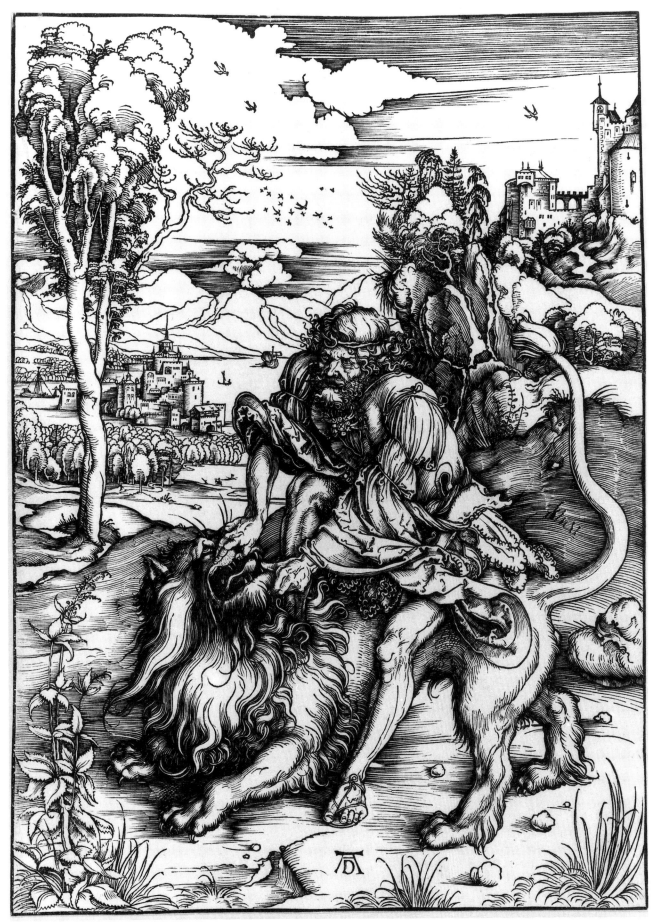

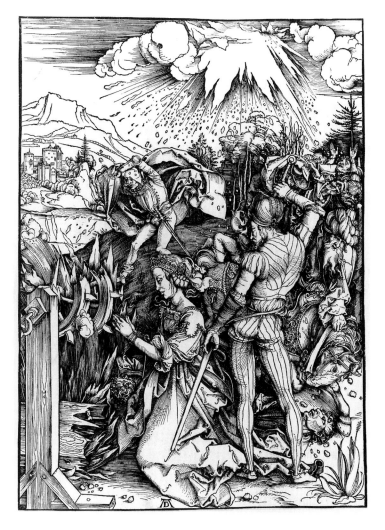

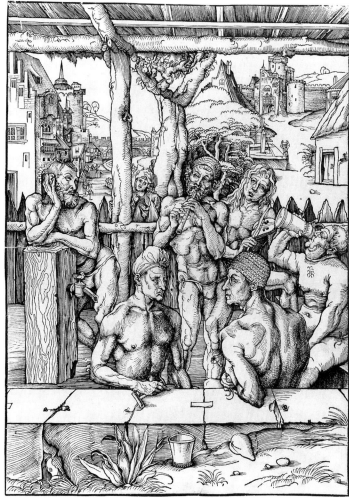

180. Albrecht Dürer,
Martyrdom of St. Catherine.
Woodcut (B.120),
387 × 284 mm. British
Museum, London.

181. Albrecht Dürer,
Men's Bath. Woodcut
(B.128), 393 × 283 mm.
British Museum, London.

The *Men's Bath* is an especially telling example because of its secular subject and its self-evident, though perhaps secondary, function as a demonstration piece in which the artist shows his skill in portraying the nude male figure in differing attitudes, ages, and proportions. As is clear from the widespread and varied response of his contemporaries, Dürer's youthful folio woodcuts immensely expanded the pictorial possibilities of this most purely linear technique. It is self-evident that he was no longer designing woodcuts that were made to be hand colored; rather, these were intended as self-sufficient images meant to be enjoyed as works of precise, energetic, and innovative draftsmanship.[7] The stark, linear elegance of Dürer's early woodcuts declares a graphic sensibility already anticipated by the engravings of Schongauer, but in some respects even better suited to the capacities of relief printmaking.

Was this step into refined woodcut making taken alone, or was Dürer already relying on the assistance of a skilled block cutter? Everything we know about the development of the woodcut suggests that elaborate and skilled cutting required the expertise of a specialist, and that by virtue of the book trade such specialists would have been readily avail-

able in a city like Nuremberg. There is general agreement that by 1500 Dürer was indeed availing himself of the services of professional cutters. However, many years ago William Ivins made a compelling case for Dürer actually having cut his earliest folio woodblocks himself — specifically the *Martyrdom of St. Catherine* and *Samson Rending the Lion*. In his detailed examination of these two surviving woodblocks and the manner in which they differ from a third example that we know from documentary evidence was not cut by Dürer or under his auspices, Ivins points out a number of remarkable subtleties in the tapering of ridges in the relief of the block, and in the cutter's unusual respect for preserving modulations of line. He concludes that such exceptional surgery as we find here must reflect the superior sensibility of the author of the design and not the hand of an intermediary.[8]

It is not necessarily the case that understanding the sense of a thing makes one best equipped to reproduce it technically. Nevertheless, the features of the cutting which Ivins identifies are indeed extraordinary, and at the very least they do suggest that a single and devoted hand was responsible for both blocks. Given Dürer's many talents, we would be foolish to exclude the possibility that this hand

172

EPITOME IN DIVAE PARTHENICES MARI AE HISTORIAM AB ALBERTO DVRERO NORICO PER FIGVRAS DIGES TAM CVM VERSIBVS ANNE XIS CHELIDONII

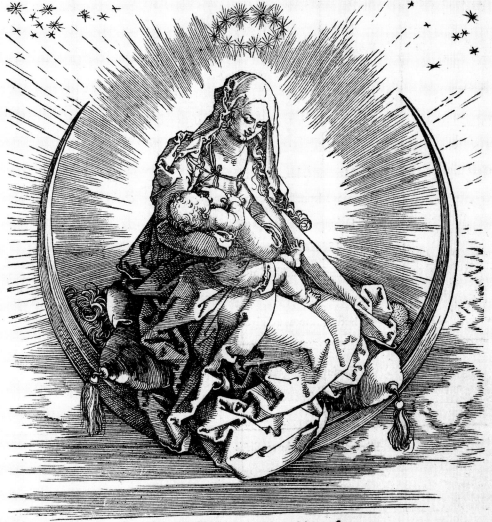

Quiſquis fortunæ correptus turbine.perfers
Quam tibi iacturam fata ſiniſtra ferunt.
Aut animæ delicta gemis.Phlegethontis & ígnes
Anxius æternos corde tremente paues.
Quiſquis & vrgeris iam iam decedere vita
Alterius:migrans:neſcius hoſpitij.
Huc ades:auxilium:pete:continuoq̃ rogabo
Pro te:quem paui lacte:tulíq̃ ſinu.
Ille deus rerum mihi ſubdidit aſtra:deoſq̃.
Flectitur ille meis O homo ſuppliciis.

182. Albrecht Dürer,
Title page for *Life of the
Virgin*. Woodcut (B.76),
image 203 × 196 mm.
British Museum, London.

173

was his own, particularly since he must have been exposed to block cutting while still apprenticed in Wolgemut's shop. One can well imagine Dürer undertaking such an onerous task simply in order to discover for himself something further about the possibilities of the medium that so fascinated him at this stage of his career. The prints themselves show that he was demanding more from woodblocks than anyone had before, and his own recognition of this is indicated by the fact that he was the first of the *peintre-graveurs* to sign his woodcuts consistently. Against Ivins's hypothesis is the tremendous in-

vestment of Dürer's time and labor that the cutting would have required. Secondly, these woodcuts betray such a remarkable degree of skill in the cutting that it is hard to imagine them having been trial pieces. And lastly, since designing and cutting blocks are such markedly different skills, we cannot assume one ability follows easily from the other. The truth about the actual cutting of Dürer's earliest blocks will likely always remain a matter of speculation. But regardless of who actually finished the blocks, Dürer's early woodcuts set a technical standard rarely approached in the entire history of relief cutting on plank.

Over the course of the first decade of the sixteenth century in Germany, only very few painters began to experiment with the woodcut in ways that genuinely tested the range of its pictorial possibilities. What is striking about this critical phase in the history of fine woodcut-making is the degree to which it was concentrated within a few major centers. Between the years 1500 and 1510 we find exceptional woodcuts being fostered only by Dürer and his workshop in Nuremberg, by Lucas Cranach in Wittenberg, and by Hans Burgkmair in Augsburg. All three towns were then becoming major centers of humanist learning, and Nuremberg and Augsburg already boasted important book printing houses as well. The University of Wittenberg and the Saxon court were jockeying for a position in European patronage and learning. If there were but three major figures investing their efforts in woodcut design at this stage, they were nevertheless extraordinary and well-placed talents.

The accomplishment of this phase of experimentation in fine woodcut-making culminated in 1511 with the issuing of Albrecht Dürer's three *Large Books* published simultaneously in that year

185. Lucas Cranach the Elder, *Suicide of Marcus Curtius*. Woodcut (B.112), 335 × 235 mm. British Museum, London.

(figs. 182–84). In retrospect the impact of this event upon printmaking was decisive, both north and south of the Alps.[9] On that occasion a standard was set, and for at least two generations afterward the fine woodcut would be measured against Dürer's achievement.

Lucas Cranach began making woodcuts around 1501–02, and over the following several years made a number of elaborate compositions of religious and secular subjects. He began his career in Vienna, where printing had barely started and where there is no evidence of artists actively making prints at that time. Despite the city's significance as an academic and administrative capital, Viennese patronage could not contain Cranach's prodigious talents as an artist, and he soon left for greener pastures. Particularly from 1505 onward, Cranach's folio woodcuts reflect his close familiarity with Dürer's early work: the *Adoration of the Sacred Heart of Mary* (B.76) of 1505, the *Temptation of St. Anthony* (B.56) and *St. George with two Angels* (B.67) of 1506, the *Suicide of Marcus Curtius* of ca. 1507 (fig. 185), the *Judgment of Paris* (B.114) of 1508, and several distinguished compositions from 1509 after his visit to the Netherlands, some of which we shall

discuss shortly in connection with Cranach's role in the invention of techniques for color printing. At the time that he emerged as a major figure in printmaking, Cranach was working under the aegis of Friedrich the Wise, Elector of Saxony, an affiliation no doubt partly accounting for the artist's extraordinary venture, between 1506 and 1509, into prints of courtly subject matter, in one case on quite a large scale. His woodcut of the *Stag Hunt* of ca. 1506 (fig. 186) was printed from two separate blocks measuring together more than 370 × 510 mm.[10] This is one of several such subjects he designed in these years, the remainder being depictions of court tournaments, though none of them is the equal of the *Stag Hunt* in size. Three of the *Tournaments* (B.125–27) dated 1509 apparently represent a sequence of actual events staged in the previous year and celebrated in verse by the Saxon court poet Sibutus. Presumably the great *Stag Hunt* had a documentary purpose similar to an illustrated chronicle of court life, and in this sense the woodcuts can be seen as a counterpart to medieval texts on ideal rulership, such as *The Mirror of Princes*, a kind of tract being revived at the time in the court of Maximilian I.[11]

186. Lucas Cranach the Elder, *Stag Hunt*. Woodcut from two blocks (B.119), 370 × 510 mm. Herzog Anton Ulrich-Museum, Braunschweig.

Friedrich's official authorization of Cranach's print production is evident from the fact that most of his prints carry the Elector's coats of arms. Therefore, nearly the entirety of Cranach's graphic work in these years was made under a kind of retainer. We do not know just how the income gained through these publications was distributed, though there is no reason to conclude that the majority of Cranach's blocks and plates or the income gained from them accrued to the property of his patron. Presumably most of the blocks and plates remained in the family workshop over the decades. This implies that the arms of Saxony served primarily as an honorific gesture to Cranach's patron, who we know provided for the artist's living in other ways. The arms may also have operated somewhat like a privilege, that is to say an exclusive authorization to publish prints under Friedrich's legal protection.[12] Cranach's prints had the effect of advertising the artistic and intellectual vitality of the Duchy and the magnificence of its patronage, matters of very great importance to Friedrich the Wise. His wish to disseminate works of art bearing his insignia was a major step in the aristocratic sponsorship of printmaking, a critical factor in the rising status of the woodcut at exactly this time.

Dürer's early career as an independent painter and printmaker was shaped in the thriving, conservative, competitive, and commercial center of Nuremberg. Cranach, on the other hand, moved almost immediately under the umbrella of Saxon court patronage. Then much later, because of circumstances he could never have foreseen, Cranach was swept into the first tide of the Lutheran movement. Hans Burgkmair, the third major figure to make a fundamental contribution to fine woodcut design in these years, made his career by combining the separate advantages of training, location, and patronage enjoyed by his two gifted contemporaries. Like Dürer, who served his apprenticeship in close relation to the Koberger printing house, Burgkmair worked for the printer Erhard Ratdolt for several years prior to attaining independent rights as a painter in Augsburg. He seems to have begun designing woodcuts under his own name only after returning from a trip to Italy in 1507, at which point he entered into imperial service.

Burgkmair's early single-leaf woodcuts unmistakably betray his experience of Italian style. We are bound to ask what importance time in Italy might have had for his decision to design his own woodcuts alongside his work as a painter. Burgkmair's earliest woodcuts are richly pictorial — for example, the *St. Luke Painting the Virgin* (B.24) of 1507, and two other markedly Italianate *Madonnas* of 1508. Of these, the *Virgin and Child with a Round Arch* (fig. 187) includes in the first state a wide, printed frame around the central composition. The frame itself, along with the fact that the one surviving

impression of this state was carefully colored by hand, suggests that Burgkmair meant to imitate the formal characteristics of a small devotional painting. It has been plausibly suggested that Burgkmair colored the woodcut himself, a view substantiated by the remarkable and vivid handling of the pigments.[13] In the same year, Burgkmair was also granted two important commissions for elaborate woodcut designs, both of them major innovations in northern printmaking. The first of these was for the famous equestrian figures of *St. George and the Dragon* and *Maximilian I*, which we shall discuss at length. Second, Burgkmair was enlisted to illustrate Balthasar Springer's report of a trading expedition to Africa, Arabia, and East India sponsored by the Welser Corporation of Augsburg through its Spanish and Portuguese offices in 1505–06.

187. Hans Burgkmair, *Virgin and Child with a Round Arch*, 1508. Hand-colored woodcut (B.8), 269 × 190 mm. Ashmolean Museum, Oxford.

188. Hans Burgkmair, *The King of Cochin*, 1508. Woodcut, three blocks from a frieze (B.177), 276 × 1100 mm. British Museum, London.

Burgkmair depicted the inhabitants of these exotic lands in a set of woodcuts in frieze format that were printed from six blocks stretching altogether nearly two meters in length.[14] Somewhat in the manner of a broadsheet, these woodcuts of *Exotic Peoples* (fig. 188) were accompanied by a brief, descriptive text running in columns above the illustrations and describing the lands and peoples portrayed. An independent, multiblock woodcut frieze of this scale had no precedent in northern European print-making. However, there were relevant prototypes made earlier on Italian soil.

We have already discussed Jacopo de' Barbari's *View of Venice*, the first truly monumental woodcut generated through a collaboration between northern sponsorship and Italian expertise. In addition to the *View of Venice*, Jacopo made two woodcuts of undetermined meaning, the very puzzling *Battle of Naked Men and Satyrs* (Pass. III, p. 141, no. 31) and the multi-block *Triumph of Men over Satyrs* (fig. 79).[15] In their format and their fascination with the "primitive," both of these prints anticipate Burgkmair's depiction of exotic peoples. The format and the scale of the figures in the woodcut series of *Exotic Peoples* find even closer parallels in Jacob of Strasbourg's *Triumph of Caesar* (Pass. I, p. 133, no. 1) dated 1504, designed and published in Venice, a composition inspired by Mantegna's celebrated series of canvases in Mantua. Jacob's woodcut was executed in no fewer than twelve blocks, altogether running to a length of four and a half meters.[16] As an Alsatian block cutter who had settled in Italy,

Jacob's work testifies again to the fertile exchange between German and Venetian woodcut-making at the time. Burgkmair's frieze is especially important for having introduced such an unusual subject into the north, for its monumental scale, and for the frieze format. However, we cannot claim it as an example of exceptionally refined design or cutting. The subject of the frieze appears to have been very topical, since it was quickly copied, and yet extant impressions of Burgkmair's original version are extremely rare. This suggests what we can just as well infer from the format itself: that such woodcuts were normally pasted onto walls and thereby soon damaged and lost to posterity.[17]

Burgkmair's journey to Italy was therefore instrumental in his decision to begin making elaborate woodcuts as part of the regular enterprise of his workshop, and his motives in doing so were several. It appears he was particularly impressed during his time in Italy with the capacity of woodcut to imitate painting both in scale and through the addition of color. Second, he was stimulated in at least two instances by specific commissions, both of them apparently involving Maximilian's court official Conrad Peutinger, about whom we shall hear more.[18] Third, we know that Burgkmair had available to him the skills of two experienced block cutters during these seminal years. Wolfgang Resch was resident in Burgkmair's house in 1508, and so we presume he was at that time an active member of the workshop. Cornelis Liefrinck of Antwerp also worked on Burgkmair's designs. This we know

DER KVNIG VON GVTZIN

from the fact that Cornelis left his monogram on the verso of the block for the King of Cochin, one of the groupings of *Exotic Peoples*.[19] By the end of the decade Burgkmair had emerged as the foremost woodcut designer in Augsburg, and was already drawn into the employ of the Emperor, who would consume much of his talent over the years to come.

The quality and aspiration of these early woodcuts by Dürer, Cranach, and Burgkmair, their close connection to aristocratic patronage, and the indirect importance of Italian precedents all suggest that the medium was attaining new stature in a few major artistic centers in northern Europe. The advantages of woodcut for making images of a generous scale and especially for translating qualities of draftsmanship were quickly becoming apparent in this experimental phase of its history. And yet without the craft of first-rate block cutters to alleviate the tremendous labor of execution, it is unlikely the woodcut could have sustained the interest of these otherwise heavily employed and ambitious masters.

COLOR PRINTING

The clearest symptom that woodcuts were bettering their station in the art market during the first decade of the sixteenth century is the invention of an especially luxurious type of print, the chiaroscuro woodcut.[20] Our curiosity about this invention cannot help but be piqued by the remarkable and illustrious attention given it at the time, and by un-

resolved questions about who should receive credit for inventing the technique. This episode in the early history of color printing reveals much about the specialized practices underlying Renaissance experimentation with graphic techniques and also something about the patronage that lay behind the luxury print trade. But let us consider the broader question of the evolving relation between prints and drawings in the northern workshop, and how the changing evaluation of drawings must have encouraged forays into printing with color.

Although Vasari claimed that his countryman Ugo da Carpi was responsible for the invention of the chiaroscuro woodcut, there is no doubt that on this point of priority he was flatly mistaken.[21] Conceding certain important moments of cross-influence, no one any longer disputes the fact that the chiaroscuro woodcut made its first appearance in Germany and then in Italian workshops only some years after. Furthermore, chiaroscuro color prints in Germany and Italy evolved in close correlation with their respectively distinctive styles of drawing. Both north and south, the primary motive behind the early chiaroscuro woodcut was a desire to approximate by an efficient and mechanical means the essential visual qualities of certain types of finished drawings. In fact, the very appearance of the chiaroscuro woodcut is an important indication of the rising status of drawings during the Renaissance, for if drawings of particular sorts were now being deemed worthy of imitation, then it stands to reason that they were also being sought

as desirable objects in their own right, not by artists alone, but by collectors as well.[22]

It is no surprise that book printers took the first steps toward engineering the mechanics of color printing. The central figure in this research was Erhard Ratdolt, a German printer who established a successful press in Venice and then in 1486 moved back to Augsburg where he quickly became one of the wealthiest men in the city.[23] Ratdolt began using multiple woodblocks to print colors in a modest way already while he was in Venice.[24] On his return to Augsburg he availed himself of Hans Burgkmair's maturing talents as a draftsman and continued his experiments with color printing. An example of the fruit of this collaboration is the *Crucifixion* page from a Missal published in Augsburg in 1494 which Ratdolt printed with a black line block followed by individual color blocks in red, gold, blue, and olive green.[25] The effect is essentially the same as what can be obtained manually by stenciling with a template and a brush. At this stage Ratdolt's and Burgkmair's relatively narrow purpose was to contrive an efficient means of book production that would rival the manuscript trade. Yet these experiments were to have their most lasting effect on the single-leaf woodcut, for it was surely not coincidental that just a few years after leaving Ratdolt's employ, Burgkmair was to play a critical role in the development of the true chiaroscuro color woodcut.

As A. M. Hind long ago pointed out, Ratdolt's early use of color printing for book illustration was, at base, a technical innovation and not a formal or aesthetic one. By the late 1490s, however, there were more imaginative experiments with color printing being undertaken in response to virtuoso drawing styles practiced in painters' workshops, the most important of these experiments being Mair von Landshut's colored engravings (fig. 190). Although Mair made prints in the conventional intaglio manner, nearly half of his known engravings were done in special impressions on papers that were tinted in a brown, green, or blue tone. Several of these colored prints are dated 1499, and they include both sacred and profane subjects.[26] Occasionally the impressions on tinted paper were then augmented with a brush in touches of white or gold highlight. Mair appears to have been among the first to work up intaglio prints with colors in this way, and he certainly provides us the first instance we have of prints so obviously made in imitation of the formal properties of finished drawings. Indeed, it is fair to say that Mair's colored engravings are tantamount to being counterfeit drawings.

Not surprisingly, Mair's colored (not yet color-printed) engravings approximate a type of drawing on tinted paper that he practiced himself, a style that was to become much favored among northern painters over the following two decades; this was the so-called chiaroscuro pen or brush drawing done

like Mair's engravings on prepared, colored paper and then heightened in white (fig. 189). Typically, both chiaroscuro drawings and prints sought to achieve markedly "graphic" kinds of effects. In particular, they employ a mannered and self-consciously stylish handling of light and color in an essentially non-representational way. The chiaroscuro type of drawing is the descendant of Italian silverpoint workshop studies done on tinted grounds, a type of drawing made in Italy throughout most of the fifteenth century. These silverpoints, usually figure studies or detailed studies of drapery, hands, or faces, were probably used to enhance the stock of available patterns in the workshop.[27] They were very often taken from life, and otherwise probably copied from existing drawings or finished paintings. No doubt these drawings were occasionally sold or traded to other artists, and finished examples may sometimes also have been sold or given to collectors or patrons.

Formally speaking, the practice of drawing in silverpoint, pen, or brush and heightening with white on a colored ground allowed the artist to model by working outward from a middle-range of value towards darker and lighter tones. This was a customary procedure for painters working up their panels in color from an intermediate hue, first deepening the shadowed areas with black and then building up highlights to be capped in bright rivulets of lead white. The shop practice of modeling on single-colored paper in this manner is the origin of what we now term the chiaroscuro technique. It

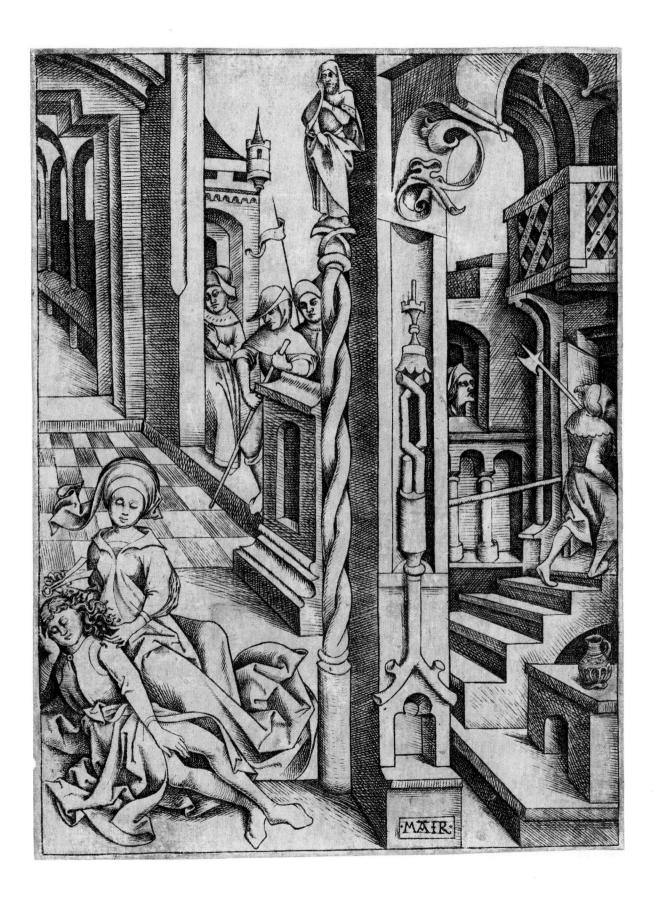

181

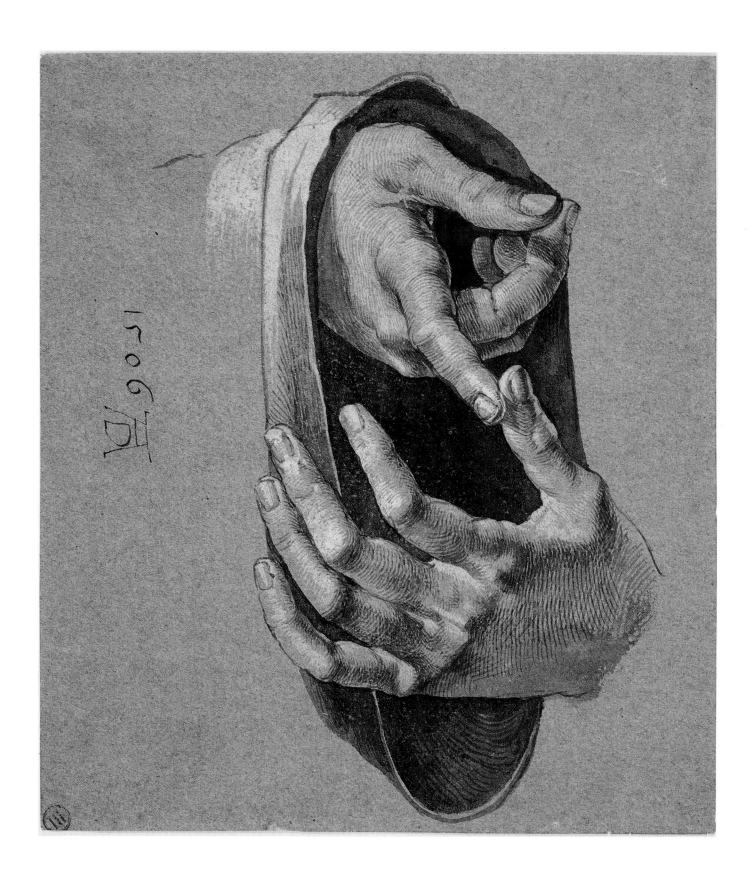

is a formal strategy well-suited to the "tactile" manner of rendering that Heinrich Wölfflin long ago identified as essential to the Renaissance artistic sensibility.

Silver- and lead-point drawings began to go out of fashion towards the end of the fifteenth century in Italy but for some time remained common in northern workshops. Metalpoint is a demanding technique. Not only is the mark of the stylus mostly indelible once made on a prepared ground, but its subtlety compels the draftsman to model within a very limited tonal range. Perhaps for this reason artists began turning more often to pen and ink or brush drawing on tinted paper.[28] Though colored papers were usually tinted by wiping them with a rag or washing them with a brush in the workshop, some tinted papers could be purchased. The famous Venetian blue paper (*carta azzurra*) was most prized among these, and a favorite of Albrecht Dürer. Dürer was probably first encouraged to pursue brush drawing on blue paper in Italy where, especially in the hands of Gentile Bellini and Carpaccio, the technique had become very accomplished.[29] In 1506 during his second Italian journey Dürer executed a series of drawings made in preparation for paintings being done either on commission or for the market. Among them are his studies for *Christ among the Doctors* (fig. 191). These drawings and the equally renowned drapery studies of Leonardo exemplify at the highest level the advantages of the chiaroscuro technique for attaining a strongly plastic image, dimensionally convincing and at the same time abstracted by the artificial tinting of the ground.

In the first decade of the sixteenth century the practice of drawing on richly colored paper was adopted with special enthusiasm by a group of painters active in southeastern Germany and Austria, a group now commonly referred to as the Danube school. The style of draftsmanship developed among these artists was certainly much influenced by their familiarity with Dürer's prints and to a lesser extent with his tonal drawings as well. His so-called *Green Passion* cycle begun ca. 1504 supplied them with an important precedent for the use of chiaroscuro technique. Lucas Cranach the Elder provided a second and more pertinent tributary to the new Danube style when he took up chiaroscuro drawing in the early years of the century. Among Cranach's most striking images done in this technique are *John the Baptist in the Wilderness* (Lille, Musée des Beaux-Arts) from ca. 1503 and *St. Martin Dividing his Cloak* (Munich, Graphische Sammlung) of 1504 (fig. 192).[30]

Dürer employed the technique of brush drawing on prepared paper mainly in its more staid capacity for making workshop models and preparatory studies for paintings. In contrast, Cranach and the Danube artists appear from the outset to have exploited the technique not so much for its rep-resentational power and plasticity as for its dramatic, pyrotechnic effects. The Danube masters developed an extravagantly calligraphic use of line and a remarkable sense for investing their highlights with an electrical charge. To this end they preferred the nervous potentialities of penwork to the more languorous motions of the brush, and they employed the medium mainly for narrative subjects set in intensely agitated or mood-ridden landscapes. Consider, for example, Albrecht Altdorfer's drawing *St. Nicholas of Bari Quieting a Storm* (Oxford, Ashmolean) (fig. 193).[31] As we can see here, already early in his career Altdorfer took the chiaroscuro pen drawing technique to a high degree of abstraction.[32] The indulgent spontaneity of his penwork and the looseness of his figure style give these drawings an

191. Albrecht Dürer, *Hands of Christ*, 1506. Brush heightened in white on blue Venetian paper, 208 × 186 mm. Germanisches National-museum, Nuremberg.

192. Lucas Cranach the Elder, *St. Martin Dividing his Cloak*, 1504. Pen and ink and gray-brown wash heightened in white on blue paper, 185 × 127 mm. Staatliche Graphische Sammlung, Munich.

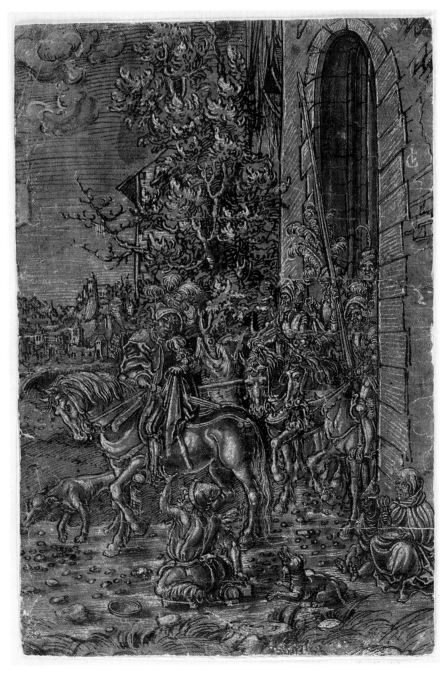

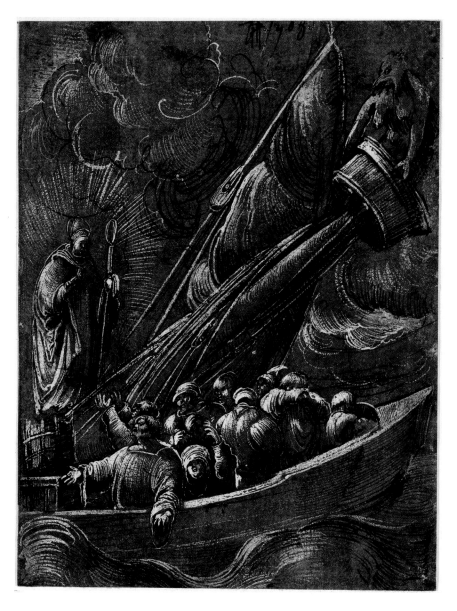

193. Albrecht Altdorfer, *St. Nicholas of Bari Quieting a Storm*, 1508. Pen and ink and grayish-brown wash heightened in white on brown prepared paper, 190 × 148 mm. Ashmolean Museum, Oxford.

194. Niklaus Manuel Deutsch, *Suicide of Lucretia*, 1517. Tempera and pen on panel, 325 × 260 mm. Kunstmuseum, Basel.

eccentric place in the history of Renaissance artistic invention. In the hands of the Danube painters what was once a practical aspect of workshop procedure seems to have become an arena for stylistic extravagance and for this reason a successful fashion in the market.

The evidence that chiaroscuro drawings were already being made for a collector's market is inferential but convincing. To begin with, there is the relative frequency of classical and other esoteric subjects represented in the early examples of these drawings, subjects that lie outside the normal iconographic repertoire of the period. The unusual status of chiaroscuro drawings is further attested to by the fact that this type of drawing would eventually come to be imitated in painting as well as in printmaking. The Swiss artist Niklaus Manuel Deutsch made at least three panel paintings imitating drawings in this style. Perhaps the most compelling of these is a poignant image of the *Suicide of*

Lucretia dated 1517 (fig. 194).[33] The painting is drawn in black outline and highlighted in white against a deep chocolate-toned field, and the composition is framed in a trompe l'oeil of classical style imported from Italy and especially favored in the Augsburg Renaissance. The *Lucretia* is nothing less than a homage in painting to a style of drawing made fashionable and worthy of the interests of collectors in the previous decade.

These are the prevailing conditions of taste that set a context for the invention of the chiaroscuro woodcut as an elite form of Renaissance woodcut and as a collector's item. The crucial steps to creating this new form of print were taken between the years 1507 and 1510, and here we are particularly fortunate to have well-documented evidence. On 24 September 1508 Conrad Peutinger, counselor to the Emperor Maximilian and Secretary to the City of Augsburg, wrote a letter to Friedrich the Wise of Saxony. In his letter Peutinger recalls a picture (or pictures) of an armored equestrian figure — a *kurisser* — made by Friedrich's court painter (Lucas Cranach). This *kurisser*, apparently sent to Peutinger sometime the year before, is described as having been "printed in gold and silver." Almost certainly the item in question was an impression of a color woodcut of *St. George and the Dragon* by Lucas Cranach, two examples of which still survive (fig. 195).[34]

Cranach's color print so impressed Peutinger that he immediately set out to sponsor experiments of a similar kind. Although Peutinger does not mention Burgkmair by name, it is clear that he employed his fellow Augsburger to meet this challenge. The two of them had already collaborated on the woodcut frieze of *Exotic Peoples* based on the reports of Springer's voyage that appeared in the same year. Furthermore, Peutinger had demonstrated his interest in color printing in an exquisite edition of classical inscriptions, *Romanae vetustatis fragmenta*, which he had collected together and arranged to be published by Ratdolt in Augsburg in 1505. This luxurious edition printed the texts of the inscriptions in an antique type-face in red, black, and gold. The gold was applied over a red bole (fig. 196).[35]

Along with his letter to the court of Saxony, Peutinger sent proof impressions (*ain prob*) of equestrian figures printed in gold and silver on parchment ("von gold und silber auf pirment getrukt krisser"). In return Peutinger asked for an opinion about whether or not they are well printed ("ob die also gut getrukt seien oder nit"). On the following day Peutinger wrote to Duke Georg of Saxony, once more proclaiming the wonders of this technique and asking for his assessment as well.[36] Evidently these lavish experimental woodcuts were proving to be a matter of great interest in aristocratic circles. The *kurisser* that Peutinger commended to Friedrich in his letter were almost certainly trial impressions of the two equestrian figures designed by Burgkmair

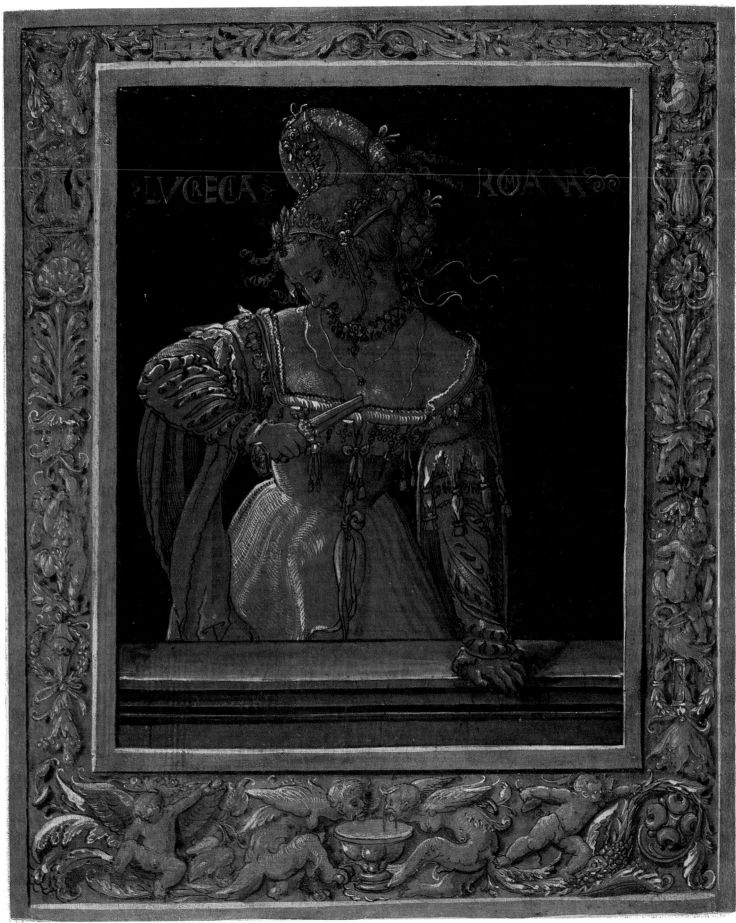

LVCRECA ROMA

195. Lucas Cranach the Elder, *St. George and the Dragon*. Chiaroscuro woodcut from two blocks, heightened with brush on blue tinted paper (B.65), state I, 234 × 160 mm. British Museum, London.

196. (facing page) Colophon from Conrad Peutinger, *Romanae Vetustatis fragmenta* (Augsburg: G. Ratdolt, 1505), fol. 7v. Color printed text in black, red, and gold. Newberry Library, Chicago.

and dated 1508 — a *St. George* (fig. 197), no doubt intended to challenge Cranach's color woodcut of the same subject, and a companion figure of *Maximilian I* in ceremonial armor (fig. 198).[37]

This flurry of activity over the production of elaborate equestrian figures can almost certainly be tied to the particular political aspirations of Maximilian himself in these years. We know he was engaged in promoting the status of the knightly order of St. George in connection with his campaign to mount a crusade against the Turks, an ambition he never realized and which in any case may have had more to do with his pursuit of the crown of the Holy Roman Empire than with a lust for martial glory. Maximilian proved successful in this regard, and was crowned in Trent early in 1508.[38] The pendant 1508 color woodcuts of St. George and the Emperor by Burgkmair, effectively Maximilian's court artist, must certainly be understood as a response to these circumstances. It is not at all unreasonable to suppose that Cranach's first experiments issuing from the Saxon court were also stimulated by the revival of St. George's chivalric associations. Indeed, Albrecht Dürer himself issued an engraving of *St. George on Horseback* (B.54) in the same year. The possibility that this print was published in order to take advantage of current fashion is supported by the fact that Dürer altered the date in the plate from 1505 to 1508, a change clearly visible in the print itself.[39]

Since examples of these first color woodcuts by Cranach and Burgkmair survive, we can get a very clear idea of how the technique of chiaroscuro woodcut evolved in the initial exchange of expertise between the two artists. All three woodcuts follow essentially the same procedure with slight variations. First, a sheet of paper or parchment was tinted with wash. In the London impression of Cranach's *St. George* (fig. 195), the blue ground was applied in broad lateral strokes that have the effect of suggesting gradations of atmosphere in the landscape. Then a line block was printed in black onto the tinted paper. Finally, on top of the black line block the artist printed a second line block designed to register a pattern of highlights distributed around the composition. Cranach inked his highlight block with a sticky substance which he apparently printed and then flocked with gold, traces of which remain in the London impression. In the Dresden impression the sticky substance is nearly all that remains of this stage since the gold has come off over time.[40] Cranach was apparently not content to release his print after the final stage of printing and flocking, for he then set about scraping away the wash at certain points in the background of the London impression, allowing the white of the paper to reemerge in a manner that lends additional shape to the distant hills.[41] Clearly he treated the project with much the same care as he would have lavished on a finished drawing. It is worth noting that the

linear pattern of the colored line block used for the highlights would not produce a coherent image on its own. Cranach's outline block, on the other hand, stands as an independent woodcut, and was in fact published this way sometime after his initial explorations with color. Although the ever-present arms of Saxony are incorporated into the black line block, Cranach's initials *LC* appear only in the highlight block.

Cranach's *St. George* genuinely succeeds in achieving the same general effect as a chiaroscuro drawing, a feat accomplished by transposing Mair von Landshut's essential idea from engraving into woodcut and adding to it the notion of a colored line block to supplant the heightening in white that Mair applied by hand. The orderly steps of the invention seem clear enough to this point. Cranach's ground-breaking woodcut must have been executed

Following pages:

197. Hans Burgkmair, *St. George and the Dragon*, 1508. Chiaroscuro woodcut from two blocks on blue tinted paper (B.23), state I, 323 × 230 mm. Ashmolean Museum, Oxford.

198. Hans Burgkmair, *Maximilian I*, 1508. Chiaroscuro woodcut from two blocks on red tinted paper (B.32), 322 × 228 mm. Ashmolean Museum, Oxford.

DIVVS·GEORGIVS
CHRISTIANORVM·
MILITVM·PRO·
PVGNATOR

M·D·VIII

H·BVRGKMAIR

188

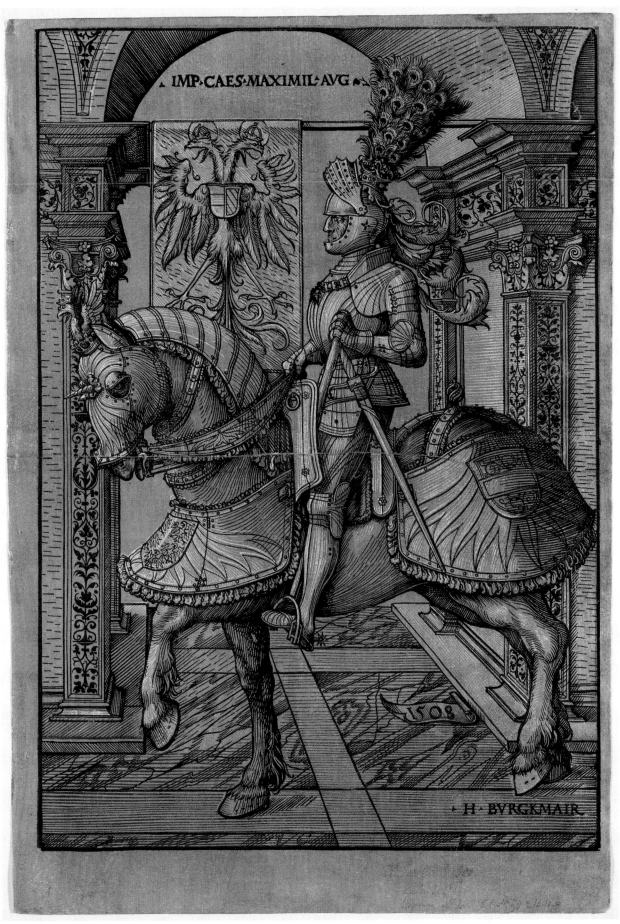

IMP·CAES·MAXIMIL·AVG

·H·BVRGKMAIR

189

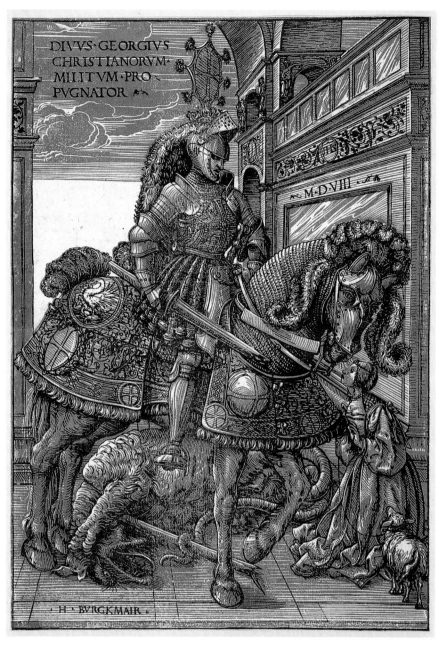

within the image:

DIVVS·GEORGIVS
CHRISTIANORVM·
MILITVM·PRO·
PVGNATOR

M·D·VIII

·H·BVRGKMAIR·

199. Hans Burgkmair, *St. George and the Dragon.* Chiaroscuro woodcut from two blocks (B.23), state III, 325 × 230 mm. Fitzwilliam Museum, Cambridge.

sometime during 1507, a date consistent with its style. Burgkmair's responses — the *St. George* and the *Maximilian I* — are both dated 1508 in the black line blocks, a date confirmed by Peutinger's letters in September of that year. The circumstances make it self-evident that Peutinger meant to stage a kind of *agon* between Cranach and Burgkmair in the manner of Pliny's famous and much quoted story about the contest of Apelles and Protogenes wherein each attempts to better the other in the skill of his brush.

So far as we know, only five impressions survive from this first stage in Hans Burgkmair's experiment with color woodcut printing. There are but two impressions of the *St. George* in the first state, and three of the *Maximilian*. Furthermore, there is reason to suppose that at least two (and possibly four) of these five impressions may have been paired

when they were initially distributed.[42] If we consider this group together, it appears that Burgkmair first tried the sequence of printing established by Cranach and then revised it, and that he introduced an additional sophistication into the color printing. Careful comparison of the two surviving impressions of the *St. George* and *Maximilian* now in Oxford shows that the *St. George* was printed first in black and then in silver on the blue paper, exactly the procedure used by Cranach even down to the choice of background color, except that Burgkmair probably used a metallic ink rather than flock the silver as Cranach had done with his gold. The technique thus appears to differ both from Cranach's experiments and from Ratdolt's 1505 endeavor with printing gold letters. We can see from the superimposition of colors that both of Burgkmair's blocks had a complete borderline framing the entire composition, an addition that must have been introduced to help solve the delicate problem of alignment.

In printing the impression of the *Maximilian* now at Oxford, done in a strikingly bold combination of metallic ink on red tinted paper, Burgkmair reversed the order by printing the black line block last. This solution is decidedly the more successful from a formal point of view and became the standard sequence for chiaroscuro printing thereafter. Burgkmair also contrived a way to apply the metallic pigment in both gold and silver. It appears he did this by masking off an area around the better part of the block and laying gold onto the exposed portions. He next uncovered the block and inked the remaining portion in silver, probably at both stages by applying the ink with a brush. When the result was printed, slight traces of the gold were left on top of the silver at points along the margin. There is no doubt this must have been accomplished in one printing of the block, as it would simply not have been possible to print the highlight block twice with such exact register. One can be quite certain that this unusual feature was not accidental or a consequence of color change over time, since the effect occurs not only in the impression of the *Maximilian* at Oxford, but in the aesthetically much less impressive combination of colors used for the Berlin impression as well.[43]

Thus, it seems reasonable to conclude that the Oxford impression of *St. George* may be the earliest among all five surviving examples of the first states to be pulled. Since there are other reasons to suppose that the two impressions in the Ashmolean Museum were meant as a pair and therefore printed in an early campaign, these prints may take us very close in time to Burgkmair's breakthrough.[44] And finally, the actual cutting of the black line block for the *Maximilian* is decisively more skilled than the handling of the block for the *St. George*, a discrepancy evident in less obvious degree in the color blocks. These differences are sufficient to attribute the blocks for the two woodcuts to different

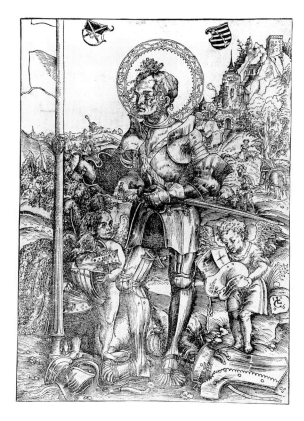

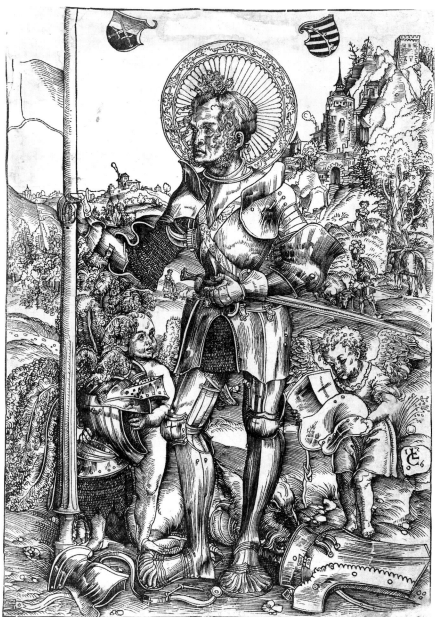

Formschneider. But they also suggest that Burgkmair learned something in between about how to design a pair of complementary woodblocks. The visual evidence suggests that significant progress was made between the manufacture of these two woodcuts.

The introduction of the tone block as a means of printing the background color and simultaneously generating the highlights was the next logical step in this development, and indeed properly speaking it introduced the next formal state of each woodcut (fig. 199).[45] Although technically this was a relatively rudimentary move, as we shall see it appears to have been taken competitively and with great seriousness by the various parties involved. To make a tone block the artist works in the negative, so to speak. The majority of the tone block's surface remains uncut and prints a flat field of color, substituting for tinted paper. Excavated portions of the block then expose the white of the paper in the normal manner of relief printing, creating highlights that instead of being printed are actually blank areas exposing the untouched ground. It is a clever but simple strategy, both technically economical and formally striking.

The historical claim to inventing the genuine tone block is mired in confusion. At the center of the problem are two chiaroscuro woodcuts by Lucas Cranach dated in the line blocks to 1506 — *Venus and Cupid* (figs. 202–03) and *St. Christopher* (figs. 204–05). If these woodcuts were indeed completed as chiaroscuro prints already in that year, then they would almost certainly predate Cranach's own two-block *St. George* done on hand-colored

paper, and also Burgkmair's first color prints done in answer to Cranach's. However, the legitimacy of the 1506 date on both of the Cranach woodcuts has been challenged on a slate of practical, iconographic, and stylistic grounds. To begin with, we can reasonably suppose that Cranach's experiments with printing on hand-colored paper would have preceded the invention of a tone block that produces much the same effect in a more efficient, if more mechanical, way. The possibility has been raised that the line blocks bearing the date might actually have been designed in 1506, and then the tone blocks added only at some later point.[46] This hypothesis is at first attractive, but it runs into serious difficulty on other grounds.

We know that Cranach was formally granted the right to display the winged serpent as his coat of arms only in 1508, and yet this insignia is included along with the early date in the line block of both

200. Lucas Cranach the Elder, *St. George with Two Angels*. Woodcut (B.67), state II, after altered arms, 375 × 273 mm. British Museum, London.

201. Lucas Cranach the Elder, *St. George with Two Angels*. Woodcut (B.67), state I, before altered arms, 387 × 276 mm. The rays of the halo added in pen and ink. Staatliche Graphische Sammlung, Munich.

203. Lucas Cranach the Elder, *Venus and Cupid*, dated 1506. Chiaroscuro woodcut from two blocks (B.113), state I, 285 × 195 mm. Kupferstichkabinett, Dresden.

prints. Furthermore, the arms of Saxony (the crest with crossed swords) appeared in Cranach's early work with the black field in the lower portion of the crest (sable in base). After 1508 the black field in these arms was consistently transposed into the upper portion. In both of the woodcuts dated 1506 the crest appears in its post-1508 configuration.[47] A couple of additional points need to be made about the heraldic evidence. It appears to be true that Cranach employed the winged serpent only after 1509, though this is not to say he absolutely could not have done so on occasion before that time. So far as we know, there would have been no legal ban against electing such an emblem, although one must remember Cranach's well-being depended upon the favor of his patron, and he can hardly have been willing to compromise that for the sake of vanity. The fact remains that if we exclude the two prints in question, we have no other examples of images dated prior to 1509 where the winged serpent occurs. Cranach's portrayal of the coats of arms of Saxony is, on the other hand, not so consistent. There are several instances of woodcuts dated 1506 in which the arms appear in their later configuration because Cranach altered his blocks by inserting plugs with the revised arms to correct this detail.[48] The standing figure of *St. George* with a banner is but one example of this campaign (figs. 200–01). However, none of the impressions of the *St. Christopher* or the *Venus and Cupid* we have

examined shows evidence that such a change was ever made in the block.

Finally, formal analysis of the two woodcuts strengthens the argument that in both cases the line and tone blocks were originally conceived as complementary to one another. We would call particular attention to the treatment of the clouds and the rock formations in the background of the *St. Christopher*. In the line block the clouds are suggested by a scattering of discontinuous, curling lines, and the central rocky areas are also quite sparely defined. Especially if we compare the treatment of the sky to other Cranach woodcuts, we discover that he either tended to leave this area blank or he worked it up with rather fully developed cloud patterns.[49] It has been noted that the highlighted accents of the clouds introduced by the tone block are not consistently coordinated to the line block in the *St. Christopher*. Although this is surely true, left to itself the line block is very ineffectual in this portion of the print. The two components do, however, work well together to lend vitality to the composition.[50] In the *Venus and Cupid* the treatment of the clouds in the line block is also fragmented and unsatisfying by itself, and in this case the highlights of the tone block are designed in close structural harmony with the outlines of the black line block. The same is true for the modeling of the figures in which black and white lines working together give an essential fullness of contour to the form.

One final point: Cranach contrived a visual pun in the foreground of his classical subject, an image "made by chance," to quote H. W. Janson's description of such Renaissance visual conceits. Among the cloud forms gathered at her feet to signify Venus's celestial nature, the form curled up by the side of her foot has fleetingly assumed the shape of a conch shell.[51] Indeed, she seems to stand upon it. This reference to Venus's birth from the foam of the sea — an allusion to her profane aspect — is quite evident when seen with the advantage of the highlights from the tone block, but less so in an impression taken from the line block alone. And furthermore, so far as we are aware, the deteriorated condition of the line block in those cases where it was printed and distributed suggests that these impressions post-date the earliest chiaroscuro impressions. Therefore, it appears most likely that the design of the *Venus and Cupid* was initially realized as a chiaroscuro woodcut rather than improvised from a previous composition in black and white. Of the two woodcuts claiming this early date, the *St. Christopher* most likely precedes the *Venus and Cupid*, being less adept both in its formal coordination of the two blocks and in its technical execution of them. Nevertheless, it too appears to have been conceived as a unit and not an afterthought.

Adding a tone block to a previously existing line block was undoubtedly a common practice among printmakers once the principle of the tone block

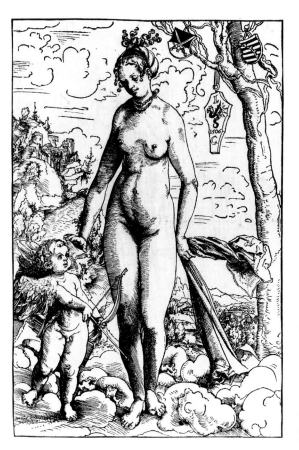

202. Lucas Cranach the Elder, *Venus and Cupid*, dated 1506. Woodcut (B.113), state II, 280 × 190 mm. British Museum, London.

192

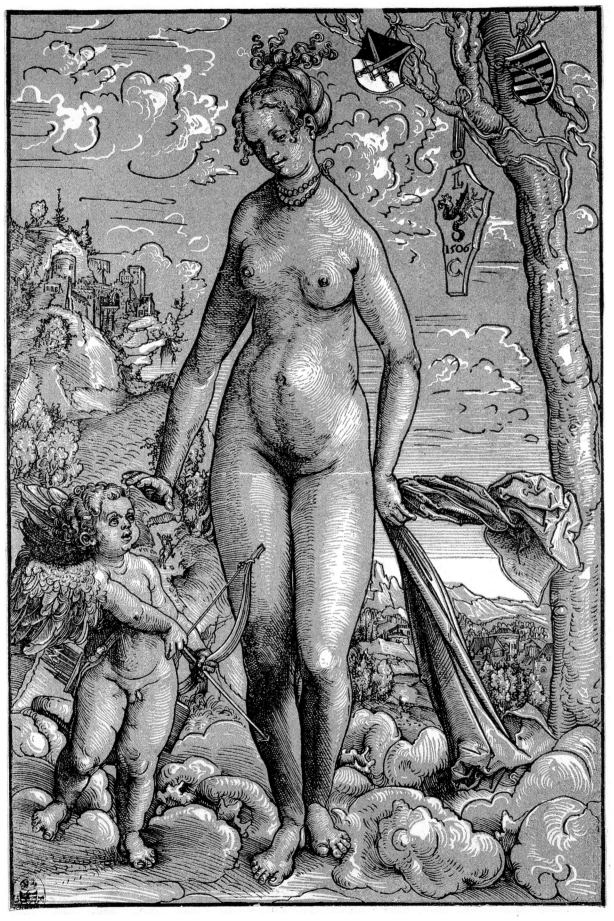

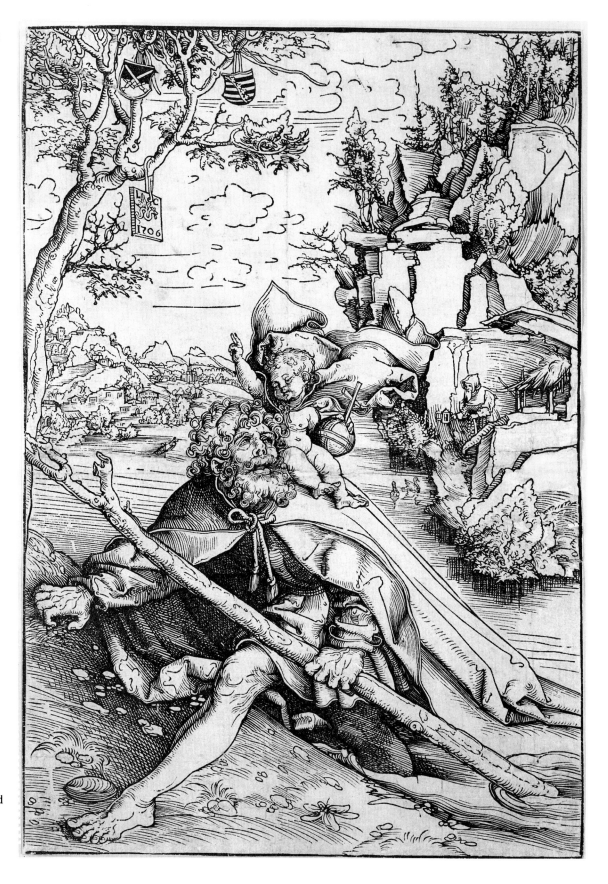

204. Lucas Cranach the Elder *St. Christopher*, dated 1506. Woodcut (B.58), 282 × 193 mm. Kupferstichkabinett, Berlin.

205. Lucas Cranach the Elder, *St. Christopher*, dated 1506. Chiaroscuro woodcut from two blocks (B.58), 282 × 193 mm. British Museum, London.

194

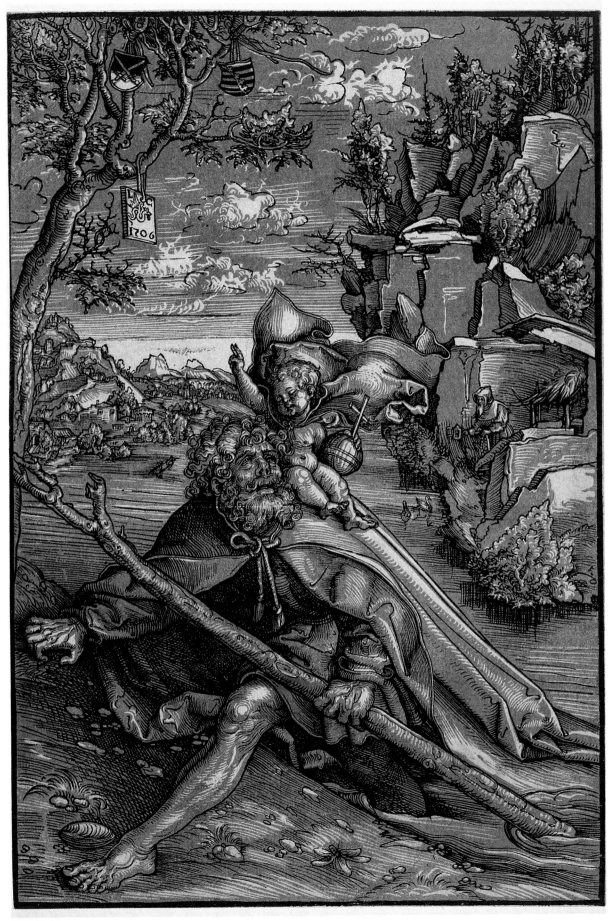

195

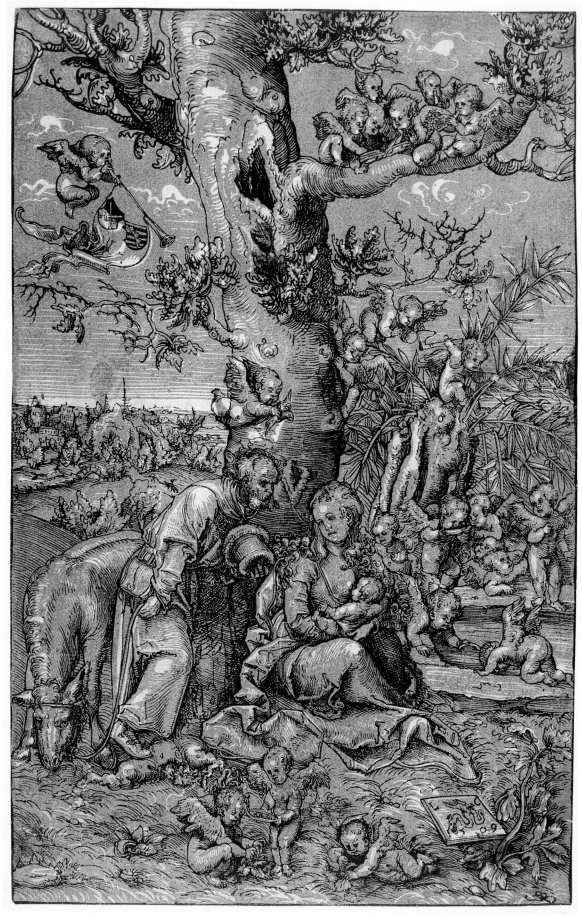

196

became known.[52] The later addition of a tone block might sometimes have been used to mask the flaws in a degenerating line block, or simply as a means of producing a new image to sell. Such a case can be made for Cranach's charming portrayal of the *Rest on the Flight into Egypt* of 1509 (figs. 206–07), a woodcut that is altogether typical for its date given the richness of detail registered in the line block. To be sure, the tone block adds to the vivacity of the design, but contributes nothing essential to the pictorial completeness of the image. Here we have an instance in which Cranach may at some later point have singled out a very successful black-line woodcut for enhancement with a tone block. Because of the potential longevity of a well-cut woodblock, woodcuts were often altered and repaired in the course of their history. For example, at least one additional tone block was made for Cranach's *St. Christopher*, and the *Venus and Cupid* line block was reworked into a second state in order to adjust the sloping curve of the right side of the goddess's shoulder (fig. 203).[53]

Independent of the special quality brought to them by the chiaroscuro tone blocks, where do the two woodcuts dated 1506 seem to fall within Cranach's stylistic chronology? Between 1508 and 1509, Cranach designed several folio-size woodcuts of marked sophistication: the *Judgment of Paris* (B.114) dated 1508, the *St. Jerome Penitent* (B.63) and the *Rest on the Flight into Egypt* already men-

tioned, the latter two both dated 1509. The treatment of the figures and the landscapes suggests that the *Venus and Cupid* and the *St. Christopher* sit comfortably among these designs rather than with his earlier woodcuts of 1506,[54] the *St. Christopher* falling within the decisive year of 1508, and the *Venus and Cupid* in the following year.

Ever since 1900, when Eduard Flechsig first proposed a discrepancy in the dates on these prints, the majority of scholars have agreed in placing them both around 1509. But how has this mystery been explained? All those who favor the later date attribute it to fraud, a dishonest attempt on Cranach's part to claim priority in the invention of the true chiaroscuro printing technique. A hypothetical reconstruction of the sequence of events would thus run as follows: Sometime in 1508 or 1509 Cranach discovered the progress being made with his original idea for color printing. Probably he came across it in Augsburg where we know experiments were already taking place and where Cranach might have passed on his way home from the Netherlands where he journeyed in 1508. From there we must suppose that he rushed home, made two woodcuts in the chiaroscuro manner with printed tone blocks, and purposely issued them with dates two to three years prior to their actual manufacture.

If Cranach was guilty of fraud, then the episode underscores even more dramatically the importance that the invention of chiaroscuro printing assumed in the mind of the period. In our view the weight of evidence does indeed support this rather convoluted, not to say compromising, interpretation of the facts. At least no better explanation has yet emerged to address the challenges made to the 1506 dates. However, in rejecting 1506 we are left without any firm date for the printing of the first tone block. For in retrospect one cannot be absolutely certain just when Burgkmair's woodcuts of *St. George* (fig. 199) and *Maximilian* received their tone blocks. In order to print a new state with a tone block it was necessary to discard the colored line block employed in the first state, since the highlights would now be rendered by the paper showing in the unprinted ground and so prove redundant with those registered by the original colored line block. For a valuable print of this kind it seems unlikely that such a well-crafted line block would have been too readily discarded for the sake of a new and in some ways less supple device for achieving a related if often less dazzling effect. Furthermore, the deteriorated condition of Burgkmair's key blocks by the time the tone blocks were introduced suggests that this stage was reached well into the life of the print. In the end there is no way of knowing exactly how long an interlude there might have been. Was the idea of printing the colored ground really generated first in Augsburg, or should Wittenberg be given the credit? There is a certain poetic justice in this story if the theory about

207. Lucas Cranach the Elder, *Rest on the Flight into Egypt*, Woodcut (B.3), outline block only, 285 × 189 mm. C. G. Boerner, cat. no. 41, 1965.

206. Lucas Cranach the Elder, *Rest on the Flight into Egypt*. Chiaroscuro woodcut from two blocks (B.3), 285 × 185 mm. British Museum, London.

costuming of figures in Burgkmair's three-block print are all indebted to the artist's encounters on his journey south three years before. The setting and its ornamentation are unmistakably Italianate. For example, the ranking of façades stepping down into a depressed middle-ground recalls a scenic preference common in Italian perspective city views.[57] Behind, the prow of a gondola and an arched bridge indicate the presence of a canal, which, together with the distinctively flared chimney pots, affirms that Burgkmair meant to stage this grim apparition of death in the city of Venice. Scholars have regularly pointed out that Burgkmair's treatment of the classically attired young woman and the violence of the narrative are also indebted to Italy.[58] Burgkmair's subject, on the other hand, is more typically northern and also startlingly brutal in its conception of the death figure. Notice the emaciated spectre's contrived pose — its right foot depressing the chest of the young soldier in the manner of a ritual triumph, and its left foot in sinister embrace with the foot of its victim.[59] With both hands death rends the soldier's jaws to rip out the living soul as if he were Samson breaking the lion, and at the same moment this sinister horror catches the hysterical young girl's skirt in its teeth, blocking her escape.

Impressions of Burgkmair's *Lovers Overcome by Death* show consistent difficulties with the alignment of the sparely designed line block, although the registering of the two tone blocks in relation to one another was managed with astonishing precision from the very beginning. How Burgkmair, his block cutter, or his printer managed this feat and yet proved unable to solve the same problem for the line block (the last to be printed), remains a mystery. Difficulty with the line block persisted throughout the first two states, but was evidently solved by Jost de Negker himself in the third state, where our survey of impressions shows remarkable consistency in achieving a precise overlay of all three blocks (fig. 209).

As in the case of this exquisite example, the employment of double tone blocks can create the striking effect of a wash drawing, a quality sometimes inhibited by the stark contrast of the black line block in impressions where the color tones are of more delicate value. Apparently de Negker recognized this problem, since in a small number of cases (again in the third state), he inked the line block with a grayish-toned ink to reduce the intensity of the line. Although still uncommon in the north, the sort of wash drawing approximated in this woodcut was being widely used by Florentine and Roman draftsmen at the time. Indeed, it is the very sort of drawing that Italian chiaroscuro woodcuts were soon thereafter developed to replicate. In 1516 the Venetian Ugo da Carpi sought an exclusive privilege to protect his own claim to the invention of the chiaroscuro printing technique.[60]

Cranach's forgery is correct. Since there would have been no reason for Cranach to dissemble had he actually invented the tone block, the artist himself has given us our most convincing evidence that Burgkmair outstripped him. By so cleverly attempting to defraud history, Cranach ultimately betrayed his own cause.

Given the doubtful status of the two blocks dated 1506, and recognizing that it is uncertain when various other color-printed woodcuts carrying dates in their line blocks were actually given tone blocks, the first secure date for a true chiaroscuro woodcut is Burgkmair's justly famous *Lovers Overcome by Death*, dated 1510 in the first (proof?) state of the line block (fig. 208). This woodcut is the earliest we know to have been printed in three blocks — two tone blocks accompanying a highly abbreviated line block.[55] Since all three are essential to the coherence of the image, it is manifestly a print that is chiaroscuresque in its conception.[56] If we are finally to award the palm not just to the one who first generated the idea but to the realization of its character within the medium, then the credit must surely go to the Burgkmair team in Augsburg.

The *Lovers Overcome by Death* is a startling achievement in several respects important to our account of techniques in fine woodcut printing. It demonstrates that although Italy and the north proceeded according to their own lights in the matter of chiaroscuro printing, the northern invention did not evolve altogether on its own. The style of rendering, the design of the architecture and the

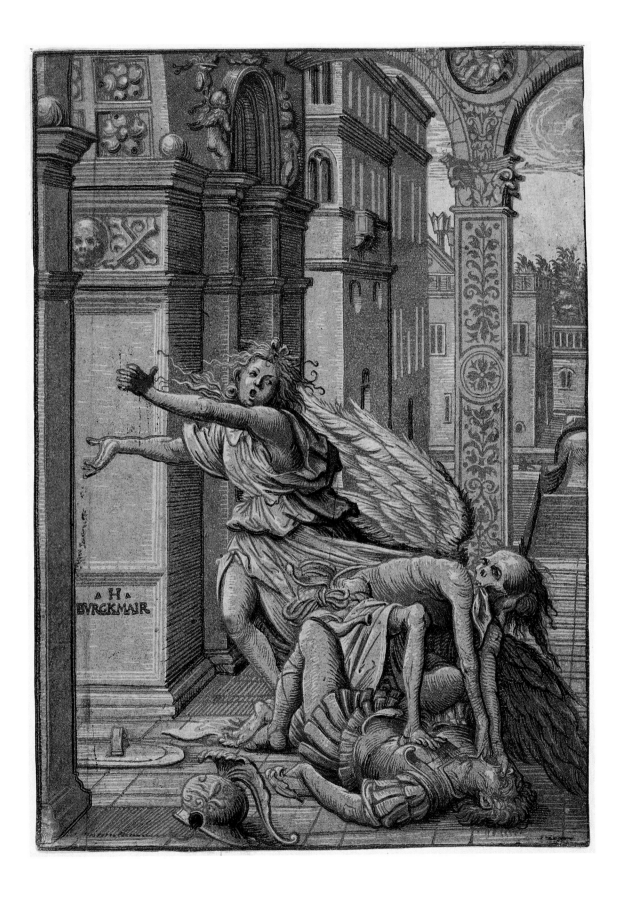

In this light it is indeed curious that, although made in Augsburg, the first securely dated true chiaroscuro woodcut shows so much evidence of contact with Venice. Apart from Burgkmair's own experience in Italy, we should recall the many years which Ratdolt spent as a book printer in Venice, where he first experimented with color printing techniques. Undoubtedly, he and Burgkmair must have returned to Germany with a collection of Italian drawings in hand. Would Burgkmair have conceived this woodcut had he never been exposed to contemporary Italian drawing style? Most likely not. Therefore it is all the more intriguing that, after first being challenged by Cranach, Burgkmair's rightful claim to the invention of chiaroscuro woodcut should have been challenged a second time by a Venetian.

It is certain that Burgkmair could not have achieved his best chiaroscuro blocks without the assistance of a highly skilled cutter. This brings us to consider the importance of Jost de Negker, a block cutter who has been closely tied to the evolution of the fine woodcut in northern Europe, but whose career during these critical years cannot be reconstructed with much certainty. We know that de Negker came originally from the Netherlands where he cut a number of blocks that bear his initials. Only one of these carries a date — a woodcut of *St. Martin Dividing his Cloak* designed by Lucas van Leyden that appeared in a Breviary published in Leiden in 1508 — a *terminus ante quem* for Jost's debut as a professional cutter. Our next secure document is a lengthy letter of 1512 written by de Negker to Maximilian from Augsburg about the arrangements for cutting blocks for certain of the Emperor's projects. In this letter de Negker defends himself for having undertaken work in addition to his tasks for Maximilian, making clear that by then he had been under contract to the Emperor for some while. He goes on to describe a chiaroscuro woodcut portrait of Hans Paumgartner which he claims to have made from three blocks ("sein angesicht gekunderfeit mit drei formen") (fig. 210).[61] Though the term *gekunderfeit* implies that de Negker drew as well as cut this portrait,[62] the well-known woodcut in question is certainly Hans Burgkmair's design. It is dated 1512, in the very year of de Negker's letter, and bears the artist Burgkmair's name alone on the block. De Negker may mean to say that he actually transcribed Burgkmair's design onto the block, or it may simply be hyperbole in support of an appeal for patronage. In any case, this is an especially noteworthy example of sophisticated cutting, the portrait of Paumgartner being the first chiaroscuro woodcut to forego the use of a black line block altogether in favor of a purely coloristic interplay of tone blocks.

The *Hans Paumgartner* woodcut of 1512 appears to be a clear instance in which de Negker collaborated in the making of a Burgkmair print from

the outset. Scholars have often assumed that de Negker was instrumental in the development of Burgkmair's color-printed woodcuts already from the first experiments,[63] yet we have no definite evidence that the block cutter was yet in Augsburg in 1508. At what point between 1508 and 1512 did he enter onto the Augsburg scene? De Negker's name (and often his address) appear in letterpress on a great number of impressions of Burgkmair's woodcuts dated from 1508 on.[64] However, of the woodcuts dated 1508 to 1512, this is true only of the later impressions, that is to say of the second, third, or later states. For example, in the case of the two equestrian figures commissioned by Peutinger, impressions of just the black line block and of the two line blocks with metallic colors appeared before any impressions bearing de Negker's address. His name occurs only on late impressions from the line blocks alone and on impressions with the tone blocks which were clearly substituted late in the history of the block.[65]

We can conclude that Jost de Negker probably inherited or purchased the line blocks to publish under his own name only after the completion of some initial editions. This in itself is not sufficient to claim that he was uninvolved in the cutting from the beginning. At this stage in the history of relationships among designers, block cutters, and printer/publishers, it is very difficult to determine any definite pattern regarding the ownership of blocks or plates. However, Renate Kroll, who has given closer attention than any other scholar to the styles and techniques of block cutters in the Augsburg milieu, believes on stylistic grounds that the line blocks for the equestrian figures of *St. George* and *Maximilian I* of 1508 were most likely not cut by de Negker, but by Cornelis Liefrinck, whom we know for certain to have been in Burgkmair's service already in that year.[66] Thus, though there is very good reason to suppose that de Negker did cut the actual tone blocks for these prints, we have no assurance exactly when this might have happened, and no reason to suppose because of it that he was present in 1508 when the prints were first designed and their line blocks cut at Peutinger's request. We would further point out that the fourth and fifth states of the *Maximilian I* bearing de Negker's name and address also carry an altered date of 1518, which has often been assumed to be an erroneous correction made on the block. It might just as well be intended to record the actual year in which de Negker republished the woodcut under his own auspices, possibly in order to coincide with the convening of the Reichstag in that year, when fancy prints of the Emperor would have been in special demand.[67]

There is a similar pattern in the publication history of the *Lovers Overcome by Death*. It carries a date of 1510 in the first state, which was then eliminated in the second and third states when

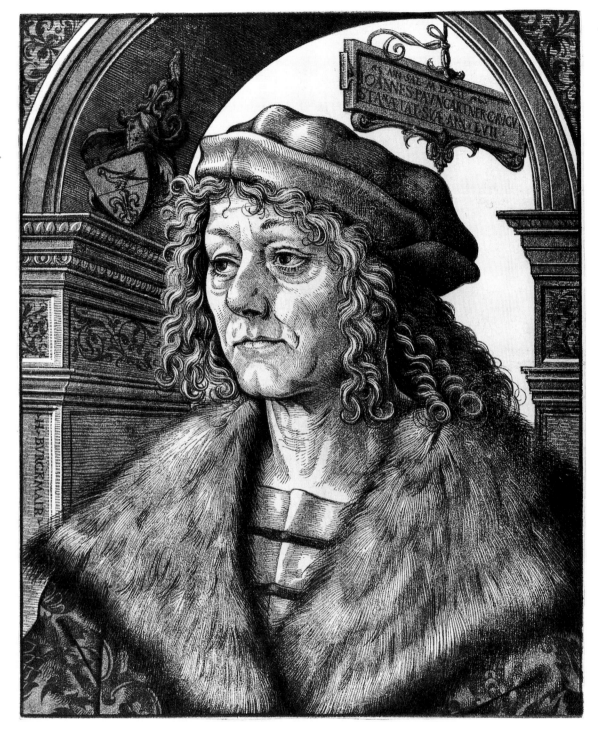

210. Hans Burgkmair,
Hans Paumgartner, 1512.
Chiaroscuro woodcut from
three blocks (B.34),
292 × 241 mm. Ashmolean
Museum, Oxford.

de Negker's name and address were imprinted. Therefore, the presence of his name alone cannot help us establish the earliest point of his engagement in the manufacture of this particular block. Typically these signatures were typeset, sometimes within the field of the image itself but more often in the margin. The history of dates on Burgkmair woodcuts is also complex. However, close inspection shows that the date was originally cut into the block and later removed. It seems plausible that when de Negker took control of a block he sometimes deemed it desirable to eliminate evidence of out-

datedness in order to present his publication as if it were fresh and newly printed. This is a symptom of a print market not yet attuned to the value of older works.

In sum, we have no incontrovertible proof that Jost de Negker participated directly in the making of color-printed woodcuts before 1512 when he openly boasts of his contribution. Meanwhile, the forged dates for two of Cranach's chiaroscuro woodcuts suggest that the invention of the specific technique of the tone block need not be placed earlier than 1509, and that it was probably not Cranach who

73.

211. Albrecht Altdorfer, *Fall and Redemption of Man: Harrowing, Deposition, Resurrection, Noli me tangere*. Woodcuts (B.34, 31, 35, 36), full sheet ca. 225 × 150 mm, images ca. 73 × 48 mm. Cleveland Museum of Art, Cleveland.

212–15. Albrecht Dürer, *Small Woodcut Passion: Harrowing, Deposition, Resurrection, Noli me tangere*. Woodcuts (B.41, 42, 45, 47), each ca. 127 × 97 mm. British Museum, London.

first employed it. This leaves the workshop of Burgkmair our leading candidate for the invention of the tone block. Hans Burgkmair's *Lovers Overcome by Death* of 1510 fixes a date for a print conceived from the outset as a chiaroscuro design. Yet the fact that this woodcut employs the technique in a markedly complex way — two tone blocks accompanying a partial line block, none of the three bearing the complete matrix of the design — suggests it was not the first trial in the series. De Negker's letter of 1512 to Maximilian implies that he had been in Augsburg in the Emperor's employ for some period before this date (according to Renate Kroll by the time Burgkmair's chiaroscuro woodcut portrait of *Julius II* was made in 1511,[68] and according to Tilman Falk probably since as early as

1510).[69] This leaves in dispute the question of whether de Negker cut the original blocks for the *Lovers Overcome by Death*. What is known for certain of his style of cutting prior to this date — for example the blunt trimming of the hatching in Lucas van Leyden's *St. Martin* (Holl. X, 221, 37) — gives us no good reason to assign the 1510 blocks to his hand, but neither does it speak decisively against him. Burgkmair justly deserves the credit for refining the chiaroscuro technique. Whether de Negker designed or cut the earliest tone block is a question we cannot answer.

Once he had arrived at the center of activity in northern European woodcut production, Jost de Negker ambitiously pursued the entrepreneurial benefits of his skill and surely helped to raise the esteem of his profession. We can sense something of the differing self-conceptions of Burgkmair and de Negker from the very manner of their signatures. Burgkmair inscribed his name in Roman capitals, evoking the classical pretensions of his own artistic style (fig. 197). Jost de Negker on the other hand preferred a floridly gothic script of the sort favored among Netherlandish calligraphers. A somewhat blockier variation of this script was also being promoted as part of Maximilian's archaistic court style.[70] These signatures reflect conscious allegiances with Italianate and Germanic traditions. Probably at some point after 1512 de Negker began to commission designs from Burgkmair directly, printing and publishing them under his own auspices. We know for certain that he operated as an independent publisher of commissioned or pirated woodcuts for several decades after his early dealings with Burgkmair, and that his son David de Negker continued his father's trade well into the second half of the century. Jost de Negker's unusually long and prolific career exemplifies an important commercial development in northern European print production — the rise of the independent *Formschneider*.

ALTDORFER AND THE MINIATURE WOODCUT

We can see evidence of the fact that the woodcut was beginning to attract a more discriminating public in the range of possibilities being explored over the second decade of the sixteenth century. Apart from the experiments that led to chiaroscuro woodcuts, testing the limits of scale is perhaps the most significant and most obvious aspect of innovation in woodcut making at this stage. At one extreme, the Emperor Maximilian's projects led to extravagant new achievements on the monumental scale, while on the other extreme Albrecht Altdorfer invested his talent in creating woodcuts of incredible miniature refinement. From its very beginnings

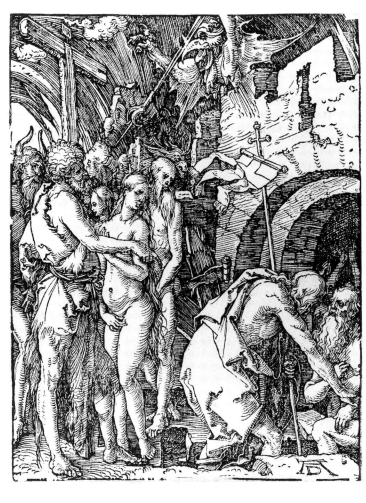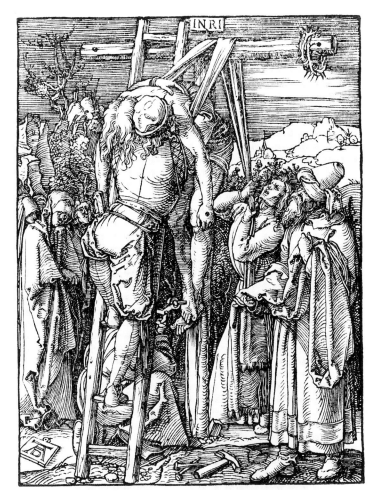
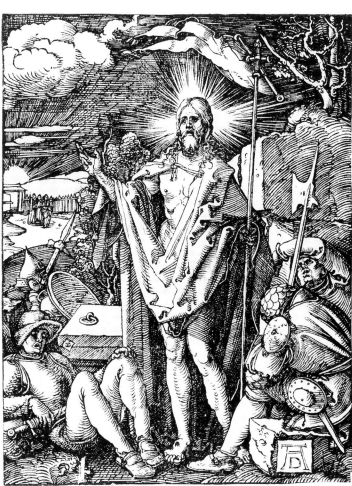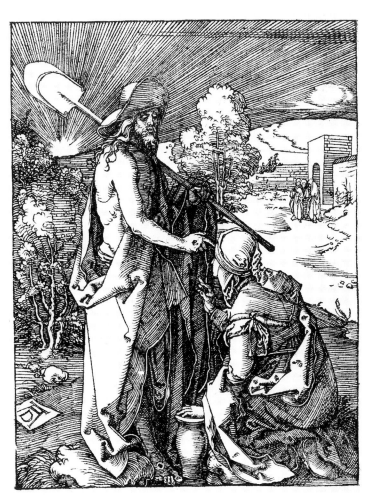

one of the major attractions of intaglio printmaking was the potential for working on a small and intimately precious scale, but because of its tools and material, woodcut presented obvious difficulties. Altdorfer, by this time a master of the miniature engraving, set out to demonstrate the possibilities for making small and intricate woodcuts as well. The results are scarcely short of miraculous.

As best we know, Altdorfer began to design woodcuts only around 1511–12.[71] Most of these are extraordinarily detailed and minute compositions that seem to evolve coherently out of the style of his engravings. Consequently, Altdorfer's designs put tremendous demands on the skill of the block cutter. None of Altdorfer's woodcuts (and none of his surviving blocks) carry the mark or the signature of a *Formschneider*. Yet the presence of one or more silent partners can hardly be doubted, craftsmen whose identities remain unknown to us despite the truly heroic achievement of their work. Altdorfer could only have returned to the medium because he discovered artisans equal to the demands of his draftsmanship. It is certainly not coincidental that Dürer issued his three *Large Books* in the very same year that Altdorfer began making woodcuts again. Between 1511 and 1520 Altdorfer fostered some of the most technically impressive prints ever realized from cutting on the plank, relief prints of such precision that scholars have often (and incorrectly) supposed them to have been done in boxwood or on endgrain.

From 1511 we have three woodcuts, from 1512 another three, and from 1513 four more, nine out of these ten portraying religious subjects. At first Altdorfer appears to have been quite regular about monogramming and dating each of his prints. Although there are several exceptional designs among these first blocks, the technical masterpiece is Altdorfer's cycle of forty prints, dated on the basis of their style to about 1513, depicting the *Fall and Redemption of Man* (B.1–40; fig. 211).[72] This cycle illustrates the entire course of Christian redemption from the Original Sin to the Last Judgment. The series is historically important in many ways, not least for its highly inventive narration and its technical sophistication that posed an explicit challenge to Albrecht Dürer's three *Large Books*. Altdorfer's *Fall and Redemption* begins with the *Fall and Expulsion of Adam and Eve* (B.1) followed by events from the life of the Virgin, the early life of Christ, the Passion, the Resurrection, and the Last Judgment, thus in its subject matter offering a comprehensive sweep of Christian history designed to echo Dürer's achievement. Another and commonly cited prototype for the cycle is Dürer's *Small Woodcut Passion* (figs. 212–15) also published for the first time in 1511, though the three *Large Books* come closest in their collective theme. There can be little doubt that Altdorfer was familiar with all of Dürer's woodcut publications of 1511, and certain compositions from the *Small Engraved Passion* (B.3–18) as well. The blocks for the *Fall and Redemption of Man* are just over one-quarter the size of the blocks for Dürer's *Small Woodcut Passion*.

Although throughout this project Altdorfer betrays his awareness of Dürer's precedent, his narratives are entirely his own and they are highly individual in their interpretation of commonly represented biblical events. He stages his narratives in ways that are both spatially and psychologically centripetal, the compositions tending to draw attention into a scene rather than being addressed outward to the viewer as we are accustomed to see in Dürer's work. Altdorfer often veils the features of his main actors and shrouds his landscapes and architectural spaces in darkness, and as a consequence his subjects are frequently difficult to make out. Like the minuteness of the prints, his narrative strategy compels us to close and intimate inspection.

From a technical standpoint, Altdorfer's mature woodcuts should be considered as an intentional tour de force in diminution. Since they were partly made to be appreciated for their extraordinary precision in rendering the artist's designs in relief, it behooves us to evaluate the technical implications of this aspect of his work more closely. So far as we know, none of the original blocks for the *Fall and Redemption of Man* has survived. Nevertheless, several of Altdorfer's woodblocks for other prints are extant, most of them in the famous Derschau collection housed in Berlin. As further evidence of his technique, we are fortunate to have at hand a precious original block drawn by Altdorfer but only partly cut before having been abandoned by the *Formschneider*. This block shows a complete composition for a *Lamentation over Christ* (fig. 216) on the recto, including the artist's monogram and the date 1512. It is almost certainly contemporary with the earliest stages of the biblical cycle and may even represent a prior phase of the project.[73] On the reverse are pen trials and some quickly executed figure studies (fig. 217). The studies of children playing, three heads, and some hatching on the verso appear to be pen warm-up sketches where the artist accustomed himself to the feel of drawing on the resistent surface of the wood. Apart from some wormholes the block itself is excellently preserved.

Altdorfer's intricately finished design tells us a good deal about his procedure and the approach to cutting such a block. First, the *Lamentation* is oriented parallel to the grain, as was technically preferable for woodcut compositions in vertical format. When the fine, reliefed ridges of a woodblock are badly worn from printing, the fiber gradually breaks down in the softer wood between the striations of the grain leaving a jagged profile along the ridge of lines cut across the grain. This registers in late impressions as an irregular, dotted line where once a continuous, printed line appeared. From the evidence of impressions taken from deteriorated

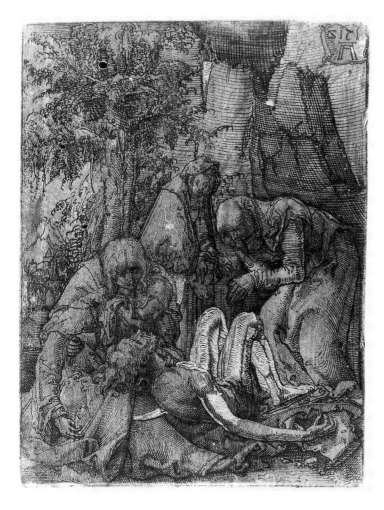

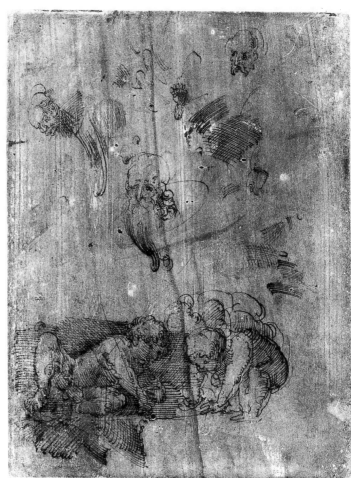

blocks, as well as from many actual sixteenth-century blocks, we can see the preference of woodcut designers for laying out compositions on an axis parallel to the grain. This orientation tends to mean that fewer lines are cut against the grain where they are more likely to splinter and become unstable over time.

If we exclude the possibility that the marginal drawings for the *Prayerbook of Maximilian* were intended to be made into woodcuts, there are no extant drawings on paper by Altdorfer that we know to have been made explicitly for transfer to woodblocks. This is not surprising. Given the intricacy of Altdorfer's style it would certainly have been necessary for him to draw his final compositions directly onto the block rather than on paper for transfer. All the sketches on the *Lamentation* block are unmistakably in Altdorfer's hand; however, the finished drawing for the *Lamentation* differs in execution not only from the trial sketches on the verso but from Altdorfer's other drawings from the same period that were done on paper. When Altdorfer drew on the block he paid very close attention to the expectations and abilities of his cutter. This is evident, for example, in the deliberateness of the line and in the care given to patterns of shading and modeling. Although Altdorfer made

no concession in the density of his linear networks, they are nonetheless coherent and distinctly laid out. Unlike in the flamboyant chiaroscuro drawings or the impulsive trial studies on the verso of the block, in designing the *Lamentation* Altdorfer was careful to restrain gestural superfluity and to control his love of caprice.

Since Altdorfer appears not to have given his block a painted ground, the absence of contrast means that the drawing is more difficult to make out than it would have been if set down against a coat of white paint. However, the smokey, grayish-brown nut color of the wood is still adequate to set off the black lines of Altdorfer's pen.[74] Only a very small portion of this block was actually cut, mainly along the raised legs of Christ and on the shoulders of Christ and the Virgin. The incomplete Munich block and the several completed and badly worn Altdorfer blocks now in Berlin[75] exhibit certain common features in their cutting, yet these similarities are not sufficient to posit a single *Formschneider* responsible for the entire corpus of Altdorfer's woodcuts. We have no sure information about the time required to complete such a cycle, but the forty blocks for the *Fall and Redemption of Man* would most likely have taken one cutter a good two to three years. If Altdorfer did not collaborate with

216. Albrecht Altdorfer, *Lamentation over Christ*. Pen and ink on woodblock, 123 × 94 mm. Staatliche Graphische Sammlung, Munich.

217. Albrecht Altdorfer, *Studies*. Pen and ink on verso of the block.

a single cutter, he must at least have supported for some years a workshop that maintained close continuity by training block cutters to the particular sensitivities required by his designs.

Altdorfer's surviving original blocks were cut almost exclusively with a sharp pointed knife, although occasionally one can see that a chisel might have been employed to trim-up a contour on the free side of a reliefed form. It also appears that much of the finest hatching was done simply by making an incision in the hardwood and pressing it apart without the need of removing a sliver between the reliefed lines. A characteristic feature of Altdorfer's woodcuts is the thickening of line at the point where parallel hatchings intersect to create a shivering line across a shadowed area (fig. 218). Here the pressure of a knife was used to push the ridges of relief lines together. Altdorfer was also fond of ranks of curling, scale-like patterns, for example to model the contour of a limb. These are undercut on a regular bias so as to create the effect of a row of dinner plates lying staggered on top of one another. The undercutting makes it possible for the block to register a very fine line while at the same time leaving it firmly supported. Where there are tight cross-hatchings, one axis tends to be cut evenly, and then the cross axis cut space by space with each trapezoid flicked out one by one. Cross-hatched areas caused the greatest danger of fracturing the reliefed lines because of the unavoidable need to cut regularly across the grain where the wood naturally becomes more friable. As a consequence there is a tendency to avoid cross-hatching along the strict vertical/horizontal axis of the block.

We are fortunate to have examples of uncut sheets from the *Fall and Redemption of Man* that can tell us something more about the means used for printing very small woodcuts. In the sheets preserved at Cleveland, for example, each carries the impressions from four separate blocks symmetrically arranged with a generous space of unprinted paper left between them (fig. 211). Those in Erlangen contain six impressions each, and according to

218. Albrecht Altdorfer, detail from *Fall and Redemption of Man*: *Resurrection*. Woodcut, 39 × 44 mm. Private collection.

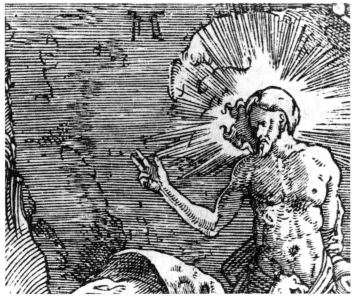

Winzinger originally had eight.[76] Close examination of the sheets in Cleveland reveals that four separate blocks were arranged with spacers between them and pins at the corners apparently to hold the blocks together on the printing bed. The lines on the relief of the blocks penetrated deeply into the thickness of the soft, pillowy paper that Altdorfer employed here. Traces of contraction of the paper are apparent from the paper having been well dampened before printing. These extraordinarily fresh, untrimmed impressions are all identified as proof sheets by Winzinger. There is no reason to suppose this is true. Since the sequences of subjects on each sheet are not iconographically arranged, it is clear that they were intended to be cut apart and trimmed. In all likelihood printing several blocks together separated by margins in this way was simply a matter of efficiency and a way of ensuring an accurate register. Several blocks were placed together in order to present a wide enough surface area to level the platen of the press and to achieve the degree of evenness required for such precise printing.[77] There is no doubt that a strong and evenly balanced mechanical press and an ink of perfect consistency were essential to printing woodcuts as demanding as these.

A careful study of Altdorfer's woodcuts for the *Fall and Redemption* shows how quickly he learned to accommodate the tolerances of the new medium and to develop a remarkable vocabulary for evoking distinctive qualities of form and atmosphere. In its own terms the cycle rivals his small engravings and those of the Nuremberg Little Masters beginning to be made about the same time.[78] These meticulous kinds of prints were virtuoso demonstrations of skilled artisanry designed to flaunt the tolerances of the medium. It is typically assumed that Altdorfer's illustrations of biblical history were issued for an illiterate market as a kind of *Biblia pauperum*, or poor man's Bible, a presumption based mainly on the prejudiced assessment of the woodcut as an inferior medium.[79] In fact, the *Fall and Redemption of Man* must have been intended from the beginning as a collector's item suited for an album, a library, or a print cabinet.

EMPEROR MAXIMILIAN'S WOODCUT PROJECTS

We have already seen how in the late fifteenth century the woodcut evolved through adept northern European book printing enterprises partly to serve the end of civic promotion. Anton Koberger's *Weltchronik* and Jacopo de' Barbari's *View of Venice* sponsored by Anton Kolb would have demonstrated to an alert propagandist like the Emperor Maximilian something of the possibility held out by the woodcut. Maximilian cannot have failed to recognize the success of Kolb's celebration of Venice any more

than he can have overlooked Hartmann Schedel's hyperbole when in his *Weltchronik* he located Nuremberg at the center of the world. For his part, Maximilian was quite clear on one point: the world and its history centered upon him. These earlier ventures in publishing set an example which he was soon to follow. It was certainly not coincidental that Jacopo de' Barbari appeared in Nuremberg and entered into Maximilian's service in 1500, the very year in which the great woodcut *View of Venice* was printed.

Although Maximilian's publishing projects were impressive in scale and in scope, much of the result is wearisome judged against products of the best of court patronage at the time. As a patron he was lavishly ambitious, but he was also a great pincher of pennies; he was a visionary in what he proposed for his artists and writers, but an incessant meddler in the results, and little of what Maximilian sponsored went to press in his own lifetime. Nevertheless, his patronage had much to do with the evolution of commercial print production in Germany, and particularly with the rise in importance of professional block cutters, many of whom passed through Maximilian's service at one stage or another. It is primarily this aspect of his contribution that concerns us here.

Augsburg, the location of the Imperial Council, was the obvious place for Maximilian's publication projects to be coordinated. Not only was Augsburg an important administrative seat, it was also well supplied with expertise in printing. Recall that Erhard Ratdolt had maintained a press there since 1486, and that by 1510 Hans Burgkmair had become accomplished in the design of exceptional woodcuts. Augsburg was a wealthy town and had an elite craft tradition, in many aspects surpassing that of Nuremberg. Preeminent in fine cabinetry and in certain kinds of metalworking, especially armor and weapons manufacture, it could rightly be expected to provide all of the technical needs for major printing schemes. And yet, as it turned out, even the resources of Augsburg proved insufficient to meet the Emperor's demands.

Maximilian's projects were initiated with the *Freydal*, *Theuerdanck*, and *Weisskunig*, two illustrated romances and an idealized biography, all conceived in book format and each in a different way testifying to the splendor of Maximilian's court and its chivalric traditions. Plans for the *Theuerdanck* were under way at least as early as 1505.[80] In conjunction with these there was to be an illustrated *Genealogy of the Hapsburgs* printed by Ratdolt and adorned with over ninety woodcuts designed by Burgkmair. Then came the monumental woodcuts of the *Triumphal Arch* and the *Triumphal Procession*, designed in the workshops of Albrecht Dürer, Hans Burgkmair, and Albrecht Altdorfer, perhaps the best known of Maximilian's productions. There were others as well, but the last and among the most innovative of his undertakings was an edition of a prayerbook, with a newly edited text and with margins lavishly decorated by Dürer, Burgkmair, Altdorfer, and Cranach. The *Prayerbook of Maximilian* survives in a proof edition of 1513, ten copies printed on vellum, and a few more on paper. The proof was probably intended as the layout for a printed book to be outfitted with woodcuts copied from the marginal pen drawings. And yet, like the majority of Maximilian's publications, this too was never realized in its final form.[81]

Our first record of the *Genealogy of the Hapsburgs* appears in a series of documents from the year 1510 when we find Conrad Peutinger, in effect Maximilian's literary agent, attempting to cope with an uncooperative labor force. We have already encountered Peutinger who, it will be remembered, sponsored the pair of colored woodcuts by Burgkmair in 1508. On 17 November 1510 Peutinger wrote from Augsburg that one of the block cutters at work on the *Genealogy* had decamped, and that no one in the city was adequate to complete the job. A month later we find him beset with the same dilemma, not knowing if and when the unnamed cutter would return. One rumor had it that he would be back in a matter of days, another that he had gone off to Nuremberg indefinitely. This personnel problem appears to have been solved in the following couple of weeks, since Peutinger then authorized payment of over one hundred *gulden* to Hans Burgkmair, a carpenter, and two block cutters for the design and execution of ninety-two woodcuts and other undescribed items.[82]

This was merely the first in a series of troubles in enlisting and retaining suitable block cutters. Peutinger was certainly a good judge of artistic as well as technical matters, and he had to be especially alert because his patron was obsessively attentive to detail. Peutinger was now in the position of having to organize Maximilian's publishing operation, and he was fortunate to engage the services of Jost de Negker. At that point, in a long letter addressed directly to the Emperor, de Negker wrote from Augsburg one of the most revealing documents we have from this phase in the history of woodcut making. (The letter, dated 27 October 1512, has already been referred to in relation to the woodcut portrait of Hans Paumgartner.) In the main part of this letter de Negker writes about the arrangements for cutting a large set of woodblocks, apparently those for the *Theuerdanck* (figs. 219–21).[83] He expresses his willingness to undertake the charge, and states that he knows two other able cutters ready to assist. He accepts an annual fee of one hundred *gulden* for each of his block cutters, but urges that this be paid partly in advance to cover their subsistence. His proposal is formulated in terms of annual wages, importantly not as a contract for piecework. Furthermore, he

asks for a private workshop where the block cutters might be able to labor undisturbed. In return, de Negker confidently pledges the following:

> Thus, I will devote myself to arranging everything for the two block cutters, to preparing and finally with my own hand laying out, making ready and refining everything, such that all the work and its parts will be alike in cutting, so no one will be able to recognize more than one hand.[84]

Jost de Negker's negotiation sounds very much like what we would expect of a court painter — someone not only familiar with his patron, but like a painter offering appropriate reassurances about the participation of assistants and the ultimate responsibility of the master for seeing that in the end everything will look as it ought to look.

Further on in the letter Hans Schäufelein is mentioned as the designer ("reisser oder maller"). Apparently Schäufelein was under contract to the printer Johann Schönsperger, who was remiss in paying for his work. Therefore, Schäufelein asked de Negker to intervene with the Emperor on his behalf. Here we have a glimpse of the hierarchy of patronage that descends from Maximilian to the chief block cutter, then to the printer, and finally, most subordinate of all, to the draftsman. (It should be noted that Leonard Beck and Hans Burgkmair were engaged along with Schäufelein to make the drawings.) The designs were valued at two *gulden* for every three drawings, whereas the assistant block cutters were to be paid a hundred *gulden* a year, and expected to complete around two blocks a month for what would amount to a total cost of about 490 *gulden* for 118 blocks — more than four *gulden* per block, and well over six times the cost of the finished drawings on the blocks. One should keep in mind that these estimates are conservative in that they do not account for de Negker's retainer, which was probably greater than the hundred *gulden* per year requested for his assistants. In addition, there was, of course, the cost of having the blocks prepared by a carpenter, acquisition of the paper, and the actual printing.[85] These very substantial figures should be considered in light of the fact that the *Theuerdanck* woodcuts are only moderately complex designs measuring ca. 160 × 140 mm. Given the relative time invested, the designer's fee per block compared to the cutter's (1:6) suggests that the draftsman was being very well paid for his drawings.

These preliminary expenses were only the beginning. In 1517 Maximilian expressed himself dissatisfied with the required proof impressions submitted for his approval. As we can see through comparison with the next edition of 1519, significant changes were made in over half of the 118 blocks. In some of the illustrations, entire figures were replaced by cutting sections out of the blocks and inserting plugs cut with new designs. In many cases it appears that the new designs were revisions by Beck of original designs by Schäufelein and Burgkmair. In any case, the inept Beck appears to have managed the changes throughout. Several of these changes were made in order to convert one character in the allegory to another, to account for a change Maximilian made in the text, or simply to remove one character from a scene altogether (figs. 220–21)! The rationale for all these changes seems consistently a matter of conformity to the text rather than anything to do with style, inferior workmanship, or damage to the blocks.[86] Beck's style in those cases where he actually introduced figures of his own clashes so stridently, especially in Burgkmair's compositions, that it is evident Maximilian's concerns were strictly with the letter of the text and not the formal character of the drawings. Though this is not surprising, it is an expression of the priorities of the single most important patron north of the Alps.

The organizational problems surrounding the *Theuerdanck* illustrations must have been relatively simple compared to the arrangements for cutting Maximilian's edition of saints for the *Heilige Sippe* (120 blocks) and the *Triumphal Procession* (136

219. Hans Leonhard Schäufelein, *Theuerdanck on his Sickbed*, from *Der Theuerdanck*, fol. 70. Woodcut, 160 × 140 mm. Österreichische Nationalbibliothek, Vienna.

blocks). In both of these instances, woodblocks survive with the signatures of the block cutters and their dates of completion on the reverse. In the *Heilige Sippe* no fewer than eight signatures are identifiable, among them Jost de Negker and at least two other Netherlanders, the brothers Cornelis and Willem Liefrinck. Between 1516 and 1518 all of these cutters along with three others were simultaneously at work on designs for the *Triumphal Procession* as well.[87] The initial sketches for the *Triumphal Procession* were made by Maximilian's court painter Jörg Kölderer and then reinterpreted onto the blocks by a far more distinguished crew — Hans Burgkmair, Albrecht Altdorfer, Leonhard Beck, Hans Springinklee, Hans Schäufelein, and Albrecht Dürer. These blocks then entered the cutters' assembly line.[88] A chronological list of precisely dated blocks by each cutter done for the *Triumphal Procession* and *Heilige Sippe* confirms a rate of production corresponding to that proposed by de Negker for the *Theuerdanck*. Though the sequences are very irregular, just as de Negker promised in his letter these block cutters commonly managed to complete two compositions a month, sometimes three.

On the basis of surviving documents we cannot draw very precise conclusions about the organization of this workshop of block cutters. In a letter from Conrad Peutinger to Maximilian on 9 June 1516, Peutinger reports that a majority of the blocks were left undone, since only one cutter was still in Nuremberg under contract. In Augsburg five cut-

ters were nominally at work, and a sixth, "genannt Cornelius" (probably Cornelis Liefrinck), was expected soon from Antwerp. However, lack of payment was causing dissent in the ranks.[89] At this point, revisions and confusions still persisted over the illustrations for the three books, while cutting blocks for the *Triumph* was only just getting under way. Jost de Negker seems to have played a prominent role in the completion of all these cycles. Though Peutinger was clearly in charge of the details of production, it is probable that we have here the fulfillment of de Negker's earlier proposal for a large atelier placed under his supervision. The Liefrinck brothers were the start of a family workshop of printmakers that continued to be active throughout the century. The volatile Hieronymus Andreae, one of Dürer's favored block cutters, was also prominent among Maximilian's staff. The great *Triumphal Arch*, perhaps the best known of Maximilian's woodcut projects, is an enormous architectural composition with a complex iconographic program intended for mural display. The *Arch* was initially laid out by Kölderer, and rendered more or less aesthetically palatable through the combined efforts of Dürer and his workshop. It was then entrusted entirely to the supervision of Hieronymus Andreae for cutting its 192 blocks.[90] The whole undertaking must have been inspired by the sorts of temporary but extravagant architectural constructions thrown up by artists for festivals and processions.

The full complement of Maximilian's stable of

220. Hans Burgkmair, *Theuerdanck Walking on a Wheel of Swords*, from *Der Theuerdanck*, fol. 90. Woodcut, state I, 160 × 140 mm. Österreichische Nationalbibliothek, Vienna.

221. Hans Burgkmair, *Theuerdanck Walking on a Wheel of Swords*, from *Der Theuerdanck*, 1517. Woodcut, state II, 160 × 140 mm. British Museum, London.

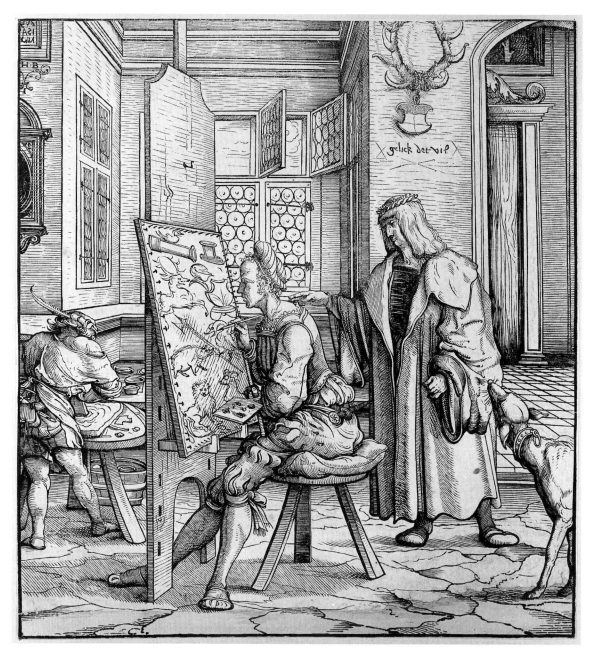

artists and craftsmen was a formidable collection of talent, and yet none of this effort would emerge from the presses until well after Maximilian went to his grave. When the Emperor died in 1519, the *Genealogy*, *Weisskunig*, *Freydal*, *Heilige Sippe*, *Prayerbook*, and *Triumphal Procession* remained unfinished. Only the *Theuerdanck* (1517) and the *Triumphal Arch* (1517–18) were realized in publication, though even then Maximilian had still not settled his accounts on the blocks for the *Triumphal Arch*.[91] Judging from what we know of the individual progress of many of these projects, this failure cannot be attributed to the legion of literary men, managers, designers, craftsmen, and publishers engaged in carrying them out. Rather, the obstacle lay in Maximilian's own close supervision and compulsive intervention at every stage.

Despite these interventions, however, Maximilian's patronage played an absolutely critical role in the reorganization of print manufacture during the sixteenth century.

Unfortunately not so much owing to a pride in connoisseurship as merely to a cumbrous obsession with detail, Maximilian's constant oversight of his artisans lends special meaning to the scene from the *Weisskunig* in which the Emperor is shown offering instructions over the shoulder of a painter (fig. 222). Perhaps we are intended to recognize the artist as the author of the image itself, Hans Burgkmair. Aptly enough, it appears that this composition also failed to meet Maximilian's expectations. The deer's antlers on the wall behind and the motto "gelick det vil" (luck goes far) were removed in the published state along with some other minor

223. Hans Burgkmair, *Weisskunig in a Painter's Workshop*, from *Der Weisskunig*. Woodcut, state II, 215 × 195 mm. Kupferstichkabinett, Berlin.

changes (fig. 223). We cannot know whether Maximilian objected to the horns poised above his royal crown, the concession to fortune in the motto, or both.

MAXIMILIAN'S BLOCK CUTTERS THEREAFTER

If Maximilian's luck did go far, it was mainly because, unlike his printing projects, he was given no opportunity to have a say in the matter. But fortune eventually exacted its price. In 1519 Maximilian died, and a gulf opened in the flourishing Augsburg printing trade, forcing the Emperor's cadre of woodblock cutters to disperse across Europe in search of further employment. As a result, several of the most skilled craftsmen in the history of the medium went on to establish themselves as woodcut publishers in their own right. This legacy of trained *Formschneider* who gained their independence in the second and third decade of the sixteenth century must be counted among Maximilian's most valuable contributions to the history of the print.

Jost de Negker

The enterprising Jost de Negker made a lasting impact on the course of woodcut production in northern Europe. His career is an important instance of a block cutter emerging from apprenticeship under

Maximilian to take over the manufacture and trade of woodcuts. Recall that he appears to have joined Hans Burgkmair's workshop in Augsburg sometime around 1510, perhaps on the recommendation of his fellow countryman Cornelis Liefrinck, who was then already in Burgkmair's employ. Probably through his relationship with Burgkmair, de Negker soon came to the attention of the close circle of civic and court officials, humanists, and businessmen who controlled Augsburg's elite system of patronage — Conrad Peutinger, the printer Johann Schönsperger, Hans Paumgartner. By 1512 he was in a position to write to the Emperor himself. The professional relationship that evolved between Burgkmair and de Negker seems to have resulted in this enterprising artisan taking charge of a great many blocks done from Burgkmair's designs. In effect, de Negker became Burgkmair's publisher. We should probably understand this arrangement as one in which de Negker commissioned designs, cut them himself or had them cut by an assistant, and then printed and purveyed the impressions under his address for his own continued profit. This practice on de Negker's part extended to the publication of designs by Christoph Amberger, Hans Schäuffelein, Hans Weiditz, and Jörg Breu as well. A favorite tactic of his was to supply the artists' compositions with elaborate, ornamental woodcut frames that could be varied and repeated, especially for cycles of related subjects. He also issued pirated copies of woodcuts by other masters. Among these is a set of anatomical illustrations copied from Vesalius's famous edition published in Venice with woodcuts by Jan van Calcar. The last dated work by de Negker is a copy of Hans Holbein the Younger's *Dance of Death* cycle made by Heinrich Vogtherr the Elder. De Negker pirated the pirate of this series, and then published it auspiciously in 1544, the very year of his own demise.[92] Like many printmaking operations throughout the sixteenth century, Jost de Negker's workshop became a family affair. After his death, his operations as a printer and publisher were taken over by his son David, who inherited a number of blocks from his father. David de Negker is recorded as active for at least a decade in Augsburg, and then subsequently in Leipzig and Vienna.[93]

Hans Lützelburger

Among the several skilled artisans we know to have honed their talents in Maximilian's print factory, the remarkable Hans Lützelburger is unsurpassed. A few scattered traces of his accomplishment make it possible to reconstruct the barest outlines of what appears to have been a very brief but distinguished career. Lützelburger has been convincingly identified as the *Formschneider* who signed himself Hans Franck on a number of woodblocks done for Maximilian in Augsburg during the late teens. We do not know exactly how long he continued to work in Augsburg, since there is evidence of his having contributed his services elsewhere before he reappeared in Basel. But by 1522 he almost certainly was in Basel. There he engaged in a number of projects for printmakers and publishers culminating with the execution of woodblocks for Hans Holbein the Younger's extraordinary cycle the *Dance of Death*. Lützelburger died only a few years later in 1526, leaving a portion of the Holbein blocks unfinished.[94]

Whether he was still in Augsburg or, as seems less likely, already in Basel, it was also in 1522 that Lützelburger published his first undoubted masterpiece, the *Battle of Naked Men and Peasants* (fig. 224) designed by the anonymous Master NH.[95] This exceptional woodcut poses several intriguing questions pertinent to our study of the rise of the professional woodblock cutter and to our inquiry into the status of woodcuts as works of art. Therefore, we shall take the liberty of pursuing a more sustained examination of Lützelberger's special genius as it is manifested in this particular image.

The *Battle of Naked Men and Peasants* has come down to us in at least two separate editions. Several impressions of the woodcut were printed with two supplementary woodblock panels placed at opposite corners along the lower margin of the composition, the one on the left bearing the inscription HANNS . LEVCZELLBVRGER . FVRMSCHNIDER . 1.5.2.2., and the other on the right showing a sample alphabet of Roman capitals. These panels immediately reveal something of the intention underlying this edition of the woodcut, and also a clue to the commercial relationship obtaining between the cutter and designer. Their inscriptions declare Lützelburger's skills as a block cutter and as a designer and cutter of letters. The fact that Lützelburger added his name on a separate block, rather than in the composition itself where the monogram of the designer appears, can be interpreted in one of two ways. There may have been a change in the initial arrangements; for example, Lützelburger might have retained the block for lack of payment and as a result published it conspicuously under his own name. Or it may have been his intention all along to publish the print in the fashion that we see it here, allowing him ample room to flaunt his abilities without intruding on the image itself. We cannot be certain, but it appears that the earliest impressions of the print either carry Lützelburger's panels or have been trimmed to the margins of the scene, thereby precluding a determination of whether they once bore the additional panels.

Recognizing that the promotional aspect of this woodcut is unusually direct also gives us some purchase on the meaning of its curious subject matter. There is an important precedent for the scene: Antonio Pollaiuolo's *Battle of the Nudes* (fig.

HANNS
LEVCZELLBVRGER
FVRMSCHNIDER
· I · Ƽ · Z · Z ·

A B C D E F G
H I K L M N O
P Q R S T V X
Y Z

56) done a half a century before, a print that spawned a motley lineage of imitations in Italy and the north including a woodcut copy by Lucantonio degli Uberti. Yet our woodcut is a curious and distant member of this family, not a battle of naked men *all'antica* but of naked men and peasants. It appears that the Master NH was not concerned with staging a classical skirmish. His naked figures suggest primitives or savages, and wield hooks, yokes, and clubs as well as swords, rapiers, and roundel shields.[96] This oddly exotic feature alongside the unmistakably German peasantry and the equally local firwood forest makes for an improbable combination. We are reminded less of Arcadia than of the atavistic fascination with the forest and its legends that so intrigued the artists of the Danube school. The print is a vernacular improvisation on the quintessentially Italianate motif of the antique battle.

In this sense the local character of the scene and its transformed classical theme can be understood as a kind of artistic declaration of independence not at all surprising to discover in the wake of Maximilian's patronage. Indeed, the Emperor's sponsorship of works such as the *Theuerdanck* and the *Triumphal Procession* was prompted by just such aspirations.[97] In keeping with its implied allegori-

cal theme, the *Battle of Naked Men and Peasants* can also be interpreted as an exercise in high and low styles — the portrayal of the nude figure as a paradigm of idealized classical style set alongside the bucolic estate in its customary trappings. Here we must recall Albrecht Dürer's much-quoted declaration "that an able and practiced artist can demonstrate his great power and art better in a coarse and rustic figure, in a lesser thing, than many in a great work."[98] In this woodcut Lützelburger and the Master NH have made a demonstration piece of many parts, a means of declaring their virtuosity and at the same time promoting the elements of a new northern style.[99] It would have been an apt and impressive way for Lützelburger to present his credentials to the Basel publishers on his arrival in the city.

Campbell Dodgson long ago proposed that the battle scene includes among its figures portraits of both Lützelburger and the Master NH. The two men in question appear near the left margin, one brandishing a flask and pointing with a trimmed stick to the *cartellino* bearing the designer's initials, the other holding a flagon and pointing to the same *cartellino* with his index finger (fig. 225). We might conclude simply from the location of these figures and their attention to the signature that they are

224. Master NH, *Battle of Naked Men and Peasants*. Woodcut (Pass. III.443–44), state I, 149 × 295 mm. Öffentliche Kunstsammlung, Basel.

213

Ain Jnſel haiſſe Vtopien
Die leye nit ferr von Moſan
Da giſchach ain ſollich aſchlagen
Hundert tauſent hort ich ſagen
Doch iſt es eben vil der Jar
Das ich gelaub es ſey nit war
Wann wie wolt ain nackend man
Ain angelegten panren bſtan
Der maiſter der das hat erdicht
Der hat ſein kunſt dahin gericht
Das man erkennen mug da bey
Waß hoher kunſt im maalen ſey
Auß maalen kumpt gar vil zu druck
Durch formen ſchneyden manig ſtuck
Vnd welcher ſollich kunſt mit waiß
Der maalt ain eſel für ain gaiß
Vnd ain Teifel für ain Engel
Ain nerff für ain pꝛeſenſtengel
Maalen kumpt von alter her
Maalen hat groſſ lob vnd eer
Bey den alten offt erworben
Das zaigen die vor ſeind geſtorben
Pythio Micon Timagor

Poligrot Appollodor
Der auch das erſt penſel fand
Cleophante gab farb den gwand
Gyges nach den ſchatten maale
Prothagein die kunſt nie faale
Dꝛ doch Appelles über wand
Mit kläger lyni die er fand
Zenſio die weiber maals ſo fein
Das darzu flugen die vögelein
Vnd wolten darvon eſſen
Parthaſis ſich nie verɡeſſen
Der maalt ain ſtich von kläger art
Damon Zenſia betrogen ward
Wer maalen will ſoll ſein gelert
Jn künſten vil / als drinn begert
Die rechten kunſt der maalerey
Jn perſpectiua / Geometrey
Es ſoll auch gar nit nichte
Verſaumen der Poeten dichte
Mit ſinnen ſey er geſchwind vnd bhend
Den ſinnen volgen nach die hend
Das er herfür kund bringen
Maß vnd gſtalt in allen dingen

Mit ir natur vnd aigenſchafft
Vil farben macht er auß dem ſafft
Grün / plaw / pꝛann / wie mans haben will
Wer maalen will der darff noch vil
Erfarung land vnd leüte
Berg vnd tal / hoch gebürg vnd weyte
Fiſch / vögel / aller thier geſtalt
Er kennen ſoll / wie manigfalt
Gott hat ſy all geziret
Den hymel vmb her ſiert
Mit liechter vil entpꝛennet
Da bey man wol erkennet
Den ſchöpffer hoch ins hymels throne
Der alle gaben taile gar ſchone
Mit rechter maß wer es begert
Deſ maalens ſeind nit vil gelert
Darumb man billich loben ſoll
Den / der ſein kunſt beweiſt wol
Als diſer auch ain maiſter was
Doch iſt im lieber das wein glaß
Das bꝛaucht er für ain langen ſpieß
Er thů ims nach / den das verdꝛieß.

225. Master NH, *Battle of Naked Men and Peasants* (detail lower left).

226. Master NH, *Battle of Naked Men and Peasants*. Woodcut (Pass. III.443–44), state II with verse text. Staatliche Kunsthalle, Karlsruhe.

meant to be understood as self-portraits. To be sure, this would be appropriate given what we have determined thus far about the purposes behind the image. However, Dodgson's argument rests additionally on the evidence of a second state of the woodcut which includes in place of the appended blocks a lengthy verse text purporting to explain the subject matter of the print (fig. 226). The text consists of thirty-four couplets written in a forced rhyme and purports not only to interpret the subject of the print but goes on to rehearse the virtues of antique painters as recounted mainly by Pliny, and then concludes by mocking the artist of the broadsheet for his dissolute habits.[100] The woodcut together with its accompanying verse seems to comprise a sort of scholarly in-joke. In both its classical and parodic aspects the character of the broadsheet is strikingly literary, though we would certainly be hesitant to say graceful. The coy erudition of the verse and its turns on classical commonplaces suggest that both author and audience bear their learning lightly, an aspect of the woodcut broadsheet that by this stage in our discussion should no longer seem out of place.

The verse goes on in venerable Renaissance tradition to refashion Pliny's familiar litany of ancient painters, and finally in the closing lines the poem turns its attention once again to the skills of the artist: "Therefore one should justly praise / whoever demonstrates his art well. Like this one who was also a master / though he prefers a wine glass;

he wields it instead of a long spear."[101] Unfortunately we are left to guess at the identity of the artist and whoever was responsible for this bumbling but witty vernacular text. The closing jibe is suitably topical. We might recall here that Swiss printmakers especially were gaining a reputation for being camp followers or lansquenet prone to wander off to foreign wars. For example, one thinks of Urs Graf, an occasional soldier who made a great many images of mercenaries. The Nuremberg sculptor and woodcut-maker Peter Flötner has also given us a figure of an artist turned mercenary titled *Veit Bildhauer* — "Veit the Sculptor" (fig. 227). An unrecorded state of this print carries a short verse text in which a lansquenet laments how he once carved beautiful images, "artistic in both the Italian and the German fashion," but that no one any longer values these. Therefore, though he could cut naked figures which would easily sell "in Mark and Stetten," this is not to his taste, and he has thus been driven to take up his halberd and go off to serve a prince.[102] Such twists of fortune may indeed have become proverbial among the shifty practitioners of the print and printing trades in these volatile years.

Hans Lützelburger went on to complete his career as a block cutter in the artistic circle of Johannes Froben of Basel, patron of Holbein and publisher of both Thomas More and Erasmus. How carefully directed and appropriate a statement the *Battle of Naked Men and Peasants* must have

214

Ueyt Pildhaver.

Vil schöner Pild haß ich geschnitten Die weren weyt in Marck vñ Stetten
Künstlich auf welsch vñ deutschen sitten So aber ich das selb nit kan
Wiewol die Kunst yetz nimer gilt Muß ich ein anders fahen an
Ich kündt dan schnitzen schöne pilt Vñ wil mit meiner Hellenparten
Nacket vnd die doch leben thetten Eyns großmöchtigen Fürsten wartten

227. Peter Flötner,
Lansquenet. Woodcut
(G.832), 319 × 180 mm.
Ashmolean Museum,
Oxford.

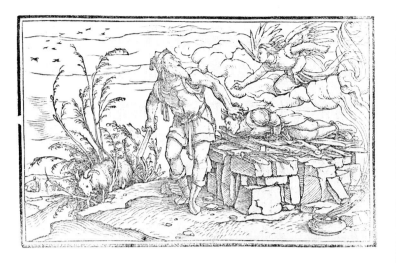

been! This was a vibrant intellectual circle, far less conservative than the imperial stronghold of Augsburg, and certainly much more alert to the tremors of Reformation thought unsettling northern Europe at the time. It would be extremely interesting to know something about Lützelburger's religious convictions in these years, since it is certain that he participated in the production of illustrations for several editions of the Bible based on Luther's German translation and pirated in Basel by Adam Petri in 1522–23. The most impressive project of this type was the *Icones Biblicae* (fig. 228), a cycle of illustrations in horizontal format designed by Holbein after those in Luther's Wittenberg Bible. In addition, at least one broadsheet meant to further the Lutheran cause is thought to have been cut by Lützelburger.[103]

In his final years Lützelburger must have been cutting blocks at a furious pace, to judge from the numbers of works attributed to him. Some of these must have been done under his supervision rather than by his own hand, although we have no record of his maintaining assistants. Most celebrated among his accomplishments in Basel is the cycle of the *Dance of Death*, not published until 1538 by Melchior Trechsler at Lyons, long after Lützelburger's death (fig. 229). In his preface to the first edition, Jean de Vauzelles aptly eulogizes the skill of the artist "who makes me think that death herself is afraid this excellent painter renders her so alive that she can no longer inspire fear."[104] The unnamed master who is said to have beguiled death herself, but was nonetheless himself taken prematurely, can only be the block cutter Lützelburger. Startlingly, no reference is made in the preface or in a colophon to Hans Holbein the Younger, then very much alive and an artist of international distinction whose name could only have contributed to the value of this edition had he been recognized as its inventor.[105]

The misattribution of the woodcuts for the *Dance*

of Death was evidently not due to conscious neglect but was a result of all record of Holbein's authorship somehow having been lost in the intervening years. This fact alone tells us something more about the priorities of publishers and printers in the day-to-day reality of production and trade. The most recent reconstructions of the artistic relations in Froben's publishing house suggest that the enterprising Frenchman Jacob Faber, a skilled cutter and chief supplier of metalcuts for Froben's books, eventually operated as an independent agent commissioning and trading blocks and plates with French and Swiss publishers. In 1524 Faber left permanently for France, moving to Paris and possibly also Lyons, where Protestant sympathies were particularly strong among the rank and file in the printing houses. During these years Faber was in close contact with major figures in the Reformation movement and may have adopted the new faith. He may well be identical with one Jacques Lefevre (the Gallic version of Jacob Faber) who, along with several others, was accused of heresy in Paris in 1534–35.[106]

It appears that Holbein, and likely also Lützelburger, were at one point working for Faber. However, as best we know, it was Lützelburger who dealt with the Trechsler firm over the *Dance of Death* blocks, and after his death the Holbein blocks (forty-one out of fifty-one complete) were transferred to Lyons. Only those blocks finished by Lützelburger were printed in the edition of 1538. The remaining ten blocks, as the preface tells us, were acknowledged as too difficult for anyone to attempt other than the deceased master himself.[107] These circumstances help explain why Lützelburger and not Holbein was initially credited with the designs for the *Dance of Death*. Though history has rightly deprived him of this honor, there can hardly be any doubt about the importance of Lützelburger's contribution to furthering the quality of fine woodcut-making in northern Europe.

Hieronymus Andreae

Hieronymus Andreae, also known simply as "Hieronymus Formschneider," ranks among those distinguished masters celebrated in Johann Neudörfer's 1547 chronicle of Nuremberg's artists and craftsmen. Indeed, he is the only professional block cutter to be so honored. Neudörfer makes a point of the man's versatility, and mentions that he had his own printing house (*Druckerei*), from which we must infer he ran his own press. Apart from conventional relief work of the sort we have been discussing, Hieronymus, like Lützelburger, was expert in fashioning elaborate scripts in woodblock. As we have already noted, the lavish inscriptions on and beneath Maximilian's *Triumphal Arch* (B.138) were also cut in Hieronymus's shop along with the figural blocks, an accomplishment well known to Neudörfer, since he was responsible for drafting the calligraphy. Neudörfer was a professional writing master and came to be the chief practitioner of fine calligraphy (*Schönschreibkunst*) in Renaissance Germany. Apparently Hieronymus was also skilled in cutting stamps, punches, and coins. Neudörfer describes how he set a test for him cutting *Fraktur* letters in wood and after that into steel punches.[108] Indeed, Hieronymus's talents seem to have been well acknowledged by Maximilian himself who, it is said, when sojourning in Nuremberg went daily to watch him at work in his shop in the Frauengäßlein.[109] Whether this flattering report be true or false, we must surely observe that here it was Hieronymus Formschneider, not Albrecht Dürer, being cast in the role of Apelles basking in the admiration of his latter-day Alexander. As we have seen, Maximilian put a very special premium on the technical execution of his projects despite his unwillingness to pay for them.

The possibility of Hieronymus's intimacy with the Emperor is perhaps not entirely far-fetched, since there is evidence that he may have matriculated at the University of Leipzig in 1504. This might well explain the curiousness of an artisan having adopted a latinized surname. Coincidentally, nearly forty years earlier the very same university enrolled none other than Martin Schongauer.[110] It appears that artisans who worked for a university — painters or printers for example — were sometimes granted the right to matriculate without ever actually engaging in academic studies, because the affiliation allowed them to receive certain benefits such as relief from guild obligations. Hieronymus's adopted name and his later connections imply, however, that he very likely did study.[111]

Little else can be inferred about Hieronymus's career prior to his participation in the block cutting for the projects under way in Augsburg during the mid-teens. Probably he was never actually with Jost de Negker in Augsburg, but working independently in a shop of his own in Nuremberg

where he is recorded as having taken citizenship in 1523. Nuremberg's free trade policy surely made it an appealing place for a man of Hieronymus's talents and publishing ambitions. However, his subsequent career, like that of many of his contemporaries in the printing trade, was to be marked by repeated legal and political disturbances.

What can be further reconstructed of Hieronymus's biography gives us a fascinating glimpse of a printmaker's life during a very unstable phase in Nuremberg's history. In December 1524 the printer Hieronymus Höltzel (who had previously issued a number of designs from Dürer's shop) was jailed by the city council for the publication of writings by Andreas Karlstadt and Thomas Müntzer, two of the most radical agitators in the early years of the Reformation. Höltzel claimed to have obtained these texts through some unnamed peddler, and it seems they were not the only subversive writings then in his possession.[112] Such trafficking in illicit religious texts was by no means a minor matter. The Nuremberg council well recognized the threat posed by printed propaganda in an uneasy political atmosphere. As a result, artists, and particularly printmakers, were very much under the spotlight. The Nuremberg authorities' nervousness over any form of social or religious agitation was manifested again in the following month when the brothers Sebald and Barthel Beham and their colleague Georg Pencz, the "three Godless Painters" as they came to be known, were brought to trial for atheism. Not incidentally, all of them were also printmakers by trade.[113]

Then in the spring of 1525 came the cataclysm of the great Peasants' War, an eruption on a scale unparalleled in the history of the region. In May of that year Hieronymus Andreae was jailed for his sympathies with the peasantry during the revolt. A few tantalizing details regarding the circumstances of this case survive. The charge seems to have turned upon an alleged exchange of correspondence between Hieronymus and a radical reformer and outright supporter of the peasants, the preacher Bernhard Bubenleben.[114] It appears that while in prison Hieronymus managed to receive a lengthy letter on behalf of the disaffected peasants, a letter that contained a number of "poisonous passages" which the council regarded as highly threatening, and to which he seems to have responded. Hieronymus was released only later after the intervention of influential friends on the council, and apparently after having compromised a number of partisans to the revolt.[115] These events probably do tell us something about Hieronymus's politics, even if the details may be partly or largely invented. Throughout the tribulations of the early Reformation, printers and printmakers were regularly involved in publications promoting one cause or another, indeed often two conflicting causes simultaneously. Being printers, controversy was their

natural milieu and also an opportunity for commercial gain.[116] Regardless of where Hieronymus's actual convictions lay, it is striking to find him accused of such a serious offense and then, as the documents clearly show, in the very wake of his acquittal once again dealing in good faith with the Nuremberg council and the imperial household!

It appears that the matter of Maximilian's various unfinished publications lay dormant for several years after the Emperor's death. Finally, in the spring of 1526 the Archduke Ferdinand began to press for their completion. From the 1st of March we have a letter on behalf of the Archduke to Marx Treitsauerwein, Chancellor of Lower Austria, regarding several of Maximilian's uncompleted woodcut projects including the *Triumphal Arch*. The blocks for the *Triumphal Arch*, at this point scattered about, were to be brought together and transported to Vienna. The letter commands the publication of an edition of however many impressions the blocks will allow, and requests 300 examples for the Archduke. The same request is made with some variation for the remaining projects, most of which still required the completion of the blocks.[117] Evidently the Archduke had decided to sponsor an extravagant commemoration of his grandfather's career, a policy which must certainly have been meant to prop up Ferdinand's own claim to the imperial throne.

In order to tie up the last of Maximilian's projects, Ferdinand's agents found themselves having to confront the formidable Hieronymus Andreae, albeit through the auspices of the Nuremberg council. Hieronymus was still in possession of the blocks for the *Triumphal Arch* and it seems he was holding them as collateral against an account left unpaid by the deceased Emperor.[118] Conceivably from the beginning Hieronymus had been granted the especially difficult charge of cutting the blocks for the *Arch*, the one project for which the final designs issued mostly from Dürer's Nuremberg workshop. Andreae's monogram appears on nearly all of them, which suggests that whether or not he cut each of them himself, he at least took responsibility for finishing them in the manner earlier proposed by de Negker on behalf of his assistants in Augsburg. Hieronymus very likely planned to publish the *Arch* on his own at some point. In fact, sometime around 1520 he did separately issue three sets of the historical compositions with accompanying texts.[119] So far as we know, this initial pirating provoked no official reaction. The question of payment for the blocks seems to have been quickly resolved, and they were passed on to the Nuremberg council for transfer to Vienna.

Hieronymus Andreae's subsequent career continued in this litigious vein. In 1527 he is listed among the book printers in Nuremberg,[120] and by this time had taken over the cutting of the blocks for Dürer's treatises, a potentially lucrative project which would immediately bring about further legal difficulties. The same year, Hieronymus published under his own name a copy of a Lutheran prayerbook, omitting the reformer's name on the title page. The prayerbook was illustrated with woodcuts by Sebald Beham.[121] In the wake of Dürer's death the following year, both Hieronymus and Beham were accused of plagiarizing a treatise on the proportions of the horse based on Dürer's studies. Dürer's widow Agnes received an injunction from the Nuremberg council prohibiting publication of the text and illustrations.[122] After this stormy phase in Hieronymus's commercial operations he seems to have kept himself within the law for a time. Then in 1542 he was accused of slandering a council elder and failed to appear in court for the hearing. For this he was stripped of his position as official stamp cutter and sentenced to be jailed for two weeks, resulting in his temporary flight from the city. Three years later he was active again in Nuremberg and so far as we know finished his life in relative calm, dying in 1556.[123] Hieronymus's criminal record ran to a considerable length by the end of a career spanning four decades, yet, despite all of his encounters with the law in the constrained political atmosphere of Nuremberg, the irascible block cutter's talents appear to have been too valuable to incur permanent disfavor or exile.

Hieronymus Andreae will no doubt always be best known for having cut the blocks for the *Triumphal Arch* and the *Small Triumphal Car* (fig. 235). His last contributions to the Dürer corpus were the illustrations for two of the treatises, an uninspiring and laborious task.[124] It is noteworthy that he seems not to have been entrusted with more of Dürer's finer woodcuts, perhaps because the artist was too alert to turn over his work to an opportunist of such ambition and occasional unscrupulousness! Hieronymus's career as a block cutter for the nearly thirty years it persisted after Dürer's death has not been systematically traced apart from the scattered documents mentioned above. It must be that throughout this period he maintained a workshop of some size and devoted a significant amount of his efforts to printing small books and pamphlets as well as single-sheet woodcuts, both legitimately commissioned and pirated.

Here we have further evidence of the importantly unfixed position of the professional block cutter in northern Renaissance Europe. Indeed, this protean aspect of the early print trade became one of its defining features during the decades of Hieronymus Andreae's career. Deemed a "free art" in most towns, the small printers and printmakers usually worked independently of guild regulations in a trade that, because of its relative degree of literacy, must have maintained more than a strictly commercial relationship with academic, administrative, and entrepreneurial circles. As makers and pur-

veyors of religious pieties, artistic pleasures, sensational happenings, and sundry propaganda, they were situated at a point that was particularly sensitive to social and political tension, and very well placed to take advantage of it. The woodcut played an essential part in the invention of propaganda both in visual imagery and as a literary form. With presses at hand, whenever the printmakers or their patrons found themselves aggrieved about something they were in a very good position to advertise it.

CORNER PRESSES AND THEIR PUBLIC

Until now we have devoted our attention mainly to the evolution of sixteenth-century northern woodcuts meant for the more discriminating eye. These prints were typically designed by artists of recognized stature, on occasion actually commissioned for members of a social and political elite, and executed by craftsmen of astonishing skill able to cut into a block what were often perversely difficult drawings. And yet, as we have repeatedly implied, the audience for prints is a notoriously difficult one to circumscribe, the more so as we enter into the mature phase of Renaissance printmaking. We must now open the borders of this delicate inquiry, but in so doing try to define the territory as tactfully as possible in order to avoid the ready trap of historical anachronism. Scholars have often assumed too clear a distinction between the "fine" woodcut and a class of images they have designated as "popular." Though the term "popular" has a familiar enough ring to the modern ear, most of us would be hard pressed to define it in relation to works of art: art for an uneducated public? art for everybody, educated and uneducated alike? In the modern-day context, art and popularity are contradictory terms.

Popular prints as an acknowledged category of images is primarily a creation of the eighteenth century — *Populärgraphik, volksprenten, stampe popolari, imagerie populaire.* The production of popular prints led to the recycling of earlier broadsheets for this market and also the invention of catchpenny prints for children as a commercial enterprise. These prints were purposefully unsophisticated in their design, and also in the message they sought to deliver.[125] Prints of this sort were recognizably propagated "for the people," in sharp contrast to the "fine art" being cultivated by the academies. And, like folk art, it is a feature of these later popular prints that they were typically made by the "common people" for one another. A consciousness of class is frequently evident in their subject matter, which tended to address social relations as something relative and dynamic rather than hierarchically fixed. Unlike the stock kinds of social satire common in fifteenth- and sixteenth-century prints where the conventional orders of the medieval estates tended to be statically reaffirmed, the iconography of popular prints inclined to express populist views. In genuinely popular prints, social relations and social identities are not only described, but often challenged as well. The prints of concern to us, by contrast, were the product of an urban artisanry most often in close connection with the patronage of a cultural elite.[126]

In sixteenth-century European society there was as yet no precise counterpart to the notion of elite and popular culture. The very concept of a fine art first achieved definition in the learned discourse of the Renaissance at the very time the idea was made tangible through the practice of systematic collecting. Popular art as it eventually came to be understood depended upon being set against this as yet incompletely articulated aesthetic standard. In its early phase Renaissance art criticism was concerned with matters of quality and decorum, but these standards were not contingent upon some particular level of audience. To be sure, a distinction could be made between high and low styles, and between lofty and coarse subject matter. However, as Dürer explains in his aesthetic excursus, subject matter had nothing necessarily to do with quality, or with the public to whom a work of art was addressed. For him a work of art was essentially the invention of a skilled artist, and in principle it was something that could be understood and appreciated as much if not better by a craftsman as by a nobleman. If poorly done it would lack that quality Dürer understood to be essential to any work of art: inspiration realized with consummate skill. This is not meant to imply that sixteenth-century prints were not made with a particular audience in mind. One need hardly point out that a tiny print of a classical subject perfect for pasting into an album bore a different anticipation of audience than an illustrated broadsheet slandering the Pope. Devotional prints intended specifically for convents, designs for smiths working in precious metals, prints displaying domestic wares for young housewives, and farmers' almanacs all had their intended if not exclusive clientele.[127] The point is simply that the inclusive and at the same time polarizing term *popular* is not at all useful as a means either of grouping together or of discriminating among these various and quite specific audiences in a subtle way. Indeed, it is finally a misleading term for prints made during the period of the Renaissance.

However, at the same time that prints were establishing themselves as objects of interest to the collectors and aristocratic patrons in northern Europe, ambitious designers and publishers were indeed seeking to broaden the perimeters of their audience. What partly accounts for the variousness of print production, especially in the second quarter of the sixteenth century, is the emergence of small, specialized printing shops, the so-called corner press

printers or *Winkeldrucker*, who split off from the employ of painters and the larger book publishers to set up operations on their own. We shall now turn our attention to two such workshops in two major northern cities, workshops with extended histories differing markedly in ways that help illustrate this next phase in the commercial evolution of the print.

The Liefrincks and the Start of Print Publishing in Antwerp

As the network of commissioning, copying, pirating, and trading became more lively, it also grew more complex. In the first generation of *peintre-graveurs*, engravings and woodcut designs were conceived more often than not as a complementary sideline to a painter's trade. At this preliminary stage there remained an important separation between painters' workshops and the larger commercial world of the book publisher. But as the demands of block cutting grew more taxing and more sophisticated, a cadre of trained specialists emerged, specialists who quickly acquired not just the skill of block cutting but in a short time the knowledge of printing techniques and of type presses. They certainly learned something of how to exploit the values of an open market for printed images as well. Through prolonged association with printers and publishers, some of these block cutters, and of course all of the typesetters, must also have attained a degree of practical literacy.

The history of the Liefrinck family well reflects the consequences of these newly distributed skills and entrepreneurial ambitions. As we have already seen, early in their careers as woodblock cutters the brothers Cornelis and Willem Liefrinck were drafted into imperial service. Although Cornelis himself disappears from the records after his work in Augsburg during the teens, he had a son who followed him into the printmaking trade. Furthermore, Cornelis's widow was independently engaged in the family business in Antwerp at least as late as 1545. At the sale of Cornelis Bos's confiscated goods in that year she acquired the blocks for Titian's ten block woodcut frieze of the *Triumph of Christ* (fig. 242), and sometime thereafter printed an edition under her own name.[128] This was a revealing moment in the history of Netherlandish corner press printing and will shortly be treated in more detail.

Willem did eventually come back from Augsburg to Antwerp where he is recorded as having been received into the St. Luke's Guild as a master in 1528, and is listed categorically as a printer (*printere*). In that same year Willem took on the first of four recorded pupils, Sylvester van Parys, who himself went on to a prolific career as a block cutter and printer in Antwerp.[129] Willem's activities can be traced through a number of works that carry either his address or what appears to be his printer's mark. Prominent among them is Jan Swart van Groningen's woodcut frieze of the *Turkish Cavalry* (Holl. 4) dated 1526, which bears the address "Geprent tantwerpe By my Willem Liefrinck figuersnyd."[130] The fact that the date of the print places it prior to Willem having been formally registered in the guild could mean that he only acquired and published the blocks sometime after they were designed and cut. Delen is inclined to see the hand of Willem Liefrinck behind a number of refined woodcuts by masters such as Jan de Cock, Jan Gossaert, and Pieter Coecke van Aelst published during the period before his death in 1542, though he gives no argument for this claim.[131]

Willem left six children including a daughter Willemyne, who shortly after Willem's death married the print designer and engraver Frans Huys. One of Willem's sons, Hans (also known as Jan or Jean) Liefrinck, eventually became a central operator in the Antwerp print trade and, in retrospect, the most important figure in the extended family network. The degree to which Hans was actually engaged in making the prints issued in connection with his name remains unclear. Almost certainly he was not a designer.[132] Hans is first listed in the Antwerp St. Luke's Guild as a printer in 1538. Then in 1543 he applied to Charles V for an imperial privilege to protect the publication of a representation of the *Siege of Heinsberg*. Liefrinck complains in his petition that this print, among others, was being pirated and his profits undercut by works of lesser calibre, particularly, as he says, because the common people are unable to judge an original work made from life and will take a coarse imitation in its place. He points out that copyists are free of the expense of paying artists for their designs. The privilege was granted for two years' time with a penalty against copying of fifty *Carolus guilder* in gold, a very substantial sum indeed.[133] The seriousness of the fine suggests, as we might expect, that privileges of this kind were mainly gestures of intimidation and probably only rarely enforceable.

We next hear of Hans Liefrinck along with Cornelis's widow in 1545, building up his stock of woodblocks and intaglio plates through purchases from the sale of Bos's workshop. Then in 1549 he is involved in a debt over an exchange of "paintings and other works of art," suggesting that Hans was in the business of dealing in art more generally. Much later, in 1556, he acquired what must have been a large additional cache of copper plates and blocks for 288 *guilder* from Bos's widow in Groningen.[134] Some of the results of this acquisition are recorded in an arrangement of 1558 when Hans supplied Christopher Plantin, an occasional print dealer as well as a book publisher, with multiple impressions

of several prints presumably taken from his available stock. Among these are prints engraved by Bos.[135] Hans was made Dean of the Antwerp guild in 1556. His daughter Myncken eventually became active as an illuminator and publisher in Antwerp, and we know that his cousin also worked as a printmaker in Leiden until well into the seventeenth century.[136]

Initially, the Liefrincks consolidated their position as print publishers by cornering the Netherlandish market for aristocratic portraiture in woodcut. Hans Burgkmair had initiated a special fashion for equestrian portraits with his luxurious chiaroscuro prints from 1508. The early mint impressions of these woodcuts may have been commissioned or purchased in a single lot by the Emperor or his agents for complimentary distribution among preferred members of the aristocracy. Burgkmair's luxury woodcuts were in a class of their own, but over the long term Burgkmair's equestrian portrait of Maximilian I had a prolific legacy. Once Jost de Negker gained possession of the blocks, and once printing in precious metals on prepared ground was abandoned in favor of using tone blocks, the clientele for Burgkmair's equestrian figures must have expanded to encompass a much wider public. Portraits of the nobility appear to have become one of the most sought after subjects in the woodcut market during the second quarter of the sixteenth century.

The equestrian portrait type was imitated with enthusiasm, initially by printmakers in Antwerp and Amsterdam. There the first Netherlandish examples appeared in 1518, made after designs by Jacob Cornelisz. van Oostsanen.[137] Shortly thereafter an avid fashion for aristocratic ceremonial portraiture emerged. Hans Liefrinck made an enterprising and timely choice of specialization, and soon after, his workshop became the major source for these portraits. The possibility that his uncle may have been involved in cutting at least one of the blocks for Burgkmair's chiaroscuro prints in Augsburg in 1508 suggests that Hans's interest in this sort of image was, quite literally, a family affair.

During the course of his long career, Hans Liefrinck had occasion to traffic with nearly all practitioners of the trade in Antwerp and certain people active elsewhere as well. Hans's success was especially furthered by the talents of Cornelis Anthonisz., a painter, printmaker, and cartographer of Amsterdam whose woodcut designs were printed (in some cases also cut) and sold in Antwerp shops. From 1538 to 1548 a series of some fifty woodcut portraits after designs by Cornelis Anthonisz. appeared in Antwerp under the addresses of Hans Liefrinck and his father's pupil Sylvester van Parys, the block cutter whom we also find among those certified by Plantin later in the century.[138] A large group of these woodcuts survive in very early, hand-colored impressions illuminated with the aid of stencils. We can presume these stenciled

230. Cornelis Antonisz., *Eleonora of France*. Woodcut, stencil colored, block ca. 325 × 260 mm. Rijksmuseum, Amsterdam.

impressions were relatively cheaply produced "luxury" woodcuts prepared in the workshop prior to selling.[139] It was no doubt expedience that made it permissible for the illuminator to employ a multi-purpose stencil which cavalierly reversed the overlapped forelegs of Eleonora of France's steed (fig. 230)! This demonstrates that illuminators, and no doubt woodcut designers, were freely reversing patterns as a means of quickening assembly-line production. The very fact of having prepared stencils for a series of woodcuts itself envisions a substantial edition of colored prints. Yet even in a case such as this we cannot presume the audience was middle brow in its tastes, since there is good evidence that a set of these equestrian figures attracted the interest of a princely collector at least as early as the later sixteenth century, and may well have been purchased by the family from Liefrinck directly.[140] The history of equestrian portraiture in woodcut offers a revealing instance of how the print trade was capable of appropriating for a larger market very specialized kinds of images. Aristocratic portraiture in sixteenth-century prints testifies to a rebirth of the ancient practice of iconography — the delineation of famous persons recognizable by inscription, physiognomic type, and attribute.

It is important to get a sense of the range of Hans Liefrinck's publications as they extend beyond woodcuts and portraits. In addition to his portrait repertoire, Liefrinck printed some designs after Italian masters such as Enea Vico, suites of ornamental woodcuts and engravings, satirical subjects, maps, and a book of architecture. We also know he

231. Jan Swart van
Groningen, *John the Baptist
Addressing Four Men*, 1553.
Etching on iron (Holl. 4),
242 × 186 mm.
Rijksmuseum, Amsterdam.

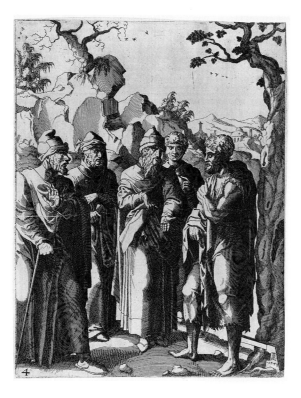

dealt in prints with the Plantin firm in 1558, and that he very often published prints designed and cut by other masters.[141] Liefrinck employed his contemporary and sometime co-worker Pieter van der Heyden, the engraver of Pieter Bruegel the Elder's inventions. The engravers Pieter and Frans Huys (Frans was also Hans's brother-in-law) apparently also worked for Liefrinck.[142] In the 1550s a cycle of ten etchings designed by Jan Swart representing the *Life of John the Baptist* appeared over Liefrinck's signature (fig. 231). These richly pictorial compositions were probably etched in the Liefrinck workshop after drawings by Swart rather than reprinted from plates acquired by Liefrinck.[143] Liefrinck's etching style is controlled and systematic in a manner that leads one to suppose it was calculated in a conscious endeavor to reproduce specific prototypes by another master. There is extensive use of a ruler in laying the lines and a very regimented use of hatching. This series appears to be an important moment in the development of an artistic mentality directed to reproductive printmaking in northern European art.

Considering his wholesale purchase of plates from Bos's estate, no doubt Liefrinck printed and sold large numbers of works that do not carry his signature and so remain unassociated with his name. It appears from the signatures and the several designers who can be connected with Hans Liefrinck that he was running a printing shop on a grander scale than those managed by some other corner presses in the Netherlands, for example those of his occasional collaborators Sylvester van Parys and Martin Peeters, also of Antwerp,[144] and Jan

Ewoutsz. of Amsterdam.[145] Hans Liefrinck represents a crucial stage in the commercial development of printmaking in that, as a corner press publisher, he extended his network of designers and the scope of his taste well beyond the city of Antwerp. In addition, he expanded the production of his atelier to include the commissioning and execution of prints in all media. Hans played no substantial role in the history of Antwerp book publishing. Instead, he made his career at that crossing point of technical understanding, artistic judgment, and entrepreneurship on which the larger and famously successful publishing house of Hieronymus Cock was established.

As woodcut printmaking began to be coordinated regularly by these small corner presses rather than by painters' shops, the anticipation of public demand and the ability of printmakers and sellers to respond to tastes and subject matter interests in the market must have become suppler and increasingly more fluid. In Antwerp this seems to have entailed a gradual displacement of the woodcut by engraving and etching. This same pattern is also expressed in the editorial decisions of the Plantin publishing house that led the way to the eventual domination of engraving in northern European book illustration. Commercial expansion in print production and a taste for intaglio prints converged in both the Netherlands and Italy, a phenomenon that cannot be readily explained in economic terms alone. Large-scale editions were much more readily achievable in woodcut. Yet the monopolization of the print trade around mid-century occurred in engraving and etching rather than in the more economical medium of woodcut. This change is conspicuously evident in the publications of the Liefrincks during the second and third quarters of the century. The complex matter of changing preferences from woodcut to intaglio will require further attention when we turn in a more concerted way to studying the nature of the print market.

Hans Liefrinck's entrepreneurial approach to print publishing must have been in some respects anticipated by Cornelis Bos, as we have seen from the evidence of Bos's workshop recorded on the occasion of its dissolution in 1544. Unlike Liefrinck, Bos was a rather prolific printmaker who also dealt in books. We know from the extensive legal proceedings against him that he had accepted a large number of books on consignment from the painter Pieter Coecke van Aelst, specifically some nine hundred volumes of Coecke's translations of Serlio and Vitruvius.[146] In Bos's inventory there is mention of these, as well as of a volume of Galen's *Anatomy*, a number of other anatomies, and a world chronicle along with some miscellaneous books left unidentified.[110] But carefully noted by the authorities is a Flemish Bible of 1538, translated by the Protestant Jacques van Liesvelt who was condemned as a heretic and beheaded in 1545. Bos also

printed maps, in at least one case apparently on commission.

Whether Bos was turning a good profit or not, there is no sure way of telling. He owed a major debt to Pieter Coecke for whom he seems to have been acting in part as a distributor. There are two interesting sides to this conjunction as revealed in the documents surrounding Bos's flight from Antwerp. One is that he seems to have proven a very poor hand at bookselling, since only a portion of the volumes in his care actually sold during the four years in which he had them. It is very likely that Bos's engagement in the book business was not simply a matter of selling. It has been convincingly argued that he had a hand in the production of Coecke's editions of Vitruvius and Serlio, more specifically that Bos was responsible for the woodcut illustrations. We also know that he produced an edition of moresque designs in woodcut, and copied an edition of anatomical illustrations from an influential Strasbourg publication.[148] Either he was an able block cutter himself, or more likely he retained a professional cutter. It is worth remembering that book production was usually a very expensive undertaking, since a substantial first investment was required to bring out an edition, these expenses having to be covered or arranged on credit until profits could be recovered through sales. The degree of Bos's financial commitment to the Coecke project is unclear, but if he was sharing the expenses of initial outlay, these may well have contributed to the straitened circumstances revealed in the 1544 accounts. Bos's stocks suggest a commercially aggressive shop, yet the debts accumulated at the time of his disappearance from Antwerp (he owed the butcher, the baker, etc.), as well as the unsold copies of Pieter Coecke's publications, imply that he had some serious cash flow problems.

In the end it must have been Bos's political difficulties and perhaps poor judgment in the book trade that prohibited him from furthering his enterprise to the extent that Liefrinck was able to do. In an important way, therefore, it was the achievements of the Liefrinck family that set the local example for momentous commercial development of print publishing in the Netherlands as we see it evolve with Hieronymus Cock and his successors, the Galle and Wierix families, active much later in the century. The Liefrinck workshop exemplifies the special importance of Antwerp publishing; like the culture and politics of the city itself, it was expansive and commercially ambitious. Partly because of its complex economic, religious, and political circumstances, Antwerp was the most artistically vibrant city in northern Europe in the middle decades of the sixteenth century. The repertoire of these corner presses shows that by the 1540s Antwerp printmakers had begun to address a progressive community of artists and literati of quite different and distinctly more sophisticated inclinations than the audience being sought by the generation of print publishers then active in contemporary Nuremberg.[149]

Hans Guldenmund and Print Publishing in Nuremberg

Hans Guldenmund came from an accomplished family of merchants, printers, and artisans who were well established in Nuremberg and elsewhere by the time he began his career. One branch of the family was engaged in book printing in Italy already in the 1470s. Hans's father was probably a goldsmith and apparently accumulated considerable wealth, since between 1513 and 1518 he was included among the *Genannten*, honorary appointments to the city's Outer Council.[150] Hans himself seems to have started out as an illuminator and a dealer in prints and pamphlets. He is recorded in the trade already in 1513, and in 1518 was in the service of Koberger coloring a copy of *Theuerdanck* for a fee of four and a half *gulden*. So far as we know, Hans was not himself a block cutter. Early sources refer to him as a book dealer, a printer, and a *Briefmaler*. He was certainly an illuminator, but as in the case of Hans Liefrinck, we cannot say for certain whether he was also a designer. Guldenmund did, however, publish woodcuts designed by Sebald Beham, Hans Brosamer, Albrecht Dürer, Peter Flötner, Georg Pencz, Erhard Schön, and Virgil Solis — a near complete inventory of notable draftsmen at work in Nuremberg through the first half of the century. From around 1530 to 1545 he was, along with Nicolaus Meldemann, the predominant printer of Hans Sachs's broadsheets and pamphlets. As a part of this operation Guldenmund retained at least two typesetters whom we know by name. He remained active until his death in 1560, for nearly fifty years regularly issuing pamphlets, broadsheets, and single-leaf woodcuts under his own name. In addition, a good many works must have been lost to us through random destruction or censorship, and numerous extant woodcuts not identified as such must also have been among his publications. Perhaps most important of all from an historical perspective, Hans Guldenmund was closely associated with the origins of the news sheet, or *newe Zeytung*, an innovation of profound consequence in the history of printing.[151]

Like his contemporary Hieronymus Andreae, Guldenmund encountered persistent legal difficulties with the Nuremberg town council during the course of his long career. Indeed, much of what we know about him comes as a consequence of these incidents. On various occasions he was reprimanded for being involved in publications that were deemed to be defamatory, obscene, or religiously suspect. The record of Guldenmund's public transgressions provides us with a sharp view

of the precariousness of corner press publishing in these years. The first recorded case dates from 1521, when he was cited for printing a slanderous broadsheet — apparently an undignified caricature of one Heinrich Polderlein (or Pölerla), shown seated upon a cow and sporting a large feather "in the Swiss manner." Guldenmund was interrogated, asked to whom he had distributed this broadsheet, and instructed to retrieve all of the impressions. After some dispute over who was responsible for the caricature, the council found Guldenmund guilty and sentenced him to a term in prison. Heinz Steigel, supposedly the designer of the block, was meanwhile given an official reprimand and his house was searched. Both men were threatened with and may also have endured torture. Some months later Guldenmund's sentence, which he had apparently not yet served, was remitted at the request of Johann Stabius, former court astronomer to Maximilian and an important patron and iconographic adviser to Albrecht Dürer.[152] Among the notable aspects of this episode is the fact that Guldenmund the publisher, or more properly the printer, was held primarily responsible for the indiscretions. Further, it is telling that a scholar and courtier of Stabius's stature made the effort to lighten Guldenmund's sentence. In similar circumstances Hieronymus Andreae had also benefitted from highly placed connections. Given the practical need of scholars and other men of political influence to engage the power of the press, it is not surprising that they were on familiar terms with the likes of a *Briefmaler* or a *Formschneider*. Likely these acquaintanceships often became more than just a matter of business between a patron and a client. Dürer's much touted intimacy with the intellectual and commercial aristocracy of Nuremberg was perhaps not so extraordinary as we are inclined to assume.

Guldenmund ran afoul of the law again in 1527, this time for printing a pamphlet entitled *Eyn wunderliche Weyssagung von dem Babsttum* predicting the corruption and fall of the papacy. It was comprised of a cycle of crudely executed woodcuts with short rhyming couplets by Hans Sachs accompanying each image, as well as a preface by the radical Lutheran reformer Andreas Osiander. The pamphlet was sponsored by Osiander. In order to give further credence to the slander and to offset responsibility, Osiander claimed that the woodcuts had been copied from a cycle of medieval wall paintings supposed to have been discovered in a Carthusian monastery in Nuremberg. (Along with a religious attack we also have here an early case of art historical fraud. In fact, the images were derived from an Italian millennialist tract that had appeared in Bologna about ten years earlier.)

The judgment of the Nuremberg council has intriguing implications for our understanding of official attitudes toward censorship. All examples of Guldenmund's pamphlet were first confiscated along with the woodblocks used to print the illustrations. In fact the council went to some effort to retrieve six hundred copies that had already been dispatched to the Frankfurt Fair for sale. However, on a plea of financial hardship it was decided Guldenmund could have the blocks back and actually continue to publish them so long as they were issued without the texts! Not only that, but in recognition of his financial loss Guldenmund was compensated twelve *gulden* by the council. Another curious aspect of the case is that the basis for allowing the images to be printed was that they were previously available, which seems to say that since nothing new had been invented, the legal requirement for council review prior to printing had not been violated. Does this imply that the council believed Osiander's claim about the monastery paintings, or that the illustrated Italian text had been introduced as evidence? The design of the shabby woodcuts has now been attributed to Erhard Schön who, interestingly enough, is never mentioned in the suit.[153]

It is not clear what to make of this judgment. After all, Hans Guldenmund's illustrations do contain obscure but nonetheless self-evidently antipapal references. For example, the opening woodcut facing Osiander's preface shows the figure of a pope bearing a palm in his left hand and feeding gold coins to a bear in his right, signifying, as the text explains, the squandering of papal wealth on war. The bears are also probably meant as a reference to Bern and the papal Swiss guard (fig. 232). However, like much theological allegory of the period, the actual iconographic program is esoteric, its symbolic character not unlike contemporary treatises on the art of memory.[154] Images of this type are dependent upon an accompanying text for their meaning. Given that a text can be readily enough typeset by a printer, and Guldenmund certainly had the resources to do this, the most effective impediment to further publication of the satire would have been to retain or destroy the blocks. Yet this was clearly not of very serious concern. The Nuremberg council formally accepted the Reformation into the city shortly before this episode, and their moderate ruling can be understood as a gesture sufficient to avoid antagonizing the court and the papacy — more a matter of public relations than religious conflict. But what might the market have been for these rather graceless woodcuts Guldenmund was so anxious to retain? For this we can provide no entirely satisfactory answer. The blocks did prove to have some market value. So far as we know, the images were never published alone without a text of some sort, but the blocks as well as copies of them did appear later on with different commentaries attached. It seems as if the council's judgment was simply a way of allowing Guldenmund to keep his

capital assets while denying him the right to make use of them in Nuremberg.

Not surprisingly, the rise of political and religious pamphleteering in the Reformation led to further impositions of official censorship. Nuremberg's conservative and often paternalistic leadership had long assumed the right to control any form of public activity in the city, but this was not exercised over publications until the troubles of the religious uprising and especially after the outbreak of the great Peasants' War in 1525. The Diet of Nuremberg in 1524 granted municipal authorities the right to search printing shops and confiscate banned material. Then in 1530 the Diet of Augsburg required that the date, the place of publication, and the printer's name appear on all publications. In principle the Diet had the authority to insist upon these regulations being enforced throughout the duchies and the franchized governments of the German imperial cities, but the evidence is that the actual power to do so was limited. Of course, we cannot be certain to what extent mere intimidation might have succeeded in suppressing many illicit publications, but the abundance of propaganda that does survive attests either to substantial failure or to a measure of benign neglect.[155]

In loco parentis, the council concerned itself not only with distractions of the spirit, but also with temptations of the body. Guldenmund provided the authorities with reason for concern in this domain as well. In 1535 it came to the attention of the Nuremberg council that Guldenmund was in possession of "a most shameful and sinful little book, containing many obscene pictures of unconventional lovemaking" (ain gannz schenndtlich und lesterlich püechlein, darynnen vyl unzüchtiger gemeel von unordentlicher lieb). Guldenmund confessed that nine copies of this mysterious book had been sent to him by the Augsburg woodblock cutter Hans Schwarzenberger on the understanding that they be taken on consignment to Frankfurt and sold there on Schwarzenberger's behalf. Guldenmund claimed he had indeed carried them along, but only disposed of them later in Leipzig. Furthermore, he testified that the blocks were then in the possession of some friend or relation of Schwarzenberger's in Augsburg. This information comes down to us in a letter written from the Nuremberg council to its counterpart in Augsburg warning of the publication, "since lustful images alone can provoke great scandal and incite the young to sinful vices" (dieweyl aus sollichen unzüchtigen gemelldten allain grosse ergernus ervolgt unnd der jugenndt zu sündtlichen lastern ain anraytzung geben mag). Nuremberg requested of Augsburg that the council send along a copy of the book should one be discovered, although they are quick to point out "not because we are eager to see it" (nit darumb, das wir dess zu sehen begirig).[156] Pornographic prints from the Renaissance are now something of a rarity and no cycle survives that can be securely associated with Guldenmund's case, but this says nothing certain about the availability of such prints at the time.

Guldenmund and Schwarzenberger's "little book" cannot help but bring to mind the most infamous case of printed pornographic images in the Renaissance, Marcantonio's *Modi* engravings done after Giulio Romano. These prints, which were issued some years earlier in Rome, brought

down the wrath of none other than the Pope, and subsequently led to Marcantonio's imprisonment. The ensuing campaign to eliminate all trace of Giulio's sixteen explicit illustrations of lovemaking was almost entirely successful, since only one decorously edited set of the original cycle is presently known. However, what appears to be a close copy of the Marcantonio prints with their accompanying verses does survive. The illustrations are in woodcut and were probably printed in Venice around 1527. Might it be that Guldenmund's book is part of this recension? It is certainly true that most of the instances of erotica in German printmaking of the early sixteenth century betray direct dependence on Italian sources, and of course, the commercial relations between Venice, Nuremberg, and Augsburg at the time were intimate.[157] Infractions of this kind were dealt with in varying degrees of harshness. In Amsterdam in 1545, for example, the printer Pieter Janszoen Tibaut was reprimanded for printing pornographic broadsheets. He was sentenced to stand for two hours "op de kaek" with the broadsheets hanging around his neck, and thereafter to offer devotions to the Virgin in a local church.[158]

Guldenmund's legal difficulties persisted, including disputes over copyright.[159] Yet we should not allow the predominance of legal documentation to weigh too heavily in our understanding of this printer and his career. We can see reflections of close, indeed personal, relationships within the printmaking circle of Nuremberg in such records as the 1531 testament of the woodblock cutter Katherina Hettwig, where Guldenmund is listed along with Paul Lautensack as the guardian of her two children. Furthermore, at the point of her death Katherina records an unpaid debt to Dürer's sister-in-law.[160] These sorts of records evoke a quite different picture from what we glean from reading through the chronic disputes recorded in Hampe's transcriptions of the council minutes.

The range of Guldenmund's output was considerable. During the 1530s he became the premier publisher of broadsheets in Nuremberg. Most

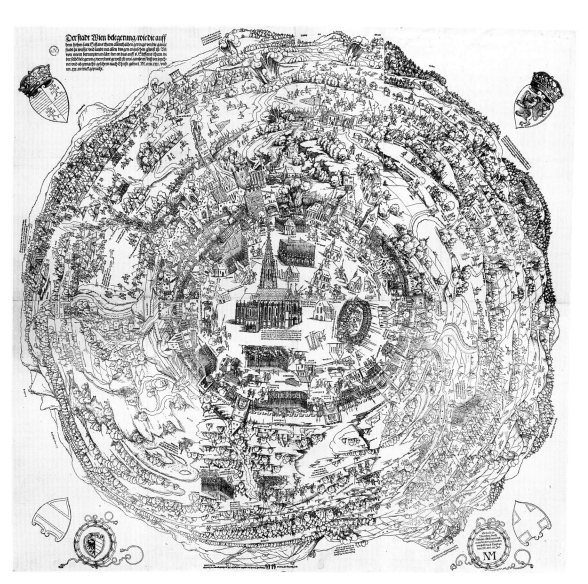

233. Nicolaus Meldemann, *Siege of Vienna*, 1529. Woodcut from six blocks (G.283–88), 812 × 856 mm. Kupferstichkabinett, Berlin.

226

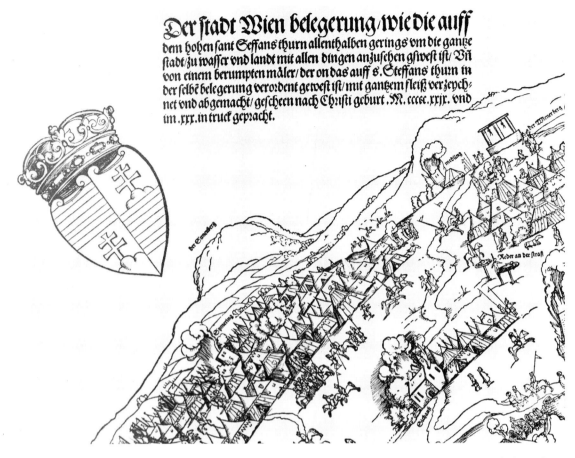

Der stadt Wien belegerung/wie die auff dem hohen sant Seffans thurn allenthalben gerings vm die gantze stadt/zu wasser vnd landt mit allen dingen anzusehen gswest ist/ Vñ von einem berumpten mäler/ der on das auff s.Steffans thurn in der selbe belegerung verordent gewest ist/ mit gantzem fleiß verzeych net vnd abgemacht/ gescheen nach Christi geburt.M.cccc.xxix. vnd im.xxx.in truck gepracht.

of them bore texts by Hans Sachs, the majority carrying the address of Guldenmund's shop in the Fleischbank or that of his competitor and occasional collaborator Nicolaus Meldemann, though virtually every corner press active in the city and a good many in Augsburg had some part in issuing Sachs's work.[161] These broadsheets treated subjects like the *Four Wonderful Qualities and Effects of Wine* (G.1175) satirizing intemperence, the *Slanderer* (G.1013) who needs a padlock on his tongue, or the *Lament of the Wildmen over a Faithless World* (G.1106). Sachs's rhymed parables and evangelistic tirades must have served a hearty appetite for moral platitude, and one can hardly escape the conclusion that the Meistersingers made their reputations professing the public and private values of the Nuremberg citizenry at their most banal.

Guldenmund also issued a great many aristocratic portraits including, it appears, a large number of unsigned copies taken from the Liefrinck woodcut portraits discussed earlier. Some of these were actually done by making insets in the block where smaller blocks could be inserted showing different heads for different figures, yet another variant in the evolution of assembly-line technique.[162] Representations of mercenaries, the Turkish military, and other soldiers constitute the third major group of his prints. In addition to these major preoccupations, he published the occasional biblical subject, a couple of anatomies, ornamental images, and ceremonial

displays. Intermittently he took commissions from the town council — four *gulden* in 1541 for a view of the city of Algiers, and ten *gulden* in 1543 for a portrait of the Emperor. Finally, there are a very few pamphlets and broadsheets that carry sensational accounts of current events, heralding the advent of the news sheet, ancestor to the modern tabloid.[163]

Unquestionably, the event of paramount concern to the whole of northern Christendom during this period, Protestant and Catholic alike, was the Turkish invasion of central Europe. Indeed, it would be fair to say that in Europe the flagrant passion for access to the latest news (*die neue Zeitung*) came about because of the Turkish threat. The arrival of Ottoman forces on the outskirts of Vienna in 1529 was a most dramatic and terrifying moment, and the rush to publish an account of it brought Guldenmund into direct competition with the block cutter and printer Nicolaus Meldemann, who went on to share a large portion of the broadsheet business. Meldemann had traveled to Vienna and there, after some difficulty, acquired a plan of the siege. The plan was drawn, Meldemann tells us, by some local painter (unnamed) who had climbed to the top of St. Stephen's Cathedral and sketched a detailed panorama of the city with the positions of the surrounding Turkish forces. After returning to Nuremberg, Meldemann cut the plan into six blocks and published it in 1530 under a privilege granted by the Nuremberg council (figs. 233–34). In his

227

235. Albrecht Dürer,
Small Triumphal Car
(Burgundian Marriage).
Woodcut from two blocks
(Holl. 253), 373 × 433 mm
and 380 × 424 mm. British
Museum, London.

dedication printed on the plan, Meldemann laments the fact that the panorama omits a great number of buildings in the city, and thereby gives a less clear picture of its defenses. But he says a more detailed view would have required too much paper, and contrary to his wishes this would have made it too expensive for the common man (*gemeiner mann*). At the same time Guldenmund seems to have cobbled together a similar woodcut from available but less authoritative sources. However, he was prohibited

from publishing it on the ground that Meldemann had been granted official priority with a privilege from the council. Hence Guldenmund was forced to withdraw his blocks, and instead he put together a pamphlet reporting the siege, once again with a text by Hans Sachs, and in addition several woodcut broadsheets illustrating the Turkish military and their atrocities, also with texts by Sachs.[164]

The corner press printmakers in Germany promptly came into their own during the second

228

quarter of the sixteenth century. In these years, not accidentally coincident with the spread of the Reformation, woodcut production had shifted significantly from the workshops of painters to the printing shops of illuminators and block cutters. This was as much true of printmaking in Antwerp and Augsburg as it was in Nuremberg. It happened at a time when partisan interest in exploiting the press was at its height. These specialists in small, no doubt speculative and very risky printing pro-

jects depended on being able to complete and distribute work quickly. Able draftsmen were plentiful, and probably rather cheap in a competitive place like Nuremberg. As a consequence, relatively few woodcuts issued by the corner pressmen carry the signature of their designer. Furthermore, the printers were ready to pirate anyone else's work and publish it whenever it seemed promising enough. The corner presses were manifestly creatures of the open market, and the open market was rapidly

coming to dominate the art of printmaking. By the 1540s the entrepreneurial corner press print publishers had effectively taken control of woodcut production, and within a decade they were to have the intaglio medium in their hands as well.

Let us conclude by reflecting upon the general pattern of subject matter being underwritten by this generation of independent printers. A quick survey of the woodcuts carrying the addresses of Nuremberg printers reveals a pattern essentially identical to the distribution of Guldenmund's publications noted above. About a third are representations of military types, of contemporary battles, and to a lesser extent of costume studies typically in the form of dances, festivals, and processions of the patriciate, the burgher, and the peasant classes. This repertoire of contemporary observation must reflect the perception of certain "life styles" as interesting superficially for their dress and their conduct, and perhaps more complexly for their defining roles in the social structure of the Renaissance.[165] Another third of these woodcuts are portraits, mainly of the nobility, and after that portraits of prominent religious figures, most often reformers.

The fourth and most innovative group of subjects are those woodcuts representing "moralities" of various sorts. These constitute about one-quarter of the whole. By moralities we mean to include explicit allegories and satires of a religious, social, or domestic kind — evocations of folly, spiritual corruption, injustice, and so forth. One should add that the bent for social commentary in the moralities and the moralizing inclination evident among the so-called genre "life-style" subjects blur the line

between these two categories. In the end nearly all the new subjects carry a message that is difficult to avoid. Quite clearly the thematic content of a great many of these prints was determined by the spate of vernacular doggerel being turned out by the likes of Hans Sachs, Meistersinger of Nuremberg. Sachs's *Fastnachtspiele* and rhymed songs suggest that the German cities of the Renaissance boasted a wide audience receptive to such vernacular satires and moral fables. Whether the crowds that attended the plays and the verse contests of the Meistersingers were drawn mainly from the artisanry, or whether they also extended to the proletariat and the well-to-do, Sachs's fare seems to have fed an appetite for accessible wit and general self-congratulation.

Military and costume figures, portraits, and moralities were the major classes of subject matter issued by the corner presses in the second quarter of the sixteenth century. Woodcuts of conventional religious subjects constitute only a small fraction of the whole, perhaps 5 percent. Then in addition we find a smattering of ornamental, architectural, and wallpaper prints, maps and city views, playing cards, and a few images of prodigies or marvels. If we compare these proportions to the general output of Nuremberg woodcuts, we find those from the painters' ateliers to be more conservative. There biblical subjects and images of saints are most common of all, in fact comprising nearly one-third rather than a mere 5 percent of the total. When the corner presses commissioned, pirated, or purchased a woodblock, they tended to look for something new. It appears the presses were consciously innovative in this respect, and therefore an important

index — not to say an influential arbiter — of changing tastes.

Obviously one needs to be cautious about drawing conclusions from all but the most obvious patterns revealed in such a survey.[166] And yet the general inclinations are evident. Moreover, it is broadly consistent with what was happening in Augsburg, the other major source of German single-leaf woodcuts in these years. The presses of Hans Guldenmund, Nicolaus Meldemann, Albrecht Glockendon, and a variety of other less prolific masters were changing the habits of the print-buying populace in the German cities. It would seem they were extending the horizons of that population to include less sophisticated as well as less traditional interests. Tendance of the soul began to give way to social admonishment. One cannot avoid the distinct impression that the Nuremberg woodcuts were most often meant to appeal to a conservative, not to say smug, urban citizenry. These woodcuts are far from subversive. On the contrary, in contrast to the works of the Liefrincks and of the Antwerp printers generally, they tend to affirm the social norms of the community.[167] Is there then a place in Guldenmund's audience for the *gemeiner Mann* so frequently invoked in sixteenth-century German tracts? It is vexingly difficult to decide whether this "common man" was in reality no more than a phrase used by that part of the population traditionally engaged in literary and artistic pursuits to describe everyone else, or whether it was indeed an identifiable group being newly recruited to the audience for prints. At the very least, if we compare the Nuremberg corner press prints with the work of the previous gener-

ation, or for that matter with those of Antwerp, there is a lowering of sights. The single-leaf woodcut mainly sought vernacular appeal and addressed itself more broadly to the tastes and means of the burgher and the literate artisan.

MURAL WOODCUTS AND THEIR PROPER WALLS

During the second quarter of the sixteenth century, large and often complex woodcuts meant for wall display entered the repertoire of corner pressmen. It is well to remember that another important consequence of Maximilian's monumental woodcut projects was the promotion of this medium as a suitable form of interior decoration in the north.[168] The survival rate of these imposing woodcuts is very poor, however, especially in the north, since most of them were almost certainly pasted onto walls where they could not escape dampness and eventual demolition. Far less mural decoration of any kind survives from this period in northern Europe than survives in Italy, although there is no doubt that wall decoration was being practiced in northern courts. The disappearance is mainly due to the conditions of a harsh climate that were inimical to conserving fresco or any other medium applied directly to the walls, a circumstance which partly explains why the less expensive woodcut came to serve this purpose in the first place. Multi-block woodcuts were conceived in various arrangements, often in frieze compositions in continuous

231

sequence such as a triumphal procession, or as a series of discrete images linked together by a repeated ornamental frame. In addition there were rectangular compositions, sometimes of truly impressive expanse. Woodcuts must have offered a comparatively expedient means of adorning the spaces above wainscotting and over the hearth. Yet because of the extreme rarity of early impressions, the absence of examples surviving *in situ*, and the sparseness of documentation about their use, these large and ambitious woodcuts present an especially difficult problem for the historian concerned to interpret their significance.

The range of subject matter in northern European mural woodcuts is remarkably broad and seems to cut across the obvious boundaries of decorum appropriate to civic, ecclesiastical, and domestic settings. Mural woodcuts extend from classical and ceremonial subjects such as triumphs and festivals (fig. 235), maps and city plans (fig. 233), religious and moral allegories, parodies of rural folk (fig. 236), and courtly fashion shows masquerading as biblical and historical subjects (fig. 237). Large wood-

cuts were a particular specialty among Nuremberg corner printers in the 1530s. Sebald Beham's *Fountain of Youth* (fig. 238) is among the finest of the genre to come down to us. Consciously Italianate in its design and lavish in its display of the nude, many of the figures are in fact witty quotations from Marcantonio's prints. For example, the graceful study of Venus disrobing in the *Judgment of Paris* (fig. 125) has been recast by Beham as a naked bather flourishing her bath towel! An early hand-colored impression of this woodcut now in Oxford carries the address of Albrecht Glockendon and a verse text dated to 1531.[169] The Oxford impression is additionally interesting because it incorporates an indiscretion that the artist or the printer saw fit to excise before reissuing the print in later editions. In the first state of the block a woman crouching in the foreground is shown urinating (fig. 239), and in the following state this detail is eliminated (fig. 240),[170] a change in the block made presumably for reasons of modesty that nevertheless has the dubious consequence of rendering her pose merely obscene rather than

237. Sebald Beham, *Parable of the Prodigal Son.* Woodcut from eight blocks (B.128), 665 × 940 mm. British Museum, London.

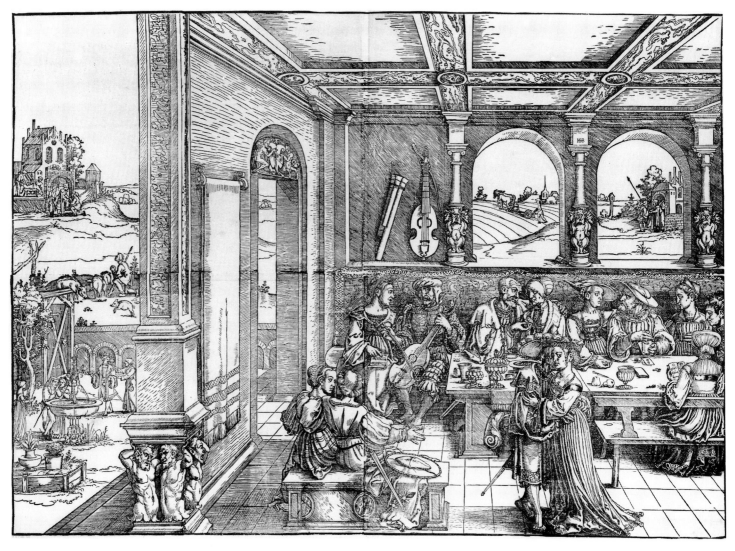

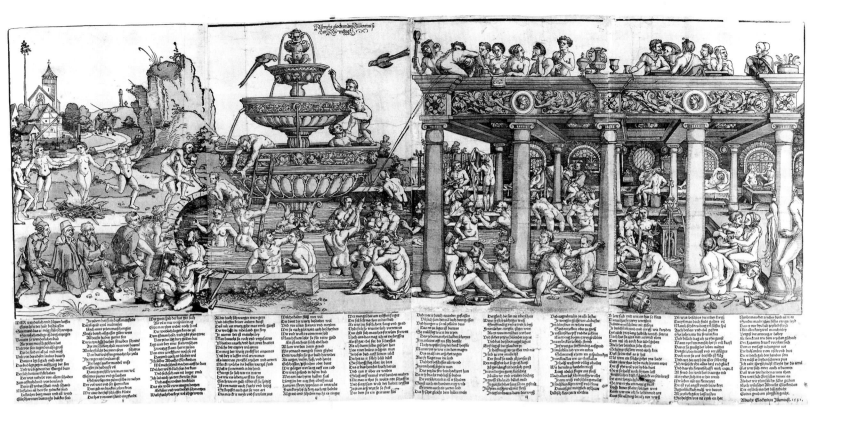

The text beneath the image (the woodcut panels) contains dense letterpress inscriptions in Early New High German, largely illegible at this resolution.

unashamedly natural. Erotic indulgence was particularly common in large-scale woodcuts, a feature that anticipates an aspect of taste more commonly associated with cabinet paintings and small sculptures or with Dutch and Italian genre subjects in the following century. An elaborate wallpaper design of *Nymphs and Satyrs* (fig. 241), probably designed by Sebald Beham, has been pointed out to conceal in its network of vines a barely disguised outline of male and female genitalia.[171]

By the second quarter of the century Nuremberg began to specialize in more vulgar subjects like the peasant carousings of Sebald Beham or Erhard Schön's *Distribution of Fool's Caps* (fig. 236), or in elaborate biblical subjects in palatial settings like Sebald Beham's *Parable of the Prodigal Son* (fig. 237) and the *Feast of Herod* (Pauli 832). Meanwhile, Jörg Breu the Younger of Augsburg was designing courtly subjects of his own such as *Susanna and the Elders* (G.396), cut in four blocks, and *David and Bathsheba* (G.393–94), made from eight blocks. All of these offer the double-edged appeal of titillation and moral admonishment.

Netherlandish mural woodcuts are fewer in number but equally diverse. Some correspond to elevated tastes, such as Lucas van Leyden's *Twelve Kings of Israel* (B.14) and *Nine Worthies* (B.15), comprising friezes of two meters and one and a half meters respectively. As the fashion for large woodcuts increased, corner press publishers put together sets of blocks with ornamental frames in order to make them more suitable for mural installation. For example, Doen Pietersz. of Amsterdam compiled an elaborate frieze illustrating the *Biblia pauperum*

composed of twelve sets of woodcuts by Lucas van Leyden and Jacob Cornelisz. van Haarlem in a double row (one above the other), the entire set fitted out with elaborate architectural frames and inscriptions in letterpress. Doen appears to have been the first to recognize this means of marketing (or remarketing) woodcuts, a strategy he began already in the late teens. This is another case in which an imaginative publisher and printer established an important niche in the specialized woodcut trade. Other mural woodcuts are of a more vernacular turn, for example the *Ship of Sant Reynuut* (Nijhoff 13–20) from the Leyden school, also published by Doen Pietersz., a condemnation of false piety and every other imaginable vice. In a pronounced classical vein, Jan Scorel probably designed a handsomely composed frieze depicting a *Lion Hunt* (Nijhoff 302–04) printed from six blocks and over a meter and a half in length.[172]

On whose walls were these impressive, sometimes erotic, sometimes slanderous, and sometimes pious and edifying extravagances displayed? The answer to this question must be sought in a dimension of northern European taste about which we are very ill informed: the secular decoration of interiors. To be sure there is something to be gleaned from household inventories and records of aristocratic patronage, but the arrangement and display of works of art is infrequently recorded. Our knowledge of such practices in Germany and the Netherlands is far more limited than it is for Italy and France. Nevertheless, there are some contemporary textual sources that help to provide a context not only for understanding something about large

238. Sebald Beham, *Fountain of Youth*. Woodcut from four blocks (B.165), state I, 375 × 1090 mm. Ashmolean Museum, Oxford.

233

239. Sebald Beham,
Fountain of Youth (detail),
state I. Ashmolean
Museum, Oxford.

240. Sebald Beham,
Fountain of Youth (detail),
state II. British Museum,
London.

woodcuts, but about the iconographic repertoire of prints in general.

In his treatise on architecture *De re aedificatoria*, Leone Battista Alberti considers the proper way to adorn the summer rooms of a private residence. He recommends that they be decorated with mathematical concepts for the learned, by which he apparently means a display of complex perspectives such as the ideal city views and intarsia paneling that came into fashion at just the time he was writing. There should be pictures of the world — maps, descriptions of charted lands and recent discoveries. He recommends paintings of exotic subjects portrayed from life, riddles (*aenigmata*), and also fables (*apologi*) meant to sharpen the intellect. Each of these subjects calls to mind certain German single-leaf woodcuts from the following century.

Alberti's text is an architect's prescription. We find a different kind of evidence about notions of interior display in a long and rather tedious dialogue by a Latin schoolmaster named Andreas Meinhard. This text is a good deal closer to our present problem. It is a panegyric written in 1508 to celebrate the city of Wittenberg and its patron Frederick the Wise, and it is staged as a tour in which a newly arrived and bedazzled young pupil is conducted through the town and shown its many splendors. During a visit to the Prince's castle, Meinhard recites the subjects portrayed in the paintings adorning its walls. Included among them are various *gesta*, ancient histories and myths such as the testing of Mutius Scaevola, the conspiracy of Porsenna and Cloelia, Pyramis and Thisbe, Perseus and Andromeda, Jason and Medea, and the Labors of Hercules, along with various Old Testament stories. All this is presented as a kind of *Bildungsführung*, a gallery of moral instruction for the eager and in-

experienced young man.[173] Attempts have been made to link these descriptions to actual decorations at the court where Lucas Cranach and Jacopo de' Barbari had already been at work by this time.[174] However, the dialogue is better understood as a literary exercise reflecting current fashion, and not as a Baedeker's guide to the Saxon art collection. Nevertheless, what strikes us about this "inventory," as well as about the kinds of subject matter recommended by Alberti, is the remarkable correspondence with the repertoire of classical and moralizing tales and decorative compositions represented by the work of Renaissance printmakers.

We find parallels between the subjects favored in monumental woodcuts and the rare evidence of actual mural programs as well. Especially germane in the present context is Albrecht Dürer's commission for a mural cycle in the council chamber of the Nuremberg town hall, a project that was apparently begun by Dürer shortly after his trip to the Netherlands but only completed sometime later by his students. It seems the artist's first proposal may have been for a set of roundels of subjects drawn from the so-called Power of Women topos, for which a preparatory sketch by the artist survives. At some point this plan appears to have been rejected in favor of loftier sentiments — *Maximilian's Triumphal Car*, the *Calumny of Apelles*, and the *Continence of Scipio*, all subjects clearly directed to the celebration of justice and political order.[175] So far as the standards of decorum for official government programs are concerned, it is telling that the droll but unmistakably misogynist roundels portraying the power of women seem not to have found favor. What strikes one about all of these subjects, including those rejected, is once again their regular occurrence in sixteenth-century prints. *Maximilian's Car* is a ceremonial subject

234

commissioned and printed more than once in wood-cut, Dürer's design executed by Hieronymus Andreae being a fine example (fig. 235), and although the two classical subjects are themselves rare, we can find many subjects of their general sort. The Power of Women, or *Weibermacht*, theme was among the most popular subjects exploited by printmakers in the first half of the sixteenth century, and often occurs in cycles, sometimes with ornamental borders that testify to their intended use as mural decoration.[176]

A woodcut like Beham's *Feast of Herod*, would have perfectly fitted a dance hall, and the *Fountain of Youth* perhaps a bath house, where the problem of fresco deterioration would have been particularly severe. There are rare indications that mural prints of small scale may have been displayed in public inns or taverns as well. An Antwerp painting by the Braunschweig Monogrammist of a *Tavern Scene* (Berlin, Gemäldegalerie) from the 1540s, for example, depicts a woodcut frieze of lansquenets that is peeling off the wall.[177] Given certain of the subjects represented in these woodcuts, taverns are not an unlikely destination for them. However, inclusion of the print in the *Tavern Scene* serves an iconographic purpose, and it should therefore not be taken as sufficient evidence to confirm an actual

practice. The parallels to be found in the Nurem-berg town hall are certainly suggestive so far as the iconographic suitability of many monumental woodcuts for civic settings is concerned. And in this context we should recall that in these same years town councils began to commission large panoramic city views and aerial maps, which must certainly have found a place in governmental chambers.

As we have already seen in Italian practice, the actual display of monumental woodcuts was managed in one of two ways — applying them directly to the wall in the fashion of patterned wall-papers, or fixing them down onto canvas so that they could be hung or rolled up and stored away. The latter practice was especially employed for maps, as we know from many later inventories. Dürer's *Triumphal Arch* for Maximilian was also treated in this way by its more appreciative recipients.[178] When Meinhard composed his imaginary tour of the interiors of Renaissance Wittenberg, there is no doubt that he meant us to understand that he was talking about paintings and not pasted-down wood-cuts. Nevertheless, his text gives us a sense of how works of art displayed in formal secular contexts were intended to be understood. Many of the mor-alizing subjects and the vast numbers of exempla drawn from mythology and ancient history for

241. Sebald Beham, *Tapestry of Nymphs and Satyrs*. Woodcut (Pauli 1342, 1342a), each block 535 × 325 mm. Ashmolean Museum, Oxford.

242. Titian, *Triumph of Christ*.
Woodcut from ten blocks (Dreyer no.
I), 385 × 2642 mm. British Museum,
London.

prints must surely have been meant to appeal to their purchasers in this way.[179]

We have earlier suggested that certain woodcuts should be recognized as relatively exclusive productions made for a limited clientele. Although one would expect these mural compositions to have been costly to produce just because of the amount of paper and the scale of the blocks, which were time consuming to cut and difficult to print, the evidence on this point is ambiguous. In his series of biographies of Nuremberg craftsmen written in 1547, Johann Neudörfer says of Peter Flötner, the German sculptor, woodcut designer, and probably also block cutter: "If he had had a publisher, he would have been just as impressive in large works as he was in small things."[180] Here Neudörfer appears to be giving a firm opinion that mural woodcuts were exceptional enterprises for woodcut designers, and that the resources of a corner pressman (*ein Verleger*) were important in bringing them about. Likewise, a broadsheet depicting the *Quarrel of Seven Fools* (G.1183) closes with the following couplet: "Printed at Nuremberg by Hans Guldenmund / this folly cost him many *pfundt*." This double-entendre is as much a complaint on behalf of the publisher's account book as it is a play on the subject of the broadsheet.

But how valuable were the larger mural woodcuts, and consequently who might have been able to own them? The evidence for answering this question is thin, like so much else of interest to us. There are, however, a couple of indications about prices for large woodcuts in the north, though they are difficult to apply in a general way. In the sale of Cornelis Bos's workshop, the single most frequent item found among the stocks of prints is referred to only as a *Triumph* or a *Triumph of Christ*. It has previously gone unnoticed that this print is none other than Titian's *Triumph of Christ*, unknown in any early edition. The first recorded edition is from 1543 when it appeared with the address of Joos Lambrecht, a printer in Ghent.[181] The next extant edition (undated) carries the address of Cornelis Liefrinck's widow, whom we know to have purchased the blocks of the *Triumph* in Bos's workshop in 1545 at the highest price paid for any single item in the inventory (fig. 242). A large number of impressions were also bought by Hans Liefrinck, some ninety of them in four separate lots. There can be no doubt that the Bos inventory does indeed record the Titian blocks along with a huge number of impressions taken from them. He must therefore have acquired the blocks from Ghent in the previous year and been printing them himself.

In any case, the prices paid by the several buyers for impressions of this woodcut are startlingly low. This is particularly striking at a point when the fashion for the Italian style was bursting forth in the Netherlands as the careers of Lambert Lombard and Frans Floris were getting under way. Yet, despite the example of the Venetian High Renaissance style that Titian's woodcut must have represented at that moment in Antwerp, it seems that an impression of the multi-block woodcut could be had for an average of three *groten*. Though copies of an anatomy with nineteen woodcut illustrations were being sold for a little over one *grote*, canvases were being sold for five to ten times the amount of the Titian frieze. Taking into account that this was a public sale based upon a legal confiscation, and that the prices were therefore effectively wholesale, the value of these objects over the counter might have been two to three or more times the amounts recorded in the inventory. Nevertheless, we must seriously contemplate the prospect that a print of this stature — some two

and a half meters of woodcut — might well have been within financial reach of a skilled workman. In Antwerp, admittedly a prosperous town, a mason or carpenter might earn on the average twelve to twenty-seven *groten* a day in the summer.[182]

Anton Kolb obviously regarded the great *View of Venice* at three ducats as an expensive work to buy, since he was obliged to defend the price in his application for a privilege from the Senate. Large woodcuts were the first sort of print that regularly included a privilege for protection against copying, and Kolb is the first printer we know to have been granted one for an image. This reflects the greater susceptibility of woodcuts to pirating and forgery, and it also implies that they were a substantial investment on the part of the printer and therefore well worth the trouble of taking extra measures to protect. When granted to the artist or printer, these privileges were usually imperial, though sometimes civic, and often recorded in Latin. We should not underestimate the bureaucratic tangle, and perhaps also the money or personal influence required to obtain one. In addition to their legal standing, privileges certainly gave a sort of imprimatur, lending a publication an amount of prestige.[183] Perhaps in the discrepancy between the enormous bird's-eye city views and Titian's exported *Triumph* we have a sense of the scope in the commercial value of Renaissance mural woodcuts; in one case a map recording the prosperity of a great trading empire, and in the other a religious allegory modernizing the woodcut's traditional iconographic domain.

PRINTS AND FACTS: THE SPECIALIZED MARKETS

It is a commonplace that the printing of texts revolutionized the exchange of information in western society. However, although the parallel seems obvious enough, this premise has much less frequently been applied to the early history of the printed image. Printed images just as much as printed texts revolutionized the business of publicity and all that implies in early modern Europe. When Hans Guldenmund published his pamphlet account of the Turkish siege of Vienna, and Nicolaus Meldemann his woodcut view of the city and the Ottoman forces surrounding it, both were capitalizing on the public dread of the heathen warrior who was now crashing the gateway to Europe. It is no surprise that the printed news sheet was born sensational. From the very outset, the use of printing as a means of reporting events provoked a concern about the truthfulness of the information being disseminated by this new and highly efficient means of communication. What was the understanding of "truth" in the use of printed images for reporting? How did the corner pressmen think about the nature of an image as a witness to fact, and were replicated images in any way understood to be different from autonomous images so far as their veracity was concerned?

Recall Israhel van Meckenem's engraving of the icon of the *Imago Pietatis* in Rome (fig. 33). In the inscription Israhel terms his printed replica of the venerable image a *contrafactur*, a medieval Latin word meaning portrayal, imitation, and sometimes also counterfeit. Israhel's print is the first instance in the Renaissance where this term is applied to an actual image; interestingly enough it is also the first northern image to declare itself to be an actual

237

243. Anonymous, *Announcement of a Shooting Contest*, 1501 (Cologne). Woodcuts, hand-colored, sheet 615 × 466 mm. National Gallery of Art, Washington, D.C.

reproduction of another image. In Germany around 1500 the word *contrafactur* meaning portrait or portrayal entered the vernacular vocabulary of terms applied to images. The history of its usage implies that there must have been a need for a term to describe what was being perceived at the time as a new form of representation. *Conterfeit* or *conterfeyt* — and even more insistently the related word *abconterfeitung* — imply an image that has been taken from an actual prototype.[184] We find the term itself and additional claims to authenticity of representation invoked constantly in the titles of sixteenth-century German woodcuts portraying certain types of subject matter, particularly portraits, topographical views, and contemporary events, whether human, natural, or supernatural. A *conterfeit* presumes an origin to which the image remains faithful in its own terms, and in this sense its meaning is more particular than what is implied in a *Bild* or *Figur*, which might be any sort of

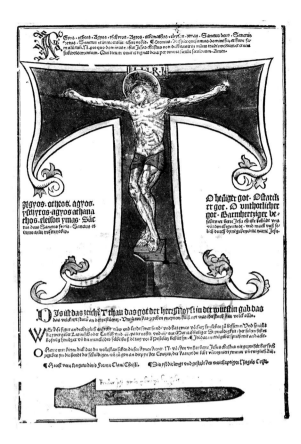

244. Anonymous, *Christ Crucified on a T-Cross*. Woodcut (Schreiber 931), 368 × 256 mm. Kupferstichkabinett, Berlin.

advance of technical knowledge in the Renaissance has often been pointed out, for our purposes most provocatively by William Ivins in his seminal study of prints and visual communication. Ivins stresses the special role of what he terms, in a rather cumbersome phrase, the "exactly repeatable pictorial statement."[186] Printmakers were aware of the practical value of prints in this respect. For example, a broadsheet intended to serve as an *apotropaic* against pestilence includes a representation of a nail purporting to be a relic from the Crucifixion, and the text makes a special point of the nail being depicted in its actual size (fig. 244).[187] One recognizes that in the absence of standardized measurements, a print was the only effective means of conveying a fact such as this to a large number of people. Or again a broadsheet of 1501 published in Cologne announces a shooting contest and the cash awards to be distributed to the best marksmen with crossbow and musket (fig. 243).[188] The length of the course is given as three hundred feet, or "work shoes" (*foesse oder werckshoe*), to be measured out according to a bar laid out across the lower margin of the woodcut. This gauge is joined with two other printed standards: the circle and the shorter bar of "two fingers' width" measure the size of the targets and the increment of spacing. It is a way of making it possible to practice for the contest! Like the length of a "work shoe," replicated images proved themselves useful for conveying many practical and

picture invented or taken from life. What is striking about this obscure bit of etymology is simply that the word *conterfeit* seems to enter the vocabulary of image making not long after the advent of printing. Is this entirely coincidental?

The assertions of authority in the titles of portraits and other subjects are literally declarations of witness in which the author of the image testifies to its authenticity. Portraits employing the term *conterfeit* in their titles are most often of religious figures (mainly reformers), of humanists, of political leaders, and of foreign potentates or military men. That is to say, they portray people of interest for their accomplishments and, very often, for their infamies. Imperial portraits, the commonest currency on the market, seem to have been thought more prototypical and therefore usually do not carry the term. Miraculous occurrences and mutant births, on the other hand, are frequently so labeled, as are battle scenes, sieges, and city views.[185]

Certainly the notion of the witnessed image did not arise historically with the print. There had been portraits of contemporaries and portrayals of current events before. Yet the replicated image had an important edge as a means of conveying fact, and at the same time a special liability. On the one hand, a replicated image could have the authority that comes with being widely familiar. On the other, the presence of an identical image simultaneously available to many allowed for independently checking its accuracy. The importance of replication for the

245. Augustin Hirschvogel, *Plan of Vienna*, 1552. Etching (Schwarz 82) on six sheets of paper, joined, ca. 840 × 850 mm. Albertina, Vienna.

ordinary things of the most mundane sort. In this respect they helped to standardize what was already familiar.

At the same time, the principle of accurate portrayal, the *conterfeit*, was applied with equal vigor to conveying information about remote and exotic things, or about things of a scope stretching beyond the normal capacity to measure. A deepening obsession with remote occurrences was a feature of sixteenth-century life, and printed images like printed texts were exploiting this interest. It would surely be mistaken to imply that technical innovation alone somehow brought about such an important change in viewpoint. Far more important than the advent of the technology of printing was the sense underlying the early pamphlet literature that events on the periphery of Europe were indeed threatening to overturn the world as it was commonly understood. Not only was the Turkish invasion a matter of critical concern, the constant promise brought by the discoveries held a similar, if less ominous interest. At one side there was the Ottoman peril, thought by many to be a sword of judgment poised to confirm a catastrophic failure of Christendom, and on the other side the discovery of new worlds, which seemed a confirmation of the daring and righteous ambitions of a chosen people. At many points these heady motives are evident in the journalistic endeavors of the print.

Printed Maps and City Views

The usefulness of the print as a recorder of material fact is closely tied to its perceived value as a means of reporting, and this value was being actively cultivated by the corner pressmen. Nicolaus Meldemann's panorama of the *Siege of Vienna* (fig. 233) declares itself partly a topographical document and partly a news account. Not only does it claim to set out the fortifications along with the main structures of the city and the lay of the land around; it also depicts particular encounters, maneuvers, and shocking acts of violence. We know the woodcut was carried out with the official blessing of the city of Nuremberg, support conveyed not only through the privilege granted to Meldemann, but also by the sum of fifty *gulden* advanced by the council for the printer's expenses. Advertising the imminent Turkish threat was not simply a gratuitous gesture to sensationalism on the council's part. It was also an expedient way of encouraging allegiance to the Emperor and keeping the local population alert to the need for maintaining order and stability in defense of the city.[189]

In the history of mapmaking, however, this 1529 mural-scale plan is retardataire. The awkward imposition of a horizontal perspective scheme onto a groundplan format serves the journalistic aims of the print, but not its allied pretense to map the city.

Accurately mapping the layout of a town was a problem in surveying that had for a century attracted artists and humanists with an interest in measurement and perspective. Already around 1430, none other than Alberti devised a radial scheme for plotting the exact location of buildings and other monuments in Rome. This system for generating what we now term an "ichnographic plan" was later adapted by Leonardo for a scaled map of the town of Imola, and then again by Raphael as a means for laying out plans of architectural complexes. Contrast, for example, Meldemann's panorama to the later circular plan of Vienna by the etcher and cartographer Augustin Hirschvogel showing the city with its fortifications as they were rebuilt after the Turkish siege (fig. 245). Hirschvogel's plan was completed in six etched plates in 1547, and then printed in 1552 along with the artist's treatise outlining his method for making the survey.[190] In the Netherlands the painter, printmaker, and cartographer Cornelis Anthonisz. printed his alarmingly vertiginous bird's-eye view of Amsterdam from twelve blocks in 1544 (fig. 249). This plan has the distinction of joining advanced survey techniques with a perspective view to give an essentially complete, but illusionistic, rendering of the city. Cornelis was also experienced in navigation techniques, on which he published a handbook for general use including, like Hirschvogel, a description of the necessary instruments and their use.[191]

Though the technical history of surveying and mapmaking is an altogether fascinating subject in itself, our purpose here is to underscore the special importance of printing and printmakers in this development. There is nothing coincidental about the fact that printmakers played a central role in prompting and in some cases advancing the new descriptive science. We recall that the stocks in Alessandro Rosselli's workshop included a large number of printed maps. Indeed, his father Francesco was a cartographer himself and collaborated on the composition of important maps, city plans, and city views. In 1506 Francesco Rosselli and Matteo Contarini published a large, planispheric world map, the first printed map to include findings from the voyages of Columbus. This was by no means his only important contribution to the field. Other evidence suggests that Francesco, like Hirschvogel after him, was well traveled and furthermore that he moved in lofty academic circles. Among the few documents we have of his life is one recording his presence at an important lecture given by the respected mathematician Luca Pacioli, who specialized in perspective geometry.[192]

North of the Alps, the oldest extant world globe was designed in 1492 by the Nuremberg geographer Martin Behaim, whose travels are celebrated, and probably exaggerated like most else, in Hartmann Schedel's *Weltchronik*. We know from the document of payment that the vellum map cover-

246. Erhard Etzlaub, *Rom Weg Map*. Woodcut, 402 × 285 mm. British Library, London.

ing Behaim's globe was illuminated by the printer and *Briefmaler* Georg Glockendon. Around 1500 Glockendon also printed Erhard Etzlaub's widely employed *Rom Weg*, a broadsheet road map of central Europe and Italy showing routes from Nuremberg to Rome (fig. 246). This woodcut map was likely made for pilgrims undertaking the journey to Rome in the Holy Year being celebrated at the turn of the century, and is oriented in the customary perspective of German maps at the time with south placed at the top. As a practical plan for travelers it was designed to be used with a compass, and trails of dots along the roadways mark out the distances in miles.[193] German printers were quick to begin issuing maps laid out in gores for covering globes. These gores, spear-shaped panels to be fitted onto a sphere, were being printed in woodcut at least as early as 1515 by the Nuremberger Johannes Schöner. Printers, block cutters, and *Briefmaler* were everywhere involved in furthering the new descriptive science of surveying.

Meanwhile, Renaissance exploration was aggressively expanding the margins of the known world. Revisions of Ptolemy's geography and his mapping scheme proceeded apace throughout the first half of the sixteenth century, a development that obviously begged for more accurate means of recording and disseminating newly acquired information. The advantage of having uniform and widely available maps, particularly the portolan charts used by navigators, must have been obvious. With a common set of maps in circulation, the findings of voyagers and surveyors could, in principle, be more effectively coordinated, and thereby a more accurate diagram of the known world approached. Printing could most easily provide such a stable foundation for the systematic improvement of geography. But was it doing so? In mapping, the problem of scale is especially acute, since the order of reduction in scale allows for a vast exaggeration of error when a map or chart is actually put into practical use by a traveler or navigator. Therefore, printing carried an enlarged potential for perpetuating error as much as it also contributed to overcoming it. Furthermore, map printing posed new demands on the existing technical capacity of printmakers — for example, extra-large presses were required for accurately printing wall maps composed of unusually large sheets, and new means had to be developed for introducing dense networks of texts into woodblocks. Although serious cartographers turned to the press early on, map printing would need to prove itself in a trial period before it was to become the medium in which the definitive records of current knowledge could be safely logged.

Printed world maps began to emerge in the late fifteenth century with editions of Ptolemy's *Geography*, a text which had finally reached Italy from Byzantium by about 1400. The earliest printed edition of the text appeared in Bologna, probably in 1477, a publication that has the additional distinction of being the first instance we know in which copper engravings were used for book illustration.[194] What must have been a serious technical inconvenience to the printer reflects the demand for a level of detail not readily achievable in small-scale woodcutting. A great many editions and translations of Ptolemy's text followed, often illustrated with maps adhering to ancient tradition and often mixed with modern revisions. Much as with the erosion of Ptolemaic cosmology, new observations began to press against old assumptions until the discrepancies between ancient authority and modern calculation gradually caused the received scheme of understanding to come apart. Whereas the Ptolemaic construction of the universe collapsed largely from the calculations of Copernicus, the nearer problem of undermining Ptolemy's venerable geography required the contribution of many hundreds of investigators.

In the course of this steady accumulation of knowledge, printers and scholars strove for a better means of reproducing maps. Inevitably there were conflicting demands — the commercial aspirations of printers, the limitations of woodblock cutters, and scholars' insistence on tastefulness and precision. Willibald Pirckheimer's efforts in bringing out a revised edition and translation of Ptolemy give us a sense of the realities confronting printers and scholars in the making of cartographic illustrations, and especially the conflicting demands

of the printer's economy, the aspirations of geographers, and the limits of technique. To begin with, Pirckheimer's ambition required him to look beyond the experienced Koberger printing house of Nuremberg. He went first to Basel, where it seems he also sought access to a prized Greek manuscript of Ptolemy's text,[195] and then later to Strasbourg where he was finally successful in soliciting the services of Johann Grüninger. Grüninger already had some suitable blocks for the woodcut maps from an earlier edition of Ptolemy. He also had a special large press he had built for printing them. Hans Koberger served as Pirckheimer's agent in this project. It was not uncommon for major printers who were often heavily burdened with manuscripts to farm out jobs to other houses, particularly in a case like this where a certain specialty was involved.

Johann Grüninger was among the most experienced printers in Europe by this time and he seems to have entered into Pirckheimer's project with great enthusiasm. But very quickly the two of them fell into disagreement over the content and execution of the new illustrations, indeed so dramatically that one cannot but wonder why more care was not taken to make expectations clearer from the outset.[196] Grüninger wrote early on in the project to say that the important *universal*, or world map, was nearly drafted on paper and could soon be put onto the block for cutting. In the letter he asks Pirckheimer's permission to add personifications of the winds around the periphery. When he later received portions of the text and illustrations for approval, Pirckheimer was miffed. He found the woodcuts placed out of order and badly done. To make matters worse, he discovered they had been sullied with fanciful and irrelevant details, "lots of tomfoolery and old wives tales" (fil gauckelweys vnd alter weyber fabel), as he put it.

By this he meant the colorful exotica, the fantastic beasts and cannibals which customarily enliven presentation maps of this period. Pirckheimer denounced this as the stuff of children and ignorant folk only bound to incur the scorn of proper scholars. Were he in Grüninger's place, he says, he would have had the proofs burnt. Adding insult to injury, Pirckheimer wrote that he had shown the proofs to his close friend Dürer who judged them utterly without merit ("keyn eyniger guter strich"). Furthermore, he accuses the printer of violating instructions by typesetting the annotations separately from the original text rather than interlinearly as he was asked to do. Pirckheimer reminds Grüninger that his work will have to pass the scrutiny of learned painters from the south. Along with the irresponsible proofreading of the text, the entire enterprise, he suggests, is bound to be taken for the work of hacks. It seems that printers were subjected to remarkable indignities by their authors from the earliest stages of academic publishing. Propelled by a wish to have the book ready for the next Frankfurt Fair, Grüninger argues in his own defense that the woodcuts embellish the text and make it a valuable thing — beautiful like the *Theuerdanck*, he says, and thus all the more worthy of purchase. He claims to have shown the ornamented edition to scholars and dealers who agreed with him about its quality. Exasperated to the end, Pirckheimer seems to have publicly washed his hands of the matter in so far as he could. Objections notwithstanding, the edition was published in 1525 close to schedule.[197]

Johann Grüninger's press had been operating under his supervision since the latter part of the fifteenth century. In retrospect, Pirckheimer and Koberger ought to have anticipated the difficulties in which they found themselves, since Grüninger's publications were typically fraught with errors.

247. Martin Waldseemüller, *Gores for a World Globe*, 1507. Woodcut, 185 × 350 mm. James Ford Bell Library, University of Minnesota.

Even so he was probably responsible for printing two of the most studied monuments in the early history of mural map printing. The first of these was Martin Waldseemüller's *World Map* of 1507, best known for being the earliest surviving map to include the word *America*, an event seconded in the same year with the publication of a set of woodcut printed gores for covering a world globe (fig. 247). The mural map has come down to us in only one recorded example, almost certainly a late impression, which is now in the Wolfegg collection in Bavaria.[198] It is a large wall map printed from twelve blocks. The rarity of early wall maps stems from two conditions. Like all monumental woodcuts intended for mural display, they were easily damaged and eventually destroyed. Furthermore, as a practical matter, maps simply became obsolete. The Wolfegg copy managed to survive by the good fortune of having been folded into an album at some early date.

The history behind the making of the Waldseemüller map is dauntingly complex and cannot occupy much of our attention here. In brief, it emerged from a small community of cartographers working under the patronage of Duke René of Lorraine in the relatively isolated town of Saint-Dié. This group seems to have had its own press. However, as recent investigation has shown, both typographical and circumstantial evidence points to the block cutting and printing having been turned over at some point to Grüninger in Strasbourg. This may have been due to the loss of a job printer who had previously been retained at Saint-Dié. Whether Grüninger was the very first to print the map or inherited the project later is more difficult to surmise since, as Elizabeth Harris has shown, the one extant impression was probably produced around 1525, nearly twenty years after it was first drawn and cut into the blocks.[199] The map also includes a significant editorial change — two sizable plugs in one block show that the Cape Verde Islands were moved about ten degrees north of their placement on the original woodblock. This must have occurred some while before the present impression was pulled, since shrinkage has separated the plugs sufficiently to leave a clear trace of the changes. Secondly, there is an alteration in the coastline of Central America.[200] Grüninger's name and address appear nowhere on the map. The absence of a printer's address is most curious for so extravagant an undertaking as this.

Grüninger's second major accomplishment in mural map printing, the *Carta Marina* also of 1525, dates from the very year in which he was embroiled in his dispute with Pirckheimer. This is a navigational map printed from twelve blocks, and is likewise extant in only one impression (fig. 248). The *Carta Marina* is in substantial part a reduced version of a second Waldseemüller map composed around 1516. Although there is a useful index and a panel for listing errata, the map was expressly intended for the layman and not the professional geographer. Explanatory texts, labels, and place names are in German rather than Latin, and the map is replete with the kind of fabulous embellishments that so disconcerted Pirckheimer in the edition of Ptolemy published the same year. Despite their deteriorated relations, Grüninger actually attempted to involve Pirckheimer in this project as well, requesting that he write the guide for the map. Predictably, Grüninger failed to enlist his services, and the accompanying text was written by the more dilettantish Lorenz Fries, author of sundry religious, astrological, and medical pamphlets as well as editor of the flawed 1522 edition of Ptolemy that Pirckheimer had sought to rectify. The *Carta Marina* sold for five *gulden* and was accompanied by a guidebook that provided instructions and a diagram on how to cut and paste the sheets onto canvas in their proper sequence and overlap. Despite the attention given to space for errata, the publishers themselves seem not to have paid much attention to important discoveries that had been made since 1516. For example, the evidence provided by Magellan's voyages was overlooked, though reports were already in circulation through printed news sheets.[201] This should come as no great surprise, given what we have already seen of Grüninger's press. Once again the map itself contains no printer's address. Nevertheless, its identification is assured by the handbook, by Grüninger's correspondence at the time, and by the style of draftsmanship pointing to Hans Baldung's Strasbourg workshop.[202]

A look at the range of printed cartographic material published between 1500 and 1550 leaves us with a mixed impression about the practical and progressive value of printed maps. Certainly the woodcut mural maps contributed widely to the encouragement of a lay interest in geography. Indeed, most were compiled precisely for the sedentary merchants, the amateur geographers, the humanist scholars, or aristocratic savants wanting a better picture of the world they inhabited.[203] Likewise, the numbers of printed Ptolemies in the Renaissance were not meant for the practical needs of the navigators. In fact, all the while that editions of Ptolemy were rolling obliviously from the European presses, the Ptolemaic construction of geography was rapidly being undermined by the accumulation of new observations. Contemporary with the renewed interest in Ptolemy came the writing of a brand of descriptive geography derived ultimately from the work of Strabo. Sebastian Muenster was the foremost exponent of this type of geographical writing. In 1544 Muenster printed the first edition of his famously successful *Cosmography*, a historical and cultural geography written for the armchair voyager, richly illustrated and voraciously encyclopedic in its incorporation of cartographic, ethnographic, historical, and con-

temporary sources. Muenster's *Cosmography* was printed in several languages, including Latin, and continued to be updated from one edition to the next for over a hundred years. Despite an often indiscriminate mixing of fable with reliable reporting, the *Cosmography* actually supplied the basic fund of cultural and geographical knowledge shared among the literate in sixteenth-century European society. Much like the woodcut maps, the illustrated chorographical and cosmographical texts from this period vividly mirror the curiosity of Europe's lay public about the world at large.[204]

Were the printed maps at all a progressive ingredient in the evolution of world geography in the Renaissance? Opinions differ on this question.[205] Like so much investigation going on in the period, the furthering of geographical knowledge depended a great deal on the interest, imagination, and skill of the upper echelon artisanry as well as on the court and those university scholars who were engaged in collecting and analyzing new information about the globe. It was not at all surprising to find a printmaker designing apparatus for surveying — a man like Augustin Hirschvogel, for example, who had fine metalworking in his background, or a compass-maker like Etzlaub, who made roadmaps to go with his instruments. On a more elevated level, the suggestion that Francesco Rosselli had an interest in the work of the geometer Luca Pacioli reflects the importance of perspective construction for painters and cartographers alike. Contributions and cross-fertilizations of this kind were important. The trading in such practical skills was as much a necessary catalyst in the history of map printing as it was in surveying or navigation. The tight relation that obtained between the artisanry and certain

gains in scientific observation marks the sixteenth century as a critical turning point in the history of technology.

However, it is easy to overestimate the value of publication for the dissemination and improvement of early scientific knowledge. Map printing during these years kept up only randomly with recent discoveries. New information was coming in at such a rate and in such various forms — extending from new maps to written accounts — that one could hardly expect printers to keep abreast of it. Furthermore, much of the ambitious voyaging was not being done merely in order to publish valuable trade routes throughout the capitals of Europe, but for commercial reasons entirely counter to the interests of general knowledge. Until a common fund of geographical data came to be widely shared, the printmakers were bound to lag behind in their contributions. It was only after mid-century when the situation had matured sufficiently that we find authoritative printed atlases becoming available. Also around this time certain of the technical complications of printing texts on maps were resolved by a conversion from woodcut to intaglio map printing.[206] The shift from woodblocks to copper plates came about with a general preference for intaglio book illustration that ensued only after 1550. This maturation of cartographical printing was achieved by the Netherlanders Abraham Ortelius and Gerard Mercator who compiled printed atlases that were genuinely practical and up-to-date. From that point on, printing played a profound role in the distribution of geographical science, an endeavor that in earlier decades must have been retarded by printers one step for every two they advanced.

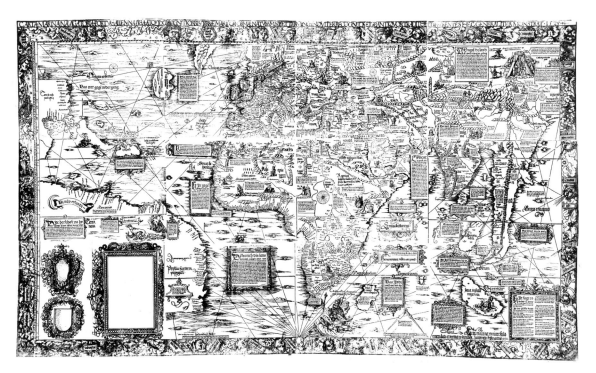

248. Lorenz Fries, *Carta Marina* (Strasbourg: Johannes Grüninger, 1525). Woodcut from twelve blocks, 1150 × 2000 mm. Bayerische Staatsbibliothek, Munich.

Printed Herbals and Descriptive Botany

Renaissance botanical illustration presents us with a clearer instance in which the image, and secondarily the print, played a critical role in the evolution of empirical science. In his provocative essay on prints and the transmission of technical information, William Ivins makes this point more insistently than other scholars had before him. Ivins's main objective is to outline the special importance of artists learning to render objects effectively in line drawing such that these could be translated into prints and reproduced for wide distribution. He recognizes this combination of formal and technical ability as necessary for certain kinds of scientific progress to occur. However, like the history of map printing, the development of printed herbal illustration was not at first closely paralleled by improvements in practical application or in the advance of scientific understanding. Instead, botanical illustration lurched its way toward modern techniques of description and taxonomy, alternately exceeding and trailing the investigations of sixteenth-century naturalists. Taken from the perspective of the history of woodcut printing, it is a story well worth retelling for the light it sheds on the importance of printmakers as witnesses in the recording of empirical fact.

The herbal was kept alive from antiquity through the later Middle Ages primarily as a source of medical knowledge, and it changed relatively little over the intervening centuries prior to the Renaissance. Surviving examples from the illustrated manuscript tradition show a pattern of degeneration due to repeated copying without recourse to natural specimens. There are occasional instances in which drawings appear to have been done from life, but these are exceptional and isolated cases. Already in the first century A.D. the natural historian Pliny the Elder lamented a decline in the quality of plant illustration.[207] For the most part it is hard to imagine specific plants actually being identified from their textual descriptions or from illustrations alone. Herbals must have been used primarily as medical reference works, stores of remedies for apothecaries who already knew how to identify the relevant plants. The individual species included in these early herbals were not categorized by botanical type. They were arranged alphabetically by name, or alternatively by their therapeutic application, which also affirms that herbals were being used as a medical reference rather than a field guide. The ancestral herbal texts were more closely studied in Italy than they were in the north, not only because of scholarly respect for the classical tradition but because the flora described in them were predominantly Mediterranean and thus more familiar in the Italian countryside. Nevertheless, whatever medical or philological interest the herbals may have held, it was not sufficient to provoke a systematic campaign to illustrate the plant kingdom anew until the late fifteenth century.

Then in 1485 a surprising book issued from the printing house of Peter Schöffer in Mainz — the *Gart der Gesundheit*, or *Herbarius zu Teutsch* as it is sometimes called. Schöffer is best known as the inheritor of Gutenberg's printing establishment, and as the printer he is the only person named anywhere in the herbal. The text tells us that the herbal was sponsored by a wealthy patron, who remains unnamed; nor is the author or the artist who did the illustrations identified. From at least the sixteenth century onwards, however, the text was standardly attributed to Johann von Cube, who was the town physician in Frankfurt when the herbal was first compiled. And a marked similarity with the style of Erhard Reuwich is evident in the woodcut frontispiece. Based on these observations, and on a reference in the text to the patron having made a journey eastward where certain of the plants were collected and drawn, it has been reasonably inferred that the *Gart der Gesundheit* resulted from a collaboration between Erhard Reuwich and Bernhard von Breydenbach, indeed the very same alliance that produced the *Sanctae peregrinationes* published in Mainz in the following year.[208] These connections, albeit not conclusive, are nonetheless compelling. The frontispiece, though less lavish than its counterpart in the *Sanctae peregrinationes*, is certainly related to it in style. The plant studies pose such a different problem in rendering that they cannot be attributed with much confidence. Yet the notion that a gifted collaboration might have resulted simultaneously in a landmark in botanical history and in illustrated travel literature, the diagramming of the world on both a micro- and macrocosmic level, has obvious appeal.

More important than the question of attribution is the fact that we are assured in the text of the *Gart der Gesundheit* that the plants were actually drawn from life, an assertion that seems justified in many if not all instances. This claim can be measured by comparing the *Gart* to its immediate predecessor, the so-called *Latin Herbarius* published one year earlier in 1484, also from Schöffer's press (fig. 250).[209] For example, in the illustration for borage (*Borago officinalis* L.) in the *Latin Herbarius*, the root is shown in a stylized fashion, and the plant is splayed in an attempt to reveal the flowers and the different dimensions of the leaves at various points along the stem. In contrast, the 1485 *Gart der Gesundheit* records with startling clarity the ungulations of the leaves and stems, the puckered shapes of the larger leaves, the buds, and the five-petaled flowers with their stamens (fig. 252). Furthermore, this is a rare instance in the *Gart* of a plant shown as if it were growing from the ground rather than pruned or with its roots bared for display. Variations in rendering elsewhere in the herbal may reflect different sorts of models being

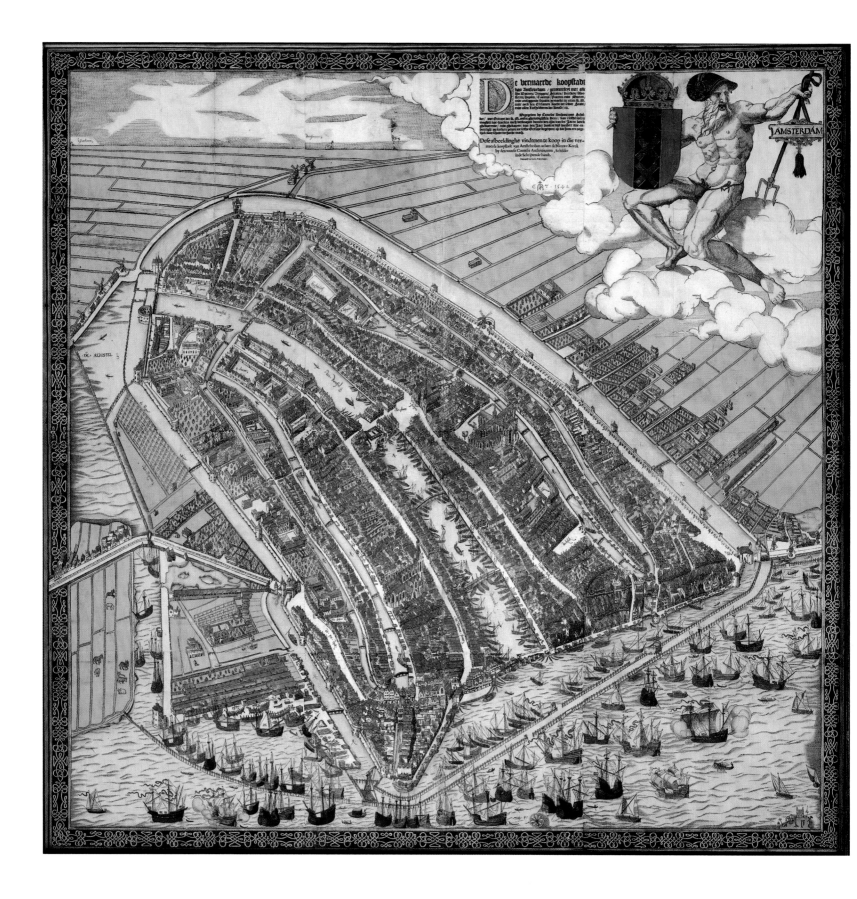

used by the draftsmen — not only live plants, but dried specimens, and possibly painted herbals and other pictorial sources. There were probably more hands than one at work on the designs for the *Gart der Gesundheit*. Considering the varied use of shadow and line to evoke texture, and the careful posing of the plant to present its particular features advantageously, we can hardly doubt that the drawing was executed by a painter or a *Briefmaler* well versed in rendering form in light and shade. Indeed, the modeling of the image is such as to suggest it may actually have been copied from a painting rather than from the plant itself. Whatever its particular prototype, the later woodcut is unusually masterful, and certainly a help in identifying the plant in nature.

However, the differences between these two early printed herbals are not consistent. For example, the attention to lifelikeness means that specimens in both, but more frequently in the later *Gart*, exclude important stages in the leafing or blossoming of a plant probably because only one example was studied. Furthermore, the impression we have of the draftsman's rigorous attention to detail often distracts us from recognizing conventional elements, the suggestion of hirsute stems indicated by the prominent thorn shapes on the borage plant, for example. Or in the case of the dill plant (*Anethum graveolens* L.), the feathery pinnate leaves are given too much dimension by the artist's reluctance to employ a single line to suggest a significant form (fig. 253). Inaccurate proportions of this sort are very common and confusing. Moreover, the flowers and seeds of the dill are excluded altogether. In the earlier Latin herbal, on the other hand, these stages as well as the softness of the leaves are quite adequately recorded (fig. 251). Whether taken from life or not, naturalism cannot escape a need for artistic convention.

The return to original specimens so proudly proclaimed in the text of the *Gart der Gesundheit* may be largely genuine, but for two reasons the practical consequences of this revolution are not so obvious as they are often taken to be by historians of art or of botanical and technical illustration. First, there is no consistent approach to what needs to be described for purposes of identification. For example, whereas the roots are indicated at least in a schematic way throughout the *Latin Herbarius*, this is done only erratically in the *Gart*. Second, the graphic language of the draftsmen has certain obvious limits for translating the complex and varied shapes and textures of botanical specimens. As a first effort in woodcut herbal illustration from life, the practical deficiency of the *Gart der Gesundheit* as a field guide for identifying particular plants is not surprising.

Whatever the practical failings of these Mainz herbals, they demonstrate that by the late fifteenth century the desire to record botanical fact afresh

had regained a foothold. Artists were beginning to describe the particulars of things effectively and therefore to offer a distinct advantage to the herbalist. At the same time the cultivation of an ability to make a detailed *conterfeit* of a given specimen reintroduced a need for some guidelines about what was and what was not a useful symptom of identity. Once set the task, artists could, and indeed did, proceed to acquire the means of describing specimens in greater detail. Yet this introduced a set of variables that the descriptive science of botany was as yet ill equipped to sort out. So for a considerable time the capacity for precision in the image outstripped the analytical precision of the naturalist. Whether this phase of discontinuity was a necessary step towards the development of a systematic taxonomy is difficult to answer, though it is hard not to agree with William Ivins that certain scientific advances could only have been made after coherent means of visual description were in place, and that such steps were doubtless encouraged by the advantages of reproduction.

As long as medicinal and natural historical texts demanded no more than specificity and nothing systemic in botanical illustration, significant artistic advances would continue to be separated by interludes of redundant copying and recopying. Surprisingly enough, it took nearly a half century after the publication of the *Gart der Gesundheit* for the second major breakthrough to occur. In 1530 the Strasbourg publisher Johann Schott issued the *Herbarum vivae eicones*, its text mainly a composite of various Renaissance and earlier sources and essentially medieval in its approach. It was put together by Otto Brunfels, a pastor and sometime naturalist who culminated a short and varied career as the town physician at Bern. However, despite the archaism of its text, the *Herbarum* includes a cycle of woodcut illustrations of quite astonishing subtlety, accuracy, and elegance (fig. 254).[210]

The credit for making these illustrations falls to the remarkable draftsman and block cutter Hans Weiditz. Like many other woodcut designers of his generation, Weiditz's talent was abundant and must have been well enough recognized by his contemporaries. Yet for a long time his achievements were submerged in the complex history of early book illustration, where blocks were traded around and comparatively few artists were identified by name or initials, either on their compositions or in printers' colophons and authors' prefaces. Only the bare outlines of Weiditz's early career have thus far been discerned. His style seems to have matured during the late teens when he was in the service of Hans Burgkmair in the flourishing days of Augsburg printing. Weiditz later returned to Strasbourg, probably in 1522 or 1523, and completed his career in the service of printers there and elsewhere. He is especially notable for his illustrations to a range of classical and humanist

249. Cornelis Anthonisz., *Plan of Amsterdam*, 1544. Woodcut (Holl. 47), 1080 × 1057 mm. Rijksmuseum, Amsterdam.

250–51. (top) *Borage* and *Dill*, from *Herbarius Latinus* (Mainz: Peter Schöffer, 1484). Woodcut. Pierpont Morgan Library, New York.

xriij

Borago boriʒ

borago eſt calida & huͤmida in pͦmo ʒdu. Eius folia duͤſuͤt viridia pͦcipue cͦpeuͤt medicine. exſiccata no cͦſeruͤt ſcͦario ſemen. Uirtute ha bet generandi bonuͤ ſanguine. vnde valet. oua leſcentibus ex egritudine eius decoctio. valet etiͤ cordiacis ſiue ſincopiſantibus et melͤcolicis bo rago cuͤ carnibus comeſta vel loco oleruͤ. Contra ſincopim tali mow fiat potus. R. ſucci boragi nis. lb. j. vim decoctͦnis citri ʒrt. j. oſſ de corde

₤

Anetuͤ **Dille**

Anetuͤ eſt caliduͤ inter ſcͤm et terciuͤ ʒ8. et ſiccuͤ inter pͦmuͤ et ſcͤm ʒ. Et qͤn aduritur fit ſiccuͤ in ſcͦo. Eſt reſolutiuiͤ z maturatiuiͤ apoſtematuͤz vlceruͤ. notanter ſemen aneti intelligiſͦ otuſuͤm cuͤ radice altee z auxugia porci vz ad apoſtema ta flecmatica maturaw ea ad ſanei generationͤe. Et cinis ſeminis aneti cͦbuſti valet vlceribus exſiccanw ea cuͤ puluere radicis ypͦeos nͦiſcenw Jtem oleum aneti cͦfert doloribus neruoruͤm et

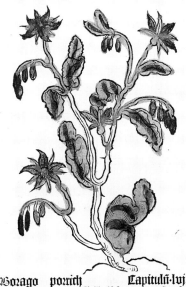

Borago porrich **Capitulͤu·luj.**

Drago latine et grece· In dem buͤch genͤat circa inſtans ſtat geſchriebͤe daz borrich ſy leyſ vn feucht an dem anfang des erſten grats·Das krut iſt vns woͤl bekant·vn hait breyt bletter die ſynt ruch·vn ſo ſie gruͤne ſynt ſo bruchet man ſie in der artzny vnd nie dorre·Der ſame iſt faſt guͤt genutzet vnd weret zwey iare·Platearius das krut geſotten mit wyn vn den gedruckͤe macht

252–53. (bottom) *Borage* and *Dill*, from *Gart der Gesundheit* (Mainz: Peter Schöffer, 1485). Woodcut. Pierpont Morgan Library, New York.

Anetum **dille** **Cap·riij·**

Netuͤ latine·arabice veſet· Der meiſter Serapio in dͤe buͤch aggregatoris in dem capitel veſet·id eſt Anetum ſpricht daz Anetis allen luten ſy woͤl bekant·vnd ſyne natur iſt warme machen in dem leſten des dritten grats·vnd drucken machen an dem anfang des andern grats· Der wirdig meiſter Auicenna ſprichet daz dyſſe genutzet macht woͤl ſlaffen vnd ſunderlich das oͤle do von

literary texts, the best known of these being his extraordinary woodcuts for Petrarch's *De remediis utriusque fortunae*.[211] The illustration of this text must have been highly demanding terrain for any artist's inventiveness. The diversity of Weiditz's oeuvre is largely the result of his service to major publishers and corner press printers for whom he made everything from narrative compositions to border designs. His style bears the unmistakable stamp of the Augsburg Italianate classicism encouraged by Burgkmair, yet with a distinctive vitality and dense pictorial intricacy very much his own. Among Weiditz's artistic influences we must also include Albrecht Dürer's work, particularly the numerous plant studies in watercolor and bodycolor which still remain models of precise botanical observation.[212] Following Dürer's initiation of the practice, by the second quarter of the century careful renderings of plants in watercolor had apparently become fairly common in the workshops of south German painters.

Looked at in the full scope of Weiditz's career,

his skilled nature studies stand at one margin of a truly diverse achievement. There is absolutely no doubt that the illustrations for the *Herbarum vivae eicones* were taken from actual specimens, fresh or, in certain instances, possibly dried. Although the woodcuts themselves are proof enough of this, some years ago a number of the watercolor studies Weiditz made as models for the woodblock drawings were discovered by Walther Rytz in the library of Bern University. The watercolor model and the woodcut for the common comfrey are exemplary (figs. 256–57). Unfortunately a great number of these watercolors were seriously mutilated in the later sixteenth century when the original album was pillaged and remounted in order to illustrate another herbal. Nevertheless, enough survive to give us a clear idea of the artist's procedures and objectives. In Weiditz's watercolors the plants are described in minute detail with insets devoted to particular features such as the root system, the bud, or the blossom. They differ from the typical Düreresque nature study in having been first

254. Hans Weiditz, *Borage (Borago officinalis* L.), from Brunfels, *Herbarum vivae eicones* (Strasbourg, 1530–36). Woodcut, page 308 × 195 mm. Staatsbibliothek, Berlin.

255. *Borage (Borago officinalis* L.), from J. de Cuba (E. Rösslin), *Kreuterbuch* (Frankfurt: Christian Egenolff, 1533). Woodcut, image 85 × 35 mm. British Museum, London.

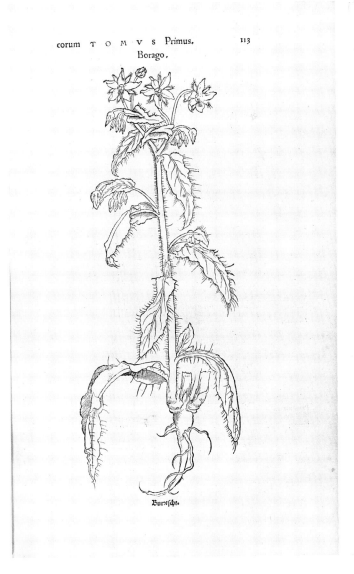

Walwurtz mänalin. g 4

256. Hans Weiditz,
Common Comfrey
(*Symphytum officinale* L.).
Watercolor with body color.
Universität Bern, Bern.

257. Hans Weiditz,
Common Comfrey
(*Symphytum officinale* L.),
from Brunfels, *Herbarum
vivae eicones* (Strasbourg,
1530–36). Woodcut, page
308 × 195 mm.
Staatsbibliothek, Berlin.

drawn carefully with a pen and then worked up with brush in color. It appears that they were done in some haste to meet the publisher's deadline, since many are incompletely modeled and colored. Schott's determination to have a record of the woodcut illustrations in watercolor is noteworthy in itself, since they were probably meant to serve as models for illuminators engaged in hand-coloring copies of the herbal. In his careful study of the Plattner herbal, Rytz was also able to recover a number of fragments of text that had been written around the plant studies in the original album. There is good reason to suppose that these annotations were made by Weiditz himself, since they include along with the name of the plant, citations of the day, month, and year in which the specimen was drawn, notes about the size, the color, and also about the textural qualities of the plant.[213] For the most part these sorts of observations stand in marked contrast to the borrowed descriptions in

Brunfels's printed text. A few of the descriptions are in fact very precise, but usually one can be certain of the actual identity of a particular plant only by referring to its illustration. Brunfels's unusually detailed characterization of the borage plant (fig. 254), for example, was taken from Albertus Magnus's natural history of about 1250.[214] Here is a case that illustrates in microcosm the peculiar circumstances of Renaissance botany. While the draftsman worked attentively from a newly collected specimen (like the one Albertus himself may have examined), the sixteenth-century author deferred to the authority of Albertus's text.

Since individual portions of the plants as they are depicted in the watercolors have been severed and relocated on the page in the woodcuts, the scale of the woodcuts differs from the scale of the watercolors. Since they are in reverse, it is obvious that the watercolors were models for the woodcuts and not copies of them. Moreover, the watercolors

258. German School,
*Buttercups, Red Clover, and
Plantain*, 1526. Watercolor
and body color on vellum,
299 × 217 mm. Rhode
Island School of Design,
Providence.

were not used as templates for tracing the wood-block drawings.[215] Judging from the delicacy of the woodcuts, they were done with a quality and an exactness that point again to the hand of Weiditz. Very close attention was given to the outline in the watercolor with an occasional alteration in the turn of a shape. Slight adjustments were made to eliminate an overlapping leaf or some other such detail that might become confused when translated into line, and the length of a specimen was frequently truncated or compressed to fit the proportions of the block.

251

However graceful these compositions are, the intent to describe, that is to make a true *conterfeit*, overrides formal criteria. For example, in his watercolors Weiditz sometimes set certain details against a darker field in order to reveal shape and color more distinctly. The Bern watercolors are not presentation drawings for a collector who might be attracted to the natural beauty of the objects, but rather descriptions to be used for practical identification. In precisely this respect the character and the intention of the Weiditz watercolors differ from the celebrated nature studies by Dürer and his followers.[216] Dürer's famous *Large Piece of Turf* (Vienna, Albertina), including several specimens rendered, as it were, *in situ*, was meant to portray a living complex of organisms rather than to expose the special characteristics of any single plant. Such studies of individual plants as do appear by Dürer and his school offer a much closer comparison to Weiditz's studies for the herbal. The agreed masterpiece of this genre is surely the watercolor *Iris* now in Bremen (Kunsthalle), a work most closely associated with the *Large Piece of Turf* and dated accordingly around 1503, hence early in Dürer's career.[217] Grouped around these watercolors are a considerable number of similar nature studies much debated as to their date and attribution. We need not enter into this vexing controversy, so well analyzed by Fritz Koreny, though a couple of general observations relevant to our present inquiry can be drawn from earlier examples.

Nature studies were surely undertaken in painters' workshops at least by the mid-fifteenth century when we find details of striking realism occurring in Netherlandish and, somewhat later, in German panel painting. A recently discovered watercolor of *Peonies* (J. P. Getty Museum), convincingly attributed to Martin Schongauer, is a remarkable and noteworthy instance of what fifteenth-century studies of this type might have looked like.[218] Although, presumably for lack of interest, these early workshop studies have been almost entirely lost to us, a considerable number of magnificent northern European plant studies do survive from the sixteenth century (fig. 258). The mainstream of this naturalistic genre sprang from Dürer's circle in the 1520s, when we find a number of German artists engaged in making detailed plant studies on vellum following his exquisite example. Some of these were then acquired by the Imhoff family in Nuremberg, also the richest repository of Dürer's work at the time.[219] The passion for naturalist illustration continued unabated into the Dürer Renaissance; over the century, plant studies obviously graduated from being workshop models to prized collectors' items.

Who actually initiated the *Herbarum vivae eicones*? It is reasonable to suppose that an inquisitive churchman turned naturalist like Otto Brunfels would eventually have come across some of these visually striking portraits of local flora that were circulating in painters' workshops, recognized their practical and naturalistic value, and so conceived the idea of compiling a newly illustrated herbal. However, the botanical historian T. A. Sprague points out that the text may have been begun sometime before the illustrations, since the early chapters of the Latin edition are unillustrated.[220] Further evidence in the text suggests a complicated relationship between the two contributors. In both the dedicatory epistle to the Latin edition and the introduction to the German edition, Brunfels laments inaccuracies resulting from the hasty accumulation of often imperfect specimens. Here Brunfels must be referring as well to the damages and other irregularities recorded by Weiditz's ever faithful hand. Evidently Brunfels did not have the opportunity to supervise the illustrations to his own satisfaction, a pattern recalling Pirckheimer's frustration over his edition of Ptolemy. The author's remarks, along with the evidence of haste in preparing the watercolors, point to Schott as the prime mover behind the project.[221] We know that Brunfels and Schott were very close colleagues whose fortunes had crossed much earlier owing to common sympathies with the Reformation. The cadre enlisted to make the herbal included in addition two other Lutheran partisans, Michael Herr who worked as an editor and translator and Nikolaus Prügner who, along with various herbalists and an elderly peasant woman, took charge of supplying specimens.[222]

Conflicting intentions aside, it was, after all, Weiditz who gave us the first botanical studies of the Renaissance that can hold a claim to being properly scientific in their concern for unmediated descriptive accuracy and completeness. The text of Brunfels's herbal, on the other hand, takes no particular advantage of this opportunity to clarify the botanical relations among plants or to investigate their individual structures.[223] Since the *Herbarum vivae eicones* is arranged alphabetically, as was typical for the period, it also makes no pretense to classifying plants in any other respect. Descriptive matters were being left entirely to portrayal, and taxonomy was ignored altogether. The imbalance of talent and original contribution invested in the illustrations in contrast to the text can best be put down to the limited ambitions of the printer. As Schott's fellow townsman Johann Grüninger had earlier insisted in his dispute with Pirckheimer, good illustrations sell the book. By implication, a scholarly production was not the first objective of a profit-minded press.

Indeed, there is every evidence that printed herbals were a great commercial success, and because of these reference books, herbal medicine came to dominate therapeutics for a century and a half.[224] To what extent herbal illustrations were actually being used to identify plants is difficult to say.

Certainly as a field guide Weiditz's woodcuts superceded their predecessors by a large margin. It can be inferred that the adequacy of pictorial representation achieved by 1530 may also in some ways have inhibited the development of text description. Hieronymus Bock, a naturalist who wrote shortly after Brunfels, published an herbal without illustrations. Here he was following certain classical authorities who claimed that illustrations were more confusing than helpful. Secondly, Bock saw that the cost of illustrations would have made the text unaffordable. As a consequence of their absence he felt compelled to give much fuller descriptions than his predecessors had done.[225] Furthermore, Bock paid closer attention to the structures and habits of the plants themselves, relying more on his own field experience than was true of most earlier authors. As a consequence, historians of science have singled him out, along with his fellow countryman Valerius Cordus and the Frenchman Jean Ruel, the translator of Dioscorides, for having taken the preliminary steps toward the modern system of descriptive botany and plant classification.[226]

Then, in a curious sub-plot to the story of the illustrated herbal, the notion of the *conterfeit* gained something of its old pejorative meaning, and the legal history of printing acquired a new precedent. Once Brunfels's herbal was published, a large number of its illustrations were promptly pirated by the Frankfurt publisher Christian Egenolff for his *Kreuterbuch*. These copies were to accompany a minor reworking of the fifteenth-century *Gart der Gesundheit* text, which Egenolff had commissioned from the naturalist Eucharius Rösslin and published in 1533. As we can see from a comparison of the two versions of the borage plant, the copies were made in smaller scale and appear in reverse of the Weiditz figures (figs. 254–55). To counter this infringement, Schott brought a formal complaint against his onetime colleague. Eventually Egenolff issued a defense of his action, a plea which makes for very interesting reading. Here Egenolff protests that the text of his herbal is an old one, and he cites general agreement that the reprinting of old books is permissible, especially those that are meant to help people in times of sickness. Furthermore, since his book includes many illustrations that do not appear in Schott's, it cannot literally be termed a copy. Then he advances a still trickier argument. He says that if we compare one plant to another, are we to suppose that rosemary, asphodel, borage, or some other herb can be drawn or represented in any other shape or form than it is in itself?[227] In effect, Egenolff asks if he is required to offer his readers some other sort of image just because Schott has now been granted an exclusive privilege for illustrating nature according to its true aspect! In this precocious bit of sophistry Egenolff raises the ticklish question of how a genuine *conterfeit* of a natural thing can be claimed to be the property of a

PICTORES OPERIS,
Heinricus Füllmaurer. Albertus Meyer.

SCVLPTOR
Vitus Rodolph. Speckle.

259. *Portraits of A. Meyer, H. Füllmaurer, and V. Speckle*, from Fuchs, *De Historia stirpium* (Basel, 1542). Woodcuts, page 380 × 240 mm. Staatsbibliothek, Berlin.

single publisher, or for that matter the invention of one artist. Then, once again shifting his ground, he goes on to say that if Dürer and others hold privileges for their designs of Adam and Eve, Actaeon, or the fighting Achilles, this hardly implies that no other artist is allowed to illustrate the same stories. After all, he says, one must be true to one's sources. Just as we cannot state that a particular herb has the opposite property from what it actually possesses simply in order to avoid copying someone else's text, neither can we insist upon an illustrator falsifying the facts for the sake of a copyright![228]

Egenolff's imaginative excuses do little to mask the important point underlying what is at base a typical dispute over publishers' rights. An accurate set of botanical illustrations was a rare and valued result of artistic skill and refined block cutting, not to discount the effort of bringing together so many specimens for study in the first place. This necessary coalescence of botanical, artistic, and artisanal abilities explains the fact that a printed herbal was the very first, and possibly the only, case in the history of early book illustration to acknowledge not just the author, but the painter, the transfer draftsman, and the block cutter for their contributions to the project — Leonhart Fuchs's *De historia stirpium commentarii insignes* published in Basel by Michael Isengrin in 1542 (fig. 259).[229] The unprecedented recognition granted to the illustrations and to their makers in the Fuchs herbal

253

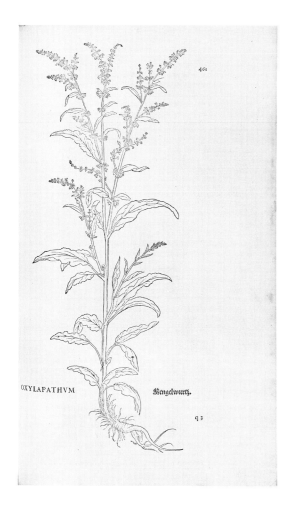

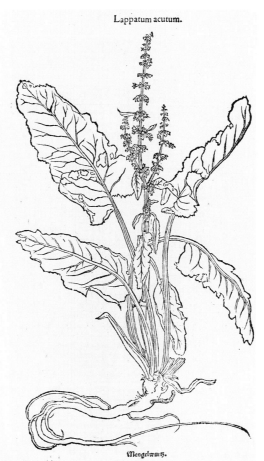

Lappatum acutum.

OXYLAPATHVM Mengelwurtz.

Mengelwurtz.

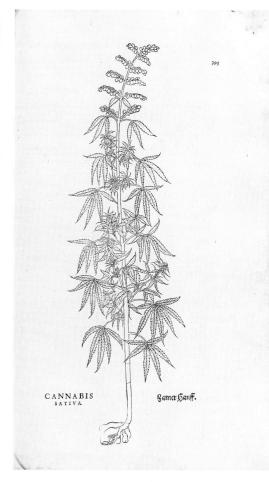

CANNABIS SATIVA Zamer Hanff.

260. *Bitter Dock* (*Rumex obtusifolius* L.), from Fuchs, *De Historia stirpium* (Basel, 1542). Woodcut, page 380 × 240 mm. Staatsbibliothek, Berlin.

261. Hans Weiditz, *Bitter Dock* (*Rumex obtusifolius* L.), from Brunfels, *Herbarum vivae eicones* (Strasbourg, 1530–36). Woodcut, page 308 × 195 mm. University Library Special Collections, Amsterdam.

262. *Hemp* (*Cannabis sativa* L.), from L. Fuchs, *De Historia stirpium* (Basel, 1542). Woodcut, page 380 × 240 mm. Staatsbibliothek, Berlin.

gives the clearest evidence of the significance attributed to botanical representation at the time. Brunfels's initial catalogue included about 135 plants, later increased to 260 or so. Fuchs's herbal contains around 550 plants with 511 illustrations. Indeed, the quality and quantity of the illustrations, and a number of corrections to Brunfels's herbal along with a practical glossary of terms, constitute what is new in the way of natural history in the Fuchs herbal (fig. 260). On the average, the woodcuts set a standard for botanical illustration that holds up to this day for clarity and directness. Fuchs's text descriptions of plants known in antiquity are drawn largely from Dioscorides, and his scheme of classification is primarily pharmaceutical and economic. He makes no pretense about his main intention, which is to set the identification of medicinal plants on a better footing. In the preface to his text, Fuchs laments the laziness of physicians who neglect the study of herbs, and of the herbalists who will sell whatever is given to them by old women of the countryside. Fuchs's aim was mainly practical, the improvement of the German pharmacopoeia.[230] As an aside we should note that when Fuchs published the German edition of his herbal in the following year, in his preface he explained the purpose of rendering the text into the vernacular. It was in order that the "common man" might learn the means of healing with medicinal plants.[231] Evidently to Fuchs the category of *gemeiner Mann* simply meant

those who were unable to read Latin. His common man was, however, literate, and furthermore able to afford to buy a very handsome quarto volume lavishly illustrated with woodcuts!

Fuchs explicitly declares that his illustrations were designed to eliminate shadows and other artistic effects that might obscure the true form of the plant. In contrast, Weiditz's acutely observed drawings are occasionally faithful to the conditions of a single specimen to the point of recording withered blossoms and even obvious accidental damages such as crippled stems and ravaged leaves.[232] This is evident if we compare the condition of the specimen represented by Weiditz with the same herb illustrated by Fuchs (figs. 260–61). Given the conventions of representation at the time, the degree of care taken by Weiditz to note the exact condition of the very plant he had before his eyes is astonishing, since no accomplished artist of his generation was unaware of the classical principle of idealization. The artistic imperative to perfect nature by capturing what is essential and generic rather than peculiar to the individual instance was hardly a lesson that needed recalling. In this light we must recognize Weiditz's rigorous attention to his specimens as a truly radical response to the generalized kind of plant illustration that preceded him. Given Brunfels's disclaimer regarding the illustrations to his text, we can only assume that Weiditz acted on the instruction of his publisher, Johann Schott,

who must have told him to take a meticulously accurate *conterfeit* from life, not deviating in any detail from the specimen. To be sure, Weiditz had the example of Dürer and others before him as a measure of what unadorned truth to nature might be. What strikes us as remarkable is that, despite the very practical purpose of herbal illustration and despite the proto-scientific aspiration to record a type, Weiditz was so uncompromising in his attention to accidental rather than typical properties. It was precisely this aspect of naturalistic herbal illustration that Leonhard Fuchs and his draftsman rejected, isolating the Brunfels/Weiditz masterpiece artistically and scientifically as a ground-breaking achievement of a sort never to be repeated. Yet it has been shown that in his attempt to provide a corrective to Brunfels, Fuchs's own draftsmen found themselves occasionally referring to the Weiditz woodcuts for a reliable account of appearance, even when they had fresh specimens at hand! And furthermore, in the construction of more complete, so to speak, idealized illustrations, they sometimes amalgamated specimens intentionally. Thus, both sexes of the plant *Canabis sativa* are shown together in one plant (fig. 262), in contrast to Weiditz who remained faithful to his single specimen.[233] In another case Fuchs has a plant inappropriately depicted as flowering and fruiting simultaneously, and elsewhere depicts more than one species of a particular plant springing from a single root.[234] As we can see, the Renaissance idea of a "true" portrayal was subtly nuanced and variable.

Pier Andrea Mattioli's commentary on the ancient Greek herbal of Dioscorides carries the art of plant illustration in woodcut to its pictorial culmination. Mattioli began in 1544 by translating Ruel's Latin edition of Dioscorides into Italian as a basis for introducing his own commentary on the ancient text and at the same time making Dioscorides available to readers in the vernacular. The larger edition of Mattioli's *Commentarii in sex libros pedacii Dioscorides* was published first in 1562 in a Bohemian translation, then in German in 1563, and finally in 1565 in Latin by the Venetian publisher Valgrisi.[235] For nearly a decade Mattioli had served in Prague as physician to Archduke Ferdinand of Tyrol whose treasury sponsored the herbal. Not incidentally, Ferdinand went on to found one of the largest print collections in Europe, and also an internationally famous cabinet of art and curiosities. His interest in botanical texts was not an isolated one. Though Mattioli had published earlier editions of a commentary on Dioscorides in Italian and Latin, these contained rather small and unexceptional illustrations. The larger and newly illustrated Prague edition was obviously embarked upon to provide Mattioli's work with skilled, more lavish and suitably legible plant studies. According to the preface of the later editions, the models for these woodcut illustrations were done by an Italian artist resident in Ferdinand's court, Giorgio Liberale. Another artist named Wolfgang Meyerpeck is also cited in connection with the project.[236]

A large portion, in fact very likely all of the blocks, were cut in Augsburg rather than Prague,

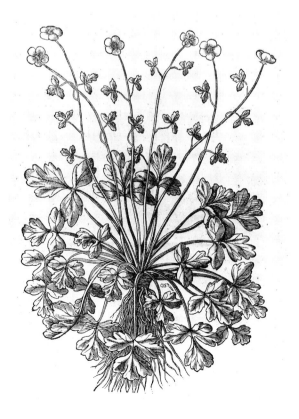

263. *Buttercup* (*Ranunculus nemorosus*), for Mattioli, *New Kreüterbuch/ Commentarii*. Woodcut proof impression. Stadtarchiv, Augsburg.

264. *Jasmine*, for Mattioli, *New Kreüterbuch/ Commentarii*. Woodcut proof impression. Stadtarchiv, Augsburg.

255

265. *Common Comfrey,*
from Mattioli, *New
Kreüterbuch/Commentarii*
(Prague, 1563). Woodcut,
page 340 × 220 mm.
Staatsbibliothek, Berlin.

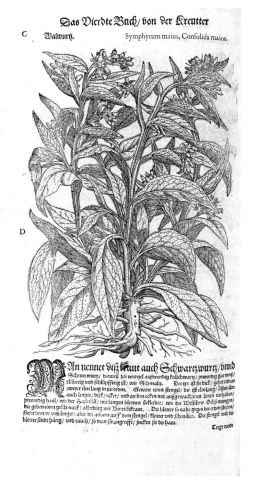

Das Vierdte Buch/ von der Kreutter

Walwurtz. Symphytum maius, Consolida maior.

the articulation of line drawing as sufficient in itself.

The evolution of printed herbals affords us an opportunity to reflect upon one of the most complex and engaging problems in the history of early modern European culture: the contemporaneous development of empiricism in art and science. Each of the three major botanical publications that have concerned us adopts a somewhat different approach to plant description, ranging from the rigorous truth to detail in the Brunfels herbal, to Fuchs's more synthetic renderings, and finally to the pictorially rich but botanically standardized middle ground exemplified by the Mattioli corpus. Although all three herbals express their respect for naturalistic verity, nevertheless each of these cycles of plant illustration bears the unmistakable stamp of its own individual or collective style. In his classic study on the problem of representation, *Art and Illusion*, Ernst Gombrich characterizes this problem of variable naturalism as "the riddle of style."[238] It was a problem also recognized as such by theorists in the Renaissance. Indeed, Christian Egenolff already posed the question succinctly in his claim against Schott, when he argued that there is but a single truth to the art of representation. Egenolff's facetiousness notwithstanding, it is evident from the various herbal prefaces as well as from the images themselves that certain of these naturalists understood the accurate delineation of plants to be a kind of index or benchmark for the truthful imitation of nature in general. Because of their practical purpose, herbals were consciously engaged in defining the terms of mimesis by their example. Along with anatomy, botanical illustration thereby came to hold a special kind of authority in matters of representation during the Renaissance.

At the same time, these naturalists knew that the problem posed by visual description was an issue debated by the ancients, and we have also noted that certain of the sixteenth-century botanists who made important headway in developing new schemes of classification purposely eschewed the use of illustration. One must add that their suspicion about the reliability of visual evidence had some foundation. The persistent survival of bizarre notions about the mandrake (or mandragora) plant is a case in point. The mandrake was already deemed to be magical as well as medicinal by the ancients. It was also thought to be fatal to the gatherer unless extracted by means of various ritual machinations. The roots of the mandrake were supposed to be shaped like homunculi, either male or female depending upon the sex of the plant, and to emit a tiny scream when uprooted. Although doubts were repeatedly expressed about these properties from antiquity onwards, the myth was sustained nevertheless, and artists continued to portray the plant accordingly. The *Gart der Gesundheit* acknowledged the superstition with a fully anthropomorphized illustration of a mandrake alongside a

which must reflect difficulties in finding enough craftsmen who were up to the task. Fragments of correspondence regarding these arrangements have come down to us along with a set of four unpublished proof impressions taken from the freshly cut blocks in Augsburg (figs. 263–64).[237] Mattioli's commentary on Dioscorides became the most frequently reissued and widely disseminated corpus of plants in the sixteenth century. From beginning to end, his magnum opus went through sixty-one editions with various degrees of revision and addition to the text. Apparently Mattioli's herbal contains a good many errors, some of them resulting from poor specimens that had been dried out and then revived by soaking in water. The greater number of plants was bound to lead to errors as well. The quarto illustrations are characterized by a patterned richness and pictorial fullness, often an almost decorative preference for qualities of light and shadow, that make these plant studies the very opposite of the standard invoked by Brunfels and Fuchs (figs. 257, 265). Mattioli's artists designed many of the blocks with a density of line that, unlike the herbals of Brunfels and Fuchs, would seem to preclude the addition of hand-coloring. Clearly this must have been a formal decision on the part of the author or the publisher, and it signals a shift towards regarding

preponderance of specimens purportedly depicted from life. Traveling in such good company, fanciful illustrations of this kind were bound to be a potent means of perpetuating fallacy. In the case of the mandrake, the expectations of a gullible public went on being served by disreputable herbalists who purveyed appropriately crafted root plants under the mandrake label. Indeed, in his entry on the mandragora, Fuchs specifically condemns the deceitful practice of those herbalists and dismisses the popular superstition about the plant.[239]

The proclivity to invent detail and the perpetuation of unconscious error are not problems any more endemic to visual description than to the written word. However, it is surely true that visual evidence was gaining in authority and practical value. At first the diametrical shift in approach between the Brunfels and Fuchs herbals seems surprising: the one recording every accidental peculiarity, and the other at least in principle cleaving to a generic mean. But this epistemological disagreement is emblematic of the way in which the world was being catalogued in other contexts as well. Consistent with the late Renaissance preference for an encyclopedic approach to knowledge in general, we find collectors assembling curiosity cabinets filled with natural and man-made exotica, with records of mutant births, and with other strange and hybrid creatures. Broadsheets also began to be increasingly more obsessed with such oddities. Curiosity cabinets sought to describe the world by establishing the outer perimeters of possibility more than by uncovering its norms. In this scheme for arranging the world, identity lay more in uniqueness than in relatedness, an approach to classification that would soon give way to the more abstract and seemingly rationalized systems of relationship favored by the early proponents of scientific method. A similar shift from the individual to the generic — from Brunfels to Fuchs — can be traced in the maturation of botanical illustration as well. But these contrasting tendencies to the particular and to the general were for a time coexistent in the Renaissance search for empirical truth.

As an aid to scientific inquiry it is not clear that visual description necessarily favored one side of this dichotomy or the other. For some time, historians of science were reluctant to stake much importance on the development of botanical illustration for modern schemes of scientific classification. Naturalistic rendering was treated as a sideline in the progression towards a scientific method primarily attained by other, more theoretically based means.[240] The botanical historians Sprague and Nelmes, for example, contested the notion put forward by some of their predecessors that Brunfels and Fuchs should be commemorated as the fathers of German botany. They suggested instead that the two are better thought of as the founders of plant iconography.[241] Surely it is the draftsmen who

deserve that title, since for the most part it was the image and not the label that made a correct identification possible. Histories of Renaissance anatomy have sometimes taken a similar stance, glossing illustrated tracts according to whether early anatomists had got it right or not without speculating about what it meant to be able to describe effectively through images in the first place. In 1543 Vesalius's *De humanis corporis* was printed. This happened only one year after Fuchs's *De historia stirpium* appeared, the exact counterpart to Vesalius's text in the history of descriptive botany.[242] Recall that Vesalius's anatomy is lavishly illustrated with woodcuts by the Netherlander Jan van Calcar. Like Fuchs's project, it too depended upon a highly successful collaboration between a physician and an artist. Vesalius was widely copied and quickly supplanted Galen as the authority in the field. From all that has been said thus far, it should be clear that the almost simultaneous appearance of these two publications on very different topics ought not to be considered coincidental. Nevertheless, we must still ask ourselves whether skilled woodcut illustration was merely the handmaiden of empirical study in a prescientific age, or in fact a significant cause in the unfolding of scientific method.

William Ivins's essay on the impact of the print in the early history of science and technology underscores the value of replication as a means of placing identical information in many different hands for comparison and eventual emendation. This was particularly advantageous for the beginnings of systematic botanical description, because it made possible the identification of plants in very different regions and climates by scholars familiar with different vernacular names. Renaissance botanists devoted themselves vigorously to getting down a uniform nomenclature, and initially to squaring classical knowledge with current understandings. Only once this was accomplished could the corpus of known species begin to be increased with some confidence, a need made all the more urgent by voyagers to Asia and the New World who were returning with great numbers of specimens previously unknown to Europeans. In this respect botanical illustration played an essential service simply by helping to place an unruly house in order.

However, accurate visual representation was more than just a technical accomplishment. It was a highly specialized form of observation employed by artists who had achieved their own standards of verity quite apart from the focused interests of natural philosophers. These two independent perspectives found a common purpose in botanical illustration, a purpose that proved vastly helpful in the eventual elimination of certain kinds of received error. Making illustrations was a way of checking facts, and by mid-century it was being

supported by other means as well. Public and private botanical gardens were being planted, and collections of dried specimens were being assembled into *herbaria*. In such a climate the illustrated herbal was bound to become the standard point of reference for scholars attempting to devise different schemes of classification.

There was another sense in which making an orderly house was becoming tantamount to a demand for reorganizing the entire approach to classifying plants. To accommodate the rapidly increasing number of specimens, one required a system of classification that was internally coherent, a system that associated plants on some "natural" rather than "artificial" basis. From this point of view, neither Brunfels, Fuchs, nor Mattioli is credited with providing any significant theoretical insight into the layout of their subject. As physicians they were mainly gatherers concerned to improve the services of the apothecary. For them the alphabetical ordering of plants by name sufficed, or at most a system of arrangement by cures, the "virtues" of the plants as they were termed. Naturalists of a more analytical mind derived their first intuitions from Theophrastus and Aristotle rather than from Dioscorides. Jean Ruel published a study in 1536 that includes a list of descriptive terms well ahead of what Fuchs provided in his glossary six years later. Ruel's terminology, applying as it does to the structures and habits of plants, denotes an analytical understanding that goes beyond description alone. Such terminology parallels what the artist does in choosing to make clear the number of petals on a flower, or the precise joining of one part to another. Meanwhile in Italy the Bolognese naturalist Luca Ghini was assembling material and helping to found botanical gardens that eventually fed the work of an entire generation of Italian naturalists, though in fact he published little himself. Finally, in a very brief career, Valerius Cordus, an Italian-trained German botanist, compiled verbal descriptions of some five hundred plants with careful attention to their physical features and their patterns of growth, fruition, and habitat. Cordus's work, the first to make possible plant identification without illustration, was only published in 1561.[243]

Significantly enough, these preliminary steps towards a natural system of classification were taken by scholars not directly engaged in improving herbal illustration, nor can it be shown that they were directly dependent upon it. It would appear that Ruel, Cordus, and most importantly the later Italian botanist Andrea Cesalpino derived their observations more from the direct experience of actual specimens, and though illustrated herbals may have been of help, they cannot be seen as seminal to the evolution of modern taxonomy. Obviously at a certain level illustrations were extremely useful in confirming general patterns of morphology, and it was precisely morphological features that provided

botanists with their first evidence for developing a structural taxonomy. It would be principles of reproduction, however, that eventually became the basis for plant classification, and this demanded a better understanding of how plants actually work than was yet available.

The sixteenth century was a period of sorting out botanical patterns largely on visible evidence, and eventually on the basis of what Aristotle defined as criteria of substance rather than accident. The relation of leaves to the stem and the particular arrangement of blossoms were deemed substantive or "natural" properties. On the other hand, the color, the scent, and the therapeutic value of a plant were considered accidental or "artificial" properties in Aristotle's scheme.[244] This approach is most clearly expressed by Cesalpino in his treatise *De plantis* published in Florence in 1583. "We look for those similarities and differences which make up the essential nature of plants, not for those which are only accidental to them; for things perceived by the senses become comprehended primarily from their essential nature and only secondarily from their accidents."[245] Quite clearly what Cesalpino means by the senses is in fact the singular sense of sight. It is sight that perceives the "essential" properties of a thing. That his understanding of essence should be rooted in the visible structure of the plant signals the true importance of illustration for the evolution of systematic botany. Essence is in reality what can be very well described in the schematized medium of line drawing, a medium useless for recording therapeutic value or scent, and only suggestive in its ability to convey color. Gombrich observes in reference to Ivins's thesis that the importance of the "exactly repeatable pictorial statement" has been over-emphasized precisely because such qualities as color are in fact not capable of exact replication.[246] Thus we are reminded that the sixteenth-century foundations of plant taxonomy are tightly connected to what is capable of efficient representation.

The evolution of woodcut herbal illustration points to a momentary attempt to confront the implications of linear portrayal for principles of classification. An awareness of this underlies Fuchs's caveat about "artistic effects" interfering with the recording of essential properties. The step taken by Mattioli's illustrators to enhance the pictorial aspect of drawing would seem to be a capitulation, in effect a choice in favor of trompe l'oeil virtuosity over diagrammatic simplicity. It seems at least a tacit acknowledgment that illustration was finally more an artistic than an analytical enterprise. It is not our place here to speculate further about the implication of this relationship between the history of art and science, a task that properly requires the understanding of a historian of botany.

* * *

258

Modern historiography vacillates over the interpretation of the role of the artisanry in Renaissance science. How much weight should be given to the gathering of empirical knowledge as part of the ground work for the coming scientific revolution? Are the technical achievements of the Renaissance — the invention of printing and of navigational instruments, or indeed the capacity to render things coherently — mere accompaniments to an intellectual change of more elemental consequence?[247] One school insists that technical accomplishments of this sort were gained through entirely traditional Aristotelian, essentially medieval, notions about the world. According to this view, technology and the investigations of the artisanry may have provided a degree of practical expertise, but they contributed little or nothing to the conceptual changes associated with the theory and practice of modern science. On the other hand, it has been argued that the artisanry played more than just a functional role in the cultivation of a scientific method. Concerned as it often was with solutions to practical problems, the artisanry can be seen to have provided the Renaissance with a concept of progress in human achievement, an idea of progress that was complementary to and indeed even anticipated the humanist challenge to classical authority generally seen as the true precondition to modern scientific thought. Making an instrument that could function effectively was a form of investigation in its own right. An ability to record something as complex as the lay of a distant continent or the particulars of a botanical specimen are not adequately described as improvements of technique, of *techne* alone. Absent a concomitant effect upon theory, upon *ars*, these accomplishments would not have happened, or if they had, they would surely not have been systematically pursued.

There are a good many vernacular treatises written by Renaissance artisans for their peers and for the education of the lay public, in fact a number of them by printmakers. These "how to do it" books and pamphlets consciously offer themselves as contributions to the progress of knowledge, and in their practical aspect they can be seen as important anticipations of empirical method.[248] One of the effects of the handbook fad was certainly to broaden lay interest in their subjects, and thereby to cultivate patronage among the literate and more educated classes. Albrecht Dürer's treatises were, after all, published in both German and Latin, and they could be found in the library of anyone with a pretense to learning. It was their author's stated intention that they be for the benefit of his fellow artisans, but his actual readership must have extended well beyond them. Dürer's learned contemporaries recognized this wider appeal and consequently saw to their publication in a scholarly form. To be sure Dürer was not typical of the artisanry. On the other hand, many followed in his footsteps.

By 1550 technical illustration, news sheets, maps, anatomies, and the entire category of description and reportage were dependent upon the printed image. The line on the page became the essential medium for recording visual information, the medium of portrayal. The implications of this development are of course legion, and quite independent of objective standards of correctness. The fact is that prints had effectively become the measure of one very particular but ultimately very potent kind of visual truth in the Renaissance, the truth of the eye-witness account or *conterfeit*. For reasons more practical than aesthetic and more traditional than technical, it was mainly the woodcut that set this standard. Woodcuts could be printed more quickly and in larger numbers than engravings or etchings, and furthermore they were more readily accommodated in texts. We can only speculate about what might have occurred in the development of botanical classification had the first hundred years of plant illustration been carried out in engraving rather than in woodcut. But we can say with confidence that, in the half century between 1500 and 1550, in lofty and humble circumstances alike, the printed image more often than not meant a woodcut.

VI

Artistic Experiment and the Collector's Print

MAX LEHRS, THE scholar who brought order to the history of German and Netherlandish engraving, took it for granted that the earliest intaglio prints were thought of primarily as workshop models and patterns; he considered it unlikely that they could have been much esteemed as valuable objects in their own right.[1] Much the same conclusion can be drawn for Italian prints of the fifteenth century. Lehrs's view still seems well founded, in part because it establishes a convincing parity between engravings and woodcuts, which were certainly acquired for what we might call secondary purposes. Being almost exclusively of devotional subjects, most fifteenth-century woodcuts served as a substitute for a visit to the altar of the local church, as a talisman for warding off the plague, or as a remembrance of a pilgrimage once made to a holy shrine. Aesthetic and utilitarian properties of decorated objects being at one level indistinguishable, it would be presumptuous to suppose that these early prints were unappreciated as images, yet, for the most part their interest must have lain elsewhere.

Within three to four generations prints had come to be taken for granted throughout most of Europe, and the status of the print had changed markedly. Alongside their many other uses, prints had attained a position in the art market. It would be the crudest anachronism to suppose that the replication of printed images brought about a "media blight" in the Renaissance, but it seems very likely that by 1550 a great many more people possessed images than had ever possessed them before, and furthermore that a lot of these happy customers had by then begun to hoard prints in rather large numbers. The relatively sudden technical change allowing for private accumulation of images on a large scale must have had profound, if in many ways his-

torically unrecoverable, implications for the perception of the visual arts in western culture. One aspect of this phenomenon that we can approach as historians, however, is the collecting of prints, particularly where it became a systematic endeavor. Here we refer to the activity of acquiring images for storing away in an orderly manner and keeping them for occasional private consultation. The strategy of arranging prints in albums, in portfolios, and in the drawers of cabinets is the most original contribution the print made to Renaissance collecting practices. These organizing strategies are also the ones most particular to prints as a class of object, and therefore this kind of collecting requires our closest attention. The evidence for collecting prints in the Renaissance is various and sometimes difficult to interpret, but taken together it points to clear and convincing conclusions. Especially in the years between 1500 and 1550 the evolution of print production, and along with it the emergence of new notions about what it was that constituted a work of art, drew the print increasingly to the center of sophisticated interests. This occurred in slightly different ways and at markedly different paces in Italy and in the north, but the results proved to be equally consequential for both.

ITALY

The vast majority of prints produced in Italy during the first thirty years of the sixteenth century were the result of a more or less close collaboration between a printmaker and an artist. At the beginning of the century it was principally the independent printmakers, and, to a lesser degree, the painters who not only initiated the creation of a printed image but were actively involved in all the

stages of its production. However, as time went by the publishers acquired an increasingly important role in the making of prints. By the middle of the century, not only were they choosing the subject matter of most prints to be published, they were also commissioning painters or draftsmen to design them and printmakers to incise them. These different roles became increasingly separated from one another, with the result that little communication, let alone collaboration, was needed between the *inventor* of the image, its *sculptor*, and its *excudetor*. The publisher, moreover, became responsible for marketing the print, and therefore for understanding or encouraging the taste of its public.

Eventually, these changes in emphasis produced a slow dilution in the quality of the prints produced as each of the players involved was implicitly or explicitly discouraged from innovation. The painters, particularly the inventive ones, slowly distanced themselves from what was becoming a more mechanical form of art, and their role was taken over by professional draftsmen. Printmakers no longer sought to distinguish their products from those of their competitors. For the convenience of the publishers, they stuck to the rules introduced by Marcantonio and then codified in many a workshop thereafter.

Over the first half of the century, however, a small number of printmakers refused to yield to this inertia. For reasons of their own, they were not easily attracted to prevailing conventions like most of their colleagues but preferred to risk exploring new avenues in printmaking. Not all of them were great printmakers, but most of them happened to be gifted artists, who had approached prints with the aim of expressing in that medium something they had found wanting in painting or drawing. Some may have decided to make prints simply in order to further their fame by disseminating their inventions, and some were fascinated by graphic techniques and the possibilities these afforded. Some were simply very curious craftsmen with a taste for experimentation and a wish to associate a particular style with their name. Not all were *peintre-graveurs*. The separation between the artist-printmaker and the professional engraver who worked with others became increasingly blurred, and, equally, some of the technical innovators undoubtedly shared their time between routine work with or for others and their own experimentation. Their contributions to the history of Renaissance printmaking — ranging in importance from very small to gigantic — were taken up eagerly by their less imaginative colleagues, and eventually became part of the repertoire required by publishers from any professional engraver in their employ.

The Innovators and Their Followers

We have already encountered Giulio Campagnola as a brilliant young man whose ability in every skill, command of languages, erudition, and lofty associations appear to have made him, during the first five years of the new century, the golden boy of Venetian art. The promise was not to be fulfilled in his musical career, nor did he become a recognized humanist or painter, but he was without doubt an important player in the development of Renaissance printmaking. His major contribution was the introduction of stipple-engraving, a technique where shading was obtained by dots produced by the point of the graver. This innovation allowed a much greater range of tone from white to black, and at the same time a more controllable graduated transition between lighter and darker areas of the image. The disadvantages of the technique were that it was immensely more time-consuming than ordinary engraving, that the dots produced, unless of sufficient size, would wear down quite quickly, and, finally, that it was extremely difficult to freshen-up a tired-looking plate by re-engraving it — a common strategy in printmaking. Whereas pushing the burin along the existing, shallowed grooves was a well-tried and effective method of freshening worn plates, hitting again the myriad of existing dots was an impossible task, and creating new dots would easily produce patches of ink where new and old dots joined together. This is precisely why there are no known instances of Giulio's plates being reworked in later states by retouching the dotted areas of the image.

Giulio, however, was obviously not much worried about the vulnerability of his newly invented technique. He was much more excited by what it offered: the effect of *sfumato* that Giorgione was cultivating in painting at the time. This is not the place to rehearse the arguments about the internal chronology of Giulio's prints.[2] What is crucial is the role Giulio's prints must have played in confirming and disseminating such exciting departures in Venetian art that as a result became associated in many eyes, within and without Venice, with the novelty of printmaking itself.

Prints were therefore perceived not only as works of art, as they had been in certain quarters for some time, but as trendsetters. Their subject matter, the clear or hidden meaning of each part of the composition, the emotions or moods expressed, the subtle allusions to classical, historical, or contemporary events, the connections with other works by past or contemporary masters, the ingenuity and skill of the printmaker, all must have been the topic of lively discussion among the owners of Giulio's prints. As we shall see, his prints were acquired by the leading collectors of the time, something that

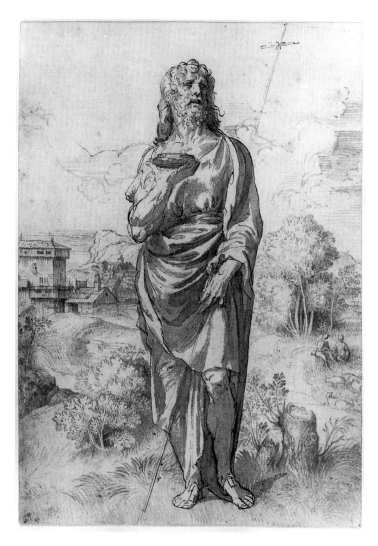

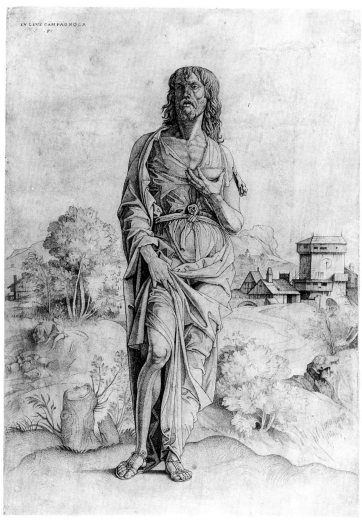

266. Giorgione and Giulio Campagnola, *St. John the Baptist*. Point of the brush (landscape) and pen and ink and wash (figure), 320 × 219 mm. Cabinet des Dessins, Louvre, Paris.

267. Giulio Campagnola, *St. John the Baptist*. Engraving and stipple-engraving (H.V.201.12), 351 × 240 mm. British Museum, London.

must not have remained unnoticed for long by those painters whose accomplishments were being imitated and advertised abroad.

It is likely that both Giorgione and Titian were involved in the making of a small number of Giulio's prints, as Oberhuber has cogently demonstrated,[3] but surely not by providing a drawing and leaving Giulio to engrave a print based on it. The relationship must have been much closer, a full collaboration between painter and printmaker experimenting together with light effects and chiaroscuro as they developed the image. This is the only possible explanation for the existence of a drawing in the Louvre (fig. 266) preparatory to the *St. John the Baptist* (fig. 267), where Giorgione was employed to provide only the landscape, the standing figure of the saint having almost certainly already been engraved on the plate.[4] Such a relationship also explains the extraordinary beauty of a small group of Giulio's prints that shine above the rest in their refinement. Oberhuber was certainly right in identifying Giorgione's contribution to the *Venus Reclining in a Landscape* (fig. 268), with its extraordinary richness of tone and subtlety of lighting in the description of volume and texture. Oberhuber

must also be correct in suggesting that Titian looked over Giulio's shoulder while he engraved his *Christ and the Samaritan Woman* (fig. 269), a print in which the complexity of the spatial arrangement of the two figures in the landscape and the daring approach to their poses and movements, let alone light effects, could never have been conceived by Giulio alone.[5]

Such a close collaboration has considerable implications for the history of printmaking during the period. It suggests that the status of printmakers in Venice around 1510 was close to that held by painters; that making prints was no less demeaning than making paintings; and, possibly, that buying prints for one's albums was no less exciting than acquiring pictures for one's walls. It further suggests that young painters such as Giorgione and Titian may have recognized that prints were able to give a true idea of their artistic achievements and consequently were an ideal means of spreading the taste for their inventions more quickly and effectively.[6]

The effects of Giulio's technical achievement were not as dramatic as one might have expected, first because of the labor it required, but principally because the prevailing taste for *sfumato*, which first

262

268. Giulio Campagnola, *Venus Reclining in a Landscape*. Stipple-engraving (H.V.202.13), 119 × 183 mm. Cleveland Museum of Art, Cleveland.

269. Giulio Campagnola, *Christ and the Samaritan Woman*. Engraving and stipple-engraving (H.V.200.11), 130 × 185 mm. Kupferstichkabinett, Berlin.

270. Master of the Beheading of St. John the Baptist, *The Beheading of St. John the Baptist.* Engraving and stipple-engraving (H.V.98.1), 209 × 166 mm. British Museum, London.

to the letter, and in his best print — the allegory of the *Triumph of the Moon* (fig. 271), known in three states — it is clear that the artist went from pure line engraving to rich dotted work, exactly as Campagnola had done.[8]

Giulio Campagnola produced only nine prints in his revolutionary technique, and because of their delicacy only a few successful impressions could have been pulled from each of the plates. This would have greatly restricted their circulation in the rest of Italy, let alone outside it. Even so, most printmakers of his and the following generation profited by his experience, and started using dots more consistently in order to enrich the black and white palette in their prints. Starting with Marcantonio and his followers and carrying over to Dürer and his, printmakers employed dots between their cross-hatched lines to give greater intensity to blacks, and placed them at the tapering end of lines when they needed to create a more subtle transition between the dark and the light areas of the image. All nine of Giulio's prints were probably made within the span of three years, yet their subtle effect can be traced throughout the history of Renaissance printmaking.

Marcantonio Raimondi's greatest contribution to the development of printmaking was his devising of a controlled and repeatable method of creating elements of chiaroscuro, a system that combined hatching, cross-hatchings, flicks, and dots. The characteristics and enormous influence of this technique on the history of prints and, in particular, on the origin of Italian reproductive printmaking have been discussed. Even here he continued to experiment, as in his engraving of the *Apollo Belvedere* (B.XIV.249.330), done only with parallel lines and no cross-hatching at all, a tour de force of which he must have been proud. This was not, however, Marcantonio's only legacy. He may also have shown some interest in woodcuts, although the evidence here is very inconclusive.[9] An impressive rendering of the *Incredulity of St. Thomas*, printed as a book frontispiece in Venice in 1522,[10] is very likely taken from a much earlier design by Marcantonio. As Lippmann recognized, the block was undoubtedly cut by Ugo da Carpi but, although it does not carry his signature, it is inscribed with Marcantonio's monogram:[11] most likely this is another case of Ugo having copied a work by one of his colleagues and not an instance of genuine collaboration.[12]

Marcantonio was also the first engraver in Italy to etch, and it is this little-known aspect of his oeuvre that we wish to examine more closely. He was also the first we know of to use a mixed technique of etching and engraving on copper plates. Wilde describes a number of prints by Marcantonio in which etched lines appear, and he divides them into three categories according to the degree of etched versus engraved work present in each print, the last group made of prints exclusively etched.[13]

led Giulio to explore its possibilities in engraving, soon faded from contemporary painting. Neither in painting nor in printmaking did the Giorgionesque style spread much further than Venice and its territories (though these did include most of Lombardy at the time). Some engravers whose aesthetic concerns remained close to those expressed in these prints made use of Giulio's lesson. The so-called Master of the Beheading of St. John the Baptist, an artist probably active in Milan, found Giulio's technique useful in conveying Leonardo's handling of chiaroscuro (fig. 270). Marcello Fogolino, who seldom worked further than a hundred miles from Venice, mixed drypoint and stipple-engraving in small and refined prints that almost equal Giulio's in the range of their tonality, if not in their overall aesthetic merit.[7] Closer still to Campagnola, and possibly even superior to him in quality, was the mysterious Ferrarese printmaker known only by the initials *PP*. Just nine prints have been recorded by his hand, all combining engraving with drypoint and stipple work, and all of extraordinary subtlety. This Master PP followed Giulio's experience almost

In Wilde's view, Marcantonio was not particularly interested in exploiting the different character of the lines afforded by the new technique; on the contrary, he always attempted to blend the two techniques imperceptibly when they were used on one plate.[14] The obvious conclusion is that he used etching because he considered it a much speedier way than engraving to incise a plate.[15]

Eventually Marcantonio abandoned etching, but only after using it to some degree in forty or more plates.[16] All of these can be placed confidently on the basis of their style in a very short period, probably around 1515.[17] The prints bear witness to trial and error in the combination of engraving and etching, and to a slow but constant refinement in the artist's handling of technical problems this posed in a small plate. Marcantonio must have spent at least a few months of intensive experimentation trying to bend the new technique to his formal wishes, and though he finally gave up etching, the facility of design offered by the diminished resistance of the wax allowed him a confidence and liveliness often missing in his more contrived engravings (fig. 272).

Another common denominator among this group of mixed-technique prints is their small size: indeed, they represent about one-third of Marcantonio's small prints, most of which were produced before

272. Marcantonio Raimondi, *Woman Pulling her Hair*. Etching (B.XIV.329.437), 105 × 60 mm. British Museum, London.

273. Francesco Parmigianino, *Sleeping Girl*. Black chalk with white heightening, 231 × 175 mm. Courtauld Institute Galleries, London.

274. Francesco, Parmigianino, *Sleeping Girl*. Etching (B.XVI.12.10), 130 × 113 mm. Metropolitan Museum of Art, New York.

Raphael's death.[18] Their subject matter is also interesting: twice as many of the etchings have a secular rather than religious subject, quite at odds with the rest of Marcantonio's work during this period — the only time in his life when religious images prevailed. It was during the middle years of the second decade of the century that Marcantonio made as many as sixty *santini*, small images of saints meant, one assumes because of their extreme rarity, to be carried about as amulets. Only half a dozen of these are etched, making the imbalance in subject matter even more significant. Most of the etchings are signed with his monogram, his usual practice at the time, and most, if not all, appear to be done from Marcantonio's own designs. This again deviates from the rest of his oeuvre, where about half the prints result from a collaboration with another artist. Moreover, there seems to be an obvious assonance between these prints and his surviving small sketches.[19]

In the context of Marcantonio's activity in Rome between 1511 and 1515, we might conclude that he was not too unhappy about the results of his attempts at etching. His customers were almost certainly unaware that these prints were technically unusual, but would have found them appealing for their small size, their refinement, and their often esoteric subject matter. Yet Marcantonio abandoned the technique, perhaps because he was not

confident enough to apply it to larger plates; indeed, it is curious that there is not even one larger etched plate by him.

This was a challenge for others to take up. It was almost certainly through Marcantonio that Parmigianino had his first encounter with etching, a sufficiently good reason for acknowledging the importance of these early experiments in the medium. Most scholars now agree that Parmigianino first took up etching around the time he arrived in Bologna in 1527, having fled Rome at the time of the Sack.[20] It is not unlikely that Marcantonio himself taught him the secrets of etching on copper, either in Rome or, more probably, in Bologna where they had both taken refuge from the German invaders. Popham even suggests that Parmigianino worked on the small plate of the *Sleeping Cupid* (B.11) under the watchful eye of the more experienced etcher: the print is a close copy of one of the slain children in Marcantonio's *Massacre of the Innocents*. This is not improbable, and it is also possible that Parmigianino's next step would have been the sketch of an *Arm*, an etching faithfully taken from a drawing made in preparation for Ugo da Carpi's *Diogenes*.[21] In this print Parmigianino tested, on a small scale, his ability to produce a range of blacks in an etching as effectively as had been done in the drawing, in Ugo's woodcut, and, conceivably, in Caraglio's engraving

266

of the same subject.[22] Before launching himself confidently into the full-scale project of making a print, Parmigianino probably rehearsed the technical steps and aesthetic success of a complete image by etching his *Sleeping Girl* (fig. 274) on the basis of an earlier, finished design, a richly textured black chalk drawing heightened with white (fig. 273).

Parmigianino made seventeen prints in all and, in a progression not dissimilar to the one we have described for Marcantonio, went from a combination of etching and engraving to a mixture of these two with drypoint, and finally to the exclusive use of etching. As we know, he had gained invaluable experience on the characteristics and effects of printed ink from his collaboration with Caraglio, Ugo da Carpi, and Antonio da Trento, and he seems to have thrown himself with the greatest enthusiasm into the exploration of etching. Although all Parmigianino prints were likely pro-

duced in a very short period, it is clear that it took some time until he felt he had completely mastered the new medium. This was a period of furious experimentation, best revealed by the number and quality of his preparatory drawings. For the *Adoration of the Shepherds* (B.3) and the *Judith* (B.1) he made careful drawings to scale, with lighting and chiaroscuro fully worked out, and only minor details changed on the plate, an easy and natural development of the procedure followed for the *Sleeping Girl*. The exceptional impression of the *Adoration* in the British Museum (fig. 276) shows, however, that he was not completely satisfied with the effects produced by the sole combination of etching and engraving, and he added a considerable amount of surface tone, working with his fingers to spread it carefully over the darker areas and to wipe it away from the lighter ones. A similarly rich chiaroscuro effect was achieved in the *Lovers* by adding lines in drypoint to those areas where a velvety mid-

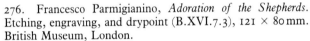

275. Francesco Parmigianino, *Lovers*. Etching (B.XVI.14.14), 149 × 104 mm. Graphik-Sammlung E.T.H., Zurich.

276. Francesco Parmigianino, *Adoration of the Shepherds*. Etching, engraving, and drypoint (B.XVI.7.3), 121 × 80 mm. British Museum, London.

268

tone was needed.[23] Yet even this was not deemed entirely successful, since in a beautiful impression in Zurich — one, by the way, that has a small sketch in pen and ink by the artist on its verso — Parmigianino felt the need to add considerable surface tone over the top third of the print (fig. 275).

These partial successes (partial, we hasten to add, only so far as Parmigianino was concerned!) suggest a reason for the change of attitude obvious in the later prints. Parmigianino seems to have decided at this point to devote a considerably greater amount of time to the preparation for each print. He must also have realized that etching was not the medium for highly tonal works, and that a different, more linear approach would generate more exciting results. For his grandest composition, the *Entombment*, known in two versions, both in pure etching, Parmigianino made something like twenty preparatory drawings, extending from the slightest sketches working out a profile or the position of a limb, to full compositional studies.[24] Moreover, as a *pentimento* in the underdrawing reveals, an oil sketch was probably done in between the two etchings, and it is not impossible that this small, quick sketch was made just to work out the chiaroscuro effects in the second, darker version of the print.[25] For the first version of this image Parmigianino used a thinner etching needle than hitherto, so thin that he could produce densely hatched areas without worrying excessively about foul biting at the crossing of the lines. In spite of this, he was still careful to bite the plate very lightly. Such tight and regular cross-hatching, in a way still reminiscent of Marcantonio's etchings, appeared so contrived as

to stifle the movement of the figures and freeze the mood of the print, giving it the effect of a sculpted relief (fig. 277). Therefore, when Parmigianino tried to rework the plate by strengthening most of the shaded areas and adding contour lines to many of the figures, he fell prey to his own enthusiasm in experimenting with acid. Something went very obviously wrong either with the varnish or with the length of time the plate was left in the acid: a rare impression has survived (fig. 278), showing the devastating effects of foul biting on this magnificent plate. The artist could not possibly retrieve the image from the corroded surface and was forced to copy it onto another plate, thus producing the second version of the print (fig. 279). This is very much bolder in its approach: the tool is thicker, the biting is deeper, the lines have all the character and vigor of those in the drawings. The print is full of restlessness and drama.

This is one of Parmigianino's greatest achievements in all media, and it is fitting, given what we

277. Francesco Parmigianino, *Entombment*. Etching, first version (B.XVIII.300.46), state I, 274 × 206 mm. British Museum, London.

278. Francesco Parmigianino, *Entombment*. Etching, first version (B.XVIII.300.46), state II, 274 × 206 mm. Private collection.

279. Francesco Parmigianino, *Entombment*. Etching, second version (B.XVI.8.5), 331 × 240 mm. Albertina, Vienna.

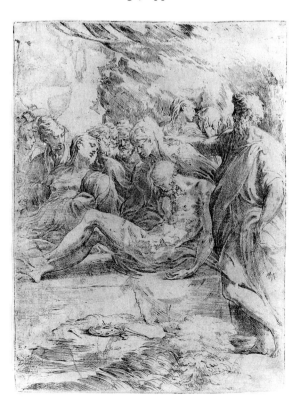

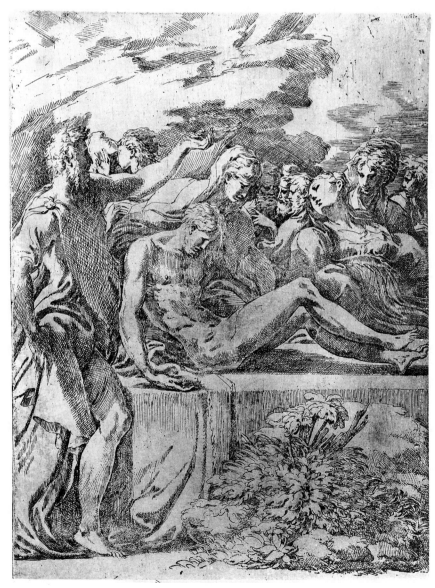

269

280. Francesco
Parmigianino, *Peter and
John Healing the Lame Man
at the Beautiful Gate.*
Etching and woodblock
(B.XVI.9.7),
276 × 407 mm. Museum of
Fine Arts, Boston.

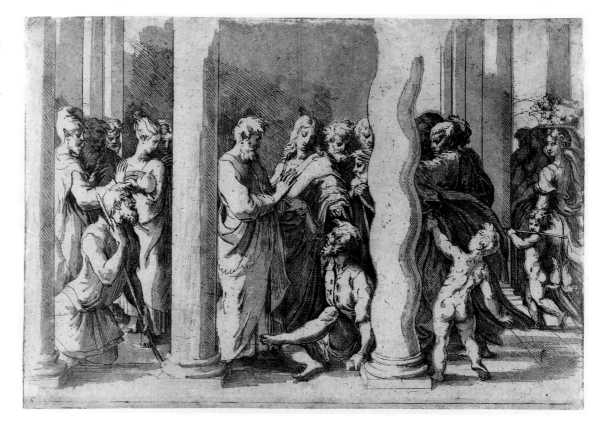

281. (facing page left)
Andrea Meldolla, called
Schiavone, *Christ Healing
the Sick.* Etching and
drypoint with brush and
with white heightening on
color-washed paper
(B.XVI.48.15), sheet
220 × 159 mm. Pinacoteca
Nazionale, Bologna.

know of his character, that he should have abandoned printmaking soon after completing his masterpiece. He may have tried one more experiment — its attribution is unsure — that of combining two quite different media: etching for design and woodcut for tone. The etching with tone block of *Peter and John Healing the Lame Man at the Beautiful Gate* seeks the effect of a free line drawing in which shadows are applied with a brush (fig. 280). The combination did not really work, as the flatness of the single tone block is not balanced, let alone enlivened, by the etched design. In a very close copy of the print this shortcoming was made up with the addition of a second tone block.[26] The incomplete success achieved in this work, and the difficulties undoubtedly encountered in printing it — using successively a flat press and a roller press, and registering the two images accurately — may have helped to turn Parmigianino away from printmaking. If indeed it is by Parmigianino and if it was etched after the *Entombment*,[27] the fact that the artist almost certainly needed Antonio da Trento to cut the woodblock would mean that the making of this complex print predates Antonio's disappearance from the workshop in 1529.[28] Moreover, if no impressions can be found of the original printed with two tone blocks rather than one — as opposed to the deceptive copy described by Reed, which is found printed with two tone blocks — one might infer that Antonio ran away just half way through producing the print. This in turn would confirm our supposition that, if Parmigianino started making

his own prints upon arrival in Bologna, all the etchings were done in a fairly short burst of enthusiastic experimentation.

The influence of Parmigianino's few etchings was enormous, not only on his direct followers, such as the Master FP and Vincenzo Caccianemici, but on every printmaker after him, and particularly on the whole school of the Veneto, where Battista Franco and Andrea Meldolla, called Schiavone, inspired by Parmigianino's prints, carried on their own experiments precisely in the direction that we have seen Parmigianino abandon.[29] Schiavone pursued the line of working on the plate and on the inking, printing, and paper, with as complex a combination of techniques and media as he could devise. Almost every impression of his prints is a unique combination of engraving, etching, drypoint, surface tone, and colored inks on more or less intensely colored paper, often touched up with white heightening, ink, or washes (fig. 281).[30]

Schiavone's unprecedented experiments are only radical symptoms of a practice that is an almost necessary corollary of printmaking, particularly of engraving and etching, activities that take place in the isolation of the printmaker's workshop, that do not demand the help of assistants, but that require continuous attention to technical details, practices, and patterns. The challenge of going beyond the constraints of a technique in order to improve or change results that have already been achieved — either by oneself or by others — was part of the very nature of artistic endeavor as the Renaissance

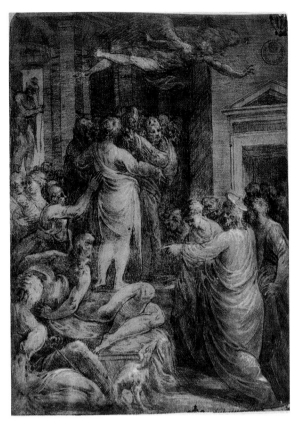

techniques that helped their contemporaries and those who followed to make more supple and complex prints. Domenico Campagnola, for instance, attempted to describe nature with flowing lines, which, although seemingly very confusing in their directions, create an obvious feeling of movement in his plates. This approach influenced many printmakers, among them even the great Parmigianino. The so-called Master of 1515, often wrongly identified with the sculptor Bambaia,[35] was the only engraver of his time to use drypoint on a major

282. Giorgio Ghisi, *Hercules Victorious over the Hydra*. Engraving (B.XV.402.44), 348 × 210 mm. Metropolitan Museum of Art, New York.

understood it, and most printmakers, particularly those working outside an organized shop, intervened at some point in the life of their finished plates, and in the use of their inks or papers, in order to experiment with a new technical solution. Very often new ideas were born of mistakes made during daily operations, errors that suggested new formal solutions or improvements on the technique.[31] On occasion Marcantonio played with surface tone in his prints, and so did most other printmakers, from the Master HFE to Giorgio Ghisi.[32] The Master IICA went further when he lightly scored through the shaded parts of the hills in the landscape of his *Nativity* in order to produce his own version of a middle tone,[33] a somewhat gentler approach than Marcantonio's application of pumice to the plate of his *Judgment of Paris*.[34] Marcantonio, again, showed the way in making a plate accommodate the subject rather than vice versa by cutting the copper around the roundel in which Jupiter is enthroned at the top of the *Quos Ego* (B.352); so did the Master FP in order to accommodate the staff of St. James (B.XVI.20.4) or, with even greater coyness, Giorgio Ghisi to allow the Hydra to show off its menacing claw (fig. 282).

A small number of other printmakers — perhaps less distinguished artists than Giulio Campagnola, Marcantonio, or Parmigianino, but nonetheless as curious and enthusiastic in their approach to making prints — contributed in one way or another to the development of new formal solutions and

271

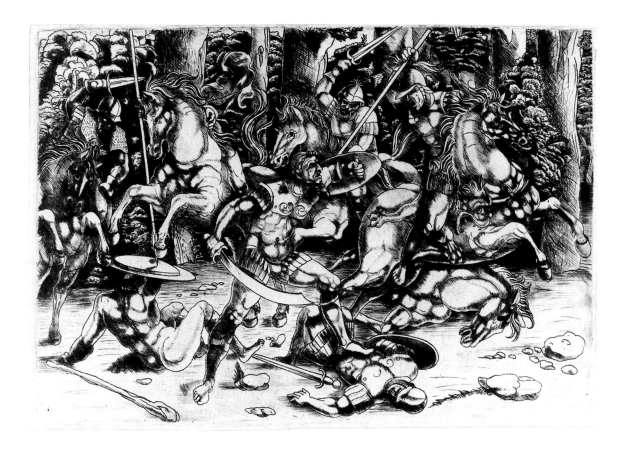

scale on large plates, sometimes to the exclusion of other techniques. They are extraordinary to look at, as the Master fully exploited the properties of the raised burr to achieve effects unknown anywhere else in the sixteenth century (fig. 283). The fact that he had obviously fewer followers than Domenico had a lot to do with the fragility of the lines on his plates, and the very small editions that could have been pulled from them. The more experimental the printmaker, it seems, the less concerned he was about the number of impressions of his work that might become available to others. This had been the case with both Giulio Campagnola and Parmigianino, and it was true also of another very inventive but equally private printmaker, Domenico Beccafumi.

Beccafumi was the most experimental printmaker in Italy in the sixteenth century. During the last ten years of his life, at a time when he was established as the foremost Sienese painter of his generation and was much sought after with commissions for new paintings and frescoes, he locked himself in his studio to dally with printmaking. He had experimented almost obsessively with light and chiaroscuro effects throughout his earlier career, and he found printmaking a practical, manageable, and private solution to the problems of his aesthetic search. As a painter he had also tried new combinations of colors and hues, from the most lurid to the most restrained, playing one against the other in the most imaginative and adventurous manner.

He attempted virtually all the figurative media, from painting to drawing, from marble intarsia to bronze-casting, from engraving to chiaroscuro woodcut, and in most of these Beccafumi opened new and unexplored avenues, making contributions that were highly personal, idiosyncratic, and — surprisingly — soon forgotten.

It is likely that Beccafumi's first contact with printmaking occurred on his trip to Rome around 1510–12,[36] where he must have seen Marcantonio's engravings. His first active involvement, however, is thought to have been the series of woodcuts he cut himself in the 1530s to illustrate the alchemical properties of metals.[37] These charming, mysterious, and bizarre small woodcuts well exemplify Beccafumi's approach to printmaking (fig. 284). They are different from almost anything done in the medium before then — the only precedent being Domenico Campagnola's woodcuts of 1517 — in that the artist obviously used the knife with the same freedom he would have used his pen, completely disregarding the woodcutting conventions by then well established in German and Italian relief prints. The cutting — which, as the tablet clearly indicates, was the work of the artist himself and not of a professional cutter — is, to say the least, crude. This is compensated for, however, not only by the unexpected liveliness of the images, but by the subtle control of chiaroscuro through what appears at first sight to be a haphazard variety of linear patterns used to describe blackness.

There was nothing coarse, however, in any of Beccafumi's later prints. One can quite easily follow his development as a printmaker through the ever increasing complexity of his technique and the richness of his tone. His first attempt was as experimental as one might expect from so unconventional an artist: a beautiful figure of a *Bearded Man* (fig. 285), incised with a burin on a scrap piece of metal of irregular shape, printed on top of some writing on the verso of a sheet of drawings made by an ungifted, and probably very young, apprentice in the workshop.[38] He continued with the engraving of *Two Nudes in a Landscape* (fig. 286), carefully prepared in a drawing now in Chatsworth (fig. 287). Yet, when it came to incising the plate, he must have realized that working out the chiaroscuro as he had planned it in red chalk would prove insufficient in a print composed of lines that could not melt together to create tone in the manner of his drawing. The translation from one medium to another posed a particular problem to Beccafumi around the face of the standing man, which is in almost complete shade in the drawing and needs no resolution. As this lack of detail is impossible to achieve in an engraving, the artist opted for adding

two tone blocks to the image, thus achieving the desired effect of dimming the light and, at the same time, correcting through the color shading the appearance of the right arm, which in the engraved plate seemed to be bent at a completely unnatural angle (fig. 288).[39]

As the preceding example shows, Beccafumi was not afraid of change as he developed an image. His next attempt, the *Three Lying Nudes* (fig. 293), had its seed in a tiny sketch in pen and ink (fig. 289).[40] This evolved into a large, complex drawing in black chalk, black ink, and white heightening on prepared brown paper (fig. 292), in reverse of the first drawing, obviously made and incised in preparation for a print.[41] The drawing in turn led to an engraving (fig. 290) and, immediately after, to a print combining the complete engraving with a woodcut tone block printed in gray (fig. 291). Still unhappy with the result, Beccafumi discarded this tone block and cut a new one, printing it again in gray.[42] The result of this extraordinary experimentation is remarkably close in spirit and appearance to Beccafumi's grisaille paintings in oil on cardboard of about a decade earlier which, most intriguingly, are known in several almost identical

284. Domenico Beccafumi, from *The Alchemical Properties of Metals*. Woodcut, 178 × 120 mm. British Museum, London.

285. Domenico Beccafumi, *A Bearded Man*. Engraving, ca. 130 × 60 mm. Uffizi, Florence.

273

versions (figs. 294–95).[43] There are, in fact, two further drawings of a *Lying Nude*, again almost identical, that hark back to the small Uffizi drawing but in execution show a much bolder approach to highlights and to the use of a middle tone. They also reveal, in their use of a thicker more brush-like hatching, Beccafumi's increasing impatience with engraving and his almost natural inclination towards the weight of the woodcut line (figs. 296–98).

Beccafumi went on experimenting feverishly. There are a number of richly worked drawings on colored papers, full of texture and alight with daring chiaroscuro, and obviously made in preparation for prints that either have not survived or were never made. There are also engravings which clearly need the complement of one or more tone blocks and yet have come to us only in their naked state.[44] As these trials continued, the border between drawings and prints became increasingly blurred: the more the artist used washes for the drawings, the less important the engraved lines became in the prints. After trying to strengthen the

burin lines by swelling them in a manner thought to have been invented by Goltzius some fifty years later, Beccafumi confined the engraved lines to the darkest area of the strongly lit print of the *Two Apostles* (fig. 299).[45] He then introduced a second tone block and experimented with vivid colors. This combination must have been a nightmare to register accurately because the plates had to be printed in a roller press after the tone blocks had been printed in a flat press. Nonetheless, they are of sensational beauty (fig. 297).

Perhaps because of the technical difficulty and inconvenience of having to use two presses, or simply because he was still unhappy with the formal results, Beccafumi eventually renounced the use of the intaglio plate entirely and concentrated on woodblocks. Having started with two, he proceeded to three and, finally, four, in a feat of registration that has hardly been rivalled since (fig. 300). He also became increasingly daring in the choice and combination of his colors: from the most striking coupling of black and green, or black

286. Domenico, Beccafumi, *Two Nudes in a Landscape*. Engraving, 269 × 169 mm. Fitzwilliam Museum, Cambridge.

287. Domenico Beccafumi, *Two Nudes in a Landscape*. Red chalk, 224 × 158 mm. Duke of Devonshire and the Chatsworth Settlement Trustees, Chatsworth.

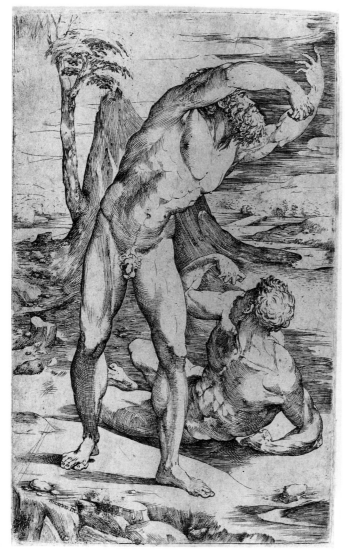

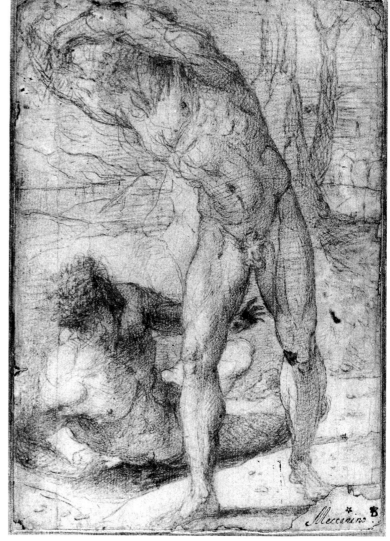

274

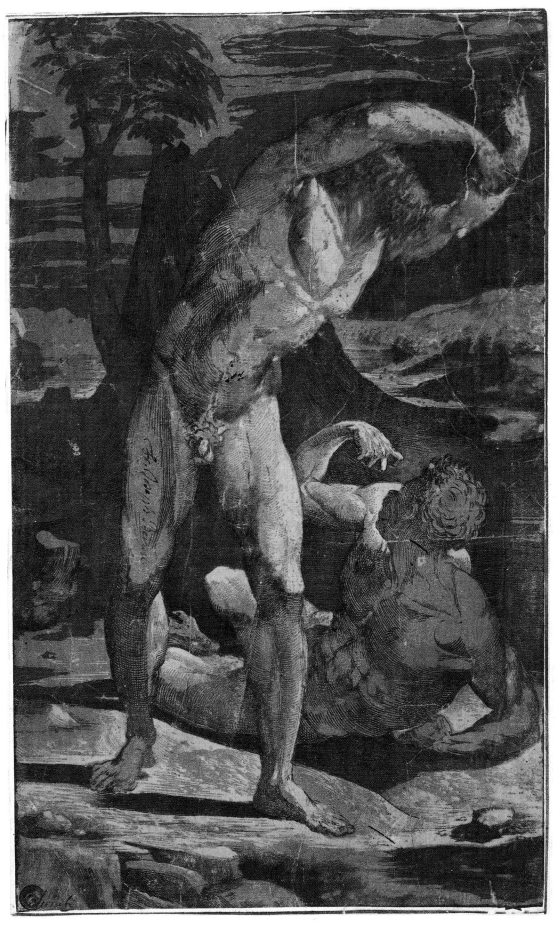

288. Domenico Beccafumi, *Two Nudes in a Landscape*. Engraving and two woodblocks, 262 × 164 mm. Fitzwilliam Museum, Cambridge.

289. Domenico Beccafumi, *Lying Nude*. Pen and ink, 76 × 111 mm. Uffizi, Florence.

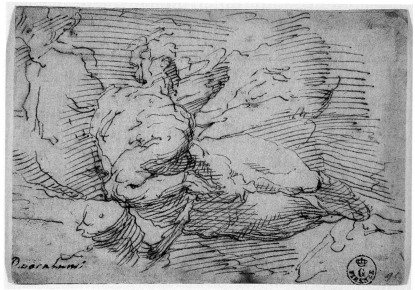

290. Domenico Beccafumi, *Three Lying Nudes*. Engraving, 208 × 409 mm. Cleveland Museum of Art, Cleveland.

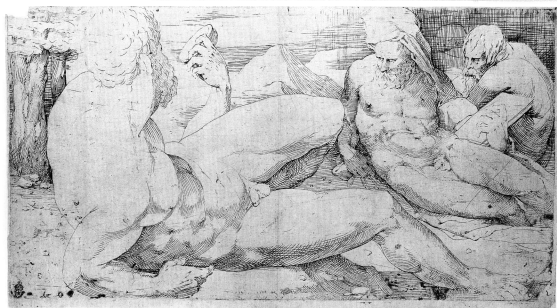

291. Domenico Beccafumi, *Three Lying Nudes*. Engraving and one woodblock, 212 × 407 mm. Pinacoteca Nazionale, Siena.

292. Domenico Beccafumi, *Three Lying Nudes*. Black chalk, pen and ink with white heightening on brown-prepared paper, 234 × 419 mm. Cleveland Museum of Art, Cleveland.

293. Domenico Beccafumi, *Three Lying Nudes*. Engraving and one woodblock, 204 × 395 mm. Library of Congress, Washington, D.C.

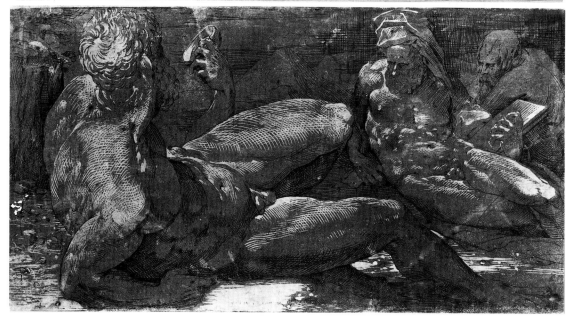

276

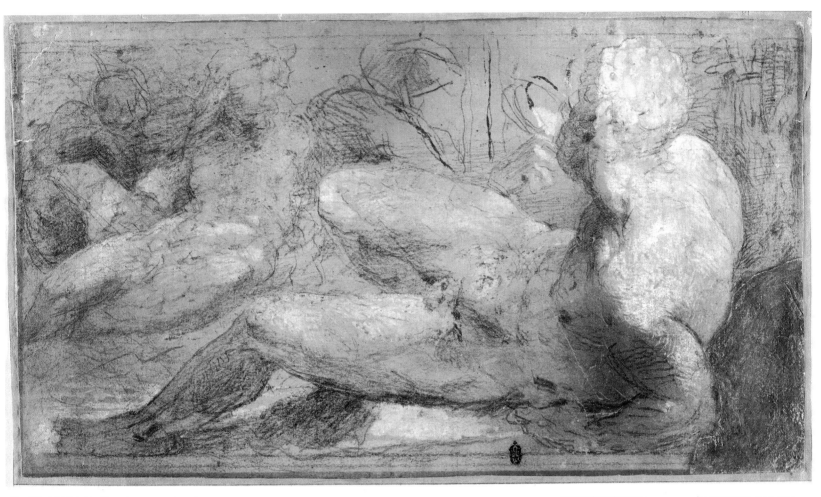

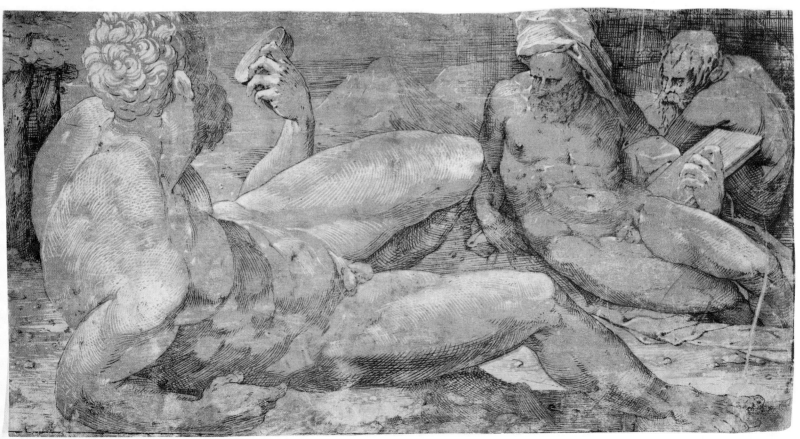

277

278

294. Domenico Beccafumi, *Virgin and Child*. Oil and varnish on cardboard, 257 × 191 mm. Uffizi, Florence.

295. Domenico Beccafumi, *Virgin and Child*. Oil and varnish on cardboard, 177 × 171 mm. Uffizi, Florence.

Following pages:

296. (top) Domenico Beccafumi, *Lying Nude*. Black chalk and wash with white heightening, 221 × 430 mm. Albertina, Vienna.

297. (bottom) Domenico Beccafumi, *Group of Lying Nudes*. Engraving and two woodblocks, 155 × 234 mm. Fondation Custodia, Paris.

298. (left) Domenico Beccafumi, *Nude Holding a Tablet*. Pen and ink, black chalk and wash, 331 × 231 mm. Cabinet des Dessins, Louvre, Paris.

299. (right) Domenico Beccafumi, *Two Apostles*. Engraving and one woodblock 413 × 209 mm. Uffizi, Florence.

280

and salmon pink, to the subtlest association of three slightly different shades of grayish blue or greenish gray. But what makes these woodcuts the most extraordinary color prints of the Italian Renaissance is the utterly novel way in which the blocks were cut. For Beccafumi used his knife in a manner we would now recognize as typical of a wood-engraver rather than a wood-cutter, giving the impression of having carved out the dark rather than the light areas: the printed lines get thinner and thinner against the whiteness of the paper,

recreating the effect of the highlights in his wash drawings (fig. 301). The richness of texture produced by these hatchings in white on a dark background effectively adds another "tone" to the three effected by the color blocks. The artist's continuous excitement with the changes and improvements he could make to these images is testified to by the number of states one can detect in the prints. The three impressions in the British Museum of an *Apostle* (Pass. 9), for instance, are three different stages in the development of the print. They confirm, if such a confirmation were indeed still necessary, that Beccafumi treated every single impression of his prints as a work of art in its own right, as a statement of a new achievement in his struggle to capture dark and light within the confines of two dimensions.

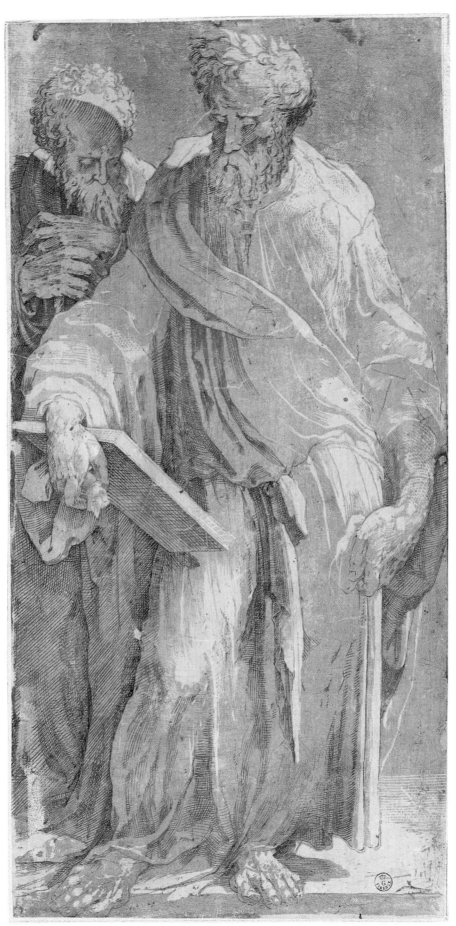

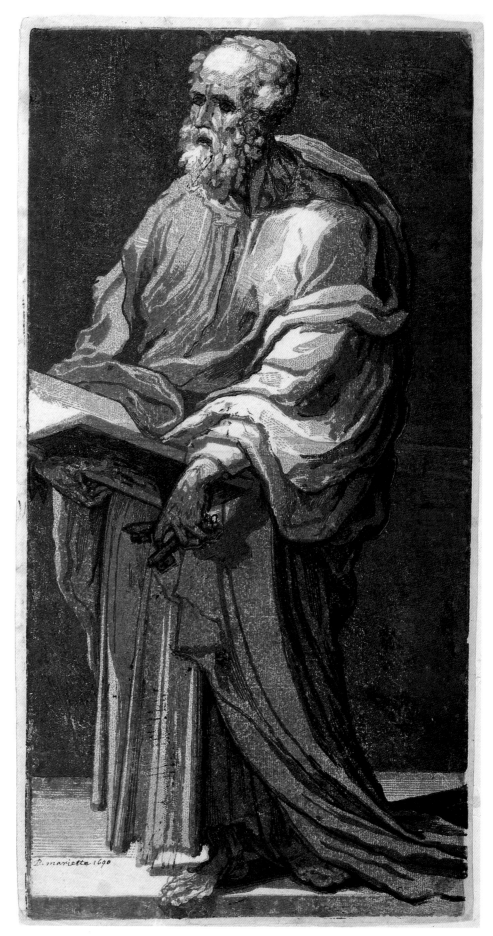

300. Domenico
Beccafumi, *St. Peter*.
Chiaroscuro woodcut from
four blocks, 411 × 210 mm.
Albertina, Vienna.

282

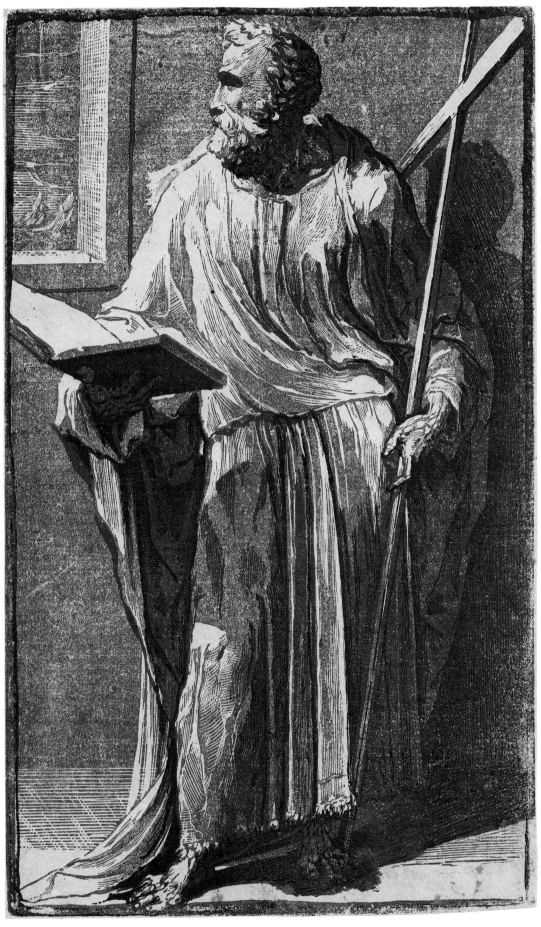

301. Domenico
Beccafumi, *St. Philip*.
Chiaroscuro woodcut
from three blocks,
282 × 170 mm.
Rijksmuseum, Amsterdam.

Italian Printmakers:
Their Milieu and the Market

Vasari liked Beccafumi's prints so much that he admitted to having one of his *Apostles* in the *Libro dei disegni*, his collection of drawings.[46] This is one of only two references in the *Vite* to prints owned by the author,[47] although Vasari must have had access to hundreds, many of which he described in some detail in his life of Marcantonio. Between about 1510, when, as Vasari put it, "printmaking had become praised and well thought of," and 1568, when the second edition of his book was published with an entire new chapter about prints, devoted "to all those who take delight in works of this kind" — that is, print collectors — the status of prints and printmakers had changed greatly.[48] Vasari considered prints good means for recording the *invenzione* and *disegno* of great painters, but was scarcely interested in the possibility of their being works of art in their own right. No print, not even his own impression of Beccafumi's very special chiaroscuro woodcut, was described in the *Vite* as itself possessing the three qualities of a true work of art: *invenzione*, *disegno*, and *colore*.[49] It is highly indicative of Vasari's attitude that he makes no mention in the *Vite* of any prints after his own designs, not even of the plate that his friend Enea Vico engraved in 1542.[50] Yet one should not underestimate the importance played by prints in the writing of the *Vite*. Vasari often relied wholly on engravings when describing frescoes he had not seen recently — or ever — assuming that they were faithful reproductions, at least of the *disegno*; this led him to a number of mistakes.[51] Though he was a most attentive chronicler of contemporary art, Vasari's views were biased by the changing perception of prints during the time he was composing the second edition of his *Vite*, published in 1568. While it is true that most prints published in Italy during the 1550s and 1560s were reproductive and would have been useful in refreshing an art historian's memory about the appearance of some fresco or painting, it should have been equally clear to Vasari that engravings by Marcantonio, Marco Dente, or Caraglio were no such thing. To a modern art historian it is bewildering that he did not distance himself enough from the issue to realize that most of the works by the printmakers active in the first forty years or so of his century were, at best, close interpretations and, at worst, straightforward and often fragmentary appropriations of the *invenzione* or *disegno* of their models. When Vasari did realize that there was some difference between painting and print, he always assumed that this was a reflection of the engraver's incompetence.

We have commented already on the documents suggesting that Italian printmakers were highly thought of at the beginning of the sixteenth century, that they were moving in the exalted circles of the great and the good, and that their praises were sung by poets and humanists. It is doubtful whether Vasari mingled with the engravers of his time, just as he would not have spent his evenings with the craftsmen who decorated majolica dishes, however good they may have been. This might have had a lot to do with his snobbishness, but his writing must nonetheless reflect a view generally held in the mid-sixteenth century that prints were a *cosa bassa*, a low thing, an attitude Vasari attributes specifically to Caraglio.[52] What had happened in those two generations to depreciate the esteem for prints so radically?

It is worth looking more closely at the few records that shed light on the lives of printmakers in that period. We start in 1508 on a high note, when Francesco Rosselli was singled out among the distinguished audience of a lecture on Euclid's fifth book given by the famous mathematician Fra Luca Pacioli. A year later the same Luca Pacioli wrote to Pietro Soderini, in the treatise *De divina proportione*, that the book's woodcut illustrations had been cut by the hand of Leonardo himself.[53] This was not true, but it echoed a similar claim made by Pacioli in the manuscript, in which the writing of the letters and the drawing of the figures had been credited to Leonardo.[54] Pacioli liked to boast about his closeness to Leonardo, from whose writings he had appropiated much of the material for *De divina proportione*.[55] But more interesting for us is that such claims could be transferred to the woodcut illustrations of the printed edition, indicating the status of professional woodblock cutters at the time. In those years the cutters' jobs were threatened by envious painters, who were slowly realizing the threat of competition from prints. In 1512, for instance, Venetian painters complained to the Signoria that hand-colored prints were being pasted onto wood panels and sold as paintings, an offence specifically prohibited by the Capitolo della Mariegola dei Depentori, which provided in such cases for the seizure of the offending article and a stiff fine of 500 ducats.[56] On the other hand, only five years later the Confraternita di San Rocco in Rome commissioned Baldassarre Peruzzi to design some woodcuts to publicize the forthcoming celebrations for their patron saint, and provided cash for pasting these prints, presumably to the walls of the city.[57]

There was nothing undignified in being a printmaker at this time. Aretino seemed to know most of the leading ones, and it is easy to extrapolate his own views about them from his published writings and letters. In Aretino's *La Cortigiana*, of 1526, there is a scene in which a *cameriere* called Flaminio describes to a colleague the marvels of all the Italian cities he is going to visit and where great men live. He mentions the rulers and the great politicians of the time, the literary gurus, the powerful men of

the Church, the poets, and so forth. Among the painters, and in the company of such distinguished artists as Titian and Michelangelo, he mentions Marcantonio and Caraglio: "and I cannot deny that Marcantonio was unique with the burin, but Gian Giacomo Caraglio from Verona his pupil has overtaken him . . . as can be seen in his works engraved in copper."[58]

One must take these words with a pinch of salt. Aretino was using *La Cortigiana* to pay back a conspicuous number of old debts, and both Marcantonio and Caraglio engraved portraits of him. The one by the former, which Vasari rightly called Marcantonio's best portrait and Bartsch his most beautiful print,[59] was indeed an extraordinary tour de force, a piece of bravura for which Aretino could only have been grateful (fig. 302).[60] In the inscription on Marcantonio's portrait, the poet is called "the man whose sharp tongue lays bare virtues and vices."[61] This declaration is matched by the text on Caraglio's plate, "castigator of princes" (flagellum principum). Both portraits aimed at confirming Aretino's stature as the most feared intellectual of his time, an image that he himself was cultivating with passion.

Enea Vico made a portrait of Aretino as well, but chose to inscribe it not only with the customary flattering dedication to the sitter but also with the words *amico singulariss[imo]* (B.XV.333.238), a testimony to their friendship and, by the way, to the lofty circles in which Enea moved. Several letters to him from Aretino have in fact survived, sent from Venice between 1546 and 1550, and they give a very good idea of the attitude towards prints of one of the leading intellectuals of the first half of the sixteenth century. In a letter to Enea of January 1546, Aretino suggests to the engraver that it might not be wise to make a version of Michelangelo's *Last Judgment* from anything but a drawing that Bazzacco had made of it, which we assume must have been a censored version of the fresco, since Aretino goes on to say that such display of nudity might offend the Lutherans.[62] In a letter of April 1548, obviously in reaction to a solicitation for advice from the engraver, then twenty-five years old, the poet warns the artist about his future if he really decides to leave "l'arte bella" in which he is "piu' che solo" (the good art in which he is more than alone, that is to say in which he has no rivals) in order to go and work as a painter in a court. There, Aretino reminds the young Vico, he has to keep his mouth firmly shut; the only other alternative in such circumstances would be to agree with whatever his master says.[63] Only a month later Aretino sent another letter to Vico in order to convince him not to abandon printmaking. It is likely that Vico had in the meantime protested to him that the life of an engraver was becoming increasingly enslaved to the whims of painters and publishers, since Aretino suggests that it is more

PETRVS ARRETINVS ACERRIMVS VIRTVTVM AC VITIORVM DEMOSTRATOR

dignified to be an independent printmaker among the best who engrave after the drawings by other painters than to be an artist enslaved by the whims of a prince.[64] Enea must, however, have persisted in his plans, and we know that Aretino sought to help him by introducing him to the court of Charles V. In August 1550 the poet wrote to the very powerful Cardinal Antoine Perrenot de Granvelle, who was attached to the court at Augsburg, introducing Vico, the bearer of the letter. Aretino describes him as one of the most gifted and famous printmakers in Italy, who is bringing his engraved portrait of the Emperor as a gift to Charles V, a gift that, no doubt, the Cardinal will make sure His Majesty will be given a chance to see.[65] There is another letter connected with this episode, a touching note to Vico attached to the letter that the en-

302. Marcantonio Raimondi, *Portrait of Pietro Aretino*. Engraving (B.XIV.374.513), 213 × 150 mm. British Museum, London.

285

303. Enea Vico, *Academy of Baccio Bandinelli*. Engraving (B.XV.305.49), 306 × 525 mm. British Museum, London.

304. Agostino Veneziano, *Academy of Baccio Bandinelli*. Engraving (B.XIV.314.418), 274 × 301 mm. British Museum, London.

graver was meant to take to Granvelle in Augsburg: Aretino pleads with Enea not to try to chat to the Emperor, however much he thinks he has to say, and to let his printed work speak for him.[66] Aretino was obviously referring to one of Vico's most accomplished engravings, proudly signed INVENTUM SCULPTUMQUE AB AENEA VICO PARMENSE .MDL. (B.XV.339.255). This entire correspondence not only reveals the esteem in which Vico was held by Aretino, but also confirms that prints were at the time considered worthy gifts to emperors.[67] Vico

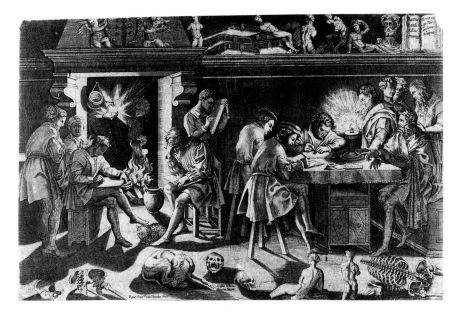

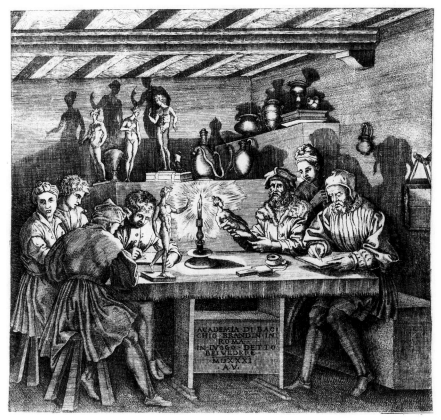

and Caraglio were the only two engravers mentioned by Aretino in his list of the greatest Italians included in his *Ternali in Gloria della Reina di Francia*: their names are preceded only by those of the very greatest painters and sculptors of their age, such as Titian, Michelangelo, Sansovino, and Cellini, and are followed by a long catalogue of painters, starting from Vasari, Salviati, and Bronzino.[68] Vico, who thought nothing of engraving his own coat of arms, probably for distribution to his important friends (B.XV.299.35), was also close enough to the powerful Baccio Bandinelli, who asked him to engrave a depiction of his famous academy (fig. 303). The interesting twist to this commission was that it was in fact an update of an earlier version, engraved in 1531 by Agostino Veneziano (fig. 304). Apart from an obvious change in style and the addition of a pile of books — suggesting that the apprentices were working in a cultured environment — the most striking change was the introduction of the insignia of *cavaliere*. This title was conferred on Bandinelli by Clement VII and Charles V, and appears as a coat of arms both over the mantelpiece and embroidered on Bandinelli's own coat.[69] Gian Giacomo Caraglio was also made a *cavaliere* in 1552 by the King of Poland, probably, however, because of his work as jeweler to the court. Caraglio thought that a print was not enough of a celebration for the event and instead commissioned a painting from Paris Bordon. This shows Caraglio receiving his insignia from a crowned eagle, representing Poland, while his goldsmith's tools are lying on the table; the Arena of Verona is discernible in the background, and no printmaker's tools are anywhere to be seen.[70] Vasari was probably well informed when he stated that Caraglio had stopped making prints because he felt it was a lowly craft.

But neither was Agostino Veneziano completely innocent of snobbishness. His own signature evolved from a simple monogram[71] to a rather ordinary *Agustin di Musi* in about 1515 (B.XIV.311.414) to a slightly less provincial *Agustino Di Musi* (B.IV. 308.409), and then to a definitely self-important *Augustinus Venetus de Musis* in 1518.[72] Being noblemen by birth, neither Ugo da Carpi nor Vincenzo Caccianemici needed to puff himself up; they became printmakers out of passion, not necessity.[73] These two, who belonged to different generations, created a line of amateur printmakers, another sign that there was no necessary stigma attached to making prints in the first half of the sixteenth century.[74] This is also apparent in the case of Andrea Meldolla, who came from a wealthy military family and apparently moved in the circle of *gentil' huomini*, who corresponded with Aretino (who mentions him in a poem) and who was probably self-taught in the art of printmaking.[75] Giulio Sanuto was a member of one of Venice's most prominent families, and a professional map-maker who

engraved as a hobby from about 1540 onwards.[76] At the other end of the social scale, Giovanni Britto, the German woodcut maker working with Titian in Venice, thought nothing of pestering Aretino two or three times a day — and during a heatwave — in order to obtain a *sonetto* to append to the woodcut *Portrait of Titian* (fig. 305)![77] Such instances clearly imply that prints and printmaking were as much a matter of interest among the literati as among artists.

To assume that printmakers were considered craftsmen rather than artists and that prints were a lesser form of art is to apply a twentieth-century prejudice to a sixteenth-century situation. There was no clear distinction then between a beautifully executed painting and an equally proficient print, except for the obvious fact that expensive materials had been used for making the former, mere paper and ink for the latter. Prints were almost always referred to as *desegni stampati* or *desegni a stampa* (printed drawings or drawings in print), and great printmakers were appreciated as much as the best contemporary draftsmen. The situation evolved slowly over the first half of the century, so that by the time Vasari was writing the second edition of the *Vite*, he — and no doubt others — perceived a difference between the best, most imaginative prints and the skilled reproductions. Because of the increasing intervention of shrewd operators such as Lafrery, however, the number of engravings belonging to the latter category ballooned in the 1540s until the finer form of printmaking was inexorably squeezed out of the market.

Nevertheless, printmaking earned great prestige

throughout two generations of artists and collectors. Fame came to the best printmakers not because of their skill with the burin; this was, after all, expected of them, as it was expected of painters that they should know how to mix colors or of sculptors that they could use a chisel. Their fame came instead from the intelligence and imagination they displayed in their prints. The extent to which they borrowed motifs from other artists, necessarily painters, was judged irrelevant, since it was seen as paying the right and proper tribute to those who had "invented" a particular interpretation of the subject matter. The reason why prints by the engravers of the first two generations of the sixteenth century are never exact reproductions of anything — whether a drawing or fresco by Raphael, or a piece of antique sculpture — is not because the printmakers were incapable of exact copying of a prototype (we know they could do that perfectly well),[78] but because it did not occur to them that their prints should look exactly like works by other artists.

If Marcantonio, Caraglio, or Bonasone were to read Vasari's 1568 edition of the *Vite*, let alone twentieth-century art history, he would probably be bemused, if not offended, by the assumption that his prints were "after" this or that. Their intention in appropriating a figure, a group of figures, or even an entire composition, was to pay homage to the *invenzione* of one of the great *capiscuola* of their time — Raphael, Michelangelo, Parmigianino, Giulio Romano, Titian, and so forth. When given a chance to work together with one of these giants, the engravers translated their compositions into prints that were doubly appreciated, as being by the hand of two artists of great standing. When drawing from the work of artists with whom they could not collaborate, they never attempted exact translations into prints, but aimed instead to improve on the *invenzione* and *disegno* — by adding figures, moving the composition around, changing the landscape, introducing new meanings. Stefania Massari has recently shown how very intimately these printmakers must have known their sources, particularly Ficino, Pico della Mirandola, and Leone Ebreo, when they conceived their allegorical and mythological prints — choosing one particular episode of a story, illustrating every nuance of it through the subtle choice of allusive symbology, and often "improving" on the subject matter by conflating it with that of a similar, but normally unrelated, allegory.[79]

These learned artists intrigued their customers by adding esoteric connotations to the *invenzioni* of the great masters of their age. The more they added, the more their prints were appreciated in their own right. One of the many symptoms of this changed attitude is that the prints listed as "by Raphael" in the Rosselli inventory of 1525 are called "by Marcantonio" in Doni's letter to Vico

appended to *Il disegno* of 1549.[80] But as time went by, and as printmakers got increasingly distanced from their sources, this difference between appropriation (and improvement) and copy/reproduction became more and more blurred. One should not forget that the best printmakers in most places outlived the *capiscuola*, and that collaborations with lesser painters were bound to produce lesser prints. Perin del Vaga worked very closely with Bonasone, Vico, and possibly Ghisi; Salviati collaborated with Vico; Giulio Romano with Ghisi. In most of these cases the painter produced very detailed preparatory drawings for the engraver.[81]

While working on these projects, the printmakers continued to produce independent works as well. It is natural that for these compositions they borrowed freely and copiously from the *invenzioni* of the painters they were working with. The situation changed when there was no longer a direct relationship between draftsman and engraver; it is natural that the less confident the engraver was of his own imaginative skills, the more closely he would have followed the prototype. This remoteness was bound to become a sliding path to reproduction.

When Agostino Veneziano engraved the *School of Athens* in 1523, closely inspired by Raphael's famous fresco, he felt free to turn the group of Pythagoras and the ancient philosophers into one of St. Luke and the Evangelists, and to add inscriptions in Greek on the book and the tablet that glorify the Virgin.[82] This episode says a lot about the relationship between Agostino's *inventio* and Raphael's *inventio*, and possibly about the level of learning in the printmaker's circle as well, some members of which were no doubt intended to appreciate the subtlety of Agostino's changes. When, however, seven years later, Agostino engraved Giulio Romano's *Venus and Vulcan Surrounded by Cupids* (B.XIV.261.349), he followed the painter's design very closely,[83] but — perhaps with Giulio's agreement — pathetically acknowledged the *inventio* to Raphael by inscribing the print RAPH.URB.DUM.VIVERET.INVEN. (Created by Raphael of Urbino when he was alive). As time went by, the separation between *inventor* and engraver increased. When in 1545 Beatrizet used a drawing made by Bandinelli before 1520 as a starting point for the print of the *Fight between Reason and Love* (B.XV.262.44), he came very close to reproducing it, as there was very little *inventio* he could or wished to add to it, with the exception of an interesting interpretation in Latin distichs.[84] Similarly, when he engraved a set of prints in 1542 after some highly finished allegorical drawings by Michelangelo,[85] Beatricetto could not possibly be expected to "improve" on them — not that he attempted to do so. These prints are reproductions, not only because they copy their prototypes exactly, but also because they emulate the tonal effects of the drawn lines.

It was through inscriptions that engravers often acknowledged the *inventio* of other artists,[86] and it was through the careful use of words that they claimed the paternity of their own *inventio*, even when, as we have seen, they had borrowed quite shamelessly from other sources. The word *scalpsit* (or *sculpsit*) was used only in specific circumstances (see p. 306), whereas *fecit* (or *faciebat*) became the preferred term in the 1540s and 1550s,[87] with Bonasone, Vico, Beatrizet, and Ghisi making use of it for many of their works. It was probably because of the plethora of *fecit* on prints by their competitors that printmakers started looking for different terms. Bonasone, Vico, and Beatrizet began using *incidit* or *incidebat* (from *incidere*, to incise), Bonasone alone used *celavit* (from *caelare*, to chisel), and Vico alone used *excidebat* (from *excidere*, to cut). *Restituit* (from *restituere*, to restore, but also replace) was a form that has often been interpreted to mean that the printmaker had re-engraved a worn-out plate, but it has been demonstrated that this was not always the case, and that in a number of instances Vico and Beatrizet used it to mean they were engraving a second version of that subject.[88] This variety of Latin inscriptions confirms that these prints were intended to serve a cultured market. Only Vico ever inscribed his prints in Italian, *intagliate in istampa di rame* or *intagliava* (engraved in a copper plate), and he did this just twice: once on the frontispiece of a book (B.XV. 342.320) and once in a very special print dedicated to Cosimo de' Medici (B.XV.349.419). The dedication to important patrons was becoming more common at the time, a further indication of the increasing esteem of prints. Vico, for instance, dedicated one of his more famous prints, the *Conversion of St. Paul* (B.XV.386.13) to Cosimo, a print singled out by Doni as among the best prints of the century in his collection.[89]

There is not much evidence that prints were looked upon with disdain during the first half of the century, and the sudden change in attitude that seems to inform Vasari's writings may be related to the "industrialization" of the printing business in the 1540s and 1550s, when publishers took over most of the print production in Italy, and changed its nature. It is probably untrue that Michelangelo's seventieth birthday was celebrated with the publication of Bonasone's engraved portrait,[90] but it is documented that the printmaker, notwithstanding his fame, was not admitted to the Compagnia dei Pittori of Bologna until 1571, although he had been a member of the Quattro Arti Riunite since 1556, when he was at least in his thirties.[91] Whether one should read too much into such a record is difficult to say, but it tallies with a number of other documents in the 1550s and 1560s, including Benvenuto Cellini's *Trattati . . . dell'oreficeria . . . e della scultura* (published in 1568), which show that the attitude to prints and professional printmakers had

changed dramatically since the time, two generations earlier, when printmakers were being compared to Polygnotus and Phidias.

We have suggested that at the beginning of the century Italian prints were largely being sold within those circles in which printmakers moved. Now we must ask ourselves: who bought prints over the following fifty years? That they were being collected is obvious, not only because so many prints were produced and in so many different centers, but also because a number of surviving documents, albeit a small number, demonstrate the presence of collectors. These documents shed some light on the sort of person who collected prints during that period, and whether prints were regarded primarily as documents, or as works of art in their own right.

The prints themselves can tell us something about the emergence of collecting. From early on, printmakers seem to have allowed for the fact that their prints needed to be framed, or at least mounted in some way. This we can deduce from the space (from two to five millimeters) left in a number of them between the image — itself often surrounded by a borderline — and the platemark. The example seems to have been set in Italy by the printmakers of the Ferrarese school, who often provided their engravings with recessed framing devices, shaded on one or two sides,[92] or with illusionistic frames.[93] This model was taken up by Milanese and other printmakers all over northern Italy,[94] and it was further refined by Agostino Veneziano:[95] in his *Diogenes* of 1515 there is an obvious trompe l'oeil of a recessed mount or frame, made by shading two sides of the print and leaving the other two white, while at the same time engraving four oblique perspectival lines to connect the corners of the borderline with those of the platemark, very much in the Ferrarese tradition we have just mentioned (fig. 306). Marcantonio often allowed an unusually wide space between the edge of the image and the platemark (B.23, 32, 37, 44, 45, 46, 61, 445), sometimes making sure that it was larger at the foot of the print than at the sides and top (B.60). This idea must have caught on in Rome, since Ugo da Carpi provided some of his best prints with a trompe l'oeil mount, often inscribed with his name and/or that of Raphael at the bottom (fig. 307). In the so-called *Raphael and his Mistress*, Ugo developed the concept into a full illusionistic frame, an idea that was somewhat more crudely imitated by Antonio da Trento in his *St. John the Baptist* (B.XII.73.17) and in a number of small woodcuts connected with Parmigianino's set of *Apostles* (for instance B.69.1; 70.3; 70.5; 70.11). Many other examples and shapes of framing devices exist among chiaroscuro woodcuts.[96] The fashion continued, and examples can be found, for instance, in a number of prints by Caraglio (B.XV.91.56) — some of which have complex frames engraved around the image

(B.XV.71.7; 98.64) — and also in the work of Bonasone (B.XV.135.86). The use of this device reached its most extravagant form with Nicolas Beatrizet (B.XV.249.19) and Giorgio Ghisi. Ghisi surrounded two of his prints with detailed depictions of frames in trompe l'oeil, one being the small *Portrait of François Duaren*, the other the very large *Apollo and the Muses* (fig. 308).[97] This long list includes prints of many sizes, subjects, and different media. It suggests that at least some prints were assimilated to paintings and thus provided with a "frame" by their authors, a task that had fallen to artists throughout the Renaissance. A curious print of the *School of an Ancient Philosopher* — ascribed to Caraglio by Bartsch, possibly by Lorenzo Costa, but proudly signed in a tablet .D.IGNOTO (that is, by an unknown, B.XV.91.57) — shows in the background a map with much coastline, likely another pun on the author's name (fig. 309). However, here its interest lies in the fact that the map on the wall is obviously framed and glazed, possibly the first depiction we have of a work of graphic art thus treated.

The available records confirm that collecting and framing prints was not unusual.[98] Marcantonio Michiel recorded works by Jacopo de' Barbari and Dürer, almost certainly prints, in the Venetian house of Cardinal Grimani in 1521;[99] Michiel also noted, when visiting the house of Giovanni Antonio Venier in 1528, that his tapestry of the *Preaching of St. Paul* was known through a print.[100] In the house of Antonio Foscarini, in 1530, he saw a "book of prints by several hands."[101] Michiel's teacher, Battista Egnazio, probably owned an impression of Jacopo de' Barbari's *View of Venice*, which he left in his will to the lawyer and humanist Antonio Marsilio. He also appears to have exchanged portraits of celebrities — presumably prints — with Dürer's friend Pirckheimer.[102]

By far the greatest print collection in Venice, however, was that of Gabriele Vendramin. It was part of his *camerino delle antigaglie*, the famous collection of paintings, drawings, miniatures, sculptures, and curiosities that he left to his seven nephews at his death in 1552.[103] Vendramin was obviously very fond of his cabinet and devoted a large part of his will to setting out clear instructions to his heirs so that they would not break up his treasure. As far as we are concerned here, it is interesting to note that he gave considerable importance to his prints. They are noted just after the mention of his paintings and drawings, and before the long list of all else that was in his collection, from antique sculpture to animal horns: "many drawings printed on paper from copper or wood, some put in a number of books and a large part not in said books."[104] The inventory of the *camerino*, made in 1567, lists, among hundreds of works of art, 835 prints; there are also a number of other prints in several large and small albums whose contents are

306. Agostino Veneziano,
Diogenes. Engraving
(B.XIV.161.197),
77 × 119 mm. British
Museum, London.

woodcut; as for "do quadreti picoli a stampa del Campagnola" (two small printed pictures by Campagnola), there is little doubt that this describes two small engravings by Giulio or Domenico, framed. Another framed print is probably "una tavoleta picola in stampa de rame" (a small panel from a copper plate), and "un quadro de una sumercion de Faraon con un adornamento negro dorado col suo timpano soazado et dorado" is almost certainly a description of an impression of Titian's magnificent woodcut (in twelve sheets) of the *Submersion of Pharaoh's Army in the Red Sea*,[105] mounted in a "black and gilt frame of the type with a carved and gilt tympanum." With the exception of this last work, which was kept in a different room, probably on account of its size, all other prints were in a number of cupboards in the *camerino*, mixed with the drawings, which formed an equally impressive collection. Only one printmaker, Dürer, is identified by name, while others are simply referred to as "diversi valenthomeni . . . diversi authori . . . un todesco" and so forth. It is likely that Vendramin was acquainted with contemporary printmakers; he certainly knew Enea Vico, since the latter describes in his *Discorsi* some rare coins he saw in Vendramin's collection,[106] and Vendramin may have acquired prints directly from the engraver. A number of individual prints and cycles are identifiable, such as Dürer's *Passion* and *Apocalypse* series; others, called "de Raphael d'Urbin," are likely to be by Marcantonio, but it is not certain who was the engraver of the "istoria de psiche."[107]

not listed in detail. These probably bring the total number of prints in the collection to well above a thousand. Most of them appear to have been kept in albums of various sizes, from octavo to imperial, some long and narrow, some short and wide, all bound in leather of different colors; at least a hundred prints were kept rolled up, and some seem to have been loose. It is also clear that some were framed. It is probable that "un altro quadretto de un retratto un rinoceronte" (another small picture of a depiction of a rhinoceros) refers to Dürer's

307. Ugo da Carpi, *David
Slaying Goliath*.
Chiaroscuro woodcut from
three blocks (B.XII.26.8),
260 × 387 mm. Royal
Library, Windsor.

Engravings are mixed with woodcuts, and there is a specific mention of a chiaroscuro woodcut. Apart from size, there is no indication of the order in which the prints were kept, not even of whether they were divided by artist or subject, although the former arrangement is more likely, since some albums are described as containing only German prints and some Italian. Moreover, even among the albums of drawings, there were some devoted to particular artists, such as Mantegna and Domenico Campagnola.

It is particularly interesting to note that several prints in the Vendramin collection were framed, and that among them were two by Campagnola. It may well be that the pen and ink inscription IVLIVS CĀPAGNOLA — lettered in beautiful Roman capitals on a number of early impressions of his prints — is the first case we have of prints personally signed by

308. Giorgio Ghisi, *Apollo and the Muses*. Engraving (B.XV.406.58), 336 × 422 mm. Metropolitan Museum of Art, New York.

309. Attributed to Lorenzo Costa, *School of an Ancient Philosopher*. Engraving (B.XV.91.57), 151 × 149 mm. British Museum, London.

291

hand.[108] Hind agrees that the inscriptions seem to be by Giulio's hand,[109] and the fact that they appear in two impressions of the same print, the *Young Shepherd* in Bologna and London, does suggest to us that these were special impressions for special customers and that the lettering cannot be that of a later collector. Moreover, the extraordinarily tonal impression of the *Venus* in Cleveland (fig. 268), surely printed by Giulio, has the inscription penned over a rectangular space obtained by carefully wiping off the surface tone from the plate. If this is true, it gives credence to Zerner's hypothesis that forged "proof" impressions of Marcantonio's prints — in which parts of the plate were masked out with a stencil during printing and which, moreover, were printed on vellum — had a market in early Cinquecento Italy. It would have made no sense to print working proofs on vellum, and these forgeries must have been specifically produced for collectors' cabinets.[110]

This extraordinarily rich collection of prints, and the number of other references to prints in Venetian houses mentioned above, leave little doubt that print collecting was pursued in that city during the first half of the sixteenth century. Michiel's writings and Vendramin's inventory also offer evidence of the type of people who bought them. Like Cardinal Grimani, all of Michiel's contacts belonged to the leading families in Venice, those few who could hope to see one of their members become a *doge* or *patriarca*. The collection of the Parmese Cavaliere Francesco Baiardo, who died in 1561, was still more extraordinary than Vendramin's.[111] It contained two albums of prints and drawings mixed together (one containing eleven prints by Beatrizet); there was also one album exclusively of prints, fifty-nine in number, including Dürer's *Passion*, and another album of seventy-five prints, all by German artists. In another room there was a print of the *Fire of Troy* after Giulio Romano, possibly kept loose, and in the second and third *camerini* there were as many as sixteen prints, all framed and hanging on the walls among paintings and drawings by various hands, but mostly by Parmigianino. Among the impressive list of prints are some of the finest of the previous forty years: Dürer's *St. Eustace, Sea Monster, Melencolia I, Nemesis*, and others; Marcantonio's *Mars and Venus, Massacre of the Innocents, Parnassus, Judgment of Paris*, and others — all are called "di Rafaele." In addition, Baiardo owned Baccio Bandinelli's two best prints, the *Massacre of the Innocents*, engraved by Marco Dente, and the *Martyrdom of St. Lawrence*, engraved by Marcantonio. It is possible that Baiardo himself compiled this very impressive collection, but it is also conceivable, as Fagiolo dell'Arco suggested,[112] that it was in fact Parmigianino's own print collection, and that Baiardo acquired the whole studio on the death of the painter. In fact, it might have already been in his

possession before then, if Popham is correct that he obtained it as security in connection with the unfinished frescoes at the Steccata.[113] That it was Parmigianino's collection makes great sense, as the inventory lists more than five hundred of his works, and very few collectors are known to have been so single-minded, particularly in the sixteenth century. This hypothesis is strengthened by the fact that we know Parmigianino copied many of these prints in his drawings and that his first etching, the *Sleeping Cupid*, was copied from Marcantonio's *Massacre of the Innocents* (see above). The painter also made copies of three different figures from this print in drawings,[114] and at least another four drawings are known by him that are copies of other Marcantonio engravings.[115] Finally, there is evidence that Parmigianino had access to Dürer's prints, since he made copies of them as well.[116] Parmigianino's print collection may in fact have been started before he went to Rome, for the frescoes at Fontanellato, a cycle he carried out in 1523–24, include a number of borrowings from prints by Marcantonio and Dürer.[117] Moreover, one of his earliest drawings boasts a detail copied from a print from the school of Mantegna.[118]

There are records of a number of other collections that appear, however, to have been formed after the middle of the century; the renewed interest in prints may have been an unexpected and somewhat ironic consequence of Vasari's codification of the history of printmaking, in spite of his uncomplimentary attitude.[119] One collection belonged to Marco Benavides, one of the two earliest print

collectors of whom we have an engraved likeness by Enea Vico. The other was Anton Francesco Doni, of whom Enea made two portraits in the form of medallions, as if they were part of Doni's collection of medals (fig. 310).[120] Doni's seriousness as a print collector can be deduced from a letter he wrote to Enea on 31 August 1549 in which he discusses some of his prints. He names Schongauer, Dürer, and Lucas van Leyden, without specifying what he possesses by them, and he goes into greater detail about his Italian prints. Apart from the *medaglie* and other engravings by Enea, he mentions Marcantonio's four most famous prints, the *Massacre of the Innocents*, the *Parnassus*, the *Judgment of Paris*, and the *Quos Ego*; the *Laocoon* by Marco Dente; the *Loves of the Gods* by Caraglio; and, finally, the *Massacre of the Innocents* and *Martyrdom of St. Lawrence* after Bandinelli.[121] The astonishing similarity of these two collections is a good indication of the taste for prints at the time, a taste that valued what we still consider the best prints of the period.

This is precisely what is so remarkable about all the surviving records of print collecting in the first half of the sixteenth century: the prints named in documents consistently represent the "top" end of the market. It is true that these were the ones that the people normally involved with inventories, such as notaries or relatives and friends of the deceased, were most likely to recognize; it also true that these were more likely to be the prints about which a collector would want to boast. Sabba Castiglione, for instance, in his *Ricordo cerca gli ornamenti della casa* of 1549, mentions that gentlemen adorn their houses with engravings and woodcuts, both Italian and German, and that the best are by Dürer and Lucas. In another *ricordo*, Sabba describes receiving from Germany a print by Dürer and looking "with delectation and great pleasure" (con dilettatione e piacer grande) at the composition, its figures, animals, perspectives, buildings, landscapes, and so forth.[122] Francisco de Holanda's list of worthy printmakers includes, again, Dürer, Marcantonio, Agostino Veneziano, Lucas, and Mantegna.[123] Bernardino Scardeone, who published in 1560 a history of Padua and who had been a friend of Girolamo Campagnola — Giulio's father and, in turn, a close friend of Mantegna's[124] — mentions in his book that he owned nine prints by Mantegna; these, he says, were "greatly esteemed, and possessed by only a few" (in maxima extimatione, et a paucis habentur).[125]

One of the most illuminating documents about the taste for prints in sixteenth-century Italy, however, is a long letter written by Aretino to the painter Francesco Salviati in August 1545.[126] The poet had just received the "figure stampate" (printed figures), possibly more than one impression, of

311. Enea Vico, *Conversion of St. Paul.* Engraving from two plates (B.XV.286.13), 531 × 931 mm. British Museum, London.

293

Enea Vico's rendition of Salviati's *Conversion of St. Paul* (fig. 311), a very large engraving from two plates, almost a meter in width.[127] The letter describes Aretino's reactions to the print in great detail: after a careful analysis of the various elements of what he calls a "stupendo componimento" (stupendous composition, that is, the *disegno*), the poet comments on the effects of the light descending on the two halves of the print in different ways (an implicit reference to *colore*). He goes on to comment on the extraordinary disparity in the reactions of St. Paul and of his horse to the apparition of God, calling this "il miracolo dei miracoli della santa *inventione*" (the miracle of miracles of the holy *invenzione*, presumably meaning the sublime invention): a different fear grips the horse from that which grips the humans, and this is magisterially shown in the print. There follows a lengthy account of the variety of armor, the cuirasses and spears that shine in the sudden light of the apparition, and of the ruins to the right, unmatched by the splendor of Rome itself. At this point the argument changes slightly in direction, as Aretino begins to compare various features of the print with the achievements of other painters, recognizing, as it were, the paternity of such borrowings: the "tondaggine delle linee" (the roundness of the lines), of which Michelangelo could be so proud; the appearance of youthfulness in the young and of "venustà" in the old, that only Raphael had managed to convey so effectively; the distant landscape in the center and the thick vegetation at the left, that Dürer himself had failed to portray so beautifully. Artists much closer to Aretino had recognized that motifs for the horses had been borrowed from their own work, and were delighted: "ma bisognerebbe che voi sentisse favellarne al Sansovino e a Titiano . . . i quali vi amano da figlio" (but you should hear Sansovino and Titian discuss your print . . . they love you as their son). Salviati's *invenzione* is thus praised as the ability to interpret the subject matter in a novel way — "non parlo per non sapere a niun modo esprimere l'eccellenza della novità", that is, I say nothing more, as I cannot find words to express the excellence of the novelty — having borrowed judiciously from the greatest painters of his century. There is then another shift in the argument of the letter, as the painter now devotes his attentions to the quality of the engraving: Aretino had earlier referred to the extraordinary effects of the light and to the "morbidezza" (softness) with which hair and beards appear to grow on the heads and cheeks of the figures, and he now chuckles at the amazing contrast the engraver has managed to achieve between the rustic edge of the stone carrying the inscription and the smoothness of the polished surface in which such words have been incised, on which "rilucono tanto i raggi del Solar Pianeta" (the rays of the Sun shine so much). So, Aretino

continues, "perchè nulla manchi nel felice invento, la diligentia del Bolognese Marco Antonio è vinta dal sicuro e gagliardo stile del Parmigiano Enea" (so that nothing be short of the felicitous invention, the diligence of the Bolognese Marco Antonio is overcome by the confident and vigorous style of the Parmesan Enea). Salviati's invention is well served by Vico's proficient technique. This is great consolation not only to Aretino himself, but to all painters who can see how a *disegno* can be turned so effectively into a print: "gli esercitanti in la pittura si gratifichino di sì eccessiva perfettion di disegno in netto rame impresso" (the practitioners of painting can be gratified by such perfection of *disegno* so sharply engraved in copper). The letter concludes by thanking Salviati again for the "dono di sì pretiose carte" (the gift of such precious sheets), because of which Aretino needs to worry only about the multitude of visitors who continuously run to his house to admire them.

We have devoted so much space to this letter because it seems to encapsulate quite neatly the variety of reasons for which a cultured man such as Aretino may have enjoyed looking at prints. There is, obviously, a great deal of rhetorical exaggeration in his words, but his attitude to printmaking is quite clear: this *Conversion of St. Paul* is the result of a close collaboration between a good contemporary painter, who has learned to borrow from the best of his peers, and a skillful engraver, who has mastered his art so perfectly that he can express with full confidence the complexities of *colore* in black and white. No wonder that the print, dedicated to the generosity of Cosimo de' Medici, is proudly inscribed FRANCISCI FLOR. JO. CAR. SALVIATI ALUMNI . INVENTUM . AENEAS PARMEN . EXCIDEBAT. ANNO D. M.D.XLV. (Invented by Francesco of Florence, disciple of Cardinal Giovanni Salviati, engraved by the Parmesan Enea in 1545).[128]

Michael Bury's conclusion, that prints were often collected in the same spirit as drawings, since they conveyed the same information and gave the same pleasure as drawings, must be correct.[129] But there was a range of approaches taken among the collectors: Vendramin, Sabba, and Aretino may have looked at their prints with the same enthusiasm and delight as they did other works of art in their possession. On the other hand, Parmigianino and Vincenzo Borghini were apparently more interested in their value as records of works by other artists. Borghini wrote in 1552 to Vasari, asking him to buy on his behalf as many prints after Michelangelo as he could find, saying that he was, literally, dying to have them.[130] The influence of prints on other art forms, from goldsmith work to majolica dish painting, is so well documented and affected so many centers that it is likely that every major workshop possessed at least some prints, probably a substantial collection.[131] Unfortunately only a few records from the period survive to confirm

this.[132] The words Enea Vico used when applying for a privilege on 19 November 1546 are, however, illuminating: "for the benefit and use of all the painters and sculptors and other people of standing."[133]

In Lorenzo Lotto's *Libro di spese diverse*, where he kept a full record of his accounts for the years 1538–56, prints appear twice: in 1549, on his departure for Ancona from Venice, Lotto left nineteen prints to his friend the jeweler Bartolomeo Carpan in whose house he had stayed for one and a half months while gravely ill. Carpan was to sell them and give the proceeds to Menega, the servant who had taken care of the painter during the illness. Unfortunately there is no mention of the value of the gift, an unusual omission in Lotto's diaries, which normally detail finances with care, nor is there a description of the prints themselves.[134] The second reference to prints appears in Lotto's records of expenses for 6 October 1542: on that day he spent one *lira* and 4 *soldi* for "3 prezi [*sic*] de disegni da stampa." We do not know what prints he bought, although it is interesting that he acquired them as part of a spending spree on materials in preparation for his move to Treviso, where he thought at the time he would settle forever.[135] The amount spent is the same as the cost, a couple of months earlier, of a piece of silk to cover the box in which he wanted to place a Crucifix to give as a present to his niece Lucrezia who was about to take the veil.[136] The three prints, therefore, could not have been of very high value. It is, however, interesting to note that the acquisition is placed in the column of the expenses made "per l'arte," and not in that recording the painter's personal expenses where, for instance, a book on the life of Marcus Aurelius is listed.[137] Obviously Lotto acquired prints as records of images that might become useful as inspiration for the commissions he was expecting in Treviso; perhaps he bought the prints in Venice because he thought that he would not find them as easily in the smaller center.

Where did humanists, collectors, and painters acquire prints in Renaissance Italy? Very few records survive, particularly in relation to the "top" end of the market, where we can assume prints were often acquired directly from the printmaker. We have seen that in 1552 Borghini asked Vasari to look for prints after Michelangelo in Rome, and we can assume that by that time the market there was securely in the hands of the print publishers. But it is also likely that elsewhere in Italy, and in Rome before the 1530s, *cartolai* and *librai* (card and book shops) were trading in prints. As we have already mentioned, it was at a *libraio* around 1471 that Ludovico Lazzarelli was said to have acquired a set of the so-called *Tarocchi*,[138] and it was in the *bottega* of a Venetian *cartolaio* in San Moisè that a number of prints were described in a 1534 inventory: "carte grande e tromphi grandi, et trionfi [*sic*] pizoli et

altre sorte . . . con le charte stampade e da stampar e cartoni incartonadi . . . li sono le stampe e forme" (large sheets and large triumphs, and small triumphs and of other kinds . . . with cards printed and to be printed and cardboard sheets . . . there are [also] prints and plates [or blocks]).[139] It is clear that Jacobus Chartularius was selling the large, multi-block woodcuts that had been fashionable in Venice for some thirty years; his stock probably included playing cards and the plates as well — but more probably blocks — for making these or other prints. Although the inventory lists the value attributed to the stock by an independent *cartoler*, it does not mention the number of prints involved, thus making a calculation of their individual prices impossible. In the shop of the *libraro* Domenego de Soresini, whose contents were inventoried on 2 November 1554, there was an impressive stock of books, illustrated and not, as well as a rich assortment of colors, mostly greens, blues, and reds. These were obviously used for coloring the woodcuts, whether they were single-leaf or bound as illustrations in the books for sale. There was, moreover, "uno fasso de desegni fra a pena et a stampa" (a bundle of drawings, both in pen and printed).[140] In this context it is useful to remember that professions related to the arts were often closely connected. It was in the *bottega* of the *cartolaio* Alessandro Rosselli that prints by Marcantonio and Marco Dente could be acquired in 1525. It may therefore be useful to look still more closely at the extensive inventory of this shop, taken at the death of Alessandro on behalf of the two minor orphans who were his beneficiaries.[141]

The shop was a mixture of *cartolaio*, *stampatore*, and *merciaio*, and yet scholars have, quite rightly, concentrated on the items that had come to the shop from Francesco Rosselli, Alessandro's father and arguably the most prolific printmaker in fifteenth-century Florence. As we have noted, among the stocks are all the plates for the so-called Broad Manner prints and an impressive number of maps, all engraved by Francesco. What interests us particularly here, however, is the large number of prints which we can safely assume are not by Francesco, and which therefore constitute his son's stock in trade as a *cartolaio* and *stampatore*. There are more woodblocks and woodcuts than there are plates and engravings: the woodblocks include a small number of games, fans, and ornamental prints, seven images of "uomini famosi" (famous men), one of a "pantera" (panther) and a much larger group of blocks for single-leaf woodcuts of religious subject matter.

Unfortunately the blocks and plates are not priced, either individually or as stock, but luckily the prints in the shop are. We learn that while an ordinary woodcut printed by Lorenzo — son of Alessandro and one of the two minors left at his death — cost as little as 2 *denari*,[142] an ordinary

engraving also printed by Lorenzo cost about ten times as much, 1 *soldo* and 8 *denari*. The *Massacre of the Innocents* "by" Baccio Bandinelli (fig. 312), on the other hand, of which there were 16 impressions in the shop, was valued at 1 *lira* each, that is to say about twelve times the price of an ordinary engraving. Moreover, the 305 royal-size engravings "di Rafaelo da Urbino," presumably by Marcantonio and Marco Dente, were each valued at 5 *soldi* and 6 *denari*, and the 449 small prints "di Rafaelo da Urbino" at 4 *soldi* and 4 *denari* each. If, for ease of understanding the relationship among their respective values, we turn all such sums into *denari*, the result is that an ordinary woodcut cost 2, an ordinary engraving 20, a small print by Marcantonio 52, a larger one by Marcantonio 66 and the very large print by Marco Dente after Bandinelli, printed from two plates, 240 (fig. 312). These values are confirmed in a further document, dated five days later but mysteriously little discussed in the literature.[143] This document ratified the agreement between the uncle of the orphans and a

printer who was to continue the activities of the shop by selling its wares and printing from its woodblocks and plates. In this document, the only prices that have changed are those of the prints by Marcantonio: the royal-size engravings were to be sold at 10 *soldi*, which correspond in our scale in *denari* to 120, almost twice as much as in the inventory. To put such sums in a more meaningful perspective, it may be worth mentioning that at the time the inventory was taken, the magistrate agreed that Marco del Pecchia, the uncle, would be entitled to receive 7 *lire* and 10 *soldi* per year for providing food and support to each of the two minors, and that, in fact, five years later the magistrate agreed to adjust this sum retroactively to 9 *lire* on the basis of the evidence supplied by Marco.[144] It thus appears that a royal-size print by Marcantonio and Marco Dente's two-sheet masterpiece, only just completed, were respectively worth about twenty days, and two months, of maintenance of a contemporary Florentine bourgeois teenager. On a more serious note, the cost of a Marcantonio

312. Marco Dente, *Massacre of the Innocents*. Engraving (B.XIV.24.21), 410 × 585 mm. Albertina, Vienna.

print would equal the wages of a manual laborer for seven days; and that of Bandinelli's print, his wages for a little less than a month.[145]

A careful reading of the inventory sheds some additional light on the changing taste for prints, in that the list does not seem to include any impression from the plates by Francesco Rosselli himself. They are not mentioned separately, and they cannot be among the *quaderne* of ordinary prints because none of these includes sheets larger than a *foglio comune*. Moreover, no mention of value is made in relation to any one of his plates, nor to the workshop tools. The only indication that any value at all might be attached to the plates is in the last line of the inventory where the weight of copper is given. There can be no doubt that this inventory is an accurate assessment of the value of the goods in the workshop, since it was prepared for a magistrate in charge of protecting the interest of two minors and was compiled in the presence of Giovan Domenico Spadini, a *cartolaio*. It thus appears that Francesco Rosselli's impressive plates, which, as we have seen, must have made him a fortune, were only worth their scrap value twenty-five years after he patiently engraved them. Impressions of his prints were so unsalable that his own son had not one of them among the tens of thousands of prints in the shop. Popular imagery and low-value prints, such as woodcuts of religious subject matter, were represented in force in the shop; their sheer number makes it very unlikely that they were the *dernier cri* of fashion as well. The response of the public for whom such woodcuts were destined was necessarily less attuned to changes in the style of contemporary art, and no doubt Alessandro Rosselli had a good stock of images of St. Sebastian or St. Roch, some possibly pulled from blocks that were decades old, which would come in handy in case of a threat of plague. But the inventory of his shop suggests that those among his customers who might have been looking for engravings instead of woodcuts would have been much more demanding; they were not interested in images from the previous generation, but only in the newest and most fashionable prints by the greatest contemporary artists, and they were prepared to pay for them.

Some buyers must have been painters, as much interested in the *disegno* as in the mere pleasure of looking at the work of an admired designer or engraver. Savonarola used the print as an example in a sermon on the importance of the order in God's creation: "If a pupil has a print from the painter, which he has to paint, if he does not follow the order of that print the painter says: 'You have made a mistake.' So too God in his concerns wished to make a print so that whoever falls away from that order is at fault, and will be punished thereafter."[146] Apart from its metaphorical interest, this passage tells us that the nature and artistic function of the print was proverbial already by the close of the fifteenth century. But the message conveyed by prints became increasingly complex during the first half of the sixteenth century, and connoisseurs of the type we have described here began looking for *invenzione* as well in their prints.[147] It was for the delight of this group of buyers that prints offered obscure and mysterious subjects, puns, subtle allusions, and quotations from antique sources or contemporary literature. Dozens of interpretations have been offered by *intenditori* and scholars for the meaning of Marcantonio's so-called *Dream of Raphael* since the time it was made, but none has proven conclusive;[148] most of the small etchings and engravings this printmaker made in the second decade of the century have their subject matter still unexplained. In the privacy of their *studioli*, collectors like Vendramin and Sabba Castiglione could enjoy such complex images, exercising their wit in inventing interpretations. They could also delight in discovering the ingenuity of the artist who had found new ways for expressing sentiments and situations through the balance of composition, the placement of figures, facial expressions, and gestures.[149] When a print was the result of a collaboration between painter and engraver, we can infer that such subtleties were automatically attributed to the *invenzione* of the painter.

The private enjoyment of prints also helped proliferate another genre of images: the erotic, sometimes pornographic, subject.[150] The two best-known series of Renaissance erotic prints, the *Modi* and the *Loves of the Gods*, resulted from collaborations between some of the most distinguished practitioners of the time. Giulio Romano and Marcantonio made the first set, and Rosso, Perin del Vaga, and Caraglio the second. The involvement of such prominent artists is in itself an indication of the market level for which these prints were destined. Indeed, Vasari intimated that sets of the *Modi* had been found in places where one would never have expected them to be.[151] They certainly became the talk of the town very quickly, so much so that Ariosto felt compelled to refer to them in the prologue of the Roman edition of his comedy *I Suppositi*, published on 27 September 1524.[152] The passage is fairly obscure, based as it is on a play on words that must have been accompanied by telling gestures, a pun on "suppositions" in the sense of misunderstandings (the theme of the comedy) and on "superpositions," in the sense of the position of bodies disposed over other bodies. That this passage relates to the *Modi* is clear from the allusion to "Elephantide's lascivious pictures," the late-Alexandrine Kama Sutra,[153] and because the reference is fully explained in mid-century editions of the *I Suppositi*.[154] We know that in 1550 a print dealer bought as many as 250 sets of the copies of Caraglio's prints made by René Boyvin,[155] and there is no reason to believe that their prototypes, or the *Modi*, were available in smaller numbers. It

313. Marcantonio
Raimondi, *Woman with
Dildo*. Engraving,
141 × 70 mm.
Nationalmuseum,
Stockholm.

the 1460s and copied widely; there is hardly an engraving of this type by an Italian artist that was not mimicked somewhere in Germany or the Netherlands, and vice versa, within a few years from the date of its creation.[157]

It is a tribute to the efficiency of the Pope's power of suppression that the *Modi* were more or less stamped out in Rome. One set seems to have reached Venice, however, since it is likely that the set of woodcut copies of ca. 1527 was printed there.[158] These were accompanied by a series of exceedingly lewd sonnets by Aretino, who, on 9 November of that year, sent a gift of his "libro di sonetti e de le figure lussuriose" (book of sonnets and of the lascivious figures) to his friend Cesare Fregoso.[159] Aretino sent another copy to the surgeon Battista Zatti, accompanying it with a letter in which he argues that he composed the sonnets because he was moved by the "spirito che mosse Giulio Romano a disegnarle" (the spirit that moved Giulio Romano to create them) and also as a gesture of defiance against the hypocrisy of those who sing praises to creation but forget that sex is a basic requirement for it. The letter closes with a somewhat disconcerting hymn to the penis.[160] It is likely that a relatively large number of such prints have been lost over the centuries, destroyed in one of dozens of puritanical purges, whether under the auspices of a Swiss preacher, a Roman pope, or an English queen. It seems that the *Modi*, surviving in just nine small fragments of heads now in the British Museum, were not the only pornographic prints Marcantonio engraved, for there is also a fragment of a sexually explicit print by him in the Nationalmuseum of Stockholm (fig. 313).[161]

PRINT PUBLISHING IN ITALY

In our survey of Italian printmaking thus far, we have witnessed the birth and gradual evolution of two parallel trends in the publishing of prints: on the one hand, that of the printmaker acting as his own publisher; on the other, that of a professional book publisher or, in rare instances from about 1515, a professional print publisher taking over this side of the marketing of prints. In the case of most fifteenth- and early sixteenth-century printmakers, it is clear that they took care of the printing and selling of their wares. Some of the more enterprising among them, such as Giovanni Antonio da Brescia and Nicoletto da Modena, went further than marketing just their own prints: they acquired the plates of other printmakers, substituted their own signatures for those of the engravers of the plates, and sold these prints as their own. Just as Israel van Meckenem can be described as the first print publisher north of the Alps, Giovanni Antonio and Nicoletto can be designated the earliest in the south.

is possible that the *Loves of the Gods* had been produced, if not as direct competition to the *Modi*, as a response to the success Marcantonio's prints had obviously enjoyed. Since the *Modi* had been confiscated and Marcantonio jailed for having engraved them, one might assume it would not have been prudent to issue a similar set straight away. The fact that the *Loves of the Gods* could indeed be published so soon after the other set without incurring the wrath of the Pope shows that what had really offended the authorities was the explicit portrayal of sexual activity. Once this display had been toned down, by a few well-placed folds of drapery and less detailed descriptions of conjugal gymnastics in the beds of the ancient gods, and once some competent if mildly allusive verses had been inscribed on the plates, all was well. There are as many as five different sets of copies of the *Loves of the Gods*,[156] making this group of engravings one of the most successful series in the Renaissance. Prints of erotic subject matter had been produced in every printmaking center across Europe since

In Italy the birth of the role of the print publisher proper is more complex than in the north, and its seeds are found in two quite distinct traditions. The first is that of the traditional book publisher, who commissioned or at least took upon himself the financial responsibility of carrying out a project that involved, especially for an illustrated book, quite considerable investment in the materials used and in the wages of a number of specialized artists and craftsmen. The publisher's gain took the form of a short-term benefit generated by the cash flow from a sufficiently large first edition, and the long-term value of having both the title and the blocks as assets. The first edition would have to cover most if not all the costs of production, from the author's fee to the pay of the dozens of professionals involved and to the extremely high cost of paper.[162] Very few publishers had sufficient resources to cover all these expenses beforehand: many contracts survive to testify to the partnerships made between paper manufacturers, two, three, or even four or five publishers, and *librai* and *cartolai*, all taking shares in a particular book in exchange for the materials or skills each of them provided. Yet, in Italy the book would eventually appear with the imprint of only one of them, its original promoter.[163] It was, for instance, partly from the share they had in every single book produced in Padua in the fifteenth and sixteenth centuries — because of their absolute monopoly on paper used there — that the Cornaro family made their enormous fortune.[164]

The publisher also had to be concerned with the lasting value of his investment, represented by the title and contents of his books, by the workshop materials such as fonts and presses, and by the woodblocks used in his illustrated books. While his materials could be physically protected from damage, the protection of a copyright was a much greater headache: piracy from other publishers, as we have seen, was a problem of enormous scale throughout the Renaissance, and was fought from an early age by issuing a book publisher protection in the form of a privilege. This, however, had very little effect outside the territory of the city or state in which it had been issued, and the copying and pirating of books from other centers was a common event. When prints in Italy began to fall within the commercial territory of book publishers, as they had done in the north, the rules and customs of this trade were naturally applied to the publishing of prints as well, a condition that strongly informed the profile of the emerging professional print publisher.

The second force that greatly influenced the birth of professional print publishing in Italy was the increasing awareness among artists at the beginning of the sixteenth century of the importance, and therefore the market value, of their ideas, that is to say of their *invenzione* and *disegno*. The consequence of this attitude, when related to prints, was the extension of the proprietary rights of the artist from the drawing to the prints made in collaboration with the engraver or block cutter. As long as the product of this collaboration was numerically small, as in the case of Parmigianino and Antonio da Trento, Rosso and Caraglio, and possibly Titian and Ugo da Carpi, it was easy for the artist to keep some control over the publishing of the prints, and therefore over the spread of his inventions. When, as in the obvious case of Raphael, the size of the operation became such that the artist himself was unable to manage it personally and delegated it to somebody else, this latter figure in due course inevitably turned himself into a professional print publisher.

When il Baviera took complete charge of the print publishing of Raphael's workshop, he had no other example to follow than that established by book publishers, and the two traditions we have mentioned naturally fused themselves in the new role of the professional print publisher. For the first time in the history of printmaking, it was neither the initiative of a *peintre-graveur* nor a partnership between an artist and a professional engraver or cutter that created a print, but rather a third party who commissioned a part of the job from each specialist independently. Il Baviera apparently controlled more and more closely the use of Raphael's drawings destined for prints, and almost certainly had ultimate responsibility for putting together the designers and the engravers. As a result, also for the first time, a publisher held on to the plates, initially on behalf of Raphael and later almost certainly on his own behalf, thus becoming the first professional print publisher, and setting the example. Il Baviera's suffocating and unprecedented stronghold on plates by Marcantonio, Agostino Veneziano, and Marco Dente da Ravenna resulted in the outcome we could expect from similar experience in the book publishing trade, that is, the pirating of the plates and the introduction of privileges into the world of printmaking.

It was an established practice for Venetian book publishers of the late fifteenth century to protect their rights with a privilege, and the Senate, well aware of the increasing value to its coffers of the publishing trade in the city, was eager for a time to please them.[165] Soon publishers started including their woodcut illustrations in their applications for copyright: in 1498 Antonio Zanoti applied to the Senate for a privilege to publish several *officieti e mexali*, and went on to specify that "le qual dite opere vuole fare tute istoriade cum frixi et figure et in miniadure in desegno, facte de intajo," that is, that he intended to decorate these books with friezes and images drawn in illumination, made by incising. The confusion in the terminology derived from the formulas used until then in such applications to the authorities, formulas which referred to printed books with illuminated and not printed

299

illustrations.[166] The first privilege that appears to have been granted for an independent print was given to Anton Kolb on 30 October 1500 for Jacopo de' Barbari's *View of Venice*. This copyright was to last four years, a period of time apparently deemed sufficient to allow the publisher to sell enough impressions of the giant mural woodcut to recover the exceptional costs he claimed to have incurred in producing it. In this case, the Senate also agreed to waive all taxes deriving from his selling impressions of the prints in the Dominio Veneto at a specified price of three ducats each.[167] Really surprising is that no mention of the privilege is found on the print itself; this is at variance with the contemporary custom for Venetian books, and must mean that the publisher was sufficiently confident that no one within the territory of the Venetian state would actually attempt to pirate this vast print, and that he applied for the privilege merely to protect himself in such an unlikely case.

As the fashion for large woodcuts in Venice grew, Kolb's example was followed by many other publishers, large and small. On 30 March 1504, for instance, the miniaturist Benedetto Bordon was granted a ten-year privilege for a twelve-block woodcut frieze of the *Triumph of Caesar*. His application is particularly interesting because Bordon states that he had drawn the images himself onto the woodblocks and that he had commissioned the cutting of the blocks. It is also worth remarking that the reasons for which the miniaturist argues he deserves to obtain a privilege are not only to be protected while recovering the large costs he had incurred, but also to pay for the labor of his notable invention (la fatica habuta per tale inventione notabile).[168] It is, again, surprising that no mention of the privilege is found on the print. Less unexpected is the omission of the name of the cutter, Jacobus Argentoratensis, since Jacopo de' Barbari's name does not appear on the *View of Venice* either, although, as we have noted, the figure of Mercury there may allude to his authorship. The circumstances are analogous but obviously not quite the same, as de' Barbari was the designer for Kolb, and Jacob of Strasbourg the cutter for Bordon. But the relevant common denominator is the fact that, albeit at the two ends of the spectrum insofar as the size of their publishing ventures was concerned, the two entrepreneurs were the ones who applied for and were granted the privileges, and who were thus establishing their rights to the ownership not only of the blocks but of the resulting images, regardless of who had designed or cut them. Ugo da Carpi, who, as we know, was granted a privilege in 1516 for his chiaroscuro woodcuts — calling himself "intagliador de figure de legno" (cutter of woodblocks) — was probably marketing his prints independently, since he applied to the Senate under his own name.[169]

The increasingly important role of publishers

was not likely to please cutters, let alone designers, for long. In fact, an impression of the *Triumph*, once seen by Heinecken but untraced since, bore an inscription attributing the publishing of the print to Jacob of Strasbourg: it could have been a pirated copy, or the result of a later agreement between cutter and designer.[170] We know of many applications for privileges by a number of Venetian publishers during the first twenty years of the century. Some were granted to designers turned publishers, such as Giovanni da Brescia, and some to well-known book publishers turned print publishers, such as Bernardino Benalio or the brothers de Gregori.[171] Some applied for one print at a time, some for many; some asked for protection for as long as ten years, some for shorter periods.[172] But it was probably not until 1515 that any mention of a privilege appeared on a single-leaf woodcut, and it is extremely interesting that this happened in the case of the first such woodcut in Venice in which the names of the cutter and the publisher appeared together, the *Sacrifice of Abraham*, presumably drawn by Giulio Campagnola and cut by Ugo da Carpi.[173] The inscription in the tablet reads:

> In Venetia per Ugo da carpi
> Stampata per Bernardino
> benalio; Cū privilegio [con]cesso
> per lo Illustrissimo Senato.
> Sul cāpo de san Stephano.

The situation seems to have changed since the events discussed above, because, although it was Benalio who held the privilege, it was Ugo, the cutter, who is mentioned first on the print. The balance is redressed, however, by the appearance of the address of the publisher, in Campo Santo Stefano, another first in the history of Italian printmaking. It is obvious that the address was meant to encourage customers to go there and buy impressions of the print, making it the first print shop we know ever to have been advertised on a print.

This tablet set a precedent that was quickly followed by most other publishers in the city and then outside it both north and south of the Alps. Titian's woodcuts of the *Triumph of Christ* and the *Virgin and Child with St. John the Baptist and St. Gregory the Great*, both published by Gregorio de Gregoriis in 1517, were inscribed with the first mention ever on a print, as far as we can ascertain, of the word *excudit*, albeit in a slightly different form: "Gregorius de gregoriis excusit." It is very likely that this term came to printmaking from the art of intarsia — which had such influence on the birth of woodcutting in Italy —[174] where it was conventionally used. There is, for instance, a self-portrait by Antonio Barili, once part of the decoration of the stalls of the Chapel of St. John in the Cathedral of Siena, which is inscribed HOC EGO ANTONIUS BARILIS OPUS COELO NON PENICELLO EXCUSSI AN. DN .MCCCCII. (This work I Antonio

Barili created with the scalpel not with the brush, 1502).[175] When Lucantonio degli Uberti pirated the *Triumph of Christ*, he reverted to the formula normally used in books, though adapted to resemble Antonio Pollaiuolo's one example. The tablet reads: "Opus Luce Antonii R[?]/ ubertii i venetiis ipreso."[176] None of these prints bears the name of the designer, and the attribution of some of them is therefore still disputed. The first print to correct this state of affairs, and indeed to set a trend that would last for centuries, is the *St. Jerome* signed by Titian and Ugo da Carpi, probably the earliest known example of an Italian chiaroscuro woodcut, and furthermore the first woodcut for which the *invenzione* is manifestly attributable to a painter of repute. We have discussed the importance of this step towards collaboration in our reconstruction of the relationship between designers and cutters and its parallel with the relations between painters and engravers.[177]

During the first half of the century many of the prominent book publishers of Venice turned to print production from time to time, including the brothers de Jesu, Francesco Marcolini, and the brothers Michele and Francesco Tramezzini, who also had a subsidiary in Rome. Marcolini was praised by Aretino, in the *Cortigiana*, also as a cutter,[178] and may have been the first Italian publisher to have made a self-portrait in a woodcut.[179] Between 1500 and 1529, when his shop and its stock went up in flames,[180] Benalio seems to have devoted an increasing amount of his time to the production of prints rather than books, since the number of books with his imprint decreased every year, while his applications to the Senate for print privileges are more numerous than for almost any other Venetian book publisher.[181] This was the top end of the market. Little documentation has survived about the production of cheap, popular prints — now much rarer than Titian's woodcuts — but one should not forget that they did exist. At the same time as Benalio was asking privileges for his prints we find, a few hundred yards away a "donna margarita, relitta da Cosma da Modena, la qual stampa santi" (Donna Margarita, widow of Cosma from Modena, who prints images of saints).[182] The earlier practice of making simple images at low cost clearly persisted.

There is a specific reason why Ugo da Carpi applied for the copyright for chiaroscuro woodcuts in 1516: German examples by Cranach, Burgkmair, or Baldung must have arrived in Venice at just the time Ugo was working on his project and when other cutters were starting to experiment with color woodcuts by imitating the northern prints.[183] When Ugo went to Rome before 1518 and set himself up as a woodcut maker and publisher, he brought with him the conventions of the Venetian printmaking community. As discussed elsewhere, his prints appear to be the first images

to be given the protection of a privilege by the Pope, and are inscribed at length with the penalties incurred by transgressors of the copyright.[184] They also carry the privilege obtained from the Venetian Senate, and must have been among the most frequently protected prints in the Renaissance.[185] Although the first two books printed in Italy appeared in the Roman territories (in 1465 and 1467), Rome had been slower than Venice in realizing the potential of the trade in book publishing. As early as 1469 the Venetian Consiglio issued the first privilege ever granted to an Italian printer: they were so impressed with Johannes de Spira's first two books that they decreed he would be the sole printer allowed to publish books in Venice for five years.[186] The wording of the minutes of the Consiglio explains in plain terms what was to become the Senate's policy on book printing for a long time to come: "tale inventum, aetatis nostrae peculiare et proprium...omni favore et ope fovendum atque agendum est" (this invention, so different and special to our age, should be encouraged and nourished with any possible help and action).[187]

By the end of the fifteenth century, Venice was the pre-eminent publishing center in Europe, with more than 3,750 *incunabula* to her name.[188] It was natural that a government of merchants, such as that of Venice, would be quicker than the Roman Curia in devising strategies to protect such an enormous source of revenue. The first privilege granted to an author was given in 1486 to Marco Antonio Coccio da Vicovaro, called il Sabellico, for a history of Venice,[189] and the first granted for a print was that protecting Jacopo de' Barbari's magnificent *View* of the city.[190] During the first decade of the new century almost every book and print published in Venice was thus covered by a copyright. In due course the situation got so out of hand — with publishers and authors applying for privileges "just in case," with no real intention of actually publishing the protected work — that on 1 August 1517 the Senate decreed that all privileges granted hitherto were being revoked, and that privileges would from then on be granted only for new books (and, one assumes, new prints, since all documents relating to woodcuts are worded in exactly the same manner as they are in the case of books), and only by a two-thirds majority in a sitting with a quorum of 150 senators.[191] As we know, this did not deter the publishers of single-leaf woodcuts, who continued to apply for privileges to protect their prints. To avoid lengthening unwittingly the period of copyright, in 1534 the Senate decided that works for which a privilege had been granted would lose such protection if not printed within a year.[192] In the meantime in Rome the issue of privileges had suddenly been brought to the attention of Leo X when it was discovered in 1515 that the Milanese publisher Alessandro Minuziano had found a loophole in the privilege granted to

314. Nicolas Beatrizet, *Portrait of Antonio Salamanca*. Engraving (B.XV.243.6), 196 × 135 mm. British Museum, London.

Filippo Beroaldo for his *Storie*. Minuziano did not copy the whole book once it had appeared, but page after page (obtained illegally) while it was being printed. The main reason the Pope was so exceedingly angry was that he had paid the vast sum of 500 ducats for the manuscript.[193] These events explain why the wording of papal privileges inscribed on the prints by Ugo da Carpi in 1518 is so extraordinarily sweeping, threatening as it does immediate excommunication for anyone daring to challenge it. This was the only way for the Pope to extend the protection of the copyright outside the territories controlled by Rome to the whole of the Christian world. Yet privileges continued to be issued for prints less frequently in Rome than in Venice. It is not clear whether the set of *Capitals, Entablatures, and Bases of Columns* (B.XIV.382.525–33), engraved by Agostino Veneziano in 1528, was protected by a Venetian or a Roman privilege, but because of the Sack of 1527, it is much more likely to have been Venetian. All the plates carry the inscription "Cautum sit ne aliquis imprimat ut in privilegio constat" (Beware not to copy as it is covered by a privilege). Agostino himself copied the entire set in 1536, after he had moved back to Rome, but in this second set there is no mention of a privilege. As far as we are aware, no print was granted a privilege from the authorities of Rome and Venice at the same time.[194]

To go back, however, to Ugo da Carpi's Roman woodcuts, these are of further interest to us in that their inscriptions make it clear they were printed in Ugo's shop: "Rome.Apud.Vgvm.de.Carpi.inpressam."[195] Since Ugo was copying prints by the leading engravers of the day, in open competition with il Baviera, it is somewhat curious that il Baviera never sought to reaffirm his position by inscribing his name on the prints he published, something he might have wanted to do particularly after Raphael's death in 1520. Il Baviera's anonymity, only breached by Vasari's revelations, may have been exactly what Raphael had stipulated in order to keep sufficient control of those prints that were spreading the novelty of his *invenzioni* and *disegni* to the world.

It is, however, only within the Roman territory presumably controlled by il Baviera that such anonymity persisted, applying, as we have seen, not only to the publisher himself, but, to some extent, to the engravers employed by him. Outside Raphael's circle, engravers freely and conspicuously signed their prints; this served not only to spread their fame, but also to let their potential customers know where their prints were available. Caraglio, for instance, monogrammed or signed most of his work, and it is likely that he sold it himself, since not one of his prints bears the name of a publisher. Some were active as print publishers possibly as early as the mid-1520s. Antonio Labacco, from Vercelli, had published his *Libro . . . appartenente*

all'Architettura . . . already in 1522,[196] and was recorded as having a *bottega* in Campo Marzio in 1526 and 1527.[197] Labacco was one of the founders of the association of the Virtuosi del Pantheon; he was a book publisher and also a publisher of architectural prints.

On 13 June 1546 Labacco introduced to the Virtuosi another publisher whose production would become known to all with an interest in prints: Antonio Salamanca. Despite the wide familiarity of his name, a result of the fact that he inscribed it on all of his published plates, Salamanca remains one of the most mysterious historical figures in our story. The established facts about his publishing career are few, even though it made him a fortune.[198] He was the first print publisher to commission an engraved portrait of himself, indeed one of remarkable frankness (fig. 314). By 1527 he had a shop as *libraro* in Campo dei Fiori, in a large building that he owned and where he employed eight people.[199] The earliest print with a date that appears to be contemporary with the inscription of the Salamanca *excudit* is inscribed 1538 — that is to say, a case where the date does not refer to the engraving of a plate bought at a later stage by the publisher. The latest example is 1554.[200] On 20 December 1553 he entered into a partnership with the much younger Antonio Lafrery; this was a complete merger of the business, although not of the ownership, of their two shops, and apparently resulted not only in a sharp decline in Salamanca's

activity but in a conspicuous flourishing of Laf-rery's.[201] Salamanca died in August or September 1562, and his activity was continued by his son Francesco, who availed himself of a clause in the 1553 contract between his father and Lafrery in order to split up the partnership and regain full possession of his father's original stock of plates, tools, and prints.[202] Although Antonio Salamanca is said to be Milanese,[203] his name clearly indicates a Spanish origin. In fact, it is almost certain that he can be identified with the printer Antonio Martinez de Salamanca, active in the Rome book trade since at least 1519, and publisher of a number of Spanish books in the 1520s.[204] There is also an interesting mention of a "Marco Antonio qm Cosalvo Martinez di Salamanca, libraio in Campo de Fiori" in a document of 5 December 1546 in which he is said to have sold a "vigna fuori Porta Portese."[205] The acquisition of a *vigna* or vineyard was a common shortcut for acquiring Roman citizenship, as it demonstrated possession of tangible assets in Rome or its territories at a much cheaper cost than a house in the city would have done, and thus was used by many printers and publishers when they first settled in Rome. In this context it is worth pointing out that at the time most publishers in Rome, whether of books or prints, were foreigners, generally from northern Italy or Germany. Their monopoly was very much resented by the locals.[206]

In the absence of fuller documentary evidence about Salamanca's early activity as a book and print publisher, we must turn to the prints in order to attempt a reconstruction of his career. We have collated about 190 prints that bear his name as publisher, but fewer than thirty of these have any likelihood of having been engraved at the same time as their *excudit*, that is to say, of having been commissioned by Salamanca himself: two from Agostino Veneziano, four from Bonasone, five from Enea Vico, seven from Beatrizet, and the rest from engravers who did not leave their signature on the plates. It is possible that these anonymous prints are among those he published during the period between his first appearance in documents, 1519, and his first dated print, 1538. Salamanca therefore acquired from others the vast majority (85 percent) of the prints bearing his *excudit*; and the inscription with his name appears only in the second or later states of such prints. Since as many as ninety-three are among those plates that we believe must have been commissioned by il Baviera from Marcantonio, Agostino Veneziano, and Marco Dente, it seems very likely that Salamanca bought, if not all il Baviera's stock, at least the main part of it, including all the most famous images, from the *Quos Ego* to the *Judgment of Paris*. He also bought about forty plates from the so-called Master of the Die, and twelve from Enea Vico. There are two main types of address on these prints, the first an extended version normally engraved in beautiful

Roman lettering, the second a contracted *Ant. Sal. exc.* in italics. It is possible that the latter form, which generally appears on very worn impressions, refers to another Antonio Salamanca — possibly a younger brother or cousin of Francesco — who was active in 1567.[207] If he belonged to the same family, this would not alter our calculations, since he likely would have acquired the plates from his distinguished namesake.

An analysis of the subject matter of the prints Salamanca either commissioned or acquired sheds some light on the type of market he was attempting to satisfy. Although he was operating in the cradle of Christendom, only 19 percent of the prints issued with his name were of religious subjects, a per-centage that drops even further if one eliminates those which were obviously intended as repro-ductions of famous religious paintings rather than as devotional images in themselves. As many as 55 percent of his plates, on the other hand, were depictions of episodes from ancient history and mythology, and 26 percent were prints of archi-tectural or ornamental subject matter. Such a break-down speaks for itself: the customers who were expected in the *bottega* in the Campo dei Fiori were not the pilgrims, but rather those who were familiar with Greek and Roman history and myth, together with painters, collectors, and scholars in-terested in the historical remains found in such abundance all over the city.

We do not really know what the relationship was between Salamanca and the printmakers of his time, but the statistics mentioned above seem to suggest that he would rather have bought an old plate to freshen than commission a new one, poss-ibly because the former solution was the cheaper. When he did ask engravers to produce a plate for him, he did not consistently go to the best; almost half of his commissions were carried out by en-gravers who did not sign their plates, and who were not very good. Apart from his acquisition of earlier plates, possibly from il Baviera and possibly in bulk, all his secondhand plates appear to have come from only two sources: the Master of the Die, from whom he bought at least forty plates (he could have bought them from the Master's heirs), and Enea Vico, with whom he must have had a closer re-lationship, since he commissioned five plates from him and bought twelve. The overall picture is that of a print publisher playing safe with old, established images, some of which had been en-graved twenty years before. The few prints he commissioned from contemporaries were unadven-turous as well, being mostly of Roman architecture and ornamental details. While not too concerned about intervening on the plates to freshen them up, he appears to have been uninterested in pirating other engravers' or publishers' work. We have found only a handful of copies with his imprint, and there seems to be some explanation for the

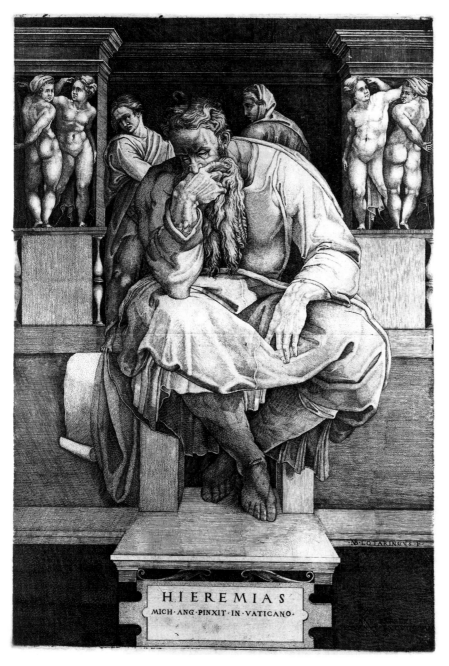

most of his activity, and in particular his greater successes and influence, occurred after the middle of the century, a date that we have not chosen arbitrarily as the end of the period discussed here. It was precisely at this time that the perception of prints started changing considerably in the minds of those who bought them, both in Italy and north of the Alps. There is a wealth of documentation relating to Lafrery's late activity, when he not only produced one of the most influential collections of prints ever published, the *Speculum Romanae Magnificentiae*, but also published the first known print catalogue, which appeared sometime after 1572.[209] Yet, though some of the engravings he included in the *Speculum* and a few of the prints listed in his catalogue were made before 1550, the vast majority were not, and it would therefore be wrong to discuss them here.

Given the dearth of documentary evidence for Lafrery's earlier activity, we must, again, turn to the prints themselves. There are fewer than a dozen with Lafrery's *excudit* dated before 1550, although a number of undated ones can be safely assumed to have been published by him during that time, bringing the total to somewhere near thirty. The majority of these plates appear to have been engraved by Nicolas Beatrizet, a not altogether surprising association, since they were both recent French settlers in Rome. There are only two prints by the Master of the Die carrying Lafrery's address in their first state, suggesting that this engraver must have still been active when the publisher began working in Rome; surprisingly, there are no prints by Giulio Bonasone or Enea Vico. On the other hand, Lafrery seems to have acquired at least four plates from the Master of the Die or his estate, two from Bonasone, three from Vico, and at least another nine from Beatrizet, although two of these first passed through the hands of Tommaso Barlacchi, yet another publisher active in the 1540s. Lafrery thus seems to have been still more active as a publisher than Salamanca, for he commissioned at least as many plates as he bought secondhand.

Although some 30 percent of the plates Lafrery published were of religious subject matter, a higher percentage than in Salamanca's repertoire, many were examples of what can properly be described as "reproductive" prints. An engraving such as the *Prophet Jeremiah* (fig. 315) is indeed a print of a "religious subject," but it is highly unlikely that it was bought principally for this reason. The buyer of such an image would be interested in it as a faithful rendition of a detail from Michelangelo's fresco in the Sistine Chapel. Its prominent inscription is an unequivocal confirmation of the raison d'être of the plate: MICH.ANG.PINXIT.IN.VATICANO. Both the signature of Beatrizet and the *excudit* of Lafrery are engraved in beautiful lettering, albeit in more discreet areas of the image. By this means a customer would know where to find another im-

315. Nicolas Beatrizet, *Prophet Jeremiah.* Engraving (B.XV.244.10), 427 × 292 mm. Rijksmuseum, Amsterdam.

existence of each of these. Obviously, he could have published all the copies without his *excudit*, but this would have been an exception at the time. In short, Salamanca was an honest and cautious print publisher, who rode the fashion for everything to do with antiquity rather than contributed, at least consciously, to create it. The inscription under his portrait by Beatrizet (fig. 314) could not be more telling: "Antonio Salamanca, who depicted the antiquities of Rome and the world" (Antonius Salamanca orbis et Urbis antiquitatum imitator).

Antonio Lafrery was, on the other hand, one of the most influential print publishers of the sixteenth century, and his *bottega* in Via del Parione was the center of the Roman print world from ca. 1544 to 1577.[208] As these dates suggest, however,

pression and what engraver to look out for if he wanted good reproductions of the best paintings in Rome. Lafrery devoted an increasing amount of his time and effort to this unexpectedly rich vein of printmaking, which reached one of its marketing peaks with the publication of the *Peter Walking on Water* (B.XV.246.16), a print whose inscription we have discussed at length elsewhere.

Lafrery's interest in paintings and frescoes by recent and contemporary masters swiftly broadened to include antique statues, monuments, and ruins. It was Lafrery's enterprise that met the rapidly increasing demand for such subjects.[210] Antique statuary was a central part of artistic culture in sixteenth-century Rome. Yet, with very few exceptions, it was not until the advent of Lafrery that engravers turned to antiquities as suitable subjects in themselves. As Borea has pointed out, most of the engravings made after the antique in Rome during the first fifty years or so of the century were interpretations rather than reproductions of ancient sculpture.[211] Borea's comparative survey of representations of the statue of Marcus Aurelius (fig. 317) by Nicoletto da Modena, Marcantonio, and Marcello Fogolino illustrates how differently these printmakers charged their subject matter. Although all three are intended to convey certain information about the whereabouts and general appearance of the sculpture, they in no way attempt to reproduce it. Nicoletto was probably the earliest of the three to tackle the subject. He set the statue in an obviously invented, enclosed space and provided it with a fanciful, decorated marble base, which he nevertheless inscribed in his own words and with antiquarian zeal: QUESTO EL CAVALLO QHESTA A SATO IANNI I ROMA (This is the horse that is in San Giovanni in Rome; fig. 318).[212] Yet, for all his undoubted admiration for the statue, Nicoletto did not bother to get any of its details right, even mistaking the position of the left rear hoof. Marcantonio must have engraved his version soon after settling in Rome. It is much closer to the original, although the engraver embellished some particulars, such as the arrangement of the mane and the decoration of the saddlecloth (fig. 319). Furthermore, for visual effect he set the statue before a darkened wall, rendering an image that looks more like marble than bronze. Marcantonio indulged in such improvisation; for example, in 1506 he went to the extreme of bringing an antique statue to "life" by showing Apollo throwing his arm around Hyacinthus's shoulders against a naturalistic backdrop while at the same time treating the god as a piece of sculpture missing parts of its genitals (fig. 316).[213] In sharp contrast is Fogolino's completely "naturalistic" interpretation of the subject (fig. 320).[214] His horse does not resemble marble, like Marcantonio's — it is made of flesh! We cannot be sure whether Fogolino ever went to Rome or whether he merely used a drawing by his fellow citizen Giovanni da Udine.[215] But obviously he had no intention of conveying anything but the vigor and liveliness of the famous sculpture.

Marco Dente, on the other hand, provided his customers with a more reliable depiction of the *Marcus Aurelius* (fig. 321). Not only are most of the details accurate, but the inscription supplies the fullest information yet, including the fact that the sculpture is made of bronze. Its base is shaped in such a curious way under the front legs of the horse that it might in fact be a realistic depiction of how it looked at the time. The setting, on the other hand, is obviously fanciful. The degree of appropriation is more restrained than in the other three examples, and correponds to Marco's more attentive approach to sculpture in general.[216] When he portrayed the *Laocoon* (B.XIV.268.353), Marco carefully recorded the broken and unrestored arms and fingers, and yet took the liberty of enlivening the expressions of the figures by outlining them in strong light and shadow. In this case the engraver remains true to archaeological detail but free to interpret emotional content.[217]

The transformation that occurred over the first fifty years of the century is well illustrated by comparing Marcantonio's image of 1506 and Beatrizet's genuine reproduction of the *Marcus Aurelius* of 1548 (fig. 322). In Beatrizet's rendition every detail is intended to convey the actual appearance of the statue, including the shape of the marble base on which it was placed in 1538, and the exact wording of its inscription. The printmaker's own words and signature are engraved *outside* the subject, and supply all the information needed by the

316. Marcantonio Raimondi, *Apollo and Hyacinthus*. Engraving (B.XIV.260.348), 296 × 224 mm. British Museum, London.

317. *Marcus Aurelius.*
Bronze, height 4240 mm.
Piazza del Campidoglio,
Rome.

318. Nicoletto da
Modena, *Marcus Aurelius.*
Engraving (H.V.120.31),
210 × 145 mm. Albertina,
Vienna.

319. Marcantonio
Raimondi, *Marcus Aurelius.*
Engraving (B.XIV.375.514),
210 × 144 mm. Albertina,
Vienna.

antiquarian — title, medium, location, publisher, year. Moreover, the setting is not naturalistic but simply a white background; it is treated clinically, but as a work of art in its own right. The print effectively becomes a document of the monument.

It is no coincidence that the word *sculpsit*[218] came into use by printmakers only in the 1550s, and that the choice of term resonates with the interest in antiquities that swept across print publishing at the time. The first generation of Marcantonio, Agostino Veneziano, and Marco Dente never employed this term,[219] and we find its first dated appearance on two prints of 1538 and 1540 by Giovanni Battista Scultori,[220] although it is most likely that the *sculptor* is here an allusion to the engraver's surname rather than to his activity. Perhaps Scultori's example inspired Enea Vico to adopt the term, which he did more than once after 1550. He may have used it as early as 1541,[221] a particularly significant year in his long-standing interest in statuary, when he was commissioned by Cardinal della Valle to make prints after three pieces of antique sculpture from della Valle's famous collection.[222] If Vico initiated the fashion for using the verb *sculptere* in relation to prints — a term

306

which certainly afforded a dignified connotation to engraving — it was quickly adopted by printmakers working within and without Rome.

Lafrery soon recognized the enormous potential in supplying collectors all over Europe with reproductions of the sculpture of antiquity. Particularly after ca. 1550 Lafrery published copiously in this area, employing all the best engravers working in Rome at the time. The inscriptions on these prints became increasingly descriptive, providing details not only about the statues depicted, but also about the collections to which they belonged. For this reason, prints such as *Rome Triumphant with Two Barbarian Kings* (fig. 323) cannot have been aimed at artists and craftsmen alone. Detailed information about the whereabouts, significance, and meaning of the statues was not of primary interest to them. The abundance of inscriptions in these prints was intended more for those knowledgeable in Roman history and mythology and eager to adorn their libraries or *studioli* with the vestiges of antiquity. Seventy percent of all Lafrery's print publishing went to satisfy such custom.

We have found little evidence of any real competition between Salamanca and Lafrery, and their

320. Marcello Fogolino, *Marcus Aurelius.* Engraving (H.V.218.3), 199 × 152 mm. Staatliche Kunstsammlungen, Dresden.

321. Marco Dente, *Marcus Aurelius.* Engraving (B.XIV.376.515), 337 × 229 mm. British Museum, London.

322. Nicolas Beatrizet, *Marcus Aurelius.* Engraving (B.XV.263.87), 360 × 243 mm. Albertina, Vienna.

professional profiles, as they emerge from a survey of their print production, confirm that their activities hardly overlapped. But Lafrery, younger, more aggressive, and patently devoted to cornering the market for reproductive prints and prints after the antique, was too great a challenge, and thus the tranquil Salamanca gave in by merging his shop with Lafrery's. Salamanca, a publisher of the old school, had been brought up in the tradition of book publishing, and was obviously increasingly uneasy about the amount of competition he was facing in what had once been his exclusive territory. The sudden fashion for prints in the 1540s also encouraged a number of other publishers to enter the market and compete with him. Tommaso Barlacchi, for instance, published more than thirty plates between about 1541 and 1550, all commissioned from the best engravers working at the time — Bonasone, Beatrizet, and Vico. Furthermore, Hieronymus Cock of Antwerp was probably in Rome between 1546 and 1548 as well.[223]

Moreover, some of the leading engravers also began to set themselves up as independent publishers, and therefore as competitors to their previous employers. Enea Vico, as we have seen, had been happy to collaborate with a number of publishers over the years, but was now issuing most of his large sets of fashionable architectural and ornamental prints, and his famous portraits, on his own. He even safeguarded himself against possible pirating by applying for privileges. Although he obviously had no difficulty in obtaining a protection from the Venetian Senate, he seems to have encountered some difficulties with the Roman authorities. Their reluctance to grant him a copyright resulted rather incongruously in a ten-year privilege from the Venetian Senate to Parma's foremost engraver for a view of one of Rome's most celebrated landmarks, the Colosseum (B.XV.349.419), the print itself dedicated to the Florentine Cosimo de' Medici. It is possibly Vico's example that revived the use of privileges outside Venice. Bonasone succeeded in securing a privilege for his *Last Judgment* after Michelangelo (B.XV.132.80), and Beatrizet for an entire group of prints, mostly, however, engraved soon after 1550.[224] During these years, around 1550, Beatrizet — who, as we have seen, had been a steady collaborator of Lafrery's for some time — seems to have begun acting as his own publisher. Several of his most ambitious prints bear the proud inscription *formis suis*, a clear indication that the plates belonged to him and were printed in his *bottega*. For some of these he succeeded in securing the protection of the papal privilege. However, it is ironic that Michele Lucchese, a mediocre printmaker cum publisher whose activity started around 1550, also obtained a papal privilege for his dreadful copies of Marcantonio's *Massacre of the Innocents* and *Martyrdom of St. Lawrence*.[225]

In France, the first privilege for a set of prints was granted by Henry II in 1556, and for a single sheet in 1559.[226] This departure may have been the result of the sudden revival of French printmaking at the time. There had been very little printmaking in France during the first forty years of the sixteenth century, and what prints had been published were mostly made in connection with the flourishing trade in illustrated books.[227] This, however, produced no outstanding designers of woodcuts, certainly none of the stature of Titian, Parmigianino, or Beccafumi in Italy or Dürer, Baldung, or Cranach in Germany. Engraving and etching were not practiced on any scale comparable to that in the major printmaking centers in Italy, Germany, or the Low Countries either, nor had there been any artist of talent in France who had turned his attention to printmaking.

The situation changed radically, and abruptly, in about 1542, when a considerable number of prints were produced at Fontainebleau in a burst of activity that subsided almost as suddenly around 1548.[228] The creation of a school of printmaking in

323. Nicolas Beatrizet, *Rome Triumphant with Two Barbarian Kings.* Engraving (B.XV.264.89), 485 × 385 mm. British Museum, London.

308

a province is in itself an unparalleled phenomenon during the sixteenth century, but what makes this case even more interesting is the shape it took. A short-lived experiment, such as at Fontainebleau, can have many possible explanations, such as the arrival of an ambitious printmaker or publisher, or the whim of the king or of another powerful patron. In this case, it was probably the influence of Primaticcio, the artist who had succeeded Rosso to direct the entire enterprise of the decoration of the palace.[229] Primaticcio had just returned from a trip to Italy and must have been inspired by what he had seen there. What is extraordinary is Primaticcio's realization that prints were the best means for establishing and recording the artistic advances made under his guidance at Fontainebleau. Primaticcio obviously understood that Raphael, Parmigianino, and Titian had used prints to establish their respective contributions in a way that could be easily grasped, immediately used, and greatly enjoyed by fellow artists and admirers elsewhere. Advances in *invenzione* and *disegno* no longer needed to be confined to those privileged enough to commission a canvas or a fresco, or to those admitted to the exclusive chambers where such masterpieces were placed. Now these inventions could travel everywhere in a barrel. The prints of the school of Fontainebleau became the only way for Primaticcio and his collaborators to communicate to the rest of the world, and particularly to their Italian colleagues, that even in such a distant outpost as this small town in France, a new, heroic style was born.

That only prints could transmit such a complex message so simply was something an entire generation was discovering at the same time — in the early to mid-1540s — everywhere else in Europe. What is even more fascinating about the experiment at Fontainebleau is that it did not quite work because it was just slightly premature. Primaticcio was a passionate admirer of Parmigianino's work and must have been bewildered by his etchings, produced, we must not forget, just before 1540, when Primaticcio had gone on his artistic fact-finding mission in Italy. When he came to set up his own il Baviera-like operation at Fontainebleau, the obvious inspiration, as far as the way his prints would look, could only have been Parmigianino's vibrant etched plates, certainly not Enea Vico's contrived imitations of Marcantonio's engravings. And in that choice lay the seed for the eventual failure of the enterprise only five or six years later.

Taste had changed, and the market for prints was widening to include different echelons of the public not interested in the imaginative recording of new artistic expression as could be represented in an experimental etching by the Master LD, full of adventurous lighting devices and daring chiaroscuro, but also defaced by the spots of foul biting and incompetent printing (fig. 324). By then, what the market seemed to have grown to appreci-

324. Master LD, *Female Nude Standing*. Etching, 227 × 143 mm. Bibliothèque Nationale, Paris.

ate and was willing to purchase were the highly finished textures of Beatrizet's engravings, which could reproduce any change of tone in a painted surface with the greatest faithfulness. Most buyers were not interested in discovering the essence of a great artist through a print made by the master himself or in collaboration with an engraver or woodcut maker; clients now wanted as close a reproduction of the master's monumental work as a black-and-white image could produce. For that purpose, etching, at least as practiced at the time, was inadequate. It comes as no surprise that soon after the disappearance of the school of Fontainebleau, the school of Parisian engraving was born, under the impulse of such proficient but ultimately uninspired *burinistes* as Milan and Boyvin. It comes as even less of a surprise to discover that it immediately flourished, and that by 1556 there was also a need for granting privileges for prints in France.

❖ THE NORTH ❖

The case for the collector's enthusiasm for northern prints must inevitably be built around the remarkable career and posthumous reputation of Albrecht Dürer. By 1500 Dürer was a decade beyond his

apprenticeship, well traveled, and an accomplished master of both woodcut design and engraving. This was a year that arrived laden with premonitions — of the Second Coming of Christ, of the Turkish conquest of Europe, of horrific plagues and cosmic disturbances. Dürer had published his woodcut masterpiece illustrating the Book of Revelations in anticipation of the half millenium, and yet only much later did he think to mark his own place in that portentous year by retrospectively signing and dating for posterity the famously iconic self-portrait now in Munich. Dürer had first trained as a goldsmith and then as a painter. He had worked as a designer for publishing houses in Nuremberg, Basel, and Strasbourg, and already journeyed once to Italy where he encountered the early flowering of the Venetian Renaissance. He had also acquired some substantial commissions for paintings in these years. After his first heady experience of the society of artists in Italy, it is certain that he thought of himself foremost as a painter and that he concentrated his greatest ambitions in practicing this ancient profession. Yet at the same time, Dürer must also have recognized the truly extraordinary strength of his talent as a printmaker.

NORTHERN ENGRAVING: THE REFINEMENT OF THE ART

By 1500 Dürer had already made a number of skilled engravings. Among the most revealing from a formal and technical point of view is the exquisite *Virgin and Child with a Monkey* of about 1498 (fig. 325). Here Dürer demonstrated his full control of the pictorial effects of the intaglio medium, having taken command of Schongauer's accomplishments in the handling of light and texture in engraving, and indeed having surpassed his predecessor in extending these effects to the rendering of landscape. The coherent depth of the background, the managing of the cloudscape, the summary reflections on the water, and the extraordinarily effective suggestion of velvet on the Madonna's sleeve are pictorial renderings of near coloristic finish. Furthermore, in its compositional clarity and serenity of mood the engraving unmistakably evokes the painted and sculpted Madonnas of contemporary Italy. When we compare this print with its carefully articulated textures and its solidly three-dimensional construction to the slightly earlier *Holy*

325. Albrecht Dürer, *Virgin and Child with a Monkey*. Engraving (B.42), 191 × 122 mm. British Museum, London.

326. Albrecht Dürer, *Holy Family with a Dragonfly*. Engraving (B.44), 235 × 184 mm. British Museum, London.

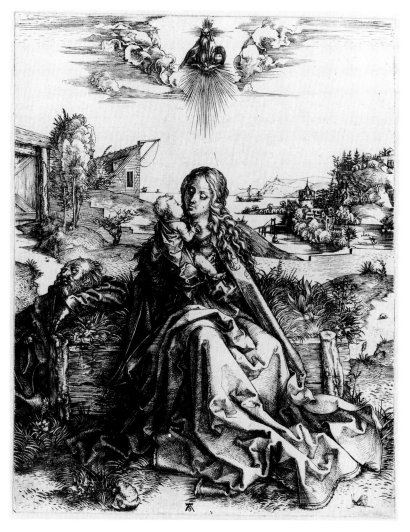

Family with a Dragonfly (fig. 326), we can see a marked evolution in Dürer's style and technique. In the earlier print his draftsmanship is comparatively loose and ragged, a more spontaneous hand enlivened by an evident familiarity with the drypoints of the Housebook Master. There are inherited formulas in the rendering of natural elements soon to be overthrown in favor of his own solutions; the contrast in the treatment of the clouds is a clear illustration of this. The whole of the engraved surface seems woven together in a common rhythm of line and pattern. From here it was a long jump in concept and in technique to the detached control and cerebral descriptiveness of the *Madonna with the Monkey*, but he made this jump in a matter of two or three years. The comparison of these two Madonnas has become something of a "set piece" for historians illustrating Dürer's chronology, and one wonders whether he might not have acknowledged the importance of this moment himself. In the later of the two prints the tethered monkey has correctly been interpreted as signifying the power of Mary's virtue come to tame the lust of Eve, and, of course, it is a deliberate zoological study as well. Yet one wonders whether the monkey's quite proper theological role is altogether sufficient to explain its engaging and undeniably sympathetic appeal. The ape was also an ancient figure of the painter's mimetic power. Seen in this lighter mood, it expresses the artist's satisfaction over the miracles he has managed to perform with an austere palette of black and white.

In 1500, how might Dürer's abilities as an engraver have looked to him ranged against those of his German and Italian peers? Schongauer had died already some years before, a technician of unparalleled skill whose engravings continued to be widely imitated. However, from Dürer's perspective, Schongauer's designs, if not his ductile technique, now belonged to another age. At the turn of the century Israhel van Meckenem was probably the most productive and commercially successful engraver in Europe. But how could this have counted much with Dürer, an artist who had never released a print copied from another master? The most artistically powerful example set for Dürer must certainly have been the ageing Mantegna, whose work, along with that of Pollaiuolo, he had copied meticulously in drawings as early as 1494–95 at the time of his journey to the south.[230] It was probably then that he met Jacopo de' Barbari who, Dürer later remarked, first introduced him to the geometric construction of human proportion.[231] In 1500 Jacopo's *View of Venice* was published and he emigrated north to Dürer's home town in order to work for Maximilian. Jacopo's iconographic ingenuity and his supple figure style were a stimulation to Dürer, already Jacopo's equal in handling the burin. Perhaps most important at this moment was the mere inspiration of Jacopo's career as a

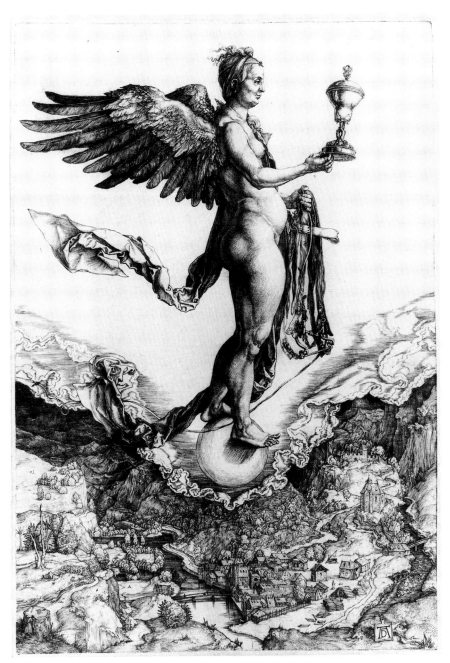

learned painter and printmaker who had succeeded in exporting his talents to the courts of northern Europe. In 1506 on his second trip to Venice Dürer reported the opinion of Venetian artists that if Jacopo were any good he would have stayed at home.[232] But in 1500 Jacopo's presence in Nuremberg could only have been a further sign that horizons for painters and printmakers were broadening. The artist's view from Nuremberg now encompassed Italy, while at the same time Maximilian began to cultivate an appreciation for the artistic and literary inheritance of German lands. Dürer was therefore very well placed. He was widely experienced for his years, and he was brilliant. It was his moment. The printmaker's art must have seemed a bright and open sea of uncharted possi-

327. Albrecht Dürer, *Nemesis*. Engraving (B.77), state I, 333 × 229 mm. British Museum, London.

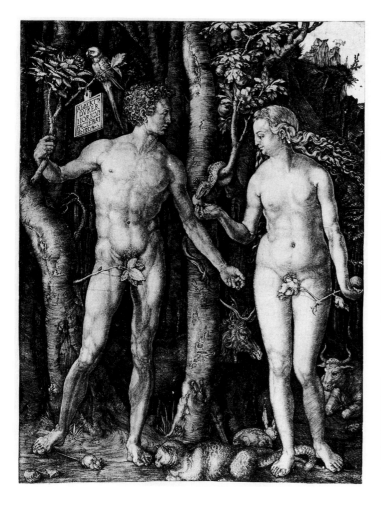

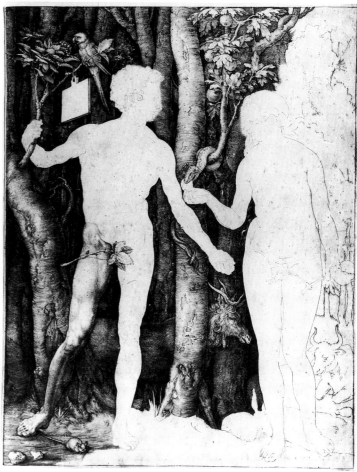

328. Albrecht Dürer, *Adam and Eve*, 1504. Engraving (B.1), state III, 252 × 195 mm. British Museum, London.

329. Albrecht Dürer, *Adam and Eve*, 1504. Engraving (B.1), proof state I, 252 × 195 mm. Albertina, Vienna.

bility. Only later did he allude to this in his fitful confession to Jacob Heller, claiming that had he only stuck to engraving he would have been richer by a thousand *gulden*.[233]

Albrecht Dürer's *Madonna with the Monkey* is a tour de force in the use of engraving to mirror pictorial effects. It is the closest Dürer ever came in a print to approximating the qualities of color and texture of painting. From about 1500 he undertook a concerted, indeed systematic, re-examination of engraving that led to the publication of several extraordinary prints in the years immediately following. Especially worth mention are his two monumental engravings — the *St. Eustace* (B.57), a rigorous study of natural forms and their surfaces; and the *Nemesis* (fig. 327), not only an essay on Vitruvius but a study of heraldic page design imposed over a vertiginous landscape perspective. Notice that in the *Nemesis* Dürer reintroduced the cloud formula of his earlier *Holy Family with the Dragonfly* but now as a way of consciously asserting the abstract premise of this new print by artificially joining two very different subjects within a single frame. Both the *St. Eustace* and the *Nemesis* are dazzling achievements of burin work carried out on prints of exceptional size, but neither of them would have made a very good painting. At an

important level, both of these prints are investigations into the nature of engraving itself. From this point onward Dürer's style of engraving would differ from the style of his drawings, differ in ways that cleave to the particular formal capacities of the burin as against the charcoal stick, the pen or silverpoint, and the brush. His engraved designs periodically affected the character of his woodcuts, but not the reverse. These prints declare the independence of intaglio technique in Dürer's oeuvre.

By this time there could be little doubt that Dürer would invest a major portion of his life in making prints, and that he would commit the best part of it to the meticulous engraving and printing of copper plates. In his early apprenticeship with his father, Dürer discovered the goldsmith's special passion for working precious materials with finely honed tools, a craft of exact weights and measures and intense concentration, requiring much vigilance to avert the tiny but costly accident. Perhaps for these very practical reasons the goldsmith's trade was inclined to be conservative. Its renaissance had to wait two generations or more before patrons were willing to commit such expensive metal to artisanal flights of fancy. Dürer's genius lay in marrying the patience and technical precision of precious metalworking with a brilliance for pictorial

invention that in the end could be exercised better as a printmaker than as a goldsmith. Formally speaking, Dürer's mature engravings recommend themselves to us as finely crafted objects and as exemplars of the intaglio process itself. In this way they are like Schongauer's. When Dürer's command of the intaglio technique fully matured, he consciously set out to identify and to demonstrate what he considered to be the essential premises of engraving. From then on his work proclaims a kind of purism determined by the materials and the techniques employed rather than by the artist's concern to transform the plate, the paper, and the ink into something other than itself. Thus Dürer set a particular value to engraving that has in various ways prejudiced the interpretation of graphic sensibility ever since.

An engraving was no incidental thing for Dürer — not a workshop pot boiler nor a woodcut design made in an afternoon and passed on to a block cutter for execution. His more complex engravings surely took him a good deal longer than the small oils on panel or canvas he regularly did for patrons or the market, an exercise made simpler by the efforts of apprentices who could scrape and finish the surfaces and lay the grounds and underpainting for his pigments. "Of ordinary pictures I will make a pile in a year," he wrote to Heller.[234] In contrast, the engraved *Adam and Eve* of 1504 (fig. 328) took some four years all told from his earliest studies of the *Apollo Belvedere* up until the final printing of the completed plate. At an important stage in working out his figure studies in pen, Dürer silhouetted the nude Adam and Eve against an ink-black backdrop to set them off in stark relief, a formal strategy for designing prints that we have already recognized in the work of Mantegna (fig. 49), from whom Dürer may have taken the idea.[235] To begin with, he must have understood this engraving to be a definitive statement for the intaglio medium. It is the only one of his prints to be claimed with his full name inscribed alongside the customary monogram and the date: ALBERTUS DURER NORICUS FACIEBAT. The full signature recalls the one engraving issued by Antonio Pollaiuolo, and this is probably not accidental. Pollaiuolo's *Battle of the Nudes* (fig. 56) is also distantly echoed in Dürer's staging of these model figures against a pattern of dark foliage. The *Adam and Eve* was Dürer's banner as printmaker. Moreover, the latinized signature with its explicit reference to his northern patrimony confirms that he calculated it to be a declaration of independence made partly for the benefit of his Italian colleagues.

As he gradually prepared his final composition, Dürer must have made a great number of studies, several of which survive. These studies range from proportional constructions of the figures to detailed studies of parts of the figures and the landscape. Here both formal and narratival considerations were being unfolded, for example in the gestures and positioning of arms and hands, which betray a telling intersection of compositional and symbolic thoughts (fig. 330).[236] Adam's complicity in the Fall was a pivotal matter of interpretation, and we can see the artist meditating on this question as he supplies and removes the fruit from Adam's hand, vacillating from gestures of reluctance to deliberate possession, and finally to an awkward and empty-handed erotic provocation. Eve, by contrast, maintains her counterpointed pose, concealing a bitten apple in her twisted hand rotated behind, while accepting the serpent's offer gingerly with her right. So precious were the records supplied by the drawings, and more surprisingly by the proof states Dürer pulled while engraving the plate, that he obviously took some trouble to retain them. Two different states have come down to us — the first of these in at least three impressions.[237] It was either Dürer's habit or that of his pupils to keep his proof states, a striking indication of the degree of artistic self-consciousness that permeated his atelier in these years of constant and probing experimentation.

The trial proofs for the *Adam and Eve* (fig. 329) also give us valuable instruction on the artist's formal and technical procedures. He inked the proofs dryly so as to expose each line with maximum clarity. The proofs tell us that his final design for the plate was in all likelihood complete in every detail before any work with the burin was commenced, since he engraved whole areas of fore- and background while still leaving parts of each undone. The design must have been laid on the plate by some direct means, either by drawing with pen or pencil directly onto the copper, or by car-

330. Albrecht Dürer, *Adam's Arms and Hands*. Pen and brown and black ink, 216 × 275 mm. British Museum, London.

313

boning or tracing the design onto the plate. The incision of the preliminary outline is too sure to have been executed freehand with a drypoint. All the lines and flicks of the outlines suggest the determined application of a burin tip rather than the more agile and less committed stroke of a drypoint stylus. When he engraved, Dürer worked his way across the plate, maneuvering it around on its pillow, and proceeding across the composition from the right to the left (recorded in reverse in the impressions). He laid in the background, leaving the sensitive areas of the figure until he had completed working around it. We can see a similar strategy in the trial proof for the earlier *Hercules* (B.73).[238] This order of procedure was to avoid a slip of the burin that could mar the most lightly engraved parts.

The *Adam and Eve* illustrates the essential strategy of Dürer's engraving technique. He incised his plates relatively deeply even in areas of light stippling. This approach, which explains much of the graphic richness and strength of line in his engravings, Dürer learned from his predecessor Schongauer. Both artists worked deep into the copper, a proclivity that required very careful planning given the difficulty of disguising any changes that required a burnisher. It is also a technique designed to yield an edition of high quality in a larger number of impressions. Though he tried various shades of black and brownish ink over his career, the shiny brilliance of Dürer's blacks set a standard for his contemporaries. His usual formula for black ink helps to strengthen the linear character of the engravings, bringing out the sharp articulation of their design and setting it more starkly against the white of the paper. For his most ambitious engravings, Dürer's attention to detail in printing appears to have extended to selecting unusually thin papers of fine surface texture.[239]

Throughout the better part of his life Dürer continued to press the margins of his understanding of engraving technique, though nothing matched the breakthroughs that he managed between 1498 and 1504. To be sure, his skill in printing his plates must have continued to evolve, but this is a difficult thing to trace. One reason for the difficulty is the likelihood that around 1500 he adopted a practice of printing his plates in limited editions on demand. It is not that he printed to order, though he may well have done this also, but rather that he would print a run of impressions which were then put out to market, and subsequently reprint a plate as its popularity warranted.[240] (We are assuming that Dürer did his own printing of engravings, a conclusion that so far as we know has never been doubted. It is of course possible that he employed a pressman for this work, but the individual character of many impressions inclines us to suppose otherwise.) Printing plates in stages obviated the need to keep large stocks of impressions stored in the

workshop. It allowed for printing when supplies of good paper became available. And finally it would have made practical sense from the point of view of Dürer's cash flow. The only risk entailed in managing his plates in this way lay in the possibility of their being stolen or becoming accidentally damaged before the plate was printed out to the artist's satisfaction. Otherwise, it was simply the most practical means for publishing a stock of copper plates. Printing in stages was also a way of responding more sensitively to the market. Finally, it was a periodic encouragement to review the past phases of one's own style, and an opportunity to transform earlier work by experimenting with papers and inkings on different plates at various points in one's career.

Dürer observed that each individual impression from a single plate has its own character, a point of connoisseurship that he was the first to record: "We see when we print two impressions from one engraved plate or cast two figures in one mold that one can readily perceive the differences between them. Since this is evident in the most certain of things, how much more so in those done by hand."[241] Here Dürer turns to the mechanics of replication, so utterly familiar to him, in order to illustrate a general point about the impossibility of eliminating differences in man-made things. This remark stands out as one of the astonishingly few references to the practice of printmaking to be

314

found anywhere in his voluminous writings. In practice, Dürer cultivated subtle differences in the impressions of his engravings by experimenting with various tones and applications of ink and with the wiping of the plate. There can be no doubt that he often applied surface tone in printing his engravings, and that he did so for very particular and controlled effects.

Not unlike Schongauer, over the last decade of his life Dürer took an increasingly austere approach to the intaglio medium. His plates were designed to display the articulateness of the engraved line and its capacity for defining form in a language that is as much sculptural as graphic in its monumentality (fig. 331). Until the last stage of his career Dürer had surprisingly few imitators in the medium of engraving, and barely a handful were in any way equal to the challenge he posed them. Altdorfer was among the most gifted and the most individual. However, his roots as an engraver tapped somewhat different resources from Dürer's, drawing especially on the minute craft of the ornamental metalworker or niellist for his concentrated but remarkably draftsmanlike designs often akin to miniature silverpoint studies (figs. 332–33). He tended to avoid larger compositions, which he reserved to chiaroscuro drawings, pen and inks, and woodcuts. Altdorfer persisted until late in the second decade of the century, albeit restricting himself mainly to very small engravings. Then in the face of escalating civic responsibilities he too seems to have abandoned his burin in favor of the more expeditious new technique of etching. Though Hans Burgkmair designed a vast number of woodcuts, he never attempted engraving at all, so far as we know, and made only a single etching.

Lucas Cranach the Elder made very few engravings, all of them after he entered the patronage of Friedrich the Wise. His well-known *Penance of St. John Chrysostom* (fig. 335), done in response to Dürer's engraving of the same subject (B.63), shows him capable of being an intaglio printmaker of the first rank. This print carries the adeptness of Cranach's draftsmanship effectively into the language of the burin. A fetching little plate of a disconsolate *Putto Bearing the Arms of Saxony* in the Kunsthalle in Hamburg (fig. 334), bearing the date 1509, shows how sensitively Cranach could handle the burin. This print has the spontaneous look of a trial piece; the lightness of touch and freedom of line are as supple as if it were made with the stroke of a quill.[242] Otherwise he made only a handful of portraits in engraving, probably on demand, and none of them equal to the deftness of the *Chrysostom* or the little *Putto*. Given Cranach's talents, we can well imagine he might have become an exceptional practitioner of the art had his responsibilities as a painter to the court of Saxony not eclipsed this aspect of his career almost entirely. Cranach's case underscores the point that engraving of the standard

332. (left) Albrecht Altdorfer, *St. Christopher*, 1511. Engraving (Holl. 21), 88 × 46 mm. Ashmolean Museum, Oxford.

333. Albrecht Altdorfer, *Head of a Young Man*, 1507. Engraving (B.62), 30 × 24 mm. British Museum, London.

334. Lucas Cranach the Elder, *Putto Bearing the Arms of Saxony*, 1509. Engraving, 98 × 65 mm. Kunsthalle, Hamburg.

set by Schongauer and Dürer required a massive investment of time on the part of the master.

Dürer spawned the very important group of Nuremberg engravers known as the Little Masters — that unholy triad including the two Beham brothers and Georg Pencz who were exiled from the city in 1525, ostensibly for sacrilege. These artists were of great importance in pursuing certain features of refined engraving initiated by Dürer and eventually cultivated by collectors. The Little Masters adopted their engraving technique directly

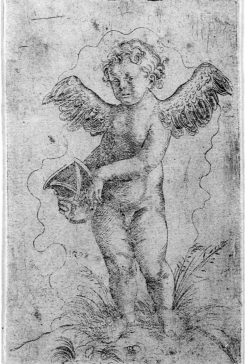

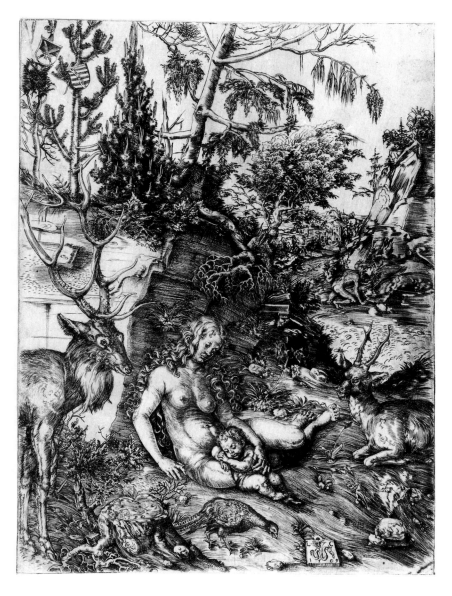

be rid of his predecessor. The macabre and troublesome *Sleeping Child with Death Heads* (B.28), a subtly engraved study of a solitary *Skull* (Pauli 34), and the marginally pornographic personification of *Night* (B.153) typify a repertoire of prints apparently directed to the more private tastes of collectors. Among the most astonishing of these prints is Barthel's image of a woman mourning the stillbirth of her child in the strange allegory *Still-Birth and the Miser* (fig. 337). Although Barthel's obsession with the themes of love, death, and fortune is not exceptional for the time, the inventiveness of this imagery is nevertheless brilliant and idiosyncratic.

Only Lucas van Leyden can truly be said to have challenged Albrecht Dürer's preeminence in the field of engraving throughout the first two decades of the sixteenth century. Lucas built upon a rich tradition of Netherlandish painting with its own circle of patronage, and upon lively art markets in Bruges and later in Antwerp, and an active history of publishing and woodcut making. He was the first internationally known *peintre-graveur* to emerge in the Netherlands, where material conditions for a printmaker's success were at least as promising as those Dürer encountered in Nuremberg. Lucas was probably almost twenty years Dürer's junior. He completed his apprenticeship under Cornelis Engebrechtsz., the leading painter in the town of Leiden. Lucas began making his own engravings in just those years when Dürer's accomplishments as a printmaker were trickling into every attentive and well-connected workshop from Venice to Antwerp. In his *Vite*, Vasari actually stages his account of Lucas's career as a competition between these two northern masters, as though each new invention by one was an artistic gauntlet cast before the other.[244] Surely there is something to the notion that Lucas began to specialize in engraving so early in his career because of the possibilities made evident by Dürer's prints and the reputation they brought him. But Vasari's view has also done a disservice to our understanding of Lucas's contribution to printmaking by placing him so much in the shadow of his predecessor. Over the centuries the common tendency to measure Lucas's qualities as an engraver against those of his putative rival has obscured some of the more important differences in their employment of the medium.

From his very first recorded steps taken around 1505, Lucas van Leyden's art shows a preference for intimate narratives, engaging wit, and subtle irony quite alien to Dürer's more self-consciously sober and erudite approach to subject matter. Lucas consistently sought unusual subjects, and moreover eccentricly altered the conventional choice of moment in his way of telling stories. These narrative strategies are already evident in his earliest engravings. The *Mahomet and the Monk Sergius* (fig. 338) of 1508 taken from *Mandeville's Travels*,

335. Lucas Cranach the Elder, *Penance of St. John Chrysostom*, 1509. Engraving (B.1), 258 × 201 mm. British Museum, London.

336. Barthel Beham, *Genius*, 1520. Engraving (B.32), 59 × 36 mm. Metropolitan Museum of Art, New York.

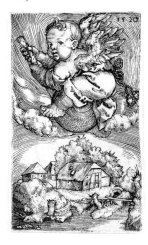

from Dürer and developed his capacity for capturing the feel and the look of metallic finery. Accordingly, they became specialists in small prints for albums. This they did with sometimes renegade independence, especially in their invention of narrative, allegorical, and emblematic subjects of striking originality. The Little Masters were much more closely attuned to the secular tastes of court patronage than was their mentor.[243] Dürer, of course, was of an earlier generation; he was steeped in the intellectual milieu of urban humanism and at the same time passionately caught up in the swell of religious controversy.

Barthel Beham was undoubtedly the most inspired of this group. Indeed, many of Sebald's peculiar subjects are copied from his brother's engravings. Though at times moody and melancholic, Barthel's prints are often charged with coy wit and a clever sense of parody. His pesky little *Genius* of 1520 (fig. 336), piloting an aerial hobby horse above a landscape, was surely intended to prod its grander prototype, Dürer's large *Nemesis*, rather like an impetuous New Year's child overly anxious to

316

strictly from a commercial point of view, Dürer established a level of production on the basis of fewer but hardier plates, whereas Lucas finished many more plates, but those were capable only of smaller editions. We have no sound evidence to indicate that either artist sacrificed quality for commercial advantage.

Unlike Dürer, Lucas began an engraving by drawing his composition delicately onto the plate freehand with a fine drypoint stylus. This is evident in good impressions of engravings made throughout his career, but especially in his early work. For example, in the *Raising of Lazarus* (fig. 340), an inspired composition from his youth, the uncompleted arcs of the drypoint design are clearly visible as hairline scratches above the copse of trees in the center background. Freely looping strokes of foliage, the profiles of major landscape features, and the outline of figures from his drypoint trials typically appear meandering in and around the

337. Barthel Beham, *Still-Birth and the Miser.* Engraving (B.38), 76 × 52 mm. British Museum, London.

338. Lucas van Leyden, *Mahomet and the Monk Sergius,* 1508. Engraving (B.126), 287 × 216 mm. British Museum, London.

and the *St. Paul Led Away to Damascus* (fig. 339) of 1509 are excellent examples of Lucas's oblique iconographic perspective and his anecdotal, not to say understated, approach to the dramatic.[245] We can interpret the high degree of individuality in these subjects as a direct symptom of the circumstances of printmaking after 1500. Lucas's deviation from the expected was most surely calculated to catch the eye of a buyer. Caprice was an obvious means of confronting the challenge of an open market where prints were beginning to be sought more by collectors with an interest in their individual style and content rather than primarily by artists seeking models for the studio.

Lucas made over 175 recorded engravings and etchings in an active career of about twenty-five years, as compared to Dürer's tally of around 105 five made over about three decades, roughly half Lucas's rate of production. Both men were active as painters and woodcut designers as well, but Lucas's comparatively prolific output has something to do with his technique. Certainly the rarity of good impressions in comparison to Dürer's work can be explained by his technique. Lucas tended to incise his plates with a shallower stroke, leaving them to wear more quickly under the pressure of the press. Carel van Mander implies that Lucas's prints were highly priced, and relays a report from the artist's daughter that he carefully monitored the quality of the prints taken from his plates and destroyed inferior impressions in large numbers.[246] Because of their relative delicacy of line, Lucas's engravings required especially careful inking and printing to bring out their subtlety. It is difficult to evaluate anecdotal evidence of the sort reported by van Mander. However, his remarks do imply that seventy years after Lucas's death good impressions of his work were rare, anxiously sought after, and deemed to be expensive. If we consider the matter

339. Lucas van Leyden, *St. Paul Led Away to Damascus*, 1509. Engraving (B.107), 281 × 407 mm. Kunstsammlungen, Veste Coburg.

finished marks of the burin. Lucas's initial approach to the plate is symptomatic of his relatively free and intuitive way of developing an image overall. Further remnants of Lucas's preliminary thinking appear in pentimenti, for example in the *Raising of Lazarus* where certain background figures have been dramatically altered in scale or eliminated altogether because of their disproportion. The two men walking forward beneath the trees in the center background were sharply reduced in size, and for the very same reason another over-sized figure was burnished out of the landscape pocket deep in the lower right corner of the print. Still more striking alterations occur between the first and second state of Lucas's *David and Abigail* (B.24).[247] In part these are merely the more conspicuous lapses of Lucas's juvenilia. And yet they also illustrate an approach to the plate that allowed a generous scope for trial and error that is characteristic of the artist's work in general.

Lucas must have regularly made preparatory studies for his most important engravings. A particularly revealing example of a drawing for an

intaglio print that has come down to us is the study in brush point and pen and ink for his portrait of Maximilian I of 1520 (fig. 364). In designing his model for this print, a milestone in the history of mixed intaglio technique, the areas to be engraved were rendered in brush and ink, and those to be etched were delineated by networks of pen lines.[248] Once again the artist did not attempt to lay out the engraved areas with a comparably linear technique. From this and from the character of the visible dry-point lines in so many of his engravings, it seems obvious that Lucas often, and perhaps always, translated his designs onto the plate freehand rather than by some system of tracing or carboning. In this sense it is fair to say that Lucas approached engraving rather as if it were a species of drawing. The finish of his finer prints is redolent of the Netherlandish tradition of draftsmanship. And like this richly pictorial art, Lucas's engravings with their painterly and atmospheric qualities and their rolling and softly integrated landscapes diverge from the graphic intensity of Dürer's prints. Over the course of his career, Lucas's pictorialism evolved

towards suppler shading, lighter tones of ink, and more delicate chiaroscuro effects. Furthermore, this was an aesthetic preference that had a continuing history in Netherlandish intaglio prints, most notably in the work of Frans Crabbe.[249]

Thus, in the works of Albrecht Dürer and Lucas van Leyden we recognize an important polarity in their perceptions of the engraved print and its particular aesthetic and representational power. The German inheritance from Martin Schongauer was vigorously sustained in Dürer's understanding of the nature of engraving. His concentration on crisp linearity and formal elegance and his love of a glossy black design arrayed over the paper, his intimate, often claustrophobic, interiors and his glowering landscapes of the middle and later years, set a standard for graphic sensibility that has been revived repeatedly in the history of western prints. The Little Masters, especially the Beham brothers, and also Dürer's more brittle imitator Heinrich Aldegrever expressed this understanding of the medium in their preference for profound chiaroscuro effects and in the jewel-like brilliance of their tiny ornamental prints, virtuoso declarations of high artisanry. On the other hand, in the Netherlands, with its more evolved legacy of drawing from life and with its rich history of landscape representation in painting, artists adopted engraving somewhat as a replicable extension of pencil drawing or metalpoint. The tendency of engraving to emphasize sharpness of line was seen more as an obstacle to be overcome. For these masters the value of engraving lay in the degree to which its tonal range could be lightened and made more suggestive in order to accommodate delicate atmospheric effects. Engraving, like other forms of pictorial art, was essentially a medium of representation, and only after that a medium with characteristics of its own.

Although by the middle of the sixteenth century the professional engraver who specialized in the translation of someone else's designs had become established in the north, we have no special reason to doubt Adam Bartsch's assumption that the *peintre-graveurs* actually did engrave their own plates. Why was it that in northern Europe during the first quarter of the sixteenth century no painter employed a skilled engraver to execute his designs, or for that matter made some arrangement of the sort that evolved between Marcantonio and Raphael? Why should this expedient have been inimical to northern artists of Dürer's generation, if in fact it was? Of course, Bartsch stresses the importance of the painter as engraver on the principle that only the hand of the creator could properly realize the true spirit of his own invention.

The print made by an engraver after the design of a painter can be perfectly compared to a work translated into a language different from that of the author; and just as a translation can only be

exact when the translator has penetrated the author's ideas, similarly a print will never be perfect if the engraver does not have the talent to seize the spirit of the original and to render its merit by the trace of his burin.[250]

This is an argument we have encountered before regarding Dürer's early woodcuts.[251] In the case of engraving, Bartsch's premise is more compelling, since the essential character of an engraved line seems more immediately a result of the engraver's actual application of the burin to the plate than does the character of the woodcut seem a result of the block cutter's carefully relieving the artist's original design from the plank. However, essential to Bartsch's view is the assumption that an artist's detailed original design could not be transferred to an engraving plate with sufficient accuracy, and therefore that the value of a designer engraving his own plate would have weighed heavily in the

340. Lucas van Leyden, *Raising of Lazarus.* Engraving (B.42), 285 × 203 mm. Petit Palais, Paris.

319

eyes of northern artists and patrons. Successful collaborations were achieved in Italy early on, most notably those between Raphael and Marcantonio and between Parmigianino and Caraglio. Given what we know about Italian precedents, about the practice of woodcut making, and about the participation of assistants in painting, is such an assumption about individual authorship somehow especially appropriate for engraving in the north?

Let us first consider the practical side of the question. We have no sure evidence of exactly how Dürer actually accomplished the transfer of his designs to the plate. In the rare instances where a finished drawing for an engraving does survive, the translation from one medium to the next required a significant change in graphic language, just as Bartsch asserts — for example with Dürer's drawing in silverpoint over charcoal made in preparation for his late engraved portrait of Friedrich the Wise of Saxony, dated 1524 (figs. 341–42). The engraving develops the basic design in much greater linear detail, reinterpreting the tonal suggestions of the drawing into the idiom of the burin. Prints closely connected to finished drawings are in fact often engraved portraits, where the artist had a special

reason for preserving the study, either to sell it or to pass it along to the sitter as part of the commission. We can never be certain in such cases that a further drawing did not intervene. However, preliminary drawings with a level of detail comparable to a densely engraved plate are practically impossible to achieve. The medium of engraving has much finer tolerances than pen or even metalpoint drawing. In the case of some less demanding prints, near complete, line-for-line preliminary drawings were managed. There are pen drawings for engravings by Aldegrever made with such care and deliberateness in laying out the lines of the figures and setting that it appears they might even have been made for an engraver other than the designer himself. A good example of this is the drawing in pen and ink for the *Creation of Eve* for a print cycle of 1541 (figs. 343–44). Yet deviations from the drawings in Aldegrever's finished engravings suggest that the artist allowed for improvisation on the plate, and consequently that the designer and the engraver were one and the same. In this case, for example, Aldegrever increased the population of rabbits from one to two, and added some stars in the heavens to make it clear that the odd shape

341. Albrecht Dürer, *Friedrich the Wise of Saxony*. Silverpoint over charcoal, 177 × 138 mm. Ecole Nationale Supérieure des Beaux-Arts, Paris.

342. Albrecht Dürer, *Friedrich the Wise of Saxony*, 1524. Engraving (B.104), 193 × 127 mm. Museum of Fine Arts, Boston.

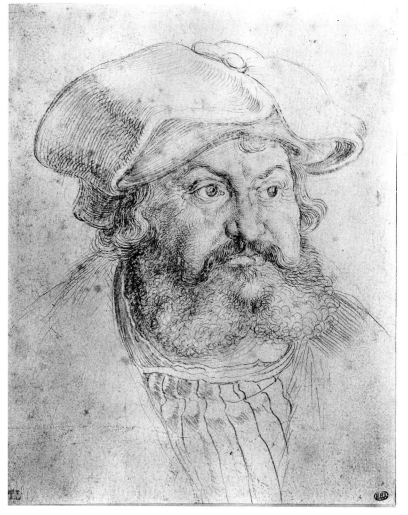

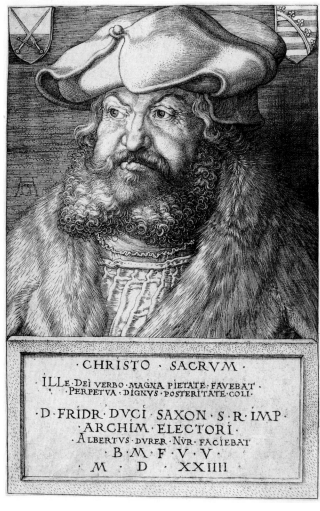

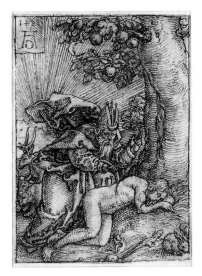

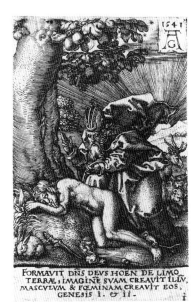

FORMAVIT DÑS DEVS HOEN DE LIMO
TERRÆ, IMAGINÊ SVAM CREAVIT ILLV,
MASCVLVM & FŒMINAM CREAVIT EOS,
GENESIS I. & II.

among the trees is indeed the crescent moon, and thus that the creation is shown to take place in deepest night. Aldegrever's predilection for slavishly detailed preparatory studies relaxed later in his career, but the existence of these earlier models does demonstrate the plausibility of accurate translation for prints of less demanding scale and complexity. Aldegrever's later practice can be seen in his finely executed drawings for the cycles of *Virtues* and *Vices* done a decade later (figs. 345–46), by which time he had turned to pen and ink with a very delicate wash rather than the linear approach, which required less interpretation on the plate.[252] Tonal drawings, as we have already noted, were the usual type of preliminary study for engravings. The Aldegrever drawings are all executed in a manner that suggests the finality of an exact model achieved after a number of preliminary stages.

Viribus Inuidiæ soboles spoliatü Amori
Quæm sequitur recta spesque fidesq́ via

It is worth recalling that woodcut design in this period often entailed an intermediate hand — for example in certain of Maximilian's projects. There is good evidence that either the block cutter or a transfer draftsman often edited an original design to make it more manageable for the cutter. One might suppose a similar latitude could be granted to a trusted engraver. However difficult it may have been for artists to make drawings detailed enough to provide exact models for engravers, it is very clear that engravers were able to reproduce one engraving in another, sometimes with absolutely astonishing precision. Copying prints had already become a regular means of training apprentices in draftsmanship. But these sorts of exercises rarely ever approached the capacity to deceive. Much more intriguing are those exceptional cases where a replica was made with rigorous care, presumably in order to serve the market for an unusually successful engraving once the original plate had been lost. It is rarely possible to know now whether such replicas are piracies or whether they were made by the author of the original or under his supervision. In some cases a copy is intentionally marked by a telling detail, as with the two versions of Marcantonio's *Massacre of the Innocents* with and without the fir tree (figs. 133–34). In addition to these, a meticulous and truly deceptive copy of the version with the fir tree also survives.[253] A parallel case has been uncovered in the work of Lucas van Leyden — a near line-for-line copy of his *Crowning of Thorns* (B.69), a truly remarkable demonstration of technical virtuosity. Here the engraver of the second version signalled the difference between the two plates by showing one of the mockers with his tongue stuck out, as if to make a wry comment on his achievement.[254] Certainly engravers had the ability to copy a prototype with extreme precision, but no drawing made in the same size as the print could adequately record the engraved detail in Dürer's portrait of Friedrich the Wise, or any engraving of comparable intricacy.

The absence of the professional reproductive engraver at this stage in the history of northern prints had also something to do with the purely technical demands of the medium. The engraver's skill was less available because it had never been as much in demand as skill in the cutting of woodblocks. Consequently, it fell to artists to interpret their own inventions on the plate until a greater population of engravers emerged and the demand for intaglio prints made this degree of specialization worthwhile. In general the evidence, and just as important the lack of contrary evidence, is convincing that northern painters of this generation typically did engrave their own plates. We have no documents that refer to specialists in engraving hired by designers, or the other way around. No plates bear more than one signature unless it is the address of a publisher, or a monogram added by a later hand to reattribute a plate for commercial reasons. Meanwhile, credible evidence of authorship was becoming more important to patrons and collectors as well as to other artists and craftsmen. The very presence of monogrammed signatures on prints and drawings demonstrates the pervasiveness of this change in attitude beginning already in the late fifteenth century and markedly more prominent in the north than in Italy. Dürer certainly felt strongly about piracy, and as far as one can tell from the evidence of his several legal encounters, his concern was more than just commercial. It centered on the use of his signature by, as it were, unauthorised agents.[255] There is also good reason to believe that artists and patrons thought differently about different media and were discriminating and technically alert to these aspects of connoisseurship. For example, from an early date it was typical of northern European inventories to distinguish between prints and drawings, whereas in Italy the convention was to refer to works on paper collectively as *disegni*. Here Italian nomenclature betrays a tendency to classify prints and drawings more by their function as records of pictorial ideas rather than as different types of art.[256]

The rising valuation of prints can be attributed partly to the esteem engravings achieved among collectors pursuing the works of a few important masters. Collectors, especially in the north, expected their artists to betray the rigor of their efforts. Not only did these masters engrave their own plates, they made a conspicuous point of their labor in doing so. Indeed, their virtuosity has been heralded repeatedly in the literature of connoisseurship. What is less acknowledged is that in its first phase the primacy of the *peintre-graveur* was so remarkably short-lived. Engraving reserved a place for prints in the Renaissance art collection, and just as it accomplished this elevation of status the artist/engraver became nearly extinct. The term *peintre-graveur* can apply to only a handful of Italian engravers in the sixteenth century; it designated a practice among painters that went into decline at least a decade earlier than it did in the north. The eclipse of the German and Netherlandish *peintre-graveurs* awaited the introduction of Cock's publishing house around 1550. The explanation for this change is complex. Among other things it has to do with practical and commercial matters such as the enormous investment of time required of the artist and the need to establish networks for distributing prints to a growing population of collectors. On a more elusive plane it has to do with the changing taste for styles and subject matter in prints and the capacity of engraving to meet these tastes effectively. The success of Renaissance engraving is a story that has been told often and well. What we lack is an explanation for its fragility and its quick demise. A clue to this problem lies in the fragmented early history of etching.

ETCHING: THE FAILED EXPERIMENT

From a strictly technical point of view, the arts of engraving and woodcut had been completely mastered in their essential elements by the second decade of the sixteenth century. The challenge of working in miniature scale posed the last frontier for virtuoso display of the burin, and in larger format printmakers were experimenting with pictorial scope and narrative elaboration. This was a generation of printmakers in the thrall of experimental curiosity, and as they continued to explore intaglio technique for a brief period, several of the *peintre-graveurs* in the north turned their attention to making etched plates.[257] In its early stages etching does not seem to have evolved as coherently as the other classic techniques of printmaking. Perhaps because its beginnings are difficult to trace and remain at many points obscure, it will repay the effort of trying to make the outlines somewhat clearer. Etching began as a series of false starts that never quite found resolution in the hands of the first artists who tried it, although among them were many of the most prominent intaglio printmakers at work during the first half of the century. In this sense it was initially a failed experiment. And yet etching eventually became both the preference of painters and the staple of the printmaker's art, a technique of tremendous importance for the future of printmaking in general. Why were the initial attempts, many of them highly successful from a technical point of view, repeatedly deemed unsatisfactory by those who undertook them?

The Hopfers of Augsburg and the History of Iron Etching

It is generally held that the printing of etched plates started in Germany, probably in Augsburg in the workshop of Daniel Hopfer.[258] Daniel, the son of a painter, evolved a distinctive etching style that he passed on to his two sons, Hieronymus and Lambert, who carried it on for another generation, one in Augsburg and the other in Nuremberg. The basis for Daniel Hopfer's priority in the invention of the etched print is sound, but the commonly held view that this was a by-product of armor decoration is not so well founded. As we have previously noted, recipes for etching iron and steel are recorded at least as early as 1400.[259] However, scholars have been unable to show that etching elaborate armor designs came into practice in Italy or Germany much before the end of the fifteenth century, that is to say at just about the time we believe iron plates for making prints were beginning to be made by the very same means.[260] Both technically and formally the two crafts seem to have evolved in concert with one another to a degree that

makes it gratuitous to argue for the priority of one technique over the other.

When were the first etchings printed? Historians have expended more effort in trying to identify the first etching actually dated in the plate than they have in solving the problem of when the technique itself came into use. We shall enter into the particulars of this competition primarily to argue that printing from etched plates started a good deal earlier than most authors continue to assume, and that it began well before the first etching known to bear its correct date in the plate. In the present state of our knowledge, the prize for the latter distinction goes to a work of 1515 by Albrecht Dürer. However, evidence suggests that Daniel Hopfer began etching iron plates for printing as early as 1500.

Hopfer acquired Augsburg citizenship and was already listed on the tax rolls as an artist in 1493. By 1505 he had married well and owned a house in the center of the city.[261] What seem stylistically and technically to be his earliest prints, and thereby the earliest etchings known to us, reflect a tentative handling of the medium betrayed in a slight but conspicuous raggedness of line and a rawness of surface that we recognize as especially characteristic of etchings printed from iron or steel plates.[262] These prints also show an undeniable affinity with the style of Augsburg painting around the late fifteenth and early sixteenth century, in particular the works of Hans Holbein the Elder. Hopfer's

347. Daniel Hopfer, *Man of Sorrows*. Etching on iron (Holl. 24), 218 × 151 mm. Staatliche Graphische Sammlung, Munich.

323

Man of Sorrows, signed with his initials, falls within this small group of early works (fig. 347). Because the bulk of Daniel's etchings were probably not made earlier than the teens, scholars have tended to be diffident about placing his first trials much before then. However, since he was well established in Augsburg long before the turn of the century, there is simply no logical reason for locating his first known prints any later than 1500, where the stylistic evidence would suggest they properly belong.[263]

As the *Man of Sorrows* demonstrates, Daniel Hopfer's earliest etchings were done in line-work. However, the workshop style invented by him, and carried on principally by his son Hieronymus in Nuremberg, is best known for techniques of a very different sort. The Hopfers are recognized for a variety of techniques that create silhouettes against a dark field — sometimes foliate and dotted patterns, sometimes texts and figures — yielding an effect now commonly referred to by historians of armor as the "Hopfer style" (fig. 348). The immediate source of this style is local, although it sprang from an established vocabulary of Italianate motifs that had emerged especially in Burgkmair's woodcuts and architectural decoration. Burgkmair was the major artist to cultivate a taste for Italianate touches among patrons in Renaissance Augsburg. The techniques for rendering these decorative effects through etching are very interesting and have never been explained in any detail. The key to their understanding lies in the Hopfers' way of applying the ground for stopping out the plate, and also in the ways the plate was then exposed to acid. Several early recipes for etching along with an examination of impressions of the etchings themselves make it possible to reconstruct much of their approach.

An appropriate point to begin our consideration of the Hopfer style is with a little-discussed trial piece by Daniel Hopfer that may reflect an early step in developing the technique. This is one of two such prints (B.16 and B.90), the first of them a

small ornamental panel showing *Two Cupids with the Sudarium* that was initially etched in line (fig. 349), and then re-etched in a second state to achieve a remarkable and unprecedented soft, tonal gray shading over the figures (fig. 350). In his classic study on the origins of etching, Gustav Pauli compared this effect to that of an aquatint, even though it was made long before the recognized debut of the aquatint technique.[264] From the two surviving states, we know for certain that the process required at least two bitings. Close examination of the impressions suggests that the second state was obtained by brushing the ground onto the plate just as if one were heightening a drawing in lead white, and then re-exposing it to the mordant in a shallow open bite. (In contrast to line etching, open biting simply means that an open field of the plate is exposed to the acid.) As is evident even in reproduction, the edges of the unprinted areas have exactly the character of a brush stroke. Such an exposure to the mordant would have resulted in a slightly roughened surface sufficient to retain ink in a thin layer.[265] In fact this is not at all comparable to the technique of aquatint, which yields a more textured pattern. The formal consequence of the Hopfer technique, creating as it does a sort of permanent surface tone on the plate, is very close to what was then being achieved in chiaroscuro woodcuts.

It appears that Daniel Hopfer made his experiments with etched tone during or before the early teens, when the first evidence of a direct connection between his work and etched armor emerges. A suit of Augsburg armor, datable between 1512 and 1515 on documentary grounds, was decorated with a number of motifs copied directly from Hopfer's prints, not only from his etchings but also from his woodcuts. Although it has been so argued, this does not establish Daniel Hopfer as the actual etcher of the armor.[266] Whether or not he had a hand in designing or etching this set of armor, the connection does provide us with a *terminus ante quem* for the several prints it copies, and among these is the other of the two known etchings done in the tonal style we have just described (B.90).[267] If, as seems likely, these tonal prints are his first investigations of open biting, then they do indeed find a connection with armor decoration, but as a source for it and not a derivation from it.[268]

Let us now examine a mature instance of the technique — Hieronymus Hopfer's profile portrait of Charles V made in 1520. Here is the full range of effects associated with the Hopfer style: floral patterns, raised text, and dotted areas against a black field, the whole set amidst a composition done in delicate line etching (figs. 351–52). Along with the open-bitten areas, Hieronymus has employed a refined use of etched line with crosshatching and stippling. The two separate strategies entailed in line etching and open biting, and the occasional superimposition of etched line onto an open-bitten area, give good evidence that the biting process was again accomplished in at least two different stages, possibly with different consistencies of mordant. This is confirmed by close examination of the actual etched plate, which still survives in the Kupferstichkabinett in Berlin. We can reconstruct the artist's procedure as follows: the plate was first decorated in paint, or possibly varnish or wax, with the floral and grotesque forms surrounding the portrait and the letters of the text and the dot pattern on the panel below. This could have been done by laying the ground and then scratching out the areas between the patterns. However, it appears much more likely that the patterns were painted on freehand and then cleaned up with a stylus around the edges. The delicate interior details of the grotesques were then drawn in with a stylus. To make the sorts of designs characteristic of the Hopfer style, where various patterns are arrayed directly alongside passages of simple line-etching, the artist needed to use something other than a viscous wax ground. Fifteenth- and sixteenth-century handbooks already describe the use of paint and varnish for etching grounds, lead white mixed with linseed oil apparently being a standard recipe.

After the patterns were applied, the remaining parts of the plate including the area for the portrait were stopped-out, and the first stage of biting was accomplished. Then the bitten areas were stopped-out and the portrait was drawn in with line-work and

351. Hieronymus Hopfer, *Charles V*, 1520. Etching on iron (B.58), 225 × 156 mm. British Museum, London.

352. Hieronymus Hopfer, *Charles V* (detail).

325

stippling. A second biting was done, completing the plate.[269] This procedure could be reversed (first the figure, then the background work), still obtaining the same effect. However, we know that the normal practice, among engravers at least, was to complete the background before undertaking the finer work of the figure, thereby lessening the risk of accidental damage to this more delicate area.

Hieronymus was as accomplished a technician as any when it came to etching iron, and his methods may have been various. Modern practices cannot always be applied confidently when analyzing historical techniques. For example, some recipes for mordants either state or imply that the final condition of the acid mixture was paste-like rather than fluid, and consequently that it had to be smeared onto the plate.[270] With a mordant such as this, specific areas could more readily be deepened without having to go through the process of stopping-out other areas. Furthermore, the time required for successful biting was often quite lengthy, encouraging an artist to make various kinds of interventions along the way.

The many surviving plates from the Hopfer workshop show that the plates were bitten very shallowly in the open areas where patterned designs were applied. The etched fields in these areas are roughly textured in contrast to the unetched and smooth surface of the steel plate, this texture being the main reason why the plate could retain ink after wiping. Both biting and inking such plates for printing must have been a delicate operation; the innovative features of this etching style were no doubt costly in the labor required at every stage. Although the Hopfer style allowed for certain fashionable decorative effects not readily achievable with engraving, it was a vestigial endeavor in the long-term history of the etching technique; the employment of open biting for patterned backgrounds was never adopted by later practitioners. It had several drawbacks. First, Hopfer's style was technically demanding and thus contrary to what became a basic attraction of etching, namely its speed of execution. Most likely, the disappearance of this style had to do with difficulties in the biting and printing of such plates as well. Close examination of impressions of Hopfer etchings shows that there were indeed problems getting an even tone in the blackened areas, which often register with an aqueousness that implies a separation of the ink where it accumulated too heavily on the uneven surfaces of the open-bitten areas. Again the actual plates provide confirmation of difficulties and evidence of foul biting.[271]

The demise of the Hopfer etching style must therefore have been a consequence of technical dissatisfaction as much as of taste. Intaglio printmaking was evolving primarily as a pictorial medium cultivated in line-work and tonal effects rather than in the decorative patterns amenable to procedures

of open biting. Daniel's sons turned to line-work as they began to make their money through copies rather than their own inventions. Line-work was the predominant wave in German engraving. Where pattern was used, for example in the many ornamental prints by the Little Masters, it was a glinting kind of pattern rendered as if on the surface of a metallic object. This required a degree of control in mimetic effects unreachable by the Hopfer style. Furthermore, none of the family members was an especially good draftsman, though Daniel certainly surpassed his sons in this regard. The Hopfer style disappeared from active intaglio printmaking and their works eventually became collectors' items. A great many of the Hopfers' plates survive to this day, and it is a testimony to the family's initial care in attending to them that they were able to be reprinted as late as the nineteenth century showing very little damage from rust.

Though they never gained an artistic following, the Hopfers carved out a niche of their own in the early history of etching on iron and steel. They learned to handle etching with consummate expertise, and produced a body of work that developed a close kinship with armor decoration. What was the market for the Hopfers' prints? It is not enough to suppose that their prints were made primarily as patterns for metalsmiths. Certainly this was a part of it, as the popularity of the Hopfer style in German metalwork of the second quarter of the century testifies. But they were making prints that must have appealed to other interests as well. A good number of Daniel's plates depict unusual religious subjects, and often these include lengthy passages of scripture in the vernacular etched into the plate. In his eccentric choice of subjects he sought to provoke the curiosity of his audience in much the same way as did Lucas van Leyden. But unlike Lucas's religious prints, which only rarely seem to allude to contemporary religious controversy, many of Daniel's etchings betray a sympathy with the Reformation movement that was encroaching upon the imperial Catholic stronghold of Augsburg in the 1520s.[272] These appear to be among the earliest intaglio prints designed to spread the evangelical faith and were surely not made for the elite circles who patronized the armor manufacturers. The additional strength of iron and steel plates made them especially good for large editions, if propaganda was the object.

Among Daniel Hopfer's religious subjects with an evangelical cast are three prints of ca. 1520 that also serve to document the interior of the newly constructed church of St. Catherine in Augsburg (B.25–27). These are slightly modified views of the church interior, one of which portrays the New Testament *Parable of the Mote and the Beam* (fig. 353). As an illustration of spiritual blindness, this particular parable was much favored by Reformation polemicists. So far as we can tell, these church

interiors are not strictly documentary nor were they mainly designed for their religious content. They may have sold to visitors as souvenirs, though the church is nowhere identified with an inscription. The reformed evangelical content is not made explicit and would probably have been considered indiscreet if it were. In contrast to these didactic themes, Daniel made a number of very large etchings of religious subjects disposed in extravagant architectural settings. Some of them were printed from more than one plate and have the character of altarpieces. Especially impressive is a *Holy Conversation* (B.19) printed on three sheets and architecturally divided to form a triptych, manifestly not a Protestant image. Indeed, this print is of such scale (295 × 435 mm) that one can easily imagine it pasted onto boards and used as a small domestic altarpiece.

In addition to his religious subjects, Daniel also printed many secular images including military, genre, and folkloric subjects; some of these he seems to have invented himself, and a good many he copied from others. The sheer range of Daniel Hopfer's subject matter is truly remarkable and quite unlike the repertoires of contemporary printmakers, not to say armor decorators. Daniel's tangential position in the history of the Renaissance print has more to do with the peculiarities of his technical inventiveness than it does with any limit to his imagination. His liturgical, homiletic, and devotional subjects had wide appeal, and the durability of iron plates was a significant commercial advantage. Probably the Hopfers catered to an artistically less discriminating clientele than either Lucas or Dürer, and in this sense they were the true successors of Israhel van Meckenem, who first recognized the potential of the intaglio medium to invade and colonize the market for decorative and devotional prints.

Many years after Hopfer first attempted etching on iron as a way of making intaglio prints, this method was hesitantly taken up by a small but prominent number of printmakers. None of them found the Hopfer style at all congenial, however. Those who troubled to learn the technique of acid biting were mainly interested in exploring its capacity to render a freer idiom of line drawing than engraving would allow. No doubt this was a powerful attraction for artists of Dürer's generation and younger, particularly those many who had practiced woodcut design. Nevertheless, with a couple of exceptions, etching on iron failed to take hold among northern European printmakers until the middle of the century, when a very different set of conditions prevailed in the print market.

It appears that Albrecht Dürer and Marcantonio Raimondi began etching almost simultaneously around 1515. Given the history of exchange between these two masters, it must be asked whether their adoption of the technique was entirely coinci-

dental or the result of some transfer of knowledge. We know that Marcantonio had lately pirated Dürer's *Life of the Virgin*, and conversely that Dürer initiated some contact with Raphael about this time. Countering such a hypothesis are two important differences that sharply divide their experiments with the medium, one technical and one stylistic. Already in the earliest of his plates, Marcantonio mixed etching with engraving, which tells us that he was almost certainly etching on copper, a technique not yet available in the north, where copper mordants were still unknown (fig. 272). Dürer's etchings, like those of the Hopfers', are done exclusively on iron or steel. Secondly,

353. Daniel Hopfer, *Parable of the Mote and the Beam*. Etching on iron (B.25), 298 × 197 mm. British Museum, London.

354. Albrecht Dürer, *Man of Sorrows*, 1515. Etching on iron (B.22), 111 × 66 mm. Art Institute of Chicago.

Marcantonio's etchings are stylistically very close imitations of his burin technique. He appears to have been attracted to the medium entirely for reasons of expedience, that is to say, because it offered him a less laborious means of achieving much the same effect as could be managed more tediously with engraving. Dürer, on the other hand, used etching experimentally and was inclined to indulge the inherent tendency of the medium for charged and spontaneous linear display. Just as he did with engraving, Dürer orchestrated etching for its most tractable and accessible qualities.

Therefore, we are left with no good reason to posit a causal connection between the adoption of etching in Italy and in the north. Neither Daniel Hopfer's nor Dürer's etchings had anything to teach Marcantonio from a formal point of view, and since both northern masters etched with iron mordants there is no reason to suppose any tech-

355. Albrecht Dürer, *Angel with the Sudarium*, 1516. Etching on iron (B.26), 185 × 134 mm. Metropolitan Museum of Art, New York.

nical secrets were exchanged between north and south either. The fact that Dürer and Marcantonio experimented with etching at this phase in their careers probably had much more to do with their independent stylistic and commercial interests than with any rivalry. The fact that Marcantonio almost certainly used copper plates for etching and engraving means that he probably preceded Lucas van Leyden in this, the first northern printmaker known to have employed mixed technique. There is still no satisfactory explanation of when and where a copper mordant first came into use, though Leonardo seems to have been aware of a procedure for distilling one, and already around 1504 he explicitly recommended etching on copper in his notebooks. In any case the evidence points to Italy for the discovery of an acid to bite copper, an advance that would ultimately make etching artistically viable in the Renaissance.[273]

Albrecht Dürer made only six known etchings. The earliest of these would appear to be the small *Man of Sorrows* (fig. 354) and the *Agony in the Garden* (B.19), both dated 1515. Though stylistically close, the technical awkwardnesses are more pronounced in the *Man of Sorrows*, suggesting this print may well be the earliest of the group. The frankly experimental etched study sheet known as the *Desperate Man* (B.70), with its capricious and tangled grouping of figures, is too technically accomplished to pre-date the *Man of Sorrows*.[274]

That the *Desperate Man* survives in a significant number of impressions is yet further testimony to the attention paid to retaining a full record of Dürer's workshop practice regardless of whether a particular object fit the expectations for a finished work of art. Dürer's command of the etching technique is best expressed in the *Angel with the Sudarium* of 1516 (fig. 355), and the ambitious *Landscape with a Large Cannon* of 1518 (fig. 356). In these prints Dürer exploited vigorous breadth of line and aggressive calligraphy to evoke contrasts of light and shadow, an aesthetic consequence that would become typical of iron etching in Germany. In retrospect it appears that it took Dürer a year or so to realize the eccentricities of working in this medium, by which time he was able to produce a masterpiece in the *Angel with the Sudarium*. He then abandoned the technique, with the exception of the *Landscape with a Large Cannon*, his largest etched plate and also his last. Dürer's return to etching for this subject reflects a judgment that it was somehow particularly well suited to rendering landscape. He may also have been prompted by the topical nature of the print. The Turks manning their artillery are not only staffage meant to enliven the scene, they also allude to the military threat that was once again pressing against western Europe in those years. Iron etching was a medium that suited topical subjects unusually well because it offered the advantage not only of rapid execution but of a relatively large edition as well.

Following soon in Dürer's wake were Albrecht Altdorfer, Sebald Beham, Urs Graf, and Hans Burgkmair, all of whom attempted etching on iron. Among these artists Beham made the most sustained commitment to the medium, though this was essentially confined to a two-year period of furious activity in 1519 and 1520 when he seems to have produced an extraordinary number of intaglio prints.[275] We know that Beham made around eighteen etchings of various subjects, two of them dated 1519, both loosely drawn and betraying evident technical difficulties that were quickly overcome in his subsequent plates. Unlike Dürer, Sebald Beham almost immediately learned to control detail effectively in iron etching and subdued it to much the same end as in his engravings (fig. 357). Beham worked primarily on a miniature scale in both media, as Marcantonio had done already in the mid-teens.

356. Albrecht Dürer, *Landscape with a Large Cannon*, 1518. Etching on iron (B.99), 220 × 327 mm. British Museum, London.

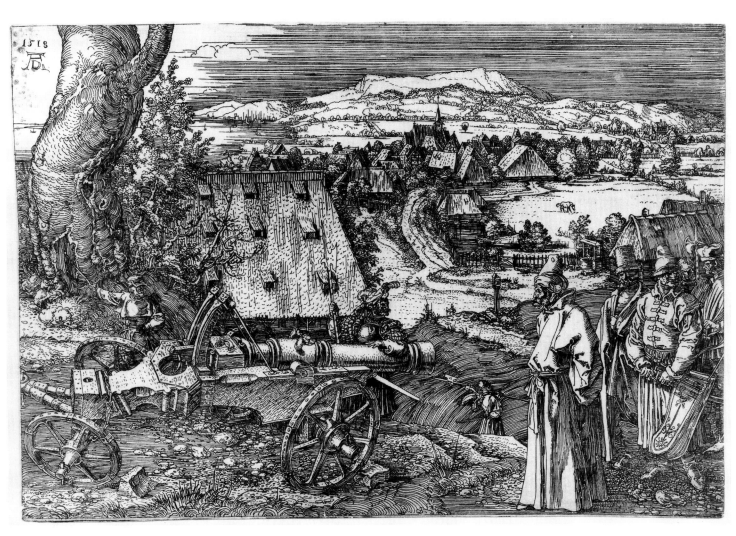

357. Sebald Beham, *Fortune*, 1520. Etching on iron (B.139), 120 × 79 mm. Rijksmuseum, Amsterdam.

358. Urs Graf, *Girl Washing her Feet*, dated 1513. Etching on iron, unique (Holl. 9), 136 × 68 mm. Öffentliche Kunstsammlung, Basel.

Urs Graf is often credited with having made the earliest etching to be dated actually in the plate, the seductive image of a young girl washing her feet (fig. 358). This is one of only two etchings known by Graf, and it survives in a single recorded impression in Basel. Indisputedly the plate for this print is inscribed with the date 1513, and yet the legitimacy of this date has been questioned by scholars on several grounds. The first objection rests upon the various forms of Graf's signature and when they appear in his work. The inscription URSUS GRAF VON BASEL is written in cipher in the upper right of the print. (Graf's cipher is a simple type known as Caesarian code in which each letter of the alphabet is substituted directly for some other letter, number, or sign.) There is no other known instance of Graf having used this cipher before 1523. Secondly, the monogram in the lower left conforms to the type Graf employed only from 1520 onwards. Thirdly, the style and costume of the figure are more closely associated with works of this later date.[276] On each count a matter of several years is in question, not a short period in Graf's career. These are credible and convincing grounds for challenging the verity of the 1513 date. Indeed, Hans Koegler, the first rigorous proponent of a later date, suggests that on stylistic grounds 1523 rather than 1513 would be a more appropriate point for the invention of the *Girl Washing her Feet*.

Did Graf consciously forge an early date for some private or commercial reason, or did he merely retain the date from a much earlier study after he transformed it into a print? For example, the print recalls a drawing of a *Foolish Virgin* dated 1513.[277] Graf's etching mirrors the contrapposto of the young virgin with her raised foot as though he were actually improvising on this earlier study, yet the proportions of the figure in the drawing and the etching are markedly different. It is possible that the date 1513 was taken from this very drawing as Graf reworked the figure into a much later print. One cannot but be struck by the parallel episode in Lucas Cranach's career when it seems he predated a woodblock in order to claim priority in the invention of the chiaroscuro technique. Can such deviousness have twice sought to reshape the early history of print technology? The evidence here is inconclusive, but the possibility of fraud once again highlights the importance granted to these achievements at the time.

It would seem that Graf has declared the time, the place, and the authorship of this invention too loudly. Indeed, he protests too much. Not only is the print signed, but also monogrammed, inscribed with the emblem of the city of Basel, and in addition to that, dated. Such vehemence alone should raise our suspicions. Given what else we know about the author of this etching, his over-clarification is more likely to be a matter of coyness than carefulness. One is tempted to speculate that the seductive

gesture of the young girl is itself meant as an enciphered warning that we not be misled. There can hardly be any doubt that Graf was unusually proud of this print and that he was taking special measures to sport his cleverness. Whatever the exceptional qualities of its design, the print appears to have had a short history. It survives in a single impression that suggests some trouble with the biting, as if Graf overreached himself technically as well.

Dürer's experience of etching was confined to a period of only three years and a mere six plates. Beham made many more, but apparently also within a very short time. And Urs Graf seems to have done only two. We now come to Hans Burgkmair, who made just one, the *Venus, Mercury, and Cupid* (fig. 359), and by good fortune the original plate for this solitary experiment has been preserved. Metallurgical analysis shows it to be of carburized, wrought iron sheets forged together into a pile and hammered flat, a preparation employed for centuries in the making of sword blades.[278] Impressions from the plate show the characteristic troubles of iron etching. Burgkmair used a stylus with a blunt tip to produce a relatively uniform, heavy line. Where he hatched too densely, the biting, always shallow, went foul and created rutted valleys in the plate. These uneven areas tend to print an irregular cloudy black or, because of problems in the wiping, seem as if they were rubbed to white. The portions around Mercury's hand holding the caduceus, beneath his other elbow, above Venus's forearm, and along the left contour of the tree behind her are instances of these difficulties. Whether the evident raggedness of line in this print is due to the impurity and unevenness of the metal, the inconsistency and application of iron mordants, or both, these technical symptoms are magnified in Burgkmair's print, and are frequently recognizable in other early attempts at etching.

Burgkmair's single attempt at iron etching is often tied to the importance of Augsburg as an armor manufacturing capital. Indeed, as with Daniel Hopfer, there are close connections between the evolution of his style and that of the armor decorators, both, of course, closely tied to the patronage of Maximilian's court. However, there is no sure evidence that Burgkmair was directly involved in making armor either before or after 1518–20 when the *Venus, Mercury, and Cupid* is most reliably dated.[279] Like Dürer, he seems to have tried and abandoned etching as unsuitable to his standard of finish.

Burgkmair chose an unprecedented and unrepeated subject for his only attempt at etching. It appears as if his experiment was both technical and iconographic, a clue to the self-conscious nature of the *Venus, Mercury, and Cupid* and the probable exclusiveness of its audience. Although in Renaissance iconography Venus and Mercury rarely ever

appear together, and so far as we know never as a couple in a narrative context, Burgkmair shows them encountering one another in a verdant landscape. Mercury lies fast asleep beneath a palm tree, leaning against a rustic spout to a natural spring, his head resting on his hand in the familiar pose of the melancholic. His caduceus hangs loosely from his other hand and his winged helmet has been cast

aside on the ground. Venus prods him awake with the nocked end of Cupid's arrow while her frustrated son circles blindfolded above, wielding an empty bow. Obviously Burgkmair had an allegorical theme in mind and he laced it with comedy. There is one narrative context in which the two gods do appear, though in company with others — the Judgment of Paris, where Mercury often plays the role of master of ceremonies. In one version of

359. Hans Burgkmair, *Venus, Mercury, and Cupid.* Etching on iron (B.1), 182 × 131 mm. British Museum, London.

331

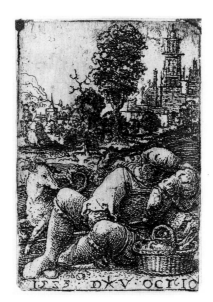

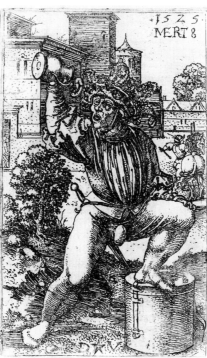

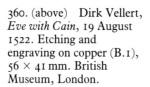

Copper Etching in the Netherlands

Etching failed to satisfy the practical and aesthetic demands of the first generation of *peintre-graveurs* who experimented with it in Germany between 1515 and 1520. But just as Dürer, Beham, and Burgkmair were abandoning the technique, it acquired a new life in the Netherlands, where it suddenly appeared in the competent hands of no less an artist than Lucas van Leyden. Lucas's known etchings are only six in number, all of them dated in the same year and all of them done in a mixed technique of etching and burin work on copper, thereby establishing them as the first recorded examples of copper plate etching north of the Alps.[282] The capacity of copper to accept burin and drypoint work to enhance or correct the bitten lines of an etched plate, and secondly its resistance to corrosion, are the most notable advantages that copper holds over iron as an etching metal. Other factors that may have affected artists' preferences are more difficult to weigh in retrospect. However, it is worth remarking that copper seems to have yielded a greater delicacy and consistency of line, whereas iron better resisted the pressure of the press.

Since all the known recipes for etching prior to this time are for iron and steel, it would appear that copper mordants were as yet of no practical use to metallurgists.[283] In his *Schilder-Boeck*, Carel van Mander offers a muddled account of Lucas's introduction to intaglio technique without seeming to include etching, suggesting that he learned en-

360. (above) Dirk Vellert, *Eve with Cain*, 19 August 1522. Etching and engraving on copper (B.1), 56 × 41 mm. British Museum, London.

361. (above right) Dirk Vellert, *Man Asleep*, 10 October 1523. Etching (on iron?) (B.15), 74 × 63 mm. British Museum, London.

362. Dirk Vellert, *Drunken Drummer*, 8 March 1525 [=1526]. Etching (on iron?) (B.16), 93 × 58 mm. British Museum, London.

363. Lucas van Leyden, *Maximilian I*. Pen and point of the brush in black and gray ink, 259 × 194 mm. Fondation Custodia (Coll. F. Lugt), Paris.

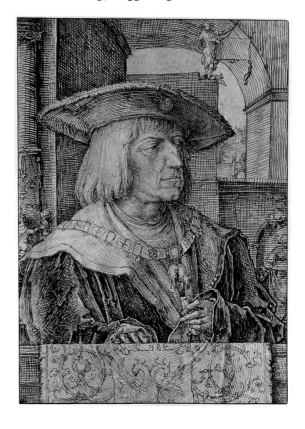

the story, Mercury and the three goddesses come upon Paris asleep, and exactly like Mercury in Burgkmair's print, Paris must be roused to his duty.[280] Certainly Burgkmair was aware of the subject. It appears as if he has simply stepped back in the story and portrayed Venus prodding Mercury in order to get on with claiming her victory. The arrow wrested from Cupid will be restored when he is put in range of Paris.[281] This print is therefore reminiscent of Dürer's etching of the *Desperate Man* in that it bears the stamp of an experiment in subject as well as technique. But it was technically unsuccessful. What appears to have been Burgkmair's first etching appears also to have been his last.

graving from the armor etchers, with some additional advice from an unnamed goldsmith.[284] Furthermore, he brings up the subject immediately after giving fulsome praise to Lucas's best-known and most extravagant print in mixed technique, the 1520 portrait of Maximilian I (fig. 364). However, this conjunction appears to be purely accidental, since he makes no mention of the print as an etching, he is confused about the date of the portrait, and he gives no clue that he recognizes the significance of etching on copper rather than iron.

Like Marcantonio, who preceded him in the use of this technique possibly by as much as five years, Lucas made etchings that were stylistically consistent with his engravings. The formal distinctions that do exist between his etched and engraved plates are a consequence of limitations in his ability to control the etching technique rather than a wish to diverge from his usual approach to intaglio design. He was probably attracted to the facility that etching offered him, however, and this was undoubtedly a reason for choosing this medium for his portrait of Maximilian, meant to commemorate the Emperor's death in 1519. Lucas's portrait was directly inspired by Dürer's 1519 woodcut and is also contemporary with Hieronymus Hopfer's iron etching, the latter a particularly instructive comparison to Lucas's technique. Political events like the death of an emperor and the coronation of a successor offered a natural opportunity for the print trade and at the same time provided a stimulation to new inventions.

In Lucas's portrait of Maximilian I the densely modeled architectural background, the costume, and the hands are laid down in etching. The detailed and sensitive treatment of the face and throat are done with the burin. The hair looks to be a mix of etching with some sparse engraving, though this is very difficult to tell. The composition is transcribed from the exquisite preliminary drawing now in the Lugt Collection in Paris (fig. 363).[285] Lucas's use of mixed technique is far more subtly integrated in his other etchings. The preparatory drawing plots the etched and engraved areas by employing pen and brush respectively. But even though the engraved areas are relatively separate there is no sharp sense of discrepancy. This is mainly because Lucas employed etching styluses of differing sharpness and thereby managed variations in the width of his etched lines comparable to those done with engraving tools. In his few other works in the medium he employed the burin primarily to strengthen areas of shadow with cross-hatched lines, modifying the tone of a contour or deepening an outline. His etched lines can be fine enough that it is sometimes very difficult or impossible to distinguish them from delicate work added in engraving.[286]

Shortly after Lucas van Leyden's flirtation with copper etching, it began to be practiced in Antwerp by Dirk Vellert, a specialist in designing glass painting who started to make prints in 1522. Surprisingly enough, Vellert is the first Antwerp artist we know to have made intaglio prints, a curious fact given that only a generation later this would become the printmaking capital of northern Europe. Vellert's habit of dating his works to the day — prints, drawings, and paintings alike — allows us to trace his explorations rather exactly during the very few years he practiced intaglio printmaking regularly.[287] We have five prints from 1522, perhaps the earliest being a rather awkward engraving dated only to the year. Following that are three tiny etchings enhanced with the burin, all of them done during a few weeks in late summer with a blunt quality of line that effectively veils the distinction between etched and burin work (fig. 360). Vellert made three more etchings (fig. 361) and three engravings in 1523, two engravings in 1525 (fig. 362), and then another etching and an engraving in

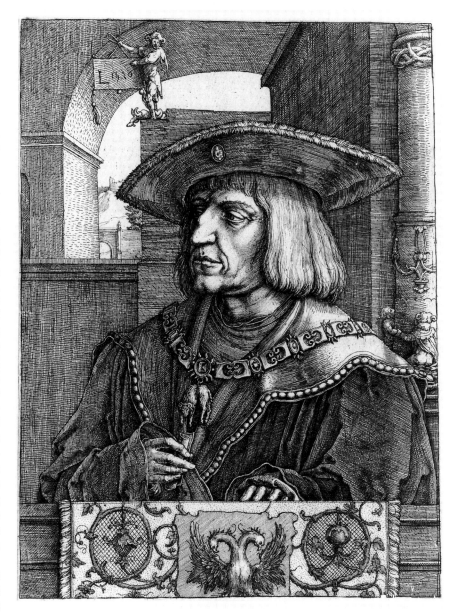

364. Lucas van Leyden, *Maximilian I*, 1520. Etching and engraving on copper (B.172), 260 × 195 mm. British Museum, London.

365. Frans Crabbe, *Esther before Ahasuerus*. Etching on copper (Holl. 1), 262 × 192 mm. British Museum, London.

366. Frans Crabbe, *Esther before Ahasuerus*. Drawing in pen and ink, 261 × 194 mm. J. Paul Getty Museum, Malibu.

1526.[288] None of those etchings dated after 1522 seems to include any use of the burin, and at least one and possibly all four of the etchings from 1523 and 1525 look as if they were printed from iron plates. If so, this would constitute our first case of an artist who actually turned from copper to iron etching rather than the reverse. The turning point in this sequence is the *Man Asleep* from 10 October 1523 (fig. 361), which betrays evidence of foul biting and a kind of impulsiveness in the drawing that marks it off as an experimental foray possibly into what was for him the unaccustomed technique of etching on iron.[289] We have but one additional etching by his hand. This is in copper and comes very much later as part of another chapter in the history of the medium. Like Sebald Beham, though he was very skilled in the technique, Vellert appears to have become rather quickly disenchanted with etching. The tight chronology he has provided us gives an unusually close glimpse of his progress. Since Vellert's earliest etchings show a command of the technique's capacity for minute detail equal to what he could accomplish in engraving, there must have been a number of trials that have been lost to us. He reserved etching for work in miniature scale, whereas the finest engravings of this period were done several times larger in quarter folio. If indeed Vellert did switch to iron plates, this must surely have been motivated by a desire for making larger editions. Probably because of the use of iron there is no sign of formal improvement in the later etchings, iron being more difficult to control than copper on such a small scale. Then in 1526 he

seems to have discarded printmaking for nearly twenty years.

Meanwhile copper etching was adopted by only a very few other artists in the Netherlands, most notably Frans Crabbe, who must be credited with having most sensitively evolved the subtleties of the medium. He worked in Malines, apparently beginning as an engraver in the early 1520s; he then turned to copper etching, rarely mixing it with engraving, and later etched on iron. Crabbe drew very precise preparatory studies for his etchings and then transferred them to the plate by some direct means. This we can see, for example, by comparing a preparatory drawing in pen and ink for Crabbe's *Esther and Ahasuerus* with the final print (figs. 365–66). The drawing is executed in formulaic patterns of hatching and stippling, penwork that anticipates very little of the subtlety of tone and effects of lighting evident in the final print. Apart from this, only minor adjustments were made on the plate, for example the sensitive tilt of Esther's head and the delicate rendering of her features. There are traces throughout the drawing that it was incised. Hence the transfer was accomplished by gently impressing the drawing into the wax ground and then working it through to the copper with the stylus. When a transparency of the drawing is laid over the print, a slight reorientation of certain of the figures in relation to the architectural infrastructure of the composition betrays the use of the drawing as a pattern that slipped by a couple of millimeters in the transfer.[290]

Crabbe's technique carries the Netherlandish

preference for lightness of line and tonal delicacy to a fine degree (fig. 367). He used a good deal of stippling, and had a way of trailing the etching stylus like the track of a seismograph recording a gentle tremor. This along with Crabbe's occasional turn to sepia inks for printing begins to approach the textural and descriptive range of pen and charcoal drawings. In its early stages Crabbe's technique, like that of his predecessor Lucas van Leyden, makes little concession to commercial objectives. His copper plates must have worn out very quickly indeed. Probably for this reason, as well as because of his contact with Nicolas Hogenberg, Crabbe turned to iron plates later on.[291]

Frans Crabbe's prints comprise the strongest fiber in a fabric sustaining the practice of copper etching in the north beyond the preliminary explorations of Lucas van Leyden and Dirk Vellert until it eventually became a widespread practice later in the century. Vellert, however, did return to this technique at least once, and the result is an artistic masterpiece and a technical landmark of great importance to the history of the medium. In 1544 he composed a large, ambitious plate representing the *Deluge* staffed with some eighty energetic figures in an animated and complex landscape (fig. 368). As a cursory survey of earlier Renaissance portrayals of the biblical flood makes clear, the coherent staging of frenzied chaos and atmospheric effects demanded by this subject creates very special difficulties that were successfully confronted by very few masters.[292] Here it is worth recalling that 1544 was the year in which Antwerp underwent one of its first religious crises, resulting in the suppression of a local Lutheran movement and the expulsion of several artists, the printmaker Cornelis Bos among them. It was a year of new and stringent censorship laws that certainly affected artists well beyond those few who were actually prosecuted.[293] The subject of Vellert's last intaglio print may therefore be covertly topical. But the narrative is challenging enough given its tragic scope, the complex perspective of marine and landscape space, and the requirement for an encyclopedia of episodic detail. Partly with the help of Italian examples, Vellert solved these visual and narratival problems effectively. It is his major effort as a printmaker and additionally important for its introduction of a transalpine epic style into northern landscape prints. Appropriate to the pictorial ambition of his project, Vellert succeeded in redefining the approach to mixing etching and engraved work on a copper plate.

Fortunately a proof state of this print has come down to us heavily worked over with what are almost certainly Vellert's own corrections in pen (fig. 369). This impression, now in the British Museum, is liberally marked with additions to the contours and interior modeling of figures and objects. A number of these changes were engraved

onto the second state and a number left out (fig. 370). The care taken with the additions and the fact that only a portion of them were then carried over to the finished state strongly argue for the penwork being Vellert's own. Close examination of the proof impression shows that Vellert etched his entire composition in detail, leaving only some areas in the interior modeling of the figures and other contained surfaces for treatment with the burin. Furthermore, the variable depth and intensity of the etched lines shows without a doubt that Vellert bit the plate more than once in the process. It appears that he then worked in areas throughout the entire plate with the burin, strengthening many details and filling in some of the finer points of modeling with additional hatching and stippling. Here Vellert's technique integrates etching and engraving to a much greater degree than had previously been done in any extant print north or south of the Alps. Furthermore, at a point when iron

367. Frans Crabbe, *Solomon and Sheba*. Etching on copper (Holl. 2), 252 × 192 mm. British Museum, London.

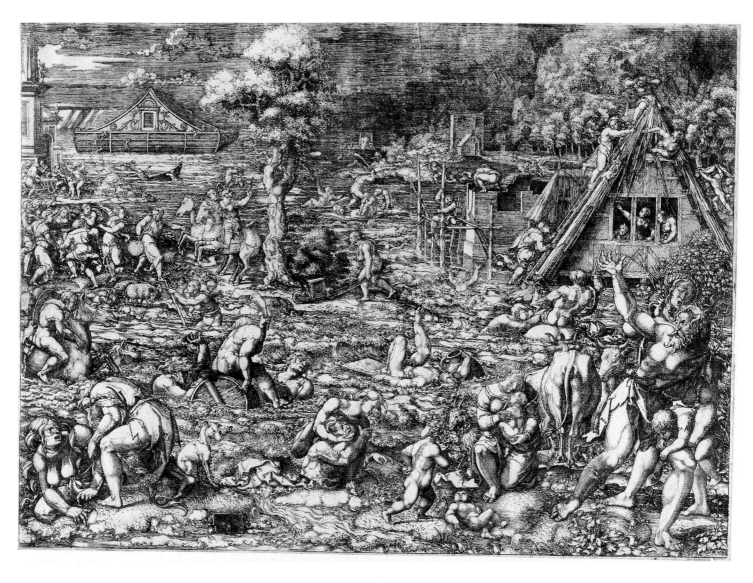

368. Dirk Vellert, *Deluge*,
1544. Etching and
engraving on copper (B.2)
state I (with additions in
pen), 284 × 392 mm.
British Museum, London.

369. Dirk Vellert, *Deluge*
(detail) (B.2), state I.
British Museum, London.

370. Dirk Vellert, *Deluge*
(detail) (B.2), state II.
Rijksmuseum, Amsterdam.

and copper were still in competition in Netherlandish etching, he demonstrated the pictorial range and tonal nuance that could be recorded and successfully inked and printed from a large copper plate.[294]

Both Vellert and Crabbe tended to ink their plates rather dryly so that on close examination the lines appear slightly softened and granular. This has the effect of further blurring the usual distinction between an etched and an engraved line, often making it impossible to be certain whether a given stroke was achieved in one technique or the other. Vellert was especially adept at this. Unraveling the complex mix of techniques in the *Deluge* is a profoundly puzzling exercise. In contrast, the German *peintre-graveurs* inclined to nurture the distinctive properties of the etching medium rather than assimilating it to engraving. Thus their engravings tend to glossy metallic surfaces and clean fluctuating lines that better display the virtuosity of the burin, whereas their etchings indulge the greater freedom of draftsmanship permitted to the stylus. Likewise, the Germans incorporate

rather than resist the tendency of acid biting into iron plates to yield nervously aggressive areas of black thrown up sharply against unsullied patches of white paper.

Netherlandish printmakers, by contrast, tended to accommodate etching and engraving within an aesthetic standard they brought to them, subordinating technique to the end of representation. For just this reason we should not be surprised that it was the Antwerp firm of Hieronymus Cock that eventually promoted the reproductive and the topographical print in northern Europe.[295] In the Netherlands, the value of a particular medium lay in its capacity for transformation. Late in the century that virtuoso of the burin Hendrick Goltzius would caricature this local attitude to the protean aspect of technique by enforcing a style of drawing taken straight from the engraver's tool, and meanwhile flaunting the display of the burin in his engravings. The sensitive relationship between technique and representation in Netherlandish printmaking had an especially complex history in the sixteenth and seventeenth centuries.

Albrecht Altdorfer: Opportunity as the Mother of Invention

The second phase of the early history of iron etching in Germany opened at roughly the moment when the first wave of *peintre-graveurs* abandoned the technique, and simultaneously with the advent of copper etching in the Netherlands. Under an extraordinary set of circumstances Albrecht Altdorfer began to take etching seriously, and in so doing he set a direction for the future of the medium. Here we will center on a very short period in Altdorfer's career as a printmaker, a matter of three or four years starting in 1519 when the religious and artistic climate of Regensburg began to be transformed by a cruel, though not exceptional, sequence of events. This was a period of varied and concentrated activity for Altdorfer. He initiated a serious campaign of etching, he contrived a unique multiblock color woodcut, and he introduced two new categories of subject matter into the print repertoire. In these respects it was a highly inventive phase in an inventive career. This in itself is worthy of our attention, but perhaps more significant for an understanding of the larger patterns of print production in the early sixteenth century is the circumstance that promoted Altdorfer's new interests.

Illustrative of this are two etchings that record with palpable immediacy the interior nave and the entry porch of the Regensburg Synagogue, an important architectural monument of the early Gothic period in Germany (figs. 371–72). These etchings are the first northern prints we know to have been directed primarily to recording the lineaments of an actual architectural structure.[296] Furthermore, they are either the very first, or among the first, in a series of etchings Altdorfer devoted to topographical subjects, an indication that for some reason he deemed etching especially appropriate to this purpose. To be sure, representing buildings was not new to him when he made these prints. His paintings and drawings are rich with elaborate and sometimes spectacular ecclesiastical and palatial structures. But even when they seem to respond to some existing building, his other architectural studies all have a more fanciful or dramatic air about them, a quality that the *Synagogue* interiors entirely lack. What strikes us most about these etchings, in contrast, is their unadorned, soberly documentary point of view. The nave of the building is described from an angle taken to reveal its structure as fully as possible. The shadowed lighting effectively captures the obscure atmosphere of a high-walled and sparsely fenestrated structure. As we can make out from the step barely visible into the nave, the portico must have lain against the right (probably south) wall. Here the artist has depicted two figures, one of them carrying a large codex and both dressed in variations of the costume worn by male Jews at the

time.[297] If the visual tenor of these images is restrained, their inscriptions demand a very different response. The panel of text above the nave reads: ANNO. D[OMI]NI. D XIX / IVDAICA. RATISPONA / SYNAGOGA. IVSTO / DEI. IVDICIO. FVNDIT[I]S / EST EVERSA. (In the year of our Lord 1519 the Jewish Synagogue of Regensburg is, by the lawful judgment of God, cast down from its very foundations). And above the portico: PORTICVS SYNAGOGAE / IVDAICAE RATISPONEN[SIS] / FRACTA. 21 DIE. FEB. ANN[O]. 1519 (The portico of the Jewish Synagogue of Regensburg, destroyed the 21st day of February in the year 1519). Precisely this was the occasion that provoked Altdorfer to publish an architectural record of the building.

Jews in the Imperial Cities were under the legal protection of the Emperor, the so-called *Judenschutz*, a privilege for which the Emperor taxed them lavishly. This was a chronic source of contention between the city, the Church, and the Emperor. The Regensburg quarter, located in the center of the town, held one of the last Jewish groups allowed to remain in the Imperial Cities. Nuremberg, for example, had expelled its population in 1498, perhaps not incidentally the year that Dürer brought out his illustrations of the *Apocalypse*. The Regensburg community was among the most venerable and prosperous in Europe, but all this came abruptly to an end in the course of a single week during that winter month in 1519. For some time Regensburg's economy had been flagging. As Johann Cochläus described it in 1512, it was "a bishopric and imperial city, once powerful and still today adorned with magnificent buildings, but utterly devoid of treasures."[298] One consequence of its decline was that the Jews were repeatedly accused of improper dealings by the artisanry, who were at that time seeking an explanation for their own misfortunes. The artisans' appeals continued to be rejected by the court until the brief interregnum following the death of Maximilian on 12 January 1519.

Encouraged by the anti-Semitic preachings of the charismatic Balthasar Hubmaier, a group of townsmen appeared before the council with a list of charges ranging from general economic oppression to illegal trade practices and the fencing of stolen goods. Their principal demands were that all goods held as collateral be returned to their former owners, that all debts be canceled, and that the entire Jewish population be summarily expelled from the city. The council retired for a very brief deliberation and then granted these requests. An embassy was sent immediately to the gates of the Jewish quarter to proclaim the confiscation and exile to the Elders. The population, then numbering some five hundred souls and including the eighty pupils of its distinguished *Schul*, was apparently given a mere five, or more probably eight, days to depart from the city. According to early

accounts, the destruction of the synagogue began almost immediately, then the cemetery was dug up, the gravestones were broken apart for building material, and eventually the entire domestic quarter was leveled. Albrecht Altdorfer was a member of the council that bore responsibility for this momentous decision.[299]

Scholars have speculated with surprising exactness about when Altdorfer might have composed his studies of the synagogue. Franz Winzinger mysteriously hypothesizes that the designs were made "the day prior to the announcement of the expulsion." Wilhelm Volkert supposes a twenty-four hour extension may have been given before the demolition in order for the sketches to be done, and Reinhild Janzen assumes they were made "soon afterwards . . . from memory."[300] Since there appears to be no certain evidence about the matter, these rather precise statements would seem to reflect nothing more than the powerful journalistic feeling evoked by the etchings and a consequent desire to accommodate their sense of immediacy with an equally explicit account of their making. These dramatic circumstances do indeed suggest that Altdorfer made his drawings during the short period between the council's ban and the subsequent razing of the building. The date recorded in both plates is, of course, the date of the demolition cited in the inscription and not necessarily the date of the prints themselves. It stands to reason, however, that the urgency of events would have encouraged a comparable urgency in the production of the prints, and that Altdorfer elected the

PORTICVS SINAGOGAE
IVDAICAE RATISPONEN
FRACTA. ZI DIE. FEB.
ANN. 1519.

expedient medium of etching for exactly this purpose.[301] There is simply no reason to suppose he would have been driven to set down these unprecedented records without some specific purpose in mind. Furthermore, symptoms of technical difficulty in the etching and printing of the plates and casual irregularities in the perspective construction of the architecture point to the pair having been a somewhat rushed job.[302] There was a practical function being served in these self-evidently journalistic prints: to document the structure, as well as its abrupt obliteration, and to publish these facts abroad. In light of this, and of the poignant implications of the Regensburg expulsion, the most remarkable aspect of these images is just how unremarkable they are as architectural records, coldly dispassionate and rather hollow. The tension between the sensational appeal of the inscriptions and their impersonal quality as architectural portraits, as *conterfeiten*, must betray some sort of division in the artist's own motives. It would seem to be just this conflict that marks their significance for the history of European printmaking.

In hindsight, the expulsion of the Jews can be seen as the opening gambit in a highly successful campaign for renewing the city's economic fortunes. During the destruction of the synagogue, one of the workman was said to have survived a disastrous fall from the vault. The recovery was proclaimed a miracle and attributed to the powers of the *Schöne Maria* of Regensburg, a venerated cult image that had long been in the city's care. Because the Virgin had expressed her favor at this

particular moment, it was naturally taken as a sign that the exile of the Jews had won her approval. She appears to have provided a somewhat Delphic omen, however, since the victim of the accident died within the year! Nevertheless, a successful appeal had by then been made to the papacy to proclaim an indulgence for those making a pilgrimage in honor of the *Schöne Maria*. Rome was coming under seige from the burgeoning popularity of Luther in northern Europe and so was perhaps quicker than usual to support the wishes of its German constituencies. The consequences of granting this pilgrimage are well known.[303] For a period of several years Regensburg became a popular objective for pilgrims seeking indulgences and the benefit of the Virgin's healing powers. They came from areas all across northern and especially central Europe, in a wave that was dramatically counter to the early advances of Luther's evangelism with its bitter antagonism to cult worship and idolatry.[304] Almost overnight Regensburg stirred from its commercial stagnation to become one of the most heavily trafficked towns in Europe, hosting hundreds of thousands of pilgrims over the next five years. A highly interesting woodcut by Altdorfer's sometime collaborator, the Regensburg designer and block cutter Michael Ostendorfer, depicts these ecstatic crowds gathered beneath the statue of the Virgin and processing with their offerings about the little wooden chapel temporarily set up in her honor (fig. 373). At some point Dürer acquired an impression of this print, which survives with an inscription in his own hand condemning the worship of false idols. It is among our most explicit clues to Dürer's sympathy for Luther's anti-Catholic teachings.[305]

For the industry in manufacturing religious souvenirs, and for printmakers especially, this was an opportunity of unimagined proportions. The first bits of published propaganda about the expulsion and the wondrous workings of the *Schöne Maria* had to find printers in other towns since, despite Regensburg's long-standing importance as a bishopric, it appears nobody there was equipped to print pamphlets even on a small scale. Heretofore official business had been farmed out to Bamberg, and between 1519 and 1521 accounts of the many dozens of miracles performed by the cult figure as well as texts of popular songs celebrating the pilgrimage were being printed in Landshut, Nuremberg, Augsburg, or Munich. Then in 1521 Regensburg got its first local printer, Paul Kohl.[306] There was, predictably, a boom in religious paraphernalia as well. The manufacture of stamped and cast commemorative plaques showing the image of the *Schöne Maria* exploded, with some 12,000 sold to visitors in 1519 and nearly 119,000 in the following year.[307] And the printmakers had a field day, Altdorfer the first among them. Probably between 1519 and 1521 Altdorfer designed at least

372. Albrecht Altdorfer, *Porch of the Regensburg Synagogue*, 1519. Etching on iron (B.64), 164 × 117 mm. British Museum, London.

375. Albrecht Altdorfer, *Schöne Maria of Regensburg.* Color woodcut from six blocks (B.51), state I, 339 × 246 mm. National Gallery of Art, Washington, D.C.

373. Michael Ostendorfer, *Pilgrims at the Shrine of the Schöne Maria, Regensburg.* Woodcut (G.967), block 580 × 391 mm; sheet 635 × 391 mm. Kunstsammlungen, Veste Coburg.

374. Michael Ostendorfer, *Hans Hieber's Plan for the New Church of the Schöne Maria.* Woodcut (G.968), 618 × 531 mm. British Museum, London.

seven different prints of the *Schöne Maria* of Regensburg in various guises.[308] Most conspicuous among these is a garish, multi-block color woodcut (fig. 375). Unlike the chiaroscuro technique, each of the five separate colors is printed without overlap. This was actually just a more elaborate version of the scheme designed by Ratdolt over a generation earlier for creating a colored image by more efficient means than stenciling but to the same effect. Not surprisingly, Altdorfer's design was difficult to print with an accurate registering of its several blocks, and it can be judged retardataire in comparison to developments in chiaroscuro woodcut printing by this time.

We are not clear to what extent the retailing of these various images was done by local institutions or by the artists themselves, but surviving documents point towards the use of middlemen. Ostendorfer's 1522 woodcut of the planned church dedicated to the *Schöne Maria* was accompanied by a text that Kohl provided from his own fonts (fig. 374). Ostendorfer was paid twelve *gulden* outright for his design and, given the amount of the fee, probably also for the finished block. Kohl then sold 1,500 of them to the council for one *kreutzer* each,

slightly more than a 100 percent profit. Probably in the same year, Kohl printed a forty-page pamphlet describing the miracles of the Virgin with a woodcut title page by Ostendorfer. The council paid twenty *gulden* for one thousand copies (1.2 *kreutzer* each), and a further two thousand copies were inventoried among the stocks of the Chapel of the Beautiful Virgin. (Some copies were printed on vellum, and some were hand-colored at a charge of two *gulden* for a thousand.)[309] Funds from the pilgrimage were being put towards the construction of a new church to house the cult figure, and presumably as part of this promotion a woodcut portraying the proposed new building was commissioned from Ostendorfer. Likely the major income from these various publications was being realized by the Church and the city government, whereas smaller items such as Altdorfer's less conspicuous engravings and woodcuts were being purveyed from the workshop, from stalls by the painter's assistants, or by peddlers working under franchise.

Artists and printers were thus providing a substantial service to the town's economy by advertising the pilgrimage. In the longer term Altdorfer

Ganntz schön bistu mein freundtin vnd ein mackel ist nit in dir.
Aue Maria.
Ganntz schön bistu mein freundtin vnd ein mackel ist nit in dir.
Aue Maria.
Ganntz schön bistu mein freundtin vnd ein mackel ist nit in dir.
Aue Maria.

switched his allegiance to the Reformation cause along with the changing official sympathies of the city. The printer Paul Kohl was quicker. He exploited both sides of the religious fence virtually from the time he settled in Regensburg. Typographical evidence shows that Kohl was anonymously publishing Luther's writings from at least 1522 onwards at the same time he was avidly helping to fuel the adoration of the *Schöne Maria*.[310] This, like so much other evidence about commerce, printing, and the arts, should come as no surprise. Artists' and printers' private convictions may have had little to do with their professional practices. For example, Lucas Cranach the Elder served as Luther's chief propagandist in artistic matters, while at the same time acquitting commissions for the reformer's arch rival, Cardinal Albrecht of Brandenburg. Professional opportunities were not necessarily judged in terms of personal or ideological loyalty, though in some cases they could result in legal prosecution. Is it fair to conclude that Cranach and Kohl held no compelling views about the two radically opposed causes they were simultaneously promoting? Probably not. Given these and other similar cases we cannot assume such a cohesion between public and private values in the urgent climate of sixteenth-century commercial and intellectual life. By extension, it is a risky business to speculate too precisely about Albrecht Altdorfer's intentions in recording and publishing the two views of the Regensburg synagogue. His intentions are ultimately unrecoverable, and they can certainly have been as various as his sundry personae — those of a successful printmaker exploring a new technique, an architect fascinated by an ancient and exotic structure, a local official interested in recording a consequence of a decision he had participated in making, a gifted opportunist exploiting a highly volatile and commercially advantageous circumstance.

So far as Altdorfer's personal sympathy, or lack of sympathy, for the banished Jews is concerned, the opinion of historians has wavered dramatically over time.[311] Whether the resonance of these images betrays Altdorfer as a humane or condemnable observer is a judgment that must be left to the individual. Our present concern is with their importance as recorded observations and what this may imply about etching, the sort of subject matter deemed appropriate to it, and the audience for it. Technical problems evident in all of the surviving impressions examined imply that the *Synagogue* views were made at a stage when Altdorfer was not yet fully in control of the medium.[312] This further suggests that he elected etching initially for practical rather than aesthetic reasons, indeed in all probability for reasons of expediency. Here there are two aspects to consider: the relative speed of production that we properly associate with etching, and also the potential size of the edition. Iron plates would have stood up to the pressure of the roller press far longer than copper. Even considering the shallower bite of an etched as opposed to an engraved line, a plate well etched in forged iron or steel would outlast any engraved copper plate that had not been re-worked at least once in its history. The seventeenth- and nineteenth-century editions of Hopfer etchings and the present condition of their surviving plates tend to confirm this conclusion. There is no way of telling how large an edition Altdorfer may have printed, whether he was anxious to issue the print for sale to the Jews prior to their departure, or whether it was retailed primarily to pilgrims and other travelers to the town or sold to collectors with an interest in antiquarian subjects or simply those taken by its newsworthiness. In any case, iron etching made it possible for Altdorfer to bring the image quickly into print and eventually to make a large edition if he chose to do so.

The Etched Landscape: A Print Collector's Genre

There is general agreement that Altdorfer's earliest etching is a small print of a *Lansquenet* (Holl. 63) made on iron and extant in only one rather poorly printed impression slightly marred by rust (Berlin, Kupferstichkabinett). Winzinger dates this print quite credibly to ca. 1516 on grounds of style and costume. We cannot be surprised that the proposed date places it at just the time etching was being tried out by Dürer. Conspicuous technical difficulties and its probable early date suggest that this was Altdorfer's trial piece. There is debate about just how long after making the *Lansquenet* he returned to etching in earnest. The *Synagogue* views, which we place in 1519 on circumstantial grounds, show exactly the same technical problems with the biting and printing as the *Lansquenet*. Thus, we are inclined to regard them as the artist's first serious commitment, his point of entry, as it were, not only to making etchings but also to making topographical prints. Altdorfer pursued his fascination with descriptive imagery in a series of nine extraordinarily vibrant and freely etched landscapes (figs. 376–77). Just as the *Synagogue* views were the earliest purely architectural portraits in prints to be made so far as we know by any artist north or south of the Alps,[313] the pure landscape etchings appear to be among the very first prints of their kind on the European market.

Though not dated in the plate, these landscapes form a relatively tight stylistic group. They have been variously distributed by scholars over the teens and 1520s, and sometimes later. The discovery of several dated copies established probable *termini* of 1522 or 1523 for at least four of the nine

landscapes.[314] It has been argued on the basis of purported stylistic similarities with certain of Altdorfer's landscape drawings of 1511–13 that a couple of the etchings may precede the *Synagogue* views by a considerable margin.[315] Most scholars, however, have tended to place them between about 1517 and 1523.[316] Though it is a rather small point given the evidence at hand, we do not find the arguments for dating any of the etched landscapes earlier than the 1519 *Synagogue* prints convincing. Dürer's *Landscape with a Large Cannon* of 1518 may have partly caused Altdorfer to consider etching as an apt medium for pure landscape compositions. Stylistic affinities point strongly away from the impulsive early drawings of 1511–13, and toward the more thoughtful pen drawings with body and watercolor of the early to mid-1520s, for example the *Alpine Landscape with a Church* of 1522 (from the Koenigs collection, stolen during World War II) and the *Landscape with a Pine and a Woodcutter* in Berlin. Probably also around 1520 Altdorfer was making pure landscape paintings such as the *Landscape with a Footbridge* now in the National Gallery in London. Only two such paintings survive, the second of them a *Landscape with a Castle* in Munich, both rather small works done on parchment and pasted down on panel. They clearly constitute an emerging new genre, their size and medium establishing them as steps from finished drawings in color towards the more permanent medium of oil on panel. Thus there is an energetic

convergence of interest in pure landscape evident in Altdorfer's workshop beginning in the lively years around 1520 and after.

Finally, from the technical point of view we can see precisely the same problems afflicting the *Lansquenet* and the two *Synagogue* prints, especially the irregular biting and printing in the densely hatched areas of shadow. One can recognize progress in sorting this out between the views of the portico and of the interior nave. Difficulty in the darkest areas of a print where lateral biting intrudes on dense hatching are characteristic of many artists' initial attempts at etching in iron, perhaps because the medium seemed at first to encourage crepuscular compositions that then brought out the irregularities of iron plates. Altdorfer's landscape etchings, however, take a wholly different approach, employing a much looser network of hatching throughout. It is certainly a quality congenial to Altdorfer's free style of draftsmanship, but also to the exigencies of etching. In these prints the etched line is typically broken into dashes over much of the plate, suggesting a different sort of problem from those encountered in the architectural settings, presumably a difficulty with the consistency of the ground, or its receptiveness to Altdorfer's variously gauged styluses. Winzinger concludes that the broken line was intentional, meant to give a lightly "impressionistic" effect to the drawing, but this is belied by the fact that even Altdorfer's monogram is often fractured from irregular biting.[317]

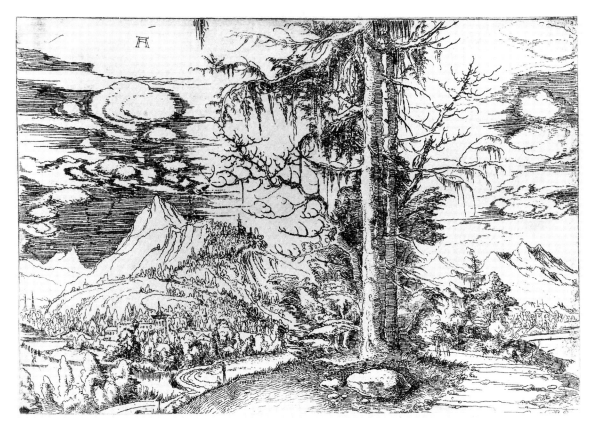

376. Albrecht Altdorfer, *Landscape with a Double Pine*. Etching on iron (B.70), 110 × 162 mm. British Museum, London.

343

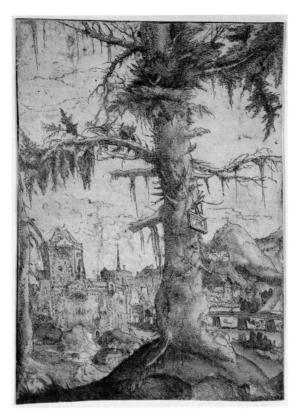

Very likely, Altdorfer came to accept this peculiarity as consistent with the lightness of his touch, as we may infer from his increased use of stippling in the landscape prints and a preference for shallow biting. This more technical explanation of the chronology joins the evolution of Altdorfer's formal and topical interests closely to his understanding of the etching medium and what could be done with it. On this basis it seems prudent to adjust the date of the earliest landscape etchings to follow on the creation of the *Synagogue* prints, which then would have initiated Altdorfer's fascination with topographical subjects and with the expedient new means of printmaking.

Historically most prophetic is the correlation of Altdorfer's descriptive or documentary use of prints with his turn from woodcut and engraving to the new technique of etching. Altdorfer's invention of pure landscape painting, surely one of the most significant innovations in the history of western art, was certainly not taken without an awareness of its great importance. That he should choose to announce this departure by elaborating the theme in a cycle of prints seems altogether appropriate. The delicacy of line and the rarity of extant impressions point to the etched landscapes having been thought of by the artist as exclusive. Being the first printed images of their kind, essentially without figures and indisputably intimate, convincing evocations of a verdant and mountainous countryside with its beautifully tangled firs and nestled dwellings, we can only conclude that Altdorfer was

out to cultivate a new patch in the collector's market. A compelling argument has been made that Altdorfer's treatment of landscape as an independent genre suited to painting and to prints reflects a new concept of the relation between subject, style, and authorship in the minds of northern patrons. In this view, landscape offered "a theater for personal style" with an appeal to a small coterie of collectors close to the artist.[318] Here it is important to emphasize the significance of these etching as separate compositions, and thus different in meaning and aesthetic appeal from the observed or invented topographical illustrations in printed books, which already had a history of their own by this time. Purchasers of Altdorfer's etchings were undoubtedly to be found among the buyers of elegant landscape drawings in pen and ink and chiaroscuro or colored ground technique. This sort of collector's item had been evolving in the Danube school for at least a decade and was apparently now deemed ready to be transferred into an efficient medium of replication on the one hand, and into the more substantial medium of panel painting on the other.

It has been observed that the lightness of the etched landscapes seems particularly complementary to hand-coloring the prints with watercolor washes, and so it is not surprising that among the best impressions a very few have been so enhanced, very possibly by Altdorfer himself (fig. 377).[319] In these exceptional cases the etchings take on the character of Altdorfer's landscape drawings in body and watercolor, yet another indication that the prints were designed for a discriminating market. The attraction of finding a fully mechanical means of making colored landscape prints emerged over a decade later in a unique impression of a print by a follower of Altdorfer (fig. 378). A line etching of a young couple embracing beneath a tree has been given a wooden tone block, a curious adaptation of the chiaroscuro woodcut technique. The northern master responsible for this remarkable print must certainly have picked up the idea from Italy where the mixing of intaglio and relief techniques was employed by Parmigianino's shop for a composition after Raphael. Parmigianino's example was then later followed by Beccafumi.[320]

The importance of the introduction of landscape as a legitimate subject in its own right has been most sensitively explored by Ernst Gombrich in a seminal essay on the origin of Renaissance aesthetic categories for subject matter and their relation to collecting.[321] Gombrich identifies the earliest pertinent reference to landscapes in a report by Marc Antonio Michiel on his visit to Cardinal Grimani's collection in Venice in 1521, where he delighted in "molte tavolette de paesi," in all probability a response to northern paintings. At this date Marc Antonio Michiel was likely not looking at "pure" landscapes, but rather at

378. Monogrammist PS
(?), *Lovers under a Tree*,
1538. Etching (probably on
iron) with woodcut tone
block (Holl. I.3a),
135 × 125 mm. Kunsthalle,
Hamburg.

works in which, for an Italian critic, landscape was deemed to hold the main interest. Later on, in 1548, Paolo Pino makes reference to the northerners' special gift for landscape, which he attributes to the inspiration they found in painting the wildness of their own surroundings.[322] Gombrich connects the emergence of the landscape genre with a collector's interest that must initially have evolved on Italian soil and was then served to a large degree by German and Netherlandish artists. The priority of any particular market aside, here is further evidence of the importance of Altdorfer's experiments at a critical stage in the evolution of the art market. Let us once again recall the pressures and advantages of his political as well as artistic involvements in these years, the sudden international prominence of Regensburg, and the temporary revival of its trading connections. These circumstances coalesce with Altdorfer's break into new areas of subject matter, pointing to a disturbing connection between artistic invention and volatile and violent times.

Altdorfer's style of draftsmanship as we see it transposed in his landscape prints was entirely congenial to copper etching. Yet the biting and the uneven quality of line point to the landscapes having been done in iron like his earlier and later etchings. Furthermore, an impression of one of the landscape etchings now in Berlin (B.67) almost certainly shows evidence of rust damage partly cleaned away.[323] This conclusion is supported by the fact that we have no confirmed evidence of copper etching anywhere in Germany at this time, and therefore no reason to suppose that the technique was available to him. Again, particularly for a style that inclined to shallow biting, iron had the advantage of relative endurance. But just how much this mattered to him for the landscapes we

cannot say. Certainly it mattered for the series of twenty-three designs for goldsmith's work Altdorfer etched sometime in the 1530s. These were probably meant as pattern books for workers in precious metals, but more importantly were intended for the well-to-do patron of such objects as a kind of catalogue of styles, conceivably also as an aid in commissioning and designing precious vessels.

Altdorfer's decision to pair etching with landscape opened a long and magnificent chapter in the history of intaglio printmaking. There was immediate local enthusiasm expressed in the works of Altdorfer's brother Erhard and his artistic sibling Wolf Huber. Jacob Binck, the most flexible and widely traveled if not the most talented artistic thief of his time, began pirating their compositions. But the main legacy of Altdorfer's innovation occurred in the work of Augustin Hirschvogel during the 1540s and 1550s, and of Hanns Lautensack in the 1550s. It appears that both Hirschvogel and Lautensack turned intermittently or perhaps regularly to copper etching, although by this stage it becomes very difficult to see the difference on the basis of impressions alone.[324] Hirschvogel was broad-minded in his interests and widely traveled and experienced. We have earlier noted his cartographical expertise, but he is best known for the pastoral, dreamy views of the Salzkammergut that occupied him for much of the 1540s, such con-

379. Hanns Lautensack,
*Landscape with a Pollarded
Willow*, 1553. Etching
printed on blue paper
(B.26), 168 × 112 mm.
British Museum, London.

spicuous displays of the calligraphic freedom of etched line that they take on a mannered, if charming, redundancy. Yet in rare instances Hirschvogel's observation sufficiently dominates his style to yield images of remarkable graphic spareness (fig. 380).

Lautensack devoted himself largely to portraits and quiet forest landscapes very much in the manner of Altdorfer. Both Hirschvogel and Lautensack also occasionally printed their landscape etchings on colored papers (fig. 379). We find the earliest sure evidence of copper etching in Lautensack's portraits, where he followed the expedient employed by Lucas van Leyden of etching the landscape background and then engraving the figure. Yet unlike Lucas, Marcantonio, or Vellert before him, Lautensack did not integrate his burin work with etched line. His etched landscapes appear to be done entirely in that medium. Possibly his earliest masterpiece in copper etching is the set of two panoramic views of Nuremberg commissioned by the town council and printed in 1552, each from three separate plates.[325] Across the sky are the city arms flanked by personifications of plenty in a strapwork cartouche, embraced by a banderole identifying the compass direction: "A true portrayal of the praiseworthy Imperial City of Nuremberg, against the rising of the sun, 1552" (Warhafftige Contrafactur der Löblichen Reÿchstat Nuremberg gegen dem Aufgang der Sonnen, 1552) (fig. 381). Hanns has proudly installed himself in the center of the scene where we find him seated with pen and paper amongst the city's admiring patricians.

The rapid success of the landscape etching is a subtle measure of an emerging collector's market in northern Europe, and almost certainly also in Italy where northern images of landscape were much admired. Not only do these etchings offer landscape prints as an appropriate subject for collecting and display, they imply a taste for descriptive and topographical prints generally, and they also foreshadow the eventual success of etching as an expression of individual draftsmanship. Hirschvogel's and Lautensack's pastoral scenes were suited to being framed and hung on a wall or to being quietly perused in a portfolio or album. Altdorfer's etchings, even though they were very likely etched on iron, retain the delicacy of line that one expects from his pen drawings. However, technical difficulties in registering subtle designs were probably the reason that iron plates were abandoned in favor of copper, a discriminating preference for formal over commercial advantage and a sure sign of collectors' demands.

In the Netherlands, artists also wavered for a time between iron and copper, although they began to use mixed technique on copper at an early date and continued to do so. In an important sense the etched landscape print scouted the way for Hieronymus Cock, the Antwerp print publisher who entered the market around 1550 and thereby redefined the relation of artists to the making of intaglio prints. Following in the wake of Antonio Salamanca and Antonio Lafrery in Rome, Cock explored many subjects but especially cultivated the taste for topographical and reproductive prints in the north.[326] Since the early seventeenth century,

380. Augustin Hirschvogel, *Castle Yard*, 1546. Etching (B.71), 143 × 215 mm. British Museum, London.

devotees of the *peintre-graveurs* have disparaged this printing house's publications, and particularly in modern times it is the commercial aspect of Cock's prints, their mass production, that has been criticized. Yet we must recognize that Cock had some of his commissioned designs executed in a mixed technique of etching and engraving because he must have found this to be the most effective means of faithfully replicating drawing. A more crassly commercial publisher would have eschewed mixed technique for pure engraving or etching on iron. This he did not do. By now it should be clear that this crucial shift in print patronage around mid-century had much to do with the stumbling evolution of etching advanced by the prior generation. Not only the important school of landscape etching in Germany but also the experiments in mixed technique on copper were crucial developments in this regard. Furthermore, the Netherlandish sensitivity to capturing the quality of draftsmanship shaped a taste for prints that guided Cock in his commissions and guided his best etchers and engravers in rendering designs onto the plate.

Northern Printmakers: Their Milieu and the Market

Opportunities for the acquisition of prints must have been various already from the fifteenth century onwards, and probably these did not differ a great deal whether one set out to buy in Nuremberg or Venice or Antwerp. Absent any extensive records of purchase, we must turn first to the makers and what can be said about their means for reaching the market. There is enough fragmentary evidence for us to form at least a vague idea of northern print selling and its evolution from the latter part of the fifteenth century onwards. At the point when prints were mainly being produced by monasteries and cardmakers, and in the ateliers of precious metalworkers and painters, they were probably also being sold from these places as well, or by booksellers and sundry shops. A monastery would have printed cheap devotional images for its own brothers or sisters and for its congregation, and perhaps also for sale to occasional visitors and pilgrims. Recall that documents from the Einsiedeln Monastery in Switzerland, for which the Master ES made centennial prints, stipulate that no foreigner was allowed to sell religious objects on their premises, a clear indication that in some ecclesiastical establishments prints were actually monopolized as an important source of income. We can see this practice continuing in the commercial relations surrounding the Regensburg pilgrimage, where prints were bought up in large quantity by the city and ecclesiastical authorities, obviously in order to retail them for profit.

Local marketing of local products must have continued to account for a large percentage of the lower end of the print trade until well into the nineteenth century. In Bruges, where the art market had become highly evolved after a century of wealthy international patronage, there were shops specializing in print selling already in the fifteenth century.[327] In those days prints traveled mostly with their owners rather than being exported for sale abroad. Book shops dealing in prints and other small domestic items and entertainments persisted, reflecting the print's incidentalness and also its association with other sorts of printed matter generally appealing to the literate. As we have seen, Alessandro Rosselli's shop dealt in all manner of things in addition to maps and prints. In much the same vein, in 1546 we find a Bruges dealer named Hubert Croc renewing his legal right to sell prints, books, cloth, bonnets, and games. He also printed votives for the brothers and sisters of the religious houses, kermis flags, broadsheets, and New Year's cards. In his appeal Hubert further explains that he sells his wares in other towns in Flanders and often in Spain. As testimony to his skill he attached seven prints to the request. Croc was then fifty-six years old and had apparently been managing his trade in varieties for a very long time.[328] This had doubtless been a common sort of undertaking for nearly a century.

Sales by the keepers of variety shops or print and book shops were supplemented by the colporteur, or itinerant peddler. In Basel in 1466, a painter named Adam tried to recover a debt from someone to whom he had given a bunch of "saints" to sell for him. Adam testifies that he printed and colored these himself.[329] Maurits de Meyer refers to a fifteenth-century inventory of a Deventer bookseller recording "eight books of paper saints" and "a peddler's basket with prints and blocks."[330] Best known of all is the contract made between Albrecht Dürer and his colporteur on 8 July 1497, the height of the summer months so full of promise for a wandering trader. Dürer engaged Contz Sweitzer to travel from town to town selling prints at prices fixed by Dürer himself. For this, Contz was paid a weekly wage of half a *gulden* with three (old) *pfund* for daily expenses. A document of 1500 concerning another matter indicates that Dürer later employed Jacob Arnolt, the brother of a local painter, to sell his prints.[331] An artist like Urs Graf, who regularly left his shop to follow the mercenary armies as a lansquenet, must have served as his own colporteur. Then during the restless period of the Reformation, when pamphlets and prints were being issued in large numbers for propaganda purposes, and their suppression was pursued with equal if ineffectual vigor, the trader's lot became a very risky one.[332] Perhaps partly due to these uneasy times, the traveling peddlers enhanced their already proverbial reputation for misconduct.

381. Hanns Lautensack, *View of Nuremberg from the East*, 1552. Etching on three copper plates (B.59), state II, 297 × 1528 mm. British Museum, London.

The record of Dürer's practices has provided us with much of our information about print distribution in the Renaissance. It may be more than just accidental that we only know of his use of a peddler on these two occasions early in his career and so close together. According to Vasari, in 1504 Dürer discovered that Marcantonio was forging his work. Sometime later a print seller was caught in Nuremberg itself offering works falsely marked with Dürer's name, and there were other complaints about piracy. Given Dürer's proprietary nature, he may have been led to seek a more controllable means of distributing his work. From his letters, we know he dispatched his mother and his wife to sell his prints at fairs and religious festivals. The household accounts of the Saxon court in 1513 reveal that through one of his apprentices Dürer sent Friedrich the Wise a selection of his latest copper engravings.[333] Then in 1523 Dürer wrote a letter to Felix Frey, a cleric and later Reformer in Zurich. On request he sent along a drawing of dancing apes with a mild excuse, saying that he had not seen any apes for some time. In the postscript Dürer added greetings to the artist Hans Leu and some other friends and enclosed other examples of his work: "Divide these five pieces among yourselves, apart from them I have nothing new" (Teillent dis füff stücklin und[er] vch, ich hab sunst nix news).[334] He made a point of these prints being his most recent ones, implying that his friends would have already had, or at least known, his earlier work. Most important of all is Dürer's Netherlandish Diary, which records the distribution of a great many prints, sometimes sold outright, sometimes exchanged for goods or services, sometimes apparently given out of generosity or in the hope of receiving future patronage.

There is other evidence to suggest that much of the selling continued to be done by the makers of the prints themselves or by members of their household. The common practice among corner

press woodcut printers of listing their street address on broadsheets suggests that "over the counter" selling went on regularly. Yet at the same time certain sorts of prints traveled across Europe with remarkable facility. For example, the landscape from Lucas van Leyden's *Susanna and the Elders* (fig. 382) of ca. 1507 was copied in Rome by Marcantonio for the background of his much-admired *Lucretia* (fig. 113), and then in recompense the graceful figure of Lucretia from Marcantonio's print was pirated by Lucas for his engraving *Adam and Eve Mourning the Death of Abel* of 1529 (fig. 383). Since most artists were not so widely traveled, and those who bought prints for their own interest cannot account for the fluid exchange among artists in distant places, one must resort to some other explanation for how prints were exported abroad in significant numbers.

The creation of a lively international trade in art was, after all, an important aspect of Renaissance culture, though its longer range connections were as yet tenuous and much more geared to traffic in luxury items than in relatively minor things. One thinks of the Vatican tapestries designed by Raphael in Rome, and thereafter the cartoons sent to Flanders for weaving. Precious metalwork from Nuremberg and cabinetry from Augsburg were sought after by Italian patrons, just as the Hapsburg court imported its mounted lapis lazuli and chalcedony vessels from Milan, and German and Netherlandish humanists bought coins, carved gems, and other antiquities through Italian dealers. Prints by comparison were inexpensive to buy and to ship. They could be bundled up and tucked into barrels along with bulk shipments of paper or books and sent by barge, pack train, and wagon along the cheaper routes. There are bits of evidence that major mercantile firms may have engaged in the print trade on the side, or at least served as shipping conduits for art dealers and their agents. For example, in accounts of the various branches of the

348

great Fugger house of Augsburg we find occasional references to prints among the shipments — in 1539–40 the Antwerp office recorded a group of hand-colored prints and also maps mounted on canvas; and in Neusohl a bundle of broadsheets and "ein Kunstbuch Albrethen Dürers," the last of these probably one of the *Large Books* of woodcuts.[335] It is not surprising that most of the prints listed have been colored, and usually fixed to canvas for display, since otherwise we would not expect them to be listed separately or shipped in individual lots. Precisely because of the convenience and relative cheapness of shipping bundles of prints, almost no packing lists including them have come to light before the middle of the sixteenth century, and even after that such records are exceedingly rare.

The most likely place for print dealers and publishers to have exchanged prints in large numbers was at the great trade fairs, most prominently the Frankfurt Fair, which from the early sixteenth century onward served as the major clearing house for new publications as well as a place to buy stocks of paper, maps, prints, and many other sorts of commodities. The Frankfurt Fair had been in existence since at least the thirteenth century, and, like many other annual town fairs in the Middle Ages, it was an event for exchanging goods of all sorts. Originally the fair was held only in the early fall; this *Herbstmesse* normally began in the middle of August on the Sunday before the feast of the Assumption of the Virgin and then lasted for about a month. It seems that it was customary to devote several days to securing passage to the city and making arrangements for the traders, a week to negotiating sales, a week in which accounts payable were due, and a final period for sorting out the flotsam and arranging to dispose of remaining stocks. Beginning in 1330 a second, spring fair was authorized, generally to be held during Lent; this fair was of lesser importance and initially shorter

in length. Although the dates varied over the centuries, what little information we have about the fair during the Renaissance suggests that this seasonal pattern was maintained except under extreme conditions of war or plague.[336]

From the first half of the sixteenth century onward the Frankfurt Fair was the main event for European printers wishing to acquire quantities of paper and to sell their publications, and for dealers to purchase and to sell books and prints. In 1520 the Nuremberg educator and cleric Johann Cochlaeus wrote to Pirckheimer from the Frankfurt Fair, remarking that although Albrecht Dürer's prints were hard to come by, those by Lucas of Holland were available in abundance.[337] This is a small but telling piece of evidence. Not only does it show that the German scholar was very well aware of the fame of a printmaker who so far as we know rarely strayed beyond the town of Leiden, but also that Cochlaeus took for granted that prints by noted masters would be on offer at Frankfurt. Most interesting of all is that the relative availability of a particular printmaker's work was so evident to Cochlaeus, and furthermore that he troubled to comment upon it.

Dealing in prints at the Frankfurt Fair supports our speculation that book publishers were involved in exporting prints well before the middle of the century, though we are unable to provide any more direct evidence to support this. There are many reasons why printmaking and book printing should have flourished in the same places and why these two trades should have become so closely intertwined. The Kobergers had the most established and widespread string of agents of any printing house in Europe. These agents did job-printing, purchased and shipped supplies and raw materials, and received and sold books from Koberger presses. In Nuremberg the Kobergers maintained a stable of designers and block cutters, the milieu where Dürer first cultivated his talents. Is it pos-

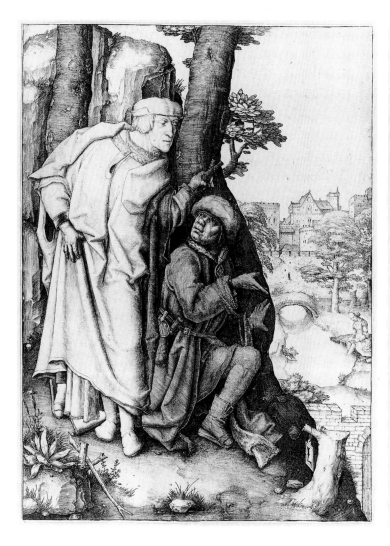

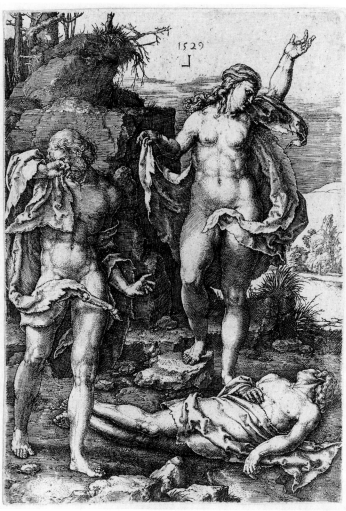

382. Lucas van Leyden,
Susanna and the Elders.
Engraving (B.33),
198 × 147 mm. British
Museum, London.

383. Lucas van Leyden,
*Adam and Eve Mourning
the Death of Abel*,
1529. Engraving (B.6),
162 × 115 mm. British
Museum, London.

sible that the Koberger house never took commercial advantage of the extraordinary production of fine prints nurtured under the wing of his own publishing house? Yet, so far as we know, there is not a single reference to a shipment of prints anywhere in the Koberger correspondence or account books. Apart from an occasional legal dispute or a casual reference such as we find in Cochlaeus's letter, the traffic in prints has persistently eluded documentation. From the perspective of the economic historian, prints may forever remain a furtive commodity in Renaissance cultural traffic.

The manner in which prints were distributed and purchased brings us directly to the question of their relative value in northern markets. Let it be clear at the outset that there is no very precise answer to this question either. Many difficulties underlie the subject of what prices were paid for early prints in northern Europe. It seems safe to say that prints were on the average not very expensive. All of the evidence points toward this general conclusion. However, the evidence is widely scattered, fragmentary, and because of the complexities of Renaissance currency exchange, very resistant

to meaningful correlation and analysis. Precisely because the values in question are small, the slightest error in calculating them against any uniform standard (costs of staples, wage labor, etc.) makes a substantial difference in the conclusion to be drawn. Such pitfalls become all the more perilous when making comparisons among cases in different towns or purchases made under different circumstances.

This much said, we may nevertheless hope to substantiate the premise that before the middle of the sixteenth century woodcuts and engravings were not expensive north of the Alps. What does this mean? In one of his recorded sermons around 1500, the Strasbourg preacher Geiler von Kaisersberg refers to a simple image of the *Visitation* that can by bought for a *pfennig*.[338] This is a casual reference made for effect, but a sign that devotional prints could be had for a pittance. Some paste prints are recorded with what appear to be purchase prices noted on them. In 1487 a paste print now in the Munich Library was purchased for ten *kreutzer*.[339] Two paste prints discovered in a monastery in Teplice, Bohemia, are inscribed as having been purchased in 1508 for three *heller* each.

350

Yet another print from the same group is marked five *heller*.[340] Considering that these were rather gaudy and complicated to make, though small, they must have been more valuable than a hand-colored woodcut. The Nuremberg merchant Anton Tucher bought three impressions of an engraved *St. Jerome* and four of the *Melencolia I* by his fellow townsman and personal acquaintance Albrecht Dürer. This transaction is noted in Tucher's account book for 1515 with the price of one and a half *gulden*, hence a substantial fifty-four *pfennig* for each print.[341] Carel van Mander states that during his lifetime Lucas van Leyden's folio engravings brought him a gold *guilder* a piece.[342] As already mentioned, Michael Ostendorfer's 1522 woodcut of the planned *Chapel of the Schöne Maria of Regensburg* was printed with its accompanying text by Paul Kohl, who then sold 1,500 impressions to the town council for one *kreutzer* each.[343] This was a wholesale transaction, and one supposes the prints were retailed by the council for at least twice as much. An inventory record of the Nuremberg painter Hans Schmid taken in 1544 records "various woodcuts" and a block for two *pfund* and three *pfennig*, the whole lot for slightly more than Tucher paid for a single engraving by Dürer a generation earlier.[344] Maps were certainly a related commodity, though different in that they were sometimes of practical use and often meant for wall display. In a Nuremberg bookseller's inventory in 1530, four maps of Vienna (specified as uncolored) were valued at twenty-five *pfennig* each. In Amsterdam in 1543 a map of the Oosteriche Zee cost one *guilder* eight *stuiver*. Cornelis Anthonisz.'s huge bird's-eye view of Amsterdam, on the other hand, sold for thirty-six *guilder* in 1538. Even this meager list of examples betrays the fact that prices where they do survive are usually attached to exceptional items. Apart from large maps, all are valued in relatively small currency denominations, though even these are in most cases clearly out of reach of the poorer classes.

For the entire span of time that concerns us here, the only concentrated cluster of evidence about prices comes from Albrecht Dürer's Diary recording the accounts of his visit to the Netherlands.[345] This document has the advantage of providing partial records of several different kinds of transactions involving prints, and at the same time yields useful information about his expenses, thereby giving us an idea of the relative worth Dürer assigned to his prints. One might be inclined to suppose that because of Dürer's unusual distinction his case might be eccentric, perhaps inflated in relation to prices typically being asked for prints at the time. However, the Diary, like much else we know about this artist, suggests that on the level of everyday dealing Dürer had few pretensions and probably offered his work at expected values, though like anyone else he would have done his best to make a profit. As a record of dealing prac-

tices and prices, the Diary reflects an encouraging degree of consistency at one level, but again one must not overestimate its usefulness for coming to very precise conclusions about the marketing value of given sorts of prints. The difficulty with analyzing the Diary lies more in Dürer's varied purposes in distributing his work. The Netherlands journey was undertaken with a range of objectives in mind: to witness the coronation of Charles V at Aachen, and at the same time to seek a renewal of the annual pension granted him by Maximilian before his death; to see foreign towns; to marvel at and on occasion to purchase something of the riches and exotica that passed through Antwerp's port; and to meet artists, craftsmen, merchants, and dignitaries. In addition, the trip was certainly intended to make money, as in fact it did. Dürer sought the company of diplomatic and mercantile agents, often drew their portraits as a means of getting extra cash, and gave them or sold them his prints. He was treated with respect and much favor in return. Some, such as the Italian silk merchant Tomaso Bombelli and his family, drew Dürer into their intimate midst, dined with him repeatedly, and even invited him to travel with them.

Finally, and perhaps most importantly, this journey was an opportunity for Dürer to make himself better known abroad, both as a gentleman of distinction and as an artist. This last objective he pursued by the vigorous dissemination of his graphic art, which he brought along in substantial quantity, including work from as far back as the late 1490s. Thus, we often find him distributing prints, sometimes in large numbers, as a way of acknowledging favors and hospitality. He traded a full set of his prints to the Italian painter Tommaso Vincidor, a pupil of Raphael, then in Antwerp on behalf of the Vatican to negotiate a set of tapestries. The prints given to Tommaso were meant to be exchanged for work by Raphael, then only recently deceased. When the Antwerp painter Joachim Patinir lent Dürer his apprentice and some colors, apparently to help out with a commission, Dürer repaid each of them with prints. He used prints for tips, occasionally to pay his way, and very often as barter for other goods. Almost certainly his valuation of an exchange depended upon what he could get in return, and whether a gesture of generosity or a hard bargain was more appropriate to the occasion. Despite these many variables in the way Dürer conducted the dispersal of his art, there are a small number of transactions that have the look of being typically commercial. Where these transactions tend to confirm one another we can begin to get a sense of what Dürer's prints were worth to him monetarily.

First let us say a brief word about coinage. The problem of evaluating coins and currency is not fully considered in any of the commentaries on the Diary, though one can appreciate the tangled nature

of dealing with money in Dürer's day by the fact that he mentions over a dozen different coinages and moneys of account in the Diary: the *rhenisch gulden, stüber, pfennig, weißpfennig, heller, blanke, pfund, ort, philips gulden,* "light florin," "horn florin," ducat, and *angel.* Attempting to correlate these denominations with one another in their relatively small amounts would be truly bewildering. However, the basic coin Dürer seems to have carried to cover his expenses was the *gulden.* Almost certainly in this case the *gulden* meant the Rhenish *gulden* (rather than the so-called Nuremberg gold *gulden*).[346] The Rhenish *gulden* was a gold coin of stable value, and thus the likely one for a person to use if traveling through several principalities employing many different currencies. Though for interpreting many transactions it is necessary to be sure of the coin, we are able to approach the specific problem of print prices in other terms. Most of the transactions made after Dürer crossed the Maas River and traveled on into Brabant are recorded in *stüber,* which must refer to the Flemish *stuiver.* At several points Dürer notes that he and his wife exchanged currency in the Netherlands at a rate of twenty-four *stuiver* to the (Rhenish) *gulden,* indicating that Dürer's *gulden* was a stronger currency than the Flemish *guilder* then employed in the Netherlands, which is on occasion also mentioned by him when he encountered it. For our purposes it will be clearest and most consistent if we discuss prices exclusively in terms of the *stuiver,* and furthermore reckon our objective correlations of value for the Netherlands and particularly Antwerp where these transactions were made, rather than for Dürer's native Germany. Also for the sake of clarity we shall break costs down into fractions of *stuiver,* rather than introduce an actual unit such as the *denar,* which would render our explication still more tedious and difficult to follow.

The first and most revealing of Dürer's transactions occurred at the very beginning of his stay in Antwerp when he made a substantial sale to Sebald Fischer. Perhaps because it was the first such sale on a long journey, this exchange is noted in more detail than any other in the entire text of the Diary. The number of prints purchased also reveals that Fischer was buying as a dealer who expected to resell his acquisitions. He purchased sixteen sets of the small woodcut *Passion* for six *stuiver* each; thirty-two of the woodcut *Large Books* for six *stuiver* each book; and six engraved *Passions* for twelve *stuiver* each. He then bought individual prints from lots of engravings mixed with woodcuts that Dürer had apparently organized by dimension.[347] Of these Fischer bought eight whole sheets for three *stuiver* each; twenty half-sheets for 2.2 *stuiver* each, and forty-five quarter-sheets for .53 *stuiver* each.

There is a tenuous but convincing internal consistency to these figures. For example, the small woodcut *Passion* is comprised of thirty-eight blocks, printed four to a sheet on eleven half-folio sheets, while the engraved *Passion* includes only sixteen plates of smaller dimension. Yet the engraved cycle is twice the price. This reflects the artist's labor in engraving the plates, the exceptional care required to print them, and the smaller potential size of the edition. Since the three *Large Books* and the small woodcut *Passion* were very likely to be popular items, the price for them could be set relatively low. The four woodcut cycles are alike in that they all include texts in Latin aimed above the average reader, though at the same time they could be well enough appreciated without reference to the texts. Given the survival rate of the 1511 editions it is safe to assume that Dürer printed them in substantial numbers. A month after the Fischer deal, Dürer sold a small woodcut *Passion* for twelve *stuiver,* twice the price paid by Fischer, whereas at the end of the following summer he sold thirty-six of the *Large Books* for the same price he had before, namely six *stuiver* for each book.

Where the Diary refers to a price for the three *Large Books* the figure is either equal to or less than the cost of the small woodcut *Passion.* Recall that the cycles collected in Dürer's 1511 edition of the *Large Books* are the large woodcut *Passion,* the *Life of the Virgin,* and the *Apocalypse,* twelve, sixteen, and twenty blocks respectively, forty-eight woodcuts altogether printed on folio paper with text on the versos. The language of the Diary does not make it entirely clear whether prices referring to the *Large Books* indicate the cost of each cycle within the trilogy, or of all three taken together. Whereas previous scholars have either concluded the latter, or more typically been non-committal, it is most probable that these references mean one of the books and not all three. Otherwise the price for the luxury set of three cycles would be far too low. In a case where Dürer notes that a certain number of the *Large Books* were sold at six *stuiver,* we interpret this to mean six per book. Therefore, a set of three bound together (probably only stitched and not yet put between boards) would have cost eighteen *stuiver.*[348] A discriminating collector like Hans Tucher would have seen to having his suites of prints bound together in an appropriate fashion. We have an account of 1512 in which Tucher paid the Nuremberg printer Hieronymus Höltzel one *gulden* to bind three large and three small *Passions,* perhaps intending them as gifts or possibly for sale.[349]

The selections of mixed sheets arranged by size demonstrate Dürer's tendency to associate and evaluate his prints first by scale rather than by subject, a habit that remains consistent throughout the Diary.[350] Here again we can confirm the general sense of his pricing by reference to the only point in the Diary where he records a specific amount received for a single, identifiable print. In early September 1520 Dürer mentions selling an *Adam*

and Eve, certainly the famous 1504 engraving, for four *stuiver*. This figure is appropriately one *stuiver* higher than the three *stuiver* average for prints selected from the full-sheets of mixed engravings and woodcuts sold to Sebald Fischer a month before. Interestingly enough, this appears close to the price paid by Anton Tucher in 1515 for his impressions of the *St. Jerome* and the *Melencolia I*. Presuming the same basic currency and rate of exchange, Tucher's prints would have been a little more expensive, costing him about five rather than four *stuiver* each.[351] The overall pattern suggests that, on the average, woodcuts were less valued than engravings. The single-leaf woodcuts included among the mixed sets were probably valued more highly than the bound cycles of woodcut prints like the small *Passion* or the *Apocalypse*. Was there a bulk rate?

After the medium in which a print was made, its price was correlated next to size, though not in strict proportion. Surprisingly, the quarter-sheets are a quarter rather than half the value of the half-sheets, whereas the whole sheets are less than half again as expensive as the half-sheets. Thus, a quarter-sheet is valued at around a sixth of a whole sheet, whereas a half-sheet is surprisingly expensive, nearly three-quarters the cost of a whole. This tells us that value by size more directly reflects the tolerances and preferences of the market rather than investment of the artist's effort, which would be more accurately correlated to the surface area of each image and the minuteness of detail. Age and poor condition generally detracted from value. Large single sheets brought a lot more per square inch than suites of woodcuts; but small engravings from a series like the engraved *Passion* were worth more per plate (.75 *stuiver*) than the mixed quarter-sheets (.53 *stuiver*). Probably the mixed lots of full and half-sheets were heavily laced with woodcuts, the quarter-sheets less so, since Dürer designed very few small woodblocks. It is also possible that he included work from his pupils among the mixed sets, since we know that in the Netherlands he was distributing prints by both Baldung and Schäufelein.

A more precise breakdown of value is simply not possible. Dürer's inclination to give or sell prints in mixed lots implies that his clients would have been happy to have prints by his hand in any medium, and that they too were accustomed to intermingling woodcuts and engravings. There are, however, clear suggestions that Dürer thought of certain prints as valuable in particular ways for different sorts of people. For example, Master Aegidius, Charles V's porter, conveyed seven prints from Dürer to Conrat Meit, a sculptor specializing in exquisite little boxwood cabinet pieces who was then at work at the court of Margaret of Austria. From the entry in the Diary it is evident that Dürer had not yet met Conrat, but knew and admired his work. These prints were recent ones and clearly selected for someone whose professional judgment Dürer respected in a special way. In recognition of his service for helping to make this gesture, the porter Aegidius was given impressions of the *Nemesis* and the *Eustace*, large and valuable engravings but made much earlier in the artist's career and so, we might suppose, less representative of his current style.[352]

The real inconsistencies that emerge from the prices listed in the Diary arise from the several cases in which Dürer was paid lavishly for his work. For example, four months after he sold his small woodcut *Passion* for six *stuiver*, he sold one for the lofty price of three *guilder* (Flemish), a tenfold increase. The engraved *Passion*, which went for twelve *stuiver* in the late summer, was sold for three *guilder*, five times as much, only a month later. There are other examples of this sort, which only suggest what we would in any case expect, namely that Dürer's higher prices depended on the generosity of a patron. As we noted, his first substantial exchange was with a dealer. The same is apparently true of a large lot Dürer recorded in November 1520, a batch of prints sold for eight *guilder* altogether. When the items in this transaction are valued at the prices received from Sebald Fischer, we reach a figure closer to five and a half *guilder* rather than eight, a significant difference, but allowing for vagueness in the list (seventeen etchings identified as a single item, or nineteen woodcuts and "seven bad ones"), this increase is nothing to compare with individual cases such as the thousand percent inflation in the small woodcut *Passion* cited above. Dürer obviously had a working figure in mind as a sort of floor price for certain prints and cycles of prints, but even this was undoubtedly ignored from time to time when, for example, he gave away a print to favor the child of his host or the servant of a valued colleague.

The "standard" figures suggested by the Sebald sale are therefore our most useful index for assessing the value of Dürer's prints. These figures can be correlated to personal expenses recorded within the Diary, such as Dürer's typical price of two to three *stuiver* for a meal. He frequently dispensed one to two *stuiver* for tips, not to be undervalued in a traveler's economy where tipping was as often a means of hiring help as it was a gesture of generosity. Losing anywhere from two *stuiver* to half a *guilder* at one sitting gambling was common on the journey. More tellingly, Dürer purchased two copies of a Flemish *Volksboek* — the *Til Eulenspiegel* — for one *stuiver*, and he paid one to three *stuiver* for printed religious pamphlets by Luther. More than once he paid six *stuiver* for a pair of shoes.

If we review the prices for prints in this light, we can see that a small (quarter-sheet) engraving could probably be had for less than a *stuiver*, a large and very finely worked print such as the *Adam and Eve* of 1504 for significantly less than a pair of shoes and

353

equal to two dinners at an inn. Perhaps more useful for setting a lower limit on Dürer's market than these overly individual correlations within the Diary is the value of wage labor during this period. In a thriving sixteenth-century northern town like Nuremberg or Augsburg, the average daily wage for an unskilled laborer was about 16–18 *pfennig*, a mason (semi-skilled) earned 22–26 *pfennig*, and a journeyman carpenter (skilled) 28 *pfennig*.[353] Recall Tucher's purchase of Dürer engravings in 1515 at an average of 54 *pfennig* a print. In Antwerp (where we are figuring a comparable engraving cost four to five *stuiver*) an unskilled laborer made about three *stuiver*, a semi-skilled mason about four *stuiver*, and a carpenter (semi-skilled) five *stuiver* a day in summer.[354] It is not a simple matter to convert the figures for German towns into a meaningful relation with Dürer's Antwerp dealings since they are separate economies, and in any case we are figuring moneys of account against international exchange rates on the Rhenish *gulden*, a coin of fixed metallic content. Our calculations independently suggest that prints were a good deal more expensive in Nuremberg than they were in the flourishing economy of Antwerp, and in both cases one can reasonably conclude they were very expensive for the lower echelons of society. Prints of this rank would probably have been within reach of those artisans who were among the better off, but quite obviously a prohibitive luxury for a day laborer, the average peasant, or even many skilled artisans.

We now enter into the murky terrain of sixteenth-century print collecting in northern Europe, a subject about which there is a certain amount of direct evidence and much in addition we are compelled to infer. The circumstances of systematic print collecting in the north prior to 1550 are not as well documented as they are for Italy. This reflects not only the accidents of surviving evidence, but also the greater degree of attention given by travelers and literati to collecting practices when they took the trouble to record their experiences when visiting the households of prominent artists and patrons in Renaissance Italy. Prints offered themselves to collectors as different from other acquirable works of art in one especially important respect — their availability. Quite simply, prints were there in much larger numbers than other sorts of collectable objects, and as a consequence certain ambitions came within reach of print collectors that were not possible for collectors of classical gems, portraits, or precious goldsmithing. For example, a print collector could aspire to certain orders of completeness not conceivable in these other realms. A collector could hope to have an impression of every print made by a particular artist, or to have a collection constituting an orderly and extensive illustration of the available history of artists and styles. To be sure, these were merely hypothetical

possibilities and almost certainly not the conscious objective of collectors during the first generation of the *peintre-graveurs*. Nevertheless, as prints came to be accumulated in significant quantity, schemes had to be devised — both historical and ahistorical — to bring order to their vast numbers. By the close of the sixteenth century, collectors were indeed declaring such systematic intentions.

In 1609 the German chorographer Matthias Quadt von Kinkelbach published a traveler's guide in praise of his country. Matthias was also a print collector and an occasional, if undistinguished, printmaker as well. Because he had some special expertise in the subject, he gives attention to the printmaking as one of Germany's most important contributions to the history of modern technology. Indeed, the only portion of his guide to treat the visual arts is mainly devoted to explaining how the craft of engraving arose out of metalworking to become a major art form in northern lands. Matthias recalls the founding achievements of the Master FvB, the earliest engraver known to him, and of Israhel van Meckenem and Martin Schongauer, whom he takes to be Dürer's teacher. He praises Albrecht Dürer and Lucas van Leyden equally, and notes that he is familiar with more than 170 engravings by Lucas, though not any woodcuts. He goes on to critique the derivativeness of their followers in Germany and the Netherlands, and eventually arrives at the reproductive engravers of the late sixteenth century. Although Matthias has no sympathy with what he regards as the commercialized products of the Antwerp publishing houses, he concedes the usefulness of their maps for the writer and traveler and he especially acknowledges the technical virtuosity of the most recent generation of engravers like the Sadelers and the Doetechums.[355] The text draws upon various earlier commentators on the arts, probably including van Mander, as well as the author's own knowledge, and is the first coherent history of printmaking as such to be written by a northerner.

Matthias Quadt's short history represents one perspective that had informed the interpretation, collection, and ordering of prints in northern Europe for nearly a century. As best we can reconstruct, the initial stimulus to collect the work of particular artists and to collect according to historical and local preferences had its roots in the literature of chorography, a form of regional and civic panegyric extending back to Hartmann Schedel of Nuremberg. It was in these regional or "national" histories written in the wake of the Nuremberg *Weltchronik* that the accomplishments of artists and craftsmen first began to be lauded for the distinction they brought to their towns and their country. The earliest printed reference to Dürer occurs in 1505 in just such a text composed by Jacob Wimpheling, who already then remarked upon the fact that Dürer's work was widely recognized in Italy.[356]

354

Shortly thereafter in a cosmography written as a Latin school text in 1511, Johann Cochlaeus cites Dürer for the particular subtlety of his engravings of the *Passion*, printed, as he says, by the artist himself, and sought by dealers across Europe.[357] The chorus of eulogies that followed Dürer's death in 1528 elaborated on what by then must have be ome overly familiar themes in the conservative a:.d self-congratulatory circles of Nuremberg's humanist elite. And yet, despite their formulaic ring, these testimonials all point to a growing consciousness that an internationally recognized artist was something to boast about, a point of local distinction.

Coincident with the emphasis on the achievements of individual artists, the addition of monograms and initials as signatures to prints became increasingly more common and self-conscious. Consider Dürer's famous and much-imitated *cartellino* (fig. 327) which he used as an ornamental frame for his initials, or the elaborately encoded signature of Urs Graf (fig. 358). Cranach's crowned serpent (fig. 335) is another instance of a printmaker capitalizing on the fame of a distinctive, identifying mark made as much for recognition as for commercial protection. As a way of drawing attention to authorship, artists began to play with the location of their signatures, sometimes doing so in highly inventive and witty turns. Self-portraits began to appear in prints at the same time that signatures came into regular use. Israhel van Meckenem not only gave us the earliest instance of a northern artist's full signature incised in the plate, he was also the first printmaker we know to have engraved a self-portrait. By virtue of his skill in self-advertisement, Israhel made it likely that all early accounts of printmaking would mention him by name. Dürer refrained from self-portraiture in prints, though he did not stint to portray himself extravagantly in drawings and paintings. That Dürer observed this boundary may tell us something more about his private conception of the printed portrait.

The encouragement of artistic fame, the development of an interest in accumulating prints systematically, and the cultivation of a taste for their aesthetic properties, their rarity, and their relative antiquity happened only gradually. Kinkelbach's history of regional styles and the evolution of the individual artist's oeuvre reflects the modern construction of art history that was first fully laid out by Vasari, and then later by Matthias Quadt's northern contemporary Carel van Mander. Their essentially biographical construction of the history of art helped to shape collectors' attitudes, as indeed collectors' interests helped to shape that characteristic form of historical writing. Moreover, in addition to being a part of this new domain of history, prints were distinct in that they were also especially well suited to provide an illustration of it. By 1600 nothing could serve as a visual resource for an account of the history of art in antiquity and the Renaissance nearly so well as a systematically arranged print collection of several thousand items, including the designs of *peintre-graveurs* alongside the works of topographical and reproductive engravers.

How did this sense of historical self-awareness begin to manifest itself in the habits and attitudes of collectors? Much good evidence suggests that the first major collections of prints and drawings were furnished mainly from the legacy of artists' workshops. Buying up the stocks of a painter's workshop was surely the quickest means of putting together a sizable group of prints, and selling these assets was also a way for an artist's family to cover inherited debts. Artists had assembled prints initially as workshop material for copying and for training apprentices, stocks that would normally have passed from generation to generation through the family or from master to favored pupil. During the period that most concerns us, however, two changes would have affected this tradition. First, it is obvious that finished drawings were beginning to find a place in the market.[358] Second, the greater consciousness of artistic innovation and the consequent need to establish an individual and "up-to-date" style meant that prints and drawings from an earlier period would have ceased to attract very much attention in the workshop.[359] We find this reflected, for example, in Dürer's insistence on giving his latest work to fellow artists, though elsewhere he was selling prints done as much as fifteen years earlier. Nevertheless, any painter's shop that had been active for a couple of decades must have been a potential gold mine for the collector of prints and drawings. Recall the purchases from Cornelis Bos's workshop when it was liquidated by the Antwerp authorities. Heinrich (not Hanns) Lautensack left behind chests of woodblocks for his book illustrations, engravings, drawings, and metalworking tools.[360] A significant portion of the collection of prints and drawings in Dresden was apparently acquired at the end of the sixteenth century from the Cranach family.[361] Albrecht Altdorfer's household appears from its inventory to have been as rich as those of the nobility for whom he worked, since here only a mention of prints occurs amid the tally of precious metalwork, fabric, and other luxuries.[362] Parts of the collection of late fifteenth- and early sixteenth-century German prints and drawings now at the University in Erlangen betray evidence of having originated in the Wolgemut workshop in Nuremberg.[363] Jacopo de' Barbari appears to have left a significant portion of his belongings, including workshop material, with his last patron, Margaret of Austria, who took him under her wing in his declining years. Inventories of her collection record that a large number of Jacopo's engraved plates were in her possession.[364] A substantial remnant of the paintings and drawings from Hans Holbein the Younger's workshop found their way

into the Amerbach collection of Basel, some of it possibly at the time of the artist's death, and thereafter some further portion from other artists' collections of Holbein's work. By similar means Basilius Amerbach acquired substantial portions of the work of Urs Graf and Niklaus Manuel Deutsch much later in the century.[365] In 1545 Hans Baldung Grien bequeathed his workshop to Nikolaus Kraemer, a painter and fellow member of the Strasbourg guild Zur Steltz. From there it went to a wine merchant, chronicler, and sometime painter Sebald Büheler who lived until 1595. Hence, a significant portion of this legacy remained together throughout most of the century before being distributed to collectors.[366] Finally, the stocks of the Dürer atelier served as the foundation of what must have been the very valuable collection of the powerful Imhoff merchant and banking family who acquired it over a long period of years beginning already in the artist's own lifetime.

At a time when just a few artists were gaining wide recognition, their legacy of workshop material must have been actively sought after by fellow practitioners as well as collectors. The many handbooks on the fundamentals of design and perspective that were written, illustrated, and printed by artists over the course of the sixteenth century give us a measure of the need to establish oneself in the annals of the history of one's craft.[367] Redundant and retardataire as most of these "how-to-do-it" primers are, they nevertheless document the intentions of artists to ensure recognition of their own contribution to technical and artistic betterment. These handbooks are cursory, and largely unoriginal popular counterparts of Dürer's treatises, and they tell us that the compulsion to bequeath one's particular skills to posterity became widespread in the early years of printing. In a similar vein we find evidence of prize albums being put together out of workshop stocks. Jacopo de' Barbari's "little book" (maister Jakobs büchlein) that Dürer made a special point of requesting from Margaret of Austria when he visited her a few years after the artist's death may be another instance of an artist compiling a marketable workshop record. Margaret reportedly told Dürer it had already been promised to her court painter Bernard van Orley, thus delivering one of the several disappointments he suffered at her hands.[368]

As the art market evolved in concert with changing attitudes toward the value of prints, and especially of drawings, workshop albums were undoubtedly also being sought after by collectors. Such albums constituted a very individual and therefore privileged order of memorabilia. One album of this sort from Dürer's shop survives intact with 211 prints and 13 drawings handsomely arranged, including Dürer's three Large Books (not bound together!). The album includes the vast majority of Dürer's print production and has been traced back to Hans Döring, a one-time pupil of

Dürer's who must have acquired or compiled it while he was still connected with the workshop. The most personal item in Döring's album is Dürer's vivid account of a nightmare in which he envisioned a great flood descending from the heavens, a description accompanied by a watercolor illustration. The prints are in general segregated from the drawings, and for the most part divided among themselves by medium, even to the extent of etchings being grouped together apart from engravings. Technical discriminations of this sort are especially telling and, at this date, almost certainly reflect the point of view of an artist/collector.[369] Although the Dürer album is extraordinary in having survived intact the covetousness of collectors and dealers, it represents a practice that must have been increasingly common as artists became internationally recognized and sought after for their products. The several preparatory drawings for engravings by Heinrich Aldegrever must have come from an album of the same sort. Indeed, the very album which contained at least some and very probably all of these drawings as well as a complete set of Aldegrever's prints is described by the German artist and art historian Joachim Sandrart already in the seventeenth century when it was in the collection of the Swedish royal ambassador.[370]

The rising esteem of the peintre-graveurs coincided chronologically with the debut of the finely engraved, miniature-scale album prints by the Little Masters and Altdorfer in Germany, and by Dirk Vellert and the less gifted Master S in the Netherlands. The fact that this refinement of engraving evolved in order to appeal to more elevated tastes is implicit in the increasingly secular and learned cast of the subject matter of many of the engravings, a characteristic of intaglio prints in general from around 1510 onward. Most likely there was little of what we could properly call organized print collecting being done until near the middle of the century, although its beginnings surely lie with the taste for these precious objects that emerged in the second and third decades. Albums were undoubtedly the earliest form of systematic print collecting, whether they were being compiled by collectors or their librarians, or assembled for use in the workshop and then later sold on the market. As a practical solution to the problem of storing and arranging prints, albums had obvious advantages. Albums of prints fitted neatly into the household library to await occasional consultation, they provided a convenient format to scan for a pattern, and they made an exquisite gift for an intimate friend or a potential patron.

Considering the taste for prints in the north, we must recall again the importance of mural woodcuts there as well as in Italy. But it was German, and afterwards Netherlandish, publishers who cultivated the widest range of mural prints in the first half of the century, and above all it was Maximilian through his patronage of an exceptional stable of

German woodcut designers who sponsored the artistic woodcut and the mural woodcut as an aspect of political self-advertisement. A related secular trend can be seen in the expansion of interest in portrait engravings and woodcuts, a genre that grew steadily in the north and south throughout the sixteenth century, parallel to the growing popularity of assembling collections of painted portraits. Finally, there is the fashion for unusual moralities and literary and allegorical subjects among many northern printmakers, subjects often cultivated under the influence of Italian engraving. These are merely additional dimensions to the taste for prints in the period, and further evidence of their increasing and more frequently esoteric appeal.

Such are the indirect traces of the beginnings and motives of print collecting in northern Europe, a process that evolved more slowly there than it did in Italy but that would eventually prove to be more sustained and varied in its tastes and practices than Italian collecting. Our first significant documentation of something that can be legitimately termed a print collection in northern Europe comes from the Imhoff family archives. The Imhoffs were fortunate to have had access to what was certainly the richest mine of graphic genius to be found anywhere in Germany at the time, namely, the stocks of Albrecht Dürer's shop, much of which had remained in the hands of Dürer's family after the artist's death. During his lifetime Dürer must have given many important objects, and certainly impressions of most of his prints, to his longtime friend Willibald Pirckheimer. However, evidence about the extent of Pirckheimer's holdings is not at all specific.[371] Shortly after mid-century the largest single cache of Dürer's work could be found in the possession of the Imhoffs, a patrician banking family in Nuremberg that had close dealings with the artist throughout his mature years. Hans Imhoff the Elder was Dürer's contemporary, and the two seem to have been close personal as well as business acquaintances. The Imhoffs looked after Dürer's shipments and finances, particularly while he was traveling in Italy and the Netherlands, and somewhere along the line they became serious collectors of Dürer's art as well. No doubt Dürer gave many things to Hans out of friendship, and also in exchange for the services that the Imhoff bank could provide an artist who had complex financial dealings and an international clientele.

Through a series of later acquisitions the Imhoff family went on to build its holdings of Dürer's work long after the artist's death. To begin with, Pirckheimer's impressive library, and along with it some representation of Dürer's art, very likely including certain of the notebooks, came to the Imhoffs through marriage.[372] The working material from Dürer's shop was passed on to his brother Andreas, also a painter. According to early sources, he was given Dürer's most valuable colors and all of his drawings, engraved copper plates, cut woodblocks, and impressions taken from them. In 1557, after Andreas had died, his wife Ursula sold a significant portion of Albrecht's work to Willibald Imhoff the Elder, who also purchased the remains of Georg Pencz's shop with whatever that might have contained of his master's legacy.[373] Then in 1568 Willibald purchased an album of prints and drawings by Dürer and Raphael (the latter presumably engravings by Marcantonio). This album certainly originated in Dürer's shop.[374] The Imhoff collection is recorded in several inventories from the 1550s onward, the most complete appraisal dating from 1580 at the time of Willibald's death. By then the family's holdings were substantial. Some thirty albums of prints are listed, and there are references to specific prints as well. Those prints given separate entries are special items — for example hand-colored engravings, including an impression of the *Adam and Eve* printed on parchment and fixed to a panel, a *St. Jerome* illuminated by Willibald's mother, and the copper plate for Dürer's portrait of Pirckheimer.

The contents and the history of the Imhoff collection point to certain motives behind its accumulation. Willibald the Elder was a scholar and a connoisseur of recognized stature who was sought after as a consultant on art and antiquities and traveled across Europe in search of objects for his collection. Among his intentions in acquiring Dürer's art was undoubtedly a desire to preserve an important remnant of Nuremberg's cultural heritage. It has been suggested that Willibald may also have had commercial aspirations in mind, a plausible hypothesis given the evidence of escalating prices for Dürer's work towards the end of the century and the increasing difficulty collectors encountered in obtaining it. We know from annotations in the inventory that Willibald was attentive to the quality of what he bought, and very probably he did contemplate selling parts of the collection.[375] Whatever commercial interests the Imhoffs may have had, their desire to bring these objects together nevertheless reflects a sense of pride in local artistic inheritance, placing a special premium on Dürer's work over the fashion for Italian art and antiquities that dominated much princely collecting at the time. As an example of early northern European print collecting on a substantial scale, the Imhoff's success shows us the advantage of being able to build upon the stocks of a workshop and the inheritance of an artist's pupils active in the same region. This was an approach that other collectors also adopted.

What do these northern European collections tell us about the early motives that stimulated collectors to acquire prints in large numbers? Often the reason for collecting prints must at first have been circumstantial. We know from exchanges in letters that Dürer's prints were the occasional ob-

ject of learned conversation, and were therefore treasured and exchanged among an elite. Pirckheimer probably possessed most if not all of Dürer's prints, since as a close friend of the artist he would have been given them. But we have no reason to suppose from this man's consuming interest in classical gems and fine carpets that he would have been led to assemble prints in a serious way had it not been for this acquaintance. The same may also be said of Hans Imhoff, Philip Melanchthon, and others in Dürer's immediate circle. Gathering the master's work and exchanging it among themselves, their holdings would eventually have reached critical mass and been brought together in albums to be stored in a library or gathered into drawers and portfolios for greater convenience. Only at that point can one begin to speak properly of a collection of prints as something more than a private treasure of memorabilia.

Then there was the impulse to praise local heroes. The humanist practice of personal commemoration has its larger dimension in local and regional panegyric. As we can see from the eulogies marking Dürer's passing in 1528, the careful tending of his reputation owed much to local pride. No doubt Pirckheimer and Imhoff valued Dürer's work partly in this light. A discernible cultural patriotism was suddenly developing in Antwerp, Basel, and Nuremberg, seeking to promote the work of northern artists and to defend it against the widely declared superiority of Italy. Later in the century we find the defense of northern style registered explicitly in the writings of Domenicus Lampsonius, Johann Fischer, and Bernard Jobin.[376] Collections of prints arranged by artists and by regional styles are a reflection of this burgeoning sense of cultural self-importance. By the latter part of the century "a history" of artists and styles was coming in reach of those who had prints available to them in significant numbers. In 1547 Neudörfer explicitly observed that Sebald Beham's prints were available in sufficient number that one could get an idea of the artist's entire career by acquiring them, and elsewhere he comments on the expense of getting hold of all of Dürer's engravings and woodcuts.[377] From this testimony we can see that prints were supporting the value of having a comprehensive knowledge of an artist's career, an objective being encouraged by Vasari's *Vite* and other texts describing the character and achievements of the new art of the Renaissance.

In northern Europe this awareness of having fostered an important artistic tradition culminated in the Dürer Renaissance, a concerted attempt to revive as well as to enshrine the style of Dürer and Lucas van Leyden. For various reasons too complex to investigate here, an intense enthusiasm for the work of these two artists became widespread during the last years of the century, a period otherwise characterized by a contrasting courtly art of extreme mannerist virtuosity. Copies, forgeries, and improvisations of the founding members of the *peintre-graveurs* appeared on the market, while dealers busily reworked and reprinted what they could still find in the way of original plates. On occasion these later printings sought to enhance the virtues of an image by hand-coloring them or printing them on vellum and even on fabric. A number of apparently late impressions of Dürer engravings were impressed onto a rich, fine-grained pale yellow silk known as *Atlas*, a material receptive to printing in a roller press even to the point of disguising the wear of a well-used plate.[378] These gilded artifacts are collector's items of a high order, and reflect the adulation we find in accounts of German printmaking written in the wake of this enthusiastic revival. The Dürer Renaissance consummated the values promoted by the early humanist panegyrics in praise of local talent. But most interesting for our purposes is the fact that the possibility of taking this retrospective view was a direct consequence of art history being accessible through prints.

VII

Epilogue

FROM THE MOMENT craftsmen started making prints on paper, the astonishing and diverse possibilities of this new medium began to be explored. As the value of the print as aesthetic object slowly came to be cultivated, the range of utilitarian and ornamental uses also continued to expand.[1] Renaissance prints went on serving as models for other prints, for panel painting, manuscript illumination, calligraphy, sculpture in wood and stone, precious metalwork, leather decoration, carved mother-of-pearl, bone and ivory work, embroidery patterns, majolica decoration, glazed oven tiles, locksmithery, cabinetmaking, glass painting, enamel work, cloth printing, tapestry, and whatever else might usefully receive an ornament. Apart from these and many other functional employments for prints, they of course also went on satisfying religious and fetishistic needs — as makeshift house altars and devotional icons for sticking on choir stalls, as pilgrim's badges and pennants, as *apotropaics*, as paste-in prayerbook illustrations and ornamental book covers, or as lining for the alms box meant to inspire generosity in the giver. Prints were kept and stored in a variety of ways, and sometimes they were displayed on the wall. A great many paintings from the fifteenth century onwards show what are unmistakably prints fixed to the walls of domestic interiors, usually devotional prints forming part of the setting for a religious subject. They appear above hearths and elsewhere around the room in a manner that would seem to reflect contemporary practice. A careful search through the paintings of Pieter Bruegel the Elder, that wiley recorder of habits, will discover a circus of prints pasted on the outside walls of a church and on school doorways, stuck onto trees, displayed all over the exteriors of houses in Carnival, glued on the backs of benches, and pinned on people's hats and clothing. Examples of this sort are too numerous to inventory here. Furthermore, we need not rely upon paintings alone. In the popular genre of "household verses" in the fifteenth century, a kind of domestic shopping list, we find that a "Brieff an die wand" was an essential appointment for a comfortable sitting room. A century later the inventory of Cornelis Bos's house and workshop records a broadsheet pasted on canvas and displayed over the hearth.[2] And the record of prints openly displayed in Italian interiors is considerable and convincing. This practice was a popular one south as well as north of the Alps.

In the second edition of Aretino's *Cortigiana* published in 1534, we get a vivid portrait of a street peddler named Furfante (Scoundrel!) hawking his broadsheets on the streets of Rome.

> Pretty stories, stories, stories, the war of the Turks in Hungary, the sermons of Father Martino, the Council, stories, stories, the facts of England, the festivities of the Pope and the Emperor, the circumcision of the Voivoda, the Sack of Rome, the Siege of Florence, the skirmish at Marseilles and its conclusion, stories, stories . . .[3]

At this point the narrator gives his companion one *giulio* to buy himself a print. The news often traveled in printed pictures. Prints or broadsheets of this kind were deployed to praise local heroes for their worthy achievements, to broadcast public commemorations, to make people more famous abroad; and somewhat less often they were engaged in slandering campaigns.[4] Prints recalled major battles and sieges lifted. They reported the news and prophesied the future. Prints brought people together in portraits that could be treasured in solitude or slotted into collections of noteworthies living and deceased, distant and familiar.

Prints served as an expedient way to decorate interiors and furnishings, to mock-up fake intarsia, to paper walls and ceilings with elaborate patterns, narrative subjects, genres and allegories, to decorate marriage *cassoni*, to provide a substitute for painted

359

murals, running friezes, and *sopra porte*. They were made for New Year's cards bearing greetings and a blessing of good fortune from the Christ child. They recorded and advertised the coats of arms of the nobility and its pretenders. On occasion thousands of woodcut arms were required to label the tents and wagons of Saxon soldiers bivouacked on campaign. Triumphal entries of princes and emperors were occasions that kept the printmakers at work making illustrated programs and chivalric displays. Prints provided *ex libris* for the humanist's library, obscure allegorical devices for the erudite, and illustrated wall calendars and almanacs for the peasantry. They were commissioned for a spectrum of practical and documentary projects like publishing representations of counterfeit coins for distribution to currency exchanges, recording city views for proud town councils, duplicating local road maps, making guidebooks to the Holy Land and portolan maps of the global seas. Prints also helped explain how to do things, for example how to make a correct perspective or to draw a face or hands in several variations. Broadsheets sometimes even offered first aid advice. And then finally, despairing of an eventual sale, the unmarketed or damaged printmaker's stock was often recycled for use in stiffening book bindings, an undignified haven from which a number of rare woodcuts and engravings have been recovered. A list such as this, by no means exhaustive, only reminds us of the omnipresence of the print in sixteenth-century European life.

ᘓᗞᵒᗱᵉ ITALY ᗱᵉᵒᗞᘓᵉ

Our investigations of sixteenth-century printmaking have shown how, in a matter of about two generations, the status of prints slowly but inexorably changed. At first most printmakers in Italy worked independently, making engravings whose quality necessarily relied upon the resources of their imagination in inventing compositions and upon their technical skill in realizing them. During the first two decades of the century significant changes occurred in the techniques employed to engrave a plate, mostly the result of experiments designed to enhance pictorial qualities in black and white. Thanks to the example of Dürer and Marcantonio, engravers soon settled on a common technical language, and only a very small, albeit aesthetically significant, number of them felt the need to transcend the boundaries of these new conventions. Meanwhile, engravers who were poor draftsmen were left either to serve the bottom end of the market or to seek talented artists who could provide them with what they themselves lacked.

Not coincidentally, this was a time when leading painters were being drawn to the comparatively new but quickly developing medium of print-making. There they not only discovered a new means of expression, but also an effective way of multiplying their revenues. Prints came to be seen and understood as they were commonly termed, that is to say as "printed drawings." By allying skill in *disegno* with the printmaker's expertise, the partnership of Raphael with Marcantonio, and later with Marco Dente and Agostino Veneziano, changed the direction and the pace of these developments. They stimulated a fashion for prints, and as a consequence most Italian artists of repute, whether in Venice, Florence, or Parma, became involved in one way or another with the medium.

In 1527 the Sack of Rome dispersed il Baviera's workshop, possibly at just the time he was effecting another major change in this progression, for il Baviera was disrupting the purpose of collaboration between painters and printmakers by inserting himself as a wedge between them. It was much easier for him to control production by acquiring finished drawings from painters and allotting them to engravers of his choice — providing them with the copper plates, which he then retained. By this means he was able to manipulate the burgeoning market for prints in Raphael's style and rapidly progressed towards the making of what we now call reproductive prints. Throughout this period a few independent printmakers refused to conform, continuing instead to explore the artistic potentials of their craft. But their influence on the general development of printmaking was limited by their comparatively small number, and by the fact that most of them failed to create new techniques to improve on the engraving method codified by Marcantonio. This was deemed easy to learn, and applicable to all possible needs. In the meantime, an analogous phenomenon affected woodcuts, in that the proud independence of those craftsmen who once designed and cut their own book illustrations gave way to a close collaboration between designers and cutters. Eventually this relationship was also disturbed by the influence of publishers, who began retaining the ownership of blocks and applying for privileges under their own names.

Michelangelo, the only great painter living in Rome after Raphael's sudden death, was not at all interested in prints. Michelangelo was absent from the print scene, and for many years no publisher of il Baviera's enterpreneurial skills was at work in Rome. As a result, many independent printmakers were able to carve a niche for themselves as *peintre-graveurs*, working either on their own or in collaboration with painters. The fourth decade of the sixteenth century saw the flourishing of great masters of the burin, who were not only technically very proficient, but becoming increasingly ambitious in their interpretations of subject matter. Their iconography could be as complex, refined, and sophisticated as any. These engravers were held to be artists of distinction. They moved in

humanist circles, among those who admired and collected their prints as if they were the equal of fine drawings. In the perception of these collectors, there was no difference in value between a print done after a printmaker's own design and one achieved in collaboration; indeed, at times it must have been difficult to distinguish between the two. Like painters, printmakers borrowed freely from other masters.

In the 1540s certain tendencies destined to affect printmaking for several decades began to converge into what are now recognizable patterns. By this time the leading engravers had refined Marcantonio's system to such a degree that they could obtain whatever pictorial effects they required. The most active collaborations no doubt entailed a lively exchange, the painter providing a finished tonal drawing, the engraver an emulation of its effects. As the proficiency of the printmakers and the fashion for prints increased, painters looked ever further afield for printmakers, thus opening the way to the principle of reproduction. This was the moment for the ascendency of the publisher, another level of commercial organization that brought with it a loss of concern about the integrity of the images and a predictable disposition to print plates until they were exhausted.

The gradual shifting of roles was propelled by certain fashionable interests that prints were especially well suited to address. A demand for the achievements of antiquity grew from all quarters, including north of the Alps. Publishers like Salamanca, Lafrery, and later Hieronymus Cock found themselves ideally placed to serve this market. On the other hand, the position of engravers was not helped by the political and religious climate of the time: the Council of Trent had just begun (1545 to 1563), and a wind of pious and belligerent conservatism blew through the streets of Rome. It was not an ideal time for exercising the imagination in the invention of secular themes, let alone for improvising on episodes from the Old and New Testaments. What would eventually be required by the vigilant authorities was a devout and traditional rendering of religious subjects, and an equally restrained interpretation of the myths and allegories of the past suitably presented as examples of Christian virtue. This transformed prints from innovative and challenging works of art to images valued only as vehicles for a moralizing message.[5] In such a climate, publishers sought new, safe, cheap, and easily accessible subjects, turning their attention to documenting the remnants of antiquity, and demanding from their printmakers more attention to the actual appearance of the ancient monuments they were depicting. Consistent with this regimented approach to documentation was new conservatism on the religious front, one equally concerned to restrain improvisation.

By mid-century, the print was losing its autonomy as a work of art in Italy, and becoming instead a record of artistic achievement. With a few exceptions, almost entirely confined to the etching school of Verona,[6] printmakers no longer challenged their discipline as artists but worked as craftsmen in the service of publishers.

It is therefore not surprising to discover that painters who once contributed to making prints became preoccupied with exploiting reproductive printmaking in order to enhance their fame. Let us take Titian as an example. During the first and second decades of the century he had been one of the great innovators in printmaking, and throughout the next thirty years he continued, albeit spasmodically, to provide his favorite woodblock cutters with designs, probably drawing these directly on the blocks for them to cut. This must have been the case with the beautiful self-portrait cut by Britto in 1550, an image celebrated by Aretino in a specially composed sonnet.[7] Yet by the mid-1560s Titian had given up manual involvement in the making of prints. His understanding of the role of prints had changed, and he sought to take advantage of their new popularity as reproductions. To this end he kept a firm grip on the production of prints after his own paintings. When Cornelis Cort arrived in Venice in 1565 he stayed in Titian's house and made engravings after the master's works and under his supervision.[8] There Cort produced at least six engravings, all dutifully inscribed with Titian's name as their inventor, and all executed to an extremely high standard of craftsmanship noted with enthusiasm by Lampsonius in a famous letter to Titian.[9] This letter of 13 March 1567, together with a number of other documents, shows that Titian immediately set about to spread the knowledge of his paintings across Europe by sending impressions of Cort's prints to all and sundry. Lampsonius comments on the enjoyment they gave his own master, the Archbishop of Liège, and we further know that Titian had already sent an impression to the Emperor when he wrote to the Duchess of Parma, enclosing "a sheet of that design," for he thought that she might enjoy receiving "the news about this print."[10]

Titian's concerns about reproductive printmaking were so serious that in January 1567 he applied to the Venetian Senate for a privilege to protect a number of engravings made after his designs, only one of which is specifically mentioned. This application is revealing of the all-pervading change in the attitude to prints. Titian states that he has set about to have a group of his designs engraved and printed "à comune comodo de' studiosi della pittura" (for the common enjoyment of the students of painting). He has done this because: "some people who know little about art enter this profession [i.e., printmaking], and in order to avoid too much labor, and out of sheer avidity, they make prints which not only defile the originals but im-

pinge on the honor of the inventor and at the same time cheat the public with false images of little value."[11] It is difficult to be completely sure of what Titian is complaining about, whether of the poor reproductions engravers made of his paintings, or of copies they made of the engravings done under his own authorization by Cort. The document has always been read as meaning the former, but the use of the word *ritagliar* (re-engrave) rather than *intagliar* (engrave) in some crucial points of the application — particularly since the latter form is also present more than once — suggests that he was really concerned about pirated copies of Cort's prints. This interpretation would also explain why Titian states that his inventions had been turned into prints "con mia gran fatica e spesa" (with my great labor and expense). If he were simply complaining about the fact that poor engravers were making poor reproductions of his paintings, he would not claim that he had spent so much effort and money in the matter, since one assumes that he would not have been involved at all.

In any event, Titian asked the Senate to protect his prints for a period of fifteen years with a copyright threatening severe punishment for anybody found re-engraving his drawings without his consent anywhere within the Venetian territories, or found selling such prints made elsewhere and imported. Large fines were specified for every one of these possible crimes, the fines to be multiplied by the number of impressions found. Having obtained on 4 January the *nihil obstat* of the inquisitor Valerio Faenzi, who found the *Trinità* "cosa degnissima, et rappresenta degnamente la Santa Trinità" (a very good thing, which represents well the Holy Trinity), Titian was formally given the protection he sought, on 4 February. In the meantime, however, he must have reconsidered the whole issue, for he approached the Senate for a much more sweeping privilege applying to all prints that at any time in the future he might print himself or have others print for him after his own designs. This most extraordinary request, the first real copyright for the invention of a painter, was agreed to by the Consiglio dei Dieci on 22 January 1567, on the condition that they be shown any such prints in advance, to check for obscenity, and that an impression of each print be left with their secretary. The secretary was to sign each impression deposited to make sure that a true record remained of the works covered by the privilege. This appears to be a first example of the *dépôt légal* for a print. As soon as he had obtained such powerful protection, Titian had an inscription added to all the plates by Cort.[12]

We have devoted so much attention here to the documents relating to Titian's privileges because they reflect most powerfully the situation of Italian printmaking in the 1560s. Prints had ceased to be regarded as works of art, but were perceived —

even by a great artist who had expressed himself through prints throughout his working life — as mere reproductions of other objects. Their value was no longer in the quality of their own invention, composition, and command of tonality (*invenzione*, *disegno*, and *colore*), but only in their ability to convey those characteristics as they found them in the works which they copied. In Italy this attitude to prints as subordinate objects would last for several centuries, and it also found expression in Vasari's second edition of the *Vite*, published in 1568. As we have seen, Vasari treated prints as valuable documents of what paintings and frescoes looked like, useful reproductions that helped to spread the fame of Italian art to the rest of the world. He could not fathom the concept that Marcantonio's engravings had not, in fact, been reproductions of Raphael's work. Like Cellini, who published his *Due Trattati . . . dell'Oreficeria* at the same time, Vasari saw printmaking as a craft, and congratulated engravers only for their ability to emulate the quality of paintings. No imagination was required of them, let alone experimentation. Undoubtedly, the history of Italian taste for prints would have been different had Vasari adopted Raphael's or Parmigianino's regard for the medium, rather than Michelangelo's. On the other hand, taste in general was changing, and some of the excesses of Mannerism were being counterbalanced by an increasing demand for a polished and detailed naturalism: highly finished presentation drawings and small paintings were competing more with prints, and printmakers, in their turn, responded by making their prints imitate drawings more than ever before. Thus the interest in the medium as an independent means of artistic expression was helped to fade by its own practitioners.[13]

The stocklist of publisher Antonio Lafrery's holdings published in 1572 provides us with an excellent means of assessing the shift in the appreciation of prints during the nearly three decades after Aretino enthused over Salviati and Vico's *Conversion of St. Paul*.[14] Lafrery's list or *Indice* is prefaced by a message to his customers describing his commercial objectives. From this we can see how his stocks must have differed from those of a *libraio* selling prints a generation earlier in the 1540s:

> Having for a long time occupied myself with obtaining many descriptions, designs and portraits printed for the service of virtuosi in the form of single sheets or of books of notable works from antiquity and modern times, I have resolved for the enjoyment of those who delight in them, to gather them together and publish a brief summary of them and an index.[15]

There follows the list of his wares divided into five groups, "per dargli qualche forma" (to give it some shape): first, maps and plans of cities and of some

recent battles; second, prints after antique monuments and statues, with the inclusion of some important contemporary buildings; third, "Inventioni poetiche o imaginate da diuersi e ingeniosissimi Scultori e Pittori" (inventions from poetry or newly imagined by different and most ingenious sculptors and painters), that is to say, prints reproducing contemporary sculpture and painting; fourth, episodes of the Old and New Testaments; fifth, portraits and medals of well-known people, books of architecture, ornament, and perspective, to which, for the greater satisfaction of readers, whenever known the name of their maker (*artifex*) has been added.

The arrangement of Lafrery's stocklist may well reflect an order of popularity. As had been the case with Francesco Rosselli fifty years before, maps and plans played a major part in Lafrery's business interests and probably constituted the bread and butter of his activity, a hypothesis supported by the extraordinary riches in the stock, with Italian maps and city plans accounting for only about half the entries, and the others recording almost every known land.[16] Then come prints after the antique: a depiction of every ancient monument in Italy that was still standing in some form or other was available, together with details of reliefs and statuary *in situ*. In some cases, more than one version of the same subject appears — seen either from different angles ("un altro dissegno della medesima della parte di fuori et di dentro," that is, another image of the same subject viewed from outside and inside), or sometimes with a reconstruction shown alongside its present condition ("in forma com'era antichamente. Altra forma del medesimo, come si uede hora"). The monuments listed include not only those within the city of Rome, but the major sites *fuori porta*, on the Via Appia, Via Ostiense, and so forth. Among the statues are all the most famous surviving sculptures of antiquity, whether accessible in public places or displayed in the private collections of Rome.[17]

The next group of prints in Lafrery's list includes many of the engravings we have earlier considered, prints that may have come to him from il Baviera, and certainly those from Salamanca. Along with these were many more that he had bought from engravers or their estates, or commissioned himself. In stark contrast to earlier practice, Lafrery describes prints by Marcantonio, Agostino Veneziano, Caraglio, or Enea Vico as the work of Raphael, Bandinelli, Giulio Romano, or Michelangelo. This is an almost ironic recapitulation of a tendency we have seen before: while at the beginning of the century prints were described in contemporary accounts as having been made by Marcantonio and Giulio Campagnola, as time went on they came to be referred to as the work of Raphael, Parmigianino, Titian, and Salviati. But the reasons for this were different from what now prompted Lafrery. Earlier cognoscenti had learned to recognize the degree of collaboration between painters and printmakers, and knew that painters could not have produced their striking results without the contribution of talented engravers. It was thus an implicit tribute to the skill of printmakers like Campagnola and Vico when their prints were referred to as "by" Titian and Salviati respectively. However, by the middle of the century when the cooperative relationship between painters and printmakers had broken down, the practice among engravers of identifying a print by the name of its inventor had become common. It was a shift that perfectly suited the completely different needs of a market much more interested in the work being reproduced than in the print itself.[18]

A final and especially conspicuous feature of the third and fourth classes of Lafrery's prints is that they are divided not by inventor, but by subject matter: for instance, among the prints of the New Testament, the list starts with three versions of the Annunciation, continues through the episodes of the Life of Christ, followed by the Life of the Virgin and the Lives of the Saints and ending with two versions of the Last Judgment. Then the sequence is repeated for smaller prints (described as being "in carta mezzana"), showing us that Lafrery's customers chose their prints first by subject and size rather than by inventor or engraver. This pattern became typical of most print collectors, particularly north of the Alps. In Italy, on the other hand, there had been such a strong tradition of collecting prints as works of art, that for several decades many continued to assemble them according to engravers rather than inventors.[19] This was partly a result of Vasari's own codification of the art of printmaking formulated in the second edition of the *Vite*. The gist of Vasari's immensely influential writing about printmaking, however, was that in Italy prints came to be regarded as a *cosa bassa*, a low thing, and in the eyes of many they remained so for centuries.

THE NORTH

In northern Europe the evolution of the print into an object of refined interest took a different course from that in Italy. For a start, the self-conscious and articulate understanding of artistic innovation that guided and enriched Italian notions about works of art was not so evident in Germany and the Netherlands in the early sixteenth century. Albrecht Dürer was, of course, an exception to this. In the writings of his maturity, Dürer reveals a profound and complex view of artistic invention, one that was very much abreast and at points in advance of contemporary Italian thinking on the subject.[20] Furthermore, there can be no doubt that by the time of his second trip to Italy in 1506 Dürer's technical sophistication and his employment of the

print medium for theoretical demonstrations and learned discourse equalled that of any master north or south of the Alps. And yet, is it really proper to regard him as a true counterpart to Mantegna, a figure whose special importance for the history of printmaking Dürer himself certainly recognized?

In a famous letter to Willibald Pirckheimer written from Venice in 1506, Dürer expressed his regret that whereas in Venice he was treated as a gentleman, at home he was regarded as a parasite.[21] This trenchant sense of dissatisfaction must have been quelled over the years as he came to be at the center of a group of unusually learned and distinguished humanists in Nuremberg, a circle that by all accounts held him in every way a peer. Although we might well think of him as enjoying the same status as Giulio Campagnola held in Venice, in fact Dürer made a special point of presenting himself as an artist of modest background and little schooling. He expressed a preference for publishing his treatises in the vernacular rather than seeing them rendered into Latin, as they eventually were, and we have it in his own words that he intended his writings explicitly for the education of fellow artists and craftsmen rather than as contributions to learning in the larger sense.

It has often been observed that the Renaissance came gradually to the north, and only in selective ways. To be sure, an attraction to representing secular themes arose in Germany and the Netherlands just as it had in Italy, although initially northern printmakers tended to prefer courtly (or mock courtly) scenes, moral exempla, and satirical vignettes rather than to adopt subjects from the antique or engage in the invention of abstruse allegories.[22] Only later in the second and third decades of the sixteenth century did the print emerge as a legitimate realm for displays of classical learning and the exchange of humanist arcana. Many northern artists, incuding Dürer and Jan Gossaert, explored the classical world and studied ancient art with real seriousness, yet their response to the antique was heavily encumbered. Not only was the inheritance of antiquity necessarily an import, it was also very often tainted by a suggestion of moral corruptness.[23] Antique art became a model of ideal proportion in Dürer's early engravings, but, as in Gossaert's, in Dürer's later work it more often served as a stimulus to the erotic. A stricter sense of propriety, and perhaps also an abiding conviction about the instructive value of images, may have helped to postpone acceptance of the idea that a work of art might be something truly autonomous, an object to be valued more for its inventiveness than for its message.

Differences in attitude to decorum were not limited to secular matters alone. Indeed, as a result of the upheavals of the Reformation, the divide between Italy and the north was even more greatly magnified in the religious sphere. The Reformation generated a crisis that involved both artists and intelligensia in Germany, Switzerland, and the Netherlands, and it had complex and contradictory effects on the evolution of print production during the second quarter of the sixteenth century. Outbreaks of iconoclasm sought to purge the churches of devotional imagery and had the consequence of eliminating a major source of patronage for painters and sculptors in many northern cities. Whereas the Sack of Rome was comparatively local and relatively focused in its impact on Italian art, the effects of the Reformation in the north were general and long lasting. Commissions for altarpieces all but ceased wherever the climate of theological controversy was unstable, a fact that left many artists in need of finding other means of making their way. On the one hand, a painter and printmaker like Lucas Cranach the Elder managed to thrive under these conditions. Not only did he become the principal propagandist and book illustrator for Luther at Wittenberg, but at the same time he managed to work elsewhere for Catholic patrons, somehow remaining able to cross sharp ideological boundaries without giving serious offense. But there were others like Hans Holbein the Younger whose career as an artist was deeply affected by recurrent religious strife. Holbein contributed a great many woodcut designs to book publishers, including illustrations to the Luther Bible, and like Cranach he enjoyed the patronage and respect of men on different sides of the controversy. However, probably in large part because of the unrest, and particularly because of the constant threat of iconoclastic outbreaks, Holbein eventually declined the offer of a pension in Basel and finished his career in England where he worked mainly as a portraitist.

The iconoclastic attacks against painted and sculpted altarpieces, stained glass windows, and other traditional forms of religious art set in holy places gave a certain leeway to the less conspicuous and more flexible medium of the printed image. Prints, after all, could be passed readily from hand to hand and kept in private portfolios and libraries, well concealed from those who might disapprove of them. It was even suggested that because prints were merely black and white, in their restrained and unadorned simplicity they were especially well suited to expressing Protestant religious sentiments.[24] The Lutherans did avoid having images of holy figures set on their altars, but they nevertheless printed a great many broadsheets showing theological allegories and also vernacular Bibles well illustrated with narrative scenes taken from Scripture. Printed allegories and book illustrations supported the Protestant emphasis on independent learning and the personal exercise of piety. By giving privilege to private observance over public display, the image-shy reformers can be said to have given the print a new importance, while at the same time eliminating much of its competition in the production of religious art.

The private pursuit of faith and knowledge spon-

sored by religious reformers encouraged the increase of private libraries, the very locations where print collections would eventually be housed and quietly consulted. The reform-minded clergy and their colleagues in university faculties very likely became an important part of the clientele for more sophisticated printmakers. By the 1530s and 1540s these reformers constituted an intellectual community comparable to the cultivated circles in which Italian printmakers had begun to move, albeit with different scholarly interests and probably far less lurid tastes. In the Protestant universities of Germany the practice of making *alba amicorum* began. These albums were collections of signatures, epigrams, emblems, and coats of arms usually assembled by a teacher or theologian as commemorations bestowed by his intimate friends.[25] The illustrated *album amicorum* has obvious structural similarities with the print collector's album. These were personal and comparatively private compilations, and in fact since it was common to construct such albums by interleaving an available cycle of illustrations such as Holbein's *Dance of Death* or a series of Bible illustrations, many of the albums included large numbers of printed images along with inscriptions, drawings, and colored illuminations. One of the earliest and most famous of these albums belonged to the Antwerp cartographer Abraham Ortelius, a man who moved in academic circles, and who we also know to have been a keen collector of prints.[26] These were some of the conditions in which prints must have come to be appreciated for their particular and distinctive qualities in northern cities. They were in many ways less secular, less libertine, and less courtly circumstances than in Giulio Campagnola's and Titian's Venice or Marcantonio's Rome.

And yet, apart from some critical differences, northern Renaissance printmaking succeeded on much the same foundation as it had in Italy — on the imagination and technical prowess of a small number of exceptional masters. We have seen that in the north the collection of works by particular artists probably began in a casual and unsystematic way largely within local circles. This must have continued and intensified throughout the century, propelled by the success of Vasari's *Vite* and afterwards by Carel van Mander's *Schilder-Boeck*. The modern biographical construction of art history had begun to emerge, and print collectors were building the pictorial archives to illustrate it. Albums of prints recorded in inventories from the late sixteenth century and after are often arranged by national schools and then by artists just as we would now expect them to be. In the second half of the century evidence suggests that the value of certain prints began to rise and their rarity became an important factor. The account books and correspondence of the Antwerp book publisher Christopher Plantin show that he was also engaged in acquiring selected prints for favored clients and personal acquaintances across Europe. We learn that Dürer's prints were being avidly sought after, and that they had become difficult to find and very expensive. In negotiations of 1567 Plantin furnished Francesco Gentili of Padua with various prints, including impressions of the *St. Eustace*, *St. Jerome*, and *Melencolia I* for a total of three *guilder*; and in the following year another *St. Eustace* for the extraordinary price of three *guilder* ten *stuiver*, and a *Melencolia I* for a mere fifteen *stuiver*.[27] The very high price for the *St. Eustace* must reflect not only its rarity, but also an informed admiration for Dürer's earliest engraved masterpiece.

In so far as the Renaissance was a period in which collecting took on a more conspicuous importance for the arts, the assembling of prints and drawings was merely one part of an overall pattern. However, the correlation between the rise of systematic collecting and the careers of those printmakers who brought it about is not self-evident. Within the span of barely three remarkable generations the discipline of printmaking had come to prominence, and then with still more startling dispatch its champions withdrew from the stage leaving no true successors. Around 1550 in Antwerp, Augsburg, Basel, Nuremberg, and Strasbourg there were no virtuosi able to compete with the founding generation of engravers. In the north, as in Italy, the explanation for these two conflicting trends must be sought in the success of the major print publishing houses — Antonio Salamanca and Antonio Lafrery in Rome, Hieronymus Cock in Antwerp, and eventually others in Amsterdam, Frankfurt, Florence, and elsewhere. There can be no doubt that the rise of print collecting and the increase in print publishing in the second half of the century were closely interlocked, each working as an encouragement to the ambitions of the other. The marked, if temporary, eclipse of the *peintre-graveur* certainly came about because of the added efficiency of these publishing houses that were able to commission designs from many different artists, transform them into prints, and then purvey them internationally. The *peintre-graveurs* were thus left to pasture by the very act of capitalizing on their achievements. Along with the publishing houses and organized dealing, the idea of the "old master" print came into being. And little more than a generation later the value of the old master print would be firmly established by what modern historians have come to label the "Dürer Renaissance."

The repertoire of Hieronymus Cock's publishing house in the third quarter of the sixteenth century gives us a clear and unambiguous sign that the accumulation of prints had become a more widespread, worthy, and learned avocation throughout Europe.[28] When Cock first returned from Italy and released his portfolio of Roman ruins he introduced the topographical *veduta* into northern printmaking.

It must have proven a commercial success, since Cock went on to employ many of the most talented draftsmen in the Netherlands and abroad to supply his presses with ample designs. In addition, he must have trained some of the skilled technicians who transferred these drawings, engraving and etching them onto his plates. Eventually Cock issued the majority of his prints in suites or cycles meant for binding and setting onto library shelves as a resource for occasional reference and entertainment. Certainly he, like Lafrery, exported his editions across the continent of Europe, and undoubtedly they were carried still further across the seas to Asia and America as well. Over some thirty years of activity, Cock cultivated a range of different subjects, from topographical and scenic views to biblical and devotional themes, from historical topics to mythological subjects, and from portraiture to genre scenes and satires. Like Lafrery, Cock was a man of the marketplace, a cataloguer of tastes and topical interests, and a speculator in the realm of pictorial fancy. These publishers' careers signal a major shift in the attitude to prints, and indeed in the understanding of pictorial images generally.

To a greater extent than was true in Italy, northern painters and printmakers seem to have concentrated their attention on rendering the world, especially the natural world, in all its particularity and variableness. In a way, the entire enterprise of northern art could be described as being directed toward the modest if challenging notion that the true purpose of making art was simply to portray. This may partly account for the fact that the practice of reproductive printmaking emerged only gradually in the north, more specifically in Antwerp, and really not until after the middle of the sixteenth century. Certainly the habit of copying other images was common enough. However, what had not yet evolved was the concept of "reproduction" itself, with its necessary and quite specified sense of the work of art as an object worthy of being reproduced rather than merely imitated or improvised upon.[29] In so far as any image was essentially a representation of something else, apart from authorship there was nothing inherent to distinguish a portrait taken from life from a skillful copy of that portrait. Hence the need to adopt a term like *conterfeit* to alert the beholder to the exact intention underlying certain kinds of pictures made to convey the truth and integrity of some original object or experience. It is useful to recall that the Italians invented the idea of art, whereas northern artists for their part invented the genre of pure landscape. Not incidentally, both of these two profound Renaissance contributions to the history of art were furthered in large part through the agency of prints.

As prints continued to be accumulated throughout Europe, purely as a practical matter their sheer numbers would eventually distinguish them in the minds of collectors from other categories of col-

lectable objects. And at the same time that prints were coming to be appreciated as works of art they were also being valued in many quarters as useful records of stories, places, and events, in effect as repositories of knowledge. When applied to the problem of ordering a print collection, the documentary attribute of the print yielded quite different schemes of arrangement from those we have discussed thus far. Our very familiarity with arranging works of art by artists and schools inclines us to forget that this did not become the exclusive means of art historical classification until rather recently. In fact, well into the nineteenth century and long after Adam Bartsch completed his corpus, prints in European collections were often still collected topically and kept in albums (or atlases), where they were arranged and valued as a form of visual documentation, sometimes with little or no regard for their authorship.[30] Like the organization of print collections by artist, the topical or encyclopedic scheme of arrangement according to subject matter, predominently a northern preference, also first came into use during the Renaissance.

How did encyclopedic print collecting get its start? The model for ordering knowledge by topic was obviously the scholar's library, where an affinity between images and books was already well in place. As we have seen in the cases of Hartmann Schedel and Jacopo Rubieri, books were among the earliest repositories for images collected singly. In books they found a protected haven in happy subordination to a text, whether in some pertinent or altogether random relationship, certainly an obvious solution for an educated person. Schedel's library contained somewhere between seven hundred and a thousand texts, all arranged according to subject, with many sub-categories corresponding to his particular avocational and professional interests — humane letters, medicine, history, theology, natural and moral philosophy, rhetoric, cosmography, geography, alchemy, distillation, and so forth.[31] The arrangement of humanist libraries gave prominence to classical literature, new branches of natural philosophy, and other fields of study that would have important effects on the way collectors eventually thought about and organized much larger numbers of prints than anything Schedel could ever have imagined. In this way what began as an aspect of text illustration was gradually extended to the illustration of what we might call the universal or encyclopedic text of human knowledge.

In 1552, long after Hartmann Schedel's death, his library was sold to Johann Jakob Fugger, and in 1571 it was sold again to Albrecht V of Bavaria, whence it arrived at its present location in Munich. Fortuitously, when Schedel's library came to Albrecht's court it was placed under the supervision of a medical doctor and avid cultural taxonomist named Samuel Quiccheberg. At that time Quiccheberg was Albrecht's court librarian, and he was

probably also responsible for the arrangement of the *Kunstkammer*, among the richest and most celebrated collections of art and learning to be found anywhere in Europe, a display boasting along with many other marvels an entire stuffed elephant![32]

Quiccheberg was born in Antwerp and educated at the universities of Basel, Augsburg, and Munich. In 1563 he traveled to Italy to collect antiquities for Albrecht, and he was in touch with European scholars of botany, mineralogy, and zoology as well as other academic specialties. In 1565 Quiccheberg published the first detailed scheme for constructing an encyclopedic collection, or what he himself termed a theater of universal knowledge.[33] Quiccheberg's plan was intended as a model for the arrangement of an art and curiosity cabinet, though it appears not to be based on Albrecht's actual collection. The treatise takes the form of a series of inscriptions or *tituli* for the ordering of knowledge by topics, each *titulus* heading a display that might include beneath it images, texts, maps, designs, or actual specimens, instruments, or machinery, as appropriate. The theater is divided into five main classes: religious history, archaeology, natural history, human manufactures, and lastly "pictures" — *picturae / imagines / effigies* (pp. 39–46).[34] In drawing up his proposal, Quiccheberg was aware of the most ambitious precedent for his idea, the renowned Memory Theater of Giulio Camillo (died 1544). So far as we know, Camillo's theater was never actually completed, though it was certainly known in some form during his lifetime. And yet, however ephemeral, Camillo's idea remained wildly popular within French and Italian intellectual circles through the middle of the sixteenth century.[35] From what we can tell, Quiccheberg's scheme is less abstract in its prescription and less cosmic in its scope than Camillo's, and thus possibly more influential on actual collecting practices.

In the last section of Quiccheberg's treatise, where he takes up the class or category of images in his universal theater, he sets forth an outline for organizing a print collection. This is the first such prescription that we know to have been written down anywhere.[36] Actually, prints (woodcuts and engravings) are mentioned variously throughout the treatise where maps, portraits, and other images are recommended as illustrations for other categories of knowledge. However, in the fifth and final class he singles out engravings and maps as worthy of being bound into volumes and shelved in a part of the museum all their own. Here the treatise definitely reflects a practice of arranging and storing prints that was already familiar. Although we cannot be certain that prints were topically arranged in Albrecht's *Kunstkammer*, they were certainly so organized in the large collection assembled by Ferdinand of Tyrol between about 1565 and 1595, a collection that has come down to us virtually intact in a set of more than thirty-five albums including over five thousand prints, organized by topics — religious subjects in various divisions, moralities, architecture, landscapes, portraits, metalworking patterns, etc.[37]

Initially the Renaissance collectors in the north evolved two separate solutions to the problem of ordering printed images. One gave priority to the artists and their oeuvres, and the other, more "scientifically" inclined, gave priority to technical matters and to the subjects of images. Among the most original and at the same time revealing collections of the latter sixteenth century was that brought together by Basilius Amerbach between about 1560 and his death in 1591.[38] In addition to a special interest in the mechanics of technique that caused him to accumulate tools as well as works of art,[39] Amerbach seems to have drawn a distinction between his print collection and his collection of drawings, paintings, and cabinet pieces. He inventoried his drawings by artist and paid relatively little attention to subject matter or condition. His print collection, however, was completely inventoried in a document of some three hundred pages in which he not only gave attention to authorship, including speculation about problems of attribution, but ordered the images according to their subject matter in the encyclopedic manner.

Amerbach is the first collector we know to have made a distinction between prints and drawings in this way, and thereby to acknowledge the importance of prints as documentary images over their value as works of art. One should not understand this as a reactionary strategy returning the print to the status it held prior to the accomplishments of the *peintre-graveurs*. Rather, Amerbach seems to have acknowledged the implication of the print revolution that occurred through the publishing houses, transforming for a time the medium of replication into one of reproduction and recording. Amerbach recognized the suitable alliance of the print with topical arrangements. Most of the great Baroque collections we know of — for example those of Samuel Pepys, Rembrandt, Philippe de Marolles, or Paul Beheim — embraced one or the other and more often both of these solutions.[40] Organizing what sometimes amounted to many thousands of images into an intellectually coherent and visually manageable form was, after all, an intimidating prospect. In hindsight we can see in these two different systems a reflection of the double appeal of prints as works of art and as bearers of meaning, the two essential properties that came to distinguish them in the minds of collectors.

Therefore the epilogue to the Renaissance of printmaking became an acknowledgment of certain properties inherent to the medium: its efficiency of replication, its proliferation, its practical use, and its commercial potential. Yet these material properties did not necessarily run contrary to the promotion of Renaissance artistic values. Not only

367

did the print assist in constructing the idea of artistic invention in western thought, it also played a decisive role in celebrating, broadcasting, and eventually documenting this idea. Although the publishing houses along with the practice of reproductive engraving in Italy and the north temporarily eliminated the *peintre-graveur*, in the last quarter of the sixteenth century the virtuoso printmaker would be reborn, and reborn with a vengeance. Already by the 1580s the uniformities of the publishing house style were converted by Hendrick Goltzius into a language of individual statement, a dazzling signature style forged out of the technical conveniences of earlier engravers. This was the beginning of a second revolution in printmaking, now based on a fundamental challenge to the uniformities of commercial production. It was a challenge that gained full force in the following century with the extraordinary etchings of Hercules Seghers and Rembrandt, two masters who often reworked their plates and their impressions to create what are effectively monotypes. This approach to the print sought once again to subvert its mechanical advantage in the name of art.

Currencies, Values, and Wages

RENAISSANCE MONETARY TRANSACTIONS were complex. Anyone wishing a general discussion of this bewildering realm of the real and imaginary is encouraged to read Carlo Cipolla's excellent introduction to the topic: *Money, Prices and Civilization in the Mediterranean World: Fifth to the Seventeenth Century* (Princeton, 1956).

In brief, monetary calculations and exchange were conducted on the basis of three different sorts of quantities: (1) currencies or "real" coins; (2) locally minted and locally recognized coins; (3) moneys of account. "Real" or "big" coins like the Rhenish *gulden*, the *Carolus guilder*, or the gold florin or Venetian ducat carried significant value in their metal content and were actually used, for the most part, only in major transactions. These real coins are now typically labeled "currencies" by economic historians. Local or "petty" coins such as the *pfennig*, the *stuiver*, or the *soldo* served for all daily transactions of minor sorts, and on a strictly local basis. Beyond their purely local use the value of these coins depended upon establishing a relationship to one or more of the "real" coins. Finally, moneys of account acted as calculating denominations, that is to say, quite literally, as the means of keeping accounts. Denominations in moneys of account might or might not employ the same designations as those used for local coins and real currencies. In Germany, for example, the standard money of account was the *pfund*, a denomination for which no actual coin existed. In Florence, on the other hand, the florin or *fiorino* was a standard money of account like the *lira* but also a circulating coin. Like local coins, the actual value of moneys of account depended upon their relation to real coin — a relation that sometimes fluctuated according to the actual metal content of these coins, and sometimes according to a variety of external economic factors.

At an event like the Frankfurt Fair, negotiations took place among tradesmen from all parts of Europe, and these merchants carried with them many different currencies and local coins. On such occasions there were exchange booths set up to manage the necessary conversions. The number of different coins, currencies, and moneys of account mentioned by Albrecht Dürer in his Netherlandish Diary (Chapter VI, pp. 352–54) gives one a full sense of the practical confusions encountered by a traveler in this period. For much the same reason that Dürer's accounts present us with a bewildering prospect of financial calculations and conversions, it is extremely difficult for the historian to make meaningful comparisons among prices from one location to another. This is especially true when the amounts involved are small. Indeed, in the matter of print prices, attaining a very precise gauge of real value is well nigh impossible.

We can, however, get some sense of the value of minor commodities in local contexts. In order to do this, modern economic historians generally construct a scale of real value in monetary terms by establishing chronological curves in the price of basic commodities within a certain region. Typically these calculations are based on changes in the price of grain in relation to the value of wage labor. In the Renaissance those who were dependent upon daily wage labor were unskilled and semi-skilled, and were towards the lower end of the economic spectrum. For our purposes the daily fees given for wage labor are the most available and reliable figures we have for providing some tangible idea of the cost of living in late fifteenth- and early sixteenth-century Europe. Often the figures given in detailed studies are seasonal, being lower in winter and higher for the summer months (when daylight allowed for longer hours and the countryside drew workers away from the town). In cases where abundant statistics are available, seasonal patterns are averaged and approximate figures given for decades or quarter centuries. You will see that changes in amount (versus "real" value) are relatively slight and tend to occur gradually, though sharp deviations do happen where the statistics have been correlated in sufficient density to record abrupt local changes, for example changes resulting from plague or famine. We have usually not bothered to take these into account. In correlating wage labor with print prices we must recognize that the recipients of such wages were not likely to have been among the actual purchasers of prints. Indeed, unskilled labor usually meant a bare subsistence living. However, reaching conclusions about actual conditions on an individual basis even from detailed wage labor series is risky business.[1] In the most prosperous of European cities such as Antwerp, Venice, Nuremberg, and Florence, the Renaissance was a time of advantage for certain groups among the artisanry. For some of them, prints, and indeed the decorative arts, were almost certainly becoming accessible, a matter of interest, and indeed a matter of status.

It is useful to keep in mind the fact that the sixteenth century was a period of general inflation in Europe, and that wage earners especially experienced a gradual and sometimes dramatic loss in real buying power. It has also been pointed out that a lag in the relationship of wages to prices is a normal pattern since the early modern period in European economic history, and yet the sixteenth century appears to have been one in which this disparity was somewhat greater than usual. The explanations and interpretations of this are various and complex, always in some respect related to the influx of precious metals from the New World. Although it seems fair to conclude that specialists in these matters are themselves unclear about the causes and implications of inflation during the Renaissance, our very limited objectives can be addressed more or less independently.

The cities included in our survey are chosen because of their relevance to the discussion of prices elsewhere in the text, and also because the statistics are available for these locations. Although some additional information on other towns can be found in the chapter notes, we would like to have included more material on Nuremberg, and also something of use on Venice and Amsterdam. However, the rigorous kind of study needed for a precise examination of monetary value in the Renaissance has thus far been done only for a few specific areas, Antwerp most thoroughly. The information summarized below can be enhanced by reference to the sources cited in the notes to the text.

ANTWERP

Antwerp's economy was in an overall climb throughout the period between 1470 and 1550, though with some flat periods. It had the most active international exchange bank in northern Europe. Wages for skilled and unskilled labor continued to rise gradually, and during the sixteenth century it was even common for craftsmen and manual workers to occupy what were for them relatively expensive middle-class houses. Antwerp was, in this respect, exceptional among European cities where most wage earners are presumed to have experienced a significant loss in real income over our period.[2]

Coinage:[3]

The basic monetary units in real coin were Flemish and Brabant silver *ponds*. Furthermore, in the fifteenth century the Rhenish gold *gulden* was widely used in the Netherlands as real coin. Later on, in 1526, the gold *Carolus guilder* was introduced by Charles V, and it then came into regular use alongside the *pond*. In the second half of the sixteenth century the *pond* disappeared as actual coin and became merely a calculating designation. The basic local coin was the silver *groot* or groat.

1 Flemish *pond* = 20 *schellingen* = 240 *denieren* or *groten* or *penningen*
1 Brabant *pond* = 20 *schellingen* = 240 *denieren* or *groten* or *penningen*
1 *Carolus guilder* (*gulden* or florin) = 20 *stuivers* or *patars*

Equivalences:

1 Flemish *pond* = 1.5 Brabant *ponds* = 6 *Carolus guilder*
1 Brabant *pond* = 4 *Carolus guilder*
1 *stuiver* = 2 Flemish *groten* = 3 Brabant *groten*

Moneys of Account:

Designated moneys of account in the Netherlands were also often actual coins. Initially the pound Flemish groat (*groot*), and thereafter the Flemish *guilder* (florin or *gulden*) at 20 *stuiver* (the *stuiver* equal to 2 Flemish groats), served as link money in a fixed ratio of exchange with the *pond*. To accommodate changes in value the groat and the *stuiver* fluctuated in its silver content depending upon the value of the *pond*.[4] Dürer's dealings in the Netherlands were managed mainly in *stuiver*,[5] whereas Cornelis Bos's goods were valued in Brabant *ponds*.[6] On the other hand, the Plantin printing house accounts from 1560 onwards were mainly kept in *Carolus guilder*.[7]

ANTWERP WAGES:[8]

YEAR	UNSKILLED (mason's laborer)	SKILLED (mason or carpenter)
1475	5–7 *d*	9–12 *d*
1500	5–7 *d*	9–12 *d*
1525	6–9 *d*	12–15 *d*
1550	9–12 *d*	12–15 *d*

AUGSBURG

In Augsburg, a town of about 40,000 people, prices increased steadily from the mid-fifteenth century and then rapidly in the early sixteenth century, especially for foodstuffs. Prices far outstripped the gradual increase in wages, resulting in a sharp decline in real income, a disparity that was greater in the south of Germany than it was in the north. (The town council allotted day wages that are considered to have been barely at subsistence level.) Our main interest in Augsburg lies in the second decade of the sixteenth century with Maximilian's accounts for his woodcut projects. There is a notable gap between skilled and semi-skilled wages compared to Nuremberg. Though our statistics for Nuremberg are scant, these results could be interpreted as reflecting the absence of a guild structure.[9]

Coinage:

The basic monetary unit was the *gulden* = 20 *schillingen* = 240 *pfennige*. Locally minted coins were the *pfennig* and the *heller*, and later on the *kreutzer*, the *taler*, and the *mark*. The real value of the Augsburg *pfennig* fluctuated on the basis of a silver equivalence in conversions to real currency: 1 Rhenish *gulden* in 1445 = 160 *d*; 1476 = 210 *d*; 1490 = 212 *d*, etc.[10]

Equivalences:[11]

1 *kleines pfund* = 20 *schillinge* = 60 *pfennige* = 120 *heller* (up to 1500)
1 *großes pfund* = 240 *heller*
1 *pfund* = 60 *pfennige* (from 1500)
1 *rechnungsgulden* = 210 *pfennige*
 = 60 *kreutzer*
 = 210 *pfennige* (from 1539)
 = 72 *kreutzer* (later)

Conversions:

Initially the pound (or *pfund*) was the basic calculating denomination, designated in two forms — large and small. Around 1500 the *pfund* was superceded by the *gulden* (the *rechnungsgulden* or "guilder of account") as the chief money of account, and after 1539 the *pfund* went out of use. Also from 1500 onward the gold *gulden* (the *Reichsgulden* or florin and the Rhenish gold *gulden*, both circulating as actual coins of different worth) became the main currency of real value. In addition, the Esslingen *Münzkonvention* of 1524 elevated the silver *gulden* to an imperial coin of equal value to the gold *gulden* (established by fixing the ratio of its silver content to gold).[12]

AUGSBURG WAGES:[13]

YEAR	UNSKILLED (day laborers)	SEMI-SKILLED (mason)
1499–1520		24 *d*
1499–1503	8–12 *d*	
1500–1509	8–14 *d*	
1503–1521		32 *d* (winter = 24 *d*)
1510–1527	10.5 *d*	
1528–1553	10.5–14 *d*	27–35 *d*

NUREMBERG

Nuremberg's economy was based on its mercantile activity and its industrial and craft production. Over the course of the Renaissance, when banking and trade practices were evolving at a rapid pace, Nuremberg's conservative social, political, and economic policies caused the city to lose ground to its main rivals. By the latter half of the sixteenth century Nuremberg's prominence was eclipsed by Augsburg — a city that was both socially and economically more progressive, and was also better located for taking advantage of major trading arteries.

Coinage:

The basic monetary unit was the *gulden* = 20 *schilling* = 240 *pfennig* = 480 *heller*. When the designation is in actual coinage (versus money of account), this normally indicates the Rhenish *gulden* minted by the Rhenish *Kurfürsten* throughout this period. Also in use was the florin or gold *gulden* = 30 silver *schilling* = 240 silver *pfenning*. Although the gold *gulden* served as the main gauge of real value in northern Europe during the Renaissance, it gradually lost power to its main rival, the Venetian gold ducat.

Equivalences:[14]

1 *alt pfund* = 30 *denar* (up to 1500)
1 *neu pfund* = 4 *alt pfund* = 120 *denar*
1 Rhenish *gulden* = 2 *pfund*
1 florin or gold *gulden* = 8 *alt pfund* 12 *pfenning* = 252 *neu pfenning*
 = 2 *neu pfund* 1 *schilling*
 = 60 *kreutzer*
 = 72 *kreutzer* (after 1524)

Moneys of Account:

As in Augsburg, the *pfund* was the usual money of account in the fifteenth century, but was then used erratically in the following decades with a variable relation to the gold *gulden*. An approximate relation of the *pfund* as a calculating denomination to the actual florin or gold *gulden* is given in the table of conversions above.

NUREMBERG WAGES[15]

YEAR	UNSKILLED	SEMI-SKILLED (mason)	(carpenter)
1482–84			24 *d*
1538–40	24 *d*		
1500–1550	16–18 *d*	22–26 *d*	28 *d*

FLORENCE

The Florentine economy followed the general European pattern of inflation. The wages for unskilled labor had been in decline since the middle of the fourteenth century. (There were some abrupt shifts in unskilled wages during 1525–26 when the Rosselli inventory was being compiled, though skilled wages seem to have remained relatively constant. The stipend in the will left to care for the children seems lean at best by average living standards of the time, which may imply some other source of assistance.) Even while wages nominally increased, they decreased in purchasing power throughout the Renaissance when measured against the price of grain. However, the Florentine economy was generally prosperous, and although the pattern of inflation was damaging overall, it did not necessarily erode the ability of individual workers to maintain themselves comfortably.[16]

Coinage:[17]

Like Venice, Florence operated according to a bimetallic system. The basic monetary unit was the internationally recognized gold florin or *fiorino*. In addition, a silver florin as well as a great many other local coins made of silver and copper (*monete di piccioli*) were in circulation. Whereas these coins served people in their day-to-day transactions, the gold florin, like the Venetian ducat, was employed only for banking and international trade. The value of the gold florin remained relatively stable between 1450 and 1500, and gradually increased as its dominance on the international market became evident.

Equivalences:

In Italy designations for actual coins also sometimes operated as moneys of account, a system of "ghost money" with occasional live ghosts. *Monete di piccioli* fluctuated in value and in metal content like local coins elsewhere, varying according to the value of baser metals in relation to gold. Calculations were therefore managed in moneys of account, normally in denominations of the florin (operating as a money of account), or more commonly in denominations of the *lira*. The real value of these coins was tied to the gold florin or ducat.

Moneys of Account:

The regular money of account was the *lira* (or *libra*) = 20 *soldi* = 240 *denari*. (When the florin was used as an accounting designation it also carried these conventional denominations.) From the fourteenth century onward the value of the *lira* was in steady decline in relation to the gold florin. This relationship was apparently monitored daily by posting two different rates of exchange, an official rate and another available "at the counter."[18] The following table gives an indication of the curve in actual value of the *lira* and *soldo* over the period of interest to us here:

1 gold florin = 117 *soldi* = 6 *lire* = 117 *soldi* (1480)
 = 8 *lire* = 140 *soldi* (1500–25)
 = 8 *lire* = 150 *soldi* (1533)[19]

FLORENTINE WAGES[20]

YEAR	UNSKILLED (manual labor)	SEMI-SKILLED (masons, etc.)
1475	8.0	15 (*soldi*)
1500	9.3	14.5
1525	9–10	15–20
1531	16	30
1534	9–11	15–18
1550	12–14	21–28

Abbreviations

B.	Bartsch, Adam. *Le Peintre graveur.* 21 vols. Leipzig, 1803–21.
G.	Geisberg, Max. *The German Single-Leaf Woodcut: 1500–1550.* 4 vols. Revised and edited by Walter Strauss. New York, 1974.
H.	Hind, Arthur M. *Early Italian Engraving.* 7 vols. London and New York, 1938–48.
Holl.	Hollstein, F. W. H. *Dutch and Flemish Etchings, Engravings and Woodcuts, ca. 1450–1700.* Amsterdam, 1949– .
	Hollstein, F. W. H. *German Engravings, Etchings and Woodcuts, ca. 1400–1700.* Amsterdam, 1954– .
JKSW	*Jahrbuch der Kunsthistorischen Sammlungen in Wien* (formerly: *Jahrbuch der Kunsthistorischen Sammlungen des allerhöchsten Kaiserhauses, Wien*)
Lehrs	Lehrs, Max. *Geschichte und kritischer Katalog des deutschen, niederländischen und französischen Kupferstichs im XV. Jahrhundert.* 16 vols. Vienna, 1908–34.
Pass.	Passavant, J. D. *Le Peintre-graveur.* 6 vols. Leipzig, 1860–64.
Pauli	Pauli, Gustav. *Hans Sebald Beham. Ein kritisches Verzeichniss seiner Kupferstiche, Radierungen und Holzschnitte.* Strasbourg, 1901.
Schreiber	Schreiber, Wilhelm Ludwig. *Handbuch der Holz- und Metalschnitte des XV. Jahrhunderts.* 8 vols. 1st ed. Berlin, etc., 1891–1911. 3rd. ed. Stuttgart, 1969.
Thieme–Becker	Thieme, Ulrich and Felix Becker. *Allgemeines Lexikon der bildenden Künstler.* 37 vols. Leipzig, 1907–50.

Notes to the Text

Notes to Chapter I

1. R. Forrer, *Die Zeugdrucke der byzantinischen, romanischen, gotischen und spätern Kunstepochen* (Strasbourg, 1894); Arthur M. Hind, *An Introduction to a History of Woodcut*, (New York, 1935; repr. London and New York, 1963), vol. I, pp. 67–69. The precedent of cloth printing is certain, though recent investigations have cast doubt upon the dating of many extant examples of the technique thought to have been made nearer to the inauguration of woodblock printing on paper. Donald King, "Textiles and the Origin of Printing in Europe," *Pantheon* 20 (1962), pp. 23–30. Evidence from inventories and from surviving examples of cloth appears contemporaneously with the spread of woodcut printing on paper. For a review of the evidence and examples, see Leonie von Wilckens, "Der spätmittelalterliche Zeugdruck nördlich der Alpen," *Anzeiger des Germanischen Nationalmuseums* (1983), pp. 7–18; and Hellmut Rosenfeld, "Wann und wo wurde die Holzschnittkunst erfunden?" *Archiv für Geschichte des Buchwesens* 34 (1990), pp. 327–42.

2. On the relation of engraving to earlier practices of metalworkers, see the important study of Johann Michael Fritz, *Gestochene Bilder: Gravierungen auf deutschen Goldschmiedearbeiten der Spätgotik* (Cologne and Graz, 1966), who cites the twelfth-century text.

3. J. W. Enschedé, "Een Drukkerij buiten Mechelen voor 1466," *Het Boek* 7 (1918), pp. 286–92. The inventory was compiled on the occasion of the death of the Abbess of Bethania, and includes reference to nine woodblocks ("novem printe lignee ad imprimendas ymagines"), some sort of press apparatus ("primo unum instrumentum ad imprimandas scripturas et ymagines cum diversis modici valoris asseribus, una lectita sine lecto"), and various other trappings. The evidence for monastic sponsorship or production is concentrated in northern Europe. See Hind, *History of Woodcut*, I, p. 108, for a list of cases. The classic study of the early devotional woodcut is Adolf Spamer, *Das kleine Andachtsbild vom XIV. bis zum XX. Jahrhundert* (Munich, 1930). For more focused investigations, see Martin Weinberger, *Die Formschnitte des Katharinenklosters zu Nürnberg* (Munich, 1925). Richard S. Field, "Woodcuts from Altomünster," *Gutenberg Jahrbuch* (1969), pp. 183–211, cites a document for an expensive paper purchase (p. 184) that suggests some of these houses may have produced very large editions of prints. See also H. D. Saffrey, "L'arrivée en France de saint François de Paule et l'imagerie populaire à Toulouse au XVe siècle," *Nouvelles de l'estampe*, no. 86 (May 1986), pp. 6–23, for monastic woodcuts in France.

4. Lucien Febvre and Henri-Jean Martin, *The Coming of the Book: The Impact of Printing, 1450–1800*, trans. David Gerard (London, 1976), pp. 184–85.

5. There are very rare cases where a printed image appears to have been taken from an actual piece of metalwork. One case of an image of an angel probably from the foot of a chalice may date from the fifteenth century: Zofia Ameisenova, "Nieznany wzór zlotniczy z XV W. W bibliotece Jagiellonskiej," in *Studia nad ksiazka: Poswiecone Pamieci Kazimierza Piekarskiego* (Warsaw, 1951), pp. 365–69. Max Loßnitzer, "Zwei Inkunabeln der deutschen Radierung," *Mitteilungen der Gesellschaft für vervielfältigende Kunst* (1910), pp. 36–39, describes another curious intaglio impression rubbed directly from an etched sword blade, possibly by Sebald Beham.

6. Hellmut Lehmann-Haupt, *Gutenberg and the Master of the Playing Cards* (New Haven and London, 1966), attempts to associate the initiation of engraving by the Master of the Playing Cards directly with Gutenberg's invention, but this proposition must be firmly dismissed.

7. Anne H. van Buren and Sheila Edmunds, "Playing Cards and Manuscripts: Some Widely Disseminated Fifteenth-Century Model Sheets," *Art Bulletin* 56 (1974), pp. 12–30.

8. Jan Piet Filedt Kok, "The Development of Fifteenth-Century German Engraving and the Drypoint Prints of the Master of the Amsterdam Cabinet," in Jan Piet Filedt Kok, et al., *Livelier than Life: The Master of the Amsterdam Cabinet, or the Housebook Master, ca. 1470–1500*, exh. cat. (Amsterdam: Rijksprentenkabinet, 1985), pp. 23–39.

9. Sandra Hindman and James Douglas Farquhar, *Pen to Press: Illustrated Manuscripts and Printed Books in the First Century of Printing* (Baltimore, 1977), ch. 3.

10. The volume is now in the Biblioteca Classense in Ravenna. For an account of the literature on the collection, see Erwin Rosenthal, "Two Unrecorded Italian Single Woodcuts and the Origin of Wood Engraving in Italy," *Italia medioevale e umanistica* 5 (1962), pp. 353–70; and Fiora Bellini, *Xilografie italiane del Quattrocento da Ravenna e da altri luoghi*, exh. cat. (Rome, 1987).

11. Arthur M. Hind, *Early Italian Engraving* (London, 1938–48), vol. I, p. 13; and Hind, "Fifteenth-Century Italian Engravings at Constantinople," *Print Collector's Quarterly* 20 (1933), pp. 279–96.

12. Richard Stauber, *Die Schedelsche Bibliothek*, ed. Otto Hartig (Freiburg im Breisgau, 1908). Béatrice Hernad, *Die Graphiksammlung des Humanisten Hartmann Schedel*, exh. cat. (Munich: Bayerische Staatsbibliothek, 1990). Most if not all of these prints have been removed from the books and are now kept separately.

13. Jean Adhemar, "Les premiers éditeurs d'estampes," *Nouvelles de l'estampe*, no. 6 (1972), pp. 3–5; and Paolo Bellini, "Stampatori e mercanti di stampe in Italia nei secoli XVI e XVII," *I quaderni del conoscitore di stampe* 26 (1975), pp. 19–22.

14. Timothy Riggs, *Hieronymus Cock: Printmaker and Publisher in Antwerp* (New York and London, 1977); and Louis Lebeer, "Propos sur l'importance de l'étude des éditeurs d'estampes, particulièrement en ce qui concerne Jérôme Cock," *Revue belge d'archéologie et d'histoire de l'art* 37 (1968), pp. 19–135.

Notes to Chapter II

1. For example, in Ulm the guild of carpenters, coopers, and cabinetmakers was defined by a common use of the wooden mallet, while the smiths, including metalworkers of various sorts as well

as stone masons, were distinguished because their prevalent tool was a metal hammer. Eugen Nübling, *Ulms Handel und Gewerbe im Mittelalter* (Ulm, 1899–1900), vol. II, p. 307. For a recent study of artists' guilds and their relation to the evolution of a medium, see Michael Baxandall, *The Limewood Sculptors of Renaissance Germany* (New Haven and London, 1980), ch. 4.

2. René de Lespinasse, *Les métiers et corporations de la ville de Paris* (Paris, 1886–97), vol. II, pp. 187–96.

3. Johann Michael Fritz, *Gestochene Bilder: Gravierungen auf deutschen Goldschmiedearbeiten der Spätgotik* (Cologne and Graz, 1966), for a thorough discussion of the history of inscribed surface ornamentation in goldsmithery.

4. A. J. J. Delen, *Histoire de la gravure dans les anciens Pays-Bas et dans les provinces belges, des origines jusqu'à la fin du XVIII^e siècle* (Paris and Brussels, 1924–25), vol. I, p. 24, notes that *prentere* (doubtless including document illuminators and block printers) were already cited in the painters' guild in 1442. Hanns Floerke, *Studien zur niederländischen Kunst- und Kulturgeschichte* (Munich and Leipzig, 1905), p. 154, notes that in Antwerp in the sixteenth century there were nearly twice as many painters and engravers as there were bakers: 300 to 169. Maarten Peeters, a printmaker and print publisher, and Hans Liefrinck were both elected Dean of the St. Luke's Guild (1546 and 1558 respectively), implying that the status held by printmaking specialists was in no way secondary to the painters, sculptors, and book printers. On the Antwerp guild records, see Philip Rombouts and Th. van Lieris, *De Liggeren en andere historische archieven der Antwerpsche Sint Lucasgilde* (Antwerp, [1864–76]), vol. I, pp. 37ff. and *passim*.

5. For a summary of guild patterns in the Netherlands and further literature, see Lorne Campbell, "The Art Market in the Southern Netherlands in the Fifteenth Century," *Burlington Magazine* 118 (1976), p. 191.

6. Lespinasse, *Les métiers*, II, pp. 187–96.

7. For the Strasbourg guilds in general, see Thomas A. Brady, *Ruling Class, Regime and Reformation in Strasbourg, 1520–1555* (Leiden, 1978), ch. 3; and Jean Rott, "Artisanat et mouvements sociaux à Strasbourg autour de 1525," in *Artisans et ouvriers d'Alsace* (Strasbourg, 1965), pp. 137–70.

8. See Giancarlo Schizzerotto, *Le incisioni quattrocentesche della Classense* (Ravenna, 1971), pp. 106, 109–12. The problem was not a recent one, as Giovanni, Domenico's father, is cited in a similar document in 1442. The della Setas must count among the first printselling dynasties.

9. Prince d'Essling, *Les livres à figures vénitiens* (Paris and Florence, 1907–14), vol. III, p. 112, n. 1: "disegnator, depentor de Santi, indorador, scrittor, cartoler, miniador, intajador."

10. See Maria Grazia Ciardi Duprè, et al., *L'Oreficeria nella Firenze del Quattrocento*, exh. cat. (Florence, 1977). The Arte della Seta is not to be confused with the family mentioned above.

11. Paul Koelner, *Die Safranzunft zu Basel und ihre Handwerke und Gewerbe* (Basel, 1935), pp. 297–300. Urs Graf is listed as a goldsmith both in Basel and later in Solothurn. Thieme–Becker, XIV, pp. 486–88, s.v. Graf.

12. Peter Amelung, *Der Frühdruck im deutschen Südwesten, 1473–1500*, exh. cat. (Stuttgart: Württembergische Landesbibliothek, 1979), p. 6. Hans Rott, *Quellen und Forschungen zur südwestdeutschen und schweizerischen Kunstgeschichte im XV. und XVI. Jahrhundert* (Stuttgart, 1933–38), vol. II, pt. 2, *Alt-Schwaben und die Reichsstädte*, pp. 15–17, 73–75. Franz Friedrich Leitschuh, *Studien und Quellen zur deutschen Kunstgeschichte des XV.–XVI. Jhs.* (Fribourg, Switzerland, 1912), pp. 188–91. Woodcut cardmakers were very successful in Ulm during the fifteenth century, having a lively export business and in at least one known instance cutting blocks for book illustration as well. Nübling, *Ulms Handel und Gewerbe*, pp. 300–09. Ulm also had a Brotherhood of St. Luke to which many artists belonged, including printmakers. However, it was an honorary religious and charitable confraternity and not,

strictly speaking, a guild. The *Stiftungsbrief* of 1499 for the Brotherhood established in the Wengenkloster Kirche addresses painters, sculptors, and document printers (*Briefdrucker*). The Ulm Stadtarchiv retains only a later copy recording the membership from 1499 to 1518: "*Bruderschaft der Mahler und bildhauer in der Wangen*" (Sig. H. Schmid 21/1, doc. 6533, fols. 180r–180v).

13. Arthur M. Hind, *An Introduction to a History of Woodcut* (repr. London and New York, 1963), vol. I, pp. 83, 89–90.

14. See Rombouts and Lieris, *De Liggeren*; Heinrich von Loesch, *Die Kölner Zunfturkunden nebst anderen Kölner Gewerbeurkunden bis zum Jahre 1500* (Bonn, 1907), vol. I, pp. 137–39; Charles-Guillaume-Adolphe Schmidt, *Zur Geschichte der ältesten Bibliotheken und der ersten Buchdrucker zu Strassburg* (Strasbourg, 1882), vol. II, pp. 39–43, 77–78.

15. Koelner, *Die Safranzunft*, pp. 299–300.

16. Paul Kristeller, *Early Florentine Woodcuts* (London, 1897), pp. xvii–xviii.

17. For Flötner's architectural designs, see Max Geisberg, *The German Single-Leaf Woodcut, 1500–1550*, ed. W. Strauss, vol. III, nos. 835–44. Flötner signed these prints more prominently than his other subjects. There are a large number of impressions of German woodcuts from the second quarter of the sixteenth century which have architectural designs printed on their versos. This must reflect a workshop practice for the secondary use of unsold impressions, e.g., on the verso of a woodcut by Sebald Beham (Pauli, 1237) in Nuremberg, Germanisches Nationalmuseum.

18. Rudolf Endres, "Zur Einwohnerzahl und Bevölkerungsstruktur Nürnbergs im 15./16. Jahrhundert," *Mitteilungen des Vereins für Geschichte der Stadt Nürnberg* 57 (1970), p. 256.

19. Hans Lentze, "Nürnbergs Gewerbeverfassung des Spätmittelalters im Rahmen der deutschen Entwicklung," in *Beiträge zur Wirtschaftsgeschichte Nürnbergs*, ed. Stadtarchiv Nürnberg (Nuremberg, 1967), vol. II, pp. 604–19.

20. Gerald Strauss, *Nuremberg in the Sixteenth Century*, 2nd rev. ed. (Bloomington, Ind., 1976), pp. 134–45. Ernst Mummenhoff, "Handwerk und Freie Kunst in Nürnberg," *Bayerische Gewerbe-Zeitung* 3 (Nuremberg, 1890), pp. 266–67; and Mummenhoff, "Freie Kunst und Handwerk in Nürnberg," *Korrespondenzblatt des Gesamtvereins der deutschen Geschichts- und Altertumsvereine* 54 (1906), cols. 105–19. Jacob Stockbauer, *Nürnbergisches Handwerksrecht des XVI. Jahrhunderts* (Nuremberg, 1879), analyzes the standardization of the craft regulations in sixteenth-century Nuremberg. Oscar von Hase, *Die Koberger*, 2nd rev. ed. (Leipzig, 1885; repr. Amsterdam and Wiesbaden, 1967), p. 56, notes that on the formal entry of Archduke Ferdinand in 1521 the printers presented themselves among the sworn crafts, sporting a tenuous association with this group. The printers were expected to register annually with the council, though they were not bound by any of the regulations normally attached to the designated crafts. This appears to have been done in order to keep a closer eye on the printers rather than as an attempt to organize them.

21. Lore Sporhan-Krempel, "Kartenmaler und Briefmaler in Nürnberg," *Philobiblon* 10 (1966), p. 140; Theodore Hampe, ed., *Nürnberger Ratsverlässe über Kunst und Künstler im Zeitalter der Spätgotik und Renaissance* (Vienna and Leipzig, 1904), vol. I, p. 268, doc. no. 1860; p. 415, doc. no. 2996.

22. Hampe, *Nürnberger Ratsverlässe*, I, pp. 410–11, doc. no. 2960 (11 May 1546): "Tell the sworn goldsmiths, since engraving on tin and copper pieces is not forbidden by law, but rather is a free art, the apprentices are instructed to pursue it without constraint" (Den geschwornen goldsmiden sagen, dweil das graben auf messing und kupferin stocklin im gsetz nit verpoten, sonder ein freie kunst ist, so wiß mans den gsellen, so es treiben nit abzestellen).

23. Hind, *History of Woodcut*, I, pp. 91, 211, 279, though without reference to a primary source.

24. Sporhan-Krempel, "Kartenmaler und Briefmaler," p. 143; Hampe, *Nürnberger Ratsverlässe*, I, p. 235, doc. nos. 1556–58. In 1527 the

council passed a regulation insisting that all items published by book and woodcut printers had to be cleared by the authorities.

25. Wolfgang Reuter, "Zur Wirtschafts- und Sozialgeschichte des Buchdruckgewerbes im Rheinland bis 1800," *Archiv für Geschichte des Buchwesens* 1 (1958), pp. 692–94; Hase, *Die Koberger*, pp. 55–57; Hans W. Bieber, "Die Befugnisse und Konzessionierungen der Münchner Druckereien und Buchhandlungen von 1485 bis 1871," *Archiv für Geschichte des Buchwesens* 2 (1958/60), p. 406.

26. Koelner, *Die Safranzunft*, p. 311.

27. Brady, *Ruling Class*, pp. 14, 112–24; Schmidt, *Zur Geschichte*, II, p. 78.

28. George H. Putnam, *Books and their Makers during the Middle Ages* (New York and London, 1896), vol. I, p. 451; Graham Pollard, "The Company of Stationers before 1557," *The Library*, ser. 4, *Transactions of the Bibliographical Society of London*, ser. 2 (1937), pp. 1–38.

29. Natalie Z. Davis, "A Trade Union in Sixteenth-Century France," *Ecomomic History Review*, 2nd ser., 19 (1966), pp. 50–55.

30. On the general phenomenon of printing, see Lucien Febvre and Henri-Jean Martin, *The Coming of the Book: The Impact of Printing, 1450–1800*, trans. David Gerard (London, 1976); and more recently Elizabeth Eisenstein, *The Printing Press as an Agent of Change* (Cambridge, 1979), 2 vols.

31. Max Hasse, "Maler, Bildschnitzer und Vergolder in den Zünften des späten Mittelalters," *Jahrbuch der Hamburger Kunstsammlungen* 21 (1976), pp. 31–42, studies the effect of the widepread commissioning of sculpted and painted retables in Germany after 1460, showing how the guilds — which typically separated the *Flachmaler* from the *Bildschnitzer* — then rationalized their regulations in order to take advantage of a lucrative opportunity.

32. Sylvia Thrupp, "The Gilds," in M. M. Postan and H. J. Habakkuk, eds., *Economic Organization and Policies in the Middle Ages*, Cambridge Economic History of Europe, vol. 3, (Cambridge, 1963), pp. 230–80.

33. Richard A. Goldthwaite, *The Building of Renaissance Florence: An Economic and Social History* (Baltimore and London, 1980), p. 416.

34. For women and card making: Sporhan-Krempel, "Kartenmaler und Briefmaler," pp. 138–40; Thrupp, "The Gilds," pp. 275–76. The Ulm Stadtarchiv legal records cite "Anna Peter, Kartomaler," fined in 1508 (Sig. A. 3963: *Strafbuch der Ainung*, fol. 31r). Rott, *Quellen und Forschungen*, III, *Oberrhein*, pt. 1, p. 80, cites Dorthea Karrer, *Kartenmalerin*, active in 1524. An amusing court record from Frankfurt in the 1460s or 1470s cites "Elsa, Kartenmacherin" being sued for having called someone's wife "eynen gelen heßlichen unflat" (a shrieking, ugly bit of muck). Walther Karl Zülch and Gustav Mori, eds., *Frankfurter Urkundenbuch zur Frühgeschichte des Buchdrucks* (Frankfurt, 1920), p. 2.

35. Nuremberg, Stadtarchiv, *Inventarbcher des Stadtsgerichts*, fols. 219v–220v [Signature: Rep. B. 14/VI]. We cannot be certain that the designation *formschneiderin* does not merely indicate the profession of her (deceased?) husband. The context, however, suggests otherwise.

36. Johann Neudörfer, *Nachrichten von Künstlern und Werkleuten daselbst aus dem Jahre 1547*, ed. G. W. K. Lochner (Vienna, 1875), p. 141.

37. For further evidence of women active in the print trade, see Walther Karl Zülch, *Frankfurter Künstler, 1223–1700* (Frankfurt, 1935), p. 111 (the mother of Kilian Began assisting her son). A woman is listed among the card and saints painters in Basel during the last two decades of the fifteenth century: Rott, *Quellen und Forschungen*, III, *Der Oberrhein*, pt. 2, pp. 80–82. Maurits de Meyer, *Populäre Druckgraphik Europas: Niederlande, vom 15. bis zum 20. Jahrhundert* (Munich, 1970), p. 251, cites a reference to "verlichterissen" (female illuminators) in the Antwerp guild in 1453. For women registered in the Brussels guilds, see Guillaume Des Marez, *L'organisation du travail à Bruxelles au XVe siècle*, Academie Royale des Sciences de Belgique. Memoires couronnés, no. 65 (Brussels, 1903/04), p. 112. Another dimension to this question is the record of actions taken by widows of prominent printmakers to protect their rights to their husbands' publications. The suits undertaken in Nuremberg by the widows of Albrecht Dürer and the block cutter Hieronymus Andreae are well-known instances.

38. The inventory survives in Florence, Archivio di Stato. Heinrich Brockhaus, "Ein altflorentiner Kunstverlag," *Mitteilungen des Kunsthistorischen Instituts in Florenz* 1 (1911), pp. 97–110, gives the first explication of the inventory. The complete inventory of the artistic paraphernalia is printed in Iodoco del Badia, "La bottega di Alessandro di Francesco Roselli merciaio e stampatore (1525)," in *Miscellanea Fiorentina di Erudizione e Storia* (Florence, 1894), vol. II, no. 14, pp. 24–30. A slightly revised version appears in Hind, *Early Italian Engraving*, I, appendix, pp. 304–09. At the time of going to press, we note that another, possibly earlier, version of the inventory has been found in the Archivio di Stato, Florence (Magistrato dei Pupilli avanti il Principato 189): see Sebastiano Gentile, *Firenze e la scoperta dell'America*, exh. cat. (Florence: Biblioteca Laurenziana, 1992–93), pp. 247–50, cat. no. 116. Regarding specific aspects of the inventory, see Christian Hülsen, "Die alte Ansicht von Florenz im Kgl. Kupferstichkabinett und ihr Vorbild," *Jahrbuch der Königlich preussischen Kunstsammlungen* 35 (1914), pp. 98–102; John Goldsmith Phillips, *Early Florentine Designers and Engravers* (Cambridge, Mass., 1955), pp. 73–74; and Roberto Almagià, "On the Cartographic Work of Francesco Rosselli," *Imago Mundi* 8 (1951), pp. 27–34.

39. Only nine books are recorded, all religious texts save a copy of Josephus's *Jewish Wars* and a volume of Dante.

40. The Florentine *libre* (or *libbra*) is calculated at the rate of 0.339 kg. According to the authoritative study on the history of Italian measures, this has remained relatively constant over the centuries. Ronald Edward Zupko, *Italian Weights and Measures from the Middle Ages to the Nineteenth Century*, Memoires of the American Philosophical Society, no. 145 (Philadelphia, 1981), p. 133.

41. Peter W. Parshall, "Kunst en reformatie in de Noordelijke Nederlanden — enkele gezichtspunten," *Bulletin van het Rijksmuseum* 35 (1987), pp. 164–75, on the involvement of Netherlandish artists in Reformation politics.

42. The most complete study of Bos's career is Sune Schéle, *Cornelis Bos: A Study of the Origins of the Netherland Grotesque* (Stockholm, 1965), esp. pp. 14–25. The most thorough discussion of the legal case and the inventory can be found in J. Cuvelier, "Le graveur Corneille van den Bossche (XVIe siècle)," *Bulletin de l'Institut Historique Belge de Rome* 20 (1939), pp. 5–49. See also Prosper Verheyden, "Anatomische uitgave van Cornelius Bos en Antoine des Goys, Antwerpen, 1542," *De Gulden Passer* 18 (1940), pp. 143–67.

43. For further information, consult the standard work on the subject: Dard Hunter, *Papermaking: The History and Technique of an Ancient Craft*, 2nd rev. ed. (New York, 1978), esp. chs. 4–6. A more technical examination of papermaking with additional bibliography can be found in Timothy D. Barrett, "Early European Papers: Contemporary Conservation Papers," *Paper Conservator* 13 (1989), esp. pts. 1 and 2. The only study thus far devoted specifically to the history of paper used for prints is the helpful pamphlet by Andrew Robison, *Paper in Prints*, exh. cat. (Washington, D.C.: National Gallery of Art, 1977).

44. This terminology was applied relatively consistently throughout Europe in the Renaissance, the early terms being for the most part identical to their modern counterparts: Bale = *Ballen* (German); *ballot*, *fardeau* or *fardel* (French); *balla* (Italian). Ream = *Ries* or *Ryß* (German); *rame* (French); *risma/risima* (Latin/Italian); *rieme* (Dutch). Quire = *Buch* (German); *main* (French); *quaderno* (Italian); *boeck* (Dutch). The most comprehensive reference work for the terminology of printing in various European languages is Emile Joseph Labarre, *Dictionary and Encyclopaedia of Paper and Paper-making*, 2nd rev. ed. (Amsterdam, 1952).

45. Curt F. Bühler, "Last Words on Watermarks," *Papers of the*

Bibliographical Society of America 67 (1973), p. 14. A fifteenth-century Alsatian account cites a bale of 27 reams. See Schmidt, *Zur Geschichte*, II, p. 39.

46. Rinaldo Fulin, "Nuovi documenti per servire alla storia della tipografia Veneziana," *Archivio Veneto* 23 (1882), pt. 2, p. 403. The document of 1507 reads: "e spender fin a lire vinti de pizoli de la balla de risme cinque l'una." In 1473 Italian paper of unspecified size was calculated at five reams in a shipment from Florence to Venice (Bühler, "Watermarks," p. 14). Occasionally a bale was also constituted of five bundles of two reams each. Labarre, *Dictionary*, p. 222.

47. Aurelio and Augusto Zonghi and A. F. Gasparinetti, *Zonghi's Watermarks*, Monumenta Chartae Papyraceae Historiam Illustrantia, vol. 3, ed. E. J. Labarre (Hilversum, 1953), p. 28.

48. Gerhard Piccard, "Die Wasserzeichenforschung als historische Hilfswissenschaft," *Archivalische Zeitschrift* 52 (1956), p. 69, refers to this as normal practice for writing paper. See also Charles Verlinden, *Dokumenten voor de geschiedenis van prijzen en lonen in Vlaanderen en Brabant (XVe–XVIIIe)*, Rijksuniversiteit te Gent, werken uitgegeven door de faculteit van de letteren en wijsbegeerte, no. 125 (Bruges, 1959), p. 14.

49. On the Bolognese standard, see Gerhard Piccard, "Carta bombycina, carta papyri, pergamena graeca," *Archivalische Zeitschrift* 61 (1965), pp. 56–58.

50. These designations correspond to the English terms *imperial*, *royal*, *medium*, and *small*; in German the two largest tended to be grouped under *Großformat* (large), then *Median* (medium) and *Kanzlei* (official or chancellery) format. Piccard, "Carta bombycina," p. 58. Variations of 6 mm can occur as a result of pressure applied in the drying. Gerhard Piccard, "Papiererzeugung und Buchdruck in Basel bis zum Beginn des 16. Jahrhunderts," *Archiv für Geschichte des Buchwesens* 8 (1967), cols. 274, 277. Gerhard Piccard, *Die Kronen-Wasserzeichen: Findbuch I* (Stuttgart, 1961), p. 22.

51. Many of the prints in the Rosselli inventory are referred to by paper sizes: e.g., *foglio comune*, *foglio reale*. Yet surviving impressions of these specific prints correspond almost exactly to one-half the regular Bolognese dimensions for small (*reçute*) and royal (*reale*) size. Hind, *Early Italian Engraving*, I, p. 305, gives the following correlations for identifiable prints in the Rosselli inventory: the ordinary size (*foglio comune*) about 14.2 × 21.3 cm, and the royal size (carta reale) about 29.5 × 43.4 cm. Hind concludes these were usual measures for *comune* (*reçute*) and *reale* paper. More likely the terms used in the Florentine inventory simply distinguish large from small, or full from half-sheets. Notably, these measurements do correspond to the Bolognese scale: *foglio comune* equals the Bolognese *carta reçute* if one supposes some trimming at the edges; *carta reale* is equal to the Bolognese *carta reale* halved.

52. "*Halb bogen, viertel bögenle, grosen pogen.*" Hans Rupprich, ed., *Dürer: Schriftlicher Nachlass* (Berlin, 1956), vol. I, p. 152, lines 73–77.

53. Hase, *Die Koberger*, II, appendix, p. viii, letter no. 7. Other references to paper purchases occur in letter nos. 6, 9 (1497), 24–25 (1499), 29 (1500), 35, 37, 42 (1501), and 50 (1502).

54. Terisio Pignatti, "La pianta di Venezia di Jacopo de' Barbari," *Bollettino dei Musei Civici Veneziani* 9 (1964), pp. 40–41, lists eleven of the the surviving impressions of the first state, all but one printed one sheet to a block. There is another not recorded by him in the Kupferstichkabinett, Staatliche Museen, Berlin. Since all the examples known to us except one are framed and/or glued down on canvas, no comprehensive check for watermarks can easily be made. We are assured by Dr. E. Schaar (personal communication) that the impression in the Hamburg Kunsthalle, now on separate sheets and not backed, shows no readily visible evidence of watermarks. Furthermore, Elizabeth Lunning has unframed the impression at the Boston Museum of Fine Arts and confirms that no watermark is visible on these sheets either.

It seems quite safe to assume that the first edition paper was unmarked.

55. Douglas Lewis, *The Drawings of Andrea Palladio*, exh. cat. (Washington, D.C.: National Gallery of Art, 1981), pp. 23–24, cat. no. 5, records an architectural drawing on a single sheet of paper measuring 72.6 × 58.1 cm bearing an anchor watermark apparently from Udine in the Veneto (Vladimir Mošin, *Anchor Watermarks*, Monumenta Chartae Papyraceae Historiam Illustrantia, vol. 13, ed. J. S. G. Simmons (Amsterdam, 1973), no. 717). The drawing dates from 1529–30 and is of course considerably smaller than the *View of Venice* paper. Italy appears to have supplied the larger sizes of standard papers to most of Europe well into the sixteenth century. We find German demands for imperial and royal folio served strictly by Italian mills prior to 1500 and regularly thereafter. See Piccard, "Die Wasserzeichenforschung," p. 75.

56. "14 quaderni di fogli reali bolognesi," cited in Giovanni Gaye, *Carteggio inedito d'artisti dei secoli XIV. XV. XVI. (1326–1672)* (Florence, 1840), p. 89; and "uno quaderno di carta reale fabriana," cited in Amalia Mezzetti, *Girolamo da Ferrara detto da Carpi: L'opera pittorica* (Milan, 1977), p. 64, both documents from sixteenth-century sources. The "viij belel Basler bappir" and the fifty bales of "median meidlandesch bappir" come from the records of Peter Drach in Speyer, ca. 1484. See Ferdinand Geldner, "Das Rechnungsbuch des Speyrer Druckherrn, Verlegers und Großbuchhändlers Peter Drach," *Archiv für Geschichte des Buchwesens* 5 (1964), col. 57.

57. Johannes [Kening], Pinicianus *Joanis Piniciani Promptuarium* (Augsburg: Silvan Otmar, 1516). This useful source is discussed by Rudolf Hirsch, "Bibliotheca, Charte, Instrumenta Scriptoria: A Chapter in the Latin-German Vocabulary of Pinicianus (1516)," *Bibliothek und Wissenschaft* 9 (1975), pp. 134–57. *Carta fina* (fine or thin paper), *carta greve* (coarse or heavy paper), and *carta involti* (wrapping paper), appear already in fourteenth-century documents. See Zonghi and Gasparinetti, *Watermarks*, p. 22. In Germany the distinction is made between *Schreibpapier* and *grobes Papier*.

58. Piccard, "Die Wasserzeichenforschung," pp. 64–69, 74–83. For a specific instance of regulating paper production, see the Regensburg statute of 1539 treating all aspects from gathering raw material to the finished product. See Augustin Blanchet, *Essai sur l'histoire du papier et de sa fabrication* (Paris, 1900), pp. 78–105. Indirect evidence that rag dealers may have attained some stature and diversification early on comes from a court case brought against one Petruzzo, a rag dealer from Florence (resident in Padua), who in 1450 was sued by Donatello for the substantial sum of 25 ducats. Apparently Petruzzo had ordered a model for a statue which he had neither paid for nor collected. H. W. Janson, *The Sculpture of Donatello* (Princeton, 1957), vol. II, pp. 187–88.

59. Zülch and Mori, eds., *Frankfurter Urkundenbuch*, p. 62.

60. In the seventeenth century such variation in the sizing of paper came to be consciously exploited for its effect, allowing the ink to bleed and create a softened and uneven line, for example. Robison, *Paper in Prints*, p. 13; and Sue Welsh Reed, "Types of Paper Used by Rembrandt," in *Rembrandt: Experimental Etcher*, exh. cat. (Boston: Museum of Fine Arts, 1969), pp. 178–80.

61. The pioneering study is C. M. Briquet, *Les Filigranes*, 4 vols., facsimile of the 1907 ed., ed. and intro. Allan Stevenson (Amsterdam, 1968). See also compilations being published in the series: Monumenta Chartae Papyraceae Historiam Illustrantia [hereafter MCPHI], in Hilversum and Amsterdam, The Netherlands. Finally the series of volumes of illustrations from the watermark repository in the Hauptstaatsarchiv, Stuttgart (Findbuch der Wasserzeichenkartei) arranged according to types and published under the editorship of Gerhard Piccard. For a useful though outdated bibliography, see *A Short Guide to Books on Watermarks* (Hilversum, 1955). On the archive and its uses, see Piccard, *Die Kronen-Wasserzeichen*, pp. 11–12. On the general question of water-

marks and their historical use, see Piccard, "Die Wasserzeichen-forschung;" Bühler, "Watermarks," pp. 1–16; and Vladimir Mošin, "Die Filigranologie als historische Hilfswissenschaft," *Papiergeschichte* 23 (1974), pp. 29–48.

62. Theo Gerardy, "Der Identitätsbeweis bei der Wasserzeichen-datierung," *Archiv für Geschichte des Buchwesens* 9 (1969), cols. 734–78, treats specifically the problem of identifying precise correspondances between single watermarks given their potentially minute variations.

63. It has been estimated that a pair of molds could yield at least 500,000 sheets of paper and would normally have been used for less than a year before replacement. This assumes no accidental damage. See Piccard, "Die Wasserzeichenforschung," pp. 74, 95; and Piccard, *Die Kronen-Wasserzeichen*, p. 9. However, on the implications of these conclusions and contradictory opinions, see Bühler, "Watermarks," *passim*.

64. Eva Ziesche and Dierk Schnitger, "Elektronenradiographische Untersuchungen der Wasserzeichen des Mainzer Catholicon von 1460," *Archiv für Geschichte des Buchwesens* 21 (1980), cols. 1303–60, studies the paper stocks used for printing this incunabulum by photographing and comparing the sieves and their watermarks, identifying specific molds and pairs of molds, and thereby constructing a chronology for the use of paper in the printing. Such an investigation could be usefully applied to something like the 1511 edition of Albrecht Dürer's three *Large Books*.

65. Piccard, "Papiererzeugung und Buchdruck," col. 289. Piccard, *Die Kronen-Wasserzeichen*, pp. 22, 26. Piccard, *Die Ochsenkopf-Wasserzeichen: Findbuch II*, pt. 1 (Stuttgart, 1966), p. 25. Max Preger, "Ravensburger Wasserzeichen," *Schwäbische Heimat* 33 (1982), pp. 26–27. The Parlement of Paris passed an act in 1538 attempting to regulate the use of watermarks in the rich paper-producing region of Troyes. The intent was to ensure that watermarks corresponded to quality and format. See Louis Le Clert, *Le papier: Recherches et notes pour servir à l'histoire du papier principalement à Troyes et aux environs, depuis le quatorzième siècle* (Paris, 1926), vol. I, pp. 38–39.

66. For a severe critique of the problem of dating by watermarks, see Bühler, "Watermarks," pp. 1–16.

67. Mošin, *Anchor Watermarks*, XIII, pp. xxxiii–xxxv.

68. On this question, see especially Robison, *Paper in Prints*.

69. Werner Schade, *Cranach: A Family of Painters*, trans. Helen Sebba (New York, 1980), pp. 411–12, doc. nos. 194, 218. Two recorded documents show that Cranach had a book shop and sold paper to the Wittenberg town council.

70. In Strasbourg, for example, a transit tax of five *schilling* was charged for each bale passing beyond the city, and a tax of two to four *pfennig* a ream for good quality paper sold in the city. Schmidt, *Zur Geschichte*, II, p. 39.

71. Koelner, *Die Safranzunft*, pp. 298–303.

72. For documents giving paper prices, see for Frankfurt: Zülch and Mori, *Frankfurter Urkundenbuch*, p. 62; Piccard, *Die Ochsenkopf-Wasserzeichen*, p. 25; Geldner, "Das Rechnungsbuch des Speyrer," col. 57. For Nuremberg: Bernhard Hartmann, "Konrad Celtis in Nürnberg." *Mitteilungen des Vereins für Geschichte der Stadt Nürnberg* 8 (1889), p. 62. For Ravensburg: Gerhard Piccard, "Zur Geschichte der Papiererzeugung in der Reichstadt Memmingen," *Archiv für Geschichte des Buchwesens* 3 (1961), col. 598; Piccard, *Die Ochsenkopf-Wasserzeichen*, p. 25; Lore Sporhan-Krempel, "Handel und Händler mit Ravensburger Papier," *Papiergeschichte* 22 (June 1972), p. 34; Reutter, "Wirtschafts- und Sozialgeschichte," p. 667; Gerhard Piccard, *Die Turm-Wasserzeichen: Findbuch III* (Stuttgart, 1970), p. 21.

73. In 1471 Alesso Baldovinetti purchased some quires of royal-size paper to make a cartoon for an altarpiece. (Ruth Wedgwood Kennedy, *Alesso Baldovinetti: A Critical and Historical Study* (New Haven, 1938), p. 246): "quaderni di fogli reali da straccio per soldi 5 el quaderno." Five *soldi* per book equals 5 *lire* or 1 florin a

ream. Interestingly, the paper is specifically designated as rag, though of course paper for cartoons did not require the same level of quality as for a print. In a series of purchases made between the years 1478 and 1484, the Convent of S. Jacob of Ripoli paid between three to eight *lire* a ream for good quality Bolognese and Fabriano papers. P. Vincenzio Fineschi, *Notizie storiche sopra la stamperia di Ripoli* (Florence, 1781). Bartolomeo di Sandro, a stationer (*cartolaio*) in Florence, received ten *lire* a ream for Bolognese royal folio paper intended for Michelangelo cartoons in 1504, and in the following year a lot of the same grade of paper was sold for eleven *lire* a ream (Gaye, *Carteggio*, pp. 89, 92).

74. Fulin, "Nuovi documenti," p. 403.

75. Le Clert, *Le papier*, I, p. 112; Annie Parent, *Les métiers du livre à Paris au 16e siècle* (Geneva, 1974), pp. 59–60, n. 2; Febvre and Martin, *Coming of the Book*, p. 112; Ernest Coyecque, "Cinq libraires Parisiens sous François I, 1521–1524," *Mémoires de la Société de l'Histoire de Paris et de l'Ile-de-France* 21 (1894), pp. 134–35.

76. Under inflation toward the end of the century the price climbed very high. See Verlinden and Scholliers, *Dokumenten*, pp. 361–62.

77. Leon Voet, *The Golden Compasses* (Amsterdam, 1972), vol. II, pp. 40–42. Plantin was also engaged in dealing paper in small lots to other Antwerp printers and craftsmen.

78. Piccard, *Die Kronen-Wasserzeichen*, p. 24.

79. Rupprich, ed., *Dürer*, I, p 53.

80. For a discussion of print prices including this case, see Chapter VI.

81. Piccard, "Die Wasserzeichenforschung," p. 97.

82. Elizabeth Lunning's essay on the qualities of sixteenth- and seventeenth-century Italian papers describes significant regional characteristics of papers. These are mainly symptoms of mold and watermark construction as they affect variable density and texture. Sue Welsh Reed and Richard Wallace, et al., *Italian Etchers of the Renaissance and Baroque*, exh. cat. (Boston: Museum of Fine Arts, 1989), pp. xxxii–xlii.

83. Voet, *Golden Compasses*, II, ch. 3. On inks in general during this period, see Colin H. Bloy, *A History of Printing Inks, Balls and Rollers, 1440–1850* (London and New York, 1967); Monique Zerdoun Bat-Yehouda, *Les encres noires au moyen âge (jusqu'à 1600)* (Paris, 1983), pp. 257–302; and Annette Manick, "A Note on Printing Inks," in Reed and Wallace, et al., *Italian Etchers*, pp. xliv–xlvii. On the related preparation of drawing inks, see the classic study by Joseph Meder, *The Mastery of Drawing*, trans. Winslow Ames (New York, 1978), vol. I, pp. 43–45. As an intriguing aside, Vasari mentions that the incorporation of printer's ink as a pigment had already caused catastrophic darkening of the colors in Raphael's famous *Transfiguration*. Vasari implies that the practice was widespread. Giorgio Vasari, *Le vite de' più eccellenti pittori, scultori ed architettori*, ed. G. Milanesi (Florence, 1878–85), vol. IV, p. 378.

84. Bloy, *History of Printing Inks*, p. 42, records the effect of this impurity. For example, there is just such a brown-toned impression of Lucas van Leyden's first dated print, the *Mohammed and the Monk Sergius* of 1508 (British Museum). Ellen S. Jacobowitz and Stephanie Loeb Stepanek, *The Prints of Lucas van Leyden and his Contemporaries*, exh. cat. (Washington, D.C.: National Gallery of Art, 1983), pp. 60–62, cat. no. 11.

85. *Lettere di artisti italiani ad Antonio Perrenot di Granvelle* (Madrid, 1977), pp. 45–54. Ghisi later writes to thank Granvelle for the recipe, but declares it is not the right one, since it must be used on a heated plate. He sends along a print as an example. According to Manick, "Note on Printing Inks," p. xlv, the source of difference between German and Italian inks was the use of vine black and lamp black respectively.

86. In an account of supplies acquired by the printer Paulus Hürus: "2 dozenas cadrans de ffust grans" (2 dozen large wooden boards). See Aloys Schulte, *Geschichte der grossen Ravensburger Handelsge-*

sellschaft, 1380–1530 (Stuttgart and Berlin, 1923), vol. I, p. 351.

87. In 1495 Peter Danhauser acquired thirty or more ample size blocks to the *gulden* to supply his cutters in Nuremberg. Hartmann, "Konrad Celtis," pp. 61–62.

88. Cennino Cennini, *Il libro dell'arte*, ch. 173.

89. A. E. Popham, "Observations on Parmigianino's Designs for Chiaroscuro Woodcuts," in *Miscellanea I. Q. van Regteren Altena* (Amsterdam, 1969), p. 49, quoting a document of 1558. A document from a church in Württemberg in 1590 refers to a block of "Byren Bom" with a drawing of a religious satire inscribed on it. See Werner Fleischauer, "Das Zwinglische Bett: Ein Tübinger Holzschnitt im Dienste orthodoxer Polemic," in *Hundert Jahre Kohlhammer, 1866–1966* (Stuttgart, etc.), 1966), p. 319. A contract of 1573–77 in France records the struggle to find a craftsman capable of cutting a coat of arms and a portrait in boxwood. Henri Bouchot, "La préparation et la publication d'un livre illustré an XVIe siècle, 1573–1588," *Bibliothèque de l'École des Chartes* 53 (1892), pp. 612–23.

90. Vasari refers to pear and boxwood blocks used by Ugo da Carpi (Vasari, *Vite*, I, p. 212, ch. 21). Hind, *History of Woodcut*, I, p. 8, suggests that box may have been in use already in the fifteenth century by Venetian cutters who would likely have been the first to have it available, given that the main source at the time was Turkey. Hind also reports an opinion that the block for Hans Holbein the Younger's woodcut *Portrait of Erasmus* (Basel, Öffentliche Kunstsammlung) is made from boxwood, though its color and grain correspond to other examples from the period that are shown not to be boxwood.

91. Jost Amman, *Eygentliche Beschreibung aller Stände auff Erden . . .* (Frankfurt, 1568).

92. Apart from the many individual Renaissance blocks scattered among various print collections, there are also a few large collections of them. The Kupferstichkabinett, Staatliche Museen, Berlin, houses the Derschau collection of blocks, mostly sixteenth-century German, which were all reprinted in a modern edition during the early nineteenth century. See Hans Albrecht von Derschau, *Holzschnitte alter deutscher Meister* (Gotha, 1808). See also the Musée de l'Imprimerie et de la Banque, Lyons. Maurice Audin, *Les peintres en bois et les tailleurs d'histoire à propos d'une collection de bois gravés conservée au Musée de l'Imprimerie et de la Banque* (Lyons, n.d.), containing 595 woodblocks (mainly for book illustrations) from the mid-sixteenth to the eighteenth century. The Galleria Estense, Modena, contains a collection of 2,600 blocks, a portion of which date from the early period. See *I legni incisi della Galleria Estense: Quattro secoli di stampa nell'Italia Settentrionale*, exh. cat. (Modena: Galleria Estense, 1986).

93. These are now in the Staatliche Graphische Sammlung in Munich and the Kupferstichkabinett in Berlin. Franz Winzinger, "Albrecht Altdorfers Münchner Holzstock," *Münchener Jahrbuch der bildenden Kunst*, 3rd ser., I (1950), p. 191, identifies the wood as box, whereas in his later catalogue of Altdorfer's prints the Munich and the Berlin Derschau blocks are all termed *hart Ahorn* (maple). Franz Winzinger, *Albrecht Altdorfer: Die Graphik* (Munich, 1963), p. 49.

94. Klaus-Dieter Jäger and Renate Kroll, "Holzanatomische Untersuchungen an den Altdorfer-Stöcken der Sammlung Derschau: Ein Beitrag zur Methodik von Holzbestimmungen an Kunstgegenständen," *Forschungen und Berichte, Staatliche Museen zu Berlin* 6 (1964), pp. 24–39, with extensive documentation on the history of the question. The authors point out the difficulties in distinguishing among species within a closely related group, and in addition the problems posed by wild and cultivated varieties entirely on the basis of wood anatomy (pp. 37–39).

95. For example, the block for Dürer's *Hercules* (B.127), in the British Museum, and of the *Samson and the Lion* (B.2) in New York, Metropolitan Museum.

96. The larger Dürer blocks in the British Museum collection measure 24 mm in thickness. The original block for Hans Holbein the Younger's *Portrait of Erasmus* (Holl. XIV.149.9), now in Basel, Öffentliche Kunstsammlung, is about 10 mm thick and is attached to another block to give it a depth of ca. 25 mm. The British Museum collection includes a fifteenth-century votive woodcut block with separate compositions on each side (Schreiber, III, no. 1678; on reverse of Schreiber, IV, no. 1812).

97. One can see the latter difficulty in the block for Altdorfer's *Sacrifice of Isaac* (Berlin, Staatliche Museen Kupferstichkabinett), inv. 431.

98. C. P. Burger, Jr., "Zestiende-eeuwsche volksprenten, later als kinderprenten herdrukt," *Catalogus der tentoonstelling van de ontwikkeling der boekdrukkunst in Nederland*, exh. cat. (Haarlem, 1923), pp. 165–69.

99. The partly cut block for Albrecht Altdorfer's *Lamentation* in Munich surprisingly shows no trace at all of a ground. Altdorfer himself drew this design on the block directly and almost certainly without any mechanical means of transfer, yet unless the ground has since evaporated it appears this must have been accomplished against the dusky tone of the natural wood itself.

100. Wilhelm Ludwig Schreiber, *Handbuch der Holz- und Metalschnitte des XV. Jahrhunderts*, 3rd ed. (Stuttgart, 1969), vol. VII, p. 19, cites the Nuremberg document but gives no specific date for it.

101. "Dazu was ir noch für taflen ze machen haben, die machend, und machend sy uff düns bapir; so ir keins hand, wil ich üch shiken. Es kompt im gar übel, das irs uff so dicks bapir gmacht hand; ye düner s'bapir ist, ye baß er dadurch sehen mag, denn er mus alle lätz oder hindersich uffs holtz ryssen etc." Paul Leemann-van Elck, *Die Offizin Froschauer: Zürichs berühmte Druckerei im 16. Jahrhundert* (Zurich and Leipzig, 1940), pp. 197–98.

102. Hind, *History of Woodcut*, I, p. 7, illustrates the tool. There are many signatures of block cutters which include an illustration of a tool as a part of their insignia, but these are too conventionalized to be useful in determining the character of these tools any more precisely. For a collection of examples, see S. R. Koehler, "Über die Technik des alten Holzschnittes," *Chronik für vervielfältigende Kunst* 3 (1890), pp. 82–84.

103. Koehler, "Über die Technik," pp. 82–84. Delen, *Histoire de la gravure*, I, pp. 1–2. Although it is generally held that this technique was introduced only much later, Delen reports sixteenth-century blocks from the Plantin publishing house in Antwerp that are cut on end-grain.

104. Two possible exceptions are the woodcuts by Domenico Beccafumi and Domenico Campagnola which exhibit certain patterns of white-line woodcutting that are very like wood engraving. See Chap. VI.

105. Zülch and Mori, eds., *Frankfurter Urkundenbuch*, p. 2.

106. For impressions of Urs Graf's set of white-line woodcuts of the *Standard Bearers of the Swiss Confederacy* of 1521 most of the plank surface needed to be inked evenly. Dabbers would more likely deposit ink into the grooves meant to print white. Some of these impressions show patterns that suggest the use of a roller, for example white lines at oblique angles that look like the terminus of the incomplete stroke of a roller. In other cases there are margins of white or missed areas that suggest a brush. See the impressions in Basel, Öffentliche Kunstsammlung, of *Zurich* (H.29), rolled; and *Schaffhausen* (H.38), possibly brushed.

107. Hind, *Early Italian Engraving*, I, appendix, pp. 307–08. The important treatise on metallurgy by Biringuccio, published in 1540, uses *stagno* for both tin and pewter. Vannocchio Biringuccio, *The Pirotechnia* [1540], trans. C. S. Smith and M. T. Gnudi (repr. New York, 1959), pp. 374–75, notes.

108. Hind, *Early Italian Engraving*, V, p. 101.

109. Fritz, *Gestochene Bilder*, p. 32, suggests that the Housebook Master used tin plates for his drypoints, a choice that would have yielded still fewer impressions than those possible in drypoint on copper.

110. F. Braudel and F. Spooner, "Prices in Europe from 1450–1750,"

in Postan and Habakkuk, eds., *The Economy of Expanding Europe in the Sixteenth and Seventeenth Centuries*, Cambridge Economic History, vol. 4 (Cambridge, 1967), p. 425.

111. Biringuccio, *Pirotechnia*, pp. 368–69.

112. The plate was examined at Sotheby's, London, in 1990.

113. Voet, *Golden Compasses*, II, p. 226, doc. no. 1597, notes the variant value of copper plates beaten and unbeaten, cleaned and uncleaned in the 1560s, e.g., "3 lbs of beaten copper, not cleaned, at 15 *stuiver* per lb: 2 guilders 5 *stuiver* 'I shall have the woman clean it.'"

114. *Bergwerck- und Probierbuchlein*, trans. and annot. Annalese Sisco and Cyril S. Smith (New York, 1949), p. 45. Several editions of this handbook appeared anonymously from German presses in the sixteenth century. The anti-alchemical Biringuccio, *Pirotechnia*, p. 52, speaks only of its inherent nature, ignoring the astrological interpretation.

115. Georgius Agricola, *De re metallica*, trans. Herbert Clark Hoover and Lou Henry Hoover (New York, 1950), p. 511.

116. Abraham Bosse, *Traicté des manières de graver en taille douce sur l'airin* (Paris: chez ledit Bosse, 1645), p. 12.

117. Many of Enea Vico's plates bear generous margins between border and platemark. This must indicate a significant dip in the price of copper, the presence of a larger composition on the reverse, or a notable luxury.

118. A startling example of the continued life of a copper plate is the case of the Master ES's large *Einsiedeln Madonna* (L.81). Curiously enough the plate seems to have wandered from the Monastery of Einsiedeln in Switzerland to northern Italy where it was used again for an engraving from around 1490–1500 in the style of Urbino. See Holm Bevers, *Meister ES: Ein Oberrheinischer Kupferstecher der Spätgotik*, exh. cat. (Munich: Staatliche Graphische Sammlung, 1986–87; Berlin: Kupferstichkabinett, 1987), pp. 45–46.

119. Fritz, *Gestochene Bilder*, pp. 383–86, studies the origins of the engraving technique in detail and discusses its relation to intaglio printing.

120. Robert B. Gordon, "Sixteenth-Century Metalworking Technology Used in the Manufacture of Two German Astrolabes," *Annals of Science* 44 (1987), pp. 72–75.

121. For example, several details in the right foreground such as the rocks engraved over the perspective lines of the floor pattern.

122. Valentin Boltz [von Ruffach], *Illuminierbuch: Wie man allerlei Farben bereiten, mischen und auftragen soll* ... (Basel, 1549), ed. C. J. Benzinger (repr. Munich, 1913), p. 127: "Stahel, ysen, kupffer oder andere metall zumachen, dass man daryn graben, stechen oder schnyden mag. So nimm Salmiax und gmein saltz jedes glych so vyl und so vyl gmalen wynstein. Setz es über ein gut für in einem starcken irdnen hafen. Leg das metall daryn und lass es wol sieden 1 Stund, so weichet es von diser etzung. Wiltu es dann wider herten, so mach es ob einer glut, gar glüendt heiss, züchs ussher und stoss es in ein kalt wasser, so wirt es gar hart. Ye minder du es glüendt machst, je minder es hertet." Biringuccio, *Pirotechnia*, p. 372, also gives a recipe for softening metals.

123. Stamps of hardened steel could be used even for decorating brass. The trace of letter stamping is distinguishable from the ridge of metal pillowing-up around the impressed character. Gordon, "Metalworking Technology," fig. 10, illustrates a letter stamped in brass. For copper plates, see Tony Campbell, "Letter Punches: A Little-Known Feature of Early Engraved Maps," *Print Quarterly* 4 (1987), pp. 151–54; and Tony Campbell, *The Earliest Printed Maps, 1472–1500* (Berkeley and Los Angeles, 1987), pp. 223–25. The inventor of this technique appears to have been a German printer active in Rome, Conrad Sweynheim.

124. For example: "vingt quatre petis carreaulx de plusieurs sortes de sainctz et sainctes, servans aux Suffraiges d'icelles Heures à la Bible, le tout en cuyvre et non montées ... Douze pieces de carreaulx ou sont protrectz engravez plusieurs saintz et sainctes,

125. en cuyvre, montées sur plombes," from the inventory of a Paris book printer, Didier Maheu, made on behalf of his wife in 1522. See Coyecque, "Cinq libraires Parisiens," pp. 86–87. There are many such references.

125. On the very problematic relation between intaglio printmaking and niello, see Arthur M. Hind, *Nielli, Chiefly Italian of the XV Century, Plates, Sulphur Casts and Prints, Preserved in the British Museum* (London, 1936); Phillips, *Early Florentine Designers*, ch. 1; and Jay A. Levenson, Konrad Oberhuber and Jacquelyn L. Sheehan, *Early Italian Engravings from the National Gallery of Art* (Washington, D.C., 1973), appendix B.

126. Elizabeth Coombs, Eugene Farrell, and Richard S. Field, *Paste-prints: A Technical and Art Historical Investigation* (Cambridge, Mass., 1986); and Carl Wehmer, "Gutenbergs Typographie und die Teigdrucke des Monogrammisten d," in *Essays in Honor of Victor Scholderer*, ed. D. E. Rhodes (Mainz, 1970), pp. 426–84, explain the technique in detail.

127. David Woodward, "The Woodcut Technique," in *Five Centuries of Map Printing*, ed. David Woodward (Chicago and London, 1975), pp. 46–47.

128. Gustav Mori, *Das Schriftgiesser-gewerbe in Süddeutschland und den angrenzenden Ländern* (Stuttgart, 1924).

129. For example, the relief printed border decorations and narrative panels surrounding the text in so many Books of Hours published in Paris in the late fifteenth and early sixteenth centuries are often questioned as to whether they are metalcuts or woodcuts. Casts of relief blocks may have been used here. See the inventory references to many small lead and copper plates fixed to wood in the Parisian book printers' inventories mentioned above.

130. Gustav Pauli, *Inkunabeln der deutschen und niederländischen Radierung* (Berlin, 1908), remains an authoritative discussion of the subject. More recently, see Wolfgang Wegner, "Eisenradierung," *Reallexikon zur deutschen Kunstgeschichte* (Stuttgart, 1958), vol. IV, cols. 1140–52; Wolfgang Wegner, "Aus der Frühzeit der deutschen Ätzung und Radierung," *Philobiblon* 2 (1958), pp. 178–90.

131. Cyril Stanley Smith, *Sources for the History of the Science of Steel, 1532–1786* (Cambridge, Mass., and London, 1968), for an anthology of sources and a discussion of Renaissance iron and steel manufacture.

132. E. Harzen, "Ueber die Erfindung der Aetzkunst," *Archiv für die zeichnenden Künste* [*R. Naumann's Archiv*] 5 (1859), pp. 119–36. Hermann Warner Williams, Jr., "The Beginnings of Etching," *Technical Studies* 3 (1934/35), pp. 16–18, cites two English manuscripts from the early fifteenth century describing the process. Apparently the first printed text including a recipe for etching occurs in a Netherlandish tract of 1513: *T Bouck va Wondre*, reprinted with commentary by H. G. T. Frencken (Roermond, 1934). A somewhat later treatise on iron etching (also apparently for armorers) has been published by William M. Ivins, Jr., "An Early Book about Etching," *Bulletin of the Metropolitan Museum of Art* 12 (1917), pp. 174–76. This concerns a booklet printed in Augsburg in 1531. For work in Italy, see Biringuccio, *Pirotechnia*, p. 372, transmitting recipes which he probably copied from German treatises. The most thorough discussion of the technique appears in Wegner, "Eisenradierung," cols. 1140–52; and Paul Post and Alexander von Reitzenstein, "Eisenätzung," in *Reallexikon zur deutschen Kunstgeschichte* (Stuttgart, 1958), vol. IV, cols. 1075–1103. See also the recent review of the literature in Kristin von Held, "Anfänge und Entwicklung der Eisenradierung von 1500–1540" (Magisterarbeit: Ludwig-Maximilians-Universität, Munich, 1988). On the general subject of metals, see Cyril Stanley Smith, *A History of Metallography* (Chicago, 1960), pp. 10–13.

133. Boltz, *Illuminierbuch*, pp. 119–20.

134. Wegner, "Ätzung und Radierung," p. 187. Johann Neudörfer is reported to have etched letters not only in iron, steel, and copper,

but in tin and brass as well. There was also a technique in use early on for etching stone.

135. Maurice Audin, *Guide raisonné du Musée de l'Imprimerie et de la Banque*, 2nd ed. (Lyons, n.d.), pp. 13–14, 37; Michael Clapham, "Printing," in *A History of Technology*, ed. Charles Singer, et al. (Oxford, 1957), vol. III, p. 408; J. W. Enschedé, "Houten handpersen in de zestiende eeuw," *Tijdschrift voor Boek- en Bibliotheekwezen* 4 (1906), pp. 195–215, 262–72, *passim*.

136. Henry Meier, "The Origin of the Printing and Roller Press," *Print Collector's Quarterly* 28 (1941), pt. 1, pp. 9–55, discusses the many possible prototypes and alternatives for a platen press.

137. Henry Meier, *Woodcut Stencils of 400 Years Ago* (New York, 1938), p. 9, citing Louis Morin, "Essai sur les dominotiers troyens," *Bulletin du Bibliophile* (Paris, 1897), pp. 619–25.

138. Febvre and Martin, *Coming of the Book*, pp. 110–11.

139. Antonio Bertolotti, *Artisti Veneti in Roma nei secoli XV, XVI e XVII* (Venice, 1884; repr. Bologna, 1965), p. 43.

140. Theodor Herberger, *Conrad Peutinger in seinem Verhältnisse zum Kaiser Maximilian I* (Augsburg, 1851), p. 26. See also Febvre and Martin, *Coming of the Book*, p. 66, on simple press design.

141. Febvre and Martin, *Coming of the Book*, pp. 65, 110–11. By 1540–50 presses were valued 23 to 30 *livres*.

142. Voet, *Golden Compasses*, II, pp. 132–33.

143. Clapham, "Printing," p. 382, points out that the linen press includes the basic elements of the flat bed screw press.

144. An excellent example of blind printing in a Renaissance woodcut occurs in an impression of Hans Baldung's *St. Christopher* (B.38) of ca. 1510–11, now in the British Museum, London. The impressed profile of an uninked printing of this woodcut is still very evident alongside the existing image, suggesting that the sheet has never been washed or pressed. Presumably the block was blind printed on the same sheet of paper as the inked impression in order to balance the press at the beginning of a run.

145. For the use of blindprinting and of woodblocks for balancing a press, see David L. Paisey, "Blind Printing in Early Continental Books," in *Book Production and Letters in the Western European Renaissance: Essays in Honor of Conor Fahy*, ed. A. L. Lepschy, et al. (London, 1986), pp. 220–33.

146. Meier, "Printing and Rolling Press," p. 189, proposes that the double screw press also referred to in the inventory may have been used for printing large woodblocks, if not also for drying prints or pressing books.

147. The only candidate for an earlier reference to a roller press does not stand up to scrutiny. Giuseppe Praga, "Oreficeria e incisione in Dalmazia a mezzo il quattrocento," *Archivio storico per la Dalmazia* 16 (January 1934), pp. 477–83, transcribes a household inventory of a jeweler who died in Zara, Dalmatia, in 1451 or 1452, recording "una stampa cum un stampadur." The author argues this must have been a roller press, since the owner worked in metal and therefore would likely have engraved rather than cut wood or coins. In the absence of any evidence of print production in the shop, it is much more likely this refers to a device for stamping coins or plaques.

148. Meier, "Printing and Rolling Press," pp. 189–90. For a discussion of the evidence for early printing methods given by impressions of Mantegna's work and by the Bramante/Prevedari project, see below Chapters III–IV.

149. One of the presses is termed "een druckpersse van den figueren." This sounds like a woodblock press for "printing figures." The term *figueren* occurs elsewhere in the inventory in reference to woodblocks. In any case this is not a press for letter text, and it should be noted that a platen press was conventionally termed a *druckpers*. A second entry refers to "Noch een trecperse nyet vol zijnde," that is, "another press, not yet completed." "Another" could mean of the same sort, but much more likely it just means another press, not necessarily of the same type. More important is the distinction between *druck* (push) and *trec* (pull). We may be

quite sure the difference is not simply a scribal variation in the spelling of *druck*, since the second entry occurs only five lines below the first and makes specific reference to the earlier press. Furthermore, in the subsequent list of sales we rediscover the *druckperse* purchased by the engraver Kaerle van der Heyden who also bought up a number of prints from Bos's stocks. The common action for printing with a platen press is to *pull* laterally on the bar (*trekken*) which turns the screw and lowers the platen. Since the purchaser of the press was an engraving specialist, it seems more likely this was in fact a roller press for intaglio printing.

150. Jane Hutchinson, "The Housebook Master and the Mainz Marienleben," *Print Review* 5 (1976), pp. 97–113, speculates that a small "tabletop" roller press was already in use by the end of the fifteenth century.

151. Prosper Verheyden, "Aanteekeningen betreffende Mechelsche Drukkers en Boekhandelaars," *Bulletin du Cercle archéologique littéraire et artistique de Malines* 20 (1910), p. 195.

152. Bosse, *Traicté des manières de graver*, pls. 11–16.

153. The document is transcribed and interpreted by Wilhelm Ludwig Schreiber, *Die Meister der Metallschneidekunst* (Strasbourg, 1926), pp. 12–14. There appears to be no other surviving reference to either of the two parties involved in the contract. On Lübeck printmakers of the sixteenth century and later, see W. L. von Lütgendorff, "Lübecker Briefmaler, Formschneider und Kartenmacher," *Mitteilungen des Vereins für Lübeckische Geschichte und Altertumskunde* 14 (1920), pp. 101–34.

154. Luca Beltrami, "Bramante e Leonardo praticarono l'arte del bulino? Un incisore sconosciuto: Bernardo Prevedari," *Rassegna d'Arte* 17 (1917), pp. 187–94. The contract is transcribed on p. 194.

155. See Chapter IV.

156. A. E. Popham, "The Engravings and Woodcuts of Dirick Vellert," *Print Collector's Quarterly* 12 (1925), pp. 343–68. Examples are a small engraving (B.11) dated seventeen days after the previous print; and an intricate little etching (B.17) recorded only four days after the next previous date.

157. Alan Shestack, "Some Preliminary Drawings for Engravings by Heinrich Aldegrever," *Master Drawings* 8 (1970), pp. 141–48.

158. Joh. Stradanus, *Nova Reperta*.

159. Alan Shestack, *Master E.S.: Five Hundredth Anniversary Exhibition*, exh. cat. (Philadelphia: Museum of Art, 1967), introduction.

160. Delen, *Histoire de la gravure*, I, p. 5.

161. Friedrich Lippmann, *Der Kupferstich*, ed. F. Anzelewsky, 7th ed. (Berlin, 1963), p. 8. Heinrich Leporini, *Der Kupferstichsammler* (Berlin, 1924), p. 19, cites comparable figures. Arthur M. Hind, *A Short History of Engraving and Etching* (Boston and New York, 1908), p. 15, concurs on the outside figures. Of course, these numbers do not apply to the later technique of steel facing copper plates.

162. Rupprich, *Dürer*, I, pp. 86, 95–96.

163. *Albrecht Dürer, Master Printmaker*, exh. cat. (Boston: Museum of Fine Arts, 1971), pp. 269–71, cat. nos. 216–17. Curiously enough the hypothesis about bookplates justifying the large number of impressions and the observation of the use of surface tone occur in the same catalogue entry describing an impression in Boston.

164. Henri Zerner, "L'estampe érotique au temps de Titien," *Tiziano e Venezia: Convegno Internazionale di Studi, Venezia, 1976*, ed. Neri Pozza (Vicenza, 1980), p. 88, n. 10.

165. Heinrich Zeising, *Theatrum Machinarum* (Leipzig, 1622), pt. 4, p. 19.

166. Christoff Weigel, *Abbildung Der Gemein-Nützlichen Haupt-Stände* (Regensburg, 1698), p. 215. On copper engraving and woodcutting in general, pp. 201–17. This source is cited by Bruno Weber, ed. *Wunderzeichen und Winkeldrucker, 1534–1586* (Zurich, 1972), p. 30, n. 71.

167. Voet, *Golden Compasses*, II, pp. 220–21, n. 3. This figure receives support from a second document of 1587, a contract between the architectural draftsman Juan de Herrera and two Italian printers brought to Spain especially to print a set of engraved plates of the Escorial. The contract stipulates 4,000 impressions from each plate. Italian paper was imported for the task. C. Wilkinson Zerner, et al., *Philipp II and the Escorial: Technology and the Representation of Architecture*, exh. cat. (Providence, R.I.: Brown University, 1990), pp. 44–45.

168. Carel van Mander, *Het Schilder-Boeck* (Haarlem, 1604; repr. New York, 1980), fol. 212v.

Notes to Chapter III

1. S. H. Steinberg, *500 Years of Printing*, 3rd ed. (Harmondsworth, Middlesex, 1974), p. 158.

2. Lilli Fischel, *Bilderfolgen im frühen Buchdruck: Studien zur Inkunabel-Illustration in Ulm und Strassburg* (Constance and Stuttgart, 1963), p. 13, n. 11.

3. Most recently, Jan Piet Filedt Kok, et al., *Livelier than Life: The Master of the Amsterdam Cabinet, or the Housebook Master, ca. 1470–1500*, exh. cat. (Amsterdam, 1985), pp. 19–21, 281–84, with further bibliography.

4. There is no better survey of this field than Arthur M. Hind's *An Introduction to a History of Woodcut* (New York, 1935; repr. London and New York, 1963), where pp. 396–558 of the second volume are devoted to Italian fifteenth-century book illustration.

5. Most recently on the fate of this project, see Peter Dreyer, "Botticelli's Series of Engravings 'of 1481'," *Print Quarterly* 1 (1984), pp. 111–15. There are earlier cases of the use of engravings in a printed book, one by the same publisher as the Botticelli prints: Antonio Bettini da Siena, *Monte Santo di Dio* (Florence: Niccolo di Lorenzo, 1477), including three engravings printed directly on the book paper. Arthur M. Hind, *Early Italian Engraving* (London, 1938–48), vol. I, pp. 97–98. Another case is that of the *Summula de pacifica conscientia* (Milan: Filippus de Lavagnia, 1479), for which see Hind, *History of Woodcut*, II, p. 521. The earliest instance is an engraved map; see Hind, *History of Woodcut*, II, p. 528.

6. *Le cinquième centenaire de l'imprimerie dans les anciens Pays-Bas*, exh. cat. (Brussels: Bibliothèque Royale, 1973), pp. 219–22, cat. no. 102, gives a detailed account of the various extant states of the edition, reflecting the difficulties the printer faced in attempting to integrate intaglio and letterpress.

7. Paul Kristeller, *Early Florentine Woodcuts* (London, 1897; repr. London, 1968), p. ii.

8. Prince d'Essling, *Le livres à figures vénitiens* (Paris and Florence, 1907–14), vol. III, pp. 53–55.

9. For a similar practice in Rome and in Naples, see Hind, *History of Woodcut*, II, pp. 398 and 410, respectively.

10. D'Essling, *Les livres à figures*, p. 53. Moreover, not all copies of the same edition of a book contain either the same woodcut illustrations, the same number of them, or the same combinations.

11. See Paul Kristeller, "La xilografia veneziana," *Archivio Storico dell'Arte* 5 (1892), pp. 95–114.

12. In the 1486 edition of *Supplementum Chronicarum*, printed by Bernardino Benalio; see Hind, *History of Woodcut*, II, p. 456.

13. We know, for instance, that Erhard Ratdolt took his stock of initials to Augsburg when he moved back there. See Hind, *History of Woodcut*, II, p. 460.

14. Kristeller, "La xilografia veneziana". In these cases he was also able to ascertain that the cuts were not casts of each other, another common practice, for which, see Hind, *History of Woodcut*, II, pp. 413, 521.

15. Hind, *History of Woodcut*, II, pp. 410–12.

16. Kristeller, "La xilografia veneziana." Giancarlo Schizzerotto,

Le incisioni quattrocentesche della Classense (Ravenna, 1971), pp. 114–20, has convincingly ascribed one woodcut to Lorenzo.

17. We know, for instance, of a Bernardus, "painter of Augsburg," who was a partner of Ratdolt's, and whose name appears on a number of books, often before that of the publisher himself. Hind, *History of Woodcut*, II, pp. 458–60.

18. *Ibid.*, pp. 464–66.

19. It is interesting to note that it was always the cutters, rather than the designers, who signed the blocks — the monograms most often found are those of the Masters "b," "N," and "ia." This was a custom that would be followed thereafter in many similar situations, both in woodcut and in engraving. It was also the practice in Florence; see Kristeller, *Early Florentine Woodcuts*, p. xxxviii.

20. Hind, *History of Woodcut*, II, pp. 483, 485, 494. Hind suggests that parallel hatching came to Venice through Florentine book illustration; see, however, Kristeller, *Early Florentine Woodcuts*, p. xl, and our discussion here of this issue in relation to engravings and drawings on pp. 66–68.

21. Kristeller, *Early Florentine Woodcuts*, *passim*.

22. Hind, *History of Woodcut*, II, p. 538.

23. Kristeller, *Early Florentine Woodcuts*, p. xi; see also Hind, *History of Woodcut*, II, p. 531.

24. Hind, *History of Woodcut*, pp. 533–36. But see, for an opposite view, Kristeller, *Early Florentine Woodcuts*, pp. xxiv–xxv.

25. Hind, *History of Woodcut*, II, p. 529; and Kristeller, *Early Florentine Woodcuts*, p. xxii. For a recent discussion of the subject, see *Le temps revient: Il tempo si rinuova: feste e spettacoli nella Firenze di Lorenzo il Magnifico*, exh. cat. (Florence, 1992), *passim*.

26. Stephan Fridolin, *Der Schatzbehalter: Ein Andachts- und Erbauungsbuch aus dem Jahre 1491*, facsimile with text and commentary by Richard Bellm (Wiesbaden, 1962).

27. Adrian Wilson, *The Making of the Nuremberg World Chronicle* (Amsterdam, 1976), pp. 66–67.

28. Elizabeth Rücker, *Hartmann Schedels Weltchronik* (Munich, 1988), pp. 232–35, transcribes the documents.

29. There were at least two archetypes made for the printing, a layout for the illustrations with pen sketches giving a rough approximation of each subject and its placement on the page, and a second layout with only a summary indication of each illustration and the text written in where the letterpress was to be placed. Peter Zahn, "Neue Funde zur Entstehung der Schedelschen Weltchronik, 1493," *Renaissance Vorträge. Stadt Nürnberg Museen 2/3* (1973), pp. 1–46.

30. For an interesting discussion of authors, printers and subsistence, though with several misleading conclusions about printmakers, see William A. Coupe, " 'Poets' and Patrons: Some Notes on Making Ends Meet in Sixteenth-Century Germany," *German Life and Letters* 36 (1983), pp. 183–97.

31. Danhauser was a jurist by training and a close friend of Konrad Celtis whom he later followed to Vienna. Danhauser eventually became Professor of Jurisprudence there in 1512. The Danhauser contracts have been cited frequently in the literature on prints. For transcriptions, see Bernhard Hartmann, "Konrad Celtis in Nürnberg" *Mitteilungen des Vereins für Geschichte der Stadt Nürnberg* 8 (1889), pp. 61–62; and more recently Elisabeth Caesar, "Sebald Schreyer: Ein Lebensbild aus dem vorreformatorischen Nürnberg," *Mitteilungen des Vereins für Geschichte der Stadt Nürnberg* 56 (1969), p. 55.

32. For the value of the *gulden*, see Appendix. The contract reads 192 drawings for 8 *gulden* 2 *pfund*, and 5 drawings for 1 *pfund* 20 *denar* (nearly the same amount per image); and then 20 very cheap drawings for 1 *pfund* 2 *denar* (only 1.6 *d* compared to 10 and 11 *d* for the other 197). Note that these figures add up to 8 *g* 4 *pf* 22 *d*, which does *not* tally with the sum of 9 *g* 3 *pf* 4 *d* given in the contract. We have no explanation for this discrepancy. A cost of 2 *fl* 1 *pf* 20 *d* for two reams of paper for the designs is also recorded.

33. The 37 *gulden* figure of course takes account of the increase in the

number of designs. There were 233 large and 83 small drawings put on the blocks, the small ones half the size judging from the next entry, for a total of 37 *g* 1 *p* 16 *d*, about 34 *d* for the large blocks and 17 *d* for the small ones. It is worth noting in this context that a drawing of an *Annunciation* by Dürer is inscribed apparently in his hand "vmb ein pfund." Hans Rupprich, ed., *Dürer: Schriftlicher Nachlass* (Berlin, 1956–59), vol. I, p. 206.

34. Item von den figuren in die hulzen prettlein zu schneiden zalt Sebolten Gallenssdorfer, nemlich von 233 grossen, ie von einem 4 *pf* 15 *d*, und 83 kleinen, je von zweien 4 *pf* 15 *d*, tut 1235 *pf* 8 *d*, facit an geld, den gulden zu 8 *pf* 10 *d* gerechnet, 148 fl. 1 *pf* 28 *d*.

35. There are a number of single woodcuts which have been connected with this apparently aborted project. Valerian von Loga, "Beiträge zum Holzschnittwerk Michel Wolgemuts," *Jahrbuch der königlich preussischen Kunstsammlungen* 16 (1895), pp. 236–39, proposes 25 sheets in Berlin, Kupferstichkabinett; 13 in Vienna, Hofbibliothek; and one in a private collection in Hannover which he supposes may have been intended for it. Most of these compositions are woodcut copies of Italian engravings including a series of the *Triumphs of Petrarch* that provide a *terminus post quem* of 1492, right for the Danhauser project. Von Loga provides only circumstantial evidence to support his hypothesis that these were intended for the *Archetypus* — their probable origin in the Wolgemut workshop, their date, and the classical and Petrarchan themes. Von Loga notes that known impressions are probably late, seventeenth to eighteenth century. Most recently a monumental, two-block woodcut showing a schematic stemma of the Roman emperors from the foundation of the empire to Theodosius has been attributed to the Danhauser project (Wilson, *Nuremberg World Chronicle*, p. 242), yet this proposal is made without any explanation or argument for the connection. There is an impression of this woodcut now in Berlin (Kupferstichkabinett, German School, inv. 477-112), not specifically cited by von Loga, and there especially seems no reason to assume any connection, particularly as the woodcut (565 × 440 mm) is much too large for a book illustration. Although reference to these various woodcuts as part of the original Danhauser project persists in the scholarly literature, we see no firm grounds for accepting the connection.

36. For example, Francesco Petrarch's *Von der Artzney bayder Glück* with an extensive program of illustrations designed specially for the text took over ten years to appear from the Augsburg press. The text was translated from the Latin: *De remediis utriusque fortunae*. The most recent discussion of this remarkable cycle of illustrations is: Hans-Joachim Raupp, "Die Illustrationen zu Francesco Petrarca, 'Von der Artzney bayder Glueck des guten und widerwertigen' (Augsburg 1532)," *Wallraf-Richartz-Jahrbuch* 45 (1984), pp. 61–62, for details of its production. A still more conspicuous case of retarded publication was the woodcut projects of Maximilian I (see Chapter V).

37. Rücker, *Weltchronik*, p. 124. Already within a couple of years Johannes Schönsperger of Augsburg published a pirate edition in smaller format.

38. The woodcut survives in three states and was reprinted in the nineteenth century. It is assembled from six blocks to a full dimension of 1340 × 2820 mm. See the important study of Jacopo de' Barbari by Jay Alan Levenson, "Jacopo de' Barbari and the Northern Art of the Early Sixteenth Century" (Ph.D. diss., New York University, 1978). The most extensive discussion of the print is Juergen Schulz, "Jacopo de' Barbari's *View of Venice*: Map Making, City Views, and Moralized Geography Before the Year 1500," *Art Bulletin* 60 (1978), pp. 425–74. For further bibliography, see Terisio Pignatti, "La pianta di Venezia di Jacopo de' Barbari," *Bolletino dei Musei Civici Veneziani* 9, 1–2 (1964), pp. 48–49. A total of twelve sets of impressions from the first state survive, five of these in Venice. A list of eleven with minimal descriptions is given in Pignatti, pp. 40–41. Schulz, p. 474, restores an additional copy (Berlin, Staatliche Museen) which Pignatti believed to have been destroyed.

39. Among Koberger's records of accounts with foreign agents we find reference to "Anthoni Kolb 34 Exemplare, abzüglich 51 Dukaten 18 Pf. 16 H." (1499).

40. Terisio Pignatti, "The Relationship between German and Venetian Painting in the Late Quattrocento and Early Cinquecento," in *Renaissance Venice*, ed. John Hale (London, 1973), pp. 250–54.

41. For the documents bearing on Jacopo's early career, see Luigi Servolini, *Jacopo de' Barbari* (Padua, 1944), pp. 45–76. A summary and interpretation of the documents relevant to Jacopo and Albrecht Dürer is given in Hind, *Early Italian Engravings*, V, pp. 142–43.

42. The full text of the document (which survives only in an abstracted copy) is given by Schulz, "Jacopo de' Barbari's *View*," p. 473.

43. Rudolf Hirsch, *Printing, Selling and Reading, 1450–1550* (Wiesbaden, 1967), ch. 6. This is the earliest record we know of. In 1502 Aldus Manutius was given an exclusive patent for his Greek type. The history of printers' protections in Venice is given in more detail by Leonardas Vytautas Gerulaitis, *Printing and Publishing in Fifteenth-Century Venice* (Chicago and London, 1976), ch. 3. This subject is taken up on pp. 299–302.

44. Paul Kristeller, *L'œuvre de Jacopo de' Barbari* (Berlin, 1896), pp. 3–4. This conclusion is repeated in the catalogue by Horst Appuhn and Christian von Heusinger, *Riesenholzschnitte und Papiertapeten der Renaissance* (Unterschneidheim, 1976), p. 45.

45. For a full discussion of Kolb's paper, see Chapter II.

46. For a condensed summary of the prices for Aldus's books, see Harry George Fletcher III, *New Aldine Studies: Documentary Essays on the Life and Work of Aldus Manutius* (San Francisco, 1988), pp. 90–91. It has been noted elsewhere that the prices listed in Aldus's catalogues are probably not normal retail prices. Most often they are lower. These lists may have been directed to dealers rather than collectors and therefore indicate wholesale prices. See Gerulaitis, *Printing in Venice*, p. 9.

47. Cited by Fletcher, *Aldus Manutius*, p. 90.

48. It has also been proposed that one of the four winds is a self-portrait. Pignatti, "La pianta," pp. 11, 15.

49. Holm Bevers, *Meister E.S. Ein Oberrheinischer Kupferstecher der Spätgotik*, exh. cat. (Munich: Staatliche Graphische Sammlung; and Berlin: Kupferstichkabinett, 1987), pp. 64–66, cat. no. 72.

50. Lilli Fischel, "Le Maître E.S. et ses sources Strasbourgeoises," *Archives Alsaciennes d'Histoire de l'Art* 14 (1935), pp. 187–89, arguing the relation of the Master ES to Hans Hirtz, the Master of the Karlsruhe Passion. In response, see Bevers, *Meister E.S.*, p. 65.

51. Fritz Koreny, *Spielkarten, ihre Kunst und Geschichte in Mitteleuropa*, exh. cat. (Vienna: Albertina, 1974), pp. 227–28, cat. no. 172. The bowman's popularity continued at least another two centuries. E.g., an engraving after Jacques de Gheyn II (Holl. 108).

52. Fischel, "Le Maître E.S.," pp. 185–229; and Lilli Fischel, "Werk und Name des 'Meisters von 1445,'" *Zeitschrift für Kunstgeschichte* 13 (1950), pp. 108–12. Qualifying this view, see Bevers, *Meister E.S.*, pp. 65, 79.

53. Fritz Koreny, "Über die Anfänge der Reproduktionsgraphik nördlich der Alpen" (Doctoral diss., University of Vienna, 1968), *passim*. See especially the conclusions on pp. 70–79, 150–52. The case here is built mainly upon the engravings of the Master of the Banderoles and Israhel van Meckenem, whom we shall discuss later. See pp. 10–16 on the distinction between various types of dependency — copy, reproduction, engraving "after" (*Nachstich*), replica, forgery, etc.

54. See Koreny's review of Bevers, *Meister E.S.*, in *Print Quarterly* 4 (1987), pp. 304–08, for illustrations.

55. Bevers, *Meister E.S.*, *passim*, in general takes this view of the Master ES. He does, however, regard certain works as very much closer to reproductive prints than seems plausible. Bevers's opinion is cogently challenged by Koreny (review, *Print Quarterly*, pp. 304–08), who regards the Master ES as more independent than his contemporaries and not properly classified as a reproductive

engraver. For example, in his relation to the Master of the Karlsruhe Passion — first analyzed by Fischel and again by Bevers — Koreny sees the Master ES as working within a trend and "not reinterpreting consciously selected prototypes." It should be clear that we fully agree with the latter opinion.

56. See Bevers, *Meister E.S.*, cat. nos. 30–32, pp. 43–46.

57. Horst Appuhn, *Meister E.S. — Alle 320 Kupferstiche* (Dortmund, 1989), pp. 373–77, points to several possible readings for the E and ES monograms as a reference to the establishment or some devotional formula issued by it. None of these is entirely convincing, and in the absence of identifiable abbreviations one is further compelled to question the adequacy of this explanation. See also *St. Philip and St. James the Minor* (Lehrs II.96), an example in which the date appears to have been awkwardly fitted around elements in the print. For the most part the subjects portrayed in signed and dated prints are arguably suited to the monastery's interests. However, see the exception taken by Fedja Anzelewsky, "Le Maître des Cartes à Jouer, le Maître E.S. et les débuts de la gravure sur cuivre," in *Le beau Martin: Gravures et dessins de Martin Schongauer*, exh. cat. (Colmar, 1991), p. 118.

58. Impressions (British Museum, London) exhibiting this feature are: Dated 1466: Lehrs. II.149 (St. I). Dated 1467: Lehrs II.61, 76, 96, 150.

59. See Koreny, "Reproduktionsgraphik," pp. 80–88.

60. Alan Shestack, *Fifteenth Century Engravings of Northern Europe from the National Gallery of Art*, exh. cat. (Washington, D.C., 1967), see entries on these masters.

61. Bevers, *Meister E.S.*, p. 7.

62. "Dise figur ist meiner jugent vor das beste kunststück geacht worden das im theutschen land is aus gangen, deshalben ich es auch in meine bibel han geleimt nit von wegen der hystorien, sie kan war vnd auch nit sein. Aber do der Dürer von nürnburck seine kunst liess auss geen, do galt dise nit mer welche auch alle kunststhdecker vberthrift. Diser Kunststhdecker hat der Hübsch martin geheissen von wegen seiner kunst." On the contents of the *Plock Bible* (Berlin, Kupferstichkabinett), see Werner Timm, "Die Einklebungen der Lutherbibel mit den Grünewaldzeichnungen," in *Forschungen und Berichte: Staatliche Museen zu Berlin* (Berlin, 1957), pp. 105–21. Timm transcribes the text of Plock's remark on p. 118.

63. It is telling that the largest sixteenth-century print collection we know of, that of Ferdinand of Tyrol begun not too long after Plock must have written this comment, includes not one single work by Schongauer (Peter W. Parshall, "The Print Collection of Ferdinand, Archduke of Tyrol," *JKSW* 78 (1982), p. 182), though it does include a rare work by a close imitator shortly to be discussed, the Master PM.

64. The chronology of Schongauer's work is difficult to plot precisely because of the absence of dated works. However, the main outlines of his development are generally agreed upon. See the detailed study by Eduard Flechzig, *Martin Schongauer* (Strasbourg, 1951), pp. 188–249; and the concordance of opinions on chronology in *Le beau Martin*, pp. 242–45.

65. Lehrs, VI, includes most of the Schongauer followers.

66. Lehrs, VI, pp. 180–81.

67. Koreny, "Reproduktionsgraphik", p. 70, note 1.

68. Lehrs, VI, pp. 178–280.

69. Lehrs, VI, pp. 281–90, suggests Master PM was active in the lower Rhine region, perhaps in Cologne.

70. Max Lehrs, "Der Meister PM," *Jahrbuch der königlich preussischen Kunstsammlungen* 19 (1898), pp. 135–38. Max Geisberg, *Geschichte der deutschen Graphik vor Dürer* (Berlin, 1939), pp. 195–96, dismisses the idea that these are preparatory studies for a *Fall of Man*. Two impressions are recorded by Lehrs (VI, p. 285), both of high quality (S. Spencer Churchill collection, Northwick Park, now in the British Museum; and Paris, Dutuit collection).

71. For a summary of what is known about Israhel's career with further bibliography, see Shestack, *Fifteenth-Century Engravings*.

More recently, see *Israhel van Meckenem und der deutsche Kupferstich des 15. Jahrhunderts*, with several articles appearing as a special issue of: *Monatsschrift Unser Bocholt* 3/4 (1972). Fritz Koreny, *Hollstein's German Engravings, Etchings and Woodcuts, 1400–1700* (Blaricum, 1986), vol. XXIV; and Adam Bartsch, *The Illustrated Bartsch*, vol. IX, compiled by Fritz Koreny (the commentary volume forthcoming).

72. Jacob Wimpheling, *Epithoma Germanorum iacobi wympfelingii* (Strasbourg: Johannes Prüss, 1505), ch. 68: "Icones Israhelis Alemani p[er] unuiversam Europa[m] desiderant habenturq[ue] a pictoribus in summo p[i]c[t]io." Confirmation of Israhel's date of death is given by a drawn copy of his (now lost) mortuary tablet. See Antony Griffiths, "The Rogers Collection in the Cottonian Library, Plymouth," *Print Quarterly* 10 (1993), pp. 19–36.

73. We are indebted to Lynette M. F. Bosch's work on Spanish manuscript illumination and its dependence on prints for information about Israhel's influence in those parts.

74. Koreny, "Reproduktionsgraphik," pp. 112–42; and Fritz Koreny, "Aux origines de la gravure sur cuivre allemande: reproductions, cartes à jouer, livres de modèles," *Nouvelles de l'estampe* nos. 64–65 (July–October 1982), pp. 9–10. *Hans Holbein der Ältere und die Kunst der Spätgotik*, exh. cat. (Augsburg: Rathaus, 1965), pp. 162–68, cat. nos. 193–204. The engravings are closely related to scenes in Holbein's *Weingartner Altar* of 1493 (Augsburg, Dom).

75. Shestack, *Fifteenth-Century Engravings*, nos. 214–15.

76. Carlo Bertelli, "The 'Image of Pity' in Santa Croce in Gerusalemme," in *Essays in the History of Art Presented to Rudolf Wittkower*, ed. Douglas Fraser, et al. (London, 1967), pp. 40–55, gives the fullest history of the icon. Scholars have always given priority to the larger of the two engravings of the icon which also mentions Santa Croce in the inscription. However, the smaller of them (Lehrs IX.167) is in fact a closer copy of the actual icon. On Israhel's engravings and their reproductive function, see Peter Parshall, "*Imago contrafacta*: Images and Facts in the Northern Renaissance," forthcoming in *Art History* 16 (1993).

77. Berlin, Kupferstichkabinett, Cim. 30/286, 8°, 17 paper folios with a handwritten text in Latin.

78. The Master ES's series (Lehrs II.100–11), was loosely copied by Israhel (Lehrs IX.237–47), and copied in reverse by the Master of the Banderoles (Lehrs IV.49–54).

79. There are other similar cases. The connection between these particular saints (including one Evangelist) is obscure, save that Theophista was the wife of Eustace. The signature is placed between these two as though they were meant as a pair and the others meant to be cut apart. See also Lehrs IX.305, 306, 450.

80. Anni Warburg, *Israhel van Meckenem* (Bonn, 1930), pp. 24–29; and Henry Meier, "Some Israhel van Meckenem Problems," *Print Collector's Quarterly* 27 (1940), pp. 41–46. A depiction of the siege also occurs in the *Housebook*. See Filedt Kok, et al., *Master of the Amsterdam Cabinet*, pp. 218–19, cat. no. 117.

81. Meier, "Some Israhel van Meckenem Problems," pp. 28–31.

82. The laced bodice of Salome's costume is close to that of the lady shown in the midst of a jaunty turn just to the right of the musicians' platform, but the band of her headdress is folded up and she wears an elaborate necklace. On the question of the inverted composition and its narrative implication in prints and other works of art in the Renaissance, see Peter W. Parshall, "Lucas van Leyden's Narrative Style," *Nederlands Kunsthistorisch Jaarboek* 29 (1978), pp. 213–31, *passim*.

83. Devotional images also often carry blank banderoles. One wonders, for example, about Israhel's engraving of the *Virgin and Child with St. Andrew and the Marriage of St. Catherine* [Lehrs IX.214] set in a small gothic chapel. St. Andrew intercedes for a male supplicant. A banderole stretches from his hands through those of his patron to the Virgin. Was it intended for the names of individual purchasers of the print? Dürer's drawing of the *Angels' Mass* (Rennes, Musée) includes a blank panel in which the artist himself apparently has inscribed "Do schreibt hrein was jr wollt" (You

can write here what you will). Erwin Panofsky, *Albrecht Dürer* (Princeton, 1948), vol. II, p. 92, no. 891.

84. This purpose for the empty banderole is suggested by Adolf Spamer, *Das kleine Andachtsbild vom XIV. bis zum XX. Jahrhundert* (Munich, 1930), p. 47. For a complex argument suggesting ways in which a fifteenth-century Italian might have sought to create a text out of an image, see Patricia Emison, "The Word Made Naked in Pollaiuolo's *Battle of the Nudes*," *Art History* 13 (1990), pp. 261–75.

85. Given that its style reflects the influence of the Master ES, a date in the 1470s was proposed by Max Geisberg, *Der Meister der Berliner Passion und Israhel van Meckenem* (Strasbourg, 1903), p. 110. Geisberg suggests that the unsigned print, though unmistakably done in Israhel's hand, reflects a lost original, perhaps by the Master ES. See Lehrs IX.487, citing the opinion of Geisberg (with which he disagrees). This possibility cannot be excluded; however, nothing in the Master ES's repertoire substantiates it, and furthermore the costumes of the contemporary characters (specifically the co-existence of pointed and round-toed shoes and several other details reflecting the archly fashion-conscious climate of the time) very strongly suggests a date in the late 1480s. We would like to thank Anne H. van Buren for her conclusions about the costumes (personal communication).

86. The texts are transcribed and the Psalms identified by Max Geisberg, *Verzeichnis der Kupferstiche Israhels van Meckenem* (Strasbourg, 1905), p. 182, no. 384. The remaining passages from Psalms are 37:26; 52:4; 28:3.

87. On the constitution of Schedel's collection, see Béatrice Hernad, *Die Graphiksammlung des Humanisten Hartmann Schedel*, exh. cat. (Munich, 1990).

88. *Ibid.*, pp. 66–67.

89. For a discussion of this subject and additional and more modest examples, see Richard S. Field, "A *Passion* for the Art Institute," *Print Quarterly* 3 (1986), pp. 191–216.

90. Hernad, *Hartmann Schedel*, p. 53, has looked unsuccessfully for traces of a separate collection.

91. Wimpheling, *Epithoma*, ch. 68.

92. See Francis Ames-Lewis, "A Northern Source for Mantegna's *Adoration of the Shepherds*," *Print Quarterly* 9 (1992), pp. 268–71.

93. See *Andrea Mantegna*, exh. cat. (London: Royal Academy of Arts, 1992), *passim*.

94. For the most recent survey on these workshops, see Jay A. Levenson, Konrad Oberhuber and Jacquelyn L. Sheehan, *Early Italian Engravings from the National Gallery of Art*, exh. cat. (Washington, D.C., 1973), pp. 1–9, 13–21. For the Master of the Vienna Passion, see Mark J. Zucker, "The Madonna of Loreto: A Newly Discovered Work by the Master of the Vienna Passion," *Print Quarterly* 6 (1989), pp. 149–60.

95. Levenson, et al., *Early Italian Engravings*, p. xvii.

96. To our knowledge, there are no drawings from that school that employ parallel hatching before ca. 1475. See Annamaria Petrioli Tofani, *Il disegno fiorentino del tempo di Lorenzo il Magnifico*, exh. cat. (Florence: Uffizi, 1992). Parallel hatching appears first in Pollaiuolo's drawings of the mid-1470s, such as the sheet with *Three Nudes* in the Louvre (cat. no. 9.1) or the study for a *St. John the Baptist* in the Uffizi (cat. no. 6.4), and, slightly later, in Ghirlandaio's works, such as the *Portrait of a Woman* from Chatsworth (cat. no. 4.6). Some of Leonardo's silverpoint drawings, in which he made use of parallel hatching, have been dated to the late 1470s and early 1480s: see J. Levenson, ed., *Circa 1492*, exh. cat. (Washington D.C., 1991), pp. 272–73, cat. nos. 171–71a.

97. See U. Dorini, *Statuti per l'Arte di Por Santa Maria del tempo della Repubblica* (Florence, 1934), pp. 400–01.

98. See Maria Grazia Ciardi Duprè, *L'oreficeria nella Firenze del Quattrocento*, exh. cat. (Florence, 1977), p. 208.

99. See pp. 106–07.

100. *Virgin and Child*, Vienna; *Sea Gods*, Chatsworth.

101. See Levenson, et al., *Early Italian Engravings*, pp. 81–157; also Laure Beaumont-Maillet, Gisèle Lambert and François Trojani, *Suite d'estampes de la Renaissance italienne dite Tarots de Mantegna* (Paris, 1986), with further literature, and the review by Kristen Lippincott, "'Mantegna's *Tarocchi*,'" *Print Quarterly* 3 (1986), pp. 357–60. For a recent survey on the subject of the *Tarocchi*, see the entry by Marzia Faietti in Alessandra Mottola Molfino and Mauro Natale, *Le Muse e il Principe*, exh. cat. (Modena, 1991), pp. 431–37.

102. See Sidney Colvin, *A Florentine Picture-Chronicle* (London, 1898), pp. 34–36. See also John Goldsmith Phillips, *Early Florentine Designers and Engravers* (Cambridge, Mass., 1955), *passim*.

103. "Francesco Rosselli," in Levenson, et al., *Early Italian Engravings*, pp. 47–59.

104. Hind, *Early Italian Engraving*, I, App. I, p. 307, inv. nos. 37, 39.

105. Our chronology, in accordance with received wisdom, presupposes that the first state of this series was engraved before Francesco left for Hungary. Madeline Cirillo Archer has recently suggested that this form of Rosary was not introduced to Florence before 1481 or even the mid-1480s, though this obviously clashes with all the stylistic and technical evidence; see her article "The Dating of a Florentine *Life of the Virgin and Christ*," *Print Quarterly* 5 (1988), pp. 395–402. More research is needed on the subject.

106. Louise Richards, "Antonio Pollaiuolo: Battle of the Naked Men," *Bulletin of the Cleveland Museum of Art* 55 (1968), pp. 63–70. On the other hand, we know that Mantegna used the same batch of paper for printing his plates (and for two drawings) over a number of years. See *Andrea Mantegna*, pp. 199, 473.

107. See L. A. Armstrong, "Copies of Pollaiuolo's *Battling Nudes*," *Art Quarterly* 31 (1968), pp. 155–67. Laurie Fusco has recently suggested that the *Battle*'s date may have to be moved to the late 1480s, but her arguments, based on the dependence on a statue excavated in Rome in 1488, are not at all convincing. See Laurie Fusco, "Pollaiuolo's *Battle of Nudes*: A Suggestion for an Ancient Source and a New Dating," in Mauro Natale, ed., *Scritti di Storia dell'Arte in onore di Federico Zeri* (Milan, 1984), pp. 196–99.

108. Alan Shestack, *Master E.S.: Five Hundredth Anniversary Exhibition*, exh. cat. (Philadelphia, 1967), no. 66, agrees with the generally held view that this was printed as a white line engraving by inking the surface of the plate as if it were a woodblock. According to Nicholas Stogdon, all known impressions have in fact been printed with white ink onto paper prepared with black pigment brushed on its surface; see N. G. Stogdon, *German and Netherlandish Woodcuts*, sale cat. (Berlin and London, 1991–92), no. 17. For two examples of white line woodcuts, see the 1491 edict printed by Mathias van der Goes in Antwerp (see *Le cinquième centenaire*, p. 373, no. 169, pls. 87–88), and the *Virgin in Glory Crowned by Two Angels*, Augsburg 1502 (Schreiber 2869; see Campbell Dodgson, *Catalogue of Early German and Flemish Woodcuts Preserved in the Department of Prints and Drawings in the British Museum* (London, 1911), vol. II, p. 202).

109. As has recently been made clear by Oberhuber and Faietti who reconstructed the body of his drawn oeuvre: see M. Faietti and K. Oberhuber, *Bologna e l'Umanesimo, 1490–1510*, exh. cat. (Bologna, 1988).

110. An impression of Mantegna's *Bacchanal with Wine Vat* in Caen is said to be on colored paper but has not been seen by the authors. See *Exposition des gravures italiennes des XVe et XVIe siècles*, exh. cat. (Caen, 1976), cat. no. 30.

111. An incomplete burning of the char or a reaction between paper and ink can produce such effect. See Chapter II, p. 21.

112. The same explanation applies to the contemporary but very distant workshop of the so-called Master of the Dutuit Mount of Olives, whose small engravings are often printed in similar variations of brown.

113. For examples of impressions in red, see Mantegna's *Flagellation* in the Berlin Kupferstichkabinett and Giovanni Antonio da Brescia's

Virgin and Child (London, British Museum). An impression of a print by Nicoletto in green can also be found in the British Museum (H.118).

114. H.I.259.E.III.22 and also 23, 47, 48.

115. E.g., the *Ornament Panel* (H.107) in Boston, Museum of Fine Arts.

116. See Antony Griffiths, *Prints and Printmaking: An Introduction to the History and Techniques* (London, 1980), p. 149.

117. Levenson, et al., *Early Italian Engravings*, p. 468.

118. E.g., the *Guardian Angel* (H.12) in Amsterdam.

119. See, e.g., Hind, *History of Woodcut*, II, p. 450.

120. See Evelina Borea, "Stampa figurativa e pubblico dalle origini all'affermazione nel Cinquecento," in *Storia dell'Arte Italiana* (Turin, 1979), pt. 1, vol. II, p. 326.

121. See H.A.I.71.

122. See, e.g., H.A.I.43, 50 and 68.

123. See, e.g., Taddeo Crivelli in Hind, *Early Italian Engraving*, I, p. 14; Giovanni Pietro da Birago in Levenson, et al., *Early Italian Engravings*, pp. 272ff.; and Cristoforo Cortese in Fiora Bellini, *Xilografie italiane del Quattrocento da Ravenna e da altri luoghi*, exh. cat. (Rome, 1987), pp. 33–34.

124. See the list in Hind, *Early Italian Engraving*, I, pp. 120–21. An interesting case was brought to light a few years ago, when a battered and very fragmentary woodcut of an *Adoration of the Magi* was discovered pasted onto the back of a panel painted by Lippo Vanni. See Ulrich Middeldorf, "Two Sienese Prints," *Burlington Magazine* 116 (1974), pp. 106–10.

125. Martin Wackernagel, *The World of the Florentine Renaissance Artist: Projects and Patrons, Workshop and Art Market*, trans. Alison Luchs (Princeton, 1981), p. 172, n. 155. The average size of such devotional images in Florence was between 150 and 350 mm (Wackernagel, p. 174); the engravings from Rosselli's series are, without their borders, about 220 mm high. It is also probable that the "pictor cartarum" mentioned in a census of 1501 (K. Frey, *Die Loggia dei Lanzi zu Florenz* (Berlin, 1855), p. 346) made a living just by hand-coloring such prints.

126. Item II.19.

127. This was noticed by Hind, *Early Italian Engraving*, I, p. 66. In the Louvre impression, the left half shows a blank strip of paper at its right edge so that the right half could be pasted over it. The obvious traces of slightly inked parts of the right half on this strip indicate clearly that the whole subject was engraved on a single plate, but that there was no sheet of sufficient size to print the two together. The same solution was probably used for the *Conversion of St. Paul*. We have seen that problems of this sort occurred, for example, in the Bramante/Prevedari discussed on pp. 106–07, the largest Italian print from a single plate made in the fifteenth century, though here the technique chosen for the printing was different.

128. The artist must have realized that the best way to avoid the two halves being irregularly matched when stuck together was to provide a wide enough strip of blank paper on each of the two sheets as well as a clear borderline as guide; a late impression in Vienna shows such a strip, at least 16 mm wide, beyond a clearly engraved borderline at the right edge of the left sheet. Moreover, the left edge of the image engraved on the right sheet looks "open," so as to help the matching of the two halves.

129. See Lilian Armstrong Anderson, "Copies of Pollaiuolo's Battling Nudes," *Art Quarterly* 31 (1968), pp. 155–67.

130. There they are described as a "Firenze in sei fogli reali" (H.I.B.III.18) and as a "Roma in tre pezzi in 12 fogli reali." On the maps, see Roberto Weiss, *The Renaissance Discovery of Classical Antiquity* (Oxford, 1973), p. 92.

131. One should not overlook, however, the important northern example of the *Swiss War*, an engraving in six sheets by the Master PW, for which, see Hernad, *Hartmann Schedel*, pp. 51, 272–74.

132. Jean Michel Massing, "'The Triumph of Caesar' by Benedetto

Bordon and Jacobus Argentoratensis: Its Iconography and Influence," *Print Quarterly* 7 (1990), pp. 2–21.

133. For engraving, see H.I.279.F.1; for woodcut, see Hind, *History of Woodcut*, II, p. 432.

134. H.V.22 and *Andrea Mantegna*, p. 453, cat. no. 148.

135. Hind, *History of Woodcut*, II, p. 435, fig. 205.

136. Peter Burke, *Culture and Society in Renaissance Italy, 1420–1590* (London, 1972), p. 145. We would like to thank M. Jacobsen for bringing this work to our attention.

137. For which, see "La giostra Romanza di Lorenzo del 1469" in *Le temps revient*, p. 168.

138. This issue was discussed by Konrad Oberhuber in a paper he presented to the Colloquium, "Il disegno al tempo di Lorenzo," Florence, 5 June 1992. At the time of going to press the papers had not been published.

139. See Riccardo Pacciani, "Immagini, arti e architetture nelle feste di età laurenziana", in *Le temps revient*, pp. 123, 135, nn. 28, 31.

140. Bellini, *Xilografie italiane*, *passim*; and Schizzerotto, *Le incisioni quattrocentesche*. See also the booklet that was issued to accompany a traveling exhibition of the woodcuts in Canada and the United States: Robin Healey, *Fifteenth-Century Italian Woodcuts from the Biblioteca Classense, Ravenna* (Toronto, 1989); during 1989 and 1990 the exhibition traveled to Hamilton (Ontario), Chicago, and New York. Traces have been found in the albums of at least fifteen more prints, now missing.

141. Bellini, *Xilografie italiane*, p. 29, cat. no. 130. One of the sheets thus treated did not come to us from the Classense but from another library in Ravenna. But this is not a strong argument against Rubieri's ownership, since the volumes were dispersed in the area around Pesaro and Ravenna sometime between Rubieri's death and the early eighteenth century, and particularly since the blackening of the *St. Christopher* — untouched in the Pesaro example (fig. 83) — is absolutely in keeping with the coloring of the rest of the page, and the ink used around the saint seems to be the same used for the borderlines around the letters, perhaps even for the writing itself.

142. Where this does occur, the "duplicated" saint is part of a group (and in such cases is often blackened out) or is one of the figures which had been pasted over with another image, possibly of the same saint.

143. The former possibility is supported by the fact that many of the images have been localized to areas Rubieri lived in or visited where these specific saints were venerated. On the other hand, a systematic record of souvenirs from shrines would likely have yielded more duplication of subject.

144. A. M. Hind, "Fifteenth-Century Italian Engravings at Constantinople," *Print Collector's Quarterly* 20 (1933), p. 279; Hind, *Early Italian Engraving*, I, p. 13; Julian Raby, "European Engravings," *Islamic Art* 1 (1981), p. 44.

145. Raby, "European Engravings," p. 45.

146. Hind, *Early Italian Engraving*, I, p. 13.

147. Raby, "European Engravings," p. 45.

148. *Ibid.* But see also J. M. Rogers's suggestion that they might have been part of the ransom paid by the Aggoyunlu prince Yusuf-cha Mirza for his freedom: in Levenson, ed., *Circa 1492*, p. 70.

149. The "Otto" print, H.I.A.IV.21.

150. But see Hind, *Early Italian Engraving*, I, p. 25; Zucker, "'Madonna of Loreto,'" pp. 149–60; and Bartsch, *Illustrated Bartsch*, vol. XXIV, compiled by M. J. Zucker.

151. Examples of inter-workshop copies are plenty, as are copies of German prints. In fact, three of the prints in this group are copies of German prototypes. For a discussion of this issue, see H. Theodor Musper, ed., *Der Einblatt Holzschnitt und die Blockbücher des XV. Jahrhunderts* (Stuttgart, 1976).

152. Raby, "European Engravings," p. 45.

153. It is difficult to speculate whether Benedetto might have given the collection to the Sultan during his stay in Istanbul, or would have

154. Shestack, *Fifteenth-Century Engravings*, cat. no. 3.

155. Hind, *Early Italian Engraving*, I, p. 85.

156. Eight of the prints in the Bibliothèque Nationale come from the founder's collection, the Abbé de Marolles; the remaining thirty-six had passed through the famous Wilson collection, sold in London in 1828. Whether they had been the printmaker's own collection is impossible to say, but it is obvious that they had not been kept together as a pack of cards, as they appear to belong to two different series. See Martha Wolff, "Some Manuscript Sources for the Playing Card Master's Number Cards," *Art Bulletin* 64 (1982), pp. 587–600.

157. They are practically all in Amsterdam, where they came from the collection of Pieter Cornelis, Baron van Leyden, who probably bought them *en bloc* sometime in the mid-eighteenth century. See Filedt Kok, *Master of the Amsterdam Cabinet*, pp. 34, 91.

158. Jean Michel Massing, "Schongauer's 'Tribulations of St. Anthony': Its Iconography and Influence on German Art," *Print Quarterly* 1 (1984), pp. 229–30, nn. 58–59.

159. See Hind, *Early Italian Engraving*, I, p. 12. See also M. Holmes, "The Influence of Northern Engravings on Florentine Art during the Second Half of the Fifteenth Century" (M.Phil. thesis, London, Courtauld Institute, 1983), with further literature.

160. Michael Bury, "The Taste for Prints in Italy to c. 1600," *Print Quarterly* 2 (1985), p. 13, n. 8.

161. *Ibid.*

162. Levenson, et al., *Early Italian Engravings*, p. 345, n. 24; Hernad, *Hartmann Schedel*, pp. 52, 140–41.

163. Even a group of playing cards are to be found stuck in two codices of 1466 and 1469 now in the Archivio di Stato, Rome: see Paul Kristeller, "Beiträge zur Geschichte des italienischen Holzschnittes," *Jahrbuch der preussischen Sammlungen* (1892), pp. 172–78; Borea, *Stampa e pubblico*, p. 327.

164. Borea, *Stampa e pubblico*, p. 329.

165. M. P. Gilmore, "Studia Humanitatis and the Professions," *Florence and Venice: Comparisons and Relations* (Florence: I Tatti, 1976–77), vol. I, p. 28.

166. Weiss, *Renaissance Discovery*, p. 205.

167. Maria Grazia Ciardi Duprè, in Elisabetta Turelli, ed., *Immagini e azione riformatrice: Le xilografie degli incunaboli savonaroliani nella biblioteca nazionale di Firenze* (Florence, 1985), pp. 11–20.

168. Levenson, et al., *Early Italian Engravings*, p. 47.

169. *Ibid.*, p. 83, n. 10.

170. They are in Paris (Bibliothèque Nationale), Chantilly, Pavia, and Naples: see Faietti, *Le Muse e il Principe*, p. 432.

171. Wackernagel, *Florentine Renaissance Artist*, p. 301.

172. Quoted in Hind, *Early Italian Engraving*, I, p. 304.

173. Faietti and Oberhuber, *Bologna e l'Umanesimo*, *passim*.

174. Viridario 1504; Faietti and Oberhuber, *Bologna e l'Umanesimo*, p. 40, n. 144.

175. Quoted in Faietti and Oberhuber, *Bologna e l'Umanesimo*, p. 124.

176. *Ibid.*, p. 30.

177. *Ibid.*, p. 215.

178. Hind, *Early Italian Engraving*, V, p. 252.

179. Paola Barocchi, ed., *Scritti d'arte del Cinquecento* (Milan and Naples, 1971), vol. I, pp. 66–70.

180. Mantegna's playfulness had already received a fitting answer in Giovanni Bellini's rendition of the same subject, now in Bristol. See *Andrea Mantegna*, pp. 263, 267. On the hidden motif in Italian Renaissance art generally, see H. W. Janson, "The 'Image Made by Chance' in Renaissance Thought," in *De artibus opuscula XL: Essays in Honor of Erwin Panofsky*, ed. Millard Meiss, pp. 254–66.

181. Hind, *Early Italian Engraving*, V, pp. 190–91, n. 1.

182. Creighton E. Gilbert, *Italian Art, 1400–1500: Sources and Documents* (Englewood Cliffs, N.J., 1980), pp. 95–97.

183. See *Andrea Mantegna*, pp. 44–54, 177, 179, 193, 211.

184. Paul Kristeller, *Andrea Mantegna* (Berlin and Leipzig, 1902), pp. 550–51, doc. nos. 112–14. It is curious that Mantegna used the plural *stampe* in the latter document.

185. G. Campori, *Raccolta di cataloghi ed inventari inediti... dal secolo XV al XIX* (Modena, 1870; repr. Bologna, 1975), p. 34. One wonders whether this might refer to the plates of the *Tarocchi*.

186. Hind, *Early Italian Engraving*, I, p. 192, no. D.I.2.

187. Borea, *Stampa e pubblico*, p. 351.

188. See *Andrea Mantegna*, pp. 56–64.

189. Hind, *Early Italian Engraving*, V, p. 134, no. 98.

Notes to Chapter IV

1. Franz Wickhoff, "Beiträge zur Geschichte der reproduzierenden Künste: Marcantons Eintritt in den Kreis Römischer Künstler," *JKSW* 20 (1899), pp. 181ff.

2. M. Faietti and K. Oberhuber, *Bologna e l'Umanesimo, 1490–1510*, exh. cat. (Bologna, 1988), p. 51.

3. David Landau, "Vasari, Prints and Prejudice," *Oxford Art Journal* 6 (1983), pp. 3–10.

4. The most detailed discussion of copying prints in other prints is: Julius Held, *Dürer through Other Eyes: His Graphic Work Mirrored in Copies and Forgeries of Three Centuries*, exh. cat. (Williamstown, Mass., 1975), *passim*.

5. Susan Lambert, *The Image Multiplied: Five Centuries of Printed Reproductions of Paintings and Drawings* (London, 1987), p. 13.

6. For a discussion of the copious bibliography on this print, see Franco Borsi, *Bramante*, crit. cat., ed. Stefano Borsi (Milan, 1989), pp. 155–62.

7. *Lotoni* was surely correctly read as brass by Arthur M. Hind, *Early Italian Engraving* (London, 1938–48), vol. V, p. 102, n. 2.

8. *Stampa* in this context can only mean plate, not print; see comments below.

9. "[D]ictus magister Bernardus teneatur et obligatus sit hinc ad festam nativitatis Domini nostri Jhesu Christi proxime futurum fabricare ipsi magistro Matheo stampam unam cum hedifitiis et figuris lotoni secundum designum in papiro factum per magistrum Bramantem de Urbino et illam stampam bene intaliare secundum dictum designum ita et taliter quod dicta stampa stampeat bonum laborem et bonas figuras et quod dictus Magister Bernardus teneatur et obligatus sit laborare in domo dicti magistri Mathei ad faciendam dictam stampam et in ea stampa laborare ad diem et de nocte secundum consuetudinem ab hodie in antea usque quo dicta stampa finita sit. Et quod dictus Matheus teneatur et obligatus sit dare ipsi magistro Bernardo pro dicta stampa bene facta et ordinata secundum dictum designum libras quadraginta octo imperiales ... Quod dictus Magister Bernardus teneatur dare ipsi magistro Matheo patronum seu disegnum factum per suprascriptum magistrum Bramantem finita et facta dicta stampa pro libris tribus imperialibus quas libras tres imperiales ipse Magister Matheus teneatur dare ipsi magistro Bernardo infra quindecim dies proxime futuros." Clelia Alberici, "L'incisione Prevedari," *Rassegna di Studi e di Notizie* 6 (1978), pp. 52–54.

10. G. Mulazzani, "Il tema iconografico dell' incisione Prevedari," *Rassegna* 6 (1978), p. 69; this interpretation is accepted by Borsi, *Bramante*, pp. 161–62.

11. Clelia Alberici, "Notizie inedite su Bernardo Prevedari e aggiunte alla 'fortuna' della sua incisione da disegno del Bramante nella pittura rinascimentale," *Rassegna di Studi e di Notizie* 8 (1980), p. 42; and Clelia Alberici, "Bernardo Prevedari incisore di un disegno del Bramante," *Arte Lombarda*, n.s. 86/87 (1988), pp. 5–13.

12. Arnaldo Bruschi, "Problemi bramanteschi," *Rassegna di Studi e di Notizie* 6 (1978), p. 57.

13. Unless, however, the press used for the printing was not one specially made for this print, but one which was not meant to be used for printing but rather for other purposes. See Chapter II: presses.

14. It is probable that Christmas was chosen as a convenient deadline rather than that the print had any particular connection with Christmas, as has been suggested by Bruschi, "Problemi bramanteschi," p. 57.

15. Alberici, "L'incisione Prevedari," p. 42.

16. Alberici, "Notizie inedite," pp. 37–44.

17. Unfortunately, what Bernardo was meant to do in Rome is not clear, nor is it evident that his activity would have anything to do with prints rather than other branches of metalwork. We know, however, that in November 1482 he was back in Milan; see Alberici, "Bernardo Prevedari," p. 6.

18. Earlier doubts about his being Milanese have recently been dispelled by Alberici, "Notizie inedite," pp. 37–44.

19. Nicholo di Lorenzo della Magna, 30 August 1481. See Hind, *Early Italian Engraving*, I, p. 99, A.V.2.1–19.

20. See G. Dillon, in Annamaria Petrioli Tofani, *Il disegno fiorentino del tempo di Lorenzo il Magnifico*, exh. cat. (Florence: Uffizi, 1992), pp. 264–67.

21. Paolo Bellini, in Corrado Gizzi, *Botticelli e Dante*, exh. cat., (Pesaro: Torre de' Passeri, 1990; Milan, 1990), pp. 41–48.

22. Peter Dreyer, "Botticelli's Series of Engravings 'of 1481'," *Print Quarterly* 1 (1984), pp. 111–15.

23. The drawing for the *Deluge* is in Hamburg, the other in the British Museum. See Hind, *Early Italian Engraving*, I, p. 7; Jay A. Levenson, Konrad Oberhuber and Jacquelyn L. Sheehan, *Early Italian Engravings from the National Gallery of Art*, exh. cat. (Washington, D.C., 1973), pp. 47–59; Tofani, *Il disegno fiorentino*, pp. 262–63.

24. Hind *Early Italian Engraving*, V, p. 315.

25. This may have inspired Mantegna, who is likely to have used the same transfer technique. See pp. 112–14.

26. A. E. Popham and Philip Pouncey, *Italian Drawings in the Department of Prints and Drawings of the British Museum: The Fourteenth and Fifteenth Centuries* (London, 1950), vol. I, p. 126, no. 210, as "Attributed to Francesco Pesellino." This kind of borrowing was not much different from Baccio Baldini's appropriations from the so-called *Picture Chronicle*, made in Finiguerra's workshop, and used for a number of his Fine Manner prints. See Hind, *Early Italian Engraving*, I, p. 6. It is in fact possible that Baldini himself had worked in collaboration with Finiguerra. See Levenson, et al., *Early Italian Engravings*, p. 16.

27. See *Andrea Mantegna*, exh. cat. (London: Royal Academy of Arts, 1992), cat. nos. 26, 27, 35, 44, 66.

28. In the four corners of the early impression in Berlin of the *Flagellation with a Pavement* (for which, see *Andrea Mantegna*, cat. no. 36), a relatively early work, there are four transfer marks (for which see below) suggesting that there must have been a complete preparatory drawing for this print. The only one that has survived is a sketch in the Courtauld Institute Galleries, London (for which see *Andrea Mantegna*, cat. no. 35).

29. *Ibid.*, cat. nos. 66, 67, 44, 45.

30. *Ibid.*, cat. nos. 29, 32, 67, 36.

31. *Ibid.*, pp. 46–47. Furio De Denaro of Triest, Italy, who first suggested this procedure to David Landau, conducted an experiment in which he repeated all the steps described here for the transfer of the image from a finished drawing to a plate. He succeeded, and presented his findings in a lecture on Mantegna in Udine in May 1992.

32. *Ibid.*, pp. 48–52.

33. *Ibid.*, pp. 53–54, 56–64.

34. Jean Michel Massing in David Chambers and Jane Martineau eds., *Splendours of the Gonzaga*, exh. cat. (London, 1981), pp. 171–72, cat. no. 125; Jean Michel Massing, *Du texte à l'image: La calomnie d'Apelle et son iconographie* (Strasbourg, 1990).

35. Popham and Pouncey, *Italian Drawings*, vol. I, p. 95, cat. no. 157; vol. 2, pl. cxlvii.

36. *Ibid.*, cat. nos. 162–63; *Andrea Mantegna*, cat. nos. 95, 82.

37. J. Byam Shaw, *Drawings by Old Masters at Christ Church, Oxford* (Oxford, 1976), pp. 185–86, cat. no. 691. See also *Andrea Mantegna*, cat. nos. 93, 83, 97.

38. Hind, *Early Italian Engraving*, V, under "Mantegna School," nos. 17, 20; and under "Giovanni Antonio da Brescia," no. 2. See also *Andrea Mantegna*, cat. nos. 93, 83, 97.

39. *Andrea Mantegna*, cat. nos. 82–83.

40. Hind, *Early Italian Engraving*, V, p. 165, no. 12.

41. Popham and Pouncey, *Italian Drawings*, I, p. 97, cat. no. 158.

42. *Ibid.*, p. 98.

43. Hind, *Early Italian Engraving*, V, p. 159, n. 1.

44. H.D.IV.6; the print was wrongly attributed to Giovanni Antonio da Brescia in Levenson, et al., *Early Italian Engravings*, p. 248.

45. Edward J. Olszewski, *The Draftsman's Eye: Late Italian Renaissance Schools and Styles*, exh. cat. (Bloomington, Ind., 1981), pp. 42–44.

46. Now at the El Paso Museum of Art.

47. Hind, *Early Italian Engraving*, V, p. 87, no. 7.

48. *Ibid.*, nos. 2, 3, 4; see also *Andrea Mantegna*, cat. no. 2.

49. Formerly in Berlin, see Faietti and Oberhuber, *Bologna e l'Umanesimo*, pp. 106–08.

50. *Ibid.*, cat. nos. 37, 92.

51. *Ibid.*, pp. 243–44.

52. Published in Julien Stock, "A Drawing by Raphael of 'Lucretia,'" *Burlington Magazine* 126 (1984), p. 423.

53. Paul Kristeller, *Giulio Campagnola: Kupferstiche und Zeichnungen* (Berlin, 1907); A. M. Hind, "Marcantonio Raimondi (1480[?]–1530[?])," *Print Collector's Quarterly* 3 (1913), pp. 243–76; Innis H. Shoemaker and Elizabeth Broun, *The Engravings of Marcantonio Raimondi*, exh. cat. (Lawrence, Kan., 1981); K. Oberhuber, "Raffaello e l'incisione," in Fabrizio Mancinelli, et al., eds., *Raffaello in Vaticano*, exh. cat. (Rome, 1985), pp. 333–42, etc.

54. The wording used in the list of Marcantonio's works after Raphael makes this clear. See Giorgio Vasari, *Le vite de' più eccellenti pittori, scultori ed architettori*, ed. G. Milanesi (Florence, 1878–85), vol. V, pp. 412–13.

55. *Ibid.*, pp. 413–14.

56. *Ibid.*, p. 414.

57. Adam Bartsch, *The Illustrated Bartsch* (University Park, Pa., and New York, 1971–), vol. XIV.

58. Grazia Bernini Pezzini, Stefania Massari, and Simonetta Prosperi Valenti Rodinò, *Raphael invenit: Stampe da Raffaello nelle collezioni dell'istituto nazionale per la grafica*, exh. cat. (Rome, 1985), p. 9.

59. Shoemaker and Broun, *Engravings of Marcantonio*, cat. no. 69; Mancinelli, et al., *Raffaello in Vaticano*, p. 276, cat. no. 103.

60. Mancinelli, et al., *Raffaello in Vaticano*, pp. 340–41.

61. A. Petrucci, *Panorama dell'incisione italiana — Il cinquecento* (Rome, 1964), p. 94, n. 9.

62. Konrad Oberhuber, *Raffaello* (Milan, 1982), p. 78.

63. For agreement on the identification, see Mancinelli, et al., *Raffaello in Vaticano*, p. 67, cat. no. 43.

64. André Chastel, *The Sack of Rome*, trans. Beth Archer (Princeton, 1983), p. 162.

65. Konrad Oberhuber, "Raffaello e l'incisione," in Mancinelli, et al., *Raffaello in Vaticano*, pp. 333–42.

66. See pp. 104–06.

67. Chastel, *Sack of Rome*, pp. 160–61.

68. Various proofs of the *Mars, Venus, and Amor* (B.345) or that of the *Galatea* in Vienna (B.350).

69. The *Martyrdom of St. Lawrence* (B.104) or the *Reconciliation of Minerva and Cupid* (B.393). Corrected proof in Stanford University; see Shoemaker and Broun, *Engravings of Marcantonio*, cat. no. 42.

70. The *Massacre of the Innocents* (B.18) or the *Portrait of Aretino* (B.513).

71. For example the *Parnassus* (B.247), of which Shoemaker and Broun illustrate a proof (*Engravings of Marcantonio*, p. 156, cat. no. 48a), may have been completed by Marco da Ravenna, while the *Solomon and the Queen of Sheba* (B.13) may have been completed by Agostino Veneziano.

72. For instance, the *Apollo and Hyacinthus* (B.348), *Two Satyrs with a Nymph* (B.305), or *The Vintage Season* (B.306). There is an interesting cache of late impressions of early prints by Marcantonio in the Wallraf-Richartz Museum, Cologne.

73. A set of twelve *Apostles* — so-called copies of those by Marcantonio — and another twelve individual prints carry Salamanca's address in later states, while the *Massacre of the Innocents* after Bandinelli is known in a late edition published by Thomassin.

74. Shoemaker and Broun, *Engravings of Marcantonio*, p. 9; Pezzini, et al., *Raphael invenit*, pp. 9–10.

75. See Shoemaker and Broun, *Engravings of Marcantonio*, cat. nos. 21, 32, 31, 43. See also Sylvia Ferino Pagden, "Invenzioni Raffaellesche adombrate nel libretto di Venezia: La 'Strage degli Innocenti' e la 'Lapidazione di Santo Stefano' a Genova," *Studi su Raffaello*, M. Sambucco Hamoud and M. L. Strocchi eds., 2 vols. (Urbino, 1987), pp. 63–72.

76. Oberhuber, "Raffaello e l'incisione," in Mancinelli, et al., *Raffaello in Vaticano*, p. 334.

77. E. Knab, E. Mitsch, E. and K. Oberhuber, *Raphael: Die Zeichnungen* (Stuttgart, 1983), cat. nos. 535, 38.

78. J. A. Gere and Nicholas Turner, *Drawings by Raphael*, exh. cat. (London: British Museum, 1983), cat. nos. 124–25.

79. *Ibid.*

80. Connected to the print by Sylvia Ferino Pagden in *Raffaello a Firenze: Dipinti e disegni delle collezioni fiorentine*, exh. cat. (Milan, 1984), pp. 308–10, cat. no. 16, fig. 46.

81. *Ibid.*, p. 310, cat. no. 45.

82. Gere and Turner, *Drawings by Raphael*, p. 171, cat. no. 139.

83. See C. H. Wood's entry in Shoemaker and Broun, *Engravings of Marcantonio*, pp. 118–19, cat. no. 31.

84. *Ibid.*, p. 119, n. 7; Pagden, *Raffaello a Firenze*, p. 308; Roger Jones and Nicholas Penny, *Raphael* (New Haven and London, 1983), pp. 129–32.

85. Jones and Penny, *Raphael*, p. 29.

86. D. Landau in Jane Martineau and Charles Hope, eds., *The Genius of Venice, 1500–1600*, exh. cat. (London, 1983), cat. no. P15.

87. Shoemaker and Broun, *Engravings of Marcantonio*, p. 146, cat. no. 43.

88. Knab, Mitsch, and Oberhuber, *Raphael*, cat. no. 545.

89. P. Joannides, *The Drawings of Raphael* (Oxford, 1983), p. 204, no. 285.

90. *Raphael dans les collections françaises*, exh. cat., intro. by André Chastel (Paris, 1983–84), pp. 345–46. One of these copies, a drawing in wash in the Louvre (which we have not seen), is described as being in reverse of the print. It may be a record of a final *modello* for the engraving, similar to the preparatory drawing for the *Morbetto* in the Uffizi. Erika Tietze-Conrat published a drawing connected with the print, which, from the illustration, appears to be a copy of a lost Raphael drawing: see "A Sheet of Raphael Drawings for the *Judgment of Paris*," *Art Bulletin* 135 (1953), pp. 300–02.

91. Vasari, *Vite*, V, p. 411.

92. Jones and Penny, *Raphael*, p. 179, feel that the inclusion of the gods in the sky ruins the composition and must have been the work of an assistant.

93. William M. Ivins, Jr., *How Prints Look: An Illustrated Guide* (Boston, 1958; rev. ed. London, 1988), p. 94; Shoemaker and Broun, *Engravings of Marcantonio*, p. 146.

94. Shoemaker and Broun, *Engravings of Marcantonio*, p. 147, n. 2.

95. One might also explain this by the physical difficulty of interrupting the forceful movement of the arm necessary to score the plate longitudinally, thereby forcing the engraver, or the assistant given this task, to score it in its entirety before the engraving proper could be started.

96. The seventeen cases of sketches considered here include a far greater number of individual drawings, as there are instances where many sketches related to one print survive. In some cases the drawings referred to may be counterproofs, in others they may be considered by some authors to be copies: these factors have been taken into account, and the reader is referred to the literature for further information about each sheet. The abbreviations (in brackets) after the number relate to whether the image is reversed (R) and those before the number to the following books, the number being that of the catalogue: KMO = Knab, Mitsch, and Oberhuber, *Raphael*; GT = Gere and Turner, *Drawings by Raphael*; M = Erwin Mitsch, *Raphael in der Albertina*, exh. cat. (Vienna, 1983); P = Petrucci, *Il Cinquecento*. For Marcantonio: B.1 (KMO 211); B.10 (KMO 583R; M 44R); B.18, 20 (KMO 340–41, 345 et al.); B.32 (KMO 219); B.52 (KMO 427R; GT 120R); B.311 (KMO 358; GT 115); B.342 (KMO 551); B.352 (KMO 535–38; GT 124–25); B.417 (KMO 450R, 452R, 480R); B.481 (GT 166R; P pl.5R). For Agostino Veneziano: B.5 (GT 146R); B.250 (KMO ill. 137); B.286 (GT 189). For Marco Dente: B.323 (KMO 530; GT 188); B.327 (M 68); B.484 (M 65R).

97. The fifteen cases of *modelli* are listed here following the same method as described in the preceding footnote. The additional references are to: SB = Shoemaker and Broun, *Engravings of Marcantonio*; H = Frederick Hartt, *Giulio Romano* (New Haven, 1958); RI = Pezzini, et al., *Raphael Invenit*. For Marcantonio: B.26 (KMO 451); B.34 (KMO 383); B.45 (SB fig. 37); B.48 (KMO 444); B.68 (KMO ill. 138); B.113 (H 6); B.116 (SB fig. 26R); B.207 (KMO 494; GT 112); B.306 (SB fig. 38aR). For Agostino Veneziano: B.43 (KMO 524R; GT 158R); B.105 (KMO ill. 129). For Marco Dente: B.4 (RI p. 73,6); B.7 (M ill. p. 137); B.54 (KMO 458–9; GT 136); B.327 (M 68).

98. Shoemaker and Broun, *Engravings of Marcantonio*, p. 133, cat. no. 38.

99. B.422; see C. L. Frommel, *Baldassare Peruzzi als Maler und Zeichner* (Vienna, 1967–68), p. 135, no. 98.

100. Seen with dealers Hill-Stone, New York, in 1989.

101. B.213; see Frommel, *Baldassare Peruzzi*, p. 51, no. 6.

102. See Christian von Heusinger, et al., *Das gestochene Bild: Von der Zeichnung zum Kupferstich*, exh. cat. (Braunschweig, 1987), *passim*.

103. Joannides, *Drawings of Raphael*, intro. (pp. 11–31).

104. Gere and Turner, *Drawings by Raphael*, cat. no. 202; B.208.

105. Joannides, *Drawings of Raphael*, intro. (pp. 11–31).

106. Knab, Mitsch, and Oberhuber, *Raphael*, cat. no. 494; B.207.

107. To these we would add the concetti for the *Massacre of the Innocents* and the *Quos Ego*, the *modelli* for which, probably linear rather than tonal in technique, were lost, possibly in the transfer to the plate.

108. Knab, Mitsch, and Oberhuber, *Raphael*, cat. no. 459. The drawing has recently been acquired by the National Gallery of Scotland.

109. Gere and Turner, *Drawings by Raphael*, cat. no. 136.

110. Knab, Mitsch, and Oberhuber, *Raphael*, ill. 138; Hartt, *Giulio Romano*, no. 6; Shoemaker and Broun, *Engravings of Marcantonio*, fig. 37.

111. Joannides, *Drawings of Raphael*, p. 28.

112. As E. Mitsch has observed in *Raphael in der Albertina: Aus Anlaß des 500. Geburtstages des Künstlers*, exh. cat. (Vienna, 1983), cat. no. 68.

113. But see Jones and Penny, *Raphael*, p. 152, n. 55; also Shoemaker and Broun, *Engravings of Marcantonio*, pp. 112–13, cat. no. 28; Jurgen Winkelmann, in Carla Bernardini, et al., *L'Estasi di Santa Cecilia di Raffaello da Urbino nella Pinacoteca Nazionale di Bologna*, exh. cat. (Bologna, 1983), pp. 179–80, re-attributes the drawing to Perino, and dates it ca. 1520.

114. Knab, Mitsch and Oberhuber, *Raphael*, cat. no. 129.
115. Mitsch, *Raphael in der Albertina*, ills. p. 137, and Pezzini, et al., *Raphael Invenit*, p. 73, cat. no. 6.
116. *Andrea Mantegna*, pp. 60, 65.
117. B.18/20; B.34/35; B.52/53; B.64/77; B.65/78; B.199/200; B.248/249; B.297/297A; B.332/333; B.493/undescribed print in British Museum (inv. no. 1866-7-14-88). To these one should add the two versions of the *Dido* (B.187), so deceptively similar that they had not been described until the differences between them were spotted by Henri Zerner, and published in "A propos de faux Marcantoine: Notes sur les amateurs d'estampes à la Renaissance," *Bibliothèque d'Humanisme et Renaissance* 22 (1961), pp. 477–81.
118. B.50/51; B.250/250A; B.328/329.
119. B.50/51; B.58/57; B.61/60; B.63/63A; B.76/64; B.91/79; B.116B/116; B.117A/117; B.210/209; B.217A/217; B.246/245; B.341/340; B.351/350; B.444/443; B.490/489.
120. B.31/30; B.38/37; B.103/102; B.347/346; B.447/476; B.482/481; B.485/484.
121. B.250A/250; B.106/105; B.237/236, B.425/424; B.212/211.
122. Shoemaker and Broun, *Engravings of Marcantonio*, p. 11; but also see, for a suggestion that plates may have been repeated so they could be sold to two different publishers at the same time, Patricia Emison, "Marcantonio's *Massacre of the Innocents*," *Print Quarterly* 1 (1984), p. 262, n. 12.
123. Shoemaker and Broun, *Engravings of Marcantonio*, p. 130, cat. no. 37.
124. See Emison, "Marcantonio's *Massacre*," *passim*.
125. Shoemaker and Broun, *Engravings of Marcantonio*, p. 108, cat. no. 26; Emison's arguments ("Marcantonio's *Massacre*," pp. 260–61) for reversing this order do not seem to take into account Marcantonio's stylistic development, as described by Shoemaker.
126. Although not relevant to the present discussion, it may be nonetheless useful to mention that there is in the British Museum a *Portrait of Clement VII* which obviously belongs to the same group, and which seems to be still undescribed.
127. Drawing in Louvre, not seen by authors, said by Shoemaker and Broun, *Engravings of Marcantonio*, p. 178, n. 4, to be copy of Marco's print.
128. A similar conclusion was reached by D. Cordellier and B. Py in the cat. nos. 33 and 34 of *Raffaello e i Suoi*, exh. cat. (Rome, 1992), pp. 108–09.
129. Typical cases are the *St. Cecilia*, copied by Marco from Marcantonio (B.116, 116B), the *Battle with a Cutlass*, copied from the latter's prototype by Agostino (B.211, 212), and the *Man Carrying the Base of a Column*, also copied by Agostino, as Shoemaker convincingly argued (B.476, 477). See Shoemaker and Broun, *Engravings of Marcantonio*, pp. 140–42.
130. Oberhuber in Mancinelli, et al., *Raffaello in Vaticano*, p. 339.
131. Pezzini, et al., *Raphael Invenit*, p. 10.
132. For example, the *Massacre of the Innocents* (B.18); the *Morbetto* (B.417); the *Parnassus* (B.247); *David and Goliath* (B.10), where the tablet added later looks very unconvincing; and *Trajan between the City of Rome and Victory* (B.361), of which there are impressions before the monogram in New York, and in a private collection.
133. See Shoemaker and Broun, *Engravings of Marcantonio*, p. 11.
134. H. Hirth, "Marcanton und sein Stil: Eine Kunstgeschichtliche Studie," Diss. (Leipzig and Munich, 1898), p. 26.
135. Wolfgang Braunfels, "Die 'Inventio' des Künstlers," *Festschrift für Ludwig Heinrich Heydenreich* (Munich, 1964), p. 20, who thought the *Massacre of the Innocents* to be the first such instance.
136. See Chastel, *Sack of Rome*, p. 161, fig. 80.
137. Early impression, before the date, in the British Museum.
138. Apart from the practice of book publishers, Marcantonio may have derived the idea of dating his prints to the day from Giorgione in Venice, who dated his so-called *Laura*, now in Vienna, in a similar fashion: "1 June 1506." He must have dropped this practice soon after settling in Rome.

139. This number, moreover, excludes the series of copies of Dürer's *Small Passion*, which should be given back to Agostino, as they have nothing of Marcantonio, stylistically or technically, and they show the tablet in a clumsy perspective which is much closer to Agostino, and totally unknown in Marcantonio.
140. See Artemis catalogue, *Master Prints and Drawings: 16th to 19th Centuries* (London, 1984) no. 7. For an interesting article on the variety of borrowings the engraver used for this print, see Gioconda Albricci, "'Lo Stregozzo' di Agostino Veneziano," *Arte Veneta* 36 (1982), pp. 55–61.
141. *Psyche's Father Consulting the Oracle* (B.235) is number 4 in a series engraved in the 1530s by the Master of the Die. It should not be forgotten that Agostino was probably in Mantua between 1527 and ca. 1530.
142. Hans Rupprich, ed., *Dürer: Schriftlicher Nachlass* (Berlin, 1956–69), vol. I, p. 158.
143. Arthur M. Hind, *An Introduction to a History of Woodcut* (repr. London and New York, 1963), vol. I, p. 91.
144. See Prince d'Essling, *Les livres à figures vénitiens* (Paris and Florence, 1907–14), vol. III, p. 118, n. 1. The cutter in this case was Eustachio Cellebrino, one of the best-known Venetian cutters of the early sixteenth-century and a competitor of the celebrated Zoan Andrea Vavassore, called Guadagnino, and of the hyperactive Lucantonio degli Uberti who, though he was a Florentine, had a Venetian career spanning about twenty-three years and was involved in manufacturing more than sixty illustrated books. For Lucantonio, see d'Essling, *Les livres*, pp. 98–107; Hind, *Early Italian Engraving*, I, pp. 211–18; and M. Muraro and David Rosand, *Tiziano e la silografia veneziana del Cinquecento*, exh. cat. (Vicenza, 1976) pp. 73–74. For Zoan Andrea, see d'Essling, *Les livres*, pp. 109–16.
145. Jean Michel Massing, "Jacobus Argentoratensis: Etude préliminaire," *Arte Veneta* 31 (1977), pp. 42–52. See also Jean Michel Massing "'The Triumph of Caesar' by Benedetto Bordon and Jacobus Argentoratensis: Its Iconography and Influence", *Print Quarterly* 7 (1990) pp. 2–21.
146. "Benedetto Bordon, miniador . . . cum gravissima fatica sua e non mediocre spesa se habi inzegnato a stampare i disegni del triumpho de Cesaro, designando quelli prima sopra le tavole . . . et deinde ha fatto intagliar quelli in ditto legname." Massing, "Triumph of Caesar," pp. 1–21.
147. See also M. Bury, "The 'Triumph of Christ,' after Titian," *Burlington Magazine* 131 (1989), pp. 188–97.
148. Muraro and Rosand, *Tiziano*, pp. 73, 85.
149. Martineau and Hope, eds., *Genius of Venice*, cat. no. P19.
150. Muraro and Rosand, *Tiziano*, p. 71.
151. Martineau and Hope, eds., *Genius of Venice*, cat. no. P17.
152. Jan Johnson, "Ugo da Carpi's Chiaroscuro Woodcuts," *Print Collector*, nos. 57–58 (1982), pp. 63–67 and pp. 68–71 for the similar inscription on B.12. For a fuller discussion of the issue of privileges in both Venice and Rome, see Chapter VI, pp. 301–02.
153. Johnson, "Ugo da Carpi," p. 64.
154. Caroline Karpinski, "The Print in Thrall to Its Original: A Historiographic Perspective," in *Retaining the Original: Multiple Originals, Copies, and Reproductions*, Studies in the History of Art, vol. 20 (Washington, D.C.: National Gallery of Art, 1989), pp. 101–09.
155. Vasari, *Vite*, V, p. 422.
156. Johnson, "Ugo da Carpi," p. 30.
157. Johnson, "Ugo da Carpi," p. 30, believes that these faithful copies were piracies that might have plagued Ugo's career: if chiaroscuro woodcuts were in any way similar to contemporary engravings, then he would not have been overly worried about these forgeries, as he was producing them himself!
158. *Ibid.*, pp. 23–29.
159. Vasari, *Vite*, V, p. 422.
160. *Ibid.*, p. 226.
161. Although such a copy has not yet been described, H. Zerner

162. A. E. Popham, "Observations on Parmigianino's Designs for Chiaroscuro Woodcuts," in *Miscellanea I. Q. van Regteren Altena* (Amsterdam, 1969), pp. 48–51.

163. See also H. Zerner, "Sur Giovan Jacopo Caraglio," in *Actes du XXIIe Congrès International d'Histoire de l'Art* (Budapest, 1972), pp. 691–95.

164. A. E. Popham, *Catalogue of the Drawings of Parmigianino* (New Haven and London, 1971), vol. I, pp. 11ff. A drawing for the *Diogenes* was sold by Sotheby's, New York, 13 January 1993, lot no. 28.

165. See Karpinski's review of Eugene A. Carroll, *Rosso Fiorentino*, in *Print Quarterly* 5 (1988), p. 173 and n. 4.

166. To further confirm the closeness of the collaboration that existed between Parmigianino and Caraglio until the Sack, a sketch in the Fitzwilliam, Cambridge, is drawn on the verso of an impression of Caraglio's *Adoration of the Shepherds* (Popham 47), while another in the Metropolitan Museum, New York (Popham 302) is drawn on the verso of an impression of the *Martyrdom of St. Peter and St. Paul*. See Popham, *Drawings of Parmigianino*, I, pp. 10–11.

167. Vasari, *Vite*, V, p. 226.

168. Popham has discussed this issue at length, and there is no need for us to paraphrase him here *in extenso*. Popham, *Drawings of Parmigianino*, I, pp. 11–17; and Popham, *Altena*, *passim*.

169. Vasari, *Vite*, V, p. 227.

170. That Parmigianino held on to at least one woodblock is confirmed by another document, an entry dated 12 February 1558 in the diary of the Venetian sculptor Alessandro Vittoria, who on that day bought a sketchbook of Parmigianino drawings together with "una tavoletta di legno di pero dissegnata con la Sibilla Cumana et Otaviano imperatore di man dil soprascritto ms. Francesco Parmigianino." Unless, that is, the sketchbook and block were part of Antonio da Trento's loot. Popham, *Altena*, p. 49.

171. Vasari, *Vite*, V, p. 423.

172. Campbell Dodgson, "'Marcus Curtius': A Woodcut after Pordenone," *Burlington Magazine* 37 (1920), p. 61.

173. The drawing, formerly in Chatsworth, was sold at Christie's, London, 3 July 1984, no. 36.

174. But see Johannes Wilde's unpublished dissertation, "Die Anfänge der italienischen Radierung," quoted in Popham, *Drawings of Parmigianino*, I, p. 14, n. 1.

175. Vasari, *Vite*, V, p. 226. The passage is unclear; he might mean drawings, and not plates.

176. Popham, *Drawings of Parmigianino*, I, pp. 16–17.

177. *Ibid.*, p. 16.

178. For the close relationship between Rosso, Parmigianino and Caraglio, see Alessandro Marabottini, *Polidoro da Caravaggio* (Rome, 1969), p. 92 and p. 292, n. 89.

179. Eugene A. Carroll, *Rosso Fiorentino*, exh. cat. (Washington, D.C.: National Gallery of Art, 1987–88) *passim*, esp. p. 9.

180. *Ibid.*, p. 96, cat. no. 19.

181. *Ibid.*, p. 98.

182. *Ibid.*, p. 23, on the authority of Vasari.

183. See *ibid.*, pp. 25–29, for the inventory of possessions abandoned by Rosso in Arezzo.

184. *Ibid.*, pp. 38, 54–58.

185. Karpinski, review in *Print Quarterly*, p. 172.

186. See Evelina Borea, 'Stampa figurativa e pubblico dalle origini all'affermazione nel Cinquecento", in *Storia dell'Arte Italiana*, (Turin, 1979), pt. 1, vol. II, pp. 317–413, esp. p. 328.

187. See Franz Unterkircher, "Der erste illustrierte italienische Druck und eine Wiener Handschrift des gleichen Werkes (Hain 15722, Cod. Vindob. 3805)" in *Hellinga: Festschrift, Feestbundel, Mélanges: Forty-three Studies in Bibliography Presented to Prof. Dr. Wytze Hellinga* (Amsterdam, 1980), pp. 498–516.

188. See Levenson, et al., *Early Italian Engravings*, pp. 42–43; Borea, "Stampa e pubblico," p. 337.

189. All appear to be, at the earliest, from an eighteenth-century edition: see Hind, *Early Italian Engraving*, V, p. 48.

190. Bernard Berenson, *Italian Pictures of the Renaissance: Florentine School* (London 1963), vol. I, p. 60; vol. II, pl. 638.

191. H.V.A.III.6 a and b: for the importance of the buildings in this image, and the alterations they went through in the copy (b), see Maria Grazia Ciardi Duprè et al., *L'Oreficeria nella Firenze del Quattrocento*, exh. cat. (Florence, 1977), p. 211.

192. Hind, *Early Italian Engraving*, V, p. 88, no. 9; Levenson, et al., *Early Italian Engravings*, pp. xxii, 273.

193. See Leo Steinberg, "Leonardo's *Last Supper*," *Art Quarterly* 36 (1973), pp. 303–16.

194. Levenson, et al., *Early Italian Engravings*, cat. no. 189, nn. 1, 2, with further references: John Shearman, *Andrea del Sarto* (Oxford, 1965), vol. II, pl. 8b; and Shearman, *Andrea del Sarto*, I, pp. 15, 24–25; II, pp. 198–200.

195. For such borrowings from Michelangelo, see Mario Rotili, ed., *Fortuna di Michelangelo nell'incisione*, exh. cat. (Benevento, 1964), pp. 48–54. For a case in which Agostino Veneziano borrowed an entire group of figures from Raphael's *School of Athens* but felt free to add a head of his own (B.XIV.366.492), and for other similar cases, see Jeremy Wood, "Cannibalized Prints and Early Art History: Vasari, Bellori and Fréart de Chambray on Raphael," *Journal of the Warburg and Courtauld Institutes* 51 (1988), pp. 210–20, esp. pp. 215 and 217, n. 52.

196. For the drawing, see Charles de Tolnay, *Michelangelo* (Princeton, 1970), vol. III, p. 221, pl. 156. For another version, by Beatrizet, see Stefania Massari, *Tra mito e allegoria: Immagini a stampa nel '500 e '600* (Rome, 1989), pp. 234–37.

197. "Ossatura", in Borea, "Stampa e pubblico," p. 361.

198. The issue is discussed fully, and with very interesting insights, by Michael Bury, "On Some Engravings by Giorgio Ghisi Commonly Called 'Reproductive,'" *Print Quarterly* 10 (1993), pp. 4–19. See also Hermann Voss, "Kompositionen des Francesco Salviati in der italienischen Graphik des XVI. Jahrhunderts," *Mitteilungen der Gesellschaft für Vervielfältigende Kunst (Beiträge der "Graphischen Künste")* (1912), pp. 30–37, 60–70.

199. The date has often been misread as 1531, inspiring some imaginative art-historical somersaults in justifying such an early date for an accomplished work, and such a long and mysterious gap between it and all the other works by Giulio which could easily be placed in the late 1530s.

200. A. P. F. Robert-Dumesnil, *Le peintre-graveur français* (Paris, 1835–71), vol. IX, p. 181, no. 1.

201. For example Beatrizet, although at times even he had to accept commissions from Barlacchi (B.XV.244.9), Lafrery (B.XV.244.10), or Salamanca (B.XV.262.44).

202. Such self-congratulatory inscriptions were not uncommon, particularly in the case of Beatrizet, and that found on one of the eleven plates of his magnificent version of Michelangelo's *Last Judgment* (B.XV.257.37) greets the customer as follows: "Iucundissime lector, ac bonarum artium cupidissime . . ." and speaks of the engraver's "labore et ingenio" in making this reproduction "elegantissime."

203. "Il poeta el pittor Vanno di pare / et tira il loro ardire tutto ad un segno / Si come espresso in queste carte appare / Fregiate dopre e dartificio degno / Di questo Roma ci puo essempio dare / Roma ricetto dogni chiaro ingegno / Da le cui grotte ove mai non saggiorna / Hor tanta luce a si bella arte torna" (B.XV.231.82).

Notes to Chapter V

1. Maurits de Meyer, *De Volks- en Kinderprent in de Nederlanden van de 15e tot de 20e eeuw* (Antwerp and Amsterdam, 1962), pp. 9–10, refers to catchpenny prints sold by publishers to retailers by the ream in the late eighteenth and nineteenth centuries, in one case a

shipment of twenty-six reams (13,000 prints), in another a dealer's statement that he sold one million prints in a three month period.

2. A fuller discussion of this subject may be found in the introduction to Linda B. and Peter W. Parshall, *Art and the Reformation* (Boston, 1986), pp. xxxii–xxxvii.

3. Karl Schottenloher, *Flugblatt und Zeitung* (Berlin, 1922). Schottenloher's researches were followed immediately by a number of other studies of the subject.

4. Max Geisberg, *Der deutsche Einblatt-Holzschnitt in der ersten Hälfte des XVI. Jahrhunderts* (Munich, 1923–30).

5. Wouter Nijhoff, *Nederlandsche Houtsneden, 1500–1550* (The Hague, 1930–39).

6. Erwin Panofsky, *Albrecht Dürer* (Princeton, 1948), vol. II, pp. 49–50.

7. For example, we are unaware of any copies of Dürer's *Large Books* which were hand-colored in his shop or shortly after. Hand-coloring and various other means of "enhancing" Dürer's prints were, however, introduced during the so-called Dürer Renaissance in the late sixteenth and early seventeenth centuries.

8. William M. Ivins, Jr., "Notes on Three Dürer Woodblocks," *Metropolitan Museum Studies* 2 (1929), pp. 102–11. The "control" case in this study is a block for the *Coat of Arms of Michael Beheim* (New York, Pierpont Morgan Library). The commission is referred to in a letter by Dürer now pasted to the verso of the block stating that the artist had completed the drawing but that it was left to Beheim to find a cutter.

9. This entailed reissuing the *Apocalypse* of 1498 along with the *Large Passion* and the *Life of the Virgin*. Far too much has been written on Dürer's influence to survey it here. A revealing study of his impact on the structure of narrative art in Italy can be found in Cecil Gould, "Dürer's Graphics and Italian Painting," *Gazette des Beaux-Arts*, 6th ser., 75 (1970), pp. 103–16.

10. Dieter Koepplin and Tilman Falk, *Lucas Cranach*, exh. cat. (Basel and Stuttgart, 1974–76), vol. I, pp. 185–217, on Cranach's activity under court patronage.

11. Marx Treitzsaurwein's *Weisskunig* written in 1514 and illustrated for Maximilian I is an example. See on the *Stag Hunt*, Koepplin and Falk, *Cranach*, I, pp. 241–43, cat. no. 138.

12. A much later document (1534) insists that as court painter Cranach was under no written contract during the reign of Friedrich or his successor. Werner Schade, *Cranach: A Family of Master Painters*, trans. Helen Sebba (New York, 1980), p. 23, nn. 108–12.

13. Campbell Dodgson, "Rare Woodcuts in the Ashmolean Museum, Oxford — II," *Burlington Magazine* 39 (1921), pp. 70–74. See also Tilman Falk, et al., *Hans Burgkmair: Das graphische Werk, 1473–1973*, exh. cat. (Stuttgart: Graphische Sammlung, Staatsgalerie, 1973), cat. no. 20.

14. Falk, et al., *Burgkmair*, cat. nos. 23–26; Tilman Falk, *Hans Burgkmair: Studien zu Leben und Werk des Augsburger Malers* (Munich, 1968), pp. 67–68. It is worth noting that one of the blocks for the frieze showing the natives of Arabia has the *Virgin and Child with a Round Arch* cut into the reverse. It survives as part of the Derschau collection now in the Kupferstichkabinett in Berlin. See Renate Kroll in *Hans Burgkmair, 1473–1531*, exh. cat. (Berlin: Staatliche Museen, 1974), pp. 37–38. Another of the blocks for the frieze is signed by Cornelis Liefrinck who, Kroll suggests, may have been recruited by the Welser corporation through its Antwerp offices. On the theme of this woodcut, see Götz Pochat, *Der Exotismus während des Mittelalters und der Renaissance* (Stockholm, 1970), pp. 152–55.

15. Jay Alan Levenson, "Jacopo de' Barbari and Northern Art of the Early Sixteenth Century" (Ph.D. diss. New York University, 1978), pp. 266–78, cat. nos. 43–44.

16. David Rosand and Michelangelo Muraro, *Titian and the Venetian Woodcut*, exh. cat. (Washington, D.C.: National Gallery of Art, 1976), p. 11, n. 20. The frieze was commissioned by the Paduan illuminator Benedetto Bordon who received a privilege for it.

There was apparently another woodcut copy by Benedetto Bordon in circulation that has not survived. See most recently Jean Michel Massing, "'The Triumph of Caesar' by Benedetto Bordon and Jacobus Argentoratensis: Its Iconography and Influence," *Print Quarterly* 7 (1990), pp. 2–21. Falk, *Burgkmair: Studien*, p. 68, mentions Mantegna's *Triumph* as a possible source for Burgkmair's woodcut, though curiously not Jacob's frieze.

17. Falk, et al., *Burgkmair*, cat. no. 26.

18. Falk, *Burgkmair: Studien*, pp. 67–68, notes Peutinger's interest in the Welser expedition.

19. A document of payment from Burgkmair to Resch records his presence in Burgkmair's house during October 1508 (Falk, *Burgkmair: Studien*, p. 116, doc. no. 37). Kroll in *Hans Burgkmair*, p. 38, also notes this fact and the Liefrinck signature.

20. For general literature on the chiaroscuro woodcut in the north, see the founding study by Anton Reichel, *Die Clair-Obscur-Schnitte des XVI., XVII., und XVIII. Jahrhunderts* (Zurich, Leipzig, and Vienna, 1926). See more recently Walter L. Strauss, *Chiaroscuro: Clair-Obscur Woodcuts by the German and Netherlandish Masters of the Sixteenth and Seventeenth Centuries* (Greenwich, Conn., 1973).

21. Giorgio Vasari, *Le vite de' più eccellenti pittori, scultori ed architettori*, ed. G. Milanesi (Florence, 1878–85), vol. V, p. 420.

22. On this subject, see Julius S. Held, "The Early Appreciation of Drawings," in *Latin American Art and the Baroque Period in Europe*, Studies in Western Art: Acts of the Twentieth International Congress of the History of Art, vol. 3 (Princeton, 1963), pp. 72–95.

23. Carl Wehmer, "Ne Italo ceder videamur: Augsburger Buchdrücker und Schreiber um 1500," in *Augusta, 955–1955*, ed. Hermann Rinn (Augsburg, 1955), p. 151. This conclusion is based on the tax rolls.

24. Arthur M. Hind, *An Introduction to a History of Woodcut*, vol. I pp. 299–304; vol. II, p. 462.

25. Falk, et al., *Burgkmair*, cat. no. 4. For Burgkmair's activity with Ratdolt, see Falk, *Burgkmair: Studien*, pp. 13–21; on color printing, pp. 15–16. Augsburg printers were experimenting with other "coloristic" effects as well. See, for example, an anonymous white-line woodcut published by Johan Otmar in Augsburg in 1502. Wilhelm Ludwig Schreiber, *Handbuch der Holz-und Metallschnitte des XV. Jahrhunderts*, 3rd ed. (Stuttgart, 1969), vol. VI, p. 44, no. 2876.

26. Lehrs, VIII, see esp. nos. 3, 5, 17, each of which survives in more than one impression, the treatment varying with each; and Franz Schubert, "Mair von Landshut," *Verhandlungen des historischen Vereins für Niederbayern* 63 (1930), pp. 22–37.

27. Joseph Meder, *Die Handzeichnung: Ihre Technik und Entwicklung*, 2nd ed. (Vienna, 1923), pp. 79–96; and Francis Ames-Lewis and Joanne Wright, *Drawing in the Italian Renaissance Workshop*, exh. cat. (Nottingham: University Art Gallery; and London: Victoria and Albert Museum, 1983), pp. 43–49.

28. Andrew Robison, *Paper in Prints*, exh. cat. (Washington, D.C.: National Gallery of Art, 1977), pp. 25–37, on the history of prepared and dyed papers.

29. Meder, *Die Handzeichnung*, pp. 175–76.

30. On chiaroscuro drawings of this period, see most recently Hans Mielke, *Albrecht Altdorfer: Zeichnungen, Deckfarbenmalerei, Druckgraphik*, exh. cat. (Berlin and Regensburg, 1988), pp. 18–19; and Koepplin and Falk, *Cranach*, I, pp. 123, 176, cat. nos. 53, 77.

31. Mielke, *Altdorfer*, p. 54, cat. no. 21.

32. *Ibid.*, pp. 18–19. Altdorfer's drawings were regularly done on colored paper from 1506 onward. Several drawings are dated to that year.

33. *Niklaus Manuel Deutsch: Maler, Dichter, Staatsmann*, exh. cat. (Bern, 1979), pp. 229–30, cat. no. 76. A second panel with a *Bathsheba* has on its reverse another chiaroscuro painting of *Death and the Maiden* (pp. 230–31, cat. nos. 77–78).

34. Campbell Dodgson, *Catalogue of Early German and Flemish Wood-*

cuts Preserved in the Department of Prints and Drawings in the British Museum (London, 1911), vol. II, pp. 286–87; Koepplin and Falk, *Cranach*, vol. I, pp. 63–64, cat. nos. 14–16. The surviving impressions are in London, British Museum, and Dresden, Kupferstichkabinett.

35. Falk, et al., *Burgkmair*, cat. nos. 21–22. On close examination the edition in Chicago, Newberry Library (on vellum), shows the clear trace of red bole (not red ink as used elsewhere for printing the red letters) beneath the gold. The red bole must have been printed with letterpress and the gold applied by hand, probably flocked on as Falk concludes.

36. 24 September 1508 from Peutinger to Friedrich of Saxony: "In verschinem jare hat euer fürstlich gnad camerer, herr Degenhart Peffinger [Pfeffinger], mir kurisser, von gold und silber durch euer fürstlich gnad maler [Cranach] mit dem truck gefertiget, geantwurt, mich damit bewegt, solliche kunst alhie auch zuwegenzupringen. Und wiewol ich des ain costen getragen, so hab ich doch von gold und silber auf pirment [parchment] getrukt kürisser zuwegengebracht, wie euer fürstlich gnad ich hiemit ain prob zuschicke, euer fürstlich durchleüchtigkeit underthäniglich bittende, wöllen die aus gnaden besichtigen und mir zu erkennen geben, ob die also gut getruckt seien oder nit." Adolf Buff, ed., "Rechnungsauszüge: Urkunden und Urkundenregesten aus dem Augsburger Stadtarchiv," *JKSW* 13 (1892), pt. 2, p. xi, doc. nos. 8560–61.

37. Eduard Chmelarz, "Jost de Negkers Helldunkelblätter Kaiser Maximilian und St. Georg," *JKSW* 15 (1894), pp. 392–97; Dodgson, "Rare Woodcuts," pp. 68–69; Reichel, *Die Clair-Obscur-Schnitte*, pp. 12–19; Falk, et al., *Burgkmair*, cat. nos. 21–22; Larry Silver, "Shining Armor: Maximilian I as Holy Roman Emperor," *Art Institute of Chicago Museum Studies* 12 (1985), pp. 8–29.

38. This connection is mentioned by Reichel, *Die Clair-Obscur-Schnitte*, p. 16.

39. The change in date has been attributed to Dürer's urgent departure from Nuremberg for Venice to escape the plague in the summer of 1505. Panofsky, *Dürer*, II, p. 24, cat. no. 161.

40. This aspect of the technique has a precedent in pasteprints, though there is no reason to suppose a direct connection. On the history of printing in metal inks and dusts, see Max Geisberg, "Holzschnittbildnisse des Kaisers Maximilian," *Jahrbuch der preussischen Kunstsammlungen* 32 (1911), p. 242. The definitive study of pasteprints is by Elizabeth Coombs, Eugene Farrell, and Richard S. Field, *Pasteprints: A Technical and Art Historical Investigation* (Cambridge, Mass, 1986). The preliminary wash in Cranach's color woodcuts may also have served as the means of wetting the paper for printing, or in any case it proved soluble when dampened, since there is evidence of bleeding and blending of the black and gold lines making it less clear in which order they were laid on. The black line block is also slightly out of register. It is hardly surprising that the difficult problem of alignment which continued to plague multi-block printing presented itself from the very beginning.

41. This is pointed out by Dodgson, *Catalogue of Woodcuts*, II, pp. 286–87, cat. no. 14.

42. The *St. George* impressions are in Berlin, Kupferstichkabinett (in black, gold, and silver on vellum), and Oxford, Ashmolean Museum (in black, gold, and silver on blue paper). The *Maximilian* impressions are in Chicago, Art Institute (in gold and black on parchment), Cleveland, Museum of Art (in white and black on blue paper), and Oxford, Ashmolean Museum (in gold, silver, and black on red paper). The Oxford impressions, both on paper, have an early provenance and show a nearly identical damage in the printing. The impressions in Berlin and Cleveland were previously together in the Liechtenstein collection, though they are on different grounds. See Falk, et al., *Burgkmair*, cat. nos. 21–22; Chmelarz, "Jost de Negkers Helldunkelblätter," pp. 392–97;

Silver, "Shining Armor," pp. 8–29; and Henry Francis, "The Equestrian Portrait of the Emperor Maximilian I by Hans Burgkmair," *Bulletin of the Cleveland Museum of Art* 39 (1952), pp. 223–25.

43. Dodgson, "Rare Woodcuts," p. 69, notes this color transition, which he attributes to the artist having used a cheaper metallic pigment that he believes must have changed color over time. However, the pattern in the shift of color in the lower areas of the composition is too regular to be either accidental deterioration of the pigment or a result of exposure from something laid over the print. Whether Burgkmair used flocking or some metallic pigment in some cases remains uncertain. There is dispute as to whether the white highlight block in the Cleveland impression was originally meant to receive gold dust. Probably it was. Robison, *Paper in Prints*, p. 29, believes that by printing the white first, the artist chose not to include the gold, but rather sought the effect of highlighting in white as with a brush. However Dodgson, *Catalogue of Woodcuts*, II, p. 74, first described this impression when still in the Liechtenstein collection as printed in a "dull white sticky-looking material." Francis describes the white pigment as a "somewhat sticky substance," which, if true, certainly implies the intention of adding gold or silver. One gets the sense that both scholars fingered the impression and prefer not to admit it. The impression of the *St. George* in Berlin shows variable discoloration of the silver from silvery to bronze to a dullish gray in a manner similar to the Oxford version. Here the shift in color to bright, burnished gold highlights is sharp and carefully calculated.

44. Both are printed on extremely thin paper which has been backed and printed with wide margins. The thinness may account for the flaw — a printer's crease — occurring at nearly the same point across both compositions, further physical evidence of the companionship between these two impressions. The Chicago impression intially appears to the naked eye to have been printed with gold ink over the black in what we regard as the first stage in Burgkmair's experiment. However, examined under the microscope, it can be seen to have been printed in the later fashion with the black line block laid on top of the gold. The deception results from the black ink adhering imperfectly where it contacted the gold. The margin around the entire woodcut shows that both the gold and black blocks were printed with borderlines aligned directly over one another. Notches at the corners of the black line block may give a clue to how the blocks were keyed. A smudge of gold on the horse's belly confirms that gold ink rather than flocked gold was used. We would like to thank Martha Tedeschi of the Prints and Drawings Department, Art Institute of Chicago, for examining this impression under the microscope on our behalf.

45. The first state impressions done on tinted paper or white parchment are often referred to as proof states, though this is technically a misnomer. The surviving examples and their distribution make clear that more than a proof state was intended.

46. Strauss, *Chiaroscuro*, pp. 8, 10, offers this last explanation without giving any argument for it.

47. These arguments are neatly summarized by Koepplin and Falk, *Cranach*, II, pp. 644–45; and N. G. Stogdon, *German and Netherlandish Woodcuts*, sale cat. (Berlin and London, 1991–92), cat. no. 23.

48. The *Ascent of the Magdalene* (B.72) and the *Martyrdom of St. Erasmus* (Holl.80), carry the earlier form of the device and are all dated 1506. The *St. George Standing with Two Angels* (B.67) appears in the earlier form and then partly altered in what must be a later state. See the impression from Adam Bartsch, *The Illustrated Bartsch*, (University Park, Pa., and New York, 1971–), vol. XI, p. 385 (where the location of the impression and the state are unidentified).

49. See, for example, B.1, 4, 17, 18, 34, 63, 67, 72.

50. On this point, see Landau as cited in Christiane Andersson and Charles Talbot, *From a Mighty Fortress: Prints, Drawings and*

Books in the Age of Luther, 1483–1546, exh. cat. (Detroit: Institute of Arts, 1983), p. 216.

51. H. W. Janson, "The 'Image Made by Chance' in Renaissance Thought," in *De artibus opuscula XL: Essays in Honor of Erwin Panofsky*, ed. Millard Meiss (New York, 1961), pp. 254–66, discusses this type of image and its classical origins, particularly in relation to Mantegna who projected a figure into a cloud formation in his *St. Sebastian* in Vienna, Kunsthistorisches Museum. Significantly, it was an idea popular in Venice where Burgkmair had contacts.

52. A practical procedure for designing a tone block after the completion of the line block is to print the line block, make a counterproof on tinted paper, heighten the result with brush in white, paste this down onto a new block, and then remove the areas of white highlight with the knife.

53. The second tone block can be recognized, among other changes, by the introduction of a bar-shaped form in the center of the circular highlight above St. Christopher's kneecap. The second state of the *Venus* exists in the line block only, further proof it was first a chiaroscuro.

54. For example, there are close stylistic affinities with the *Temptation of St. Anthony* (B.56) and *St. George standing with Two Angels* (B.67).

55. Chmelarz, "Jost de Negker's Helldunkelblätter," p. 395, first recognized this print as the secure terminus for the invention of the tone block. On Burgkmair's *Lovers overcome by Death*, see Reichel, *Die Clair-Obscur-Schnitte*, p. 53, no. 9; Falk, et al., *Burgkmair*, cat. no. 41; Andersson and Talbot, *Mighty Fortress*, cat. nos. 114, 115, p. 212. Dodgson, *Catalogue of Woodcuts*, II, pp. 85–86, records three states of Burgkmair's woodcut: I. with three blocks including the artist's name and the date MDX in the line block; II. the date removed and "Jost de Negker" imprinted vertically on the pilaster to the left; III. the cutter's signature changed to "Jost de Negker zu Augspurg" imprinted along the lower margin (though it is often trimmed off in surviving impressions). Hollstein mistakenly refers to a third tone block in state III. Stogdon, *German and Netherlandish Woodcuts*, cat. no. 22, has discovered the unrecorded first (now Ia) state from which substantial portions of the line block were removed (fig. 208). These adjustments occur at several points in the architecture and on the figures, including the sensitive area of the girl's face. This may reflect difficulties in printing, in alignment, or more likely an aesthetic decision, as Stogdon concludes.

56. Hans Baldung's *Witches' Sabbath* is also dated 1510, but like Cranach's *Holy Family in a Landscape* of 1509, we cannot be sure the tone block was not added later.

57. For a setting close in its perspective angle and architectural detail, see Gentile Bellini's *Processional Scene* (Uffizi 1293E), illustrated in Ames-Lewis and Wright, *Italian Renaissance Workshop*, cat. no. 57, pp. 264–65.

58. Falk, et al., *Burgkmair*, cat. no. 41, notes that her pose is reminiscent of Italian depictions of Daphne fleeing Apollo.

59. Julius Held, "Burgkmair and Lucas van Leyden," *Burlington Magazine* 60 (1932), pp. 308–13, believes the supine pose of the soldier is based on a drawing of *David Beheading Goliath* (London, British Museum) by Lucas van Leyden. He speculates that the drawing was introduced to Burgkmair by the block cutter Jost de Negker who, while still active in the Netherlands, had cut one of Lucas's designs. The similarities are compelling and not likely accidental. However, the style of the drawing (ca. 1514) is definitely later than the woodcut. Given that the figures are in reverse of one another, Lucas undoubtedly did not copy the print, and one must therefore posit a common model. See Wouter Kloek, "The Drawings of Lucas van Leyden," *Nederlands Kunsthistorisch Jaarboek* 29 (1978), p. 442, cat. no. 8. On the date of the drawing, see Jan Piet Filedt Kok, *Lucas van Leyden: graphiek*, exh. cat. (Amsterdam: Rijksprentenkabinet, 1978), pp. 87–88.

60. On the da Carpi case, see Chapter VI.

61. Letter from Jost de Negker to Maximilian I (27 October 1512): "dann allain ausgenomen hab ich aus geschaft des Dietrich Stainers Hansen Baumgartner sein angesicht gekunderfeit mit drei formen aines bogen gross, als die euer kais. maj. woll sehen, so die ausgedruckt werden, und sunst niemand nichtzit gemacht." Buff, ed., "Rechnungsauszüge," p. xvii, doc. no. 8594.

62. This is pointed out by Falk, *Burgkmair: Studien*, p. 103, n. 350.

63. Dodgson, "Rare Woodcuts," p. 68; A. J. J. Delen, *Histoire de la gravure dans les anciens Pays-Bas* (Paris and Brussels, 1924; repr. Paris, 1969), vol. II, pt. 2 , pp. 19–21.

64. For example: *St. George* d. 1508, B.23 (states IV/V); *Maximilian I* d. 1508, B.32 (states III/IV/V); *St. Sebastian* d. 1512, B.25; *St. Clara* with border, d. 1512, B.27; *Julius II* d. 1511, B.33 (state II); *Lovers Overcome by Death* d. 1510, B.40 (states III/IV/V); *Power of Women* d. 1519, B.1/4/6/73.

65. The impression of the *St. George* with a tone block in New York, Metropolitan Museum of Art, shows several breaks in the line block indicating that it was issued from a well-worn block.

66. *Hans Burgkmair*, p. 54, n. 16.

67. Falk, et al., *Burgkmair*, cat. nos. 22a, 22c. Cat. no. 21b, however, mentions an undescribed impression of the *St. George* with the tone block in which the 1508 date is still intact in the line block (Erlangen, Universitätsbibliothek).

68. Renate Kroll in *Hans Burgkmair*, p. 38.

69. Falk, et al., *Burgkmair*, intro., concludes that Jost's role has been undervalued and that he must have played a central part in Burgkmair's development of the chiaroscuro woodcut already from 1508 onwards. See also Reichel, *Die Clair-Obscur-Schnitte*, pp. 18–19.

70. Falk, *Burgkmair: Studien*, p. 85, notes this distinction. See, e.g., *Lovers Overcome by Death* (state III). In fact, Jost's signature is closer to the Netherlandish calligraphy used on some of Jacob Cornelisz.'s woodcuts than to Maximilian's court style.

71. Altdorfer's earliest known woodcuts were once presumed to be a unique set of tiny religious images discovered in the Benedictine Abbey at Mondsee thought to have been made around 1500 by the master himself, an inference based on a monogram and the amateurishness of the cutting. Franz Winzinger, *Albrecht Altdorfer: Die Graphik* (Munich, 1963), pp. 13, 53–55. In recent years these woodcuts have rightly been dismissed from Altdorfer's oeuvre.

72. Winzinger, *Altdorfer*, pp. 65–69. They are undated, but can be placed about 1513 on stylistic grounds.

73. Franz Winzinger, "Albrecht Altdorfers Münchner Holzstock," *Münchener Jahrbuch der bildenden Kunst*, 3rd ser., 1 (1950), pp. 191–203. Although the block is considerably larger than the blocks for the *Fall and Redemption*, it has been argued that the *Lamentation* was initially conceived as part of this lengthy cycle and then abandoned on account of a decision to reduce the scale. Winzinger points out that the dimensions of the block are exactly those of Dürer's small woodcut *Passion*, and also of Altdorfer's own *Annunciation* (B.44) dated in the following year. He speculates that the *Annunciation* and *Lamentation* were part of an initial series intended to mimic Dürer's *Passion* cycle. This seems reasonable, but he attributes the decision to economic considerations, in that cutting time would be reduced by the smaller format. Obviously the effective means of reducing the work is to shorten the cycle.

74. At some point the block was varnished front and back to protect the drawings. It is not possible to tell for certain whether any coating of oil or varnish was applied to the ground before the drawing was made. Nor can we be certain whether or how much the color of the wood may have darkened over time.

75. Berlin, Staatliche Museen, Kupferstichkabinett, has the blocks for B.41, 43, 45, 50, 53, 54, 57, 62.

76. There are impressions on uncut sheets now in the print collections in Erlangen, Universitätsbibliothek; Regensburg, Museen der Stadt; and the Cleveland Museum of Art. These are recorded in

Winzinger, *Altdorfer*, pp. 68–69.

77. For this reason we presume the entire edition had to be so printed and that these sheets cannot therefore be termed "proof impressions." The Cleveland impressions also show marks along the sides of the paper between the woodcut borders which may be the trace of clamps used while the sheets were drying.

78. Stephen Goddard, et al., *The World in Miniature: Engravings by the German Little Masters*, exh. cat. (Lawrence, Kansas: Spencer Museum of Art, 1988), pp. 13–26, on the development of the taste for miniature prints. For further discussion of the Little Masters, see Chapter VI.

79. Winzinger, "Altdorfers Münchner Holzstock," p. 196.

80. Simon Laschitzer, "Der Theuerdanck," *JKSW* 8 (1888), pp. 9–10.

81. An overview of these projects is given in Ludwig Baldass, *Der Künstlerkreis Maximilians* (Vienna, 1923). The individual works have each been given detailed treatment. See *Ausstellung Maximilian I*, exh. cat. (Innsbruck: Landhaus, 1969), and on Maximilian in general, Hermann Wiesflecker, *Kaiser Maximilian I* (Vienna, 1986), vol. V, ch. 5 (pp. 306–409), as well as the comprehensive bibliography (pp. 820–83).

82. Buff, ed., "Rechnungsauszüge," pp. xiii–xviii, doc. nos. 8575, 8577; and then the payment recorded in doc. no. 8581: Augsburg 1510 (after 15 December and before the following year). "So hab ich Hansen Burckemair, maller, den schreiner und den zwaien formschneidern für 92 bilder und anders, wie an gedachten malers handgeschrift begriffen ist, bezalt . . . fl. 113 creutzer 24." For Burgkmair's woodcuts, see also Falk, *Burgkmair*, cat. nos. 150ff. for the *Genealogy*.

83. Though the exact project is not mentioned in this letter, the document concerns a publication to be printed by Johann Schönsperger from designs contributed at least partly by Hans Schäufelein. This can only be the *Theuerdanck*.

84. Buff, ed., "Rechnungsauszüge," p. xvii, doc. no. 8594: "So will ich daran und darob sein, den zwaien formschneidern alle sachen fürordnen, beraiten und zuletst mit meiner aigen hand aus- und abfertigen und rain machen, damit die arbait und stuckwerk alle ainander des schnitz gleich und zuletst von ainer hand ausgemacht werden auch niemand mer dann ain hand daran erkennen muge."

85. *Ibid.*, for the salary request: "Darumb wa euer kais. maj. solich zwen formschneider . . . järlich auf jeden hundert guldin zu empfachen verschaffen." Laschitzer, "Der Theuerdanck," pp. 91–92, draws a slightly lower estimate per block. Later on in the letter Jost asks to have the cutters' fees delivered on a monthly basis to help with their subsistence: "So well mir euer kais. maj. bei Hansen Baumgartner verordnen, damit ich den zwen formschneidern alle monat an ir jedes hundert guldin sein gepurenden sold empfachen mug, ir narung davon zu gehaben." Laschitzer estimates the total cost of the illustrations, including wood and carpentry (but prior to printing and paper expenses), at 900 to 1,000 Rhenish *gulden*.

86. Laschitzer, "Der Theuerdanck," pp. 93–103. H. Theodor Musper's commentary to the facsimile edition *Kaiser Maximilians Theuerdanck* (Plochingen and Stuttgart, 1968), pp. 13–21, also discusses certain of these changes.

87. Simon Laschitzer, "Die Heiligen aus der 'Sipp-, Mag- und Schwägerschaft des Kaisers Maximilian I,'" *JKSW* 5 (1887), pp. 148–59, lists the signatures and dates. For the signatures and dates of the *Triumphal Procession* blocks: Franz Schestag, "Kaiser Maximilian I: Triumph," *JKSW* 1 (1883), pp. 177–80.

88. On the process of transfer, see Franz Winzinger, "Albrecht Altdorfer und die Miniaturen des Triumphzuges Kaiser Maximilians I," *JKSW* 62, n.s. 26 (1966), pp. 157–72. An example of Burgkmair's work for the *Triumph* can be seen in a superb pen and wash drawing for block no. 4 done in the same sense as the print: *Five Drummers Riding Abreast* (London, University College collection). The drawing is definitely by Burgkmair despite doubts previously

expressed, but shows no evidence of pricking or carboning. Although the exact procedures for transfer to the block are unclear, this may be a presentation drawing for Maximilian prior to Burgkmair having set the final design onto the block by redrafting it directly himself.

89. Buff, ed., "Rechnungsauszüge," pp. xx–xxi, doc. no. 8610: "aber si bitten all umb den wuchenwart guldin, so si nit arbeit haben . . . dan wa si nit arbeit haben, konden si on gelt nit lenger aufgehalten werden." If it is Cornelis Liefrinck then he must temporarily have returned to Antwerp, since as we have already noted he was in Burgkmair's service as early as 1508.

90. Most recently on this, Appuhn and Christian von Heusinger, *Riesenholzschnitte und Papiertapeten der Renaissance* (Unterschneidheim, 1976), pp. 54–61.

91. Baldass, *Künstlerkreis Maximilians*, pp. 18–19.

92. Tilman Falk in Falk, et al., *Burgkmair*, intro. After 1510 Burgkmair's single sheet woodcuts appeared almost exclusively with Jost's address where he identifies himself not as the *Formschneider*, but rather as the printer and publisher. Dodgson, *Catalogue of Woodcuts*, II, pp. 204–08, 445–46. See also Hildegard Zimmermann in Thieme–Becker, XXV, pp. 377–78. It appears he was only the publisher of the *Dance of Death* copy (Dodgson, p. 207).

93. See Augsburg, Stadtarchiv, an unpublished request to the council from 1559 (*Handwerkerakten* I, fol. 59). Then later *JKSW* 7 (1888), cxxiii (doc. no. 5057), 21 December 1566, "David de Nekher, Formschneider, welcher Kaiser Maximilian II. eine geschnittene Form präsentirt hatte, erhält aus Gnaden 15 Gulden bewilligt." Finally, a version of the *David and Bathsheba* (G.393–5) carries the signature of Samson de Negker, another of Jost's sons.

94. The connection between Hans Franck and Hans Lützelburger is based upon signatures appearing in three proof editions of Holbein's *Alphabet of Death* published in 1524: "Hanns Lützelburger / formschnider / genant Franck," in *Die Malerfamilie Holbein in Basel*, exh. cat. (Basel: Kunstmuseum, 1960), cat. no. 410, p. 322. Hans Franck is last recorded as having worked for Maximilian on the blocks he signed for the *Heilige Sippe* in 1516 and 1517, and the *Triumphal Procession* in 1517 and possibly 1518. See Laschitzer, "Die Heiligen," p. 156; and Schestag, "Kaiser Maximilian I," pp. 177–79. His activity may be evidenced earlier in Basel in a set of woodcut book illustrations for the *Neuem Plenarium* published by Adam Petri in 1514. The designs are by Hans Schäufelein, and the blocks carry the monogram *HF*. Hans Koegler, "Lützelburger," in Thieme–Becker, XXIII, p. 453.

95. Campbell Dodgson, "Hans Lützelburger and the Master N.H.," *Burlington Magazine* 10 (1906), pp. 319–22, with a concise account of the scholarship to that date on the Master NH's career. An alphabet carrying his initials was used by the printing house of Peter Schöffer in Mainz in 1522. It is assumed that he emigrated to Basel about then. For further literature on the NH woodcut, see Dodgson, *Catalogue of Woodcuts*, II, pp. 200–01; H. Theodor Musper, "Die Holzschnitte des Nicolaus Hogenbergs von München," *Jahrbuch der preussischen Kunstsammlungen* 63 (1942), pp. 171–79; Friedrich Winkler, "Die deutsche Werke Nicolaus Hogenbergs von München," *Zeitschrift des deutschen Vereins für Kunstwissenschaft* 18 (1964), pp. 54–64; and Peter W. Parshall, "Reading the Renaissance Woodcut: The Odd Case of the Master N.H. and Hans Lützelburger," *Register of the Spencer Museum of Art* 6 (1989), pp. 30–43. The identification of the Master NH as Nicolaus Hogenberg remains in doubt, and in our opinion should be rejected on stylistic grounds.

96. For prints done after Pollaiuolo, see Lilian Armstrong Anderson, "Copies of Pollaiuolo's Battling Nudes," *Art Quarterly* 31 (1968), pp. 155–67. Our print shows no definite evidence of direct dependence on the Pollaiuolo. The swords and shields shown in the woodcut seem to be contemporary in so far as they are among the arms carried in Burgkmair's *Triumphal Procession of Maximilian*.

97. On the glorification of the peasantry as a signal of local pride in Renaissance Germany, and on the interest in the wilderness, see Margaret D. Carroll, "Peasant Festivity and Political Identity in the Sixteenth Century," *Art History* 10 (1987), pp. 289–314; Larry Silver, "Forest Primeval: Albrecht Altdorfer and the German Wilderness Landscape," *Simiolus* 13 (1983), pp. 4–43.

98. Hans Rupprich, ed., *Dürer: Schriftlicher Nachlass* (Berlin, 1969), vol. III, p. 284, lines 158–61: "das ein ferstendiger geübter künstner jn grober bewrischer gestalt sein grossen gwalt vnd kunst ertzeigen kan mer jn eim geringen ding dan mencher in ein grossen werg."

99. On the consciousness of German and Italian styles within German art of this period, see Michael Baxandall, *The Limewood Sculptors of Renaissance Germany* (New Haven and London, 1980), pp. 135–42.

100. Dodgson knew the second state only in the impression in the Dresden Kupferstichkabinett which was later recorded by Max Geisberg, *The German Single-Leaf Woodcut, 1500–1550*, ed. Walter Strauss (New York, 1974), vol. III, no. 954. Another impression with the text is in Karlsruhe, Staatliche Kunsthalle. For a transcription of the complete text, see Dodgson, *Catalogue of Woodcuts*, II, pp. 196–97.

101. "Darumb man billich loben soll / Den, der sein kunst beweiset wol / Als diser auch ain maister was / Doch ist jm lieber das wein glasz / Das braucht er für ain langen spiesz / Er thue jms nach, den das verdriesz."

102. For other states, see Heinrich Röttinger, *Peter Flötners Holzschnitte* (Strasbourg, 1916), pp. 62–63, cat. no. 33.

103. Hans Reinhardt, "Einige Bemerkungen zum graphischen Werk Hans Holbeins des Jüngeren," *Zeitschrift für Schweizerische Archäologie und Kunstgeschichte* 34 (1977), pp. 243–44.

104. "Qui me faict penser, que la Mort craignant que cet excellent painctre ne la paignist tant vifue, qu'elle ne fut plus crainte pour Mort." *Les simulachres & historiees faces de la mort, autant elegamment pourtraictes, que artificiellement imaginées* (Lyons, 1538), preface, folio A iii verso.

105. Much has been written on the *Dance of Death* and on the implications of its publication in Lyons omitting all reference to Holbein. Edouard His, "Hans Lützelburger: Le graveur des Simulacres de la Mort d'Holbein," *Gazette des Beaux-Arts* 169, 2nd ser., 4 (1870), pp. 481–89. See more recently Reinhardt, "Bemerkungen," pp. 246–49, with further bibliography. The preface to the Lyons edition inspired a long controversy in the nineteenth century about whether Holbein or Lützelburger authored the designs. There is no longer any serious dispute over that question.

106. Reinhardt, "Bemerkungen," p. 235. On Protestantism and the Lyons printers, see Natalie Z. Davis, "Strikes and Salvation at Lyons," in *Society and Culture in Early Modern France* (Stanford, 1975), pp. 1–16. Hans Koegler in Thieme–Becker, XI, pp. 150–03, records Faber's (Lefevre's) Reformation contacts.

107. *Die Malerfamilie Holbein*, cat. no. 418, pp. 327–28. Reinhardt, "Bemerkungen," *passim*, esp. p. 229, discusses Faber's career and the practice of publishers employing illustrations and frontispieces inappropriate to the texts which they accompany, further implying a separation between printers and their designers and cutters. On the *Dance of Death* blocks, see pp. 246–49.

108. Johann Neudörfer, *Nachrichten von Künstlern und Werkleuten daselbst aus dem Jahre 1547*, ed. G. W. K. Lochner (Vienna, 1875), pp. 155–56. "Stählerne Punzen" (steel punches) may refer to letters cut in relief for stamping copper plates to be printed in intaglio. Such punches had long been in use for impressing letters into copper plates used for printing engraved maps. On this technique and the means for distinguishing it from typesetting or line engraved lettering, see David Woodward, "The Manuscript, Engraved, and Typographic Traditions of Map Lettering," in *Art and Cartography: Six Historical Essays*, ed. David Woodward (Chicago and London, 1987), pp. 195–99.

109. The eighteenth-century art historian Christoph Gottlieb von Murr reports that the common people had a saying: "Der Kaiser fahret abermals ins Frauengäßlein." "Formschneidkunst," *Journal zur Kunstgeschichte und zur allgemeinen Litteratur* 2 (Nuremberg, 1776), pp. 158–59.

110. For the relevant document of 1465 and its probable reference to Schongauer, see most recently *Le beau Martin: Gravures et dessins de Martin Schongauer*, exh. cat. (Colmar: Musée d'Unterlinden, 1991), pp. 38–39.

111. Georg Lenckner, "Hieronymus Andreae, Formschneider in Nürnberg, und M. Bernhard Bubenleben, Pfarrer in Mergentheim," *Württembergisch-Franken*, n.s. 28/29 (1953/54), p. 153.

112. Gerhard Pfeiffer, ed., *Quellen zur Nürnberger Reformationsgeschichte* (Nuremberg, 1968), p. 32, Council motions 229, 231, 232, 235 (17–19 December 1524).

113. This episode has been treated most extensively by Herbert Zschelletschky, *Die 'drei gottlosen Maler' von Nürnberg* (Leipzig, 1975), pp. 31–67. The initial hearing occurred on 10 January 1525 and led to the banishment of the offenders.

114. Lenckner, "Hieronymus Andreae," pp. 152–54. Lenckner discovered Andreae's name in the register of Leipzig University, where Bubenleben was a student, and furthermore noted that the two were probably from the same town of Mergentheim.

115. See Theodor Hampe, *Nürnberger Ratsverlässe über Kunst und Künstler im Zeitalter der Spätgotik und Renaissance* (Vienna and Leipzig, 1904), vol. I, p. 226, doc. nos. 1487–90, 1492–93, regarding his imprisonment in May and June of that year. Pfeiffer, *Nürnberger Reformationsgeschichte*, pp. 411–12, no. 215, transcribes a letter of 20 May 1525 from the council describing the case.

116. See Peter W. Parshall, "Kunst en reformatie in de Noordelijke Nederlanden — enkele gezichtspunten," *Bulletin van het Rijksmuseum* 35 (1987), pp. 164–75; and Keith Moxey, "The Beham Brothers and the Death of the Artist," *Record of the Spencer Museum of Art* 6 (1989), pp. 25–29.

117. *JKSW* 3 (1885), pt. II, pp. lxii–lxiv, doc. nos. 2868–69.

118. *JKSW* 10 (1889), pt. II, p. xlviii, doc. nos. 5847–49, transcribes the documents regarding the appeal for the blocks and Andreae's claim for payment due. This is not the only such incident. In 1517 the Basel council wrote to Maximilian on behalf of its citizen Heinrich Kupferwurm who was owed 22 *gulden*, nearly three months' wages, for his work (probably on the *Theuerdanck* blocks). W. Ziegler, "Heinrich Kupferwurm, Formschneider," in *Jahrbücher für Kunstwissenschaft*, ed. A. von Zahn (Leipzig, 1869), vol. II, p. 244.

119. Eduard Chmelarz, "Die Ehrenpforte des Kaiser Maximilian I," *JKSW* 4 (1886), pp. 308–13. Recall that in an earlier letter Peutinger reported that Stabius (in charge of the block cutting in Nuremberg) complained of having only one cutter available, thus requiring that he send most of the designs to Augsburg. On Andreae's abridged edition, see Joseph Meder, *Dürer-Katalog* (Vienna, 1932; repr. New York, 1971), pp. 217–23.

120. Chmelarz, "Die Ehrenpforte," p. 309. Lochner in Neudörfer, *Nachrichten*, p. 156, questions whether Andreae ran his own printing house, since he seems to have lived next to the book printer Martin Kletsch. However, someone of Andreae's substance almost certainly kept a press of his own.

121. F. W. H. Hollstein, *German Engravings, Etchings and Woodcuts, ca. 1400–1700*, III, p. 169; and Zschelletschky, *Gottlosen Maler*, pp. 173–75.

122. Zschelletschky, *Gottlosen Maler*, pp. 80–85.

123. Hampe, *Nürnberger Ratsverlässe*, I. For the documents pertinent to the slander case and change of official stamp cutter, see pp. 374–77 (doc. nos. 2683–2728, *passim*).

124. Meder, *Dürer-Katalog*, pp. 233, and for the treatises, pp. 285–88.

125. The literature on this vexing problem of definition is extensive. On theoretical aspects of the question, see especially Wolfgang

Brückner, *Populäre Druckgraphik Europas: Deutschland vom 15. bis zum 20. Jahrhundert* (Munich, 1969); Wolfgang Brückner, "Expression und Formel in Massenkunst: Zum Problem des Umformens in der Volkskunsttheorie," *Anzeiger des Germanischen Nationalmuseums* (1968), pp. 122–39; Bruno Weber, ed., *Wunderzeichen und Winkeldrucker, 1543–1586* (Zurich, 1972), esp. p. 25; and Robert Scribner, *For the Sake of Simple Folk: Popular Propaganda for the German Reformation* (Cambridge, 1981), chs. 1, 4.

126. On the politics of popular prints, see David Kunzle, "The World Upside Down: The Iconography of a European Broadsheet Type," in *The Reversible World: Symbolic Inversion in Art and Society*, ed. Barbara A. Babcock (Ithaca and London, 1978), pp. 39–94.

127. The well-known historian of folk culture Hellmut Rosenfeld exemplifies the tendency to perpetuate a Romantic notion of prints as popular art. See, for example, Rosenfeld, "Die Rolle des Bilderbogens in der deutschen Volkskultur," *Bayerisches Jahrbuch für Volkskunde* (1955), pp. 79–85; and Rosenfeld, "Kalender, Einblattkalender, Bauernkalender und Bauernpraktik," *Bayerisches Jahrbuch für Volkskunde* (1962), pp. 7–24. The more recent view is exemplified in Klaus Matthäus, "Zur Geschichte des Nürnberger Kalenderwesens: Die Entwicklung der in Nürnberg gedruckten Jahreskalender in Buchform," *Archiv für Geschichte des Buchwesens* 9 (1968), cols. 965–1396.

128. The sale records the following: "Item de weduwe Cornelis Liefrinck de vorme van den Triumphen Christi . . . 3 *l.* 12 *s.* 6 *d.*" in *pond* Brabant. J. Cuvelier, "Le gravure Corneille van den Bossche (XVIe siècle)," *Bulletin de l'Institut Historique Belge de Rome* 20 (1939), p. 48. Rosand and Muraro, *Titian*, p. 37: with the address "En Anuers, par la Vefue Margariete de Corneille Liefrinck."

129. Delen, *Histoire de la gravure*, II, pt. 2, p. 24.

130. *Kunst voor de Beeldenstorm*, ed. J. P. Filedt Kok, et al., exh. cat. (Amsterdam: Rijksmuseum, 1986), pp. 175–76, cat. no. 59; *Vorstenportretten uit de eerste helft de 16de eeuw: Houtsneden als propaganda*, exh. cat. (Amsterdam: Rijksmuseum, 1972), pp. 11–12, cat. no. 5.

131. Delen, *Histoire de la gravure*, II, pt. 2, pp. 24–25.

132. *Ibid.*, p. 25. Hans was probably born in Augsburg when his father worked on Maximilian's projects.

133. Alexandre Joseph Pinchart, *Archives des arts, sciences et lettres: Documents inédits* (Ghent, 1850–81), vol. III, pp. 314–25, for the full text of the petition and its granting. "Considéré que le commun peuple n'a pas l'intendement si vif qu'il peut considérer la grande différence des figures de luy suppliant et des aultres contrefaictes, car il semble à la pluspart d'icelluy peuple tout bon." The interest of the "common people" in a work of this kind when it was within their means is further indication that lines cannot be easily drawn between audiences.

134. Delen, *Histoire de la gravure*, II, pt. 2, p. 68, citing Franz Josef Peter van den Branden, *Balthasar Sylvius: Quatre suites d'ornements* (The Hague, 1893), p. 2. Further on the 1544 sale, see above, Chapter II. For the sale of paintings, see Prosper Verheyden, "Te Pand gegeven Drukkersgerief," *Tijdschrift voor Boek-en Bibliotheekwezen* 8 (1910), pp. 130–33.

135. Recorded in Delen, *Histoire de la gravure*, II, pt. 2, p. 160. Hans's publications are partially recorded in Hollstein, *Dutch and Flemish Etchings*, XI, nos. 1–135.

136. Known branches of the Liefrinck dynasty of printmakers begin with the brothers Willem (d. Antwerp, 1542) and Cornelis, active together for Maximilian in Augsburg. Willem sired Hans (also called Jean or Jan), who is of most interest here (d. Antwerp, 1573). Hans in turn had a daughter Myncken, a printer, block cutter, and illuminator active in Antwerp, 1567–82. Cornelis also had a son named Hans who designed maps (d. Leiden, before 1599), and he in turn had a son named Cornelis after his father, and who was also active as a painter and etcher in Leiden until the 1620s. Thieme–Becker, XXIII, pp. 206–07. *Vorstenportretten*,

pp. 35–38; and Thieme–Becker, XXIII, pp. 206–07, on the Liefrinck family.

137. *Vorstenportretten*, p. 9.

138. On the important contributions of Anthonisz. to woodcut broadsheet publication in these years, see Christine Megan Armstrong, *The Moralizing Prints of Cornelis Anthonisz.* (Princeton, 1990).

139. *Vorstenportretten*, pp. 35–39, cat. nos. 35–88. The watermarks on these prints point to an early date for their production and consequently suggest that the stenciled impressions were issued as part of the initial phases of printing in the workshop responsible for cutting the blocks. We thank Jan Piet Filedt Kok for confirming the early date of several of the colored Anthonisz. impressions.

140. Jan Piet Filedt Kok, "Een groep 16de-eeuwse Nederlandse houtsneden afkomstig uit Gotha," *Bulletin van het Rijksmuseum* 31 (1983), pp. 211–14. The largest assembly of these prints is now in Amsterdam where it came from the collection in Gotha, previously owned by the Count of Saxe-Coburg-Gotha and earlier the collection of Rudolf II of Hapsburg.

141. Delen, *Histoire de la gravure*, II, pt. 2, pp. 73, 78, 150. Hollstein, *Dutch and Flemish Etchings*, X, pp. 2–3. One hundred and thirty-five prints, many in suites, are listed under Hans Liefrinck's signature.

142. Delen, *Histoire de la gravure*, II, pt. 2, pp. 73, 112.

143. Hollstein, *Dutch and Flemish Etchings*, XXIX, pp. 123–25, nos. 3–12. See: "Keuze uit de aanwisten," *Bulletin van het Rijksmuseum* 29 (1981), p. 33. One of the etchings is dated 1553 and another 1558. Curiously they were done on iron plates despite having been made nearly a generation after the introduction of copper etching in the Netherlands.

144. Peeters, a painter and engraver, acquired a number of Lucas van Leyden's plates which he then reprinted with the addition of his own address. Peeters also published prints after Raphael, Primaticcio, and Floris and apparently copies after Dürer. Like Liefrinck, Peeters was made Dean of the Antwerp St. Luke's Guild (in his case no fewer than five time between 1533 and 1558). See Filedt Kok, *Lucas van Leyden*, p. 80.

145. On Ewoutsz., also a block cutter and printer for Anthonisz., see *Vorstenportretten*, p. 35; Ernst Wilhelm Moes and C. P. Burger, Jr., *De Amsterdamsche Boekdrukkers en Uitgevers in de zestiende eeuw* (Amsterdam and The Hague, 1900–15), pp. 148–80.

146. Sune Schéle, "Pieter Coecke and Cornelis Bos," *Oud Holland* 77 (1962), pp. 235–40; and Herman de la Fontaine Verwey, "Pieter Coecke van Aelst and the Publication of Serlio's Book on Architecture," *Quaerendo* 6 (1976), pp. 166–94.

147. Prosper Verheyden, "Anatomische uitgave van Cornelius Bos en Antoine des Goys, Antwerpen, 1542," *De Gulden Passer* 18 (1940), pp. 143–56; and Elly Cockx-Indestege, "A Hitherto Unknown Edition of W. H. Ryff's Tabulae decem, Antwerp, Cornelis Bos, c. 1542," *Quarendo* 6 (1976), pp. 16–27.

148. Schéle, "Pieter Coecke and Bos," pp. 235–40; and Schéle, *Bos*, pp. 20, 191–94, cat. no. 215.

149. On this phase of Antwerp printmaking generally, see Delen, *Histoire de la gravure*; and also Konrad Oberhuber, *Zwischen Renaissance und Barock: Das Zeitalter von Bruegel und Bellange*, Die Kunst der Graphik, vol. 4, exh. cat. (Vienna: Albertina, 1968).

150. Wolfgang von Stromer, "Die Guldenmund," in *Beiträge zur Wirtschafts- und Stadtgeschichte: Festschrift für Hektor Ammann* (Wiesbaden, 1965), pp. 353–57, traces the earlier history of the Guldenmund family.

151. Stromer, "Die Guldenmund"; Walter Fries, "Der Nürnberger Briefmaler Hans Guldenmund," *Zeitschrift für Buchkunde* 1 (1924), pp. 39–48, gives the fullest available account of his career, along with a handlist of publications signed and attributed. The early archival research was done by Josef Baader, "Beiträge zur Kunstgeschichte Nürnbergs," in *Jahrbücher für Kunstwissenschaft*, ed. A.

von Zahn (Leipzig, 1868), vol. I, p. 227. Additional archival material is published in Hampe, *Nürnberger Ratsverlässe*, I, *passim*. For the early newssheet, see Schottenloher, *Flugblatt und Zeitung*, pp. 143–78; and most recently Weber, *Wunderzeichen*, *passim*, esp. p. 29.

152. The relevant documents on the case can be found in Hampe, *Nürnberger Ratsverlässe*, vol. I, pp. 197–98, 201; doc. nos. 1287–92, 1308, 1318. Baader, "Beiträge," II, p. 51, supplies an additional detail apparently taken from another document. Stabius laid out the program for Maximilian's *Triumphal Arch* and designed Dürer's woodcut *Astronomical Maps*.

153. Arnd Müller, "Zensurpolitik der Reichsstadt Nürnberg," *Mitteilungen des Vereins für Geschichte der Stadt Nürnberg* 49 (1959), pp. 82–85. Some of the documents can be found in Hampe, *Nürnberger Ratsverlässe*, I, pp. 237–38; doc. nos. 1571, 1580. The blocks survive in the Germanisches Nationalmuseum, Nuremberg, and were later reprinted in various editions. *Die Welt des Hans Sachs: 400 Holzschnitte des 16. Jahrhunderts* (Nuremberg, 1976), pp. 17–31, cat. no. 25, for illustrations of all thirty woodcuts and further bibliography, and Jeffrey Chipps Smith, *Nuremberg: A Renaissance City, 1500–1618*, exh. cat. (Austin, 1983), p. 167.

154. On the peculiarity of mnemonic imagery and its history, see Ludwig Volkmann, "Ars Memorativa," *JKSW*, n.s. 3 (1929), pp. 111–200.

155. Müller, "Zensurpolitik," pp. 66–169. Also William A. Coupe, *The German Illustrated Broadsheet in the Seventeenth Century* (Baden-Baden, 1966), vol. I, p. 18; Theodor Hampe, "Der Augsburger Formschneider Hans Schwarzenberger und seine Modelbücher aus den Jahren 1534 und 1535," *Mitteilungen des Germanischen Nationalmuseums* (1909), pp. 59–86.

156. The document is transcribed by Hampe, "Der Augsburger Formschneider," pp. 59–60, 84–85.

157. On the *Modi*, see our discussion of the case in Chapter VI, and see Henri Zerner, "L'estampe érotique au temps de Titien," in *Tiziano e Venezia: Convegno Internazionale di Studi, Venezia, 1976* (Vicenza, 1980), pp. 85–90. In addition to the fragments from the original *Modi*, there are variations on it such as Jacopo de Caraglio's series of the *Loves of the Gods*. The pirated replica with woodcuts is now in private collection. On the entire affair, see Lynne Lawner, *I modi: The Sixteen Pleasures, an Erotic Album of the Italian Renaissance* (Evanston, 1988), pp. 15–19, 60–91, for the date and reproductions of the woodcuts. It is possible that the books being circulated in Germany in 1535 were copies (or conceivably originals) of this pirated work. Judging from Lawner's illustrations, the Italian woodblocks were either very worn or badly printed. If the former, then a substantial number might have been in circulation. Whether there was a connection, and furthermore whether the woodblocks for the booklet being handled by Guldenmund and Schwarzenberger were actually in Augsburg or ever in the hands of either one, remain matters of speculation.

158. J. G. van Dillen, *Bronnen tot de geschiedenis van het Bedrijfsleven en het Gildewezen van Amsterdam* (The Hague, 1929–74), vol. I, pp. 75–76, doc. no. 143.

159. In 1532 he was enjoined from publishing a copy of Dürer's small *Triumphal Car* on grounds that it would detract from the income of Dürer's widow. Rupprich, *Dürer*, I, pp. 241–44, doc. nos. 4, 26–34, on the rights to Dürer's publications. Other legal cases are recorded in Hampe, *Nürnberger Ratsverlässe*, I, *passim*, and are frequently noted in the secondary literature.

160. Nuremberg Stadtarchiv: Rep. B. 14/VI (*Inventarbücher des Stadtsgerichts, 16. Jht.*, vol. I, fols. 219–20).

161. For a collection of Sachs's illustrated work, see *Die Welt des Hans Sachs*, *passim*. After 1540 Georg Wachter seems to have become the main press for Sachs.

162. *Vorstenportretten*, pp. 16–17, 38–39. The trick of substituting a part of a block was not unique. Sebald Beham seems to have specialized in this system. For examples in which the upper

portion of a composition has been cut out and fitted with replaceable sections in order to change the identity of saints, or in another case to change a figure from a pilgrim to a soldier, see Gustav Pauli, *Hans Sebald Beham: Ein kritisches Verzeichniss seiner Kupferstiche, Radierungen und Holzschnitte* (Strasbourg, 1901), nos. 890, 897; G. I. 215, 217. This practice was certainly designed to allow for printing on demand.

163. Fries, "Der Nürnberger Briefmaler," pp. 42–44, usefully lists Guldenmund's various publications chronologically.

164. A brief account of some of the publications stimulated by the Turkish seige is given in Schottenloher, *Flugblatt und Zeitung*, pp. 168–72. See also Heinrich Kabdebo, "Der Antheil der Nürnberger Briefmaler Meldeman und Guldenmundt an der Literatur der ersten Wiener Türkenbelagerung," *Berichte und Mitteilungen des Altertums-Vereines zu Wien* 15 (1875), pp. 97–106, with reference to Meldeman's *Plan* and the accompanying pamphlet; Albert Ritter von Camesina, "Fliegende Blätter über das türkische Heer vor Wien im Jahre 1529 von Hans Guldenmund," *Berichte und Mitteilungen des Altertums-Vereines zu Wein* 15 (1875), pp. 107–16, with a transcription of the Hans Sachs verse texts on Guldenmund's woodcuts; and Weber, *Wunderzeichen*, p. 41.

165. See Keith Moxey, *Peasants, Warriors and Wives: Popular Imagery in the Reformation* (Chicago, 1989), *passim*.

166. These statistics are culled from a survey of woodcuts in Geisberg, *Single-Leaf Woodcut*. The statistics cannot be taken too precisely, since we do not know the percentage of survival for these prints or the regularity with which presses included their addresses on their products, and furthermore the information in the Geisberg corpus about the editions of the prints is incomplete.

167. The subject matter of these prints and their implication for private and especially public attitudes has been analyzed most deeply by Moxey, *Peasants, Warriors and Wives*.

168. Appuhn and von Heusinger's *Riesenholzschnitte* is the groundbreaking, and to date the most complete, study of this subject.

169. The color on each of the four sheets in Beham's woodcut is slightly different, implying that they were painted separately and then stuck together. The text is on yet another set of sheets glued to the woodcuts. On the quotations from Marcantonio and their implication, see Peter W. Parshall, "Reading the Renaissance Woodcut," pp. 40–41. On the iconography, see Alison Stewart, "Sebald Beham's *Fountain of Youth-Bathhouse* Woodcut: Popular Entertainment and the Large Prints by the Little Masters," *Register of the Spencer Art Museum* 6 (1989), pp. 64–88. The *Feast of Herod* (Pauli 832) was also issued in the first state with a privilege by Albrecht Glockendon, who appears to have been the chief printer of Beham's large woodcuts.

170. Glockendon published other of Beham's monumental woodcuts. The *Feast of Herod* also carries Glockendon's address on what appears to be the first state (Pauli 832). In the case of the *Large Village Fair* (Pauli 1245) the printer's signature appears on the second and later states, suggesting that Glockendon acquired the blocks after a first edition was issued under the artist's name alone.

171. Appuhn and von Heusinger, *Riesenholzschnitte*, pp. 16–17. Although it may at first seem overly fanciful to read the vine patterns in this way, the explicit subject of the design, the motif of the fig leaves and the birds suggest it is not simply a Rorschak projection of our own.

172. Jan Piet Filedt Kok, "Een *Biblia pauperum* met houtsneden van Jacob Cornelisz. en Lucas van Leyden gereconstrueerd," *Bulletin van het Rijksmuseum* 36 (1988), pp. 83–116, reconstructs what may be the longest frieze composition from the period, 3400 mm in overall length in a double row! See this article for Doen's activities as a woodcut publisher. The set of sheets for the *Sant Reynuut* in Amsterdam, Rijksmuseum, also bears Doen Pietersz.'s address. See *Kunst voor de Beeldenstorm*, pp. 155–57, cat. no. 40, for the attribution, iconography, and date. The blocks for later

woodcut of the *Lion Hunt* (ca. 1540), were cut by Jan Ewoutsz. of Amsterdam who issued many of Cornelis Anthonisz.'s woodcuts, including an allegorical frieze with ornamental borders entitled *Sorgheloos* (Nijhoff 70–75). *Kunst voor de Beeldenstorm*, pp. 238–39, cat. no. 118; pp. 271–73, cat. no. 151.

173. Andreas Meinhard, *Dialogus . . . urbis Albiorene vulgo Wittenberg dicte* (Lipsia 1508), published with a translation and introduction in *The Dialogus of Andreas Meinhardi: A Utopian Description of Wittenberg and its University, 1508*, ed. and trans. Edgar C. Reinke (Ann Arbor, Mich., 1976), gives an introduction, transcription, and translation of the Latin text. For the tour of paintings, see ch. 8.

174. G. Bauch, "Zur Cranachforschung," *Repertorium für Kunstwissenschaft* 17 (1894), pp. 421–35.

175. Mathias Mende, *Das Alte Nürnberger Rathaus* (Nuremberg, 1979), pp. 192–409. The drawings from ca. 1521–22 are catalogued in Panofsky, *Dürer*, II, p. 199, nos. 1549–51.

176. For example, see Lucas van Leyden (B.5–9, state II). See Filedt Kok, "Een *Biblia pauperum*," *passim*. Ornamental borders around folio woodcut cycles are a sure indication of mural use. See also Hans Burgkmair's *Seven Planets* (B.41–47), with running borders.

177. Moxey, *Peasants, Warriors and Wives*, pp. 93–95.

178. Lorenz Fries, *Uslegung der mercarthen oder Cartha Marina* (Strasbourg, 1525), gives careful instructions on how to assemble and paste down his *World Map* on canvas. The *Triumphal Arch* was displayed this way in Albrecht V of Bavaria's cabinet, for example. See *Inventarium aller Stück, so in der herzoglichen Kunstkammer zu sehen*, by J. B. Fickler (Munich, Staatsbibliothek, cod. bav. 2133 [1598]), fol. 138v.

179. Cortesi, in his tract *De Cardinalatu* published in 1510 describing the Cardinal's ideal palace, suggests that the walls should be decorated with paintings rather than terracotta or sculpture, since painting is a more humble medium. Prints would have accommodated this stricture even better, which may explain one purpose for Titian's monumental woodcuts. For Cortesi's text, see Kathleen Weil Garris and John F. D'Amico, "The Renaissance Cardinal's Ideal Palace: A Chapter from Cortesi's *De Cardinalatu*," in *Studies in Italian Art and Architecture, Fifteenth through Eighteenth Centuries*, ed. H. S. Millon (Rome, 1980), p. 91.

180. ". . . und wo er einen Verleger gehabt hätte, würde er in grossen Werken night weniger dann in kleinen Dingen gewaltig gewest sein." Neudörfer, *Nachrichten*, p. 115.

181. The literature on the relation of the various versions of the Titian woodcut is extensive. For a complete account with further bibliography, see Michael Bury, "The 'Triumph of Christ' after Titian," *Burlington Magazine* 131 (1989), pp. 188–97; and Peter Dreyer, *Tizian und sein Kreis: Holzschnitte* (Berlin, n.d.), pp. 32–41.

182. Verlinden (see Appendix) gives lower figures than those recorded in Hermann van der Wee, *The Growth of the Antwerp Market and the European Economy, Fourteenth–Sixteenth Centuries* (Louvain, 1963), vol. I, pp. 339–40.

183. Thomas Würtenberger, *Das Kunstlerfälschertum* (Weimar, 1940; repr. Leipzig, 1970), pp. 186–90, lists privileges for woodcuts in Venice also in 1514 (Giovanni da Brescia), and 1516 (Ugo da Carpi); and confirms that the earliest known northern European case is Dürer's imperial privilege for his edition of the *Life of the Virgin* of 1511.

184. Friedrich Kluge, *Etymologisches Wörterbuch der deutschen Sprache* (Berlin, 1963), p. 392, s.v. *Konterfei*; Jacob and Wilhelm Grimm, *Deutsches Wörterbuch* (Leipzig, 1854–), vol. II, p. 635, s.v. *conterfei*. See Peter Parshall, "*Imago contrafacta*: Images and Facts in the Northern Renaissance," forthcoming in *Art History* 16 (1993).

185. Some examples are: Michael Ostendorfer, *Sultan Suleiman* (G.978); *Jan van Leyden and his Wife* (G.7–8), the notorious "King of the Anabaptists"; an anonymous *Portrait of the Murderer Hansen von Berstatt* (G.1591); Hans Schieser, *The Swollen Girl of Esslingen* (G.1118); Heinrich Vogt, *A Miraculous Cluster of Hirsute Grapes*

(G.1542); Erhard Schön, *The Turkish Siege of Budapest* (G.1269–73); and Christoph Amberger, *King Ferdinand's Sleigh Ride* (G.49–50), purporting to record an event "as this image shows actually represented" (wie dise Figur aygentlich abconterfect anzeigt).

186. William Ivins, Jr., *Prints and Visual Communication* (Cambridge, Mass., 1953), esp. chs. 1–2.

187. Schreiber, II, 931.

188. Richard S. Field, *Fifteenth Century Woodcuts and Metalcuts from the National Gallery of Art* (Washington, D.C., n.d.), cat. no. 295.

189. Moxey, *Peasants, Warriors and Wives*, p. 78.

190. For the broader conceptual implications of advances in mapmaking in the Renaissance, see Samuel Edgerton, Jr., "From Mental Matrix to *Mappamundi* to Christian Empire: The Heritage of Ptolemaic Cartography in the Renaissance," in *Art and Cartography*, ed. D. Woodward (Chicago, 1987), pp. 10–50. The history of this type of plan is traced in John A. Pinto, "Origins and Development of the Ichnographic City Plan," *Journal of the Society of Architectural Historians* 35 (1976), pp. 35–50.

191. Johannes Keuning, "Cornelis Anthonisz.," *Imago Mundi* 7 (1950), pp. 51–65. He drew the city in 1531, and then made a painting of it with some modifications, and finally the woodcut, again modified. It was published in Amsterdam first by Cornelis himself and only after that by Jan Ewoutsz.

192. Regarding Rosselli's cartographical contributions, see Tony Campbell, *The Earliest Printed Maps, 1472–1500* (Berkeley and Los Angeles, 1987), pp. 70–78. Roberto Almagià, "On the Cartographic Work of Francesco Rosselli," *Imago Mundi* 8 (1951), pp. 27–34; Heinrich Brockhaus, "Die große Ansicht von Rom in Mantua: Die Frage nach dem Zeichner ihres Vorbildes," *Mitteilungen des Kunsthistorischen Instituts in Florenz* 1 (1911), pp. 151–55. On Rosselli and Pacioli, see Jay A. Levenson, et al., *Early Italian Engravings from the National Gallery of Art* (Washington, D.C., 1973), cat. no. 3; Gustavo Uzielli and Giovanni Celoria, *La vita e i tempi di Paolo dal Pozzo Toscanelli* (Rome, 1894), p. 526.

193. Campbell, *Earliest Printed Maps*, pp. 59–67. J. C. Smith, *Nuremberg*, p. 91, with further literature. Georg Glockendon was responsible for printing most of Etzlaub's work.

194. Campbell, *Earliest Printed Maps*, pp. 122–30, cat. nos. 95–120.

195. Basel possessed a Greek manuscript of the *Geography* (without maps), which was later edited by Erasmus in 1533 for the Froben publishing house. It appears that access to the manuscript was earlier withheld from Martin Waldseemüller when he was preparing his *World Map* in 1507. F. Grenacher, "The Basle Proofs of Seven Printed Ptolemaic Maps," *Imago Mundi* 13 (1956), p. 166.

196. This seems the more strange given the inadequacies of an edition of Ptolemy edited by Lorenz Fries and published by Grüninger only two years earlier in 1522. On this edition, see Hildegard B. Johnson, *Carta Marina: World Geography in Strassburg, 1525* (Minneapolis, Minn., 1963), pp. 41–42, n. 41.

197. *Claudii Ptolemaei geographicae enarrationis libri octo Bilibaldo Pirckheymero interprete*. f. Straßburg, Joh. Grüninger. The history of this unhappy relationship is outlined in Oscar von Hase, *Die Koberger*, 2nd rev. edn. (Leipzig, 1885; repr. Amsterdam and Wiesbaden, 1967), pp. 130–39; the letters are transcribed in the appendix (pp. cxxix–cxlvi, nos. 106–21, esp. nos. 118–20).

198. Jay A. Levenson, ed., *Circa 1492: Art in the Age of Exploration*, exh. cat. (Washington, D.C.: National Gallery of Art, 1992), pp. 232–34, cat. no. 132.

199. Elizabeth Harris, "The Waldseemüller World Map: A Typographic Appraisal," *Imago Mundi* 37 (1985), pp. 30–53, studies the evidence in meticulous detail. Her hypothesis (made on compelling typographical evidence) is that the Strasbourg printer Johann Schott worked at Saint-Dié and left after composing the first set of type for the Waldseemüller map.

200. *Ibid.*, pp. 35–37, cites both changes.

201. Johnson, *Carta Marina*, pp. 60–61.

202. *Ibid.* See also Mathias Mende, *Hans Baldung Grien: Das graphische Werk* (Unterschneidheim, 1978), pp. 65–66 and illustrations.

203. For the popularity of mural maps and descriptive geography in aristocratic circles, see Juergen Schulz, "Maps as Metaphors: Mural Map Cycles of the Italian Renaissance," in *Art and Cartography*, ed. David Woodward (London, 1987), pp. 97–122.

204. Gerald Strauss, "A Sixteenth-Century Encyclopedia: Sebastian Münster's *Cosmography* and its Editions," in *From the Renaissance to the Counter-Reformation: Essays in Honour of Garrett Mattingly*, ed. Charles H. Carter (New York, 1965), pp. 145–63. For the chorographic cosmographic traditions of historical writing in the sixteenth century, see Gerald Strauss, *Sixteenth-Century Germany: Its Topography and Topographers* (Madison, Wis., 1959), chs. 6–7. On Muenster and the ethnological aspects of descriptive geography, see Margaret T. Hodgen, *Early Anthropology in the Sixteenth and Seventeenth Centuries* (Philadelphia, 1964), ch. 5.

205. For an overview of sixteenth-century geography, see Boies Penrose, *Travel and Discovery in the Renaissance, 1420–1620* (Cambridge, Mass., 1952), esp. ch. 16, in which the argument is made that printed maps were behind the times. On the other side, see Elizabeth L. Eisenstein, *The Printing Press as an Agent of Change* (Cambridge, 1979), vol. II, pp. 512–19.

206. On the general history of introducing texts on maps, see Woodward, "Traditions of Map Lettering," pp. 174–213.

207. Karen Meier Reeds, "Renaissance Humanism and Botany," *Annals of Science* 33 (1976), p. 530, cites the classical precedent and discusses its relevance. See also Ivins, *Prints and Visual Communication*, pp. 13–15; and Ernst Gombrich, "Review of William Ivins, *Prints and Visual Communication*," *British Journal for the Philosophy of Science* 5 (1954–55), pp. 168–69.

208. Hind, *History of Woodcut*, I, pp. 348–51, 354; and most recently Jan Piet Filedt Kok, et al., *Livelier than Life: The Master of the Amsterdam Cabinet, or the Housebook Master, ca. 1470–1500*, exh. cat. (Amsterdam, 1985), p. 280, cat. no. 141.

209. On the history of printed herbals we will refer mainly to the basic study by Agnes Arber, *Herbals: Their Origin and Evolution, 1460–1670*, 2nd ed. (Cambridge, 1938), pp. 20–28; Wilfrid Blunt, *The Art of Botanical Illustration*, 2nd ed. (London, 1951), chs. 5–6; and to the more analytical chapter on the subject in A. G. Morton, *History of Botanical Science* (London and New York, 1981), ch. 5. The Latin text is compiled from various medieval sources. On the proper title for the *Gart* and reproductions of the complete of set of woodcuts for both, see Bartsch, *Illustrated Bartsch*, vol. XC, compiled by Frank J. Anderson.

210. Otto Brunfels, *Herbarum vivae eicones* (Strasbourg, 1530–35). The content of the herbal text is discussed most fully by T. A. Sprague, "The Herbal of Otto Brunfels," *Journal of the Linnean Society of London* 48 (1928), esp. pp. 79–85. Sprague also identifies each of the plants according to its species. On Brunfels, see *Neue deutsche Biographie*, vol. II, pp. 677–78; Arber, *Herbals*, pp. 52–55.

211. The illustrations and translation for this ambitious project, overseen by the court humanist Sebastian Brant, appear to have been completed in Augsburg in the late teens, though as we have earlier noted it was not published until 1532. André Chastel, "Pétrarque et son illustrateur devant la peinture," in *Études d'art médiéval offertes à Louis Grodecki*, ed. Sumner M. Crosby, et al. (Paris, 1981), pp. 343–52, with further bibliography.

212. On this complex subject, see most recently Fritz Koreny, *Albrecht Dürer and the Animal and Plant Studies of the Renaissance* (Boston, 1988). Koreny's is now the most rigorous art historical examination of nature study in this period.

213. Walther Rytz, *Pflanzenaquarelle des Hans Weiditz aus dem Jahre 1529* (Bern, 1936), pp. 5–32, *passim*. The watercolors were originally painted on both sides of each sheet, and were later cut out and remounted in an herbal compiled by the botanist Felix Plattner. In many cases where Plattner retained the watercolors from both sides of the sheet, the excised portions where a plant overlapped

214. with the watercolor on the verso have been filled in. The original format of Weiditz's album is therefore lost to us.

214. Sprague, "Herbal of Brunfels," pp. 88–89.

215. Rytz, *Pflanzenaquarelle*, p. 5.

216. This point is clearly made by Koreny, *Dürer and the Animal and Plant Studies*, pp. 176–252 (see esp. pp. 228–30, cat. nos. 82–83).

217. On the complex arguments about dating and attribution, see *ibid.*, pp. 188–91, cat. no. 66.

218. Fritz Koreny, "A Coloured Flower Study by Martin Schongauer and the Development of the Depiction of Nature from van der Weyden to Dürer," *Burlington Magazine* 133 (1991), pp. 588–97.

219. We refer in particular to a group of watercolors dated 1526, very likely having a common provenance in the Imhoff family, and thereafter sold off to garnish the *Kunstkammer* of Rudolf II. On the history and attribution of this group and the legitimacy of the date 1526, see Koreny, *Dürer and the Animal and Plant Studies*, pp. 194–96.

220. Sprague, "Herbal of Brunfels," p. 81.

221. This is the conclusion of Rytz, *Pflanzenaquarelle*, pp. 18–21.

222. Miriam U. Chrisman, *Lay Culture and Learned Culture: Books and Social Change in Strasbourg, 1480–1599* (New Haven and London, 1982), pp. 174–75. See Kenneth F. Thibodeau, "Science and the Reformation: The Case of Strasbourg," *Sixteenth-Century Journal* 7 (1976), pp. 35–80.

223. Sprague, "Herbal of Brunfels," pp. 84–86. On scientific publications in Strasbourg during this period in general, and some particular observations about Brunfels' career, see Thibodeau, "Science and the Reformation," pp. 40–43, 48–50.

224. Jerry Stannard, "The Herbal as a Medical Document," *Bulletin of the History of Medicine* 43 (1969), pp. 212–20.

225. In the printer Wendel Rihel's second preface to the reader in the later, illustrated edition he explains the difficulties involved in getting specimens, and how the wish to produce a less expensive volume had led to omitting them in the first edition despite the burden this placed on Bock's descriptions. Hieronymus Bock, *Kreüterbuech* (Strasbourg, 1546), fol. b.

226. Arber, *Herbals*, pp. 150–52, 166; Lynn Thorndike, *A History of Magic and Experimental Science* (New York, 1923–58), vol. VI (1941), pp. 273–74; Morton, *Botanical Science*, pp. 122–27; T. A. Sprague, "The Herbal of Valerius Cordus," *Journal of the Linnean Society of London* 52 (1939), pp. 1–113; and F. David Hoeniger, "How Plants and Animals were Studied in the Mid-Sixteenth Century," in *Science and the Arts in the Renaissance*, ed. John W. Shirley and F. David Hoeniger (Washington, D.C., 1985), pp. 130–48.

227. "So kundten e.g. gedenncken das man Roszmarinum, Affodillin, Boraginen etc. oder ein annder Krauth nit kan in ainer anndern formb oder gestalt mallen noch conterfayen, dan es an im selbst ist." Relevant portions of the document are transcribed in Hermann Grotefend, *Christian Egenolff der erste ständige Buchdrucker zu Frankfurt A.M. und seine Vorlaufer* (Frankfurt, 1881), pp. 16–17. For more of the text, see also "Aus den Akten des Reichskammergerichts," *Zeitschrift für die gesamte Strafrechtwissenschaft* 12 (1892), pp. 899–901.

228. Schott appears to have won his case and been granted the Egenolff blocks as compensation, since he used them for a 1534 German edition of the Brunfels herbal. Arber, *Herbals*, pp. 209–10. In any case, Egenolff's subsequent editions (e.g., his 1535 *Herbal*) exclude the copies. See Parshall, *Imago contrafacta*.

229. Arber, *Herbals*, pp. 64–70, 212–17; Blunt, *Botanical Illustration*, pp. 49–56. Albrecht Meyer drew and colored the plants for the prototype, Heinrich Füllmaurer transferred the designs to the woodblocks, and Veit Rudolf Speckle cut them. Speckle is fulsomely praised in the Latin preface. Note that the artist transferring the drawing holds it to the side of the block and appears to draw it freehand.

230. Morton, *Botanical Science*, p. 124; T. A. Sprague and E. Nelmes,

"The Herbal of Leonhardt Fuchs," *Journal of the Linnean Society of London* 48 (1931), pp. 545–54.

231. "... mein Kreüterbuch hette wollen inn die Teütschen spraach bringen / damit auch der gemein man kündte ihm selbert in der notartzney geben / und aller kranckheyt heylen." Leonhart Fuchs, *New Kreüterbuch* (Basel, 1543), p. 2.

232. Arber, *Herbals*, p. 206.

233. The flowers characteristic of the female plant — those hops-like clusters along the stem — are shown on a male plant. See Weiditz's woodcut: Brunfels, *Herbarum*, vol. III, p. 178, to confirm the error. This discrepancy is pointed out by A. H. Church, "Brunfels and Fuchs," *Journal of Botany* (1919), pp. 233–44 (cited by Sprague and Nelmes, "Herbal of Fuchs," p. 550).

234. Blunt, *Botanical Illustration*, p. 54.

235. On Mattioli's relation to his sources, see especially Karen Meier Reeds, "Renaissance Humanism," pp. 522–27, with further bibliography. For a bibliographical account of the first luxury edition, see S. Savage, "A Little-known Bohemian Herbal," *The Library*, ser. 4, *Transactions of the Bibliographical Society of London*, ser. 2, vol. 2 (1921), pp. 117–31.

236. The artists are named in the preface of the later editions. We know Liberale to have been a painter and Meyerpeck a block cutter and a draftsman. For more information regarding their activities, see Thieme–Becker, XXIII, p. 183; XXIV, p. 500.

237. Augsburg, Stadtarchiv: *Handwerker Akten* (Briefmaler, Illuministen, Formschneider). Letter: Archduke Ferdinand in Prague to the Augsburg Council, 8 November 1559; edited draft of a letter from the Augsburg Council to Ferdinand, 5 January 1560. Neither letter reveals the names of the block cutter(s). The monogram *GS* with a *Formschneider's* knife appears on around 100 of the 589 figures in the 1562 and 1563 Prague editions. When the herbal was reprinted by Valgrisi in Venice in 1565, these signatures were cut out in all blocks but one where the monogram must have been missed because it is secreted in the foliage. Two of the Augsburg Archive proof impressions carry GS's monogram in the block (fig. 263), and the other two have the name of the plant and what appears to be a different monogram inscribed in pencil on the versos: *Giassmin* and *Acoro Vero* with *M* and *M* with two initials. The hand appears contemporary with the woodcuts. This suggests two different *Formschneider*, possibly the second being Meyerpeck who used the monogram *M* to sign his woodcuts in a later publication (see G. K. Nagler, *Die Monogrammisten* (Munich and Leipzig, 1897), vol. IV, pp. 460–61, no. 1474).

238. Ernst Gombrich, *Art and Illusion: A Study in the Psychology of Pictorial Representation* (Princeton, 1960), ch. 1.

239. Fuchs, *New Kreüterbuch*, ch. cci, ill. ccxcix, also called *Alraun*. A parallel case has been documented in zoological illustration. The Flemish etcher Marcus Gheeraerts designed an image of a chameleon for an edition of Aesop's fables published in 1567. Gheeraerts's chameleon derives from an extremely accurate figure in Pierre Belon's *De aquatilibus*, but mistakenly alters the creature's unusually shaped foot. Since Gheeraert's animal is set in a picturesque landscape that held a natural attraction for later illustrators seeking models for natural histories, the error was picked up and repeated constantly throughout the seventeenth century. William B. Ashworth, Jr., "Marcus Gheeraerts and the Aesopic Connection in Seventeenth-Century Scientific Illustration," *Art Journal* 44 (1984), pp. 132–38.

240. The sceptical view of the importance of visual description is evident in Arber, *Herbals*; Thorndike, *History of Magic and Science*, vol. VI, ch. 38; and George Sarton, *Six Wings: Men of Science in the Renaissance* (Bloomington, Indiana, 1957), ch. 4. More recently historians of science have inclined to weigh illustration more heavily, e.g., Morton, *Botanical Science*, ch. 5; Reeds, "Renaissance Humanism"; and Hoeniger, "How Plants and Animals were Studied," pp. 145–46.

241. Sprague and Nelmes, "Herbal of Fuchs," pp. 546–47.

242. Morton, *Botanical Science*, p. 124, notes the dates and cites in addition the publication of Copernicus's *De revolutionibus* in 1543.

243. Morton, *Botanical Science*, pp. 120–27. The classic essay arguing the value of artistic representation in furthering the history of science is Erwin Panofsky, "Artist, Scientist, Genius: Notes on the Renaissance-*Dämmerung*," in *The Renaissance: Six Essays*, rev. ed. (New York, 1962), ch. 6.

244. The importance of the Aristotelian distinction between substance and accident for sixteenth-century plant classification is discussed by Morton, *Botanical Science*, pp. 134–44.

245. The translation is quoted from *ibid.*, p. 158, n. 46.

246. Ernst Gombrich, "Review of William Ivins," pp. 168–69.

247. The outlines of this debate are assembled in the anthology by Philip P. Wiener and Aaron Noland, eds., *Roots of Scientific Thought: A Cultural Perspective* (New York, 1957).

248. See Edgar Zilsel, "The Genesis of the Concept of Scientific Progress," pp. 251–75; and A. C. Keller, "Zilsel: The Artisans and the Idea of Progress in the Renaissance," pp. 281–86, both in Weiner and Aaron, eds., *Roots of Scientific Thought*; and William Eamon, "Arcana Disclosed: The Advent of Printing, the Books of Secrets Tradition and the Development of Experimental Science in the Sixteenth Century," *History of Science* 22 (1984), pp. 111–50. For a bibliography of practical texts pertaining to the arts, see Julius von Schlosser Magnino, *La letteratura artistica*, trans. Filippo Rossi, 3rd ed. (Florence and Vienna, 1964), books 2–5.

Notes to Chapter VI

1. Max Lehrs, *Geschichte und kritischer Katalog des deutschen, niederländischen und französischen Kupferstichs im XV. Jahrhundert* (Vienna, 1908–34), vol. I, p. 22.

2. Nor is it the place to decide whether he went from line engraving to dotted work (Arthur M. Hind, *Early Italian Engraving* (London, 1938–48), vol. V, p. 193; David Landau in Jane Martineau and Charles Hope, eds., *The Genius of Venice, 1500–1600*, exh. cat. (London: Royal Academy of Arts, 1983), pp. 312–15) or from line engraving to dotted work and back to line engraving (Jay A. Levenson, et al., *Early Italian Engravings from the National Gallery of Art* (Washington, D.C., 1973), pp. 390–401); or to debate the degree of his authorship (Landau); or whether at times he used Giorgione's and Titian's drawings (Levenson, et al.).

3. K. Oberhuber, *Disegni di Tiziano e della sua Cerchia* (Venice, 1976), p. 62, no. 12.

4. Landau in *Genius of Venice*, p. 315.

5. See also Wilhelm Suida, "Tizian, die beiden Campagnola und Ugo da Carpi," *La Critica d'Arte* 6 (1936), pp. 285–88.

6. At about the same date Leonardo considered using engraving to publish the detail of his anatomical drawings "ad artis utilitatem." He felt woodcut too coarse for the purpose. See Carmen Bambach Cappel, "Leonardo, Tagliente and Dürer: 'La scienza del far di groppi,'" *Accademia Leonardi Vinci* 6 (1991), p. 92, nn. 139–42, with further bibliography; also Paola Barocchi, ed., *Scritti d'arte del Cinquecento* (Milan and Naples, 1971), vol. I, pp. 7–8.

7. Landau in *Genius of Venice*, pp. 331–32. For a general introduction to the work by the artist, see Lionello Puppi, *Marcello Fogolino, Pittore e Incisore* (Trent, 1966).

8. Hind, *Early Italian Engraving*, V, pp. 273–77 and p. 275, no. 2.

9. The image that decorates a Roman missal of 1516 may be by his hand. This is the *Liber Quindecim Missarum Electarum Quae Per Excellentissimos Musicos Compositae Fuerunt* (Rome, 1516): the cut is illustrated in Fabrizio Mancinelli, et al., *Raffaello in Vaticano*, exh. cat. (Rome, 1984), pp. 82–83, no. 51.

10. The frontispiece is to the *Epistole & Evangelij Volgari historiade*, published by Giovanni Antonio Nicolini da Sabbio and Nicolò e Domenico dal Jesus.

11. See Friedrich Lippmann, "Ein Holzschnitt von Marcantonio Raimondi," *Jahrbuch der königlich preussischen Kunstsammlungen* I (1880), pp. 270–76. For a review of the more recent literature, see Michelangelo Muraro and David Rosand, *Tiziano e la silografia veneziana del cinquecento*, exh. cat. (Vicenza, 1976), p. 73, n. 9.

12. That Ugo copied his colleague's work was suggested by Luigi Servolini, in "Ugo da Carpi," *Rivista d'Arte* 11 (1929), p. 185. The design of the print looks indeed to be by Marcantonio, but of, at the latest, 1506. It is most unlikely that Marcantonio would have provided Ugo in 1522 with a drawing of sixteen years earlier. The issue is further complicated by the fact that, although the book is dated in the colophon "nel ano del Signore M.D.XII," it has been demonstrated beyond any doubt that this was a printer's error, and that the date should have read "M.D.XXII." See Prince d'Essling, *Etudes sur l'art de la gravure sur bois à Venise: Les livres à figures vénitiens de la fin du XVe siècle et du commencement du XVIe* (Paris and Florence, 1907–14), vol. III, pp. 124–25. Thus, most theories about a collaboration between the engraver and the cutter fall. See, for instance, Antony de Witt, *Marcantonio Raimondi* (Florence, 1968), text facing pl. 1.

13. Johannes Wilde, "Die Anfänge der italienischen Radierung" (Diss., Universität, Vienna, 1918), typescript, Courtauld Institute of Art, London.

14. Sue Welsh Reed and Richard Wallace, et al., *Italian Etchers of the Renaissance and Baroque*, exh. cat. (Boston: Museum of Fine Arts, 1989), p. 5.

15. From the dates he engraved on some of his earlier prints, we can establish that it took him about a week to complete a medium-size print, such as the *Cupid and Three Putti* (ca. 240 × 200 mm). The *Venus Wringing her Hair* (B.XIV.234.312) is dated 11 September 1506, while the *Cupid and Three Putti* is dated 18 September 1506. The etchings, however, were never as large as this engraving.

16. There are some that are not listed by Wilde, such as, for instance, B.118 and 434, fully etchings.

17. Our chronology is at variance with that proposed by Reed and Wallace, *Italian Etchers*, p. 5, who suggest the 1520s.

18. There are 122 prints by Marcantonio of less than 130 mm maximum size.

19. M. Faietti and K. Oberhuber, *Bologna e l'Umanesimo, 1490–1510*, exh. cat. (Bologna, 1988), pp. 64–86.

20. A. E. Popham, *Catalogue of the Drawings of Parmigianino* (New Haven and London, 1971), vol. I, pp. 14–15; Reed and Wallace, *Italian Etchers*, pp. 6–17.

21. Popham, *Drawings of Parmigianino*, I, p. 15. See also Chapter IV, n. 164.

22. See p. 154 for the relationship between the two prints.

23. Reed and Wallace, *Italian Etchers*, p. 10.

24. Popham, *Drawings of Parmigianino*, I, p. 94, cat. no. 196.

25. New York, private collection; the painting was seen by David Landau in the Conservation Department of the Metropolitan Museum of Art, New York, in 1990, when it was being examined under infra-red reflectography. An article on it is being written by David Ekserdjian.

26. See Reed and Wallace, *Italian Etchers*, p. 16.

27. As claimed in *ibid.*

28. See Chapter IV.

29. For a discussion of both printmakers, see Gianvittorio Dillon in *Da Tiziano a El Greco*, exh. cat. (Venice, 1981), pp. 300–19. See also Reed and Wallace, *Italian Etchers*, pp. xxii–xxiv. The best source for Battista Franco is in W. R. Rearick, "Battista Franco and the Grimani Chapel," *Saggi e memorie di storia dell'arte* 2 (1958–59), pp. 107–32.

30. Francis L. Richardson, *Andrea Schiavone*, *passim*; Landau in *Genius of Venice*, p. 338; Reed and Wallace, Italian Etchers, pp. 22–27; Dillon in *Da Tiziano a El Greco*, pp. 301–13.

31. Reed and Wallace, *Italian Etchers*, p. xxii.

32. Examples by Marcantonio include the impressions of the *Judgment of Paris* in the British Museum and Rotterdam; in the British Museum there is also an example by the Master HFE, *Sea Gods*, B.XV.462.3.II, and by Ghisi, *Nativity*, B.XV.378.3.

33. Levenson, et al., *Early Italian Engravings*, p. 336, cat. no. 134.

34. See pp. 127–28.

35. Levenson, et al., *Early Italian Engravings*, p. 456; *Andrea Mantegna*, exh. cat. (London: Royal Academy of Arts, 1992), pp. 62, 187.

36. *Domenico Beccafumi e il suo tempo*, exh. cat. (Milan, 1990), pp. 84ff.; see also the review by David Landau, "Beccafumi," *Print Quarterly* 8 (1991), pp. 450–51.

37. *Domenico Beccafumi*, pp. 502–04; see also Donato Sanminiatelli, *Domenico Beccafumi* (Milan, 1967), pp. 130–31; and Mino Gabriele, *Le incisioni alchemico-metallurgiche di Domenico Beccafumi* (Florence, 1988).

38. See Ulrich Middeldorf, "Two Sienese Prints," *Burlington Magazine* 116 (1974), pp. 106–10. The drawing is in the Uffizi, Florence (inv. no. 14522).

39. For a discussion of this print, see Craig Hartley, "Beccafumi 'glum and gloomy,'" *Print Quarterly* 8 (1991), pp. 418–22.

40. *Domenico Beccafumi*, p. 476, cat. no. 142.

41. Edward J. Olszewski, *The Draftsman's Eye: Late Italian Renaissance Schools and Styles*, exh. cat. (Bloomington, Ind., 1981), pp. 30–32, cat. nos. 5–7; *Domenico Beccafumi*, pp. 480–81, cat. nos. 148–50.

42. See Hartley, "Beccafumi", pp. 418–25.

43. See also *Domenico Beccafumi*, cat. nos. 155–58.

44. *Domenico Beccafumi*, cat. nos. 151, 153, 150, 152 and fig. 13 on p. 422.

45. J. D. Passavant, *Le peintre-graveur* (Leipzig, 1864), vol. VI, p. 149, no. 3.

46. Giorgio Vasari, *Le vite de' più eccellenti pittori, scultori ed architettori*, ed. G. Milanesi (Florence, 1878–85), vol. V, p. 653.

47. The other being that of engravings by Gherardo del Fora copied from Schongauer and Dürer, which he described as "ritratte... benissimo; come si può vedere in certi pezzi del nostro Libro, insieme con alcuni disegni di mano del medesimo" (copied ... well; as one can see in some examples in our Libro, together with some drawings by the same hand): Vasari, *Vite*, III, p. 240.

48. *Ibid.*, V, p. 414: "era venuta in pregio e reputazione la cosa delle stampe"; *Ibid.*, p. 442: "a tutti coloro ancora che di cosi' fatte opere si dilettano". See David Landau, "Vasari, Prints and Prejudice," *Oxford Art Journal* 6 (1983), *passim*.

49. See David Rosand, "Raphael, Marcantonio and the Icon of Pathos," *Source: Notes in the History of Art* 3 (1984), pp. 34–52.

50. B.XV.301.40. See Evelina Borea, "Stampa figurativa e pubblico dalle origini all'affermazione nel Cinquecento", in *Storia dell'Arte Italiana* (Turin, 1979), pt. 1, vol. II, p. 403. Vasari clearly did not trust printmakers to match the quality of his art. When discussing the paintings of Frans Floris, which he only knew through prints, Vasari notes that Floris was being called the new Raphael, but that there was little evidence of such gifts in the prints, although, he adds, these never succeed to convey the quality of their models. Vasari, *Vite*, VII, p. 585. See Caroline Karpinski, "The Print in Thrall to its Original: A Historiographic Perspective," in *Retaining the Original: Multiple Originals, Copies, and Reproductions*, Studies in the History of Art, vol. 20 (Washington, D.C.: National Gallery of Art, 1989), p. 103.

51. See Jeremy Wood, "Cannibalized Prints and Early Art History: Vasari, Bellori and Fréart de Chambray on Raphael," *Journal of the Warburg and Courtauld Institutes* 51 (1988), pp. 210–20, esp. pp. 211, 219.

52. Vasari, *Vite*, V, p. 425.

53. "Tanto ardore ut schemata quoque sua Vincii nostri Leonardi manibus sculpta". Luca Pacioli, *De divina proportione* (Venice: Paganino de Paganinis, June 1509), A.ii.v.

54. See Stanley Morrison, *Fra Luca de Pacioli* (New York, 1933), p. 10.

55. *Ibid.*

56. Muraro and Rosand, *Tiziano*, p. 47, n. 11.

57. C. L. Frommel, *Die Farnesina und Peruzzis Architektonisches Frühwerk* (Berlin, 1961), p. 186.

58. "e non niego che Marcantonio non fosse unico nel burino, ma Gianiacobo Caraglio Veronese suo allievo lo passa . . . come si vede nelle opere intagliate da lui in rame." *La Cortigiana*, act III, scene vii.

59. Vasari, *Vite*, V, p. 414, and B.XIV.375.513.

60. Innis H. Shoemaker and Elizabeth Broun, *The Engravings of Marcantonio Raimondi*, exh. cat. (Lawrence, Kan., 1981), p. 150, cat. no. 46.

61. "Acerrimus virtutum ac vitiorum demonstrator". This motto became so much identified with Aretino that it was used as the main inscription of the frontispiece of one of the most important editions of his letters: *De le lettere di M. Pietro Aretino Libro Primo Ristampato Nuovamente con Giunta Daltre XXV* (Venice: Marcolini, September 1538). The same motto appears around the frame of the portrait of Aretino by Sebastiano del Piombo, described by Vasari, and now in Arezzo, Palazzo Comunale: see Mauro Lucco, *L'opera completa di Sebastiano del Piombo* (Milan, 1980), pp. 116–17, no. 71.

62. See *Lettere di Pietro Aretino*, III, pp. 328r-v.

63. *Ibid.*, IV, p. 225v.

64. *Ibid.*, pp. 234r–v.

65. *Ibid.*, V, pp. 291v–292r.

66. *Ibid.*, pp. 314r–v.

67. There is a further mention of Enea in a letter to Titian written in November 1550, when the painter was at Augsburg: *ibid.*, VI, p. 32v.

68. *Ibid.*, pp. 22r–27v.

69. Ettore Camesasca, *Artisti in Bottega* (Milan, 1966), p. 445; Olszewski, *The Draftsman's Eye*, p. 99. In this context it is worth remembering that Anton Francesco Doni included six printmakers among the greatest artists of all time in the list of 42 that prefaces his *Disegno*, published in 1549: they are Dürer, Vico, Lucas, Caraglio, Schongauer, and Marco Dente, in this order. Moreover, when in the concluding chapter Doni appeals to Bandinelli to act as the final judge in the *paragone* between painting and sculpture — in order to establish which is the nobler of the two arts — he does so on the basis of the excuse that Bandinelli had acquired the *principato del disegno* (the supremacy of *disegno*) thanks, above all, to his two engravings of the *Martyrdom of St. Lawrence* and the *Massacre of the Innocents*. See Doni, *Disegno*, p. 39. Doni was obviously under the impression that Bandinelli had engraved the two prints himself: otherwise he would no doubt have included Marcantonio, the author of one of them (the other being by Dente), in the group of the great and the good mentioned in the preface.

70. *Dizionario Biografico degli Italiani* (Rome, 1960–), vol. XIX, p. 617; see also *Antichita' Viva* (1970), vol. IX, pp. 5off.; also Giorgio Fossaluzza, "Qualche recupero al catalogo ritrattistico del Bordon," in *Paris Bordon e il suo tempo: Atti del convegno internazionale di studi*, 28–30 October 1985, preface by Rodolfo Pallucchini (Treviso, 1987), p. 198.

71. For a reconstruction of Agostino's early career, see Dieter Kuhrmann, "Frühwerke Agostino Venezianos," in *Festschrift Kauffmann: Minuscula Discipulorum* (Berlin, 1968), pp. 173–76. The monogram Agostino used in his earliest works is no. 439 in G. K. Nagler, *Die Monogrammisten* (Munich and Leipzig, 1897), vol. I, p. 240.

72. B.XIV.320, 424; A. Petrucci, *Panorama dell'incisione italiana: Il cinquecento* (Rome, 1964), p. 31.

73. It is possible that also Marco Dente came from an old patrician family of Ravenna: see Stefania Massari, *Tra mito e allegoria: Immagini a stampa nel '500 e '600* (Rome, 1989), p. 61. For Ugo's ancestry from the Conti da Panico, see Servolini, "Ugo da Carpi,"

pp. 173–94, 297–319, esp. p. 179.

74. For Caccianemici, see Reed and Wallace, *Italian Etchers*, pp. 19–21. Another similar case is that of Niccolò della Casa, who was the nephew of the Notary to the Council of Trent: see Gottfried Buschbell, *Concilium Tridentinum*, 10, *Epistularum* (Freiburg-im-Breisgau, 1916), p. 804.

75. Richardson, *Schiavone*, pp. 6–10, 18–19, 75–79.

76. Michael Bury, *Giulio Sanuto*, exh. cat. (Edinburgh: National Gallery of Scotland, 1990).

77. Muraro and Rosand, *Tiziano*, p. 120; Landau in *Genius of Venice*, p. 339.

78. Artists were trained to copy exactly since small children. Adamo Scultori copied an engraving by his father, and proudly signed with his age, 11 years old (B.XV.418.5).

79. Massari, *Tra mito e allegoria*, *passim*, esp. pp. xi, xii, xiv.

80. See also Borea, "Stampa e pubblico", p. 384. Doni, however, made the mistake of attributing two prints, by Marcantonio and Marco Dente, to their "inventor", Baccio Bandinelli. As we know, Marcantonio's *Parnassus* did not look like Raphael's *Parnassus*.

81. See Massari, *Tra mito e allegoria*, nos. 83, 84, 100, 105, 109, 110.

82. It has been noted that these inscriptions demonstrate that either Agostino or somebody to whom he had access spoke and wrote Greek well enough to conflate two passages from Luke without making errors, either in meaning or in spelling and accentuation. See Wood, "Cannibalized Prints," pp. 215–16, n. 48.

83. Massari, *Tra mito e allegoria*, no. 94.

84. *Ibid.*

85. *Ibid.*, nos. 88–93. In 1532 and 1533 Michelangelo gave these drawings to the young Tommaso Cavalieri when he had fallen in love with him.

86. See Cappel, "Leonardo, Tagliente and Dürer", p. 88, n. 106, where she argues that the inscriptions on the prints produced in Leonardo's milieu represent an explicit acknowledgement of the master's *inventio* and of the teaching and propagating of his designs.

87. Its first datable use — albeit to mean the opposite of what it was to signify in sixteenth-century Rome — was on the Bramante/Prevedari print of 1481 (see p. 104). It was used once or twice by a number of printmakers all over Italy in the late fifteenth or early sixteenth century — Lucantonio degli Uberti (H.2), Nicoletto da Modena (H.64), Giulio Campagnola (H.1, 2), and Altobello Melone (H.1), but almost never by the first generation of printmakers working in Rome. Marcantonio and Marco Dente never employed the term; Agostino, who engraved more than 650 plates in his long career, used it only once on a print inscribed *1518* (B.XIV.320.424). This appears to be the first instance in Italy which can be securely dated (Dürer's *Adam and Eve* is dated 1504). Caraglio used *fecit* or *f.* on half a dozen occasions only.

88. See Massari, *Tra mito e allegoria*, nos. 56, 90. Enea Vico's *Tarquin and Lucretia* (B.XV.287.15) was engraved on the same plate used by Agostino Veneziano (B.XIV.169.208).

89. He describes it in a letter to Vico of 31 August 1549. Doni, *Il Disegno*, p. 51. The earliest dated dedication we have found in an engraving is on a print by Giovanni Maria da Brescia of 1512 (H.3).

90. Leo Steinberg, *Michelangelo's Last Paintings: The "Conversion of St. Paul" and the "Crucifixion of St. Peter" in the Cappella Paolina, Vatican Palace* (London, 1975), p. 42 and fig. 65; but see Stefania Massari, *Giulio Bonasone*, exh. cat. (Rome, 1983), vol. I, cat. nos. 85–87.

91. Massari, *Giulio Bonasone*, I, p. 9, and p. 26, n. 9.

92. See, for instance, Hind, *Early Italian Engraving*, I, E.III.21, 24, 25.

93. *Ibid.*, E.III.34, 36, 37.

94. *Ibid.*, E.III.56, 57, 58, 59, etc.

95. He may have been inspired in this by the Master IAM of Zwolle's *Agony in the Garden* (Lehrs, VII.182.3) which shows a similar solution.

96. B.XII.85.37; III.7; 125.26; 59.17; 143.3; 146.10.

97. Suzanne Boorsch, M. Lewis, and R. E. Lewis, *The Engravings of Giorgio Ghisi*, exh. cat. (New York: Metropolitan Museum of Art, 1985), cat. nos. 20, 23.

98. The fundamental article on Italian print collecting is by Michael Bury, "The Taste for Prints in Italy to *c.* 1600," *Print Quarterly* 2 (1985), pp. 12–26.

99. Barocchi, ed., *Scritti d'arte*, III, pp. 289–90.

100. Barocchi, *Scritti d'arte*, p. 287.

101. "Libro de dissegni a stampa e' de man de vari maestri". Theodor von Frimmel, "Der Anonimo Morelliano (Marcantonio Michiel)," in *Quellenschriften für Kunstgeschichte und Kunsttechnik des Mittelalters und der Renaissance* (Vienna, 1888), vol. I, p. 92. As usual, prints are called printed drawings or drawings from plates.

102. Jennifer Fletcher, "Marcantonio Michiel: His Friends and Collection," *Burlington Magazine* 123 (1981), pp. 459–60.

103. A. Rava, "Il 'Camerino delle antigaglie' di Gabriele Vendramin," *Nuovo Archivio Veneto* 39 (1920), pp. 155–81. No mention of prints appears in a 1601 inventory: see Jaynie Anderson, "A Further Inventory of Gabriel Vendramin's Collection," *Burlington Magazine* 121 (1979), pp. 639–48.

104. "Molti desegni stampidi in carte cum rame et legnio, parte posti in alcuni libri et una gran parte fora de essi libri." See Gustav Ludwig, "Testament des Gabriel Vendramin," in *Archivialische Beiträge zur Geschichte der Venezianischen Kunst* (Berlin, 1911), pp. 72–74.

105. Muraro and Rosand, *Tiziano*, cat. no. 8.

106. Enea Vico, *Discorsi sopra le medaglie de gli antichi* (Venice, 1555), p. 88; noted in Anderson, "A Further Inventory," p. 640, n. 5.

107. The possibilities seem to be limited to: B.XIV.257.444; XV.211.39–70; XV.76.20; XV.35.5.

108. See Hind, *Early Italian Engraving*, V, nos. 8, 9, 10, 13.

109. *Ibid.*, pp. 198–99.

110. Henri Zerner, "A propos de faux Marcantoine: Notes sur les amateurs d'estampes à la Renaissance," *Bibliothèque d'Humanisme et Renaissance* 23 (1961), pp. 477–81. See also, for some further examples, Shoemaker and Broun, *Engravings of Marcantonio*, pp. 78–79.

111. Popham, *Drawings of Parmigianino*, I, pp. 264–75; Maurizio Fagiolo dell'Arco, *Il Parmigianino: Un saggio sull'ermetismo nel Cinquecento* (Rome, 1970), pp. 238–46; Bury, "Taste for Prints," pp. 19–20.

112. Fagiolo dell'Arco, *Il Parmigianino*, p. 93.

113. A. E. Popham, "The Baiardo Inventory," in *Studies in Renaissance and Baroque Art Presented to Anthony Blunt on his 60th Birthday*, ed. Jeanne Courtauld, et al. (London, 1967), pp. 26–29.

114. Popham, *Drawings of Parmigianino*, I, nos. 49, 210, 756.

115. *Ibid.*, nos. 77, 144, 189, 746. See also Philip Pouncey, "Review of *Drawings of Parmigianino*," *Master Drawings* 14 (1976), pp. 172–76, for the importance prints played in Parmigianino's work.

116. Popham, *Drawings of Parmigianino*, I, nos. 520, 675.

117. See David Allan Brown, "A Print Source for Parmigianino at Fontanellato," in *Per A. E. Popham* (Parma, 1981), pp. 43–53.

118. See David Ekserdjian, "Parmigianino and Mantegna's 'Triumph of Caesar,'" *Burlington Magazine* 134 (1992), pp. 100–01.

119. Bury, "Taste for Prints," p. 24.

120. On the Benavides portrait (B.XV.337.252), see Bury, "Taste for Prints," p. 20, n. 57. On the two Doni portraits (B.XV.335.244 and 245), see Petrucci, *Il Cinquecento*, p. 60 and p. 100, nn. 95–96.

121. Petrucci, *Il Cinquecento*; Bury, "Taste for Prints," pp. 15–16, n. 25. The letter is appended to *Il Disegno* (Venice, 1549), pp. 51–52.

122. Bury, "Taste for Prints," p. 14, n. 23.

123. *Ibid.*, p. 24.

124. R. Lightbown, *Mantegna: With a Complete Catalogue of the Paintings, Drawings and Prints* (Oxford, 1986), pp. 16, 393.

125. Andrew Martindale, *"The Triumphs of Caesar" by Andrea Mantegna in the Collection of Her Majesty the Queen at Hampton Court* (London, 1979), p. 186, doc. no. 29.

126. *Lettere di Pietro Aretino*, III, pp. 176r–178v.

127. A drawing, attributed to Salviati and said to be the preparatory drawing for the engraving, was offered for sale at Phillips, London, 8 July 1992, lot 210.

128. Francesco had taken this surname from his first protector, the Cardinal Giovanni Salviati. Bartsch misunderstood the inscription, and attributed the invention of this print to Frans Floris.

129. Bury, "Taste for Prints," p. 22.

130. *Ibid.*, p. 14. See H. W. Frey, *Il Carteggio di Giorgio Vasari* (Munich, 1923), p. 325.

131. Patricia Collins, "Prints and the Development of *istoriato* Painting on Italian Renaissance Maiolica," *Print Quarterly* 4 (1987), pp. 223–35.

132. In another mid-century inventory of the property of Daniele da Volterra, taken at his death on 5 April 1566, there appear two bound books containing prints by Dürer, including his *Passion*. S. H. Levie, "Der Maler Daniele da Volterra" (Diss. Cologne, 1962), p. 217.

133. "A benefitio et utile di tutti li pittori et scultori et altre virtuose persone." Muraro and Rosand, *Tiziano*, p. 66, n. 49.

134. P. Zampetti, *Lorenzo Lotto: Il "Libro di Spese Diverse," con aggiunta di lettere e d'altri documenti* (Florence, 1969), pp. xxxix, 218.

135. *Ibid.*, p. 244.

136. *Ibid.*, p. 243.

137. *Ibid.*, p. 240.

138. Levenson, et al., *Early Italian Engravings*, p. 83, n. 10. See above, Chapter III, p. 98.

139. See Ernesto Lamma, "Antonello da Messina und deutsche und niederländische Künstler in Venedig. II. Zustand des Buchgewerbes in der zweiten Hälfte des XVI. Jahrhunderts," *Jahrbuch der königlich preussischen Kunstsammlungen* 23 (1902), supp. pp. 46–51.

140. *Ibid.*

141. Much has been written about this subject, but it is worth going back to a few facts in the light of our findings about the market for prints in Italy at the time. Levenson, et al., *Early Italian Engravings*, pp. 47ff. See also above, Chapter II, n. 38.

142. For currency, see Appendix; for the text, see Hind, *Early Italian Engraving*, V, p. 305.

143. Iodoco del Badia, "La bottega di Alessandro di Francesco Roselli merciaio e stampatore (1525)," in *Miscellanea Fiorentina di Erudizione e Storia* (Florence, 1894), vol. II, pp. 29–30.

144. *Ibid.*

145. See Appendix on currencies.

146. Sermons on Zacharias, in Creighton E. Gilbert, *Italian Art, 1400–1500: Sources and Documents* (Englewood Cliffs, N.J., 1980), p. 159.

147. Rosand, "Raphael," pp. 34–52.

148. See F. Gandolfo, "Il Dolce Tempo," in *Mistica, Ermetismo e Sogno nel Cinquecento* (Rome, 1978), pp. 110–12.

149. Rosand, "Raphael," *passim*. In every single document we have mentioned that pertains to the first forty years of the century, Marcantonio's prints are cited as "by" Raphael.

150. Henri Zerner, "L'estampe érotique au temps de Titien," in *Tiziano a Venezia: Convegno Internazionale di Studi, Venezia, 1976*, ed. Neri Pozza (Vicenza, 1980), pp. 85–90; for a general introduction to the subject, see Giorgio Lise, *L'incisione erotica del Rinascimento* (Milan, 1975), *passim*; and, for much richer visual documentation, see Louis Dunand and Philippe Lemarchand, *Les amours des dieux* (Lausanne, 1977); for Marcantonio's set of prints, see Lynne Lawner, *I modi* (Milan, 1984) and *idem, I modi: The Sixteen Pleasures, an Erotic Album of the Italian Renaissance* (Evanston, 1988).

151. Vasari, *Vite*, V, p. 418.

152. Ludovico Ariosto, *I Suppositi* (Rome, 1527), p. A.i.*v.* The date of publication of this comedy provides an *ante quem* for the publication

of the *Modi*.

153. See Georg Wissowa, *Paulys Real-Encyclopädie der Classischen Alter-tumswissenschaft* (Stuttgart, 1905), vol. V, pp. 2324–25, s.v. "Elephantis."

154. The text is unchanged in the editions published in Venice in 1525 and 1526, in Rimini also in 1526, and again in Venice in 1536. The 1551 and 1562 Venice editions, however, mention that "le supposizioni non sono come quelle antiche . . . come quelle che Elefantiade lasciò dipinte . . . e che renovatesi sono a i di nostri in Roma Santa, e fattesi in carte belle, piú che honeste, imprimere" (the suppositions are not like the ones from antiquity . . . such as those that Elefantiade left painted . . . that are nowadays renewed in Rome, and have been made in good prints, more than merely honest).

155. Zerner, "L'estampe érotique," p. 88, n. 10.

156. See Massari, *Tra mito e allegoria*, nos. 58–77.

157. For the richest photographic documentation on the subject, see Dunand and Lemarchand, *Les amours des dieux, passim*. See also Borea, "Stampa e pubblico", pp. 366–67.

158. Lawner, *I modi* (Milan, 1984), pp. 64–104.

159. See Fidenzio Pertile and Carlo Cordiè, *Lettere sull'arte di Pietro Aretino* (Milan, 1957–60), vol. I, p. 18.

160. *Ibid.*, II, pp. 429–31.

161. This print has rarely been discussed in the print literature. It was first published by Paul Kristeller, "Ein unbeschriebener Kupferstich von Marcanton," *Repertorium für Kunstwissenschaft* 31 (1908), pp. 63–65. Kristeller did not think it should be reproduced in a serious journal, but he let scholars know that a photograph was available in the Berlin print room. It was illustrated by Dunand and Lemarchand, *Les amours des dieux*, p. 167, fig. 380. An earlier pair of erotic prints survives only in a plate engraved on both sides. No pre-modern impression of either one is known. See Levenson, et al., *Early Italian Engravings*, pp. 526–27.

162. A contract of 25 June 1507 between a group of four publishers (published by R. Fulin in *Archivio Veneto* 23 (1882), pp. 401–04), allowed for a maximum paper wastage of 4 percent of all the supply needed to print the fifteen books covered by the agreement.

163. A. Sartori, "Documenti padovani sull'arte della stampa nel secolo XV," in A. Barzon, *Libri e stampatori in Padova: Miscellanea di studi storici in onore di Mons. G. Bellini* (Padua, 1959), *passim*.

164. *Ibid.*, pp. 131–34.

165. Muraro and Rosand, *Tiziano*, p. 48, n. 15.

166. Rinaldo Fulin, "Nuovi documenti per servir la storia della tipografia Veneziana," *Archivio Veneto* 23 (1882), pt.1, p. 130, doc. no. 74; see also G. Castiglioni, "'Frixi et figure et miniadure facte de intajo' tra silografia e miniatura in alcuni incunaboli veneziani," *Verona Illustrata* 2 (1989), pp. 19–27.

167. Muraro and Rosand, *Tiziano*, p. 49, n. 17; Luigi Servolini, *Jacopo de' Barbari* (Padua, 1944), p. 50; see also above, pp. 43–46.

168. Jean Michel Massing, "'The Triumph of Caesar' by Benedetto Bordon and Jacobus Argentoratensis: Its Iconography and Influence," *Print Quarterly* 7 (1990), pp. 4–21, with further bibliography.

169. See Servolini, "Ugo da Carpi," pp. 173–94.

170. Massing, "Triumph of Caesar," p. 4.

171. Muraro and Rosand, *Tiziano*, pp. 71–78; Michael Bury, "'The Triumph of Christ,' after Titian," *Burlington Magazine* 131 (1989), pp. 188–97.

172. Muraro and Rosand, *Tiziano*, pp. 71–78.

173. *Ibid.*, p. 78; Landau in *Genius of Venice*, pp. 320–21.

174. See d'Essling, *Les Livres à figures*, III, pp. 22–25.

175. *Ibid*, p. 27. The panel is now in Vienna, in the Museum für Angewandte Kunst.

176. Muraro and Rosand, *Tiziano*, nos. 2, 13, 3.

177. It is possible that Titian's name was inscribed on early impressions of other woodcuts of which we only have late editions, such as the *Submersion of Pharaoh's Army in the Red Sea*.

178. Muraro and Rosand, *Tiziano*, p. 141.

179. *Ibid.*, no. 89.

180. For which event, see Vittorio Rossi, "Bazzeccole bibliografiche: II. Un incendio a Venezia e il tipografo Bernardino Benalio," *Il Libro e la Stampa* 4 (1910), p. 51.

181. *Dizionario Biografico*, VIII, p. 165.

182. B. Cecchetti, "Uno stampatore di santi in Venezia nel 1514," *Archivio Veneto* 32 (1886), p. 386.

183. A copy of Baldung's *Witches' Sabbath* by Lucantonio degli Uberti, undoubtedly cut in Venice, where he was living at the time, bears the date 1516. See Arthur M. Hind, *An Introduction to a History of Woodcut* (New York, 1935; repr. London and New York, 1963), II, p. 442; and Passavant, *Le peintre-graveur*, V, p. 64, no. 9.

184. It is possible that Ugo's eagerness to obtain a privilege in Rome as well was dictated by the fact that the so-called Master IB with the Bird, probably Giovanni Battista Palumba, had produced there a chiaroscuro woodcut, a *St. Sebastian*, that imitated the German method: see Hind, *Early Italian Engraving*, V, p. 249.

185. Ugo's continued reliance on Venetian privileges may have to do with the presence there of "Piron da Carpi," a cutter who was probably a relative of his, and who was active in Venice in the late 1520s. See Cappel, "Leonardo, Tagliente and Dürer," p. 82, n. 67.

186. See Carlo Castellani, "I Privilegi di Stampa e la Proprietà Letteraria in Venezia dalla Introduzione della Stampa nella Città fin verso la Fine del Secolo Scorso," *Archivio Veneto* 36 (1888), pp. 127–39.

187. *Ibid.*, p. 129.

188. See John Hale, *A Concise Encyclopaedia of the Italian Renaissance* (London, 1981), p. 268.

189. Castellani, "I Privilegi," p. 130.

190. See pp. 43–46.

191. Castellani, "I Privilegi," pp. 133–34.

192. *Ibid.*

193. See Pier Silverio Leicht, "L'editore veneziano Michele Tramezino ed i suoi privilegi," in *Miscellanea di scritti di bibliografia ed erudizione in memoria di Luigi Ferrari* (Florence, 1952), pp. 361–62.

194. This happened occasionally in the case of expensive books, for which a partnership had been formed between publishers from the two cities. *Ibid.*, pp. 363–64.

195. *The Death of Ananias* (B.XI.46.27). See fig. 153.

196. Paolo Bellini, "Stampatori e mercanti di stampe in Italia," *I quaderni del conoscitore di stampe* 26 (1975), pp. 19–45.

197. So much so that he could call himself a *banchiere*. See Petrucci, *Il Cinquecento*, p. 55.

198. *Ibid.*

199. *Ibid.*, p. 97, n. 69

200. F. Ehrle, *Roma prima di Sisto Quinto* (Rome, 1908), p. 13. A print by Iacopo Francia, dated 1530 (Hind, *Early Italian Engravings*, V, p. 234, no. 13), carries in its second state the *excudit* of Salamanca: Leandro Ozzola thus claimed that this was the earliest dated print published by Salamanca ("Gli editori di stampe a Roma nei secoli XVI e XVII," *Repertorium für Kunstwissenschaft* 33 (1910), pp. 400–11). The form of the inscription, however, makes it likely that it does not refer to this Antonio Salamanca (see below). The date appears in the plate already in its first state.

201. Ehrle, *Roma*.

202. *Ibid.*

203. Petrucci, *Il Cinquecento*, p. 97, n. 69.

204. See H. Thomas, "Antonio [Martinez] de Salamanca, Printer of La Celestina, Rome, c. 1525," *Library*, 5th ser., 8 (1953), pp. 45–50.

205. G. L. Masetti Zannini, *Stampatori e Librai a Roma nella Seconda Meta' del Cinquecento: Documenti Inediti* (Rome, 1980), p. 120.

206. For example, Francesco Priscianese — originally a Florentine publisher, who by then considered himself a native — wrote a letter to Pietro Vettori on 6 May 1543, announcing that he was considering returning to Florence. In colorful terms he declared his intention "to slap the stick on the hand of those barbarous drunkards, who in this business have taken over just as they

please without any hindrance" (schiantar la palma in mano a questi barbari ubriaconi, la quale in quest'arte a lor senno et senza contrasto alcuno si vanno usurpando). *Ibid.*, p. 131.

207. The name is recorded in Ehrle, *Roma*, p. 14, n. 3.

208. Ehrle, *Roma*, *passim*. Ozzola, "Gli editori di stampe," p. 404.

209. Ehrle, *Roma*, pp. 14–15.

210. Francis Haskell and Nicholas Penny, *Taste and the Antique: The Lure of Classical Sculpture, 1500–1900* (New Haven and London, 1981), p. 18.

211. Borea, "Stampa e Pubblico", p. 391. Also on this topic, see *Bilder nach Bildern*, exh. cat. (Münster: Westfälisches Landesmuseum, 1979), esp. pp. 126–49, for a similar study of the *Apollo Belvedere*.

212. Hind, *Early Italian Engraving*, V, p. 120, no. 31.

213. Shoemaker and Broun, *Engravings of Marcantonio*, p. 64.

214. Hind, *Early Italian Engraving*, V, p. 218, no. 3. See also Lionello Puppi, *Marcello Fogolino, Pittore e Incisore* (Trent, 1966).

215. Hind, *Early Italian Engraving*, V, p. 217. Puppi, *Fogolino*, p. 47, argues that he must have derived it from a sketchbook; on the other hand, it is known (p. 49) that Fogolino went to Ascoli Piceno for a commission, and it is likely that he would have gone to Rome *en route*.

216. Indeed, he came closest to reproducing a piece of sculpture when in 1519 he depicted the antique *Bas-relief with Three Cupids* then in the church of San Vitale in his native Ravenna (B.XIV.194.242). The relief is now in the Louvre, Paris.

217. Shoemaker and Broun, *Engravings of Marcantonio*, p. 192.

218. It may be worth noting here that the word the printmakers *should* have used is *scalpsit* rather than *sculpsit*, as the former means engrave or incise, and the latter carve or model. The usage of the verb *sculptere* may have arisen from the tradition described in the text, below.

219. The verb *sculpsit* is used in different forms on a number of prints, but always in connection with statuary, and it is obvious that in these instances it refers to the object being represented. See Marcantonio (B.330, 331, 340, 341); Agostino Veneziano (B.301); Marco Dente (B.242, 515). For a discussion of the meaning of Dente's monogram *SR* (*Sculptor Ravennatis?*), see Evelina Borea's entry for Marco Dente in *Dizionario Biografico*, XXXVIII, pp. 790–94.

220. B.XV.379.6, 383.20.

221. B.XV.289.18; 305.49; 339.255. Three prints, the first of which is dated 1541, are signed *EVS*, where the *S* may stand for *sculpsit*: B.XV.361.469; 362.472; 364.479.

222. B.XV.302.42–44. See Borea, "Stampa e Pubblico," p. 390.

223. Timothy A. Riggs, *Hieronymous Cock: Printmaker and Publisher in Antwerp* (New York and London, 1977), pp. 29–30.

224. For Beatrizet, see the slim exhibition catalogue *Nicolas Beatrizet: Un graveur lorrain à Rome* (Luneville, 1970) where, however, an interesting proof of his *St. Michael* (B.XV.254.30) is illustrated, cat. no. 21. There is a large cache of extraordinarily early, rich impressions of Beatrizet's prints in the museum of Darmstadt.

225. B.XIV.24.20.B, 92.104.C.

226. Boorsch, Lewis, and Lewis, *Giorgio Ghisi*, p. 234.

227. See R. Brun, *Le livre français illustré de la Renaissance* (Paris, 1969), *passim*.

228. H. Zerner, *Ecole de Fontainebleau: Gravures* (Paris, 1969), p. xiv.

229. *Ibid.*, p. xv.

230. The dating of the drawings after Mantegna prints is discussed by Erwin Panofsky, *Albrecht Dürer* (Princeton, 1948), vol. I, pp. 32–33; and vol. II, p. 403, handlist nos. 902–03. In 1495 he copied a lost composition of naked figures clearly derived from Pollaiuolo (Panofsky, *Dürer*, II, pp. 95–96, handlist no. 931).

231. We cannot be certain whether the meeting occurred on Dürer's first trip to Venice, though if Jacopo was actually in the city it seems hardly possible given their respective connections that it did not happen. For the report of this encounter, see Hans Rupprich, *Dürer: Schriftlicher Nachlass* (Berlin, 1956–69), vol. II, p. 32.

232. In a letter to Pirckheimer of 7 February 1506. Rupprich, *Dürer*, I, pp. 44–45.

233. Rupprich, *Dürer*, I, pp. 72–73, 26 August 1509, from the long-winded exchange over the Heller Altar.

234. *Ibid.* "Den gmaine gmäll will ich ain jahr ain hauffen machen."

235. Panofsky, *Dürer*, II, p. 58, no. 458 (New York, Pierpont Morgan Library).

236. John Rowlands, *The Age of Dürer and Holbein: German Drawings, 1400–1550* (London, 1988), pp. 80–81, cat. no. 53.

237. State I: Berlin, Kuperstichkabinett; London, British Museum; Vienna, Albertina. State II: Vienna, Albertina (unique).

238. Berlin, Kupferstichkabinett, inv. 491–1882; and Vienna, Albertina, inv. 1930–1523.

239. To be sure, one needs to be careful in sampling, since a great many impressions have at some time been washed and pressed, which affects their surface. However, watermarks tend to support the hypothesis that different papers in simultaneous use in the workshop were delegated for drawings, engravings, and woodcuts. Of course size was a factor, but not the only one. See Walter Strauss, "Die Wasserzeichen der Dürerzeichnungen," *Zeitschrift des Deutschen Vereins für Kunstwissenschaft* 25 (1971), pp. 69–74.

240. Joseph Meder, *Dürer-Katalog* (Vienna, 1932; repr. New York, 1971), gives sound evidence of this practice in his cataloguing of impressions at various stages in the use of the plates and the corresponding watermarks over the course of his career. There is other scattered evidence in early documents and collections where Dürer's youthful productions are scarce. The infrequency of late impressions also implies the plates were printed and recycled.

241. "Wir sehen, so wÿr zwen trüg fan eim gescht[oc]hen kupfer trugken od zweÿ bild jn ein modell gissen, das man sÿ for ein ander kent, aller ding halb. So es nun jn den aller gwisten dingen geschicht, vill mer jm andern, das an mittel fan der hand geschicht." (London, British Museum, MS. Sloane 5231, fol. 106v). Rupprich, *Dürer*, III p. 283.

242. The impression of the engraving is dryly printed and a bit pale but fully registers its shallow lines. It was catalogued in the nineteenth century under Cranach as doubtful: *Verzeichniss der Kupferstich-Sammlung in der Kunsthalle zu Hamburg* (Hamburg, 1878), p. 273. The engraving was then attributed to Cranach by Dieter Koepplin and Tilman Falk, *Lucas Cranach*, exh. cat. (Basel and Stuttgart, 1974–76), vol. I, pp. 232–33, cat. no. 122.

243. Stephen Goddard, et al., *The World in Miniature: Engravings by the German Little Masters*, exh. cat. (Lawrence, Kan.: Spencer Museum of Art, 1988), with a thorough bibliography of earlier literature.

244. Vasari, *Vite*, V, pp. 407–11.

245. Peter W. Parshall, "Lucas van Leyden's Narrative Style," *Nederlands Kunsthistorisch Jaarboek* 29 (1978), pp. 185–238.

246. Carel van Mander, *Het Schilder-Boeck* (Haarlem, 1604; repr. New York, 1980), fol. 212v.

247. On this aspect of Lucas's engraving technique, see especially Jan Piet Filedt Kok, *Lucas van Leyden — grafiek*, exh. cat. (Amsterdam: Rijksmuseum, 1978), pp. 73–80. Filedt Kok discovered the early state of the *David and Abigail* (Berlin, Kupferstichkabinett). See addenda to the catalogue previously cited: *Nederlands Kunsthistorisch Jaarboek* 29 (1978), pp. 515–16. Ellen S. Jacobowitz and Stephanie Loeb Stepanek, *The Prints of Lucas van Leyden and His Contemporaries*, exh. cat. (Washington, D.C.: National Gallery of Art; Boston: Museum of Fine Arts, 1983), pp. 40–42, cat. no. 1.

248. This distinction in technique is pointed out by Wouter Kloek, "The Drawings of Lucas van Leyden," *Nederlands Kunsthistorisch Jaarboek* 29 (1978), pp. 452–53, who also discusses other drawings that might have some relation to Lucas's prints.

249. On Lucas's pictorial style, see especially Jacobowitz and Stepanek, *Prints of Lucas van Leyden*, pp. 19–26.

250. "L'estampe faite par un graveur d'après le dessin d'un peintre,

peut être parfaitement comparée à un ouvrage traduit dans une langue différent de celle de l'auteur; et comme une traduction ne peut être exacte que quand le traducteur s'est pénétré des idées de l'auteur, de même une estampe ne sera jamais parfaite, si le graveur n'a le talent de saisir l'esprit de son original, et d'en rendre la valeur par les traits de son burin." Adam Bartsch, *Le Peintre graveur* (Leipzig, 1803–21), vol. I, preface, p. iii.

251. William Ivins, Jr., "Notes on Three Dürer Woodblocks," *Metropolitan Museum Studies* 2 (1929), pp. 102–11.

252. Alan Shestack, "Some Preliminary Drawings for Engravings by Heinrich Aldegrever," *Master Drawings* 8 (1970), pp. 141–48, argues for Aldegrever having engraved all his own plates despite the existence of these drawings. The largest concentration of the Aldegrever preparatory studies is presently in Amsterdam, Rijksprentenkabinet. On their provenance, see *Duitse Tekeningen, 1400–1700: German Drawings*, exh. cat. (Rotterdam: Museum Boymans-van Beuningen, 1974), cat. no. S5. These drawings are indeed very close to the final prints and are outlined in a calculated way that suggests some direct means of transfer to the plate, though no evidence of pricking or carboning is now visible.

253. Patricia Emison, "Marcantonio's *Massacre of the Innocents*," *Print Quarterly* 1 (1984), pp. 257–67.

254. Filedt Kok, *Lucas van Leyden*, p. 82. Early impressions of the copy have watermarks found on prints other than by Lucas. Filedt Kok believes the copy is attributable to Lucas himself. Julius S. Held, *Dürer through Other Eyes: His Graphic Work Mirrored in Copies and Forgeries of Three Centuries*, exh. cat. (Williamstown, Mass.: Sterling and Francine Clark Art Institute, 1975), pp. 13–17, for copying techniques and many examples.

255. On this subject, see Peter Strieder, "Copies et interprétations du cuivre d'Albert Dürer 'Adam et Eve,'" *Revue de l'Art* 21 (1973), pp. 44–47.

256. See Karpinski, "Print in Thrall," pp. 101–09.

257. The only systematic studies of this topic are the following fundamental essays: E. Harzen, "Ueber die Erfindung der Aetzkunst," *Archiv für die zeichnenden Künste* [*R. Naumann's Archiv*] 5 (1859), pp. 119–36; and Gustav Pauli, *Inkunabeln der deutschen und niederländischen Radierung* (Berlin, 1908); Wilde, "Die Anfänge." More recent syntheses with bibliography are given by Wolfgang Wegner, "Aus der Frühzeit der deutschen Ätzung und Radierung," *Philobiblon* 2 (1958), pp. 178–90; W. Wegner, "Eisenradierung," in *Reallexikon der deutschen Kunstgeschichte* (Stuttgart, 1958), vol. IV, cols. 1140–52.

258. For information on the Hopfer family, see Ed. Eyssen, "Daniel Hopfer von Kaufbeuren" (Diss., Ruprecht-Karls-Universität, Heidelberg, 1904); Th. Muchall-Viebrook, "Hopfer," in Thieme–Becker, xvii, pp. 474–79; F. W. H. Hollstein, *German Engravings, Etchings and Woodcuts, ca. 1400–1700*, vols. XV, XVA, compiled by Robert Zijlma (Blaricum, 1986). A great many of the Hopfer's plates were reprinted and, consequently, impressions of them are relatively common. Traditionally scholars have assumed that 230 plates were first reprinted by the Nuremberg book publisher and art dealer David Funck, and that the numbers added to many of the plates were introduced by him in the early seventeenth century. But Falk (Hollstein, p. 5) notes that the paper on certain of these numbered impressions points to a somewhat earlier date, in the latter part of the sixteenth century. Then a second set of 92 plates was reprinted in 1802 by the Frankfurt printer C. Wilhelm Silberberg in an edition with a title page *Opera Hopferiana*. The practice of copying that occupied the careers of Daniel's sons is thoroughly discussed in Held, ed., *Dürer through Other Eyes*.

259. See Paul Post and Alexander von Reitzenstein, "Eisenätzung," in *Reallexikon der Deutschen Kunstgeschichte* (Stuttgart, 1958), vol. IV, cols. 1075–1103.

260. For an account of the evidence for early etching on armor, see James G. Mann, "The Etched Decoration of Armour," *Proceedings of the British Academy* 28 (1942), pp. 17–45, with good illustra-

tions. There is in addition a curious iron plaque in the Germanisches Nationalmuseum, Nuremberg, an etched copy of a *Man of Sorrows* engraving by Israhel van Meckenem (B.135). It has been dated ca. 1500 (Wegner, "Ätzung und Radierung," pp. 178–79, ill. 2). The plate is decoratively blackened in the intaglio design and may have served as a book cover.

261. The family tree and the relevant biographical documents are collected in Eyssen, "Hopfer", pp. 18–24 and appendix.

262. The dispute between Erika Tietze-Conrat, "Die Vorbilder von Daniel Hopfers Figuralem Werk," *JKSW*, n.s. 9 (1935), pp. 97–110; and Erwin Panofsky, "Conrad Celtes and Kunz von der Rosen: Two Problems in Portrait Identification," *Art Bulletin* 24 (1942), pp. 44–50, over the priority of two versions of a portrait, one Italian and one by Daniel Hopfer, has been resolved in favor of Panofsky's argument for the Hopfer print. There is no reasonable case for dating it on stylistic or other grounds any earlier than 1515. See J. Levenson, et al., *Early Italian Engravings*, pp. 523–24.

263. Muchall-Viebrook, "D. Hopfer," p. 475; and Max Loßnitzer, "Zwei Inkunabeln der deutschen Radierung," *Mitteilungen der Gesellschaft für vervielfältigende Kunst* (1910), pp. 35–36, convincingly relates the *Man of Sorrows* to Holbein's Donauschingen Altar. This, and to a lesser extent the *Virgin and Child with the Arms of the Passion* (Holl.42), share unmistakable stylistic traits showing Hopfer's roots in south German art of the late fifteenth century, and both are signed "DH." Daniel does not appear to have concerned himself with recording the dates of his inventions. In dating his plates, Daniel was preceded by his son Hieronymus, who dated an etching in 1520. Daniel's first dated plate is 1522. Importantly, the prints that appear stylistically earliest are not among those later reprinted by Funck and Silberberg, suggesting that the plates were not preserved and giving further confirmation of their early date.

264. Pauli, *Inkunabeln der Radierung*, p. 4. For a recent account of the origins of aquatint, see Antony Griffiths, "Notes on Early Aquatint in England and France." *Print Quarterly* 4 (1987), pp. 255–70.

265. The reverse of the same principle could have achieved this technical result, namely brushing the acidic substance directly onto the plate and leaving it to etch, a technique known in modern printmaking as "brush biting" (Bamber Gascoigne, *How to Identify Prints* (London, 1986), p. 71). However, the trace of application as it registers in the print makes clear that the ground and not the acid was brushed on. Open biting is implied in an early Italian recipe given by none other than Luca Pacioli for etching letters. See Harzen, "Die Erfindung der Ätzkunst," pp. 124–25, n. 17.

266. Paul Post, "Ein Frührenaissanceharnisch von Konrad Seusenhofer mit Ätzungen von Daniel Hopfer im Berliner Zeughaus," *Jahrbuch der preussischen Kunstsammlungen* 49 (1928), pp. 167–86. The Hopfer prints are two woodcut title pages for books published in 1514 and 1516, which, however, may easily have been printed before then; and two etchings, B.90 and 93. Post proposed Hopfer as the etcher of this armor, but as Mann points out ("Etched Decoration," pp. 21–22), the borrowing is not sufficient argument for establishing authorship.

267. Extant impressions of the second tonal etching (B.90) all register the tonal areas rather poorly, suggesting it was probably the first of the two experiments, and thus the date of the armor places this revolutionary plate relatively early in Daniel's career. In B.90 (unlike B.16; fig. 350) the tone is added over the cross-hatching. Conceivably this betrays a later reworking of the plate. However the unsuccessful registering of the tone in surviving impressions suggests it was a first attempt at open biting and actually initiated the Hopfer style. Leonardo da Vinci is the first we know to have recorded the process of open biting in his notes pertaining to the problem of printing drawings and handwritten texts on a single plate. He envisioned the process for making metal relief rather than

intaglio plates. See Ladislao Reti, "Leonardo da Vinci and the Graphic Arts: The Early Invention of Relief-Etching," *Burlington Magazine* 113 (1971), pp. 189–95.

268. In any case, the earliest connection between the Hopfer style and armor decoration cannot be dated prior to the earliest prints done in open biting. In fact, the only signed pieces of etched armor known to carry Daniel Hopfer's name were made in the 1530s during the last years of his life. These are a set of armor for Charles V, now in the Armeria Real in Madrid and dated 1536, and an etched sword blade in Nuremberg with figures and inscriptions from proverbs dated on stylistic and iconographical grounds ca. 1530–35. Wolfgang Wegner, "Ein Schwert von Daniel Hopfer im Germanischen Nationalmuseum in Nürnberg," *Münchner Jahrbuch der bildenden Kunst*, 3rd ser., 5 (1954), pp. 124–30.

269. We know the plate was double-bitten because around the margin of the figure there are lines that clearly register a darker black against the broader and softer areas of black around the patterns, and thus are bitten still deeper so that they print, as it were, on top of the ground. See, for example, the lines of the fur of the coat that extend onto the darkened background. If the figure had been drawn and etched at the same time as the background these lines could not have occurred.

270. For the subject in general, see Cyril Stanley Smith, *A History of Metallography* (Chicago, 1960), pp. 10–13. Lead-based pigment tempered with linseed oil is recommended in a recipe of ca. 1400 and again in the sixteenth century. See the recipes published by Hermann Warner Williams, Jr., "The Beginnings of Etching," *Technical Studies* 3 (1934/35), pp. 16–18; and Williams, "Zwei Ätzrezepte aus dem Secretum Philosophorum," *Zeitschrift für historische Waffen- und Kostumkunde*, n.s. 6 (1937–39), pp. 61–62. The anonymously authored treatise published by Cammerländer in Strasbourg in 1539, recommends laying on the mordant to a thickness of "a little finger" for etching steel armor plate. Lead white and linseed oil are recommended for stopping out, but wax is suggested for areas to be etched in broader patterns. Williams, "A Sixteenth-Century German Treatise, *Von Stahel und Eysen*, trans. with explanatory notes," *Technical Studies* 4 (1935/36), ch. 6. On the other hand, Valentin von Ruffach Boltz's *Illuminierbuch* of 1549 (repr. and ed. C. J. Benzinger (Munich, 1913), pp. 119–20), instructs the craftsman to "ladle" the warmed "etching water" over the plate. Most difficult to explain for the historian with an eye accustomed to the more familiar etching technique of Dürer, Parmigianino, or Rembrandt, are the curiously mottled blacks and dilations of white evident in the broader etched areas of the Hopfers' prints, and the deepening of the blacks around the periphery of the open valleys (fig. 352). This appears to be an effect of open biting where irregularities of biting are caused by bubbles formed in the acid as it attacks the surface of the plate. Furthermore, if a broad area is etched relatively deeply, when it is printed the ink will build up around the edges of the reliefed areas and register a much darker black. Such black margins are not due to a separate stage in which the lines were strengthened, but to the initial corrosion process itself. For illustrations of these effects in modern printmaking, see Gascoigne, *How to Identify Prints*, ills. 70–71.

271. This is the case, for example, in the area around the chin of the *Charles V*. Certain of the plates have been cleaned of rust marks.

272. Wolfgang Wegner, "Beiträge zum Graphischen Werk Daniel Hopfers," *Zeitschrift für Kunstgeschichte* 20 (1957), pp. 239–60.

273. Wilde, *Die Anfänge der Radierung*, p. 5, concludes that the adoption of etching in Italy and the north was independent, in contrast to what he terms Harzen's "genetic" view, requiring the transfer of the technique from one noteworthy figure to another ("Die Erfindung der Aetzkunst," pp. 134–35). For Leonardo's reference to nitric acid, see Reti, "Leonardo da Vinci and the Graphic Arts," p. 193.

274. Variations in density of line in the *Desperate Man*, the adeptness of

inking without incurring the watery effect found in impressions of the *Man of Sorrows*, and variations in the wiping for giving surface tone, all suggest a more advanced stage.

275. Hollstein, *German Engravings*, III. The total will vary slightly with disputes over attribution. Of the twelve dated etchings, nine are from 1520. Over half of these are recorded as showing evidence of rust marks in later impressions, and the style of all is consistent with the characteristics of iron. Though it is of course possible, there is no reason to posit that Beham ever used a copper mordant.

276. The impression betrays discomfort with the technique. The inking is dry and the printing very uneven, barely registered down the right side, and like the *Aristotle and Phyllis* (Holl.9) of 1519, the lines are unevenly bitten. The arguments for a later date are given by Hans Koegler, *Beschreibendes Verzeichnis der Basler Handzeichnungen des Urs Graf* (Basel, 1926), pp. 10, 95–96, cat. no. 155; and in support of the 1513 date, Emil Major and Erwin Gradmann, *Urs Graf* (London, 1947), p. 33, cat. no. 121. The cipher code is discussed briefly by these authors (p. 34, cat. no. 126). The figure canon and calligraphic draftsmanship of the etching hold much in common with drawings of the early 1520s. For example, compare the *Girl Stepping into a Stream* (Vienna, Albertina), or the *Aristotle and Phyllis* (formerly Dessau, Schloss Georgium; present location unknown), dated 1521.

277. Karl Th. Parker, "Zu den Vorbildern Urs Grafs," *Anzeiger für Schweizerische Altertumskunde*, n.s. 24 (1922), pp. 234–35. The drawing (Basel, Öffentliche Kunstsammlung) is based on a Marcantonio engraving.

278. A. R. Williams, "The Metallographic Examination of a Burgkmair Etching Plate in the British Museum," *Journal of the Historical Metallurgy Society* 8 (1974), pp. 92–94. This is the only case we are aware of in which the metal of a printing plate has been scientifically analyzed.

279. Tilman Falk, *Hans Burgkmair: Studien zu Leben und Werk des Augsburger Malers* (Munich, 1968), pp. 74–76. The date is disputed and has been placed as late as 1527, though stylistic evidence supports the earlier date.

280. See, for example, the woodcut version of 1508 by Lucas Cranach the Elder (B.114) in which a knightly Mercury wakens Paris by prodding him with the caduceus, and a woodcut of the same subject by Altdorfer (B.60) in which Cupid appears above blindfolded.

281. Burgkmair may also have been attracted to the mythical pair because of their alchemical associations, a common connection in humanist circles and an appropriate kind of subject for an artist's first venture into the mysteries of metal chemistry. As we have already noted, Venus was associated with the element copper, and Mercury with quicksilver, both of them being staples of the alchemical laboratory. Mercury also governed the activities of craftsmen in the series of Children of the Planets. Domenico Beccafumi, whom we know to have had alchemical interests, designed an allegorical cycle of planetary gods enacting the conjunctions between the metallic elements (see above). This series of woodcuts has been plausibly connected with Biringuccio's treatise on metalworking. G. F. Hartlaub, "De Re Metallica: Eine allegorische Holzschnittfolge des Domenico Beccafumi, gennant Il Mecherino," *Jahrbuch der preussischen Kunstsammlungen* 60 (1939), pp. 103–10. Tilman Falk, "Das Johannesbild Hans Burgkmairs von 1518," in *Minuscula Discipulorum. Kunsthistorische Studien. Hans Kauffmann zum 70. Geburtstag 1966*, ed. T. Falk and M. Winner (Berlin, 1968), pp. 91–92, regards the palm tree as a symbol of inspiration, and proposes that Burgkmair's *Venus and Mercury* be read as the parents of divine love as interpreted by the Renaissance Neoplatonists Agrippa and Ficino. However, esoteric references of this sort are rather arcane for an experimental print, and as recent scholarship on Dürer's *Melencolia I* has suggested, it may prove fruitful to seek explanations in the more widely shared para-scientific lore of alchemy.

282. Bartsch already recognized that certain of Lucas's etchings were

done in mixed technique, and Pauli, *Inkunbeln der Radierung*, pp. 6–7, refers to them all as such in passing. A more detailed analysis is given by Ad Stijnman, "Lucas van Leyden and Etching," *Print Quarterly* 5 (1988), pp. 256–57. Iron or steel plates can actually be cut with a hardened steel inscribing tool. Such a tool was used to add at least some of the Funck numbers to the Hopfer plates, for example. On the steel plate for Lambert Hopfer's *Three Panels of Grotesque Ornament* (B.30; Funck 132), now in the British Museum, the engraving tool used to cut the Funck number slipped and left a long gouge crossing into the frame of the image. But the metal is clearly too resistant to permit this as a regular means of reworking and enhancing a design.

283. Conceivably the technique of etching on copper was used earlier by precious metalsmiths, though we are aware of no proof of this. The several early recipes for iron or steel mordants make no mention of other metals. Wegner, "Eisenradierung," cols. 1144–45. See also Robert James Forbes, *A Short History of the Art of Distillation* (Leiden, 1948), pp. 86–87. However, there is the letter of 1522 regarding Jan Gossaert's interest in finding an acid suitable for making etchings. If he went to the trouble of engaging Geldenauer in his quest, Gossaert must surely have been searching for a copper mordant, since iron mordants could not have been very difficult to come by. J. Sterk, "Philips van Bourgondië, 1465–1524" (Diss., Zutphen, 1980), pp. 138–39.

284. Carel van Mander, *Het Schilder-Boeck*, fol. 214r: "Het Plaet-snijden soude hij gheleert hebben van eenen die Harnassen hetste, en met sterck water beet, met oock eenigh onderwijs van eenen die Goutsmit."

285. The preliminary drawing in pen and gray ink, gray brush point and pencil, is exactly the size of the print but apparently has no visible signs of any means of transfer to the plate. Small alterations (the absence of decorative detail on the architecture) were made to simplify the composition. On the two works, see most recently Jacobowitz and Stepanek, *Prints of Lucas van Leyden*, cat. nos. 74–75. Impressions vary in inking from silvery gray to the brownish tone of the example in London, British Museum.

286. Lucas van Leyden's other prints in mixed technique are as follows: the *St. Catherine* (B.125), probably double-bitten in the lines around the head and on parts of the dress (note, for example, the thick line of the hair that reduces to a fine line just as it intersects the halo, a sign that the plate has been stopped-out and not simply strengthened with the burin; burin work appears elsewhere in the print). This elaboration in technique suggests it may be somewhat later than the others. *Til Eulenspiegel* (B.159), though ambitious in scale and subject, is etched in a heavier line, which implies it may be the earliest of the group. Then there are the *King David in Prayer* (B.29); *Young Girl and a Fool* (B.150); and *Cain Killing Abel* (B.12).

287. F. W. H. Hollstein, *Dutch and Flemish Etchings, Engravings and Woodcuts, ca. 1450–1700*, ed. D. de Hoop Scheffer (Amsterdam, 1949), vol. XXXIII, comp. Ger Luijten and Christiaan Schuckman; and A. E. Popham, "The Engravings and Woodcuts of Dirick Vellert," *Print Collector's Quarterly* 12, pt. 2 (no. 4, 1925), pp. 343–68. Popham records nineteen intaglio prints: two dated to the year, sixteen to the day, and only one undated.

288. From 1522 in chronological order: B.18 (engraved), and B.13, 1, 12, 7 (etched and engraved). From 1523: B.15, 17, 14 (etched) — the *Smithy* (B.14), which is undated, falls with these stylistically and technically. Also from 1523: B.6, 5, 3 (engraved). From 1524: B.8, 11, 10; 1525: B.19, 4 (all engraved). From 1526: B.16 (etched — Popham says the print is dated in the old style and therefore should be read 1526 and not 1525), and B.8 (engraved).

289. The impression of the *Man Asleep* in London (British Museum) may show evidence of rust. The washy areas of foul biting recall very exactly the problems encountered by Altdorfer in the *Synagogue* (B.63–64) and Burgkmair in the *Venus and Mercury* (B.1). Vellert's stylistically identical *Drummer and Boy with a Hoop*

(B.17) is technically flawless.

290. A. E. Popham, "The Engravings of Frans Crabbe van Espleghem," *Print Collector's Quarterly* 22 (1935), pp. 92–115, 194–211, catalogues the work and constructs a credible chronology primarily on the basis of style, there being only two dated prints, both from 1522. We are indebted to Lee Hendrix and Nancy Yocco for further examination of the drawing of *Esther and Ahasuerus*.

291. In several of Crabbe's later etchings the lines are heavier and less finely skeined, showing the roughness associated with iron plates. See, for example, in the *Passion* series the contrast between *Christ on the Mount of Olives* (B.7), which shows the trace of burin work in the shading of the sky, and the *Ecce Homo* (B.13).

292. Post-Quattrocento treatments invariably respond in some fashion to Michelangelo's Sistine ceiling composition. There are very few examples in northern prints. A beautiful Italianate woodcut of ca. 1527–30, now convincingly attributed to Jan van Scorel, uses the subject to display the nude in an imaginary classical landscape. Molly Faries, "A Woodcut of the *Flood* Re-attributed to Jan van Scorel," *Oud Holland* 97 (1983), pp. 5–12; Landau in *Genius of Venice*, p. 329, cat. no. P26. Despite its probable designer, this woodcut was almost certainly produced and distributed in Italy where it would have been stylistically most at home. The violence of Vellert's version is more reminiscent of much earlier examples such as the engraving by Francesco Rosselli (H.B.III.1). Vellert seems to have turned to other subjects for his figure sources, Marcantonio's *Massacre of the Innocents* for one. On Vellert's print, see Gustav Glück, "Beiträge zur Geschichte der Antwerpner Malerei im XVI. Jahrhundert," *JKSW* 22 (1901), p. 30; and Popham, "Vellert," p. 358.

293. See Chapter II.

294. *Graphik der Niederlande, 1508–1617. Kupferstiche und Radierungen von Lucas van Leyden bis Hendrik Goltzius*, exh. cat. (Munich, 1979), pp. 18–19, cat. no. 11, argues that the *Deluge* is engraved throughout, leaving open the possibility that it might also be etched in some portions. That Vellert managed the entire feat in engraving cannot be ruled out absolutely. However, in mixed technique, the etching of the plate would certainly have preceded its engraving, and if we determine the presence of etching to any degree, then we must grant that Vellert would have etched the plate extensively. Malines, for a long time enriched by the patronage of Margaret of Austria, appears to have been an important point of exchange for technical developments in Netherlandish etching. Gossaert's only etching was done in iron. As noted, Crabbe who worked there used both iron and copper. So did Hogenberg.

295. Riggs, *Hieronymus Cock*, passim.

296. Hopfer's prints of biblical parables set in the Katharinenkirche in Augsburg in all likelihood postdate Altdorfer's. See Hans Mielke, *Albrecht Altdorfer: Zeichnungen, Deckfarbenmalerei, Druckgraphik*, exh. cat. (Berlin, Kupferstichkabinett; and Regensburg: Museen der Stadt, 1988), pp. 224–25, cat. nos. 116–17. A closer parallel is Girolamo Mocetto's *Calumny of Apelles*, engraved after a drawing by Mantegna, showing in the background a reasonably accurate view (reversed!) of the Piazza SS. Giovanni e Paolo and Verrocchio's *Colleoni* monument in Venice (see above). Of course none of these is, strictly speaking, an architectural print. Book illustration offers relevant precedents: Koepplin and Falk, *Cranach*, vol. I, p. 219, cat. no. 96.

297. These robes and headgear with long folds of cloth known as liripipes descending from their hoods can be seen in many contemporary representations of Jews, for example on the title page illustration to Anthony Margaritha, *Der gantz Jüdisch glaub* (Augsburg: Heinrich Steiner, 1530).

298. Johannes Cochlaeus, *Brevis Germaniae Descriptio* (Nuremberg, 1512), cap. V:19. For a short account of the economic fortunes of the city and the Jewish population, see Walter Ziegler, "Regensburg am Ende des Mittelalters"; Fritz Blaich, "Wirtschaft und

Gesellschaft in der Reichstadt Regensburg zur Zeit Albrecht Altdorfers"; and Wilhelm Volkert, "Die spätmittelalterliche Judengemeinde in Regensburg," all in *Albrecht Altdorfer und seine Zeit*, ed. Dieter Henrich (Regensburg, 1981), pp. 61–102, 123–49.

299. There are contemporary accounts of these events, all of them sharply partisan. Among the most detailed is that of the Benedictine monk Christophoros Odofrancus [Ostrofrankus/Chr. Hofmann], *De Ratisbona metropoli Boioariae et subita ibidem proscriptione* (Augsburg, 1519). For other passages, see Raphael Straus, ed., *Urkunden und Aktenstücke zur Geschichte der Juden in Regensburg, 1453–1738* (Munich, 1960), pp. 388–92, doc. nos. 1041, 1044, 1049. For later accounts, see Carl Theodor Gemeiner, *Regensburgische Chronik* (Regensburg, 1800–24; repr. Munich, 1921), vol. IV, pp. 355–71, and *passim*. Gemeiner, *Regensburgische Chronik*, p. 356, says Altdorfer was a member of the council embassy sent to the Judengasse to proclaim the judgment to the Jewish Elders, citing records from the period "ex actis," though this has not been confirmed by more recent researches (Volkert, "Judengemeinde," p. 142). Altdorfer was a member of the larger Outer Council, not the more powerful group known as the Inner Council. Gemeiner states the decision was taken by both bodies together.

300. Franz Winzinger, *Albrecht Altdorfer: Die Graphik* (Munich, 1963), p. 28, seems to base his conclusion on the date inscribed on the nave etching, and on the documents citing the 22nd for the destruction. Volkert, "Judengemeinde," p. 139, reads the implication of the documents differently; Reinhild Janzen, *Albrecht Altdorfer: Four Centuries of Criticism* (Ann Arbor, Mich., 1980), p. 15, is just plain guessing. Apparently the Jews were given two hours to clear the synagogue of all its contents. Documents dating the actual demolition vary between 21 February and, more often, 22 February.

301. Our only independent confirmation is a *terminus ante quem* provided for the etching of the porch, copied for the setting of a *Man of Sorrows* miniature dated 1521 in the *Prayerbook of Matthäus Schwarz* (now in Berlin, Kupferstichkabinett, MS. 78 B 10, f. 16ᵛ) illuminated by Narziss Renner. For an illustration, see Georg Habich, "Das Gebetbuch des Matthäus Schwarz," in *Sitzungsberichte der Königlich Bayerischen Akademie der Wissenschaften*, Philosophisch-philologische und historische Klasse, no. 8 (Munich, 1910), pp. 1–28, pl. VII. The miniature has transformed the figure disappearing through the doorway to the left by giving it a pointed Jew's cap and a Hebrew inscription on the garment. The miniature introduces the text for the 12 Articles of Faith. Given the range of dates on the miniatures from 1520 (the frontispiece portrait) to 1521 (the date on six other miniatures), they almost certainly indicate the year in which these particular miniatures were painted.

302. All the impressions examined betray confusions in the etching of various areas on both plates, especially the *Porch*, which printed badly around the margins. The construction of the nave vault was clearly done freehand rather than with compasses and does not vanish consistently.

303. Of the voluminous literature on this event, see most recently G. Stahl, "Die Wallfahrt zur Schönen Maria in Regensburg," *Beiträge zur Geschichte des Bistums Regensburg* 2 (1968), pp. 35–282; Hans Utz, *Wallfahrten im Bistum Regensburg* (Munich, 1981); and David Freedberg, *The Power of Images* (Chicago, 1989), ch. 6.

304. Gerhard Winkler, "Die Regensburger Wallfahrt zur Schönen Maria (1519) als Reformatorisches Problem," in *Altdorfer und seine Zeit*, ed. Dieter Henrich (Regensburg, 1981), pp. 103–21.

305. Rupprich, ed., *Dürer*, I, p. 210.

306. Karl Schottenloher, "Der Buchdrucker Paul Kohl (1522–1531)," *Zentralblatt für Bibliothekswesen* 29 (1912), pp. 406–25.

307. Winkler, "Die Regensburger Wallfahrt," p. 108.

308. At a minimum these include woodcuts of the Virgin in colors (B.51), in a church (B.48), and on an altar (B.50), and engravings

of the Virgin seated in a landscape (B.12), and on an altar (B.13), and a charming image of her seeking the twelve-year-old Jesus in the Temple (Holl. 6). B.48 is copied in Renner's *Prayerbook* where it is dated 1521. Altdorfer also did a chiaroscuro drawing of the *Schöne Maria* dated 1518 (Mielke, *Altdorfer*, p. 218, cat. no. 110), and the famous woodcut of her in the *Holy Family at a Fountain* (B.59) of ca. 1511–15, showing that her popularity was not negligible prior to the pilgrimage. However, it is generally and reasonably assumed that most of the prints came with the crowds.

309. Schottenloher, "Kohl," pp. 410–11. At this time there were normally 60 *kreutzer* to the *gulden*. Recall that these transactions are wholesale and do not tell us the retail prices. Mason's day wages in Regensburg were 8.64 *kreutzer* in summer; an unskilled laborer's 5.40 *kreutzer*. See Blaich, "Wirtschaft und Gesellschaft," p. 91; Egon Beckenbauer, *Die Münzen der Reichsstadt Regensburg* (Grünwald, 1978), p. 21.

310. Schottenloher, "Kohl," pp. 411–12.

311. The scholarly response to these prints is barely mentioned by Janzen, *Altdorfer*, p. 15. It forms something of a political litmus test for German and Austrian scholars writing in the 1930s and 1940s when considerable attention was paid among historians to Altdorfer himself and to the Regensburg case. Ernst Buchner's exhibition of Altdorfer's work in Munich in 1938 elevated Altdorfer to the pantheon of German artists, and although reviews of the exhibition do not comment in any detail upon the etchings themselves, they are occasionally referred to in telling remarks. Commentators since have responded differently.

312. We have examined impressions in Amsterdam, Rijksmuseum (B.63); Berlin, Kupferstichkabinett (B.63/64); London, British Museum (B.63/64); Munich, Staatliche Graphische Sammlung (B.63/64); New York, Metropolitan Museum (B.64); Regensburg, Stadt Museum (B.63); and Vienna, Albertina (B.63) 2 impressions, and (B.64). These range widely in quality; watermarks are visible in the New York impression (bear = Berne?), and indistinctly in the Amsterdam impression (possibly a unicorn). In the Berlin impression of B.64 there are clear traces of rust marks in a rectangular pattern where something must have been laid on the plate allowing a transfer of moisture. Winzinger, *Altdorfer*, p. 115, records thirteen extant impressions of B.63 (listing incorrectly an impression in Cambridge, but omitting the second impression in Vienna); and five of B.64. Thirteen impressions of one etching is a high number measured against recorded examples of Altdorfer's other etchings.

313. In Italy examples such as the engraving by Mocetto of the *Calumny of Apelles* after Mantegna set in the Campo di San Giovanni e Paolo in Venice (fig. 106), and the view of the Tiber bridge in the background of Marcantonio's *Massacre of the Innocents* (fig. 132), though relevant precedents, are clearly meant to serve as landmarks and theatrical settings rather than autonomous architectural studies.

314. L. Grote-Dessau, "Zur Datierung der Landschaftsradierungen Albrecht Altdorfers," *Monatsheft für Bücherfreunde und Graphiksammler* 1 (1925), pp. 229–30, discovered a copy of B.74 dated 1522. Copies of others dated 1522 and 1523 appear in the manuscripts illuminated by Renner. Peter Halm, "Das Gebetbuch von Narziss Renner in der Österreichischen Nationalbibliothek," *Zeitschrift für Kunstwissenschaft* 8 (1954), pp. 65–88. These nine are complemented by a tenth etching by Albrecht's brother Erhard (B.71, under Albrecht and not Erhard).

315. Charles Talbot and Alan Shestack, *Prints and Drawings of the Danube School*, exh. cat. (New Haven: Yale University Art Gallery, 1969), pp. 55–59, suggest comparisons with drawings of this date, but then without explanation date what they regard as the two earliest prints two to three years later, ca. 1515, while at the same time questioning technical deficiency as an argument for the priority of the *Lansquenet*.

316. Altdorfer's etched landscapes are: B.66–70, 72–74, Pass. 109.

Winzinger, *Altdorfer*, pp. 116–17, dates them between 1517 and 1522, placing *Landscape with a Large Castle* (B.68) earliest, noting it must fall after the *Lansquenet* and before or contemporary with the *Synagogues* (which he dates 1519), because they are as technically accomplished. Mielke, *Altdorfer*, pp. 227–32, proposes the landscape prints were begun while Altdorfer was working on the *Prayerbook of Maximilian* ca. 1515, and dates the actual etchings from ca. 1517 on, more or less in accord with Winzinger. Neither author adduces close comparisons with dated works to substantiate their conclusions. Christopher Stewart Wood, "The Independent Landscapes of Albrecht Altdorfer" (Ph.D. diss., Harvard University, 1991), p. 294, infers that the entire group may be the result of a single campaign in 1522. And finally, Konrad Oberhuber places them between 1520 and 1522. See *Begegnungen/Ontmoetingen*, exh. cat. (Vienna: Albertina; and Amsterdam: Rijksmuseum, 1989–90), pp. 80–89, cat. nos. 27–31.

317. Winzinger, *Altdorfer*, p. 117, regarding B.72 (W.180).

318. Wood, "Independent Landscapes," chs. 7–8, esp. pp. 288–91.

319. The colored impressions in Vienna all appear to have been tinted by the same hand, and certainly by someone who understood the forms being colored. They were probably made as a set, since all of them show traces of the same framing line inked in black with a ruler. Mielke, *Altdorfer*, p. 232, regards the coloring as by Altdorfer. Oberhuber, *Begegnungen*, p. 84, points out the coincidence of Erhard's return to Regensburg in 1522, and believes the coloring, if not by Albrecht himself, was definitely done under his supervision.

320. On the chiaroscuro attributed to the Monogrammist PS's print, see H. van de Waal, "Graphische Arbeiten der Monogrammisten P.S.," *Die Graphischen Künste*, n.s. 4 (1939), pp. 47–51. Van de Waal was apparently unaware of the Italian precedents. This print is listed under Erhard Altdorfer by Hollstein, *German Engravings*, I, p. 272, no. 3a. A copy of Parmigianino's etching *Peter and John Healing the Lame Man* (fig. 280) after Raphael's tapestry cartoon is printed with two tone blocks (B.XVI.9.7).

321. Ernst Gombrich, "The Renaissance Theory of Art and the Rise of Landscape," in *Norm and Form*, 2nd ed. (London, 1971), pp. 107–21. The essay was first presented as a lecture in 1950.

322. For the Michiel and Pino quotes, see *ibid.*, pp. 109, 116.

323. The *Landscape with the Large Pine*: Berlin, Kupferstichkabinett, inv. no. 131–1929.

324. We should like to thank Jane Peters and Ad Stijnman, among others, for confirming our views about this technical unclarity.

325. The three copper plates for the east view are in Munich, Bayerische Staatsbibliothek. Lautensack began his career in Nuremberg and then moved to Vienna under the patronage of the Emperor. Among his earliest plates is an etching, probably on iron, of *David and Goliath* (B.1), dated 1551. Impressions all record fracture-like patterns across the entire plate. This technical failure probably resulted from the etching ground having dried out and cracked in the biting process, permitting the acid to penetrate along the web of fissures. The pattern of rays in the sky may have been added to cover the deformity. The number of Lautensack etchings in poor impressions without signs of rust suggest copper was his usual medium. On Lautensack's change from iron to copper, see Wegner, "Ätzung und Radierung," pp.187–88; Annegrit Schmitt, *Hanns Lautensack* (Nuremberg, 1957), p. 19.

326. See Riggs, *Hieronymus Cock*, passim; and *Bilder nach Bildern*.

327. Lorne Campbell, "The Art Market in the Southern Netherlands in the Fifteenth Century," *Burlington Magazine* 118 (1976), pp. 188–98; Jean-Pierre Sosson, "Une approche des structures économiques d'un métier d'art: La corporation des peintres et selliers de Bruges (XVe–XVIe)," *Revue des archéologues et historiens d'art de Louvain* 3 (1970), pp. 91–100.

328. Alexandre Joseph Pinchart, *Archives des arts, sciences et lettres: Documents inédits* (Ghent, 1860–81), vol. I, pp. 63–64.

329. Hans Rott, *Quellen und Forschungen zur südwestdeutschen und schweizerischen Kunstgeschichte im XV. und XVI. Jahrhundert* (Stuttgart, 1933–38), vol. III, pt. 1, *Der Oberrhein* (Stuttgart, 1936), pp. 34–35. Adam had various other dealings in printed devotional images.

330. A "book" is a quantity of paper, normally 24 sheets. Maurits de Meyer, *Populäre Drückgraphik Europas: Niederländen, vom 15. bis zum 20. Jahrhundert* (Munich, 1970), p. 27. Regrettably, no source is given for this document. For the importance of colporteurs in the Florentine book trade in the 1480s, see Susan Noakes, "The Development of the Book Market in Late Quattrocento Italy: Printers' Failures and the Role of the Middleman," *Journal of Medieval and Renaissance Studies* 11 (1981), pp. 23–55.

331. For the relevant documents, see Rupprich, ed., *Dürer*, I, p. 244; III, p. 448. Werner Schultheiss, "Ein Vertrag Albrecht Dürers über den Vertrieb seiner graphischen Kunstwerke," *Scripta Mercaturae* 1/2 (1969), pp. 77–81.

332. On broadsheet sellers in the time of unrest, see Hildegard Schnabel, "Zur historischen Beurteilung der Flugschrifthändler in der Zeit der frühen Reformation und des Bauernkrieges," *Wissenschaftliche Zeitschrift der Humboldt-Universität zu Berlin*, Gesellschafts- und Sprachwissenschaftliche Reihe, no. 14 (1965), pp. 869–80.

333. Rupprich, ed., *Dürer*, I, pp. 245, 252, 260.

334. *Ibid.*, p. 107.

335. Norbert Lieb, *Die Fugger und die Kunst im Zeitalter der hohen Renaissance* (Munich, 1958), vol. I, pp. 121–24.

336. Alexander Dietz, *Frankfurter Handelsgeschichte* (Frankfurt am Main, 1910–), vol. I, pp. 18–76.

337. For the letter to Pirckheimer, see Rupprich, ed., *Dürer*, I, p. 265. Lucas of Holland refers to Lucas van Leyden.

338. Otto Clemen, *Die Volksfrömmigkeit des ausgehenden Mittelalters* (Dresden and Leipzig, 1937), p. 14, with no specific reference to Geiler's works.

339. The print (Schreiber 2848) is in Munich, Bayerische Nationalbibliothek, and is inscribed: "Ad 15. Decemb. anno 87 kaufft pro 10 k." Max Geisberg, "Teigdruck und Metalschnitt," *Monatshefte für Kunstwissenschaft* 5 (1912), pp. 311–20. As the price is significant, there is a question as to whether it refers to the entire volume in which the print was pasted, or to the print alone.

340. On these prices, see Isak Collijn, Två 'Degtryck' i stiftsbibliotheket i Tepl," *Nordisk Tidskrift for Bok- och Bibliotheksvasen* 15 (Stockholm, 1928), pp. 107–10. The Teplice paste prints (Schreiber 2838, 2851) are presumed to date ca. 1480 and were probably made in Redwitz, Oberfranken. Both were pasted onto the cover of albums including other prints, and so like the previous instance a question has been raised as to whether the prices refer to the single prints or the volumes. The second price of 5 *heller* on another print in one of the volumes suggests the former. The *heller* was typically valued at 2 *pfennig* (30 *pfennig* to the "Old Pound"). See Theodor Hampe, "Beiträge zur Geschichte des Buch- und Kunsthandels in Nürnberg," *Mitteilungen aus dem Germanischen Nationalmuseum* (1912), p. 122.

341. Wilhelm Loose, ed., *Anton Tuchers Haushaltsbuch, 1507–1517* (Stuttgart, 1877), pp. 126–27 (fol. 121v); reprinted in Rupprich, ed., *Dürer*, I, p. 295. "Item adi 13 ottobris kauft von Türer maler 3 s.[tück] Jeronymus und 4 melemcholie von kupffer adgedruckt, damit ich den Engelhart Schauer und Jacob Rumpff gen Rom verert hab, dafur par 1 1/2 *gulden*."

342. Van Mander, *Het Schilder-Boeck*, fol. 212v.

343. Gemeiner, *Regensburgische Chronik*, IV, pp. 475–76. An interesting price comparison is the 40-page pamphlet recording miracles performed by the *Schöne Maria* that was printed by Kohl in the same year with a small, crudely done title page woodcut by Ostendorfer (Schottenloher, "Kohl," pp. 411–12). The council bought the pamphlets at a rate of 50 copies per *gulden*, only slightly more expensive than the 60 per *gulden* price for Ostendorfer's woodcuts of the *Chapel*. This makes clear that an impression of a well-executed folio woodcut was at least equal in value to

several quires of printed text. An unskilled laborer in Regensburg earned a little more than five *kreutzer* a day in summer; a skilled worker earned half again as much. Fritz Blaich, "Wirtschaft und Gesellschaft," p. 91.

344. Nuremberg, Stadtarchiv, *Inventarbücher des Stadtgerichts*, vol. III, fol. 25. "Item etliche künst brieff unnd model zwey pfünd drey pfennig."

345. The Diary was probably passed on through Pirckheimer to the Imhoff family and then the Duke of Arundel, where it may well have been burned in the disastrous fire of 1642. It survives in two copies from the sixteenth and early seventeenth centuries, the latter being the most reliable. For details on the manuscripts, see Rupprich, ed., *Dürer*, I, pp. 146–47. The text reprinted in Rupprich (pp. 148–202, with notes) gives the apparatus for the two sources. William Martin Conway, *The Writings of Albrecht Dürer* (repr. London, 1958), ch. 7, gives a reliable translation.

346. Rupprich, ed., *Dürer*, I, p. 179, n. 4, gives the gold value conversions for the various *gulden* mentioned, and also assumes the standard coin to be the Rhenish *gulden*. Dürer received 2 Rhenish *gulden* in payment for a *Madonna* shortly after arriving in Antwerp (after 5 August) and made some larger purchases in that currency (3 September).

347. On the arrangement and selection of objects distributed, see Robert Grigg, "Studies on Dürer's Diary of his Journey to the Netherlands: The Distribution of the *Melencolia I*," *Zeitschrift für Kunstgeschichte* 49 (1986), pp. 398–409.

348. Each cycle taken alone is comprised of many fewer blocks than the small woodcut *Passion*, though the blocks are much larger in scale and consume more paper. Thus it is consistent that a copy of one of the three books would cost the same as a small woodcut *Passion*. Dürer often disposed of the books separately (the *Apocalypse* twice, the *Life of the Virgin* six times, and once the "large books" were recorded collectively with each cycle then listed separately). Unfortunately, in none of these cases can a price be established. Even though the books were published together in 1511 as a single project he distributed them individually more often than together, further suggesting that he treated them as separate items.

349. "Item adi 26 marczo dem Jeronymus Holczel von 3 groß und 3 clain passion einczupintten von Turer." From Anton Tucher's *Haushaltsbuch*, the passage also reprinted in Rupprich, ed., *Dürer*, I, p. 294.

350. On the size designations, see Grigg, "Studies on Dürer's Diary"; and Max Lehrs, "Die Kupferstichsammlung der Stadt Breslau," *Jahrbuch der königlich preussischen Kunstsammlungen* 3 (1882), pp. 211–14.

351. Tucher's purchase was apparently also figured in Rhenish *gulden* (Loose, ed., *Tuchers Haushaltsbuch*, pp. 183–84), the basis for our calculation of Dürer's prices. The comparison is worth making because the two prices are quite close and thus tend to confirm one another, although the five year lapse of time must be accounted for.

352. See the entry for 19 August 1520. These two prints were given away together on other occasions with similar implication. The prints Dürer sent to Meit were the *St. Jerome*, the *Melencolia I*, the *St. Anthony* of 1519, a *Veronica* (either B.25, the engraving of 1513, or B.26, the etching of 1516) and the "three new Marys."

353. For these statistics, see Gerald Strauss, *Nuremberg in the Sixteenth Century*, 2nd rev. ed. (Bloomington, Ind., 1976), pp. 203–06. See also Philip Broadhead, "Popular Pressure for Reform in Augsburg, 1524–34," in *Stadtbürgertum und Adel in der Reformation*, ed. Wolfgang J. Mommsen, et al. (Stuttgart, 1979), p. 81, on unskilled wages in Augsburg.

354. See Appendix.

355. Matthias Quadt von Kinkelbach, *Teutscher Nation Herligkeitt: Ein außführliche bechreibung des gegenwertigen/alten/und uhralten Standts Germaniae* (Cologne: Wilhelm Lützenkirchen, 1609), pp. 425–35.

356. Jacob Wimpheling, *Epithoma Germanorum iacobi wympfelingii* (Strasbourg: Johannes Prüss, 1505), ch. 68, fols. xxxix-xl: De Pictura & Plastice. Wimpheling praises Israhel van Meckenem and Martin Schongauer in advance of Dürer, whom he also counts as Martin's pupil. For a discussion of the beginnings of German art historiography, see Wilhelm Waetzold, *Deutsche Kunsthistoriker*, 2 vols. (Leipzig, 1921–24); Rudolf Kaufmann, *Der Renaissancebegriff in der deutschen Kunstgeschichtsschreibung* (Winterthur, 1932).

357. Cochlaeus, *Descriptio*, ch. 4, fol. 45r. The passage is quoted by Rupprich, ed., *Dürer*, I, p. 293. Cochlaeus contributed a hexastich to Chelidonius's text for the 1511 edition of the *Small Woodcut Passion* (Rupprich, p. 462).

358. Julius Held, "The Early Appreciation of Drawings," in *Latin American Art and the Baroque Period in Europe*, Studies in Western Art: Acts of the Twentieth International Congress of the History of Art, vol. 3 (Princeton, 1963), pp. 72–95.

359. This attitude would not necessarily have been pervasive, and in any case it was a distinctly Renaissance prejudice. Rembrandt sought out early prints of all sorts with great enthusiasm.

360. Walther Karl Zülch, *Frankfurter Künstler, 1223–1700* (Frankfurt, 1935), pp. 342–44.

361. The Dresden princely collection stems ultimately from the Electors of Saxony who were Cranach's major patrons.

362. Walter Boll, "Albrecht Altdorfers Nachlass," *Münchner Jahrbuch der bildenden Kunst*, n.s. 13 (1938/39), pp. 91–102.

363. Dieter Kuhrmann, *Altdeutsche Zeichnungen aus der Universitätsbibliothek Erlangen*, exh. cat. (Munich: Staatliche Graphische Sammlung, 1974), pp. 6–7.

364. Hind, *Early Italian Engravings*, V, p. 141. The inventory records 23 copper plates representing "divers mistères," several of which may have been engraved back and front. Jacopo appears to have been engaged by Margaret in 1510, and was pensioned for his age and poor health the following year. He died by 1516.

365. Elisabeth Lanolt and Felix Ackermann, *Sammeln in der Renaissance: Das Amerbach-Kabinett. Die Objekte im Historischen Museum Basel*, exh. cat. (Basel: Kunstmuseum, 1991), intro.; and Tilman Falk, *Die Zeichnungen des 15. und 16. Jahrhunderts im Kupferstichkabinett Basel*, pt. 1: *Das 15. Jahrhundert, Hans Holbein der Ältere und Jörg Schweiger, die Basler Goldschmiederisse* (Basel and Stuttgart, 1979), pp. 11–33, traces the workshop provenance of the earlier drawings in the Basel collection.

366. Robert Stiassny, *Hans Baldung Griens Wappenzeichnungen in Coburg*, 2nd ed. (Vienna, 1896), pp. 11–14. After Kraemer's death in 1553, his wife Dorothea gave the objects to Sebald, her brother.

367. For a preliminary list, see Julius [von] Schlosser Magnino, *La letteratura artistica*, trans. Filippo Rossi, 3rd ed. (Florence and Vienna, 1964), pp. 276–80.

368. Rupprich, ed., *Dürer*, I, p. 173.

369. Interestingly, a number of the important engravings in this album have been trimmed in silhouette around the figures before being mounted onto their album paper. For details on the album's history and contents, see Peter W. Parshall, "The Print Collection of Ferdinand, Archduke of Tyrol," *JKSW* 78 (1982), pp. 147–48. Convincing traces of these albums are difficult to uncover after so many centuries in which individual prints and drawings have regularly proven more valuable than the conservation of their original setting. Max Loßnitzer cites evidence of a lost album from Sebald Beham's shop in "Zwei Inkunabeln," pp. 35–39.

370. *Joachim von Sandrarts Academie der Bau-, Bild, und Mahlerey-Künste von 1675*, ed. and comm. A. R. Peltzer (Munich, 1925), p. 92. Sandrart cites preparatory drawings for engravings of the *Labors of Hercules* and the *Virtues and Vices*. See also *Duitse Tekeningen, 1400–1700*, S 5. The album from 1637 is now in Amsterdam, Rijksmuseum Prentenkabinett. It belonged to Pieter Spiering Silvercrona, Swedish Ambassador to The Hague.

371. Kurt Pilz, "Willibald Pirkheimers Kunstsammlung und Bibliothek," in *Willibald Pirkheimer, 1470/1970*, ed. Karl B. Glock and I. Meidinger Geise (Nuremberg, 1970), pp. 93–110.

372. Pirckheimer's library was sold by the Imhoffs to the Earl of Arundel in 1636. Exactly what was entailed we do not know, but by then the Imhoffs seem to have been dismembering manuscripts and selling parts of their holdings for some time already. David Howarth, *Lord Arundel and his Circle* (New Haven and London, 1985), pp. 154–56.

373. Theodor Hampe, "Kunstfreunde im alten Nürnberg und ihre Sammlungen," *Mitteilungen des Vereins für Geschichte der Stadt Nürnberg* 15 (1903), p. 74.

374. For a summary of these inheritances, further bibliography, and a discussion of an important workshop album, see Hendrik Budde, "Das 'Kunstbuch' des Nürnberger Patriziers Willibald Imhoff und die Tier- und Pflanzenstudien Albrecht Dürers und Hans Hoffmanns," *JKSW* 82/83 (1986/87), pp. 213–17.

375. Anton Springer, "Inventare der Imhoff'schen Kunstkammer zu Nürnberg," *Mitteilungen der Kaiserlich- Königlichen central-commission zur Erforschung und Erhaltung der Baudenkmale* 5 (Vienna, 1860), pp. 352–57. At one point in an earlier inventory there is an annotation that a particular album of drawings could fetch twice the price if he were to send it to Italy or the Netherlands. The collection was gradually dispersed by the Imhoff family during the late sixteenth and early seventeenth century; part of it was sold to the Earl of Arundel (see note 372 above), and part to a collector in Leiden named Mattheusen von Overbeck. Among the items acquired by Arundel was a copy of Dürer's Netherlandish Diary. There was an attempt to make a large sale to Rudolf II, and eventually part of the collection went to Vienna, probably through the Hapsburg household. See also Parshall, "Print Collection of Ferdinand," pp. 140–41, with further bibliography. The Imhoff inventories have been moved around to various locations in Nuremberg during recent years. When consulted they were on deposit in the Nuremberg Stadtbibliothek, 64.4⁰, 65.4⁰, 66.4⁰. Succeeding Imhoff's collection in Nuremberg were two large collections from the early seventeenth century, one brought together by Paul Beheim and another by Paul Praun, the latter known to us from a late eighteenth-century inventory compiled just before the collection was broken up. Praun's collection included especially rich stocks of prints by Nuremberg artists, particularly by Dürer and his followers. See Wilhelm Schwemmer, "Aus der Geschichte der Kunstsammlungen der Stadt Nürnberg," *Mitteilungen des Vereins für Geschichte der Stadt Nürnberg* 40 (1949), pp. 124–25. Part of Derschau's collection of woodblocks is described in the 1808 introduction to the publication of his holdings as having come from Pirckheimer as well. See Hans Albrecht von Derschau, *Holzschnitte alter deutscher Meister*, intro. Rudolph Z. Becker (Gotha, 1808), p. 1.

376. Friedrich Thöne, "Johann Fischart als Verteidiger deutscher Kunst," *Zeitschrift des deutschen Vereins für Kunstwissenschaft* 1 (1934), pp. 125–33.

377. Johann Neudörfer, *Nachrichten von Künstlern und Werkleuten daselbst aus dem Jahre 1547*, ed. G. W. K. Lochner (Vienna, 1875), p. 138; and p. 133, regarding the value of Dürer's work: "und so einer alle seine gerissene [designed, i.e. woodcuts] und gestochene Kunst kaufen will, deren ein grosse Meng ist, kann ers unter 9 f. [*gulden*] nicht wol zu wegen bringen."

378. Among the plates reprinted in this manner are the *St. Eustace* (B.77), *Knight, Death and the Devil* (B.98), and the *Portrait of Erasmus* (B.107), examples of each in Vienna, Albertina, and *Frederick the Wise of Saxony* (B.104).

Notes to Chapter VII

1. The most comprehensive discussion of the various uses of early prints and their matrices appears in Arpad Weixlgärtner, "Ungedruckte Stiche: Materialien und Anregungen aus Grenzgebieten der Kupferstiche," *JKSW* 29 (1911), pp. 259–385. See also Alpheus Hyatt Mayor, *Prints and People: A Social History of the Printed Picture* (New York, 1971).

2. On early references to wall display, see the following: Michel Melot, "Note sur une graveur encadrée du XVIe siècle," *Nouvelle de l'Estampe* 9 (May/June 1973), pp. 9–11, 13. Theodor Hampe, ed., *Gedichte vom Hausrat aus dem XV. und XVI. Jahrhundert* (Strasbourg, 1899), appendix I, p. 2, for the household verse from ca. 1480–1500. For the entry in the inventory of Bos's goods, see J. Cuvelier, "Le graveur Corneille van den Bossche (XVIe siècle)," *Bulletin de l'Institut Historique Belge de Rome* 20 (1939), p. 37: "een papieren brieve op lijwaet voer de schouwe."

3. "A le belle istorie, istorie, istorie, la guerra del Turco in Ungheria, le prediche di fra Martino, il Concilio, istorie, istorie, la cosa d'Inghilterra, la pompa del Papa e dell'Imperatore, la circumcision del Voivoda, il sacco di Roma, l'assedio di Fiorenza, lo abbocamento di Marsilia con la conclusione, istorie, istorie." (*La Cortigiana*, Act I, Scene IV)

4. On the less familiar topic of slanderous images, see Otto Hupp, *Scheltbriefe und Schandbilder: Ein Rechtsbehelf aus dem 15. und 16. Jahrhundert* (Munich and Regensburg, 1930). See also Arthur M. Hind, *Early Italian Engraving* (London, 1938–48), vol. V, pp. 252–54, nos. E.III.6, 7; Evelina Borea, "Stampa figurativa e pubblico dalle origini all'affermazione nel Cinquecento," in *Storia dell'Arte Italiana* (Turin 1979), pt. I, vol. II, p. 339; H. W. Janson, "Titian's *Laocoon Caricature* and the Vesalian-Galenist Controversy," in *Art Bulletin* 28 (1946), pp. 49–53.

5. See Stefania Massari, *Tra mito e allegoria: Immagini a stampa nel '500 e '600* (Rome, 1989), pp. xix–xx.

6. For which, see Gianvittorio Dillon, in Rodolfo Pallucchini, et al., *Da Tiziano a El Greco*, exh. cat. (Venice, 1981), p. 300.

7. See p. 287. Though this is very likely not true of Boldrini's woodcut of *Venus and Cupid* (1567), a case in which the figures were probably borrowed from a Titian drawing and the landscape then made up by the woodcutter. See M. Muraro and David Rosand, *Tiziano e la silografia veneziana del cinquecento*, exh. cat. (Vicenza, 1976), p. 137, cat. no. 78.

8. See Fabio Mauroner, *Le Incisioni di Tiziano* (Venice, 1941), p. 67, n. 37. Cort's work was probably helped by reduced versions drawn from the master's large canvases. See Konrad Oberhuber, *Renaissance in Italien* (Vienna, 1966), pp. 199–202.

9. The letter was first published by G. Gaye, *Carteggio inedito di artisti dei secoli XIV. XV. XVI (1326–1672)* (Florence, 1840), vol. III, pp. 242–43. See also Muraro and Rosand, *Tiziano*, p. 65.

10. "una carta di detto disegno," "le primitie di essa stampa." The print in question is the *Trinità*, made after a painting now in the Prado, Madrid. For the document, see Paul Kristeller, "Tizians Beziehungen zum Kupferstich," *Die graphischen Künste* 34 (1911), supp., pp. 23–26.

11. "Alcuni huomini poco studiosi dell'arte per fuggir la fatica, et per avidità de guadagno si mettono a questa professione defraudando l'honore del primo autore di dette stampe col peggiorarle, et l'utile delle fatiche altrui; oltra l'ingannar il popolo con la stampa falsificata, et de poco valore." The print in question in these documents is referred to only as "un disegno del paradiso." All quotations from these documents are taken from Kristeller's transcriptions in "Tizians Beziehungen."

12. Titian obviously kept the plates after Cort's departure for Rome, so that some prints appear to be dated 1565 but to carry already the privilege which was obtained only two years later. See Maria Catelli Isola, *Immagini da Tiziano*, exh. cat. (Rome, 1976–77) p. 42, no. 34.

13. For example, we have seen that in 1552 Borghini asked Vasari to let him have as many prints after Michelangelo as he could lay his hands on. See Michael Bury, "The Taste for Prints in Italy to c. 1600," *Print Quarterly* 2 (1985), p. 14.

14. For the stocklist, see F. Ehrle, *Roma Prima di Sisto V* (Rome, 1908), pp. 54–59.

15. "Havendo fatto già longo tempo impresa di far stampare in seruigio e piacere de virtuosi assai descrittioni, disegni e ritratti in carte spicciolate a in libri interi di diuerse e notabili opere antiche, et moderne; mi sono risoluto per colmo della comodità di chi se ne diletta, a raccorne e stamparne un breue estratto e indice." Ehrle, *Roma*, p. 54.

16. For an important survey of map-making in sixteenth-century Italy, see R. V. Tooley, "Maps in Italian Atlases of the Sixteenth Century," *Imago Mundi* 3 (1939), pp. 12–47. For the close correlations between maps and prints, see also the very interesting article by David Woodward, "The Evidence of Offsets in Renaissance Italian Maps and Prints," *Print Quarterly* 8 (1991), pp. 234–51.

17. As we have already seen, Lafrery often employed Beatrizet to engrave reproductions of monuments and statuary, and he made sure that full explanations about their whereabouts, size, and importance were provided in the plate in the form of inscriptions. Beatrizet often signed such extraordinary images with his full name, and they were frequently a real tour de force of engraving skill. However, this is never acknowledged in Lafrery's list.

18. In Lafrery's *Indice*, only one name of an engraver is mentioned, that of Enea Vico. His name appears twice — once in connection with a single sheet (B.XV.295.28), "Le noue Muse di Enea Vico"; and once with a bound volume listed among the fifth group (B.XV.341.257–319), the "medaglie delle Donne Auguste di Enea Vico" (medals of the Augustean Women of Enea Vico).

19. Bury, "Taste for Prints," pp. 16–17, 20.

20. Erwin Panofsky, *Albrecht Dürer* (Princeton, 1948), ch. 7. On Dürer's and Italian theory, see Peter Parshall, "Camerarius on Dürer: Renaissance Biography as Art Criticism," in *Joachim Camerarius (1500–1574)*, ed. Frank Baron (Munich, 1978), pp. 11–29.

21. Hans Rupprich, ed., *Dürer: Schriftlicher Nachlass* (Berlin, 1956–69), vol. I, p. 59.

22. See especially the engravings of the Housebook Master and Israhel van Meckenem (Chapter III).

23. On the northern response to Italian art and its classical ideals, see Patricia Emison, "The Little Masters, Italy and Rome," in Stephen Goddard, et al., *The World in Miniature: Engravings by the German Little Masters*, exh. cat. (Lawrence, Kan., 1988), pp. 30–40.

24. Donald B. Kuspit, "Melanchthon and Dürer: The Search for the Simple Style," *Journal of Medieval and Renaissance Studies* 3 (1973), pp. 177–202; and Linda B. and Peter W. Parshall, *Art and the Reformation* (Boston, 1986), pp. xxi–xlvi.

25. On the subject generally, see Max Rosenheim, "The Album Amicorum," *Archaeologia or miscellaneous tracts relating to antiquity* 62 (1910), pp. 251–308. Printed books with illustrations were also used as a basis for these albums — editions of Hans Holbein the Younger's *Dance of Death* and Alciati's *Emblemata* being especially preferred. In such cases the folios of the printed book were interleaved with blank sheets to receive inscriptions, signatures, and other images. On a related type, the artist's *Stammbuch*, see Peter Amelung, "Die Stammbücher des 16./17. Jahrhunderts als Quelle der Kultur- und Kunstgeschichte," in *Zeichnung in Deutschland: Deutsche Zeichner, 1540–1640*, exh. cat. (Stuttgart: Staatsgalerie, 1980), vol. II, pp. 211–22. It appears that this new genre was initiated around the middle of the sixteenth century, and may well have started within the milieu of German Reformers and university faculty at Wittenberg, a circle we also know to have exchanged prints.

26. Ortelius's *Album Amicorum* was probably begun around 1573 and was richly decorated with emblems and watercolors by several artists in the Antwerp circle. It has been published in facsimile by Jean Puraye (Amsterdam, 1969). On his print collection, see Iain Buchanan, "Dürer and Abraham Ortelius," *Burlington Magazine* 124 (1982), pp. 734–41.

27. Max Rooses, ed., *Correspondance Christophe Plantin*, 2nd ed. (Antwerp, 1896), vol. I, pp. 133–35. The currency employed must be the *Carolus guilder*, then at rough parity with the Rhenisch *gulden*. Discounting inflation, the price is twelve to fifteen times what Dürer received for his *Meisterstiche* in Antwerp in 1520–21. The more moderate cost of the three prints sold in 1567 at one *guilder* each (a four- to five-fold rise) can be compared to Hieronymus Cock's suite of architectural views of the *Baths of Diocletian* sold in 1568 at one *guilder* a set. A. J. J. Delen, "Christoffel Plantin als prentenhandelaar," *De Gulden Passer* 10 (1932), pp. 1–24.

28. On the implications of the publishing house phenomenon in the Netherlands, see Hans Mielke, "Antwerpener Graphik in der 2. Hälfte des 16. Jahrhunderts," *Zeitschrift für Kunstgeschichte* 38 (1975), esp. pp. 30–31.

29. There are exceptions, in particular the tendency to archaism in northern painting and printmaking throughout the sixteenth century. But the copying of works from the school of Rogier van der Weyden in engravings from the first or second quarter of the sixteenth century is a very different matter from the reproducing of a contemporary work of art for its own sake. On this subject in general in the Renaissance, see *Bilder nach Bildern*, exh. cat. (Münster: Westfälisches Landmuseum, 1979), pp. x–xi; and chs. 1–3.

30. Here we refer to the great collections of William Drugulin, Frederick Muller, and the *Atlas van Stolk*, where prints, like photographs, were accumulated primarily as illustrations rather than as works of art. Similarly, in the introduction to the 1808 publication of impressions from Derschau's collection of woodblocks, the prints are first acclaimed for their vivid record of German history and culture, after that as artifacts of a proto-industrial technology, and only lastly as works of art designed by notable masters. Hans Albrecht von Derschau, *Holzschnitte alter deutscher Meister*, intro. Rudolph Z. Becker (Gotha, 1808), *passim*, esp. p. 2.

31. Richard Stauber, *Die Schedelsche Bibliothek*, ed. Otto Hartig (Freiburg im Breisgau, 1908), pp. 103–37; and Wolfgang Milde, "Über Bücherverzeichnisse der Humanistenzeit," in *Bücherkataloge als buchgeschichtliche Quellen in der frühen Neuzeit*, ed. Reinhard Wittman, Wolfenbütteler Schriften zur Geschichte des Buchwesens, no. 10 (Wiesbaden, 1984), pp. 27–31.

32. A manuscript copy of the first known inventory of the *Kunstkammer* was compiled in 1598 and is on deposit in Munich, Bayerische Staatsbibliothek, cod. Bav. 2133: *Inventarium aller Stück, so in der herzoglichen Kunstkammer zu sehen*, by J. B. Fickler. By then there were extensive accommodations for prints and drawings listed as mounted and unmounted, mainly in drawers. The objects were looted by the Swedes in 1632. The library, arranged along the same lines as Schedel's, survived the plundering. See Otto Hartig, *Die Gründung der Münchener Hofbibliothek* (Munich, 1917), pp. 70–72.

33. Samuele Quiccheberg, *Inscriptiones vel tituli Theatri amplissimi* (Munich: Adam Berg, 1565), title page, 33 folios. The copy consulted is in Munich, Bayerische Staatsbibliothek: 4° Rar. 1534. For literature on this treatise, see Theodor Volbehr, "Das 'Theatrum Quicchebergicum.' Ein Museumstraum der Renaissance," *Museumskunde* 5 (Berlin, 1909), pp. 201–08; criticized by Rudolf Berliner, "Zur älteren Geschichte der allgemeinen Museumslehre in Deutschland," *Münchner Jahrbuch der bildenden Künste*, n.s. 5 (1928), pp. 327–52; Otto Hartig, "Der Artzt Samuel Quicchelberg, der erste Museologe Deutschlands," *Bayerland* 44 (1933), pp. 630–33.

34. Quiccheberg also envisions a printing house, a metalworking shop, a foundry and a pharmaceutical laboratory as well (pp. 23–24),

though one supposes the ambition of the treatise was understood in ideal terms. Nevertheless, we have in this text another important anticipation of Baconian science, and in particular of the *New Atlantis*. There was at least one other, though less elaborate attempt to design a structure for such a theater in Renaissance Germany: Gabriel Kaltemarckt, *Bedencken, wie eine Kunst-Cammer aufzerichten seyn möchte. 1587* (Dresden, MS. Sächs. Hauptstaatsarchiv, Loc. 9835), published by Barbara Gutfleisch and Joachim Menzhausen, "'How a Kunstkammer should be formed.' Gabriel Kaltemarckt's advice to Christian I of Saxony on the formation of an art collection, 1587," *Journal of the History of Collections* 1 (1989), pp. 1–32.

35. On the general subject of memory theaters (and Camillo's in particular), see Frances Yates, *The Art of Memory* (London, 1966), ch. 6. Camillo's theater is mentioned in a letter written to Erasmus from Venice in 1532, and again by a traveler to the French court in 1558, both informants claiming to have seen a version of it. Quiccheberg refers to Camillo in his text and seems to regard his predecessor as holding outmoded ideas. See Elisabeth Hajós, "References to Giulio Camillo in Samuel Quicchelberg's 'Inscriptiones vel tituli Theatri Amplissimi'," *Bibliothèque d'Humanisme et Renaissance* 25 (1963), pp. 207–11.

36. Elizabeth M. Hajós, "The Concept of an Engravings Collection in the Year 1565: Quiccchelberg, 'Inscriptiones vel Tituli Theatri Amplissimi,'" *Art Bulletin* 40 (1958), pp. 151–56. On Quiccheberg's significance for Renaissance print collecting, see Peter W. Parshall, "The Print Collection of Ferdinand, Archduke of Tyrol," *JKSW* 78 (1982), pp. 182–84.

37. Parshall, "Print Collection of Ferdinand of Tyrol," *passim*.

38. Paul Ganz and Emil Major, "Die Entstehung des Amerbach'schen Kunstkabinetts und die Amerbach'schen Inventare," *Jahresbericht der Öffentlichen Kunstsammlung in Basel*, n.s. 3 (1907), pp. 1–68. The inventories themselves are in Basel, Kupferstichkabinett (Archive 2). The Amerbach collection eventually came to the University Library in Basel and the Öffentliche Kunstsammlung. Otto Fischer, "Geschichte der Öffentlichen Kunstsammlung," in *Öffentliche Kunstsammlung Basel. Festschrift zur Eröffnung des Kunstmuseums* (Basel, 1936), pp. 9–10, speculates that certain of the rarer early prints in this collection may have been acquired originally by Johannes Amerbach. However, see the cautionary view of Tilman Falk, *Die Zeichnungen des 15. und 16. Jahrhunderts im Kupferstichkabinett Basel*, pt. 1: *Das 15. Jahrhundert, Hans Holbein der Ältere und Jörg Schweiger, die Basler Goldschmiederisse* (Basel and Stuttgart, 1979), pp. 11–20. Falk gives the most recent and meticulous reconstruction of the history of the collection.

39. On the acquisition, see Falk, *Die Zeichnungen*, pp. 16–17.

40. William Robinson, "This Passion for Prints," in *Printmaking in the Age of Rembrandt*, exh. cat. (Boston: Museum of Fine Arts; and St. Louis: Art Museum, 1981), pp. xxvii–xlviii.

Notes to the Appendix

1. For a discussion of the pitfalls of these statistics for evaluating actual financial conditions, see Richard A. Goldthwaite, *The Building of Renaissance Florence: An Economic and Social History* (Baltimore and London, 1980), ch. 6.

2. Hermann van der Wee, *The Growth of the Antwerp Market and the European Economy, Fourteenth–Sixteenth Centuries* (Louvain, 1963), vol. II, pp. 384–88.

3. Charles Verlinden, *Dokumenten voor de geschiedenis van prijzen en lonen in Vlaanderen en Brabant (XVe–XVIIIe eeuw)* (Bruges, 1959), no. 125, pp. 14–15; Leon Voet, *The Golden Compasses* (Amsterdam, 1969–72), vol. II, pp. 445–47.

4. Wee, *Growth of the Antwerp Market*, I, pp. 107–11.

5. See Chapter VI, pp. 351–54.

6. Cuvelier, "Le graveur Corneille van den Bossche (XVIe siècle)," *Bulletin de l'Institut Historique Belge de Rome* 20 (1939), pp. 44–49.

7. Voet, *Golden Compasses*, I, p. 440. Wee, *Growth of the Antwerp Market*, I, pp. 110–11, on the *Carolus* gold *guilder*, introduced in an unsuccessful attempt to stabilize the relationship between gold and silver in the Netherlands. Voet, p. 446, unaccountably dates its introduction to 1517 prior to Charles's ascent to the Hapsburg throne.

8. These statistics are taken from Verlinden, *Dokumenten*, no. 136 (1965), pp. 379–86, whose tables give wages annually throughout the period. The wages are recorded in Brabant money: d = *denieren* (groats or *groten*).

9. For economic trends in Renaissance Germany in general, see Wilhelm Abel, "Landwirtschaft 1500–1648," in Hermann Aubin and Wolfgang Zorn, eds., *Handbuch der deutschen Wirtschafts- und Sozialgeschichte* (Stuttgart, 1971), vol. I, pp. 386–413, and errata. On Augsburg specifically, see M. J. Elsas, *Umriss einer Geschichte der Preise und Löhne in Deutschland vom ausgehenden Mittelalter bis zum Beginn des neunzehnten Jahrhunderts* (Leiden, 1936–49), vol. I, pp. 74–77; and Philip Broadhead, "Popular Pressure for Reform in Augsburg, 1524–1534," in *Stadtburgertum und Adel in der Reformation*, ed. Wolfgang J. Mommsen, et al. (Stuttgart, 1979), p. 81. The discrepancy between unskilled and semi-skilled wages and its possible significance was pointed out to us by Michael Foley.

10. See Elsas, *Geschichte der Preise und Löhne*, I, pp. 112–16, 118–22. For general reference on German coinage, see Ludwig Veit, *Das Liebe Gelt* (Munich, 1969), pp. 135–40; and Franz Engel, *Tabellen alter Münzen, Maße und Gewichte zum Gebrauch für Archivbenützer* (Rinteln, 1965), pp. 13–15.

11. Elsas, *Geschichte der Preise und Löhne*, I, pp. 118–20.

12. *Ibid.*, pp. 113–22. Documents from Augsburg reflecting the use and value of the currency are lacking for the period immediately after 1500. The actual silver equivalent for the *rechnungsgulden* declined slightly over the first half-century.

13. The wages are averaged from the tables in *ibid.*, pp. 731–33.

14. Veit, *Das Liebe Gelt*, pp. 134–35.

15. These statistics are averaged from various sources, since, to the best of our knowledge, no systematic study of Nuremberg wages and prices has so far been published. Gerald Strauss, *Nuremberg in the Sixteenth Century*, 2nd rev. ed. (Bloomington, Ind., 1976), pp. 203–05, gives only very general figures and a selection of commodity prices for the century as a whole. More precise cases including some figures on wage earnings are cited in the actual documents published by Albert Gümbel, "Die Baurechnung über die Erhöhung der Türme von St Sebald in Nürnberg, 1481–1495," *Mitteilungen des Vereins für Geschichte der Stadt Nürnberg* 20 (1913), pp. 35–62; and Werner Schultheiss, "Baukosten Nürnberger Gebäude in Reichstädtischer Zeit," *Mitteilungen des Vereins für Geschichte der Stadt Nürnberg* 55 (1967/68), pp. 270–99.

16. Raymond de Roover, *The Rise and Decline of the Medici Bank: 1397–1494* (Cambridge, Mass., 1963), pp. 31–34. Goldthwaite, *Building of Renaissance Florence*, ch. 6, and appendices.

17. Mario Bernocchi, *Le Monete della Repubblica Fiorentina* (Florence, 1947–76), vol. III, is the standard corpus for information on the value of coinage and moneys of account.

18. Goldthwaite, *Building of Renaissance Florence*, p. 430, App. I, with exchange values calculated by year up until 1533.

19. *Ibid.*, p. 301.

20. Giuseppe Parenti, "Prezzi e salari a Firenze dal 1520 al 1620," in *I prezzi in Europa dal XIII secolo a oggi*, ed. Ruggiero Romano (Turin, 1967), pp. 224–26; and Goldthwaite, *Building of Renaissance Florence*, pp. 437–38.

Bibliography

Documents:

Augsburg, Stadtarchiv: *Handwerkerakten* (Briefmaler, Illuministen, Formschneider).

Munich, Bayerische Staatsbibliothek. *Inventarium aller Stück, so in der herzoglichen Kunstkammer zu sehen*, by J. B. Fickler (1598). Cod. Bav. 2133.

Nuremberg, Stadtarchiv. *Inventarbücher des Stadtsgerichts, 16. Jh.* Sig. Rep. B. 14/VI.

Nuremberg, Stadtbibliothek. *Imhoff Archiv.* Sigs. 64.4°, 65.4°, 66.4°.

Ulm, Stadtarchiv. "*Bruderschaft der Mahler und bildhauer in der Wangen.*" Sig. H. Schmid 21/1, doc. 6533.

Ulm, Stadtarchiv. *Strassbuch der Ainung.* Sig. A. 3963.

Books, articles, and catalogues:

Adhemar, Jean. "Les premiers éditeurs d'estampes." *Nouvelles de l'estampe*, no. 6 (1972): 3–5.

Agricola, Georgius. *De re metallica.* Translated by Herbert Clark Hoover and Lou Henry Hoover. New York, 1950.

Alberici, Clelia. "Bernardo Prevedari incisore di un disegno del Bramante." *Arte Lombarda*, n.s. 86/87 (1988): 5–13.

Alberici, Clelia. "L'incisione Prevedari." *Rassegna di Studi e di Notizie* 6 (1978): 52–54.

Alberici, Clelia. "Notizie inedite su Bernardo Prevedari e aggiunte alla 'fortuna' della sua incisione da disegno del Bramante nella pittura rinascimentale." *Rassegna di Studi e di Notizie* 8 (1980): 37–44.

Albrecht Dürer, 1471–1971. Exhibition catalogue. Nuremberg: Germanisches Nationalmuseum. Munich, 1971.

Albrecht Dürer, Master Printmaker. Exhibition catalogue. Boston: Museum of Fine Arts, 1971.

Albricci, Gioconda. "'Lo Stregozzo' di Agostino Veneziano." *Arte Veneta* 36 (1982): 55–61.

Almagià, Roberto. "On the Cartographic Work of Francesco Rosselli." *Imago Mundi* 8 (1951): 27–34.

Ameisenova, Zofia. "Nieznany wzór zlotniczy z XV W. W bibliotece Jagiellonskiej." In *Studia nad ksiazka: Poswiecone Pamieci Kazimierza Piekarskiego*, pp. 365–69. Warsaw, 1951.

Amelung, Peter. *Der Frühdruck im deutschen Südwesten, 1473–1500.* Exhibition catalogue. Stuttgart: Württembergische Landesbibliothek, 1979.

Amelung, Peter. "Die Stammbücher des 16./17. Jahrhunderts als Quelle der Kultur- und Kunstgeschichte." In *Zeichnung in Deutschland: Deutsche Zeichner, 1540–1640*, vol. II, pp. 211–22. Exhibition catalogue. Stuttgart: Staatsgalerie, 1979–80.

Das Amerbach-Kabinett: Die Objekte im Historischen Museum Basel. 4 vols. Exhibition catalogue. Basel: Kunstmuseum, 21 April–21 July 1991.

Ames-Lewis, Francis. "A Northern Source for Mantegna's *Adoration of the Shepherds.*" *Print Quarterly* 9 (1992): 268–71.

Ames-Lewis, Francis and Joanne Wright. *Drawing in the Italian Renaissance Workshop.* Exhibition catalogue. Nottingham: University Art Gallery; and London: Victoria and Albert Museum, 1983.

Amman, Jost. *Eygentliche Beschreibung aller Stände auff Erden . . .* Frankfurt, 1568.

Anderson, Jaynie. "A Further Inventory of Gabriel Vendramin's Collection." *Burlington Magazine* 121 (1979): 639–48.

Anderson, Lilian Armstrong. "Copies of Pollaiuolo's Battling Nudes." *Art Quarterly* 31 (1968): 155–67.

Andersson, Christiane and Charles Talbot. *From a Mighty Fortress: Prints, Drawings and Books in the Age of Luther, 1483–1546.* Exhibition catalogue. Detroit: Institute of Arts, 1983.

Andrea Mantegna. Exhibition catalogue. London: Royal Academy of Arts, 1992.

Appuhn, Horst. *Meister E.S.: Alle 320 Kupferstiche.* Dortmund, 1989.

Appuhn, Horst and Christian von Heusinger. *Riesenholzschnitte und Papiertapeten der Renaissance.* Unterschneidheim, 1976.

Arber, Agnes. *Herbals: Their Origin and Evolution: A Chapter in the History of Botany, 1470–1670.* 2nd ed. Cambridge, 1938.

Archer, Madeline Cirillo. "The Dating of a Florentine *Life of the Virgin and Christ.*" *Print Quarterly* 5 (1988): 395–402.

Aretino, Pietro. *De le lettere di M. Pietro Aretino Libro Primo Ristampato Nuovamente con Giunta Daltre XXV.* Venice: Marcolini, September 1538.

Aretino, Pietro. *Lettere di Pietro Aretino.* 6 vols. Paris, 1609–10.

Armstrong, Christine Megan. *The Moralizing Prints of Cornelis Anthonisz.* Princeton, 1990.

Armstrong, L. A. See Anderson.

Ashworth, William B., Jr. "Marcus Gheeraerts and the Aesopic Connection in Seventeenth-Century Scientific Illustration." *Art Journal* 44 (1984): 132–38.

Aubin, Hermann and Wolfgang Zorn. *Handbuch der deutschen Wirtschafts- und Sozialgeschichte.* Stuttgart, 1971–.

Audin, Maurice. *Guide raisonné du Musée de l'Imprimerie et de la Banque.* 2nd ed. Lyons, n.d.

Audin, Maurice. *Les peintres en bois et les tailleurs d'histoires à propos d'une collection de bois gravés conservée au Musée de l'Imprimerie et de la Banque.* Lyons, n.d.

"Aus den Akten des Reichskammergerichts [Frankfurt, Stadtarchiv]." *Zeitschrift für die gesamte Strafsrechtwissenschaft* 12 (1892): 899–901.

Ausstellung Maximilian I. Exhibition catalogue. Innsbruck: Landhaus, 1 June–5 October 1969.

Baader, Josef. "Beiträge zur Kunstgeschichte Nürnbergs." In *Jahrbücher für Kunstwissenschaft*, edited by A. von Zahn, pp. 221–69. Leipzig, 1868.

Badia, Iodoco del. "La bottega di Alessandro di Francesco Rosselli merciaio e stampatore (1525)." In *Miscellanea Fiorentina di Erudizione e Storia.* Vol. II. Florence, 1894.

Baldass, Ludwig. *Der Künstlerkreis Kaiser Maximilians.* Vienna, 1923.

Barrett, Timothy D. "Early European Papers: Contemporary Conservation Papers." *Paper Conservator* 13 (1989).

Barocchi, Paola, ed. *Scritti d'arte del Cinquecento.* 3 vols. Milan and Naples, 1971–77.

Bartsch, Adam. *The Illustrated Bartsch.* University Park, Pa., and New York, 1971–.

Bartsch, Adam. *Le Peintre graveur.* 21 vols. Leipzig, 1803–21.

Bauch, G. "Zur Cranachforschung." *Repertorium für Kunstwissenschaft* 17 (1894): 421–35.

BIBLIOGRAPHY

Baxandall, Michael. *The Limewood Sculptors of Renaissance Germany.* New Haven and London, 1980.

Le beau Martin: Gravures et dessins de Martin Schongauer. Exhibition catalogue. Colmar: Musée d'Unterlinden, 1991.

Beaumont-Maillet, Laure, Gisèle Lambert, and François Trojani. *Suite d'estampes de la Renaissance italienne dite Tarots de Mantegna ou Jeu du Gouvernement du Monde au Quattrocento Ferrare vers 1465.* 2 vols. Paris, 1986.

Beckenbauer, Egon. *Die Münzen der Reichsstadt Regensburg.* Grünwald, 1978.

Beets, N. "Een godsdienstige allegorie in Houtsnede." *Oud Holland* 49 (1932): 182–90.

Begegnungen/Ontmoetingen: Meisterwerke der Zeichnung und Druckgraphik aus dem Rijksprentenkabinet in Amsterdam und der Albertina in Wien. Exhibition catalogue. Vienna: Albertina; and Amsterdam: Rijksmuseum, 1989–90.

Bellini, Fiora. *Xilografie italiane del Quattrocento da Ravenna e da altri luoghi.* Exhibition catalogue. Rome, 1987.

Bellini, Paolo. "Stampatori e mercanti di stampe in Italia nei secoli XVI e XVII." *I quaderni del conoscitore di stampe,* 26 (1975): 19–45.

Beltrami, Luca. "Bramante e Leonardo praticarono l'arte del bulino? Un incisore sconosciuto: Bernardo Prevedari." *Rassegna d'Arte* 17 (1917): 187–94.

Berenson, Bernard. *Italian Pictures of the Renaissance: Florentine School.* 2 vols. London, 1963.

Bergwerck- und Probierbüchlein, [ca. 1500–1520]. Translated and annotated by Annaliese Sisco and Cyril S. Smith. New York, 1949.

Berliner, Rudolf. "Zur älteren Geschichte der allgemeinen Museumslehre in Deutschland." *Münchner Jahrbuch der bildenden Künste,* n.s. 5 (1928): 327–52.

Bernardini, Carla, et al. *L'Estasi di Santa Cecilia di Raffaello da Urbino nella Pinacoteca Nazionale di Bologna.* Exhibition catalogue. Bologna: Pinacoteca Nazionale, 1983.

Bernini, Pezzini Grazia, Stefania Massari, and Simonetta Prosperi Valenti Rodinò. *Raphael invenit: Stampe da Raffaello nelle collezioni dell'istituto nazionale per la grafica.* Exhibition catalogue. Rome, 1985.

Bernocci, Mario. *Le Monete della Repubblica Fiorentina.* 3 vols. Florence, 1974–76.

Bertelli, Carlo. "The 'Image of Pity' in Santa Croce in Gerusalemme." In *Essays in the History of Art Presented to Rudolf Wittkower,* edited by Douglas Fraser, Howard Hibbard, and Milton J. Lewine, pp. 40–55. London, 1967.

Bertolotti, Antonio. *Artisti Veneti in Roma.* Venice, 1884. Reprinted Bologna, 1965.

Bevers, Holm. *Meister E.S.: Ein Oberrheinischer Kupferstecher der Spätgotik.* Exhibition catalogue. Munich: Staatliche Graphische Sammlung, 1986–87; and Berlin: Kupferstichkabinett, 1987.

Bieber, Hans W. "Die Befugnisse und Konzessionierungen der Münchner Druckereien und Buchhandlungen von 1485 bis 1871." *Archiv für Geschichte des Buchwesens* 2 (1958/60): 405–30.

Bilder nach Bildern. Exhibition catalogue. Münster: Westfälisches Landesmuseum, 1979.

Biringuccio, Vannoccio. *The Pirotechnia [1540].* Translated by C. S. Smith and M. T. Gnudi. 1st ed. 1942; reprinted New York, 1959.

Blaich, Fritz. "Wirtschaft und Gesellschaft in der Reichsstadt Regensburg zur Zeit Albrecht Altdorfers." In *Albrecht Altdorfer und seine Zeit: Vortragsreihe der Universität Regensburg,* edited by Dieter Henrich, pp. 83–102. Regensburg, 1981.

Blanchet, Augustin. *Essai sur l'histoire du papier et de sa fabrication.* Paris, 1900.

Bloy, Colin H. *A History of Printing Inks, Balls and Rollers, 1440–1850.* London and New York, 1967.

Blunt, Wilfrid. *The Art of Botanical Illustration.* 2nd ed. London, 1951.

Bock, Hieronymus. *Kreüterbuech.* Strasbourg, 1546.

Boeheim, Wendelin, ed. "Urkunden und Regesten aus der k. k. Hofbibliothek." *JKSW* 7, part 2 (1888): xci-cccxiv.

Boll, Walter. "Albrecht Altdorfers Nachlass." *Münchner Jahrbuch der bildenden Kunst,* n.s. 13 (1938/39): 91–102.

Boltz [von Ruffach], Valentin. *Illuminierbuch: Wie man allerlei Farben bereiten, mischen und auftragen soll . . .* Basel: Jakob Kündig, 1549. Reprinted and edited by C. J. Benzinger. Munich, 1913.

Boorsch, Suzanne, M. Lewis, and R. E. Lewis. *The Engravings of Giorgio Ghisi.* Exhibition catalogue. New York: Metropolitan Museum of Art, 1985.

Borea, Evelina. "Stampa figurativa e pubblico dalle origini all'affermazione nel Cinquecento." In *Storia dell'Arte Italiana,* part 1, vol. II, pp. 317–413. Turin, 1979.

Borsi, Franco. *Bramante.* Critical catalogue edited by Stefano Borsi. Milan, 1989.

Bosse, Abraham. *Traicté des manières de graver en taille douce sur l'airin.* Paris: Chez ledit Bosse, 1645. Reprinted in Luigi Servolini. *Abraham Bosse e il suo Trattato della Calcografia con ventiquattro incisioni.* Bologna, 1937.

Bouchot, Henri. "La préparation et la publication d'un livre illustré au XVIe siècle, 1573–1588." *Bibliothèque de l'École des Chartes* 53 (1892): 612–23.

T Bouck va Wondre (1513). Reprinted with commentary by H. G. T. Frencken. Roermond, 1934.

Brady, Thomas A. *Ruling Class, Regime and Reformation in Strasbourg, 1520–1555.* Leiden, 1978.

Branden, Franz Josef Peter van den. *Balthasar Sylvius: Quatre suites d'ornements.* The Hague, 1893.

Braunfels, Wolfgang. "Die 'Inventio' des Künstlers; Reflexionen über den Einfluß des neuen Schaffensideals auf die Werkstatt Raffaels und Giorgiones." In *Studien zur toskanischen Kunst. Festschrift für Ludwig Heinrich Heydenreich,* pp. 20–28. Munich, 1964.

Briquet, C. M. *Les Filigranes.* 4 vols., facsimile of the 1907 ed. Edited with an introduction by Allan Stevenson. Amsterdam, 1968.

Broadhead, Philip. "Popular Pressure for Reform in Augsburg, 1524–1534." In *Stadtbürgertum und Adel in der Reformation: The Urban Classes, the Nobility, and the Reformation,* edited by Wolfgang J. Mommsen, et al., pp. 80–87. Stuttgart, 1979.

Brockhaus, Heinrich. "Ein altflorentiner Kunstverlag." *Mitteilungen des Kunsthistorischen Instituts in Florenz* 1 (1911): 97–110.

Brockhaus, Heinrich. "Die große Ansicht von Rom in Mantua: Die Frage nach dem Zeichner ihres Vorbildes." *Mitteilungen des Kunsthistorischen Instituts in Florenz* 1 (1911): 151–55.

Brown, David Allan. "A Print Source for Parmigianino at Fontanellato." In *Per A. Popham,* pp. 43–53. Parma, 1981.

Brückner, Wolfgang. "Expression und Formel in Massenkunst: Zum Problem des Umformens in der Volkskunsttheorie." *Anzeiger des Germanischen Nationalmuseums* (1968): 122–39.

Brückner, Wolfgang. *Populäre Druckgraphik Europas: Deutschland vom 15. bis zum 20. Jahrhundert.* Munich, 1969.

Brun, Robert. *Le livre français illustré de la Renaissance.* Paris, 1969.

Brunfels, Otto. *Herbarum vivae eicones.* 3 vols. Strasbourg: Johann Schott, 1530–35.

Bruschi, Arnaldo. "Problemi bramanteschi." *Rassegna di Studi e di Notizie* 6 (1978): 57–66.

Buchanan, Iain. "Dürer and Abraham Ortelius." *Burlington Magazine* 124 (1982): 734–41.

Budde, Hendrik. "Das 'Kunstbuch' des Nürnberger Patriziers Willibald Imhoff und die Tier- und Pflanzenstudien Albrecht Dürers und Hans Hoffmanns." *JKSW* 82/83 (1986/87): 213–41.

Buff, Adolf, ed. "Rechnungsauszüge: Urkunden und Urkundenregesten aus dem Augsburger Stadtarchiv. Erster Theil (von 1442–1519)." *JKSW* 13 (1892), part 2.

Bühler, Curt F. "Last Words on Watermarks." *Papers of the Bibliographical Society of America* 67 (1973): 1–16.

Burger, C. P., Jr. "Zestiende-eeuwsche volksprenten, later als kinderprenten herdrukt." In *Catalogus der tentoonstelling van de*

ontwikkeling der boekdrukkunst in Nederland, pp. 165–69. Exhibition catalogue. Haarlem: Het Paviljoen te Haarlem, November 1923.

Burke, Peter. *Culture and Society in Renaissance Italy, 1420–1590.* London, 1972.

Bury, Michael. *Giulio Sanuto.* Exhibition catalogue. Edinburgh: National Gallery of Scotland, 1990.

Bury, Michael. "On Some Engravings by Giorgio Ghisi Commonly Called 'Reproductive.'" *Print Quarterly* 10 (1993): 4–19.

Bury, Michael. "The Taste for Prints in Italy to c. 1600." *Print Quarterly* 2 (1985): 12–26.

Bury, Michael. "The 'Triumph of Christ,' after Titian." *Burlington Magazine* 131 (1989): 188–97.

Buschbell, Gottfried. *Concilium Tridentinum, 10 Epistularum.* Freiburg-im-Breisgau, 1916.

Caesar, Elisabeth. "Sebald Schreyer: Ein Lebensbild aus dem vorreformatorischen Nürnberg." *Mitteilungen des Vereins für Geschichte der Stadt Nürnberg* 56 (1969): 1–213.

Camesasca, Ettore. *Artisti in Bottega.* Milan, 1966.

Camesina, Albert Ritter von. "Fliegende Blätter über das türkische Heer vor Wien im Jahre 1529 von Hans Guldenmund." *Berichte und Mitteilungen des Alterthums-Vereines zu Wien* 15 (1875): 107–16.

Campbell, Lorne. "The Art Market in the Southern Netherlands in the Fifteenth Century." *Burlington Magazine* 118 (1976): 188–98.

Campbell, Tony. *The Earliest Printed Maps, 1472–1500.* Berkeley and Los Angeles, 1987.

Campbell, Tony. "Letter Punches: A Little-Known Feature of Early Engraved Maps." *Print Quarterly* 4 (1987): 151–54.

Campori, G. *Raccolta di cataloghi ed inventari inediti . . . dal secolo XV al XIX.* Modena, 1870. Reprinted Bologna, 1975.

Cappel, Carmen Bambach. "Leonardo, Tagliente and Dürer: 'La scienza del far di groppi.'" *Accademia Leonardo da Vinci* 6 (1991): 72–98.

Carroll, Eugene A. *Rosso Fiorentino.* Exhibition catalogue. Washington, D.C.: National Gallery of Art, 1987–88.

Carroll, Margaret D. "Peasant Festivity and Political Identity in the Sixteenth Century." *Art History* 10 (1987): 289–314.

Castellani, Carlo. "I Privilegi di Stampa e la Proprietà Letteraria in Venezia dalla Introduzione della Stampa nella Città fin verso la Fine del Secolo Scorso." *Archivio Veneto* 36 (1888): 127–39.

Castiglioni, G. "'Frixi et figure et miniadure facte de intajo' tra silografia e miniatura in alcuni incunaboli veneziani." *Verona Illustrata* 2 (1989): 19–27.

Catelli Isola, Maria. *Immagini da Tiziano.* Exhibition catalogue. Rome, 1976–77.

Cecchetti, B. "Uno stampatore di santi in Venezia nel 1514." *Archivio Veneto* 32 (1886): 386.

Cennini, Cennino. *Il Libro dell'arte.*

Chambers, David and Jane Martineau, eds. *Splendours of the Gonzaga.* Exhibition catalogue. London, 1981.

Chastel, André. "Pétrarque et son illustrateur devant la peinture." In *Études d'art médiéval offertes à Louis Grodecki*, edited by Sumner M. Crosby, et al., pp. 343–52. Paris, 1981.

Chastel, André. *The Sack of Rome.* Translated by Beth Archer. Princeton, 1983.

Chmelarz, Eduard. "Die Ehrenpforte des Kaisers Maximilian I." *JKSW* 4 (1886): 289–319.

Chmelarz, Eduard. "Jost de Negker's Helldunkelblätter Kaiser Maximilian und St. Georg." *JKSW* 15 (1894): 392–97.

Chrisman, Miriam U. *Lay Culture and Learned Culture: Books and Social Change in Strasbourg, 1480–1599.* New Haven and London, 1982.

Ciardi Duprè, Maria Grazia, et al. *L'oreficeria nella Firenze del Quattrocento.* Exhibition catalogue. Florence, 1977.

Le cinquième centenaire de l'imprimerie dans les anciens Pays-Bas. Exhibition catalogue. Brussels: Bibliothèque Royale Albert Ier, 11 September–27 October 1973. Brussels, 1973.

Cipolla, Carlo. *Money, Prices and Civilization in the Mediterranean World: Fifth to the Seventeenth Century.* Princeton, 1956.

Clapham, Michael. "Printing." In *A History of Technology*, edited by Charles Singer, E. J. Holmyard, A. R. Hall, and Trevor I. Williams, vol. III, pp. 377–416. Oxford, 1957.

Clemen, Otto. *Die Volksfrömmigkeit des ausgehenden Mittelalters.* Dresden and Leipzig, 1937.

Cochlaeus, Johannes. *Brevis Germaniae Descriptio.* Nuremberg, 1512. Edited with commentary and translation by Karl Langosch. Darmstadt, 1960.

Cockx-Indestege, Elly. "A Hitherto Unknown Edition of W. H. Ryff's *Tabulae decem*, Antwerp, Cornelis Bos, c. 1542." *Quaerendo* 6 (1976): 16–27.

Collijn, Isak. "Två 'Degtryck' i stiftsbiblioteket i Tepl." *Nordisk Tidskrift for Bok- och Biblioteksvasen* 15 (Stockholm, 1928): 103–11.

Collins, Patricia. "Prints and the Development of *istoriato* Painting on Italian Renaissance Maiolica." *Print Quarterly* 4 (1987): 223–35.

Colvin, Sidney. *A Florentine Picture-Chronicle.* London, 1898.

Conway, William Martin, trans. and ed. *Literary Remains of Albrecht Dürer.* Cambridge, 1889. Republished as *The Writings of Albrecht Dürer.* Introduction by Alfred Werner. London, 1958.

Coombs, Elizabeth, Eugene Farrell, and Richard S. Field. *Pasteprints: A Technical and Art Historical Investigation.* Cambridge, Mass., 1986.

Coupe, William A. *The German Illustrated Broadsheet in the Seventeenth Century.* 2 vols. Baden-Baden, 1966.

Coupe, William A. "'Poets' and Patrons: Some Notes on Making Ends Meet in Sixteenth-Century Germany." *German Life and Letters* 36 (1983): 183–97.

Coyecque, Ernest. "Cinq librairies Parisiennes sous François I, 1521–1529." *Mémoires de la Société de l'Histoire de Paris et de l'Ile-de-France* 21 (1894): 53–136.

Cuvelier, J. "Le graveur Corneille van den Bossche (XVIe siècle)." *Bulletin de l'Institut Historique Belge de Rome* 20 (1939): 5–49.

Davis, Natalie Z. "Strikes and Salvation at Lyons." In *Society and Culture in Early Modern France*, pp. 1–16. Stanford, 1975.

Davis, Natalie Z. "A Trade Union in Sixteenth-Century France." *Economic History Review*, 2nd ser., 19 (1966): 48–69.

Delen, A. J. J. "Christoffel Plantin als prentenhandelaar." *De Gulden Passer* 10 (1932): 1–24.

Delen, A. J. J. *Histoire de la gravure dans les anciens Pays-Bas et dans les provinces belges, des origines jusqu'à la fin de XVIe siècle.* 3 vols. Paris and Brussels, 1924–25. Reprinted Paris, 1969.

Derschau, Hans Albrecht von. *Holzschnitte alter deutscher Meister.* Introduction by Rudolph Z. Becker. Gotha, 1808.

Des Marez, Guillaume. *L'organisation du travail à Bruxelles au XVe siècle.* Academie Royale des Sciences de Belgique. Mémoires couronnés, no. 65. Brussels, 1903/4.

Dietz, Alexander. *Frankfurter Handelsgeschichte.* 5 vols. Frankfurt am Main, 1910–25.

Dillen, J. G. van. *Bronnen tot de geschiedenis van het Bedrijfsleven en het Gildewezen van Amsterdam.* 3 vols. The Hague, 1929–74.

Dizionario Biografico degli Italiani. Rome, 1960–.

Dodgson, Campbell. *Catalogue of Early German and Flemish Woodcuts Preserved in the Department of Prints and Drawings in the British Museum.* 2 vols. London, 1911. Reprinted Vaduz, 1980.

Dodgson, Campbell. "Hans Lützelburger and the Master N.H." *Burlington Magazine* 10 (1906): 319–24.

Dodgson, Campbell. "'Marcus Curtius': A Woodcut after Pordenone." *Burlington Magazine* 37 (1920): 61.

Dodgson, Campbell. "Rare Woodcuts in the Ashmolean Museum, Oxford — II." *Burlington Magazine* 39 (1921): 68–75.

Domenico Beccafumi e il suo tempo. Exhibition catalogue. Milan, 1990.

Doni, Anton Francesco. *Il Disegno.* Venice, 1549.

Dorini, U. *Statuti per l'Arte di Por Santa Maria del tempo della Repubblica.* Florence, 1934.

BIBLIOGRAPHY

Dreyer, Peter. "Botticelli's Series of Engravings 'of 1481'." *Print Quarterly* 1 (1984): 111–15.

Dreyer, Peter. *Tizian und sein Kreis: Holzschnitte*. Berlin, n.d.

Duitse Tekeningen, 1400–1700: German Drawings. Exhibition catalogue. Rotterdam: Museum Boymans-van Beuningen, 1 June–14 July 1974.

Dunand, Louis and Philippe Lemarchand. *Les amours des dieux*. Lausanne, 1977.

Eamon, William. "Arcana Disclosed: The Advent of Printing, the Books of Secrets Tradition and the Development of Experimental Science in the Sixteenth Century." *History of Science* 22 (1984): 111–50.

Edgerton, Samuel, Jr. "From Mental Matrix to *Mappamundi* to Christian Empire: The Heritage of Ptolemaic Cartography in the Renaissance." In *Art and Cartography*, edited by D. Woodward, pp. 10–49. Chicago, 1987.

Eeghen, I. H. van. "Jacob Cornelisz, Cornelis Anthonisz en hun familierelaties." *Nederlands Kunsthistorisch Jaarboek* 37 (1986): 95–132.

Ehrle, F. *Roma prima di Sisto Quinto*. Rome, 1908.

Eisenstein, Elizabeth L. *The Printing Press as an Agent of Change*. 2 vols. Cambridge, 1979.

Elsas, M. J. *Umriss einer Geschichte der Preise und Löhne in Deutschland vom ausgehenden Mittelalter bis zum Beginn des neunzehnten Jahrhunderts*. 2 vols. in 3 parts. Leiden, 1936–49.

Ekserdjian, David. "Parmigianino and Mantegna's 'Triumph of Caesar.'" *Burlington Magazine* 134 (1992): 100–01.

Emison, Patricia. "Marcantonio's *Massacre of the Innocents*." *Print Quarterly* 1 (1984): 257–67.

Emison, Patricia. "The Word Made Naked in Pollaiuolo's *Battle of the Nudes*." *Art History* 13 (1990): 261–75.

Endres, Rudolf. "Zur Einwohnerzahl und Bevölkerungsstruktur Nürnbergs im 15./16. Jahrhundert." *Mitteilungen des Vereins für Geschichte der Stadt Nürnberg* 57 (1970): 242–71.

Engel, Franz. *Tabellen alter Münzen, Maße und Gewichte zum Gebrauch für Archivbenützer*. Rinteln, 1965.

Enschedé, J. W. "Een Drukkerij buiten Mechelen voor 1466." *Het Boek* 7 (1918): 286–92.

Enschedé, J. W. "Houten handpersen in de zestiende eeuw." *Tijdschrift voor Boek- en Bibliotheekwezen* 4 (1906): 195–215, 262–77.

d'Essling, Prince. *Etudes sur l'art de la gravure sur bois à Venise. Les livres à figures vénitiens de la fin du XVe siècle et du commencement du XVIe*. 5 vols. in 3 parts. Paris and Florence, 1907–14. Reprinted Turin, 1967.

Evelyn, John. *Sculptura: or the History, and Art of Chalcography and Engraving in Copper*. London, 1662.

Exposition des gravures italiennes des XVe et XVIe siècles. Exhibition catalogue. Caen, 1976.

Eyssen, Ed. "Daniel Hopfer von Kaufbeuren." Dissertation, Ruprecht-Karls-Universität, Heidelberg, 1904.

Fagiolo dell'Arco, Maurizio. *Il Parmigianino: Un saggio sull'ermetismo nel Cinquecento*. Rome, 1970.

Faietti, Marzia. In Alessandra Mottola Molfino and Mauro Natale, *Le Muse e il Principe*. Exhibition catalogue. Modena, 1991.

Faietti, M. and K. Oberhuber. *Bologna e l'Umanesimo, 1490–1510*. Exhibition catalogue. Bologna, 1988.

Falk, Tilman. *Hans Burgkmair: Studien zu Leben und Werk des Augsburger Malers*. Munich, 1968.

Falk, Tilman. "Das Johannesbild Hans Burgkmairs von 1518." In *Minuscula Discipulorum. Kunsthistorische Studien. Hans Kauffmann zum 70. Geburtstag 1966*, edited by T. Falk and M. Winner, pp. 85–94. Berlin, 1968.

Falk, Tilman. *Die Zeichnungen des 15. und 16. Jahrhunderts im Kupferstichkabinett Basel*, part 1: *Das 15. Jahrhundert, Hans Holbein der Ältere und Jörg Schweiger, die Basler Goldschmiederisse*. Basel and Stuttgart, 1979.

Falk, Tilman, et al. *Hans Burgkmair: Das graphische Werk, 1473–1973*. Exhibition catalogue. Stuttgart: Graphische Sammlung, Staatsgalerie, 1973.

Faries, Molly. "A Woodcut of the *Flood* Re-attributed to Jan van Scorel." *Oud Holland* 97 (1983): 5–12.

Febvre, Lucien and Henri-Jean Martin. *The Coming of the Book: The Impact of Printing, 1450–1800*. Translated by David Gerard. London, 1976.

Field, Richard S. *Fifteenth Century Woodcuts and Metalcuts from the National Gallery of Art*. Washington, D.C., n.d.

Field, Richard S. "A *Passion* for the Art Institute." *Print Quarterly* 3 (1986): 191–216.

Field, Richard S. "Woodcuts from Altomünster." *Gutenberg Jahrbuch* (1969): 183–211.

Filedt Kok, Jan Piet. "Een *Biblia pauperum* met houtsneden van Jacob Cornelisz. en Lucas van Leyden gereconstrueerd." *Bulletin van het Rijksmuseum* 36 (1988): 83–116.

Filedt Kok, Jan Piet. "Een groep 16de-eeuwse Nederlandse houtsneden afkomstig uit Gotha." *Bulletin van het Rijksmuseum* 31 (1983): 211–14.

Filedt Kok, Jan Piet. *Lucas van Leyden — grafiek*. Exhibition catalogue. Amsterdam: Rijksmuseum, 9 September–3 December 1978.

Filedt Kok, Jan Piet, et al. *Livelier than Life: The Master of the Amsterdam Cabinet, or the Housebook Master, ca. 1470–1500*. Exhibition catalogue. Amsterdam: Rijksprentenkabinet, 1985.

Fineschi, P. Vincenzio. *Notizie storiche sopra la stamperia di Ripoli*. Florence, 1781.

Fischel, Lilli. *Bilderfolgen im frühen Buchdruck: Studien zur Inkunabel-Illustration in Ulm und Strassburg*. Constance and Stuttgart, 1963.

Fischel, Lilli. "Le Maître E.S. et ses sources Strasbourgeoises." *Archives Alsaciennes d'Histoire de l'Art* 14 (1935): 185–229.

Fischel, Lilli. "Werk und Name des 'Meisters von 1445.'" *Zeitschrift für Kunstgeschichte* 13 (1950): 105–24.

Fischer, Otto. "Geschichte der Öffentlichen Kunstsammlung." In *Öffentliche Kunstsammlung Basel: Festschrift zur Eröffnung des Kunstmuseums*, pp. 7–118. Basel, 1936.

Flechsig, Eduard. *Martin Schongauer*. Strasbourg, 1951.

Fleischauer, Werner. "Das Zwinglische Bett: Ein Tübinger Holzschnitt im Dienste orthodoxer Polemik." In *Hundert Jahre Kohlhammer, 1866–1966*, pp. 319–23. Stuttgart, etc., 1966.

Fletcher, Harry George, III. *New Aldine Studies: Documentary Essays on the Life and Work of Aldus Manutius*. San Francisco, 1988.

Fletcher, Jennifer. "Marcantonio Michiel: His Friends and Collection." *Burlington Magazine* 123 (1981): 453–67.

Floerke, Hanns. *Studien zur niederländischen Kunst- und Kulturgeschichte: Die Formen des Kunsthandels, das Atelier und die Sammler in den Niederlanden vom 15.–18. Jahrhundert*. Munich and Leipzig, 1905.

Forbes, Robert James. *Short History of the Art of Distillation*. Leiden, 1948.

Forrer, Robert. *Die Zeugdrucke der byzantinischen, romanischen, gotischen und spätern Kunstepochen*. Strasbourg, 1894.

Francis, Henry. "The Equestrian Portrait of the Emperor Maximilian I by Hans Burgkmair." *Bulletin of the Cleveland Museum of Art* 39 (1952): 223–25.

Freedberg, David. *The Power of Images*. Chicago, 1989.

Frey, H. W. *Il Carteggio di Giorgio Vasari*. Munich, 1923.

Frey, K. *Die Loggia dei Lanzi zu Florenz*. Berlin, 1855.

Fridolin, Stephan. *Der Schatzbehalter: Ein Andachts- und Erbauungsbuch aus dem Jahre 1491*. 2 vols. Facsimile with text and commentary by Richard Bellm. Wiesbaden, 1962.

Fries, Lorenz. *Uslegung der mercarthen oder Cartha Marina*. Strasbourg: Johannes Grüninger, 1525.

Fries, Walter. "Der Nürnberger Briefmaler Hans Guldenmund." *Zeitschrift für Buchkunde* 1 (1924): 39–48.

Frimmel, Theodor "Der Anonimo Morelliano (Marcantonio Michiel's *Notizie d'opere del disegno*)." In *Quellenschriften für Kunstgeschichte und Kunsttechnik des Mittelalters und der Neuzeit*, vol. I, pp.

418

22–99. Vienna, 1888.

Fritz, Johann Michael. *Gestochene Bilder: Gravierungen auf deutschen Goldschmiedearbeiten der Spätgotik.* Cologne and Graz, 1966.

Frommel, C. L. *Baldassare Peruzzi als Maler und Zeichner.* Vienna, 1967–68.

Frommel, C. L. *Die Farnesina und Peruzzis Architektonisches Frühwerk.* Berlin, 1961.

Fuchs, Leonhart. *De historia stirpium commentarii insignes.* Basel: Michael Isengrin, 1542.

Fuchs, Leonhart. *New Kreüterbuch.* Basel: Michael Isingrin, 1543.

Fulin, Rinaldo. "Nuovi documenti per servire alla storia della tipografia Veneziana." *Archivio Veneto* 23 (1882), pt. 1, pp. 84–212; pt. 2, pp. 390–405.

Fusco, Laurie. "Pollaiuolo's *Battle of Nudes*: A Suggestion for an Ancient Source and a New Dating." In *Scritti di Storia dell'Arte in onore di Federico Zeri,* edited by Mauro Natale, pp. 196–99. Milan, 1984.

Gabriele, Mino. *Le incisioni alchemico-metallurgiche di Domenico Beccafumi.* Florence, 1988.

Gandolfo, F. "Il Dolce Tempo." In *Mistica, Ermetismo e Sogno nel Cinquecento,* pp. 110–12. Rome, 1978.

Ganz, Paul and Emil Major. "Die Entstehung des Amerbach'schen Kunstkabinetts und die Amerbach'schen Inventare." *Jahresbericht der Öffentlichen Kunstsammlung in Basel,* n.s. 3 (1907): 1–68.

Garris, Kathleen Weil and John F. D'Amico. "The Renaissance Cardinal's Ideal Palace: A Chapter from Cortesi's *De Cardinalatu.*" In *Studies in Italian Art and Architecture, Fifteenth through Eighteenth Centuries,* edited by H. S. Millon, pp. 45–119. Rome, 1980.

Gascoigne, Bamber. *How to Identify Prints.* London, 1986.

Gaye, Giovanni. *Carteggio inedito d'artisti dei secoli XIV. XV. XVI. (1326–1672).* 3 vols. Florence, 1839–40.

Geisberg, Max. *Der deutsche Einblatt-Holzschnitt in der ersten Hälfte des XVI. Jahrhunderts.* 37 vols. Munich, 1923–30.

Geisberg, Max. *The German Single-Leaf Woodcut, 1500–1550.* 4 vols. Revised and edited by Walter Strauss. New York, 1974.

Geisberg, Max. *Geschichte der deutschen Graphik vor Dürer.* Berlin, 1939.

Geisberg, Max. "Holzschnittbildnisse des Kaisers Maximilian." *Jahrbuch der preussischen Kunstsammlungen* 32 (1911): 236–48.

Geisberg, Max. *Der Meister der Berliner Passion und Israhel van Meckenem.* Strasbourg, 1903.

Geisberg, Max. "Teigdruck und Metallschnitt." *Monatshefte für Kunstwissenschaft* 5 (1912): 311–20.

Geisberg, Max. *Verzeichnis der Kupferstiche Israhels van Meckenem.* Strasbourg, 1905.

Geldner, Ferdinand. "Das Rechnungsbuch des Speyrer Druckherrn, Verlegers und Großbuchändlers Peter Drach." *Archiv für Geschichte des Buchwesens* 5 (1964), cols. 1–196.

Gemeiner, Carl Theodor. *Regensburgische Chronik.* 4 vols. Regensburg, 1800–24. Reprinted Munich, 1971.

Gentile, Sebastiano. *Firenze e la scoperta dell'America.* Exhibition catalogue. Florence: Biblioteca Laurenziana, 1992–93.

Gerardy, Theo. "Der Identitätsbeweis bei der Wasserzeichendatierung." *Archiv für Geschichte des Buchwesens* 9 (1969), cols. 734–78.

Gere, J. A. and Nicholas Turner. *Drawings by Raphael.* Exhibition catalogue. London: British Museum, 1983.

Gerulaitis, Leonardas Vytautas. *Printing and Publishing in Fifteenth-Century Venice.* Chicago and London, 1976.

Gilbert, Creighton E. *Italian Art, 1400–1500: Sources and Documents.* Englewood Cliffs, N.J., 1980.

Gilmore, M. P. "Studia Humanitatis and the Professions." *Florence and Venice: Comparisons and Relations.* Vol. I. Florence: I Tatti, 1976–77.

Gizzi, Corrado. *Botticelli e Dante.* Exhibition catalogue Pesaro: Torre de' Passeri. Milan, 1990.

Glück, Gustav. "Beiträge zur Geschichte der Antwerpner Malerei im XVI. Jahrhundert." *JKSW* 22 (1901): 1–34.

Goddard, Stephen, et al. *The World in Miniature: Engravings by the German Little Masters, 1500–1550.* Exhibition catalogue. Lawrence, Kansas: Spencer Museum of Art, 1988.

Goldthwaite, Richard A. *The Building of Renaissance Florence: An Economic and Social History.* Baltimore and London, 1980.

Gombrich, Ernst. *Art and Illusion: A Study in the Psychology of Pictorial Representation.* 2nd rev. ed. Princeton, 1961.

Gombrich, Ernst. "The Renaissance Theory of Art and the Rise of Landscape." In *Norm and Form,* pp. 107–21. 2nd ed. London, 1971.

Gombrich, Ernst. "Review of William Ivins, *Prints and Visual Communication.*" *British Journal for the Philosophy of Science* 5 (1954/55): 168–69.

Gordon, Robert B. "Sixteenth-Century Metalworking Technology Used in the Manufacture of Two German Astrolabes." *Annals of Science* 44 (1987): 71–84.

Gould, Cecil. "Dürer's Graphics and Italian Painting." *Gazette des Beaux-Arts,* 6th ser., 75 (1970): 103–16.

Graphik der Niederlande, 1508–1617. Kupferstiche und Radierungen von Lucas van Leyden bis Hendrik Goltzius. Exhibition catalogue. Munich: Staatliche Graphische Sammlung, 12 October–2 December 1979. Munich, n.d.

Grenacher, F. "The Basle Proofs of Seven Printed Ptolemaic Maps." *Imago Mundi* 13 (1956): 166–71.

Griffiths, Antony. "Notes on Early Aquatint in England and France." *Print Quarterly* 4 (1987): 255–70.

Griffiths, Antony. *Prints and Printmaking: An Introduction to the History and Techniques.* London, 1980.

Griffiths, Antony. "The Rogers Collection in the Cottonian Library, Plymouth." *Print Quarterly* 10 (1993), pp. 19–36.

Grigg, Robert. "Studies on Dürer's Diary of his Journey to the Netherlands: The Distribution of the *Melencolia I.*" *Zeitschrift für Kunstgeschichte* 49 (1986): 398–409.

Grote-Dessau, L. "Zur Datierung der Landschaftsradierungen Albrecht Altdorfers." *Monatshefte für Bücherfreunde und Graphiksammler* 1 (1925): 229–30.

Grotefend, Hermann. *Christian Egenolff der erste ständige Buchdrucker zu Frankfurt A.M. und seine Vorlaufer.* Frankfurt, 1881.

Gümbel, Albert. "Die Baurechnung über die Erhöhung der Türme von St. Sebald in Nürnberg, 1481–1495." *Mitteilungen des Vereins für Geschichte der Stadt Nürnberg* 20 (1913): 10–94.

Gutfleisch, Barbara and Joachim Menzhausen. "'How a Kunstkammer Should be Formed.' Gabriel Kaltemarckt's Advice to Christian I of Saxony on the Formation of an Art Collection, 1587." *Journal of the History of Collections* 1 (1989): 1–32.

Habich, Georg. "Das Gebetbuch des Matthäus Schwarz." In *Sitzungsberichte der Königlich Bayerischen Akademie der Wissenschaften.* Philosophisch-philologische und historische Klasse, no. 8. Munich, 1910.

Hajós, Elizabeth M. "The Concept of an Engravings Collection in the Year 1565: Quicchelberg, 'Inscriptiones vel Tituli Theatri Amplissimi.'" *Art Bulletin* 40 (1958): 151–56.

Hajós, Elisabeth M. "References to Giulio Camillo in Samuel Quicchelberg's 'Inscriptiones vel tituli Theatri Amplissimi.'" *Bibliothèque d'Humanisme et Renaissance* 25 (1963): 207–11.

Hale, John. *A Concise Encyclopaedia of the Italian Renaissance.* London, 1981.

Halm, Peter. "Das Gebetbuch von Narziss Renner in der Österreichischen Nationalbibliothek." *Zeitschrift für Kunstwissenschaft* 8 (1954): 65–88.

Hampe, Theodor. "Der Augsburger Formschneider Hans Schwarzenberger und seine Modelbücher aus den Jahren 1534 und 1535." *Mitteilungen aus dem Germanischen Nationalmuseum* (1909): 59–86.

Hampe, Theodor. "Beiträge zur Geschichte des Buch- und Kunsthandels in Nürnberg." *Mitteilungen aus dem Germanischen Nationalmuseum* (1912): 109–57.

Hampe, Theodor, ed. *Gedichte vom Hausrat aus dem XV. und XVI. Jahrhundert*. Strasbourg, 1899.

Hampe, Theodor. "Kunstfreunde im alten Nürnberg und ihre Sammlungen." *Mitteilungen des Vereins für Geschichte der Stadt Nürnberg* 15 (1903): 57–124.

Hampe, Theodor, ed. *Nürnberger Ratsverlässe über Kunst und Künstler im Zeitalter der Spätgotik und Renaissance*. 3 vols. Vienna and Leipzig, 1904.

Hans Burgkmair, 1473–1531. Exhibition catalogue. Berlin: Staatliche Museen, 1974.

Hans Holbein der Ältere und die Kunst der Spätgotik. Exhibition catalogue. Augsburg: Rathaus, 1965.

Harris, Elizabeth. "The Waldseemüller World Map: A Typographic Appraisal." *Imago Mundi* 37 (1985): 30–53.

Hartig, Otto. "Der Artzt Samuel Quicchelberg, der erste Museologe Deutschlands." *Bayerland* 44 (1933): 630–33.

Hartig, Otto. *Die Gründung der Münchener Hofbibliothek*. Munich, 1917.

Hartlaub, G. F. "De Re Metallica: Eine allegorische Holzschnittfolge des Domenico Beccafumi, genannt Il Mecherino." *Jahrbuch der preussischen Kunstsammlungen* 60 (1939): 103–10.

Hartmann, Bernhard. "Konrad Celtis in Nürnberg." *Mitteilungen des Vereins für Geschichte der Stadt Nürnberg* 8 (1889): 1–68.

Hartley, Craig. "Beccafumi 'glum and gloomy,'" *Print Quarterly* 8 (1991): 418–25.

Hartt, Frederick. *Giulio Romano*. 2 vols. New Haven, 1958.

Harzen, E. "Ueber die Erfindung der Aetzkunst." *Archiv für die zeichnenden Künste [R. Naumann's Archiv]* 5 (1859): 119–36.

Hase, Oscar von. *Die Koberger*. 2nd rev. ed. Leipzig, 1885. Reprinted Amsterdam and Wiesbaden, 1967.

Haskell, Francis and Nicholas Penny. *Taste and the Antique: The Lure of Classical Sculpture, 1500–1900*. New Haven and London, 1981.

Hasse, Max. "Maler, Bildschnitzer und Vergolder in den Zünften des späten Mittelalters." *Jahrbuch der Hamburger Kunstsammlungen* 21 (1976): 31–42.

Healey, Robin. *Fifteenth-Century Italian Woodcuts from the Biblioteca Classense, Ravenna*. Toronto, 1989.

Held, Julius. "Burgkmair and Lucas van Leyden." *Burlington Magazine* 60 (1932): 308–13.

Held, Julius S., ed. *Dürer through Other Eyes: His Graphic Work Mirrored in Copies and Forgeries of Three Centuries*. Exhibition catalogue. Williamstown, Mass.: Sterling and Francine Clark Art Institute, 1975.

Held, Julius S. "The Early Appreciation of Drawings." In *Latin American Art and the Baroque Period in Europe*, pp. 72–95. Studies in Western Art: Acts of the Twentieth International Congress of the History of Art, vol. III. Princeton, 1963.

Held, Kristin von. "Anfänge und Entwicklung der Eisenradierung von 1500–1540." Magisterarbeit. Ludwig-Maximilians-Universität, Munich, 1988.

Herberger, Theodor. *Conrad Peutinger in seinem Verhältnisse zum Kaiser Maximilian I*. Augsburg, 1851.

Hernad, Béatrice. *Die Graphiksammlung des Humanisten Hartmann Schedel*. Exhibition catalogue. Munich: Bayerische Staatsbibliothek, 1990.

Heusinger, Christian von, et al. *Das gestochene Bild: Von der Zeichnung zum Kupferstich*. Exhibition catalogue. Braunschweig, 1987.

Hind, Arthur M. *Early Italian Engraving*. 7 vols. London, 1938–48.

Hind, Arthur M. "Fifteenth-Century Italian Engravings at Constantinople." *Print Collector's Quarterly* 20 (1933): 279–96.

Hind, Arthur M. *A History of Engraving and Etching*. New York, 1963.

Hind, Arthur M. *An Introduction to a History of Woodcut, With a Detailed Survey of Work Done in the Fifteenth Century*. 2 vols. New York, 1935. Reprinted London and New York, 1963.

Hind, Arthur M. "Marcantonio Raimondi (1480[?]–1530[?])." *Print Collector's Quarterly* 3 (1913): 243–76.

Hind, Arthur M. *Nielli, Chiefly Italian of the XV Century: Plates, Sulphur Casts and Prints, Preserved in the British Museum*. London, 1936.

Hind, Arthur M. *A Short History of Engraving and Etching*. Boston and New York, 1908.

Hindman, Sandra and James Douglas Farquhar. *Pen to Press: Illustrated Manuscripts and Printed Books in the First Century of Printing*. Baltimore, 1977.

Hirsch, Rudolf. "Bibliotheca, Charte, Instrumenta Scriptoria: A Chapter in the Latin-German Vocabulary of Pinicianus (1516)." *Bibliothek und Wissenschaft* 9 (1975): 134–57.

Hirsch, Rudolf. *Printing, Selling and Reading, 1450–1550*. Wiesbaden, 1967.

Hirth, H. "Marcanton und sein Stil: Eine Kunstgeschichtliche Studie." Dissertation. Leipzig and Munich, 1898.

His, Edouard. "Hans Lützelburger: Le graveur des Simulacres de la Mort d'Holbein." *Gazette des Beaux-Arts*, 169, 2nd ser., 4 (1870): 481–89.

Hodgen, Margaret T. *Early Anthropology in the Sixteenth and Seventeenth Centuries*. Philadelphia, 1964.

Hoeniger, David. "How Plants and Animals were Studied in the Mid-Sixteenth Century." In *Science and the Arts in the Renaissance*, edited by John W. Shirley and F. David Hoeniger, pp. 130–48. Washington, D.C., 1985.

Hollstein, F. W. H. *Dutch and Flemish Etchings, Engravings and Woodcuts, ca. 1450–1700*. Amsterdam, 1949–.

Hollstein, F. W. H. *German Engravings, Etchings and Woodcuts, ca. 1400–1700*. Amsterdam, 1954–.

Holmes, M. "The Influence of Northern Engravings on Florentine Art during the Second Half of the Fifteenth Century." M.Phil. thesis. London, Courtauld Institute, 1983.

Howarth, David. *Lord Arundel and his Circle*. New Haven and London, 1985.

Hülsen, Christian. "Die alte Ansicht von Florenz im Kgl. Kupferstichkabinett und ihr Vorbild." *Jahrbuch der Königlich preuszischen Kunstsammlungen* 35 (1914): 90–102.

Hunter, Dard. *Papermaking: The History and Technique of an Ancient Craft*. 2nd rev. ed. New York, 1978.

Hupp, Otto. *Scheltbriefe und Schandbilder: Ein Rechtsbehelf aus dem 15. und 16. Jahrhundert*. Munich and Regensburg, 1930.

Hutchinson, Jane. "The Housebook Master and the Mainz Marienleben." In *Tribute to Wolfgang Stechow*, ed. Walter L. Strauss, pp. 96–113. Published as *Print Review* 5 (1976).

Israhel van Meckenem und der deutsche Kupferstich des 15. Jahrhunderts. 750 Jahre Stadt Bocholt, 1222–1972. Beiträge zur Ausstellung. Bocholt, 1972.

Ivins, William M., Jr. "An Early Book about Etching." *Bulletin of the Metropolitan Museum of Art* 12 (1917): 174–76.

Ivins, William M., Jr. *How Prints Look: An Illustrated Guide*. Boston, 1958. Revised edition by Marjorie B. Cohn. Boston, 1987.

Ivins, William M., Jr. "Notes on Three Dürer Woodblocks." *Metropolitan Museum Studies* 2 (1929): 102–11.

Ivins, William M., Jr. *Prints and Visual Communication*. Cambridge, Mass., 1953.

Jacobowitz, Ellen S. and Stephanie Loeb Stepanek. *The Prints of Lucas van Leyden and His Contemporaries*. Exhibition catalogue. Washington, D.C.: National Gallery of Art, 5 June–14 August; Boston: Museum of Fine Arts, 14 September–20 November 1983.

Jacobsen, Michael A. "The Engravings of Mantegna." Ph.D. dissertation. Columbia University, 1976.

Jäger, Klaus-Dieter and Renate Kroll. "Holzanatomische Untersuchungen an den Altdorfer-Stöcken der Sammlung Derschau: Ein Beitrag zur Methodik von Holzbestimmungen an Kunstgegenständen." *Forschungen und Berichte, Staatliche Museen zu Berlin* 6 (1964): 24–39.

Janson, H. W. "The 'Image Made by Chance' in Renaissance Thought." In *De artibus opuscula XL: Essays in Honor of Erwin Panofsky*, edited by Millard Meiss, pp. 254–66. New York, 1961.

Janson, H. W. *The Sculpture of Donatello*. 2 vols. Princeton, 1957.

Janson, H. W. "Titian's *Laocoon Caricature* and the Vesalian-Galenist Controversy." *Art Bulletin* 28 (1946): 49–53.

Janzen, Reinhild. *Albrecht Altdorfer: Four Centuries of Criticism*. Ann Arbor, Mich., 1980.

Joannides, P. *The Drawings of Raphael*. Oxford, 1983.

Johnson, Hildegard B. *Carta Marina: World Geography in Strassburg, 1525*. Minneapolis, Minn., 1963.

Johnson, Jan. "Ugo da Carpi's Chiaroscuro Woodcuts." *Print Collector*, nos. 57–58 (1982): 2–87.

Johnson, John and William A. Chatto. *A Treatise of Wood Engraving*. London, 1839.

Jones, Roger and Nicholas Penny. *Raphael*. New Haven and London, 1983.

Kabdebo, Heinrich. "Der Anteil der Nürnberger Briefmaler Meldemann und Guldenmundt an der Literatur der ersten Wiener Türkenbelagerung." *Berichte und Mitteilungen des Alterthums-Vereines zu Wien* 15 (1875): 97–106.

Karpinski, Caroline. *Italian Printmaking. Fifteenth and Sixteenth Centuries: An Annotated Bibliography*. Boston, 1987.

Karpinski, Caroline. "The Print in Thrall to Its Original: A Historiographic Perspective." In *Retaining the Original: Multiple Originals, Copies, and Reproductions*, pp. 101–09. Studies in the History of Art, vol. XX. Washington, D.C.: National Gallery of Art, 1989.

Karpinski, Caroline. Review of Eugene A. Carroll, *Rosso Fiorentino*. In *Print Quarterly* 5 (1988): 171–73.

Kaufmann, Rudolf. *Der Renaissancebegriff in der deutschen Kunstgeschichtsschreibung*. Winterthur, 1932.

Keller, A. C. "Zilsel: The Artisans and the Idea of Progress in the Renaissance." In *Roots of Scientific Thought: A Cultural Perspective*, edited by Philip P. Wiener and Aaron Noland, pp. 281–86. New York, 1957.

Kennedy, Ruth Wedgwood. *Alesso Baldovinetti: A Critical and Historical Study*. New Haven, 1938.

Keuning, Johannes. "Cornelis Anthonisz." *Imago Mundi* 7 (1950): 51–65.

King, Donald. "Textiles and the Origin of Printing in Europe." *Pantheon* 20 (1962): 23–30.

Kloek, Wouter. "The Drawings of Lucas van Leyden." *Nederlands Kunsthistorisch Jaarboek* 29 (1978): 425–58.

Kluge, Friedrich. *Etymologisches Wörterbuch der deutschen Sprache*. 19th ed. Berlin, 1963.

Knab, E., E. Mitsch, E. and K. Oberhuber. *Raphael: Die Zeichnungen*. Stuttgart, 1983.

Koegler, Hans. *Beschreibendes Verzeichnis der Basler Handzeichnungen des Urs Graf*. Includes exhibition catalogue. Basel, 1926.

Koehler, S. R. "Über die Technik des alten Holzschnittes." *Chronik für vervielfältigende Kunst* 3 (1890): 82–84.

Koelner, Paul. *Die Safranzunft zu Basel und ihre Handwerke und Gewerbe*. Basel, 1935.

Koepplin, Dieter and Tilman Falk. *Lukas Cranach*. Exhibition catalogue. Basel: Kunstmuseum, 1974, 2 vols. Basel and Stuttgart, 1974–76.

Koreny, Fritz. *Albrecht Dürer and the Animal and Plant Studies of the Renaissance*. Boston, 1988.

Koreny, Fritz. "A Coloured Flower Study by Martin Schongauer and the Development of the Depiction of Nature from van der Weyden to Dürer." *Burlington Magazine* 133 (1991): 588–97.

Koreny, Fritz. "Aux origines de la gravure sur cuivre allemande: reproductions, cartes à jouer, livres de modèles." *Nouvelles de l'estampe*, nos. 64/65 (July/October 1982): 9–10.

Koreny, Fritz. *Spielkarten, ihre Kunst und Geschichte in Mitteleuropa*. Exhibition catalogue. Vienna: Albertina, 1974.

Koreny, Fritz. "Über die Anfänge der Reproductionsgraphik nördlich der Alpen." Doctoral dissertation. University of Vienna, 1968.

Kristeller, Paul. *Andrea Mantegna*. Berlin and Leipzig, 1902.

Kristeller, Paul. "La xilografia veneziana." *Archivio Storico dell'Arte* 5 (1892): 95–114.

Kristeller, Paul. "Beiträge zur Geschichte des italienischen Holzschnittes." *Jahrbuch der preussischen Sammlungen* (1892): 172–78.

Kristeller, Paul. *Early Florentine Woodcuts*. London, 1897. Reprinted London, 1968.

Kristeller, Paul. "Ein unbeschriebener Kupferstich von Marcanton." *Repertorium für Kunstwissenschaft* 31 (1908): 63–65.

Kristeller, Paul. *Giulio Campagnola: Kupferstiche und Zeichnungen*. Berlin, 1907.

Kristeller, Paul. *L'œuvre de Jacopo de' Barbari*. Berlin, 1896.

Kristeller, Paul. "Tizians Beziehungen zum Kupferstich." *Die graphischen Künste* 34, suppl. (1911): 23–26.

Kuhrmann, Dieter. *Altdeutsche Zeichnungen aus der Universitätsbibliothek Erlangen*. Exhibition catalogue. Munich: Staatliche Graphische Sammlung, 7 June–28 July 1974.

Kuhrmann, Dieter. "Frühwerke Agostino Venezianos." In *Festschrift Kauffmann: Minuscula Discipulorum*, pp. 173–76. Berlin, 1968.

Kunst voor de Beeldenstorm. Edited by J. P. Filedt Kok, et al. Exhibition catalogue. Amsterdam: Rijksmuseum, 13 September–23 November 1986.

Kunzle, David. "The World Upside Down: The Iconography of a European Broadsheet Type." In *The Reversible World: Symbolic Inversion in Art and Society*, edited by Barbara A. Babcock, pp. 39–94. Ithaca and London, 1978.

Kuspit, Donald B. "Melanchthon and Dürer: The Search for the Simple Style." *Journal of Medieval and Renaissance Studies* 3 (1973): 177–202.

Labarre, Emile Joseph. *Dictionary and Encyclopaedia of Paper and Paper-making*. 2nd rev. ed. Amsterdam, 1952.

Lambert, Susan. *The Image Multiplied: Five Centuries of Printed Reproductions of Paintings and Drawings*. London, 1987.

Lamma, Ernesto. "Antonello da Messina und deutsche und niederländische Künstler in Venedig. II. Zustand des Buchgewerbes in der zweiten Hälfte des XVI. Jahrhunderts." *Jahrbuch der königlich preussischen Kunstsammlungen* 23 suppl. (1902): 46–53.

Landau, David. Review of *The Illustrated Bartsch*, vols. 7-11, 7-12, 7-13, 8-14, 8-15, 8-16, 8-17, 13-24, 13-25. *Burlington Magazine* 125 (1983): 169–73.

Landau, David. "Vasari, Prints and Prejudice." *Oxford Art Journal* 6 (1983): 3–10.

Landolt, Elisabeth. *Beiträge zu Basilius Amerbach (1533–1591)*. Basel, 1991.

Landolt, Elisabeth and Felix Ackermann. *Sammeln in der Renaissance: Das Amerbach-Kabinett. Die Objekte im Historischen Museum Basel*. Exhibition catalogue. Basel: Kunstmuseum, 21 April–21 July 1991.

Laschitzer, Simon. "Die Heiligen aus der 'Sipp-, Mag- und Schwägerschaft des Kaisers Maximilian I.'" *JKSW* 5 (1887): 117–262.

Laschitzer, Simon. "Der Theuerdanck." *JKSW* 8 (1888): 1–107.

Lawner, Lynne. *I modi*. Milan, 1984.

Lawner, Lynne. *I modi: The Sixteen Pleasures, an Erotic Album of the Italian Renaissance*. Evanston, 1988.

Lebeer, Louis. "Propos sur l'importance de l'étude des éditeurs d'estampes, particulièrement en ce qui concerne Jérôme Cock." *Revue belge d'archéologie et d'histoire de l'art* 37 (1968): 99–135.

Le Clert, Louis. *Le papier: Recherches et notes pour servir à l'histoire du papier principalement à Troyes et aux environs depuis le quatorzième siècle*. 2 vols. Paris, 1926.

Leemann-van Elck, Paul. *Die Offizin Froschauer: Zürichs berühmte Druckerei im 16. Jahrhundert*. Zurich and Leipzig, 1940.

I legni incisi della Galleria Estense: Quattro secoli di stampa nell'Italia Settentrionale. Exhibition catalogue. Modena: Galleria Estense, 1986.

Lehmann-Haupt, Hellmut. *Gutenberg and the Master of the Playing Cards*. New Haven and London, 1966.

Lehrs, Max. *Geschichte und kritischer Katalog des deutschen, nieder-*

BIBLIOGRAPHY

ländischen und französischen Kupferstichs im XV. Jahrhundert. 16 vols. Vienna, 1908–34.

Lehrs, Max. "Die Kupferstichsammlung der Stadt Breslau." *Jahrbuch der königlich preussischen Kunstsammlungen* 3 (1882): 210–23.

Lehrs, Max. "Der Meister PM." *Jahrbuch der königlich preussischen Kunstsammlungen* 19 (1898): 135–38.

Leicht, Pier Silverio. "L'editore veneziano Michele Tramezino ed i suoi privilegi." In *Miscellanea di scritti di bibliografia ed erudizione in memoria di Luigi Ferrari,* pp. 357–67. Florence, 1952.

Leitschuh, Franz Friedrich. *Studien und Quellen zur deutschen Kunstgeschichte des XV. XVI. Jhs.* Fribourg, Switzerland, 1912.

Lenckner, Georg. "Hieronymus Andreae, Formschneider in Nürnberg, und M. Bernhard Bubenleben, Pfarrer in Mergentheim." *Württembergisch-Franken,* n.s. 28/29 (1953/54): 152–54.

Lentze, Hans. "Nürnbergs Gewerbeverfassung des Spätmittelalters im Rahmen der deutschen Entwicklung." In *Beiträge zur Wirtschaftsgeschichte Nürnbergs,* edited by the Stadtarchiv Nürnberg, vol. II, pp. 593–619. Nuremberg, 1967.

Leporini, Heinrich. *Der Kupferstichsammler.* Berlin, 1924.

Lespinasse, René de. *Les métiers et corporations de la ville de Paris.* 2 vols. Paris, 1886–92.

Lettere di artisti italiani ad Antonio Perrenot di Granvelle. Madrid, 1977.

Levenson, Jay A., ed., *Circa 1492: Art in the Age of Exploration.* Exhibition catalogue. Washington, D.C.: National Gallery of Art, 1992.

Levenson, Jay A. "Jacopo de' Barbari and the Northern Art of the Early Sixteenth Century." Ph.D. dissertation. New York University, 1978.

Levenson, Jay A., Konrad Oberhuber, and Jacquelyn L. Sheehan. *Early Italian Engravings from the National Gallery of Art.* Exhibition catalogue. Washington, D.C.: National Gallery of Art, 1973.

Levie, S. H. "Der Maler Daniele da Volterra." Dissertation. Cologne, 1962.

Lewis, Douglas. *The Drawings of Andrea Palladio.* Exhibition catalogue. Washington, D.C.: National Gallery of Art, 1981.

Lieb, Norbert. *Die Fugger und die Kunst im Zeitalter der hohen Renaissance.* 2 vols. Munich, 1958.

Lightbown, R. *Mantegna: With a Complete Catalogue of the Paintings, Drawings and Prints.* Oxford, 1986.

Lippincott, Kristen. "'Mantegna's *Tarocchi.*'" *Print Quarterly* 3 (1986): 357–60.

Lippmann, Friedrich. "Ein Holzschnitt von Marcantonio Raimondi." *Jahrbuch der königlich preussischen Kunstsammlungen* 1 (1880): 270–76.

Lippmann, Friedrich. *Der Kupferstich.* 1893. 7th ed., revised by F. Anzelewsky. Berlin, 1963.

Lise, Giorgio. *L'incisione erotica del Rinascimento.* Milan, 1975.

Loesch, Heinrich von. *Die Kölner Zunfturkunden nebst anderen Kölner Gewerbeurkunden bis zum Jahre 1500.* 2 vols. Bonn, 1907.

Loga, Valerian von. "Beiträge zum Holzschnittwerk Michel Wolgemuts." *Jahrbuch der königlich preussischen Kunstsammlungen* 16 (1895): 224–40.

Loose, Wilhelm, ed. *Anton Tuchers Haushaltbuch, 1507 bis 1517.* Stuttgart, 1877.

Loßnitzer, Max. "Zwei Inkunabeln der deutschen Radierung." *Mitteilungen der Gesellschaft für vervielfältigende Kunst* (1910): 35–39.

Lucco, Mauro. *L'opera completa di Sebastiano del Piombo.* Milan, 1980.

Ludwig, Gustav. "Testament des Gabriel Vendramin." In *Archivialische Beiträge zur Geschichte der Venezianischen Kunst,* pp. 72–74. Berlin, 1911.

Lütgendorff, W. L. von. "Lübecker Briefmaler, Formschneider und Kartenmacher." *Mitteilungen des Vereins für Lübeckische Geschichte und Altertumskunde* 14 (1920): 101–34.

Major, Emil and Erwin Gradmann. *Urs Graf.* London, 1947. German edition, Basel, 1942.

Die Malerfamilie Holbein in Basel. Exhibition catalogue. Basel: Kunst-

museum, 1960.

Mancinelli, Fabrizio, et al. *Raffaello in Vaticano.* Exhibition catalogue. Rome, 1985.

Mander, Carel van. *Het Schilder-Boeck.* Haarlem, 1604. Reprint: 2 vols. New York, 1980.

Mann, James G. "The Etched Decoration of Armour." *Proceedings of the British Academy* 28 (1942): 17–45.

Marabottini, Alessandro. *Polidoro da Caravaggio.* 2 vols. Rome, 1969.

Martindale, Andrew. *"The Triumphs of Caesar" by Andrea Mantegna in the Collection of Her Majesty the Queen at Hampton Court.* London, 1979.

Martineau, Jane and Charles Hope, eds. *The Genius of Venice, 1500–1600.* Exhibition catalogue. London: Royal Academy of Arts, 1983.

Masetti, Zannini, G. L. *Stampatori e Librai a Roma nella Seconda Metà del Cinquecento: Documenti inediti.* Rome, 1980.

Massari, Stefania. *Giulio Bonasone.* 2 vols. Exhibition catalogue. Rome: Istituto Nazionale per la Grafica, 1983.

Massari, Stefania. *Tra mito e allegoria: Immagini a stampa nel '500 e '600.* Rome, 1989.

Massing, Jean Michel. *Du texte à l'image: La calomnie d'Apelle et son iconographie.* Strasbourg, 1990.

Massing, Jean Michel. "Jacobus Argentoratensis: Etude préliminaire." *Arte Veneta* 31 (1977): 42–52.

Massing, Jean Michel. "Schongauer's 'Tribulations of St. Anthony': Its Iconography and Influence on German Art." *Print Quarterly* 1 (1984): 221–36.

Massing, Jean Michel. "'The Triumph of Caesar' by Benedetto Bordon and Jacobus Argentoratensis: Its Iconography and Influence." *Print Quarterly* 7 (1990): 2–21.

Master Prints and Drawings: 16th to 19th Centuries. Artemis catalogue. London, 1984.

Matthäus, Klaus. "Zur Geschichte des Nürnberger Kalenderwesens: Die Entwicklung der in Nürnberg gedruckten Jahreskalender in Buchform." *Archiv für Geschichte des Buchwesens* 9 (1968), cols. 965–1396.

Mauroner, Fabio. *Le incisioni di Tiziano.* Venice, 1941.

Mayor, Alpheus Hyatt. *Prints and People: A Social History of the Printed Picture.* New York, 1971.

Meder, Joseph. *Dürer-Katalog.* Vienna, 1932. Reprinted New York, 1971.

Meder, Joseph. *Die Handzeichnung: Ihre Technik und Entwicklung.* Vienna, 1919. 2nd ed. Vienna, 1923.

Meder, Joseph. *The Mastery of Drawing.* Translated by Winslow Ames. 2 vols. New York, 1978.

Meier, Henry. "The Origin of the Printing and Roller Press." *Print Collector's Quarterly* 28 (1941), part 1, pp. 9–55.

Meier, Henry. "Some Israhel van Meckenem Problems." *Print Collector's Quarterly* 27 (1940): 41–46.

Meier, Henry. *Woodcut Stencils of 400 Years Ago.* New York, 1938.

Meinhard, Andreas. *The Dialogues of Andreas Meinhardi: A Utopian Description of Wittenberg and its University, 1508.* Edited and translated by Edgar C. Reinke. Ann Arbor, Mich., 1976.

Melot, Michel. "Note sur une gravure encadrée du XVIe siècle." *Nouvelles de l'Estampe* 9 (May/June 1973): 9–11, 13.

Mende, Mathias. *Das Alte Nürnberger Rathaus.* Nuremberg, 1979.

Mende, Matthias. *Hans Baldung Grien: Das graphische Werk.* Unterschneidheim, 1978.

Meyer, Maurits de. *Populäre Druckgraphik Europas: Niederlande, vom 15. bis zum 20. Jahrhundert.* Munich, 1970.

Meyer, Maurits de. *De Volks- en Kinderprent in de Nederlanden van de 15e tot de 20e eeuw.* Antwerp and Amsterdam, 1962.

Mezzetti, Amalia. *Girolamo da Ferrara detto da Carpi: L'opera pittorica.* Milan, 1977.

Middeldorf, Ulrich. "Two Sienese Prints." *Burlington Magazine* 116 (1974): 106–10.

Mielke, Hans. *Albrecht Altdorfer: Zeichnungen, Deckfarbenmalerei, Druck-*

graphik. Exhibition catalogue. Berlin: Kupferstichkabinett; and Regensburg: Museen der Stadt, 1988.

Mielke, Hans. "Antwerpener Graphik in der 2. Hälfte des 16. Jahrhunderts." *Zeitschrift für Kunstgeschichte* 38 (1975): 29–83.

Milde, Wolfgang. "Über Bücherverzeichnisse der Humanistenzeit." In *Bücherkataloge als buchgeschichtliche Quellen in der frühen Neuzeit*, edited by Reinhard Wittmann, pp. 19–31. Wolfenbütteler Schriften zur Geschichte des Buchwesens, no. 10. Wiesbaden, 1984.

Mitsch, E. *Raphael in der Albertina: Aus Anlaß des 500. Geburtstages des Künstlers*. Exhibition catalogue. Vienna, 1983.

Moes, Ernst Wilhelm and C. P. Burger, Jr. *De Amsterdamsche Boekdrukkers en Uitgevers in de zestiende eeuw*. 4 vols. Amsterdam and The Hague, 1900–15.

Mori, Gustav. *Das Schriftgiesser-gewerbe in Süddeutschland und den angrenzenden Ländern*. Stuttgart, 1924.

Morin, Louis. "Essai sur les dominotiers troyens." *Bulletin du Bibliophile* (Paris, 1897): 554–59, 619–25.

Morrison, Stanley. *Fra Luca de Pacioli*. New York, 1933.

Morton, A. G. *History of Botanical Science*. London and New York, 1981.

Mošin, Vladimir. *Anchor Watermarks*. Monumenta Chartae Papyraceae Historiam Illustrantia, vol. XIII. Edited by J. S. G. Simmons. Amsterdam, 1973.

Mošin, Vladimir. "Die Filigranologie als historische Hilfswissenschaft." *Papiergeschichte* 23 (1974): 29–48.

Moxey, Keith. "The Beham Brothers and the Death of the Artist." *Record of the Spencer Museum of Art* 6 (1989): 25–29.

Moxey, Keith. *Peasants, Warriors and Wives: Popular Imagery in the Reformation*. Chicago and London, 1989.

Mulazzani, G. "Il tema iconografico dell'incisione Prevedari." *Rassegna* 6 (1978): 67–71.

Müller, Arnd. "Zensurpolitik der Reichsstadt Nürnberg." *Mitteilungen des Vereins für Geschichte der Stadt Nürnberg* 49 (1959): 66–169.

Müller, Christian. *Sammeln in der Renaissance. Das Amerbach-Kabinett. Zeichnungen Alter Meister*. Exhibition catalogue. Basel: Kunstmuseum, 21 April–21 July 1991.

Mummenhoff, Ernst. "Freie Kunst und Handwerk in Nürnberg." *Korrespondenzblatt des Gesamtvereins der deutschen Geschichts- und Altertumsvereine* 54 (1906), cols. 105–19.

Mummenhoff, Ernst. "Handwerk und Freie Kunst in Nürnberg." *Bayerische Gewerbe-Zeitung* 3 (Nuremberg, 1890): 266–67.

Muraro, M. and David Rosand. *Tiziano e la silografia veneziana del cinquecento*. Exhibition catalogue. Vicenza, 1976.

Murr, Christoph Gottlieb von. "Formschneiderkunst." *Journal zur Kunstgeschichte und zur allgemeinen Litteratur* 2 (Nuremberg, 1776): 75–179.

Musper, H. Theodor, ed. *Der Einblatt Holzschnitt und die Blockbücher des XV. Jahrhunderts*. Stuttgart, 1976.

Musper, H. Theodor. "Die Holzschnitte des Nicolaus Hogenberg aus München." *Jahrbuch des preussischen Kunstsammlungen* 63 (1942): 171–79.

Musper, H. Theodor, commentator. *Kaiser Maximilians Theuerdanck*. Facsimile ed. Plochingen and Stuttgart, 1968.

Nagler, G. K. *Die Monogrammisten*. 5 vols. Munich and Leipzig, 1897.

Neudörfer, Johann. *Nachrichten von Künstlern und Werkleuten daselbst aus dem Jahre 1547*. Edited by G. W. K. Lochner. Vienna, 1875.

Nicolas Beatrizet: Un graveur lorrain à Rome. Exhibition catalogue. Luneville, 1970.

Nijhoff, Wouter, ed. *Nederlandsche Houtsneden, 1500–1550*. 2 vols., catalogue and portfolio. The Hague, 1930–39.

Niklaus Manuel Deutsch: Maler, Dichter, Staatsmann. Exhibition catalogue. Bern: Kunstmuseum, 22 September–2 December 1979.

Noakes, Susan. "The Development of the Book Market in Late Quattrocento Italy: Printers' Failures and the Role of the Middleman." *Journal of Medieval and Renaissance Studies* 11 (1981): 23–55.

Nübling, Eugen. *Ulms Handel und Gewerbe im Mittelalter*. 2 vols. Ulm, 1899–1900.

Oberhuber, Konrad. *Renaissance in Italien*. Vienna, 1966.

Oberhuber, Konrad. *Zwischen Renaissance und Barock: Das Zeitalter von Bruegel und Bellange*. Die Kunst der Graphik, vol. 4. Exhibition catalogue. Vienna: Albertina, 9 November 1967–18 February 1968.

Oberhuber, Konrad. *Disegni di Tiziano e della sua cerchia*. Exhibition catalogue. Venice: Fondazione Cini, 1976.

Oberhuber, Konrad. *Raffaello*. Milan, 1982.

Odofrancus, Christophoros [Ostrofrankus / Chr. Hofmann]. *De Ratisbona metropoli Boioariae et subita ibidem proscriptione*. Augsburg, 1519.

Olszewski, Edward J. *The Draftsman's Eye: Late Italian Renaissance Schools and Styles*. Exhibition catalogue. Bloomington, Indiana, 1981.

Ortelius, Abraham. *Album Amicorum* [ca. 1573]. Facsimile by Jean Puraye. Amsterdam, 1969.

Ozzola, Leandro. "Gli editori di stampe a Roma nei secoli XVI e XVII." *Repertorium für Kunstwissenschaft* 33 (1910): 400–11.

Pacioli, Luca. *De Divina Proportione*. Venice: Pagano de Paganinis, June 1509.

Pagden, Sylvia Ferino. "Invenzioni Raffaellesche adombrate nel libretto di Venezia: La 'Strage degli Innocenti' e la 'Lapidazione di Santo Stefano' a Genova." In *Studi su Raffaello*, edited by M. S. Hamoud and M. L. Strocchi. 2 vols. Urbino, 1987.

Pagden, Sylvia Ferino. *Raffaello a Firenze: Dipinti e disegni delle collezioni fiorentine*. Exhibition catalogue. Milan, 1984.

Paisey, David L. "Blind Printing in Early Continental Books." In *Book Production and Letters in the Western European Renaissance: Essays in Honor of Conor Fahy*, edited by A. L. Lepschy, et al., pp. 220–33. London, 1986.

Pallucchini, Rodolfo, et al. *Da Tiziano a El Greco: Per la storia del Manierismo a Venezia*. Exhibition catalogue. Venice: Palazzo Ducale. Milan, 1981.

Panofsky, Erwin. *Albrecht Dürer*. 2 vols. Princeton, 1948.

Panofsky, Erwin. "Artist, Scientist, Genius: Notes on the Renaissance-Dämmerung." In *The Renaissance: Six Essays*, pp. 123–82. Rev. ed. New York, 1962.

Panofsky, Erwin. "Conrad Celtes and Kunz von der Rosen: Two Problems in Portrait Identification." *Art Bulletin* 24 (1942): 39–54.

Parent, Annie. *Les métiers du livre à Paris au 16e siècle*. Geneva, 1974.

Parenti, Giuseppe. "Prezzi e salari a Firenze dal 1520 al 1620." In *I prezzi in Europa dal XIII secolo a oggi*, edited by Ruggiero Romano, pp. 203–58. Turin, 1967.

Paris Bordon e il suo tempo: Atti del convegno internazionale di studi, 28–30 October 1985. Treviso, 1987.

Parker, Karl Th. "Zu den Vorbildern Urs Grafs." *Anzeiger für Schweizerische Altertumskunde*, n.s. 24 (1922): 227–35.

Parshall, Linda B. and Peter W. Parshall. *Art and the Reformation*. Boston, 1986.

Parshall, Peter W. "Camerarius on Dürer: Renaissance Biography as Art Criticism." In *Joachim Camerarius (1500–1574)*, edited by Frank Baron, pp. 11–29. Munich, 1978.

Parshall, Peter W. "*Imago contrafacta*: Images and Facts in the Northern Renaissance". *Art History* 16 (1993): 57–82.

Parshall, Peter W. "Kunst en reformatie in de Noordelijke Nederlanden—enkele gezichtspunten." *Bulletin van het Rijksmuseum* 35 (1987): 164–75.

Parshall, Peter W. "Lucas van Leyden's Narrative Style." *Nederlands Kunsthistorisch Jaarboek* 29 (1978): 185–238.

Parshall, Peter W. "The Print Collection of Ferdinand, Archduke of Tyrol." *JKSW* 78 (1982): 139–84.

Parshall, Peter W. "Reading the Renaissance Woodcut: The Odd Case of the Master N.H. and Hans Lützelburger." *Register of the Spencer Museum of Art* 6 (1989): 30–43.

Passavant, J. D. *Le Peintre-graveur*. 6 vols. Leipzig, 1860–64.

Pauli, Gustav. *Hans Sebald Beham: Ein kritisches Verzeichniss seiner Kupferstiche, Radierungen und Holzschnitte*. Strasbourg, 1901.

BIBLIOGRAPHY

Pauli, Gustav. *Inkunabeln der deutschen und niederländischen Radierung.* Berlin, 1908.

Penrose, Boies. *Travel and Discovery in the Renaissance, 1420–1620.* Cambridge, Mass., 1952.

Pertile, Fidenzio and Carlo Cordiè. *Lettere sull'arte di Pietro Aretino.* 3 vols. Milan, 1957–60.

Petrucci, A. *Panorama dell'incisione italiana—Il cinquecento.* Rome, 1964.

Petz, Hans, ed. "Urkunden und Regesten aus dem königlichen Kreisarchiv zu Nürnberg." *JKSW* 10 (1889): xx–lxii.

Pfeiffer, Gerhard, ed. *Quellen zur Nürnberger Reformationsgeschichte.* Nuremberg, 1968.

Phillips, John Goldsmith. *Early Florentine Designers and Engravers.* Cambridge, Mass., 1955.

Piccard, Gerhard. "Carta bombycina, carta papyri, pergamena graeca." *Archivalische Zeitschrift* 61 (1965): 46–75.

Piccard, Gerhard. *Die Kronen-Wasserzeichen: Findbuch I.* Stuttgart, 1961.

Piccard, Gerhard. *Die Ochsenkopf-Wasserzeichen: Findbuch II.* 3 vols. Stuttgart, 1966.

Piccard, Gerhard. *Die Turm-Wasserzeichen: Findbuch III.* Stuttgart, 1970.

Piccard, Gerhard. "Papiererzeugung und Buchdruck in Basel bis zum Beginn des 16. Jahrhunderts." *Archiv für Geschichte des Buchwesens* 8 (1967), cols. 26–322.

Piccard, Gerhard. "Die Wasserzeichenforschung als historische Hilfswissenschaft." *Archivalische Zeitschrift* 52 (1956): 62–115.

Piccard, Gerhard. "Zur Geschichte der Papiererzeugung in der Reichstadt Memmingen." *Archiv für Geschichte des Buchwesens* 3 (1961), cols. 595–611.

Pignatti, Terisio. "La pianta di Venezia di Jacopo de' Barbari." *Bollettino dei Musei Civici Veneziani* 9, 1–2 (1964): 9–49.

Pignatti, Terisio. "The Relationship between German and Venetian Painting in the Late Quattrocento and Early Cinquecento." In *Renaissance Venice,* edited by John Hale, pp. 244–73. London, 1973.

Pilz, Kurt. "Willibald Pirkheimers Kunstsammlung und Bibliothek." In *Willibald Pirkheimer, 1470/1970,* edited by Karl B. Glock and I. Meidinger-Geise, pp. 93–110. Nuremberg, 1970.

Pinchart, Alexandre Joseph. *Archives des arts, sciences et lettres: Documents inédits.* 3 vols. Ghent, 1860–81.

Pinicianus [Kening], Johannes. *Joanis Piniciani Promptuarium vocabulorum aedium partium, locorum, artificum, instrumentorum, multarum quoque rerum nomina continens, etc.* Augsburg: Silvan Otmar, 1516.

Pinto, John A. "Origins and Development of the Ichnographic City Plan." *Journal of the Society of Architectural Historians* 35 (1976): 35–50.

Pochat, Götz. *Der Exotismus während des Mittelalters und der Renaissance.* Stockholm, 1970.

Pollard, Graham. "The Company of Stationers before 1557." *The Library.* ser. 4. *Transactions of the Bibliographical Society of London,* ser. 2 (1937): 1–38.

Popham, A. E. "The Baiardo Inventory." In *Studies in Renaissance and Baroque Art Presented to Anthony Blunt on his 60th Birthday,* edited by Jeanne Courtauld, et al., pp. 26–29. London, 1967.

Popham, A. E. *Catalogue of the Drawings of Parmigianino.* 3 vols. New Haven and London, 1971.

Popham, A. E. "The Engravings and Woodcuts of Dirick Vellert." *Print Collector's Quarterly* 12, pt. 2 (no. 4, 1925): 343–68.

Popham, A. E. "The Engravings of Frans Crabbe van Espleghem." *Print Collector's Quarterly* 22 (1935): 92–115, 194–211.

Popham, A. E. "Observations on Parmigianino's Designs for Chiaroscuro Woodcuts." In *Miscellanea I. Q. van Regteren Altena,* pp. 48–51. Amsterdam, 1969.

Popham, A. E. and Philip Pouncey. *Italian Drawings in the Department of Prints and Drawings of the British Museum: The Fourteenth and Fifteenth Centuries.* 2 vols. London, 1950.

Post, Paul. "Ein Frührenaissanceharnisch von Konrad Seusenhofer mit Ätzungen von Daniel Hopfer im Berliner Zeughaus." *Jahrbuch der preussischen Kunstsammlungen* 49 (1928): 167–86.

Post, Paul and Alexander von Reitzenstein. "Eisentäzung." In *Reallexikon zur deutschen Kunstgeschichte,* vol. IV, cols. 1075–1103. Stuttgart, 1958.

Postan, M. M. and H. J. Habakkuk, eds. *The Cambridge Economic History of Europe.* 8 vols. Cambridge, 1966–89.

Praga, Giuseppe. "Oreficeria e incisione in Dalmazia a mezzo il Quattrocento." *Archivio storico per la Dalmazia* 16 (January 1934): 477–83.

Preger, Max. "Ravensburger Wasserzeichen." *Schwäbische Heimat* 33 (1982): 25–33.

Printmaking in the Age of Rembrandt. Exhibition catalogue. Boston: Museum of Fine Arts; and St. Louis: Art Museum, 28 October 1980–12 April 1981. Boston, 1981.

Ptolemaeus, Claudius. *Claudii Ptolemaei geographicae enarrationis libri octo Bilibaldo Pirckheymero interprete.* Strasbourg: Joh. Grüninger, 1525.

Puppi, Lionello. *Marcello Fogolino, Pittore e Incisore.* Trent, 1966.

Putnam, George H. *Books and their Makers during the Middle Ages.* 2 vols. New York and London, 1896–97.

Quadt von Kinkelbach, Matthias. *Teutscher Nation Herligkeitt: Ein außfuhrliche bechreibung des gegenwertigen/alten/und uhralten Standts Germaniae.* Cologne: Wilhelm Lützenkirchen, 1609.

Quiccheberg, Samuele. *Inscriptiones vel tituli Theatri amplissimi.* Munich: Adam Berg, 1565.

Raby, Julian. "European Engravings." *Islamic Art* 1 (1981): 44–49.

Raffaello e i Suoi. Exhibition catalogue. Rome: Villa Medici, 1992.

Raphael dans les collections françaises. Exhibition catalogue. Paris: Grand Palais, 1983–84.

Raupp, Hans-Joachim. "Die Illustrationen zu Francesco Petrarca, 'Von der Artzney bayder Glueck des guten und widerwertigen' (Augsburg 1532)." *Wallraf-Richartz-Jahrbuch,* 45 (1984): 59–112.

Rava, A. "Il 'Camerino delle antigaglie' di Gabriele Vendramin." *Nuovo Archivio Veneto* 39 (1920): 155–81.

Rearick, W. R. "Battista Franco and the Grimani Chapel." *Saggi e memorie di storia dell'arte* 2 (1958/59): 107–32.

Reed, Sue Welsh. *Rembrandt: Experimental Etcher.* Exhibition catalogue, pp. 178–80. Boston: Museum of Fine Arts, 1969.

Reed, Sue Welsh and Richard Wallace, et al. *Italian Etchers of the Renaissance and Baroque.* Exhibition catalogue. Boston: Museum of Fine Arts, 1989.

Reeds, Karen Meier. "Renaissance Humanism and Botany." *Annals of Science* 33 (1976): 519–42.

Reichel, Anton. *Die Clair-Obscur-Schnitte des XVI., XVII., und XVIII. Jahrhunderts.* Zurich, Leipzig, and Vienna, 1926.

Reinhardt, Hans. "Einige Bemerkungen zum graphischen Werk Hans Holbeins des Jüngeren." *Zeitschrift für Schweizerische Archäologie und Kunstgeschichte* 34 (1977): 229–60.

Reti, Ladislao. "Leonardo da Vinci and the Graphic Arts: The Early Invention of Relief-Etching." *Burlington Magazine* 113 (1971): 189–95.

Reuter, Wolfgang. "Zur Wirtschafts- und Sozialgeschichte des Buchdruckgewerbes im Rheinland bis 1800." *Archiv für Geschichte des Buchwesens* 1 (1958): 642–736.

Richards, Louise. "Antonio Pollaiuolo: Battle of the Naked Men." *Bulletin of the Cleveland Museum of Art* 55 (1968): 63–70.

Richardson, Francis. *Andrea Schiavone.* Oxford, 1980.

Riggs, Timothy A. *Hieronymus Cock: Printmaker and Publisher in Antwerp.* New York and London: Garland Dissertations in the Fine Arts, 1977.

Robert-Dumesnil, A. P. F. *Le peintre-graveur français.* 11 vols. Paris, 1835–71.

Robison, Andrew. *Paper in Prints.* Exhibition catalogue. Washington, D.C.: National Gallery of Art, 1977.

Rombouts, Philip and Th. van Lieris. *De Liggeren en andere historische archieven der Antwerpsche Sint Lucasgilde.* 2 vols. Antwerp,

[1864–76].

Rooses, Max, ed. *Correspondence Christophe Plantin.* 2nd ed. Antwerp, 1896.

Roover, Raymond de. *The Rise and Decline of the Medici Bank: 1397–1494.* Cambridge, Mass., 1963.

Rosand, David. "Raphael, Marcantonio and the Icon of Pathos." *Source: Notes in the History of Art* 3 (1984): 34–52.

Rosand, David and Michelangelo Muraro. *Titian and the Venetian Woodcut.* Exhibition catalogue. Washington, D.C.: National Gallery of Art, 1976.

Rosenfeld, Hellmut. "Kalender, Einblattkalender, Bauernkalender und Bauernpraktik." *Bayerisches Jahrbuch für Volkskunde* (1962): 7–24.

Rosenfeld, Hellmut. "Die Rolle des Bilderbogens in der deutschen Volkskultur." *Bayerisches Jahrbuch für Volkskunde* (1955): 79–85.

Rosenfeld, Hellmut. "Wann und wo wurde die Holzschnittkunst erfunden?" *Archiv für Geschichte des Buchwesens* 34 (1990): 327–42.

Rosenheim, Max. "The Album Amicorum." *Archaeologia or Miscellaneous Tracts Relating to Antiquity* 62 (1910): 251–308.

Rosenthal, Erwin. "Two Unrecorded Italian Single-Leaf Woodcuts and the Origin of Wood Engraving in Italy." *Italia medioevale e umanistica* 5 (1962): 353–70.

Rossi, Vittorio. "Bazzeccole bibliografiche: II. Un incendio a Venezia e il tipografo Bernardino Benalio." *Il Libro e la Stampa* 4 (1910): 51.

Rotili, Mario, ed. *Fortuna di Michelangelo nell'Incisione.* Exhibition catalogue. Benevento, 1964.

Rott, Hans. *Quellen und Forschungen zur südwestdeutschen und schweizerischen Kunstgeschichte im XV. und XVI. Jahrhundert.* 3 vols. in 6 parts. Stuttgart, 1933–38.

Rott, Jean. "Artisanat et mouvements sociaux à Strasbourg autour de 1525." In *Artisans et ouvriers d'Alsace*, pp. 137–70. Strasbourg, 1965.

Röttinger, Heinrich. *Peter Flöttners Holzschnitte.* Strasbourg, 1916.

Rowlands, John. *The Age of Dürer and Holbein: German Drawings, 1400–1550.* London, 1988.

Rücker, Elisabeth. *Hartmann Schedels Weltchronik.* Munich, 1988.

Rupprich, Hans, ed. *Dürer: Schriftlicher Nachlass.* 3 vols. Berlin, 1956–69.

Rytz, Walther. *Pflanzenaquarelle des Hans Weiditz aus dem Jahre 1529.* Bern, 1936.

Saffrey, H. D. "L'arrivée en France de saint François de Paule et l'imagerie populaire à Toulouse au XVe siècle." *Nouvelles de l'estampe*, no. 86 (May 1986): 6–23.

Sandrart, Joachim von. *Joachim von Sandrarts Academie der Bau-, Bild-, und Mahlerey-Künste von 1675.* A. R. Peltzer, editor and commentator. Munich, 1925.

Sanminiatelli, Donato. *Domenico Beccafumi.* Milan, 1967.

Sarton, George. *Six Wings: Men of Science in the Renaissance.* Bloomington, Ind., 1957.

Sartori, A. "Documenti padovani sull'arte della stampa nel secolo XV." In A. Barzon. *Libri e stampatori in Padova: Miscellanea di studi storici in onore di Mons. G. Bellini*, pp. 111–231. Padua, 1959.

Savage, S. "A Little-known Bohemian Herbal." *The Library*, ser. 4. *Transactions of the Bibliographical Society of London*, ser. 2, vol. 2 (1921): 117–31.

Schade, Werner. *Cranach: A Family of Master Painters.* Translated by Helen Sebba. New York, 1980.

Schéle, Sune. *Cornelis Bos: A Study of the Origins of the Netherland Grotesque.* Stockholm, 1965.

Schéle, Sune. "Pieter Coecke and Cornelis Bos." *Oud Holland* 77 (1962): 235–40.

Schestag, Franz. "Kaiser Maximilian I: Triumph." *JKSW* 1 (1883): 154–81.

Schizzerotto, Giancarlo. *Le incisioni quattrocentesche della Classense.* Ravenna, 1971.

Schlosser Magnino, Julius [von]. *La letteratura artistica.* Translated by

Filippo Rossi. Revised by Otto Kurz. 3rd ed. Florence and Vienna, 1964.

Schmidt, Charles-Guillaume-Adolphe. *Zur Geschichte der ältesten Bibliotheken und der ersten Buchdrucker zu Strassburg.* Strasbourg, 1882.

Schmitt, Annegrit. *Hanns Lautensack.* Nuremberg, 1957.

Schnabel, Hildegard. "Zur historischen Beurteilung der Flugschriftenhändler in der Zeit der frühen Reformation und des Bauernkrieges." *Wissenschaftliche Zeitschrift der Humboldt-Universität zu Berlin.* Gesellschafts- und Sprachwissenschaftliche Reihe, no. 14, pp. 869–81. Berlin, 1965.

Schottenloher, Karl. "Der Buchdrucker Paul Kohl (1522–1531)." *Zentralblatt für Bibliothekswesen* 29 (1912): 406–25.

Schottenloher, Karl. *Flugblatt und Zeitung.* Berlin, 1922.

Schreiber, Wilhelm Ludwig. *Handbuch der Holz- und Metalschnitte des XV. Jahrhunderts.* 8 vols. 1st ed. Berlin, etc., 1891–1911. 3rd ed. Stuttgart, 1969.

Schreiber, Wilhelm Ludwig. *Die Meister der Metallschneidekunst.* Strasbourg, 1926.

Schubert, Franz. "Mair von Landshut: Ein niederbayerischer Stecher und Maler des ausgehenden XV. Jahrhunderts." In *Verhandlungen des historischen Vereins für Niederbayern*, vol. LXIII, pp. 1–150. Landshut, 1930.

Schulte, Aloys. *Geschichte der grossen Ravensburger Handelsgesellschaft, 1380–1530.* 3 vols. Stuttgart and Berlin, 1923.

Schultheiss, Werner. "Baukosten Nürnberger Gebäude in Reichsstädtischer Zeit," *Mitteilungen des Vereins für Geschichte der Stadt Nürnberg* 55 (1967/68): 270–99.

Schultheiss, Werner. "Ein Vertrag Albrecht Dürers über den Vertrieb seiner graphischen Kunstwerke." *Scripta Mercaturae* 1/2 (1969): 77–81.

Schulz, Juergen. "Jacopo de' Barbari's *View of Venice*: Map Making, City Views, and Moralized Geography Before the Year 1500." *Art Bulletin* 60 (1978): 425–74.

Schulz, Juergen. "Maps as Metaphors: Mural Map Cycles of the Italian Renaissance." In *Art and Cartography*, edited by David Woodward, pp. 97–122. London, 1987.

Schwemmer, Wilhelm. "Aus der Geschichte der Kunstsammlungen der Stadt Nürnberg." *Mitteilungen des Vereins für Geschichte der Stadt Nürnberg* 40 (1949): 97–206.

Scribner, Robert. *For the Sake of Simple Folk: Popular Propaganda for the German Reformation.* Cambridge, 1981.

Servolini, Luigi. *Jacopo de' Barbari.* Padua, 1944.

Servolini, Luigi. "Ugo da Carpi." *Rivista d'Arte* 11 (1929): 173–94.

Shaw, J. Byam. *Drawings by Old Masters at Christ Church, Oxford.* 2 vols. Oxford, 1976.

Shearman, John. *Andrea del Sarto.* 2 vols. Oxford, 1965.

Shestack, Alan. *Fifteenth-Century Engravings of Northern Europe from the National Gallery of Art.* Exhibition catalogue. Washington, D.C.: National Gallery of Art, 3 December 1967–7 January 1968.

Shestack, Alan. *Master E.S.: Five Hundredth Anniversary Exhibition.* Exhibition catalogue. Philadelphia: Museum of Art, 1967.

Shestack, Alan. "Some Preliminary Drawings for Engravings by Heinrich Aldegrever." *Master Drawings* 8 (1970): 141–48.

Shoemaker, Innis H. and Elizabeth Broun. *The Engravings of Marcantonio Raimondi.* Exhibition catalogue. Lawrence, Kan., 1981.

A Short Guide to Books on Watermarks. Hilversum, 1955.

Silver, Larry. "Forest Primeval: Albrecht Altdorfer and the German Wilderness Landscape." *Simiolus* 13 (1983): 4–43.

Silver, Larry. "Shining Armor: Maximilian I as Holy Roman Emperor." *Art Institute of Chicago Museum Studies* 12 (1985): 8–29.

Les simulacres et historiees faces de la mort, autant elegamment pourtraictes, que artificiellement imaginées. Lyons, 1538.

Smith, Cyril Stanley. *A History of Metallography.* Chicago, 1960.

Smith, Cyril Stanley. *Sources for the History of the Science of Steel, 1532–1786.* Cambridge, Mass., and London, 1968.

Smith, Jeffrey Chipps. *Nuremberg: A Renaissance City, 1500–1618.* Austin, 1983.

Sosson, Jean-Pierre. "Une approche des structures économiques d'un métier d'art: La corporation des peintres et selliers de Bruges (XVe–XVIe)." *Revue des archéologues et historiens d'art de Louvain* 3 (1970): 91–100.

Spamer, Adolf. *Das kleine Andachtsbild vom XIV. bis zum XX. Jahrhundert.* Munich, 1930.

Sporhan-Krempel, Lore. "Handel und Händler mit Ravensburger Papier." *Papiergeschichte* 22 (June 1972): 29–36.

Sporhan-Krempel, Lore. "Kartenmaler und Briefmaler in Nürnberg." *Philobiblon* 10 (1966): 138–49.

Sprague, T. A. "The Herbal of Otto Brunfels." *Journal of the Linnean Society of London* 48 (1928): 79–124.

Sprague, T. A. "The Herbal of Valerius Cordus." *Journal of the Linnean Society of London* 52 (1939): 1–113.

Sprague, T. A. and E. Nelmes. "The Herbal of Leonhardt Fuchs." *Journal of the Linnean Society of London* 48 (1931): 545–642.

Springer, Anton. "Inventare der Imhoff'schen Kunstkammer zu Nürnberg." *Mittheilungen der Kaiserlich-Königlichen central-commission zur Erforschung und Erhaltung der Baudenkmale* 5 (Vienna, 1860): 352–57.

Stahl, G. "Die Wallfahrt zur Schönen Maria in Regensburg." *Beiträge zur Geschichte des Bistums Regensburg* 2 (1968): 35–282.

Stannard, Jerry. "The Herbal as a Medical Document." *Bulletin of the History of Medicine* 43 (1969): 212–20.

Stauber, Richard. *Die Schedelsche Bibliothek.* Edited by Otto Hartig. Freiburg im Breisgau, 1908.

Steinberg, Leo. "Leonardo's *Last Supper.*" *Art Quarterly* 36 (1973): 297–410.

Steinberg, Leo. *Michelangelo's Last Paintings: The "Conversion of St. Paul" and the "Crucifixion of St. Peter" in the Cappella Paolina, Vatican Palace.* London, 1975.

Steinberg, S. H. *500 Years of Printing.* 3rd ed. Harmondsworth, Middlesex, 1974.

Sterk, J. "Philips van Bourgondië, 1465–1524." Dissertation. Zutphen, 1980.

Stewart, Alison. "Sebald Beham's *Fountain of Youth-Bathhouse* Woodcut: Popular Entertainment and the Large Prints by the Little Masters." *Register of the Spencer Art Museum* 6 (1989): 64–88.

Stiassny, Robert. *Hans Baldung Griens Wappenzeichnungen in Coburg.* 2nd ed. Vienna, 1896.

Stijnman, Ad. "Lucas van Leyden and Etching." *Print Quarterly* 5 (1988): 256–57.

Stock, Julien. "A Drawing by Raphael of 'Lucretia.'" *Burlington Magazine* 126 (1984): 423–24.

Stockbauer, Jacob. *Nürnbergisches Handwerksrecht des XVI. Jahrhunderts.* Nuremberg, 1879.

Stogdon, N. G. *German and Netherlandish Woodcuts.* Sale catalogue VIII. Berlin: Salander-O'Reilly Galleries, Inc.; and London: Michael Simpson Ltd., December 1991–January 1992.

Straus, Raphael, ed. *Urkunden und Aktenstücke zur Geschichte der Juden in Regensburg, 1453–1738.* Munich, 1960.

Strauss, Gerald. *Nuremberg in the Sixteenth Century.* 2nd rev. ed. Bloomington, Ind., 1976.

Strauss, Gerald. "A Sixteenth-Century Encyclopedia: Sebastian Münster's *Cosmography* and Its Editions." In *From the Renaissance to the Counter-Reformation: Essays in Honour of Garrett Mattingly,* edited by Charles H. Carter, pp. 145–63. New York, 1965.

Strauss, Gerald. *Sixteenth-Century Germany: Its Topography and Topographers.* Madison, Wis., 1959.

Strauss, Walter L. *Chiaroscuro: Clair-Obscur Woodcuts by the German and Netherlandish Masters of the XVIth and XVIIth Centuries.* Greenwich, Conn., 1973.

Strauss, Walter L. "Die Wasserzeichen der Dürerzeichnungen." *Zeitschrift des Deutschen Vereins für Kunstwissenschaft* 25 (1971): 69–74.

Strieder, Peter. "Copies et interprétations du cuivre d'Albert Dürer 'Adam et Eve.'" *Revue de l'Art* 21 (1973): 44–47.

Stromer, Wolfgang von. "Die Guldenmund." In *Beiträge zur Wirtschafts- und Stadtgeschichte: Festschrift für Hektor Ammann,* pp. 353–61. Wiesbaden, 1965.

Suida, Wilhelm. "Tizian, die beiden Campagnola und Ugo da Carpi." *La Critica d'Arte* 6 (1936): 285–89.

Talbot, Charles and Alan Shestack. *Prints and Drawings of the Danube School.* Exhibition catalogue. New Haven: Yale University Art Gallery, 1969.

Tanner, Paul. *Sammeln in der Renaissance. Das Amerbach-Kabinett. Die Basler Goldschmiederisse.* Exhibition catalogue. Basel: Kunstmuseum, 1991.

Le temps revient: il tempo si rinuova: feste e spettacoli nella Firenze di Lorenzo il Magnifico. Exhibition catalogue. Florence, 1992.

Theophilus. *The Various Arts.* Translated by C. R. Dodwell. London, 1961.

Thibodeau, Kenneth F. "Science and the Reformation: The Case of Strasbourg." *Sixteenth-Century Journal* 7 (1976): 35–50.

Thieme, Ulrich and Felix Becker. *Allgemeines Lexikon der bildenden Künstler.* 37 vols. Leipzig, 1907–50.

Thomas, H. "Antonio [Martinez] de Salamanca, Printer of La Celestina, Rome, c.1525." *Library,* 5th ser., 8 (1953): 45–50.

Thöne, Friedrich. "Johann Fischart als Verteidiger deutscher Kunst." *Zeitschrift des deutschen Vereins für Kunstwissenschaft* 1 (1934): 125–33.

Thorndike, Lynn. *A History of Magic and Experimental Science.* 8 vols. New York, 1923–58.

Tietze-Conrat, Erika. "A Sheet of Raphael Drawings for the *Judgment of Paris.*" *Art Bulletin* 135 (1953): 300–02.

Tietze-Conrat, Erika. "Die Vorbilder von Daniel Hopfers Figuralem Werk." *JKSW,* n.s. 9 (1935): 97–110.

Timm, Werner. "Die Einklebungen der Lutherbibel mit den Grünewaldzeichnungen." In *Forschungen und Berichte: Staatliche Museen zu Berlin,* pp. 105–21. Berlin, 1957.

Tiziano e Venezia, Convegno Internazionale di Studi, Venezia 1976. Vicenza, 1980.

Tofani, Annamaria Petrioli. *Il disegno fiorentino del tempo di Lorenzo il Magnifico.* Exhibition catalogue. Florence: Uffizi, 1992.

de Tolnay, Charles. *Michelangelo.* 5 vols. Princeton, 1970.

Tooley, R. V. "Maps in Italian Atlases of the Sixteenth Century." *Imago Mundi* 3 (1939): 12–47.

Turelli, Elisabetta, ed. *Immagini e azione riformatrice: Le xilografie degli incunaboli savonaroliani nella biblioteca nazionale di Firenze.* Florence, 1985.

Unterkircher, Franz, "Der erste illustrierte italienische Druck und eine Wiener Handschrift des gleichen Werkes (Hain 15722, Cod. Vindob. 3805)." In *Hellinga: Festschrift, Feestbundel, Mélanges: Forty-three Studies in Bibliography presented to Prof. Dr. Wytze Hellinga,* pp. 498–516. Amsterdam, 1980.

Utz, Hans J. *Wallfahrten im Bistum Regensburg.* Munich, 1981.

Uzielli, Gustavo and Giovanni Celoria. *La vita e i tempi di Paolo dal Pozzo Toscanelli.* Rome, 1894.

van Buren, Anne H. and Sheila Edmunds. "Playing Cards and Manuscripts: Some Widely Disseminated Fifteenth-Century Model Sheets." *Art Bulletin* 56 (1974): 12–30.

Vasari, Giorgio. *Le vite de' più eccellenti pittori, scultori ed architettori.* 9 vols. Edited by G. Milanesi. Florence, 1878–85.

Veit, Ludwig. *Das Liebe Gelt.* Munich, 1969.

Verheyden, Prosper. "Aanteekeningen betreffende Mechelsche Drukkers en Boekhandelaars." *Bulletin du Cercle archéologique littéraire et artistique de Malines* 20 (1910): 191–236.

Verheyden, Prosper. "Anatomische uitgave van Cornelius Bos en Antoine des Goys, Antwerpen, 1542." *De Gulden Passer* 18 (1940): 143–67.

Verheyden, Prosper. "Te Pand gegeven Drukkersgerief." *Tijdschrift voor Boek- en Bibliotheekwezen* 8 (1910): 130–33.

Verlinden, Charles. *Dokumenten voor de geschiedenis van prijzen en lonen in Vlaanderen en Brabant (XVe-XVIIIe eeuw).* Rijksuniversiteit

te Gent, werken uitgegeven door de faculteit van de letteren en wijsbegeerte, no. 125 (Bruges, 1959), no. 136 (Bruges, 1965).

Verwey, Herman de la Fontaine. "Pieter Coecke van Aelst and the Publication of Serlio's Book on Architecture." *Quaerendo* 6 (1976): 166–94.

Verzeichniss der Kupferstich-Sammlung in der Kunsthalle zu Hamburg. Hamburg, 1878.

Voet, Leon. *The Golden Compasses.* 2 vols. Amsterdam, 1969–72.

Volbehr, Theodor. "Das 'Theatrum Quicchebergicum.' Ein Museumstraum der Renaissance." *Museumskunde* 5 (Berlin, 1909): 201–08.

Volkert, Wilhelm. "Die spätmittelalterliche Judengemeinde in Regensburg." In *Albrecht Altdorfer und seine Zeit*, edited by Dieter Henrich, pp. 123–49. Regensburg, 1981.

Volkmann, Ludwig. "Ars Memorativa." *JKSW*, n.s. 3 (1929): 111–200.

Vorstenportretten uit de eerste helft de 16de eeuw: Houtsneden als propaganda. Exhibition catalogue. Amsterdam: Rijksmuseum, 1972.

Voss, Hermann. "Kompositionen des Francesco Salviati in der italienischen Graphik des XVI. Jahrhunderts." *Mitteilungen der Gesellschaft für Vervielfältigende Kunst (Beiträge der "Graphischen Künste")* 34 (1912): 30–37, 60–70.

Waal, H. van de. "Graphische Arbeiten des Monogrammisten P.S." *Die Graphischen Künste*, n.s. 4 (1939): 47–61.

Wackernagel, Martin. *The World of the Florentine Renaissance Artist: Projects and Patrons, Workshop and Art Market.* Translated by Alison Luchs. Princeton, 1981.

Waetzoldt, Wilhelm. *Deutsche Kunsthistoriker.* 2 vols. Leipzig, 1921–24.

Warburg, Anni. *Israhel van Meckenem.* Bonn, 1930.

Weber, Bruno, ed. *Wunderzeichen und Winkeldrucker, 1543–1586.* Zurich, 1972.

Wee, Hermann van der. *The Growth of the Antwerp Market and the European Economy, Fourteenth–Sixteenth Centuries.* 3 vols. Louvain, 1963.

Wegner, Wolfgang. "Aus der Frühzeit der deutschen Ätzung und Radierung." *Philobiblon* 2 (Hamburg, 1958): 178–90.

Wegner, Wolfgang. "Beiträge zum graphischen Werk Daniel Hopfers." *Zeitschrift für Kunstgeschichte* 20 (1957): 239–59.

Wegner, Wolfgang. "Ein Schwert von Daniel Hopfer im Germanischen Nationalmuseum in Nürnberg." *Münchner Jahrbuch der bildenden Kunst*, 3rd ser., 5 (1954): 124–30.

Wegner, Wolfgang. "Eisenradierung." In *Reallexikon zur deutschen Kunstgeschichte*, vol. IV, cols. 1140–52. Stuttgart, 1958.

Wehmer, Carl. "Gutenbergs Typographie und die Teigdrucke des Monogrammisten d." In *Essays in Honor of Victor Scholderer*, edited by D. E. Rhodes, pp. 426–84. Mainz, 1970.

Wehmer, Carl. "Ne Italo ceder videamur: Augsburger Buchdrucker und Schreiber um 1500." In *Augusta, 955–1955*, edited by Hermann Rinn, pp. 145–72. Augsburg, 1955.

Weigel, Christoff. *Abbildung Der Gemein-Nützlichen Haupt-Stände . . . biß auf alle Künstler und Handwerker nach Jedes Ambts- und Beruffs-Verrichtungen.* Regensburg, 1698.

Weinberger, Martin. *Die Formschnitte des Katharinenklosters zu Nürnberg.* Munich, 1925.

Weiss, Roberto. *The Renaissance Discovery of Classical Antiquity.* Oxford, 1973.

Weixlgärtner, Arpad. "Ungedruckte Stiche: Materialien und Anregungen aus Grenzgebieten der Kupferstichkunde." *JKSW* 29 (1911): 259–385.

Die Welt des Hans Sachs: 400 Holzschnitte des 16. Jahrhunderts. Nuremberg, 1976.

Wickhoff, Franz. "Beiträge zur Geschichte der reproduzierenden Künste: Marcantons Eintritt in den Kreis Römischer Künstler." *JKSW* 20 (1899): 181 ff.

Wiener, Philip P. and Aaron Noland, eds. *Roots of Scientific Thought: A Cultural Perspective.* New York, 1957.

Wiesflecker, Hermann. *Kaiser Maximilian I.* 5 vols. Vienna, 1971–86.

Wilckens, Leonie von. "Der spätmittelalterliche Zeugdruck nördlich der Alpen." *Anzeiger des Germanischen Nationalmuseums* (1983): 7–18.

Wilde, Johannes. "Die Anfänge der italienischen Radierung." Dissertation. Philosophische Fakultät der k. k. Universität, Vienna, 1918. (Typescript, Courtauld Institute of Art.)

Williams, A. R. "The Metallographic Examination of a Burgkmair Etching Plate in the British Museum." *Journal of the Historical Metallurgy Society* 8 (1974): 92–94.

Williams, Hermann Warner, Jr. "The Beginnings of Etching." *Technical Studies* 3 (1934/5): 16–18.

Williams, Hermann Warner, Jr. "A Sixteenth-Century German Treatise, *Von Stahel und Eysen*, translated with explanatory notes." *Technical Studies* 4 (1935/6): 63–92.

Williams, Hermann Warner, Jr. "Zwei Ätzrezepte aus dem Secretum Philosophorum." *Zeitschrift für historische Waffen- und Kostümkunde*, n.s. 6 (1937–39): 61–62.

Wilson, Adrian. *The Making of the Nuremberg World Chronicle.* Amsterdam, 1976.

Wimpheling, Jacob. *Epithoma Germanorum iacobi wympfelingii.* Strasbourg: Johannes Prüss, 1505.

Winkler, Friedrich. "Die deutschen Werke Nicolaus Hogenbergs von München." *Zeitschrift des deutschen Vereins für Kunstwissenschaft* 18 (1964): 54–64.

Winkler, Gerhard B. "Die Regensburger Wallfahrt zur Schönen Maria (1519) als Reformatorisches Problem." In *Altdorfer und seine Zeit*, edited by Dieter Henrich, pp. 103–21. Regensburg, 1981.

Winzinger, Franz. *Albrecht Altdorfer: Die Graphik.* Munich, 1963.

Winzinger, Franz. "Albrecht Altdorfer und die Miniaturen des Triumphzuges Kaiser Maximilians I." *JKSW* 62, n.s. 26 (1966): 157–72.

Winzinger, Franz. "Albrecht Altdorfers Münchner Holzstock." *Münchener Jahrbuch der bildenden Kunst*, 3rd ser., 1 (1950): 191–203.

Wissowa, Georg. *Paulys Real-Encyclopädie der Classischen Altertumswissenschaft.* Stuttgart, 1905.

de Witt, Antony. *Marcantonio Raimondi.* Florence, 1968.

Wolff, Martha. "Some Manuscript Sources for the Playing Card Master's Number Cards." *Art Bulletin* 64 (1982): 587–600.

Wood, Christopher Stewart. "The Independent Landscapes of Albrecht Altdorfer." Ph.D. dissertation. Harvard University, 1991.

Wood, Jeremy. "Cannibalized Prints and Early Art History: Vasari, Bellori and Fréart de Chambray on Raphael." *Journal of the Warburg and Courtauld Institutes* 51 (1988): 210–20.

Woodward, David. "The Evidence of Offsets in Renaissance Italian Maps and Prints." *Print Quarterly* 8 (1991): 234–51.

Woodward, David. "The Manuscript, Engraved, and Typographic Traditions of Map Lettering." In *Art and Cartography: Six Historical Essays*, edited by David Woodward, pp. 174–212. Chicago and London, 1987.

Woodward, David. "The Woodcut Technique." In *Five Centuries of Map Printing*, edited by David Woodward, pp. 25–50. Chicago and London, 1975.

Würtenberger, Thomas. *Das Kunstlerfälschertum.* Weimar, 1940. Reprinted Leipzig, 1970.

Yates, Frances. *The Art of Memory.* London, 1966.

Zahn, Peter. "Neue Funde zur Entstehung der Schedelschen Weltchronik, 1493." *Renaissance Vorträge: Stadt Nürnberg Museen* 2/3 (1973): 1–46.

Zampetti, P. *Lorenzo Lotto: Il "Libro di Spese Diverse," con aggiunta di lettere e d'altri documenti.* Florence, 1969.

Zeising, Heinrich. *Theatrum Machinarum.* 6 parts. Leipzig: Henning Grossen d.J., 1613–22.

Zerdoun Bat-Yehouda, Monique. *Les encres noires au moyen âge (jusqu'à 1600).* Paris, 1983.

Zerner, C. Wilkinson, et al. *Philip II and the Escorial: Technology and the Representation of Architecture.* Exhibition catalogue. Providence, R.I.: Brown University, 1990.

Zerner, Henri. "A propos de faux Marcantoine: Notes sur les amateurs d'estampes à la Renaissance." *Bibliothèque d'Humanisme et Re-*

naissance 22 (1961): 477–81.

Zerner, Henri. *Ecole de Fontainebleau: Gravures*. Paris, 1969.

Zerner, Henri. "L'estampe érotique au temps de Titien." In *Tiziano e Venezia: Convegno Internazionale di Studi, Venezia, 1976*, edited by Neri Pozza, pp. 85–90. Vicenza, 1980.

Zerner, Henri. "Sur Giovan Jacopo Caraglio." In *Actes du XXIIe Congrès International d'Histoire de l'Art*, pp. 691–95. Budapest, 1972.

Ziegler, W. "Heinrich Kupferwurm, Formschneider." In *Jahrbücher für Kunstwissenschaft*, edited by A. von Zahn, p. 244. Leipzig, 1869.

Ziegler, Walter. "Regensburg am Ende des Mittelalters." In *Albrecht Altdorfer und seine Zeit*, edited by Dieter Henrich, pp. 61–82. Regensburg, 1981.

Ziesche, Eva and Dierk Schnitger. "Elektronenradiographische Untersuchungen der Wasserzeichen des Mainzer Catholicon von 1460." *Archiv für Geschichte des Buchwesens* 21 (1980), cols. 1303–60.

Zilsel, Edgar. "The Genesis of the Concept of Scientific Progress." In *Roots of Scientific Thought*, edited by Philip Wiener and Aaron Noland, pp. 251–75. New York, 1957.

Zimmerman, Heinrich and Franz Kreyczi, eds. "Urkunden und Regesten aus dem k. u. k. Reichs-Finanz-Archiv." *JKSW* 3, part 2 (1885): i–lxxxi.

Zonghi, Aurelio and Augusto, and A. F. Gasparinetti. *Zonghi's Watermarks*. Monumenta Chartae Papyraceae Historiam Illustrantia, vol. III. Edited by E. J. Labarre. Hilversum, 1953.

Zschelletzschky, Herbert. *Die 'drei gottlosen Maler' von Nürnberg*. Leipzig, 1975.

Zucker, Mark J. "'The Madonna of Loreto': A Newly Discovered Work by the Master of the Vienna Passion." *Print Quarterly* 6 (1989): 149–60.

Zülch, Walther Karl. *Frankfurter Künstler, 1223–1700*. Frankfurt, 1935. Reprinted 1967.

Zülch, Walther Karl and Gustav Mori, eds. *Frankfurter Urkundenbuch zur Frühgeschichte des Buchdrucks*. Frankfurt, 1920.

Zupko, Ronald Edward. *Italian Weights and Measures from the Middle Ages to the Nineteenth Century*. Memoires of the American Philosophical Society, no. 145. Philadelphia, 1981.

Index

Aachen, 351
academies, 8, 286
Accademia Romana, 100
Achillini, Giovanni Filoteo, 99
Adam (painter in Basel), 347
Agricola, Georg, 24
alba amicorum, 365
Alberti, Leon Battista, 65, 100, 102, 170, 234, 240
Albrecht of Brandenburg, 31, 342
Albrecht V of Bavaria, 366
albums, 13, 16, 52, 64, 81, 91–95, 206, 219, 243, 249, 260, 289–92, 316, 346, 356, 357–58, 365–67
alchemy, 24, 27, 272, 407 n.281
Aldegrever, Heinrich, 30, 319–21, 356; *figs. 343–46*
Altdorfer, Albrecht, 6, 22, 183, 202, 204–7, 209, 315, 329, 337–46, 355–56, 408 n.289, 408 n.296; *figs. 193, 211, 216–18, 332–33, 371–72, 375–77*
Altdorfer, Erhard, 345, 409 n.314, 410 n.319
amateur printmakers, 286
Amberger, Christoph, 212
Amerbach, Basilius, 356, 367
Amerbach, Hans, 16
Amerbach, Johannes, 11, 414 n.38
America. *See* New World
Amman, Jost, 22; *figs. 4, 5*
Amsterdam, 8–10, 14, 221, 226, 233, 240, 351, 365
Ancona, 295
Andrea, Zoan, 113
Andreae, Hieronymus, 9, 209, 217–18, 223–24, 235, 375 n.37
Anthonisz., Cornelis, 221, 240, 351, 366 n.145, 397 n.172; *figs. 230, 249*
Antwerp, 6, 8–10, 12, 14, 19–21, 31–32, 178, 209, 220–23, 229, 231, 235, 236, 237, 308, 316, 333, 335–36, 346–47, 349, 351–52, 354, 358, 365–67, 378 n.103, 384 n.108
Appian, 88
aquatint, 324
Ardinghelli, Niccolò, 94
Aretino, Pietro, 94, 146, 284–87, 293–94, 298, 301, 359, 361–62
Aretino, Spinello, *fig. 66*
Arezzo, 159
Argentoratensis, Jacobus. *See* Jacob of Strasbourg
Ariosto, Lodovico, 297
Aristotle, 100, 258
armor, 9, 207, 324–47 passim
Arnolt, Jacob, 347
Arundel, Earl of, 411 n.345, 411 n.372, 412 n.375
Ascoli Piceno, 405 n.215
Aspertini, Amico, 99, 100
astrology, 169
Attavante (di Gabriello di Vante Attavanti), 95
Augsburg, 10, 24, 27, 34, 57, 174, 177, 179–80, 184, 197–98, 200, 202, 207, 209, 211–12, 216–18, 220–21, 225–27, 229, 231, 233, 247, 249, 255–56, 285–86, 323–26, 339, 348–49, 354, 365–67, 381 n.13, 382 n.37, 397 n.157; Church of St. Catherine, 326–27; *fig. 353*; Diet of, 225
Aurelius, Marcus, 295

Baiardo, Francesco, 292
Baldini, Baccio, 67, 72–73, 76, 83, 89, 108, 162, 387 n.26; *figs. 52, 87–88, 95–96*
Baldovinetti, Alesso, 377 n.73
Baldung Grien, Hans, 19, 243, 301, 308, 353, 356, 380 n.144, 393 n.56

il Bambaia (Agostino Busti), 271
Bamberg, 33, 339
Bandinelli, Baccio, 13, 120, 122, 143–44, 146, 286–87, 292–93, 296–97, 363, 402 n.80
Barbari, Jacopo de', 16–17, 38, 43–45, 56, 64, 77, 80, 88–89, 95, 100, 145, 178, 207, 234, 289, 300–01, 311, 355–56; *figs. 18, 19, 61, 79*
Barberiis, Philippus de, 95
Bari, 144
Barili, Antonio, 300
Barlacchi, Tommaso, 304, 308, 390 n.201
Bartolommeo, Fra', 95
Basel, 9–11, 16–17, 24, 212, 214, 216, 253, 309, 330, 347, 358, 365–67, 394 n.95, 395 n.118
Baviero de' Carrocci (il Baviera), 121–23, 130, 133, 136, 138, 141, 144, 146, 150, 159, 162, 299, 302–03, 309, 360, 363
Bazzacco (draftsman), 285
Beatrizet, Nicholas, 167–68, 288–89, 292, 303–05, 308–09, 413 n.17; *figs. 178, 314–15, 322–23*
Beccafumi, Domenico, 6, 169, 272–73, 281, 284, 308, 344, 378 n.104, 407 n.281; *figs. 284–301*
Beck, Leonard, 208–09
Behaim, Martin, 240–41
Beham, Barthel, 217, 315–17, 319; *figs. 336–37*
Beham, Sebald, 217–18, 223, 232–235, 315–16, 319, 329, 331–33, 358, 373 n.5, 374 n.17, 397 n.162; *figs. 237–41, 357*
Beheim, Paul, 367, 412 n.375
Bellini (family), 35
Bellini, Gentile, 94
Bellini, Giovanni, 38, 100, 183, 386 n.180
Belon, Pierre, 400 n.239
Benalio, Bernardino, 150, 300, 301
Benavides, Marco, 292
Benintendi (family of waxworkers), 73
Benivieni, Antonio, 95
Bentivoglio, Giovanni II, 99
Berlinghieri, Francesco, 94
Bern, 224, 247, 252
Beroaldo, Filippo, 99, 302
Betti, Betto, 94
Binck, Jacob, 345
Birago, Giovanni Pietro da, 83, 163; *fig. 174*
Biringuccio, Vannoccio, 24, 378 n.107, 407 n.281
Bisticci, Vespasiano da, 95
blind printing, 29
Boccaccio, Giovanni, 35
Bocholt, 57
Bock, Hieronymus, 253
Boldrini, Niccolò, 412 n.7
Bologna, 16, 17, 90, 99, 119, 121, 154–55, 159, 166, 224, 241, 258, 266, 270, 288; University, 99
Boltz, Valentin, 26–27
Bombelli, Tomaso, 351
Bonasone, Giulio, 121, 130, 163, 166–67, 287–89, 303–04, 308; *fig. 177*
book illustration, 2–3, 5, 10, 22, 31, 33–46, 58, 62, 64, 169, 180, 244–58, 364
book printing and publishing, 2, 5, 10–12, 15, 17, 20, 23, 28, 30, 33–46, 95, 174, 216, 219–20, 222–23, 241, 284, 310, 349, 364–65
borders, 71, 81–82, 91, 95, 235, 249, 289
Bordon, Benedetto, 88–89, 147, 150, 300, 391 n.16; *fig. 81*
Bordon, Paris, 286
Borghini, Vincenzo, 294–95, 412 n.13

Borsteld, Bertold, 30
Bos, Cornelis, 13–14, 20, 23–24, 29–30, 220–23, 236, 335, 355, 359
Bosse, Abraham, 24, 30
botteghe. See workshops
Botticelli, Sandro, 35, 38, 95, 108, 120
Bouts, Dirk, 48, 53
Boyvin, René, 297, 309
Brabant, 352
Bramante, Donato, 23, 104, 106–07, 119–20, 147, 402 n.87
Brandini, Bartolomeo, 99
Brant, Sebastian, 399 n.211
Braunschweig Monogrammist, 235
Bregno, Andrea, 119
Brescia, Giovanni Antonio da, 69, 76, 78, 89–90, 102, 112–13, 117, 131, 163, 298, 300, 384 n.113, 398 n.183; *fig. 102*
Brescia, Giovanni Maria da, 78, 402 n.89; *fig. 59*
Breu, Jörg, 212, 233
Breydenbach, Bernard von, 34–35, 86, 245; *Peregrinationes in Terram Sanctam, fig. 9*
Briefmaler, 10, 169, 223–24, 240, 247
Britto, Giovanni, 287, 361; *fig. 305*
Broad Manner, 72–73, 295
broadsheets, 22, 29, 62, 214, 223–24, 226–27, 239, 257, 347–49, 359, 364
Bronzino (Angelo di Cosimo, called), 286
Brosamer, Hans, 223
Bruegel, Pieter the Elder, 222, 359
Bruges, 35, 316, 347
Brunfels, Otto, 247, 250, 252–58
Brussels, 12, 14
Bubenleben, Bernhard, 217
Buffalmacco, Buonamico Cristofani, 162
Büheler, Sebald, 356
Burgkmair, Hans, 169, 174, 177–80, 184, 187–91, 197–202, 207–10, 212, 221, 247, 249, 301, 315, 324, 329, 331–32, 393 n.51, 408 n.289; *figs. 187–88, 197–99, 208–210, 220–23, 359*
burin, 4, 8, 24, 26, 28, 31, 46–47, 49, 51, 68–73, 99, 102, 274, 285, 312, 314, 317, 320
Busti, Agostino. *See* il Bambaia

Caccianemici, Vincenzo, 270, 286
Calandra, Silvestro, 101
Calcar, Jan van, 212, 257
calendars, 90
Camillo, Giulio, 367
Campagnola Domenico, 9, 28, 271–72, 290–91, 378 n.104
Campagnola, Girolamo, 293
Campagnola, Giulio, 6, 9, 79, 100–03, 125, 150, 261–62, 264, 271–72, 290–93, 300, 363–65, 402 n.87; *figs. 266–69*
Capodiferro, Evangelista Maddaleni dei, 100, 102
Caraglio, Jacopo *or* Gian Giacomo, 121, 130, 146, 154, 159, 266–67, 284–87, 289, 293, 297, 299, 302, 320, 363, 397 n.157; *figs. 158, 161, 164, 168*
Carpaccio, Vittore, 35, 183
Carpan, Bartolomeo, 295
Carpi, Ugo da, 146, 150, 153–54, 179, 264, 266–67, 286, 289, 299, 300–01, 302, 398 n.183; *figs. 152–56, 159–60, 163, 307*
carta lucida, 110–20
cartography. *See* maps
cartolaio. See market (shops)

INDEX

Casa, Niccolò della, 166
Castiglione, Sabba, 293–94, 297
casting, 9, 14, 26–27, 340
catchpenny prints. *See* popular prints
Cavalieri, Tommaso, 402 n.85
celavit/caelavit, 288
Cellebrino, Eustachio, 389 n.144
Cellini, Benvenuto, 286, 362
Celtis, Konrad, 381 n.31
Cennini, Cennino, 21
censorship, 225, 285
Cesalpino, Andrea, 258
Cesena, Peregrino da, 99
Charles V, Emperor, 14, 155, 220, 285–86, 351, 353
Chartularius, Jacobus, 295
chiaroscuro drawings, 66, 180–84, 205, 315, 344
chiaroscuro prints, 21, 150, 179–202, 221, 270, 273–81, 289, 291, 300–01, 324, 340, 344
ciappola, 68, 73–74
Cima, Giovanni Battista, 38
Civitali, Matteo, 36
Clement VII, Pope, 144, 286
Cochläus, Johann, 338, 349–50, 355
Cock, Hieronymus, 6, 222–23, 308, 322, 336, 346–47, 361, 365–66
Cock, Jan de, 220
Codro (Cortesi Urceo, Antonio), 99
Coecke van Aelst, Pieter, 220, 222
collecting and collectors, 56, 64–65, 91–94, 99, 180, 184, 206, 243, 252, 284–98, 315–17, 342–58 passim, 361, 365–68; inventories, 101, 289–93. *See also* albums; curiosity cabinets
Colmar, 50, 56
Cologne, 10, 17, 239
colore, 165, 284, 294, 362
colored prints: by hand, 11, 13, 64, 94, 223, 232, 270, 284, 295, 340, 344, 349, 351, 357, 385 n.125; mechanically, 176, 179–202, 221, 250, 337, 340. *See also* chiaroscuro prints; stenciling
Company of Stationers, London, 11
Confraternita di San Rocco, 284
Contarini, Matteo, 240
contracts, 23, 30, 39–42, 200, 207–08, 340, 347
contrafactur/conterfeit, 43, 200, 237–40, 252–55, 259, 339, 366
Copernicus, 241
copying and copies, 4–5, 47, 54–56, 73, 104, 131–41, 150, 165, 226, 288, 322, 358, 366, 402 n.78. *See also* forgeries
Cordus, Valerius, 253, 258
Cornaro (family), 299
Cornelis, Pieter, 386 n.157
Cornelisz. van Oostanen, Jacob, 221, 233
Cort, Cornelis, 361–62
Cosma, Donna Margarita, 301
Costa, Lorenzo, 101, 289; *fig. 309*
countermarks, 18
counterproofs, 130
Crabbe, Frans, 319, 334–36; *figs. 365–67*
Cranach, Lucas the Elder, 19, 29, 169, 174–77, 179, 183–87, 190–92, 197–98, 200–01, 207, 234, 301, 308, 315, 325, 330, 342, 355, 364, 407 n.280; *figs. 185–86, 192, 195, 200–07, 334–35*
Croc, Hubert, 347
Cube, Johann von, 245
curiosity cabinets, 257, 289, 297
currencies, 352–53, Appendix

Danhauser, Peter, 40–42, 378 n.87
Dante Alighieri, 35
dates (on prints), 145, 166, 168, 401 n.15
David, Gerard, 48
dedications, 288, 294, 308
Dei, Benedetto, 94–95
Dei, Miliano, 94–95
della Robbia (family), 73
della Seta, Domenico, 8
della Seta, Francesco, 8
della Valle, Cardinal Andrea, 306
Dente, Marco, 13, 120–23, 128, 130–32, 136–39, 141, 144, 146, 154, 162, 284, 292–93, 295–96, 299, 303, 305–06, 360, 402 n.69, 402 n.80, 402 n.87; *figs. 140, 145–47, 149, 312, 321*

Deutsch, Niklaus Manuel, 24, 184, 356; *figs. 7, 194*
Dioscorides, 253–56, 258
disegno, 28, 103, 144, 154, 165, 284, 287, 294, 297, 299–302, 309, 322, 360, 362
display, 14, 38, 81–88, 95, 169–70, 178, 209, 231–37, 243, 284, 289–92, 351, 356–59
Doetechum, Jan and Lucas, 354
Donatello (Donato di Niccolò di Betto Bondi, called), 376 n.58
Doni, Anton Francesco, 287–88, 293, 402 n.69
Döring, Hans, 356
dotted prints, 91
drawings: preparatory, 39–41, 100, 104–31, 147–59, 165, 180, 198, 204–05, 249–50, 267, 273, 299, 313, 318, 321, 334, 356; watercolor, 249. *See also* chiaroscuro drawings; metalpoint; transfer techniques
drypoint, 4–5, 24, 28, 55, 62, 65, 69–71, 74, 264, 267, 271–72, 314, 317–18
Dürer Renaissance, 6, 358, 365, 391 n.7
Dürer, Agnes, 218, 397 n.159
Dürer, Albrecht, 5, 6, 15–16, 19–22, 28–29, 31, 39, 42–43, 46, 52–53, 56–57, 64, 69, 76–78, 81, 119, 123, 145–46, 169, 170, 174, 176–77, 179, 183, 187, 204, 207, 209, 213, 217–19, 223–24, 234–35, 242, 249, 252–53, 255, 259, 264, 289, 292–94, 308–20, 322–23, 327–29, 331–33, 338–39, 342–43, 347–49, 351–58, 360, 363–65, 375 n.37, 377 n.64, 396 n.144, 397 n.159, 398 n.183, 401 n.47, 402 n.69, 403 n.132, 407 n.270; *figs. 179–84, 191, 212–15, 235, 325–31, 341–42, 354–56*
Dürer, Andreas, 357
Dürer, Ursula, 357

Ebreo, Leone, 287
edition size, 31–32, 69, 72, 74, 264, 272, 297, 314, 317, 342
Egenolff, Christian, 253, 256
Egnazio, Battista, 289
Einsiedeln, Monastery of, 49, 50, 347, 379 n.118
enamel, 67
Engebrechtsz., Cornelis, 316
Erasmus of Rotterdam, 63, 214
erotica, 90, 91, 225–26, 232, 297–98, 316, 364
Este, Duke Borso da Ferrara, 98, 101
etching, 14, 24, 27, 30–32, 159, 222, 240, 264–70, 323–47, 361; biting, 269, 309, 324–26, 334, 342–43; copper, 264–70, 327–28, 332–47; grounds, 27, 324; iron, 27–28, 323–32, 337–47 passim; mixed technique, 265–67, 270, 328, 332, 335–36, 347; mordants, 27, 324–25, 328
Etzlaub, Erhard, 241, 244; *fig. 246*
Euclid, 284
Ewoutsz., Jan, 14, 222, 397 n.172, 398 n.191
excidit, 288
excudit, 300, 302–04
Eyck, Jan van, 53

Faber, Jacob, 216
Fabriano, 17
Faenzi, Valerio, 362
Fagiuoli, Girolamo, 159
Fedeli, Matteo de', 104, 106–07
Ferdinand, Archduke of Tyrol, 218, 255, 367, 373 n.20, 383 n.63
Ferrara, 71–72, 79–80, 91, 94, 100, 264, 289
Ficino, Marsilio, 64, 287
Filarete, Antonio Averlino, 98
Fine Manner, 4, 71–74, 94–95, 108, 162
Finiguerra, Maso, 67–68, 83, 94, 98–99, 108, 110, 112, 387 n.26; *fig. 98*
Fischer, Johann, 358
Fischer, Sebald, 352, 353
Florence, 9–10, 12, 19, 35, 38, 67–68, 71–74, 79, 82, 87, 89–90, 94–95, 98, 101, 108, 110, 112, 119–21, 144, 160, 162–63, 198, 258, 295–96, 308, 360, 365, 389 n.144, 404 n.206; Duomo, 162; SS. Annunziata, 163; S. Onofrio, 88
Floris, Frans, 236, 396 n.144, 401 n.50, 403 n.128
Flötner, Peter, 8, 9, 214, 223, 236; *fig. 227*
Fogolino, Marcello, 264, 305; *fig. 320*
Fondaco dei Tedeschi, 45

Fontainbleau, 31, 308–09
Fontanellato, Castle, 292
Fora, Gherardo del, 401 n.47
forgeries and piracy, 54–56, 136, 141, 146, 154, 191–92, 197–98, 212, 218, 220, 212, 253, 292, 299–301, 303, 322, 330–31, 348, 358, 362
Formschneider. See woodblock cutters
Foscarini, Antonio, 289
foul biting. *See* etching (biting)
frames. *See* display
Francia, Francesco, 99, 101, 117, 119
Franck, Hans. *See* Hans Lützelburger
Franco, Battista, 270
Frankfurt Fair, 19–20, 224–25, 242, 349, 369
Frankfurt, 10, 19–20, 224–25, 242, 245, 253, 349, 365
free arts (*freie Künste*), 9–10, 218
Fregoso, Cesare, 298
Frey, Felix, 348
Friederich, Pfaltzgraf, 12
Friedrich the Wise of Saxony, 100, 176–77, 184, 234, 315, 320, 322, 348
Fries, Lorenz, 243; *fig. 248*
Froben, Johannes, 214, 216
Froschauer, Heinrich, 22
Fuchs, Leonhart, 253–58
Fugger, Johann Jakob, 24, 349, 366
Füllmaurer, Heinrich, 399 n.229

Galen, 222, 257
Galle (family), 223
Gallensdorfer, Sebolt, 41
Geiler von Kaisersberg, Johann, 63, 350
Geldenauer, Gerardus, 408 n.283
Gentili, Francesco, 365
George, Duke of Saxony, 184
Gheeraerts, Marcus, 400 n.239
Ghent, 236
Ghini, Luca, 258
Ghirlandaio, Domenico, 35, 95
Ghisi, Giorgio, 167, 271, 288–89, 377 n.85; *figs. 282, 308*
Giorgione, 100, 119, 261–62, 264, 389 n.138
Giotto, 168
Giovanni, Berto di, *fig. 116*
Giunti (family), 19
Glockendon, Albrecht, 231–32
Glockendon, Georg, 12, 241
Goes, Mathias van der, 384 n.108
goldsmiths, 1, 7–9, 11, 24, 26, 30, 50, 68, 72–73, 90, 94, 98–99, 104, 107, 223, 310–13, 345
Goltzius, Hendrik, 6, 274, 336, 368
Gonzaga (family), 102, 112
Gonzaga, Marquis Francesco, 101
Gossaert, Jan, 220, 364, 408 n.283, 408 n.294
Graf, Urs, 9, 214, 329–31, 347, 355–56, 378 n.106; *fig. 358*
Granvelle, Antoine Perrenot de, 21, 285–86
Gregoriis, Gregorio de, 300
Grimani, Cardinal Domenico, 289, 292, 344
Groningen, 220
Groningen, Jan Swart van, 220; *fig. 231*
Grünewald, Matthias, 52
Grüninger, Johann, 242, 243, 252
guilds, 7–12, 14, 35, 68, 73, 95, 220–21, 284, 288, 396 n.144
Guldenmund, Hans, 223–28, 230–31, 236–37
Gutenberg, Johann, 2, 28, 245

Haarlem, 8
Halle, 52
hatching (parallel, cross- etc.), 38, 46–47, 51, 65, 67–76, 113, 264, 325, 335, 348
Heller, Jacob, 312–13
Henry II, King, 308
herbals, 64, 244–59
Herr, Michael, 252
Herrera, Juan de, 380 n.167
Hettwig, Katherina, 11, 226
Heyden, Kaerle van der, 380 n.149
Heyden, Pieter van der, 222
Hirschvogel, Augustin, 240, 244, 345–46; *figs. 245, 380*

Hogenberg, Nicolas, 335
Holanda, Francisco de, 293, 408 n.294
Holbein, Hans the Elder, 57, 323
Holbein, Hans the Younger, 212, 214, 216, 355–56, 364–65, 378 n.90; *figs. 228–29*
Höltzel, Hieronymus, 217, 352
Hopfer (family), 27, 326, 408 n.296
Hopfer, Daniel, 323–28, 331, 342; *figs. 347–50, 353*
Hopfer, Hieronymus, 323–26, 333; *figs. 351–52*
Hopfer, Lambert, 323
Housebook Master, 5, 24, 57, 61, 62, 95, 311; *fig. 43*
Huber, Wolf, 345
Hubmaier, Balthasar, 338
Hurning, Hans, 146
Hürus, Paulus, 377 n.86
Huys, Frans, 220, 222
Huys, Pieter, 222
Hypnerotomachia Poliphili, fig. 12

illumination (documents and manuscripts), 5, 7–9, 11, 34–36, 46, 48, 57, 64, 81–82, 88, 90, 100, 147, 180, 221, 223, 245, 250, 299, 359
Imhoff (family), 252, 356–57, 411 n.345
Imhoff, Hans the Elder, 357–58
Imhoff, Willibald the Elder, 357
incidit, 288
indulgences, 58, 339
ink, 5, 21, 23, 32, 36, 69–72, 76, 78–79, 94, 108, 190, 270, 314, 335
inscriptions and lettering, 81, 90, 119, 122, 134, 141–46, 162–68, 217, 288–89, 294, 298, 304–07, intarsia, 9, 36, 234, 300, 359
invenit, 144, 147
inventories. *See* collecting (collector's inventories)
invenzione/inventio, 103, 144, 154, 162–65, 284, 287, 294, 297, 299, 300–02, 309, 362–63
Isengrin, Michael, 253
Istanbul, 5, 94–95

Jacob of Strasbourg, 88–89, 147, 150, 178, 300; *fig. 81*
Japanese woodcuts, 29
de Jesu (family), 301
Jobin, Bernard, 358
Joris, David, 14
Judenschutz, 338

Kammermeister, Sebastian, 39, 40
Karlstadt, Andreas, 217
Kinkelbach, Matthias Quadt von, 354–55
Koberger, Anton, 10, 16, 19, 38–39, 40, 42–44, 177, 223, 242, 349, 350
Koberger, Hans, 242
Kohl, Paul, 339–40, 342, 351
Kolb, Anton, 16, 43, 237, 300
Költerer, Jörg, 209
Köln, Franz von, 23
Kraemer, Nikolaus, 356
Kupferwurm, Heinrich, 395 n.118

Labacco, Antonio, 302
Lafrery, Antonio, 6, 103, 122, 132, 168, 287, 302–05, 307, 308, 346, 361–63, 365–66
Lambrecht, Joos, 236
Lampsonius, Domenicus, 358, 361
Landino, Christoforo, 108
Landshut, 339
Landshut, Mair von, 78, 180, 187; *figs. 189–90*
Lautensack, Hanns, 345–46; *figs. 379, 381*
Lautensack, Heinrich, 355
Lautensack, Paul, 226
Lazzarelli, Ludovico, 98, 295
Lefevre, Jacques. *See* Jacob Faber
Legname, Giovanni Filippo dal, 95
Leiden, 8, 200–21, 316, 412 n.375
Leiden, Hans, 30
Leinberger, Hans, 8
Leipzig, 212, 217, 225; University of, 217
Lendinara, Lorenzo Canozi di, 36
Leo X, Pope, 150, 301
Leo, Ambrosius, 88
Leonardo da Vinci, 117, 120, 163, 183, 240, 264, 284, 328, 400 n.6, 406 n.267

Leto, Pomponio, 100, 119
lettering. *See* inscriptions
Leu, Hans, 348
Leyden, Baron van, 386 n.157
Liberale, Giorgio, 255
libraio. See market (shops)
Liefrinck, Cornelis, 178, 200, 212, 220–21, 223, 231, 391 n.14, 396 n.136
Liefrinck, Hans (also called Jan), 220–23, 227, 231, 236, 373 n.4, 396 n.136
Liefrinck, Myncken, 221, 396 n.136
Liefrinck, Willem, 209, 220, 396 n.136
Liefrinck, Willemyne, 220
Liesvelt, Jacques van, 222
Lippi, Filippino, 95, 116–17; *fig. 109*
Little Masters, 315–16, 319, 326, 356
Lombard, Lambert, 236
Lotto, Lorenzo, 295
Louvain, 8–9
Lübeck, 30
Lucas van Leyden, 6, 21, 28, 31–32, 61, 123, 200, 233, 293, 316–19, 322, 326–28, 332–33, 335, 346, 348, 351, 354, 358, 364, 393 n.59, 396 n.144, 402 n.69; *figs. 338–40, 363–64, 382–83*
Lucchese, Michele, 308
Lunardi, Camillo, 99
Luther, Martin, 52, 58, 216, 339, 342, 353. *See also* Reformation
Lützelburger, Hans, 212–14, 216–17
Lyons, 10–11, 216

Magellan, Ferdinand, 243
Magnus, Albertus, 250
Mainz, 2, 34, 44, 52, 245, 247, 394 n.95
Malines, 334, 409 n.294
Mander, Carel van, 32, 317, 332, 351, 354–55, 365
Mansion, Collard, 35
Mantegna, Andrea, 4, 9, 24, 38, 50, 56, 65–72, 74, 76, 78–79, 83, 87–90, 100–03, 107, 112–14, 117, 120, 125, 130–31, 134, 178, 291–93, 311, 313, 364, 387 n.25, 393 n.51, 408 n.296, 409 n.313; *figs. 45–51, 67, 76, 99–101, 103–05, 107*
Mantua, 9, 71–72, 79, 83, 90, 100, 102, 112, 178, 389 n.141
Manutius, Aldus, 9, 35, 38, 44, 382 n.43
maps, 8–9, 13, 22, 26, 30, 43–44, 88, 221, 234–35, 237, 240–44, 259, 286, 289, 295, 349, 362–63
Marcolini, Francesco, 301
Margaret of Austria, 353, 355–56, 408 n.294
margins, 91–94
Maria, Duchess of Parma, 361
market, 8, 12–13, 95, 222–23, 285–86, 322, 345, 347–58 passim; fairs and shrines, 91, 163, 303; handling and transport, 95, 101; peddlers, 98, 347–48, 359; shops, 12–15, 72, 86, 95–98, 295, 297, 299–304, 362. *See also* Frankfurt Fair; prices for prints
Marolles, Phillipe de, 367
Marquis Francesco. *See* Gonzaga
Marsilio, Antonio, 289
Massys, Cornelis, 14
Massys, Jan, 14
Master Aegidius, 353
Master ES, 4, 46–52, 57, 59, 65–66, 76, 347, 379 n.118, 384 n.85; *figs. 20, 21, 22, 23, 58*
Master FP, 270, 271
Master FvB, 354
Master HFE, 271
Master IAM of Zwolle, 402 n.95
Master IB with the Bird, 404 n.184. *See also* Palumba, Giovanni Battista
Master IICA, 271
Master LCZ, 78
Master LD, 309; *fig. 324*
Master NH, 212–13; *figs. 224–26*
Master of 1515, 271; *fig. 283*
Master of Balaam, *fig. 1*
Master of St. Wolfgang, 95
Master of the Banderoles, 59, 62, 382 n.53
Master of the Beheading of St. John the Baptist, 264; *fig. 270*
Master of the Berlin Passion, 57
Master of the Die, 121, 130, 163, 167–68, 303–04

Master of the Dutuit Mount of Olives, 384 n.112
Master of the Karlsruhe Passion, 382 n.55
Master of the Playing Cards, 4, 65–66, 95, 373 n.6; *fig. 3*
Master of the Vienna Passion, 67, 94–95
Master PM, 55; *fig. 31*
Master PP, 264; *fig. 271*
Master S, 356
Mattioli, Pier Andrea, 255–56, 258
Maximilian I, Emperor, 9, 29, 43, 176, 178, 184, 187, 200, 202, 206–13, 217–18, 221, 224, 231, 235, 311, 318, 322, 331, 333, 338, 351, 356
Mechelen, 2, 30
Meckenem, Israhel van, 5, 24, 50, 52, 54, 56–59, 61–65, 102, 237, 298, 311, 327, 354–55, 382 n.53, 397 n.152; *figs. 6, 28, 32–42, 44*
Meda, Antonio, 107
Medici (family), 82
Medici, Antonio di Bernardo de', 94
Medici, Cardinal Giulio de', 166
Medici, Cosimo de', 288, 294, 308
Medici, Lorenzo de', 99
Mehmed II, Sultan, 94
Meinhard, Andreas, 234–35
Meit, Conrad, 353
Melanchthon, Philip, 358
Meldemann, Nicolaus, 223, 227–28, 231, 237, 240; *figs. 233–34*
Meldolla, Andrea, 270, 286; *fig. 281*
Melone, Altobello, 402 n.87
Memling, Hans, 48
Mercator, Gerard, 244
Mergentheim, 395 n.114
metalcuts, 26
metalpoint, 65, 180, 183, 312, 315, 319–20
metalwork, 5, 7–8, 11, 26–27, 46, 48, 50, 57, 107, 207, 315, 347, 355, 359. *See also* armor
Meyer, Albrecht, 399 n.229
Meyerpeck, Wolfgang, 255
Meyr, Cunrad, 16
Michelangelo Buonarroti, 95, 119, 143–44, 147, 163, 165–66, 285–88, 294–95, 304, 308, 360, 362–63, 377 n.73, 408 n.292, 412 n.13
Michelino, Domenico di, 162–63; *fig. 173*
Michiel, Marcantonio, 289, 292, 344
Milan, 17, 24, 90, 101, 107, 117, 120, 163, 264, 289, 303, 348; Santa Maria delle Grazie: 163
Milan, Pierre, 309
Minuziano, Alessandro, 301–02
Mirandola, Pico della, 99, 287
Mocetto, Girolamo, 9, 80, 88, 90, 101, 114–15, 408 n.296, 409 n.313; *fig. 106*
Modena, Nicoletto da, 9, 76, 79–80, 89, 102, 298, 305, 402 n.87; *figs. 63, 68, 91, 318*
Monogrammist AG, 54
Monogrammist PS, *fig. 378*
monograms. *See* signatures
Montagna, Benedetto, 9, 38, 101–02
Montefeltro, Duke Federigo da, 95
More, Thomas, 214
Moretus, J.J., 31
Morgiani, Lorenzo, 38
Muenster, Sebastian, 243–44
multi-plate, multi-block prints. *See* scale
Munich, 10, 339
Münster, 59
Müntzer, Thomas, 217

Negker, David de, 202, 212
Negker, Jost de, 198, 200–02, 207–09, 211–12, 217–18, 221
Nelle, Johan, 17
Neudörfer, Johann, 12, 217, 236, 358, 379 n.134
Neusohl, 349
Neuss, 59
New World, 243, 257
news sheet, 223, 227, 237, 259
Niccolò di Lorenzo, 108
nielli, 26, 67–68, 79, 94, 98–99, 110, 315
night scene, 125
Nordlingen, 146
numbering. *See* plates
Nuremberg, 5, 9, 10–12, 16, 20–21, 35, 38, 42–44,

Index

46, 52, 64, 144, 172, 174, 207, 209, 214, 217–18, 223–27, 229–30, 232–36, 240–42, 252, 309, 311, 315, 323–24, 338–39, 346–49, 351–52, 354–55, 357–58, 364–65, 392 n.39; Diet of, 225; Katharinenkloster, 22
Nuremberg *Weltchronik*, 38–43, 354; *figs. 15–17*

Olmütz, Wenzel von, 54–55, 57; *fig. 27*
Order of St. George, 187
Orley, Bernard van, 356
Ortelius, Abraham, 244, 365
Osiander, Andreas, 224
Ostendorfer, Michael, 339–40, 351; *figs. 373–74*
Otmar, Johan, 391 n.25
Otto prints, 89, 95
Overbeck, Mattheusen von, 412 n.375

Pacioli, Luca, 240, 244, 284
Padua, 8, 9, 88, 91, 95, 101, 293, 299, 365, 391 n.16
Palumba, Giovanni Battista, 99, 102, 404 n.184; *fig. 90*
Pannartz, Arnold, 95
paper, 1, 13–21, 30, 32, 40, 43, 106, 297, 299, 314; colored, 76, 78, 94, 180, 183, 187, 191, 270, 273–74, 346; sizing, 17, 20
Paris, 8–10, 19–20, 26, 28–29, 216, 309, 377 n.65, 379 n.129
Parma, 308, 360; Santa Maria della Steccata, 292
Parmigianino (Francesco Mazzuoli), 6, 22, 103, 146, 154–55, 157, 159, 169, 266–67, 269, 270–72, 287, 289, 292, 294, 299, 308–09, 320, 344, 362–63, 407 n.270; *figs. 157, 165, 273–80*
Parys, Sylvester van, 220–22
paste prints, 26–27, 64, 350, 392 n.40
Pasti, Matteo de', 36
Patinir, Joachim, 351
pattern books and sheets, 14, 48, 51, 68, 74, 90, 104, 180, 260, 345
Paumgartner, Hans, 200, 207, 212
Peasants' War, 217, 225
Pecchia, Marco del, 296
Peeters, Martin, 222, 373 n.4
Pencz, Georg, 217, 223, 315, 357
Penni, Giovan Francesco, 123, 128, 130–31, 154, 162
Penni, Luca, 167
Pepys, Samuel, 367
Pera, 94
Perugino, Pietro, 88, 163
Peruzzi, Baldassarre, 153–54, 284
Pescia, Piero Pacini da, 38
Petrarch, Francesco, 249
Petri, Johann, 38, 216
Petruzzo (Florentine rag dealer), 376 n.58
Peutinger, Conrad, 178, 184, 190, 207, 209, 212; *Romanae Vetustatis fragmenta, fig. 196*
Phillip II, Emperor, 20
Pico Master, 36
Piero della Francesca, 101
Pietersz., Doen, 233
Pinicianus, Johannes, 17
Pino, Paolo, 345
pinxit, 147
Pio, Giovanni Battista, 99
Pirckheimer, Willibald, 20, 241–43, 252, 289, 349, 357–58, 364, 411 n.345
Pisa, Camposanto, 162
plague images, 46, 58, 169, 239, 260
Plantin, Christopher, 20–21, 29, 220–22, 365, 377 n.77, 378 n.103
platemark, 16
plate tone and surface tone, 6, 80, 267–71, 315
plates, 14, 24, 27, 49, 73, 95, 106, 112, 121–22, 132–36, 271; burnishing, 24, 73, 112, 128, 314; materials, 23, 26, 28, 30, 104, 168, 273, 285, 289, 294–95, 331, 345; numbering, 122; ownership, 50, 57, 101, 122, 136–42, 150, 155–59, 295, 298–99, 303–04, 308, 360; pentimenti, 107, 113, 138, 159, 318; scoring, 127, 271
Plattner, Felix, 250
playing cards, 2, 5, 9–11, 36, 295, 347, 386 n.163
Pleydenwurff, Hans, 38–40
Pliny the Elder, 100, 190, 214, 245
Plock, Hans, 52–53

Polderlein, Hans, 224
Poliziano, Angelo, 99
Pollaiuolo, Antonio, 8–9, 73–74, 76, 83, 88, 94, 98, 101–02, 134, 212, 301, 311, 313; *figs. 56–57*
Polybius, 94
popular prints, 22, 219, 301
Pordenone, Giovanni Antonio, 159
Power of Women, 234–35
Prague, 255
Praun, Paul, 412 n.375
presses, 13–14, 16, 21, 28–30, 69–70, 72, 106–07, 206, 274, 342
Prevedari, Bernardo, 24, 26, 30, 70, 104, 106–07, 122, 147, 385 n.127, 402 n.87; *figs. 92–94*
prices for prints, 43, 236–37, 295–97, 300, 350, 369
Primaticcio, Francesco, 309
printing problems, 69–72, 106, 108, 190, 198, 309, 326, 339, 342–43
Priscianese, Francesco, 404 n.206
privileges, 43, 150, 167, 220, 237, 253, 295, 299–302, 308–09, 360–62
proof states, 184, 208, 210, 242–43, 292, 313–14, 335, 405 n.224
Prügner, Nikolaus, 252
Prustinck, Loy, 14
Ptolemy, 241–43, 252
publishers of prints, 103, 122, 136, 150, 166, 219–23, 288, 298–309, 360–63, 365–66, Chapter VII passim

Quiccheberg, Samuel, 366–67

Raimondi, Marcantonio, 5, 6, 30–31, 56–57, 76–78, 80, 99–100, 102, 113, 117, 119–23, 125, 127–28, 130–34, 136–39, 141, 143–47, 150, 154, 159, 162–63, 225–26, 232, 261, 264–67, 269, 271–72, 284–85, 287, 289, 290, 292–99, 303, 305–06, 308–09, 319–20, 322, 327–29, 333, 346, 348, 357, 360–63, 365, 402 n.87, 408 n.292; *figs. 60, 89, 111–13, 115, 117, 121, 125–26, 128–29, 132–39, 141, 144, 148, 150–51, 272, 302, 313, 316, 319*
Raphael, 13, 31, 57, 76, 100, 102, 113, 119, 120–25, 127–28, 130–31, 133, 136–38, 141, 143–46, 150, 154, 159, 162–63, 166–67, 240, 287–89, 292, 294, 296, 299, 302, 309, 319–20, 327, 344, 348, 351, 357, 360, 362–63, 377 n.83, 396 n.144; *figs. 114, 118–20, 122–24*
Ratdolt, Erhard, 177, 180, 184, 190, 200, 207, 340, 381 n.13
Ravenna, 5, 95
Ravensburg, 19, 21
Reformation, 12, 14, 52, 58, 170, 177, 216–18, 222, 224–25, 229–30, 239, 252, 285, 326–27, 335, 342, 347–48, 364–65, 413 n.25; *See also* Martin Luther
Regensburg, 337–40, 342, 345, 347; Synagogue, 337–44; *figs. 371–72. See also Schöne Maria*
Reggio, Simone da, 113
remarques, 100
Rembrandt van Rijn, 21, 80, 367–68, 407 n.270, 411 n.359
René, Duke of Lorraine, 243
replicas and versions, 73, 131–41, 153–54, 269, 273, 288, 322
reproductive prints, 4, 47–49, 57, 103–67, 222, 284, 287–88, 305–08, 336, 360–63, 366
Resch, Wolfgang, 178
restituit, 288
return stroke, 69, 74
Reuwich, Erhard, 35, 44, 245
reversal of images, 22–23, 55, 57, 106, 112–17, 124–41, 159, 221, 250–51, 253, 273. *See also* transfer techniques
rework, 74
Riario, Pietro, 100, 119
Ripanda, Jacopo, 100, 117, 119, 130; *fig. 110*
Ripoli, Convent of S. Jacob, 377 n.73
Robetta, Cristofano, 9, 76, 89, 90, 102
Romano, Giulio, 123, 128, 130–31, 141, 154, 162, 225–26, 287–88, 292, 297–98, 363; *fig. 127*
Rome, 6, 10, 28, 57–58, 91, 99–100, 103, 108, 117, 119–21, 128, 141, 143, 146, 150, 153–55, 159–60, 162, 168, 198, 225, 240–41, 266, 272, 284, 289, 292, 294–95, 297–98, 301–05, 307–08, 339, 346,

348, 360–61, 363, 365; Palazzo Chigi, 166; Sack of, 120, 122, 141, 146, 154–55, 159, 266, 302, 360, 364; Santa Maria sopra Minerva, 162; Sistine Chapel, 304
Rosselli, Alessandro di Francesco, 12–13, 16, 20, 23, 29, 240, 295, 297, 347
Rosselli, Cosimo, 73, 95
Rosselli, Francesco, 9, 12–13, 24, 29, 72–74, 76, 83, 88–89, 94–95, 108, 110, 112, 240, 244, 284, 287, 295, 297, 363; *figs. 53–55, 73–75, 80, 97*
de' Rossi (family), 132
Rösslin, Eucharius, 253
Rosso Fiorentino, Giovanni Battista di Jacopo (called il Rosso), 146, 159–60, 297, 299, 309; *figs. 167, 169*
Rouen, 11
Rubieri, Jacopo de, 5, 90, 94, 366
Rudolf II, Emperor, 399 n.218, 412 n.375
Ruel, Jean, 253, 255, 258
Rusch, Nicolaus, 34

Sabellico. *See* Vicovaro
Sachs, Hans, 22, 223–24, 227–28, 230
Sadeler (family), 354
Saint-Dié, 243
Salamanca, Antonio, 6, 103, 122, 132, 166, 302–04, 307–08, 346, 361, 363, 365
Salamanca, Francesco, 303
Salimbeni, A.M., 99
Salviati, Cardinal Giovanni, 294
Salviati, Francesco, 286, 288, 293–94, 362–63
Sandrart, Joachim, 356
Sandro, Bartolomeo di, 377 n.73
Sansovino, Jacopo, 286, 294
Santi, Giovanni, 100
santini, 36, 266, 301
Sanuto, Giulio, 286
Saragossa, 21
Sarto, Andrea del, 120, 163
Savonarola, Girolamo, 95, 297
scale, 43–45, 70, 83–89, 99, 104, 110, 119, 142, 150, 160, 166, 231–37, 265, 294–95, 300
scalpsit/sculpsit, 288, 306
Scardeone, Bernardino, 293
scatoline d'amore, 89
Schäufelein, Hans, 208–09, 212, 353, 394 n.83; *fig. 219*
Schedel, Hartmann, 5, 38–39, 42–43, 64–65, 95, 207, 240, 354, 366
Schiavone. *See* Andrea Meldolla
Schmid, Hans, 351
Schöffer, Peter, 245, 394 n.95
Schön, Erhard, 223–24, 233; *figs. 232, 236*
Schöne Maria of Regensburg, 339–42; *figs. 373–75*
Schöner, Johannes, 241
Schongauer, Martin, 4, 50–58, 65, 95, 172, 217, 252, 293, 311, 313–15, 319, 354, 401 n.47, 402 n.69; *figs. 24–26, 29, 30*
Schönsperger, Johann, 208, 212, 382 n.37, 394 n.83
Schott, Johann, 247, 250, 252–54, 256, 398 n.199
Schott, Peter, 34
Schreyer, Sebald, 38–40, 42
Schwarzenberger, Hans, 225, 397 n.157
Scorel, Jan, 233, 408 n.292
Scultori, Giovanni Battista, 21, 167, 306
Seghers, Hercules, 368
Serlio, Sebastiano, 222–23
Sforza, Gian Galeazzo, 101
Sibutus, 176
Sicily, 121
Siena, 153, 272; Cathedral, 300
signatures and signature tablets, 49, 54, 57, 191–92, 74, 89, 101–02, 104, 141–46, 202, 286, 291–92, 298, 300–04, 313, 322, 330, 355, 362
silhouetting, 91
silverpoint. *See* metalpoint
sizing. *See* paper
Soderini, Pietro, 284
Solis, Virgil, 223
Soresini, Domenego de, 295
Sorg, Anton, 34
Spadini, Giovan Domenico, 297
Speckle, Veit Rudolf, 399 n.229

Spira, Johannes de, 301
Springer, Balthasar, 177, 184
Springinklee, Hans, 209
Stabius, Johann, 224, 395 n.119, 397 n.152
stampiglia, 36
stamping, 26, 217–18, 339
states, 74, 122, 281
Steigel, Heinz, 224
stenciling, 14, 221, 340
stereotyping, 26–27
stipple engraving, 261–62
Stosch, Baron Philippe de, 95
Stoss, Veit, 8
Strabo, 243
Strasbourg, 8–12, 34, 47, 63, 147, 223, 243, 247, 309, 350, 356, 365
Swart, Jan, 222
Sweitzer, Contz, 347
Sweynheim, Conrad, 95, 379 n.123

textile printing, 1, 21
Theophilus, 1
Theophrastus, 258
Tibaut, Pieter Janszoen, 226
Titian, 38, 100, 146, 150, 220, 236–37, 262, 285–87, 290, 294, 299–301, 308–09, 361–63, 365; *figs. 152, 242, 305*
tone block. *See* chiaroscuro prints
Tramezzini, Francesco, 301
Tramezzini, Michele, 301
transfer techniques, 22–23, 34, 41, 106, 110–17, 124–30, 154, 273, 314, 318–20, 334. *See also* reversal of images
Trechsler, Melchior, 216
Treitsauerwein, Marx, 218
Trent, Council of, 361
Trento, Antonio da, 146, 154–55, 157, 159, 267, 270, 289, 299; *fig. 162*
Treviso, 295
Troyes, 20, 28
Tucher, Anton, 351, 353–54
Tucher, Hans, 352
Turin, 88
Turkey, Ottoman Empire, 91, 94, 220, 227–28, 237, 240, 310, 329
Turrecremata, Johannes, 162
type and type-faces, 9, 13, 19, 26, 36, 42, 184

Uberti, Lucantonio degli, 87, 163, 213, 301, 389 n.144, 402 n.87
Udine, Giovanni da, 305
Ulm, 9–10, 34
unfinished plates and blocks, 88, 107, 204
Urbino, 95, 150

Vaga, Perino del, 159, 168, 288, 297
Valgrisi, Vincenzo, 255
Valturius, Robertus, 36
Vanni, Lippo, 385 n.124
Vasari, Giorgio, 22, 35, 101, 103, 119–23, 127, 130–31, 144, 146, 153, 155, 157, 159, 167, 179, 284–88, 292, 294–95, 297, 302, 316, 348, 354, 358, 362, 363, 365, 377 n.83
Vatican, Stanza di Eliodoro, 121
Vauzelles, Jean de, 216
Vavassore, Zoan Andrea (called Guadagnino), 398 n.144
Vellert, Dirk, 30, 333–36, 346, 356; *figs. 360–62, 368–70*
Vendramin, Gabriele, 289–92, 294, 297
Veneto, Dominio, 300
Veneziano, Agostino, 120–23, 128, 130–33, 136–39, 142–46, 150, 154, 159–60, 162–63, 167, 198, 286, 288–89, 293, 299, 302–03, 306, 360, 363; *figs. 130–31, 142–43, 170, 175, 304, 306*
Venice, 5, 8–12, 16, 18–19, 28, 35–36, 38, 43–44, 46, 88, 90–91, 95, 98–100, 102, 115, 119–21, 125, 180, 198, 206, 212, 226, 236, 255, 261–62, 264, 284–85, 287, 289, 292, 295, 298–302, 311, 316, 344, 347, 360, 364–65, 389 n.138, 390 n.170, 392 n.39, 393 n.51, 398 n.183; Church of SS. Giovanni e Paolo, 115; *fig. 106*; Consiglio dei Dieci, 362; Senate, 45, 147, 150, 299–301, 308
Venier, Giovanni Antonio, 289
Vercelli, 302
Verona, 16, 17, 19, 35–36, 285–86, 361
Verrocchio, Andrea, 115
Vesalius, Andreas, 212, 257
Vettori, Pietro, 404 n.206
Vicentino, Niccolò, 157, 159; *fig. 166*
Vico, Enea, 165, 167, 221, 284–88, 290, 293–95, 303–04, 306, 308–09, 362–63, 379 n.117; *figs. 303, 310–11*
Vicovaro, Antonio Coccio da (called il Sabellico), 301
Vienna, 176, 212, 218, 227, 240, 381 n.31, 410 n.325, 412 n.375

Villamena, Francesco, 122
Vincidor, Tommaso, 146, 351
Virgil, 95
Virtuosi del Pantheon, 302
Vitruvius, 100, 222–23
Vittoria, Alessandro, 21
Vogtherr, Heinrich the Elder, 212
Volterra, Daniele da, 403 n.170
Voragine, Jacopo da, 34, 38

Waldseemüller, Martin, 243, 398 n.195; *fig. 247*
wall decoration. *See* display
Walther, Friedrich, 146
watermarks, 15–19, 74, 396 n.139. *See also* countermarks
Weiditz, Hans, 212, 247, 249–50, 252–55; *figs. 254, 256–57, 261*
Weigel, Christoff, 31
Welser Corporation, 177, 391 n.14
Weyden, Rogier van der, 47–48, 413 n.29
Wierix (family), 223
Wimpheling, Jacob, 57, 65, 354
Wittenberg, 174, 197, 234–35, 364, 413 n.25; University, 174
Wolgemut, Michael, 38–40, 42–44, 174, 355
wood engraving, 23, 281
woodblocks: alteration of, 192, 197, 200, 208–10; cutters, 6, 9–11, 23, 28, 30, 34, 36, 38–39, 41, 43, 45–46, 88, 147, 159, 272, 284, 287, 300–01, Chapter V passim, 322, 339, 361; materials, 21–23, 150, 204, 289, 390 n.170; ownership of, 40, 153, 211, 218, 224, 295, 300, 360
workshops or *botteghe*, 12–15, 68, 73, 94–95, 98, 107, 120, 131, 146, 150, 155, 287, 295–97, 302–09, 355–56
Württemberg, 378 n.89
Würzburg, 24

Yusuf-cha-Mirza, Prince, 385 n.148

Zainer, Günther, 10, 34
Zainer, Johannes, 34
Zanoti, Antonio, 299
Zatti, Battista, 298
Zeising, Heinrich, 31
zig-zag stroke, 74–76
Zurich, 17, 22, 348